2 0 0 0
ARTIST'S & GRAPHIC DESIGNER'S MARKET

2,500 PLACES TO SELL YOUR ART & DESIGN

EDITED BY

MARY COX

WRITER'S DIGEST BOOKS
CINCINNATI, OHIO

Praise for
Artist's & Graphic Designer's Market

"Good marketing info was never more important to the young or established illustrator. Here it is . . . concise, up-to-date, effective."

—Terrence Brown
Faculty, School of Visual Arts
Director, Society of Illustrators

If you are an editor, art director, creative director, art publisher or gallery director and would like to be considered for a listing in the next edition of *Artist's & Graphic Designer's Market*, send a SASE (or SAE and IRC) with your request for a questionnaire to *Artist's & Graphic Designer's Market*—QR, 1507 Dana Ave., Cincinnati OH 45207. Questionnaires received after March 13, 2000, will be held for the 2002 edition.

Managing Editor, Annuals Department: Cindy Laufenberg
Supervisory Editor: Barbara Kuroff
Production Editor: Tricia Waddell

Writer's Digest website: http://www.writersdigest.com

International Standard Serial Number 1075-0894
International Standard Book Number 0-89879-913-9

Attention Booksellers: This is an annual directory of F&W Publications. Return deadline for this edition is December 31, 2000.

contents at a glance

Contents

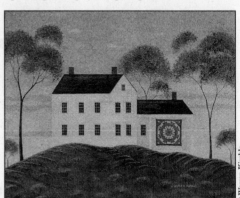

Page 10

© Warren Kimble

The Markets

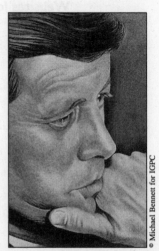

© Michael Bennett for IGPC

Page 357

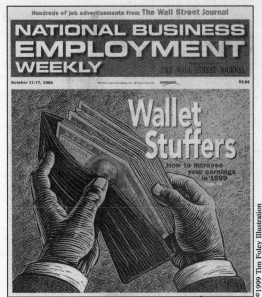

Page 171

Page 531

From the Editor

I know a little bit about you. I know you have artistic talent and you're creative. I know you have dreams, and you're willing to work to make them come true. The fact that you hold this book in your hands tells me that.

You and I and the listings in this book are partners of sorts. I work to find out who's buying artwork and creative services. Art directors, publishers and gallery dealers participate by spelling out their needs in their listings. You do your part by researching listings and sending samples according to professional standards. Two silent partners in this endeavor are Action and Time.

In this business of ours we need a Board of Directors. For President of our Board, I nominate Leonardo da Vinci. He was so innovative and creative—ahead of his time. He never fails to inspire me to do my best. I know, he's not exactly available for meetings, but, hey, it's an *imaginary* Board, so why not get the best?

Alyssa Deal, art director for Liggett-Stashower, one of the listings in this book (page 617), commissioned this marvelous drawing of da Vinci for a B.F. Goodrich Aerospace marketing campaign. When completing the assignment, illustrator Mark Summers rendered the face to resemble da Vinci's famous self-portrait, "but with a slight push towards caricature." Notice the subtle way he softened the expression and added the master's expressive hand holding one of the magnificent flying machines from his journals.

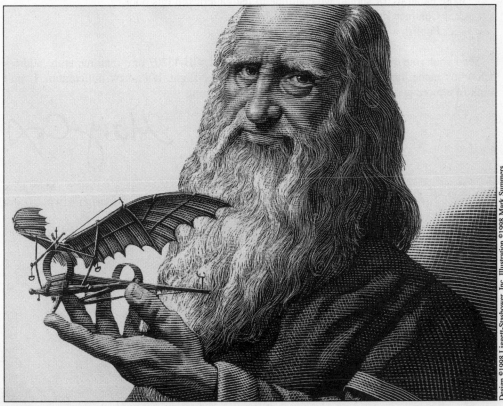

Design ©1998 Liggett-Stashower, Inc. Illustration ©1998 Mark Summers

You'll find this and other pieces of art throughout the pages of this book. Each piece is chosen purposefully to show you the kinds of artwork listings use. Perhaps more importantly, the art shows the *caliber* of art expected from you. The articles in this book are important, too. If you're looking for inspiration, read our features on **Warren Kimble** (page 9) and **Dean Mitchell** (page 364)—and take the advice of Gibson Greetings designer **Linda Butler** on page 36.

This book works.

But don't take my word for it. If you have any doubts, just read *Artist's & Graphic Designer's Market* Success Stories on page 347. Listen as art directors **Jon Schindehette** of Wizards of the Coast, **Valerie Sanford** of Silver Wave Records and art buyer **Christine Molitor** of The Zipatoni Co. reveal what they need from you.

Help us decide what to call this book.

Most of our readers are illustrators, fine artists and cartoonists. The few designers I hear from do double-duty as illustrators. To make sure the book's title reflects the readership, we want your vote. All votes received by March 30, 2000 will be entered into a drawing for $100 worth of art books from North Light Books. **Cast your vote!**

 1. Rate your top three choices (first choice #1, second choice #2, etc.):

 _____ *Artist's & Graphic Designer's Market*

 _____ *Artist's & Illustrator's Market*

 _____ *Artist's, Illustrator's & Cartoonist's Market*

 _____ *Illustrator's, Animator's & Cartoonist's Market*

 _____ *Illustrator's Market*

 2. Would you like a separate market book for galleries and fine art markets so we can list more galleries, or should we continue to list galleries in this book?

 _____ Continue listing galleries in this book

 _____ Publish a separate book of gallery listings

Send your vote to me at 1507 Dana Ave., Cincinnati, OH 45207 or e-mail me at the address below my name. In the meantime, let your dreams take flight. It's a new millennium. I can't think of a more perfect time to take off on a new beginning.

Mary Cox

Mary Cox
artdesign@fwpubs.com

P.S. Don't forget to cast your vote by March 30, 2000. Leonardo and I are counting on you!

Quick-Start Guide to Selling Your Work

I'd like to let you in on a little secret. No matter how often we artists tell ourselves we create for the pure joy of it, and that it doesn't matter whether anyone ever *sees* our art, there's nothing quite like the heady, exciting feeling of seeing your work published or hanging in a gallery! It feels great! Your self-esteem goes through the roof and you're walking on air for days!

If you haven't ever felt that thrill, I hope this book will help you experience it —just once. Once you've tasted it, you just might get hooked!

That's not to say you won't get your share of rejection as you begin submitting to potential clients and galleries. I can safely say you will. It's just part of being an artist. But if you hang in there and learn from your experiences along the way, I guarantee you'll be well on your way to a great freelance career.

This article is written for artists who have never used this book before. (If any of you old hands are still reading, you have my blessing to skip to the next article or go in search of new listings in your favorite section.)

What you'll find in this book

Artists sometimes tell us this 720-page book is overwhelming (one artist referred to it as "a formidable tome"). Don't worry, it's really not that difficult to navigate. Here's how.

The book is divided into five parts:
1. Articles about the business of art
2. Section introductions
3. Listings of companies and galleries
4. Insider Reports
5. Indexes

You are here

This guide is one of several articles to prepare you for the challenge of sending your work to listings. Every article is important—especially for first-time users of *AGDM*—so don't just skip to the listings. There's a lot to learn (like how to prepare your promotional samples) before you are ready to send out your work.

Section "intros" and listings: the heart of this book

Beyond this section, the book is further divided into 12 market sections, from Greeting Card companies to Record Labels (See Table of Contents for complete list) Each section begins with an introduction explaining how to enter markets in that section. Following section introductions, you will find Insider Reports and listings.

What are listings?

Ah, listings! They are the life's blood of this book—and our most popular feature. In a nutshell listings are names, addresses and contact information of places that buy or commission artwork, along with a description of the type of art they need. Why listings? Because to make money from your work you need to send samples of it to people who will pay for it. But more about those all-important listings later.

What are Insider Reports?

Insider Reports are interviews with artists and experts from the art world. "Insiders," as we call them, include valuable clues. We suggest you read all of them—even those not directly related to your area of interest. Since Insiders give you a richer understanding of the marketplace, you'll gain an important edge over artists who skip them.

Take advantage of Indexes

We provide 16 indexes to help you narrow your search for markets seeking specific styles and genres. Refer to the Special Markets Index starting on page 689. They'll lead you to listings looking for **Calendars**; **Calligraphy**; **Collectibles**; **Fashion**; **Humor & Cartoons**; **Informational Graphics**; **Licensing**; **Medical Illustrations**; **Multimedia Skills**; **Religious Art**; **Science Fiction & Fantasy Art**; **Sport Art**; **T-shirts**; **Textiles**; and **Wildlife Art**.

NOW, LET'S GET STARTED!

How *AGDM* "works"

Following the instructions in the listings, we suggest you send out samples of your work to a dozen (or more) targeted listings. The more listings you send to, the greater your chances. If you have talent and persistence, listings will contact you to either publish, show or buy your work. Sound simple? Hold on. You've got to follow a few rules to do it right.

Your six-point action plan

We've identified six steps to follow to gain freelance assignments or gallery opportunities through this book. (Skip one step and the whole process falls to pieces!)

1. **Identify a section**, or sections of this book most likely use the type of work you create. Be sure to use the Special Market Indexes if you specialize in a certain type of work. (See Which Listings are Best for You? on page 8 and learn more about indexes later in this article).
2. **Narrow your search** to at least a dozen "target" markets. Each listing includes several paragraphs of vital information about that market. With your highlighter or a bookmark handy, read and evaluate that information to find listings that might need your work. (See How to Read Listings and Guidelines for Working With Listings on page 5 to learn how to target markets.)
3. **Mail out samples** of your work according to the preferences of each listing.(See Successful Self-promotion on page 15 for help with samples.) Mail at least 12 samples at a time—preferably more. Sending samples is like sowing seeds. You've got to sow a lot of "seeds" to grow your business. After a few months, send follow-up samples to your target listings.
4. **Keep researching** and adding listings to your mailing list and continue sending out samples. With luck and persistence, you will be contacted by one of the art directors or gallery dealers you have mailed samples to.
5. **When you are contacted** for an assignment or portfolio review, give it all you've got. Do the best job you can and make every deadline.
6. **Repeat steps 1-4** as many times as your schedule and budget permits. When September 2001 arrives, buy the next edition of *AGDM*. Add new listings to your mailing list and look for checkmarks so you can quickly update your mailing list. Read articles and "Insiders" for ideas and inspiration.

Putting this action plan to work is the first step in launching your new venture. In the excitement of finally getting your first assignments, remember not to quit your day job until you have enough paying assignments and/or patrons to pay your expenses and keep you busy every day.

In the meantime, join an artist's group so you can network with your peers and learn more about your profession.

How to read listings

Each listing contains a description of the artwork and/or services it prefers. The information often reveals how much freelance material is used by each market, whether computer skills are needed, and which software programs are preferred.

In some sections, additional subheads help you identify potential markets. Magazine listings specify needs for cartoons and illustrations. Galleries specify media and style.

Editorial comments, denoted by bullets (•), give you extra information about markets, such

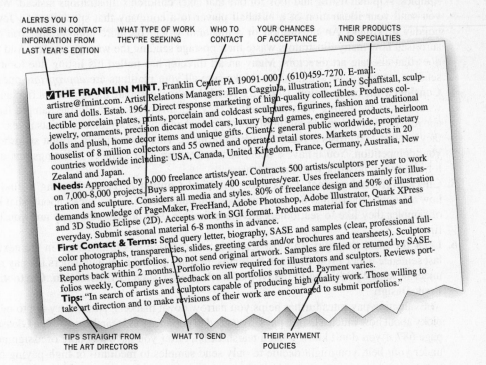

ALERTS YOU TO CHANGES IN CONTACT INFORMATION FROM LAST YEAR'S EDITION

WHAT TYPE OF WORK THEY'RE SEEKING

WHO TO CONTACT

YOUR CHANCES OF ACCEPTANCE

THEIR PRODUCTS AND SPECIALTIES

☑**THE FRANKLIN MINT**, Franklin Center PA 19091-0001. (610)459-7270. E-mail: artistre@fmint.com. Artist Relations Managers: Ellen Caggiula, illustration; Lindy Schaffstall, sculpture and dolls. Estab. 1964. Direct response marketing of high-quality collectibles. Produces collectible porcelain plates, prints, porcelain and coldcast sculptures, figurines, fashion and traditional jewelry, ornaments, precision diecast model cars, luxury board games, engineered products, heirloom dolls and plush, home decor items and unique gifts. Clients: general public worldwide, proprietary houselist of 8 million collectors and 55 owned and operated retail stores. Markets products in 20 countries worldwide including: USA, Canada, United Kingdom, France, Germany, Australia, New Zealand and Japan.

Needs: Approached by 8,000 freelance artists/year. Contracts 500 artists/sculptors per year to work on 7,000-8,000 projects. Buys approximately 400 sculptures/year. Uses freelancers mainly for illustration and sculpture. Considers all media and styles. 80% of freelance design and 50% of illustration demands knowledge of PageMaker, FreeHand, Adobe Photoshop, Adobe Illustrator, Quark XPress and 3D Studio Eclipse (2D). Accepts work in SGI format. Produces material for Christmas and everyday. Submit seasonal material 6-8 months in advance.

First Contact & Terms: Send query letter, biography, SASE and samples (clear, professional full-color photographs, transparencies, slides, greeting cards and/or brochures and tearsheets). Sculptors send photographic portfolios. Do not send original artwork. Samples are filed or returned by SASE. Reports back within 2 months. Portfolio review required for illustrators and sculptors. Reviews portfolios weekly. Company gives feedback on all portfolios submitted. Payment varies. Those willing to take art direction and to make revisions of their work are encouraged to submit portfolios."

Tips: "In search of artists and sculptors capable of producing high quality work. Those willing to take art direction and to make revisions of their work are encouraged to submit portfolios."

TIPS STRAIGHT FROM THE ART DIRECTORS

WHAT TO SEND

THEIR PAYMENT POLICIES

as company awards, mergers and insight into a listing's staff or procedures.

It takes a while to get accustomed to the layout and language in the listings. In the beginning, you will encounter some terms and symbols that might be unfamiliar to you. Refer to the Glossary on page 687 to help you with terms you don't understand.

Listings are often preceded by symbols, which help lead the way to new listings Ⓝ , changes ☑ and other information. When you encounter these symbols, refer to the inside flap of the book for a complete list of their meanings.

Guidelines for working with listings

1. **Read the entire listing to decide whether to submit your samples!** Do NOT use this book simply as a mailing list of names and addresses. Reading listings helps you narrow your mailing list and send the kind of submissions those listed here want.
2. **Read the description of the company or gallery in the first paragraph of the listing.** Then jump to the **Needs** heading to find out what type of artwork the listing prefers. Is it the type of artwork you create? This is the first step to narrowing your target market. You should only send your samples to listings that need the kind of work you create.

3. **Send appropriate submissions.** It seems like common sense to find out what kind of subject matter and samples a listing wants before sending off just any artwork you have on hand. But believe it or not, some artists skip this step. We get letters all the time from companies listed in this book. Often, they thank us for introducing them to new artists. But unfortunately they often complain about receiving inappropriate submissions from *AGDM* readers.

What's an inappropriate submission? I'll give you an example. Suppose you want to be a children's book illustrator. Well, you wouldn't send your sample of a little girl and her pet rabbit to *Business Law Today* magazine, would you? Of course not. They would rather see an illustration of a business or law subject. If you don't like to draw business samples, skip that listing and look for one that takes children's illustrations instead. Would you send your illustration of a baseball player to a company that specializes in Jewish holiday greetings? An illustration of a menorah would be more appropriate. You'd be surprised how many illustrators waste their postage sending the wrong samples. And boy, does that alienate art directors. Many an art director has pulled his listing due to artists sending inappropriate submissions. Make sure all your mailings are *appropriate* ones.

4. **Consider your competition.** Under the **Needs** heading, compare the number of freelancers who contact the listing with the number they actually work with. In the sample listing above, you'll notice the Franklin Mint is approached by 3,000 freelance artists a year. Yet they contact 500 artists a year to work on projects. This gives you an instant snapshot of your competition. You'll have a better chance sending your samples to listings that use a lot of artwork or work with many artists.

5. **Check preferred contact**. Look under the **First Contact & Terms** heading to find out how to contact the listing. Some companies and publishers are very picky about what kind of samples they like to see; others are more flexible. Just do what they say and you'll be fine!

6. **Look for what they pay.** In most sections, you can find this information in the next-to-last sentence under **First Contact & Terms**. Magazines and book publishers list pay rates under headings pertaining to the type of work you do, such as **Illustration**, **Cartoons** or **Book Design**.

Evaluating pay rates further helps you narrow down markets. At first, try not to be too picky about how much a listing pays. You need experience (and tearsheets!— see **Glossary**, page 687 if you don't know what a tearsheet is). After you have a couple of assignments under your belt, you might decide to only send samples to medium- or high-paying markets.

Try as we might to gather pay rates, many art directors are not willing to share this information with us. If the pay rate is not stated, other clues within the listing can help you determine what they probably pay. If a magazine does not state rates, the circulation figure can help. If circulation is anywhere from 50,000 or above they probably pay fairly well. If it is below 50,000 they might not have a very large budget for freelancers. Compare the circulation with a magazine with a similar circulation figure to see what the magazine probably pays. In book publishers, check to see how many books they publish a year. If they publish 100 or more books a year, they will undoubtedly pay more than the publisher who only publishes one or two books a year.

7. **Be sure to read the "tips!"** Artists tell me the information within the **Tips** really helps them get a feel for what a company is really like, and gives them valuable clues about the type of material to send. Read them!

These steps are just the beginning. As you become more advanced in reading listings, you will think of more ways to mine this book for your best clients. Some of our readers tell us they peruse listings to find the speed at which a magazine pays its freelancers. In publishing, it's often a long wait until an edition or book is actually published, but if you are paid on "accep-

tance" you'll get a check reasonably quick. Because many illustrators prefer working with publishers who pay on acceptance, the word "acceptance" is bolded in listings to make it easier to find.

When looking for galleries, savvy artists often check to see how many square feet of space is available and what hours the gallery is open. These details all factor in when narrowing down your search for target markets.

Pay attention to copyright information

It's also important to consider what **rights** listings buy. It is preferable to work with listings that buy first or one-time rights. If you see a listing that buys "all rights" be aware you may be giving up the right to sell that particular artwork in the future. (See Copyright FAQs on page 29 and Do's and Don'ts of Licensing on page 34 for specifics on which rights to retain.)

Look for specialties and niche markets

In the Advertising, Design and Related Markets section, we tell what kind of clients an ad agency has. If you hope to design restaurant menus, for example, you can target agencies that have restaurants for clients. But if you don't like to draw food-related illustration, and prefer illustrating people, you might target ad agencies whose clients are hospitals or financial institutions. If you like to draw cars, you should look for agencies with clients in the automotive industry, and so on. Many book publishers specialize, too. Look for a publisher who specializes in children's books if that's the type of work you'd like to do.

Read listings for ideas

You'd be surprised how many artists found new niches to approach by browsing the listings. One greeting card artist was browsing through listings and read about a company that produces mugs. A lightbulb went off. Now this artist has added mugs to her repertoire, along with paper plates, figurines and rubber stamps—all because she browsed the listings for ideas!

Sending out samples

Once you narrow down some target markets, the next step is sending them samples of your work. As you create your samples and submission packets, be aware your package or postcard has to look professional. It must be up to the standards art directors and gallery dealers expect. Look at the samples sent out by other artists on pages 16 and 17. Make sure your samples rise to that standard of professionalism.

New year, new listings

Use this book for one year. Highlight listings, make notes in the margins, fill it full of Post-it notes. In September of the year 2000, our next edition—the 2001 *Artist's & Graphic Designer's Market*—starts arriving in bookstores. By then, we'll have collected hundreds of new listings and changes in contact information. It is a career investment to buy the new edition every year. (And it's deductible! See our business article on page 22.) If you buy it every other year, as many artists do, you will be missing a lot of new listings and changes.

Becoming a professional

The most important information in this book isn't the listings. We have found that artists who have the most success using this book are those who take the time to read the articles and Insider Reports to learn about the bigger picture. In our Insider Reports, you'll learn what has worked for other artists, and what kind of work impresses art directors and gallery dealers.

You'll find out how joining professional organizations such as the **Graphic Artists Guild (G.A.G.)** or the **American Institute of Graphic Arts (AIGA)** can jump start your career. You'll find out the importance of reading trade magazines to learn more about the industries you hope

to approach. You'll learn about trade shows, portfolio days, websites, art reps, shipping, billing, working with vendors, networking, self-promotion and hundreds of other details it would take years to find out about on your own. Perhaps most importantly, you'll read about how successful artists overcame rejection through persistence.

In fact, the articles and interviews are so important, some artists go to the library and look up past editions just to read the interviews for additional strategies and hints.

Being professional doesn't happen overnight. It's a gradual process. I would venture to say that only after two or three years of using each successive year's edition of this book will you have garnered enough information and experience to be a true professional in your field. So if you really want to be a professional artist, hang in there. Before long, you'll feel that heady feeling that comes from selling your work or seeing your illustrations on a greeting card or in a magazine. If you really want it, and you're willing to work for it, it *will* happen.

Which Listings Are Best for You?

Listings are divided into sections such as Book Publishers or Magazines. Your talents could be marketable in several sections. Scan this list for opportunities in your area of interest:

Fine art. Galleries; Posters & Prints; and Greeting Cards, Gifts & Products will be your main markets, but Book Publishers; Magazines; Advertising, Design & Related Markets; and Record Labels seek illustration with a fine art feel.

Sculpture and crafts. Galleries is an obvious choice, but Advertising Design & Related Markets list companies that hire sculptors to create models and displays. Product manufacturers located in the Greeting Cards, Gifts & Products section hire sculptors to create ornaments and figurines. You can market your work as 3-D illustrations to companies listed in Magazines and Book Publishers.

Cartoons and comic strips. Greeting Cards, Gifts & Products; Magazines; Book Publishers; Advertising Design & Related Markets include listings that seek humorous illustrations and cartoons. Comic strip creators should look under Syndicates & Cartoon Features.

Illustration. Check Greeting Cards, Gifts & Products; Magazines; Book Publishers; Record Labels; Stock Illustration & Clip Art Firms; Advertising, Design & Related Markets.

Architectural rendering, medical and fashion illustration. Check Magazines, Book Publishers and Advertising, Design & Related Markets.

Calligraphy. Look under Book Publishers; Greeting Cards, Gifts & Products; and Advertising, Design & Related Markets.

Airbrush art. Look under Greeting Cards, Gifts & Products; Posters & Prints; Magazines; Book Publishers; and Advertising, Design & Related Markets.

Storyboards. Look under Advertising, Design & Related Markets.

Design and production. Check Greeting Cards, Gifts & Products; Magazines; Posters & Prints; Book Publishers; Record Labels; and Advertising, Design & Related Markets.

Multimedia design and animation. Check the Animation & Computer Games section. The Multimedia Index will steer you to additional listings in need of your skills.

T-shirts, mugs and toys. Check Greeting Cards, Gifts & Products; and Advertising, Design & Related Markets.

Warren Kimble: All-American Artist

BY ANNE BOWLING

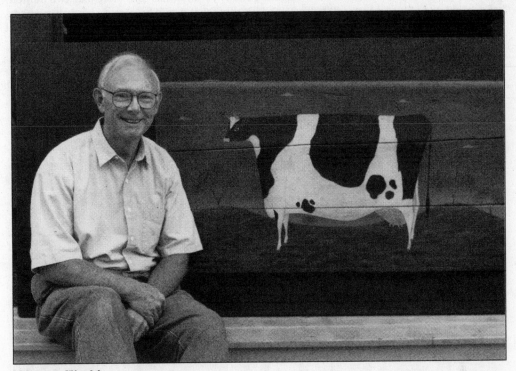

Warren Kimble

For painter Warren Kimble, success has been a very sweet surprise. The Vermont-based painter spent the better part of four decades working as everything from commercial artist to elementary school art teacher before discovering success waited for him in what he loved best. At 64, Kimble has become one of the country's best-known living folk artists, but not before he saw his share of lean years, struggling to stay in the field while supporting his family. "I always knew that painting was what I wanted to do, what I had to do," Kimble says.

Kimble spent time working at an advertising agency, created art for supermarket circulars, sold antiques and taught. During his years in the service, he worked in the Army's arts and crafts studio. "I wasn't allowed to be a painter, right? You had to make a buck," Kimble says, "so I was an advertising major because my father wanted me to do something that made money." He also spent years taking weekend tours of regional antique and folk art shows with his early American-inspired scenes of New England and stylized barnyard animals painted in acrylics on antique architectural fragments. It wasn't until the early '90s that a representative from Wild

ANNE BOWLING *is a production editor on* Writer's Market, *and a frequent contributor to* Writer's Digest Books.

Apple Graphics in Woodstock, Vermont spotted his work and proposed a series of poster prints.

Since that first series of prints was produced, Kimble designs and artwork can be found on products from calendars and coffee mugs to wallpaper and dishes. This year Kimble's art finds its way onto a line of textiles and accessories, and Kimble design makes its way into furniture, with the introduction of Lexington Industries' Warren Kimble collection Life Style. Meanwhile, there seems to be no limit to the public's appetite for Kimble prints—his rustic barns, Colonial homes, American flags and signature Holstein cows (afficionados note the Vermont-shaped patches on their flanks). And since that original contract, Kimble has seen more than two million reprints created of his artwork, all to generate an income that would have made his father proud.

"What happened to me, it just happened," Kimble says of his encounter with success. "I didn't make it happen, I didn't think it was going to happen, I always told my students it doesn't happen to most people, but it did."

Back in the days when his studio was a corner of the kitchen, Kimble found in his teaching a way to play with media in new and exciting ways—batik, ceramics, printmaking. "I've done everything because I had to learn it while teaching," he says. "What you don't know you have to find out rather quickly because you're doing something different every week. Then at night,

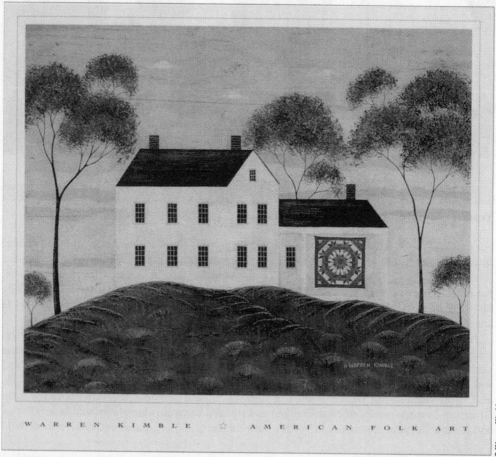

WARREN KIMBLE ☆ AMERICAN FOLK ART

© Warren Kimble

Rural Vermont scenes such as *House with Quilt* have become familiar around the world through Warren Kimble's work. This poster is sold through Wild Apple Graphics and signed prints are available through Kimble's website, http://www.warrenkimble.com.

I'd come home and I'd be so excited about some of these techniques that I'd then take them further."

That spirit of experimentation found its way into Kimble's work early—it was in the late '60s that he first began painting on antique boards. "I experimented with some folk art then, and I sold some," he recalls. "It wasn't great, but it was okay. Every now and then someone calls me and says, 'I have one of those.' I think I sold them for $35 each, which I thought was a lot of money then. They were on wood, but I didn't even know then that I had to treat the wood with gesso, so I'm amazed they're still surviving."

It took years of experimentation—working in abstracts, painting with transparent watercolors, and creating what he affectionately refers to as 'attic art'—before Kimble could get beyond his Syracuse University teaching that good art had to be serious art. He returned to folk art in the late '80s, and went on to develop his singular style. "When I picked up the folk art again, friends and fellow artists whom I respect said, 'this is finally you. You're a little humorous, and it's finally coming out that it's you, and it's not trying to be something you're not.' I think that's what some artists try to discover their whole lives. It took me all these years to find it out."

Today, Kimble's studio has moved from the kitchen to a restored, 200-year-old barn on his Vermont property, crowded with paintings, handmade birdhouses and a collection of sand pails that recall his boyhood trips to the Jersey shore. Here Kimble paints from 8 a.m. to 5 p.m. each day to keep up with the demands of his booming licensing business. His original work is shown at his own gallery in Brandon and another in a neighboring Vermont town. And his images and designs can be found nearly everywhere else.

"When we did the furniture introduction for the showrooms last year in North Carolina, I was supposed to be sitting there painting," Kimble recalls, "and people would come up and say we know your work, and we love it, but we don't know you. And they were embarrassed, but I would say to them that's the best compliment you can give me. You didn't buy my work because it was Warren Kimble, you bought it because you liked it. It wasn't the name. What better compliment could an artist get?"

Here Kimble takes a break to discuss licensing, painting, and what gives his work its popular appeal.

How do you account for the widespread popularity of your work?

We all work so darn hard night and day, we need something in our lives that creates serenity or gives us peace. What people tell me is that my paintings evoke that feeling with a little bit of whimsy. It makes them feel good. And I think that's the crux of it. People's lives are so busy they have to find peace in their surroundings. And that's what the popularity of folk art is, the softness and the easy lines, and the warmth and serenity of the whole thing.

You've mentioned Jasper Johns, Andrew Wyeth and Picasso as influences. What was it about their art you responded to?

I was influenced by Jasper Johns' flags, which I loved. I just like his experimentation with printmaking, and his work is rather simple too, they're abstract and simple but recognizable. Picasso, I like his craziness, the fun of it. It's really fun and whimsical. I don't think people want to look at it that way, but it is. And Wyeth, just the realism and the painterly quality and the brush strokes. He is very abstract too, although nobody thinks about it as being abstract. Even Jamie (Wyeth) is abstract, in not the same sense of the word people think of as being abstract. Not unrecognizable. And I love abstract. Because of my teaching and background, I do a lot of abstract painting, but nobody ever sees them, because nobody wants to see them.

Also, the English animal portraits of the 1850s had an influence—I saw those for years in the antiques business buying and selling folk art. Those artists influenced me in the sense that cows and pigs at that time were bred to be very fat for their meat content, and they were grossly obese, which made their heads and legs look smaller, so that's why the proportions are so off.

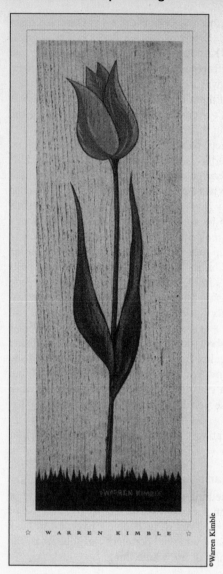

☆ W A R R E N K I M B L E ☆

The texture and grain of weathered boards and scrubbed tabletops suggest images to Kimble. He searches for the right marriage between texture and image, as in this tulip print, one of a series of four floral panels.

That's how they looked—I just took it a little further, maybe a little too far. So that's where that comes from, plus a little bit of me and a little bit of whimsy.

What prompted you to paint on antique boards?

I probably did something for the house painted on the top of a table for a coffee table or something, and saw the grain of the wood coming through and enjoyed that. I was an antiques dealer for 30 some years, so I handled many wonderful country pieces. It was mostly pine and soft woods—not oak, oak grain is so distinctive, you can't kill it. It's like plywood, if you do anything on plywood it still looks like plywood. That's not bad, but it's like continuing to paint on canvas that has the same weave. To me, that's uninteresting.

What I paint on are primarily old tabletops, and I am especially enamored of them because sometimes they'll have somebody's initials carved in them, or they've been cut on with a knife, they've been dinged, they've been spilled on, and it creates a wonderful surface, a worn surface.

You mentioned that you saw air currents in the sky from the grain of the wood—that's from washing the table a lot. It's what's called a scrubbed top. If you scrub a tabletop for 50 years, it's bound to bring up the grain a little bit and create those lines. I go antiquing into shops and barns and auctions, and I buy old tables and take the tops off, or an old bread board, and they really have to be special.

People are always trying to give me old boards, and I have to say, 'I'm sorry, but this is part of the painting to me.' I search for these things and when I see a board I know I want it feels good to me, it looks good, it has a textural quality that just says something to me. And I may not use it for a year. I decide to do a painting of something, and I'll look through my whole collection of boards—I've got maybe 20 or 25—and I'll leaf through them and I may not find one that's good for that painting, so I may have to go looking for another one, or put that idea off until I find that board, or I may go out tomorrow and find a board and say, 'Ah, that has to have something on it, this image belongs on that board, it feels right.' That doesn't happen with canvas, because canvas is always the same.

So choosing the wood is part of the process?

It is, very much so. And now I've gotten into doing some other surfaces, and in fact I just finished working with cheesecloth—it's a rag surface—and I glue it on an old board, and stretch it out and wrinkle it here and there, and it looks like an old-fashioned crazy quilt. It's a wonderful surface, so I'm trying to do some experimental surfaces at this point.

In order to grow you have to keep doing different things and trying different things, all the time you have to keep throwing paint, or putting it down, or finding out what it will do—you can't just keep doing the same thing over and over again or you don't grow.

Are there things you do outside your folk artwork that you do strictly for your own pleasure that aren't making the kind of business waves that your folk art is?

I do enough experimentation here with what I'm doing that satisfies me enough to not have to do other things. I don't feel confined right now. Maybe someday I will get back to doing those things, but I did for so many years, because of teaching and coming home at night and experimenting, that I guess it's okay. Sometimes in your life you have to say it's okay. You don't have to do anything. If I wasn't happy doing what I'm doing, then I'd have a problem. People always say to me, 'Don't you feel badly about not being able to do other things?' And I don't.

What is your painting schedule?

I still paint every day, and I work from eight or 8 or 8:30 a.m. until 5 p.m. in my studio. People are so shocked at that. People think artists aren't supposed to work or something. I think they must think that we work in a bubble, or that we must be dreamers.

If I don't keep painting, nothing is going to happen around here. And that's one of the problems with licensing, if you find yourself being in demand—'do this for this year, and do this and this'—and I get some of that. But you have to create new work, you can't just use the old all the time. And that's a gift, too, because I have to keep growing in this, not changing drastically but doing new things, and new experimentation, because if I don't, it's over.

When did you first hire an agent, and how is that relationship valuable for an artist just starting out?

It was after the prints started coming out at Wild Apple Graphics, and the prints took off, and it was obvious other licensees were coming on board and I needed someone to control that because although I'm not a bad business person I wanted to be a painter, not a business person. And so I got an agent—I just got one—I knew nothing about it or any of this business. And that agent went out and sold me.

The licensing thing escalates with notoriety. The more well-known you are, the more licenses

you get and the more people want to put you on something. Your best ally in that is your agent. Your agent is your protector, because they take care of contracts that you don't know too much about and you have to learn about, they take care of writing those correctly, and getting the best for you, and then after they get that they have to service that account and make sure that the licensee does right by you and does good things by you. As an example, in all my contracts I get to see everything before it's ever produced. I can say I don't like the way that's on there, or my name is too big, or it's not big enough, or I don't like the color, the color needs correcting.

Some critics say that with your prints and licensing agreements, your work has become too commercial. How do you respond to them?

If I had not participated in all the licensed products and so forth, my paintings would still be in the attic. But what better gift could an artist have than to have his work seen by two and a half million people, plus all these other licensed products? Most times if you're selling a painting, it goes in someone's house, and how many people see it after that? A few. The people who own it, maybe a few friends and relatives, but essentially it's buried and you never see it again. And if people feel good about what I do, what a gift. People tell me how good my work makes them feel, and what better gift could an artist have? Picasso and Cézanne are all on note cards now, and they are dead, so they don't know it. And I don't know how they would react or how they would feel, but if they're like me it would feel good.

Do you have any parting advice for developing artists?

It's good to work toward showing your work and getting it out there and so forth, but if you go in with the attitude that you want to be famous, I think that's a problem, because it just doesn't happen to everyone, and it isn't something you can make happen. It's timing, place, your ability—it can happen but it doesn't happen to many of us, so it's kind of a waste of time to work with that in mind. You should just work and enjoy it, and if it happens, it happens.

To see more of Warren Kimble's work, visit his website at http://www.warrenkimble.com.

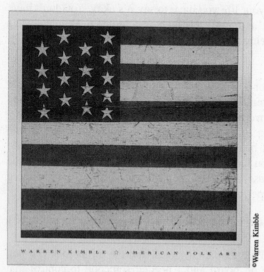

Colonial Flag, an 18 × 18 print, is typically American, typically Kimble (with maybe a nod to Jasper Johns).

Successful Self-promotion

Once you have identified your target listings in this book, the next step is introducing yourself to them by sending promotional samples. Since samples are your most important sales tool, it's important to put a lot of thought into what you send.

We divided this article into three sections, so whether you are a fine artist, illustrator or designer, check under the appropriate heading for guidelines. Read individual listings for more specific instructions.

As you read the listings, you'll see the term SASE, short for self-addressed, stamped envelope. Enclose a SASE with your submissions if you want your material returned. If you send postcards or tearsheets for art directors to keep on file, no return envelope is necessary.

We've included several samples in this section, but be sure to read *Artist's & Graphic Designer's Market* Success Stories, beginning on page 347, for more good ideas.

GUIDELINES FOR ILLUSTRATORS AND CARTOONISTS

Illustrators have several choices when submitting to markets. Many freelancers send a cover letter and one or two samples in initial mailings. Others prefer a simple postcard showing their illustrations. Here are a few of your options:

☑ **Postcard.** Choose one (or more) of your illustrations that is representative of your style, then have the image printed on postcards. Have your name, address and phone number printed on the front of the postcard, or in the return address corner. Somewhere on the card should be printed the word "Illustrator." If you use one or two colors you can keep the cost below $200. Art directors like postcards because they are easy to file or tack on a bulletin board. If the art director likes what she sees, she can always call you for more samples.

☑ **Promotional sheet.** If you want to show more of your work, you can opt for an 8×12 color or black and white photocopy of your work.

☑ **Tearsheets.** After you complete assignments, acquire copies of any printed pages on which your illustrations appear. Tearsheets impress art directors because they are proof that you are experienced and have met deadlines on previous projects.

☑ **Photographs and slides.** Some illustrators have been successful sending photographs or slides, but printed or photocopied samples are preferred by most art directors.

☑ **Query or cover letter.** A query letter is a nice way to introduce yourself to an art director for the first time. One or two paragraphs stating you are available for freelance work is all you need. Include your phone number, samples or tearsheets.

If you send 8×12 photocopies or tearsheets, do not fold them in thirds. It is more professional to send them flat, not folded, in a 9×12 envelope, along with a typed query letter, preferably on your own professional stationery.

Humorous illustrators and cartoonists should follow the same guidelines as illustrators when submitting to publishers, greeting card companies, ad agencies and design firms. Professional-

What makes a great illustration sample?

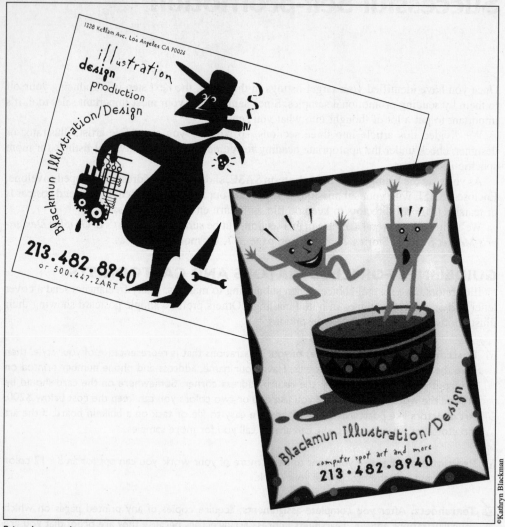

©Kathryn Blackman

Printed postcards are a great way to send examples of your illustration style to art directors. Kathryn Blackmun, a Los Angeles illustrator/designer, regularly sends samples showing illustrations she has created for recent assignments. Notice her clever technique of showing additional artwork on the back of the card. Blackmun has had great success sending frequent mailings to magazines and book publishers. She has picked up assignments from *Nailpro, Income Opportunities, National Business Employment Weekly, The New Times, The San Francisco Bay Guardian* and Alfred Publishing. The jumping chips on the above sample originally appeared as a spot illustration for *Stanford Magazine.*

looking photocopies work well when submitting multiple cartoons to magazines. When submitting to syndicates, refer to the introduction for that section on page 528.

GUIDELINES FOR DESIGNERS AND COMPUTER ARTISTS

Plan and create your submission package as if it were a paying assignment from a client. Your submission piece should show your skill as a designer. Include one or both of the following:

What makes a great design sample?

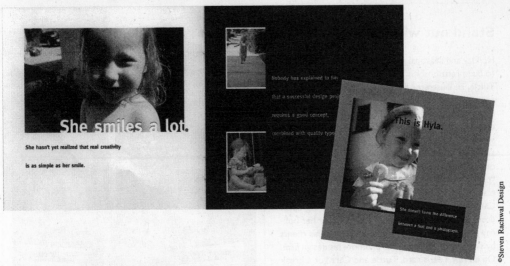

©Steven Rachwal Design

Brochures and booklets make ideal promotional vehicles for designers because they show off both your design sense and computer know-how. Steven Rachwal designed this 6-page 4¾ × 4¾ booklet to market his one-man design firm, Steven Rachwal Design. Rachwal's little girl, Hyla, helped out by looking adorable. The copy reads (in part): "This is Hyla. She doesn't know the difference between a font and a photograph. She smiles a lot . . . Nobody has explained to her that a successful design project requires a good concept, combined with quality typography and imagery . . . She likes to eat. And if you work with me I can assure you she will."

☑ **Cover letter.** This is your opportunity to show you can design a beautiful, simple logo or letterhead for your own stationery. Have the stationery printed on good paper. Then write a simple cover letter stating your experience and skills.

☑ **Sample.** Your sample can be a copy of an assignment you have done for another client, or a clever self-promotional piece. Design a great piece to show off your capabilities. For ideas and inspiration, browse through *Fresh Ideas in Promotion*, edited by Lynn Haller and *Creative Self-Promotion on a Limited Budget*, by Sally Prince Davis (North Light Books).

How to stand out from the crowd

Your potential clients are busy! Piles of samples cross their desks each day. They may spend only a few seconds glancing at each sample while making their way through the "slush" pile (an industry term for unsolicited submissions). Make yourself stand out in simple, effective ways:

☑ **Tie in your query letter with your sample.** When sending an initial mailing to a potential client, include a query letter of introduction with your sample. Type it on a great-looking letterhead of your own design. Make your sample tie in with your query letter by repeating a design element from your sample onto your letterhead. List some of your past clients within your letter.

☑ **Send artful invoices.** After you complete assignments, a well-designed invoice (with one of your illustrations or designs strategically placed on it, of course) will make you look professional and help art directors remember you (and hopefully, think of you for another assignment!)

☑ **Follow-up with seasonal promotions.** Holiday promotions build relationships while remind-

ing past and potential clients of your services. So get out your calendar now and plan some special promos for one of this year's holidays!

Stand out with holiday promos

Holiday and seasonal promotions are a surefire way to build relationships and name recognition. Jean Tuttle, an illustrator from Dobbs Ferry, New York, created this shiny black cat to send Halloween greetings to her favorite clients. Tuttle printed the cards on photo-quality glossy paper using her Epson color stylist 800 printer. She took a little extra time and actually cut out each sample so the cat's ears stick out, and applied magenta, turquoise and chartreuse "peel and stick" mylar shapes to the cat's eyes to make them glow. Then she mounted each card on Canson's rich color paper. Tuttle's husband, graphic designer James Carr, designs the layout for her holiday promos. Carr sends the same card to his clients by switching the message to promote his design firm. On a New Year's card, Tuttle and Carr got a break on printing costs because they told the the printer he could send it to *his* clients, too—a win-win situation if there ever was one.

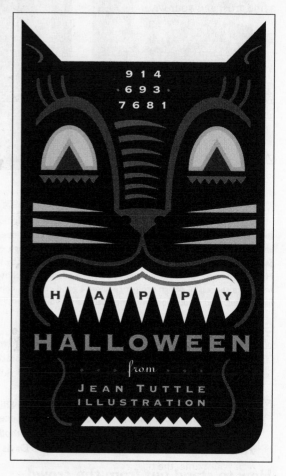

Are portfolios necessary?

You do not need to send a portfolio when you first contact a market. But after buyers see your samples they may want to see more, so have a portfolio ready to show.

Many successful illustrators started their careers by making appointments to show their portfolios. But it is often enough for art directors to see your samples.

Some markets in this book have drop-off policies, accepting portfolios one or two days a week. You will not be present for the review and can pick up the work a few days later, after they've had a chance to look at it. Since things can get lost, include only duplicates that can be insured at a reasonable cost. Only show originals when you can be present for the review. Label your portfolio with your name, address and phone number.

Portfolio pointers

The overall appearance of your portfolio affects your professional presentation. It need not be made of high-grade leather to leave a good impression. Neatness and careful organization

are essential whether you are using a three-ring binder or a leather case. The most popular portfolios are simulated leather with puncture-proof sides that allow the inclusion of loose samples. Choose a size that can be handled easily. Avoid the large, "student" size books which are too big to fit easily on an art director's desk. Most artists choose 11 × 14 or 18 × 24. If you are a fine artist and your work is too large for a portfolio, bring your slides and a few small samples.

☑ Don't include everything you've done in your portfolio. Select only your best work and choose pieces germane to the company or gallery you are approaching. If you're showing your book to an ad agency, for example, don't include greeting card illustrations.

☑ In reviewing portfolios, art directors look for consistency of style and skill. They sometimes like to see work in different stages (roughs, comps and finished pieces) to see the progression of ideas and how you handle certain problems.

☑ When presenting your portfolio, allow your work to speak for itself. It's best to keep explanations to a minimum and be available for questions if asked. Prepare for the review by taking along notes on each piece. If the buyer asks a question, take the opportunity to talk a little bit about the piece in question. Mention the budget, time frame and any problems you faced and solved. If you are a fine artist, talk about how the piece fits into the evolution of a concept, and how it relates to other pieces you've shown.

☑ Don't ever walk out of a portfolio review without leaving the buyer a business card or sample to remember you by. A few weeks after your review, follow up by sending a small promo postcard or other sample as a reminder.

GUIDELINES FOR FINE ARTISTS

Send a 9 × 12 envelope containing material galleries request in their listings. Usually that means a query letter, slides and résumé, but check each listing. Some galleries like to see more. Here's an overview of the various components you can include:

☑ **Slides.** Send 8-12 slides of similar work in a plastic slide sleeve (available at art supply stores). To protect slides from being damaged, insert slide sheets between two pieces of cardboard. Ideally, slides should be taken by a professional photographer, but if you must take your own slides, refer to *Photographing Your Artwork*, by Russell Hart (North Light Books). Label each slide with your name, the title of the work, media, and dimensions of the work and an arrow indicating the top of the slide. Include a list of titles and suggested prices they can refer to as they review slides. Make sure the list is in the same order as the slides. Type your name, address and phone number at the top of the list. Don't send a variety of unrelated work. Send work that shows one style or direction.

☑ **Query letter or cover letter.** Type one or two paragraphs expressing your interest in showing at the gallery, and include a date and time when you will follow up.

☑ **Résumé or bio.** Your résumé should concentrate on your art-related experience. List any shows your work has been included in and the dates. A bio is a paragraph describing where you were born, your education, the work you do and where you have shown in the past.

☑ **Artist's statement.** Some galleries require a short statement about your work and the themes you are exploring. Your statement should show you have a sense of vision. It should also explain what you hope to convey in your work.

☑ **Portfolios.** Gallery directors sometimes ask to see your portfolio, but they can usually judge from your slides whether your work would be appropriate for their galleries. Never visit a gallery to show your portfolio without first setting up an appointment.

☑ **SASE.** If you need material back, don't forget to include a SASE.

Iris prints retain fine art look

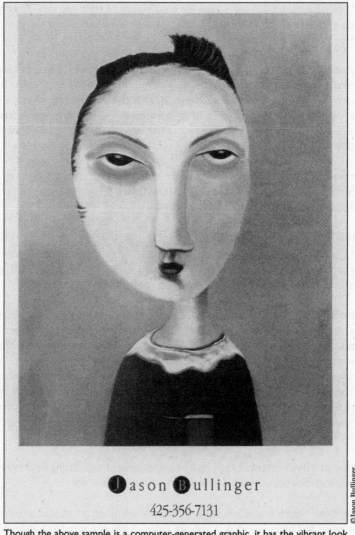

Jason Bullinger
425-356-7131

©Jason Bullinger

Though the above sample is a computer-generated graphic, it has the vibrant look of a fine art print. Jason Bullinger of Everett, Washington, rendered the drawing using a Wacom Drawing Tablet and Painter software. He output this image and 10 others onto a 20×30" sheet using an Iris printer. Bullinger sends out 8½" color sheets as an initial mailing and sends follow-up mailings every 4 months with new images of his work.

Self-promotion Strategies

Self-promotion is an ongoing process of building name recognition and reputation by introducing yourself to new clients and reminding past clients you are still available.

Experts suggest artists spend about one-third of each week and up to ten percent of their gross income on self-promotion. Whether you decide to invest this much time is up to you, but it is important to build time into your schedule for promotional activities.

It's a good idea to supplement your mailings with other forms of self-promotion. There are many additional strategies to make prospective clients aware of you and your work. Consider some of these options:

☑ **Talent directories.** Many graphic designers and illustrators buy pages in illustration and design annuals such as *Black Book*, *The American Showcase* and *RSVP*. These go to thousands of art directors and many keep their directories for up to five years.

A page in one of these directories can run from $2,000 to $3,500 and you have no control over who receives them. Yet, some artists who buy pages claim they make several times the amount they spend. One bonus to these directories is they provide you with up to 2,000 loose pages, depending on the book, to use as samples.

☑ **Media relations.** The media is always looking for good public interest stories. If you've done something unique with your work, send a press release to magazines, newspapers and radio stations. This kind of exposure is free and will help increase public awareness of you and your work.

☑ **Pro bono work.** Donating your design or illustration services to a favorite charity or cause not only makes you feel good—it can be good public relations. These jobs can offer you added exposure and an opportunity to acquaint potential clients with your work. For example, a poster designed for your local ballet company may put your work in front of area business communicators, gallery directors and shop owners in need of artistic services. If you design a brochure for a charity event, you'll reach everyone on the charity's mailing list. Only donate free services to nonprofit organizations in need of help—don't give away work to a client who has the means to pay.

☑ **Networking.** Attending seminars, organization meetings, trade shows, gallery openings and fundraisers is a good way to get your name out. It doesn't hurt to keep a business card on hand.

☑ **Contests and juried shows.** Even if you don't win, contests provide good exposure. Judges of design and illustration contests are usually art directors and editors who may need work in the future. Winners of competitions sponsored by design magazines like *HOW* and *Print* are published in awards annuals that result in national exposure. Since there are many categories and levels of awards there are many chances to win. Judges of fine art shows are often gallery directors. Entering a juried show will also allow you to show your work to the community.

☑ **Home shows.** If you are a fine artist and have a body of work nearly complete, go over your mailing list and invite a select number of people to your home to preview the work. (Before pursuing this option, however, make sure you are not violating any contracts you already have with galleries.)

A Simple Plan for Organizing Your Business

Hate the word "business?" Lots of artists do. But you must have an organized system for keeping track of assignments and sales or you won't make any money and will have to give up your dream. Luckily, it's not hard to set up a few simple systems to keep you on track.

I. KEEP A DAILY RECORD

Visit an office supply store and pick out a journal, ledger or computer software program to keep track of your business expenses and sales. If you are an illustrator or designer, assign a job number to each assignment. Record the date of the project, the client's name, any expenses incurred, sales tax and payments due.

A simple system consists of just two folders per year—one for expenses and one for sales. Every time you purchase art supplies, place the receipt in your yearly "expenses" folder. When you make a sale, photocopy the check or place a receipt in your "sales" folder.

It doesn't matter what system you choose, but you must keep a record of every artwork you sell or every commercial assignment you undertake, along with receipts for every business expense. Keep all receipts, canceled checks, contracts and sales records. Record your expenses daily, showing what was purchased, from whom, for how much and the date. Log automobile expenses separately showing date, mileage, gas purchased and reason for trip. Use your journal or ledger to keep track of mailings to potential clients, galleries and collectors.

2. SET THE RIGHT PRICE

One of the hardest things for artists and freelancers to master is what to charge. It's difficult to make blanket statements about what to charge for illustration and design. Every slice of the market is somewhat different. Nevertheless, there is one recurring pattern: hourly rates are generally only paid to designers working inhouse on a client's equipment. (Clients are more likely to pay hourly if they can easily keep track of the hours freelancers work.) Freelancers working out of their own studios (this is nearly always the arrangement for illustrators) are almost always paid a flat fee or an advance against royalties.

If you are unsure about what to charge begin by devising an hourly rate, taking into consideration the cost of your materials and overhead and what you think your time is worth. (If you are a designer, determine what the average salary would be for a full-time employee doing the same job.) Then estimate how many hours the job will take and quote a flat fee based on these calculations. *Setting the Right Price for Your Design & Illustration*, by Barbara Ganim (North Light Books), includes easy-to-use worksheets to help you set prices for 33 kinds of projects.

There is a distinct difference between giving the client a job estimate and a job quotation. An estimate is a "ballpark" figure of what the job will cost, but is subject to change. A quotation is a set fee which, once agreed upon, is pretty much set in stone. Make sure the client understands which you are negotiating. Estimates are often used as a preliminary step in itemizing costs for a combination of design services such as concepting, typesetting and printing. Flat quotations are usually used by illustrators, as there are fewer factors involved in arriving at fees.

For recommended charges for different services, refer to the *Graphic Artist's Guild's Handbook of Pricing & Ethical Guidelines*. Many artists' organizations have hotlines you can call to find out standard payment for the job you're doing.

As you set fees, certain stipulations call for higher rates. Consider these bargaining points:

☑ **Usage (rights).** The more rights bought, the more you can charge. For example, if the client asks for a "buyout" (to buy all rights), you can charge more because by relinquishing all rights to future use of your work you will be losing out on resale potential.

☑ **Turnaround time.** If you are asked to turn the job around quickly, charge more.

☑ **Budget.** Don't be afraid to ask a project's budget before offering a quote. You won't want to charge $500 for a print ad illustration if the ad agency has a budget of $40,000 for that ad. If the budget is that big, ask for higher payment.

☑ **Reputation.** The more well-known you are, the more you can charge. As you become established, periodically raise your rates (in small steps) and see what happens.

Pricing Your Fine Art

There are no hard and fast rules for pricing your fine artwork. Most artists and galleries base prices on market value—what the buying public is currently paying for similar work. Learn the market value by visiting galleries and checking prices of works similar to yours. When you are starting out don't compare your prices to established artists, but to emerging talent in your region. Consider these when determining price:

☑ **Medium.** Oils and acrylics cost more than watercolors by the same artist. Price paintings higher than drawings.

☑ **Expense of materials.** Charge more for work done on expensive paper than for work of a similar size on a lesser grade paper.

☑ **Size.** Though a large work isn't necessarily better than a small one, as a rule of thumb you can charge more for the larger work.

☑ **Scarcity.** Charge more for one-of-a-kind works like paintings and drawings, than for limited editions such as lithographs and woodcuts.

☑ **Status of artist.** Established artists can charge more than lesser-known artists.

☑ **Status of gallery.** It may not be fair, but prestigious galleries can charge higher prices.

☑ **Region.** Works usually sell for more in larger cities like New York and Chicago.

☑ **Gallery commission.** The gallery will charge from 30 to 50 percent commission. Your cut must cover the cost of materials, studio space, taxes and perhaps shipping and insurance, and enough extra to make a profit. If materials for a painting cost $25; matting, framing cost $37; and you spent five hours working on it, make sure you get at least the cost of material and labor back before the gallery takes their share. Once you set your price, stick to the same price structure wherever you show your work. A $500 painting by you should cost $500 whether it is bought in a gallery or directly from you. To do otherwise is not fair to the gallery and devalues your work.

As you establish a reputation, begin to raise your prices—but do so cautiously. Each time you "graduate" to a new price level, you will not be able to come back down.

3. LEARN TO NEGOTIATE A CONTRACT

Contracts are simply business tools to make sure everyone is in agreement. Ask for one any time you enter into a business agreement. Be sure to arrange for the specifics in writing, or provide your own. A letter stating the terms of agreement signed by both parties can serve as an informal contract. Several excellent books such as *The Artist's Friendly Legal Guide* (North Light Books) provide sample contracts you can copy and *Business and Legal Forms for Illustrators*, by Tad Crawford (Allworth Press), contains negotiation checklists and tear-out forms. The sample contracts in these books cover practically any situation you might run into.

The items specified in your contract will vary according to the market you are dealing with and the complexity of the project. Nevertheless, here are some basic points you'll want to cover:

Commercial contracts

☑ **A description of the service you are providing**.

☑ **Deadlines for finished work**.

☑ **Rights sold**.

☑ **Your fee**. Hourly rate, flat fee or royalty.

☑ **Kill fee**. Compensatory payment received by you if the project is cancelled.

☑ **Changes fees**. Penalty fees to be paid by the client for last-minute changes.

☑ **Advances**. Any funds paid to you before you begin working on the project.

☑ **Payment schedule**. When and how often you will be paid for the assignment.

☑ **Statement regarding return of original art**. Unless you are doing work for hire, your artwork should always be returned to you.

Gallery contracts

☑ **Terms of acquisition or representation**. Will the work be handled on consignment? What is the gallery's commission?

☑ **Nature of the show(s)**. Will the work be exhibited in group or solo shows or both?

☑ **Time frames**. At what point will the gallery return unsold works to you? When will the contract cease to be in effect? If a work is sold, when will you be paid?

☑ **Promotion**. Who will coordinate and pay for promotion? What does promotion entail? Who pays for printing and mailing of invitations? If costs are shared, what is the breakdown?

☑ **Insurance**. Will the gallery insure the work while it is being exhibited?

☑ **Shipping**. Who will pay for shipping costs to and from the gallery?

☑ **Geographic restrictions**. If you sign with this gallery, will you relinquish the rights to show your work elsewhere in a specified area? If so, what are the boundaries of this area?

4. GET PAID

If you are a designer or illustrator, you will be responsible for sending out invoices for your services. Clients generally will not issue checks without them. Most graphic designers arrange to be paid in thirds, billing the first third before starting the project, the second after the client approves the initial roughs, and the third upon completion of the project. Illustrators are generally paid in full either upon receipt of illustration, or on publication. So mail or fax an invoice as soon as you've completed the assignment.

Standard invoice forms allow you to itemize your services. The more you spell out the charges, the easier it will be for your clients to understand what they are paying for. Most designers charge extra for changes made after approval of the initial layout. Keep a separate form for change orders and attach it to your invoice.

If you are an illustrator, your invoice can be much simpler, as you'll generally be charging a flat fee. It's helpful, in determining your quoted fee, to itemize charges according to time, materials and expenses (the client need not see this itemization—it is for your own purposes).

Most businesses require your social security number or tax ID number before they can cut a check so include this information in your bill. Be sure to put a due date on each invoice, include the phrase "payable within 30 days" (or other preferred time frame) directly on your invoice. Most freelancers ask for payment within 10-30 days.

Sample invoices are featured in *The Designer's Commonsense Business Book*, by Barbara Ganim (North Light Books) and *Business and Legal Forms for Illustrators*, by Tad Crawford (Allworth Press).

If you are working with a gallery, you will not need to send invoices. The gallery should send you a check each time one of your pieces is sold (generally within 30 days). To ensure that you are paid promptly, call the gallery periodically to touch base. Let the director or business manager know that you are keeping an eye on your work. When selling work independently of a gallery, give receipts to buyers and keep copies for your records.

5. TAKE ADVANTAGE OF TAX BREAKS

You have the right to take advantage of deducting legitimate business expenses from your taxable income. Art supplies, studio rent, advertising and printing costs, and other business expenses are deductible against your gross art-related income. It is imperative to seek the help of an accountant or tax preparation service in filing your return. In the event your deductions exceed profits, the loss will lower your taxable income from other sources.

To guard against taxpayers fraudulently claiming hobby expenses as business losses, the IRS requires taxpayers to demonstrate a "profit motive." As a general rule, you must show a profit three out of five years to retain a business status. If you are audited, the burden of proof will be on you to demonstrate your work is a business and not a hobby.

The nine criteria the IRS uses to distinguish a business from a hobby are: the manner in which you conduct your business, expertise, amount of time and effort put into your work, expectation of future profits, success in similar ventures, history of profit and losses, amount of occasional profits, financial status, and element of personal pleasure or recreation. If the IRS rules that you paint for pure enjoyment rather than profit, they will consider you a hobbyist. Complete and accurate records will demonstrate to the IRS that you take your business seriously.

Even if you are a "hobbyist," you can deduct expenses such as supplies on a Schedule A, but you can only take art-related deductions equal to art-related income. If you sold two $500 paintings, you can deduct expenses such as art supplies, art books, magazines and seminars only up to $1,000. Itemize deductions only if your total itemized deductions exceed your standard deduction. You will not be allowed to deduct a loss from other sources of income.

How to deduct business expenses

To deduct business expenses, you or your accountant will fill out a 1040 tax form (not 1040EZ) and prepare a Schedule C. Schedule C is a separate form used to calculate profit or loss from your business. The income (or loss) from Schedule C is then reported on the 1040 form. In regard to business expenses, the standard deduction does not come into play as it would for a hobbyist. The total of your business expenses need not exceed the standard deduction.

There is a shorter form called Schedule C-EZ for self-employed people in service industries. It can be applicable to illustrators and designers who have receipts of $25,000 or less and deductible expenses of $2,000 or less. Check with your accountant to see if you qualify.

Deductible expenses include advertising costs, brochures, business cards, professional group dues, subscriptions to trade journals and arts magazines, legal and professional services, leased office equipment, office supplies, business travel expenses, etc. Your accountant can give you a list of all 100 percent and 50 percent deductible expenses (such as entertainment).

As a self-employed "sole proprieter" there is no employer regularly taking tax out of your paycheck. Your accountant will help you put money away to meet your tax obligations and may advise you to estimate your tax and file quarterly returns.

Your accountant also will be knowledgeable about another annual tax called the Social Security Self-Employment tax. You must pay this tax if your net freelance income is $400 or more.

The fees of tax professionals are relatively low, and they are deductible. To find a good accountant, ask colleagues for recommendations, look for advertisements in trade publications or ask your local Small Business Association. And don't forget to deduct the cost of this book.

Home Office Deduction

If you freelance fulltime from your home, and devote a separate area to your business, you may qualify for a home office deduction. If eligible you can deduct a percentage of your rent and utilities, expenses such as office supplies and business-related telephone calls.

The IRS does not allow deductions if the space is used for reasons other than business. A studio or office in your home must meet three criteria:
- The space must be used exclusively for your business.
- The space must be used regularly as a place of business.
- The space must be your principle place of business.

The IRS might question a home office deduction if you are employed fulltime elsewhere and freelance from home. If you do claim a home office, the area must be clearly divided from your living area. A desk in your bedroom will not qualify. To figure out the percentage of your home used for business, divide the total square footage of your home by the total square footage of your office. This will give you a percentage to work with when figuring deductions. If the home office is ten percent of the square footage of your home, deduct ten percent of expenses such as rent, heat and air conditioning.

The total home office deduction cannot exceed the gross income you derive from its business use. You cannot take a net business loss resulting from a home office deduction. Your business must be profitable three out of five years. Otherwise, you will be classified as a hobbyist and will not be entitled to this deduction.

Consult a tax advisor before attempting to take this deduction, since its interpretations frequently change.

Refer to IRS Publication 587, Business Use of Your Home, for additional information. *Homemade Money*, by Barbara Brabec (Betterway Books), provides formulas for determining deductions and provides checklists of direct and indirect expenses.

Whenever possible, retain your independent contractor status

Some clients automatically classify freelancers as employees and require them to file Form W-4. If you are placed on employee status, you may be entitled to certain benefits, but a portion of your earnings will be withheld by the client until the end of the tax year and you could forfeit certain deductions. In short, you may end up taking home less than you would if you were classified as an independent contractor.

The IRS uses a list of 20 factors to determine whether a person should be classified as an independent contractor or an employee. This list can be found in Publication 937. Note, however, that your client will be the first to decide whether or not you will be so classified.

Report all income to Uncle Sam

Many artists are tempted to sell artwork without reporting it on their income tax. You may think this saves money, but in the broader scheme it can do real damage to your career and credibility—even if you are never audited by the IRS. Unless you are reporting your income, the IRS will not categorize you as a professional and you won't be able to deduct your expenses! And don't think you won't get caught if you neglect to report income from clients. If you bill any client in excess of $600, the IRS requires the client to provide you with a form 1099 at the end of the year. Your client must send one copy to the IRS and a copy to you to attach to your income tax return. Likewise, if you pay a freelancer over $600, you must issue a 1099 form. This procedure is one way the IRS cuts down on unreported income.

Report sales tax on art sales

Most states require a two to seven percent sales tax on artwork you sell directly from your studio or at art fairs or on work created for a client, such as art for a logo. You must register with the state sales tax department, which will issue you a sales permit or a resale number, and send you appropriate forms and instructions for collecting the tax. Getting a sales permit usually involves filling out a form and paying a small fee. Reporting sales tax is a relatively simple procedure. Record all sales taxes on invoices and in your sales journal. Every three months, total the taxes collected and send it to the state sales tax department.

In most states, if you are selling to a customer outside of your sales tax area, you do not have to collect sales tax. However, this may not hold true for your state. You may also need a business license or permit. Call your state tax office to find out what is required.

Save money on art supply sales tax

As long as you have the above sales permit number, you can buy art supplies without paying sales tax. You will probably have to fill out a tax-exempt form with your permit number at the sales desk where you buy materials. The reason you do not have to pay sales tax on your art supplies is that sales tax is only charged on the final product. However, you must then add the cost of materials into the cost of your finished painting or the final artwork for your client. Keep all of your purchase receipts for these items in case of a tax audit. If the state discovers that you have not collected sales tax, you will be liable for tax and penalties.

If you sell all your work through galleries they will charge sales tax, but you will still need a tax exempt number so you can get a tax exemption on supplies.

Some states claim "creativity" is a non-taxable service, while others view it as a product and therefore taxable. Be certain you understand the sales tax laws to avoid being held liable for uncollected money at tax time. Write to your state auditor for sales tax information.

6. LEARN YOUR WAY AROUND THE POST OFFICE

If you are an illustrator or designer sending out samples, you can save big bucks by mailing bulk. Fine artists should send submissions via first class mail for quicker service and better handling. Package flat work between heavy cardboard or foam core, or roll it in a cardboard tube. Include

For More Information

Most IRS offices have walk-in centers open year-round and offer over 90 free IRS publications to help taxpayers. Some helpful booklets include Publication 334—Tax Guide for Small Business; Publication 505—Tax Withholding and Estimated Tax; and Publication 533—Self Employment Tax. Order by phone at (800)829-3676. There's plenty of great advice on the Internet, too. Check out the official IRS website: http://www.irs.ustreas.gov/prod/cover.html. Fun graphics lead you to information and you can even download tax forms.

If you don't have access to the Web, the booklet that comes with your tax return forms contains addresses of regional Forms Distribution Centers you can write to for information. The U.S. Small Business Administration offers seminars on taxes, and arts organizations hold many workshops covering business management, often including detailed tax information. Inquire at your local arts council, arts organization or university to see if a workshop is scheduled.

your business card or a label with your name and address on the outside of the packaging material in case the outer wrapper becomes separated from the inner packing in transit.

Protect larger works—particularly those that are matted or framed—with a strong outer surface, such as laminated cardboard, masonite or light plywood. Wrap the work in polyfoam, heavy cloth or bubble wrap and cushion it against the outer container with spacers to keep from moving. Whenever possible, ship work before it is glassed. If the glass breaks en route, it may destroy your original image. If you are shipping large framed work, contact a museum in your area for more suggestions on packaging.

The U.S. Postal Service will not automatically insure your work, but you can purchase up to $600 worth of coverage. Artworks exceeding this value should be sent by registered mail. Certified packages travel a little slower, but are easier to track.

Consider special services offered by the post office, such as Priority Mail, Express Mail Next Day Service and Special Delivery. For overnight delivery, check to see which air freight services are available in your area. Federal Express automatically insures packages for $100 and will ship art valued up to $500. Their 24-hour computer tracking system enables you to locate your package at any time.

UPS automatically insures work for $100, but you can purchase additional insurance for work valued as high as $25,000 for items shipped by air (there is no limit for items sent on the ground). UPS cannot guarantee arrival dates but will track lost packages. It also offers Two-Day Blue Label Air Service within the U.S. and Next Day Service in specific zip code zones.

Before sending any original work, make sure you have a copy (photostat, photocopy, slide or transparency) in your files. Always make a quick address check by phone before putting your package in the mail.

GOOD LUCK!

If you are just starting out, it may be all you can handle to create and submit your work. But if you intend on making a living from your work, you must go beyond that and become an expert business person as well. If you have any suggestions for future business articles, or if you've discovered a business strategy we've missed, please write to *Artist & Graphic Designer's Market*, 1507 Dana Ave., Cincinnati OH 45207 or e-mail us at artdesign@fwpubs.com.

Copyright FAQs

BY POPPY EVANS

If you find a seed catalog at a flea market dating back to 1920, can you use the illustrations within it?

Can you make a drawing from a photograph of a tree you find in a magazine?

Who owns the rights in these situations? What are your rights as an artist?

Contracts between artists and art buyers present a formidable challenge of legalese and business terminology that are difficult for even the most experienced artists to decipher. Here's what you need to know.

Q: What is a copyright?

A: According to the dictionary, copyright is "the exclusive legal right to reproduce, publish, and sell a literary, musical or artistic work." Technically, anything you produce is copyrighted as soon as you produce it if it falls under the the category of being a literary, musical or artistic work. As the owner of a copyrighted work you own the rights to its reproduction, display, distribution and adaptation to derivative works. Ideas, on the other hand, need to be patented or otherwise protected. You can't copyright an idea for a "Bald Guy" line of apparel, but you can copyright the "Bald Guy" illustration that will appear on it to protect yourself from having another person copy it.

Q: What constitutes copyright infringement?

A: Anyone who copies a protected work owned by someone else or exercises an exclusive right without authorization is liable for infringement. The penalties for copyright infringement are very high, as much as $100,000 for each act of "willful infringement," meaning that you knew you were copying someone else's work but did it anyway.

Q: What is a copyright notice?

A: A copyright notice consists of the word "Copyright" or its symbol ©, the year the work was created or first published, and the full name of the copyright owner. It should be placed where it can easily be seen, on the front or back of an illustration or artwork. It's also common practice to place your printed copyright notice on slides or photographs sent to potential clients or galleries by affixing labels to slide mounts or to the back of photographs.

Q: Why should I place a copyright notice on my work?

A: The symbol © is primarily a warning to potential plagiarizers. Works published before 1989 must carry a copyright notice to be protected under copyright laws. Works published after that time don't need to carry a copyright notice to be protected by copyright laws. Although, according to today's laws, placing the copyright symbol on your work isn't absolutely necessary to claim copyright infringement, it's always in your best interest to have used this symbol as a warning if you do take a plagiarizer to court.

POPPY EVANS *is a graphic designer and writer for the design industry.*

Q: Should I register my copyrighted work with the U.S. Copyright Office?

A: The moment a piece of work is created, it is copyrighted material. The benefits for registering your work are basically procedural and can give you additional clout if an infringement does occur and you decide to take the offender to court. In fact, without a copyright registration, it may not be economically feasible for you to file suit to protect your copyright. You'd be entitled only to your damages and the infringer's profits. These may not equal the cost of litigating the case. Registering your work before or shortly after publication is important, because you need to register your work before litigation occurs.

Q: How do I apply for a copyright?

A: To register your work with the U.S. Copyright office, call the Copyright Form Hotline at (202) 707-9100 and ask for package 115 and circulars 40 and 40A. (Cartoonists should ask for package 111 and circular 44.) You can also write to the Copyright Office, Library of Congress, Washington DC 20559, Attn: Information Publications, Section LM0455. Registering your work will cost $20.

Q: Why do I need to learn about transferring copyright?

A: Transferring a copyright on a temporary basis is how artists make a living off their work. Savvy artists who understand how this works can reap financial benefits by collecting more than one fee for the art they produce. There are many types of transfer rights that can be negotiated.

When you sign an agreement with a magazine for one-time rights to an illustration, you are transferring part of your copyright to the magazine. In this instance, ownership of some of your exclusive rights are transferred because you've given the magazine the right to use your illustration one time. As evidence that the transfer has taken place and permission has been granted, you sign a contract or other document stating the terms of the transfer agreement.

Q: Why is it important to negotiate rights?

A: Negotiating the rights for an assignment is just as important as negotiating the fee. If you fail to do this, you could be throwing away future opportunities to promote and profit from your work as well as jeopardize your relationship with your client through misunderstandings.

Q: What happens when I agree to a contract that allows my client "one-time rights" to my work? How does this differ from "first rights" or "exclusive rights"?

A: "One-time rights" means the artwork is "leased" for one use. The buyer has no guarantee he is the first to use the art. If your client wants "first rights" he should expect to pay slightly more for the privilege of being the first to use the art. "Exclusive rights" means the buyer can use the art exclusively in his particular market. With an agreement of this type, your art may be used exclusively by the buyer in the greeting card industry, but you would retain the rights to sell the art to a magazine because it would be used in a noncompeting market. In all of these instances, the rights revert back to you after use.

Q: What are reprint rights, subsidiary rights and promotion rights?

A: Reprint or serial rights give a publication the right to print your work after it has already appeared in another publication. Subsidiary rights cover additional rights purchased such as including an illustration in the second printing or paperback edition of a book. Granting promotion rights allows your client to use your work for promotional purposes. In the case of an editorial illustration, this would apply if the article where the illustration appears is subsequently reprinted and used as a subscription premium. Artists granting reprint, subsidiary or promotion rights should check their contract to see if they will be paid a percentage of the original price when a reprint is made. Industry standards range from 25-50%.

Q: A client has asked me to illustrate a series of cartoon characters for animation as "work for hire." Will I lose my claim to future use of these characters?

A: Be careful when agreeing to this contract. It means you won't own your copyrighted work—your client will. As an artist, you would be surrendering all rights to use these character illustrations in the future, plus any claims to additional compensation through royalties if the animation becomes a big success. "Work for hire" contracts are often used if the work involved is a contribution to a collective work such as a motion picture or animated cartoon. "Work for hire" also refers to artwork produced as part of your employment, but as a freelancer, you won't be entitled to any type of employment benefits if you agree to these terms—you're just missing out on the opportunity to realize additional income you deserve.

Q: What's an "all rights" contract?

A: This involves selling or assigning all rights to a piece of artwork for a specified period of time. The buyer has no limitations placed upon use of the art during an agreed-upon time period, but when that time period has ended, rights revert back to the artist.

Q: Can anybody use a copyrighted work after the artist who created it dies?

A: Copyright protection lasts for the life of the artist plus 70 years. For works created by 2 or more people, protection lasts for the life of the last survivor plus 70 years. For works created anonymously or under a pseudonym, protection lasts for 100 years after the work is completed or 75 years after publication, whichever comes first. Older artistic creations which are no longer protected by copyright fall into a category called public domain, and can be used by anyone without permission. This means that uncredited illustrations and photographs found in printed materials published prior to 1925 can be used without copyright restrictions. Other work in the public domain and not protected by copyright is work created by the U.S. government.

Q: I want to do some drawings of Frank Sinatra and sell copies. What are the rules when it comes to illustrating celebrities?

First of all, if you're not working from your own photographs or memory, you need to obtain permission from the photographer who created the photo you will be using as reference material. (You do not need to get permission from photographers if you create portraits or caricatures based on dozens of photographs from different sources and you are careful to not to include elements that would make it obvious you copied from a particular photograph.)

Secondly, under the rights of publicity, Frank Sinatra had exclusive right during his lifetime to control the use of his image in prints, poster, etc. The rights of publicity aren't covered under copyright law, but are covered by state law and may vary from state to state. In most states, these rights pass to the heirs after the individual's death, so you're likely to run into legal problems if the distribution of your Frank Sinatra drawing is on a national level. In this case, you would be wise to obtain permission from his heirs.

Q: Can I use someone else's photograph as reference material for a painting I'm creating?

A: If you're copying a photograph, you must get the photographer's permission. Photographs are protected by copyright laws just as illustrations are. Even though it's in a different medium, you're violating the photographer's copyright if you copy a photograph in your painting. If a photographer grants permission to use one of his photos as a reference, he may also require that you credit him when your painting is completed. However, if it's not in your agreement, you aren't under legal obligation to do this.

Q: Can I draw a sculpture I recently saw in a gallery and use it as an illustration subject?

A: You can't draw the sculpture without contacting the artist and getting written permission. A sculpture, like a photograph, is a copyrighted piece of art.

Q: The photograph I want to use as a reference is from a stock photo I've paid for as a "one-time" use situation. Can't I create an illustration from it if I've paid for these rights?

A: Your "one-time rights" in this situation apply to using the photograph in a piece of published material—not re-creating it as an illustration for which you could ultimately claim exclusive rights. The stock agency is strictly a licensing agent in this agreement. You still need to obtain permission from the photographer before using a stock photo as the basis for your own illustration.

Q: If I see a photo of Mount Fuji in *National Geographic*, can I develop an illustration from this?

A: Photographs that appear in magazines are usually copyrighted by the magazine or by the photographer or sometimes by both. Under copyright law, the owner of the photo's copyright has the exclusive right to this image. Again, you would need to get permission from the magazine and/or photographer in order to use it as the basis for your own illustration.

Q: When I do an illustration, I draw and paint images from a variety of published photographs and combine them with backgrounds I've drawn from other published photos. To protect myself, do I still need to get permission from the photographers or publishers involved?

A: To constitute a copyright infringement, a "copy" must be "substantially similar" to the original work. If your finished illustration looks different from any of the originals you used as a reference material, you shouldn't need to obtain permission.

Q: How does licensing work?

A: When you grant a license for a copyrighted piece of artwork you're giving permission for an individual or company to make a derivative work—a work derived from the original that produces a second-generation image or product for a specific time period for a specific use. The derivative work can take many forms; companies could feature your art on apparel, notecards or products. Because derivative works are based on an original and are usually created as products for sale, it's not unusual for the creator of the original to receive royalty compensation.

Q: What are royalty fees?

A: Royalty fees are the percentage of the sales that an artist receives every time a derivative work is sold, typically around 5-7% of the wholesale price. Not all licensing agreements involve royalties, but it's always in an artist's best interest to seek compensation of this type. Other things to look for in an agreement are a say in quality control and product distribution.

Q: How do stock agencies work when they license the use of stock illustration? What kind of compensation can I expect if I grant licensing rights of my illustration to a stock agency?

A: Stock agencies grant a license for one-time use of an image to a user for an agreed-upon fee. Stock illustration agencies generally have a contractual arrangement with their artists that involves royalty compensation every time the illustration is used. In most cases, this percentage will range from 30-50%. Stock agencies will often take work originally commissioned for an-

other job, giving artists a way to generate additional income from work that has appeared elsewhere.

Q: Can I create a duplicate of a painting I've just sold if another buyer wants to buy it as well?

A: This depends on your arrangement with the art buyer. If you do not sell the copyright to your painting and express this in writing, you can create a duplicate of it. However, many art collectors purchase an original with the belief that the work is unique and will remain so. The best way to avoid trouble is to make clear in writing that you are free to produce the same or similar piece for someone or have the buyer acknowledge in writing that the piece was purchased with no express or implied warranties.

Q: Can I sell reproductions of a drawing after I've sold the original?

Selling a work of art is separate and distinct from selling your copyright to it. Unless you sign a document to the contrary, your copyright isn't transferred when you sell the drawing, meaning that because you own the copyright to the original, you can legally sell reproductions of it.

I **_For More Information_**

Any more questions? Lots of information on copyright is available just for the asking. Visit the official site for the United States Copyright Office at http://lcweb.lo c.gov/copyright/ or contact the U.S. Copyright Office, Library of Congress, 101 Independence Ave., S.E., Washington DC 20559-6000, or call the Copyright Office information line at (202) 707-3000.

The Do's and Don'ts of Art Licensing

BY LANCE J. KLASS

Congratulations! You've just received a letter back from a company you've contacted that's very interested in licensing your art to use on their products. At last you feel you're on your way to financial success doing something you've always wanted to do.

But wait! There's a long licensing agreement enclosed with their letter, and every time you read it you come upon more and more things you either don't understand or aren't sure of. Yet you don't want to take a long time getting back to them and you may be afraid that if you ask too many questions, they might just change their mind and go with some other artist instead.

So what do you do? Do you sign the agreement just the way it's written, follow their instructions and hope for the best? Do you get an expensive lawyer to decipher it all? Or do you try to puzzle it out by yourself, hoping everything will work out OK?

Well, if you're like most artists, you've probably never seen a real licensing agreement. In fact, you probably know next to nothing about what should and shouldn't be in an art licensing agreement. After all, you're an artist, not a lawyer. Many artists choose to go ahead and sign the agreement, hoping for the best and putting their trust in this wonderful company that loves their art. But that can lead to serious trouble.

Over the years I've spent as a licensing agent I've spoken with many artists who have unknowingly signed away full reproduction rights to their art, never gotten paid for the use of their art or made next to nothing out of a license. Many lost their original artistic works to companies who demanded them but never returned them—the list of horrors goes on and on. And each one is completely avoidable if you understand a few basic things about licensing art, and know what to watch out for in any license.

BASICS YOU NEED TO KNOW

The word **license** means the "freedom to do something." So when you give a company a license to use your art, that means you're giving them the freedom or ability to use your art in a certain way, on a certain type of product, for a certain period of time, and with certain restrictions on usage.

Another key concept has to do with the difference between **copyrights** and **reproduction rights**. While you own the copyright to your art for 75 years from the time you created it—whether or not you've registered that copyright with the U.S. Copyright Office—you also own the reproduction rights. That means that no one can reproduce your art without your OK.

When you sign a license with a company, you're selling them the right to reproduce your art in a very narrow, specific way and for a very limited period of time, generally several years.

Here are some key guidelines that will save you some heartache:

LANCE J. KLASS *is president of Porterfield's Fine Arts, 5 Mountain Road, Concord NH 03301, (603)228-1864, fax (603)228-1888. You can find out more about art licensing by visiting Porterfield's internet site at http://www.porterfieldsfineart.com.*

ALWAYS MAKE SURE YOUR LICENSE INCLUDES, AT MINIMUM:

☑ the names of the specific works of art you're licensing

☑ what specific types of products the art will be reproduced on

☑ the producer's or publisher's written agreement to put your copyright notice on every product sold which bears your art

☑ the countries in which the products will be sold

☑ a period of time (six months or a year) during which time the company has to bring to market (produce and sell) products with your art, or else give up their right to use your art

☑ a termination date for the agreement, generally two or three years after signature

☑ an "indemnification clause" which says the company will protect you from any lawsuits that might arise from any of their business activities which in any way relate to products carrying your art (so you're protected if, say, a child swallows a product with your art on it and the parents sue)

☑ a statement saying you can cancel the agreement if they don't abide by its terms or if they go bankrupt

☑ a specific statement of any nonrefundable advance payment to be made to you against future royalties, the specific royalty percentage to be paid to you on a quarterly basis, and the requirement that each royalty check be accompanied by a clear statement of how they came up with the royalty amount

☑ your right to have their books audited at your own expense to make certain they have paid you what is due to you

NEVER, EVER ALLOW THEM TO:

☑ gain the copyright for or gain full and complete reproduction rights to any of your art

☑ gain the right to sublicense your art to other companies without your having to approve and sign each specific sublicensing agreement

☑ gain ownership of your original works of art as part of the licensing agreement

Remember that companies seek art because they must have it to sell their products, make money, and keep their companies alive. While there are many disreputable companies that will try to take advantage of your lack of knowledge, most companies will give you a fair deal because that's the way they do business. They may want more art from you down the road if they're successful with the art covered by your license.

One option is to seek representation from an experienced licensing agent or agency. Look for a member of the International Licensing and Manufacturing Association (LIMA), the official trade group for the licensing field. LIMA members have to uphold certain ethical standards and can lose their membership in LIMA if they abuse artists' rights.

Whether you go with a reputable agent, or decide to go it alone, use the do's and don'ts above as your guideline in protecting your rights.

Greeting Card Illustration—Still the Best Job in the World

BY LINDA BUTLER

"I am in the greeting card business now," I said, creasing my school notebook paper along the blue-ruled lines. With a simple fold, my poetry and flower drawing became a card. I carefully penciled a © and the logo "LCB Productions" on the back of every card. I was eight years old. I still have those cards.

Then, when I was 15, Faroy, Inc. asked me to design a line of cards. I was thrilled to see my printed artwork in stores. Making paintings for greeting cards had to be the best job in the world! Even though I've had a variety of jobs such as art director, giftware designer and children's book illustrator, I keep coming back to my childhood dream. I'm now a senior stylist at Gibson Greeting Cards. I love my work. If you too have considered the business of using beautiful ideas and images to make people feel good, read on.

Linda Butler

PURSUE "PICKUPABILITY"

A successful greeting card artist not only keeps up with, but anticipates trends in lifestyles, design and color, so do your homework. Know your customer (over 90% of card buyers are women). Go to trade shows and study trade magazines.

Analyze card displays in retail stores. What makes you want to pick up a card for a closer look? The color, styling and caption all evoke emotional appeal. Chances are it's not just the beautiful artwork and sentiment. It may be the mystery of a die-cut window, an intricate fold or sparkling attachment that catches your eye. Can you resist touching the velvety flocking or textured paper? Some cards even use music and aromatherapy scents to attract buyers. These embellishments enhance what we call a card's "pickupability." Once a card is out of the rack and in your hand, it is half sold. That's why although more consumers are using e-mail to send greetings, the sensual experience of an actual greeting card can never be replaced.

Learn all you can about these special effects that add interest and perceived value. Find out the budget limitations—you can't have them all on the same card! Keep a reference collection of cards that use special processes and folds.

NURTURE YOUR SPIRIT

One of the best things about being a freelancer is that you can work and live your life to suit who you really are. Create a professional mission statement for yourself. What do you really want in your life? Find a word or image that symbolizes your passion and purpose and place it

LINDA BUTLER *is a senior stylist for Gibson Greetings in Cincinnati, Ohio.*

over your desk to keep you focused on what you value most. My Superman poster gives me courage every time I look at it.

Isolation has got to be the hardest part of freelancing. Joining an *Artist's Way* support group (based on Julia Cameron's wonderful book, *The Artist's Way*) or taking life-drawing and flower painting classes with kindred spirits will also keep your skills fresh. You'll meet your fellow freelancers night and day at copy centers like Kinko's, where you can use fax machines, computers, copy machines, light tables or papercutters without having to purchase them.

ESTABLISH A MORNING RITUAL

Freelancers need self-discipline to stay on schedule. Make getting down to business in the morning easier. Try the novelist's trick of leaving your work at a point where it's easy to start on the next morning. A writer might stop typing in the middle of a sentence, then shut down the computer for the night, eager to pick up where he left off.

Have a morning ritual, something to do every day to prepare yourself for work. Facing a blank piece of paper in the morning is daunting, especially if it must be filled with something wonderful by the end of your workday. Unblock your creativity by filling that page with the first images and ideas that come to mind. Doodle daily. Free-associate, add a few words, imagine your creativity is water running through rusty pipes. Keep your pencil moving and eventually the creative stream will run clear.

DEVELOP YOUR PERSONAL STYLE

To develop your artistic style examine your work as a whole. Hang color copies of your art on your wall where you see it every day. What makes your artwork unique? Is the quality consistently high? Does your personal style come through even when you use different materials, colors, or subject matter? A highly identifiable style is essential to establishing a clientele. If you do ten projects and it looks like the work of ten different artists, art directors will have a hard time remembering *you*.

When you get an assignment, remember the art director wants a specific look he knows you can do to fill a certain slot in his line. This is not the time to go off on a tangent and surprise him with a new style! By all means, however, experiment with new mediums and stylings on your own time and use what you've learned to enhance your existing style. Send new samples to update your file every six minths. Show that you're productive, even if you have to make up an assignment for a portfolio piece.

Designer's Tip:

Develop your color sense by using Pantone Matching System (PMS) color chips. A quilt maker showed me how she matched solid color fabrics to each color in a printed fabric for her quilt squares. You can analyze the color palette of anything by matching PMS chips to the colors in it. Try this with a Monet painting or your favorite shirt. Put the chips together on a 3 × 5 card and start a color palette file.

THE CARE AND FEEDING OF ART DIRECTORS

Greeting card companies are always getting paintings and sketches in the mail with notes asking, "Can you use something like this for a card?" This drives art directors crazy. Find out what they need before sending them your work, then submit only samples appropriate for that client. Call the marketing department and ask for a catalog and the name of a store near you where you can study their products. Some companies mail a "Needs List" to freelancers, or they put one on their corporate website. Ask them what holiday line they are planning right now

and send them ideas for that specific holiday. Your ideas for other holidays may be shelved (or forgotten) until they're ready to work on that season.

Be your own art director. Step back and look at your project objectively. Write down needed changes and check them off as you make them. Also, double-check your assignment instructions. You'd be surprised at the simple mistakes artists make, such as forgetting to leave enough room for the caption on the artwork.

If you're too busy to take a job, say no to it up front. It's better than taking on too much and missing the deadline. An art director will call back if you turn down a job, but may not if you accept an assignment and finish late. Reliability beats creative brilliance. You may want to perfect your precious work of art, but the art director has a slot to fill fast.

Don't annoy the art director. Call only if you have a good reason, not just to chat. If you must call with a question, remember a busy art director often doesn't keep a copy of your assignment for company files, so you may have the only copy. With hundreds of assignments out, he can't possibly remember each one. If you have a question, first fax your assignment sheet and any visual information so the art director will have an idea of what you're talking about. Your work order (ticket) should indicate size, paper, folds, attachments, processes, caption, sentiment, tag line and their locations.

For your easy reference, keep a loose-leaf notebook with a page for every client. Take notes on phone calls, mailings, assignments and meetings. If they make comments on your portfolio samples, write them here. If they mention their birthday or that they love cats, make a note of that too. When you come across an article that will interest them, send it to them with a note. Mail a "teaser" postcard with your latest work on it and the statement "to see more, call this number." Always tuck in a return-response card with your samples. Remember, the greeting card industry is about building and strengthening relationships.

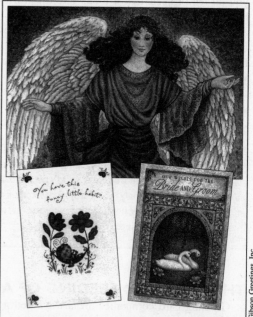

Breathtaking angels, snoozing bumblebees and idyllic swans are all in a day's work for greeting card stylist Linda Butler.

Linda Butler's Trend List

As a greeting card stylist for Gibson Greetings, Linda Butler must constantly stay on top of trends in the market. You should, too. When you visit stores and browse magazines, keep your eyes open. When you spot a new trend, add it to this list.

☐ **Lifestyle Trends:**
 People yearn for less hectic lifestyles that are more stable and balanced
 Look for symbols of simplicity, peace, reflection, harmony
 More people value inner peace over acquiring things.

☐ **Color Trends:**
 Relaxing pastel and intense shades of blue, green and violet
 Nature's earthtones - black, brown, gray-green, spice tones, butter yellow
 Metallics, brushed silver and gray
 Light, soft, fresh, gentle transparent washes of color

☐ **Giftware Trends:**
 Aromatherapy products in a container that is a gift in itself
 Ornaments for holidays year-round
 Plush beanbag animals
 Dolls of all kinds
 Scrapbooking
 Inspirational products featuring Christian and New Age spirituality

☐ **Marketing Trends:**
 Multicultural markets: African-American, Native American, Asian and Hispanic
 The baby and new parent market

☐ **Card Trends:**
 Filmy sheer materials, a veiled look such as vellum paper folded over full-color artwork
 Garden themes and big single flowers
 A return to nostalgia and "classic" looks of the '50s
 Photographic cards
 Childhood storybook stylings
 Angels
 Handmade collage with found objects
 Lettering as a background pattern texture
 Folk art handcrafted look
 Fairies
 Frogs
 Cats

The Markets

Greeting Cards, Gifts & Products

The first market we'd like to introduce to you is the most popular with *Artist's & Graphic Designer's Market* readers. If you haven't visited this section before, you'll be amazed to discover so many opportunities for your work! You'll also find find hundreds of other opportunities in the areas of gifts and other image-bearing products.

Although greeting card companies make up the bulk of the listings, businesses need images for all kinds of products. You could see your work featured on: balloons, banners, party favors, shopping bags, T-shirts, school supplies, personal checks, mugs or limited edition plates.

FIVE STEPS TO SELLING MORE WORK

1. Go through the listings in the following section and keep a highlighter handy.
2. Read each listing carefully and note the products each company makes and the specific types of images they look for.
3. Highlight listings of companies that might use the type of images you create.
4. Send samples to your target listings.
5. Note that gift companies may have different submission criteria from greeting card companies, so refer to the following guidelines before mailing your samples.

Submitting to greeting card companies

☑ Do NOT send originals. Companies want to see photographs, photocopies, printed samples, computer printouts, slides or tearsheets.

☑ Before you make copies of your sample, render the original artwork in watercolor or gouache in the standard industry size, $4\frac{5}{8} \times 7\frac{1}{2}$ inches.

☑ Artwork should be upbeat, brightly colored, and appropriate to one of the major categories or niches popular in the industry (see sidebar).

☑ Leave some space at the top or bottom of the artwork, because cards often feature lettering there. Check stores to see how much space to leave. It is not necessary to add lettering, because companies often prefer to use staff artists to create lettering.

☑ Have photographs, photocopies or slides made of your completed artwork.

☑ Make sure each sample is labeled with your name, address and phone number.

☑ Send three to five appropriate samples of your work to the contact person named in the listing. Include a brief (one to two paragraph) cover letter with your initial mailing.

☑ Enclose a self-addressed stamped envelope if you need your samples back.

☑ Within six months, follow-up with another mailing to the same listings.

Submitting to gift & product companies

Send samples similar to those you would send to greeting card companies, only don't be concerned with leaving room at the top of the artwork for a greeting. Some companies prefer you send postcard samples or color photocopies. Check the listings for specifics. Read how freelancer Alison Jerry tailors her submissions to match a company's needs, on page 349.

Set the right price

Most card and paper companies have set fees or royalty rates that they pay for design and illustration. What has recently become negotiable, however, is rights. In the past, card companies almost always demanded full rights to work, but now some are willing to negotiate for other arrangements, such as greeting card rights only. If the company has ancillary plans in mind for your work (calendars, stationery, party supplies or toys), they will probably want to buy all rights. In such cases, you may be able to bargain for higher payment.

The plates and collectibles market

Limited edition collectibles—everything from Elvis collector plates to porcelain lighthouses—appeal to a wide audience and are a lucrative niche for artists. To do well in this field, you have to be flexible enough to take suggestions. Companies test market to find out which images will sell the best, so they will guide you in the creative process. For a collectible plate, for example, your work must fit into a circular format or you'll be asked to extend the painting out to the edge of the plate.

Popular images for collectibles include Native American, wildlife, animals (especially kittens and puppies), children, religious (including madonnas and angels), stuffed animals, dolls, TV nostalgia, gardening, culinary and sports images. You can submit slides to the creative director of companies specializing in collectibles. See our collectibles index on page 689. For special insight into the market, attend one of the industry's trade shows held yearly in South Bend, Indiana; Secaucus, New Jersey; and Anaheim, California.

Make way for cyber cards!

Greeting cards have made their way onto the web and this is bound to have a big impact on the industry. With the click of a mouse, card senders can swiftly send greetings to friends over the Internet. Whether this will emerge as a viable paying market for freelancers remains to be seen and we'll keep you posted. Meanwhile, check out a few websites and keep your eyes open for new opportunities: See Blue Mountain Arts at http://www.bluemountain.com; How Are You at http://www.howareyou.com; and Regards at http://www.regards.com. More greeting card websites can be found on page 683.

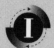

For More Information

Greetings Today is the official publication of the Greeting Card Association. Subscriptions are reasonably priced. To subscribe call 1-800-627-0932.

Party & Paper is a trade magazine focusing on the party niche. Visit their website at http://www.partypaper.com for industry news and subscription information.

The National Stationery Show, the "main event" of the greeting card industry, is held each May at New York City's Jacob K. Javits Center. Other industry events are held across the country each year. For upcoming trade show dates, check *Greetings Today* or *Party & Paper*.

insider report

Pushing the envelope: selling your cards at trade shows

Kevan Atteberry

Kevan Atteberry's line of greeting cards, odd is good, features a pleasingly quirky cast of characters like Ned ("Ned and his sock puppet startle each other in the darkened foyer") and Simon ("For his birthday, Simon enjoys several rounds of pocket pool . . . winning 4 out of 7 games"). "I have kind of an odd sense of humor," Atteberry says.

The Washington-state illustrator already had a successful business, Aardvark Illustrations & Graphics, when he launched odd is good in January 1997. "I wanted my illustrations to make more money than they were making, and I wanted them to keep making money," Atteberry says. "Cards seemed like a natural. My images could be earning income for me long after I finished drawing them."

Atteberry started out as a designer more than 20 years ago "with a leaning toward illustration, which I love. Eventually I was able to move most of my design business into illustration." He's done packaging design, editorial pieces for magazines and point-of-purchase art. "I still do this type of work because the card business is not to the point where I can do that solely. I have done illustrations for other card companies in the past, some of the bigger ones, and what they were paying me and the potential for what the card could make seemed not an unfair spread. That's what convinced me to start my own company."

For years prior to beginning odd is good, Atteberry researched the greeting card market "without knowing I did it," he says. "I'd always go shop card stores to see what was new and what was out there. I always kept track of the little lines and how they were doing." Researching the market is an important consideration for an illustrator tossing around the idea of creating a card line.

"It's funny the stuff that sells. I watch trends come and go. Women buy 90% of all greeting cards, so you see a lot of male-bashing and 'men-are-stupid' cards out there," Atteberry says. "With my line, I try to stay away from gender humor. I really want to have a line of cards that men can go in and buy too."

KEVAN ATTEBERRY

Occupation: Illustrator/Designer
Cardline: odd is good

For anyone considering venturing into the greeting card world with their own line, Atteberry's best advice is to consider the cost and realize you must

have distribution. "If you have a nice line and a couple of little stores in your town that are going to buy them, that's great. But how many are they going to buy—36? 48? 148? That's not going to pay for the print run. There is money to be made, but only if you can get distributed and sold."

After creating a line with 12 card designs, Atteberry attended a small trade show. "Sales were terrible, but we got a lot of interest and picked up our first sales rep." Later that year, he decided to increase the line and take it to the National Stationery Show, held every May in New York City at the Javits Convention Center. "This show is a must if you want to get seen by the people who are buying. The first year we went with 24 cards in the line. I had pretty good sales and hooked up with some more reps around the country. When we went back in 1998, we had built up the line to 48 cards and did 10 times the sales of the year before."

The bigger the line, says Atteberry, the more serious you're perceived by reps and buyers. "The most important thing to remember, for anyone starting their own card company, is that cards are a low-ticket item. They sell for two bucks and your percentage after everyone gets their cut is not that huge. You have to sell lots of them.

"Likewise for the reps—they have to sell lots to make any money. If you're a small line they know they're not going to sell [a lot], so they're less interested in taking you on." Reps carry a number of different lines. They're more likely to show a line with 144 designs and sell everything from one order rather than a small line of 48 cards,

Ned and his sock puppet startle each other in the darkened foyer.

...ah for cryin' out loud, Sid! You forgot to say no salt on the rim, didn't you?!

© Kevan Atteberry

The slug card is one or Kevan Atteberry's most popular cards and the first card with a bonus drawing inside. Ned and his sock puppet is his own personal favorite. "I don't know who buys that card and for what purpose and who they give it to, but it's just my favorite."

where they might sell just a few of them, Atteberry says.

"I think just being at the New York Stationery Show two or three years in a row makes a big difference, too," says Atteberry. It's the largest gift show geared strictly toward the stationery industry and stationery stores. "Upstairs they have all the bigger booths. Downstairs they have about 300 booths for smaller companies like myself and people acting as their own publisher and manufacturer, out there selling. It's a great place to research the market."

Sales reps attend stationery shows scouting for new lines to take on. "Reps from around the country might see your line and ask, 'Do you have anybody representing you in New Mexico or in Iowa? We'd be interested in carrying your line.' For hooking up with sales reps, it's one of the best places to go."

At this point the odd is good line has reps shopping it in most of the U.S. Atteberry's line now includes 74 card designs and he unveiled a new line of winter holiday cards at the May 1999 New York Stationery Show. He prints 12 cards at a time with a run of 3,000 cards each, printing 36,000 cards every 6 months. "That doesn't mean they're selling, but that's what I'm printing. They will sell eventually, but initially, it's a huge financial investment."

Atteberry doesn't consider big card companies like Hallmark and American Greetings as competition for odd is good. "With smaller lines, the people who are buying them are smaller boutiquey places—bookstores, gift stores, coffee shops. They don't want to carry cards you can also find across the street at Rite-Aid. They want individual, unique cards no one else is going to have in their area.

"I think if my cards were sold side-by-side with cards from bigger companies, they would hold their own. But theirs are sold in huge banks of cards. Mine should really be all together. They look like a definite line, as opposed to the hodgepodge of some of the bigger guys. Mine look more designery."

The majority of Atteberry's odd is good cards feature a small bonus drawing inside. One of his most popular cards features two green, polka-dotted slugs on stools in a margarita bar—one not looking so good. The front reads, " . . .ah for cryin out loud, Sid! You forgot to say no salt on the rim, didn't you?!" The inside features a small line drawing of a slug in a party hat saying "Party smart!" Atteberry started the inside drawings on his second set of 12 cards. "It was amazing how people responded to that," he says. "It's like they're getting an extra joke for the buck."

As his line progressed, Atteberry learned that greeted cards sell much better than ungreeted cards. "When I started the line, I thought ungreeted was the way to go. But I greeted the second batch, and they sold much better. When I buy cards, I always want a blank one, but I'm not in the majority," says Atteberry. Could be he's just wittier than most people.

—Alice Pope

Editor's note: For more information about the National Stationery Show visit their website at http://www.glmshows.com/glmshows/stationery/ or call 1-800-272-SHOW.

Greeting Cards 101

- **Seasonal cards** express greetings for holidays, like Christmas, Easter or Valentine's Day.
- **Everyday cards** express non-holiday sentiments. **Birthday cards** are the most popular everyday cards. The "everyday" category includes everything from sympathy cards to notes that just say "**Hi**"
- Categories are further broken down into the following areas: **traditional**, **humorous** and "**alternative**" cards. "Alternative" cards feature quirky, sophisticated or offbeat humor.
- The Greeting Card Industry is also called the "Social Expressions" industry.
- According to the Greeting Card Association, the most popular card-sending holidays are, in order:

1. Christmas	7. Halloween	13. Passover
2. Valentine's Day	8. St. Patrick's Day	14. Secretary's Day
3. Mother's Day	9. Jewish New Year	15. National Boss's Day
4. Father's Day	10. Hannukkah	16. April Fool's Day
5. Graduation	11. Grandparent's Day	17. Nurses' Day
6 Thanksgiving	12. Sweetest Day	

- Women buy 85 to 90 percent of all cards
- The average person receives eight birthday cards a year.

ACME GRAPHICS, INC., 201 Third Ave. SW, Box 1348, Cedar Rapids IA 52406. (319)364-0233. Fax: (319)363-6437. President: Stan Richardson. Estab. 1913. Produces printed merchandise used by funeral directors, such as acknowledgments, register books and prayer cards. Art guidelines available.
- Acme Graphics manufactures a line of merchandise for funeral directors. Floral subjects, religious subjects, and scenes are their most popular products.
Needs: Approached by 30 freelancers/year. Considers pen & ink, watercolor and acrylic. "We will send a copy of our catalog to show type of work we do." Art guidelines available for SASE with first-class postage. Looking for religious, church window, floral and nature art. Also uses freelancers for calligraphy and lettering.
First Contact & Terms: Designers should send query letter with résumé, photocopies, photographs, slides and transparencies. Illustrators send postcard sample or query letter with brochure, photocopies, photographs, slides and tearsheets. Accepts submissions on disk. Samples are not filed and are returned by SASE. Reports back within 10 days. Call or write for appointment to show portfolio of roughs. Originals are returned. Requests work on spec before assigning a job. Pays by the project, $50 minimum or flat fee. Buys all rights.
Tips: "Send samples or prints of work from other companies. No modern art or art with figures. Some designs are too expensive to print. Learn all you can about printing production."

ADVANCE CELLOCARD CO., INC., 2203 Lively Blvd., Elk Grove Village IL 60007-5209. President: Ron Ward. Estab. 1960. Produces greeting cards.
Needs: Considers watercolor, acrylic, oil and colored pencil. Art guidelines for SASE with first-class postage. Produces material for Valentine's Day, Mother's Day, Father's Day, Easter, graduation, birthdays and everyday.
First Contact & Terms: Send query letter with brochure and SASE. Accepts disk submissions compatible with Mac formated Illustrator 5.5, Photoshop 3.0 or Power Mac QuarkXPress 3.0. Samples not filed are returned by SASE. Reports back within weeks. Originals are not returned. Pays average flat fee of $75-150/design. Buys all rights.
Tips: "Send letter of introduction, and samples or photostats of artwork."

ALASKA MOMMA, INC., 303 Fifth Ave., New York NY 10016. (212)679-4404. Fax: (212)696-1340. E-mail: licensing@alaskamomma.com. President, licensing: Shirley Henschel. "We are a licensing company representing artists, illustrators, designers and established characters. We ourselves do not buy artwork. We act as a licensing agent for the artist. We license artwork and design concepts to toy, clothing, giftware, textiles, stationery and housewares manufacturers and publishers."
Needs: "We are looking for people whose work can be developed into dimensional products. An artist must have a distinctive and unique style that a manufacturer can't get from his own art department. We need art that can be applied to products such as posters, cards, puzzles, albums, etc. No cartoon art, no abstract art, no b&w art."
First Contact & Terms: "Artists may submit work in any form as long as it is a fair representation of their style."

Prefers to see several multiple color samples in a mailable size. No originals. "We are interested in artists whose work is suitable for a licensing program. We do not want to see b&w art drawings. What we need to see are transparencies or color photographs or color photocopies of finished art. We need to see a consistent style in a fairly extensive package of art. Otherwise, we don't really have a feeling for what the artist can do. The artist should think about products and determine if the submitted material is suitable for licensed product. Please send SASE so the samples can be returned. We work on royalties that run from 5-10% from our licensees. We require an advance against royalties from all customers. Earned royalties depend on whether the products sell."

Tips: "Publishers of greeting cards and paper products have become interested in more traditional and conservative styles. There is less of a market for novelty and cartoon art. We need artists more than ever as we especially need fresh talent in a difficult market."

ALEF JUDAICA, INC., 8440 Warner Dr., Culver City CA 90232. (310)202-0024. Fax: (310)202-0940. President: Guy Orner. Estab. 1979. Manufacturer and distributor of a full line of Judaica, including menorahs, Kiddush cups, greeting cards, giftwrap, tableware, etc.

Needs: Approached by 15 freelancers/year. Works with 10 freelancers/year. Buys 75-100 freelance designs and illustrations/year. Prefers local freelancers with experience. Works on assignment only. Uses freelancers for new designs in Judaica gifts (menorahs, etc.) and ceramic Judaica. Also for calligraphy, pasteup and mechanicals. All designs should be upper scale Judaica.

First Contact & Terms: Mail brochure, photographs of final art samples. Art director will contact artist for portfolio review if interested, or portfolios may be dropped off every Friday. Sometimes requests work on spec before assigning a job. Pays $300 for illustration/design; pays royalties of 10%. Considers buying second rights (reprint rights) to previously published work.

N ALLPORT EDITIONS, 2337 NW York, Portland OR 97210-2112. (503)223-7268. Fax: (503)223-9182. E-mail: info@allport.com. Website: http://www.allport.com. Contact: Creative Director. Estab. 1983. Produces greeting cards and stationery. Specializes in greeting cards: fine art, humor, some photography, florals, animals and collage.

Needs: Approached by 100 freelancers/year. Works with 10 freelancers/year. Buys 40 freelance designs and illustrations/year. Art guidelines free for SASE with first-class postage. Uses freelancers mainly for art for cards. Also for final art. Prefers art scaleable to card size. Produces material for all holidays and seasons, birthdays and everyday. Submit seasonal material 1 year in advance.

First Contact & Terms: Illustrators and cartoonists send query letter with photocopies, photographs, photostats, tearsheets and SASE. Accepts submissions on disk compatible with PC formatted EPS files with PC Preview or Quark document. Samples are filed or returned by SASE. Reports back within 3 months. Portfolio review not required. Rights purchased vary according to project. Pays for illustration by the project. Finds freelancers through artists' submissions and stationery show in New York.

Tips: "Try and match style of our line."

AMBERLEY GREETING CARD CO., 11510 Goldcoast Dr., Cincinnati OH 45249-1695. (513)489-2775. Fax: (513)489-2857. Art Director: Dave McPeek. Estab. 1966. Produces greeting cards. "We are a multi-line company directed toward all ages. We publish conventional as well as humorous cards."

● Art director told *AGDM* that soft inspirational and lightly religious themes are becoming a trend.

Needs: Approached by 20 freelancers/year. Works with 10 freelancers/year. Buys 250 illustrations/year. Art guidelines not available. Works on assignment only. Considers any media.

First Contact & Terms: Send query letter with brochure, color photocopies and SASE. Calligraphers send photocopies of lettering styles. Samples are filed or returned by SASE if requested by artist. Reports back to artist only if interested. Call for appointment to show portfolio of original/final art. Pays illustration flat fee $75-80; pays calligraphy flat fee $20-30. Buys all rights.

Tips: "Send appropriate materials. Go to a card store or supermarket and study the greeting cards. Look at what makes card art different than a lot of other illustration. Caption room, cliché scenes, "cute" animals, colors, etc. Buy some samples and re-execute them in your style (as an exercise only—don't try to re-sell them!). Research publishers and send appropriate art! I wish artists would not send a greeting card publisher art that looks unlike any card they've ever seen on display anywhere."

AMCAL INC., 2500 Bisso Lane, Bldg. 500, Concord CA 94520. (925)689-9930. Fax: (925)689-0108. Publishes calendars, notecards, Christmas cards and other book and stationery items. "Markets to better gift, book and department stores throughout U.S. Some sales to Europe, Canada and Japan. We look for illustration and design that can be used many ways—calendars, note cards, address books and more so we can develop a collection. We license art that appeals to a widely female audience." No gag humor or cartoons.

Needs: Needs freelancers for design and production. Prefers work in horizontal format. Art guidelines for SASE with first-class postage or "you can call and request."

First Contact & Terms: Designers send query letter with brochure, résumé and SASE. Illustrators send query letter with brochure, résumé, photographs, SASE, slides, tearsheets and transparencies. Include a SASE for return of submission. Will contact artist for portfolio review if interested. Pays for illustration by the project, advance against royalty.

Tips: "Research what is selling and what's not. Go to gift shows and visit lots of stationery stores. Read all the trade magazines. Talk to store owners."

AMERICAN GREETINGS CORPORATION, One American Rd., Cleveland OH 44144. (216)252-7300. Director of Creative Recruitment: Steven Tatar. Estab. 1906. Produces greeting cards, stationery, calendars, paper tableware products, giftwrap and ornaments—"a complete line of social expressions products."
Needs: Prefers local artists with experience in illustration, decorative design and calligraphy. Usually works from a list of 100 active freelancers. Guidelines available for SASE.
First Contact & Terms: Send query letter with résumé. "Do not send samples." Pays $200 and up based on complexity of design. Does not offer royalties.

AMERICAN TRADITIONAL STENCILS, 442 First New Hampshire Turnpike, Northwood NH 03261. (603)942-8100. Fax: (603)942-8919. E-mail: judy@amtrad-stencil.com Website: http://www.Amtrad-stencil.com. Owner: Judith Barker. Estab. 1970. Manufacturer of brass and laser cut stencils and 24 karat gold finish charms. Clients: retail craft, art and gift shops. Current clients include Michael's Arts & Crafts, Old Sturbridge and Pfaltzgraph Co., JoAnn's Fabrics and some Ben Franklin stores.
Needs: Approached by 1-2 freelancers/year. Works with 1 freelance illustrator/year. Assigns 2 freelance jobs/year. Prefers freelancers with experience in graphics. Art guidelines not available. Works on assignment only. Uses freelancers mainly for stencils. Also for ad illustration and product design. Prefers b&w camera-ready art.
First Contact & Terms: Send query letter with brochure showing art style and photocopies. Samples are filed or are returned. Reports back in 2 weeks. Call for appointment to show portfolio of roughs, original/final art and b&w tearsheets. Pays for design by the hour, $8.50-20; by the project, $15-150. Pays for illustration by the hour, $10-15. Rights purchased vary according to project.
Tips: "Join the Society of Craft Designers—great way to portfolio designs for the craft industry. Try juried art and craft shows—great way to see if your art sells."

AMPERSAND PRESS, 750 Lake St., Port Townsend WA 98368. (360)379-5187. Fax: (360)379-0324. E-mail: info@ampersandpress.com. Website: http://www.ampersandpress.com. President: Amy Mook. Estab. 1994. Produces games, t-shirts and rubber stamps. Specializes in nature themes, gardening and wild animals.
Needs: Approached by 10+ freelancers/year. Works with 2-3 freelancers/year. Buys 40-100 freelance designs and illustrations/year. No cartoons or cutsey. Works on assignment only. Uses freelancers mainly for illustrating games (gameboard cards and box). Considers watercolor, color pencil, pen & ink, wood cut, scratch board, computer. Computer experience not required, but knowledge of Adobe Photoshop, Adobe Illustrator and QuarkXPress is helpful. Produces material for everyday.
First Contact & Terms: Designers send query letter with brochure, photocopies, résumé and photographs. Illustrators send query letter with photocopies, photographs, photostats and résumé. Send follow-up postcard every year. Accepts disk submissions compatible with PC format, Adobe Illustrator 4.0, QuarkXPress 3.2 or higher or PageMaker 6.5. Samples are filed. Reports back only if interested. Will contact for portfolio review of b&w, color and final art if interested. Rights purchased vary according to project; negotiable. Pays 3% royalties plus $50-150/small card illustration, $300-2,000/large illustration. Finds freelancers through word of mouth and submissions.
Tips: "Bring your portfolio in a form which allows for quick and easy viewing."

AMSCAN INC., 80 Grasslands Rd., Elmsford NY 10523. (914)345-2020. Senior Vice President of Creative Development: Diane D. Spaar. Estab. 1954. Designs and manufactures paper party goods. Extensive line includes paper tableware, invitations, giftwrap and bags, decorations. Complete range of party themes for all ages, all seasons and all holidays. Features a gift line which includes sculpted frames, lamps, and wall hangings for baby; candle holders, frames, mugs, etc. for everyday giftline.
Needs: "Ever-expanding department with incredible appetite for fresh design and illustration. Subject matter varies from baby, juvenile, floral, type-driven and graphics. Designing is accomplished both in the traditional way by hand (i.e., painting) or on the computer using a variety of programs like Aldus FreeHand, Adobe Illustrator, Fractal Design Painter and Adobe Photoshop."
First Contact & Terms: "Send samples or copies of artwork to show us range of illustration styles. If artwork is appropriate, we will pursue." Pays by the project $300-2,000 for illustration and design.

ANGEL GRAPHICS, 903 W. Broadway, Fairfield IA 52556. (515)472-5481. Fax: (515)472-7353. Website: http://www.angelgraphicsinc.com. Project Manager: Julie Greeson. Estab. 1981. Produces full line of posters for wall decor market.
• Also has listing in Posters & Prints section.
Needs: Buys 50-100 freelance designs and illustrations/year. Uses freelancers mainly for posters. Also "may consider your design for use in our line of wall decor." Considers any media. Looking for realistic artwork.
First Contact & Terms: Send query letter with photographs, slides or reproductions; not originals. Samples are not filed and are returned by SASE. Company will contact artist for portfolio review if interested. Negotiates rights purchased. Pays by the project, competitive prices. Can use previously published works.

APPLE ORCHARD PRESS, P.O. Box 240, Dept. A, Riddle OR 97469. Art Director: Gordon Lantz. Estab. 1988. Produces greeting cards and book products. "We manufacture our products in our own facility and distribute them nationwide. We make it a point to use the artist's name on our products to help them gain recognition. Our priority is to produce beautiful products of the highest quality."

Needs: Works with 4-8 freelancers/year. Buys 50-75 designs/year. Uses freelancers mainly for note cards and book covers. All designs are in color. Considers all media, but prefers watercolor and colored pencil. Looking for florals, cottages, gardens, gardening themes, recipe book art, Christmas themes and animals. "We are not interested in Halloween or in anything 'off color.' We usually produce four or more images from an artist on the same theme at the same time." Produces material for Christmas, Valentine's Day and everyday. Submit seasonal material 9-12 months in advance, "but will always be considered for the next release of that season's products whenever it's submitted."

First Contact & Terms: Submit photos, slides, brochure or color copies. Must include SASE. "If we are not interested in a submission without SASE, it will be discarded. We only file samples if we are interested." Reports back quarterly. Company will contact artist for portfolio review if interested. Portfolio should include slides and/or photographs. Pays one-time flat fee/image. Amount varies. Rights purchased vary according to project.

Tips: "Please do not send pictures of pieces that are not available for reproduction. We must eventually have access to either the original or an excellent quality transparency. If you must send pictures of pieces that are not available in order to show style, be sure to indicate clearly that the piece is not available. We work with pairs of images. Sending quality pictures of your work is a real plus."

☑ **AR-EN PARTY PRINTERS, INC.**, 3775 W. Arthur, Lincolnwood IL 60645. (847)673-7390. Fax: (847)673-7379. E-mail: terry@ais.net Website: http://ar-en.com. Vice President: Terry Morrison. Estab. 1978. Produces stationery and paper tableware products. Makes personalized party accessories for weddings, and all other affairs and special events.

Needs: Works with 2 freelancers/year. Buys 10 freelance designs and illustrations/year. Art guidelines not available. Works on assignment only. Uses freelancers mainly for new designs. Also for calligraphy. Looking for contemporary and stylish designs. Prefers small (2×2) format.

First Contact & Terms: Send query letter with brochure, résumé and SASE. Samples are filed or returned by SASE if requested by artist. Reports back within 2 weeks. Company will contact artist for portfolio review if interested. Rights purchased vary according to project. Pays by the hour, $60 minimum; by the project, $1,000 minimum.

Tips: "My best new ideas always evolve from something I see that turns me on. Do you have an idea/style that you love? Market it. Someone out there needs it."

ARTISTS TO WATCH, 500 N. Robert St., #302, St. Paul MN 55101. (612)222-8102. (800)945-5454. Fax: (612)290-0919. E-mail: artwatch@bitstream.net. Owner: Kathryn Shaw. "Full-service licensing agency and manufacturer of high-quality greeting cards featuring the work of contemporary international artists. We have national and international distribution—great exposure for new artists."

- Artists to Watch has a growing list of licensing partners including Disney, Rug Barn, Dayton Hudson Corporation, Antioch Publishing, Landmark Calendars, Ink-a-Dink-a-Doo, Computer Expressions, Rivertown Trading, Rizzoli and Reco.

Needs: Seeks artists with distinctive style, visual appeal, and mature skills. Art guidelines available. Considers all media and all types of prints.

First Contact & Terms: Send letter with a sample of work. Replies in 6 weeks. "Send something that is representative of artist's work that artist. We'll call you if we'd like to see more. Use of artwork is compensated with royalty payments."

Tips: Owner offers the following advice, condensed from guidelines. "Artists to Watch licenses the work of artistically mature individuals chosen for their progressive style and the spiritual, social or cultural message in their work. We are honored and excited to introduce our artists to the world. Our card lines are renowned for their distinctive design, striking images and great greetings. Our cards convey a consistent message through artwork, text and form. Please do not send original work! Be sure to include a broad enough sample of your work to clearly demonstrate your range, style and ability."

ARTVISIONS, 12117 SE 26th St., Suite 202A, Bellevue WA 98005-4118. (425)746-2201. E-mail: neilm@artvisions.com. Website: http://www.artvisions.com. Owner: Neil Miller. Estab. 1993. Markets include publishers, manufacturers and others who may require fine art.

Handles: Fine art licensing of greeting cards, gifts and products. See listing in Artists' Reps section.

**FOR EXPLANATIONS OF THESE SYMBOLS,
SEE THE INSIDE FRONT AND BACK COVERS OF THIS BOOK.**

ARTWORKS LICENSING, 107 Monument Ave., Old Bennington VT 05201. (802)442-3831. Fax: (802)447-3180. E-mail: decamp@bennington.edu. Owner/Licensing Agent: Kate Philbin. Estab. 1996. Art licensing agency. "We market artists' work and negotiate rights for reproduction to a variety of manufacturers including stationery products, giftware, housewares, clothing and textiles."

• Owner told AGDM that licensing fine art to the commercial art market is a growing trend because many manufacturers are using only outside artists for their products, and computer technology has made it easy to apply art to many products with good results.

Needs: Approached by over 150 freelancers/year. Works with 25 freelancers/year. Art guidelines free for SASE with first-class postage. Considers all media in color except photography. "We look for representational art in color that has a popular appeal and is appropriate for use on consumer products such as greeting cards, posters, giftware, calendars, etc."

First Contact & Terms: Artists should request submission guidelines first. Submissions should include 12-24 labeled photographs, slides or color copies; and bio. "No originals." Samples are not filed and are returned by SASE. Reports back within 1 month. Company will contact artist for portfolio review if interested. Rights purchased vary according to project; negotiable. "The artist receives 50% commission for each contract we negotiate for them. There are no fees for the artist." Finds freelancers through submissions, galleries, word of mouth and shows.

Tips: "For licensing, artists should have a substantial body of work (25-50 images) in a representational style. It's an asset to have popular themes—holidays, cats, dogs, etc."

☑ **BARTON-COTTON INC.**, % 10099 SE White Pelican Way, Jupiter FL 33469. (410)247-4800. Contact: Art Acquisitions Manager. Licensing: Carol White. Produces religious greeting cards, commercial all occasion, Christmas cards, wildlife designs and spring note cards. Licenses wildlife art, photography, traditional Christmas art for notecards, Christmas cards and all occasion cards.

Needs: Buys 150-200 freelance illustrations/year. Submit seasonal work any time. Free art guidelines for SASE with first-class postage and sample cards; specify area of interest (religious, Christmas, spring, etc.).

First Contact & Terms: Send query letter with résumé, tearsheets, photocopies or slides. Submit full-color work only (watercolor, gouache, pastel, oil and acrylic). Previously published work and simultaneous submissions accepted. Reports in 1 month. Pays by the project, $300-2,500 for illustration and design. Also needs calligraphy, package/product design, pays $500-3,000. **Pays on acceptance.**

Tips: "Good draftsmanship is a must. Spend some time studying current market trends in the greeting card industry. There is an increased need for creative ways to paint traditional Christmas scenes with up-to-date styles and techniques."

FREDERICK BECK ORIGINALS, 27 E. Housatonic, Pittsfield MA 01201-0989. (818)998-0323. Fax: (818)998-5808. Art Director: Mark Brown. Estab. 1953. Produces silk screen printed Christmas cards, traditional to contemporary.

• This company is under the same umbrella as Editions Limited and Gene Bliley Stationery. One submission will be seen by all companies, so there is no need to send three mailings. Frederick Beck and Editions Limited designs are a little more high end than Gene Bliley designs. The cards are sold through stationery and party stores, where the customer browses through thick binders to order cards, stationery or invitations imprinted with customer's name. Though some of the same cards are repeated or rotated each year, all companies are always looking for fresh images. Frederick Beck and Gene Bliley's sales offices are still in Chatsworth, CA, but art director works from Pittsfield ofice.

BEISTLE COMPANY, 1 Beistle Plaza, Box 10, Shippensburg PA 17257. (717)532-2131. Fax: (717)532-7789. E-mail: beistle@cvn.net; Website: http://www.beistle.com. Product Manager: C.M. Luhrs-Wiest. Estab. 1900. Manufacturer of paper and plastic decorations, party goods, gift items, tableware and greeting cards. Targets general public, home consumers through P-O-P displays, specialty advertising, school market and other party good suppliers.

Needs: Approached by 250-300 freelancers/year. Works with 50 freelancers/year. Prefers artists with experience in designer gouache illustration. Also needs digital art (Macintosh platform or compatible). Art guidelines available. Looks for full-color, camera-ready artwork for separation and offset reproduction. Works on assignment only. Uses freelance artists mainly for product rendering and brochure design and layout. Prefers designer gouache and airbrush technique for poster style artwork. 50% of freelance design and 50% of illustration demand knowledge of QuarkXPress, Adobe Illustrator, Adobe Photoshop or Fractal Design Painter. Also uses freelance sculptors.

First Contact & Terms: Send query letter with résumé, brochure, SASE and slides or color reproductions. Samples are filed or returned by SASE. Art Director will contact artist for portfolio review if interested. Sometimes requests work on spec before assigning a job. Pays by the project. Considers buying second rights (reprint rights) to previously published work. Finds artists through word of mouth, magazines, submissions/self-promotions, sourcebooks, agents, visiting artists' exhibitions, art fairs and artists' reps.

Tips: "Our primary interest is in illustration; often we receive freelance propositions for graphic design—brochures, logos, catalogs, etc. These are not of interest to us as we are manufacturers of printed decorations. Send color samples rather than b&w. There is a move toward brighter, stronger designs with more vibrant colors and bolder lines. We have utilized more freelancers in the last few years than previously. We predict continued and increased consumer interest—greater juvenile product demand due to recent baby boom and larger adult market because of baby boom of the '50s." Advises freelancers to learn to draw well first and study traditional illustration.

BEPUZZLED, 22 E. Newberry Rd., Bloomfield CT 06040. (860)769-5723. Fax: (860)769-5799. Creative Services Manager: Sue Tyska. Estab. 1986. Produces games and puzzles for children and adults. "Bepuzzled mystery jigsaw games challenge players to solve an original whodunit thriller by matching clues in the mystery with visual clues revealed in the puzzle."

• BePuzzled now publishes a newspaper as part of the new product line "Extra Extra." They buy eight to ten humorous or editorial cartoons/year. Cartoonists should call and send a query letter with tearsheets. Pays $150-300 for black-and-white cartoons; $200-400 for color.

Needs: Works with 20 freelance artists/year. Buys 20-40 designs and illustrations/year. Prefers local artists with experience in children's book and adult book illustration. Uses freelancers mainly for box cover art, puzzle images and character portraits. All illustrations are done to spec. Considers many media.

First Contact & Terms: Send query letter with brochure, résumé, SASE, tearsheets, photographs and transparencies. Samples are filed. Reports back within 2 months. Art Director will contact artist for portfolio review if interested. Portfolio should include original/final art and photographs. Original artwork is returned at the job's completion. Sometimes requests work on spec before assigning a job. Pays by the project, $300-3,000. Finds artists through word of mouth, magazines, submissions, sourcebooks, agents, galleries, reps, etc.

Tips: Prefers that artists not "ask that all material be returned. I like to keep a visual in my files for future reference. New and fresh looking illustration styles are key."

BERGQUIST IMPORTS, INC., 1412 Hwy. 33 S., Cloquet MN 55720. (218)879-3343. Fax: (218)879-0010. E-mail: bbergqu106@aol.com. President: Barry Bergquist. Estab. 1948. Produces paper napkins, mugs and tile. Wholesaler of mugs, decorator tile, plates and dinnerware.

Needs: Approached by 5 freelancers/year. Works with 5 freelancers/year. Buys 50 designs and illustrations/year. Prefers freelancers with experience in Scandinavian and wildlife designs. Works on assignment only. Also uses freelancers for calligraphy. Produces material for Christmas, Valentine's Day and everyday. Submit seasonal material 6-8 months in advance.

First Contact & Terms: Send query letter with brochure, tearsheets and photographs. Samples are not filed and are returned. Reports back within 2 months. Request portfolio review in original query. Artist should follow-up with a letter after initial query. Portfolio should include roughs, color tearsheets and photographs. Rights purchased vary according to project. Originals are returned at job's completion. Requests work on spec before assigning a job. Pays by the project, $50-300; average flat fee of $50 for illustration/design; or royalties of 5%. Finds artists through word of mouth, submissions/self-promotions and art fairs.

☑ **BERNARD FINE ART**, Box 1528, Historic Route 7A, Manchester Center VT 05255. (802)362-0373. Fax: (802)362-1082. Vice President: Michael Katz. Licenses art for balloons, bookmarks, calendars, CD-ROMs, collectible figurines, decorative housewares, decorations, games, giftbags, gifts, giftwrap, greeting cards, limited edition plates, mugs, ornaments, paper tableware, party supplies, personal checks, posters, prints, school supplies, stationery, T-shirts, textiles, toys, wallpaper, etc.

Needs: Approached by hundreds of freelancers/year. Works with 50-100 freelancers/year. Buys 1,200-1,500 designs and illustrations/year. Art guidelines free for SASE with first class postage. Considers all media and all styles. Prefers final art under 24×36, but not required. Produces material for all holidays. Submit seasonal material 6 months in advance.

First Contact & Terms: Designers send brochure, photocopies, photographs, slides, tearsheets, transparencies and SASE. Illustrators send query letter with photocopies, photographs, photostats, transparencies, tearsheets, résumé and SASE. Send follow-up postcard every 3 months. Accepts disk submissions compatible with Photoshop, Quark or Illustrator. Samples are filed or returned by SASE. Reports back in 1 month. Will contact artist for portfolio review if interested. Portfolio should include color final art, photographs, photostats, roughs, slides, tearsheets. Buys all rights.

GENE BLILEY STATIONERY, 27 E. Housatonic, Pittsfield MA 01201-0989. (818)998-0323. Fax: (818)998-5808. Art Director: Mark Brown. General Manager: Gary Lainer. Sales Manager: Ron Pardo. Estab. 1967. Produces stationery, family-oriented birth announcements and invitations for most events and Christmas cards.

• This company also owns Editions Limited and Frederick Beck Originals. One submission will be seen by both companies. See listing for Editions Limited/Frederick Beck.

BLISS HOUSE INC., 380 Union St., Suite 232, W. Springfield MA 01089. (413)737-0757. Fax: (413)781-3770. E-mail: blisshouse@aol.com. Website: http://www.blisshouse.com. President, licensing: Jerry Houle. Estab. 1984. Licenses balloons, bookmarks, calendars, CD-ROMs, collectible figurines, decorative housewares, decorations, games, giftbags, gifts, giftwrap, greeting cards, limited edition plates, mugs, ornaments, paper tableware, school supplies, stationery, t-shirts, textiles, toys, wallpaper and licensed product services. Licensing agency representing: Charlie Chaplin, Curious George, Marx Brothers, Velveteen Rabbit, Ship of Dreams, Victory Garden, Samuel Adams, Davey & Goliath, Kids Say the Darndest Things and The Royal County of Berkshire Polo Club, Monty Python, Fairydale, Gene, Mike Mulligan and his Steamshovel, and The Art of Margret and H.A. Rey.

Needs: Approached by 10-20 freelancers/year. Works with 20+ freelancers/year. Licensed properties are responsible for hundreds of freelance designs and illustrations, 12 sculptures/year. Prefers freelancers with experience in upmarket children's designs and whimsical designs. Art guidelines available. Works on assignment only. Uses freelancers mainly for licensed art. Also for desktop publishing, brochures. Considers brochures, products. Looking for work exclusively

with product illustration and sculpting for our licensed properties. 50% of freelance design work demands knowledge of Aldus PageMaker, Adobe Photoshop and Adobe Illustrator. Produces material for all holidays and seasons and everyday. Submit seasonal material 15 months in advance.

First Contact & Terms: Designers send query letter with photocopies, photographs and résumé. Illustrators and cartoonists send query letter with photocopies, photographs and follow-up postcard every 3 months. Sculptors send letter with photographs. Accepts disk submissions compatible with Adobe Illustrator. Samples are filed. Reports back in 1-2 weeks. Will contact for portfolio review of color, photographs, photostats and roughs if interested. Rights purchased vary according to project. Finds freelancers through word of mouth.

N BLOOMIN' FLOWER CARDS, 2510 N. 47th St., Unit E, Boulder CO 80301. (800)894-9185. Fax: (303)545-5273. President: Don Martin. Estab. 1995. Produces greeting cards, stationery and gift tags.

Needs: Approached by 50-100 freelancers/year. Works with 12-15 freelancers/year. Buys 20-30 freelance designs and illustrations/year. Art guidelines available. Uses freelancers mainly for card images. Considers all media. Looking for florals, garden scenes, herbs, peppers, vegetables, holiday florals, birds, and butterflies—bright colors, no photography. Produces material for Christmas, Easter, Mother's Day, Father's Day, Valentine's Day, Earth Day, birthdays, everyday, get well, romantic and thank you. Submit seasonal material 8 months in advance.

First Contact & Terms: Designers send query letter with slides, transparencies, photocopies, photographs and SASE. Illustrators send postcard sample of work, photocopies and photographs. Samples are filed or returned with letter if not interested. Reports back if interested. Portfolio review not required. Rights purchased vary according to project. Pays royalties for design. Pays by the project or royalties for illustration. Finds freelancers through word of mouth, submissions, and local artists guild.

BLUE SKY PUBLISHING, 6395 Gunpark Dr., Suite M, Boulder CO 80301. (303)530-4654. Fax: (303)530-4627. Estab. 1989. Produces greeting cards. "At Blue Sky Publishing, we are committed to producing contemporary fine art greeting cards that communicate reverence for nature and all creatures of the earth, that express the powerful life-affirming themes of love, nurturing and healing, and that share different cultural perspectives and traditions, while maintaining the integrity of our artists' work."

Needs: Approached by 500 freelancers/year. Works with 30 freelancers/year. Licenses 80 fine art pieces/year. Works with freelancers from all over US. Prefers freelancers with experience in fine art media: oils, oil pastels, acrylics, calligraphy, vibrant watercolor and fine art photography. "We primarily license existing pieces of art or photography. We rarely commission work." Looking for colorful, contemporary images with strong emotional impact. Art guidelines for SASE with first-class postage. Produces cards for all occasions. Submit seasonal material 1 year in advance.

First Contact & Terms: Send query letter with SASE, slides or transparencies. Samples are filed or returned. Reports back within 2-3 months only if interested. Transparencies are returned at job's completion. Pays royalties of 3% with a $150 advance per image. Buys greeting card rights for 5 years (standard contract; sometimes negotiated).

Tips: "We're interested in seeing artwork with strong emotional impact. Holiday cards are what we produce in biggest volume. We are looking for joyful images, cards dealing with relationships, especially between men and women, with pets, with Mother Nature and folk art. Vibrant colors are important."

BONITA PIONEER PACKAGING, 500 Bonita Rd., Portland OR 97224. (503)684-6542. Fax: (503)639-5965. E-mail: parker@bonitapioneer.com. Creative Director: Jim Parker. Estab. 1928. Produces giftwrap, shopping bags, boxes and merchandise bags.

Needs: Approached by 20 artists/year. Works with 10-20 artists/year. Buys 30-50 designs and illustrations/year. Prefers artists with experience in giftwrap, fabric or textile design. Considers acrylic, computer design, process and flat color design. Seeks upscale, traditional and contemporary styles. Prefers 15″ or 20″ cylinder repeats. Produces material for all occasions. 70% of design purchases are Christmas motifs. Considers submissions year-round.

First Contact & Terms: Send query letter with brochure, tearsheets and slides. Samples are not filed and are returned only if requested by artist. Reports back within 3 weeks. To show a portfolio, mail thumbnails, roughs, slides and photographs. Original artwork is not returned to the artist after job's completion. Pays average flat fee of $200-750/design. Buys all rights.

Tips: "Know the giftwrap market and be professional. Understand flexographic printing process limitations."

BRAZEN IMAGES, INC., 269 Chatterton Pkwy., White Plains NY 10606-2013. (914)949-2605. Fax: (914)683-7927. Website: http://www.brazenimages.com. President/Art Director: Kurt Abraham. Estab. 1981. Produces greeting cards and postcards. "Primarily we produce cards that lean towards the erotic arts; whether that be of a humorous/novelty nature or a serious/fine arts nature. We buy stock only—no assignments."

Needs: Approached by 10-20 freelancers/year. Works with 10 freelancers/year. Buys 10-30 freelance designs and illustrations/year. Uses freelancers mainly for postcards. Considers any media "I don't want to limit the options." Prefers 5×7 (prints); may send slides. Produces material for Christmas, Valentine's Day, Hanukkah, Halloween, birthdays, everyday and weddings.

First Contact & Terms: Send query letter with photographs, slides, SASE and transparencies. Samples are filed or returned by SASE if requested by artist. Reports back ASAP depending on workload. Company will contact artist for portfolio review if interested. Portfolio should include final art, photographs, slides and transparencies. Buys one-time rights. Originals are returned at job's completion. Pays royalties of 2%. Finds artists through artists' submissions.

BRILLIANT ENTERPRISES, 117 W. Valerio St., Santa Barbara CA 93101. Art Director: Ashleigh Brilliant. Publishes postcards.
Needs: Buys up to 300 designs/year. Freelancers may submit designs for word-and-picture postcards, illustrated with line drawings.
First Contact & Terms: Submit 5½ × 3½ horizontal b&w line drawings and SASE. Reports in 2 weeks. Buys all rights. "Since our approach is very offbeat, it is essential that freelancers first study our line. Ashleigh Brilliant's books include *I May Not Be Totally Perfect, But Parts of Me Are Excellent*; *Appreciate Me Now and Avoid the Rush*; and *I Want to Reach Your Mind. Where Is It Currently Located?* We supply a catalog and sample set of cards for $2 plus SASE." Pays $60 minimum, depending on "the going rate" for camera-ready word-and-picture design.
Tips: "Since our product is highly unusual, familiarize yourself with it by sending for our catalog. Otherwise, you will just be wasting our time and yours."

BRUSH DANCE INC., 100 Ebbtide Ave., Bldg. #1, Sausalito CA 94965. (415)331-9030. Fax: (415)331-9059. E-mail: brushdance@brushdance.com. Website: http://www.brushdance.com. Contact: Production Director. Estab. 1989. Produces greeting cards, calendars, postcards, candles, bookmarks, blank journal books and magnets. "Brush Dance creates products that help people express their deepest feelings and intentions. We combine humor, heartfelt sayings and inspirational writings with exceptional art."
Needs: Approached by 200 freelancers/year. Works with 5 freelancers/year. Art guidelines for 9 × 11 SASE with $1.50 postage. Uses freelancers mainly for illustration and calligraphy. Looking for non-traditional work conveying emotion or message. Prefers 5 × 7 or 7 × 5 originals or designs that can easily be reduced or enlarged to these proportions. Produces material for all occasions.
First Contact & Terms: Call or write for artist guidelines before submitting. Send query letter. Samples are filed or returned by SASE. Reports back only if interested. Buys all rights. Originals are returned at job's completion. Pays royalty of 5-7.5% depending on product. Finds artists through word of mouth, submissions, art shows.

BURGOYNE, INC., 2030 E. Byberry Rd., Philadelphia PA 19116. (215)677-8962. Fax: (215)677-6081. Contact: Christine Cathers Donohue. Estab. 1907. Produces greeting cards. Publishes Christmas greeting cards geared towards all age groups. Style ranges from traditional to contemporary to old masters' religious.
Needs: Approached by 150 freelancers/year. Works with 25 freelancers/year. Buys 50 designs and illustrations/year. Prefers freelancers with experience in all styles and techniques of greeting card design. Art guidelines available free for SASE with first-class postage. Uses freelancers mainly for Christmas illustrations. Also for lettering/typestyle work. Considers watercolor and pen & ink. Produces material for Christmas. Accepts work all year round.
First Contact & Terms: Send query letter with slides, tearsheets, transparencies, photographs, photocopies and SASE. Samples are filed. Creative Director will contact artist for portfolio review if interested. Pays flat fee. Buys first rights or all rights. Sometimes requests work on spec before assigning a job. Interested in buying second rights (reprint rights) to previously published work, first rights or all rights.
Tips: "Send us fewer samples. Sometimes packages are too lengthy. It is better to send one style that is done very well than to send a lot of different styles that aren't as good. Also, please remember to send a SASE."

CANETTI DESIGN GROUP INC., P.O. Box 57, Pleasantville NY 10570. (914)238-1076. Fax: (914)238-3177. Marketing Vice President: M. Berger. Estab. 1982. Produces greeting cards, stationery, games/toys and product design.
Needs: Approached by 50 freelancers/year. Works with 20 freelancers/year. Works on assignment only. Uses freelancers mainly for illustration/computer. Also for calligraphy and mechanicals. Considers all media. Looking for contemporary style. Needs computer-literate freelancers for illustration and production. 80% of freelance work demands knowledge of Adobe Illustrator, Adobe Photoshop, Aldus FreeHand, Form 2/Strata.
First Contact & Terms: Send postcard-size sample of work and query letter with brochure. Samples are not filed. Portfolio review not required. Buys all rights. Originals are not returned. Pays by the hour. Finds artists through agents, sourcebooks, magazines, word of mouth and artists' submissions.

CAPE SHORE, INC., division of Downeast Concepts, 20 Downeast Dr., Yarmouth ME 04096. (207)846-3726. E-mail: capeshore@downeastconcepts.com. Website: http://www.downeastconcepts.com. Creative Director, licensing: Janet Ledoux. Estab. 1947. "Cape Shore is concerned with seeking, manufacturing and distributing a quality line of gifts and stationery for the souvenir and gift market." Licenses art by noted illustrators with a track record for paper products and giftware.
Needs: Approached by 100 freelancers/year. Works with 50 freelancers/year. Buys 400 freelance designs and illustrations/year. Prefers artists with experience in illustration. Art guidelines free for SASE. "A division of Downeast Concepts, Woodkrafter Kits, has need for freelance designers that work in wood for use on high end children's toys." Uses freelance artists mainly for illustrations for boxed notes, Christmas card designs, ceramics and other paper products. Considers watercolor, gouache, acrylics, tempera, pastel, markers, colored pencil. Looking for art photography subjects rendered in a realistic style, stylized realistic looks and humor in good taste. Prefers final artwork on flexible stock for reproduction purposes.
First Contact & Terms: "Do not telephone; no exceptions." Send query letter with photocopies and slides. Samples are filed or are returned by SASE. Art Director will contact artist for portfolio review if interested. Portfolio should include slides, finished samples, printed samples. Pays by the project, $150 minimum. Also needs caligraphers and package/product designers, pay rate negotiable. Buys reprint rights or varying rights according to project.

Tips: "Cape Shore is looking for realistic detail, good technique, bright clear colors and fairly tight designs, traditional themes or very high quality stylized looks for the souvenir and gift market. We will sometimes buy art for a full line of products, or we may buy art for a single note or gift item. Proven success in the giftware field a plus, but will consider exceptional unpublished illustrators. If you have a great idea, we will consider it. Stick with what you love to do and do it well—it will be your best work."

CARDMAKERS, Box 236, High Bridge Rd., Lyme NH 03768. Phone/fax: (603)795-4422. Fax: (603)795-4222. E-mail: diebold@sover.net. Website: http://www.cardmakers.com. Principle: Peter Diebold. Estab. 1978. Produces greeting cards. "We produce special cards for special interests and greeting cards for businesses—primarily Christmas. We have now expanded our Christmas line to include 'photo mount' designs, added designs to our everyday line for stockbrokers and are have recently launched a new everyday line for boaters."

Needs: Approached by more than 100 freelancers/year. Works with 5-10 freelancers/year. Buys 10-20 designs and illustrations/year. Prefers professional-caliber artists. Art guidelines for SASE with first-class postage. Works on assignment only. Uses freelancers mainly for greeting card design, calligraphy and mechanicals. Also for paste-up. Considers all media. "We market 5×7 cards designed to appeal to individual's specific interest—golf, tennis, etc." Prefers an upscale look. Submit seasonal ideas 6-9 months in advance.

First Contact & Terms: Designers send query letter with SASE and brief sample of work. Illustrators send postcard sample or query letter with brief sample of work. "One good sample of work is enough for us. A return postcard with boxes to check off is wonderful. Phone calls are out; fax is a bad idea." Samples are filed or are returned by SASE. Reports back to artist only if interested. Portfolio review not required. Pays flat fee of range of $100-300 depending on many variables. Rights purchased vary according to project. Interested in buying second rights (reprint rights) to previously published work, if not previously used for greeting cards. Finds artists through word of mouth, exhibitions and *Artist's & Graphic Designer's Market* submissions.

Tips: "We like to see new work in the early part of the year. It's important that you show us samples *before* requesting submission requirements. Getting published and gaining experience should be the main objective of freelancers entering the field. We favor fresh talent (but do also feature seasoned talent). PLEASE be patient waiting to hear from us! Make sure your work is equal to or better than that which is commonly found in use presently."

CAROLE JOY CREATIONS INC., 107 Mill Plain Rd., #200, Danbury CT 06811. (203)798-2060. Fax: (203)748-5315. President: Carole Gellineau. Estab. 1986. Produces greeting cards. Specializes in cards, notes and invitations by and for people who share an African heritage.

Needs: Approached by 200 freelancers/year. Works with 5-10 freelancers/year. Buys 100 freelance designs, illustrations and calligraphy/year. Prefers artists "who are thoroughly familiar with, educated in and sensitive to the African-American culture." Art guidelines available. Works on assignment only. Uses freelancers mainly for greeting card art. Also for calligraphy. Considers full color only. Looking for realistic, traditional, Afrocentric, colorful and upbeat style. Prefers 11×14. 20% freelance design work demands knowledge of Adobe Illustrator, Adobe Photoshop and QuarkXPress. Also produces material for Christmas, Easter, Mother's Day, Father's Day, graduation, Kwanzaa, Valentine's Day, birthdays and everyday. Also for sympathy, get well, romantic, thank you, serious illness and multicultural cards. Submit seasonal material 1 year in advance.

First Contact & Terms: Designers send query letter with brochure, photocopies, photographs and SASE. "No phone calls, please. No slides." Illustrators and cartoonists send query letter with photocopies and photographs. No phone calls or slides. Calligraphers send samples and compensation requirements. Samples are not filed and are returned. Reports back only if interested. Portfolio review not required. Buys all rights. Pays for illustration by the project.

Tips: "Excellent illustration skills are necessary and designs should be appropriate for African-American social expression. Writers should send verse that is appropriate for greeting cards and avoid lengthy, personal experiences. Verse and art should be uplifting."

[N] ⊕ CARTEL INTERNATIONAL, Box 918, Edinburgh Way, Harlow Essex CM20 2DU England. Phone: 01279 641125. Fax: 01279 635672. Group Publishing Director: Linda Worsfold. Publishes greeting cards, posters, stationery and calendars.

Needs: Produces material for everyday, special occasions, Christmas, Valentine's Day, Mother's Day, Father's Day and Easter, plus quality artwork for posters.

First Contact & Terms: Send query letter with brochure, photographs, transparencies, photocopies and slides. Accepts disk submissions compatible with QuarkXPress. Send SyQuest disks. Samples not filed are returned. Reports back within 30 days. To show portfolio, mail roughs, photostats and photographs. Originals returned after job's completion. Pays royalties or pays by the project. Negotiates rights purchased.

NEED HELP? For tips on finding markets and understanding listings, see our Quick-Start Guide in the front of this book.

CASE STATIONERY CO., INC., 179 Saw Mill River Rd., Yonkers NY 10701. (914)965-5100. President: Jerome Sudnow. Vice President: Joyce Blackwood. Estab. 1954. Produces stationery, notes, memo pads and tins for mass merchandisers in stationery and housewares departments.
Needs: Approached by 10 freelancers/year. Buys 50 designs from freelancers/year. Works on assignment only. Buys design and/or illustration mainly for stationery products. Uses freelancers for mechanicals and ideas. Produces materials for Christmas; submit 6 months in advance. Likes to see youthful and traditional styles, as well as English and French country themes. 10% of freelance work requires computer skills.
First Contact & Terms: Send query letter with résumé and tearsheets, photostats, photocopies, slides and photographs. Samples not filed are returned. Reports back. Call or write for appointment to show a portfolio. Original artwork is not returned. Pays by the project. Buys first rights or one-time rights.
Tips: "Find out what we do. Get to know us. We are creative and know how to sell a product."

H. GEORGE CASPARI, INC., 35 E. 21st St., New York NY 10010. (212)995-5710. Contact: Lucille Andriola. Publishes greeting cards, Christmas cards, invitations, giftwrap and paper napkins. "The line maintains a very traditional theme."
Needs: Buys 80-100 illustrations/year. Prefers watercolor and other color media. Produces seasonal material for Christmas, Mother's Day, Father's Day, Easter and Valentine's Day.
First Contact & Terms: Send samples to Lucille Andriola to review. Prefers unpublished original illustrations, slides or transparencies. Art Director will contact artist for portfolio review if interested. **Pays on acceptance**; negotiable. Pays flat fee of $400 for design. Finds artists through word of mouth, magazines, submissions/self-promotions, sourcebooks, agents, visiting artist's exhibitions, art fairs and artists' reps.
Tips: "Caspari and many other small companies rely on freelance artists to give the line a fresh, overall style rather than relying on one artist. We feel this is a strong point of our company. Please do not send verses."

CATCH PUBLISHING, INC., 456 Penn St., Yeadon PA 19050. (610)626-7770. Fax: (610)626-2778. Contact: Michael Markowicz. Produces greeting cards, stationery, giftwrap, blank books and posters.
Needs: Approached by 200 freelancers/year. Works with 5-10 freelancers/year. Buys 25-50 freelance designs and illustrations/year. Art guidelines for SASE with first-class postage. Works on assignment only. Uses freelancers mainly for design. Considers all media. Produces material for Christmas, New Year and everyday. Submit seasonal material 1 year in advance.
First Contact & Terms: Send query letter with brochure, tearsheets, résumé, slides, SASE and transparencies. Samples are not filed and are returned by SASE if requested by artist. Reports back within 2-6 months. Company will contact artist for portfolio review if interested. Portfolio should include final art, slides or large format transparencies. Rights purchased vary according to project. Originals are returned at job's completion. Pays royalties of 10-12% (may vary according to job).

CATHEDRAL ART METAL CO., INC., 25 Manton Ave., Providence RI 02909-3349. (401)273-7200. Website: http://cathedralart.com. Art Director: Fritzi Frey. Estab. 1920. Produces collectible figurines, gifts and ornaments. Specializes in giftware and jewelry.
Needs: Approached by 20-30 freelancers/year. Works with 10 freelancers/year. Buys 100 freelance designs and illustrations/year. Uses freelancers mainly for product development and execution. Considers work in metal, pewter, etc. Looking for traditional, floral, sentimental, cute animals, adult contemporary, religious and Victorian. Produces material for Christmas, Easter, Mother's Day, Father's Day, graduation, Halloween, Hanukkah, New Year, Thanksgiving, Valentine's Day, birthdays and everyday. "Open to any submissions." Submit seasonal material 1 year in advance.
First Contact & Terms: Designers send photocopies and photographs. Illustrators send photocopies. Accepts disk submissions compatible with Mac Photoshop, Illustrator and Quark. Send TIFF or EPS files. Samples are not returned, unless requested with SASE. Reports back in 2 weeks only if interested. Portfolios required from illustrators and sculptors; will contact artist for portfolio review of photographs if interested. Rights purchased vary according to project.

CEDCO PUBLISHING CO., 100 Pelican Way., San Rafael CA 94901. E-mail: sales@cedco.com. Website: http://www.cedco.com. Contact: Licensing Department. Estab. 1982. Produces 215 upscale calendars and books.
Needs: Approached by 500 freelancers/year. Works with 25 freelancers/year. Buys 48 freelance designs and illustrations/year. Art guidelines for SASE with first-class postage. "We never give assignment work." Uses freelancers mainly for stock material and ideas. "We use either 35mm slides or 4×5s of the work."
First Contact & Terms: "No phone calls accepted." Send query letter with photographs and tearsheets. Samples are filed. "Send non-returnable samples only." Reports back to the artist only if interested. To show portfolio, mail thumbnails and b&w photostats, tearsheets and photographs. Original artwork is returned at the job's completion. Pays by the project. Buys one-time rights. Interested in buying second rights (reprint rights) to previously published work. Finds artists through art fairs and licensing agents.
Tips: "Full calendar ideas encouraged!"

☑ **CENTRIC CORP.**, 6712 Melrose Ave., Los Angeles CA 90038. (323)936-2100. Fax: (323)936-2101. E-mail: centric@juno.com. Vice President: Neddy Okdot. Estab. 1986. Produces fashion watches, clocks, mugs, frames, pens and T-shirts for ages 13-60.
Needs: Approached by 40 freelancers/year. Works with 6-7 freelancers/year. Buys 50-100 designs and illustrations/

year. Prefers local freelancers only. Works on assignment only. Uses freelancers mainly for watch and clock dials, frames, mugs, T-shirts and packaging. Also for mechanicals. Considers graphics, computer graphics, cartoons, pen & ink, photography. 95% of freelance work demands knowledge of QuarkXPress, Adobe Illustrator, Adobe Photoshop and Adobe Paintbox.

First Contact & Terms: Send postcard sample or query letter with appropriate samples. Accepts submissions on disk. Samples are filed if interested. Reports back only if interested. Originals are returned at job's completion. Also needs package/product designers, pay rate negotiable. Requests work on spec before assigning a job. Pays by the project. Pays royalties of 1-10% for design. Rights purchased vary according to project. Finds artists through submissions/self-promotions, sourcebooks, agents and artists' reps.

Tips: "Show your range on a postcard addressed personally to the target person."

CHRISTY CRAFTS, INC., P.O. Box 492, Hinsdale IL 60521. (630)323-6505. President: Betty Christy. Produces gifts, greeting cards and mail-order craft kits and supplies of the 1800s.

Needs: Approached by many freelancers/year. Works with 10-20 freelancers/year. Prefers freelancers with experience in crafts. Catalog available by mail. Uses freelancers mainly for craft kits and projects that fit 1800s. Looking for crafts of the 1800s. "No needlework." 50% of freelance design demands computer skills. Produces material and craft kits for all holidays and seasons. Submit seasonal material 6 months in advance.

First Contact & Terms: Send query letter or phone with idea. Samples are not filed and are returned. Reports back within days. Portfolio review not required. Negotiates rights purchased or rights vary according to project. Pays for design by the project; pays flat fee for illustration or by the project. Finds freelancers through submissions and craft organizations.

Tips: "Get an idea and call or write. I am always willing to listen and refer if I can't use."

CLAY ART, 239 Utah Ave., S. San Francisco CA 94080-6802. (650)244-4970. Fax: (650)244-4979. Art Director: Thomas Biela. Estab. 1979. Produces giftware and home accessory products: cookie jars, salt & peppers, mugs, pitchers, platters and canisters.

Needs: Approached by 70 freelancers/year. Prefers freelancers with experience in 3-D design of giftware and home accessory items. Works on assignment only. Uses freelancers mainly for illustrations and 3-D design. Seeks humorous, whimsical, innovative work.

First Contact & Terms: Send query letter with brochure, résumé, SASE, tearsheets and photocopies. Samples are filed. Reports back to the artist only if interested. Call for appointment to show portfolio of thumbnails, roughs and final art and color photostats, tearsheets, slides and dummies. Negotiates rights purchased. Originals are returned at job's completion. Pays by project.

☑ **CLEO, INC.**, 4025 Viscount Ave., Memphis TN 38118. (901)369-6657. Fax: (901)369-6376. Senior Director of Creative Resources: Claude Patat. Estab. 1953. Produces giftwrap and gift bags. "Cleo is the world's largest Christmas giftwrap manufacturer. Also provides extensive all occasion product line. Other product categories include some seasonal product. Mass market for all age groups."

Needs: Approached by 25 freelancers/year. Works with 40-50 freelancers/year. Buys more than 200 freelance designs and illustrations/year. Uses freelancers mainly for giftwrap and gift bags (designs). Also for calligraphy. Considers most any media. Looking for fresh, imaginative as well as classic quality designs for Christmas. 30″ repeat for giftwrap. Art guidelines available. Submit seasonal material at least a year in advance.

First Contact & Terms: Send query letter with slides, SASE, photocopies, transparencies and speculative art. Accepts submissions on disk. Samples are filed if interested or returned by SASE if requested by artist. Reports back to the artist only if interested. Rights purchased vary according to project; usually buys all rights. Pays flat fee. Also needs package/product designers, pay rate negotiable. Finds artists through agents, sourcebooks, magazines, word of mouth and submissions.

Tips: "Understand the needs of the particular market to which you submit your work."

🅽 **COLORS BY DESIGN**, 7723 Densmore Ave., VanNuys CA 91406. (818)376-1226. Fax: (818)376-1669. Creative Director: Victoria Cole. Produces greeting cards, stationery, imprintables, invitations and notecards. "Our current products are bright, bold, whimsical, watercolors using calligraphy and quotes. We are open to new lines, new looks."

Needs: Works with 20-25 freelance artists/year. Buys 100-200 freelance designs and illustrations/year. Uses freelance artists for all products. Considers all media. "Looking for humor cards and cards that fit into our current line." Cards are 5×7. Produces material for all holidays and seasons. "Anytime we welcome everyday submissions; in June, submit Mother's Day, Father's Day, Easter, graduation and Valentine's Day; in January, submit Christmas, New Year's, Hanukkah, Passover, Thanksgiving, Halloween, Rosh Hashanah."

First Contact & Terms: "Please write for our submission guidelines and catalogue." Samples are returned by SASE. Reports back within 6 weeks. Art Director will contact artist for portfolio review if interested. Portfolio should include color roughs, final art and photographs. Originals are not returned. Pays royalties of 3-5% and $350 advance against royalties/piece. Buys all rights or negotiates rights purchased, reprint rights.

Tips: "Phone calls are discouraged. No photography, computer generated imagery or cartoons."

COMSTOCK CARDS, INC., 600 S. Rock Blvd., Suite 15, Reno NV 89502. (702)856-9400. Fax: (702)856-9406. E-mail: comstock@intercomm.com. Website: http://www.comstockcards.com. Production Manager: David Delacroix.

Estab. 1987. Produces greeting cards, notepads and invitations. Styles include alternative and adult humor, outrageous, shocking and contemporary themes; specializes in fat, age and funny situations. No animals or landscapes. Target market predominately professional females, ages 25-55.
Needs: Approached by 250-350 freelancers/year. Works with 30-35 freelancers/year. "Especially seeking artists able to produce outrageous adult-oriented cartoons." Uses freelancers mainly for cartoon greeting cards. Art guidelines for SASE with first-class postage. No verse or prose. Gaglines must be brief. Prefers 5×7 final art. Produces material for all occasions. Submit holiday concepts 11 months in advance.
First Contact & Terms: Send query letter with SASE, tearsheets or photocopies. Samples are not usually filed and are returned by SASE if requested. Reports back only if interested. Portfolio review not required. Originals are not returned. Pays royalties of 5%. Pays by project, $50-150 minimum; may negotiate other arrangements. Buys all rights.
Tips: "Make submissions outrageous and fun—no prose or poems. Outrageous humor is what we look for—risque OK, mild risque best."

CONCORD LITHO GROUP, 92 Old Turnpike Rd., Concord NH 03301. (603)225-3328. Fax: (603)225-6120. Vice President/Creative Services: Lester Zaiontz. Estab. 1958. Produces greeting cards, stationery, posters, giftwrap, specialty paper products for direct marketing. "We provide a range of print goods for commercial markets but also supply high-quality paper products used for fundraising purposes."
Needs: Buys 300 freelance designs and illustrations/year. Works on assignment only but will consider available work also. Uses freelancers mainly for greeting cards, wrap and calendars. Also for calligraphy and computer-generated art. Considers all media but prefers watercolor. Art guidelines available for SASE with first-class postage. "Our needs range from generic seasonal and holiday greeting cards to religious subjects, florals, nature, scenics, "cutsies," whimsical art and inspirational vignettes. We prefer more traditional designs with occasional contemporary needs. Always looking for traditional religious art." Prefers original art no larger than 10×14. Produces material for all holidays and seasons: Christmas, Valentine's Day, Mother's Day, Father's Day, Easter, Thanksgiving, New Year, birthdays, everyday and other religious dates. Submit seasonal material 6 months in advance.
First Contact & Terms: Send introductory letter with résumé, brochure, photographs, slides, photocopies or transparencies. Accepts submissions on disk. Samples are filed. Reports back within 3 months. Portfolio review not required. Rights purchased vary according to project. Originals are returned at job's completion. Pays by the project, $200-800. "We will exceed this amount depending on project."
Tips: "Keep sending samples or color photocopies of work to update our reference library. Be patient. Send quality samples or copies."

CONTEMPO COLOURS, 1 Paper Place, Kalamazoo MI 49001. (616)349-2626. Fax: (616)349-6412. Design Manager: Kathleen Pavlack. Produces paper-tableware products; general and seasonal, birthday, special occasion, invitations, stationery, wrapping paper, thank you notes, T-shirts, mugs, confetti and party accessories for children and adults.
Needs: Approached by 200 freelance artists/year. Uses artists for product design and illustration. Art guidelines for SASE with first-class postage. Prefers flat 4-color designs; but will also accept 4-color pieces. Produces seasonal material for Christmas, Mother's Day, Thanksgiving, Easter, Valentine's Day, St. Patrick's Day, Halloween and New Year's Day. Submit seasonal material before June 1; everyday (not holiday) material before March.
First Contact & Terms: Send query letter with 9×12 SASE so catalog can be sent with response. Accepts submissions on Mac disk. Disclosure form must be completed and returned before work will be viewed. Call or write to schedule an appointment to show portfolio. Portfolio should include original/final art and final reproduction/product. Previously published work OK. Originals are returned to artist at job's completion. "All artwork purchased becomes the property of Beach Products. Items not purchased are returned." Pays average flat fee of $500 or royalties of 3-5% for illustration and design; license fees negotiable. Considers product use when establishing payment.
Tips: "Artwork should have a clean, professional appearance and be the specified size for submissions, as well as a maximum of four flat colors."

COTTAGE ART, a licensed division of Crockett Cards, P.O. Box 1428, Manchester Center, VT 05255. Owner: Jeanette Robertson. Estab. 1994. Produces greeting cards and notecards. "All of our designs are one color, silk screened, silhouette designs. Most cards are blank notes. They appeal to all ages. They are simple yet bold due to the silk screening method."
Needs: Uses freelancers mainly for design. Considers flat b&w; ink, marker, paint. Looking for silhouette designs only. Any subject considered. Art guidelines for SASE with first-class postage. "Remember they are only one color, solid, no tones." Prefers no larger than 8½×11.
First Contact & Terms: Send query letter with SASE and photocopies. Samples are returned by SASE. "If no SASE, they are disposed of. When an ad says SASE—do it!" Reports back within 2 weeks with SASE. Portfolio review not required. Pays $1-50 and free cards. Finds artists through submissions.
Tips: "Being a new company we are interested in artists who are willing to work with us and grow with us. Our company seeks out industry 'holes.' Things that are missing, such as designs that appeal to men. We like 'Victorian' paper cut out look in wildlife, sports, country, coastal, flowers and bird designs."

COURAGE CENTER, 3915 Golden Valley Rd., Golden Valley MN 55422. Fax: (612)520-0299. E-mail: artsearch@courage.org. Website: http://www.couragecards.org. Art and Production Manager: Laura Brooks. Estab. 1970. "Courage Cards are holiday cards that are produced to support the programs of Courage Center, a nonprofit provider of rehabilitation services that helps people with physical, communication and sensory disabilities live more independently."

Needs: In search of holiday art themes including: traditional, diversity, winter scenes, nostalgic, religious, Americana, non-denominational, business-appropriate, ethnic, world peace and "earthly" holiday designs. Features artists with disabilities, but all artists are encouraged to enter the annual Courage Card Art Search. Art guidelines available with 52¢ postage.

First Contact & Terms: Send query letter, fax or e-mail with name and address for Art Search application and guidelines. Artist retains ownership of the art. Pays $350 honorarium in addition to nationwide recognition through distribution of more than 500,000 catalogs and promotional pieces, TV, radio and print advertising. Also needs calligraphy.

Tips: "Do not send originals. We prefer that entries arrive as a result of the Art Search. The Selection Committee chooses art that will reproduce well as a card—colorful contemporary and traditional images for holiday greetings and all-occasion notecards. Participation in the Courage Cards Art Search is a wonderful way to share your talents and help people live more independently."

CREATIF LICENSING, 31 Old Town Crossing, Mount Kisco NY 10549. (914)241-6211. E-mail: creatiflic@aol.com. Website: http://members@aol.com/creatiflic. President: Paul Cohen. Licensing Manager. "Creatif is a licensing agency that represents artists and concept people." Licenses art for commercial applications for consumer products in gift stationery and home furnishings industry.

Needs: Looking for unique art styles and/or concepts that are applicable to multiple products. "The art can range from fine art to cartooning."

First Contact & Terms: Send query letter with brochure, photocopies, photographs, SASE and tearsheets. Pays royalties of 50%. Negotiates payment based on artist's recognition in industry. "If we are interested in representing you, we will present your work to the appropriate manufacturers in the clothing, gift, publishing, home furnishings, paper products (cards/giftwrap/party goods, etc.) areas with the intent of procuring a license. We try to obtain advances and/or guarantees against a royalty percentage of the firm's sales. We will negotiate and handle the contracts for these arrangements, show at several trade shows to promote your style and oversee payments to ensure that the requirements of our contracts are honored. Artists are responsible for providing us with materials for our meetings and presentations and for protection of copyrights, trademarks. For our services, as indicated above, we split revenues from any licenses we negotiate. Royalty rate varies depending on the experience and marketability of the artist. We also vary advance structure depending on if the artwork is existing vs. new. If the artist has a following we are more flexible. There are no fees if we are not productive."

Tips: Common mistakes illustrators make in presenting samples or portfolios are "sending oversized samples mounted on heavy board and not sending appropriate material. Color photocopies and photos are best."

CREATIVE CARD CO., (formerly Century Engravings), 1500 W. Monroe St., Chicago IL 60607. Wedding Art Director: Nanci Barsevick. Estab. 1955. Produces wedding invitations and announcements, Christmas cards and stationery.

Needs: Approached by 30 freelancers/year. Works with 10 freelancers/year. Buys 60 freelance designs and illustrations/year. "Prefers freelancers with experience in our production techniques (embossing, die-cutting and foil stamping)." Art guidelines free for SASE with first-class postage. Uses freelancers mainly for design and illustration of wedding invitations. Considers all media. Produces material for personalized Christmas, Rosh Hashanah, New Year, graduation, wedding invitations and birth announcements. Submit seasonal material 1 year in advance.

First Contact & Terms: Send query letter with SASE. Samples are not filed and are returned by SASE. Reports back within 3 weeks. Artist should follow-up with letter after initial query. Pays average flat fee of $250/design; pays more for full color or complicated artwork. Pays by the project for calligraphy. Buys reprint rights or all rights. No royalties.

Tips: "Send in any roughs or copies of finished ideas you have, and we'll take a look. Write for specs on size first (with SASE) before submitting any material. In wedding invitations, we seek an elegant card featuring embossing, foil stamping and die-cutting. Have a look at what is out there."

✔ **CREEGAN CO., INC.**, 510 Washington St., Steubenville OH 43952. (740)283-3708. Fax: (740)283-4117. E-mail: creegans@weir.net. Website: http://www.weir.net/Creegans. President: Dr. G. Creegan. Estab. 1961. "The Creegan Company designs and manufactures animated characters, costume characters and life-size audio animatronic air-driven characters. All products are custom made from beginning to end."

Needs: Approached by 10-30 freelance artists/year. Works with 3 freelancers/year. Prefers local artists with experience in sculpting, latex, oil paint, molding, etc. Artists sometimes work on assignment basis. Uses freelancers mainly for design comps. Also for mechanicals. Produces material for all holidays and seasons, Christmas, Valentine's Day, Easter, Thanksgiving, Halloween and everyday. Submit seasonal material 3 months in advance.

First Contact & Terms: Send query letter with résumé. Samples are filed. Reports back. Write for appointment to show portfolio of final art, photographs. Originals returned. Rights purchased vary according to project.

CROCKETT CARDS, (formerly The Crockett Collection), P.O. Box 1428, Manchester Center VT 05255-1428. (802)362-0641. Fax: (802)362-5590. E-mail: sscheirer@aol.com. Website: http://www.crockettcards.com. President: Sharon Scheirer. Estab. 1929. Publishes mostly traditional, some contemporary, humorous and whimsical silk screen Christmas and everyday greeting cards, postcards, notecards and bordered stationery on recycled paper. Christmas themes are geared to sophisticated, upscale audience.

Needs: Approached by 50 freelancers/year. Works with 20-30 freelancers/year. Buys 20-40 designs/year. Produces

products by silk screen method exclusively. Considers cut and pasted paper designs and gouache. Prefers 5×7 or 4½×6½. Art guidelines free for SASE with first-class postage. Produces material for Christmas and everyday. Submit seasonal material 1 year in advance.

First Contact & Terms: Send query letter with SASE. Request guidelines which are mailed out once a year in February, one year in advance of printing or check website for guidelines. "Please do not ask us to check your website. We prefer to look at 'the real thing' in person at submission time." Submit unpublished, original designs only. Art should be in finished form. Art not purchased is returned by SASE. Reports back in 3 months. Buys all rights. Pays flat fee of $90-150 for illustration/design. Finds artists through *Artist's & Graphic Designer's Market* submissions.

Tips: "Designs must be suitable for silkscreen process. Airbrush, watercolor techniques and pen & ink are not amenable to this process. Bold, well-defined designs only. Our look is traditional, mostly realistic and graphic. Request guidelines and follow instructions. Don't submit inappropriate work."

[N] SUZANNE CRUISE PRODUCTIONS INC., 9222 Belinder, Leawood KS 66206. (913)648-2190. Fax: (913)648-2110. President: Suzanne Cruise. Estab. 1990. Licenses calendars, craft papers, decorative housewares, gift-bags, gifts, giftwrap, greeting cards, keychains, mugs, ornaments, prints, rubber stamps, stickers, tabletop, and textiles. "We are a full-service licensing agency, as well as a full-service creative agency representing freelance artists. Our services include, but are not limited to, screening manufacturers for quality and distribution, negotiating rights, oversee-ing contracts and payments and exhibiting at several major trade shows annually."

Needs: Seeks established and emerging artists with distinctive styles suitable for the ever-changing consumer market. Looking for artists that manufacturers cannot find in their own art staff, or in the freelance market, who have a style that has the potential to become a classic license. Works on assignment only. "We represent a wide variety of freelance artists, offering their work to manufacturers of goods such as gifts, textiles, home furnishings, clothing, book publishing, social expression (greeting cards, giftwrap, party goods, etc.), puzzles, rubber stamps, etc. We prefer to work with freelancers with experience in these markets. We look for art that has popular appeal. It can be traditional, whimsical, cute, humorous, seasonal or everyday, as long as it is not 'dated'."

First Contact & Terms: Send query letter with color photocopies, tearsheets or actual samples. No originals. Samples are returned by SASE. Reports back only if interested. Portfolio required. Request portfolio review in original query. Buys all rights.

CUSTOM STUDIOS INC., 6118 N. Broadway St., Chicago IL 60660-2502. (773)761-1150. President: Gary Wing. Estab. 1966. Custom T-shirt manufacturer. "We specialize in designing and screen printing custom T-shirts for schools, business promotions, fundraising and for our own line of stock."

Needs: Works with 10 freelance illustrators/year. Assigns 12 freelance jobs/year. Especially needs b&w illustrations (some original and some from customer's sketch). Uses artists for direct mail and brochures/fliers, but mostly for custom and stock T-shirt designs.

First Contact & Terms: Send query letter with résumé, photostats, photocopies or tearsheets. "We will not return originals or samples." Reports in 3-4 weeks. Mail b&w tearsheets or photostats to be kept on file. Pays for design and illustration by the hour, $28-35; by the project, $50-150. Considers turnaround time and rights purchased when establish-ing payment. For designs submitted to be used as stock T-shirt designs, pays 5-10% royalty. Rights purchased vary according to project.

Tips: "Send 5-10 good copies of your best work. We would like to see more black & white, camera-ready illustrations—copies, not originals. Do not get discouraged if your first designs sent are not accepted."

DALEE BOOK CO., 129 Clinton Place, Yonkers NY 10701. (914)965-1660. Vice President: Charles Hutter. Estab. 1964. "We manufacture photo albums, scrapbooks, telephone address books and desk sets. Custom manufacturing for the industry and private labeling."

Needs: Approached by 5 freelance artists/year. Works with 1 feelance artist/year. Buys 1-3 designs and illustrations/year from freelance artists. Prefers local artists only. Works on assignment only. Uses freelance artists mainly for labels and mechanicals. Considers any media.

First Contact & Terms: Send query letter with photocopies. Samples are not filed and are returned by SASE if requested by artist. Reports back to the artist only if interested. Write to schedule an appointment to show a portfolio or mail roughs and color samples. Original artwork is not returned at the job's completion. Pays by the project, $200-500 average. Buys all rights.

[N] DECORATORS WALK, 245 Newtown Rd., Plainview NY 11803. (516)249-3100. Fax: (516)249-3929. E-mail: jhthorp@aol.com. Director of Design: Roberta Nickelson. Produces printed and woven textiles. Decorative fabrics manufacturer and supplier to the high-end decorative trade.

Needs: Approached by 200-250 freelancers/year. Works with 2-5 freelancers/year. Buys 5-10 freelance designs/year. Prefers freelancers with experience in textile design. Uses few freelancers for creation of new fabric designs.

First Contact & Terms: Send letter with photocopies and résumé. Samples are filed. Company will contact artist for portfolio review of color and final art if interested.

DECORCAL, INC., 165 Marine St., Farmingdale NY 11735. (516)752-0076 or (800)645-9868. Fax: (516)752-1009. President: Walt Harris. Produces decorative, instant stained glass, as well as sports and wildlife decals.

Needs: Buys 50 designs and illustrations from freelancers/year. Uses freelancers mainly for greeting cards and decals;

also for P-O-P displays. Prefers watercolor.

First Contact & Terms: Send query letter with brochure showing art style or résumé and photographs. Samples not filed are returned. Art director will contact artist for portfolio review if interested. Portfolio should include final reproduction/product and photostats. Originals are not returned. Sometimes requests work on spec before assigning a job. Pays by project. Buys all rights. Finds artists through word of mouth, magazines, submissions/self-promotions, sourcebooks, agents, visiting artists' exhibitions, art fairs and artists' reps.

Tips: "We predict a steady market for the field."

DESIGN DESIGN, INC., P.O. Box 2266, Grand Rapids MI 49501. (616)774-2448. Fax: (616)774-4020. Creative Director: Tom Vituj. Produces humorous and traditional fine art greeting cards, stationery, journals, address books, magnets, sticky notes and giftwrap.

Needs: Uses freelancers for all of the above products. Considers most media. Produces cards for everyday and all holidays. Submit seasonal material 1 year in advance.

First Contact & Terms: Send query letter with appropriate samples and SASE. Samples are not filed and are returned by SASE if requested by artist. To show portfolio, send color copies, photographs or slides. Do not send originals. Pays royalties.

DESIGNER GREETINGS, INC., Box 140729, Staten Island NY 10314. (718)981-7700. E-mail: designer@planet.eart hcom.net. Art Director: Fern Gimbelman. Produces all types of greeting cards. Produces alternative, general, informal, inspirational, contemporary, juvenile and studio cards.

Needs: Works with 16 freelancers/year. Buys 250-300 designs and illustrations/year. Works on assignment only. Also uses artists for calligraphy, airbrushing and pen & ink. No specific size required. Produces material for all seasons; submit seasonal material 6 months in advance.

First Contact & Terms: Send query letter with brochure or tearsheets and photostats or photocopies. Samples are filed or are returned only if requested. Reports back within 3-4 weeks. Call or write for appointment to show portfolio of original/final art, final reproduction/product, tearsheets and photostats. Originals are not returned. Pays flat fee. Buys all rights.

Tips: "We are willing to look at any work through the mail (photocopies, etc.). Appointments are given after I personally speak with the artist (by phone)."

☑ **DIMENSIONS, INC.,** 1801 N 12th St., Reading PA 19604. (610)372-8491. Fax: (610)372-0426. Designer Relations Coordinator: Pamela Keller. Produces craft kits and leaflets, including but not limited to needlework, stained glass, painting projects, iron-on transfer, printed felt projects. "We are a craft manufacturer with emphasis on sophisticated artwork and talented designers. Products include needlecraft kits and leaflets, wearable art crafts, baby products. Primary market is adult women but children's crafts also included."

Needs: Approached by 50-100 freelancers/year. Works with 200 freelancers/year. Develops more than 400 freelance designs and illustrations/year. Uses freelancers mainly for the original artwork for each product. Art guidelines for SASE with first-class postage. In-house art staff adapts for needlecraft. Considers all media. Looking for fine art, realistic representation, good composition, more complex designs than some greeting card art; fairly tight illustration with good definition; also whimsical, fun characters. Produces material for Christmas; Valentine's Day; Easter; Halloween; everyday; birth, wedding and anniversary records. Majority of products are everyday decorative designs for the home.

First Contact & Terms: Send cover letter with color brochure, tearsheets, photographs or photocopies. Samples are filed "if artwork has potential for our market." Samples are returned by SASE only if requested by artist. Reports back within 1 month. Portfolio review not required. Originals are returned at job's completion. Pays by project, royalties of 2-5%; sometimes purchases outright. Finds artists through magazines, trade shows, word of mouth, licensors/reps.

Tips: "Current popular subjects in our industry: florals, country/folk art, garden themes, ocean themes, celestial, Southwest/Native American, Victorian, juvenile/baby and whimsical."

JOHN DIXON, INC., 24000 Mercantile Rd., Beachwood OH 44122-5913. (216)831-7577. Fax: (216)831-6793. President: Michael Wieder. Estab. 1979. Produces window treatments. Fabricator and distributor of quality custom window treatments.

Needs: Approached by 1-2 freelancers/year. Works with 1-2 freelancers/year. Buys 1-2 freelance designs and illustrations/year. Prefers freelancers with experience in working with window treatments. Works on assignment only. Uses freelancers mainly for custom painting window treatments. Looking for all styles. Produces material for everyday.

First Contact & Terms: Send query letter with brochure, photographs and résumé. Samples are not filed and are returned if requested. Reports back within 1 week. Portfolio review required only if interested in artist's work. Artist should follow-up with call or letter after initial query. Pays for design by the project. Finds freelancers through word of mouth.

SASE MEANS SELF-ADDRESSED, STAMPED ENVELOPE. Send SASEs when requesting return of your samples.

DLM STUDIO, 3158 Morley Rd., Shaker Heights OH 44122. (216)721-4444. Fax: (216)721-6878. E-mail: pat@dlmstudio.com. Website: http://www.dlmstudio.com. Vice President: Pat Walker. Estab. 1984. Produces fabrics/packaging. Specializes in wallcovering design, entire package with fabrics, also ultra-wide "mural" borders.

Needs: Approached by 20-50 freelancers/year. Works with 10-20 freelancers/year. Buys hundreds of freelance designs and illustrations/year. Art guidelines free for SASE with first-class postage. Works on assignment only. Uses freelancers mainly for designs, color work. Also for photo styling. Looking for traditional, floral, texture, woven, menswear, children's and novelty styles. 50% of freelance design work demands computer skills. Wallcovering CAD experience a plus. Produces material for everyday.

First Contact & Terms: Illustrators send query letter with photocopies, examples of work, résumé and SASE. Accepts disk submissions compatible with Illustrator or Photoshop files (Mac), SyQuest, Jaz or Zip. Samples are filed or returned by SASE on request. Reports back within 2-4 weeks. Request portfolio review of color photographs and slides in original query, follow-up with letter after initial query. Rights purchased vary according to project. Pays by the project, $500-1,500, "but it varies." Finds freelancers through agents and local ads, word of mouth.

Tips: "Send great samples, especially traditional patterns. Novelty and special interest also strong, and digital files are very helpful."

✅ **DUNCAN DESIGNS**, 2050 N. Acacia St., Fullerton CA 92631. (714)879-1360. Fax: (714)879-4611. President: Catherine Duncan. Estab. 1969. Produces collectible figurines, decorative housewares, gifts and giftwrap. Specializes in historical figurines.

Needs: Approached by 50 freelancers/year. Works with 10 freelancers/year. Uses freelancers mainly for sculpture/graphic arts. Also for mechanicals, P-O-P displays, paste-up. Considers all media. Prefers historical, traditional. Art guidelines available. Works on assignment only.

First Contact & Terms: Send query letter with photocopies, photographs, résumé. Send follow-up postcard every month. Samples are not filed and are returned. Reports back within 1 month. Portfolio review required. They may be dropped off Monday through Friday and should include color final art, photographs, photostats. Request portfolio review in original query. Rights purchased vary according to project. Payment varies.

EDITIONS LIMITED/FREDERICK BECK, 27 E. Housatonic, Pittsfield MA 01201-0989. (413)443-0973. Fax: (413)445-5014. Art Director: Mark Brown. Estab. 1958. Produces holiday greeting cards, personalized and box stock and stationery.

> ● Editions Limited joined forces with Frederick Beck Originals last year. The company also runs Gene Bliley Stationery. See editorial comment under Frederick Beck Originals for further information. Mark Brown is the art director for all three divisions.

Needs: Approached by 100 freelancers/year. Works with 20 freelancers/year. Buys 50-100 freelance designs and illustrations/year. Prefers freelancers with experience in silkscreen. Art guidelines available. Uses freelancers mainly for silkscreen greeting cards. Also for separations and design. Considers offset, silkscreen, thermography, foil stamp. Looking for traditional holiday, a little whimsy, contemporary designs. Size varies. Produces material for Christmas, graduation, Hannukkah, New Year, Rosh Hashanah and Valentine's Day. Submit seasonal material 15 months in advance.

First Contact & Terms: Designers send query letter with brochure, photocopies, photographs, résumé, tearsheets. Samples are filed. Reports back within 1 month. Will contact artist for portfolio review of b&w, color, final art, photographs, photostats, roughs if interested. Buys all rights. Pays $150-300/design. Finds freelancers through through word of mouth, past history.

📷 **ELEGANT GREETINGS, INC.**, 2330 Westwood Blvd., Suite 205, Los Angeles CA 90064-2127. (310)446-4929. Fax: (310)446-4819. President: S. Steier. Estab. 1981. Produces greeting cards, stationery and children's novelties; a traditional and contemporary mix, including color tinted photography; geared toward children 8-18, as well as schoolteachers and young adults 18-35.

Needs: Approached by 15 freelance artists/year. Works with 3 freelance artists/year. Buys varying number of designs and illustrations/year. Artist guidelines free for SASE with first-class postage. Prefers local artists only. Sometimes works on assignment basis only. Uses freelance artists mainly for new designs, new concepts and new mediums. Also uses freelance artists for P-O-P displays, paste-up and mechanicals. Looking for "contemporary, trendy, bright, crisp colors." Produces material for all holidays and seasons. Submit 1 year before holiday.

First Contact & Terms: Send query letter, brochure, photocopies, photographs and SASE. Samples are not filed and are returned. Reports back within 1 month. To show a portfolio, mail appropriate materials. Original artwork returned at the request of the artist. Pay is negotiable. Rights purchased vary according to project.

Tips: "We are currently looking for stuffed animal designs as well as home decor product including table and desk accessories. We review everything. We look for an almost finished product."

📰 **KRISTIN ELLIOTT, INC.**, 6 Opportunity Way, Newburyport MA 01950. (978)526-7126. Creative Director: Barbara Elliot. Publishes greeting cards and stationery products.

Needs: Works with 50 freelance artists/year. Uses freelancers mainly for illustration and graphic design. Prefers watercolor and gouache. Produces material for Christmas and everyday. Also produces notecards and imprintables.

First Contact & Terms: Send published samples, color copies, slides or photos.

☑ **ENCORE STUDIOS, INC.**, 17 Industrial West, Clifton NJ 07012. (800)526-0497. Phone/fax: (973)472-3005. E-mail: encore17@aol.com. Website: http://www.encorestudios.com. Art Director: Marcia Altman. Estab. 1979. Produces personalized wedding, bar/bat mitzvah, party and engraved invitations, birth announcements, stationery, Christmas and Chanukah cards and Jewish New Year.

Needs: Approached by 50-75 freelance designers/year. Works with 20 freelancers/year. Prefers freelancers with experience in creating concepts for holiday cards, invitations, announcements and stationery. Art guidelines available for SASE with first-class postage. "We are interested in designs for any category in our line. Looking for unique type layouts, textile designs and initial monograms for stationery and weddings, holiday logos, flowers for our wedding line, Hebrew monograms for our bar/bat mitzvah line, religious art for Bar/Bat Mitzvah and Chanukah." Considers b&w or full-color art. Looking for "elegant, graphic, sophisticated contemporary designs." 20% of freelance work demands knowledge of Macintosh: QuarkXPress, Adobe Illustrator, Adobe Photoshop. Submit seasonal material all year.

First Contact & Terms: Send query letter with brochure, résumé, SASE, tearsheets, photographs, photocopies or slides. Samples are filed or are returned by SASE if requested by artist. Reports back within 2 weeks only if interested. Write for appointment to show portfolio, or mail appropriate materials. Portfolio should include roughs, finished art samples, b&w photographs or slides. Pays by the project. Negotiates rights purchased.

ENESCO CORPORATION, 225 Windsor Dr., Itasca IL 60143. (630)875-5300. Fax: (630)875-5349. Contact: New Submissions/Licensing. Producer and importer of fine gifts and collectibles, such as ceramic, porcelain bisque and earthenware figurines, plates, hanging ornaments, bells, thimbles, picture frames, decorative housewares, music boxes, dolls, tins, crystal and brass. Clients: gift stores, card shops and department stores.

Needs: Works with 300 freelance artists/year. Assigns 1,000 freelance jobs/year. Prefers artists with experience in gift product and packaging development. Uses freelancers for rendering, illustration and sculpture. 50% of freelance work demands knowledge of Adobe Photoshop, QuarkXPress or Adobe Illustrator.

First Contact & Terms: Send query letter with brochure, résumé, tearsheets, photostats and photographs. Samples are filed or are returned. Reports back within 2 weeks. Pays by the project.

Tips: "Contact by mail only. It is better to send samples and/or photocopies of work instead of original art. All will be reviewed by Senior Creative Director, Executive Vice President and Licensing Director. If your talent is a good match to Enesco's product development, we will contact you to discuss further arrangements. Please do not send slides. Have a well thought-out concept that relates to gift products before mailing your submissions."

☑ **EPIC PRODUCTS INC.**, 17370 Mt. Herrmann, Fountain Valley CA 92708. (714)641-8194. Fax: (714)641-8217. President: Steve DuBow. Estab. 1978. Produces paper tableware products and wine and spirits accessories. "Epic Products manufactures products for the gourmet/housewares market; specifically products that are wine-related. Many have a design printed on them."

Needs: Approached by 50-75 freelance artists/year. Works with 10-15 freelancers/year. Buys 25-50 designs and illustrations/year. Prefers artists with experience in gourmet/housewares, wine and spirits, gift and stationery.

First Contact & Terms: Send query letter with résumé and photocopies. Samples are filed. Reports back within 1 week. Write for appointment to show portfolio. Portfolio should include thumbnails, roughs, final art, b&w and color. Buys all rights. Originals are not returned. Pays by the project.

☑ **EQUITY MARKETING, INC.**, 6330 San Vicente, Los Angeles CA 90048. (323)932-4300. Studio Director: Sue Davis. Specializes in design, development and production of promotional, toy and gift items, especially licensed properties from the entertainment industry. Clients include Tyco, Applause, Avanti and Ringling Bros. and worldwide licensing relationships with Disney, Warner Bros., 20th Century Fox and Lucas Film.

Needs: Needs product designers, sculptors, packaging and display designers, graphic designers and illustrators. Prefers whimsical and cartoon styles. Products are typically targeted at children. Works on assignment only.

First Contact & Terms: Send résumé and non-returnable samples. Will contact for portfolio review if interested. Rights purchased vary according to project. Pays for design by the project, $50-1,200. Pays for illustration by the project, $75-3,000. Finds artists through word of mouth, network of design community, agents/reps.

Tips: "Gift items will need to be simply made, priced right and of quality design to compete with low prices at discount houses."

☑ **EVERTHING METAL IMAGINABLE, INC. (E.M.I.)**, 401 E. Cypress, Visalia CA 93277. (209)732-8126 or (800)777-8126. Fax: (209)732-5961. E-mail: webmaster@emiartbronze.com. Website: http://www.emiartbronze.com. Artists' Liaison: Dru McBride. Estab. 1967. Wholesale manufacturer. "We manufacture lost wax bronze sculpture." Clients: wholesalers, premium incentive consumers, retailers, auctioneers, corporations.

Needs: Approached by 10 freelance artists/year. Works with 20 freelance designers/year. Assigns 5-10 jobs to freelance artists/year. Prefers artists that understand centrifugal casting, bronze casting and the principles of mold making. Uses artists for figurine sculpture and model making.

First Contact & Terms: Send query letter with brochure or résumé, tearsheets, photostats, photocopies and slides. Samples not filed are returned only if requested. Reports back only if interested. Call for appointment to show portfolio of original/final art and photographs "or any samples." Pays for design by the project, $500-20,000. Buys all rights.

Tips: "Artists must be conscious of detail in their work, be able to work expediently and under time pressure and be able to accept criticism of work from client. Price of program must include completing work to satisfaction of customers. Trends include children at play."

N **FAIRCHILD ART/FAIRCHILD PHOENIX**, 2110 Stonewood Dr., Charlotte NC 28210. (704)525-6369. Owner/
President: Marilynn Fairchild. Estab. 1985. Produces fine art greeting cards, stationery, posters and art prints.
Needs: Approached by 10-15 artists/year. Works with 1 or 2 artists/year. Buys 10-20 designs and illustrations/year.
Prefers "quality fine artists." Uses freelancers mainly "when artwork is needed to complement our present product
line." Considers all media. Prefers "work which is proportionate to 25×38 or 23×35 printing sheets; also sizes useful
for printing 2-up, 4-up or 10-up on these size sheets." Produces material for birthdays and everyday. Submit 1 year
before holiday. 10-25% of freelance works demands knowledge of Aldus FreeHand, Adobe Illustrator or CorelArt.
First Contact & Terms: Send query letter with brochure, résumé, tearsheets, photographs or photocopies. Samples
are filed or are not returned. Reports back to the artist only if interested. Write for appointment to show portfolio, or
mail finished art samples, b&w and color photostats, tearsheets and photographs. Pays flat fee for illustration/design,
$100-300; or by the hour, $15 minimum. Rights purchased vary according to project.
Tips: This company looks for professionalism in its freelancers.

FINE ART PRODUCTIONS, RICHIE SURACI PICTURES, MULTIMEDIA, INTERACTIVE, 67 Maple St.,
Newburgh NY 12550-4034. Phone/fax: (914)561-5866. E-mail: rs7.fap@mhv.net or richie.suraci@bbs.mhv.net. Web-
sites: http://www.mhv.net/~rs7.fap/networkerotica.html, or http://indyjones.simplenet.com/kunda.htm or http://www.bro
adcast.com/books. Contact: Richie Suraci. Estab. 1994. Produces greeting cards, stationery, calendars, posters, games/
toys, paper tableware products, giftwrap, CD-ROMs, video/film backgrounds, magazine, newspaper print. "Our products
are fantasy, New Age, sci-fi, outer space, environmental, adult erotica."
Needs: Prefers freelancers with experience in sci-fi, outer space, adult erotica, environmental, fantasy and mystical
themes. Uses freelancers for calligraphy, P-O-P displays, paste-up and mechanicals. Art guidelines for SASE with first-
class postage. Considers all media. 50% of freelance work demands knowledge of Adobe Illustrator, Adobe Photoshop,
QuarkXPress, Aldus FreeHand, Aldus PageMaker, SGI and ImMix. Produces material for all holidays and seasons and
Valentine's Day. Submit seasonal material 1 year in advance.
First Contact & Terms: Send postcard sample or query letter with brochure, tearsheets, résumé, photographs, slides,
SASE, photocopies and transparencies. Accepts submissions on disk (Macintosh). "If sending disks send $3\frac{1}{2}''$ disks
formatted for Apple computers." Samples are filed or returned by SASE if requested by artist. Reports back within 3-
4 months if interested. Company will contact artist for portfolio review if interested. Portfolio should include thumbnails,
roughs, final art, photostats, tearsheets, photographs, slides and transparencies. Rights purchased vary according to
project. Originals are returned at job's completion. Pays by the project. Finds artists through agents, sourcebooks,
magazines, word of mouth and submissions.
Tips: "Send unique material that is colorful. Send samples in genres we are looking for."

FISHER-PRICE, 636 Girard Ave., E. Aurora NY 14052. (716)687-3983. Fax: (716)687-5281. Director, Product Art:
Henry Schmidt. Estab. 1931. Manufacturer of toys and other children's products.
Needs: Approached by 10-15 freelance artists/year. Works with 25-30 freelance illustrators and sculptors and 15-20
freelance graphic designers/year. Assigns 100-150 jobs to freelancers/year. Prefers artists with experience in children's
style illustration and graphics. Works on assignment only. Uses freelancers mainly for product decoration (label art).
Prefers all media and styles except loose watercolor. Also uses sculptors. 25% of work demands knowledge of Aldus
FreeHand, Adobe Illustrator, Adobe Photoshop.
 • This company has two separate art departments: Advertising and Packaging, which does catalogs and promo-
 tional materials; and Product Art, which designs decorations for actual toys. Be sure to specify your intent when
 submitting material for consideration. Art Director told *AGDM* he has been receiving more samples on disk or
 through the Internet. He says it's a convenient way for him or his staff to look at work.
First Contact & Terms: Send query letter with samples showing art style or slides, photographs and transparencies.
Samples are filed. Reports back to the artist only if interested. Call to schedule an appointment to show a portfolio.
Portfolio should include original, final art and color photographs and transparencies. Pays for design and illustration by
the hour, $25-50. Buys all rights.

FOTOFOLIO, INC., 536 Broadway, New York NY 10012. (212)226-0923. Fax: (212)226-0072. E-mail: fotofolio@ao
l.com. Website: http://www.fotofolio.com. Editorial Coordinator: Cindy Williamson. Estab. 1976. Produces greeting
cards, calendars, posters, T-shirts, postcards and a line of products for children including a photographic book, Keith
Haring coloring books and notecards.
Needs: Buys 5-60 freelance designs and illustrations/year. Reproduces existing works. Primarily interested in photogra-
phy. Produces material for Christmas, Valentine's Day, birthday and everyday. Submit seasonal material 8 months in
advance. Art guidelines for SASE with first-class postage.
First Contact & Terms: Send query letter with SASE c/o Editorial Dept. Samples are filed or are returned by SASE
if requested by artist. Editorial Coordinator will contact artist for portfolio review if interested. Originals are returned
at job's completion. Pays by the project, $7\frac{1}{2}$-15% royalties. Rights purchased vary according to project. Finds artists
through word of mouth, magazines, submissions/self-promotions, sourcebooks, agents, visiting artist's exhibitions, art
fairs and artists' reps.
Tips: "When submitting materials, present a variety of your work (no more than 40 images) rather than one subject/
genre."

☑ **THE FRANKLIN MINT**, Franklin Center PA 19091-0001. (610)459-6629. Fax:(610)459-7270. E-mail: artistre@f mint.com. Artist Relations Managers: Ellen Caggiula, illustration; Lindy Schaffstall, sculpture and dolls. Estab. 1964. Direct response marketing of high-quality collectibles. Produces collectible porcelain plates, prints, porcelain and cold-cast sculpture, figurines, fashion and traditional jewelry, ornaments, precision diecast model cars, luxury board games, engineered products, heirloom dolls and plush, home decor items and unique gifts. Clients: general public worldwide, proprietary houselist of 8 million collectors and 55 owned and operated retail stores. Markets products in 20 countries worldwide including: USA, Canada, United Kingdom, France, Germany, Australia, New Zealand and Japan.

Needs: Approached by 3,000 freelance artists/year. Contracts 500 artists/sculptors per year to work on 7,000-8,000 projects. Buys approximately 400 sculptures/year. Uses freelancers mainly for illustration and sculpture. Considers all media. Considers all styles. 80% of freelance design and 50% of illustration demand knowledge of Aldus PageMaker, Aldus FreeHand, Adobe Photoshop, Adobe Illustrator, QuarkXPress and 3D Studio Eclipse (2D). Accepts work in SGI format. Produces material for Christmas and everyday. Submit seasonal material 6-8 months in advance.

First Contact & Terms: Send query letter, biography, SASE and samples (clear, professional full-color photographs, transparencies, slides, greeting cards and/or brochures and tearsheets). Sculptors send photographic portfolios. Do not send original artwork. Samples are filed or returned by SASE. Reports back within 2 months. Portfolio review required for illustrators and sculptors. Reviews portfolios weekly. Company gives feedback on all portfolios submitted. Payment varies.

Tips: "In search of artists and sculptors capable of producing high quality work. Those willing to take art direction and to make revisions of their work are encouraged to submit their portfolios."

N **FREEDOM GREETINGS**, Dept. AM, 1619 Hanford St., Levittown PA 19057. (215)945-3300. Send submissions to Creative Director Jim Plesh %Plesh & Associates, 75 West St., Walpole MA 02081. (508)668-1224. President: Jay Levitt. Creative Director: Jim Plesh. Estab. 1969. Produces greeting cards featuring flowers and scenery.

Needs: Approached by over 100 artists/year. Buys 200 designs from artists/year. Works on assignment only. Considers watercolor, acrylic, etc. Prefers novelty. Call for size specifications. Produces material for all seasons and holidays; submit 14 months in advance.

First Contact & Terms: Send query letter with résumé and samples. Samples are returned by SASE. Reports within 10 days. To show a portfolio, mail roughs. Originals returned to artist at job's completion. Pays average flat fee of $150-275, illustration/design. Buys all greeting and stationery rights.

Tips: "We also seek illustrations of blacks in situations similar to those found on our photographic lines."

GALISON BOOKS/MUDPUPPY PRESS, 28 W. 44th St., New York NY 10036. (212)354-8840. Fax: (212)391-4037. E-mail: gmanola@galison.com. Website: http://www.galison.com. Design Director: Gina Manola. Estab. 1978. Produces boxed greeting cards, puzzles, address books and specialty journals. Many projects are done in collaboration with museums around the world.

Needs: Works with 10-15 freelancers/year. Buys 20 designs and illustrations/year. Works on assignment only. Uses freelancers mainly for illustration. Considers all media. Also produces material for Christmas and New Year. Submit seasonal material 1 year in advance. 100% of design and 5% of illustration demand knowledge of QuarkXPress.

First Contact & Terms: Send postcard sample, photocopies, résumé and tearsheets (no unsolicited original artwork) and SASE. Accepts submissions on disk compatible with Adobe Photoshop, Adobe Illustrator or QuarkXPress (but not preferred). Samples are filed. Reports back to the artist only if interested. Request portfolio review in original query. Art Director will contact artist for portfolio review if interested. Portfolio should include color photostats, slides, tearsheets and dummies. Originals are returned at job's completion. Pays by project. Rights purchased vary according to project. Finds artists through word of mouth, magazines and artists' reps.

Tips: "Looking for great presentation and artwork we think will sell and be competitive within the gift market."

GALLANT GREETINGS CORP., P.O. Box 308, Franklin Park IL 60131. (847)671-6500. Fax: (847)671-7500. E-mail: sales@gallantgreetings.com. Website: http://www.gallantgreetings.com. Vice President Sales and Marketing: Chris Allen. Estab. 1966. Creator and publisher of seasonal and everyday greeting cards.

Needs: Looking for traditional and humorous material for Christmas, Easter, Mother's Day, Father's Day, graduation, Halloween, Thanksgiving, Valentine's Day, birthdays, everyday and most card-giving occasions.

First Contact & Terms: Samples are not filed or returned. Reports back only if interested.

GALLERY GRAPHICS, INC., P.O. Box 502, Noel MO 64854. (417)475-6191. Fax: (417)475-3542. Art Director: Donna Schwegman. Estab. 1979. Produces bookmarks, calendars, giftbags, gifts, giftwrap, greeting cards, stationery, prints, notepads, notecards. Gift company specializing primarily in Victorian and country designs.

Needs: Approached by 100 freelancers/year. Works with 5 freelancers/year. Buys 36 freelance illustrations/year. Art guidelines available. Uses freelancers mainly for illustration. Considers any 2-dimensional media. Looking for country, teddy bears, florals, traditional. Prefers 16×20 maximum. Produces material for Christmas, Valentine's Day, birthdays, sympathy, get well, thank you. Submit seasonal material 8 months in advance.

First Contact & Terms: Accepts disk submissions compatible with Photoshop or FreeHand. Send TIFF or EPS files. Samples are filed or returned by SASE. Reports back within 3 weeks. Will contact artist for portfolio review of color photographs, photostats, slides, tearsheets, transparencies if interested. Payment negotiable. Finds freelancers through submissions and word of mouth.

[N] C.R. GIBSON CO., A division of Thomas Nelson Gifts, 32 Knight St., Norwalk CT 06856-5220. (203)847-4543. Fax: (203)847-1165. Freelance Coordinator: Barbara Andresen. Estab. 1870. Produces stationery, paper tableware products, giftwrap, gift books, baby books, wedding books, photo albums, scrap books, kitchen products (recipe books and coupon files). "The C.R. Gibson Company has a very diversified product line. Generally we sell our products to the better markets including department stores, gift shops and stationery stores. Our designs are fashionable without being avant-garde, always in good taste."

Needs: Approached by 250-300 freelancers/year. Works with 50 freelancers/year. Buys 100 freelance designs and illustrations/year. Prefers artists with experience in traditional materials; rarely uses computer generated art. Art guidelines for SASE with first-class postage. Works on assignment 90% of time. Looking for conservative, traditional looks— no abstract or regional themes. Most designs subject-oriented—"pretty," fashionable and in good taste. Computer skills are helpful. Produces material for Christmas, Valentine's Day, birthdays and everyday. Submit Christmas material 1 year in advance.

First Contact & Terms: Send query letter with brochure, photographs, slides, SASE, color photocopies and transparencies. Samples are sometimes filed or are returned. Company will contact artist for portfolio review if interested. Rights purchased vary according to project. Finds artists through word of mouth, submissions and agents.

Tips: "Try to be aware of current design themes and colors. Most of our designs are subject-oriented and not abstract prints or designs. Before we can review any artwork we require artists to sign a submission agreement. Look at our line of product. Don't send anything that isn't appropriate. We only use full color work."

GIBSON GREETINGS, INC., 2100 Section Rd., Cincinnati OH 45237. (513)841-6600. Design Director: Gwent Markley. Estab. 1850. Produces greeting cards, giftwrap, stationery, calendars and paper tableware products. "Gibson is a leader in social expression products."

Needs: Approached by 300 freelancers/year. Works with 200 freelancers/year. Buys 3,500 freelance designs and illustrations/year. Prefers freelancers with industry experience in social expression. Alternative designs accepted. Works on assignment only. Uses freelancers mainly for greeting cards. Considers any media and a wide variety of styles. 40% of freelance work demands knowledge of Adobe Illustrator, Adobe Photoshop and QuarkXPress. Produces material for all holidays and seasons. Submit seasonal material 1 year in advance.

First Contact & Terms: Send query letter with résumé, SASE, tearsheets, photographs, photocopies, photostats, slides, transparencies. Do not submit original work! Samples are filed if accepted or returned by SASE. Reports back within 3-4 weeks. Company will contact artist for portfolio review if interested. Portfolio should include final art, tearsheets, photographs, transparencies. "Artwork is bought outright—all rights and art belong to company." Originals are not returned. Pays by the project, or flat fee, varies.

Tips: "Excellent drawing skills are essential. Must be diversified in all media; experience in social expression field is a definite advantage."

GLITTERWRAP, INC., 701 Ford Rd., Rockaway NJ 07866. (973)625-4200. Fax: (973)625-9641. Art Director: Susan Guerra. Estab. 1987. Produces giftwrap, gift totes and allied accessories. Also photo albums, diaries and stationery items for all ages—party and special occasion market.

Needs: Approached by 50-100 freelance artists/year. Works with 10-15 artists/year. Buys 10-30 designs and illustrations/year. Art guidelines available. Prefers artists with experience in textile design who are knowledgable in repeat patterns or surface. Uses freelancers mainly for occasional on-site Mac production at hourly rate of $15-25. Freelance work demands knowledge of QuarkXPress, Aldus FreeHand, Adobe Illustrator and Adobe Photoshop. Considers many styles and mediums. Style varies with season and year. Consider trends and designs already in line, as well as up and coming motifs in gift market. Produces material for Christmas, graduation, birthdays, Valentine's Day, Hanukkah and everyday. Submit seasonal material 6-8 months in advance.

First Contact & Terms: Send query letter with brochure, tearsheets, photographs, slides, transparencies or color copies of work. Do not send original art or oversized samples. Samples are filed or are returned by SASE if requested. Reports back in 2-3 weeks. "To request our submission guidelines send SASE with request letter. To request catalogs send 11 × 14 SASE with $3.50 postage. Catalogs are given out on a limited basis." Rights purchased vary according to project.

Tips: "Giftwrap generally follows the fashion industry lead with respect to color and design. Adult birthday and baby

MARKET CONDITIONS are constantly changing! If you're still using this book and it is 2001 or later, buy the newest edition of *Artist's & Graphic Designer's Market* at your favorite bookstore or order directly from Writer's Digest Books (1-800-289-0963).

shower/birth are fast-growing categories. There is a need for good/fresh/fun typographic birthday general designs in both adult and juvenile categories."

✔ **GOES LITHOGRAPHING COMPANY SINCE 1879**, 42 W. 61st St., Chicago IL 60621-3999. (773)684-6700. Fax: (773)684-2065. E-mail: goeslitho@ameritech.net. Website: http://www.goeslitho.com. Contact: Linda Goes or Cynthia Thompson. Estab. 1879. Produces stationery/letterheads to sell to printers and office product stores.

Needs: Approached by 5-10 freelance artists/year. Works with 2-3 freelance artists/year. Buys 4-30 freelance designs and illustrations/year. Art guidelines for SASE with first-class postage. Uses freelance artists mainly for designing holiday letterheads. Considers pen & ink, color, acrylic, watercolor. Prefers final art 17×22, CMYX color compatible. Produces material for Christmas and Thanksgiving.

First Contact & Terms: "I will send examples for your ideas." Samples are not filed and are returned by SASE. Reports back within 1-2 months. Pays $100-200 on final acceptance. Buys first rights and reprint rights.

Tips: "Keep your art fresh and be aggressive with submissions."

GREAT AMERICAN PUZZLE FACTORY INC., 16 S. Main St., S. Norwalk CT 06854. Fax: (203)838-2065. Website: http://www.greatamericanpuzzle.com. Art Director: Anne Mulligan. Licensing: Praticia Duncan. Estab. 1975. Produces jigsaw puzzles and games for adults and children. Licenses wildlife, Americana and cats for puzzles (children's and adults).

Needs: Approached by 150 freelancers/year. Works with 15 freelancers/year. Buys 50 designs and illustrations/year. Uses freelancers mainly for puzzle material. Art guidelines for SASE with first-class postage. Looking for "fun, busy and colorful" work. 100% of graphic design requires knowledge of QuarkXPress, Adobe Illustrator or Adobe Photoshop.

First Contact & Terms: Send postcard sample or query letter with brochure, tearsheets and photocopies. Do not send originals or transparencies. Samples are filed or are returned. Art Director will contact artist for portfolio review if interested. Original artwork is returned at job's completion. Pays flat fee of $800-1,000, work for hire. Royalties of 5-6% for licensed art (existing art only). Interested in buying second rights (reprint rights) to previously published work.

Tips: "All artwork should be *bright*, cheerful and eye-catching. 'Subtle' is not an appropriate look for our market. Go to a toy store and look at what is out there. Do your homework! Send a professional-looking package to appropriate potential clients. Presentation means a lot. We get a lot of totally inappropriate submissions. Proofread your résumé; typos look really unprofessional."

GREAT ARROW GRAPHICS, 2495 Main St., Suite 432, Buffalo NY 14214. (716)836-0408. Fax: (716)836-0702. E-mail: grtarrow@aol.com. Art Director: Alan Friedman. Estab. 1981. Produces greeting cards and stationery. "We produce silkscreened greeting cards—seasonal and everyday—to a high-end design-conscious market."

Needs: Approached by 80 freelancers/year. Works with 20 freelancers/year. Buys 150-200 images/year. Art guidelines for SASE with first-class postage. Prefers freelancers with experience in hand-separated art. Uses freelancers mainly for greeting card design. Considers all 2-dimensional media. Looking for sophisticated, classic, contemporary or cutting edge styles. Requires knowledge of QuarkXPress, Adobe Illustrator or Adobe Photoshop. Produces material for all holidays and seasons. Submit seasonal material 1 year in advance.

First Contact & Terms: Send query letter with photocopies and SASE. Accepts submissions on disk compatible with QuarkXPress, Adobe Illustrator or Adobe Photoshop. Samples are filed or returned if requested. Reports back within 1 month. Art Director will contact artist for portfolio review if interested. Portfolio should include color roughs, final art, photographs and transparencies. Originals are returned at job's completion. Pays royalties of 5% of net sales. Rights purchased vary according to project.

Tips: "We are most interested in artists familiar with hand-separated process and with the assets and limitations of screenprinting. Be original—be complete with ideas—don't be afraid to be different . . . forget the trends . . . do what you want."

JAN HAGARA COLLECTABLES, INC., 40114 Industrial Park, Georgetown TX 78626. (512)863-8187. Fax: (512)869-2093. Art Director: Lonnie Bear. Estab. 1975. Produces limited-edition collectibles (e.g. prints, plates, figurines, dolls, notecards and stationery products). "We design and market a line of collectible giftware with a romantic Victorian theme. Our products appeal to women in an 'empty nest' situation who prefer 'pretty' things of uniqueness and value."

Needs: Approached by 100 freelance artists/year. Works with 7 or more freelancers/year. Buys 20 designs and illustrations/year. Prefers watercolor or clay or wax sculpture. Works on assignment only. Uses freelancers mainly for executing concepts in two and three dimensions—packaging, inserts, line drawings that resemble old-fashioned engravings and sculpture. Also for calligraphy, P-O-P displays, T-shirt art (mechanical separations), jewelry sculpting (charm bracelets), coffee mug art (mechanical separations), cloisonné pin art, cross-stitch development. For 2-D work, prefers watercolor/colored pencil and pen & ink. For 3-D work, prefers wax, Sculpey, clay. "We're in need of Romantic Victorian work—turn-of-the-century nostalgia. Our subjects are children, flowers, ribbons and bows. We're also interested in the amusements of childhood: toys, dolls, teddy bears."

First Contact & Terms: Send query letter with photostats, photographs, slides, transparencies and SASE. "Do not send original work." Samples are filed or are returned by SASE if requested by artist. Reports back only if interested. To show portfolio, mail photostats of lettering or one-color artwork and tearsheets or photographs of color work. Originals usually not returned at job's completion. Pays by the project, $35-2,000. Rights purchased vary according to project.

Tips: "Show, don't tell. We don't require 'professionalism,' lawyers, or agents. We simply want creative people with a feel for our style. The only way to know if you've got what we need is to let us see your work. Although we don't require computer skills for our freelancers, we have moved to inhouse prepress ourselves. We have virtually eliminated photography by using a digital studio camera which feeds directly into our computer system. Artists should be aware that digital prepress is very much the trend and should become familiar with software for graphics, particularly QuarkX-Press and Adobe Photoshop. We also see a development in prototyping of sculpted items using computers. We are experimenting with x-ray technology and CAD software to develop plastic prototypes out of laser scintering. Sculptors interested in this trend should become familiar with STL files and CAD/CAM."

HALLMARK CARDS, INC., P.O. Box 419580, Drop 216, Kansas City MO 64141-6580.
- Because of Hallmark's large creative staff of fulltime employees and their established base of freelance talent capable of fulfilling their product needs, they are not accepting freelance submissions.

N THE HAMILTON COLLECTION, 4810 Executive Park Court, Jacksonville FL 32216-6069. (904)279-1300. Fax: (904)279-1497. Product Development: Mary Kirkland. Direct marketing firm for collectibles: sculpture or figurines. Clients: general public, specialized lists of collectible buyers and retail market in US, Great Britain, Canada, France and Germany.
Needs: Approached by 100 freelancers/year. Works with 100-200/year. Assigns all jobs (200-400) to freelancers/year. "No restrictions on locality but must have quality work and flexibility regarding changes." Uses freelancers for product design and illustration for 3-D and 2-D products. Needs fine art or tight illustration for plates. 15% of freelance work demands computer skills.
First Contact & Terms: Send query letter with brochure, photocopies, photographs, SASE, slides, tearsheets and transparencies. Samples will be returned if requested (must include a SASE or appropriate package with sufficient postage). "Please do not send original art; preferences are for photographs, slides, transparencies, and/or tearsheets." Reports within 6-12 weeks. Artist should follow-up with letter after initial query. Sometimes requests work on spec before assigning a job. Pays by project, $100-1,500. Sometimes interested in buying second rights (reprint rights) to previously published work "for product development in regard to collectibles/plates; artwork must be suitable for cropping to a circular format."
Tips: Open to a wide range of styles. "We aggressively seek out new talent for our product development projects through every avenue available. Attitude and turnaround time are important. Be prepared to offer sketches on speculation. This is a strong market (collectibles) that has continued its growth over the years, despite economic slumps."

HAMPSHIRE PEWTER COMPANY, 43 Mill St., Box 1570, Wolfeboro NH 03894-1570. (603)569-4944. Fax: (603)569-4524. E-mail: hpewter@worldpath.net. Website: http://www.hpewter.com. President: Bob Steele. Estab. 1974. Manufacturer of handcast pewter tableware, accessories and Christmas ornaments. Clients: jewelry stores, department stores, executive gift buyers, tabletop and pewter speciality stores, churches and private consumers.
Needs: Works with 3-4 freelance artists/year. "Prefers New-England based artists." Works on assignment only. Uses freelancers mainly for illustration and models. Also for brochure and catalog design, product design, illustration on product and model-making.
First Contact & Terms: Send query letter with photocopies. Samples are not filed and are returned only if requested. Call for appointment to show portfolio, or mail b&w roughs and photographs. Pays for design and sculpture by the hour or project. Considers complexity of project, client's budget and rights purchased when determining payment. Buys all rights.
Tips: "Inform us of your capabilities. For artists who are seeking a manufacturing source, we will be happy to bid on manufacturing of designs under private license to the artists, all of whose design rights are protected. If we commission a project, we intend to have exclusive rights to the designs by contract as defined in the Copyright Law and we intend to protect those rights."

HEARTPRINT, 2660 Bullock Rd., Medford OR 97504. Produces bookmarks, journals, greeting cards, mugs, ornaments, stationery, framed art.
Needs: Approached by 40-50 freelancers/year. Prefers local designers only (illustrators need not be local). Prefers illustrators with experience in watercolor. Art guidelines are available. Uses freelancers mainly for reproduction for our paper and giftware. Also for calligraphy, paste-up, P-O-P. Looking for traditional, floral, sentimental, cute animals. Prefers 5×7. 80% of freelance design and 20% of freelance illustration demands knowledge of Adobe Photoshop, Adobe Illustrator, QuarkXPress. Produces material for Christmas, Mother's Day, Father's Day, everyday, sympathy, get well, thank you, wedding. Submit seasonal material 6 months in advance.
First Contact & Terms: Designers send query letter with brochure. Illustrators send query letter with photocopies, photostats. Accepts disk submissions from illustrators if compatible with Adobe Photoshop or QuarkXPress files. Zip disks OK. Samples are filed. Reports back within 2 weeks. Portfolios may be dropped off Monday-Friday. Artist should follow-up with letter after initial query. Will contact artist for portfolio review if interested. Rights purchased vary according to project. Pays for illustration flat fee, $500/design. Finds freelancers through submissions.
Tips: "Color, color, color!"

HERITAGE COLLECTION, 79 Fifth Ave., New York NY 10003. (212)647-1000. Fax: (212)647-0188. President: Reginald Powe. Estab. 1988. Produces greeting cards, gift bags, giftwrap, mugs, placemats, etc., for the African-American.

Needs: Approached by 20-30 freelance artists/year. Works with 3-5 freelance artists/year. Buys 40-80 new freelance designs and illustrations/year. Uses freelance artists mainly for card art and verse. Considers all media. Produces material for all holidays and seasons, birthdays and Kwanzaa. Submit seasonal material 1 year in advance.

First Contact & Terms: Send query letter with SASE, tearsheets, photographs, photocopies and photostats. Samples are filed or are returned by SASE. Reports back within 1 month. Call for appointment to show portfolio of original/final art, color tearsheets. Originals are returned at job's completion. Pays royalty or buys all rights on work-for-hire basis.

 HIGH RANGE GRAPHICS, P.O. Box 346, Victor ID 83455-0346. President: Jan Stuessl. Estab. 1989. Produces T-shirts. "We produce screen-printed garments for recreational sport-oriented markets and resort markets, which includes national parks. Subject matter includes, but is not limited to, skiing, climbing, hiking, biking, fly fishing, mountains, out-of-doors, nature, canoeing and river rafting, Native American, wildlife and humorous sayings that are text only or a combination of text and art. Our resort market customers are men, women and kids looking to buy a souvenir of their vacation experience or activity. People want to identify with the message and/or the art on the T-shirt."

• According to High Range Graphics' art guidelines, it is easiest to break into HRG with designs related to fly fishing, downhill skiing, snowboarding or river rafting. The guidelines suggest that your first submission cover one or more of these topics. The art guidelines for this company are detailed and include suggestions on where to place design on the garment.

Needs: Approached by 20 freelancers/year. Works with 3-8 freelancers/year. Buys 10-20 designs and illustration/year. Prefers artists with experience in screen printing. Uses freelancers mainly for T-shirt ideas, artwork and color separations.

First Contact & Terms: Send query letter with résumé, SASE and photocopies. Accepts submissions on disk compatible with Aldus FreeHand. Samples are filed or are returned by SASE if requested by artist. Reports back within 6 months. Company will contact artist for portfolio review if interested. Portfolio should include b&w thumbnails, roughs and final art. Originals are returned at job's completion. Pays by the project, licensing fee of $300 in addition to royalties of 5% based on actual sales. Buys garment rights.

Tips: "Familiarize yourself with screen printing and T-shirt art that sells. Must have knowledge of color separations process. We look for creative design styles and interesting color applications. Artists need to be able to incorporate the colors of the garments as part of their design thinking, as well as utilize the screen printing medium to produce interesting effects and textures. However, sometimes simple is best. Four-color process will be considered if highly marketable. Be willing to work with us on design changes to get the most marketable product. Know the industry. Art that works on paper will not necessarily work on garments. No cartoons please."

HIXON & FIERING, INC., 9219 Quivira Rd., Overland Park KS 66215. (800)964-4002. Fax: (800)879-1560. Website: http://www.hfproducts.com. Art Director: Susan Crilley. Estab. 1987. Produces birth announcements and invitations. "We started out as a birth announcement company, branched off into children's party invitations and now do party invitations for adults as well. New in 1999 is our elegant wedding embossed and foil stammped line."

Needs: Approached by 30 freelancers/year. Works with 5 freelancers/year. Buys 20-30 freelance designs and illustrations/year. Uses freelancers for card design. Art guidelines available. Buys art outright and by assignment. "If the artist has a style we like and is a good conceptualizer, we will approve a color sketch, then he gives us the final product." Considers gouache, watercolor, acrylic (soft) and pastels. Also interested in computer generated art using Adobe Illustrator or Adobe Photoshop. Prefers high quality, whimsical, but not cartoonish artwork for the baby and children's lines. Nothing that could be construed as negative or off-color in any way. Prefers work that is soft, happy and colorful. Produces seasonal material for Christmas, New Year, Valentine's Day, Halloween, graduation and birthdays.

First Contact & Terms: Send query letter with color copies of work.Samples are filed or are returned. Reports back in 2 months. Pays flat fee, $250-1,000.

Tips: "We have a line of elegant, embossed and foil stamped cards for birth, christening and adult invitations. So, we need the soft, warm and cuddly children's things as well as elegant formal designs. We look for refined talent with a sweet look for our birth announcement line. Consider the product the company produces before sending samples. For instance: don't send pictures of dragons, monsters and skeletons to a birth announcement company."

HURLIMANN ARMSTRONG STUDIOS, Box 1246, Menlo Park CA 94026. (650)594-1876. Fax: (650)594-9211. E-mail: hascards@aol.com. Managing General Partner: Mary Ann Hurlimann. Estab. 1987. Produces greeting cards and enclosures, mugs, portfolios and placemats.

Needs: Approached by 60 freelance artists/year. Works with 6 freelancers/year. Buys 16 designs/year. Considers watercolor, oil and acrylic. No photography. Prefers rich color, clear images, no abstracts. "We have some cards that use

✓ A CHECKMARK PRECEDING A LISTING indicates a change in either the address or contact information since the 1999 edition.

words as the central element of the design." Not interested in computer-generated art.

First Contact & Terms: Send query letter with slides. Samples are filed. Art Director will contact artist for portfolio review if interested. Originals are returned at job's completion. Requests work on spec before assigning a job. Pays by the project, $100-300; royalties of 5% or fixed fee. Buys all rights.

Tips: "Send good quality slides of your work. We are attracted to a strong sense of individual style, technical competence, and a sense of whimsy is great."

N ▣ IDEAL INSTRUCTIONAL FAIR PUBLISHING GROUP, 7246 Sharon Dr., #1, San Jose CA 95129-4645. (408)873-9040. Fax: (408)873-9061. Art Director: Sarah Mordecai. Estab. 1898. Produces games, school supplies, toys, CD-ROMS and books.

Needs: Approached by 60 freelancers/year. Works with 15 freelancers/year. Buys 20 freelance designs and illustrations/year. Prefers local designers only. Works with illustrators "throughout the United States." Art guidelines available. Uses freelancers mainly for design and production services and b&w art. Considers all media. Prefers humorous and whimsical illustrations of cute animals and children. 90% of freelance design work demands knowledge of Adobe Photoshop, Adobe Illustrator and QuarkXPress. 25% of freelance illustration demands knowledge of Adobe Photoshop, Adobe Illustrator and Painter.

First Contact & Terms: Designers send query letter with brochure, photocopies, tearsheets, transparencies, résumé and SASE. Illustrators send postcard sample of work or query letter with photocopies, tearsheets and SASE or reply card. Samples are filed. Reports back only if interested. Company will contact artist for portfolio review. Buys all rights. Pays by the project.

Tips: "We are looking for brightly colored work and whimsical styles of art, mainly illustrations of animals and children."

N idesign GREETINGS, inc., 12020 W. Ripley Ave., Milwaukee WI 53226. (414)475-7176. Fax: (414)475-7566. President: Eileen Grasse. Estab. 1980. Produces greeting cards, stationery. "We direct our market to all ages from birth on. Cards are light and happy with short, sincere messages."

Needs: Prefers artists with experience in watercolor. Works on assignment only. Uses freelancers mainly for greeting card designs. Considers watercolor and colored pencil. "Looking for strong design with border detail—predominately floral." Produces material for all holidays and seasons. Submit seasonal material 1 year in advance.

First Contact & Terms: Send query letter with brochure, résumé, SASE, tearsheets, photographs. Samples are filed. Reports back within 2 months. Call or write for appointment to show portfolio; or mail appropriate materials. Portfolio should include finished art samples, color tearsheets and dummies. Buys all rights. Pays by the project, $200 minimum.

THE IMAGINATION ASSOCIATION, 1073 Colony St., Flower Mound TX 75028. (972)355-7685. Fax: (972)539-7505. E-mail: ia4ej@aol.com. Website: http://www.aprons-tees.com. Creative Director: Ellice Lovelady. Estab. 1992. Produces greeting cards, T-shirts, mugs, aprons and magnets. "We are primarily a freelance design firm that has been quite established with several major greeting card and T-shirt companies who, in fact, produce our work. We have a sub-division that manufactures cutting edge, contemporary aprons and T-shirts for the gourmet food market."

Needs: Works with 12 freelancers/year. Artists must be fax accessible and able to work on fast turnaround. Uses freelancers for everything. Considers all media. "We're open to a variety of styles." 10% of freelance work demands knowledge of Adobe Illustrator, Adobe Photoshop and QuarkXPress. "That is rapidly increasing as many of our publishers are going to disk." Produces material for all holidays and seasons. Submit seasonal material 18 months in advance.

First Contact & Terms: Send query letter with brochure, photographs, SASE and photocopies. Samples are filed or returned by SASE if requested by artist. Company will contact artist for portfolio review if interested. Portfolio should include final art, photographs or any material to give indication of range of artist's style. Negotiates rights purchased. Originals are returned at job's completion. Pays royalties—the amount is variable depending on assignment. Finds artists via word of mouth from other freelancers or referrals from publishers.

Tips: Looking for artist "with a style we feel we can work with and a professional attitude. Understand that sometimes our publishers and manufacturers require several revisions before final art and all under tight deadlines. Be persistent! Stay true to your creative vision and don't give up!"

INCOLAY STUDIOS INCORPORATED, 520 Library St., San Fernando CA 91344. Fax: (818)365-9599. Art Director: Shari Bright. Estab. 1966. Manufacturer. "Basically we reproduce antiques in Incolay Stone, all handcrafted here at the studio. There were marvelous sculptors in that era, but we believe we have the talent right here in the U.S. today and want to reproduce living American artists' work."

● Art director told *AGDM* that hummingbirds and cats are popular subjects in decorative art, as are angels, cherubs, endangered species and artwork featuring the family, including babies.

Needs: Prefers local artists with experience in carving bas relief. Uses freelance artists mainly for carvings. Also uses artists for product design and model making.

First Contact & Terms: Send query letter with résumé, or "call and discuss; 1-800-INCOLAY." Samples not filed are returned. Reports back within 1 month. Call for appointment to show portfolio. Pays 5% of net. Negotiates rights purchased.

Tips: "Let people know that you are available and want work. Do the best you can Discuss the concept and see if it is right for 'your talent.' "

N INKADINKADO, INC., 61 Holton St., Woburn MA 01801-5263. (617)938-6100. Fax:(617)938-5585. Director, Product Development, licensing: Katey Franceschini. Estab. 1978. Produces craft kits and nature, country, landscapes and holiday designs for art for rubber stamps. Also offers licenses to illustrators depending upon number of designs interested in producing and range of style by artist. Distributes to craft, gift and toy stores and speciality catalogs.
Needs: Works with 12 illustrators and 6 designers/year. Uses freelancers mainly for illustration, lettering, line drawing, type design. Considers pen & ink. Themes include animals, education, holidays and nature. Prefers small; about 2×3. 50% of design and illustration work demands knowledge of Adobe Photoshop, QuarkXPress, Adobe Illustrator. Produces material for all holidays and seasons. Submit seasonal material 6-8 months in advance.
First Contact & Terms: Designers and illustrators send query letter with 6 nonreturnable samples. Accepts submissions on disk. Samples are filed and not returned. Reports back only if interested. Company will contact artist for portfolio review of b&w and final art if interested. Pays for illustration by the project, $100-250/piece. Rights purchased vary according to project. Also needs calligraphers for greeting cards and stamps, pays $50-100/project.
Tips: "Work small. The average size of an art rubber stamp is 3×3."

INSPIRATIONS UNLIMITED, P.O. Box 9097, Cedar Pines Park CA 92322. (909)338-6758 or (800)337-6758. Fax: (909)338-2907. Owner: John Wiedefeld. Estab. 1983. Produces greeting cards, gift enclosures, note cards and stationery.
Needs: Approached by 15 freelancers/year. Works with 4 freelancers/year. Buys 48 freelance designs and illustrations/ year. Uses freelancers mainly for greeting cards. Will consider all media, all styles. Prefers 5×7 vertical only. Produces material for Christmas, Mother's Day, graduation, Valentine's Day, birthdays, everyday, sympathy, get well, romantic, thank you, serious illness. Submit seasonal material 1 year in advance.
First Contact & Terms: Designers and illustrators send photocopies and photographs. Samples are filed and are not returned. Reports back in 1 week. Company will contact artist for portfolio review if interested. Buys reprint rights; rights purchased vary according to project. Pays $100/piece of art. Also needs calligraphers, pays $25/hour. Finds freelancers through artists' submissions, art galleries and shows.
Tips: "Send color copies of your artwork to prospects."

✓ INTERCONTINENTAL GREETINGS LTD., 176 Madison Ave., New York NY 10016. (212)683-5830. Fax: (212)779-8564. Art Director: Nancy Hoffman. Estab. 1967. Reps artists in in 50 different countries, with clients specializing in giftware, giftwrap, greeting cards, calendars, postcards, prints, posters, stationery, china, food tins and playing cards.
Needs: Approached by several hundred artists/year. Seeking creative decorative art in traditional and computer media (Adobe Photoshop preferred; some Adobe Illustrator work accepted). Graphics, sports, occasions (i.e., Christmas, baby, birthday, wedding), humorous, "soft touch," romantic themes. No nature, landscape. Accepts seasonal material any time. Prefer: artists/designers experienced in greeting cards, paper products, giftware.
First Contact & Terms: Query with samples. Send unsolicited color copies by mail with return SASE for consideration. Upon request, submit portfolio for review. Provide résumé, business card, brochure, flier or tearsheets to be kept on file for possible future assignments. Uses original color art; Photoshop files on disk; $2\frac{1}{4} \times 2\frac{1}{4}$, 4×5, 8×10 transparencies (no slides). Pays on publication. Pays 20% royalties on sales. No credit line given. Sells one-time rights and exclusive product rights. Simultaneous submissions and previously published work OK.
Tips: Recommends the annual New York Stationery Show. In portfolio samples wants to see "a neat presentation, thematic in arrangement. In addition to having good drawing/painting/designing skills, artists should be aware of market needs."

THE INTERMARKETING GROUP, 29 Holt Rd., Amherst NH 03031. (603)672-0499. President, licensing: Linda L. Gerson. Estab. 1985. Licensing agent for greeting cards, stationery, calendars, posters, paper tableware products, tabletop, dinnerware, giftwrap, eurobags, giftware, toys, needle crafts. The Intermarketing Group is a full service merchandise licensing agency representing artists' works for licensing with companies in consumer goods products including the paper product, greeting card, giftware, toy, housewares, needlecraft and apparel industries.
Needs: Approached by 100 freelancers/year. Works with 6 freelancers/year. Licenses work as developed by clients. Prefers freelancers with experience in full-color illustration. Uses freelancers mainly for tabletop, cards, giftware, calendars, paper tableware, toys, bookmarks, needlecraft, apparel, housewares. Will consider all media forms. "My firm generally represents highly illustrated works; and illustrations for direct product applications. All works are themed." Prefers 5×7 or 8×10 final art. Produces material for all holidays and seasons and everyday. Submit seasonal material 6 months in advance.
First Contact & Terms: Send query letter with brochure, tearsheets, résumé, slides, SASE or color copies. Samples are not filed and are returned by SASE. Reports back within 3 weeks. Originals are returned at job's completion. Requests work on spec before assigning a job. Pays royalties of 2-7% plus advance against royalties. Buys all rights. Considers buying second rights (reprint rights) to previously published work. Finds new artists "mostly by referrals and via artist submissions. I do review trade magazines, attend art shows and other exhibits to locate suitable clients."
Tips: "Companies today seem to be leaning towards the tried and true traditional art approach. Companies are selective in their licenses. A well-organized presentation is very helpful."

✓ JILLSON & ROBERTS, 5 Watson Ave., Irvine CA 92618. (949)859-8781. Fax: (949)859-0257. Art Director: Joshua Neufeld. Estab. 1974. Produces giftwrap and giftbags using more recycled/recyclable products.
Needs: Works with 10 freelance artists/year. Prefers artists with experience in giftwrap design. Considers all media.

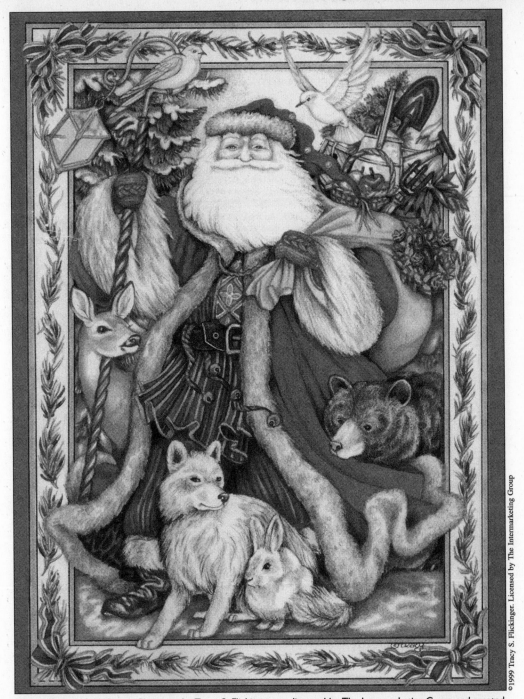

This magical image of Father Christmas by Tracy S. Flickinger was licensed by The Intermarketing Group and created exclusively for this National Wildlife Federation holiday card. Flickinger has worked with the licensing agency for 12 years, which frees her to focus on creating art, while The Intermarketing Group takes care of marketing and sales. Flickinger suggests artists find a good agent and stay focused. "Be true to yourself and do not do anything that makes you uncomfortable. Always be very willing and able to accept criticism and rejection and learn from it. Remember what you ultimately want is a happy customer."

"We are looking for colorful graphic designs as well as humorous, sophisticated, elegant or contemporary styles." Produces material for Christmas, Valentine's Day, Hanukkah, Halloween, graduation, birthdays, baby announcements and everyday. Submit 3-6 months before holiday.

First Contact & Terms: Send query letter with brochure showing art style, tearsheets and slides. Samples are filed or are returned. Reports back within 3 weeks. To show a portfolio, mail thumbnails, roughs, final reproduction/product, color slides and photographs. Originals not returned. Pays average flat fee of $250; or pays royalties (percentage negotiable).

J-MAR, INC., P.O. Box 23149, Waco TX 76702-3149. (254)751-0100. Fax: (254)751-0054. E-mail: amyb@calpha. com. Marketing Manager: Amy Brown. Estab. 1984. Produces bookmarks, gifts, posters, greeting cards, stationery, pocket-size and 5×7 name and verse cards. J-Mar produces inspirational Christian giftware and related products.

Needs: Approached by 200 freelancers/year. Works with approximately 10 freelancers/year. Buys 10 freelance designs and illustrations/year. Prefers freelancers with experience in Adobe Photoshop. Art guidelines for SASE with first-class postage. Works on assignment only. Uses freelancers mainly for illustrating, rendering. Also for paste-up, P-O-P. Considers all media. Looking for inspirational/Christian, floral, bright colors, collage/quilt effects, prints. Prefers 5×7 or 8½×11. 50% of freelance design work demands knowledge of Quark, Adobe Photoshop 3 and Adobe Illustrator. 50% of freelance illustration demands knowledge of Quark, Adobe Photoshop 3 and Adobe Illustrator. Produces material for Christmas, Easter, Mother's Day, Father's Day, graduation, New Year, Passover, Thanksgiving, Valentine's Day, birthdays, everyday, motivational, family, sympathy, get well, thank you, pastor/church thank you, christenings, juvenile, adult, love, friendship, humor, birthday, seasonal.

First Contact & Terms: Send query letter with photocopies, photographs, photostats, résumé, SASE, tearsheets. "We accept work on disk that is compatible with PC-based versions of Adobe PageMaker or PhotoShop." Samples are filed and are not returned. Reports back only if interested within 2 months. Also needs calligraphers and letterers. Company will contact artist for portfolio review of color, final art, photographs, photostats, roughs, tearsheets, thumbnails if interested. Buys all rights. Pays by the project. Finds freelancers through sourcebooks and artists' submissions.

Tips: "Please contact J-Mar via mail only. It is better to send samples and/or copies of art rather than originals. If your talent matches our needs, we will contact you to make further arrangements."

KALAN LP, 97 S. Union Ave., Lansdowne PA 19050. (610)623-1900. Fax: (610)623-0366. E-mail: chrisdee@pond.c om. Art Director: Chris Wiemer. Estab. 1973. Produces giftbags, greeting cards, school supplies, stationery and novelty items such as keyrings, mouse pads, shot glasses and magnets.

Needs: Approached by 50-80 freelancers/year. Buys 10 freelance designs and illustrations/year. Art guidelines are available. Uses freelancers mainly for fresh ideas, illustration and design. Considers all media and styles. 80% of freelance design and 50% of illustration demands knowledge of Adobe Photoshop 4 and Adobe Illustrator 7. Produces material for major holidays such as Christmas, Mother's Day, Valentine's Day; plus birthdays and everyday. Submit seasonal material 9-10 months in advance.

First Contact & Terms: Designers send query letter with photocopies, photostats and résumé. Illustrators and cartoonists send query letter with photocopies and résumé. Accepts disk submissions compatible with Illustrator 7 or Photoshop 4.0. Send EPS files. Samples are filed. Reports back within 1 month if interested in artist's work. Will contact artist for portfolio review of final art if interested. Buys first rights. Pays by the project, $75 and up. Finds freelancers through submissions and newspaper ads.

KINNERET PUBLISHING HOUSE, 14 Habanai St., Holon, Israel. (03)558-2252. Fax: (03)558-2255. E-mail: kimbrooks@netvisioni.net.il. Managing Director: Mr. Yoram Ros. Estab. 1979. Produces greeting cards, posters and post-cards.

Needs: Approached by 10-20 freelancers/year. Works with 5-10 freelancers/year. Buys 5-10 freelance designs and illustrations/year. Works on assignment only. Considers professional media. Needs computer-literate freelancers. 30% of freelance work demands knowledge of Aldus PageMaker, QuarkXPress, Aldus FreeHand, Adobe Illustrator and Adobe Photoshop. Produces material for all holidays and seasons, Hannukah, Passover, Rosh Hashanah, graduation, New Year and birthdays. Submit seasonal material 4 months in advance.

First Contact & Terms: Send query letter with brochure, photostats, résumé, photographs, slides, SASE, photocopies and transparencies. Samples are filed or returned by SASE if requested by artist. Reports back within 3 months. Company will contact artist for portfolio review if interested. Portfolio should include b&w and color thumbnails, roughs, final art, photostats, tearsheets, photographs, slides and transparencies. Buys all rights; rights purchased vary according to project. Originals are returned at job's completion. Payment is negotiable.

KIPLING CARTOONS & CREATIVE DARE DEVILS, 830 Mimosa Ave., Vista CA 92083. Creative Director: John Kipling. Estab. 1981.

Needs: Approached by 75-150 freelancers/year. Works with many freelancers/year. Interested in seeing and working with more freelancers. Prefers freelancers with experience in cartooning. Uses freelancers mainly for comics. Prefers ink renderings.

First Contact & Terms: Send photocopies and SASE or VHS tapes for animation. Samples are filed. Rights purchased vary according to project. Originals are not returned. Artist will be given credit.

[N] **KOEHLER COMPANIES**, 4600 77th St., Suite 301, Edina MN 55435-4909. (800)582-6965. Fax: (612) 893-1934. E-mail: klrcompany@aol.com. President: Bob Koehler. Estab. 1988. Manufactures wall decor, plaques, clocks and mirrors; artprints laminated to wood. Clients: gift-based and home decor mail order catalog companies. Clients include: Wireless, Signals, Seasons, Paragon and Potpourri.

Needs: Works with 24 established artists; 48 mid-career artists and 60 emerging artist/year. Considers oil, acrylic, watercolor, mixed media, pastels and pen & ink. Prefered themes and styles: humorous, Celtic, inspirational, pet (cats and dogs), golf, fishing.

First Contact & Terms: Send query letter with brochure, photocopies or photographs, résumé and tearsheets. Samples are not filed and are returned. Company will contact artist for portfolio review if interested. Pays royalties or negotiates payment. Does not offer an advance. Rights purchased vary according to project. Also works with freelance designers. Finds artists through word of mouth.

Tips: "Because we sell only to mail order catalogs both verse and art must be easy to see and understood when shrunk to a 1½" square photo in a catalog."

KOGLE CARDS, INC., 1498 S. Lipan St., Denver CO 80223-3411. Website: http://www.koglecards.com. President: Patricia Koller. Estab. 1982. Produces greeting cards and postcards for all business situations.

Needs: Approached by 500 freelancers/year. Buys 250 designs and 250 illustrations/year. Art guidelines for SASE with first-class postage. Works on assignment only. Considers all media for illustration. Prefers 5×7 or 8½×11 final art. Produces material for Christmas and all major holidays plus birthdays and all occasion; material accepted year-round. Send Attention: Art Director.

First Contact & Terms: Send query letter with brochure, photocopies, photographs and slides. Samples not filed are returned only if SASE included. Reports back within 1 month. To show portfolio, mail color and b&w photostats and photographs. Originals not returned. Pays by the project on royalty basis. Buys all rights.

Tips: "Include 8½×11 color copies of your work—they are easy to view and to keep on file for quick reference. Ignore 'trends.' Develop your own style and characters."

L.B.K. MARKETING, 7800 Bayberry Rd., Jacksonville FL 32256-6893. (904)737-8500. Fax: (904)737-9526. Art Director: Barbara McDonald. Estab. 1940. "Four companies feed through L.B.K.: NAPCO and INARCO are involved with manufacturing/distributing for the wholesale floral industry; First Coast Design produces collectible giftware; Brinn's produces collectible dolls and seasonal giftware." Clients: wholesale.

• L.B.K. Marketing has a higher-end look for their floral market products. They are doing very little decal, mostly dimensional pieces.

Needs: Works with 15 freelance illustrators and designers/year. 50% of work done on a freelance basis. Prefers local freelancers for mechanicals for sizing decals; no restrictions on artists for design and concept. Art guidelines available for SASE with first-class postage. Works on assignment only. Uses freelancers mainly for mechanicals and product design. "Need artists that are highly skilled in illustration for three-dimensional products. 75% of our work is very traditional and seasonal. We're also looking for a higher-end product, an elegant sophistication." 10% of freelance work requires computer skills.

First Contact & Terms: Designers send query letter with brochure, résumé, photocopies, photographs, SASE, tearsheets and "any samples we can keep on file." Illustrators send brochure, résumé, photocopies, photographs and SASE. If work is in clay, send photographs. Samples are filed or returned by SASE. Reports back in 2 weeks. Artist should follow-up with letter after initial query. Portfolio should include samples which show a full range of illustration style. Sometimes requests work on spec before assigning a job. Pays for design by the project, $50-500. Pays by the project for illustration, $50-2,000. Pays $15/hour for mechanicals. Buys all rights. Considers buying second rights (reprint rights) to previously published work. Finds artists through word of mouth and self-promotions.

Tips: "We are very selective in choosing new people. We need artists that are familiar with three-dimensional giftware and floral containers. We have recently merged with Brinn's. We now will be producing dolls and seasonal giftware. Our market is expanding and so are our needs for qualified artists."

THE LANG COMPANIES: Lang Graphics, Main Street Press, Bookmark and R.A. Lang Card Co., 514 Wells St., Delafield WI 53018. (414)646-3399. Fax: (414)646-4678. Product Development: Joyce Quandt. Estab. 1982. Produces high quality linen-embossed greeting cards, stationery, calendars, giftbags, and many more fine paper goods.

Needs: Approached by 300 freelance artists/year. Art guidelines available. Works with 40 freelance artists/year. Buys 600 freelance designs and illustrations/year. Uses freelancers mainly for card and calendar illustrations. Considers all media. Looking for traditional and non-abstract country, folk and fine art styles. Produces material for Christmas, birthdays and everyday. Submit seasonal material 6 months in advance.

First Contact & Terms: Send query letter with SASE and brochure, tearsheets, photostats, photographs, slides, photocopies or transparencies. Samples are filed or are returned by SASE if requested by artist. Reports back within 6 weeks. Pays royalties based on net wholesale sales. Rights purchased vary according to project.

Tips: "Research the company and submit a compatible piece of art. Be patient awaiting a response. A phone call often rushes the review and work may not be seriously considered."

LEADER PAPER PRODUCTS, 2738 S. 13th St., Milwaukee WI 53215. (414)383-0414. Fax: (414)383-0760. Creative Team Leader: Shanna dela Cruz. Estab. 1901. Produces stationery, holiday cards, invitations and scrapbook supplies. Specializes in stationery from 8½×11 to social writing and related paper products.

Needs: Approached by 20 freelancers/year. Works with 10 freelancers/year. Buys 24 freelance illustrations/year. Prefers freelancers with experience in illustration/fine art who create detailed but not necessarily realistic art. Art guidelines available. Works on assignment only. Uses freelancers mainly for illustrations. Considers any medium that is scannable. Looking for traditional, floral, some humorous, sentimental, animals, contemporary, children's book styles. Produces material for holidays and seasons, birthdays, everyday, wedding, baby, events, trends, home decor and multicultural. Submit seasonal material 6 months in advance.

First Contact & Terms: Designers send query letter with photocopies and résumé. Illustrators send query letter with color photocopies and résumé. Send follow-up postcard or call every 3 months. Accepts disk submissions compatible with Adobe Illustrator 6.0, Adobe Photoshop and Quark. Send EPS files. Samples are filed. Artist should follow-up with call and/or letter after initial query. Will contact artist for more samples and to discuss project if interested. Buys all rights. Pays for illustration by the project, $300 and up. Finds freelancers through newspaper ads in various cities and by referrals.

Tips: "Send lots of samples, showing your best neat and cleanest work with a clear concept. Be flexible."

N LEGACY PUBLISHING GROUP, 75 Green St., P.O. Box 299, Clinton MA 01510. (800)322-3866 or (978)368-8711. Fax: (978)368-7867. Artist-in-Residence: Robert H. Seaman. Produces bookmarks, calendars, gifts, Christmas cards, paper tableware and stationery pads. Specializes in journals, note cards, address and recipe books, coasters, placemats, book marks, albums, calendars and grocery pads.

Needs: Works with 6-8 freelancers/year. Buys 25-30 freelance designs and illustrations/year. Prefers traditional art. Art guidelines available. Works on assignment only. Uses freelancers mainly for original art for product line. Considers all color media. Looking for traditional, contemporary, garden themes and Christmas. Produces material for Christmas, everyday (note cards) and cards for teachers.

First Contact & Terms: Illustrators send query letter with photocopies, photographs, résumé, tearsheets, SASE and any good reproduction or color copy. We accept work compatible with Adobe or QuarkXPress plus color copies. Samples are filed. Reports back within 2 weeks. Company will contact artist for portfolio review if interested. Portfolio should include color, photographs, slides, tearsheets and printed reproductions. Buys all rights. Pays for illustration by the

©1999 R. H. Seaman/Legacy Group

Legacy Publishing Group's Artist-in-Residence Robert Hayes Seaman created this greeting card image of blueberries as part of a series. Created by using oil over latex on Bristol, Seaman completes approximately 15 paintings for Legacy a year. He used *AGDM* extensively early in his career, but now his assignments keep him busy. Seaman, who found Legacy through a referral, advises artists to "get your work in front of everyone who might be a potential buyer."

project, $600-1,000. Finds freelancers through word of mouth and artists' submissions.

[N] [⚑] THE LEMON TREE STATIONERY CORP., 25 W. Jefryn Blvd., #8, Deerpark NY 11729-5715. (516)254-4445. Fax: (516)254-4449. Estab. 1969. Produces birth announcements, invitations and wedding invitations.
Needs: Buys 100-200 pieces of calligraphy/year. Prefers local designers. Works on assignment only. Uses Mac designers. Also for calligraphy, mechanicals, paste-up, P-O-P. Looking for traditional, contemporary. 50% of freelance work demands knowledge of Adobe Photoshop, QuarkXPress, Adobe Illustrator.
First Contact & Terms: Send query letter with résumé. Calligraphers send photocopies of work. Samples are not filed and are not returned. Reports back only if interested. Company will contact artist for portfolio review of final art, photostats, thumbnails if interested. Pays for design by the project. Pays flat fee for calligraphy.
Tips: "Look around at competitors' work to get a feeling of the type of art they use."

LIFE GREETINGS, P.O. Box 468, Little Compton RI 02837. (401)635-8535. Editor: Kathy Brennan. Estab. 1973. Produces greeting cards. Religious, inspirational greetings.
Needs: Approached by 25 freelancers/year. Works with 5 freelancers/year. Uses freelancers mainly for greeting card illustration. Also for calligraphy. Considers all media but prefers pen & ink and pencil. Prefers 4½×6¼—no bleeds. Produces material for Christmas, religious/liturgical events, baptism, first communion, confirmation, ordination.
First Contact & Terms: Send query letter with photocopies. Samples are filed or returned by SASE if requested by artist. Reports back to the artist only if interested. Portfolio review not required. Originals are not returned. Pays by the project, $25 minimum. **"We pay on acceptance."** Finds artists through submissions.

[N] [⚑] THE LOLO COMPANY, 6755 Mira Mesa Blvd., Suite 123-410, San Diego, CA 92121. (800) 760-9930. Fax: (800) 234-6540. E-mail: products@lolofun.com. Website: http://www.lolofun.com. Creative Director: Robert C. Paul. Estab. 1995. Publishes board games. Prefers humorous work. Uses freelancers mainly for product design and packaging. Recent games include "Don't Make Me Laugh" and "Strange But True."
Needs: Approached by 1 illustrator and 1 designer/year. Works with 1 illustrator and 1 designer/year. Prefers local illustrators. 100% of freelance design and illustration demands knowledge of Adobe Ilustrator, Photoshop and QuarkXPress.
First Contact & Terms: Preferred submission package is self-promotional postcard sample. Send 5 printed samples or photographs. Accepts disk submissions in Windows format; send via Zip as EPS. Samples are filed. Will contact artist for portfolio review if interested. Portfolios should include artwork of characters in sequence, color photocopies, photographs, transparencies of final art and roughs. Rights purchased vary according to project. Finds freelancers through word of mouth and Internet.

[N] LOOKINGLASS, INC., 407 N. Paca St., Baltimore MD 21201. (410)547-0333. Fax: (410)547-0336. E-mail: lookinglass@erols.com. President: Louis Klaitman. Estab. 1972. Produces games/toys, trendy novelty items, party and Halloween. Also trade under Cabaret trademark. "We are product consultants and recomend new entrepeneurs to different resources for product graphics/3-D construction. We also represent many companies in novelty markets to retailers world wide."
Needs: Approached by 2 freelance artists/year. Works with 2 freelancers/year. Prefers artists with experience in trendy novelty items. Works on assignment only. Uses freelancers mainly for logo design, illustration and concepts. Also for P-O-P displays, paste-up, mechanicals and graphics. Produces material for all holidays and seasons. Submit seasonal material 6 months (minimum) in advance.
First Contact & Terms: Send query letter with brochure, résumé, SASE and tearsheets. Samples are returned by SASE only if requested by artist. Reports back to the artist only if interested. To show portfolio, mail tearsheets. Originals not returned. Payment negotiable. Rights purchased vary according to project.

MADISON PARK GREETINGS, 1407 11th Ave., Seattle WA 98122-3901. (206)324-5711. Fax: (206)324-5822. E-mail: sarahm@madpark.com. Website: http://www.madpark.com. Art Director: Sarah McHale. Estab. 1977. Produces greeting cards, stationery, notepads, frames.
Needs: Approached by 250 freelancers/year. Works with 15 freelancers/year. Buys 400 freelance designs and illustrations/year. Art guidelines available. Works on assignment only. Uses freelancers mainly for greeting cards. Also for calligraphy, reflective art. Considers all paper related media. Prefers finished card size 4⅞×7. 100% of design and 30% of illustration demand knowledge of Aldus PageMaker, Aldus FreeHand, Adobe Photoshop, QuarkXPress, Adobe Illustrator. Produces material for Christmas, Easter, Mother's Day, Father's Day, graduation, New Year, Valentine's Day, birthdays, everyday, sympathy, get well, anniversary, baby congratulations, wedding, thank you, expecting, friendship. Submit seasonal material 10 months in advance.
First Contact & Terms: Designers send photocopies, slides, transparencies. Illustrators send postcard sample or photocopies. Accepts submissions on disk compatible with Adobe Illustrator 5.0. Send EPS files. "Good samples are filed; rest are returned." Company will contact artist for portfolio review of color, final art, roughs if interested. Rights purchased vary according to project. Pays royalty of 5%.
Tips: "Study European and classic art."

[✓] FRANCES MEYER, INC., 104 Coleman Blvd., Savannah GA 31408. (912)748-5252. Fax: (912)748-8378. Contact: Leslie Ballenger. Estab. 1979. Produces scrapbooking products, stickers and stationery.

Needs: Works with 5-6 freelance artists/year. Commissions 100 freelance illustrations and designs/year. Works on assignment only. "Most of our artists work in either watercolor or acrylic. We are open, however, to artists who work in other media." Looking for "everything from upscale and sophisticated adult theme-oriented paper items, to fun, youthful designs for birth announcements, baby and youth products. Diversity of style, originality of work, as well as technical skills are a few of our basic needs." Produces material for Christmas, graduation, Thanksgiving (fall), New Year's, Halloween, birthdays, everyday, weddings, showers, new baby, etc. Submit seasonal material 6-12 months in advance.

First Contact & Terms: Send query letter with tearsheets, slides, SASE, photocopies, transparencies (no originals) and "as much information as is necessary to show diversity of style and creativity." "No response or return of samples by Frances Meyer, Inc. *without SASE!*" Reports back within 2-3 months. Company will contact artist for portfolio review if interested. Originals are returned at job's completion. Pays royalty (varies).

Tips: "Generally, we are looking to work with a few talented and committed artists for an extended period of time. We do not 'clean out' our line on an annual basis just to introduce new product. If an item sells, it will remain in the line. Punctuality concerning deadlines is a necessity."

MILLIMAC LICENSING CO., 188 Michael Way, Santa Clara CA 95051. (408)984-0700. Fax: (408)984-7456. E-mail: bruce@clamkinman.com. Website: http://www.clamkinman.com. Owner: Bruce Ingrassia. Estab. 1978. Produces collectible figurines, mugs, T-shirts and textiles. Produces a line of cartoon characters called the Clamkin® Family directed towards "children and adults young at heart."

Needs: Approached by 10 freelancers/year. Works with 2-3 freelancers/year. Buys 30-40 freelance designs and illustrations/year. Prefers freelancers with experience in cartooning. Works on assignment only. Uses freelancers mainly for line art, color separation, Mac computer assignments. Considers computer, pen & ink. Looking for humorous, "off the wall," cute animals, clever and cute. 50% of freelance design/illustration demands knowledge of Adobe Photoshop, Adobe Illustrator, Aldus FreeHand (pencil roughs OK). "Computer must be Mac." Produces material for everyday.

First Contact & Terms: Designers/cartoonists send query letter with photocopies. Sculptors send photos of work. Accepts disk submissions compatible with Mac Adobe Illustrator files. Samples are filed. Will contact artist for portfolio review if interested. Rights purchased and pay rates vary according to project. Finds freelancers through submissions. "I also find a lot of talent around town—at fairs, art shows, carnivals, students—I'm always on the lookout."

Tips: "Get a computer—learn Adobe Illustrator, Photoshop. Be clever, creative, open minded and responsible."

Ⓝ MILLROCK INC., 5 Community Dr., Sanford ME 04073. (207)324-0041. Fax: (207)324-0134. Director of Marketing: Nancy E. Watts. Estab. 1979. Produces store fixtures.

● This company is a display manufacturer of "in-stock" items and custom items. They are interested in expanding their P-O-P sales base in the greeting card and gift market, working with artists to create and enhance their material. They also welcome new ideas and merchandising concepts.

Needs: Approached by 10 freelancers/year. Uses freelancers mainly for renderings. Also for P-O-P displays. Considers both electronic and conventional media. Prefers 10×12. 90% of freelance work demands knowledge of Adobe Illustrator, Adobe Photoshop, QuarkXPress, Aldus FreeHand and Painter. Produces material for all holidays and seasons. Submit seasonal material 3 months in advance.

First Contact & Terms: Send query letter with brochure, tearsheets and résumé. Samples are filed. Company will contact artist for portfolio review if interested. Portfolio should include roughs, tearsheets and photographs. Rights purchased vary according to project. Originals are returned at job's completion. Pays by the project. Finds artists through word of mouth.

Tips: "We are looking for artists who have mechanical drawing skills."

MIXEDBLESSING, P.O. Box 97212, Raleigh NC 27624-7212. (914)723-3414. E-mail: mixbless@aol.com. Website: http://www.mixedblessing.com. President: Elise Okrend. Licensing: Philip Okrend. Estab. 1990. Produces interfaith greeting cards combining Jewish and Christian as well as multicultural images for all ages. Licenses holiday artwork for wrapping paper, tote bags, clothing, paper goods.

Needs: Approached by 10 freelance artists/year. Works with 10 freelancers/year. Buys 20 designs and illustrations/year. Provides samples of preferred styles upon request. Works on assignment only. Uses freelancers mainly for card illustration. Art guidelines for SASE with first-class postage. Considers watercolor, pen & ink and pastel. Prefers final art 5×7. Produces material for Christmas and Hanukkah. Submit seasonal material 10 months in advance.

First Contact & Terms: Send query letter with brochure, photocopies, photographs and SASE. Samples are filed. Reports back only if interested. Artist should follow-up with letter after initial query. Originals are returned at job's completion. Sometimes requests work on spec before assigning a job. Pays flat fee of $125-500 for illustration/design. Buys all rights. Finds artists through visiting art schools.

Tips: "I see growth ahead for the industry. Go to and participate in the National Stationery Show."

J.T. MURPHY CO., 200 W. Fisher Ave., Philadelphia PA 19120. (215)329-6655. Fax: (800)457-5838. President: Jack Murphy. Estab. 1937. Produces greeting cards and stationery. "We produce a line of packaged invitations, thank you notes and place cards for retail."

Needs: Approached by 12 freelancers/year. Works with 4 freelancers/year. Buys 8 freelance designs and illustrations/year. Prefers local freelancers with experience in graphics and greeting cards. Uses freelancers mainly for concept, design and finished artwork for invitations and thank yous. Looking for graphic, contemporary or traditional designs. Prefers 4×5⅛ but can work double size. Produces material for graduation, birthdays and everyday. Submit seasonal material 9 months in advance.

First Contact & Terms: Designers send query letter with brochure. Illustrators send query letter with photocopies. Samples are filed and returned with SASE. Reports back within 1 month. Company will contact artist for portfolio review if interested. Rights purchased vary. Originals not returned. Payment negotiated.

N ⚑ MY SENTIMENTS, (dba Art a deux, Ltee), 3417 Bertrand Rd., Mississauga, Ontario L5L 4G5 Canada. (905)828-7399. E-mail: bsybal@ysentiments.com. Website: http://www.mysentiments.com. Art Director: B. Sybal. Estab. 1996. Produces greeting cards, fine art reproductions only.

Needs: Approached by 2,000 freelancers/year. Works with 25 freelancers/year. "Calligraphy is a future interest." Prefers original artwork (oil on canvas, acrylic, etc.). Art guidelines available by e-mail only. Works on assignment only. Looking for traditional, floral, wildlife, pets. Prefers 4×5 transparencies only. Produces material for all holidays and seasons. Submit seasonal material 1 year in advance.

First Contact & Terms: "We post a 'call for artists' on our website. If none exists, please do not contact." Designers send query letter with photographs and SASE. Samples are not filed and are returned by SASE. Company will contact artist for portfolio review of color photographs if interested. Buys one-time rights. Royalties and/or rights are negotiated. Finds freelancers through agents and word of mouth.

NALPAC, LTD., 1111 E. Eight Mile Rd., Ferndale MI 48220. (248)541-1140. Fax: (248)544-9126. President, licensing: Ralph Caplan. Estab. 1971. Produces coffee mugs and T-shirts for gift and mass merchandise markets. Licenses all kinds of artwork for T-shirts, mugs and gifts.

Needs: Approached by 10-15 freelancers/year. Works with 2-3 freelancers/year. Buys 70 designs and illustrations/year. Works on assignment only. Considers all media. Needs computer-literate freelancers for design, illustration and production. 60% of freelance work demands computer skills.

First Contact & Terms: Send query letter with brochure, résumé, SASE, photographs, photocopies, slides and transparencies. Samples are filed or are returned by SASE if requested by artist. Reports back within 1 month. Call for appointment to show portfolio. Usually buys all rights, but rights purchased may vary according to project. Also needs package/product designers, pay rate varies. Pays for design and illustration by the hour $10-25; or by the project $40-500, or offers royalties of 4-10%.

☑ NATIONAL DESIGN CORP., P.O. Box 509032, San Diego CA 92150-9032. (619)674-6040. Fax: (619)674-4120. Art Director: Steven Duncan. Estab. 1985. Produces gifts, writing instruments and stationery accoutrements. Multi markets include gift/souvenir, mass market and premium markets.

Needs: Works with 3-4 freelancers/year. Buys 3 freelance designs and illustrations/year. Prefers local freelancers only. Must be Macintosh proficient. Works on assignment only. Uses freelancers mainly for design illustration. Also for prepress production on Mac. Considers computer renderings to mimic traditional medias. Prefers children's and contemporary styles. 100% of freelance work demands knowledge of QuarkXPress, Freehand and Illustrator. Produces material for Christmas and everyday.

First Contact & Terms: Send query letter with photocopies, résumé, SASE. Accepts submissions on disk. "Contact by phone for instructions." Samples are filed and are returned if requested. Company will contact artist for portfolio review of color, final art, tearsheets if interested. Rights purchased vary according to project. Payments depends on complexity, extent of project(s).

Tips: "Must be well traveled to identify with gift/souvenir markets internationally. Fresh ideas always of interest."

THOMAS NELSON GIFTS, INC.—C.R. GIBSON, CREATIVE PAPERS, KIDS KOLLECTION BY CREATIVE PAPER, INSPIRATIONS AND TOCCATA, 404 BNA Drive, Building 200, Suite 600, Nashville TN 37217. (615)889-9000. Fax: (615)391-3166. Vice President of Creative: Ann Cummings. Producer of stationery and gift products and giftbook publisher. Specializes in baby, children, feminine, floral, wedding, sports and kitchen-related subjects. 85-90% require freelance illustration; 50% require freelance design. Gift catalog free by request.

Needs: Approached by 200-300 freelance artists/year. Works with 30-50 illustrators and 10-30 designers/year. Assigns 30-50 design and 30-50 illustration jobs/year. Uses freelancers mainly for covers, borders, giftwrap and cards. 50% of freelance work demands knowledge of QuarkXPress, Aldus FreeHand and Adobe Illustrator. Works on assignment only.

First Contact & Terms: Send query letter with brochure, résumé, tearsheets and photocopies. Samples are filed or are returned. Reports back only if interested. Request portfolio review in original query. Portfolio should include thumbnails, finished art samples, color tearsheets and photographs. Whether originals returned to the artist depends on contract. Sometimes requests work on spec before assigning a job. Interested in buying second rights (reprint rights) to

previously published work. "Payment varies due to complexity and deadlines." Finds artists through word of mouth, magazines, artists' submissions/self-promotions, sourcebooks, agents, visiting artist's exhibitions, art fairs and artists' reps.

Tips: "The majority of our mechanical art is executed on the computer with discs and laser runouts given to the engraver. Please give a professional presentation of your work."

NEW ENGLAND CARD CO., Box 228, Route 41, West Ossipee NH 03890. (603)539-5095. Owner: Harold Cook. Estab. 1980. Produces greeting cards and prints of New England scenes.

Needs: Approached by 75 freelancers/year. Works with 10 freelancers/year. Buys more than 24 designs and illustrations/year. Prefers freelancers with experience in New England art. Art guidelines available. Considers oil, acrylic and watercolor. Looking for realistic styles. Prefers art proportionate to 5×7. Produces material for all holidays and seasons. "Submit all year."

First Contact & Terms: Send query letter with SASE, photocopies, slides and transparencies. Samples are filed or are returned. Reports back within 2 months. Artist should follow-up after initial query. Pays by project. Rights purchased vary according to project, but "we prefer to purchase all rights."

Tips: "Once you have shown us samples, follow up with new art."

N-M LETTERS, INC., 125 Esten Ave., Pawtucket RI 02860. (401)247-7651. Fax: (401)245-3182. President: Judy Mintzer. Estab. 1982. Produces birth announcements and invitations.

Needs: Approached by 2-5 freelancers/year. Works with 2 freelancers/year. Prefers local artists only. Works on assignment only. Produces material for births, weddings and Bar/Bat Mitzvahs. Submit seasonal material 6 months in advance.

First Contact & Terms: Send query letter with résumé. Reports back within 1 month only if interested. Call for appointment to show portfolio of b&w roughs. Original artwork is not returned. Pays by the project.

Ⓝ NOBLE WORKS, 108 Clinton St., P.O. Box 1275, Hoboken NJ 07030. (201)420-0095. Fax: (201)420-6617. Contact: Art Department. Estab. 1981. Produces bookmarks, greeting cards, magnets and gift products. Produces "modern cards for modern people." Trend oriented, hip urban greeting cards.

Needs: Approached by 100-200 freelancers/year. Works with 50 freelancers/year. Buys 250 freelance designs and illustrations/year. Prefers freelancers with experience in illustration. Art guidelines for SASE with first-class postage. We purchase "secondary rights" to illustration. Considers illustration, electronic art. Looking for humorous, "off-the-wall" adult contemporary and editorial illustration. Produces material for Christmas, Easter, Mother's Day, Father's Day, graduation, Halloween, Valentine's Day, birthdays, thank you, anniversary, get well, astrology, sympathy, etc. Submit seasonal material 18 months in advance.

First Contact & Terms: Designers send query letter with photocopies, SASE, slides, tearsheets, transparencies. Illustrators and cartoonists send query letter with photocopies, tearsheets, SASE. After introductory mailing send follow-up postcard sample every 8 months. Accepts submissions on Zip disk compatable with Mac QuarkXPress 3.32, Adobe Photoshop 4.0 or Adobe Illustrator 8.0. Samples are filed. Reports back within 3 months. Portfolio review required. Portfolios may be dropped off Monday-Friday and should include anything that will define artist's abilities. Buys reprint rights. Pays for design and illustration by the project. Finds freelancers through sourcebooks, illustration annuals, referrals.

Tips: "As a manufacturer must know the market niche its product falls into, so too must a freelancer."

Ⓝ ✿ NORTHERN CARD PUBLISHING, INC., 5694 Ambler Dr., Mississauga, Ontario L4W 2K9 Canada. (905)625-4944. Fax: (905)625-5995. E-mail: nclcards@aol.com. Product Coordinator: Jane Donato. Estab. 1992. Produces greeting cards.

Needs: Approached by 200 freelancers/year. Works with 25 freelancers/year. Buys 75 freelance designs and illustrations/year. Uses freelancers for "camera-ready artwork and lettering." Art guidelines for SASE with first-class postage. Looking for traditional, sentimental, floral and humorous styles. Prefers 5½×7¾ or 5×7. Produces material for Christmas, Easter, Mother's Day, Father's Day, graduation, Valentine's Day, birthdays and everyday. Also sympathy, get well, someone special, thank you, friendship, new baby, good-bye and sorry. Submit seasonal material 6 months in advance.

First Contact & Terms: Designers send query letter with brochure, photocopies, slides, résumé and SASE. Illustrators and cartoonists send photocopies, tearsheets, résumé and SASE. Lettering artists send samples. Samples are filed or returned by SASE. Reports back only if interested. Pays flat fee, $150 (CDN). Finds freelancers through newspaper ads, gallery shows and internet.

Ⓝ NOTES & QUERIES, 9003 L-M Yellow Brick Rd., Baltimore MD 21237. (410)682-6102. Fax: (410)682-5397. General Manager: Andy Meehan. Estab. 1981. Produces greeting cards, stationery, journals, paper tableware products and giftwrap. Products feature contemporary art.

Needs: Approached by 30-50 freelancers/year. Works with 3-10 freelancers/year. Art guidelines available "pending our interest." Produces material for Christmas, Valentine's Day, Mother's Day, Easter, birthdays and all occasions. Submit seasonal material 1 year in advance.

First Contact & Terms: Send query letter with photographs, slides, SASE, photocopies, transparencies, "whatever you prefer." Samples are filed or returned by SASE as requested by artist. Reports back within 1 month. Artist should follow-up with call and/or letter after initial query. Portfolio should include thumbnails, roughs, photostats or transparencies. Rights purchased or 5-7% royalties paid; varies according to project.

Tips: "Review what we do before submitting. Make sure we're appropriate for you."

THE NOTEWORTHY COMPANY, 100 Church St., Amsterdam NY 12010. (518)842-2660. Fax: (800)866-8317. Vice President Development: Steve Smeltzer. Estab. 1954. Produces bags and coloring books. Advertising specialty manufacturer selling to distributors with clients in the health, real estate, banking and retail fields.
Needs: Buys 25 illustrations/year. Prefers freelancers with experience in designing for flexographic printing. Works on assignment only. Uses freelancers mainly for stock bag art and coloring book themes.
First Contact & Terms: Send query letter with brochure, résumé, samples and SASE. Samples are filed. Pays $200 for bag design.

NOVO CARD PUBLISHERS INC., 3630 W. Pratt Ave., Lincolnwood IL 60645. (847)763-0077. Fax: (847)763-0022. Art Directors: Molly Morwaski and Tom Benjamin. Estab. 1927. Produces all categories of greeting cards.
Needs: Approached by 200 freelancers/year. Works with 30 freelancers/year. Buys 300 or 400 pieces/year. Art guidelines free for SASE with first-class postage. Uses freelancers mainly for illustration and text. Also for calligraphy. Considers all media. Prefers crop size: 5×7¾, bleed 5¼×8. Knowledge of Adobe Photoshop 4.0, Adobe Illustrator 6.0 and QuarkXPress helpful. Produces material for all holidays and seasons and everyday. Submit seasonal material 8 months in advance.
First Contact & Terms: Designers send brochure, photocopies, photographs and SASE. Illustrators and cartoonists send photocopies, photographs, tearsheets and SASE. Calligraphers send b&w copies. Accepts disk submissions compatible with Macintosh Quark and Windows 95. Art samples are not filed and are returned by SASE only. Written samples retained on file for future assignment with writer's permission. Reports back within 2 months. Pays for design and illustration by the project, $75-200.

OATMEAL STUDIOS, Box 138, Rochester VT 05767. (802)767-3171. Fax: (802)767-9890. Creative Director: Helene Lehrer. Estab. 1979. Publishes humorous greeting cards and notepads, creative ideas for everyday cards and holidays.
Needs: Approached by approximately 300 freelancers/year. Buys 100-150 freelance designs and illustrations/year. Art guidelines for SASE with first-class postage. Considers all media. Produces seasonal material for Christmas, Mother's Day, Father's Day, Easter, Valentine's Day and Hanukkah. Submit art year round for all major holidays.
First Contact & Terms: Send query letter with slides, roughs, printed pieces or brochure/flyer to be kept on file; write for artists' guidelines. "If brochure/flyer is not available, we ask to keep one slide or printed piece; color or b&w photocopies also acceptable for our files." Samples returned by SASE. Reports in 3-6 weeks. No portfolio reviews. Sometimes requests work on spec before assigning a job. Negotiates payment.
Tips: "We're looking for exciting and creative, humorous (not cutesy) illustrations and single panel cartoons. If you can write copy and have a humorous cartoon style all your own, send us your ideas! We do accept work without copy too. Our seasonal card line includes traditional illustrations, so we do have a need for non-humorous illustrations as well."

N **OFFRAY**, Rt. 24 Box 601, Chester NJ 07930. (908)879-4700. Senior Design Director: Joe Bahnken. Estab. 1900. Produces ribbons. "We're a ribbon company—for ribbon designs we look to the textile design studios and textile-oriented people; children's designs, craft motifs, fabric trend designs, floral designs, Christmas designs, bridal ideas, etc. Our range of needs is wide, so we need various looks."
Needs: Approached by 8-10 freelancers/year. Works with 5-6 freelancers/year. Buys 40-50 freelance designs and illustrations/year. Artists must be able to work from pencils to finish, various styles—work is small and tight. Works on assignment only. Uses freelancers mainly for printed artwork on ribbons. Looking for artists able to translate a trend or design idea into a 1½ to 2-inch space on a ribbon. Produces material for Christmas, everyday. Submit seasonal material 6 months in advance.
First Contact & Terms: Send postcard sample or query letter with résumé or call. Samples are filed. Reports back to the artist only if interested. Portfolio should include color final art. Rights purchased vary according to project. Pays by the project, $200-300 for design.

P.S. GREETINGS, INC., 5060 N. Kimberly Ave., Chicago IL 60630. (800)334-2141. Fax: (773)725-8655. Website: http://www.psg.fpp.com. Art Director: Jennifer Dodson. Manufacturer of boxed greeting and counter cards.
Needs: Receives submissions from 300-400 freelance artists/year. Works with 20-30 artists/year on greeting card designs. Prefers illustrations be 5×7¾ with ⅛″ bleeds cropped. Publishes greeting cards for everyday and holidays. 20% of work demands knowledge of QuarkXPress, Adobe Illustrator and Adobe Photoshop.
First Contact & Terms: Send query letter requesting artist's guidelines. All requests as well as submissions must be accompanied by SASE. Samples will *not* be returned without SASE! Reports within 1 month. Pays flat fee. Buys exclusive worldwide rights for greeting cards and stationery.
Tips: "Our line includes a whole spectrum: from everyday needs (florals, scenics, feminine, masculine, humorous, cute) to every major holiday (from New Years to Thanksgiving) with a huge Chrismas line as well. We continue to grow every year and are always looking for innovative talent."

✔ PAINTED HEARTS & FRIENDS, 1222 N. Fair Oaks Ave., Pasadena CA 91103. (626)798-3633. Fax: (626)296-8890. E-mail: richard@paintedhearts.com. Sales Manager: Judith Clemens. President: Susan Kinney. Estab. 1988. Produces greeting cards, stationery, invitations and notecards.

Jim Edmon's wacky family illustration is a top-selling card design for Oatmeal Studios. Creative Director Helene Lehrer says audiences love the over-exaggerated and varied personalities of each character and relate to its message in a positive and humorous way. In addition, Lehrer says working with Edmon is a pleasure. "He is open to our suggestions whenever it is necessary to change a sketch or design he has submitted. This is very important to our company. He meets all deadlines and his style is fun and full of energy. We love the wackiness of his characters and, over the years, his style has developed and changed, keeping his look fresh and alive."

• This company also needs freelancers who can write verse. If you can wear this hat, you'll have an added edge.

Needs: Approached by 75 freelance artists/year. Works with 6 freelancers/year. Art guidelines free for SASE with first-class postage or by e-mail. Works on assignment only. Uses freelancers mainly for design. Produces material for all holidays and seasons, birthdays and everyday. Submit seasonal material 1 year in advance.

First Contact & Terms: Send Art submissions Attn: David Mekelburg, send Writer's submissions Attn: Geri Vasquez or use e-mail. Send query letter with résumé, SASE and color photocopies. Samples are returned with SASE. Reports back only if interested. Write for appointment to show portfolio, which should include original and published work. Rights purchased vary according to project. Originals returned at job's completion. Pays flat fee of $150-300 for illustration. Pays royalties of 5%.

Tips: "Familiarize yourself with our card line." This company is seeking "young artists (in spirit!) looking to develop a line of cards. We're looking for work that is compatible but adds to our look, which is bright, clean watercolors. We need images that go beyond just florals to illustrate and express the occasion."

PANDA INK, P.O. Box 5129, Woodland Hills CA 91308-5129. (818)340-8061. Fax: (818)883-6193. E-mail: ruthluvph@worldnet.att.net. Art Director: Ruth Ann Epstein. Estab. 1982. Produces greeting cards, stationery, calendars and magnets. Products are Judaic, general, everyday, anniversay, etc.

• This company has added a metaphysical line of cards.

Needs: Approached by 8-10 freelancers/year. Works with 1-2 freelancers/year. Buys 3-4 freelance designs and illustrations/year. Uses freelancers mainly for design, card ideas. Considers all media. Looking for bright, colorful artwork, no risqué, more ethnic. Prefers 5×7. Produces material for all holidays and seasons, Christmas, Valentine's Day, Mother's Day, Father's Day, Easter, Hanukkah, Passover, Rosh Hashanah, graduation, Thanksgiving, New Year, Halloween, birthdays and everyday. Submit seasonal material 6 months in advance.

First Contact & Terms: Send query letter with résumé, SASE, tearsheets and photocopies. Samples are filed. Reports back within 1 month. Portfolio review not required. Rights purchased vary according to project. Originals are returned at job's completion. Pay is negotiable; pays flat fee of $20; royalties of 2% (negotiable). Finds artists through word of mouth and submissions.

Tips: "Looking for bright colors and cute, whimsical art. Be professional. Always send SASE. Make sure art fits company format."

PAPEL GIFTWARE®, (formerly Papel Freelance), 30 Engelhard Dr., Cranbury NJ 08512. (609)395-0022. Design Manager: Tina M. Merola. Estab. 1955. Produces everyday and seasonal giftware items and home decor items: mugs, photo frames, magnets, figurines, plush collectible figurines, candles and novelty items. Paper items include giftbags, journals, plaques and much more.

Needs: Approached by about 125 freelancers/year. Buys 250 illustrations/year. Uses freelancers for product design, illustrations on product, calligraphy, computer graphics and mechanicals. Looks for artwork that is "very graphic, easy to interpret, bold, clean colors, both contemporary and traditional looks." Produces material for Halloween, Christmas, Valentine's Day, Easter, St. Patrick's Day, Mother's Day, Father's Day, Secretary's Day, personalized, inspirational, birthday, teacher, mid-life crisis, golf, wedding. Freelancers should be familiar with Adobe Illustrator, Adobe Photoshop and QuarkXPress.

First Contact & Terms: Designers send query letter with photocopies. Illustrators send postcard sample or query letter with photocopies and SASE to be kept on file. Samples not filed are returned by SASE. Will contact for portfolio review if interested. Portfolio should include final reproduction/product and b&w and color tearsheets, photostats and photographs. Originals not returned. Sometimes requests work on spec before assigning a job. Pays by project, $125 minimum; or royalties of 3%. Buys all rights.

Tips: "I look for strong basic drawing skills with a good color sense. I want an artist who is versatile and who can adapt their style to a specific product line with a decorative feeling. Please submit as many styles as you are capable of doing. Clean, accurate work is very important and mechanicals are important to specific jobs. New ideas and 'looks' are always welcome. Keep our files updated with your future work as developed."

PAPER MAGIC GROUP INC., 401 Adams Ave., Scranton PA 18510. (570)961-3863. Fax: (570)348-8389. Creative Director for Winter Division: Peg Cohan O'Connor. Estab. 1984. Produces greeting cards, stickers, vinyl wall decorations, 3-D paper decorations. "We are publishing seasonal cards and decorations for the mass market. We use a wide variety of design styles."

Needs: Works with 60 freelance artists/year. Prefers artists with experience in greeting cards. Work is by assignment only. Designs products for Christmas, Valentine's Day, Easter, Halloween and school market. Also uses freelances for lettering and art direction.

First Contact & Terms: Send query letter with résumé, samples and SASE. Color photocopies are acceptable samples. Samples are filed or are returned by SASE only if requested by artist. Reports back within 2 months. Originals not returned. Pays by the project, $350-2,000 average. Buys all rights.

Tips: "Please, experienced illustrators only."

PAPER MOON GRAPHICS, INC., Box 34672, Los Angeles CA 90034. (310)287-3949. Contact: Creative Director. Estab. 1977. Produces greeting cards and stationery. "We publish greeting cards with a friendly, humorous approach—dealing with contemporary issues."

• Paper Moon is a contemporary, alternative card company. Traditional art is not appropriate for this company.

Needs: Works with 40 artists/year. Buys 200 designs/illustrations/year. Buys illustrations mainly for greeting cards and stationery. Art guidelines for SASE with first-class postage. Produces material for everyday, holidays and birthdays. Submit seasonal material 6 months in advance.

First Contact & Terms: Send query letter with brochure, tearsheets, photostats, photocopies, slides and SASE. Samples are filed or are returned only if requested by artist and accompanied by SASE. Reports back within 8-10 weeks. To show a portfolio, mail color roughs, slides and tearsheets. Original artwork is returned to the artist after job's completion. Pays average flat fee of $350/design; $350/illustration. Negotiates rights purchased.

Tips: "We're looking for bright, fun style with contemporary look. Artwork should have a young 20s and 30s appeal." A mistake freelance artists make is that they "don't know our product. They send inappropriate submissions, not professionally presented and with no SASE."

PAPERPOTAMUS PAPER PRODUCTS INC., Box 310, Delta, British Columbia V4K 3Y3 Canada. Alternative address for small packages or envelopes only: Box 966, Point Roberts WA 98281. (604)940-3370. Fax: (604)940-3380. (604)270-4580. Fax: (604)270-1580. E-mail: paperpotamus@paperpotamus.com. Website: http://www.paperpotamus.com. Director of Marketing: George Jackson. Estab. 1988. Produces greeting cards for women ages 16-60.

Needs: Works with 8-10 freelancers/year. Buys 75-100 illustrations from freelancers/year. Also uses freelancers for P-O-P displays, paste-up and inside text. Prefers watercolor and computer colored, but will look at all color media; no b&w except photographic. Especially seeks detailed humorous cartoons, fairies, wizards, dragons etc. and country style and Victoriana color artwork. Will use some detailed nature drawings of items women are attracted to i.e. cats, flowers, teapots, horses, etc. especially in combination. Also wants whales, eagles, tigers and other wildlife. Has both horse and wild bird card lines. Would like to see "cute" cats, Teddy bears, kids etc. Produces t-shirts in both b&w and color. Produces material for Christmas. Submit seasonal work at least 18 months before holiday. Has worked with artists to produce entire lines of cards but is currently most interested in putting selected work into existing or future card lines. Prefers 5¼×7¼ finished artwork.

First Contact & Terms: Send brochure, color photos, roughs, photocopies and SASE. No slides. Samples are not filed and are returned by SASE only if requested by artist. Reports back within 2 months. Original artwork is not returned if purchased. Pays average flat fee of $100-150/illustration or royalties of 5% on all goods artwork is used on. Prefers to buy all rights. Company has a 20-page catalog you may purchase by sending $4 with request for artist's guidelines. You can also check website for guidelines. Please do not send IRCs in place of SASE. "Do not phone or fax to inquire about your artwork. It will be returned if you send an SASE with it. If sending samples from USA, put US postage on SASE. Your samples will be mailed back to you from USA post office. If you have a web page with your artwork online, send an e-mail giving web address and it will be reviewed and e-mail sent in response."

Tips: "Know who your market is! Find out what type of images are selling well in the card market. Learn why people buy specific types of cards. Who would buy your card? Why? Who would they send it to? Why? Birthdays are the most popular occasions to send cards. Understand the time frame necessary to produce cards and do not expect your artwork to appear on a card in a store next month. Send only your best work and we will show it to the world, with your name on it."

PAPERPRODUCTS DESIGN U.S. INC., 60 Galli Dr., Suite 1, Novato CA 94949. (415)883-1888. Fax: (415)883-1999. President: Carol Florsheim. Estab. 1990. Produces paper napkins, plates, designer tissue, giftbags and giftwrap. Specializes in high-end design, fashionable designs.

Needs: Approached by 20-30 freelancers/year. Works with 10 freelancers/year. Buys 30 freelance designs and illustrations/year. Artists do not need to write for guidelines. They may send samples to the attention of Carol Florsheim. Uses freelancers mainly for designer paper napkins. Looking for very stylized/clean designs and illustrations. Prefers 6½×6½. Produces material for Christmas and everyday. Submit seasonal material 9 months in advance.

First Contact & Terms: Designers send brochure, photocopies, photographs, tearsheets. Samples are not filed and are returned. Reports back within 4-6 weeks. Request portfolio review of color, final art, photostats in original query. Rights purchased vary according to project. Pays for design and illustration by the project in royalties. Finds freelancers through agents, *Workbook*.

Tips: "Shop the stores, study decorative accessories. Read European magazines."

PAPILLON INTERNATIONAL GIFTWARE INC., 40 Wilson Rd., Humble TX 77338. (281)446-9606. Fax: (281)446-1945. Vice President Marketing: Michael King. Estab. 1987. Produces decorative accessories, home furnishings and Christmas ornaments. "Our product mix includes figurines, decorative accessories, Christmas ornaments and decor."

Needs: Approached by 20 freelance artists/year. Works with 4-6 freelancers/year. Buys 30-40 designs and illustrations/year. Prefers local artists only. Works on assignment only. "We are looking for illustrations appealing to classic and

 SPECIAL COMMENTS within listings by the editor of *Artist's & Graphic Designer's Market* are set off by a bullet.

refined tastes for our Christmas decor." Prefers 10×14. Produces material for Christmas, Valentine's Day, Thanksgiving and Halloween. Submit seasonal material 1 year in advance.

First Contact & Terms: Send query letter with brochure, SASE, tearsheets, photographs, photocopies, photostats and slides. Samples are filed and are returned by SASE if requested by artist. Reports back within 6-8 weeks. To show portfolio, mail roughs, color slides and tearsheets. Originals returned at job's completion. Pays by the project, $400 average. Negotiates rights purchased.

PARAMOUNT CARDS INC., 400 Pine St., Pawtucket RI 02860. (401)726-0800. Fax: (401)727-3890. Contact: Art Coordinator. Estab. 1906. Publishes greeting cards. "We produce an extensive line of seasonal and everyday greeting cards which range from very traditional to whimsical to humorous. Almost all artwork is assigned."

Needs: Works with 50-80 freelancers/year. Uses freelancers mainly for finished art. Also for calligraphy. Considers watercolor, gouache, airbrush and acrylic. Prefers 5½×8⅝₆. Produces material for all holidays and seasons. Submit seasonal holiday material 1 year in advance.

First Contact & Terms: Send query letter résumé, SASE (important), photocopies and printed card samples. Samples are filed only if interested, or returned by SASE if requested by artist. Reports back within 1 month if interested. Company will contact artist for portfolio review if interested. Portfolio should include photostats, tearsheets and card samples. Buys all rights. Originals are not returned. Pays by the project, $200-450. Finds artists through word of mouth and submissions.

Tips: "Send a complete, professional package. Only include your best work—you don't want us to remember you from one bad piece. Always include SASE with proper postage and *never* send original art—color photocopies are enough for us to see what you can do. No phone calls please."

PATTERN PEOPLE, INC., 10 Floyd Rd., Derry NH 03038. (603)432-7180. President: Janice M. Copeland. Estab. 1988. Design studio servicing various manufacturers of consumer products. Designs wallcoverings and textiles with "classical elegance and exciting new color themes for all ages."

Needs: Approached by 5 freelancers/year. Works with 2 freelance designers/year. Prefers freelancers with professional experience in various media. Uses freelancers mainly for original finished artwork in repeat. "We use all styles but they must be professional." Special needs are "floral (both traditional and contemporary), textural (faux finishes, new woven looks, etc.) and geometric (mainly new wave contemporary)."

First Contact & Terms: Send query letter with photocopies and transparencies. Samples are filed. Art Director will contact artist for portfolio review if interested. Portfolio should include original/final art and color samples. Sometimes requests work on spec before assigning a job. Pays for design by the project, $100-1,000. Buys all rights. Finds artists through sourcebooks and other artists.

PHUNPHIT DESIGNS, LTD., 56 Lynncliff Rd., Hampton Bays NY 11946. (516)723-1899. Fax: (516)723-3755. E-mail: nolinguini@phunphit.com. Website: http:///www.phunphit.com. President: Barbara A. Demy. Estab. 1995. Purchases art for T-shirt and sweatshirt designs.

Needs: Works with 2-4 freelancers/year. Buys 4-8 freelance designs and illustrations/year.

First Contact & Terms: Illustrators send query letter with photocopies, photographs, tearsheets, SASE. Samples are filed or are returned by SASE only. "No SASE, no reply." Reports back within 6-8 weeks. Rights purchased vary according to project. Pays average flat fee of $250-300 for illustration.

Tips: "We are currently seeking to develop a sports theme line for 1999/2000, with a limited amount of colors and simplicity of design."

N PICKARD CHINA, 782 Pickard Ave., Antioch IL 60002. (847)395-3800. President: Eber C. Morgan, Jr.. Estab. 1893. Manufacturer of fine china dinnerware. Clients: upscale specialty stores and department stores. Current clients include Cartier, Marshall Field's and Gump's.

Needs: Assigns 2-3 jobs to freelance designers/year. Prefers designers for china pattern development with experience in home furnishings. Tabletop experience is a plus but not required.

First Contact & Terms: Send query letter with résumé and color photographs, tearsheets, slides or transparencies showing art styles. Samples are filed or are returned if requested. Art Director will contact artist for portfolio review if interested. Negotiates rights purchased. May purchase designs outright, work on royalty basis (usually 2%) or negotiate non-refundable advance against royalties.

N PIECES OF THE HEART, 5841 Woodglen Dr., Agoura Hills CA 91301. (818)345-0090. E-mail: davidtami@aol.com. President: David Wank. Estab. 1989. Produces greeting cards and puzzle cards for all ages.

Needs: Approached by 5 freelancers/year. Works with 2 freelancers/year. Buys 2 freelance designs and illustrations/year. Works on assignment only. Uses freelancers mainly for cards. Also for P-O-P displays. Does not want to see line art. Produces material for all holidays and seasons. Submit seasonal material 9 months in advance.

First Contact & Terms: Send query letter with brochure, photographs and photocopies. Samples are filed. Reports back only if interested. Call for appointment to show portfolio of color thumbnails. Originals are returned at job's completion. Pays average flat fee of $75-250 for illustration/design. Buys first rights.

Tips: "Remember, art is to be used on puzzles."

PLUM GRAPHICS INC., Box 136, Prince Station, New York NY 10012. (212)337-0999. Contact: Yvette Cohen. Estab. 1983. Produces greeting cards. "They are full-color, illustrated, die-cut; fun images for young and old."
Needs: Buys 12 designs and illustrations/year. Art guidelines not available. Prefers local freelancers only. Uses freelancers for greeting cards only. Considers oil, acrylic, watercolor and computer generated medias.
First Contact & Terms: Send query letter with photocopies. Samples are filed or are returned by SASE if requested by artist. Reports back only if interested. "We'll call to view a portfolio." Portfolio should include final art and color tearsheets. Originals are returned at job's completion. Pays average flat fee of $100-450 for illustration/design. Pays an additional fee if card is reprinted. Considers buying second rights (reprint rights) to previously published work; "depends where it was originally published." Finds artists through word of mouth, submissions and sourcebooks.
Tips: "I suggest that artists look for the cards in stores to have a better idea of the style. They are sometimes totally unaware of Plum Graphics and submit work that is inappropriate."

MARC POLISH ASSOCIATES, P.O. Box 3434, Margate NJ 08402. (609)823-7661. E-mail: sedonamax@aol.com. President: Marc Polish. Estab. 1972. Produces T-shirts and sweatshirts. "We specialize in printed T-shirts and sweatshirts. Our market is the gift and mail order industry, resort shops and college bookstores."
Needs: Works with 6 freelancers/year. Designs must be convertible to screenprinting. Produces material for Christmas, Valentine's Day, Mother's Day, Father's Day, Hanukkah, graduation, Halloween, birthdays and everyday.
First Contact & Terms: Send query letter with brochure, tearsheets, photographs, photocopies, photostats and slides. Samples are filed or are returned. Reports back within 2 weeks. To show portfolio, mail anything to show concept. Originals returned at job's completion. Pays royalties of 6-10%. Negotiates rights purchased.
Tips: "We like to laugh. Humor sells. See what is selling in the local mall or department store. Submit anything suitable for T-shirts. Do not give up. No idea is a bad idea. It sometimes might have to be changed slightly to fit into a marketplace."

THE POPCORN FACTORY, 13970 W. Laurel Dr., Lake Forest IL 60045. E-mail: nancy.hensel@fgcorp.com. Website: http://www.thepopcornfactory.com. Senior Vice President and General Manager: Nancy Hensel. Estab. 1979. Manufacturer of popcorn cans and other gift items sold via catalog for Christmas, Valentine's Day, Easter and year-round gift giving needs.
Needs: Works with 6 freelance artists/year. Assigns up to 20 freelance jobs/year. Works on assignment only. Art guidelines available. Uses freelancers mainly for cover illustration, can design, fliers and ads. Occasionally uses artists for advertising, brochure and catalog design and illustration. 100% of freelance catalog work requires knowledge of QuarkXPress and Adobe Photoshop.
First Contact & Terms: Send query letter with photocopies, photographs or tearsheets. Samples are filed. Reports back within 1 month. Write for appointment to show portfolio, or mail finished art samples and photographs. Pays for design by the hour, $50 minimum. Pays for catalog design by the page. Pays for illustration by project, $250-2,000. Considers complexity of project, skill and experience of artist, and turnaround time when establishing payment. Buys all rights.
Tips: "Send classic illustration, graphic designs or a mix of photography/illustration. We can work from b&w concepts—then develop to full 4-color when selected. Do not send art samples via e-mail."

☑ **PORTERFIELD'S FINE ART**, 5 Mountain Rd., Concord NH 03301-5479. (800)660-8345 or (603)228-1864. Fax: (603)228-1888. E-mail: ljklass@mediaone.net. Website: http://www.porterfieldsfineart.com. President, licensing: Lance Klass. Licenses representational, Americana, and most other subjects "We're a full-service licensing agency." Estab. 1994. Produces collector plates and other limited editions. Also functions as a full-service licensing representative for individual artists wishing to find publishers or licensees. "We produce high-quality limited-edition collector plates and prints sold in the U.S. and abroad through direct response and retail. Seeking excellent representational art on all subjects including children, florals, landscapes, baby wildlife, foreign and domestic (cats/kittens, puppies/dogs), Americana, cottages and English country scenes."
 ● See the article on licensing by Porterfield's president, Lance Klass, on page 34.
Needs: Approached by 200 freelancers/year. Licenses many freelance designs and illustrations/year. Prefers representational artists "who can create beautiful pieces of art that people want to look at and look at and look at." Art guidelines not available. Considers existing works first. Considers any media—oil, pastel, pencil, acrylics. "We want artists who have exceptional talent and who would like to have their art and their talents introduced to the broad public."
First Contact & Terms: Send query letter with tearsheets, photographs, slides, SASE, photocopies and transparencies. Samples are filed or returned by SASE. Reports back within 2 weeks. Will contact for portfolio review if interested. Portfolio should include tearsheets, photographs or transparencies. Rights purchased vary. Pays royalties for licensed works and/or flat fee for commissioned single works; royalty for products produced directly by Porterfield's. Generally pays advance against royalties when work accepted, royalties/sale paid after product sales are made.
Tips: "We are impressed first and foremost by level of ability, even if the subject matter is not something we would use. Thus a demonstration of competence is the first step; hopefully the second would be that demonstration using subject matter that we feel would be marketable. We work with artists to help them with the composition of their pieces for particular media. We treat artists well, and actively represent them to potential licensees. Instead of trying to reinvent the wheel yourself and contact everyone 'cold,' get a licensing agent or rep whose particular abilities complement your art. For example, we specialize in the application of art of all kinds to limited and open-edition collectibles and also to print media such as cards, stationery, calendars, prints, lithographs and even fabrics. Other licensing reps and companies

specialize in decorative art, cartoons, book illustrations, etc.—the trick is to find the right rep whom you feel you can work with, who really loves your art whatever it is, and whose specific contacts and abilities can help further your art in the marketplace."

PORTFOLIO GRAPHICS, INC., 4060 S. 500 W., Salt Lake City UT 84123. (801)266-4844. Fax: (801)263-1076. E-mail: info@portfoliographics.com. Website: http://www.portfoliographics.com. Creative Director: Kent Barton. Estab. 1986. Produces greeting cards, fine art posters, prints, limited editions. Fine art publisher and distributor world-wide. Clients include frame shops, galleries, gift stores and distributors.
 • Portfolio Graphics also has a listing in the Posters & Prints section of this book.
Needs: Approached by 200-300 freelancers/year. Works with 30 freelancers/year. Buys 50 freelance designs and illustrations/year. Art guidelines free for SASE with first-class postage. Considers all media. "Open to large variety of styles." Produces material for Christmas, everyday, birthday, sympathy, get well, anniversary, thank you and friendship.
First Contact & Terms: Illustrators send résumé, slides, tearsheets, SASE. "Slides are best. Do not send originals." Samples are filed "if interested" or returned by SASE. Reports back in 2-3 weeks. Negotiates rights purchased. Pays 10% royalties. Finds artists through galleries, word of mouth, submissions, art shows and exhibits.
Tips: "Open to a variety of submissions, but most of our artists sell originals as fine art home or office decor. Keep fresh, unique, creative."

PRATT & AUSTIN COMPANY, INC., Dept. AGDM, 642 S. Summer St., Holyoke MA 01040. (413)532-1491. Fax: (413)536-2741. President: Bruce Pratt. Art Director: Lorilee Costello. Estab. 1931. Produces envelopes, children's items, stationery and calendars. Does not produce greeting cards. "Our market is the modern woman at all ages. Design must be bright, cute busy and elicit a positive response." Using more recycled paper products and endangered species designs.
Needs: Approached by 100-200 freelancers/year. Works with 20 freelancers/year. Buys 100-150 designs and illustrations/year. Art guidelines available. Uses freelancers mainly for concept and finished art. Also for calligraphy.
First Contact & Terms: Send non-returnable samples, such as postcard or color copies. Samples are filed or are returned by SASE if requested. Will contact for portfolio review if interested. Portfolio should include thumbnails,

©1999 Portfolio Graphics, Inc.

This tranquil image on a birthday card for Portfolio Graphics was created from an original oil painting by Craig Nelson. Creative director Kent Barton says he discovered Nelson in *Communication Arts*. Nelson's coastal paintings depict a variety of lifestyles as observed through years of extensive travel, and always interplay the figure to environment. He feels "an artist sees everyday life in a unique way." Nelson conducts an annual workshop in Monterey, California and is co-department Chairman of Fine Art at the San Francisco Academy of Art.

roughs, color tearsheets and slides. Pays flat fee. Rights purchased vary. Interested in buying second rights (reprint rights) to previously published work. Finds artists through submissions and agents.

THE PRINTERY HOUSE OF CONCEPTION ABBEY, Conception MO 64433. (660)944-2632. Fax: (660)944-2582. Website: http://www.msc.net/cabbey/. Art Director: Rev. Norbert Schappler. Estab. 1950. Publishes religious greeting cards. Specializes in religious Christmas and all-occasion themes for people interested in religious, yet contemporary, expressions of faith. "Our card designs are meant to touch the heart. They feature strong graphics, calligraphy and other appropriate styles."
Needs: Approached by 75 freelancers/year. Works with 25 freelancers/year. Art guidelines available for SASE with first-class postage. Uses freelancers for product illustration. Prefers acrylic, pastel, oil, watercolor, line drawings and classical and contemporary calligraphy. Looking for dignified styles and solid religious themes. Produces seasonal material for Christmas and Easter "as well as the usual birthday, get well, sympathy, thank you, etc. cards of a religious nature. Creative general message cards are also needed." Strongly prefers calligraphy to type style. 2% of freelance work requires knowledge of Adobe Photoshop or Adobe Illustrator.
First Contact & Terms: Send query letter with résumé, photocopies, photographs, SASE, slides or tearsheets. Calligraphers send any printed or finished work. Non-returnable samples preferred—or else samples with SASE. Accepts submissions on disk compatible with Adobe Photoshop or Adobe Illustrator. Send TIFF or EPS files. Reports back usually within 3 weeks. To show portfolio, mail appropriate materials only after query has been answered. "In general, we continue to work with artists once we have accepted their work." Pays flat fee of $150-300 for illustration/design, and $50-100 for calligraphy. Usually buys exclusive reproduction rights for a specified format; occasionally buys complete reproduction rights.
Tips: "Abstract or semi-abstract background designs seem to fit best with religious texts. Color washes and stylized designs are often appropriate. Designs with no backgrounds are also welcome. Remember our specific purpose of publishing greeting cards with a definite Christian/religious dimension but not piously religious. It must be good quality artwork. We sell mostly via catalogs so artwork has to reduce well for catalog." Sees trend toward "more personalization and concern for texts."

PRISMATIX, INC., 333 Veterans Blvd., Carlstadt NJ 07072. (201)939-7700. Fax: (201)939-2828. Vice President: Miriam Salomon. Estab. 1977. Produces novelty humor programs. "We manufacture screen-printed novelties to be sold in the retail market."
Needs: Works with 3-4 freelancers/year. Buys 20 freelance designs and illustrations/year. Works on assignment only. 90% of freelance work demands computer skills.
First Contact & Terms: Send query letter with brochure, résumé. Samples are filed. Reports back to the artist only if interested. Portfolio should include color thumbnails, roughs, final art. Payment negotiable.

PRODUCT CONCEPT CONSULTING, INC, 3334 Adobe Court, Colorado Springs CO 80907. (719)632-1089. Fax: (719)632-1613. President: Susan Ross. Estab. 1986. New product development agency. "We work with a variety of companies in the gift and greeting card market in providing design, new product development and manufacturing services."
● This company has recently added children's books to its product line.
Needs: Works with 20-25 freelancers/year. Buys 400 designs and illustrations/year. Prefers freelancers with 3-5 years experience in gift and greeting card design. Works on assignment only. Buys freelance designs and illustrations mainly for new product programs. Also for calligraphy, P-O-P display and paste-up. Considers all media. 25% of freelance work demands knowledge of Adobe Illustrator, Adobe Streamline, QuarkXPress or Aldus FreeHand. Produces material for all holidays and seasons.
First Contact & Terms: Send query letter with résumé, tearsheets, photostats, photocopies, slides and SASE. Samples are filed or are returned by SASE if requested by artist. Reports back within 1 month. To show portfolio, mail color and b&w roughs, final reproduction/product, slides, tearsheets, photostats and photographs. Originals not returned. Pays average flat fee of $250; or pays by the project, $250-2,000. Buys all rights.
Tips: "Be on time with assignments." Looking for portfolios that show commercial experience.

▼ PROMOTIONAL RESOURCES GROUP University Blvd. at Essex Entrance, Building 2704 B-1, P.O. Box 19235, Topeka KS 66619-0235. (785)862-3707. Fax: (785)862-1424. E-mail: erics@prgnet.com. Art Director: Eric Scott. Estab. 1982. Produces collectible figurines, toys, kids' meal sacks and cartons. "We produce kids' promotions for restaurants nationwide, including sacks, cartons, menus, activity books and toys."
Needs: Approached by 8 freelancers/year. Works with 6 freelancers/year. Buys 10 freelance designs and illustrations/year. Works on assignment only. Uses freelancers mainly for illustration and sculpting toys. Considers all media. Looking for humorous, child-related styles. Freelance illustrators should be familiar with Adobe Photoshop, Adobe Illustrator, Aldus FreeHand and QuarkXPress. Produces material for Christmas, Easter, Halloween, Thanksgiving, Valentine's Day and everyday. Submit seasonal material 3 months in advance.
First Contact & Terms: Illustrators and cartoonists send query letter with photocopies or e-mail JPEG files. Sculptors, calligraphers send photocopies. Samples are filed or returned by SASE. Reports back only if interested. Portfolio review not required. Pays by the project, $250-2,000 for illustration; $250-$400 for sculpture. Finds freelancers through word of mouth and artists' submissions.

☑ **PRUDENT PUBLISHING**, 65 Challenger Rd., Ridgefield Park NJ 07660. (201)641-7900. Fax: (201)641-5248. Marketing: Rose Bowen. Estab. 1928. Produces calendars and greeting cards. Specializes in business/corporate all-occasion and holiday cards.

Needs: Buys calligraphy. Art guidelines available. Uses freelancers mainly for card design, illustrations and calligraphy. Considers traditional media.. Prefers no cartoons or cute illustrations. Prefers 5½×7⅞ (or proportionate to those numbers). Produces material for Christmas, Thanksgiving, birthdays, everyday, sympathy, get well and thank you.

First Contact & Terms: Designers, illustrators and calligraphers send query letter with brochure, photostats, photocopies, tearsheets, photocopies. Accepts disk submissions compatible with Adobe Illustrator 7.0 and Photoshop 4.0. Samples are filed or returned by SASE if requested. Reports back ASAP. Portfolio review not required. Buys all rights. Pay is negotiable. Finds freelancers through artist's submissions, magazines, sourcebooks, agents and word of mouth.

Tips: "No cartoons."

RECO INTERNATIONAL CORPORATION, Collector's Division, Box 951, 138-150 Haven Ave., Port Washington NY 11050. (516)767-2400. E-mail: recoint@aol.com. Manufacturer/distributor of limited editions, collector's plates, lithographs and figurines. Sells through retail stores and direct marketing.

Needs: Works with freelance and contract artists. Uses freelancers under contract for plate and figurine design and limited edition fine art prints. Prefers romantic and realistic styles.

First Contact & Terms: Send query letter and brochure to be filed. Write for appointment to show portfolio. Art Director will contact artist for portfolio review if interested. Negotiates payment. Considers buying second rights (reprint rights) to previously published work.

Tips: "Have several portfolios available. We are very interested in new artists. We go to shows and galleries, and receive recommendations from artists we work with."

☑ **RECYCLED PAPER GREETINGS INC.**, 3636 N. Broadway, Chicago IL 60613. (773)348-6410. Fax: (773)281-1697. Art Manager: Cindy Elsman. Artist Coordinator: Gretchen Hoffman. Publishes greeting cards, adhesive notes, note pads and buttons.

Needs: Buys 1,000-2,000 freelance designs and illustrations. Considers b&w line art and color—"no real restrictions." Looking for "great ideas done in your own style with messages that reflect your own slant on the world." Prefers 5×7 vertical format for cards; 10×14 maximum. "Our primary interest is greeting cards." Produces seasonal material for all major and minor holidays including Jewish holidays. Submit seasonal material 18 months in advance; everyday cards are reviewed throughout the year.

First Contact & Terms: Send SASE to Gretchen Hoffman for artist's guidelines. "Please do not send slides or tearsheets. We're looking for work done specifically for greeting cards."Reports in 2 months. Portfolio review not required. Originals returned at job's completion. Sometimes requests work on spec before assigning a job. Pays average flat fee of $250 for illustration/design with copy. Some royalty contracts. Buys card rights.

Tips: "Remember that a greeting card is primarily a message sent from one person to another. The art must catch the customer's attention, and the words must deliver what the front promises. We are looking for unique points of view and manners of expression. Our artists must be able to work with a minimum of direction and meet deadlines. There is a renewed interest in the use of recycled paper—we have been the industry leader in this for almost three decades."

RED FARM STUDIO, 1135 Roosevelt Ave., P.O. Box 347, Pawtucket RI 02862-0347. (401)728-9300. Fax: (401)728-0350. Contact: Creative Director. Estab. 1955. Produces greeting cards, giftwrap and stationery from original watercolor art. Also produces coloring books and paintable sets. Specializes in nautical and traditional themes. Approached by 150 freelance artists/year. Buys 200 freelance designs and illustrations/year. Uses freelancers for greeting cards, notes, Christmas cards. Considers watercolor artwork for cards, notes and stationery; b&w linework and tonal pencil drawings for coloring books and paintable sets; will also consider other media (oils, pastel, etc.) for specialty lines. Looking for accurate, detailed, realistic work, though some looser watercolor styles are also acceptable. Produces material for Christmas and everyday occasions. Also interested in traditional, realistic artwork for religious line: Christmas, Easter, Mother's and Father's Day and everyday subjects, including realistic portrait and figure work, such as the Madonna and Child.

First Contact & Terms: First send query letter and #10 SASE to request art guidelines. Submit printed samples, transparencies, color copies or photographs with a SASE. Samples not filed are returned by SASE. Art Director will contact artist for portfolio review if interested. Pays flat fee of $250-350 for card or note illustration/design, or pays by project, $250-1000. Buys all rights.

Tips: "We are interested in clean, bright watercolor work of traditional subjects like florals, birds, kittens, some cutes, puppies, shells and nautical scenes. No photography. Our guidelines will help to explain our needs."

REEDPRODUCTIONS, 52 Leveroni Court, Suite 3, Novato CA 94949. (415)883-1851. E-mail: reedpro@earthlink.net. Owner/Art Director: Susie Reed. Estab. 1978. Produces celebrity postcards, key rings, magnets, address books, etc. Specializes in products related to Hollywood memorabilia.

Needs: Approached by 20 freelancers/year. Works with few freelancers/year. Art guidelines are not available. Prefers local freelancers with experience. Works on assignment only. Artwork used for paper and gift novelty items. Also for paste-up and mechanicals. Prefers color or b&w photorealist illustrations of celebrities.

First Contact & Terms: Send query letter with brochure or résumé, tearsheets, photostats, photocopies or slides and SASE. Samples are filed or are returned by SASE. Art Director will contact artist for portfolio review if interested.

Portfolio should include color or b&w final art, final reproduction/product, slides, tearsheets and photographs. Originals are returned at job's completion. Payment negotiated at time of purchase. Considers buying second rights (reprint rights) to previously published work.

RENAISSANCE GREETING CARDS, Box 845, Springvale ME 04083. (207)324-4153. Fax: (207)324-9564. Art Director: Janice Keefe. Estab. 1977. Publishes greeting cards; "current approaches" to all-occasion cards and seasonal cards. "We're an alternative card company with a unique variety of cards for all ages, situations and occasions."
Needs: Approached by 500-600 artists/year. Buys 300 illustrations/year. Occasionally buys calligraphy. Art guidelines available free for SASE with first-class postage. Full-color illustrations only. Produces materials for all holidays and seasons and everyday. Submit art 18 months in advance for fall and Christmas material; approximately 1 year in advance for other holidays.
First Contact & Terms: Send query letter with SASE. To show portfolio, mail color copies, tearsheets, slides or transparencies. Packaging with sufficient postage to return materials should be included in the submission. Reports in 2 months. Originals are returned to artist at job's completion. Sometimes requests work on spec before assigning a job. Pays for design by the project, $150-300 advance on royalties or flat fee, negotiable. Also needs calligraphers, pay rate negotiable. Finds artists mostly through submissions/self-promotions.
Tips: "Do some 'in store' research first to get familiar with a company's product/look in order to decide if your work is a good fit. It can take a lot of patience to find the right company or situation. Especially interested in trendy styles as well as humorous and whimsical illustration. Start by requesting guidelines and then send a small (10-12) sampling of 'best' work, preferably color copies or slides (with SASE for return). Indicate if the work shown is available or only samples. We're doing more designs with special effects like die-cutting and embossing. We're also starting to use more computer-generated art and electronic images."

[N] RHAPSODY LTD., 4337 Product Dr., Cameron Park CA 95682. Fax: (800)600-3508. E-mail: ljones@rhapsodyltd .com. Art Director: Sierra Hunter. Estab. 1994. Creates giftbags, journals, gifts, mugs, stationery and boxed blank cards. Produces high end sophisticated designs which are sold in a variety of markets including gift stores and Christian bookstores.
Needs: Approached by 30 freelancers/year. Works with 6 freelancers/year. Buys 50 freelance designs and illustrations/ year. Uses freelancers mainly for finished art. Considers color copies, transparencies, computer files, web pages, e-mail. Looking for vibrant colors, detailed, good perspective. Can provide templates to artist for product layout. Produces material for all-occasion friendship, Christmas, romance, birthday, new baby, corporate, Mother's Day, etc. Special needs for inspirational, male, corporate, romance, wedding, teen/young adult friendship, naturals/kraft, equestrian, extreme sports, music, coffee, Victorian.
First Contact & Terms: Send query letter with brochure and/or photocopies, résumé. If style seems compatible, artist will receive artist's guidelines, current catalog and samples. Company will contact artist for portfolio review if interested. Rights purchsed vary according to project. Pays for design and illustration by the project; negotiable. Finds freelancers through submissions, exhibitions, trade shows.
Tips: "Please contact by mail only. Do not send any work that needs to be returned without prior permission. All submissions will be reviewed by president or art director."

RIGHTS INTERNATIONAL GROUP, 463 First St. #3C, Hoboken NJ 07030. (201)963-3123. Fax: (201)420-0679. E-mail: hazaga@aol.com. Contact: Robert Hazaga. Estab. 1996. Agency for cross licensing. Licenses images for manufacturers of giftware, stationery, posters, home furnishing.
• This company also has a listing in the Posters & Prints section.
Needs: Approached by 50 freelancers/year. Uses freelancers mainly for creative, decorative art for the commercial and designer market. Also for textile art. Considers oil, acrylic, watercolor, mixed media, pastels and photography.
First Contact & Terms: Send brochure, photocopies, photographs, SASE, slides, tearsheets or transparencies. Accepts disk submissions compatible with Adobe Illustrator. Reports back within 1 month. Will contact for portfolio review if interested. Negotiates rights purchased and payment.

RITE LITE LTD./THE JACOB ROSENTHAL JUDAICA-COLLECTION, 260 47th St., Brooklyn NY 11220. (718)439-6900. Fax: (718)439-5197. E-mail: ritelite@aol.com. President: Alex Rosenthal. Estab. 1948. Manufacturer and distributor of a full range of Judaica ranging from mass-market commercial goods, such as decorative housewares, to exclusive numbered pieces, such as limited edition plates. Clients: department stores, galleries, gift shops, museum shops and jewelry stores.
• Company is looking for new menorah, mezuzah, children's Judaica, Passover and matza plate designs.
Needs: Approached by 15 freelancers/year. Works with 4 freelancers/year. Art guidelines not available. Works on assignment only. Uses freelancers mainly for new designs for Judaic giftware. Must be familiar with Jewish ceremonial

[N] MARKETS NEW TO THIS EDITION

objects or design. Prefers ceramic, brass and glass. Also uses artists for brochure and catalog design, illustration and layout mechanicals, P-O-P and product design. 25% of freelance work requires knowledge of Adobe Illustrator and Adobe Photoshop. Produces material for Hannukkah, Passover, Hasharah. Submit seasonal material 1 year in advance.
First Contact & Terms: Designers send query letter with brochure or résumé and photographs. Illustrators send photocopies. Do not send originals. Samples are filed. Reports back within 1 month only if interested. Portfolio review not required. Art Director will contact for portfolio review if interested. Portfolio should include color tearsheets, photographs and slides. Pays flat fee of $500/design or royalties of 5-6%. Buys all rights. "Works on a royalty basis." Finds artists through word of mouth.
Tips: "Be open to the desires of the consumers. Don't force your preconceived notions on them through the manufacturers. Know that there is one retail price, one wholesale price and one distributor price."

SANGHAVI ENTERPRISES PVT LTD., (formerly Greetwell), D-24, M.I.D.C., Satpur, Nasik 422 007 India. Fax: 91-253-351381. E-mail: sepi@bom5.usnl.com.in. Chief Executive: H.L. Sanghavi. Produces greeting cards, calendars and posters.
Needs: Approached by 50-60 freelancers/year. Buys 50 designs/year. Free art guidelines available. Uses freelancers mainly for greeting cards and calendars. Prefers flowers, landscapes, wildlife and general themes.
First Contact & Terms: Send query letters and photocopies to be kept on file. Samples not filed are returned only if requested. Reports within 1 month. Originals are returned at job's completion. Pays flat fee of $25 for design. Buys reprint rights.
Tips: "Send color photos. Do not send originals. No SASE."

SANGRAY CORPORATION, 2318 Lakeview Ave., Pueblo CO 81004. (719)564-3408. Fax: (719)564-0956. E-mail: sangray@rmi.net. Website: http://www.sangray.com. President, licensing: James Stuart. Licenses humor for gift and novelty. Estab. 1971. Produces refrigerator magnets, trivets, wall decor and other decorative accessories—all using full-color art. Art guidelines for SASE with first-class postage.
Needs: Approached by 30-40 freelancers/year. Works indirectly with 6-7 freelancers/year. Buys 25-30 freelance designs and illustrations/year. Prefers florals, scenics, small animals and birds. Uses freelancers mainly for fine art for products. Considers all media. Prefers 7×7. Submit seasonal material 10 months in advance.
First Contact & Terms: Send query letter with examples of work in any media. Samples are filed. Reports back within 30 days. Company will contact artist for portfolio review if interested. Buys first rights. Originals are returned at job's completion. Pays by the project, $250-400. Finds artists through submissions and design studios.
Tips: "Try to get a catalog of the company products and send art that closely fits the style the company tends to use."

SARUT INC., 107 Horatio, New York NY 10014. (212)691-9453. Fax: (212)691-1077. Vice President Marketing: Frederic Rambaud. Estab. 1979. Produces museum quality science and nature gifts. "Marketing firm with 20 employees. 36 trade shows a year. No reps. All products are exclusive. Medium- to high-end market."
Needs: Approached by 4-5 freelancers/year. Works with 4 freelancers/year. Uses freelancers mainly for new products. Seeks contemporary designs. Produces material for all holidays and seasons.
First Contact & Terms: Samples are returned. Reports back within 2 weeks. Write for appointment to show portfolio. Rights purchased vary according to project.
Tips: "We are looking for concepts; products not automatically graphics."

SEABRIGHT PRESS INC., P.O. Box 7285, Santa Cruz CA 95061. (831)457-1568. Fax: (831)459-8059. E-mail: art@seabrightpress.com. Website: http://www.seabrightpress.com. Editor, liecnsing: Jim Thompson. Estab. 1990. Produces greeting cards and journals. Licenses contemporary artwork greeting cards, blank journals.
Needs: Approached by 20-30 freelancers/year. Works with 5-10 freelancers/year. Licenses 10-20 freelance designs and illustrations/year. Uses freelancers mainly for notecard designs. Art guidelines available for SASE with first-class postage. Considers any media. Produces material for all holidays and seasons. Submit seasonal material 4-6 months in advance.
First Contact & Terms: Send query letter with brochure, tearsheets, photographs, photocopies and SASE. Do not submit artwork via e-mail. Samples are not filed and are returned by SASE if requested by artist. Reports back within 2 months. Portfolio review not required. Negotiates rights purchased. Originals are returned at job's completion. Pays royalties of 5-7%.
Tips: "Be familiar with the notecard market before submitting work. Develop contemporary illustrations/designs that are related to traditional card themes."

SEABROOK WALLCOVERINGS, INC., 1325 Farmville Rd., Memphis TN 38122. (901)320-3500. Fax: (901)320-3675. Marketing Product Manager: Barbara Brower. Estab. 1910. Developer and distributor of wallcovering and coordinating fabric for all age groups and styles.
Needs: Approached by 10-15 freelancers/year. Works with approximately 15 freelancers/year. Buys approximately 400 freelance designs and illustrations/year. Prefers freelancers with experience in wall coverings. Works on assignment only. Uses freelancers mainly for designing and styling wallcovering collections. Considers gouache, oil, watercolor, etc. Prefers 20½×20½. Produces material for everyday.
First Contact & Terms: Designers send query letter with color photocopies, photographs, résumé, slides, transparencies and sample of artists' "hand." Illustrators send query letter with color photocopies, photographs and résumé.

Samples are filed or returned. Reports back within 2 weeks. Company will contact artist for portfolio review of final art, roughs, transparencies and color copies if interested. Buys all rights. Pays for design by the project. Finds freelancers through word of mouth, submissions, trade shows.

Tips: "Attend trade shows pertaining to trends in wall covering. Be familiar with wallcovering design repeats."

N **⊕** **SECOND NATURE, LTD.**, 10 Malton Rd., London, W105UP England. (0181)960-0212. Fax: (0181)960-8700. E-mail: secondnature.co.uk@aol.com. Website: http://www.tcom.co.uk.Secondnature/. Contact: Ron Schragger. Greeting card publisher specializing in unique 3-D/handmade and foiled cards.

Needs: Prefers interesting new contemporary but commercial styles. Produces material for Christmas, Valentine's Day, Mother's Day and Father's Day. Submit seasonal material 18 months in advance.

First Contact & Terms: Send query letter with brochure showing art style. Samples not filed are returned only if requested by artist. Reports back within 2 months. Originals are not returned at job's completion. Pays flat fee.

Tips: "We are interested in all forms of paper engineering."

N **SHERRY MFG. CO., INC.**, 3287 NW 65th St., Miami FL 33147. (305)693-7000 ext. 348. Fax: (305)691-6132. Art Director: Kenny Oliver. Estab. 1948. Manufacturer of silk screen T-shirts with beach and mountain souvenir themes. Label: Sherry's Best. Clients: T-shirt retailers. Current clients include Walt Disney Co., Warner Bros. Looneytunes, Scooby Doo and Peanuts.

Needs: Approached by 50 freelancers/year. Works with 15 freelance designers and illustrators/year. Assigns 350 jobs/year. Prefers freelancers that know the T-shirt market and understand the technical aspects of T-shirt art. Prefers colorful graphics or highly stippled detail. Art guidelines available. 50% of freelance work demands knowledge of Adobe Illustrator, Aldus FreeHand, Adobe Photoshop.

First Contact & Terms: Send query letter with brochure showing art style or résumé and photocopies. Accepts submissions on disk compatible with Aldus FreeHand and Photoshop. Samples are not filed and are returned only if requested. Art Director will contact artist for portfolio review if interested. Portfolio should include thumbnails, roughs, original/final art, final reproduction/product and color tearsheets, photostats and photographs. Sometimes requests work on spec before assigning a job. Pays by the project. Considers complexity of project, skill and experience of artist, and volume of work given to artist when establishing payment. Buys all rights.

Tips: "Know the souvenir T-shirt market and have previous experience in T-shirt art preparation. Some freelancers do not understand what a souvenir T-shirt design should look like. Send sample copies of work with résumé to my attention."

PAULA SKENE DESIGN, 1250 45th St., Suite 240, Emeryville CA 94608. (510)654-3510. Fax: (510)654-3496. President: Paula Skene. Produces and markets greeting cards, stationery and corporate designs to meet specific client needs featuring foil stamping and embossing.

Needs: Works with 1-2 freelancers/year. Works on assignment only. Produces material for all holidays and seasons, everyday.

First Contact & Terms: Designers send tearsheets and photocopies. Illustrators send samples. Samples are returned. Reports back within 3 days. Company will contact artist for portfolio review of b&w, color final art if interested. Buys all rights. Pays for design and illustration by the project.

SMART ART, P.O. Box 661, Chatham NJ 07928. (973)635-1690. Fax: (973)635-2011. E-mail: smartart1@mindspring.com. Website: http://www.smartart.net. President: Barb Hauck-Mah. Vice President: Wesley Mah. Estab. 1992. Produces photo frame cards. "Smart Art creates unique, premium-quality cards for all occasions. We contribute a portion of all profits to organizations dedicated to helping our nation's kids."

● Smart Art is continuing to expand its photo frame card line, so they are looking for artists who can do great watercolor, collage or mixed media border designs. The cards are ready-to-use "frames" customers can slip photos into and mail to friends.

Needs: Approached by 40-50 freelancers/year. Works with 6 freelancers/year. Buys 20-25 illustrations/year. Art guidelines available for SASE with first-class postage. Works on assignment only. Uses freelancers for card design/illustration. Considers watercolor, pen & ink and collage or mixed media. Produces material for most holidays and seasons, plus birthdays and everyday. Submit seasonal material 10-12 months in advance.

First Contact & Terms: Send query letter with tearsheets, photocopies, résumé and SASE. Samples are filed or returned by SASE. Reports back within 8-10 weeks. Portfolio review not required. Sometimes requests work on spec before assigning a job. Originals are returned at job's completion. Pays royalties of 5%, based on wholesale money earned. Negotiates rights purchased. Finds artists through word of mouth and trade shows.

Tips: "Send us rough color samples of potential greeting cards or border designs you've created."

✔ **SPARROW & JACOBS**, 2870 Janitell Rd., Colorado Springs CO 80906. (719)579-9011. Fax: (719)579-9007. Art Director: Linda Duffy. Estab. 1986. Produces calendars, greeting cards, postcards. Publisher of greeting cards and other material for businesses to send for prospecting, retaining and informing clients.

Needs: Approached by 60-80 freelancers/year. Works with 30 freelancers/year. Buys 50 freelance designs and illustrations/year. Art guidelines not available. Works on assignment only. Uses freelancers mainly for illustrations for postcards and greeting cards and calligraphy. Considers all media. Looking for humorous, sophisticated cartoons and traditional homey and warm illustrations of sweet animals, client/business communications. Prefers 8×10 size. Produces material for Christmas, Easter, Mother's Day, Father's Day, graduation, Halloween, New Year, Thanksgiving, Valentine's Day,

birthdays, everyday, "just listed/just sold," time change, doctor-to-patient reminders. Submit seasonal material 1 year in advance.

First Contact & Terms: Send query letter with color photocopies, photographs, slides or tearsheets. Accepts Mac-compatible disk submissiions. Samples are filed or returned. Reports back only if interested. Portfolios of color final art may be dropped off every Monday-Friday. Buys all rights. Pays for illustration by the project, $300-375.

SPENCER GIFTS, INC., subsidiary of Universal Studios, Inc., 6826 Black Horse Pike, Egg Harbor Twp. NJ 08234-4197. (609)645-5526. Fax: (609)645-5651. E-mail: jamesstevenson@spencergifts.com. Art Director: James Stevenson. Estab. 1965. Retail gift chain located in approximately 600 malls in 43 states including Hawaii and Canada. Includes 120 new retail chain stores named "DAPY" (upscaled unique gift items) and "GLOW" stores.

● Products offered by store chain include posters, T-shirts, games, mugs, novelty items, cards, 14k jewelry, neon art, novelty stationery. Art Director says Spencer's is moving into a lot of different product lines, such as custom lava lights and Halloween costumes and products. Visit a store if you can to get a sense of what they offer.

Needs: Assigns 10-15 freelance jobs/year. Prefers artists with professional experience in advertising design. Uses artists for illustration (hard line art, fashion illustration, airbrush). Uses a lot of freelance computer art. 50% of freelance work demands knowledge of Aldus FreeHand, Adobe Illustrator, Adobe Photoshop and QuarkXPress. Also needs color separators, production and packaging people. "You don't necessarily have to be local for freelance production."

First Contact & Terms: Send postcard sample or query letter with *nonreturnable* brochure, résumé and photocopies including phone number where you can be reached during business hours. Accepts submissions on disk. Art director will contact artist for portfolio review if interested. Will contact only upon job need. Considers buying second rights (reprint rights) to previously published work. Finds artists through sourcebooks.

 STANDARD CELLULOSE & NOV CO., INC., 90-02 Atlantic Ave., Ozone Park NY 11416. (718)845-3939. Fax: (718)641-1170. President: Stewart Sloane. Estab. 1932. Produces giftwrap and seasonal novelties and decorations.

Needs: Approached by 10 freelance artists/year. Works with 1 freelance artist/year. Buys 3-4 freelance designs and illustrations/year. Prefers local artists only. Uses freelance artists mainly for design packaging. Also uses freelance artists for P-O-P displays, all media appropriate for display and P-O-P. Produces material for all holidays and seasons, Christmas, Easter, Halloween and everyday. Submit 6 months before holiday.

First Contact & Terms: Send query letter or call for appointment. Samples are not filed and are returned. Reports back to the artist only if interested. Call to schedule an appointment to show a portfolio. "We will then advise artist what we want to see in portfolio." Original artwork is not returned at the job's completion. Payment negotiated at time of purchase. Rights purchased vary according to project.

SUN HILL INDUSTRIES, INC., 48 Union St., Stamford CT 06906. Fax: (203)356-9233. E-mail: sunhill@aol.com. Creative Director: Nancy Mimoun. Estab. 1977. Manufacturer of Easter egg decorating kits, Halloween novelties (the Giant Stuff-A-Pumpkin®) and Christmas items. Produces only holiday material. Clients: discount chain and drug stores and mail-order catalog houses. Clients include K-Mart, Walmart, Walgreens and CVS.

Needs: Approached by 10 freelancers/year. Works with 1-2 freelance illustrators and 1-2 designers/year. Assigns 2-3 freelance jobs/year. Works on assignment only. Uses freelancers for product and package design, rendering of product and model-making. Prefers marker and acrylic. 50% of freelance work demands knowledge of Adobe Photoshop, Aldus PageMaker, QuarkXPress and Adobe Illustrator.

First Contact & Terms: Send query letter with brochure and résumé. Accepts submissions on disk compatible with Adobe Illustrator 5.0. Send EPS files. Samples are filed or are returned only if requested by artist. Reports back only if interested. Pays by the hour, $25 minimum; or by the project, $250 minimum. Considers complexity of project and turnaround time when establishing payment. Buys all rights.

Tips: "Send all information; don't call. Include package designs; do not send mechanical work."

SUNSHINE ART STUDIOS, INC., 51 Denslow Rd., E., Longmeadow MA 01028. (413)781-5500. Estab. 1921. Produces greeting cards, stationery, calendars and giftwrap that are sold in own catalog, appealing to all age groups.

Needs: Works with 100-125 freelance artists/year. Buys 200-250 freelance designs and illustrations/year. Prefers artists with experience in greeting cards. Art guidelines available for SASE with first-class postage. Works on assignment only. Uses freelancers for greeting cards, giftwrap, stationery and gift items. Also for calligraphy. Considers all media. Looking for traditional or humorous look. Prefers art 4½×6½ or 5×7. Produces material for Christmas, Easter, birthdays and everyday. Submit seasonal material 6-8 months in advance.

First Contact & Terms: Send query letter with brochure, résumé, SASE, tearsheets and slides. Samples are filed or are returned by SASE if requested by artist. Reports back to the artist only if interested. Portfolio should include finished

● **SPECIAL COMMENTS** within listings by the editor of *Artist's & Graphic Designer's Market* are set off by a bullet.

art samples and color tearsheets and slides. Originals not returned. Pays by the project, $250-400. Pays $25-75/piece for calligraphy and lettering. Buys all rights.

CURTIS SWANN, Division of Burgoyne, Inc., 2030 E. Byberry Rd., Philadelphia PA 19116. (215)677-8000. Fax: (215)677-6081. Contact: Christine Cathers Donohue. Produces greeting cards. Publishes everyday greeting cards based on heavily embossed designs. Style is based in florals and "cute" subjects.
 ● See also listing for Burgoyne, Inc. in this section.
Needs: Works with 10 freelancers/year. Buys 20 designs and illustrations. Prefers freelancers with experience in greeting card design. Art guidelines free for SASE with first-class postage. Considers designs and media that work well to enhance embossing. Produces material for everyday designs as well as Christmas, Valentine's, Easter, Mother's Day and Father's Day. Accepts work all year round.
First Contact & Terms: Send query letter with brochure, tearsheets, slides, transparencies, photographs, photocopies and SASE. Would like to see a sample card with embossed features. Samples are filed. Creative Director will contact artist for portfolio review if interested. Sometimes requests work on spec before assigning a job. Pays flat fee. Buys first rights or all rights.
Tips: "It is better to show one style that is done very well than to show a lot of different styles that aren't as good."

[N] A SWITCH IN ART, Gerald F. Prenderville, Inc., P.O. Box 246, Monmouth Beach NJ 07750. (732)389-4912. Fax: (732)389-4913. President: G.F. Prenderville. Estab. 1979. Produces decorative switch plates. "We produce decorative switch plates featuring all types of designs including cats, animals, flowers, kiddies/baby designs, birds, etc. We sell to better gift shops, museums, hospitals, specialty stores with large following in mail order catalogs."
Needs: Approached by 4-5 freelancers/year. Works with 2-3 freelancers/year. Buys 20-30 designs and illustrations/year. Prefers artists with experience in card industry and cat rendering. Seeks cats and wildlife art. Prefers 8×10 or 10×12. Produces material for Christmas and everyday. Submit seasonal material 6 months in advance.
First Contact & Terms: Send query letter with brochure, tearsheets and photostats. Samples are filed and are returned. Reports back within 3-5 weeks. Pays by the project, $75-150. Interested in buying second rights (reprint rights) to previously published artwork. Finds artists mostly through word of mouth.
Tips: "Be willing to accept your work in a different and creative form that has been very successful. We seek to go vertical in our design offering to insure continuity. We are very easy to work with and flexible. Cats have a huge following among consumers but designs must be realistic."

[✓] T.V. ALLEN, P.O. Box 70007, Pasadena CA 91117. (626)795-6764. Fax: (626)795-4620. Art Director: Richard Adamson. Estab. 1912. Produces greeting cards, stationery. Specializes in Christmas cards and stationery featuring illustration, foil stamping and engraving. Supplier of all major department stores and fine card and gift stores.
Needs: Approached by 20 freelancers/year. Works with 10-12 freelancers/year. Buys 20-35 freelance designs and illustrations/year. Also buys some calligraphy. Use freelancers mainly for Christmas cards. Considers all media except sculpture. Looking for traditional, humorous, cute animals and graphic designs. Prefers multiple size range. 30% of freelance work demands knowledge of Adobe Photoshop, QuarkXPress. Produces material for Christmas, Hannukkah and Valentine's Day. Submit seasonal material 8-12 months in advance.
First Contact & Terms: Send query letter with photocopies. Samples are filed. Will contact artist for portfolio review of color photographs and slides if interested. Negotiates rights purchased. Pays flat fee by the project. Will also license with option to buy out after license is completed. Finds freelancers through word of mouth, submissions, Surtex show.

[N] TJ'S CHRISTMAS, 9721 Loiret Blvd., Lenexa KS 66219. (913) 888-8338. Fax: (913) 888-8350. Creative Coordinator: Edward Mitchell. Estab. 1983. Produces figurines, decorative accessories, ornaments and other Christmas adornments. Primarily manufactures and imports Christmas ornaments, figurines and accessories. Also deals in some Halloween, Thanksgiving, gardening and everyday home decor items. Clients: higher-end floral, garden, gift and department stores.
Needs: Uses freelancers mainly for fun and creative designs. Considers most media."Our products are often nostalgic, bringing back childhood memories. They also should bring a smile to your face. We are looking for fun designs that fit with our motto, 'Cherish the Memories.' Produces material for Christmas, Halloween, Thanksgiving and everyday. Submit seasonal material 18 months in advance (submit queries for Christmas designs in July.)
First Contact & Terms: Send query letter with résumé, SASE and photographs. Will accept work on disk in PC formatted, TIFF, GIF, JPEG, AI, or PSD. Portfolios may be dropped off Monday-Friday. Samples are not filed and are returned by SASE. Reports back within 1 month. Negotiates rights purchased. Pays advance on royalties of 5%. Terms are negotiated. Finds freelancers through magazines, word of mouth and artist's reps.
Tips: "Continually search for new and creative ideas. Sometimes the craziest ideas turn into the best designs (i.e., a Santa figurine curiously holding up a Santa ornament that looks just like him.) Watch for trends (such as increasing number of baby boomers that are retiring.) Try to target the trends you see."

THE TOY WORKS, INC., Fiddler's Elbow Rd., Middle Falls NY 12848. (518)692-9665. Fax: (518)692-9186. E-mail: thetoyworks@juno.com. Art Director: Maria Riera. Estab. 1974. Produces decorative housewares, gifts, T-shirts, toys, silkscreened toys, pillows, totes, backpacks, soft sculpture and doormats.
Needs: Works with 5 freelancers/year. Buys 50 freelance designs and illustrations/year. Works on assignment only. Uses freelancers mainly for design and illustration. Looking for traditional, floral, humorous, cute animals, adult contem-

porary. 50% of freelance design demands knowledge of Adobe Photoshop, Adobe Illustrator and Quark XPress, however computer knowledge is not a must. Produces material for Christmas, Easter, Mother's Day, Valentine's Day, birthdays and everyday. Submit seasonal material 20 weeks in advance.

First Contact & Terms: Designers and illustrators send query letter with photostats, résumé, photocopies, photographs. Accepts disk submissions compatible with Postscript. Samples are filed or returned. Reports back in 1-2 weeks. Portfolio review not required. Rights purchased vary according to project. Pays for design by the project; $400-1,000; pays for illustration by the project, $400-1,200.

VAGABOND CREATIONS INC., 2560 Lance Dr., Dayton OH 45409. (937)298-1124. Art Director: George F. Stanley, Jr. Publishes stationery and greeting cards with contemporary humor. 99% of artwork used in the line is provided by staff artists working with the company.

Needs: Works with 4 freelancers/year. Buys 30 finished illustrations/year. Prefers local freelancers. Seeking line drawings, washes and color separations. Material should fit in standard-size envelope.

First Contact & Terms: Query. Samples are returned by SASE. Reports in 2 weeks. Submit Christmas, Mother's Day, Father's Day, Valentine's Day, everyday and graduation material at any time. Originals are returned only upon request. Payment negotiated.

Tips: "Important! Currently we are *not* looking for additional freelance artists because we are very satisfied with the work submitted by those individuals working directly with us. We do not in any way wish to offer false hope to anyone, but it would be foolish on our part not to give consideration. Our current artists are very experienced and have been associated with us for in some cases over 30 years."

VERMONT T'S, Main St., Chester VT 05143. (802)875-2091. President: Thomas Bock. Commercial screenprinter, specializing in T-shirts and sweatshirts. Vermont T's produces custom as well as tourist-oriented silkscreened sportwear. Does promotional work for businesses, ski-resorts, tourist attractions and events.

Needs: Works with 5-10 freelance artists/year. Uses artists for graphic designs for T-shirt silkscreening. Prefers pen & ink, calligraphy and computer illustration.

First Contact & Terms: Send query letter with brochure. Samples are filed or are returned only if requested. Reports back within 10 days. To show portfolio, mail photostats. Pays for design by the project, $75-250. Negotiates rights purchased. Finds most artists through portfolio reviews and samples.

Tips: "Have samples showing rough through completion. Understand the type of linework needed for silkscreening."

WANDA WALLACE ASSOCIATES, Box 436, Inglewood CA 90306. (310)419-0376. Fax: (310)675-8020. Website: http://www.sensorium.com. President: Wanda. Estab. 1980. Produces greeting cards and posters for general public appeal. "We produce black art prints, posters, originals and other media."

Needs: Approached by 10-12 freelance artists/year. Works with varying number of freelance artists/year. Buys varying number of designs and illustrations/year from freelance artists. Prefers artists with experience in black art subjects. Uses freelance artists mainly for production of originals and some guest appearances. Considers all media. Produces material for Christmas. Submit seasonal material 4-6 months in advance.

First Contact & Terms: Send query letter with any visual aid. Some samples are filed. Policy varies regarding answering queries and submissions. Call or write to schedule an appointment to show a portfolio. Rights purchased vary according to project. Original artwork is returned at the job's completion. Pays by the project.

☒ WARM GREETINGS, 15414 N. Seventh St., #8-172, Phoenix AZ 85022. (602)439-2001. Fax: (602)439-2001. E-mail: warmgreet@aol.com. Website: www.warmgreetings.com. Owner: Jean Cosgriff. Estab. 1978. Produces greeting cards. Southwest card company specializing in holiday cards, everyday cards, notecards and postcards.

Needs: Approached by 20 freelancers/year. Works with 10 freelancers/year. Buys 24 freelance designs and illustrations/year. Looking for golf, Southwest Christmas and traditional Christmas/holiday. Freelance design work demands knowledge of Adobe Photoshop. Produces material for Christmas, Hannukkah, New Year, Thanksgiving, birthdays and everyday. "Also looking for artwork for business holiday cards." Submit seasonal material 6 months in advance.

First Contact & Terms: Designers send query letter with brochure, photocopies, photographs and tearsheets. Illustrators and cartoonists send postcard sample of work, photocopies and photographs. After introductory mailing send follow-up postcard sample every 6 months. Samples are filed and not returned. Reports back only if interested. Portfolio review not required. Buys one-time rights. Pays by the project. Finds freelancers through submissions.

WARNER PRESS, INC., 1200 E. Fifth St., Anderson IN 46018. (765)644-7721. Creative Director: John Silvey. Estab. 1884. Produces church bulletins and church supplies such as postcards and children's materials. Warner Press is the publication board of the Church of God. "We produce products for the Christian market. Our main market is the Christian bookstore. We provide products for all ages."

● This company has gone through a restructuring since our last edition and their freelance needs have changed. They no longer publish greeting cards or posters. Their main focus is now church bulletin supplies.

Needs: Approached by 50 freelancers/year. Works with 35-40 freelancers/year. Buys 300 freelance designs and illustrations/year. Works on assignment only. Uses freelancers for all products, coloring books. Also for calligraphy. "We use local Macintosh artists with own equipment capable of handling 40 megabyte files in Photoshop, FreeHand and QuarkXPress." Considers all media and photography. Looking for bright florals, sensitive still lifes, landscapes, wildlife, birds, seascapes; all handled with bright or airy pastel colors. 100% of production work demands knowledge of QuarkX-

Press, Aldus FreeHand, Adobe Illustrator or Adobe Photoshop. Produces material for Father's Day, Mother's Day, Christmas, Easter, graduation and everyday. Submit seasonal material 18 months in advance.

First Contact & Terms: Send query letter with brochure, tearsheets and photocopies. Samples are filed and are not returned. Creative manager will contact artist for portfolio review if interested. Portfolio should include b&w and color final art, tearsheets, photographs and transparencies. Originals are not returned. Pays by the project, $250-350. Pays for calligraphy pieces by the project. Buys all rights (occasionally varies).

Tips: "Subject matter must be appropriate for Christian market. Most of our art purchases are for children's material. We prefer palettes of bright colors as well as clean, pretty pastels."

WELLSPRING, 339 E. Cottage Place, York PA 17403. (717)846-5156. Fax: (717)757-3242. E-mail: scotta@wellspring-gift.com. Art Director: Scotta Magnelli. Estab. 1980. Produces giftbags, stationery, notepads and recipe books. Specializes in quality art images reproduced on magnetic notepads, ceramic tile magnets, giftbags, notecards, recipe cards and recipe books for use primarily in the kitchen.

Needs: Approached by 15-20 freelancers/year. Works with 2-3 freelancers/year. Buys 90-100 freelance designs and illustrations/year. Prefers freelancers with experience in full-color illustration. Prefers local, but will look at work outside area. Art guidelines not available. Works on assignment only. Uses freelancers mainly for full-color illustration for use on products. Also for mechanicals, photo manipulation. Considers watercolor, acrylics, oils, gouache, electronic, pastels. Looking for traditional, floral, wildlife (realistic) art no larger than 5×6. 5% of freelance design works demands knowledge of Aldus PageMaker 6.5, Adobe Photoshop 5.0, Adobe Illustrator 7.0. Produces material for Christmas and everyday. Submit seasonal material 2-3 months in advance.

First Contact & Terms: Designers send query letter with brochure, photographs, résumé, SASE, tearsheets. Illustrators send query letter with photographs, tearsheets, SASE. Do not send original art. Accepts disk submissions in Photoshop 4.0 EPS files, Illustrator 7.0. Files accepted on CD, Jazz or Zip disks. Samples are filed. Will contact artist for portfolio review if interested. Buys all rights. Pays for illustration by the project. Payment of $50 each for every product line the art is used on after the initial line. Finds freelancers through magazines, trade shows, local art shows, artist's submissions, word of mouth.

Tips: "Keep up with trends by paying attention to what is happening in the fashion industry, attending trade shows and reading trade publications."

WEST GRAPHICS, 1117 California Dr., Burlingame CA 94010. (800)648-9378. Website: http://www.west-graphics.com. Contact: Production Department. Estab. 1980. Produces greeting cards. "West Graphics is an alternative greeting card company offering a diversity of humor from 'off the wall' to 'tastefully tasteless.' Our goal is to publish cards that challenge the limits of taste and keep people laughing."

● West Graphics' focus is 'adult' humor.

Needs: Approached by 100 freelancers/year. Works with 40 freelancers/year. Buys 150 designs and illustrations/year. Art guidelines free for SASE with first-class postage. Uses freelancers for illustration. "All other work is done inhouse." Considers all media. Looking for outrageous contemporary illustration and "fresh new images on the cutting edge." Prefers art proportionate to finished vertical size of 5×7, no larger than 10×14. Produces material for all holidays and everyday (birthday, get well, love, divorce, congratulations, etc.) Submit seasonal material 1 year in advance.

First Contact & Terms: Send query letter with SASE, tearsheets, photocopies, photostats, slides or transparencies. Samples should relate to greeting card market. Samples are not filed and are returned by SASE. Reports back within 6 weeks. Rights purchased vary. Offers royalties of 5%.

Tips: "We welcome both experienced artists and those new to the greeting card industry. Develop art and concepts with an occasion in mind such as birthday, etc. Your target should be issues that women care about: men, children, relationships, sex, religion, aging, success, money, crime, health, etc. Increasingly, there is a younger market and more cerebral humor. Greeting cards are becoming a necessary vehicle for humorously communicating genuine sentiment that is uncomfortable to express personally."

⌐N⌐ CAROL WILSON FINE ARTS, INC., Box 17394, Portland OR 97217. (503)261-1860. Contact: Gary Spector. Estab. 1983. Produces greeting cards and fine stationery products.

Needs: Romantic floral and nostalgic images. "We look for artists with high levels of training, creativity and ability."

First Contact & Terms: Send query letter with résumé, business card, tearsheets, photostats, photocopies, slides and photographs to be kept on file. No original artwork on initial inquiry. Samples not filed are returned by SASE. Reports within 2 months. Negotiates return of original art after reproduction. Payment ranges from flat fee to negotiated royalties.

Tips: "We are seeing an increased interest in romantic fine arts cards and very elegant products featuring foil, embossing and die-cuts."

Magazines

Consumer magazines and trade publications are great markets for artists and illustrators. Art directors know that great visuals hook readers into the story. A whimsical illustration can set the tone for a humorous article and a caricature might dress up a short feature about a celebrity. Smaller illustrations, called spot illustrations, break up text and lead readers from feature to feature.

To grab assignments, your work must convey the tone and content of article while fitting in with a magazine's "personality." For example, *Rolling Stone* illustrations have a more edgy quality to them than the illustrations in *Reader's Digest*, which tends to publish more conventional illustrations.

Your 3-step marketing plan

1. **Read each listing carefully.** Within each listing are valuable clues. Knowing how many artists approach each magazine will help you understand how stiff your competition is. (At first, you might do better submitting to art directors who aren't swamped with submissions.) Look at the preferred subject matter to make sure your artwork fits the magazine's needs. Note the submission requirements and develop a mailing list of markets you want to approach.

2. **Visit newsstands and bookstores.** Look for magazines not listed in *Artist's & Graphic Designer's Market*. Check the cover and interior. If illustrations are used, flip to the masthead (usually a box in one of the beginning pages) and note the art director's name. While looking at the masthead, check the circulation figure. As a rule of thumb, the higher the circulation the higher the art director's budget. When an art director has a good budget, he tends to hire more illustrators and pay higher fees. Look at the illustrations and check the illustrator's name in the credit line in small print to the side of the illustration. Notice which illustrators are used often in the publications you wish to work with. Art directors need diversity in their publications. They like to show several styles within the same issue. After you have studied the illustrations in dozens of magazines, you will understand what types of illustrations are marketable.

3. **Focus on one or two *consistent* styles to present to art directors in sample mailings.** See if you can come up with a style that is different from every other illustrator's style, if only slightly. No matter how versatile you may be, limit styles you market to one or two. That way, you'll be more memorable to art directors. Pick a style or styles you enjoy and can work quickly in. Art directors don't like surprises. If your sample shows a line drawing, they expect you to work in that style when they give you an assignment.

MORE MARKETING TIPS

☑ **Don't overlook trade magazines and regional publications.** While they may not be as glamorous as national consumer magazines, some trade and regional publications are just as lavishly produced. Most pay fairly well and the competition is not as fierce. Until you can get some of the higher circulation magazines to notice you, take assignments from smaller magazines, too. Despite their low payment, there are many advantages. You learn how to communicate with art directors, develop your signature style and learn how to work quickly to meet deadlines. Once the assignments are done, the tearsheets become valuable samples to send to other magazines.

☑ **Develop a spot illustration style in addition to your regular style.** "Spots"—illustrations that are half-page or smaller—are used in magazine layouts as interesting visual cues to lead readers through large articles, or to make filler articles more appealing. Though the fee for one spot is less than for a full layout, art directors often assign five or six spots within the same issue to the same artist. Because spots are small in size, they must be all the more compelling. So send art directors a sample showing several power-packed small pieces along with your regular style.

☑ **Invest in a fax machine and/or modem.** Art directors like to work with illustrators who own faxes, because they can quickly fax a layout with a suggestion. The artist can fax back a preliminary sketch or "rough" the art director can OK. More and more illustrators are sending images via computer modem, which also makes working with art directors easier.

☑ **Get your work into competition annuals and sourcebooks.** The term "sourcebook" refers to the creative directories published annually showcasing the work of freelancers. Art directors consult these publications when looking for new styles. If an art director uses creative directories, we include that information in the listings to help you understand your competition. Some directories like *Black Book*, *The American Showcase* and *RSVP* carry paid advertisements costing several thousand dollars per page. Other annuals, like the *Print Regional Design Annual* or *Communication Art Illustration Annual* feature award winners of various competitions. An entry fee and some great work can put your work in a competition directory and in front of art directors across the country.

☑ **Consider hiring a rep.** If after working successfully on several assignments you decide to make magazine illustration your career, consider hiring an artists' representative to market your work for you. (See the Artists' Reps section, page 655.)

For More Information

• A great source for new leads is in the business section of your local library. Ask the librarian to point out the business and consumer editions of the *Standard Rate and Data Service (SRDS)*. The huge directory lists thousands of magazines by category. While the listings contain mostly advertising data and are difficult to read, they do give you an idea of the magnitude of magazines published today. Another good source is a yearly directory called *Samir Husni's Guide to New Consumer Magazines* also available in the business section of the public library. Also read *Folio* magazine to find out about new magazine launches and redesigns.

• Each year the Society of Publication Designers sponsors an annual juried competition called, appropriately, SPOTS. The winners are featured in a prestigious exhibition. For information about the annual competition, contact the Society of Publication Designers at (212)983-8585.

• Networking with fellow artists and art directors will help you find additional success strategies. There are many great organizations out there—the Graphic Artist's Guild, The American Institute of Graphic Artists (AIGA), your city's Art Director's Club or branch of the Society of Illustrators, which hold monthly lectures and networking functions. Attend one event sponsored by each organization in your city to find a group you are comfortable with. Then join and become an active member.

insider report

A maverick weighs the rewards and rejections of cartooning

John Jonik's whimsical cartoons have appeared in *The New Yorker, Natural History* and even inside snow globes. His drawing style suggests a quilted image, with the wavering line of a needle's path. Sometimes his cartoons are simply funny takes on the human comedy, but more often Jonik uses his pen as a sword, taking stabs at everything from pesticides to presidential politics to prayer in schools.

Over the past 20 years, Jonik has enjoyed a dual career as a cartoonist and fine artist. More often than not, his cartoons support his fine art habit. But while Jonik's fine artwork—intricate fool-the-eye visual puns the artist creates out of wood and found objects—has yet to set the gallery world on fire, he sometimes is paid as much as $1,000 for an original drawing of one of his cartoons.

John Jonik

Photo: George Bilik

That's not to say he's a rich man—at least monetarily. But perhaps he has reached the ultimate success—living life on his own terms. Over the past 30 years, Jonik has earned his share of rejections and has the papers to prove it.

Do you recall your first rejection?
No. *Golf Magazine*—my first national sale—and *Ski Magazine* were buying one or two from every batch. I could draw pine trees on a hill in the background and make it look like a golf course; leave out the ruffles and you got a snow hill. The drawings were horrible but the editors didn't have any art skills, either. Some drawings came back and some didn't. I felt like everything was going normally. I don't remember a first rejection. I submitted a lot to the *Saturday Evening Post* when they were in Philadelphia and never got anywhere.

I've got a little blue book I use to take notes. It goes back to '72. I sold to *Cosmopolitan, Golf, Inside Golf, Changing Times, Oui, Gallery.* Quantity used to

JOHN JONIK

Occupation: Cartoonist/fine artist
*Clients include: The New Yorker,
 Natural History, Golf Magazine*

be pretty good, but then a lot of them were only paying $10. By the time I got to the $10 markets, I'd already sent them to all the other markets. I used to start at the top, *The New Yorker, Saturday Review, Look, Good Housekeeping, Reader's Digest.* In 1974 I sold 48 cartoons and made $3,905. In 1975 I sold ten less but I made $4,000.

This was your livelihood?
I began cartooning fulltime in the early 1970s. I was teaching at a junior college for a while, but I wasn't making anything at that, either.

Has dealing with rejection ever been a problem for you?
Only at *The New Yorker.* Sometimes I think I've got a cartoon nailed 100 percent, and when it comes back I'm pretty bummed out. Disgruntled.

How long were you submitting to *The New Yorker* before selling?
Ten years.

Have you ever gone through a period when you wondered if your talent would be recognized?
Unlike a stand-up comic, I don't get feedback from the audience, unless someone calls

Cartoons like this one published in *The New Yorker*, have helped Jonik support his fine art habit and avoid the nine-to-five rut.

up for the original or a reprint. And even then it's only one person clapping.

How often do you hear applause from your buyers?
The best time is every couple of years, when I get 40 of my drawings framed, and have a show in this bar I hang around, which is perfect for this sort of thing.

Is it true you've never thrown out a rejection slip?
Yeah. I don't know why I have them. It just happened. The end of the year, I clear my desk and put my receipts in one envelope and sort my other papers. The rejection slips were just a pile. I wasn't consciously saving them. The rejection slips are probably a foot high. The acceptances might be three inches. I'm anxious to weigh them on a postal scale. I have a friend who curates art shows, and it's the kind of thing he would put in a show of conceptual things he collects. I told him about [my rejections] once and he sounded pretty fascinated.

How do you manage to keep a pile of rejections from depressing you?
I figure they're the ones making the mistake. I don't understand why some magazines have never taken anything. I see reprints of their stuff and I think that's right up my

PREYING IN SCHOOLS

©John Jonik

Jonik's irreverant pen regularly skewers politicians, lobbyists and big business

alley. Maybe I'm a little too reactionary. I might have sent things that rubbed them the wrong way. When rejections come in, I might get a little mad, but my feeling is, if they didn't like that batch, wait until they see the next one. I've been doing that for 30 years.

Have you ever thought about becoming syndicated?
It's too much like a job. I spend 24 hours a day trying to avoid having a job.

So when do you mail your cartoons out?
Once a month I send a big flurry out, or when *The New Yorker* sends their batch back, I'll sit down and do another one and send it right back. That's the only time I do new cartoons.

When did you start licensing?
You learn soon enough that you have to do spinoffs. Ten years ago I got approached by a guy who wanted to make a clock out of a *New Yorker* idea of mine. I was getting a couple hundred bucks a month, and that was cool. Then I took a few other cartoon ideas that could be manufactured in 3-D and schlepped them around. Enesco took them—they're the ones who do *Garfield* and all that stuff—and they made a whole line of snow globes.

How well did you do with the snow globes?
Fantastic. I was getting enormous piles of loot. They sold them in Germany and Japan. And one of my designs seemed to hit and all these companies were buying them. I bought my house with the money.

Do you try to get much ad work?
No, but if they call me, and they're moderately non-terroristic, I'll do something for them. I won't do an oil company, but I'd do natural gas, for instance.

Cartooning allows you to exercise your conscience. You have the power to choose your clients.
I don't like that word [power]. Call it flexibility.

So, money's not that important to you?
I'm not necessarily trying to make money. It actually seems incidental. Basically, I'm a painter, but people buy the cartoons. If that door stays open, I'm not banging on any others.

—*Mark Heath*

ACCENT ON LIVING, Box 700, Bloomington IL 61702. Fax: (309)378-4420. E-mail: acntlvng@aol.com. Editor: Betty Garee. Estab. 1956. Quarterly magazine with emphasis on success and ideas for better living for the physically handicapped. 5×7 b&w with 4-color cover. Original artwork returned after publication if requested. Sample copy $3.50.
 • Also publishes books for physically disabled adults under Cheever Publishing.
Cartoons: Approached by 30 cartoonists/year. Buys approximately 12 cartoons/issue. Receives 5-10 submissions/week from freelancers. Interested in seeing people with disabilities in different situations. Send finished cartoon samples and SASE. Reports in 2 weeks. **Pays on acceptance;** $20 b&w; $35 full page. Buys first-time rights (unless specified).
Illustration: Approached by 20 illustrators/year. Features humorous illustration. Uses 3-5 freelance illustrations/issue. Works on assignment only. Send SASE and postcard samples to be kept on file for future assignments. Accepts disk submissions compatible with QuarkXPress. Send TIFF or EPS files. Samples not filed are returned by SASE. Reports in 2 weeks. **Pays on acceptance**; $50-100 for color cover; $10-50 for b&w and color inside. Buys first-time rights.

☑ ⊕ **ACTIVE LIFE**, LexiCon, 1st Floor, 1-5 Clerkenwell, London EC1M 5PA United Kingdom. Phone: (0171)253 5775. Fax: (0171)253 5676. Managing Editor: Helene Hodge. Editor's Assistant: Claire Selsby. Estab. 1990. Bimonthly lively lifestyle consumer magazine for the over 50s. Circ. 300,000.
Illustration: Approached by 200 illustrators/year. Buys 12 illustration/issue. Features humorous illustration. Preferred subject: families. Target group 50+. Prefers pastel and bright colors. Assigns 20% of illustration to well-known or "name" illustrators; 60% to experienced, but not well-known illustrators; 20% to new and emerging illustrators. Send non-returnable samples. Accepts Mac-compatible disk submissions. Samples are filed. Reports back within 1 month. Will contact artist for portfolio review if interested. Buys all rights. Pays on publication. Finds illustrators through promotional samples.

N AD ASTRA, 600 Pennsylvania Ave. SE, Suite 201, Washington DC 20003-4316. (202)543-1900. E-mail: adastra@ nss.org. Website: http://www.nss.org/. Editor-in-Chief: Frank Sietzen, Jr. Estab. 1989. Bimonthly feature magazine popularizing and advancing space exploration and development for the general public interested in all aspects of the space program.
Illustration: Works with 40 freelancers/year. Uses freelancers for magazine illustration. Buys 10 illustrations/year. "We are looking for original artwork on space themes, either conceptual or representing specific designs, events, etc." Prefers acrylics, then oils and collage. Send postcard sample or slides. "Color slides are best." Samples not filed are returned by SASE. Reports back within 6 weeks. Pays $100-300 color, cover; $25-100 color, inside. "We do commission original art from time to time." Fees are for one-time reproduction of existing artwork. Considers rights purchased when establishing payment.
Design: Needs freelancers for multimedia design. 100% of freelance work requires knowledge of Adobe Photoshop, QuarkXPress and Adobe Illustrator. Designers send query letter with brochure and photographs. Pays by the project.
Tips: "Show a set of slides showing planetary art, spacecraft and people working in space. I do not want to see 'science-fiction' art. Label each slide with name and phone number. Understand the freelance assignments are usually made far in advance of magazine deadline."

ADVENTURE CYCLIST, 150 E. Pine St, Missoula MT 59802. (406)721-1776. Fax: (406)721-8754. E-mail: ddambro sio@adv-cycling.org. Website: www.adv-cycling.org. Art Director: Greg Siple. Estab. 1974. Published 9 times/year. A journal of adventure travel by bicycle. Circ. 26,000. Originals returned at job's completion. Sample copies available.
Illustration: Buys 1 illustration/issue. Works on assignment only. Send printed samples. Samples are filed. Publication will contact artist for portfolio review if interested. Portfolio should include color photocopies. Pays on publication, $50-350. Buys one-time rights.

N THE ADVOCATE, 6922 Hollywood Blvd., Suite 1000, Los Angeles CA 90028. (323)871-1225. Fax: (323)467-6805. E-mail: cedwards@advocate.com. Website: http://www.advocate.com. Art Director: Craig Edwards. Associate Art Director: Wayne DeSelle. Estab. 1967. Frequency: biweekly. National gay and lesbian 4-color consumer news magazine.
Illustration: Approached by 20 illustrators/year. Buys 1-2 illustrations/issue. Has featured illustrations by Alexander Munn, Sylvie Bourbonniere and Tom Nick Cocotos. Features caricatures of celebrities and politicians, computer illustration, realistic illustration and medical illsutration. Prefered subjects: men, women, gay and lesbian topics. Considers all media. Assigns 90% of illustrations to experienced, but not well-known illustrators; 10% to new and emerging illustrators. Send postcard sample or non-returnable samples. Accepts Mac-compatible disk submissions. Samples are filed. Reports back only if interested. Portfolio review not required. Buys one-time rights. Pays on publication.
Tips: "We are happy to consider unsolicited illustration submissions to use as a reference for making possible assignments to you in the future. Before making any submissions to us, please familiarize yourself with our magazine. Keep in mind that *The Advocate* is a news magazine. As such we publish items of interest to the gay and lesbian community

N MARKETS NEW TO THIS EDITION

based on their newsworthiness and timeliness. We do not publish unsolicited illustrations or portfolios of individual artists. We do not publish cartoons or humorous illustrations. Any illustration appearing in *The Advocate* was assigned by us to an artist to illustrate a specific article."

ADVOCATE, PKA'S PUBLICATION, 301A Rolling Hills Park, Prattsville NY 12468. (518)299-3103. Art Editor: C.J. Karlie. Estab. 1987. Bimonthly b&w literary tabloid. "*Advocate* provides aspiring artists, writers and photographers the opportunity to see their works published and to receive byline credit toward a professional portfolio so as to promote careers in the arts." Circ. 12,000. "Good quality photocopy or stat of work is acceptable as a submission." Sample copies available for $4. Art guidelines for SASE with first-class postage.
Cartoons: Open to all formats except color washes. Send query letter with SASE and submissions for publication. Samples are not filed and are returned by SASE. Reports back within 2-6 weeks. Buys first rights. Pays in contributor's copies.
Illustration: Buys 10-15 illustrations/issue. Considers pen & ink, charcoal, linoleum-cut, woodcut, lithograph, pencil or photos, "either b&w or color prints (no slides). We are especially looking for horse-related art and other animals." Also needs editorial and entertainment illustration. Send query letter with SASE and photos of artwork (b&w or color prints only). No simultaneous submissions. Samples are not filed and are returned by SASE. Portfolio review not required. Reports back within 2-6 weeks. Buys first rights. Pays in contributor's copies. Finds artists through submissions and from knowing artists and their friends.
Tips: "Please remember SASE for return of materials. We hope to continue publishing 6 times per year and will need 10-15 illustrations per issue."

AGING TODAY, 833 Market St., San Francisco CA 94103. (415)974-9619. Fax: (415)974-0300. Editor: Paul Kleyman. Estab. 1979. "*Aging Today* is the bimonthly black & white newspaper of The American Society on Aging. It covers news, public policy issues, applied research and developments/trends in aging." Circ. 15,000. Accepts previously published artwork. Originals returned at job's completion if requested. Sample copies available for SASE with 77¢ postage.
Cartoons: Approached by 50 cartoonists/year. Buys 1-2 cartoons/issue. Prefers political and social satire cartoons; single, double or multiple panel with or without gagline, b&w line drawings. Send query letter with brochure and roughs. Samples returned by SASE. Reports back only if interested. Buys one-time rights. Pays $15-25 for b&w.
Illustration: Approached by 50 illustrators/year. Buys 1 illustration/issue. Works on assignment only. Prefers b&w line drawings and some washes. Considers pen & ink. Needs editorial illustration. Send query letter with brochure, SASE and photocopies. Samples are not filed and are returned by SASE. Reports back only if interested. To show portfolio, artist should follow-up with call and/or letter after initial query. Buys one-time rights. Pays on publication; $25 for b&w cover; $25 for b&w inside.
Tips: "Send brief letter with two or three applicable samples. Don't send hackneyed cartoons that perpetuate ageist stereotypes."

THE AGUILAR EXPRESSION, 1329 Gilmore Ave., Donora PA 15033. (412)379-8019. Editor/Publisher: Xavier F. Aguilar. Art Director: Aaron R. Aguilar. Estab. 1989. Biannual b&w literary magazine/newsletter. Circ. 150. Originals not returned. Sample copies available for $6. Art guidelines for SASE with first-class postage.
Illustration: Approached by 10-15 illustrators/year. Buys 1-2 illustrations/issue. Has featured illustrations by Barbara J. McPhail. Features caricatures of celebrities and politicians, humorous, realistic illustration and computer illustrations. Assigns 20% of illustrations to experienced, but not well-known illustrators; 80% to new and emerging illustrators. Considers pen & ink. "We need black line on white." Also needs creative illustrations with 1 line caption. Send query letter with SASE and photocopies. Samples are not filed and are not returned. Reports back within 1 month. Portfolio review not required. Sometimes requests work on spec. Acquires one-time rights. Cash payment for cover art. Finds artists through submissions.
Design: Needs freelancers for multimedia design. Send query letter with photocopies and SASE.
Tips: "Study sample copy of publication before submitting artwork. Follow guidelines."

AIM, Box 1174, Maywod IL 60153. (312)874-6184. Editor-in-Chief: Ruth Apilado. Managing Editor: Dr. Myron Apilado. Estab. 1973. 8½×11 b&w quarterly with 2-color cover. Readers are those "wanting to eliminate bigotry and desiring a world without inequalities in education, housing, etc." Circ. 7,000. Reports in 3 weeks. Accepts previously published, photocopied and simultaneous submissions. Sample copy $5; artist's guidelines for SASE.
Cartoons: Approached by 12 cartoonists/week. Buys 10-15 cartoons/year. Uses 1-2 cartoons/issue. Prefers education, environment, family life, humor in youth, politics and retirement; single panel with gagline. Especially needs "cartoons about the stupidity of racism." Send samples with SASE. Reports in 3 weeks. Buys all rights on a work-for-hire basis. Pays on publication; $5-15 for b&w line drawings.
Illustration: Approached by 4 illustrators/week. Uses 4-5 illustrations/issue; half from freelancers. Prefers pen & ink. Prefers current events, education, environment, humor in youth, politics and retirement. Provide brochure to be kept on file for future assignments. Samples not returned. Reports in 1 month. Prefers b&w for cover and inside art. Buys all rights on a work-for-hire basis. Pays on publication; $25 for b&w cover illustrations.
Tips: "We could use more illustrations and cartoons with people from all ethnic and racial backgrounds in them. We also use material of general interest. Artists should show a representative sampling of their work and target the magazine's specific needs. Nothing on religion."

✅ **AKC GAZETTE**, 260 Madison Ave., 4th Floor, New York NY 10016. (212)696-8370. Fax: (212)696-8299. E-mail: tgrassa@akc.org. Website: http://www.akc.org. Creative Director: Tilly Grassa. Estab. 1889. Monthly consumer magazine about "breeding, showing, and training pure-bred dogs." Circ. 58,000. Sample copy available for 9×12 SASE.
Illustration: Approached by 200-300 illustrators/year. Buys 6-12 illustrations/issue. Has featured illustrations by Pam Tanzey and Chet Jezierski. Assigns 10% of illustrations to well-known or "name" illustrators; 70% to experienced, but not well-known illustrators; 20% to new and emerging illustrators. Considers all media. 25% of freelance illustration demands knowledge of Adobe Photoshop, Adobe Illustrator, Aldus FreeHand and QuarkXPress. Send query letter with printed samples, photocopies and tearsheets. Send follow-up postcard every 6 months. Accepts Mac platform submissions—compatible with QuarkXPress (latest revision). Send EPS or TIFF files at a high resolution (300 dpi). Samples are filed. Reports back only if interested. Rights purchased vary according to project. Pays on publication; $500-1,000 for color cover; $50-150 for b&w, $150-800 for color inside. Pays $75-300 for color spots. Finds illustrators through artist's submissions.
Design: Needs freelancers for design, production and multimedia projects. Prefers local designers with experience in QuarkXPress, Photoshop and Illustrator. 100% of freelance work demands knowledge of Adobe Photoshop, Adobe Illustrator and QuarkXPress. Send query letter with printed samples, photocopies, tearsheets and résumé.
Tips: "Although our magazine is dog-oriented and a knowledge of dogs is preferable, it is not required. Creativity is still key."

AMELIA, 329 E St., Bakersfield CA 93304. (805)323-4064. Editor: Frederick A. Raborg, Jr. Estab. 1983. Quarterly magazine. Also publishes 2 supplements—*Cicada* (haiku) and *SPSM&H* (sonnets) and illustrated postcards. Emphasizes fiction and poetry for the general review. Circ. 1,750. Accepts some previously published material from illustrators. Original artwork returned after publication with SASE. Sample copy $9.95; art guidelines for SASE.
Cartoons: Buys 3-5 cartoons/issue for *Amelia*. Prefers sophisticated or witty themes (see Ford Button's, Earl Engleman's and Vahan Shirvanian's work). Prefers single panel b&w line drawings and washes with or without gagline (will consider multipanel on related themes). Send query letter with finished cartoons to be kept on file. Material not filed is returned by SASE. Reports within 1 week. Usually buys first rights. **Pays on acceptance**; $5-25 for b&w. Occasionally uses captionless cartoons on cover; $50 b&w; $100 color.
Illustration: Buys 80-100 illustrations and spots/year for *Amelia;* 24-30 spots for *Cicada*; 15-20 spots for *SPSM&H* and 50-60 spots for postcards. Considers all themes. "No taboos, except no explicit sex; nude studies in taste are welcomed, however." Prefers pen & ink, pencil, watercolor, acrylic, oil, pastel, mixed media and calligraphy. Send query letter with résumé, photostats and/or photocopies to be kept on file. Unaccepted material returned immediately by SASE. Reports in 1 week. Portfolio should contain "one or two possible cover pieces (either color or b&w), several b&w spots, plus several more fully realized b&w illustrations." Buys first rights or one-time rights (prefers first rights). **Pays on acceptance**; $50 for b&w, $100 for color, cover; $5-25 for b&w inside. "Spot drawings are paid for on assignment to an issue."
Tips: "In illustrations, it is very difficult to get excellent nude studies. Everyone seems capable of drawing an ugly woman; few capture sensuality, and fewer still draw the nude male tastefully. Frontal nudity is usually OK. Few taboos, other than the obvious. (See male nudes we've used by Susan Moffett and Miguel Angel Reyes for example.)"

✅ **AMERICA**, 106 W. 56th St., New York NY 10019. (212)581-4640. Fax: (212)399-3596. Website: http://www.ameri capress.org. Associate Editor: James Martin. Estab. 1904. Weekly Catholic journal of opinion sponsored by US Jesuits. Circ. 41,000. Sample copies for #10 SASE with first-class postage.
Illustration: Buys 3-5 illustrations/issue. Has featured illustrations by Michael O'Neill McGrath, William Hart McNichols, Gerard Quigley, Tim Foley. Features realistic illustration and spot illustration. Assigns 80% of illustrations to experienced, but not well-known illustrators; 20% to new and emerging illustrators. Considers all media. Send query letter with printed samples and tearsheets. Buys first rights. Pays on publication; $150 maximum for b&w cover; $50 for b&w inside.
Tips: "We look for illustrators who can do imaginative work for religious or educational articles. We do not use cartoons. We will discuss the article with the artist and usually need finished work in two weeks."

AMERICA WEST AIRLINES MAGAZINE, 4636 E. Elwood St., Suite 5, Phoenix AZ 85040-1963. Estab. 1986. Monthly inflight magazine for national airline; 4-color, "conservative design. Appeals to an upscale audience of travelers reflecting a wide variety of interests and tastes." Circ. 130,000. Accepts previously published artwork. Original artwork is returned after publication. Sample copy $3. Art guidelines for SASE with first-class postage. Needs computer-literate illustrators familiar with Adobe Photoshop, Adobe Illustrator, QuarkXPress and Aldus FreeHand.
Illustration: Approached by 100 illustrators/year. Buys 5 illustrations/issue from freelancers. Has featured illustrations by Pepper Tharp, John Nelson, Shelly Bartek, Tim Yearington. Assigns 95% of illustrations to experienced, but not well-known illustrators. Buys illustrations mainly for spots, columns and feature spreads. Uses freelancers mainly for features and columns. Works on assignment only. Prefers editorial illustration in airbrush, mixed media, colored pencil, watercolor, acrylic, oil, pastel, collage and calligraphy. Send query letter with color brochure showing art style and tearsheets. Looks for the "ability to intelligently grasp idea behind story and illustrate it. Likes crisp, clean colorful styles." Accepts disk submissions. Send EPS files. Samples are filed. Does not report back. Will contact for portfolio review if interested. Sometimes requests work on spec. Buys one-time rights. Pays on publication; $500-700 for color cover; $75-250 for b&w; $150-500 for color inside; $150-250 for spots. "Send lots of good-looking color tearsheets

that we can keep on hand for reference. If your work interests us we will contact you."

Tips: "In your portfolio show examples of editorial illustration for other magazines, good conceptual illustrations and a variety of subject matter. Often artists don't send enough of a variety of illustrations; it's much easier to determine if an illustrator is right for an assignment if we have a complete grasp of the full range of abilities. Send high-quality illustrations and show specific interest in our publication."

☑ **THE AMERICAN ATHEIST**, Box 5733, Parsippany NJ 07054-6733. (908)259-0700. Fax: (908)259-0748. Editorial office (to which art and communications should be sent): 1352 Hunter Ave., Columbus OH 43201-2733. Phone/fax: (614)299-1036. Editor: Frank Zindler. Estab. 1958. Monthly for atheists, agnostics, materialists and realists. Circ. 10,000. Simultaneous submissions OK. Sample copy for self-addressed 9×12 envelope or label.

Cartoons: Buys 5 cartoons/issue. Pays $25 each.

Illustration: Buys 1 illustration/issue. Especially needs 4-seasons art for covers and greeting cards. "Send samples to be kept on file. We do commission artwork based on the samples received. All illustrations must have bite from the atheist point of view and hit hard." Prefers pen & ink, then airbrush, charcoal/pencil and calligraphy. To show a portfolio, mail final reproduction/product and b&w photographs. **Pays on acceptance**; $75-100 for cover; $25 for inside.

Tips: "*The American Atheist* looks for clean lines, directness and originality. We are not interested in side-stepping cartoons and esoteric illustrations. Our writing is hard-punching and we want artwork to match. The American Atheist Press (parent company) buys book cover designs and card designs. Nearly all our printing is in black & white, but several color designs (e.g. for covers and cards) are acceptable if they do not require highly precise registration of separations for printing."

AMERICAN BANKERS ASSOCIATION-BANKING JOURNAL, 345 Hudson St., New York NY 10014. (212)620-7256. E-mail: wendyababj@aol.com. Website: http://www.banking.com. Art Director: Wendy Williams. Estab. 1908. 4-color; contemporary design. Emphasizes banking for middle and upper level banking executives and managers. Monthly. Circ. 42,000. Accepts previously published material. Returns original artwork after publication.

Illustration: Buys 4-5 illustrations/issue from freelancers. Has featured illustrations by Scott Swales and Kurt Varg. Features charts & graphs, computer, humorous and spot illustration. Assigns 50% of illustrations to well-known or "name" illustrators; 30% to experienced, but not well-known illustrators; 20% to new and emerging illustrators. Themes relate to stories, primarily financial, from the banking industry's point of view; styles vary, realistic, cartoon, surreal. Uses full-color illustrations. Works on assignment only. Send finance-related postcard sample and follow-up samples every few months. To send a portfolio, send query letter with brochure and tearsheets, promotional samples or photographs. Negotiates rights purchased. **Pays on acceptance**; $250-950 for color cover; $250-450 for color inside; $250-450 for spots.

Tips: "Look at what the art director has used for illustration in the past. And create three illustrations that would fit the style and concept for the publication."

☑ **AMERICAN BREWER MAGAZINE**, Box 510, Hayward CA 94543-0510. (510)538-9500 (mornings). E-mail: owens@ambrew.com. Website: http://www.ambrew.com. Publisher: Bill Owens. Estab. 1985. Published 6 times a year. Trade journal in color with 4-color cover focusing on the microbrewing industry. Circ. 18,000. Accepts previously published artwork. Original artwork returned after publication. Sample copies for $5; art guidelines not available.

● Bill Owens formerly published *BEER, The Magazine*, which has been discontinued.

Cartoons: Approached by 25-30 cartoonists/year. Occasionally buys cartoons. Prefers themes related to drinking or brewing handcrafted beer. Send query letter with roughs. Samples not filed are returned. Reports back within 2 weeks. Buys reprint rights.

Illustration: Buys 2 illustrations/issue. Works on assignment only. Prefers themes relating to beer, brewing or drinking; various media. Send postcard sample or query letter with photocopies. Samples are filed and are not returned without SASE. Reports back within 2 weeks. Pays $50-150 for b&w or color inside. Buys reprint rights.

Tips: "I prefer to work with San Francisco Bay Area artists. Work must be about microbrewing industry."

AMERICAN CAREERS, 6701 W. 64th St., Overland Park KS 66202. (913)362-7788 or (800)669-7795. Fax: (913)362-4864. E-mail: ccinfo@carcom.com. Publisher: Barbara Orwig. Estab. 1990. Quarterly career awareness magazine for students in middle/high school. Circ. 500,000. Accepts previously published artwork. Original artwork returned at job's completion on request. Sample copies available. 90% of freelance work demands knowledge of QuarkXPress, Aldus FreeHand and Adobe Photoshop.

Illustration: Works on assignment only. Prefers editorial illustration or career-related cartoons. Send query letter with brochure or résumé and tearsheets or proof of work. Show enough to prove work experience. Samples are filed or are returned by SASE if requested by artist. Reports back only if interested. Negotiates rights purchased. **Pays on acceptance**; $100 for b&w cover; $300 for color cover; $100 for b&w inside; $200 for color inside.

▣ **THE AMERICAN GARDENER**, (formerly *American Horticulturist*), 7931 E. Boulevard Dr., Alexandria VA 22308. (703)768-5700. E-mail: editor@ahs.org. Website: http://www.ahs.org. Editor: David J. Ellis. Managing Editor: Mary Yee. Estab. 1922. Consumer magazine for advanced and amateur gardeners and horticultural professionals who are members of the American Horticultural Society. Bimonthly, 4-color magazine, "very clean and open, fairly long features." Circ. 20,000. Accepts previously published artwork. Original artwork is returned at job's completion. Sample copies for $4.

Illustration: Buys 15-30 illustrations/year from freelancers. Works on assignment only. "Botanical accuracy is important for some assignments. All media used; digital media welcome." Send query letter with résumé, tearsheets, slides and photocopies. Samples are filed. "We will call artist if their style matches our need." To show a portfolio, mail b&w and color tearsheets and slides. Buys one-time rights. Pays $150, b&w, $300 maximum, color, inside; on publication.
Tips: "We have always been low budget but offer interesting subject matter, good display and welcome input from artists."

THE AMERICAN LEGION MAGAZINE, Box 1055, Indianapolis IN 46206. Website: http://www.legion.org. Contact: Cartoon Editor. Emphasizes the development of the world at present and milestones of history; 4-color general-interest magazine for veterans and their families. Monthly. Original artwork not returned after publication.
Cartoons: Uses 2-3 freelance cartoons/issue. Receives 100 freelance submissions/month. "Experience level does not matter, and does not enter into selection process." Especially needs general humor in good taste. "Generally interested in cartoons with broad appeal. Those that attract the reader and lead us to read the caption rate the highest attention. Because of tight space, we're not in the market for spread or multipanel cartoons but use both vertical and horizontal single-panel cartoons. Themes should be home life, business, sports and everyday Americana. Cartoons that pertain only to one branch of the service may be too restricted for this magazine. Service-type gags should be recognized and appreciated by any ex-service man or woman. Cartoons that may offend the reader are not accepted. Liquor, sex, religion and racial differences are taboo. No roughs. Send final product for consideration." Usually reports within 1 month. Buys first rights. **Pays on acceptance**; $150.
Tips: "Artists should submit their work as we are always seeking new slant and more timely humor. Black & white submissions are acceptable, but we purchase only color cartoons. Want good, clean humor—something that might wind up on the refrigerator door."

N AMERICAN LIBRARIES, 50 E. Huron St., Chicago IL 60611. (312)280-4216. Fax: (312)440-0901. E-mail: americanlibraries@ala.org. Website: http://www.ala.org/alonline. Editor: Leonard Kniffel. Senior Editor of Design: Edie McCormick. Estab. 1907. Monthly professional 4-color journal of the American Library Association for its members, providing independent coverage of news and major developments in and related to the library field. Circ. 58,000. Original artwork returned at job's completion. Sample copy $6. Art guidelines available with SASE and first-class postage.
Cartoons: Approached by 15 cartoonists/year. Buys no more than 1 cartoon/issue. Themes related to libraries only. Send query letter with brochure and finished cartoons. Samples are filed. Does not report on submissions. Buys first rights. Pays $35-50 for b&w.
Illustration: Approached by 20 illustrators/year. Buys 1-2 illustrations/issue. Assigns 75% of illustrations to experienced, but not well-known illustrators; 25% to new and emerging illustrators. Works on assignment only. Send query letter with brochure, tearsheets and résumé. Samples are filed. Does not report on submissions. To show a portfolio, mail tearsheets, photostats, photographs and photocopies. Portfolio should include broad sampling of typical work with tearsheets of both b&w and color. Buys first rights. **Pays on acceptance**; $75-150 for b&w and $250-300 for color, cover; $75-150 for b&w and $150-250 for color, inside.
Tips: "I suggest inquirer go to a library and take a look at the magazine first." Sees trend toward "more contemporary look, simpler, more classical, returning to fewer elements."

N AMERICAN SCHOOL BOARD JOURNAL, 1680 Duke St., Alexandria VA 22314. (703)838-6747. Fax: (703)549-6719. E-mail: mmann@nsba.org. Production Manager/Art Director: Michele Mann. Estab. 1891. National monthly magazine for school board members and school administrators. Circ. 60,000. Sample copies available.
Illustration: Buys 40-50 illustrations/year. Considers all media. Send postcard sample. Send follow-up postcard sample every 3 months. Accepts disk submissions. Reports back only if interested. Art director will contact artist for portfolio review of tearsheets if interested. Buys one-time rights. **Pays on acceptance.** Pays $1,200 maximum for color cover; $200-250 for b&w, $250-500 for color inside. Finds illustrators through agents, source books, on-line services, magazines, word of mouth and artist's submissions.
Tips: "We're looking for new ways of seeing old subjects: children, education, management. We also write a great deal about technology and love high-tech, very sophisticated mediums."

AMERICA'S COMMUNITY BANKER, 900 19th St. NW, Washington DC 20006. (202)857-3100. Fax: (202)857-5581. E-mail: jbock@acbankers.org. Website: http://www.acbankers.org. Art Director: Jon C. Bock. Estab. 1993. Monthly trade journal targeting senior executives of high tech community banks. Circ. 12,000. Accepts previously published artwork. Originals returned at job's completion.
Illustration: Approached by 200 illustrators/year. Buys 2 illustrations/issue. Has featured illustrations by Mike Hodges, Kevin Rechin, Jeff Fitz-Maurice, Tom Murray. Features humorous illustration, informational graphics, spot illustrations, computer illustration. Prefered subjects: business subjects. Prefers pen & ink with color wash, bright colors, painterly. Works on assignment only. Send query letter, non-returnable postcard samples and tearsheets. Accepts Windows-compatible disk submissions. Send TIFF files. Samples are filed. Reports back only if interested. "Artists should be patient and continue to update our files with future mailings. We will contact artist when the right story comes along." Publication will contact artist for portfolio review if interested. Portfolio should include mostly finished work, some sketches. Buys first North American serial rights. Pays on publication; $800-1,200 for color cover; $600-800 for color

inside; $250-300 for spots. Finds artists primarily through word of mouth and sourcebooks—*Directory of Illustration* and *Illustration Work Book*.

Tips: "Looking for: high tech/technology in banking; quick turnaround; and new approaches to illustration. If I can't find you, I can't use you."

[N] THE AMICUS JOURNAL, 40 W. 20th St., New York NY 10011. (212)727-4474. Fax: (212)727-1773. E-mail: amicus@nrdc.org. Website: http://www.nrdc.org. Managing Editor: Dana Foley. Estab. 1979. Quarterly magazine "of thought and opinion for the general public on environmental affairs." Circ. 400,000. Sample copy for SASE.

Illustration: Buys 4 illustrations/issue. Send postcard sample. "We will accept work compatible with QuarkXPress 7.0, Illustrator, Photoshop." Reports back only if interested. Buys one-time rights. Also may ask for electronic rights. Pays $100-300 for b&w inside. Payment for spots varies. Finds artists through sourcebooks and submissions.

Tips: "We work in black and white (halftones and gray scale). Our illustrations are often conceptual, thought-provoking, challenging. We enjoy thinking artists, and we encourage ideas and exchange."

[✓] ANALOG, 475 Park Ave. S., New York NY 10016. (212)686-7188. Fax: (212)686-7414. Senior Art Director: Victoria Green. Assistant Art Director: Shirley Chan Levi. All submissions should be sent to Shirley Chan Levi, assistant art director. Estab. 1930. Monthly consumer magazine. Circ. 80,000 Art guidelines free for #10 SASE with first-class postage.

Cartoons: Prefers single panel cartoons. Send query letter with photocopies and/or tearsheets and SASE. Samples are not filed and are returned by SASE. Reports back only if interested. Buys one-time rights. **Pays on acceptance**; $35 minimum for b&w cartoons.

Illustration: Buys 8 illustrations/issue. Prefers science fiction, hardwre, robots, aliens and creatures. Considers all media. Send query letter with printed samples or tearsheets and SASE. Send follow-up postcard sample every 4 months. Accepts disk submissions compatible with QuarkXPress 7.5/version 3.3. Send EPS files. Fileees samples of interest, others are returned by SASE. Reports back only if interested. "No phone calls." Portfolios may be dropped off every Tuesday and should include b&w and color tearsheets and transparencies. "No original art please, especially oversized." Buys one-time rights. **Pays on acceptance**; $1,200 for color cover; $125 minimum for b&w inside; $35-50 for spots. Finds illustrators through *Black Book, LA Workbook, American Showcase* and other reference books.

ANGELS ON EARTH MAGAZINE, 16 E. 34th St., New York NY 10016. (212)251-8127. Fax: (212)684-0679. Website: http://www.guideposts.org. Director of Art & Design: Lawrence A. Laukhuf. Estab. 1995. Bimonthly magazine featuring true stories of angel encounters and angelic behavior. Circ. 1,000,000.
● Also publishes *Guideposts*, a monthly magazine. See listing in this section.

Illustration: Approached by 500 illustrators/year. Buys 5-8 illustrations/issue. Features computer, humorous, conceptual, realistic and spot illustration. Assigns 30% of illustrations to well-known or "name" illustrators; 40% to experienced but not well-known illustrators; 30% to new and emerging illustrators. Prefers conceptual/realistic, "soft" styles. Considers all media. 2% of illustration demands computer skills. Call for submission information. Accepts disk submissions compatible with Adobe Photoshop, Adobe Illustrator. Samples are filed or returned by SASE. Art director will contact artist for portfolio review of color slides and transparencies if interested. Rights purchased vary. **Pays on acceptance**; $2,500-3,500 for color cover; $1,500-2,400 2-page spreads; $300-1,000 for spots. Finds artists through reps, *American Showcase, Society of Illustrators Annual*, submissions.

Tips: "If you submit work, know our publications! Tailor your portfolio or samples to each publication so the Art Director is not looking at one or two that fit his needs. Call me and tell me you've seen recent issues and how close your work is to some of the pieces in the magazine."

ANIMALS, 350 S. Huntington Ave., Boston MA 02130. (617)522-7400. Fax: (617)522-4885. Contact: Molly Lupica. Estab. 1868. "*Animals* is a national bimonthly 4-color magazine published by the Massachusetts Society for the Prevention of Cruelty to Animals. We publish articles on and photographs of wildlife, domestic animals, conservation, controversies involving animals, animal-welfare issues, pet health and pet care." Circ. 90,000. Original artwork usually returned after publication. Sample copy $3.95 with SAE (8½×11); art guidelines not available.

Illustration: Approached by 1,000 illustrators/year. Works with 5 illustrators/year. Buys 5 or less illustrations/year from freelancers. Uses artists mainly for spots. Prefers pets or wildlife illustrations relating to a particular article topic. Prefers pen & ink, then airbrush, charcoal/pencil, colored pencil, watercolor, acrylic, oil, pastel and mixed media. Needs editorial and medical illustration. Send query letter with brochure or tearsheets. Samples are filed or are returned by SASE. Reports back within 1 month. Publication will contact artist for portfolio review if interested. Portfolio should include color roughs, original/final art, tearsheets and final reproduction/product. Negotiates rights purchased. **Pays on acceptance**; $300 maximum for color cover; $150 maximum for b&w, $200 for color inside.

Tips: "In your samples, include work showing animals, particularly dogs and cats or humans with cats or dogs. Show a representative sampling."

ANTHOLOGY, P.O. Box 4411, Mesa AZ 85211-4411. Phone/fax: (602)461-8200. E-mail: anthology@juno.com. Website: primenet.com/~inkwell. Art Director: Sandy Nelson. Executive Editor: Sharon Skinner. Estab. 1991. Bimonthly b&w literary magazine featuring poetry, prose and artwork. Circ. 2,000. Sample copies for $3.95. Art guidelines free for #10 SASE with first-class postage.

Illustration: Approached by 3-5 illustrators/year. Buys 6-10 illustrations/issue. Has featured illustrations by Donald

Fronheiser, Shane Howerton. Features humorous, realistic and spot illustrations of sci-fi, fantasy objects. Prefers b&w ink. Assigns 100% of illustrations to new and emerging illustrators. 100% of freelance illustration demands knowledge of Aldus PageMaker or Corel Draw. Send query letter with photocopies and SASE. Accepts Window-compatible disk submissions. Send TIFF, BMP, PCX or GIF files. Samples are not filed, returned by SASE. Reports back within 3 months. Buys one-time rights. Pays in complimentary copies. Finds illustrators through word of mouth.
Tips: "Illustration is a valuable yet overlooked area for many literary magazines. The best chance illustrators have is to show the publication how their work will enrich its pages."

AOPA PILOT, 421 Aviation Way, Frederick MD 21701-4798. (301)695-2371. Fax: (301)695-2381. E-mail: mike.kline @aopa.org. Website: http://www.aopa.org. Creative Director: Art Davis. Art Director: Michael Kline. Estab. 1958. Monthly 4-color trade publication for the members of the Aircraft Owners and Pilots Association. The world's largest aviation magazine. Circ. 340,000. Sample copies free for 8½ × 11 SASE.
Illustration: Approached by 50 illustrators/year. Buys 3 illustrations/issue. Has featured illustrations by Jack Pardue, Byron Gin. Features charts & graphs, informational graphics, realistic, computer, aviation-related illustration. Prefers variety of styles ranging from technical to soft and moody. Assigns 75% of illustration to experienced, but not well-known illustrators; 25% to new and emerging illustrators. 10% of freelance illustration demands knowledge of Adobe Illustrator, Adobe Photoshop, Aldus FreeHand or 3-D programs. Send postcard or other non-returnable samples, such as photocopies and tearsheets. Accepts Mac-compatible disk submissions. Send EPS files. Samples are filed and are not returned. Will contact artist for portfolio review if interested. Rights purchased vary according to project; negotiable. **Pays on acceptance.** Finds illustrators through agents, sourcebooks, online services and samples.
Tips: "We are looking to increase our stable of freelancers. Looking for a variety of styles and experience."

N APEX MAGAZINE, P.O. Box 1721, Vail CO 81658. Phone/fax: (970)476-1495. Website: http://www.apexmag.c om. Creative Director: Tom Winter. Director of Marketing: Kevin Back. Estab. 1996. 4-color consumer magazine covering gravity fed and adrenaline focused sports. Circ. 20,000. Sample copies free for 12 × 14 SASE with $3 posgage.
Illustration: Approached by 15-20 illustrators/year. Buys 3-4 illustrations/issue. Has featured illustrations by Pete Thomas and Steve Beneski. Features realistic illustrations and spot illustrations. "We assign illustrations based upon need." Prefers realism, hip, 4-color. Assigns 10% to experienced, but not well-known illustrators; 90% to new and emerging illustrators. 0% of freelance illustration demands computer knowledge. Send postcard sample or other non-returnable hard copy. Samples are filed and are not returned. Reports back only if interested. Will contact artist for portfolio review if interested. Rights purchased vary according to project. Pays 30 days after publication. Pays $10-50 for b&w inside, $25-200 for color inside; $200 for 2-page spreads; $25 for spots. Finds illustrators through promo samples, word of mouth, other magazines.
Tips: "Our demographics are active, outdoor, motivated individuals between 16-38. We cover skiing, snowboarding, mountain biking, caving, rock and ice climbing and adventure travel. We are photo-driven and place a premium on photography. However, we use two to five illustrations a year to accent our features and other stories. A young hip style is essential. No cartoons. If we like your samples, we'll assign work based upon need."

N AQUARIUM FISH MAGAZINE, P.O. Box 6050, Mission Viejo CA 92690. (949)855-8822. Fax: (949)855-3045. Editor: Kathleen Wood. Estab. 1988. Monthly magazine covering fresh and marine aquariums and garden ponds. Circ. 75,000. Accepts previously published artwork. Originals are returned at job's completion. Sample copies available for $4. Art guidelines for SASE with first-class postage.
Cartoons: Approached by 30 cartoonists/year. Buys 6 cartoons/issue. Themes should relate to aquariums and ponds. Send query letter with finished cartoon samples. Samples are filed. Reports back within 1 month. Buys one-time rights. Pays $35 for b&w, $50 for color.
Illustration: Considers pen & ink, watercolor, air brush and colored pencil. Send query letter with photocopies. Samples are filed or returned by SASE. Reports back within 1 month. Portfolio review not required. Buys one-time rights. Pays on publication; $50-100 for b&w and $100-200 for color inside.

ARMY MAGAZINE, 2425 Wilson Blvd., Arlington VA 22201. (703)841-4300. Art Director: Patty Zukerowski. Estab. 1950. Monthly trade journal dealing with current and historical military affairs. Also covers military doctrine, theory, technology and current affairs from a military perspective. Circ. 115,000. Originals returned at job's completion. Sample copies available for $2.25. Art guidelines available.
Cartoons: Approached by 5 cartoonists/year. Buys 1 cartoon/issue. Prefers military, political and humorous cartoons; single or double panel, b&w washes and line drawings with gaglines. Send query letter with brochure and finished cartoons. Samples are filed or are returned by SASE if requested by artist. Reports back to the artist only if interested. Buys one-time rights. Pays $50 for b&w.
Illustration: Approached by 1 illustrator/year. Buys 1-3 illustrations/issue. Works on assignment only. Prefers military, historical or political themes. Considers pen & ink, airbrush, acrylic, marker, charcoal and mixed media. "Can accept artwork done with Illustrator or Photoshop for Macintosh." Send query letter with brochure, résumé, tearsheets, photocopies and photostats. Samples are filed or are returned by SASE if requested by artist. Publication will contact artist for portfolio review if interested. Portfolio should include b&w and color tearsheets, photocopies and photographs. Buys one-time rights. Pays on publication; $300 minimum for b&w cover; $500 minimum for color cover; $50 for b&w inside; $75 for color inside; $35-50 for spots.

N ARTHRITIS TODAY MAGAZINE, 1330 W. Peachtree St., Atlanta GA 30309-2858. (404)872-7100. Fax: (404)872-9559. Art Director: Jennifer Rogers. Estab. 1987. Bimonthly consumer magazine. "*Arthritis Today* is the official magazine of the Arthritis Foundation. The award-winning publication is more than the most comprehensive and reliable source of information about arthritis research, care and treatment, it is a magazine for the whole person—from their lifestyles to their relationships. It is written both for people with arthritis and those who care about them." Circ. 700,000. Originals returned at job's completion. Sample copies available. 20% of freelance work demands knowledge of Adobe Illustrator, QuarkXPress or Adobe Photoshop.

Cartoons: Accepts cartoons for spots.

Illustration: Approached by 10-20 illustrators/year. Buys 2-6 illustrations/issue. Works on assignment only. Considers oils, watercolor, collage, airbrush, acrylic, colored pencil, mixed media, pastel and computer illustration. Send query letter with brochure, tearsheets, photostats, slides (optional) and transparencies (optional). Samples are filed. Publication will contact artist for portfolio review if interested. Portfolio should include color tearsheets, photostats, photocopies, final art and photographs. Buys first time North American serial rights. Other usage negotiated. **Pays on acceptance.** Finds artists through sourcebooks, other publications, word of mouth, submissions.

Tips: "No limits on areas of the magazine open to freelancers. Two-three departments, each issue use spot illustrations. Submit tearsheets for consideration."

THE ARTIST'S MAGAZINE, 1507 Dana Ave., Cincinnati OH 45207. E-mail: tamedit@fwpubs.com. Contact: Art Director. Monthly 4-color magazine emphasizing the techniques of working artists for the serious beginning, amateur and professional artist. Circ. 275,000. Occasionally accepts previously published material. Returns original artwork after publication. Sample copy $3.50 US, $4.50 Canadian or international; remit in US funds.

● Sponsors annual contest. Send SASE for more information. Also publishes a quarterly magazine called *Watercolor Magic*.

Cartoons: Contact: Cartoon Editor. Buys 3-4 cartoons/year. Must be related to art and artists. Pays $65 on acceptance for first-time rights.

Illustration: Buys 1-2 illustrations/issue. Has featured illustrations by: Brenda Grannan, Sean Kane, Darryl Ligasan, Loren Long and Brad Walker. Features humorous and realistic illustration. Assigns 10% of illustrations to well-known or "name" illustrators; 60% to experienced, but not well-known illustrators; 30% to new and emerging illustrators. Works on assignment only. Send postcard sample or query letter with brochure, photocopies, photographs and tearsheets to be kept on file. Prefers photostats or tearsheets as samples. Samples not filed are returned by SASE. Buys first rights. **Pays on acceptance**; $275-600 for color inside; $100-275 for spots. "We're also looking for b&w spots of art-related subjects. We will buy all rights; pay $25 per spot."

Tips: "Research past issues of publication and send samples that fit the subject matter and style of target publication."

ART:MAG, P.O. Box 70896, Las Vegas NV 89170-0896. (702)734-8121. Art Director: Peter Magliocco. Contributing Artist-at-Large: Bill Chown. Art Editor: "The Mag Man." Estab. 1984. Quarterly b&w small press literary arts zine. Circ. 100. Art guidelines for #10 SASE with first-class postage.

● The 1999-2000 15th anniversary issues of *Art:Mag* will be featuring more art.

Cartoons: Approached by 5-10 cartoonists/year. Buys 5 cartoons/year. Prefers single panel, political, humorous and satirical b&w line drawings. Send query letter with b&w photocopies, samples, tearsheets and SASE. Samples are filed. Reports back within 3 months. Rights purchsed vary according to project. Pays on publication. Pays 1 contributor's copy.

Illustration: Approached by 5-10 illustrators/year. Buys 3-5 illustrations/year. Has featured illustrations by Lilia Levin, Kenneth D. Cooper and Jan L. Miller. Features caricatures of celebrities and politicians and spot illustrations. Preferred subjects: art, literature and politics. Prefers realism, hip, culturally-literate collages and b&w line drawings. Assigns 50% of illustrations to experienced but not well-known illustrators; 50% to new and emerging illustrators. Send query letter with photocopies, SASE. Reports back within 3 months. Portfolio review not required. Buys one-time rights. Pays on publication; 1 contributor's copy. Finds illustrators through magazines, word of mouth.

Tips: "*Art:Mag* is basically for new or amateur artists with unique vision and iconoclastic abilities whose work is unacceptable to slick mainstream magazines. Don't be conventional, be idea-oriented."

N ASIAN ENTERPRISE MAGAZINE, P.O. Box 2135, Walnut CA 91788-2135. (909)860-3316. Fax: (909)865-4915. E-mail: asianet@yahoo.com. Contact: Gelly Borromio. Associate Editor: Ryan Montez. Estab. 1993. Monthly trade publication. "The largest Asian small business focus magazine in U.S." Circ. 33,000.

Cartoons: Buys 12 cartoons/issue. Prefers business-humorous. Prefers single panel, political, humorous, b&w line drawings. Send query letter with samples. Samples are filed. Reports back only if interested. Buys one-time rights. Negotiates rights purchased. Pays on publication; $25-50 for b&w, $25-50 for comic strips.

Illustration: Buys 12 illustrations/issue. Features caricatures of politicians, humorous illustration and spot illustrations. Prefers business subjects. 100% of freelance illustrations demands knowledge of Adobe Photoshop, Aldus PageMaker and QuarkXPress. Send query letter with tearsheets. Accepts disk submissions. Send TIFF files. Samples are filed. Reports back only if interested. Portfolio review not required. Buys one-time rights. Negotiates rights purchased. Pays on publication; $25-50 for b&w, $200 maximum for color cover; $25-50 for b&w inside. Finds illustrators through promo samples and word of mouth.

☑ **ISAAC ASIMOV'S SCIENCE FICTION MAGAZINE,** 475 Park Ave. S., New York NY 10016. (212)686-7188. Fax: (212)686-7414. Senior Art Director: Victoria Green. Assistant Art Director: Shirley Chan Levi. All submissions should be sent to Shirley Chan Levi, assistant art director. Estab. 1977. Monthly b&w with 4-color cover magazine of science fiction and fantasy. Circ. 61,000. Accepts previously published artwork. Original artwork returned at job's completion. Art guidelines available for #10 SASE with first-class postage.

Cartoons: Approached by 20 cartoonists/year. Buys 1-2 cartoons/issue. Prefers science fiction and fantasy themes, humorous cartoons. Prefers single panel, b&w washes or line drawings with and without gagline. Send query letter with finished cartoons, photocopies and SASE. Samples are filed or returned by SASE. Reports back only if interested. Buys one-time rights or reprint rights. **Pays on acceptance**; $35 minimum.

Illustration: Buys 4 illustrations/issue. Works on assignment only. Prefers photorealistic style. Considers all media. Send query letter with printed samples, photocopies and/or tearsheets and SASE. Accepts disk submissions compatible with QuarkXPress 7.5 version 3.3. Send EPS files. Accepts illustrations done with Adobe Illustrator, Adobe Photoshop and Aldus FreeHand. Reports back only if interested. Portfolios may be dropped off every Tuesday and should include b&w and color tearsheets. Buys one-time and reprint rights. **Pays on acceptance**; $1,000-1,200 for color cover; $100-125 for b&w inside; $50 for spots.

Tips: No comic book artists. Realistic work only, with science fiction/fantasy themes. Show characters with a background environment.

☑ **ASPEN MAGAZINE,** Box G-3, Aspen CO 81612. (970)920-4040. Fax: (970)920-4044. Art Director: Paul Viola. Bimonthly 4-color city magazine with the emphasis on Aspen and the valley. Circ. 17,300. Accepts previously published artwork. Original artwork returned at job's completion. Samples copies and art guidelines available.

Illustration: Approached by 15 illustrators/year. Buys 2 illustrations/issue. Themes and styles should be appropriate for editorial content. Considers all media. Send query letter with tearsheets, photostats, photographs, slides, photocopies and transparencies. Samples are filed. Reports back only if interested. Call for appointment to show a portfolio, which should include thumbnails, roughs, tearsheets, slides and photographs. Buys first, one-time or reprint rights. Pays on publication.

N ASPIRE, 107 Kenner Ave., Nashville TN 37205. (615)386-3011. Fax: (615)385-4112. Art Director: Scott McDaniel. Estab. 1991. Bimonthly consumer magazine emphasizing women's lifestyles with a Christian slant. Circ. 100,000.

Illustration: Send query letter with printed samples. Samples are filed. Reports back only if interested. Buys first North American serial rights. Pays on publication; $300-1,000 for color inside. Pays $150 for spots.

Tips: "Read our magazine. We need fast workers with quick turnaround."

N ASSOCIATION OF BREWERS, (formerly *Zymurgy*), P.O. Box 1679, Boulder CO 80306. Magazine Art Director: Stephanie Johnson. Estab. 1978. "Our nonprofit organization hires illustrators for two magazines, *Zymurgy* and *The New Brewer*, each published bimonthly. *Zymurgy* is a journal of the American Homebrewers Association. The goal of the AHA division is to promote public awareness and appreciation of the quality and variety of beer through education, research and the collection and dissemination of information." Circ. 20,000 "*The New Brewer* is a journal of the Institute for Brewing Studies. The goal of the IBS division is to serve as a forum for the technical aspects of brewing and to seek ways to help maintain quality in the production and distribution of beer." Circ. 4,000.

Cartoons: Approached by 10 cartoonists/year. Buys 1-2 cartoons/year. Prefers humorous, b&w and color washes, b&w line drawings, with or without gagline. Send photographs, photocopies, tearsheets, any samples. No originals accepted; samples are filed. Buys one-time rights. **Pays on acceptance**, 30 day net; $75-300 for b&w cartoons; $150-350 for color cartoons.

Illustration: Approached by 50 illustrators/year. Buys 1-2 illustrations/issue. Prefers beer and homebrewing themes. Considers all media. Send postcard sample or query letter with printed samples, photocopies, tearsheets; follow-up sample every 3 months. Accepts disk submissions with EPS or TIFF files. "We prefer samples we can keep." No originals accepted. Reports back only if interested. Art director will contact artist for portfolio review of b&w, color, final art, photographs, photostats, roughs, slides, tearsheets, thumbnails, transparencies; whatever media best represents art. Buys one-time rights. **Pays 30 day net on acceptance**; $600-800 for color cover; $200-300 for b&w inside; $200-400 for color. Pays $150-300 for spots. Finds artists through agents, sourcebooks (Society of Illustrators, *Graphis*, *Print*, *Colorado Creative*), mags, word of mouth, submissions.

Design: Prefers local design freelancers only with experience in Adobe Photoshop, QuarkXPress, Adobe Illustrator. Send query letter with printed samples, photocopies, tearsheets.

Tips: "Keep sending promotional material for our files. Anything beer-related for subject matter is a plus. We look at all styles."

ASSOCIATION OF COLLEGE UNIONS-INTERNATIONAL, One City Centre, 120 W. Seventh St., Suite 200, Bloomington IN 47404-3925. (812)855-8550. Fax: (812)855-0162. E-mail: kcarnaha@indiana.edu. Website: http://acuiweb.org. Interim Production Manager: Kelly Carnahan. Estab. 1914. Professional education association journal covering "multicultural issues, creating community on campus, union and activities programming, managing staff, union operation, professional development and student development."

 ● Also publishes hardcover and trade paperback originals. See listing in the Book Publishers section for more information.

Illustration: Works on assignment only. Considers pen & ink, pencil, and computer illustration. Send query letter with

résumé, photocopies, tearsheets, photographs or color transparencies of college student union activities. Samples are filed. Reports back only if interested. Negotiates rights purchased.

Design: Needs designers for production. Send query letter with résumé and photocopies. Pays by project.

Tips: "We are a volunteer-driven association. Most people submit work on that basis. We are on a limited budget."

✔ **AUTHORSHIP**, 3140 S. Peoria, #295, Aurora CO 80014. (303)841-0246. Executive Director: Sandy Whelchel. Estab. 1937. Bimonthly magazine. "Our publication is for our 3,000 members, and is cover-to-cover about writing."

Cartoons: Samples are returned. Reports back in 4 months. Buys first North American serial and reprint rights. **Pays on acceptance**; $25 minimum for b&w.

Illustration: Accepts disk submissions. Send TIFF files.

Tips: "We only take cartoons slanted to writers."

N: AUTO RESTORER, P.O. Box 6050, Mission Viejo CA 92690. (949)855-8822. Fax: (949)855-3045. Editor: Ted Kade. Estab. 1989. Monthly b&w consumer magazine with focus on collecting, restoring and enjoying classic cars. Circ. 70,000. Originals returned at job's completion. Sample copies available for $5.50.

Illustration: Approached by 5-10 illustrators/year. Buys 1 illustration/issue. Prefers technical illustrations and cutaways of classic/collectible automobiles through 1972. Considers pen & ink, watercolor, airbrush, acrylic, marker, colored pencil, oil, charcoal, mixed media and pastel. Send query letter with SASE, slides, photographs and photocopies. Samples are filed or returned by SASE if requested by artist. Reports back to the artist only if interested. Buys one-time rights. Pays on publication; technical illustrations negotiable. Finds artists through submissions.

Tips: Areas most open to freelance work are technical illustrations for feature articles and renderings of classic cars for various sections.

AUTOMOBILE MAGAZINE, Dept. AGDM, 120 E. Liberty, Ann Arbor MI 48104. (313)994-3500. Website: http://www.automobilemag.com. Art Director: Lawrence C. Crane. Estab. 1986. Monthly 4-color "automobile magazine for upscale lifestyles." Traditional, "imaginative" design. Circ. 650,000. Original artwork is returned after publication. *Art guidelines specific for each project.*

Illustration: Buys illustrations mainly for spots and feature spreads. Works with 5-10 illustrators/year. Buys 2-5 illustrations/issue. Works on assignment only. Considers airbrush, mixed media, colored pencil, watercolor, acrylic, oil, pastel and collage. Needs editorial and technical illustrations. Send query letter with brochure showing art style, résumé, tearsheets, slides, photographs or transparencies. Show automobiles in various styles and media. "This is a full-color magazine, illustrations of cars and people must be accurate." Samples are returned only if requested. "I would like to keep something in my file." Reports back about queries/submissions only if interested. Request portfolio review in original query. Portfolio should include final art, color tearsheets, slides and transparencies. Buys first rights and one-time rights. Pays $200 and up for color inside. Pays $2,000 maximum depending on size of illustration. Finds artists through mailed samples.

Tips: "Send samples that show cars drawn accurately with a unique style and imaginative use of medium."

BACKPACKER MAGAZINE, 33 E. Minor St., Emmaus PA 18098. (610)967-5171. Fax: (617)967-8181. E-mail: jpepper1@earthlink.net. Website: http://www.bpbasecamp.com. Art Director: John Pepper. Estab. 1973. Consumer magazine covering non-motorized wilderness travel. Circ. 250,000.

Illustration: Approached by 200-300 illustrators/year. Buys 10 illustrations/issue. Considers all media. 60% of freelance illustration demands knowledge of Aldus FreeHand, Adobe Photoshop, Adobe Illustrator, QuarkXPress. Send query letter with printed samples, photocopies and/or tearsheets. Send follow-up postcard sample every 6 months. Accepts disk submissions compatible with QuarkXPress, Illustrator and Photoshop. Samples are filed and are not returned. Artist should follow up with call. Art director will contact artist for portfolio review of color photographs, slides, tearsheets and/or transparencies if interested. Buys first rights or reprint rights. Pays on publication. Finds artists through submissions and other printed media.

Tips: *Backpacker* does not buy cartoons. "Know the subject matter, and know *Backpacker Magazine*."

BALLAST QUARTERLY REVIEW, 2022 X Ave., Dysart IA 52224-9767. Contact: Art Director. Estab. 1985. Quarterly literary and graphic design magazine. "*Ballast* is an acronym for Books Art Language Logic Ambiguity Science and Teaching. It is a journal of verbal and visual wit. Audience consists mainly of designers, illustrators, writers and teachers." Circ. 600. Accepts previously published artwork. Originals returned at job's completion. Sample copies available for 5 first-class stamps; art guidelines not available.

Illustration: Approached by 30 illustrators/year. Publishes 5 illustrations/issue. Has featured illustrations by Gary Kelley, Steven Guarnaccia and Beth Bartholomew. Features humorous illustration. Seeks b&w line art—no halftones. Send postcard sample or query letter with photocopies and SASE. Samples are sometimes filed or returned by SASE. Reports back only if interested. Payment is 5-10 copies of issue. Finds artists through books, magazines, word of mouth, other illustrators.

Tips: "We rarely use unsolicited artwork. Become familiar with past issues."

BALLOON LIFE MAGAZINE, 2336 47th Ave. SW, Seattle WA 98116-2331. (206)935-3649. Fax: (206)935-3326. E-mail: tom@balloonlife.com. Website: http://www.balloonlife.com. Editor: Tom Hamilton. Estab. 1985. Monthly 4-color magazine emphasizing the sport of ballooning. "Contains current news, feature articles, a calendar and more.

Audience is sport balloon enthusiasts." Circ. 4,000. Accepts previously published material. Original artwork returned after publication. Sample copy for SASE with 8 first-class stamps. Art guidelines for SASE with first-class postage.

• Only cartoons and sketches directly related to gas balloons or hot air ballooning are considered by *Balloon Life*.

Cartoons: Approached by 20-30 cartoonists/year. Buys 1-2 cartoons/issue. Seeks gag, editorial or political cartoons, caricatures and humorous illustrations. Prefers single panel b&w line drawings with or without gaglines. Send query letter with samples, roughs and finished cartoons. Samples are filed or returned. Reports back within 1 month. Buys all rights. Pays on publication; $25 for b&w and $25-40 for color.

Illustration: Approached by 10-20 illustrators/year. Buys 1-3 illustrations/year. Has featured illustrations by Charles Goll. Features humorous illustration; informational graphics; spot illustration. Needs computer-literate illustrators familiar with Aldus PageMaker, Adobe Illustrator, Adobe Photoshop, Colorit, Pixol Paint Professional and Aldus FreeHand. Send postcard sample or query letter with business card and samples. Accepts submissions on disk compatible with Macintosh files. Send EPS files. Samples are filed or returned. Reports back within 1 month. Will contact for portfolio review if interested. Buys all rights. Pays on publication; $50 for b&w or color cover; $25 for b&w inside; $25-40 for color inside.

Tips: "Know what a modern hot air balloon looks like! Too many cartoons reach us that are technically unacceptable."

Ⓝ BARTENDER MAGAZINE, Box 158, Liberty Corner NJ 07938. (908)766-6006. Fax: (908)766-6607. E-mail: barmag@aol.com. Website: http://www.bartender.com. Editor: Jackie Foley. Estab. 1979. Quarterly 4-color trade journal emphasizing restaurants, taverns, bars, bartenders, bar managers, owners, etc. Circ. 147,000.

Cartoons: Approached by 10 cartoonists/year. Buys 3 cartoons/issue. Prefers bar themes; single panel. Send query letter with finished cartoons. Samples are filed. Buys first rights. Pays on publication; $50 for b&w and $100 for color cover; $50 for b&w and $100 for color inside.

Illustration: Approached by 5 illustrators/year. Buys 1 illustration/issue. Works on assignment only. Prefers bar themes. Considers any media. Send query letter with brochure. Samples are filed. Negotiates rights purchased. Pays on publication; $500 for color cover.

Design: Needs computer-literate designers familiar with QuarkXPress and Adobe Illustrator.

BAY WINDOWS, 631 Tremont St., Boston MA 02118. (617)266-6670. E-mail: jepperly@baywindows.com or RudyK @aol.com. Editor: Jeff Epperly. Arts Editor: Rudy Kikel. Estab. 1983. A weekly newspaper "targeted to politically-aware lesbians, gay men and other political allies publishing non-erotic news and features"; b&w with 2-color cover. Circ. 60,000. Accepts previously published artwork. Original artwork returned after publication. Sample copies available. Needs computer illustrators familiar with Adobe Illustrator or Aldus FreeHand.

Cartoons: Approached by 25 freelance cartoonists/year. Buys 1-2 freelance cartoons/issue. Buys 50 freelance cartoons/year. Preferred themes include politics and life-styles. Prefers double and multiple panel, political and editorial cartoons with gagline, b&w line drawings. Send query letter with roughs. Samples are returned by SASE if requested by artist. Reports back to the artist within 6 weeks only if interested. Rights purchased vary according to project. Pays on publication; $50-100 for b&w only.

Illustration: Approached by 60 freelance illustrators/year. Buys 1 freelance illustration/issue. Buys 50 freelance illustrations/year. Artists work on assignment only. Preferred themes include politics—"humor is a plus." Considers pen & ink and marker drawings. Send query letter with photostats and SASE. Samples are filed. Reports back within six weeks only if interested. Portfolio review not required. Rights purchased vary according to project. Pays on publication; $100-125 for cover; $75-100 for b&w inside; $75 for spots.

Ⓝ THE BERKELEY MONTHLY, 1301 59th St., Emeryville CA 94608. (510)658-9811. Fax: (510)658-9902. E-mail: monthlyart@aol.com. Art Director: Andreas Jones. Estab. 1970. Consumer monthly tabloid; b&w with 4-color cover. Editorial features are general interests (art, entertainment, business owner profiles) for an upscale audience. Circ. 80,000. Accepts previously published artwork. Originals returned at job's completion. Art guidelines for SASE with first-class postage. Sample copy and guidelines for SASE with 5 oz. first-class postage ($1.24). No nature or architectural illustrations. 100% of freelance design work demands knowledge of Adobe PageMaker, QuarkXPress, Macromedia FreeHand, Adobe Illustrator, Adobe Photoshop.

Cartoons: Approached by 75-100 cartoonists/year. Buys 3 cartoons/issue. Prefers single panel, b&w line drawings; "any style, extreme humor." Send query letter with finished cartoons. Samples are filed or returned by SASE. Reports back only if interested. Buys one-time rights. Pays $35 for b&w.

Illustration: Approached by 150-200 illustrators/year. Buys 2 illustrations/issue. Prefers pen & ink, watercolor, acrylic, colored pencil, oil, charcoal, mixed media and pastel. Send postcard sample or query letter with tearsheets and photocopies. Accepts submissions on disk, Mac compatible with Macromedia FreeHand, Adobe Illustrator, Adobe Photoshop, Adobe PageMaker or QuarkXPress. Samples are filed or returned by SASE. Reports back only if interested. Write for appointment to show portfolio of thumbnails, roughs, b&w tearsheets and slides. Buys one-time rights. Pays $100-200 for b&w inside; $25-50 for spots. Pays 15 days after publication.

Design: Needs freelancers for design and production. 100% of freelance design requires knowledge of Adobe Page-Maker, Macromedia FreeHand, Adobe Photoshop, QuarkXPress and Adobe Illustrator. Send query letter with résumé, photocopies or tearsheets. Pays for design by project.

[N] BETTER HEALTH MAGAZINE, 1450 Chapel St., New Haven CT 06511. (203)789-3972. Fax: (203)789-4053. Editor/Publishing Director: Cynthia Wolfe Boynton. Estab. 1979. Bimonthly, 4-color "consumer health magazine." Circ. 149,000. Accepts previously published artwork. Original artwork returned at job's completion. Sample copies available for $2.50. Some freelance work demands knowledge of Adobe Photoshop, QuarkXPress or Adobe Illustrator.
Illustration: Approached by 100 illustrators/year. Buys 2-4 illustrations/issue. Works on assignment only. Considers watercolor, collage, airbrush, acrylic, colored pencil, oil, mixed media, pastel and computer illustration. Send query letter with tearsheets. Accepts disk submissions compatible with Mac, Adobe Illustrator or Adobe Photoshop. Samples are filed. Reports back only if interested. Write for appointment to show a portfolio, or mail appropriate materials. Portfolio should include rough, original/final art, color tearsheets, photostats, photographs and photocopies. Buys first rights. **Pays on acceptance**; $600 for color cover; $400 for color inside.

[N] BEVERAGE WORLD MAGAZINE, 226 W. 26th St., New York NY 10001. (212)822-5930. E-mail: bevworld@ aol.com. Website: http://www.beverageworld.com. Senior Art Director: John Boudreau. Art Director/Webmaster: Robert Carmichael. Editor: M. Havis Dawson. Monthly magazine covering beverages (beers, wines, spirits, bottled waters, soft drinks, juices) for soft drink bottlers, breweries, bottled water/juice plants, wineries and distilleries. Circ. 33,000. Accepts simultaneous submissions. Original artwork returned after publication if requested. Sample copy $3.50. Art guidelines available.
Illustration: Buys 3-4 illustrations. Has featured illustrations by Craig M. Cannon and Rudy Guiterrez. Works on assignment only. Assigns 70% of illustrations to experienced, but not well-known illustrators; 30% to new and emerging illustrators. Send postcard sample, brochure, photocopies and photographs to be kept on file. Reports only if interested. Negotiates rights purchased. **Pays on acceptance**; $500 for color cover; $50-100 for b&w inside. Uses color illustration for cover, usually b&w for spots inside.
Design: Needs freelancers for design. 98% of design demands knowledge of Adobe Photoshop, Adobe Illustrator or QuarkXPress. Send query letter with brochure, résumé, photocopies and tearsheets. Pays by project.

[N] BIRD TIMES, Pet Business Inc., 7-L Dundas Circle, Greensboro NC 27407. (336)292-4047. Fax: (336)292-4272. E-mail: petbiz@compuserve.com. Website: http://www.birdtimes.com. Executive Director: Rita Davis. Bimonthly, 4-color, consumer magazine about birds including bird breed profiles, medical reports, training advice and stories about special birds. Circ. 50,000. Art guidelines are free for #10 SASE with first-class postage.
Illustration: Features realistic illustrations. Prefers watercolor, pen & ink, acrylics and color pencil. Send postcard sample. Send query letter with printed samples, photocopies, SASE and tearsheets. Accepts Windows-compatible disk submissions. Send EPS files at 266 dpi. Portfolio review not required. Pays on publication; $50 maximum for b&w, $50 maximum for color inside.
Tips: "We need artists to produce on short notice."

[N] BIRD WATCHER'S DIGEST, Box 110, Marietta OH 45750. (614)373-5285. E-mail: bwd@birdwatchersdigest.c om. Website: http://www.birdwatchersdigest.com. Editor: William H. Thompson III. Bimonthly magazine covering birds and bird watching for "bird watchers and birders (backyard and field; veteran and novice)." Circ. 90,000. Previously published material OK. Original work returned after publication. Sample copy $3.99.
Illustration: Buys 1-2 illustrations/issue. Send samples or tearsheets. Reports back within 2 months. Buys one-time rights. Pays $50 minimum for b&w; $100 minimum for color.

[N] BITCH: FEMINIST RESPONSE TO POP CULTURE, 3128 16th St., #143, San Francisco CA 94103. (415)864-6671. E-mail: shaykin@yahoo.com. Website: http://www.bitchmagazine.com. Art Director: Benjamin Shay-kin. Estab. 1995. Twice yearly b&w zine. "We examine popular culture in all its forms for women and feminists of all ages." Circ. 10,000.
Illustration: Approached by 20 illustrators/year. Buys 3-7 illustrations/issue. Has featured illustrations by Andi Zeisler, Hugh D'Andrade, Pamela Moses, Isabel Samaras and Pam Purser. Features caricatures of celebrities, conceptual, fashion and humorous illustration. Work on assignment only. Prefers b&w ink drawings and photo collage. Assigns 90% of illustrations to experienced, but not well-known, illustrators; 8% to new and emerging illustrators; 2% to well-known or "name" illustrators. Send postcard sample, non-returnable samples, or query letter with printed samples, photocopies, tearsheets and SASE. Accepts Mac-compatible disk submissions. Samples are filed and are not returned. Will contact artist for portfolio review if interested. "We are not able to pay; however, we have negotiated in the past for advertising trades, etc." Finds illustrators through magazines and word of mouth.
Tips: "We have a couple of illustrators we work with generally, but are open to others. Our circulation has been doubling annually, and we are distributed internationally. Read our magazine and send something we might like."

BLACK BEAR PUBLICATIONS/BLACK BEAR REVIEW, 1916 Lincoln St., Croydon PA 19021-8026. E-mail: bbreview@aol.com. Website: http://members.aol.com/bbreview/index.htm. Editor: Ave Jeanne. Associate Editor: Ron Zettlemoyer. Estab. 1984. Publishes semiannual b&w magazine emphasizing social, political, ecological and environ-mental subjects "for mostly well-educated adults." Circ. 500. Also publishes chapbooks. Accepts previously published artwork. Art guidelines for SASE with first-class postage. Current copy $6 postpaid in U.S., $9 overseas.
Illustration: Works with 20 illustrators/year. Buys 10 illustrations/issue. Has featured illustrations by James P. Lennon. Prefers collage, woodcut, pen & ink. Send camera-ready pieces with SASE. Artwork sent on disk must be in one of the following Microsoft Windows formats: BMP, GIF or JPG. Samples not filed are returned by SASE. Portfolio review

not required. Reports within 2 weeks. Acquires one-time rights or reprint rights. Pays on publication with sample copy for the magazine and $5-15 for cover illustration work. Pays cash on acceptance for chapbook illustrators. Chapbook illustrators are contacted for assignments. Average pay for chapbook illustrators is $20-50 for one-time rights. Does not use illustrations over 4×6. Finds artists through word of mouth, submissions and on the Internet.

Tips: "Read our listing carefully. Be familiar with our needs and our tastes in previously published illustrations. We can't judge you by your résumé—send signed copies of b&w artwork. Include title and medium. Send pieces that reflect social concern. No humor please. If we are interested, we won't let you know without a SASE. Artwork must be send via e-mail. Illustrations may be color for use on our website."

THE BLACK LILY, 8444 Cypress Circle, Sarasota FL 34243-2006. (941)351-4386. E-mail: gkuklews@ix.netcom.com. Chief Editor: Vincent Kuklewski. Estab. 1996. Quarterly b&w zine featuring fantasy and medieval short stories and poetry (pre-1600 world setting). Circ. 150.

Cartoons: Buys 2 cartoons/year. Prefers fantasy—elves, dragons, princess, knights. Prefers: single or multiple panel, humorous, b&w line drawings. Send query letterr with b&w photocopies and SASE. Samples are filed. Reports back within 1 month. Rights purchased vary according to project. **Pays on acceptance.** Pays $5-25 for b&w and comic strips.

Illustration: Approached by 50 illustrators/year. Buys 15 illustrations/issue. Has featured illustrations by Bill Reames, Richard Dahlstrom, Virgil Barfield, Cathy Buburuz. Features humorous and realistic illustrations portraying high fantasy and pre-1600 historical subjects. Prefers pen & ink. Assigns 25% to experienced, but not well-known illustrators; 75% to new and emerging illustrators. Send query letter with photocopies, SASE. Accepts Windows-compatible disk submissions. Send TIFF files. Samples are filed. Reports back within 1 month. Will contact artist for portfolio review if interested. Buys one-time rights or vary according to project. **Pays on acceptance.** Pays $25-50 for b&w cover; $5-50 for b&w inside. Pays $5 for spots.

Tips: Submit "crisp, clear black & white line drawings. Shading by stipiling preferred. Need more pre-1600 AD western Europe work, but also need Chinese/Japanese and Islamic designs. Especially interested in art with Northwoods Forest/animal/villagers/Lappland/fairy tale work. Commonly used size work is 'one-column' 3½×9. Always need cover art. We seek to never repeat the same artist on covers."

BLACK WARRIOR REVIEW, Box 862936, University of Alabama, Tuscaloosa AL 35486-0027. (205)348-4518. Website: http://www.sa.ua.edu/osm/bwr. Editor: Christopher Chambers. Biannual 4-color literary magazine publishing contemporary poetry, fiction and nonfiction by new and established writers. Circ. 2,000. Accepts previously published artwork. Original artwork is returned at job's completion. Sample copy $8.

Illustration: Approached by 50 artists/year. Buys 1-2 illustrations/issue. Has featured work by John Westmark, Santiago Uceda, Kathleen Fetters, Robert Cox and William Christenberry. Themes and styles vary. Considers color and b&w photography, pen & ink, watercolor, acrylic, oil, collage and marker. Send postcard sample. Samples are not filed. Pays on publication; $150 for b&w or color cover; $25 for b&w inside.

Tips: "Check out a recent issue."

THE B'NAI B'RITH INTERNATIONAL JEWISH MONTHLY, B'nai B'rith, 1640 Rhode Island Ave. NW, Washington DC 20036. (202)857-6646. E-mail: erozenman@bnaibrith.org. Editor: Eric Rozenman. Estab. 1886. Specialized magazine published 6 times a year, focusing on matters of general Jewish interest. Circ. 100,000. Originals returned at job's completion. Sample copies available for $2; art guidelines for SASE with first-class postage.

Illustration: Approached by 100 illustrators/year. Features caricatures of celebrities and politicians; humorous and realistic illustration; charts & graphs; informational graphics. Buys 1-2 illustrations/issue. Works on assignment only. Considers pen & ink, airbrush, colored pencil, mixed media, watercolor, acrylic, oil, pastel, collage, marker, charcoal. Send query letter with brochure and SASE. Samples are filed. Reports back only if interested. Request portfolio review in original query. Portfolio should include final art, color, tearsheets and published work. Buys one-time rights. Pays on publication; $50 for b&w cover; $400 maximum for color cover; $50 for b&w inside; $100 maximum for color inside. Finds artists through word of mouth and submissions.

Tips: "Have a strong and varied portfolio reflecting a high degree of professionalism. Illustrations should reflect a proficiency in conceptualizing art—not just rendering. Will not be held responsible for unsolicited material."

☑ BOSTONIA MAGAZINE, 10 Lenox St., Brookline MA 02446. (617)353-9711. Graphic Designer: Jussi Gamache. Estab. 1900. Quarterly 4-color alumni magazine of Boston University. Audience is "highly educated." Circ. 200,000. Sample copies free for #10 SASE with first-class postage. Art guidelines not available.

Illustration: Approached by 500 illustrators/year. We buy 3 illustrations/issue. Features humorous and realistic illustration, medical, computer and spot illustration. Assigns 10% of illustrations to well-known or "name" illustrators; 50% experienced, but not well-known illustrators; 40% to new and emerging illustrators. Considers all media. Works on assignment only. Send query letter with photocopies, printed samples and tearsheets. Samples are filed and not returned. Reports back within weeks only if interested. Will contact for portfolio review if interested. Portfolio should include color and b&w roughs, final art and tearsheets. Buys first North American serial rights. "Payment depends on final use and size." **Pays on acceptance.** Payment varies for cover and inside; pays $200-400 for spots. "Liberal number of tearsheets available at no cost." Finds artists through magazines, word of mouth and submissions.

Tips: "Portfolio should include plenty of tearsheets/photocopies as handouts. Don't phone; it disturbs flow of work in office. No sloppy presentations. Show intelligence and uniqueness of style."

Artist Mark Mabel says he was trying to convey "private joy" with his computer line drawing of a woman laughing for literary magazine *Black Bear Review*. *Black Bear Review* is a semiannual black and white magazine emphasizing social, political, ecological and environmental subjects. Mabel queried the magazine years ago using listing information from *AGDM* and has since developed an ongoing creative relationship with the editor. "Artists appreciate audiences," says Mabel. "I am glad to be recognized in the small press."

BOTH SIDES NOW, 10547 State Hwy. 110 N., Tyler TX 75704-3731. (903)592-4263. Contact: Editor. Zine emphasizing the New Age "for people seeking holistic alternatives in spirituality, life-style, and politics." Irregular, photocopied publication. Circ. 200. Accepts previously published material. Original artwork returned by SASE. Sample copy $1.

Cartoons: Buys various number of cartoons/issue. Prefers fantasy, political satire, religion and exposés of hypocrisy as themes. Prefers single or multi panel b&w line drawings. Send query letter with good photocopies. Samples not filed are returned by SASE. Reports within 3 months. Pays in copies and subscription.

Illustration: Buys variable amount of illustrations/issue. Prefers fantasy, surrealism, spirituality and realism as themes. B&w only. Send query letter with résumé and photocopies. Samples not filed are returned by SASE. Reports back within 3 months. Pays on publication in copies and subscription.

Tips: "Pay close attention to listing. Do not send color."

BOW & ARROW HUNTING MAGAZINE, 265 S. Anita Dr., #120, Orange CA 92868. (714)939-9991. Fax: (714)939-9909. E-mail: rdtorres33@aol.com. Editor: Bob Torres. Advertising Director: Chris Antonidadis. Emphasizes bowhunting and bowhunters. Published 9 times per year. Art guidelines free for SASE with first-class postage. Original artwork returned after publication.

Cartoons: Buys 2-3 cartoons/issue; all from freelancers. Prefers single panel, with gag line; b&w line drawings. Send finished cartoons. Material not kept on file returned by SASE. Reports within 2 months. Buys first rights. **Pays on acceptance**; $10-15, b&w.

Illustration: Buys 1-2 illustrations/issue; all from freelancers. Has featured illustrations by Tes Jolly and Cisco Monthay. Assigns 75% of illustrations to experienced but not well-known illustrators; 25% to new and emerging illustrators. Prefers live animals/game as themes. Send samples. Prefers photographs or original work as samples. Especially looks for perspective, unique or accurate use of color and shading, and an ability to clearly express a thought, emotion or event. Samples returned by SASE. Reports in 2 months. Portfolio review not required. Buys first rights. **Pays on acceptance**; $100 for color cover; $30 for b&w inside.

BOWLING MAGAZINE, 675 N. Brookfield Rd., Brookfield WI 53045. (414)641-2003. Fax: (414)641-2005. Editor: Bill Vint. Estab. 1933. Bimonthly 4-color magazine covering the sport of bowling in its many facets. Circ. 140,000. Sample copies for 9×12 SAE with 5 first-class stamps. Art guidelines for SASE with first-class postage.

Illustration: Approached by 12 illustrators/year. Buys 1-2 illustrations/issue. Works on assignment only. Send query letter with tearsheets, SASE and photocopies. Samples are filed or are returned by SASE. Reports back within 10 days. Rights purchased vary. **Pays on acceptance**; $250-500 for color cover; $75-250 for color inside; $25-75 b&w spots (instructional themed material).

Tips: "We do not publish cartoons as a matter of policy. Have a thorough knowledge of bowling. We have a specific interest in instructional materials that clearly illustrate bowling techniques."

BOXBOARD CONTAINERS INTERNATIONAL, (formerly *Concrete Products*), 29 N. Wacker Dr., Chicago IL 60606. (312)726-2802. Fax: (312)726-2574. Art Director: Kit Woodward. Estab. 1892. Monthly trade journal. Circ. 15,000.

Illustration: Approached by 10 illustrators/year. Buys 4 illustrations/year. Works on assignment only. 50% of freelance work demands knowledge of Adobe Illustrator. 100% of freelance work demands knowledge of QuarkXPress. Send query letter with brochure and samples. Samples are filed. Reports back to the artist only if interested. Rights purchased vary according to project. Pays $400 for color cover; $100 for b&w, $200 for color inside.

Tips: Prefers local artists. "Get lucky, and approach me at a good time. A follow-up call is fine, but pestering me will get you nowhere. Few people ever call after they send material. This may not be true of most art directors, but I prefer a somewhat casual, friendly approach. Also, being 'established' means nothing. I prefer to use new illustrators as long as they are professional and friendly."

BOYS' QUEST, 103 N. Main St., Bluffton OH 45817. (419)358-4610. Assistant Editor: Becky Jackman. Estab. 1995. Bimonthly consumer magazine "geared for elementary boys." Circ. 7,000. Sample copies $3 each; art guidelines for SASE with first-class postage.

Cartoons: Buys 1-3 cartoons/issue. Prefers wholesome children themes. Prefers: single or double panel, humorous, b&w line drawings with gagline. Send finished cartoons. Samples are filed or returned by SASE. Reports back in 2 months. Buys first rights. Pays on publication; $5-25 for b&w.

Illustration: Approached by 100 illustrators/year. Buys 6 illustrations/issue. Has featured illustrations by Chris Sabatino, Gail Roth and Pamela Harden. Features humorous illustration; realistic and spot illustration. Assigns 60% of illustrations to experienced, but not well-known illustrators; 40% to new and emerging illustrators. Prefers childhood themes. Considers all media. Send query letter with printed samples. Samples are filed or returned by SASE. Reports back within 2 months. To arrange portfolio review of b&w work, artist should follow-up with call or letter after initial query. Buys first rights. Pays on publication; $200-250 for color cover; $25-35 for b&w inside; $50-70 for 2-page spreads; $10-25 for spots. Finds illustrators through artist's submissions.

Tips: "Read our magazine. Send in a few samples of work in pen & ink."

[N] BRIDE'S MAGAZINE, Condé-Nast Publications, 140 E. 45th St., New York NY 10017. (212)880-8530. Art Director: Phyllis Cox. Estab. 1934. Bimonthly 4-color; "classic, clean, sophisticated design style." Original artwork is returned after publication.

Illustration: Buys illustrations mainly for spots and feature spreads. Buys 5-10 illustrations/issue. Works on assignment only. Considers pen & ink, airbrush, mixed media, colored pencil, watercolor, acrylic, collage and calligraphy. Needs editorial illustrations. Send postcard sample. In samples or portfolio, looks for "graphic quality, conceptual skill, good 'people' style; lively, young, but sophisticated work." Samples are filed. Will contact for portfolio review if interested. Portfolios may be dropped off every Monday-Thursday and should include color and b&w final art, tearsheets, slides, photostats, photographs and transparencies. Buys one-time rights or negotiates rights purchased. Pays on publication; $250-350 for b&w or color inside; $250 minimum for spots. Finds artists through word of mouth, magazines, submissions/self-promotions, sourcebooks, artists' agents and reps, attending art exhibitions.

[N] BRIGADE LEADER, Box 150, Wheaton IL 60189. (630)665-0630. Fax: (630)665-0372. Estab. 1960. Contact: Editor. Quarterly 2-color magazine for Christian men leading boys in Brigade. Circ. 11,000. Original artwork returned after publication if requested. Sample copy for $1.50 for postage and large SASE; artist's guidelines for SASE with first-class postage.

Illustration: Approached by more than 100 illustrators/year. Buys 1-2 illustrations/issue. Uses freelancers for editorial illustrations. Uses editorial illustration in pen & ink, airbrush, pencil and watercolor. Interested in masculine subjects (sports, camping, out of doors, family). Provide business card and photocopies to be kept on file. Works on assignment only. Pays on publication; $250 for b&w cover; $100 minimum for inside.

Tips: "Read this listing carefully."

[N] BRUTARIAN, 8433 Richmond Ave., Alexandria VA 22309. E-mail: brutarian1@juno.com. Publisher: Dominick J. Salemi. Estab. 1991. Quarterly magazine about the weirder aspects of pop culture. Circ. 3,000.

Cartoons: Approached by 100 cartoonists/year. Buys 5 cartoons/issue. Prefers humor. Send query letter with finished cartoons, photographs, photocopies, roughs, SASE and tearsheets. Samples are returned by SASE. Reports back within 60 days. Buys first rights. Pays on publication; $25-100 for b&w cartoons.

Illustration: Approached by 100 illustrators/year. Buys 5 illustrations/issue. Considers all media. Send query letter with printed samples, photocopies, SASE and tearsheets. Samples are returned by SASE. Reports back in 60 days. Art director will contact artist for portfolio review if interested. Portfolio should include b&w, color or final art photographs, photostats, roughs, slides, tearsheets, thumbnails. Buys first rights. Pays on publication; $20-50 for b&w, $100-200 for color cover; $25-100 for b&w inside. Pays $25 for spots.

Design: Needs freelancers for design. Prefers local design freelancers. 100% of freelance work demands computer skills. Send query letter with printed samples, photocopies, SASE and tearsheets.

BUCKMASTERS WHITETAIL MAGAZINE, 10350 Hwy. 80 E., Montgomery AL 36117. (205)215-3337. Fax: (334)215-3535. Vice President of Market Development & Design: Dockery Austin. Estab. 1987. Magazine covering whitetail deer hunting. Seasonal—6 times/year. Circ. 400,000. Accepts previously published artwork. Originals are not returned. Sample copies and art guidelines available. 80% of freelance work demands knowledge of Adobe Illustrator, QuarkXPress, Adobe Photoshop or Aldus FreeHand.

Cartoons: Approached by 5 cartoonists/year. Buys 1 cartoon/issue. Send query letter with brochure and photos of originals. Samples are filed or returned by SASE. Reports back within 3 months. Rights purchased according to project. Pays $25 for b&w.

Illustration: Approached by 5 illustrators/year. Buys 1 illustration/issue. Works on assignment only. Considers all media. Send postcard sample. Accepts submissions on disk. Samples are filed. Call or write for appointment to show portfolio. Portfolio should include final art, slides and photographs. Rights purchased vary. Pays on publication; $500 for color cover; $150 for color inside.

Design: Needs freelance designers for multimedia. 100% of freelance work requires knowledge of Adobe Photoshop, QuarkXPress or Adobe Illustrator. Pays by project.

Tips: "Send samples related to whitetail deer or turkeys."

[N] BUGLE—JOURNAL OF ELK AND THE HUNT, 2291 W. Broadway, Missoula MT 59807-8249. (406)523-4578. Fax: (406)523-4550. E-mail: raup@rmef.org. Website: http://www.rmef.org. Art Director: Bob Raup. Estab. 1984. Bimonthly 4-color outdoor conservation and hunting magazine for a nonprofit organization. Samples copies and art guidelines available for #10 SASE and first-class postage.

Illustration: Approached by 30-40 illustrators/year. Buys 3-4 illustrations/issue. Has featured illustrations by Pat Daugherty, Cynthie Fisher, Joanna Yardley and Bill Gamradt. Features natural history illustration, humorous illustration, realistic illustrations and maps. Preferred subjects: wildlife and nature. "Open to all styles." Assigns 60% of illustrations to well-known or "name" illustrators; 20% to experienced, but not well-known illustrators; 20% to new and emerging illustrators. Send query letter with printed samples and tearsheets. Accepts Windows-compatible disk submissions. Send EPS or TIFF files. Samples are filed. Reports back within 2 months. Will contact artist for portfolio review if interested.

Pays on acceptance; $250-400 for b&w, $250-400 for color cover; $100-150 for b&w, $100-200 for color inside; $150-300 for 2-page spreads; $50 for spots. Finds illustrators through existing contacts and magazines.

Tips: "We are looking for a variety of styles and techniques with an attention to accuracy."

BUILDINGS MAGAZINE, 427 Sixth Ave. SE, Cedar Rapids IA 52406. (319)364-6167. Fax: (319)364-4278. E-mail: elisa-geneser@stamats.com. Website: http://www.buildings.com. Art Director: Elisa Geneser. Estab. 1906. Monthly trade magazine featuring "information related to current approaches, technologies and products involved in large commercial facilities." Circ. 65,000. Original artwork returned at job's completion.

• *Buildings* has nearly doubled its pay for black & white and color illustration. In 1998 the magazine was the winner of two Maggie awards and four ASBPE (American Society of Business Press Editors) awards.

Illustration: Works on assignment only. Has featured illustrations by Jonathan Macagba, Pamela Harden, James Henry and Jeffrey Scott. Features informational graphics; computer and spot illustration. Assigns 50% of illustrations to experienced, but not well-known illustrators; 50% to new and emerging illustrators. Considers all media, themes and styles. Send postcard sample. Accepts submissions on disk compatible with Macintosh, Adobe Photoshop 4.0 or Adobe Illustator 7.0. Samples are filed. Will contact for portfolio review if interested. Portfolio should include thumbnails, b&w/color tearsheets. Rights purchased vary. **Pays on acceptance**, $250-500 for b&w, $500-1,500 for color cover; $50-200 for b&w inside; $100-350 for color inside; $30-100 for spots. Finds artists through word of mouth and submissions.

Design: 60% of freelance work demands knowledge of Adobe Photoshop, Adobe Illustrator. Send query letter with brochure, photocopies and tearsheets. Pays by the project.

Tips: "Send postcards with samples of your work printed on them. Show us a variety of work (styles), if available. Send only artwork that follows our subject matter: commercial buildings and facility management."

BULLETIN OF THE ATOMIC SCIENTISTS, 6042 S. Kimbark, Chicago IL 60637. (773)702-2555. Fax: (773)702-0725. E-mail: bullatom.sci@apc.igc.org. Website: http://neog.com/atomic/. Managing Editor: Linda Rothstein. Estab. 1945. Bimonthly magazine of international affairs and nuclear security. Circ. 15,000. Sample copies available.

Cartoons: Approached by 5-10 cartoonists/year. Buys 6-10 cartoons/issue. Prefers single panel, humorous, b&w washes and line drawings. Send photocopies. Samples are not filed and are returned. Reports back within 10 days. Buys one-time rights. **Pays on acceptance**; $35-150 for b&w.

Illustration: Approached by 20-25 illustrators/year. Buys 4-6 illustrations/year. Send postcard sample and photocopies. Samples are filed. Reports back only if interested. Buys first rights. **Pays on acceptance**; $300-500 for color cover; $100-150 for b&w inside.

Tips: "We're eager to see cartoons that relate to our editorial content, so it's important to take a look at the magazine before submitting items."

BUSINESS & COMMERCIAL AVIATION, (Division of the McGraw-Hill Companies), 4 International Dr., Rye Brook NY 10573. (914)939-0300. E-mail: 110364.3555@compuserve.com. Art Direction: Ringston Media. Monthly technical publication for corporate pilots and owners of business aircraft. 4-color; "contemporary design." Circ. 55,000.

Illustration: Works with 12 illustrators/year. Buys 12 editorial and technical illustrations/year. Uses artists mainly for editorials and some covers. Especially needs full-page and spot art of a business-aviation nature. "We generally only use artists with a fairly realistic style. This is a serious business publication—graphically conservative. Need artists who can work on short deadline time." 70% of freelance work demands knowledge of Adobe Photoshop, Adobe Illustrator, QuarkXPress and Aldus FreeHand. Query with samples and SASE. Reports in 1 month. Photocopies OK. Buys all rights, but may reassign rights to artist after publication. Negotiates payment. **Pays on acceptance**; $400 for color; $175-250 for spots.

BUSINESS LAW TODAY, 750 N. Lake Shore Dr., 8th Floor, Chicago IL 60611. (312)988-6050. Fax: (312)988-6035. E-mail: nowakt@staff.abanet.org. Art Director: Tamara Nowak. Estab. 1992. Bimonthly magazine covering business law. Circ. 56,000. Sample copies available; art guidelines not available.

Cartoons: Buys 20-24 cartoons/year. Prefers business law and business lawyers themes. Prefers single panel, humorous, b&w line drawings with gaglines. Send photocopies and SASE. Samples are not filed and are returned by SASE. Reports back within several days. Buys one-time rights. Pays on publication; $150 minimum for b&w. Please send cartoons to the attention of Ray DeLong.

Illustration: Buys 6-9 illustrations/issue. Has featured illustrations by Tim Lee, Henry Kosinski and Susan Wise. Features humorous, realistic and computer illustrations. Assigns 10% of illustrations to well-known or "name" illustrators; 80% to experienced, but not well-known illustrators; and 10% to new and emerging illustrators. Prefers editorial illustration. Considers all media. 10% of freelance illustration demands knowledge of Adobe Photoshop, Adobe Illustrator and QuarkXPress. Send query letter with printed samples. "We will accept work compatible with QuarkXPress 7.5/version 4.0. Send EPS or TIFF files." Samples are filed and are not returned. Reports back only if interested. Buys one-time rights. Pays on pubication; $750 for color cover; $520 for b&w inside, $575 for color inside; $175 for b&w spots.

Tips: "Although our payment may not be the highest, accepting jobs from us could lead to other projects, since we produce many publications at the ABA. Sometimes sending samples (three to four pieces) works best to get a sense of your style; that way I can keep them on file."

BUSINESS TRAVEL NEWS, 1 Penn Plaza, New York NY 10119. Art Director: Teresa M. Carboni. Estab. 1984. Bimonthly 4-color trade publication focusing on business and corporate travel news/management. Circ. 50,000.

Illustration: Approached by 300 illustrators/year. Buys 3-5 illustrations/issue. Has featured illustrations by Robert Pizzo, Bruce Lennon, Lisa Cangemi. Features charts & graphs, computer illustration, conceptual art, humorous illustration, informational graphics and spot illustrations. Preferred subjects: business and travel. Assigns 30% of illustrations

to well-known or "name" illustrators; 40% to experienced, but not well-known illustrators; 30% to new and emerging illustrators. 30% of freelance illustration demands knowledge of Adobe Illuatrator or Adobe Photoshop. Send postcard or other non-returnable samples. Samples are filed. Buys first rights. **Pays on acceptance**; $600-900 for color cover; $250-350 for color inside; $300 for spots. Finds illustrators through artist's promotional material and sourcebooks.
Tips: "Send your best samples suitable for the publication. We want interesting concepts and print a variety of styles, however our audience is a somewhat conservative. We serve a business market."

☑ **BUTTERICK CO., INC.**, 161 Avenue of the Americas, New York NY 10013. (212)620-2500. Art Director: Chris Lipert. Associate Art Director: Judy Perry. Quarterly magazine and monthly catalog. "*Butterick Magazine* is for the home sewer, providing fashion and technical information about our newest sewing patterns through fashion illustration, photography and articles. The Butterick store catalog is a guide to all Butterick patterns, shown by illustration and photography." Magazine circ. 350,000. Catalog readership: 9 million. Originals are returned at job's completion.
Illustration: "We have two specific needs: primarily fashion illustration in a contemporary yet realistic style, mostly depicting women and children in full-length poses for our catalog. We are also interested in travel, interior, light concept and decorative illustration for our magazine." Considers watercolor and gouache for catalog art; all other media for magazine. Send query letter with tearsheets and color photocopies and promo cards. Samples are filed or are returned by SASE if requested by artist. Does not report back, in which case the artist should call soon if feedback is desired. Portfolio drop off every Monday or mail appropriate materials. Portfolio should include final art, tearsheets, photostats, photocopies and large format transparencies. Rights purchased vary according to project.
Tips: "Send non-returnable samples several times a year—especially if style changes. We like people to respect our portfolio drop-off policy. Repeated calling and response cards are undesirable. One follow-up call by illustrator for feedback is fine."

▣ **CALIFORNIA JOURNAL**, 2101 K St., Sacramento CA 95816. (916)444-2840. Fax: (916)444-2339. Website: http://www.statenet.com. Art Director: Dagmar Thompson. Estab. 1970. Monthly magazine "covering politics, government and independent analysis of California issues." Circ. 15,000. Sample copies available. Art guidelines not available. Call.
Cartoons: Approached by 10 cartoonists/year. Buys 10-20 cartoons/year. Prefers political/editorial. Prefers single or double panel political, humorous, b&w washes, b&w line drawings without gagline. Send query letter with photocopies and samples. Samples are filed and not returned. Reports back only if interested. Buys all rights. **Pays on acceptance**; $100-300 for b&w, $300-400 for color.
Illustration: Approached by 10-30 illustrators/year. Buys 30-40 illustrations/year. Has featured illustrations by Santiago Uceda. Features caricatures of politicians; realistic, computer and spot illustration. Assigns 5% of illustrations to well-known or "name" illustrators; 50% to experienced, but not well-known illustrators; 25% to new and emerging illustrators. Prefers editoral. Considers all media. 10% of freelance illustration demands knowledge of Adobe Photoshop. Send postcard sample or query letter with photocopies. Send follow-up postcard sample every 4 months. Accepts disk submissions compatible with Mac Photoshop/Syquest on 3.5 or Zip disk. Samples are filed and not returned. Reports back only if interested. Art director will contact artist for portfolio review if interested. Buys all rights. **Pays on acceptance**; $350 minimum for color cover; $150 minimum for b&w inside; $100 minimum for spots. Finds illustrators through magazines, word of mouth and artist's submissions.
Design: Prefers California design freelancers.
Tips: "We like to work with illustrators who understand editorial concepts and are politically current."

⧉⧉ **CANADIAN BUSINESS MEDIA**, 777 Bay St., 5th Floor, Toronto, Ontario M5W 1A7 Canada. (416)596-5364. Fax: (416)596-5155. E-mail: pflug@cbmedia.ca. Website: http://www.canbus.ca. Art Director: Donna Braggins. Associate Art Directors: Esther Pflug and Ava Abbott. Assistant Art Director: Jolene Hunt. Biweekly 4-color business magazine focusing on Canadian market. Circ. 85,000.
Illustration: Approached by 200 illustrators/year. Buys 1-5 illustrations/issue. Has featured illustrations by Ross MacDonald, Joe Salina and Tracey Wood. Features caricatures of celebrities and informational graphics of business subjects. Assigns 70% of illustrations to well-known or "name" illustrators; 30% to new and emerging illustrators (who are on staff as contract designer/illustrators). 30% of freelance illustration demands knowledge of Adobe Illustrator and Adobe Photoshop. Send postcard sample, printed samples and photocopies. Accepts Mac-compatible disk submissions. Reports back only if interested. Will contact artist for portfolio review if interested. **Pays on acceptance**; $1,000-2,000 for color cover; $300-1,500 for color inside. Pays $300 for spots. Finds illustrators through magazines, word of mouth and samples.

⧉⧉ **CANADIAN DIMENSION (CD)**, 91 Albert St., Room 2-B, Winnipeg, Manitoba R3R 1G5 Canada. (204)957-1519. Fax: (204)943-4617. E-mail: info@canadiandimension.mb.ca. Office Manager: George Harris. Estab. 1963. Bimonthly consumer magazine published "by, for and about activists in the struggle for a better world, covering women's issues, aboriginal issues, the enrivonment, labour, etc." Circ. 2,600. Accepts previously published artwork. Originals returned at job's completion. Sample copies available for $2. Art guidelines available for SASE with first-class postage.
Cartoons: Approached by 10 cartoonists/year. Buys 4 cartoons/issue. Prefers political and humorous cartoons. Send query letter with roughs. Samples are filed or returned by SASE if requested by artist. Buys one-time rights. Pays $30 for b&w.

Illustrators: Approached by 5 illustrators/year. Buys 6 illustrations/year. Send query letter with brochure and SASE. Samples are filed or returned by SASE if requested by artist. Publication will contact artist for portfolio review if interested. Buys one-time rights. Pays on publication; $100 for b&w cover; $30 for b&w inside and spots. Finds artists through word of mouth and artists' submissions.

CAREERS AND COLLEGES, 989 Sixth Ave., New York NY 10018. (212)563-4688. Fax: (212)967-2531. Contact: Art Director. Estab. 1980. Quarterly 4-color educational magazine published September-May. "Readers are college-bound high school juniors and seniors and college students. Besides our magazine, we produce educational material (posters, newsletters) for outside companies." Circ. 100,000. Accepts previously published artwork. Original artwork is returned at job's completion.
Illustration: "We're looking for contemporary, upbeat, sophisticated illustration. All techniques are welcome." Send query letter with samples. "Please do not call. Will call artist if interested in style." Buys one-time rights.

✔ **CAT FANCY**, Fancy Publications Inc., Box 6050, Mission Viejo CA 92690. (949)855-8822. Monthly 4-color magazine for cat owners, breeders and fanciers; contemporary, colorful and conservative. Readers are mainly women interested in all phases of cat ownership. Circ. 303,000. No simultaneous submissions. Sample copy $5.50; artist's guidelines for SASE.
Cartoons: Buys 12 cartoons/year. Seeks single, double and multipanel with gagline. Should be simple, upbeat and reflect love for and enjoyment of cats. "Central character should be a cat." Send query letter with photostats or photocopies as samples and SASE. Reports in 2-3 months. Buys first rights. Pays on publication; $35 for b&w line drawings.
Illustration: Send query letter with brochure, high-quality photocopies (preferably color), SASE and tearsheets. Article illustrations assigned. Portfolio review not required. Pays $20-35 for spots; $20-100 for b&w; $50-300 for color insides; more for packages of multiple illustrations. Needs editorial, medical and technical illustration and images of cats.
Tips: "We need cartoons with an upbeat theme and realistic illustrations of purebred and mixed-breed cats. Please review a sample copy of the magazine before submitting your work to us."

N **CATS & KITTENS**, Pet Business Inc., 7-L Dundas Circle, Greensboro NC 27407. (336)292-4047. Fax: (336)292-4272. E-mail: petbiz@compuserve.com. Website: http://www.catsandkittens.com. Executive Director: Rita Davis. Bi-monthly, 4-color, consumer magazine about cats including breed profiles, medical reports, training advice, cats at work, cat collectibles and cat stories. Circ. 75,000. Art guidelines free for #10 SASE with first-class postage.
Illustration: Has featured illustrations by Sherry Neidigh, Charlotte Centilli and Nona Hengen. Features realistic illustrations. Prefers watercolor, pen & ink, acrylics and color pencil. Assigns illustrations to experienced, but not well-known illustrators; and to new and emerging illustrators. Send postcard sample. Send query letter with printed samples, photocopies, SASE and tearsheets. Accepts Windows-compatible, disk submissions. Send EPS files at 266 dpi. Portfolio review not required. Pays on publication; $50 maximum for b&w, $50 maximum for color inside.
Tips: "Need artists with ability to produce illustrations for specific story on short notice."

N **CHALICE PUBLICATIONS**, P.O. Box 114, American Fork, UT 84003. (801)796-5584. E-mail: chalice@mastersrpg.com. Website: http://www.mastersrpg.com/. Project Director: Jason A. Anderson. Estab. 1997. Circulation: 2,000. Publishes *Masters of Role Playing Magazine*. Art guidelines available free for 4×9 SASE with 1 first-class stamp or can be viewed on website.
Illustration: Works with 6-30 freelance illustrators/year. Assigns 1-6 freelance design jobs; 6 cover illustration jobs and 6-30 text illustration jobs/year. Prefers local illustrators with experience in fantasy and science fiction illustration. Prefered styles and themes are: Japanimation, Gothic-punk, horror, science fiction, fantasy, humor, cyberpunk, Gothic and mythology. Uses freelancers mainly for interior illustration.
First Contact & Terms: Send query letter with résumé, business card, SASE, printed samples or photocopies. Requests 15-25 samples. Samples are filed and not returned. Will contact artist for portfolio review if interested. Portfolio should include artwork of characters in sequence, b&w photographs of final art. This magazine publisher pays in copies of magazine (usually a minimum of 5 copies) plus free advertising space to promote your website or artwork. Rights purchased vary according to project. Finds freelancers through online contacts, submission guidelines requests, friends and existing illustrators.
Tips: "We specialize in giving talented new artists and illustrators an opportunity to exhibit their abilities."

N **CHARLESTON MAGAZINE**, 782 Johnnie Dodds Blvd., Suite C, Mt. Pleasant SC 29464. (843)971-9811. Fax: (843)971-0121. E-mail: gulfstream@awod.com. Website: http://www.charlestononline.com. Art Director: Melinda Smith Monk. Estab. 1973. Quarterly 4-color consumer magazine. "Indispensible resource for information about modern-day Charleston SC, addresses issues of relevance and appeals to both visitors and residents." Circ. 20,000. Art guidelines are free for #10 SASE with first-class postage.
● Also publishes *Drink Magazine*.
Illustration: Approached by 35 illustrators/year. Buys 3 illustrations/issue. Has featured illustrations by Tate Nation, Nancy Rodden, Paige Johnson, Emily Thompson and local artists. Features realistic illustrations, informational graphics, spot illustrations, computer illustration. Prefers business subjects, children, families, men, pets, women and teens. Assigns 10% of illustrations to well-known or "name" illustrators; 30% to experienced, but not well-known illustrators; 60% to new and emerging illustrators. 35% of freelance illustration demands knowledge of Adobe Illustrator, Adobe

Photoshop, Aldus FreeHand, Aldus PageMaker, QuarkXPress. Send postcard sample and follow-up postcard every month. Send non-returnable samples. Send query letter with printed samples. Accepts Mac-compatible disk submissions. Samples are filed or returned by SASE. Reports back only if interested. Will contact artist for portfolio review if interested. Buys first rights, one-time rights or rights purchased vary according to project. Pays 30 days after publication; $175 for b&w, $200 for color cover; $100-400 for 2-page spreads; $50 for spots. Finds illustrators through sourcebooks, artists promo samples, word of mouth.

Tips: "Our magazine has won several design awards and is a good place for artists to showcase their talent in print. We welcome letters of interest from artists interested in semester-long, unpaid internships-at-large. If selected, artist would provide 4-5 illustrations for publication in return for masthead recognition and sample tearsheets. Staff internships (unpaid) also available on-site in Charleston S.C. Send letter of interest and samples of work to Art Director."

CHESAPEAKE BAY MAGAZINE, 1819 Bay Ridge Ave., Annapolis MD 21403. (410)263-2662. Fax: (410)267-6924. Art Director: Karen Ashley. Estab. 1972. Monthly 4-color magazine focusing on the boating environment of the Chesapeake Bay—including its history, people, places and ecology. Circ. 35,000. Original artwork returned after publication upon request. Sample copies free for SASE with first-class postage. Art guidelines available. "Please call."

Cartoons: Approached by 12 cartoonists/year. Prefers single panel, b&w washes and line drawings with gagline. Cartoons are nautical and fishing humor or appropriate to the Chesapeake environment. Send query letter with finished cartoons. Samples are filed. Reports back to the artist only if interested. Buys one-time rights. Pays $25-30 for b&w.

Illustration: Approached by 12 illustrators/year. Buys 2-3 technical and editorial illustrations/issue. Considers pen & ink, watercolor, collage, acrylic, marker, colored pencil, oil, charcoal, mixed media and pastel. Usually prefers watercolor or oil for 4-color editorial illustration. "Style and tone are determined by the artist after he/she reads the story." Send query letter with résumé, tearsheets and photographs. Samples are filed. Reports back only if interested. Publication will contact artist for portfolio review if interested. Portfolio should include "anything you've got." No b&w photocopies. Buys one-time rights. "Price decided when contracted." Pays $50-175 for b&w inside; $75-275 for color inside.

Tips: "Our magazine design is relaxed, fun, oriented toward people having fun on the water. Style seems to be loosening up. Boating interests remain the same. But for the Chesapeake Bay—water quality and the environment are more important to our readers than in the past. Colors brighter. We like to see samples that show the artist can draw boats and understands our market environment. Send tearsheets or call for an interview—we're always looking. Artist should have some familiarity with the appearance of different types of books."

◩ CHESS LIFE, 3054 NYS Rt. 9W, New Windsor NY 12553. (914)562-8350. Senior Art Director: Jami Anson. Estab. 1939. Official publication of the United States Chess Federation. Contains news of major chess events with special emphasis on American players, plus columns of instruction, general features, historical articles, personality profiles, cartoons, quizzes, humor and short stories. Monthly b&w with 4-color cover. Design is "text-heavy with chess games." Circ. 80,000. Accepts previously published material and simultaneous submissions. Sample copy for SASE with 6 first-class stamps; art guidelines for SASE with first-class postage.

• Also publishes children's magazine, *School Mates*. Same submission guidelines apply.

Cartoons: Approached by 200-250 cartoonists/year. Buys 60-75 cartoons/year. All cartoons must have a chess motif. Prefers single panel with gagline; b&w line drawings. Send query letter with brochure showing art style. Material kept on file or returned by SASE. Reports within 6-8 weeks. Negotiates rights purchased. Pays $25, b&w; $40, color; on publication.

Illustration: Approached by 100-150 illustrators/year. Works with 4-5 illustrators/year from freelancers. Buys 8-10 illustrations/year. Uses artists mainly for covers and cartoons. All must have a chess motif; uses some humorous and occasionally cartoon-style illustrations. "We use mainly b&w." Works on assignment, but will also consider unsolicited work. Send query letter with photostats or original work for b&w; slides for color, or tearsheets to be kept on file. Reports within 2 months. Call to schedule an appointment to show a portfolio, which should include roughs, original/final art, final reproduction/product and tearsheets. Negotiates rights purchased. Pays on publication; $150, b&w cover; $300, color cover; $25, b&w inside; $40, color inside.

Tips: "Include a wide range in your portfolio."

◩ CHIC MAGAZINE, 8484 Wilshire Blvd., Suite 900, Beverly Hills CA 90211. (323)651-5400. Art Director: Nadeen Torio. Estab. 1976. Monthly magazine "which contains fiction and nonfiction; sometimes serious, often humorous. Sex is the main topic, but any sensational subject is possible." Circ. 45,000. Originals returned at job's completion. Sample copies available for $6.

Illustration: Approached by 15 illustrators/year. Buys 2 illustrations/issue. Works on assignment only. Prefers sex/eroticism as themes. Considers all media. Send query letter with tearsheets, photographs and photocopies. Samples are filed. Artist should follow up with call and/or letter after initial query. Publication will contact artist for portfolio review if interested. Portfolio should include b&w and color slides and final art. Buys all rights. **Pays on acceptance;** $500 for color inside. Finds artists through word of mouth, mailers and submissions.

Tips: "We use artists from all over the country, with diverse styles, from realistic to abstract. Must be able to deal with adult subject matter and have no reservations concerning explicit sexual images. We want to show these subjects in new and interesting ways."

◪ CHICKADEE, 179 John St., Suite 500, Toronto, Ontario M5T 3G5 Canada. (416)340-2700. Fax: (416)340-9769. Creative Director: Tim Davin. Estab. 1979. 9 issues/year. Children's discovery magazine. Chickadee is a "hands-on"

science, nature and discovery publication designed to entertain and educate 6-9 year-olds. Each issue contains photos, illustrations, an easy-to-read animal story, a craft project, fiction, puzzles, a science experiment, and a pull-out poster. Circ. 150,000 in North America. Originals returned at job's completion. Sample copies available. Uses all types of conventional methods of illustration. Digital illustrators should be familiar with Adobe Illustrator, CorelDraw or Adobe Photoshop.

• The same company that publishes *Chickadee* now also publishes *Chirp*, a science, nature and discovery magazine for pre-schoolers two to six years old, and *OWL*, a similar publication for children over eight years old.

Illustration: Approached by 500-750 illustrators/year. Buys 3-7 illustrations/issue. Works on assignment only. Prefers animals, children, situations and fiction. All styles, loaded with humor but not cartoons. Realistic depictions of animals and nature. Considers all media and computer art. No b&w illustrations. Send postcard sample, photocopies and tearsheets. Accepts disk submissions compatible with Adobe Illustrator 8.0. Send EPS files. Samples are filed or returned by SASE. Will contact for portfolio review if interested. Portfolio should include final art, tearsheets and photocopies. Buys all rights. Pays within 30 days of invoice; $500 for color cover; $100-750 for color/inside; $100-300 for spots. Finds artists through sourcebooks, word of mouth, submissions as well as looking in other magazines to see who's doing what.

Tips: "Please become familiar with the magazine before you submit. Ask yourself whether your style is appropriate before spending the money on your mailing. Magazines are ephemeral and topical. Ask yourself if your illustrations are: A. editorial and B. contemporary. Some styles suit books or other forms better than magazines." Impress this art director by being "fantastic, enthusiastic and unique."

CHILD LIFE, Children's Better Health Institute, 1100 Waterway Blvd., Box 567, Indianapolis IN 46206. (317)636-8881. Fax: (317)684-8094. Website: http://www.satevepost.org/kidsonline. Art Director: Phyllis Lybarger. Editor: Lise Hoffman. Estab. 1921. 4-color magazine for children 9-11. Monthly, except bimonthly January/February, April/May, July/August and October/November. Sample copy $1.25. Art guidelines for SASE with first-class postage.

• Art Director reports *Child's Life* has gone through a format change from conventional to nostalgic. She is looking for freelancers whose styles lend themselves to a nostalgic look. This publisher also publishes *Children's Digest, Children's Playmate, Humpty Dumpty's Magazine, Jack and Jill, Turtle Magazine* and *U.S. Kids Weekly Reader Magazine.*

Illustration: Approached by 200 illustrators/year. Works with 15 illustrators/year. Buys approximately 20 illustrations/year on assigned themes. Features humorous, realistic, medical, computer and spot illustration. Assigns 50% of illustrations to experienced, but not well-known illustrators; 50% to new and emerging illustrators. Especially needs health-related (exercise, safety, nutrition, etc.) themes, and stylized and realistic styles of children 9-11 years old. Uses freelance art mainly with stories and medical column and activities poems. Send postcard sample or query letter with tearsheets or photocopies. "Please send SASE and comment card with samples." Especially looks for an artist's ability to draw well consistently. Reports in 2 months. Buys all rights. Pays $275 for color cover; $35-90 for b&w inside; $70-155 for color inside; $210-310 for 2-page spreads; $35-80 for spots. Pays within 3 weeks prior to publication date. "All work is considered work for hire." Finds artists through submissions, occasionally through a sourcebook.

Tips: "Artists should obtain copies of current issues to become familiar with our needs. I look for the artist's ability to illustrate children in group situations and interacting with adults and animals, in realistic styles. Also use unique styles for occasional assignments—cut paper, collage or woodcut art. No cartoons, portraits of children or slick airbrushed advertising work."

⟦N⟧ CHILDREN'S PLAYMATE, Children's Better Health Institute, 1100 Waterway Blvd., Box 567, Indianapolis IN 46206. (317)636-8881. Art Director: Chuck Horseman. 4-color magazine for ages 6-8. Special emphasis on entertaining fiction, games, activities, fitness, health, nutrition and sports. Published 8 times/year. Original art becomes property of the magazine and will not be returned. Sample copy $1.25.

• Also publishes *Child Life, Humpty Dumpty's Magazine, Jack and Jill* and *Turtle Magazine.*

Illustration: Uses 25-30 illustrations/issue; buys 10-20 from freelancers. Interested in editorial, medical, stylized, humorous or realistic themes; also food, nature and health. Considers pen & ink, airbrush, charcoal/pencil, colored pencil, watercolor, acrylic, oil, pastel, collage, multimedia and computer illustration. Works on assignment only. Send sample of style; include illustrations of children, families, animals—targeted to children. Provide brochure, tearsheet, stats or good photocopies of sample art to be kept on file. Samples returned by SASE if not filed. Artist should follow up with call or letter. Also considers b&w camera-ready art for puzzles, such as dot-to-dot, hidden pictures, crosswords, etc. Buys all rights on a work-for-hire basis. Payment varies. Pays $275 for color cover; up to $155 for color and $90 for b&w inside, per page.

Tips: Finds artists through artists' submissions/self-promotions. "Become familiar with our magazine before sending anything. Don't send just two or three samples. I need to see a minimum of eight pieces to determine that the artist fits our needs. Looking for samples displaying the artist's ability to interpret text, especially in fiction for ages 6-8. Illustrators must be able to do their own layout with a minimum of direction."

CHRISTIAN HOME & SCHOOL, 3350 E. Paris Ave. SE, Grand Rapids MI 49512. (616)957-1070. Fax: (616)957-5022. E-mail: chrschint@aol.com. Website: http://www.gospel/com.net/csi/chs/. Senior Editor: Roger W. Schmurr. Emphasizes current, crucial issues affecting the Christian home for parents who support Christian education. 4-color maga-

zine; 4-color cover; published 6 times/year. Circ. 65,000. Sample copy for 9×12 SASE with 4 first-class stamps; art guidelines for SASE with first-class postage.

Cartoons: Prefers family and school themes. Pays $50 for b&w.

Illustration: Buys approximately 2 illustrations/issue. Has featured illustrations by Patrick Kelley, Rich Bishop and Pete Sutton. Features humorous, realistic, computer and spot illustration. Assigns 75% of illustrations to experienced, but not well-known illustrators; 25% to new and emerging illustrators. Prefers pen & ink, charcoal/pencil, colored pencil, watercolor, collage, marker and mixed media. Prefers family or school life themes. Works on assignment only. Send query letter with résumé, tearsheets, photocopies or photographs. Show a representative sampling of work. Samples returned by SASE, or "send one or two samples art director can keep on file." Will contact if interested in portfolio review. Buys first rights. Pays on publication; $250 for 4-color full-page inside; $75-125 for spots. Finds most artists through references, portfolio reviews, samples received through the mail and artist reps.

✔ **CHRISTIAN PARENTING TODAY MAGAZINE**, 465 Gunderson Dr., Carol Stream IL 60188-2498. (630)260-6200. Fax: (630)260-0114. E-mail: danacpt@aol.com. Website: http://www.christianparenting.com. Art Director: Cheryl Sorenson. Estab. 1988. Bimonthly 2-color and 4-color consumer magazine featuring advice for Christian parents raising kids. Circ. 90,000.

Illustration: Approached by 100 illustrators/year. Buys 6 illustrations/issue (humorous and spot illustrations). Send postcard or other non-returnable samples or tearsheets. Samples are filed. Will contact artist for portfolio review if interested. Buys first rights and one-time rights. Pays on publication. Pay varies. Finds illustrators through agents, self promos and directories.

CHRISTIAN READER, Dept. AGDM, 465 Gundersen Dr., Carol Stream IL 60188. (630)260-6200. Fax: (630)260-0114. Art Director: Jennifer McGuire. Estab. 1963. Bimonthly general interest magazine. "Stories of faith, hope and God's love." Circ. 175,000. Accepts previously published artwork. Originals returned at job's completion.

Illustration: Works on assignment only. Has featured illustrations by Rex Bohn, Ron Mazellan and Donna Kae Nelson. Features humorous, realistic and spot illustration. Prefers family, home and church life. Considers all media. Samples are filed. Reports back only if interested. To show a portfolio, mail appropriate materials. Buys one-time rights. **Pays on acceptance.**

Tips: "Send samples of your best work, in your best subject and best medium. We're interested in fresh and new approaches to traditional subjects and values."

N **CHRISTIANITY AND THE ARTS MAGAZINE**, Box 118088, Chicago IL 60611. (312)642-8606. Publisher: Marci Whitney-Schenck. Estab. 1993. "*Christianity and the Arts* is a non-profit, quarterly magazine devoted to Christian expression." Circ. 5,000. Sample copy available for $7.

Illustration: Approached by 5 illustrators/year. Buys 6 illustrations/year. Prefers spiritual, Christian themes. Considers all media. Send postcard sample or send query letter with printed samples, photocopies, tearsheets and SASE. Samples are filed or returned by SASE. Reports back within 2 months. Buys one-time rights. **Pays on acceptance**, up to $100.

Tips: "We are a struggling, non-profit magazine. Most of our contributions are donated because of our mission statement."

N **CHRISTIANITY TODAY**, 465 Gundersen Dr., Carol Stream IL 60188. (630)260-6200. Fax: (630)260-0114. E-mail: christerct@aol.com. Art Director: Carla Sonheim. Estab. 1956. Magazine "of thoughtful essays and news reporting on the evangelical Christians around the world." Published 14 times/year. Circ. 170,000.

Cartoons: Approached by 50 cartoonists/year. Buys 1 cartoon/issue. Prefers pen & ink; "must have an understanding of our subculture (evangelical Christian)." Prefers single panel b&w drawings with gagline. Send query letter with photocopies. Samples are filed or returned by SASE. Reports back only if interested. Buys first North American serial rights. **Pays on acceptance**; $25-100 for b&w.

Illustration: Approached by 100s of illustrators/year. Buys 1-4 illustrations/issue. Considers all media. 5% of freelance illustration demands computer knowledge. Send query letter with printed samples or photocopies and SASE. Samples are filed or returned by SASE. Reports back only if interested. Art director will contact artist for portfolio review if interested. Buys first North American serial rights. **Pays on acceptance.**; $500-1,000 for color cover; $200-450 for b&w, $300-700 for color inside. Pays $100-250 for spots.

Tips: "Though it is not necessary to be a Christian, it's very helpful if artists understand our subculture. I look for conceptual artists."

N **THE CHRONICLE OF THE HORSE**, Box 46, Middleburg VA 20118. Editor: John Strassburger. Estab. 1937. Weekly magazine emphasizing horses and English horse sports for dedicated competitors who ride, show and enjoy horses. Circ. 23,500. Sample copy and guidelines available for $2.

Cartoons: Approached by 25 cartoonists/year. Buys 1-2 cartoons/issue. Considers anything about English riding and horses. Prefers single panel b&w line drawings or washes with or without gagline. Send query letter with finished cartoons to be kept on file if accepted for publication. Material not filed is returned. Reports within 4-6 weeks. Buys first rights. Pays on publication $20, b&w.

Illustration: Approached by 25 illustrators/year. "We use a work of art on our cover every week. The work must feature horses, but the medium is unimportant. We do not pay for this art, but we always publish a short blurb on the artist and his or her equestrian involvement, if any." Send query letter with samples to be kept on file until published.

If accepted, insists on high-quality, b&w 8 × 10 photographs of the original artwork. Samples are returned. Reports within 4-6 weeks.

Tips: Does not want to see "current horse show champions or current breeding stallions."

N THE CHURCH HERALD, 4500 60th St. SE, Grand Rapids MI 49512-9642. (616)698-7071. E-mail: chherald@a ol.com. Estab. 1837. Monthly magazine. "The official denominational magazine of the Reformed Church in America." Circ. 110,000. Accepts previously published artwork. Originals returned at job's completion. Sample copies available for $2. Open to computer-literate freelancers for illustration.

Illustration: Buys up to 2 illustrations/issue. Works on assignment only. Considers pen & ink, watercolor, collage, marker and pastel. Send postcard sample with brochure. Accepts disk submissions compatible with Adobe Illustrator 5.0 or Adobe Photoshop 3.0. Send EPS files. Also may submit via e-mail. Samples are filed. Reports back to the artist only if interested. Portfolio review not required. Buys one-time rights. Pays on publication; $300 for color cover; $75 for b&w, $125 for color inside.

CICADA, 329 E St., Bakersfield CA 93304. (805)323-4064. Editor: Frederick Raborg. Estab. 1984. A quarterly literary magazine "aimed at the reader interested in haiku and fiction related to Japan and the Orient. We occasionally include excellent Chinese and other Asian poetry forms and fiction so related." Circ. 600. Accepts previously published artwork. Originals returned at job's completion. Sample copies available for the cost of $4.95. Art guidelines for SASE with first-class postage.

Cartoons: Approached by 50-60 cartoonists/year. Buys 2 cartoons/issue. Prefers the "philosophically or ironically funny. Excellent cartoons without gaglines occasionally used on cover." Prefers single panel b&w washes and line drawings with or without gagline. Send good photocopies of finished cartoons. Samples are filed or returned by SASE. Reports back within 2 months. Buys first rights. **Pays on acceptance;** $10 for b&w; $15 if featured.

Illustration: Approached by 150-175 illustrators/year. Buys 2 illustrations/issue. Prefers Japanese or Oriental, nature themes in pen & ink. Send query letter with photostats of finished pen & ink work. Samples are filed or returned by SASE. Reports back within 2 months. Buys first rights and one-time rights. Pays $15-20 for b&w cover; $10 for b&w inside. Pays on publication for most illustrations "because they are dictated by editorial copy." Finds artists through market listings and submissions.

CINCINNATI MAGAZINE, 705 Central Ave., Suite 370, Cincinnati OH 45202. (513)421-4300. E-mail: colleen@cint imag.emmis.com. Art Director: Colleen Lanchester. Estab. 1960. Monthly 4-color lifestyle magazine for the city of Cincinnati. Circ. 30,000. Accepts previously published artwork. Original artwork returned at job's completion.

- This magazine has been recently redesigned (June 1998). It now has new ownership, new staff and is taking a new direction from past editions.

Illustration: Approached by 20 illustrators/year. Has featured illustrations by Rowan Barnes-Murphy and C.F. Payne. Works on assignment only. Send postcard samples. Samples are filed or returned by SASE. Reports back only if interested. Buys one-time rights or reprint rights. Pays on publication; $200-800 for features; $40-150 for spots.

Tips: Prefers traditional media with an interpretive approach. No cartoons or mass-market computer art, please.

N CINEFANTASTIQUE, Box 270, Oak Park IL 60303. (708)366-5566. Fax: (708)366-1441. Editor-in-Chief: Frederick S. Clarke. Monthly magazine emphasizing science fiction, horror and fantasy films for "devotees of 'films of the imagination.' " Circ. 80,000. Original artwork not returned. Sample copy $8.

Illustration: Uses 1-2 illustrations/issue. Interested in "dynamic, powerful styles, though not limited to a particular look." Works on assignment only. Send query letter with résumé, brochure and samples of style to be kept on file. Samples not returned. Reports in 3-4 weeks. Buys all rights. Pays on publication; $150 maximum for inside b&w line drawings and washes; $600 maximum for cover color washes; $150 maximum for inside color washes.

CIRCLE K MAGAZINE, 3636 Woodview Trace, Indianapolis IN 46268. (317)875-8755. Fax: (317)879-0204. Art Director: Dianne Bartley. Estab. 1968. Kiwanis International's youth magazine for college-age students emphasizing service, leadership, etc. Published 5 times/year. Circ. 12,000. Originals and sample copies returned to artist at job's completion.

Illustration: Approached by more than 30 illustrators/year. Buys 1-2 illustrations/issue. Works on assignment only. Needs editorial illustration. "We look for variety." Send query letter with photocopies, photographs, tearsheets and SASE. Samples are filed. Will contact for portfolio review if interested. Portfolio should include tearsheets and slides. **Pays on acceptance;** $100 for b&w cover; $250 for color cover; $50 for b&w inside; $150 for color inside.

⊕ CLASSIC CD, Future Publishing, 30 Monmouth St., Bath BA1 2BW UK. Phone: 01225 442244. Fax: 01225 732 396. Art Director: David Eachus. Estab. 1990. Monthly 4-color consumer magazine to help introduce new listeners to classical music. Circ. 40,000.

Illustration: Approached by 30 illustrators/year. Buys 3 illustrations/issue. Has featured illustrations by Andrew Kingham, Chris Burke, Jake Abrahms. Features caricatures of celebrities, computer, realistic and abstract illustrations. Preferred subjects: composers, history. Assigns 80% of illustrations to well-known or "name" illustrators; 10% to experienced, but not well-known illustrators; 10% to new and emerging illustrators. Send postcard sample and follow-up postcard every 3 months. Accepts Mac-compatible disk submissions. Samples are filed. Will contact artist for portfolio review if interested. Buys one-time rights. Pays on publication; $200-350 for color cover; $100-300 for color inside;

$450 maximum for 2-page spreads. Finds illustrators through postcards, samples, other magazines.

Tips: "I look for 100% confidence and strong well-defined images, whether abstract, montage or realistic. A good striking sense of color and an obvious understanding of the brief must reflect within the finished piece. Finally, I am attracked to originality."

CLEANING BUSINESS, Box 1273, Seattle WA 98111. (206)622-4241. Fax: (206)622-6876. E-mail: wgriffin@cleaningconsultants.com. Website: http://www.cleaningconsultants.com. Publisher: Bill Griffin. Submissions Editor: Jeff Warner. Monthly magazine with technical, management and human relations emphasis for self-employed cleaning and maintenance service contractors. Circ. 6,000. Prefers first publication material. Simultaneous submissions OK "if to noncompeting publications." Original artwork returned after publication if requested by SASE. Sample copy $3.

Cartoons: Buys 1-2 cartoons/issue. Must be relevant to magazine's readership. Prefers b&w line drawings.

Illustration: Buys approximately 12 illustrations/year including some humorous and cartoon-style illustrations. Send query letter with samples. "*Don't* send samples unless they relate specifically to our market." Samples returned by SASE. Buys first publication rights. Reports only if interested. Pays for illustration by project $3-15. Pays on publication.

Tips: "Our budget is extremely limited. Those who require high fees are really wasting their time. We are interested in people with talent and ability who seek exposure and publication. Our readership is people who work for and own businesses in the cleaning industry, such as maid services; janitorial contractors; carpet, upholstery and drapery cleaners; fire, odor and water damage restoration contractors; etc. If you have material relevant to this specific audience, we would definitely be interested in hearing from you. We are also looking for books, games, videos, software, books and reports related to our specialized subject matter."

THE CLERGY JOURNAL, 6160 Carmen Ave. E., , Inver Grove Heights MN 55076. (651)451-9945. Fax: (651)457-4617. Assistant Editor: Sharilyn Figuerola. Art Director: Doug Thron. Magazine for professional clergy and church business administrators; b&w with 4-color cover. Monthly (except June and December). Circ. 10,000. Original artwork returned after publication if requested.

Cartoons: Buys 4 single panel cartoons/issue from freelancers on religious themes. Send SASE. Reports in 2 months. Pays $40-75; on publication.

CLEVELAND MAGAZINE, Dept. AGDM, 1422 Euclid Ave., Suite 730, Cleveland OH 44115. (216)771-2833. Fax: (216)781-6318. E-mail: information@clevelandmagazine.com. Contact: Gary Sluzewski. Monthly city magazine, b&w with 4-color cover, emphasizing local news and information. Circ. 45,000.

Illustration: Approached by 100 illustrators/year. Buys 3-4 editorial illustrations/issue on assigned themes. Sometimes uses humorous illustrations. 40% of freelance work demands knowledge of QuarkXPress, Aldus FreeHand or Adobe Photoshop. Send postcard sample with brochure or tearsheets. Accepts disk submissions. Please include application software. Call or write for appointment to show portfolio of printed samples, final reproduction/product, color tearsheets and photographs. Pays $300-700 for color cover; $75-200 for b&w inside; $150-400 for color inside; $75-150 for spots.

Tips: "Artists used on the basis of talent. We use many talented college graduates just starting out in the field. We do not publish gag cartoons but do print editorial illustrations with a humorous twist. Full-page editorial illustrations usually deal with local politics, personalities and stories of general interest. Generally, we are seeing more intelligent solutions to illustration problems and better techniques. The economy has drastically affected our budgets; we pick up existing work as well as commissioning illustrations."

☑ **COBBLESTONE, DISCOVER AMERICAN HISTORY,** Cobblestone Publishing, Inc., 30 Grove St., Suite C, Peterborough NH 03458. (603)924-7209. Fax: (603)924-7380. E-mail: ann_dillon@prenhall.com. Website: http://www.cobblestonepub.com. Art Director: Ann Dillon. Managing Editor: Lou Waryncia. Monthly magazine emphasizing American history; features nonfiction, supplemental nonfiction, fiction, biographies, plays, activities and poetry for children ages 8-14. Circ. 38,000. Accepts previously published material and simultaneous submissions. Sample copy $4.95 with 8×10 SASE; art guidelines for SASE with first-class postage. Material must relate to theme of issue; subjects and topics published in guidelines for SASE. Freelance work demands knowledge of Adobe Illustrator, Adobe Photoshop and QuarkXPress..

● Other magazines published by Cobblestone include *Calliope* (world history), *Faces* (cultural anthropology), *California Chronicles* (California history), *Footsteps* (African American history), *Odyssey* (science), all for kids ages 8-15, and *Appleseeds*, for ages 7-9.

Illustration: Buys 2-5 illustrations/issue. Prefers historical theme as it pertains to a specific feature. Works on assignment only. Has featured illustrations by Annette Cate, Tony Anthony, Tim Foley, Richard Schlecht, Mark James, Wenhai Ma, Rich Harrington and Cheryl Jacobsen. Features caricatures of celebrities and politicians, humorous, realistic illustration, informational graphics, computer and spot illustration. Assigns 33% of illustrations to well-known or "name" illustrators; 33% to experienced, but not well-known illustrators; 33% to new and emerging illustrators. Send query letter with brochure, résumé, business card and b&w photocopies or tearsheets to be kept on file or returned by SASE. Write for appointment to show portfolio. Buys all rights. Pays on publication; $20-125 for b&w inside; $40-225 for color inside. Artists should request illustration guidelines.

Tips: "Study issues of the magazine for style used. Send samples and update samples once or twice a year to help keep your name and work fresh in our minds. Send non-returnable samples we can keep on file—we're always interested in widening our horizons."

[N] COMBAT AIRCRAFT: The International Journal of Military Aviation, 10 Bay St., Westport CT 06880. (203)838-7979. Fax: (203)838-7344. E-mail: avmags@aol.com. Website: http://www.airpower.co.uk. Art Director: Zaur Eylanbekov. Managing Editor: Natalie Raccor. Estab. 1997. 4-color consumer magazine with 8 issues/year. Military aviation magazine with a focus on modern-day topics. Circ. 30,000.
Illustration: Approached by 25 illustrators/year. Buys 2 illustrations/issue. Has featured illustrations by Mark Styling, James Dietz, Ian Wyllie and Walter Wright. Features computer illustration and technical 3-views. Preferred subject: aviation. Prefers technical line drawings and accurate representations of aircraft. Assigns 33% of illustrations each to well-known or "name" illustrators; experienced, but not well-known, illustrators; and new and emerging illustrators. Send query letter with printed samples. Accepts Mac-compatible disk submissions. Send EPS or TIFF files. Samples are filed. Reports back within 1 month. Will contact artist for portfolio review if interested. Buys one-time rights. Pays $40-100 for color cover; $20 for color inside. Finds illustrators through artists' promotional samples.
Tips: "Please do not call with descriptions of your work; send us the samples first."

[N] COMMON GROUND, Box 34090, Station D, Vancouver, British Columbia V6J 4M1 Canada. (604)733-2215. Fax: (604)733-4415. Contact: Art Director. Estab. 1982. 12 times/year consumer magazine and holistic personal resource directory. Accepts previously published artwork. Original artwork is returned at job's completion. Sample copies for SASE with first-class Canadian postage or International Postage Certificate.
Illustration: Approached by 20-40 freelance illustrators/year. Buys 1-2 freelance illustrations/issue. Prefers all themes and styles. Considers pen & ink, watercolor, collage and marker. Send query letter with brochure, photographs, SASE and photocopies. Samples are filed or are returned by SASE if requested by artist. Reports back to the artist only if interested. Buys one-time rights. Payment varies; on publication.
Tips: "Send photocopies of your top one-three inspiring works in black & white or color. Can have all three on one sheet of 8½×11 paper or all in one color copy. I can tell from that if I am interested."

[N] COMMONWEAL, 475 Riverside Dr., Room 405, New York NY 10115. (212)662-4200. Website: http://www.commonwealmagazine.org. Editor: Margaret O'Brien Steinfels. Business Manager: Gregory Wilpert. Estab. 1924. Public affairs journal. "Journal of opinion edited by Catholic lay people concerning public affairs, religion, literature and all the arts"; b&w with 2-color cover. Biweekly. Circ. 18,000. Original artwork is returned at the job's completion. Sample copies for SASE with first-class postage. Guidelines for SASE with first-class postage.
Cartoons: Approached by 20-40 cartoonists/year. Buys 3-4 cartoons/issue from freelancers. Prefers simple lines and high-contrast styles. Prefers single panel, with or without gagline; b&w line drawings. Send query letter with finished cartoons. Samples are filed or are returned by SASE if requested by artist. Reports back within 2 weeks. Buys first rights. Pays $8.50 for b&w.
Illustration: Approached by 20 illustrators/year. Buys 3-4 illustrations/issue, 60/year from freelancers. Assigns 80% of illustrations to experienced, but not well-known illustrators; 20% to new and emerging illustrators. Prefers high-contrast illustrations that "speak for themselves." Prefers pen & ink and marker. Send query letter with tearsheets, photographs, SASE and photocopies. Samples are filed or returned by SASE if requested by artist. Reports back within 2 weeks. To show a portfolio, mail b&w tearsheets, photographs and photocopies. Buys first rights. Pays $25 for b&w cover; $10 for b&w inside on publication.

COMMUNICATION WORLD, One Hallidie Plaza, Suite 600, San Francisco CA 94102. (415)433-3400. E-mail: ggordon@iahc.com. Website: http://www.iabc.com. Editor: Gloria Gordon. Emphasizes communication, public relations for members of International Association of Business Communicators: corporate and nonprofit businesses, hospitals, government communicators, universities, etc. who produce internal and external publications, press releases, annual reports and customer magazines. Published 8 times/year. Circ. 18,000. Accepts previously published material. Original artwork returned after publication. Art guidelines available for SASE with first-class postage.
Cartoons: Approached by 6-10 cartoonists/year. Buys 6 cartoons/year. Considers public relations, entrepreneurship, teleconference, editing, writing, international communication and publication themes. Prefers single panel with gagline; b&w line drawings or washes. Send query letter with samples of style to be kept on file. Material not filed is returned by SASE only if requested. Reports within 2 months only if interested. To show portfolio, write or call for appointment. Buys first rights, one-time rights or reprint rights; negotiates rights purchased. Pays on publication; $25-50, b&w.
Illustration: Approached by 20-30 illustrators/year. Buys 6-8 illustrations/issue. Features humorous and realistic illustration; informational graphics; computer and spot illustration. Assigns 25% of illustrations to well-known or "name"

illustrators; 40% to experienced but not well-known illustrators; 35% to new and emerging illustrators. Theme and style are compatible to individual article. Send query letter with samples to be kept on file. To show a portfolio, write or call for appointment. Accepts tearsheets, photocopies or photographs as samples. Samples not filed are returned only if requested. Reports back within 1 year only if interested. To show a portfolio, write or call for appointment. Buys first rights, one-time rights or reprint rights; negotiates rights purchased. Pays on publication; $300 for b&w cover; $200-500 for color cover; $200 for b&w or color inside; $350 for 2-page spreads; $200 for spots..

Tips: Sees trend toward "more sophistication, better quality, less garish, glitzy—subdued, use of subtle humor."

N COMPUTER CURRENTS, 1250 Ninth St., Berkley CA 94710-1546. E-mail: editorial@comcurr.com. Website: http://www.currents.net. Art Director: Robert Luhn. National computing magazine that delivers how to buy, where to buy, and how to use editorial for PC and Mac business users. Emphasis is on reviews, how-tos, tutorials, investigative pieces, and more. Current slant is heavy on intranet, e-commerce, and Internet topics. Published twice a month in the San Francisco Bay Area; monthly in Los Angeles, Boston, Atlanta, Houston, Chicago and Dallas/Ft. Worth. Considers previously published material. Original artwork is returned to the artist after publication. Art guidelines free for SASE with first-class postage and available on website.

Illustration: Buys 24 cover illustrations/year in both digital and traditional form. Has featured illustrations by Mel Lindstrom, David Bishop, Steven Campbell. Assigns 30% of illustrations to well-known or "name" illustrators; 60% to experienced but not well-known illustrators; 10% to new and emerging illustrators. Send query letter with samples, tearsheets, or color photocopies that we can keep on file. Reports back if interested. Rights revert to artist. Pays $800-1,000 for covers.

Tips: "We're looking for experienced, professional artists that can work with editorial and deliver art to spec and on time. We're especially interested in artists with a distinct style who can work without constant supervision. Traditional layout and design experience a plus."

✓ CONDÉ NAST TRAVELER, 4 Times Square, New York NY 10036. (212)880-2142. Fax: (212)880-2190. Design Director: Robert Best. Estab. 1987. Monthly travel magazine with emphasis on "truth in travel." Geared toward upper income 40-50 year olds with time to spare. Circ. 1 million. Originals are returned at job's completion. Freelance work demands knowledge of QuarkXPress, Adobe Illustrator and Adobe Photoshop.

Illustration: Approached by 5 illustrators/week. Buys 5 illustrations/issue. Works on assignment only. Considers pen & ink, collage, oil and mixed media. Send query letter with tearsheets. Samples are filed. Does not report back, in which case the artist should wait for assignment. To show a portfolio, mail b&w and color tearsheets. Buys first rights. Pays on publication; fees vary according to project.

✓ CONNECTIONS, WINGTIPS, AIRWAVES, (formerly *OutPosts, WingTips, Coastines*), 3000 Second St. N., Minneapolis MN 55411-1608. (612)520-2437. Fax: (612)588-8783. E-mail: b.kraft@graf-x.net. Art Director: Bruce Kraft. Bimonthly magazines. Circ. 500,000. Sample copies and art guidelines available.

● All three are inflight magazines for Comair and ASA (both Delta Connections).

Cartoons: Approached by 10-15 cartoonists/year. Buys 2-3 cartoons/year. Prefers humor, political cartoons. Prefers single panel, political and humorous, color washes. Send query letter with photocopies and roughs. Samples are filed or returned. Reports back in 2 weeks. Buys all rights. **Pays on acceptance**; $50-250.

Illustration: Approached by 10 illustrators/year. Buys 10-15 illustrations/year. Prefers political, humor, trend issues. Considers all media. 50% of freelance illustration demands knowledge of Adobe Photoshop, Adobe Illustrator, QuarkXPress and Painter. Send postcard sample or query letter with printed samples and photocopies. After initial mailing, send follow-up postcard sample every 2-3 months. Accepts disk submissions. "We are Mac compatible and have the most updated versions of the programs." Samples are filed or returned. Reports back within 2-3 weeks. Request portfolio review in original query. Art director will contact artist for portfolio review of b&w and color thumbnails and transparencies if interested. Buys all rights. Pays on publication. Pays $50-250. Finds illustrators through word of mouth.

Tips: "See the magazines. We will often base an article on good art or ideas."

N CONSTRUCTION EQUIPMENT OPERATION AND MAINTENANCE, Construction Publications, Inc., Box 1689, Cedar Rapids IA 52406. (319)366-1597. E-mail: ckparks@constpub.com. Editor-in-Chief: C.K. Parks. Estab. 1948. Bimonthly b&w tabloid with 4-color cover. Concerns heavy construction and industrial equipment for contractors, machine operators, mechanics and local government officials involved with construction. Circ. 67,000. Original artwork not returned after publication. Free sample copy.

Cartoons: Buys 8-10 cartoons/issue. Interested in themes "related to heavy construction industry" or "cartoons that make contractors and their employees 'look good' and feel good about themselves"; single panel. Send finished cartoons and SASE. Reports within 2 weeks. Buys all rights, but may reassign rights to artist after publication. Pays $25 for b&w. Reserves right to rewrite captions.

CONSUMERS DIGEST, 8001 N. Lincoln Ave., 6th Floor, Skokie IL 60077. (847)763-9200. E-mail: bceisel@consumersdigest.com. Corporate Art Director: Beth Ceisel. Estab. 1961. Frequency: Bimonthly consumer magazine offering "practical advice, specific recommendations, and evaluations to help people spend wisely." Circ. 1,100,000. Art guidelines available.

Illustration: 75% of freelance illustration demands knowledge of Aldus FreeHand, Adobe Photoshop, Adobe Illustrator. Send postcard sample or query letter with printed samples, tearsheets. Accepts disk submissions compatible with Macin-

tosh System 8.0. Samples are filed or are returned by SASE. Reports back only if interested. Portfolio dropoffs are departmentally reviewed on the second Monday of each month and returned in the same week. Buys first rights. **Pays on acceptance**, $400 minimum for b&w inside; $300-1,000 for color inside; $300-400 for spots. Finds illustrators through *American Showcase* and *Workbook*, submissions and other magazines.

☑ **CONTACT PUBLICATIONS**, (formerly *Contact Advertising*), Box 3431, Ft. Pierce FL 34948. (561)464-5447. E-mail: nietzche@cadv.com. Website: http://www.cadv.com. Editor: Herman Nietzche. Estab. 1971. Publishes 26 national and regional magazines and periodicals covering adult-oriented subjects and alternative lifestyles. Circ. 1 million. Sample copies available. Art guidelines for SASE with first-class postage.
- Some titles of publications are *Swingers Today* and *Swingers Update*. Publishes cartoons and illustrations (not necessarily sexually explicit) which portray relationships of a non-traditional number of partners.

Cartoons: Approached by 9-10 cartoonists/year. Buys 3-4 cartoons/issue. Prefers sexually humorous cartoons. Send query letter with finished cartoons. Samples are filed or returned by SASE if requested by artist. Reports back within 30 days. Rights purchased vary according to project. Pays $15 for b&w.

Illustration: Approached by 9-10 illustrators/year. Buys 2-4 illustrations/issue. Has featured illustrations by Bill Ward, Larry Loper, Dan Rosandich and Gary Roberts. Prefers pen & ink drawings to illustrate adult fiction. Send query letter with photocopies and SASE. Accepts ASCII formatted disk submissions. Samples are filed or are returned by SASE. Reports back within 30 days. Will contact for portfolio review if interested. Portfolio should include final art. Rights purchased vary. Pays $15-35 for b&w. Finds artists through word of mouth, referrals and submissions.

Tips: "Meet the deadline."

☑ **CONTRACT PROFESSIONAL**, 125 Walnut St., Watertown MA 02472. (617)926-7077. Fax: (617)926-7013. Website: http://www.cpuniverse.com. Art Director: Bryan Carden. Estab. 1996. Published 10 times/year. 4-color consumer magazine for I.T. workers ("computer geeks") who work on a contract basis. Circ. 50,000.
- Also publishes *Business Ingenuity*.

Cartoons: Approached by 0-2 cartoonists/year. Buys 6 cartoons/year. Prefers humorous color washes. Send query letter with color photocopies and tearsheets. Samples are filed. Reports back only if interested. Buys one-time rights or rights purchased vary according to project. Pays on publication.

Illustration: Approached by 10 illustrators/year. Buys 1 illustration/issue. "Hoping to purchase more in future." Features charts & graphs, computer and humorous illustration, informational graphics and spot illustrations of business subjects. Send query letter with printed samples. Accepts Mac-compatible disk submissions. Samples are filed. Will contact artist for portfolio review if interested. Buys one-time rights. Pays on publication. Finds illustrators online and through promotional samples.

Tips: "Both magazines are fairly conservative. I find sometimes we like to stick with that approach, but often we need humor to affect it."

COOK COMMUNICATIONS MINISTRIES, 4050 Lee Vance View, Colorado Springs CO 80918. Design Manager: Scot McDonald. Publisher of teaching booklets, take home papers, visual aids and filmstrips for Christians, "all age groups." Art guidelines available for SASE with first-class postage.

Illustration: Buys about 10 full-color illustrations/month. Has featured illustrations by Richard Williams, Chuck Hamrick, Ron Diciani. Assigns 20% of illustrations to well-known or "name" illustrators; 75% to experienced, but not well-known illustrators; 5% to new and emerging illustrators. Features realistic illustration; Bible illustration; computer and spot illustration. Send tearsheets, color photocopies of previously published work; include self-promo pieces. No samples returned unless requested and accompanied by SASE. Works on assignment only. **Pays on acceptance**: $400-700 for color cover; $150-250 for b&w inside; $250-400 for color inside; $500-800 for 2-page spreads; $10-50 for spots. Considers complexity of project, skill and experience of artist and turnaround time when establishing payment. Buys all rights..

Tips: "We do not buy illustrations or cartoons on speculation. We welcome those just beginning their careers, but it helps if the samples are presented in a neat and professional manner. Our deadlines are generous but must be met. We send out checks as soon as final art is approved, usually within two weeks of our receiving the art. We want art radically different from normal Sunday School art. Fresh, dynamic, the highest of quality is our goal; art that appeals to preschoolers to senior citizens; realistic to humorous, all media."

COPING WITH CANCER, (formerly *Coping*), P.O. Box 682268, Franklin TN 37068. (615)790-2400. Fax: (615)794-0179. Editor: Kay Thomas. Estab. 1987. "*Coping with Cancer* is a bimonthly, nationally-distributed consumer magazine dedicated to providing the latest oncology news and information of greatest interest and use to its readers. Readers are cancer survivors, their loved ones, support group leaders, oncologists, oncology nurses and other allied health professionals. The style is very conversational and, considering its sometimes technical subject matter, quite comprehensive to the layman. The tone is upbeat and generally positive, clever and even humorous when appropriate, and very credible." Circ. 80,000. Accepts previously published artwork. Originals returned at job's completion. Sample copy available for $3. Art guidelines for SASE with first-class postage.
- All writers and artists who contribute to this publication volunteer their services without pay for the benefit of cancer patients, their loved ones and caregivers.

▼ CORPORATE REPORT, 105 S. Fifth St., Suite 100, Minneapolis MN 55402-9018. (612)338-4288. Fax: (612)373-0195. E-mail: jonathanh@corpreport.com. Website: http://www.corpreport.com. Art Director: Jonathan Hankin. Estab. 1969. Monthly magazine covering statewide business news for a consumer audience. Circ. 18,000. Samples available.

• *Corporate Report* won a gold award for best feature design at *Folio: Magazine*'s Ozzie awards. The magazine also won several awards for both design and editorial at the Association of Area Business Publications and the Minnesota Magazine Publishers Association. Also publishes *Ventures* magazine.

Illustration: Approached by 50 illustrators/year. Buys 2 illustrations/issue. Has featured illustrations by Victor GAD, Chuck Nendza, Joe Sorren, Darren Thompson and Jeff Tolbert. Assigns 70% of illustrations to experienced, but not well-known illustrators; 30% to new and emerging illustrators. Prefers strong graphical content; business metaphors and editorial themes. Considers all media. Send postcard sample. After initial mailing, send follow-up postcard sample every 2 months. "We will accept work compatible with QuarkXPress 4.0, Adobe Illustrator 8.0, Adobe Photoshop 5.0." Samples are filed. Reports back only if interested. To arrange portfolio review artist should follow-up with call after initial query. Portfolio should include b&w, color roughs, slides, tearsheets and transparencies. Buys one-time rights. **Pays on acceptance**; $600-1,200 for b&w and color cover; $200-600 for b&w and color inside; $100-150 for spots. Finds illustrators through agents, submissions, creative sourcebooks, magazines.

Design: Needs freelancers for production. Prefers local designers with experience in QuarkXPress magazine publication. 100% of freelance work demands knowledge of Adobe Photoshop 5.0, Adobe Illustrator 8.0, QuarkXPress 4.0. Send query letter with printed samples.

Tips: "I like work which has strong graphic qualities and a good sense of mood and color. Develop a consistent style and present work in a professional manner. Too many different styles are confusing; I like to know what to expect from an artist. The main advice I have for an illustrator trying to get work from *Corporate Report* is 'look at our publication.' I get many promo pieces from artists whose work doesn't fit our design."

ℕ COUNTRY FOLK MAGAZINE, (formerly *Writer's Guidelines: A Roundtable for Writers and Editors*), HCC 77 Box 608, Pittsburg MO 65724. Managing Editor: Susan Salaki. Estab. 1994. Magazine "capturing the history of the Ozark region of Missouri." Circ. 5,000. Sample copies available for $4. Art guidelines available for SASE with first-class postage.

Cartoons: Buys 2 cartoons/issue. All cartoons should reflect the theme of "writers seeking publication" or "country life." Prefers single panel b&w line drawings with gagline. (Send photocopies only.) Reports back within 1 month. Buys one-time rights. Pays up to $5 for quality cartoons.

Tips: "Most of the work we publish is written by older men and women who have heard stories from their parents and grandparents about how the Ozark region was settled in the 1800s. Our readers are country people—not hillbillies. Cartoons should reflect that difference. We never purchase cartoons that ridicule anyone or any type of person."

ℕ THE COVENANT COMPANION, 5101 N. Francisco Ave., Chicago IL 60625. (773)784-3000. Editor: Jane K. Swanson-Nystrom. Art Director: David Westerfield. E-mail: covcom@compuserve.com. Monthly b&w magazine with 4-color cover emphasizing Christian life and faith. Circ. 18,000. Original artwork returned after publication if requested. Sample copy $2.25. Freelancers should be familiar with Aldus PageMaker and CorelDraw. Art guidelines available.

Cartoons: Needs cartoons with contemporary Christian themes—church life, personal life, theology. Pays $15 for b&w.

Illustration: Uses b&w drawings or photos about Easter, Advent, Lent and Christmas. Works on submission only. Write or submit art 10 weeks in advance of season. Send query letter with brochure, photocopies, photographs, slides, transparencies and SASE. Reports "within a reasonable time." Pays 1 month after publication; $75 for color cover; $25 for b&w, $50 for color inside. More photos than illustrations.

Tips: "We usually have some rotating file, if we are interested, from which material may be selected. Submit copies/photos, etc. which we can hold on file."

CRAFTS 'N THINGS, 2400 Devon, Suite 375, Des Plaines IL 60018-4618. (847)635-5800. Fax: (847)635-6311. President and Publisher: Marie Clapper. Estab. 1975. General crafting magazine published 10 times yearly. Circ. 305,000. Originals returned at job's completion. Sample copies available. Art guidelines for SASE with first-class postage.

• *Crafts 'n Things* is a "how to" magazine for crafters. The magazine is open to crafters submitting designs and step-by-step instruction for projects such as Christmas ornaments, cross-stitched pillows, stuffed animals and quilts. They do not buy cartoons and illustrations.

Design: Needs freelancers for design. Send query letter with photographs. Pays by project $50-300. Finds artists through submissions.

Tips: "Our designers work freelance. Send us photos of your *original* craft designs with clear instructions. Skill level should be beginning to intermediate. We concentrate on general crafts and needlework. Call or write for submission guidelines."

CRICKET, Box 300, Peru IL 61354. Senior Art Director: Ron McCutchan. Estab. 1973. Monthly magazine emphasizes children's literature for children ages 10-14. Design is fairly basic and illustration-driven; full-color with 2 basic text styles. Circ. 78,000. Original artwork returned after publication. Sample copy $4; art guidelines for SASE with first-class postage.

Cartoons: "We rarely run cartoons, but we are beginning to look at wordless ½ page (4½ × 6½ dimension) cartoons—1-3 panels; art styles should be more toward children's book illustration."

Illustration: Approached by 800-1,000 illustrators/year. Works with 75 illustrators/year. Buys 600 illustrations/year. Has featured illustrations by Alan Marks, Trina Schart Hyman, Kevin Hawkes and Deborah Nourse Lattimore. Features humorous, realistic and spot illustration. Assigns 25% of illustrations to well-known or "name" illustrators; 50% to experienced, but not well-known illustrators; 25% to new and emerging illustrators. Needs editorial (children's) illustration in style of Trina Schart Hyman, Charles Mikolaycak, Troy Howell, Janet Stevens and Quentin Blake. Uses artists mainly for cover and interior illustration. Prefers realistic styles (animal or human figure). Works on assignment only. Send query letter with SASE and samples to be kept on file, "if I like it." Prefers photocopies and tearsheets as samples. Samples not kept on file are returned by SASE. Reports within 4-6 weeks. Does not want to see "overly slick, cute commercial art (i.e., licensed characters and overly sentimental greeting cards)." Buys reprint rights. Pays 45 days from receipt of final art; $750 for color cover; $50-150 for b&w inside; $75-250 for color inside; $250-350 for 2-page spreads; $50-75 for spots.

Tips: "We are trying to focus *Cricket* at a slightly older, preteen market. Therefore we are looking for art that is less sweet and more edgy and funky. Since a large proportion of the stories we publish involve people, particularly children, *please* try to include several samples with *faces* and full figures in an initial submission (that is, if you are an artist who can draw the human figure comfortably). It's also helpful to remember that most children's publishers need artists who can draw children from many different racial and ethnic backgrounds. Know how to draw the human figure from all angles, in every position. Send samples that tell a story (even if there is no story); art should be intriguing."

CURIO, 81 Pondfield Rd., Suite 264, Bronxville NY 10708. (914)961-8649. Fax: (914)779-4033. E-mail: qenm20b@pr odigy.com. Art Director: Michael G. Stonoha. Estab. 1996. Quarterly 4-color magazine "best described as a salon; a place where people come to exchange ideas." Audience age 25-35 urban professionals with artistic tendencies. Circ. 50,000. Sample copies for $6. Guidelines free for #10 SASE.

Cartoons: Approached by 200 cartoonists/year. Buys 10 cartoons/year. Prefers single panel, political, humorous b&w line drawings. Send b&w, color photocopies and SASE. Samples are filed. Reports back within 3 months if interested. Buys first rights, first North American serial rights; negotiable. Pays on publication in contributor copies or rates up to $140/page.

Illustration: Approached by 300 illustrators/year. Buys 20 illustrations/issue. Prefers to work with students for illustration. Features caricatures of celebrities and politicians, charts & graphs, computer, fashion and humorous illustration, informational graphics, realistic and spot illustrations. Prefers 4-color. Assigns 20% to experienced, but not well-known illustrators; 80% to new and emerging illustrators. 50% of freelance illustration demands knowledge of Adobe Illustrator, Adobe Photoshop, Aldus FreeHand, QuarkXPress. Send postcard sample and follow-up postcard every 3 months. Accepts Mac-compatible disk submissions. Send EPS files. Samples are filed. Reports back only if interested. Negotiates rights purchased. Pays on publication: $140-350 for b&w cover; $140-500 for color cover; pays in contributor copies or rates up to $140 for inside art. Finds illustrators through promotional samples, word of mouth, art fairs and visits to art schools throughout the country.

Tips: "*Curio* provides two to four pages to illustrators to design illustration essays based on our theme issues. The essays may be travelogues as appeared in our August 1996 issue, or personal essays that portray 'a simple celebration of the illustrator's work.' The pay is a $100 flat fee, but the 4 pages are yours!"

CURRICULUM VITAE, Grove City Factory Stores, P.O. Box 1309, Grove City PA 16127. E-mail: simpub@hotmail.c om. Website: http://www.geocities.com/SOHO/CAFE/2550. Editor: Michael Dittman. Estab. 1995. Biannual literary magazine. "We're a Gen-X magazine dedicated to intellectual discussion of pop culture in a satirical vein." Circ. 2,500. Sample copies available for $4 (includes postage). Art guidelines available on website or for #10 SASE with first-class postage.

Cartoons: Approached by 50 cartoonists/year. Buys 5 cartoons/year. Prefers satirical but smart (not *New Yorker*) style. Must be topical but timeless, twisted also works." Prefers single, double, or multiple panel, political and humorous, b&w washes or line drawings, with or without gaglines. Send query letter with photocopies and SASE. Samples are filed or returned by SASE. Reports back in 2 months. Negotiates rights purchased. Pays on publication; $5-25.

Illustration: Approached by 75 illustrators/year. Buys 5 illustrations/year. Has featured illustrations by Jason McElwain and Allison McDonald. Features realistic illustration. Assigns 50% of illustrations to experienced, but not well-known illustrators; 50% to new and emerging illustrators. Open to all themes and styles. Considers all media. Send query letter with photocopies and SASE. Samples are filed or returned by SASE. Reports back within 2 months. Negotiates rights purchased. Pays on publication; $25-100 for cover; $5-15 for b&w inside. Finds illustrators through word of mouth and submissions.

Tips: "Read our magazines. We like edgy, smart new-looking art. We love first timers and black & white work. We're eager to work with young artists. Be willing to work with us. Too many times young illustrators want more money than we can provide. We get great artwork all the time from young people, but many times they don't want to negotiate."

N DAIRY GOAT JOURNAL, P.O. Box 10, 128 E. Lake St., Lake Mills WI 53551. (920)648-8285. Fax: (920)648-3770. Estab. 1923. Monthly trade publication covering dairy goats. Circ. 8,000. Accepts previously published work. Sample copies available.

Cartoons: Approached by 20 cartoonists/year. Buys 2-8 cartoons/issue. Will consider all styles and themes. Prefers single panel. Samples are returned. Reports back in 3 weeks. **Pays on acceptance**; $15-25.

Illustration: Approached by 20 illustrators/year. Buys 10-30 illustrations/year. Works on assignment only. Send query letter with appropriate samples. Buys first rights or all rights. Pays $50-150 for color and b&w cover and inside.
Tips: "Please query first. We are eager to help beginners."

THE DAIRYMAN, 14970 Chandler St., Box 819, Corona CA 91718. (909)735-2730. Fax: (909)735-2460. E-mail: mdbise@aol.com. Website: http://www.hfw.com. Art Director: Maria Bise. Estab. 1922. Monthly trade journal with audience comprised of "Western-based milk producers (dairymen), herd size 100 and larger, all breeds of cows, covering the 13 Western states." Circ. 23,000. Accepts previously published artwork. Samples copies and art guidelines available.
Illustration: Approached by 5 illustrators/year. Buys 1-4 illustrations/issue. Works on assignment only. Preferred themes "depend on editorial need." Considers pen & ink, airbrush, watercolor, computer, acrylic, collage and pastel. Send query letter with brochure, tearsheets and résumé. Samples are filed or are returned by SASE if requested by artist. Reports back within 2 weeks. Write for appointment to show portfolio of thumbnails, tearsheets and photographs. Buys all rights. Pays on publication; $100 for b&w, $200 for color cover; $50 for b&w, $100 for color inside.
Tips: "We have a small staff. Be patient if we don't get back immediately. A follow-up letter helps. Being familiar with dairies doesn't hurt. Quick turnaround will put you on the 'A' list."

DAKOTA COUNTRY, Box 2714, Bismark ND 58502. (701)255-3031. E-mail: dcmag@btigate.com. Publisher: Bill Mitzel. Estab. 1979. *Dakota Country* is a monthly hunting and fishing magazine with readership in North and South Dakota. Features stories on all game animals and fish and outdoors. Basic 3-column format, b&w and 2-color with 4-color cover, feature layout. Circ. 13,200. Accepts previously published artwork. Original artwork is returned after publication. Sample copies for $2; art guidelines for SASE with first-class postage.
Cartoons: Likes to buy cartoons in volume. Prefers outdoor themes, hunting and fishing. Prefers multiple or single cartoon panels with gagline; b&w line drawings. Send query letter with samples of style. Samples not filed are returned by SASE. Reports back regarding queries/submissions within 2 weeks. Negotiates rights purchased. **Pays on acceptance**; $10-20, b&w.
Illustration: Features humorous and realistic illustration of the outdoors. Portfolio review not required. Pays $20-25 for b&w inside; $12-30 for spots.
Tips: "Always need good-quality hunting and fishing line art and cartoons."

DAKOTA OUTDOORS, P.O. Box 669, Pierre SD 57501-0669. (605)224-7301. Fax: (605)224-9210. Website: http://dakoutdoor.com. Editor: Kevin Hipple. Managing Editor: Rachel Engbrecht. Estab. 1978. Monthly outdoor magazine covering hunting, fishing and outdoor pursuits in the Dakotas. Circ. 7,500. Accepts previously published artwork. Original artwork is returned at job's completion. Sample copies and art guidelines for SASE with first-class postage.
Cartoons: Approached by 10 cartoonists/year. Buys 1-2 cartoons/issue. Prefers outdoor, hunting and fishing themes. Prefers cartoons with gagline. Send query letter with appropriate samples and SASE. Samples are not filed and are returned by SASE. Reports back within 1-2 months. Rights purchased vary. Pays $5 for b&w.
Illustration: Approached by 2-10 illustrators/year. Buys 1 illustration/issue. Features spot illustration. Prefers outdoor, hunting/fishing themes, depictions of animals and fish native to the Dakotas. Prefers pen & ink. Accepts submissions on disk compatible with Macintosh in Adobe Illustrator, Aldus FreeHand and Adobe Photoshop. Send TIFF, EPS and PICT files. Send postcard sample or query letter with tearsheets, SASE and copies of line drawings. Reports back within 1-2 months. To show a portfolio, mail "high-quality line art drawings." Rights purchased vary according to project. Pays on publication; $5-50 for b&w inside; $5-25 for spots.
Tips: "We especially need line-art renderings of fish, such as the walleye."

☑ **DATA COMMUNICATIONS MAGAZINE**, 3 Park Ave., 30th Floor, New York NY 10016. E-mail: ksurabia@cmp.com. Website: http://www.data.com. Design Director: Ken Surabian. Associate Art Director: Scot Sterling. Estab. 1972. Monthly trade journal emphasizing global enterprise networking for corporate network managers. Circ. 120,000. Art guidelines not available.
Illustration: Approached by 250 illustrators/year. Buys 125 illustrations/year. Assigns 50% of illustrations to well-known or "name" illustrators; 40% to experienced, but not well-known illustrators; 10% to new and emerging illustrators. Features realistic and conceptual illustration; charts & graphs; informational graphics; and computer and spot illustration. Assigns 33% of illustrations to well-known or "name" illustrators; 33% to experienced, but not well-known illustrators; 33% to new and emerging illustrators. Prefers conceptual style. Considers all media. 75% of freelance illustration demands computer skills. Send postcard sample. Accepts disk submissions compatible with QuarkXPress version 3.3. Send EPS files. Samples are filed. Does not report back. Will contact for portfolio review if interested. Buys web rights and worldwide rights. **Pays on acceptance**; $750-1,500 for color cover; $125-250 for b&w inside; $250-1,000 for color inside; $1,000-1,500 for 2-page spreads; $125-350 for spots.
Design: Needs freelancers for design, production. 100% of freelance work demands knowledge of Adobe Photoshop, Adobe Illustrator, QuarkXPress. Send query letter with printed samples.
Tips: "Tell the art director that you need a break. We've all needed help in the beginning. If you're good, you'll get work eventually. Be persistent."

DECORATIVE ARTIST'S WORKBOOK, 1507 Dana Ave., Cincinnati OH 45207. E-mail: amys@fwpubs.com. Art Director: Amy Schneider. Estab. 1987. "A step-by-step bimonthly decorative painting workbook. The audience is primarily female; slant is how-to." Circ. 89,000. Does not accept previously published artwork. Original artwork is

returned at job's completion. Sample copy available for $4.65; art guidelines not available.
Illustration: Buys occasional illustration; 1-2/year. Works on assignment only. Has featured illustrations by Barbara Maslen and Annie Gusman. Features humorous, realistic and spot illustration. Assigns 50% of illustrations to experienced, but not well-known illustrators; 50% to new and emerging illustrators. Prefers realistic and humorous themes and styles. Prefers pen & ink, watercolor, airbrush, acrylic, colored pencil, mixed media and pastel. Send postcard sample or query letter with tearsheets. Accepts disk submissions compatible with the major programs. Send EPS or PICT files. Samples are filed. Reports back to the artist only if interested. Buys first or one-time rights. Pays on publication; $50-100 for b&w inside; $100-350 for color inside.

N DELAWARE TODAY MAGAZINE, 3301 Lancaster Pike, Suite 5C, Wilmington DE 19805. Fax: (302)656-5843. Creative Director: Ingrid Hansen-Lynch. Monthly 4-color magazine emphasizing regional interest in and around Delaware. Features general interest, historical, humorous, interview/profile, personal experience and travel articles. "The stories we have are about people and happenings in and around Delaware. Our audience is middle-aged (40-45) people with incomes around $79,000, mostly educated. We try to be trendy in a conservative state." Circ. 25,000. Original artwork returned after publication. Sample copy available. Needs computer-literate freelancers for illustration.
Cartoons: Works on assignment only. Do not send gaglines. Do not send folders of pre-drawn cartoons. Samples are filed. Reports back only if interested. Buys first rights or one-time rights.
Illustration: Buys approximately 3-4 illustrations/issue. "I'm looking for different styles and techniques of editorial illustration!" Works on assignment only. Open to all styles. Send postcard sample. "Will accept work compatible with QuarkXPress 7.5/version 3.3. Send EPS files (CMYK, not RGB)." Send printed color promos. Publication will contact artist for portfolio review if interested. Portfolio should include printed samples and color and b&w tearsheets and final reproduction/product. Pays on publication; $200-400 for cover; $100-150 for inside; $75 for spots. Finds artists through submissions and self-promotions.

DELICIOUS! MAGAZINE, 1301 Spruce St., Boulder CO 80302. (303)939-8440. Fax: (303)440-8884. E-mail: delicious@newhope.com. Website: http://www.delicious~online.com. Art Director: Maryl Swick. Estab. 1984. Monthly magazine distributed through natural food stores focusing on health, natural living, alternative healing. Circ. 400,000 guaranteed. Sample copies available.
Illustration: Approached by hundreds of illustrators/year. Buys approximately 2 illustrations/issue. Prefers positive, healing-related and organic themes. Considers acrylic, collage, color washed, mixed media, pastel. 30% of illustration demands knowledge of Adobe Photoshop and Adobe Illustrator. Send postcard sample, query letter with printed samples, tearsheets. Send follow-up postcard sample every 6 months. Accepts disk submissions compatible with QuarkXPress 3.32 (EPS or TIFF files). Samples are filed and are not returned. Art director will contact artist for portfolio review of color, final art, photographs, photostats, tearsheets, transparencies, color copies. Rights purchased vary according to project. **Pays on acceptance**; $1,000 maximum for color cover; $250-700 for color inside; $250 for spots. Finds illustrators through *Showcase Illustration*, SIS, magazines and artist's submissions.
Design: Needs freelancers for design, production. Prefers local designers with experience in QuarkXPress, Illustrator, Photoshop and magazines/publishing. 100% of freelance work demands knowledge of Adobe Photoshop, Adobe Illustrator, QuarkXPress. Send query letter with printed samples, photocopies, tearsheets and résumé.
Tips: "We like our people and designs to have a positive and upbeat outlook."

✓ DERMASCOPE, 2611 N. Belt Line Rd., Suite 140, Sunnyvale TX 75182. (972)682-9510. Fax: (972)686-5901. Graphic Artist: Jeff Mahurin. Estab. 1978. Bimonthly magazine/trade journal, 128-page magazine for dermatologists, plastic surgeons and stylists. Circ. 14,000. Sample copies and art guidelines available.
Illustration: Approached by 5 illustrators/year. Prefers illustrations of "how-to" demonstrations. Considers all media. 100% of freelance illustration demands knowledge of Adobe Photoshop, Adobe Illustrator, QuarkXPress, Fractil Painter. Accepts disk submissions. Samples are not filed. Reports back only if interested. Rights purchsed vary according to project. Pays on publication.

DIVERSION MAGAZINE, 1790 Broadway, 6th Floor, New York NY 10019. (212)969-7500. Fax: (212)969-7557. Cartoon Editor: Shari Hartford. Estab. 1976. Monthly travel magazine for physicians. Circ. 176,000.
Cartoons: Approached by 50 cartoonists/year. Buys 100 cartoons/year. Prefers travel, food/wine, sports, lifestyle, family, animals, technology, art and design, performing arts, gardening. Prefers single panel, humorous, b&w line drawings, with or without gaglines. Send query letter with finished cartoons. "SASE must be included." Samples are not filed and are returned by SASE. Reports back in 5 days. Buys first North American serial rights. **Pays on acceptance**; $100.

N DOG & KENNEL, 7-L Dundas Circle, Greensboro NC 27407-1615. (336)292-4047. Fax: (336)292-4272. E-mail: petbiz@compuserve.com. Website: http://www.dogandkennel.com. Executive Director: Rita Davis. Bimonthly, 4-color, consumer magazine about dogs and their care. Circ. 100,000. Art guidelines free for #10 SASE with first-class postage.
Illustration: Has featured illustrations by: Sherry Neidigh, Nona Hengen and Charlotte Centilli. Features realistic illustrations of pets. Prefers watercolor, pen & ink, acrylics and color pencil. Makes assignments to experienced, but not well-known illustrators and new and emerging illustrators. Send postcard sample. Send query letter with printed samples, photocopies, SASE and tearsheets. Accepts Windows-compatible disk submissions. Send EPS files at 266 dpi. Portfolio review not required. Pays on publication; $50 maximum for b&w, $50 for color inside.

Tips: "We look for the ability to turn an assignment around in a short time span."

DOLPHIN LOG, The Cousteau Society, 61 E. Eighth St., New York NY 10003. (212)673-9097. Fax: (212)673-9183. Editor: Lisa Rao. Bimonthly 4-color educational magazine for children ages 7-13 covering "all areas of science, natural history, marine biology, ecology, and the environment as they relate to our global water system." 20-pages, 8×10 trim size. Circ. 80,000. Sample copy for $2.50 and 9×12 SASE with 3 first-class stamps; art guidelines for letter-sized SASE with first-class postage.

Illustration: Buys approximately 4 illustrations/year. Uses simple, biologically and technically accurate line drawings and scientific illustrations. "*Never* uses art that depicts animals dressed or acting like people. Subjects should be carefully researched." Prefers pen & ink, airbrush and watercolor. Send query letter with tearsheets and photocopies or brochure showing art style. "No portfolios. We review only tearsheets and/or photocopies. No original artwork, please." Samples are returned upon request with SASE. Reports within 3 months. Buys one-time rights and worldwide translation rights for inclusion in other Cousteau Society publications and the right to grant reprints for use in other publications. Pays on publication; $25-200 for color inside.

Tips: "We usually find artists through their submissions/promotional materials and in sourcebooks. Artists should first request a sample copy to familiarize themselves with our style. Send only art that is both water-oriented and suitable for children."

DRINK MAGAZINE, 782 Johnnie Dodds Blvd., Suite C, Mt. Pleasant SC 29464. (843)971-9811. Fax: (843)971-0121. E-mail: gulfstream@awod.com. Website: http://www.drinkonline.com. Art Director: Melinda Smith Monk. Estab. 1995. Quarterly 4-color consumer magazine. "The nation's leading beer, spirits and wine lifestyle magazine created for 'people with a thirst for life.' " Circ. 150,000.
 ● Also publishes *Charleston Magazine*.

Cartoons: Buys 8 cartoons/issue. Prefers single panel, humorous, b&w line drawings. Samples are filed or returned by SASE. Reports back only if interested. **Pays on acceptance**; $200-350 for b&w. "Need more samples of these!!!!"

Illustration: Approached by 50 illustrators/year. Buys 9 illustrations/issue. Has featured illustrations by Arnold Roth, The Surreal Gourmet, Jack Gallagher, Marshall Woksa, John Ueland, Leo Cullum. Features caricatures of celebrities, humorous illustration, spot illustrations, computer illustration and "unusual illustrations that add interest and pull readers into the story." Prefered subjects: men, women, libations, cigars, music, food, affordable luxuries. Assigns 25% of illustrations to well-known or "name" illustrators; 50% to experienced, but not well-known illustrators; 25% to new and emerging illustrators. 40% of freelance illustration demands knowledge of Adobe Illustrator, Adobe Photoshop, Aldus FreeHand, Aldus PageMaker, QuarkXPress. Send postcard sample and follow-up postcard every month. Send non-returnable samples. Accepts Mac-compatible disk submissions. Send EPS or TIFF files. Samples are filed. Reports back only if interested. Will contact artist for portfolio review if interested. Buys first rights and one-time rights. Rights purchased vary according to project. Pays 30 days after publication. Pays $200-1,200 color inside; $200-1,200 for 2-page spreads; $100-350 for spots. Finds illustrators through sourcebooks, promo samples, word of mouth.

Tips: "We welcome letters of interest from artists interested in semester-long, unpaid internships-at-large. If selected, artist would provide 4-5 illustrations for publication in return for masthead recognition and sample tearsheets. Staff internships (unpaid) also available on site in Charleston, S.C. Send letter of interest and samples of work to Art Director."

EAT!, 15-B Temple St., Singapore 058562. Phone: (65)323 1119. Fax: (65)323 7779/323 7776. E-mail: mag_inc@cific.net.sg. Editor: Kim Lee. Estab. 1998. Monthly 4-color cooking and dining magazine, consumer oriented, mass market. Circ. 30,000.

Cartoons: Prefers single panel, humorous, b&w washes. Send query letter with b&w photocopies. Samples are not filed and are not returned. Reports back only if interested. Negotiates rights purchased. Pays on publication. Pays $50 minimum for b&w single panel.

Illustration: Features humorous and spot illustration of people and food/dining situations. Prefers brush and ink. Send query letter with photocopies. Accepts Mac-compatible disk submissions. Send TIFF files, JPEG acceptable. Samples are not filed and are not returned. Reports back only if interested. Portfolio review required. Negotiates rights purchased. Pays $50 minimum for b&w inside. Finds illustrators through references.

Tips: "Quick turnaround, electronic contact a must. Artist should be able to conceptualize cartoon panels from stories given. An idea of Asian humor an asset. Very open to new talent. Seeking a humorous style."

ELECTRICAL APPARATUS, Barks Publications, Inc., 400 N. Michigan Ave., Suite 900, Chicago IL 60611-4198. (312)321-9440. Fax: (312)321-1288. Contact: Cartoon Editor. Estab. 1948. Monthly 4-color trade journal emphasizing industrial electrical/mechanical maintenance. Circ. 16,000. Original artwork not returned at job's completion. Sample copy $4.

Cartoons: Approached by several cartoonists/year. Buys 3-4 cartoons/issue. Prefers themes relevant to magazine content; with gagline. "Captions are typeset in our style." Send query letter with roughs and finished cartoons. "Anything we don't use is returned." Reports back within 2-3 weeks. Buys all rights. Pays $15-20 for b&w and color.

Illustration: "We have staff artists so there is little opportunity for freelance illustrators, but we are always glad to hear from anyone who believes he or she has something relevant to contribute."

ENTREPRENEUR MAGAZINE, 2392 Morse Ave., Irvine CA 92614. (949)261-2325. Fax: (949)755-4211. Website: http://www.entrepreneurmag.com. Creative Director: Mark Kozak. Design Director: Richard Olsen. Estab. 1978.

Monthly 4-color magazine offers how-to information for starting a business, plus ongoing information and support to those already in business. Circ. 600,000.

Illustration: Approached by 500 illustrators/year. Buys 5-20 illustrations/issue. Has featured illustrations by Bob Robinson, Matthew Baek, Janet Drew, David Banubo, Jimmy Holder and Brad Razka. Features computer, humorous and spot illustration and charts and graphs. Themes are business, financial and legal. Prefers realism, watercolors and bright colors. Needs editorial illustration "some serious, some humorous depending on the article. Illustrations are used to grab readers' attention." Send non-returnable postcard samples and followup postcard every 4 months or query letter with printed samples and tearsheets. Accepts Mac-compatible disk submissions. Send EPS files. Samples are filed and not returned. Will contact artist for portfolio review if interested. Buys one-time rights. **Pays on acceptance**; $300 for b&w inside; $200-500 for color inside; $800-1,200 for color cover; $300 for spots. Finds freelancers through samples, mailers, *Work Book* and SIS.

Tips: "We want illustrators that are creative, clean and have knowledge of business concepts. We are always open to new talent."

✓ ENVIRONMENT, 1319 18th St. NW, Washington DC 20036. (202)296-6267, ext. 236. Fax: (202)296-5149. E-mail: env@heldref.org. Art Director: Trina Yannicos. Editorial Assistant: Catherine Feeny. Estab. 1958. Emphasizes national and international environmental and scientific issues. Readers range from "high school students and college undergrads to scientists, business, and government leaders and college and university professors." 4-color magazine with "relatively conservative" design. Published 10 times/year. Circ. 7,500. Original artwork returned after publication. Sample copy $7; art guidelines for SASE with first-class postage.

Cartoons: Buys 1-2 cartoons/issue. Receives 5 submissions/week. Interested in single panel line drawings or b&w washes with or without gagline. Send finished cartoons and SASE. Reports in 2 months. Buys first North American serial rights. Pays on publication; $50 for b&w cartoon.

Illustration: Buys 1-2/year. Features humorous illustration, informational graphics and computer illustrations. Uses illustrators mainly for cover design, promotional work, feature illustration and occasional spots. Send postcard sample, SASE, tearsheets and photocopies. Accepts disk submissions compatible with Mac. Will contact for portfolio review if interested. Portfolio should include printed samples. Pay is negotiable.

Tips: "Send illustrations regularly to different publications to increase chances of being published. Regarding cartoons, we prefer witty or wry comments on the impact of humankind upon the environment. Stay away from slapstick humor." For illustrations, "we are looking for an ability to communicate complex environmental issues and ideas in an unbiased way."

✓ EQUILIBRIUM[10], 7111 W. Alameda Ave., L248, Lakewood CO 80226. E-mail: equilibrium10@compuserve.com. Website: http://ourworld.compuserve.com/homepages/equilibrium10. Graphic Coordinator: Brent Allan. Estab. 1984. Monthly magazine emphasizing philosophy, ideology and equilibrium: balance, opposites and antonyms for all ages. Accepts previously published material.

Cartoons: Buys 200 cartoons/year. Buys 30 cartoons/issue from freelancers. Accepts any format. Send query letter with samples and finished cartoons. Samples not filed are returned by SASE. Reports back within 3 months. Rights purchased vary. Pays on publication; $40-80, color.

Illustration: Works with 75 illustrators/year. Buys 40 illustrations/issue from freelancers. Send scanned work with GIF extension as a file attachment to e-mail address. Send query letter with brochure and samples. Samples are filed or are returned by SASE. Reports back within 3 months. Negotiates rights purchased. Pays on publication; $50 b&w cover.

Tips: "Letters and queries arriving at our office become the property of our firm and may be published 'as is'. We sometimes publish your material with another author to show contrast. Whatever our needs are, we are flexible."

ERO'S ERRANT, % Aguilar Expression, 1329 Gilmore Ave., Donora PA 15033. (412)379-8019. Editor: Xavier F. Aguilar. Estab. 1997. Annual magazine of fiction, poetry and art dealing with adult sexual themes. Published in October of each year. Circ. 100. Art guidelines for SASE with first-class postage.

Illustration: Has featured illustrations by Steve Lawes. Features humorous and realistic illustration. Assigns 25% of illustration to experienced, but not well-known illustrators; 75% to new and emerging illustrators. Considers 5 × 7 b&w line drawings. Send query letter with photocopies. Samples are not returned. **Pays on acceptance**; $10 plus 1 free copy for b&w cover; inside pages paid in free copy only.

Design: "Artwork must depict adult sexual themes. Follow guidelines."

ETCETERA, P.O. Box 8543, New Haven CT 06531. E-mail: iedit4you@aol.com. Art Director: Mindi Englart. Estab. 1996. 2 times/year b&w literary magazine. Circ: 500. Sample copies available for $3. Art guidelines free for #10 SASE with first-class postage.

Cartoons: Prefers single, double or multiple panel humorous b&w washes and line art. Send query letter with b&w photocopied samples and SASE. Samples are returned by SASE. Reports back within 5 months. Buys one-time rights. Pays on publication; 1 issue and a 1-year subscription.

Illustration: Approached by 20 illustrators/year. Buys 3-8 illustrations/issue. Has featured illustrations by: Barbara Kagan, Jonathan Talbot and Michael McCurdy. Features fine art illustration and comics. Prefers b&w only. Assigns 33% of illustrations to well-known or "name" illustrators; 33% to experienced, but not well-known illustrators; 33% to new and emerging illustrators. Send postcard sample or send query letter with printed samples, photocopies, tearsheets and SASE ("no originals, please"). Accepts Mac-compatible disk submissions. Send EPS or JPEG files. Samples are

filed or are returned by SASE. Reports back in 5 months. Will contact artist for portfolio review if interested. Buys one-time rights. Pays on publication; 1 issue plus a 1-year subscription. Finds illustrators through the Internet and word of mouth.

Tips: "We're always open to new talent. Professional, clean quality black & white work. We are open to many forms including: collage, abstract, line drawings, prints, woodcuts, images that incorporate text, avant garde. Want stark, humorous, funky, understandable work that will reproduce well via offset printing."

N EUROPE, MAGAZINE OF THE EUROPEAN UNION, 2300 M St. NW, Washington DC 20037. (202)862-9500. Editor-in-Chief: Robert J. Guttman. Emphasizes European affairs, US-European relations—particularly economics, politics and culture; 4-color. Readers are businessmen, professionals, academics, government officials and consumers. Published 10 times/year. Circ. 65,000. Free sample copy.

Cartoons: Occasionally uses cartoons, mostly from a cartoon service. "The magazine publishes articles on US-European relations in economics, trade, business, industry, politics, energy, inflation, etc." Considers single panel b&w line drawings or b&w washes with or without gagline. Send résumé, SASE, plus finished cartoons and/or samples. Reports in 3-4 weeks. Buys one-time rights. Pays $25 on publication.

Illustration: Uses 3-5 illustrations/issue. "We look for economic graphs, tables, charts and story-related statistical artwork"; b&w line drawings and washes for inside. 30% of freelance work demands knowledge of Aldus PageMaker and QuarkXPress. Send résumé, SASE and photocopies of style. Reports in 3-4 weeks. To show a portfolio, mail printed samples. Buys all rights on a work-for-hire basis. Pays on publication.

N ⬛ EVENT, Douglas College, Box 2503, New Westminster, British Columbia V3L 5B2 Canada. (604)527-5293. Editor: Calvin Wharton. Estab. 1971. For "those interested in literature and writing"; b&w with 4- or 2-color cover. Published 3 times/year. Circ. 1,100. Original artwork returned after publication. Sample copy for $6.

Illustration: Buys approximately 3 illustrations/year. Uses freelancers mainly for covers. "Interested in drawings and prints, b&w line drawings, photographs and lithographs for cover, and thematic or stylistic series of 3 works. SAE (nonresidents include IRCs). Reporting time varies; at least 4 months. Buys first North American serial rights. Pays on publication, $100 for color cover.

N EXECUTIVE FEMALE, 135 W. 50th St., 16th Floor, New York NY 10020. (212)445-6234. Website: http://www.nafe.com. Art Director: Mitch Mondello. Estab. 1972. Association magazine for National Association for Female Executives, 4-color. "Get ahead guide for women executives, which includes articles on managing employees, personal finance, starting and running a business." Circ. 200,000. Accepts previously published artwork. Original artwork is returned after publication.

Illustration: Buys illustrations mainly for spots and feature spreads. Buys 7 illustrations/issue. Works on assignment only. Send samples (not returnable). Samples are filed. Responds only if interested. Buys first or reprint rights. Pays on publication; $100-800.

N EYECARE BUSINESS/CARDINAL BUSINESS MEDIA, INC., 535 Connecticut Ave., Suite 104A, Norwalk CT 06854-1722. (203)838-9100, ext. 220 or 226. Fax: (203)838-2550. E-mail: ngcm@cardinal.com. Art Director: Greg Mursko. Assistant Art Director: Genée Kalisher. Estab. 1985. Monthly tabloid size trade magazine for opticians, optometrists and all others in the optical industry. Circ. 52,200. Sample copies available.

Illustration: Approached by many illustrators/year. Buys 4 illustrations/issue. Assigns 50% of illustrations to experienced, but not well-known illustrators; 50% to new and emerging illustrators. Prefers business/editorial style. Considers acrylic, collage, color washed, mixed media, oil, pen & ink, watercolor. 30% of freelance illustration demands knowledge of Adobe Photoshop 3.05, Adobe Illustrator 6.0. Send query letter with printed samples, photocopies, tearsheets. Send follow-up postcard sample every 3 months. Accepts disk submissions compatible with QuarkXPress 3.32 or Photoshop 3.05, EPS or JPEG or TIFF (low-rez please) on 44 MB SyQuest, Zip 100 MB, or floppy. Samples are filed. Reports back only if interested. Buys one-time rights. Pays on publication; $125-175 for b&w, $150-400 for color inside. Pays $200-400 for spots. Finds illustrators through *American Showcase*, consumer magazines, word of mouth, submissions, *Directory of Illustration*.

Design: Needs freelancers for design and production. Prefers local design freelancers with experience in QuarkXPress, Photoshop and/or Illustrator. 100% of freelance work demands knowledge of Adobe Photoshop 3.05, Adobe Illustrator 6.0, QuarkXPress 3.32. Phone art director. "After initial call a portfolio interview is required if interested or needed."

Tips: "We like work that follows current color trends in design and is a little edgy, yet freelancer should still be able to produce work for formatted pages. Should be fast and be familiar with magazine's style."

N FAMILY CIRCLE, Dept. AGDM, 375 Lexington Ave., New York NY 10017-5514. (212)499-2000. Art Director: David Wolf. Circ. 7,000,000. Supermarket-distributed publication for women/homemakers covering areas of food, home, beauty, health, child care and careers. 17 issues/year. Does not accept previously published material. Original artwork returned after publication.

Illustration: Buys 20 illustrations/issue. Works on assignment only. Provide query letter with samples or postcard sample to be kept on file for future assignments. Prefers transparencies, postcards or tearsheets as samples. Samples returned by SASE. Reports only if interested. Prefers to see finished art in portfolio. Submit portfolio by appointment every Wednesday. All art is commissioned for specific magazine articles. Negotiates rights. **Pays on acceptance.**

FASHION ACCESSORIES, 65 W. Main St., Bergenfield NJ 07621. (201)384-3336. Fax: (201)384-6776. Publisher: Sam Mendelson. Estab. 1951. Monthly trade journal; tabloid; emphasizing costume jewelry and accessories. Publishes both 4-color and b&w. Circ. 9,500. Accepts previously published artwork. Original artwork is returned to the artist at the job's completion. Sample copies for $3.
Illustration: Works on assignment only. Needs editorial illustration. Prefers mixed media. Freelance work demands knowledge of QuarkXPress. Send query letter with brochure and photocopies. Samples are filed. Reports back within 1 month. Portfolio review not required. Rights purchased vary according to project. **Pays on acceptance**; $50-100 for b&w cover; $100-150 for color cover; $50-100 for b&w inside; $100-150 for color inside.

FAST COMPANY, 77 N. Washington St., Boston MA 02114-1927. (617) 973-0350. Fax: (617)973-0353. E-mail: rrees@fastcompany.com. Website: http://www.fastcompany.com. Art Director: Patrick Mitchell. Estab. 1996. Bimonthly cutting edge business publication supplying readers with tools and strategies for business today.
Illustration: Approached by "tons" of illustrators/year. Buys approximately 20 illustrations/issue. Considers all media. Send postcard sample or printed samples, photocopies. Accepts disk submissions compatible with QuarkXPress for Mac. Send EPS files. Send all samples to the attention of: Rebecca Rees. Samples are filed and not returned. Reports back only if interested. Rights purchased vary according to project. **Pays on acceptance**, $300-1,000 for color inside; $300-500 for spots. Finds illustrators through submissions, illustration annuals, *Workbook* and *Alternative Pick*.

FEDERAL COMPUTER WEEK, 3141 Fairview Park Dr., Suite 777, Falls Church VA 22042. (703)876-5131. E-mail: jeffrey_langkau@fcw.com. Website: http://www.fcw.com. Art Director: Jeff Langkau. Estab. 1987. Four-color trade publication for federal, state and local government information technology professionals. Circ. 120,000.
● Also publishes *CIVIC.COM* and *Government Best Buys.*
Illustration: Approached by 50-75 illustrators/year. Buys 5-6 illustrations/month. Features charts & graphs, computer illustrations, informational graphics, spot illustrations of business subjects. Assigns 5% of illustrations to well-known or "name" illustrators; 85% to experienced, but not well-known illustrators; 10% to new and emerging illustrators. Send postcard or other non-returnable samples. Accepts Mac-compatible disk submissions. Samples are filed. Will contact artist for portfolio review if interested. Buys one-time rights. Rights purchased vary according to project. Pays $800-1,200 for color cover; $600-800 for color inside; $200 for spots. Finds illustrators through samples and sourcebooks.
Tips: "We look for people who understand 'concept' covers and inside art, and very often have them talk directly to writers and editors."

[N] FIELD & STREAM MAGAZINE, Dept. AGDM, 2 Park Ave., 10th Floor, New York NY 10016. (212)779-5294. Art Director: Amy Vischio. Monthly magazine emphasizing wildlife hunting and fishing. Circ. 10 million. Original artwork returned after publication. Sample copy and art guidelines for SASE.
Illustration: Approached by 200-250 illustrators/year. Buys 9-12 illustrations/issue. Has featured illustrations by Arnold Roth, Bart Forbes, Jack Unruh. Assigns 20% of illustrations to well-known or "name" illustrators; 75% to experienced, but not well-known illustrators; 5% to new and emerging illustrators. Works on assignment only. Prefers "good drawing and painting ability, realistic style, some conceptual and humorous styles are also used depending on magazine article." Wants to see "emphasis on strong draftsmanship, the ability to draw wildlife and people equally well. Artists who can't, please do not apply." Send query letter with postcard or other non-returnable sample. Reports only if interested. Call or write for appointment to show portfolio of roughs, final art, final reproduction/product and tear sheets. Buys first rights. **Pays on acceptance**; $75-300 for simple spots; $500-1,000 for single page, $1,000 and up for spreads, $1,500 and up for covers.
Tips: Wants to see "more illustrators who are knowledgeable about hunting and fishing and can handle simple pen & ink and 2-color art besides 4-color illustrations. We need 'how-to art experience in the fish/hunt field."

[N] FINAL FRONTIER, 1017 S. Mountain Ave., Monrovia CA 91016-3642. Fax: (626)932-1036. Editor: Dave Cravotta. Estab. 1988. Bimonthly 4-color consumer magazine focused on space exploration, science and technology for a lay audience. Circ. 75,000. Sample copy for 9×12 SASE and 8 first-class stamps. Write "sample copy request" on your letter for faster processing.
Cartoons: Buys at least 6 cartoons/year. Prefers single panel, humorous, b&w and color washes and b&w line drawings on outer space (*not* UFO/Star Trek/sci-fi). Reports back in 1-2 months. Buys first North American serial rights. **Pays on acceptance**. Usually pays $100 and up for b&w and color cartoons, negotiable.
Tips: "The magazine recently began running cartoons again. We have one freelancer who does occasional infographics (computer) reporting, but we are open to new talent. Most illustrations come from NASA/aerospace companies at present."

MARKET CONDITIONS are constantly changing! If you're still using this book and it is 2001 or later, buy the newest edition of *Artist's & Graphic Designer's Market* at your favorite bookstore or order directly from Writer's Digest Books (1-800-289-0963).

FIRST FOR WOMEN, 270 Sylvan Ave., Englewood Cliffs NJ 07632. (201)569-6699. Fax: (201)569-6264. Art Director: Rosemarie Wyer. Estab. 1988. Mass market consumer magazine for the younger woman published every 3 weeks. Circ. 1.4 million. Originals returned at job's completion. Sample copies and art guidelines not available.

Cartoons: Buys 10 cartoons/issue. Prefers women's issues. Prefers humorous cartoons; single panel b&w washes and line drawings. Send query letter with photocopies. Samples are filed. Reports back to the artist only if interested. Buys one-time rights. Pays $150 for b&w.

Illustration: Approached by 100 illustrators/year. Buys 1 illustration/issue. Works on assignment only. Preferred themes are humorous, sophisticated women's issues. Considers all media. Send query letter with any sample or promo we can keep. Publication will contact artist for portfolio review if interested. Buys one-time rights. **Pays on acceptance**; $200 for b&w, $300 for color inside. Finds artists through promo mailers and sourcebooks.

Tips: Uses humorous or conceptual illustration for articles where photography won't work. "Use the mail—no phone calls please."

FISH DRUM MAGAZINE, P.O. Box 966, New York NY 10156. Editor: Suzi Winson. Estab. 1988. "*Fish Drum* is an eclectic ('funky to slick') literary magazine, including poetry, prose, interviews, essays, scores and black & white art. We've upgraded the production of the magazine, and are now larger, perfect bound, offset printed." Publishes 1-2 issues yearly. Circ. 2,000. Original artwork returned at the job's completion.

Cartoons: "We have accepted and published a few cartoons, though we aren't offered many. Cartoons need to be literary, underground, Buddhist or political." Prefers single, multiple panel and b&w line drawings. Send query letter with finished cartoons. Samples are not filed and are returned by SASE if requested. Reports back within 2 months. Acquires one-time rights. Pays in copies.

Illustration: Prefers abstract, humorous or emotional art. Prefers any b&w offset-reproducible media. Send query letter with SASE and photocopies. Samples are not filed and are returned by SASE. Reports back within 2 months. Portfolio review not required. Acquires one-time rights. Pays in copies.

Tips: "We're interested in original, personal, arresting art and have a bias toward non-mainstream New Mexico artists, underground and abstract art."

N FLORIDA KEYS MAGAZINE, P.O. Box 22748, Ft. Lauderdale FL 33330. (954)764-0604. Fax: (954)760-9944. Art Director: Uli Mitten. Estab. 1978. Bimonthly magazine targeted at residents and frequent visitors to the area; covers most subjects of interest to the region. Circ. 60,000. Accepts previously published work. Originals returned at job's completion. Sample copies free for SASE with first-class postage (1st copy only).

Cartoons: Approached by 2 freelance cartoonists/year. Rarely purchases cartoons. Prefers regional issues and style; single panel b&w line drawings with gagline. Send query letter with brochure and published samples. Samples are filed. Reports back within 3 months. Rights purchased vary. Pays $20 for b&w.

Illustration: Approached by 5 freelance illustrators/year. Number purchased each year varies. Will consider all styles, themes. Interested in tropical living and environmental issues. Accepts any media. Send query letter with résumé and tearsheets. Samples are filed. Reports back within 3 months. Write for appointment to show portfolio of final art, b&w and color tearsheets, photostats, photocopies and photographs. Rights vary. Pays on publication; $20 for b&w, $25 for color.

FLORIDA LEADER MAGAZINE, P.O. Box 14081, Gainesville FL 32604-2081. (352)373-6907. Fax: (352)373-8120. E-mail: oxenpub@mindspring.com. Website: http://www.floridaleader.com. Art Director: Jeff Riemersma. Estab. 1983. 4-color magazine for college and high school students. Publishes 3 issues/year. Circ. 23,000. Sample copies for 8½×11 SASE and 4 first-class stamps. Art guidelines for #10 SASE with first-class postage.

● Oxendine Publishing also publishes *Careers & Majors Magazine* and *Student Leader Magazine*.

Illustration: Approached by hundreds of illustrators/year. Buys 4 illustrations/issue. Considers all media. 10% of freelance illustration demands computer skills. Send postcard sample. Disk submissions must be PC-based TIF or EPS images. Samples are filed and are not returned. Reports back only if interested. Rights purchased vary according to project. Pays on publication; $75 for color inside. Finds illustrators through sourcebooks and artist's submissions.

Tips: "We need responsible artists who complete projects on time and have a great imagination. Also must work within budget."

N FLY FISHERMAN MAGAZINE, 6405 Flank Dr., Harrisburg PA 17112. (717)657-9555. Art Director: David Siegfried. Estab. 1969. Bimonthly magazine covering all aspects of fly fishing including how to, where to, new products, wildlife and habitat conservation, and travel through top-of-the-line photography and artwork; 4-color. In-depth editorial. Readers are upper middle class subscribers. Circ. 150,000. Sample copies for SASE with first-class postage. Art guidelines for SASE with first-class postage.

Cartoons: Buys 1 cartoon/issue, 6-10 cartoons/year from freelancers. Prefers fly fishing related themes only. Prefers single panel with or without gagline; b&w line drawings and washes. Send query letter with samples of style. Samples are filed or returned by SASE. Reports back regarding queries/submissions within 3 weeks. Buys one-time rights. Pays on publication.

Illustration: Buys illustrations to illustrate fishing techniques and for spots. Buys 4-10 illustrations/issue, 50 illustrations/year. Buys 2-3 map illustrations/issue. Prefers pen & ink. Considers airbrush, mixed media, watercolor, acrylic, pastel and charcoal pencil. Needs computer-literate illustrators familiar with QuarkXPress and Macromedia FreeHand. Send query letter with brochure showing art style, résumé and appropriate samples, excluding originals. Samples are

filed or returned by SASE. Call or write to schedule an appointment to show a portfolio or mail appropriate materials. Buys one-time rights and occasionally all rights. Pays on publication.

Tips: Spot art for front and back of magazine is most open to illustrators.

FOCUS ON THE FAMILY, 8605 Explorer Dr., Colorado Springs CO 80920. (719)531-3400. Senior Art Director, Periodicals: Tim Jones. Estab. 1977. Publishes magazines. Specializes in religious-Christian. Publishes 9 titles/year.

Needs: Approached by 100 illustrators and 12 designers/year. Works with illustrators from around the US. Prefers designers experienced in Macintosh. Uses designers mainly for periodicals, publication design/production. 100% of design and 20% illustration demands knowledge of Aldus FreeHand, Adobe Photoshop, Adobe Illustrator, QuarkXPress.

First Contact & Terms: Send query letter with photocopies, printed samples, résumé, SASE and tearsheets. Send follow-up postcard every year. Samples are filed. Reports back within 2 weeks. Will contact artist for portfolio review of photocopies of artwork portraying family themes if interested. Buys first, one-time or reprint rights. Finds freelancers through agents, sourcebooks and submissions.

Text Illustration: Assigns 150 illustration jobs/year. Pays by project. Prefers realistic, abstract, cartoony styles.

☑ **FOOD & SERVICE**, Box 1429, Austin TX 78767. (512)457-4100. E-mail: qwilson@tramail.org. Art Director: Gina Wilson. Estab. 1940. Official trade publication of Texas Restaurant Association. Seeks illustrations (but not cartoons) dealing with business issues of restaurant owners and food-service operators, primarily in Texas, and including managers of clubs, bars and hotels. Published 6 times/year. Circ. 6,500. Simultaneous submissions OK. Originals returned after publication. Sample copy for SASE, art guidelines for SASE with first-class postage.

Illustration: Works with 15 illustrators/year. Buys 12-15 illustrations/year. Has featured illustrations by Walter Stanford, Edd Patton and AJ Garces. Features computer and spot illustration. Assigns 10% of illustration to well-known or "name" illustrators; 45% to experienced, but not well-known illustrators; 45% to new and emerging illsutrators. Uses artwork mainly for covers and feature articles. Seeks high-quality b&w or color artwork in variety of styles (airbrush, watercolor, pastel, pen & ink, Adobe Illustrator, Photoshop). Seeks versatile artists who can illustrate articles about food service industry, particularly business aspects. Works on assignment only. Send postcard or other non-returnable samples. Accepts disk submissions compatible with Adobe Ilustrator 5.0. Send EPS files on Zip disk. Will contact for portfolio review if interested. Pays $350-500 for color cover; $150-250 for b&w inside; $250-350 for color inside; $75-150 for spots. Negotiates rights and payment upon assignment. Finds artists through submissions and other magazines.

☑ **FOODSERVICE DIRECTOR MAGAZINE**, 355 Park Ave., S., 3rd Floor, New York NY 10010-1789. (212)592-6537. Fax: (212)592-6539. Website: http://www.fsdmag.com. Contact: Kathleen McCann. Estab. 1988. Monthly 4-color trade publication covering cafeteria-style food in colleges, schools, hospitals, prisons, airlines, business and industry. Circ. 45,000.

Illustration: Approached by 75 illustrators/year. Buys 1-2 illustrations/issue. Features humorous illustration, informational graphics, spot illustrations of food and kitchen art and business subjects. Prefers solid colors that reproduce well. No neon. Assigns 50% of illustration to experienced, but not well-known illustrators; 50% to new and emerging illustrators. 10% of freelance illustration demands knowledge of Adobe Illustrator, Adobe Photoshop, Aldus FreeHand, QuarkXPress. Send postcard or other non-returnable samples or query letter with photocopies. Send follow-up postcard every 6 months. Accepts Mac-compatible disk submissions. Send EPS or TIFF files. Samples are filed. Will contact artist for portfolio review if interested. Pays on publication; $350-550 for color inside; $150 for spots. Finds illustrators through samples, sourcebooks.

🅽 **FOR SENIORS ONLY, FOR GRADUATES ONLY**, 339 N. Main St., New City NY 10956. (914)638-0333. Executive Editor: Judi Oliff. Estab. 1970. Biannual and annual guidance-oriented magazines for high school seniors and 2-year-college graduates and includes features on travel. Circ. 350,000. Accepts previously published artwork. Originals are not returned. Sample copies and art guidelines free for SASE with first-class postage. 75% of freelance work demands knowledge of Aldus PageMaker.

Cartoons: Buys 10 cartoons/issue. Prefers single panel b&w line drawings with gagline. Send brochure, roughs, finished cartoon samples. Samples sometimes filed or returned by SASE if requested. Reports back if interested. Rights purchased vary according to project. Pays $15 for b&w, $25 for color.

Illustration: Buys 3 illustrations/issue. Works on assignment only. Considers pen & ink, airbrush, charcoal and mixed media. Send query letter with résumé, SASE and samples. Samples sometimes filed or returned by SASE if requested. Reports back only if interested. Rights purchased vary according to project. **Pays on acceptance**; $75 for b&w, $125 for color cover; $50 for b&w, $100 for color inside.

☑ **FORBES MAGAZINE**, 60 Fifth Ave., New York NY 10011. (212)620-2200. E-mail: bmansfield@forbes.com. Art Director: Robert Mansfield. Five associate art directors. Established 1917. Biweekly business magazine read by company executives and those who are interested in business and investing. Circ. 785,000. Art guidelines not available.

Illustration: Assigns 60% of illustrations to well-known or "name" illustrators; 20% to experienced, but not well-known illustrators; 20% to new and emerging illustrators. "Assignments are made by one of the art directors. We do not use, nor are we liable for ideas or work that a Forbes art director didn't assign. We use illustrations when they are the appropriate visual solution. We prefer contemporary illustrations that are lucid and convey an unmistakable idea, with wit and intelligence. No cartoons please. Illustration art must be rendered on a material and size that can be

separated on a drum scanner or submitted digitally. We are prepared to receive art on zip, scitex, CD, floppy disk, or downloaded via e-mail. Discuss the specifications and the fee before you accept the assignment. **Pays on acceptance** whether reproduced on not. Pays up to $3,000 for a cover assignment and an average of $450 to $700 for an inside illustration depending on complexity, time and the printed space rate. "Dropping a portfolio off is encouraged and it has its advantage, in that it permits more than one art director to review your work. Plan to leave your portfolio for few hours or overnight. It's helpful that portfolios be delivered by 11 a.m. Call first, to make sure an art director is available. Address the label to the attention of the Forbes Art Department and individual you want to reach. Attach your name and local phone number to the outside of the portfolio. Include a note stating when you need it. Robin Regensberg, the art traffic coordinator, will make every effort to call you to arrange for your pickup. Samples: Do not mail original artwork. Send printed samples, scanned samples or photocopies of samples. Include enough samples as you can spare in a portfolio for each person on our staff. If interested, we'll file them. Otherwise they are discarded. Samples are returned only if requested."

Tips: "Look at the magazine to determine if your style and thinking are suitable. The art director, associate art directors and the photo editors are listed on the masthead, located within the first ten pages of an issue. The art directors make assignments for illustration. However, it is important that you include Robert Mansfield in your mailings and portfolio review. We get a large number of requests for portfolio reviews, and many mailed promotions daily. This many explain why, when you follow up with a call we may not be able to acknowledge receipt of your samples. If the work is memorable and we think we can use your style, we'll file samples for future consideration."

FOREIGN SERVICE JOURNAL, 2101 E St. NW, Washington DC 20037. (202)338-4045. Contact: Graphic Designer. Estab. 1924. Monthly magazine emphasizing foreign policy for foreign service employees; 4-color with design in "*Harpers'* style." Circ. 11,000. Returns original artwork after publication. Art guidelines available.
Illustration: Works with 10 illustrators/year. Buys 35 illustrations/year. Needs editorial illustration. Uses artists mainly for covers and article illustration. Works on assignment only. Send postcard samples. Accepts disk submissions. "Mail in samples for our files." Publication will contact artist for portfolio review if interested. Buys first rights. Pays on publication; $500 for color cover; $100 and up for color inside. Finds artists through sourcebooks.

N **FOUNDATION NEWS & COMMENTARY**, 1828 L St. NW, Washington DC 20036. (202)466-6512. Executive Editor: Jody Curtis. Estab. 1959. Bimonthly 4-color nonprofit association magazine that "covers news and trends in the nonprofit sector, with an emphasis on foundation grantmaking and grant-funded projects." Circ. 11,000. Accepts previously published artwork. Original artwork returned after publication. Sample copy available.
Illustration: Approached by 50 illustrators/year. Buys 3 illustrations/issue. Considers all formats. Send query letter with tearsheets, photostats, slides and photocopies. Samples are filed "if good"; none are returned. Buys first rights. **Pays on acceptance**.
Tips: The magazine is "clean, uncluttered, sophisticated, simple but attractive. It's high on concept and originality. Somwhat abstract, not literal."

N **⊕** **FUTURE PUBLISHING LTD.**, 30 Monmouth St., Bath, England BA1 2BW. Phone: (01225)442244. Fax: (01225)732295. Website: http://www.netmag.co.uk. Senior Art Editor: Jez Bridgeman. Estab. 1984. Monthly 4-color computer magazines that cover many PC/Mac topics including the Internet.
 ● Future Publishing is Britain's fifth largest publisher of leisure computing and videogames magazines. They publish *.net, Amiga Format Games Master* and about 50 other titles. They also publish woodworking and craft publications.
Cartoons: Approached by 30 cartoonists/year. Buys 3 cartoons/issue. Prefers business themes. Prefers humorous. Send color photocopies. Samples are filed or returned by SASE. Reports back only if interested. Rights purchased vary according to project. Pays on publication.
Illustration: Approached by 50 illustrators/year. Buys 4 illustrations/issue. Has featured illustrations by John Bradley, Ed McLachlan, Estelle Corke, Oliver Burston, Garry Walton. Features humorous illustration, spot illustrations and computer illustrations of business subjects and computers in lifestyle. Prefers colorful, strong, bright colors. Assigns 50% of illustrations to experienced, but not well-known illustrators; 50% to new and emerging illustrators. 50% of freelance illustration demands knowledge of Adobe Photoshop. Send postcard sample and follow-up postcard every 6 months. Send query letter, photocopies and SASE. Samples are filed or returned by SASE. Reports back only if interested. Will contact artist for portfolio review if interested. Rights purchased vary according to project. Pays on publication. Finds illustrators through agents and originals book.
Tips: "A fresh approach to illustration is always welcome. Our current stable of four freelancers are reliable, affordable and can turn around jobs in good time. We are always open to new talent even if at first your portfolio doesn't apply to computer magazines. You could be what we've been looking for!"

N **THE FUTURIST**, Dept. AGDM, 7910 Woodmont Ave., Suite 450, Bethesda MD 20814. Website: http://www.wfs. org/wfs. Production Manager: Lisa Mathias. Managing Editor: Cynthia Wagner. Emphasizes all aspects of the future for a well-educated, general audience. Bimonthly b&w magazine with 4-color cover; "fairly conservative design with lots of text." Circ. 30,000. Accepts simultaneous submissions and previously published work. Return of original artwork following publication depends on individual agreement.
Illustration: Approached by 50-100 illustrators/year. Buys 3-4 illustrations/issue. Needs editorial illustration. Uses a variety of themes and styles "usually b&w drawings, often whimsical. We like an artist who can read an article and

deal with the concepts and ideas." Works on assignment only. Send samples or tearsheets to be kept on file. Accepts disk submissions compatible with Mac, Adobe Illustrator or Adobe Photoshop. Send EPS files. Will contact for portfolio review if interested. Rights purchased negotiable. **Pays on acceptance**; $500-750 for color cover; $75-350 for b&w, $200-400 for color inside; $100-125 for spots.

Tips: "Send samples that are strong conceptually with skilled execution. When a sample package is poorly organized, poorly presented—it says a lot about how the artists feel about their work." Sees trend of "moving away from realism; highly stylized illustration with more color." This publication does not use cartoons.

GALLERY MAGAZINE, Dept. AGDM, 401 Park Ave. S., New York NY 10016. (212)779-8900. Website: http://www.gallerymagazine.com. Creative Director: Mark DeMaio. Emphasizes "sophisticated men's entertainment for the upper middle-class, collegiate male; monthly 4-color with flexible format, conceptual and sophisticated design." Circ. 375,000.

Cartoons: Approached by 100 cartoonists/year. Buys 3-8 cartoons/issue. Interested in sexy humor; single, double or multiple panel, color and b&w washes, b&w line drawings with or without gagline. Send finished cartoons. Enclose SASE. Contact: J. Linden. Reports in 1 month. Buys first rights.

Illustration: Approached by 300 illustrators/year. Buys 30 illustrations/year. Works on assignment only. Needs editorial illustrations. Interested in the "highest creative and technical styles." Especially needs slick, high-quality, 4-color work. 100% of freelance work demands knowledge of QuarkXPress and Adobe Illustrator. Send flier, samples and tearsheets to be kept on file for possible future assignments. Prefers prints over transparencies. Samples returned by SASE. Publication will contact artist for portfolio review if interested. Negotiates rights purchased. Pays on publication; $350 for b&w inside; $250-1,000 for color inside; $250-500 for spots. Finds artists through submissions and sourcebooks.

Design: Needs freelancers for design and production. 100% of freelance work demands knowledge of Adobe Photoshop, Adobe Illustrator, QuarkXPress. Prefers local freelancers only. Send query letter with résumé, SASE and tearsheets. Pays by the hour, $25.

Tips: A common mistake freelancers make is that "often there are too many samples of literal translations of the subject. There should also be some conceptual pieces."

GAME & FISH PUBLICATIONS, 2250 Newmarket Pkwy., Marietta GA 30067. (770)953-9222. Fax: (770)933-9510. Graphic Artist: Allen Hansen. Estab. 1975. Monthly b&w with 4-color cover. Circ. 540,000 for 30 state-specific magazines. Original artwork is returned after publication. Sample copies available.

Illustration: Approached by 50 illustrators/year. Buys illustrations mainly for spots and feature spreads. Buys 1-8 illustrations/issue. Considers pen & ink, watercolor, acrylic and oil. Send query letter with photocopies. "We look for an artist's ability to realistically depict North American game animals and game fish or hunting and fishing scenes." Samples are filed or returned only if requested. Reports back only if interested. Portfolio review not required. Buys first rights. Pays 2½ months prior to publication; $25 minimum for b&w inside; $75-100 for color inside.

Tips: "We do not publish cartoons, but we do use some cartoon-like illustrations which we assign to artists to accompany specific humor stories. Send us some samples of your work, showing as broad a range as possible, and let us hold on to them for future reference. Being willing to complete an assigned illustration in a 4-6 week period and providing what we request will make you a candidate for working with us."

GARDEN GATE MAGAZINE, 2200 Grand Ave., Des Moines IA 50312. (515)282-7000. Fax: (515)283-2003. Art Director: Steven Nordmeyer. Estab. 1995. Bimonthly consumer magazine on how-to gardening for the novice and intermediate gardener. Circ. 300,000.

Illustration: 90% of illustration needs are conventional/watercolor illustrations. Other styles require knowledge of Adobe Photoshop 3.0, QuarkXPress 3.31 and Corel Draw 5.0. Send postcard sample, query letter with tearsheets. Accepts disk submissions compatible with QuarkXPress 7.5/version 3.31. Send EPS files. Samples are filed and are not returned. Reports back only if interested. Art director will contact artist for portfolio review of slides, tearsheets if interested. Buys all rights. Finds illustrators through artist submissions, *Black Book*, word of mouth.

Design: Prefers designers with experience in publication design. 98% of freelance work demands knowledge of Adobe Photoshop 3.0, QuarkXPress 3.31, Corel Draw 5.0. Send query letter with printed samples and tearsheets.

Tips: "Become familiar with our magazine and illustration style that is compatible."

GEORGIA MAGAZINE, P.O. Box 1707, Tucker GA 30085-1707. (770)270-6950. Fax: (770)270-6995. E-mail: ann.or owski@georgia.com. Editor: Ann Orowski. Estab. 1945. Monthly consumer magazine promoting electric co-ops (largest read publication by Georgians for Georgians). Circ. 250,000 member.

Cartoons: Approached by 10 cartoonists/year. Buys 2 cartoons/year. Prefers electric industry theme. Prefers single panel, humorous, b&w washes and line drawings. Send query letter with photocopies. Samples are filed and not returned. Reports back within 1 month if interested. Rights purchased vary according to project. **Pays on acceptance**; $50 for b&w, $50-100 for color.

Illustration: Approached by 10 illustrators/year. Prefers electric industry theme. Considers all media. 50% of freelance illustration demands knowledge of Adobe Illustrator and QuarkXPress. Send postcard sample or query letter with photocopies. Accepts disk submissions compatible with QuarkXPress 7.5. Samples are filed or returned by SASE. Reports back within 1 month if interested. Rights purchased vary according to project. **Pays on acceptance**; $50-100 for b&w, $50-200 for color. Finds illustrators through word of mouth and artist's submissions.

Design: Needs freelancers for design and production. Prefers local designers with magazine experience. 80% of design

demands knowledge of Adobe Photoshop, Adobe Illustrator and QuarkXPress. Send query letter with printed samples and photocopies.

N ☐ **GIFTWARE NEWS**, 20 N. Wacker Dr., Suite 1865, Chicago IL 60606. (312)849-2220. Fax: (312)849-2174. E-mail: delwell@talcott.com. Website: http://www.giftwarenews.net. Media Director: Doug Elwell. Monthly magazine "of gifts, collectibles, stationery, gift baskets, tabletop and home accessories." Circ. 20,000. Sample copies available. **Design:** Needs freelancers for design, production, multimedia projects and Internet, possible CD production. Prefers designers with experience in magazine design. 100% of work demands knowledge of Adobe Photoshop 4.0, Adobe Illustrator 8.0 and QuarkXPress 4.0. Send query letter with printed samples.

✓ **GIRLFRIENDS MAGAZINE**, 3415 Cesar Chavez, #101, San Francisco CA 94110. (415)648-9464. Fax: (415)648-4705. E-mail: staff@gfriends.com. Website: http://www.gfriends.com. Managing Editor: Kathleen Hildenbrand. Estab. 1994. Monthly magazine, "America's fastest growing lesbian magazine for women 25-38." Circ. 20,000. Sample copies available for $4.95. Art guidelines for #10 SASE with first-class postage.
Illustration: Approached by 50 illustrators/year. Buys 3-4 illustrations/issue. Has featured illustrations by Joanna Goodman, Christopher Buzelli, Adam Guszauson and Jennifer Mazzueo. Features caricatures of celebrities and realistic, computer and spot illustration. Assigns 10% of illustrations to well-known or "name" illustrators; 50% to experienced, but not well-known illustrators; 40% to new and emerging illustrators. Prefers any style. Considers all media. 10% of freelance illustration demands knowledge of Adobe Illustrator, QuarkXPress. Send query letter with printed samples, tearsheets, résumé, SASE and color copies. Accepts disk submissions compatible with QuarkXPress (JPEG files). Samples are filed or returned by SASE on request. Reports back within 6-8 weeks. To show portfolio, artist should follow-up with call and/or letter after initial query. Portfolio should include color, final art, tearsheets, transparencies. Rights purchased vary according to project. Pays on publication; $50-200 for color inside; $150-300 for 2-page spreads; $50-75 for spots. Finds illustrators through word of mouth and submissions.
Tips: "Read the magazine first; we like colorful work; ability to turn around in two weeks."

N **GIRLS' LIFE**, 4517 Hartford Rd., Baltimore MD 21214-9989. (410)254-9200. Fax: (410)254-0991. Art Director: Chun Kim. Estab. 1994. Bimonthly consumer magazine for 7- to 14-year-old girls. Originals sometimes returned at job's completion. Sample copies available for $5 on back order or on newsstands. Art guidelines not available. Sometimes needs computer literate freelancers for illustration. 20% of freelance work demands computer knowledge of Adobe Illustrator, QuarkXPress or Adobe Photoshop.
Illustration: Prefers anything pertaining to 7- to 14-year-old girls. Considers pen & ink, watercolor, airbrush, acrylic and mixed media. Send query letter with SASE, tearsheets, photographs, photocopies, photostats, slides and transparencies. Samples are filed or are returned by SASE if requested by artist. Publication will contact artist for portfolio review if interested. Portfolio should include tearsheets, slides, photostats, photocopies, final art and photographs. Buys first rights. Pays on publication.
Tips: Finds artists through artists' submissions. Loves humorous cartoons. "Send work pertaining to our market."

✓ **GLAMOUR**, 350 Madison Ave., New York NY 10017. Art Director: Henry Connell. Monthly magazine. Covers fashion and issues concerning working women (ages 20-35). Originals returned at job's completion. Sample copies available on request. 5% of freelance work demands knowledge of Adobe Illustrator, QuarkXPress, Adobe Photoshop and Aldus FreeHand.
Cartoons: Buys 1 cartoon/issue. Prefers feminist humor. Prefers humorous b&w line drawings with gagline. Send postcard-size sample. Samples are filed and not returned. Reports back to the artist only if interested. Rights purchased vary according to project.
Illustration: Buys 7 illustrations/issue. Works on assignment only. Considers all media. Send postcard-size sample. Samples are filed and not returned. Publication will contact artist for portfolio review if interested. Freelancers can also call to arrange portfolio drop-off. Portfolio should include final art, color photographs, tearsheets, color photocopies and photostats. Rights purchased vary according to project. Pays on publication.

N **GLASS FACTORY DIRECTORY**, Box 2267, Hempstead NY 11557. (516)481-2188. E-mail: manager@glassfactorydir.com. Website: http://www.glassfactorydir.com. Manager: Liz Scott. Annual listing of glass manufacturers in US, Canada and Mexico.
Cartoons: Receives an average of 1 submisson/week. Buys 5-10 cartoons/issue. Cartoons should pertain to glass manufacturing (flat glass, fiberglass, bottles and containers; no mirrors). Prefers single and multiple panel b&w line drawings with gagline. Prefers roughs or finished cartoons. "We do not assign illustrations. We buy from submissions only." Send SASE. Reports in 1-3 months. Buys all rights. **Pays on acceptance**; $25.
Tips: "Learn about making glass of all kinds. We rarely buy broken glass jokes. There *are* women working in glass plants. Glassblowing is overdone. What about flat glass, autoglass, bottles?"

GOVERNING, 1100 Connecticut Ave. NW, Suite 1300, Washington DC 20036. (202)862-1446. Fax: (202)862-0032. E-mail: rsteadham@governing.com. Website: http://www.governing.com. Art Director: Richard Steadham. Estab. 1987. Monthly magazine. "Our readers are executives of state and local governments nationwide. They include governors, mayors, state legislators, county executives, etc." Circ. 86,000.
Illustration: Approached by hundreds of illustrators/year. Buys 2-5 illustrations/issue. Prefers conceptual editorial

illustration dealing with public policy issues. Considers all media. 10% of freelance illustration demands knowledge of Adobe Photoshop, Adobe Illustrator, Aldus FreeHand. Send postcard sample with printed samples, photocopies and tearsheets. Send follow-up postcard sample every 3 months. "No phone calls please. We work in QuarkXPress, so we accept any format that can be imported into that program." Samples are filed. Reports back only if interested. Art director will contact artist for portfolio review if interested. Buys one-time rights. Pays on publication; $700-1,200 for cover; $350-700 for inside; $350 for spots. Finds illustrators through *Blackbook*, *LA Workbook*, online services, magazines, word of mouth, submissions.

Tips: "We are not interested in working with artists who can't take some direction. If you can collaborate with us in communicating our words visually, then we can do business. Also, please don't call asking if we have any work for you. When I'm ready to use you, I'll call you."

GRAND RAPIDS MAGAZINE, Gemini Publications, 549 Ottawa Ave., Grand Rapids MI 49503. (616)459-4545. Editor: Carole Valade. Monthly for greater Grand Rapids residents. Circ. 20,000. Original artwork returned after publication. Local artists only.

Cartoons: Buys 2-3 cartoons/issue. Prefers Michigan, Western Michigan, Lake Michigan, city, issue, consumer/household, fashion, lifestyle, fitness and travel themes. Send query letter with samples. Samples not filed are returned by SASE. Reports within 1 month. Buys all rights. Pays $35-50 for b&w.

Illustration: Buys 2-3 illustrations/issue. Prefers Michigan, Western Michigan, Lake Michigan, city, issue, consumer/household, fashion, lifestyle, fitness and travel themes. Send query letter with samples. Samples not filed are returned by SASE. Reports within 1 month. To show a portfolio, mail printed samples and final reproduction/product or call for an appointment. Buys all rights. Pays on publication; $200 minimum for color cover; $40 minimum for b&w inside; $40 minimum for color inside.

Tips: "Approach us only if you have good ideas."

☑ GRAPHIC ARTS MONTHLY, 345 Hudson St., New York NY 10014. (212)463-6579. Fax: (212)463-6530. E-mail: r.levy@gam.cahners.com. Website: http://www.gammag.com/. Creative Director: Rani Levy. Estab. 1930. Monthly 4-color trade magazine for management and production personnel in commercial and specialty printing plants and allied crafts. Design is "direct, crisp and modern." Circ. 95,000. Accepts previously published artwork. Originals returned at job's completion. Needs computer-literate freelancers for illustration.

Illustration: Approached by 150 illustrators/year. Buys 6 illustrations/issue. Works on assignment only. Considers all media, including computer. Send postcard-sized sample to be filed. Accepts disk submissions compatible with Adobe Photoshop 4.0, Adobe Illustrator 6.0 or EPS/TIFF files. Will contact for portfolio review if interested. Portfolio should include final art, photographs, tearsheets. Buys one-time and reprint rights. **Pays on acceptance**; $750-1200 for color cover; $250-350 for color inside; $250 for spots. Finds artists through submissions.

GRAY AREAS, P.O. Box 808, Broomall PA 19008-0808. E-mail: grayarea@operix.com. Website: http://www.grayarea. com/gray2.htm. Publisher: Netta Gilboa. Estab. 1991. Magazine examining gray areas of law and morality in the fields of music, law, technology and popular culture. Accepts previously published artwork. Originals not returned. Sample copies available for $8; art guidelines not available.

Cartoons: Approached by 15 cartoonists/year. Buys 2-5 cartoons/issue. Prefers "illegal subject matter" humorous cartoons; single, double or multiple panel b&w line drawings. Send query letter with brochure, roughs, photocopies or finished cartoons. Samples are filed. Reports back within 1 week only if SASE provided. Buys one-time rights.

Illustration: Works on assignment only. Has featured illustrations by Dennis Preston, Jeff Wampler and Wes Wilson. Assigns 5% of illustrations to well-known or "name" illustrators; 35% to experienced, but not well-known illustrators; 60% to new and emerging illustrators. Features humorous and computer illustration. Assigns 50% of illustrations to experienced, but not well-known illustrators; 50% to new and emerging illustrators. Prefers "illegal subject matter like sex, drugs, computer criminals." Considers "any media that can be scanned by a computer, up to 8½×11 inches." 50% of freelance work demands knowledge of Aldus PageMaker 6.0 or CorelDraw 6.0. Send postcard sample or query letter with SASE and photocopies. Accepts disk submissions compatible with IBM/PC. Samples are filed. Reports back within 1 week only if SASE enclosed. Portfolio review not required. Buys one-time rights. Pays on publication; $500 for color cover; negotiable b&w. Pays 5 copies of issue and masthead listing for spots.

Design: Needs freelancers for design. 50% of freelance work demands knowledge of Aldus PageMaker 6.0, Aldus FreeHand 5.0 or CorelDraw 6.0. Send query letter with photocopies. Pays by project.

Tips: "Most of the artists we use have approached us after seeing the magazine. All sections are open to artists. We are only interested in art which deals with our unique subject matter. Please do not submit without having seen the magazine. We have a strong 1960s style. Our favorite artists include Robert Crumb and Rick Griffin. We accept all points of view in art, but only if it addresses the subject we cover. Don't send us animals, statues or scenery."

GREENPRINTS, P.O. Box 1355, Fairview NC 28730. (704)628-1902. Editor: Pat Stone. Estab. 1990. Quarterly magazine "that covers the personal, not the how-to, side of gardening." Circ. 13,000. Sample copy for $4; art guidelines free for #10 SASE with first-class postage.

Illustration: Approached by 6 illustrators/year. Works with 15 illustrators/issue. Prefers plants and people. Considers b&w only. Send query letter with photocopies, SASE and tearsheets. Samples are filed or returned by SASE. Reports back within 2 months. Buys first North American serial rights. Pays on publication; $250 maximum for color cover; $75-100 for b&w inside; $25 for spots. Finds illustrators through word of mouth, artist's submissions.

Tips: "Read our magazine. Can you do both plants and people? Can you interpret as well as illustrate a story?"

✔ **GROUP PUBLISHING—MAGAZINE DIVISION**, 1515 Cascade Ave, Loveland CO 80538. (970)669-3836. Fax: (970)679-4372. Website: http://www.grouppublishing.com. Publishes *Group Magazine*, Art Director: Joel Armstrong (6 issues/year; circ. 50,000; 4-color); *Children's Ministry Magazine*, Art Director: RoseAnne Buerge (6 issues/year; 4-color) for adult leaders who work with kids from birth to 6th grade; *Vital Ministry Magazine*, Art Director: Bill Fisher (6 issues; 4-color) an interdenominational magazine which provides innovative and practical ideas for pastors. Previously published, photocopied and simultaneous submissions OK. Original artwork returned after publication. Sample copy $1 with 9×12 SAE.
 ● This company also produces books. See listing in Book Publishers section.
Cartoons: Generally buys one spot cartoon per issue that deals with youth or children ministry. Pays $50 minimum. Submit cartoon samples to Joel Armstrong.
Illustration: Buys 2-10 illustrations/issue. Has featured illustrations by Matt Wood, Chris Dean and Otto Pfandschimdt. Send postcard samples, SASE, slides or tearsheets to be kept on file for future assignments. Accepts disk submissions compatible with Mac. Send EPS files. Reports only if interested. **Pays on acceptance**; $75-600, from b&w/spot illustrations (line drawings and washes) to full-page color illustrations inside. Buys first publication rights and occasional reprint rights.
Tips: "We prefer contemporary, nontraditional (not churchy), well-developed styles that are appropriate for our innovative, youth-oriented publications. We appreciate artists who can conceptualize well and approach difficult and sensitive subjects creatively."

GUIDEPOSTS FOR KIDS, 1050 Broadway, Suite #6, Chesterton IN 46304. (219)929-4429. Fax: (219)926-2397. E-mail: mlyons@guideposts.org. Website: http://www.guideposts.org. Art Director: Michael C. Lyons. Estab. 1990. Bimonthly magazine "for children ages 8 to 12, value centered." Circ. 200,000.
Illustrtion: Approached by 80 illustrators/year. Buys 10 illustrations/issue. Has featured illustrations by Cliff Nielsen, Andy Powell, Sally Comport, Bina Altera, Gary Kelly. Assigns 20% of illustrations to well-known or "name" illustrators; 70% to experienced, but not well-known illustrators; 10% to new and emerging illustrators. Considers acrylic, collage, color washed, colored pencil, marker, mixed media, oil, pastel, watercolor and electronic. 25% of freelance illustration demands knowledge of Adobe Photoshop and Adobe Illustrator. Send postcard sample or send query letter with printed samples, photocopies and tearsheets. Accepts disk submissions. Samples are filed or returned by SASE. Reports back only if interested. Art director will contact artist for portfolio review of color, final art, photographs, roughs, tearsheets and thumbnails if interested. Buys first and reprint rights. **Pays on acceptance**; $400-1,400 for color inside; $120-300 for spots. Finds illustrators through submissions, invitations from guilds, exhibitions and Internet.
Design: Needs freelancers for design. Prefers designers with experience in teen or preteen age group. 25% of freelance work demands knowledge of Adobe Photoshop, Adobe Illustrator and QuarkXPress. Send query letter with printed samples, photocopies and tearsheets.
Tips: "No adults in magazine . . . kids only. Focus on 12-year-olds not 8-year-olds. Want colorful, on the edge, funky, stylized. Nonadult alternative styles are loved, traditional style sometimes used. Not really interested in humorous illustration."

Ⓝ **GUIDEPOSTS FOR TEENS**. 1050 Broadway, Chesterton IN 46304. (219) 929-4429. Fax: (219) 926-2397. E-mail: mlyons@guidepostos.org. Website: http://www.guideposts.org. Art Director: Michael C. Lyons. Bimonthly magazine for teens 13-17 focusing on true teen stories, value centered. Estab. 1998. Circ: 175,000.
Illustration: Approached by 50 illustrators per year. Buys 12-15 illustrations per issue. Considers all media including electronic. Has featured illustrations by Cliff Nielsen, Andy Powell, Sally Comport, Bina Altera, Gary Kelley. Assigns 20% of illustrations to well-known or "name" illustrators; 70% to experienced, but not well-known illustrators; 10% to new and emerging illustrators. Send postcard or tearsheets; "no large bundles, please. Disks welcome. Websites will be visited." Samples are filed if returned by SASE. Reports back only if interested. Art director will contact if more information is desired. Buys mostly first and reprint rights. Pays on invoice, net 30 days. Pays $500-900 single page; $800-1,800 per spread; $250-500 per color spot. Finds illustrators through submissions, reps and Internet.
Tips: This art director loves "on the edge, funky, stylized non-adult, alternative styles. Traditional styles are sometimes used, but we are not really interested in humorous illustration."

GUIDEPOSTS MAGAZINE, 16 E. 34th St., New York NY 10016. (212)251-8127. Fax: (212)684-0679. Website: http://www.guideposts.org. Art Director: Lawrence A. Laukhuf. Estab. 1945. Monthly nonprofit inspirational, consumer magazine. *Guideposts* is a "practical interfaith guide to successful living. Articles present tested methods for developing courage, strength and positive attitudes through faith in God." Circ. 4 million. Sample copies and guidelines are available.
 ● Also publishes *Angels on Earth*, a bimonthly magazine buying 4-7 illustrations/issue. They feature more eclectic and conceptual art, as well as realism.
Illustration: Buys 4-7 illustrations/issue. Works on assignment only. Features humorous, realistic, computer and spot illustration. Assigns 30% of illustrations to well-known or "name" illustrators; 40% to experienced, but not well-known illustrators; 30% to new and emerging illustrators. Prefers realistic, reportorial. Considers watercolor, collage, airbrush, acrylic, colored pencil, oil, mixed media and pastel. Send postcard sample with SASE, tearsheets, photocopies and slides. Accepts disk submissions compatible with QuarkXPress, Adobe Illustrator, Adobe Photoshop (Mac based). Samples are returned by SASE if requested by artist. To arrange portfolio review artist should follow up with call after

initial query. Portfolio should include 8×10 color transparencies. Buys one-time rights. **Pays on acceptance**; $2,500-3,500 for color cover; $1,500-2,400 for 2-page spreads; $300-1,000 for spots. Finds artists through sourcebooks, other publications, word of mouth, artists' submissions and Society of Illustrators' shows.
Tips: Sections most open to freelancers are illustrations for action/adventure stories. "Do your homework as to our needs. At least see the magazine! Tailor your portfolio or samples to each publication so our Art Director is not looking at one or two that fit his needs. Call me and tell me you've seen recent issues and how close your work is to some of the pieces in the magazine."

GUITAR PLAYER, 411 Borel Ave., Suite #100, San Mateo CA 94402. (415)358-9500. Fax: (415)358-9527. Website: http://www.guitarplayer.com. Art Director: Richard Leeds. Estab. 1975. Monthly 4-color magazine focusing on technique, artist interviews, etc. Circ. 150,000. Original artwork is returned at job's completion. Sample copies and art guidelines not available.
Illustration: Approached by 15-20 illustrators/week. Buys 3 illustrations/issue. Works on assignment only. Features caricature of celebrities; realistic, computer and spot illustration. Assigns 33% of illustrations to well-known or "name" illustrators; 33% to experienced, but not well-known illustrators; 33% to new and emerging illustrators. Prefers conceptual, "outside, not safe" themes and styles. Considers pen & ink, watercolor, collage, airbrush, computer based, acrylic, mixed media and pastel. Send query letter with brochure, tearsheets, photographs, photocopies, photostats, slides and transparencies. Accepts disk submissions compatible with Mac. Samples are filed. Reports back only if interested. Will contact for portfolio review if interested. Buys first rights. Pays on publication; $200-400 for color inside; $400-600 for 2-page spreads; $200-300 for spots.

☑ **HABITAT MAGAZINE**, 928 Broadway, New York NY 10010. (212)505-2030. Editor-in-Chief: Carol Ott. Art Director: Jillian Blurne. Estab. 1982. "We are a how-to magazine for cooperative and condominium boards of directors and home owner associations in New York City, Long Island, New Jersey and Westchester." Published 11 times a year; 4-color and b&w pages; 4-color cover. Circ. 18,000. Original artwork is returned after publication. Sample copy $5.
Cartoons: Cartoons appearing in magazine are "line with some wash highlights." Pays $75-125 for b&w.
Illustration: Works on assignment only. Send samples. Prefers pen & ink with wash highlights. Samples are filed. Pays $75-125, b&w.
Tips: "Read our publication, understand the topic. Look at the 'Habitat Hotline' and 'Case Notes' sections."

HADASSAH MAGAZINE, 50 W. 58th St., New York NY 10019. (212)688-0227. Fax: (212)446-9521. E-mail: hadamag1@aol.com. Estab. 1914. Consumer magazine. *Hadassah Magazine* is a monthly magazine chiefly of and for Jewish interests—both here and in Israel. Circ. 340,000.
Cartoons: Buys 1-2 freelance cartoons/issue. Preferred themes include the Middle East/Israel, domestic Jewish themes and issues. Send query letter with sample cartoons. Samples are filed or returned by SASE. Buys first rights. Pays $50, b&w; $100, color.
Illustration: Approached by 50 freelance illustrators/year. Works on assignment only. Has featured illustrations by Dick Codor and Ilene Winn Ederer. Features humorous, realistic, computer and spot illustration. Prefers themes of Jewish/family, Israeli issues, holidays. Send postcard sample or query letter with tearsheets. Samples are filed or are returned by SASE. Write for appointment to show portfolio of original/final art, tearsheets and slides. Buys first rights. Pays on publication; $400-600 for color cover; $100-200 for b&w inside; $200-250 for color inside; $100 for spots.

HARPER'S MAGAZINE, 666 Broadway, 11th Floor, New York NY 10012. (212)614-6500. Fax: (212)228-5889. Art Director: Angela Riechers. Estab. 1850. Monthly 4-color literary mgazine covering fiction, criticism, essays, social commentary and humor.
Illustration: Approached by 250 illustrators/year. Buys 5-10 illustrations/issue. Has featured illustrations by Steve Brodner, Ralph Steadman, Polly Becker, Edmund Guy, Mark Ulriksen, Victoria Kann, Peter de Seve. Features intelligent concept-oriented illustration. Preferred subjects: literary, artistic, social, fiction-related. Prefers intelligent, original thought and imagery in any media. Assigns 50% of illustrations to well-known or "name" illustrators; 25% to experienced, but not well-known illustrators; 25% to new and emerging illustrators. 10% of freelance illustration demands knowledge of Adobe Photoshop. Send non-returnable samples. Accepts Mac-compatible disk submissions. Samples are filed and are not returned. Will contact artist for portfolio review if interested. Portfolios may be dropped off and picked up the last Thursday of every month. Buys first North American serial rights. Pays on publication; $250-300 for b&w inside; $350-700 for color inside; $300 for spots. Finds illustrators through samples, annuals, reps, other publications.
Tips: "Intelligence, originality and beauty in execution are what we seek. A wide range of styles is appropriate; what counts most is content."

🔲 **HAWAII MAGAZINE**, 1210 Auahi St., #231, Honolulu HI 96814. (808)589-1515. E-mail: hawaii@fancypubs.com. Editor: John Hollon. Estab. 1984. Bimonthly "written for and directed to the frequent visitor and residents who travel frequently among the Hawaiian Islands. We try to encourage people to discover the vast natural beauty of these Islands." Circ. 90,000. Original artwork is returned after publication. Sample copies $3.95.
● Editor told *AGDM* he prefers artists who are familiar with Hawaii, so "please don't send samples unless you live in Hawaii."
Illustration: Buys illustrations mainly for spots and feature spreads. Buys 1-2 illustrations/issue. Works on assignment only. Considers pen & ink, airbrush, watercolor, acrylic, oil, charcoal pencil and calligraphy. Send postcard samples.

Samples are not filed and are returned. Reports back about queries/submissions within 1 month. To show a portfolio mail printed samples and tearsheets. Buys first rights. Pays $75 for b&w; $150 for color, inside.

HEALTHCARE FINANCIAL MANAGEMENT, 2 Westbrook Corp. Center, Suite 700, Westchester IL 60154-5700. (708)531-9600. Fax: (708)531-0032. E-mail: cstachura@hfma.org. Publisher: Cheryl Stachura. Estab. 1946. Monthly association magazine for chief financial officers in healthcare, managers of patient accounts, healthcare administrators. Circ. 35,000. Sample copies available; art guidelines not available.
Cartoons: Buys 1 cartoon/issue. Prefers single panel, humorous b&w line drawings with gaglines. Send query letter with photocopies. Samples are filed or returned. Reports back only if interested. Pays on publication.
Illustration: All freelance illustration should be sent to James Lienhart Design, 155 N. Harbor Drive, Suite 3008, Chicago IL 60601. Considers acrylic, airbrush, color washed, colored pencil, marker, mixed media, oil, pastel, watercolor. Send query letter with printed samples, photocopies and tearsheets. Samples are filed. Will contact artist for portfolio review if interested.

N HEARTLAND BOATING MAGAZINE, 319 N. 4th St., #650, St. Louis MO 63102. (314)241-4310. Fax: (314)241-4207. Website: http://www.Heartlandboating.com. Editor: Carol-Faye McDonald. Estab. 1988. Specialty magazine published 7 times per year devoted to power (cruisers, houseboats) and sail boating enthusiasts throughout middle America. The content is both humorous and informative and reflects "the challenge, joy and excitement of boating on America's inland waterways." Circ. 20,000. Occasionally accepts previously published artwork. Originals are returned at job's completion. Sample copies available for $5. Art guidelines for SASE with first-class postage. 50% of freelance work demands knowledge of Adobe Illustrator, QuarkXPress or Adobe Photoshop.
Cartoons: Approached by 10-12 cartoonists/year. Buys 2-3 cartoons/issue. Prefers boating; single panel without gaglines. Send query letter with roughs. Samples are filed or returned by SASE. Reports back within 2 months. Negotiates rights purchased. Pays $30 for b&w.
Illustration: Approached by 2-3 illustrators/year. Buys 2-3 illustrations/issue. Works on assignment only. Prefers boating-related themes. Considers pen & ink. Send postcard sample or query letter with SASE, photocopies and tearsheets. Accepts disk submissions compatible with Adobe Illustrator 5.0. Send EPS files. Samples are filed or returned by SASE. Reports back within 2 months. Portfolio review not required. Negotiates rights purchased. Pays on publication. Pay is negotiated. Finds artists through submissions.
Tips: "Submit professional cover letters with no typos. Grammar is important too!"

HEARTLAND USA, 1 Sound Shore Dr., Suite 2, Greenwich CT 06830-7251. (203)622-3456. Fax: (203)863-5393. E-mail: husaedit@aol.com. Editor: Brad Pearson. Estab. 1990. Bimonthly 4-color magazine. Audience is composed of blue-collar men. Circ. 901,000. Accepts previously published artwork. Originals are returned at job's completion. Sample copies for SASE with first-class postage.
Cartoons: Approached by 60 cartoonists/year. Buys 3-6 cartoons/issue. Preferred themes are blue-collar life-style, "simple style, light humor, nothing political or controversial"; single panel, b&w line drawings and washes with or without gagline. Send query letter with roughs. Samples are filed. Reports back within 2 weeks. Rights purchased vary according to project. Pays $150 for b&w.
Illustration: Approached by 36 illustrators/year. Buys 2 illustrations/issue. Preferred themes are blue-collar lifestyle. Prefers flexible board. Send query letter with tearsheets. Samples are filed. Reports back within 2 weeks. Call for appointment to show portfolio of printed samples, tearsheets and slides. Rights purchased vary according to project. Pays on publication; $150 for b&w or color.

HEAVEN BONE, Box 486, Chester NY 10918. (914)469-9018. E-mail: heavenbone@aol.com. Editor: Steve Hirsch. Estab. 1987. Annual literary magazine emphasizing poetry, fiction reviews, and essays reflecting spiritual, surrealist and experimental literary concerns. Circ. 2,500. Accepts previously published artwork. Original artwork is returned after publication if requested. Sample copies $8; art guidelines for SASE with first-class postage.
Cartoons: Approached by 5-7 cartoonists/year. Cartoons appearing in magazine are "humorous, spiritual, esoteric, ecologically and politically astute." Pays in 2 copies of magazine, unless other arrangements made.
Illustration: Approached by 25-30 illustrators/year. Buys illustrations mainly for covers and feature spreads. Buys 2-7 illustrations/issue, 4-14/year from freelancers. Considers pen & ink, mixed media, watercolor, acrylic, oil, pastel, collage, markers, charcoal, pencil and calligraphy. Needs computer literate illustrators familiar with Adobe Illustrator, QuarkXPress, Aldus FreeHand and Adobe Photoshop. Send query letter with brochure showing art style, tearsheets, SASE, slides, transparencies, photostats, photocopies and photographs. "Send samples of your most esoteric and nontraditional work, inclusive of but not exclusively literary—be outrageous." Accepts disk submissions compatible with Adobe Illustrator 6.0, Adobe Photoshop 4.0 or any Mac compatible format. Samples are returned by SASE. Reports back within 4-6 months. To show a portfolio, mail b&w tearsheets, slides, photostats and photographs. Buys first rights. Pays in 2 copies of magazine.
Tips: "Please see sample issue before sending unsolicited portfolio."

THE HERB QUARTERLY, P.O. Box 689, San Anselmo CA 94960. (415)455-9540. E-mail: herbquart@aol.com. Publisher: James Keough. Editor: Jennifer Barrett. "Quarterly magazine emphasizing horticulture for middle to upper class men and women with an ardent enthusiasm for herbs and all their uses—gardening, culinary, crafts, etc. Most are probably home owners." Unusual design with 2 main text columns flanked by mini-columns. Uses original artwork

extensively. Circ. 40,000. Original artwork returned after publication. Sample copy $5.

Illustration: Assigns 80% of illustrations to experienced, but not well-known illustrators; 20% to new and emerging illustrators. Accepts pen & ink illustrations, pencil, washes and 4-color watercolors. Needs illustrations of herbs, garden designs, etc. Send query letter with brochure showing art style or résumé, tearsheets, slides and photographs. Samples not filed are returned by SASE only if requested. Reports within weeks. Buys reprint rights. Pays on publication; $200 for full page; $100 for half page; $50 for quarter page; $25 for spots.

Tips: "Artist should be able to create illustrations drawn from themes of manuscripts sent to them. Send good promo pieces to keep on file. Adhere to deadlines. Be fun and creative."

N HIGH COUNTRY NEWS, 119 Grand Ave., P.O. Box 1090, Paonia CO 81428-1090. (970)527-4898. Fax: (970)527-4897. E-mail: editor@hcn.org. Website: http://www.hcn.org. Editor: Betsy Marston. Estab. 1970. Biweekly newspaper published by the nonprofit High Country Foundation. High Country News covers environmental, public lands and community issues in the 10 western states. Circ. 19,000. Art guidelines free for SASE with first-class postage.

Cartoons: Buys 1 cartoon/issue. Prefers issues affecting Western environment. Prefers single panel, political, humorous b&w washes and line drawings with or without gagline. Send query letter with finished cartoons and photocopies. "Samples are filed if they're appropriate for us or returned with SASE". Reports back only if interested. Rights purchased vary according to project. Pays on publication; $35-100 for b&w.

Illustration: Considers all media if reproducible in b&w. Send query letter with printed samples and photocopies. Accepts disk submissions compatible with QuarkXPress and Photoshop. Samples are filed or returned by SASE. Reports back only if interested. Rights purchsed vary according to project. Pays on publication; $50-100 for b&w cover; $35-75 for b&w inside. Finds illustrators through magazines, newspapers and artist's submissions.

HIGHLIGHTS FOR CHILDREN, 803 Church St., Honesdale PA 18431. (717)253-1080. Fax: (717)251-7847. Art Director: Janet Moir McCaffrey. Cartoon Editor: Rich Wallace. Monthly 4-color magazine for ages 2-12. Circ. 3 million. Art guidelines for SASE with first-class postage.

Cartoons: Receives 20 submissions/week. Buys 2-4 cartoons/issue. Interested in upbeat, positive cartoons involving children, family life or animals; single or multiple panel. Send roughs or finished cartoons and SASE. Reports in 4-6 weeks. Buys all rights. **Pays on acceptance**; $20-40 for line drawings. "One flaw in many submissions is that the concept or vocabulary is too adult, or that the experience necessary for its appreciation is beyond our readers. Frequently, a wordless self-explanatory cartoon is best."

Illustration: Buys 30 illustrations/issue. Works on assignment only. Prefers "realistic and stylized work; upbeat, fun, more graphic than cartoon." Pen & ink, colored pencil, watercolor, marker, cut paper and mixed media are all acceptable. Discourages work in fluorescent colors. Send query letter with photocopies, SASE and tearsheets. Samples to be kept on file. Request portfolio review in original query. Will contact for portfolio review if interested. Buys all rights on a work-for-hire basis. **Pays on acceptance**; $1,025 for color front and back covers; $50-500 for color inside. "We are always looking for good hidden pictures. We require a picture that is interesting in itself and has the objects well-hidden. Usually an artist submits pencil sketches. In no case do we pay for any preliminaries to the final hidden pictures." Submit hidden pictures to Jody Taylor.

Tips: "We have a wide variety of needs, so I would prefer to see a representative sample of an illustrator's style."

N HISPANIC MAGAZINE, 98 San Jacinto Blvd., Suite 1150, Austin TX 78701. (512)476-5599. Fax: (512)320-1943. E-mail: mao@hisp.com. Website: http://www.hisp.com. Creative Director: Alberto Insua. Estab. 1987. Monthly 4-color consumer magazine. Circ. 250,000.

Illustration: Approached by 100 illustrators/year. Buys 5 illustrations/issue. Has featured illustrations by Will Terry, A.J. Garces, Sonia Aguirre. Features caricatures of politicians, humorous illustration, realistic illustrations, charts & graphs, spot illustrations and computer illustration. Prefers business subjects, men and women. Prefers pastel and bright colors. Assigns 80% of illustrations to experienced, but not well-known illustrators; 20% to new and emerging illustrators. Send non-returnable postcard samples. Accepts Mac-compatible disk submissions. Send EPS or TIFF files. Samples are filed. Reports back only if interested. Will contact artist for portfolio review if interested. Buys one-time rights. Pays on publication; $500-1,000 for color cover; $300 maximum for b&w inside; $800 maximum for color inside; $250 for spots.

Tips: "Concept is very important, to take a idea or story and to be able to find a fresh perspective. I like to be surprised by the artist."

N ALFRED HITCHCOCK MAGAZINE, 475 Park Ave. S., 11th Floor, New York NY 10016. (212)686-7188. Fax: (212)686-7414. Senior Art Director: Victoria Green. Assistant Art Director: Shirley Chan Levi. All submissions should be sent to Shirley Chan Levi, assistant art director. Estab. 1956. Monthly b&w magazine with 4-color cover emphasizing mystery fiction. Circ. 202,470. Accepts previously published artwork. Original artwork returned at job's completion. Art guidelines available for #10 SASE with first-class postage.

Illustration: Approached by 300 illustrators/year. Buys 8-10 illustrations/issue. Prefers semi-realistic, realistic style. Works on assignment only. Considers pen & ink. Send query letter with printed samples, photocopies and/or tearsheets and SASE. Send follow-up postcard sample every 3 months. Samples are filed or returned by SASE. Reports back only if interested. "No phone calls." Portfolios may be dropped off every Tuesday and should include b&w and color tearsheets. "No original art please." Rights purchased vary according to project. **Pays on acceptance**; $1,000-1,200 for color cover; $100 for b&w inside; $35-50 for spots. Finds artists through submissions drop-offs, RSVP.

A.J. Garces's humorous illustration of Mexican lottery cards for the December 1998 cover of *Hispanic Magazine* was a hit with creative director Alberto Insua. Insua sought out Garces after seeing some of his previous work and paid him $800 to create this colorful cover illustration. Insua prefers illustrations with pastel or bright colors, and likes artists that are conceptual. Garces's bright watercolor and gouache illustration scored well with *Hispanic Magazine*'s circulation audience of 250,000.

Tips: No close-up or montages. Show characters within a background environment.

HOME & CONDO MAGAZINE, 2975 Horseshoe Dr., Naples FL 33942. (813)643-3933. Fax: (813)643-5017. Senior Art Director: Kate Kintz. Advertising Art Director: Amy Slel. Art Director: Roni Fields. "We are southwest Florida's resource for home and garden ideas." Published 7 times/year, plus special issues. Accepts previously published artwork. Originals returned at job's completion. Sample copies and art guidelines available. 30% of work demands knowledge of Compugraphics.
Illustration: Approached by 40 illustrators/year. Buys 2-3 illustrations/issue. Has featured illustrations by Charles Stubbs, Mark James, Jeff Cline, Dale Anderson. Assigns 15% of illustrations to well-known or "name" illustrators; 70% to experienced but not well-known illustrators; 15% to new and emerging illustrators. Works on assignment only. Prefers digital, marker, colored pencil and pastel. Send query letter and price list with brochure, tearsheets and photocopies. "No phone calls please. Welcome illustrations created in Illustrator 5.0, FreeHand or Photoshop. OK to submit on disk." Samples are filed. Reports back only if interested. Buys one time rights. Pays on publication; average pay $350.
Tips: "If an artist will work with us and be sensitive to our constraints, we'll be willing to work with the artist to find a mutually beneficial arrangement. Look through copies of our magazine or call and request a copy before you show your portfolio. Your samples should be geared toward the particular needs and interests of our magazine, and should be in keeping with the unique architecture and environment of southwest Florida."

HOME BUSINESS MAGAZINE, 9582 Hamilton, Suite 368, Huntington Beach CA 92646. (714)968-0331. Fax: (714)962-7722. E-mail: henderso@ix.netcom.com. Website: http://www.homebusinessmag.com. Creative Director: Terri Speakman. Estab. 1992. Bimonthly consumer magazine. Circ. 79,000. Sample copies free for 10×13 SASE and $2.32 in first-class posgate.
Illustration: Approached by 30 illustrators/year. Buys several illustrations/issue. Features natural history illustration, realistic illustrations, charts & graphs, informational graphics, spot illustrations and computer illustration of business subjects, families, men and women. Prefers pastel and bright colors. Assigns 85% of illustrations to well-known or "name" illustrators; 8% to experienced, but not well-known illustrators; 7% to new and emerging illustrators. 100% of freelance illustration demands knowledge of Adobe Illustrator and QuarkXPress. Send query letter with printed samples, photocopies and SASE. Send electronically as TIFF files. Samples are filed or returned if requested. Reports back only if interested. Will contact artist for portfolio review if interested. Buys reprint rights. Negotiates rights purchased. Pays on publication. Finds illustrators through magazines, word of mouth or via Internet.

☑ HOME FURNISHINGS EXECUTIVE, 305 W. High St., Suite 400, High Point NC 27260. (336)801-6152. Fax: (336)883-1195. E-mail: hfe@hpe.infi.net. Editor: Lisa Casinger. Art Director: Tracy Shelton. Estab. 1927. Monthly trade journal "of the National Home Furnishings Association. We provide in-depth coverage of trend, operational, marketing and advertising issues of interest to furniture retailers." Sample copies free for 4 first-class stamps.
Cartoons: Approached by 1-5 cartoonists/year. Buys 0-1 cartoon/issue. Prefers single panel, humorous, b&w and color washes, b&w line drawings with or without gagline. Send query letter with finished cartoons, photographs, photocopies, roughs, SASE and tearsheets. Samples are filed unless return requested by SASE. Reports back only if interested. Rights purchased vary according to project. **Pays on acceptance**.
Illustration: Approached by 1-5 illustrators/issue. Buys 10-20 illustrations/year. Features humorous and realistic illustration, charts & graphs, informational graphics and computer and spot illustration. Prefers furniture, consumers, human resources and merchandising. Considers all media. Send postcard sample or printed samples, photocopies and SASE. Accepts disk submissions. "We accept submissions compatible with QuarkXPress 7.5/V.3.32. Send EPS files." Samples are filed or are returned by SASE. Reports back only if interested. Art director will contact artist for portfolio review b&w, color, final art and tearsheets if interested. Rights purchased vary according to project. Pays on publication. Finds illustrators through submissions.
Tips: "We are only interested in work of relevance to home furnishings retailers. Do not call, send queries. Postcards showing work are great reminders of artists work. Get samples of the magazine and read them. Submissions must be pertinent to our readers."

HOME OFFICE COMPUTING MAGAZINE, Curtco Freedom Group, 29160 Heather Cliff Rd., Suite 200, Malibu CA 90265. (310)579-3400. Fax: (310)579-3304. Art Director: Mary Franz. Estab. 1980. Monthly magazine of small business/home office advice; 4-color. Circ. 380,000. Accepts previously published artwork. Originals are returned at job's completion "when possible." Sample copies available.
Illustration: Approached by 45 illustrators/year. Buys 12 illustrations/issue. Works on assignment only. Prefers pen & ink, electronic media, watercolor, collage, acrylic, colored pencil and mixed media. Freelance work demands knowledge of Adobe Photoshop and QuarkXPress. Send query letter with tearsheets. Samples are filed. Reports back only if interested. To show a portfolio, call for appointment. Portfolio should include tearsheets and slides. Buys one-time rights.

HONOLULU MAGAZINE, 36 Merchant St., Honolulu HI 96813. (808)524-7400. E-mail: honpub@aloha.net. Art Director: Michel V.M. Lê. "Monthly 4-color city/regional magazine reporting on current affairs and issues, people profiles, lifestyle. Readership is generally upper income (based on subscription). Contemporary, clean, colorful and reader-friendly" design. Original artwork is returned after publication. Sample copies for SASE with first-class postage. Art guidelines available.

Illustration: Buys illustrations mainly for spots and feature spreads. Buys 4-8 illustrations/issue. Works on assignment only. Prefers airbrush, colored pencil and watercolor. Considers pen & ink, mixed media, acrylic, charcoal, pencil and calligraphy. Send postcard or published sample showing art style. Looks for local subjects, conceptual abilities for abstract subjects (editorial approach)—likes a variety of techniques. Looks for strong b&w and woodblock work. Samples are filed or are returned only if requested. Reports back only if interested. Write to schedule an appointment to show a portfolio which should include original/final art and color and b&w tearsheets. Buys first rights or one-time rights. Pays on publication; $300-500 for cover; $75-350 for inside; $50-75 for spots. Finds artists through word of mouth, magazines, submissions, attending art exhibitions.
Tips: "Needs both feature and department illustration—best way to break in is with small spot illustration. Prefers art on Zip disk or Jazz. Friendly and professional attitude is a must."

HOPSCOTCH, The Magazine for Girls, Box 164, Bluffton OH 45817. (419)358-4610. Contact: Becky Jackman. Estab. 1989. A bimonthly magazine for girls between the ages of 6 and 12; 2-color with 4-color cover; 50 pp.; 7×9 saddle-stapled. Circ. 12,000. Original artwork returned at job's completion. Sample copies available for $3. Art guidelines for SASE with first-class postage. 20% of freelance work demands computer skills.
● Also publishes *Boys' Quest*.
Illustration: Approached by 200-300 illustrators/year. Buys 6-7 freelance illustrations/issue. Has featured illustrations by Chris Sabatino, Pamela Harden and Donna Catanese. Features humorous, realistic and spot illustration. Assigns 60% of illustrations to experienced, but not well-known illustrators; 40% to new and emerging illustrators. Artists work mostly on assignment. Needs story illustration. Prefers traditional and humor; pen & ink. Send query letter with photocopies of pen & ink samples. Samples are filed. Reports back within 2 months. Buys first rights and reprint rights. **Pays on acceptance**; $200-250 for color cover; $25-35 for b&w inside; $50-70 for 2-page spreads; $10-25 for spots.

N **HORSE ILLUSTRATED**, P.O. Box 6050, Mission Viejo CA 92690. (949)855-8822. Editor: Moira C. Harris. Managing Editor: Julie West. Estab. 1975. Monthly consumer magazine providing "information for responsible horse owners." Circ. 187,000. Originals are returned after job's completion. Sample copies available for $4. Art guidelines for SASE with first-class postage.
Cartoons: Approached by 200 cartoonists/year. Buys 1 or 2 cartoons/issue. Prefers satire on horse ownership ("without the trite clichés"); single panel b&w line drawings with gagline. Send query letter with brochure, roughs and finished cartoons. Samples are not filed and are returned by SASE. Reports back within 6 weeks. Buys first rights and one-time rights. Pays $35 for b&w.
Illustration: Approached by 60 illustrators/year. Buys 1 illustration/issue. Prefers realistic, mature line art, pen & ink spot illustrations of horses. Considers pen & ink. Send query letter with SASE and photographs. Accepts disk submissions. Samples are not filed and are returned by SASE. Reports back within 6 weeks. Portfolio review not required. Buys first rights or one-time rights. Pays on publication; $35 for b&w inside. Finds artists through submissions.
Tips: "We only use spot illustrations for breed directory and classified sections. We do not use much, but if your artwork is within our guidelines, we usually do repeat business."

HORTICULTURE MAGAZINE, 98 N. Washington St., Boston MA 02114. (617)742-5600. E-mail: hortmag@aol.com. Website: http://www.hortmag.com. Art Director: Pam Conrad. Estab. 1904. Monthly magazine for all levels of gardeners (beginners, intermediate, highly skilled). "*Horticulture* strives to inspire and instruct people who want to garden." Circ. 300,000. Originals are returned at job's completion. Art guidelines are available.
Illustration: Approached by 75 freelance illustrators/year. Buys 10 illlustrations/issue. Works on assignment only. Features realistic illustration; informational graphics; spot illustration. Assigns 80% to experienced, but not well-known illustrators; 20% to new and emerging illustrators. Prefers tight botanicals; garden scenes with a natural sense to the clustering of plants; people; hands and "how-to" illustrations. Considers all media. Send query letter with brochure, résumé, SASE, tearsheets, slides. Samples are filed or returned by SASE. Publication will contact artist for portfolio review if interested. Buys one-time rights. Pays 1 month after project completed. Payment depends on complexity of piece; $800-1,200 for 2-page spreads; $150-250 for spots. Finds artists through word of mouth, magazines, artists' submissions/self-promotions, sourcebooks, artists' agents and reps, attending art exhibitions.
Tips: "I always go through sourcebooks and request portfolio materials if a person's work seems appropriate and is impressive."

HOUSE BEAUTIFUL, 1700 Broadway, 29th Floor, New York NY 10019. (212)903-5229. Fax: (212)765-8292. Art Director: Andrzej Janerka. Estab. 1896. Monthly consumer magazine. *House Beautiful* is a magazine about interior decorating—emphasis is on classic and contemporary trends in decorating, architecture and gardening. The magazine is aimed at both the professional and non-professional interior decorator. Circ. 1.3 million. Originals returned at job's completion. Sample copies available.
Illustration: Approached by 75-100 illustrators/year. Buys 2-3 illustrations/issue. Works on assignment only. Prefers contemporary, conceptual, interesting use of media and styles. Considers all media. Send postcard-size sample. Samples are filed only if interested and are not returned. Portfolios may be dropped off every Monday-Friday. Publication will contact artist for portfolio review of final art, photographs, slides, tearsheets and good quality photocopies if interested. Buys one-time rights. Pays on publication; $600-700 for color inside; $600-700 for spots (99% of illustrations are done as spots).
Tips: "We find most of our artists through artist submissions of either portfolios or postcards. Sometimes we will

contact an artist whose work we have seen in another publication. Some of our artists are found through artist reps and annuals."

[N] HOUSE CALLS, 782 Johnnie Dodds Blvd., Mt. Pleasant SC 29464. (843)971-9811. Fax: (843)971-0121. E-mail: gulfstream@awod.com. Art Director: Melinda Smith Monk. Quarterly controlled-circulation magazine from CoreAlliance Health Services (several hospitals). "A fun and informative medical magazine." Circ. 80,000. Art guidelines for #10 SASE.

Illustration: Approached by 100 illustrators/year. Buys 35-60 illustrations/issue. Has featured illustrations by Paige Johnson, Melanie Freedman and Chris Curro. Features computer, humorous, medical and spot illustration and informational graphics—fun and colorful. Preferred subjects: children, families, men and women, teens. Considers all types of color schemes, styles and/or media. Assigns 35% of illustrations to experienced, but not well-known illustrators; 30% to well-known or "name" illustrators; 25% to new and emerging illustrators. 50% of freelance illustration demands knowledge of Adobe Illustrator, Adobe Photoshop, Aldus FreeHand, QuarkXPress and drawing or painting. Send postcard sample and follow-up postcard every month or send non-returnable samples. Accepts Mac-compatible disk submissions. Samples are filed or returned by SASE. Will contact artist for portfolio review if interested. Buys first rights or one-time rights; rights purchased vary according to project. Pays on publication, $65-850 for b&w and color inside; $450-2,000 for 2-page color spreads. Finds illustrators through sourcebooks, promotional samples and word of mouth.

Tips: "We like fun illustrations that will help draw the reader into the story. Although we're a medical magazine, we strive to be interesting and informative—never stuffy."

[✓] HOW, The Bottomline Design Magazine, 1507 Dana Ave., Cincinnati OH 45207. E-mail: amyh@fwpubs.com. Website: http://www.howdesign.com. Art Director: Amy Hawk. Estab. 1985. Bimonthly trade journal covering "how-to and business techniques for graphic design professionals." Circ. 35,000. Original artwork returned at job's completion. Sample copy $8.50.
 • Sponsors annual conference for graphic artists. Send SASE for more information.

Illustration: Approached by 100 illustrators/year. Buys 4-6 illustrations/issue. Works on assignment only. Considers all media, including photography and computer illustration. Send non-returnable samples. Accepts disk submissions. Reports back only if interested. Buys first rights or reprint rights. Pays on publication; $150-200 for b&w; $275-800 for color inside.

Tips: "Send good samples that apply to the work I use. Be patient, art directors get a lot of samples."

HR MAGAZINE, 1800 Duke St., Alexandria VA 22314. (703)548-3440. Fax: (703)548-9140. E-mail: caroline@shrm.org. Website: http://www.shrm.org. Art Director: Caroline Foster. Estab. 1948. Monthly trade journal dedicated to the field of human resource management. Circ. 120,000.

Illustration: Approached by 70 illustrator/year. Buys 4 illustration/issue. Prefers people, management and stylized art. Considers all media. 50% of illustration demands knowledge of Adobe Photoshop, Adobe Illustrator, Aldus FreeHand and QuarkXPress. Send query letter with printed samples. Accepts disk submissions. Illustrations can be attached to e-mails. *HR Magazine* is PC based. Samples are filed. Art director will contact artist for portfolio review if interested. Rights purchased vary according project. Requires artist to send invoice. Pays within 30 days. Pays $800-3,000 for color cover; $250-2,000 for color inside. Finds illustrators through sourcebooks, magazines, word of mouth and artist's submissions.

[✓] HSUS NEWS, 700 Professional Dr., Gaithersburg MD 20814. Website: http://www.hsus.org. Art Director: Paula Jawonski. Estab. 1954. Quarterly 4-color magazine focusing on The Humane Society news and animal protection issues. Circ. 450,000. Accepts previously published artwork. Originals are returned at job's completion. Art guidelines not available.

Illustration: Buys 1-2 illustrations/issue. Works on assignment only. Features natural history, realistic and spot illustration. Assigns 20% of illustrations to well-known or "name" illustrators; 80% to experienced, but not well-known illustrators. Themes vary. Send query letter with samples. Samples are filed or returned. Reports back within 1 month. To show a portfolio, mail appropriate materials. Portfolio should include printed samples, b&w and color tearsheets and slides. Buys one-time rights and reprint rights. **Pays on acceptance**; $250-500 for b&w cover; $250-500 for color cover; $300-500 for b&w inside; $300-500 for color inside; $300-600 for 2-page spreads; $75-150 for spots.

HUMPTY DUMPTY'S MAGAZINE, Children's Better Health Institute, 1100 Waterway Blvd., Box 567, Indianapolis IN 46206. (317)636-8881. Website: http://www.satevepost.org/kidsonline. Art Director: Rebecca Ray. A health-oriented children's magazine for ages 4-7; 4-color; simple and direct design. Published 8 times/year. Circ. 200,000. Originals are not returned at job's completion. Sample copies available for $1.25; art guidelines for SASE with first-class postage.
 • Also publishes *Child Life, Children's Digest, Children's Playmate, Jack and Jill, Turtle Magazine* and *U.S. Kids Weekly Reader Magazine.*

Illustration: Approached by 300-400 illustrators/year. Buys 20 illustrations/issue. Has featured illustrations by BB Sams, Alan MacBain, David Helton and Patti Goodnow. Features humorous, realistic, medical, computer and spot illustration. Assigns 90% of illustrations to experienced, but not well-known illustrators; 10% to new and emerging illustrators. Works on assignment only. Preferred styles are mostly cartoon and some realism. Considers any media as long as finish is done on scannable (bendable) surface. Send query letter with slides, brochure, photographs, photocopies,

tearsheets and SASE. Samples are filed or returned by SASE if not kept on file. Reports back only if interested. To show a portfolio, mail color tearsheets, photostats, photographs and photocopies. Buys all rights. Pays on publication; $275 for color cover; $35-90 for b&w inside; $70-155 for color inside; $210-310 for 2-page spreads; $35-80 for spots; additional payment for digital pre-separated imagery: $35 full; $15 half; $10 spot.
Tips: "Send us very consistent styles of your abilities, along with a comment card and SASE for return."

HURRICANE ALICE: A FEMINIST QUARTERLY, Rhode Island College, Dept. of English, Providence RI 02908. (401)456-8377. Fax: (401)456-8379. E-mail: mreddy@grog.ric.edu. Submissions Manager: Joan Dagle. Estab. 1983. Quarterly literary magazine featuring nonfiction, fiction, poetry, reviews and artwork reflecting the diversity of women's lives. Sample copies for $2.50. Art guidelines for SASE with first-class postage.
Cartoons: Prefers woman centered/feminist themes. Send query letter with photocopies. Samples are filed and returned by SASE when appropriate. Reports back in 4 months. Pays in copies.
Illustration: Approached by 20 illustrators/year. Accepts 3-5 illustrations/issue. Has featured illustrations by Abigail Test, Kate Duhamel and Shawn Boyle. Prefers woman-centered/feminist themes. Considers all media. Send printed samples or photocopies and SASE when appropriate. Accepts disk submissions compatible with QuarkXPress 7.5/version 3.3, send EPS files, "but prefers photocopies." Samples are filed or returned by SASE if requested. Reports back in 4 months. Pays in copies. Finds illustrators through word of mouth, submissions and previous contributors.

N HUSTLER'S BARELY LEGAL, 8484 Wilshire Blvd., Suite 900, Beverly Hills CA 90211. (323)651-5400. Art Director: Jackie Osbeek. Estab. 1993. Monthy magazine "which contains fiction and nonfiction; sometimes serious, often humorous. Sex is the main topic but any sensational subject is possible." Circ. 90,000. Originals returned at job's completion. Sample copies available for $6.
Illustration: Approached by 15 illustrators/year. Buys 2 illustrations/issue. Works on assignment only. Prefers sex/eroticism as themes. Considers all media. Send query letter with tearsheets, photographs and photocopies. Samples are filed. Artist should follow up with call and/or letter after initial query. Publication will contact artist for portfolio review if interested. Porfolio should include b&w and color slides and final art. Buys all rights. **Pays on acceptance**; $500 for full page color inside. Finds artists through word of mouth, mailers and submissions.
Tips: "We use artists from all over the country, with diverse styles, from realistic to abstract. Must be able to deal with adult subject matter and have no reservations concerning explicit sexual images. We want to show these subjects in new and interesting ways."

N HUSTLER'S LEG WORLD, 8484 Wilshire Blvd., Suite 900, Beverly Hills CA 90211. (323)651-5400. Art Director: Cynthia Patterson. Estab. 1997. Monthy magazine "which contains fiction and nonfiction; sometimes serious, often humorous. Sex is the main topic but any sensational subject is possible." Circ. 90,000. Originals returned at job's completion. Sample copies available for $6.
Illustration: Approached by 15 illustrators/year. Buys 2 illustrations/issue. Works on assignment only. Prefers foot and leg fetishes as themes. Considers all media. Send query letter with tearsheets, photographs and photocopies. Samples are filed. Artist should follow up with call and/or letter after initial query. Publication will contact artist for portfolio review if interested. Porfolio should include b&w and color slides and final art. Buys all rights. **Pays on acceptance**; $500 for full page color inside. Finds artists through word of mouth, mailers and submissions.
Tips: "We use artists from all over the country, with diverse styles, from realistic to abstract. Must be able to deal with adult subject matter and have no reservations concerning explicit sexual images. We want to show these subjects in new and interesting ways."

HX MAGAZINE, 230 W. 17th St., 8th Floor, New York NY 10011. (212)352-3535. Website: http://www.hx.com. Contact: Art Director. Weekly magazine "covering gay and lesbian general interest, entertainment and nightlife in New York City." Circ. 40,000.
Cartoons: Approached by 5 cartoonists/year. Buys 1 cartoon/issue. Prefers gay and/or lesbian themes. Prefers multiple panel, humorous b&w line drawings with gagline. Send query letter with photocopies. Samples are filed and are not returned. Reports back only if interested. Rights purchased vary according to project. Pays on publication. Payment varies.
Illustration: Approached by 10 illustrators/year. Number of illustrations purchased/issue varies. Prefers gay and/or lesbian themes. Considers all media. Send query letter with photocopies. Samples are filed and are not returned. Reports back only if interested. Art director will contact artist for portfolio review of b&w and color if interested. Rights purchased vary according to project. Pays on publication. Finds illustrators through submissions.
Tips: "Read and be familiar with our magazine. Our style is very specific."

☑ I.E. MAGAZINE, P.O. Box 9873, The Woodlands TX 77387-6873. (281)296-8472. Magazine Editor: Yolande Gottlieb. Art Editor: Debra Hensley. Estab. 1990. Annual literary magazine. "We aim to present quality literature and art. Our audience is mostly writers, poets and artists." Circ. 200. Sample copies for $6 postpaid; add $1.50 for foreign postage.
● Also publishes *Poet's Journey*, same address and art director.
Cartoons: Approached by 10 cartoonists/year. Prefers b&w line drawings. Features informational graphics; computer, humorous and realistic illustration. Considers panel, single page or multiple page strips. "Cartoons should be of interest to artists, writers or poets only!" Send query letter with postcard-size sample or finished cartoons. Samples are returned

by SASE. Reports back in 1-2 months. Buys one-time and first rights. Pays $2-5 for b&w or color cover; $1-2 for b&w or color inside; $1-3 for 2-page spreads; $1-2 for spots.

Illustration: Considers pen & ink, charcoal. Send postcard-size sample, photographs or finished cartoons and SASE. Samples are filed or returned by SASE. Reports back in 1-3 months. Buys first rights. Pays $2-5 plus copy. Always looking for interesting cover ideas.

Fine Arts: Considers drawings, paintings, sculptures, photographs and mixed media. Prefers b&w, but will try color. Send b&w prints, bio and artist's statement. Often publishes photographs of artist's with their work. Pays $2-5 plus copies.

Tips: "Please do not send us metered mail. We support artists who design postage stamps. Request guidelines with #10 SASE."

☑ **IDEALS MAGAZINE**, 535 Metroplex Dr., Suite 250, Nashville TN 37211. (615)333-0478. Fax: (615)781-1447. Editor: Michelle Burke. Estab. 1944. 4-color bimonthly seasonal general interest magazine featuring poetry and family articles. Circ. 200,000. Accepts previously published material. Sample copy $4. Art guidelines free with #10 SASE with first-class postage.

Illustration: Approached by 100 freelancers/year. Buys 8 illustrations/issue. Features realistic and spot illustration of children, families and pets. Uses freelancers mainly for flowers, plant life, wildlife, realistic people illustrations and botanical (flower) spot art. Prefers seasonal themes. Prefers watercolors. Assigns 90% of illustrations to experienced, but not well-known illustrators; 10% to new and emerging illustrators. "We are not interested in computer generated art. Must *look* as hand-drawn as possible." Send non-returnable samples or tearsheets. Samples are filed. Reports back only if interested. Do not send originals. Prefers to buy artwork outright. Pays on publication; pay negotiable.

Tips: "In submissions, target our needs as far as style is concerned, but show representative subject matter. Artists should be familiar with our magazine before submitting samples of work."

☑ **IEEE SPECTRUM**, 345 E. 47th St., New York NY 10017. (212)419-7568. Fax: (212)419-7570. Website: http://www.spectrum-ieee.org. Art Director: Mark Montgomery. Estab. 1963. Monthly nonprofit trade magazine serving electrical and electronics engineers worldwide. Circ. 320,000.

Illustration: Buys 3 illustrations/issue. Has featured illustrations by John Hersey, J.D. King, Rob Magieri, Octavio Diaz, Dan Vasconcellos, M.E. Cohen, John Howard. Features natural history; realistic illustration; charts & graphs; informational graphics; medical, computer and spot illustration. Assigns 50% of illustrations to well-known or "name" illustrators; 25% to experienced, but not well-known illustrators; 25% to new and emerging illustrators. Considers all media. 50% of illustration demands knowledge of Adobe Photoshop and Adobe Illustrator. Send postcard sample or query letter with printed samples and tearsheets. Accepts disk submissions: 3.5 Mac disk; file compressed with STUFFIT. Send RGB, TIFF or EPS files. Samples are filed and are not returned. Reports back only if interested. Art director will contact artist for portfolio review if interested. Portfolio should include color, final art and tearsheets. Buys first rights and one year's use on website. **Pays on acceptance**; $1,800 minimum for cover, negotiable if artwork is highly complex; $450 minimum for inside. Finds illustrators through Graphic Artist Guild book, *American Showcase*, *Workbook*.

Design: Needs freelancers for design and multimedia. Local design freelancers only. 100% of freelance work demands knowledge of Adobe Photoshop, Adobe Illustrator, QuarkXPress and Quark Publishing System. Send query letter with tearsheets.

Tips: "As our subject matter is varied, *Spectrum* uses a variety of illustrators. Read our magazine before sending samples. Prefer realism due to scientific subject matter."

ILLINOIS MEDICINE, 20 N. Michigan Ave., Suite 700, Chicago IL 60602. (312)782-1654. Fax: (312)782-2023. Production Design Manager: Carla Nolan. Estab. 1989. Published 18 times/year. 4-color company tabloid for the physician members of the Illinois State Medical Society featuring nonclinical socio-economic and legislative news; conservative design. Circ. 20,000. Accepts previously published artwork. Illustrations are returned at job's completion. Sample copies available.

Cartoons: Approached by 20 cartoonists/year. Buys 1 cartoon/issue. Prefers medical themes—geared to physicians; single panel, b&w washes and line drawings with gagline. Send query letter with finished cartoons. Samples are not filed and are returned with SASE. Reports back within 2 months. Buys one-time rights. Pays $50 for b&w, $100 for color.

Illustration: Approached by 30 illustrators/year. Buys 1 illustration/issue. Works on assignment only. Send postcard sample or query letter with brochure, tearsheets, photostats or photographs. Accepts disk submissions. Samples are filed. Will contact for portfolio review if interested. Artist should follow up with call or letter. Portfolio should include roughs, printed samples, b&w and color tearsheets, photostats and photographs. Buys one-time rights. **Pays on acceptance**; $500 for b&w, $800-1,200 for color. Finds artists mostly through self-promotions.

▩ **IN TOUCH FOR MEN**, 13122 Saticoy St., North Hollywood CA 91605-3402. (818)764-2288. Fax: (818)764-2307. E-mail: alan@intouchformen.com. Website: http://www.intouchformen.com. Editor: Alan Mills. Art Director: Jeff Scott. Estab. 1973. "*In Touch* is a monthly erotic magazine for gay men that explores all aspects of the gay community (sex, art, music, film, etc.)." Circ. 60,000. Accepts previously published work (very seldom). Originals returned after job's completion. Sample copies available. Art guidelines for SASE with first-class postage. Needs computer-literate freelancers for illustration.

• This magazine is open to working with illustrators who create work on computers and transfer it via modem. Final art must be saved in a Macintosh-readable format.

Cartoons: Approached by 10 cartoonists/year. Buys 1-2 cartoons/issue. Prefers humorous, gay lifestyle related (not necessarily sexually explicit in nature); single and multiple panel b&w washes and line drawings with gagline. Send query letter with finished cartoons. Samples are filed. Reports back within 1 month. Buys one-time rights. Pays $50 for b&w, $100 for color.

Illustration: Approached by 10 illustrators/year. Buys 3-5 illustrations/issue. Assigns 95% of illustrations to well-known or "name" illustrators; 5% to new and emerging illustrators. Works on assignment only. Prefers open-minded, lighthearted style. Considers all types. Send query letter with photocopies and SASE. Accepts disk submissions. Samples are filed. Reports back within 2 weeks. Will contact for portfolio review if interested. Portfolio should include b&w and color final art. Rights vary. **Pays on acceptance;** $35-75 for b&w inside, $100 for color inside.

Tips: "Most artists in this genre will contact us directly, but we get some through word-of-mouth and occasionally we will look up an artist whose work we've seen and interests us. Areas most open to freelancers are 4-color illustrations for erotic fiction stories, humorous illustrations and stand-alone comic strips/panels depicting segments of gay lifestyle. Querying is like applying for a job because artwork is commissioned. Review our publication and submit samples that suit our needs. It's pointless to send your best work if it doesn't look like what we use. Understanding of gay community and lifestyle a plus."

☑ **INDEPENDENT PUBLISHER,** (formerly *Small Press*), 121 E. Front St., Suite 401, Traverse City MI 49684. (616)933-0445. Fax: (616)933-0448. E-mail: jgdesign@northlink.net. Website: http://www.bookpublishing.com. Art Director: Eric Norton. Estab. 1983. Quarterly trade journal for independent publishers. Articles feature areas of interest for anyone in field of publishing; up to 70 reviews of books in each issue. Circ. 9,000. Accepts previously published artwork. Originals returned at job's completion. Sample copies for $5.95; art guidelines available for SASE with first-class postage.

Illustration: Approached by 10 illustrators/year. Uses 5 illustrations. Has featured illustrations by Amy Smyth, Beth Jepson and Andrew Toos. Features humorous, realistic and computer illustration. Assigns 50% of illustrations to experienced, but not well-known illustrators; 50% to new and emerging illustrators. Send postcard-size sample or query letter with printed samples and tearsheets. Send non-returnable samples. Samples are filed. Portfolio review not required. Rights purchased vary according to project. Pays on publication. Finds freelancers through samples and word of mouth.

Tips: "The answer will be 'no' until you try."

☑ **THE INDEPENDENT WEEKLY,** P.O. Box 2690, Durham NC 27715. (919)286-1972. Fax: (919)286-4274. E-mail: liz@indyweek.com. and maria@indyweek.com. Art Director: Liz Holm. Production Manager: Maria Shain. Estab. 1982. Weekly b&w with 4-color cover tabloid; general interest alternative. Circ. 50,000. Original artwork is returned if requested. Sample copies and art guidelines for SASE with first-class postage.

Illustration: Buys 10-15 illustrations/year. Has featured illustrations by Michael Brown, V. Cullum Rogers, David Terry. Assigns 33% of illustrations to well-known or "name" illustrators; 33% to experienced, but not well-known illustrators; 33% to new and emerging illustrators. Works on assignment only. Considers pen & ink; b&w and color. Samples are filed or are returned by SASE if requested. Reports back only if interested. Call for appointment to show portfolio or mail b&w tearsheets. Pays on publication; $100-200 for cover; $25-50 for b&w inside and spots.

Tips: "Have a political and alternative 'point of view.' Understand the peculiarities of newsprint. Be easy to work with and no prima donnas."

INFORMATION WEEK, 600 Community Dr., Manhasset NY 11030. (516)562-5512. Fax: (516)562-5036. E-mail: rbundi@cmp.com. Website: http://www.informationweek.com. Senior Art Director: Renee Bundi. Weekly 4-color trade publication for business and technology managers, combining business and technology issues. Circ. 400,000.

Illustration: Approached by 200 illustrators/year. Buys 400 illustrations/year. Has featured illustrations by David Peters, Bill Mayer, Rapheal Lopez, Matsu, D.S. Stevens, Wendy Grossman. Features computer, humorous, realistic and spot illustrations of business subjects. Prefers many different media, styles. Assigns 33% of illustrations to well-known or "name" illustrators; 33% to experienced, but not well-known illustrators; 33% to new and emerging illustrators. 30% of freelance illustration demands knowledge of Adobe Illustrator, Adobe Photoshop. Send postcard sample or query letter with non-returnable printed samples, tearsheets. Send follow-up postcard every 6 months. Accepts Mac-compatible disk submissions. Send EPS files. Samples are filed. Will contact artist for portfolio review if interested. Buys first rights, reprint rights or rights vary according to project. Pays on publication; $700-1,200 for color cover; $500-1,000 for color inside; $800-1,500 for 2-page spreads; $300 for spots. Finds illustrators through mailers, sourcebooks: *Showcase*, *Work Book*, *The Alternative Pick*, *Black Book*, *New Media Showcase*.

Tips: "We look for a variety of styles and media. To illustrate, sometimes very abstract concepts. Quick turnaround is very important for a weekly magazine."

INKSLINGER, 8661 Prairie Rd. NW, Washington Court House OH 43160-9490. Publisher/Editor: Nancy E. Martindale. Estab. 1993. Literary magazine published 3 times/year. "We publish poetry and some artwork." Sample copy for $4; art guidelines free for #10 SASE with first-class postage.

• In 1997, *Inkslinger* launched a supplement, *One Voice*. Art guidelines are the same.

Illustration: Number of illustrations varies. Has featured illustrations by Jennifer Fennell, Rook, Chris Patterson and Nancy Martindale. "We don't assign any work. We draw strictly from what comes in by mail." Features humorous,

Illustrator Amy Smyth originally created this eye-catching librarian as a spot illustration, but when the editors of *Small Press* saw it they decided to put it on the cover. Since this 1997 cover, *Small Press* changed its name to *Independent Publisher*. Smyth found *Small Press* through *AGDM* and sent them several mailings before they gave her this assignment. She uses this and other published pieces in her new marketing strategy of sending out 3 postcards of published work to her client list of 300 every other month. In odd months she sends out a fax promotional piece to previous clients.

realistic, fantasy and spot illustration. No holiday stuff (e.g., Santa Claus, Easter Bunny, etc.). Considers only pen & ink. Send query letter with photocopies and SASE. Samples are not filed and are returned by SASE. Reports back within 3-5 months. Buys one-time rights. Pays 1 copy plus tearsheets; extra copies at a discount. Finds illustrators through *Artist's & Graphic Designer's Market* submissions and word of mouth.

Tips: "Obtain guidelines first. We are size-specific in what we'll consider, because we cannot enlarge or reduce. We consider artwork for cover and interior. Subjects and styles wide open. Be persistent; not all editors are moved by the same style, technique, subject, etc., so know your audience; request guidelines when available."

[N] INSIDE, 226 S. 16th St., Philadelphia PA 19102. (215)893-5797. Editor: Jane Biberman. Managing Editor: Martha Ledger. Estab. 1979. Quarterly. Circ. 60,000. Accepts previously published artwork. Interested in buying second rights (reprint rights) to previously published work. Original artwork returned after publication.

Illustration: Buys several illustrations/issue from freelancers. Has featured illustrations by: Sam Maitin; David Noyes, Robert Grossman. Assigns 25% of illustrations to well-known or "name" illustrators; 50% to experienced, but not well-known illustrators; 25% to new and emerging illustrators. Prefers color and b&w drawings. Works on assignment only. Send samples and tearsheets to be kept on file. Samples not kept on file are not returned. Call for appointment to show portfolio. Reports only if interested. Buys first rights. **Pays on acceptance**; minimum $500 for color cover; minimum $250 for b&w and color inside. Prefers to see sketches.

Tips: Finds artists through artists' promotional pieces, attending art exhibitions, artists' requests to show portfolio. "We like illustrations that are strong on concept. We have a new design (Fall 1998 issue). It's friendly, modern and just a bit quirky."

[N] ISLANDS, Dept. AM, 6309 Carpinteria Ave., Carpinteria CA 93140-4728. (805)745-7100. Fax: (805)745-7102. Art Director: Albert Chiang. Estab. 1981. Bimonthly magazine of "international travel exclusively about islands." 4-color with contemporary design. Circ. 225,000. Original artwork returned after publication. Sample copies available. Art guidelines for SASE with first-class postage. 100% of freelance work demands knowledge of QuarkXPress, Aldus FreeHand, Adobe Illustrator and Adobe Photoshop.

Illustration: Approached by 20-30 illustrators/year. Buys 3-4 illustrations/issue. Needs editorial illustration. No theme or style preferred. Considers all media. Send query letter with brochure, tearsheets, photographs and slides. "We prefer samples of previously published tearsheets." Samples are filed. Reports back only if interested. Write for appointment to show portfolio or mail printed samples and color tearsheets. Buys first rights or one-time rights. **Pays on acceptance**; $500-750 for color cover; $100-400 per image inside.

Tips: A common mistake freelancers make is that "they show too much, not focused enough. Specialize!" Notices "no real stylistic trends, but desktop publishing is affecting everything in terms of how a magazine is produced."

JACK AND JILL, Children's Better Health Institute, Dept. AGDM, 1100 Waterway Blvd., Box 567, Indianapolis IN 46206. (317)636-8881. Fax: (317)684-8094. E-mail: danny885@aol.com. Website: http://www.satevepost.org/kidsonline. Art Director: Andrea O'Shea. Emphasizes educational and entertaining articles focusing on health and fitness as well as developing the reading skills of the reader. For ages 7-10. Monthly except bimonthly January/February, April/May, July/August and October/November. Magazine is 36 pages, 30 pages 4-color and 6 pages b&w. The editorial content is 50% artwork. Buys all rights. Original artwork not returned after publication (except in case where artist wishes to exhibit the art; art must be available to us on request). Sample copy $1.25; art guidelines for SASE with first-class postage.

• Also publishes *Child Life*, *Children's Digest*, *Children's Playmate*, *Humpty Dumpty's Magazine* and *Turtle*.

Illustration: Approached by more than 100 illustrators/year. Buys 25 illustrations/issue. Has featured illustrations by Alan MacBain, Phyllis Pollema-Cahill, George Sears and Mary Kurnick Maacs. Features humorous, realistic, medical, computer and spot illustration. Assigns 15% of illustrations to well-known or "name" illustrators; 70% to experienced, but not well-known illustrators; 15% to new and emerging illustrators. Uses freelance artists mainly for cover art, story illustrations and activity pages. Interested in "stylized, realistic, humorous illustrations for mystery, adventure, science fiction, historical and also nature and health subjects. Works on assignment only. "Freelancers can work in Aldus FreeHand, Adobe Photoshop or Quark programs." Send postcard sample to be kept on file. Accepts disk submissions. Publication will contact artist for portfolio review if interested. Portfolio should include printed samples, tearsheets, b&w and 2-color pre-separated art. Pays $275-335 for color cover; $90 maximum for b&w inside; $155-190 for color inside; $310-380 for 2-page spreads; $35-80 for spots. Company pays higher rates to artists who can provide color-separated art. Buys all rights on a work-for-hire basis. On publication date, each contributor is sent several copies of the issue containing his or her work. Finds artists through artists' submissions and self-promotion pieces.

Tips: Portfolio should include "illustrations composed in a situation or storytelling way, to enhance the text matter. Send samples of published story for which you did illustration work, samples of puzzles, hidden pictures, mazes and self-promotion art. Art should appeal to children first. Artwork should reflect the artist's skill regardless of techniques

HUMOR & CARTOON markets are listed in the Humor & Cartoon Index located at the back of this book.

used. Fresh, inventive colors and characters a strong point. Research publications to find ones that produce the kind of work you can produce. Send several samples (published as well as self-promotion art). The style can vary if there is a consistent quality in the work."

JACKSONVILLE, 1032 Hendricks Ave., Jacksonville FL 32207. (904)396-8666. E-mail: mail@jacksonvillemag.com. Website: http://www.jacksonvillemag.com. Contact: Art Director. Estab. 1983. City/regional lifestyle magazine covering Florida's First Coast. 10 times/yearly. Circ. 25,000. Originals returned at job's completion. Sample copies available for $5 (includes postage).
Illustration: Approached by 50 illustrators/year. Buys 1 illustration/issue. Prefers editorial illustration with topical themes and sophisticated style. Send tearsheets. Will accept computer-generated illustrations compatible with Macintosh programs: Adobe Illustrator and Adobe Photoshop. Samples are filed and are returned by SASE if requested. Publication will contact artist for portfolio review if interested. Portfolio should include b&w and color tearsheets and slides. Buys all rights. Pays on publication; $600 for color cover; $150-400 for inside depending on scope. Finds artists through illustration annuals.

JAPANOPHILE, P.O. Box 7977, 415 N. Main St., Ann Arbor MI 48104. (734)930-1553. Fax: (734)930-9968. E-mail: susanlapp@aol.com. Website: http://www.Japanophile.com. Editor and Publisher: Susan Lapp. Associate Editor: Ashley Kirch. Quarterly emphasizing bonsai, haiku, sports, cultural events, etc. for educated audience interested in Japanese culture. Circ. 800. Accepts previously published material. Original artwork not returned at job's completion. Sample copy $4; art guidelines for SASE.
Cartoons: Approached by 7-8 cartoonists/year. Buys 1 cartoon/issue. Prefers single panel b&w line drawings with gagline. Send finished cartoons. Material returned only if requested. Reports only if interested. Buys all rights. Pays on publication; $20-50 for b&w.
Illustration: Buys 1-5 illustrations/issue. Has featured illustrations by Bob Rogers. Assigns 50% of illustrations to experienced but not well-known illustrators; 50% to new and emerging illustrators. Needs humorous editorial illustration. "Will publish 2-color designs, especially for cover." Prefers sumie or line drawings. Send postcard sample to be kept on file if interested. Samples returned only if requested. Reports only if interested. Buys first-time rights. Pays on publication; $20-50 for b&w cover, b&w inside and spots.
Design: Needs freelancers for design. Send query letter with brochure, photocopies, SASE, résumé. Pays by the project, $20-50.
Tips: Would like cartoon series on American foibles when confronted with Japanese culture. "Read the magazine. Tell us what you think it needs. Material that displays a unique insight in to Japan-American cultural relations draws our attention. We have redesigned our magazine and format and are looking for artists who can help us continue to improve our look."

JEMS, Journal of Emergency Medical Services, 1947 Camino Vida Roble, Suite 200, Carlsbad CA 92008. (619)431-9797. Managing Editor: Lisa Dionne. Estab. 1980. Monthly trade journal aimed at paramedics/paramedic instructors. Circ. 45,000. Accepts previously published artwork. Originals returned at job's completion. Sample copies available. Art guidelines for SASE. 95% of freelance work demands knowledge of QuarkXPress, Adobe Illustrator and Adobe Photoshop.
Illustration: Approached by 240 illustrators/year. Buys 2-6 illustrations/issue. Works on assignment only. Prefers medical as well as general editorial illustration. Considers pen & ink, airbrush, colored pencil, mixed media, collage, watercolor, acrylic, oil and marker. Send postcard sample or query letter with photocopies. Accepts disk submissions compatible with most current versions of Adobe Illustrator or Adobe Photoshop. Samples are filed and are not returned. Portfolio review not required. Publication will contact artist for portfolio review of final art, tearsheets and printed samples if interested. Rights purchased vary according to project. Pays on publication. Pays $200-400 for color, $50-150 for b&w inside; $50-150 for spots. Finds artists through directories, agents, direct mail campaigns.
Tips: "Review magazine samples before submitting. We have had the most mutual success with illustrators who can complete work within one to two weeks and send finals in computer format. We use black & white and four-color medical illustrations on a regular basis."

N Y JEWISH ACTION, 333 Seventh Ave., New York NY 10001-5072. (212)613-8147. Fax: (212)564-9058. E-mail: charlott@ou.org. Website: http://www.oo.org. Editor: C. Friedland. Art Director: Ed Hamway. Estab. 1986. Quarterly magazine "published by Orthodox Union for members and subscribers. Orthodox Jewish contemporary issues." Circ. 25,000. Sample copies available for $9 × 12$ SASE and $1.75 postage.
Cartoons: Approached by 2 cartoonists/year. Prefers themes relevant to Jewish issues. Prefers single, double or multiple panel, political, humorous b&w washes and line drawings with or without gaglines. Send query letter with photocopies and SASE. Samples are not filed and are not returned. Reports back only if interested. Buys one-time rights. Pays within 6 weeks of publication. Pays $20-50 for b&w.
Illustration: Approached by 4-5 illustrators. Considers all media. Assigns 50% of illustrations to experienced, but not well-known illustrators; 50% to new and emerging illustrators. Knowledge of Adobe Photoshop, Adobe Illustrator and QuarkXPress "not absolutely necessary, but preferred." Send query letter with photocopies and SASE. Accepts disk submissions. Prefer QuarkXPress TIFF or EPS files. Can send ZIP disk. Samples are not filed and are not returned. Reports back only if interested. Art director will contact artist for portfolio review of photographs if interested. Buys

one-time rights. Pays within 6 weeks of publication; $25-75 for b&w, $50-200 for color cover; $20-75 for b&w, $25-100 for color inside. Finds illustrators through submissions.

Design: Needs freelancers for design and production. Prefers local design freelancers only.

Tips: Looking for "sensitivity to Orthodox Jewish traditions and symbols."

JOURNAL OF ACCOUNTANCY, AICPA, Harborside 201 Plaza III, Jersey City NJ 07311. (201)938-3450. Art Director: Jeryl Ann Costello. Monthly 4-color magazine emphasizing accounting for certified public accountants; corporate/business format. Circ. 350,000. Accepts previously published artwork. Original artwork returned after publication.

Illustration: Approached by 200 illustrators/year. Buys 2-6 illustrations/issue. Prefers business, finance and law themes. Prefers mixed media, then pen & ink, airbrush, colored pencil, watercolor, acrylic, oil and pastel. Works on assignment only. 35% of freelance work demands knowledge of Adobe Illustrator, QuarkXPress and Aldus FreeHand. Send query letter with brochure showing art style. Samples not filed are returned by SASE. Portfolio should include printed samples, color and b&w tearsheets. Buys first rights. Pays on publication; $1,200 for color cover; $200-600 for color (depending on size) inside. Finds artists through submissions/self-promotions, sourcebooks and magazines.

Tips: "I look for indications that an artist can turn the ordinary into something extraordinary, whether it be through concept or style. In addition to illustrators, I also hire freelancers to do charts and graphs. In portfolios, I like to see tearsheets showing how the art and editorial worked together."

JOURNAL OF ASIAN MARTIAL ARTS, 821 W. 24th St., Erie PA 16502-2523. (814)455-9517. Fax: (814)526-5262. E-mail: info@goviamedia.com. Website: http://www.goviamedia.com. Publisher: Michael A. DeMarco. Estab. 1991. Quarterly journal covering all historical and cultural aspects of Asian martial arts. Interdisciplinary approach. College-level audience. Circ. 12,000. Accepts previously published artwork. Sample copies available for $10. Art guidelines for SASE with first-class postage.

Illustration: Buys 60 illustrations/issue. Has featured illustrations by Oscar Ratti, Tony LaMotta and Michael Lane. Features realistic and medical illustration. Assigns 50% of illustrations to well-known or "name" illustrators; 40% to experienced, but not well-known illustrators; 10% to new and emerging illustrators. Prefers b&w wash; brush-like Oriental style; line. Considers pen & ink, watercolor, collage, airbrush, marker and charcoal. Send query letter with brochure, résumé, SASE and photocopies. Accepts disk submissions compatible with Adobe PageMaker, QuarkXPress and Adobe Illustrator. Samples are filed. Reports back within 4-6 weeks. Publication will contact artist for portfolio review if interested. Portfolio should include b&w roughs, photocopies and final art. Buys first rights and reprint rights. Pays on publication; $100-300 for color cover; $10-100 for b&w inside; $100-150 for 2-page spreads.

Tips: "Usually artists hear about or see our journal. We can be found in bookstores, libraries, or in listings of publications. Areas most open to freelancers are illustrations of historic warriors, weapons, castles, battles—any subject dealing with the martial arts of Asia. If artists appreciate aspects of Asian martial arts and/or Asian culture, we would appreciate seeing their work and discuss the possibilities of collaboration."

☑ **JOURNAL OF LIGHT CONSTRUCTION**, 932 W. Main St., Richmond VT 05477. (802)434-4747. Fax: (802)434-4467. E-mail: bgiart@aol.com. Art Director: Theresa Emerson. Monthly magazine emphasizing residential and light commercial building and remodeling. Focuses on the practical aspects of building technology and small-business management. Circ. 50,000. Accepts previously published material. Original artwork is returned after publication. Sample copy free.

Cartoons: Buys cartoons relevent to construction industry, especially business topics.

Illustration: Buys 10 illustrations/issue. "Lots of how-to technical illustrations are assigned on various construction topics." Send query letter with SASE, tearsheets or photocopies. Samples are filed or are returned only if requested by artist. Reports back if interested within 2 weeks. Call or write for appointment to show portfolio of printed samples, final reproduction/product and b&w tearsheets. Buys one-time rights. **Pays on acceptance**; $500 for color cover; $100 for b&w color inside; $200 for color inside; $150 for spots.

Design: Needs freelancers for design and production. 100% of freelance work demands knowledge of Adobe Photoshop, Adobe Illustrator and QuarkXPress on Macintosh. Send photocopies and résumé. Prefers local freelancers only. Send query letter with résumé, photocopies and SASE. Pays by the hour, $20-30.

Tips: "Write for a sample copy. We are unusual in that we have drawings illustrating construction techniques. We prefer artists with construction and/or architectural experience. We prefer using freelancers in the New England area with home computers."

N ♣ **JR JAYS MAGAZINE**, 643 Queen St. E, Toronto, Ontario M4M 1G4 Canada. (416)778-8727. Fax: (416)778-8726. E-mail: jrjay@netcome.ca. Website: http://www.canoe.ca/jrjays. Editor: Lori Linquist. Estab. 1993. Quarterly comic magazine digest for children age 7-12. Circ: 1 million (English), 300,000 (French). Sample copies and art guidelines free for #10 SASE with first-class postage and available on website.

Cartoons: Approached by 4-6 cartoonists/year. Buys 40 pages of cartoons/issue. Prefers classic "Marvelesque" style. Prefers multiple panel cartoons. Send query letter with photocopies. Samples are filed. Reports back in 2 weeks. **Pays on acceptance**; $100-125.

Illustration: Approached by 20 illustrators/year. Buys 150 illustrations/year. Considers all media. Send photocopies and SASE. Accepts disk submissions in any format. Samples are filed. Reports back in 2 weeks. Buys all rights. **Pays on acceptance**; negotiable. Finds illustrators through word of mouth.

Tips: Experience in the classic Marvel, D.C. style of the '70s an advantage.

JUDICATURE, 180 N. Michigan Ave., Suite 600, Chicago IL 60601-7401. E-mail: drichert@ajs.org. Website: http://www.ajs.org. Contact: David Richert. Estab. 1917. Journal of the American Judicature Society. 4-color bimonthly publication. Circ. 10,000. Accepts previously published material and computer illustration. Original artwork returned after publication. Sample copy for SASE with $1.47 postage; art guidelines not available.

Cartoons: Approached by 10 cartoonists/year. Buys 1-2 cartoons/issue. Interested in "sophisticated humor revealing a familiarity with legal issues, the courts and the administration of justice." Send query letter with samples of style and SASE. Reports in 2 weeks. Buys one-time rights. Pays $35 for unsolicited b&w cartoons.

Illustration: Approached by 20 illustrators/year. Buys 2-3 illustrations/issue. Has featured illustrations by Estelle Carol, Mary Chaney, Jerry Warshaw and Richard Laurent. Features humorous and realistic illustration; charts & graphs; computer and spot illustration. Works on assignment only. Interested in styles from "realism to light humor." Prefers subjects related to court organization, operations and personnel. Freelance work demands knowledge of Aldus Page-Maker and Aldus FreeHand. Send query letter, SASE, photocopies, tearsheets or brochure showing art style. Publication will contact artist for portfolio review if interestsed. Portfolio should include roughs and printed samples. Wants to see "black & white and color and the title and synopsis of editorial material the illustration accompanied." Buys one-time rights. Negotiates payment. Pays $250-375 for 2-, 3- or 4-color cover; $250 for b&w full page, $175 for b&w half page inside; $75-100 for spots.

Design: Needs freelancers for design. 100% of freelance work demands knowledge of Aldus PageMaker and Aldus FreeHand. Pays by the project.

Tips: "Show a variety of samples, including printed pieces and roughs."

KALEIDOSCOPE: International Magazine of Literature, Fine Arts, and Disability, 701 S. Main St., Akron OH 44311-1019. (330)762-9755. Editor-in-Chief: Darshan Perusek. Estab. 1979. Black & white with 4-color cover. Semiannual. "Elegant, straightforward design. Unlike medical, rehabilitation, advocacy or independent living journals, explores the experiences of disability through lens of the creative arts. Specifically seeking work by artists with disabilities. Work by artists without disabilities must have a disability focus." Circ. 1,500. Accepts previously published artwork. Sample copy $4; art guidelines for SASE with first-class postage.

Illustration: Freelance art occasionally used with fiction pieces. More interested in publishing art that stands on its own as the focal point of an article. Approached by 15-20 artists/year. Has featured illustrations by Dennis J. Brizendine and Deborah Vidaver Cohen. Features humorous, realistic and spot illustration. Send query letter with résumé, photocopies, photographs, SASE and slides. Do not send originals. Prefers high contrast, b&w glossy photos, but will also review color photos or 35mm slides. Include sufficient postage for return of work. Samples are not filed. Publication will contact artist for portfolio review if interested. Acceptance or rejection may take up to a year. Pays $25-100 for color covers; $10-25 for b&w or color insides. Rights return to artist upon publication. Finds artists through submissions/self-promotions and word of mouth.

Tips: "Inquire about future themes of upcoming issues. Considers all mediums, from pastels to acrylics to sculpture. Must be high-quality art."

KALLIOPE, a journal of women's literature and art, 3939 Roosevelt Blvd., Jacksonville FL 32205. (904)387-8211. Website: http://www.fccj.org/kalliope/kalliope.htm. Editor: Mary Sue Koeppel. Estab. 1978. Literary b&w triannual which publishes an average of 18 pages of art by women in each issue. "Publishes poetry, fiction, reviews, and visual art by women and about women's concerns; high-quality art reproductions; visually interesting design." Circ. 1,600. Accepts previously published "fine" artwork. Original artwork is returned at the job's completion. Sample copy for $7. Art guidelines available for SASE with first-class postage.

Cartoons: Approached by 1 cartoonist/year. Uses 1 cartoon/issue. Has featured illustrations by Joyce Tenneson, Aimee Young Jackson, Kathy Keler, Lise Metzger. Topics should relate to women's issues. Send query letter with roughs. Samples are not filed and are returned by SASE. Reports back within 2 months. Rights acquired vary according to project. Pays 1 year subscription or 3 complimentary copies for b&w cartoon.

Illustration: Approached by 35 fine artists/year. Buys 18 photos of fine art/issue. Looking for "excellence in fine visual art by women (nothing pornographic)." Send query letter with résumé, SASE, photographs (b&w glossies) and artist's statement (50-75 words). Samples are not filed and are returned by SASE. Reports back within 2 months. Rights acquired vary according to project. Pays 1 year subscription or 3 complimentary copies for b&w cover or inside.

Tips: Seeking "excellence in theme and execution and submission of materials. We accept three to six works from a featured artist. We accept only black & white high quality photos of fine art."

KASHRUS MAGAZINE—The Periodical for the Kosher Consumer, Box 204, Brooklyn NY 11204. (718)336-8544. Fax: (718)336-8550. Website: http://kosherinfo.com. Editor: Rabbi Wikler. Estab. 1980. Bimonthly magazine with 4-color cover which updates consumer and trade on issues involving the kosher food industry, especially mislabeling, new products and food technology. Circ. 10,000. Accepts previously published artwork. Original artwork is returned after publication. Sample copy $2; art guidelines not available.

Cartoons: Buys 2 cartoon/issue. Pays $25-35 for b&w. Seeks "kosher food and Jewish humor."

Illustration: Buys illustrations mainly for covers. Works on assignment only. Has featured illustrations by R. Keith Rugg and Theresa McCracken. Features humorous, realistic and spot illustration. Assigns 50% of illustrations to experienced, but not well-known illustrators; 50% to new and emerging illustrators. Prefers pen & ink. Send query letter with photocopies. Reports back within 7 days. Request portfolio review in original query. Portfolio should include tearsheets

Painter Kathy Keler created "Point of Balance" as part of a series in oil and alkyd on wood. She then created computer prints of the paintings that still reflect their mythical and psychological content, with an eye towards greater accessibility and marketability. The art director from *Kalliope: a journal of women's literature & art* saw Keler's fine art work and has featured her in 2 issues, including their 20th anniversary issue. To see more of Keler's work, check out her website http://www.washingtonart.com/keler.html.

and photostats. $100-200 for color cover; $25-75 for b&w inside; $75-150 for color inside; $25-35 for spots. Finds artists through submissions and self-promotions.

Tips: "Send general food or Jewish food- and travel-related material. Do not send off-color material."

N KENTUCKY LIVING, Box 32170, Louisville KY 40232. Fax: (502)459-1611. Editor: Paul Wesslund. 4-color monthly emphasizing Kentucky-related and general feature material for Kentuckians living outside metropolitan areas. Circ. 400,000. Accepts previously published material. Original artwork returned after publication if requested. Sample copy available. All artwork is solicited by the magazine to illustrate upcoming articles.

Cartoons: Approached by 10-12 cartoonists/year. Pays $30 for b&w.

Illustration: Buys occasional illustrations/issue. Works on assignment only. Prefers b&w line art. Send query letter with résumé and samples. Samples not filed are returned only if requested. Buys one-time rights. **Pays on acceptance**; $50 for b&w inside.

✓ KIPLINGER'S PERSONAL FINANCE MAGAZINE, 1729 H St. NW, Washington DC 20006. (202)887-6416. Fax: (202)331-1206. E-mail: ccurrie@kiplinger.com. Website: http://www.kiplinger.com. Art Director: Cynthia

L. Currie. Estab. 1947. A monthly 4-color magazine covering personal finance issues including investing, saving, housing, cars, health, retirement, taxes and insurance. Circ. 1,300,000. Originals are returned at job's completion. Sample copies available; art guidelines not available.

Illustration: Approached by 350 illustrators/year. Buys 10-15 illustrations/issue. Works on assignment only. Has featured illustrations by Gregory Manchess, Tim Bower, Edwin Fotheringham, Michael Paraskevas, Joe Sorren. Features computer, humorous, conceptual editorial and spot illustration. Prefers business subjects. Assigns 80% of illustrations to well-known or "name" illustrators; 10% to experienced, but not well-known illustrators; 10% to new and emerging illustrators. Looking for original conceptual art. Interested in editorial illustration in new styles, including computer illustration. Send postcard samples. Accepts Mac-compatible disk submissions. Samples are filed or returned by SASE if requested by artist. Publication will contact artist for portfolio review if interested. Portfolio should include tearsheets. Buys one-time rights. Pays on publication; $400-1,200 for color inside; $250-750 for spots. Finds illustrators through reps, online, magazines, *Workbook* and award books.

Tips: "Send us high-caliber original work that shows creative solutions to common themes. Send postcards regularly. If they're good, they'll get noticed. A fresh technique, combined with a thought-out image will intrigue art directors and readers alike. We strive to have a balance of seriousness and wit throughout."

KITE LINES, Box 466, Randallstown MD 21133-0466. Fax: (410)922-4262. E-mail: kitelines@compuserve.com. Publisher/Editor: Valerie Govig. Quarterly 4-color magazine emphasizing kites for the adult enthusiast only. Circ. 13,000. Original artwork returned after publication. Sample copy $5.50; art guidelines available.

Illustration: Buys 2-3 illustrations/year. Works on assignment primarily. Needs technical drawings of kites. Send query letter with photocopies showing art style. Samples are filed or returned by SASE. Reports back within 1 month only if interested. Portfolio review not required. Buys first rights. Pay is negotiable, up to $300 for more complicated technical work. Finds artists through word of mouth.

Tips: "Illustrations in *Kite Lines* are so closely related to an article that, if they are not provided by the author, they are assigned to meet a very specific need. Strong familiarity with kites is absolutely necessary. Good technical drawings of kite plans (for kitemaking) are needed as part of articles with instructions for building kites. (In other words, a 'package,' with article, is needed.) We often do computer re-drawing from rough originals but are open to assigning these re-drawings."

KIWANIS, 3636 Woodview Trace, Indianapolis IN 46268. (317)875-8755. Fax: (317)879-0204. E-mail: kiwanismail@kiwanis.org. Managing Editor: Chuck Jonak. Art Director: Jim Patterson. Estab. 1918. 4-color magazine emphasizing civic and social betterment, business, education and domestic affairs for business and professional persons. Published 10 times/year. Original artwork returned after publication. Art guidelines available for SASE with first-class postage.

Illustration: Works with 20 illustrators/year. Buys 3-6 illustrations/issue. Assigns themes that correspond to themes of articles. Works on assignment only. Keeps material on file after in-person contact with artist. Include SASE. Reports in 2 weeks. To show a portfolio, mail appropriate materials (out of town/state) or call or write for appointment. Portfolio should include roughs, printed samples, final reproduction/product, color and b&w tearsheets, photostats and photographs. Buys first rights. **Pays on acceptance**; $800-1,000 for cover; $400-800 for inside; $50-75 for spots. Finds artists through talent sourcebooks, references/word-of-mouth and portfolio reviews.

Tips: "We deal direct—no reps. Have plenty of samples, particularly those that can be left with us. Too many student or unassigned illustrations in many portfolios."

L.A. PARENT MAGAZINE, 443 E. Irving Dr., Burbank CA 91504. (818)846-0400. Fax: (818)841-4380. E-mail: laparent@compuserve.com. Editor: Christina Elston. Art Director: Hermineh Isaghoulian. Estab. 1979. Tabloid. A monthly city magazine for parents of young children, b&w with 4-color cover; "bold graphics and lots of photos of kids and families." Circ. 115,000. Accepts previously published artwork. Originals are returned at job's completion.

Illustration: Buys 2 freelance illustrations/issue. Assigns 50% of illustrations to experienced, but not well-known illustrators; 50% to new and emerging illustrators. Works on assignment only. Send postcard sample. Accepts disk submissions compatible with Adobe Illustrator 5.0 and Adobe Photoshop 3.0. Samples are filed or returned by SASE. Reports back within 2 months. To show a portfolio, mail thumbnails, tearsheets and photostats. Buys one-time rights or reprint rights. **Pays on acceptance**; $300 color cover (may use only 1 color cover/year); $75 for b&w inside; $50 for spots.

Tips: "Show an understanding of our publication. Since we deal with parent/child relationships, we tend to use fairly straightforward work. Read our magazine and find out what we're all about."

L.A. WEEKLY, 6715 Sunset Blvd., Los Angeles CA 90028. (323)465-9909. Fax: (323)465-1550. E-mail: weeklyart@aol.com. Website: http://www.laweekly.com. Associate Art Director: Marty Luko. Estab. 1978. Weekly alternative arts and news tabloid. Circ. 220,000. Art guidelines available.

Cartoons: Approached by over 100 cartoonists/year. "We contract about 1 new cartoonist per year." Prefers Los Angeles, alternative lifestyle themes. Prefers b&w line drawings without gagline. Send query letter with photocopies. Samples are filed or returned by SASE. Reports back only if interested. Rights purchased vary according to project. Pays on publication; $120-200 for b&w.

Illustration: Approached by over 200 illustrators/year. Buys 4 illustrations/issue. Themes vary according to editorial needs. Considers all media. Send postcard sample or query letter with photocopies. Can also e-mail final artwork." Samples are filed or returned by SASE. Reports back only if interested. Portfolio may be dropped off Monday-Friday

and should include any samples except original art. Artist should follow-up with call and/or letter after initial query. Buys first rights. Pays on publication; $400-1,000 for cover; $120-400 for inside; $120-200 for spots. Prefers submissions but will also find illustrations through illustrators' websites, *Black Book*, *American Illustration*, various Los Angeles and New York publications.

Design: Needs freelancers for design and production. 100% of freelance work demands knowledge of Adobe Photoshop 5.0, Adobe Illustrator, QuarkXPress 4.0, Corel Draw 7.0. Prefers local freelancers only. Send query letter with photocopies and résumé. Pays by the hour, $16.

Tips: Wants "less polish and more content. Gritty is good, quick turnaround and ease of contact a must."

☑ LACROSSE MAGAZINE, 113 W. University Pkwy., Baltimore MD 21210-3300. (410)235-6882. Fax: (410)366-6735. E-mail: vpowell@lacrosse.org. Website: http://lacrosse.org. Art Director: Wendy Powell. Estab. 1978. "*Lacrosse Magazine* includes opinions, news, features, student pages, 'how-to's' for fans, players, coaches, etc. of all ages." Published 8 times/year. Circ. 16,000. Accepts previously published work. Sample copies available.

Cartoons: Prefers ideas and issues related to lacrosse. Prefers single panel, b&w washes or b&w line drawings. Send query letter with finished cartoon samples. Samples are filed or returned by SASE if requested. Rights purchased vary according to project. Pays $40 for b&w.

Illustration: Approached by 12 freelance illustrators/year. Buys 3-4 illustrations/year. Works on assignment only. Prefers ideas and issues related to lacrosse. Considers pen & ink, collage, marker and charcoal. Freelancers should be familiar with Adobe Illustrator, Aldus FreeHand or QuarkXPress. Send postcard sample or query letter with tearsheets or photocopies. Accepts disk submissions compatible with Mac. Samples are filed. Call for appointment to show portfolio of final art, b&w and color photocopies. Rights purchased vary according to project. Pays on publication; $100 for b&w cover, $150 for color cover; $75 for b&w inside, $100 for color inside.

Tips: "Learn/know as much as possible about the sport."

☑ LAW PRACTICE MANAGEMENT, 1550 S. Indiana Ave., Chicago IL 60605. (803)754-3563. Website: http://www.abanet.org/lpm. Art Director: Mark Feldman, Feldman Communications, Inc., feldcom@aol.com. 4-color trade journal for the practicing lawyer about "the business of practicing law." Estab. 1975. Published 8 times/year. Circ. 20,833. Previously published work rarely used. 15% of freelance work demands computer skills.

Illustration: Uses cover and inside feature illustrations. Uses all media, including computer graphics. Mostly 4-color artwork. Send postcard sample or query letter with samples. Pays on publication. Very interested in high quality, previously published works. Pays rates $200-350/illustration. Original works negotiable. Cartoons very rarely used.

Tips: "There's an increasing need for artwork to illustrate high-tech articles on technology in the law office. (We have two or more such articles each issue.) We're especially interested in computer graphics for such articles. Recently redesigned to use more illustration on covers and with features. Topics focus on management, marketing, communications and technology."

▨ LISTEN MAGAZINE, 55 W. Oak Ridge Dr., Hagerstown MD 21740. (301)745-3888. Editor: Lincoln Steed. Monthly magazine for teens with specific aim to educate against alcohol and other drugs and to encourage positive life choices. Circ. 40,000. Accepts previously published artwork. Originals returned at job's completion. Sample copies available. Art guidelines for SASE with first-class postage. 10% of freelance work demands knowledge of CorelDraw, QuarkXPress and Aldus PageMaker. Send all queries and samples to Designer: Ed Guthero, 408 W. Idaho St., Boise ID 83702. (208)336-7339.

Cartoons: Buys 1 cartoon/issue. Prefers single panel b&w washes and line drawings. Send query letter with brochure and roughs. Samples are filed. Reports back to the artist only if interested. Buys reprint rights. Pays $30 for b&w, $150 for color.

Illustration: Approached by 50 illustrators/year. Buys 6 illustrations/issue. Works on assignment only. Considers all media. Send postcard sample or query letter with brochure, résumé and tearsheets. Accepts submissions on disk. Samples are filed or are returned by SASE. Publication will contact artist for portfolio review if interested. Buys reprint rights. **Pays on acceptance**; $200-500 for b&w, $350-700 for color cover; $50-150 for b&w, $100-200 for color inside.

Design: Needs freelancers for design. Send query letter.

LOG HOME LIVING, 4200-T Lafayette Center Dr., Chantilly VA 20151. (800)826-3893 or (703)222-9411. Fax: (703)222-3209. Art Director: Karen Sulmonetti. Estab. 1989. Monthly 4-color magazine "dealing with the aspects of buying, building and living in a log home. We emphasize upscale living (decorating, furniture, etc.)." Circ. 108,000. Accepts previously published artwork. Sample copies not available. Art guidelines for SASE with first-class postage. 20% of freelance work demands knowledge of QuarkXPress, Adobe Illustrator and Adobe Photoshop.

Cartoons: Prefers playful ideas about logs and living and wanting a log home.

Illustration: Buys 2-4 illustrations/issue. Works on assignment only. Prefers editoral illustration with "a strong style—ability to show creative flair with not-so-creative a subject." Considers watercolor, airbrush, colored pencil and pastel. Send postcard sample. Accepts disk submissions compatible with Adobe Illustrator, Adobe Photoshop and QuarkXPress. Samples are filed. Publication will contact artist for portfolio review if interested. Portfolio should include thumbnails, roughs, printed samples, or color tearsheets. Buys all rights. **Pays on acceptance**; $100-200 for b&w inside; $200-400 for color inside; $100-200 for spots. Finds artists through submissions/self-promotions, sourcebooks.

Design: Needs freelancers for design and production. 80% of freelance work demands knowledge of Adobe Photoshop,

Adobe Illustrator and QuarkXPress. Send query letter with brochure, résumé, photographs and slides. Pays by the project.

THE LOOKOUT, 8121 Hamilton Ave., Cincinnati OH 45231. (513)931-4050. Fax: (513)931-0950. Weekly 4-color magazine for conservative Christian adults and young adults. Circ. 100,000. Sample copy available for 75¢.
Cartoons: Prefers cartoons on family life and religious/church life; mostly single panel. Pays $50 for b&w.

[N] LOS ANGELES MAGAZINE, 11100 Santa Monica Blvd., 7th Floor, Los Angeles CA 90025. (310)312-2200. Creative Director: David Amario. Art Director: Holly Caporale. Monthly 4-color magazine with a contemporary, modern design, emphasizing life-styles, cultural attractions, pleasures, problems and personalities of Los Angeles and the surrounding area. Circ. 170,000. Especially needs very localized contributors—custom projects needing person-to-person concepting and implementation. Previously published work OK. Pays on publication. Sample copy $3. 10% of freelance work demands knowledge of QuarkXPress, Adobe Illustrator and Adobe Photoshop.
Illustration: Buys 10 illustrations/issue on assigned themes. Prefers general interest/life-style illustrations with urbane and contemporary tone. To show a portfolio, send or drop off samples showing art style (tearsheets, photostats, photocopies and dupe slides). Pays on publication; negotiable.
Tips: "Show work similar to that used in the magazine—a sophisticated style. Study a particular publication's content, style and format. Then proceed accordingly in submitting sample work. We initiate contact of new people per *Showcase* reference books or promo fliers sent to us. Portfolio viewing is all local."

[N] THE LUTHERAN, 8765 W. Higgins Rd., Chicago IL 60631. (773)380-2540. E-mail: lutheran@elca.org. Website: http://www.thelutheran.org. Art Director: Michael D. Watson. Estab. 1988. Monthly general interest magazine of the Evangelical Lutheran Church in America; 4-color, "contemporary" design. Circ. 650,000. Previously published work OK. Original artwork returned after publication on request. Free sample copy for 9 × 12 SASE and 5 first-class stamps. Freelancers should be familiar with Adobe Illustrator, QuarkXPress or Adobe Photoshop. Art guidelines available.
Cartoons: Approached by 100 cartoonists/year. Buys 2 cartoons/issue from freelancers. Interested in humorous or thought-provoking cartoons on religion or about issues of concern to Christians; single panel b&w washes and line drawings with gaglines. Prefers finished cartoons. Send query letter with photocopies or finished cartoons and SASE. Reports usually within 2 weeks. Buys one time rights. Pays on publication; $50-100 for b&w line drawings and washes.
Illustration: Buys 6 illustrations/year from freelancers. Has featured illustrations by Rich Nelson, Jimmy Holder, Michael D. Watson. Assigns 30% of illustrations to well-known or "name" illustrators; 70% to experienced, but not well-known illustrators. Works on assignment. Does not use spots. Send query letter with brochure and tearsheets to keep on file for future assignments. Buys one-time usage of art. Will return art if requested. Accepts disk submississions compatible with Adobe Illustrator 5.0. Samples returned by SASE if requested. Portfolio review not required. Pays on publication; $600 for color cover; $150-350 for b&w, $500 for color inside. Finds artists mainly through submissions.
Tips: "Include your phone number with submission. Send samples that can be retained for future reference. We are partial to computer illustrations. Would like to see samples of charts and graphs. Want professional looking work, contemporary, not too wild in style."

[✓] LYNX EYE, 1880 Hill Dr., Los Angeles CA 90041-1244. (323)550-8522. Co-Editor: Pam McCully. Estab. 1994. Quarterly b&w literary magazine. Circ. 500.
Cartoons: Approached by 100 cartoonists/year. Buys 10 cartoons/year. Prefers sophisticated humor. Prefers single panel, political and humorous b&w washes or line drawings. Send b&w photocopies and SASE. Samples are not filed and are returned by SASE. Reports back within 3 months. Buys first North American serial rights. **Pays on acceptance.** Pays $10 for b&w plus 3 copies.
Illustration: Approached by 100 illustrators/year. Buys 20 illustrations/issue. Has featured illustrations by Wayne Hogan, Greg Kidd, Walt Phillips. Features humorous, natural history, realistic or spot illustrations. Prefers b&w work that stands alone as a piece of art—does not illustrate story/poem. Assigns 100% of illustrations to new and emerging illustrators. Send query letter with photocopies and SASE. Samples are not filed and are returned by SASE. Reports back within 3 months. Will contact artist for portfolio review if interested. Buys first North American serial rights. **Pays on acceptance.** Pays $10 for b&w cover or inside plus 3 copies. Finds illustrators through word of mouth, sourcebooks.
Tips: "We are always in need of artwork. Please note that your work is considered an individual piece of art and does not illustrate a story or poem."

[✓] MAD MAGAZINE, 1700 Broadway, New York NY 10019. (212)506-4850. Fax: (212)506-4848. Art Director: Nadina Simon. Monthly irreverent humor, parody and satire magazine. Estab. 1952. Circ. 250,000.
Illustration: Approached by 300 illustrators/year. Works with 100 illustrators/year. Features humor, realism, caricature. Send query letter with photocopies and SASE. Samples are filed. Portfolios may be dropped off every Wednesday and can be picked up same day 4:30-5:00 p.m. Buys all rights. Pays $2,500-3,200 for color cover; $400-725 for inside. Finds illustrators through direct mail, sourcebooks (all).
Design: Also needs local freelancers for designs. Works with 2 freelance designers/year. 100% of freelance design demands knowledge of Adobe Illustrator, Adobe Photoshop and QuarkXPress. Send photocopies and résumé.
Tips: "Know what we do! *MAD* is very specific. Everyone wants to work for *MAD*, but few are right for what *MAD* needs!"

☑ **MADE TO MEASURE**, 600 Central Ave., Highland Park IL 60035. (312)831-6678. E-mail: toons@halper.com. Website: http://www.halper.com. Publisher: Rick Levine. Semiannual trade journal emphasizing uniforms and career clothes. Magazine distributed to retailers, manufacturers and uniform group purchasers. Circ. 25,000.
Cartoons: Buys 10 cartoons/issue. Requires themes relating to subject matter of magazine. Prefers single panel b&w line drawings with or without gagline. Send query letter with finished cartoons. Any cartoons not purchased are returned. Reports back within 3 weeks. Buys first rights. **Pays on acceptance**; $50 for b&w.

N MADEMOISELLE, 350 Madison Ave., New York NY 10017. (212)880-6966. Design Director: Lisa Shapiro. Monthly young womens' fashion and upscale magazine for the 18-25 year old market.
Cartoons: Approached by 50 cartoonists/year. Buys 1 cartoon/issue. Prefers Lynda Barry style cartoons. Prefers humorous. Samples are filed and not returned. Reports back only if interested. Buys reprint rights. Pays $250-900 for b&w and color cartoons.
Illustration: Approached by 300 illustrators/year. Buys 10 illustrations/issue. Prefers new looking work (modern, young, hip). Considers all media. 40% of freelance illustration demands knowledge of Adobe Photoshop, Adobe Illustrator and Aldus FreeHand. Send postcard sample. Samples are filed and are not returned. Reports back only if interested. Portfolio may be dropped off every Wednesday and should include final art and tearsheets. Buys reprint rights. Pays on publication. Pays $200-950 for inside. Pays $200 for spots. Finds illustrators through magazines and submissions.
Design: Needs freelancers for design and production. Prefers local designers. 100% of freelance work demands knowledge of Adobe Photoshop, Adobe Illustrator and QuarkXPress. Send query letter with photocopies.

N MAGICAL BLEND, 133½ Broadway, Chico CA 95928. (916)893-9037. E-mail: artmonster@magicalblend.com. Website: http://www.magicalblend.com. Art Director: René Schmidt. Estab. 1980. Bimonthly 4-color magazine emphasizing spiritual exploration, transformation and visionary arts; eclectic design. Circ. 57,000. Original artwork returned after publication. Sample copy $5; art guidelines by SASE.
Illustration: Works with 20 illustrators/year. Uses 65 illustrations/year. Has featured illustrations by Gale Taylor and William Van Horn. Assigns 1% of illustrations to well-known or "name" illustrators; 70% to experienced, but not well-known illustrators; 29% to new and emerging illustrators. Also publishes 2-3 portfolios on individual artists each issue. "We keep samples on file and work by assignment according to the artists and our time table and workability. We prefer color work. We look for pieces with a positive, inspiring, uplifting feeling." Send photographs, slides and SASE. Reports in 1 week to 6 months. Buys first North American serial rights. Pays in copies. Will print contact information with artwork if desired by artist.
Tips: "We want work that is energetic and thoughtful, and that has a hopeful outlook on the future. Our page size is 8 × 10¾. High-quality, camera-ready reproductions are preferable over originals. We like to print quality art by people who have talent, but don't fit into any category and are usually unpublished. Have technical skill, be unique, show a range of styles; don't expect to get rich from us, 'cuz we sure aren't! Be persistent."

MAIN LINE TODAY, 4 Smedley Lane, Newtown Square PA 19073. (610)325-4630. Fax: (610)325-4636. Art Director: Kelly M. Carter. Estab. 1996. Monthly consumer magazine providing quality information to the main line and western surburbs of Philadelphia. Sample copies for #10 SASE with first-class postage.
Illustration: Approached by 100 illustrators/year. Buys 3-5 illustrations/issue. Prefers comical to realistic. Considers acrylic, charcoal, collage, color washed, mixed media, oil, pastel and watercolor. 10% of freelance illustration demands knowledge of Adobe Photoshop, Adobe Illustrator and QuarkXPress. Send postcard sample or query letter with printed samples and tearsheets. Send follow-up postcard sample every 3-4 months. Samples are filed and are not returned. Reports back only if interested. Buys one-time and reprint rights. Pays on publication; $400 maximum for color cover; $100-150 for b&w inside; $100-200 for color inside. Pays $100 for spots. Finds illustrators by word of mouth and submissions.

N MANAGED CARE, % Willow Tree Design, 242 Willow Tree Rd., Monsey NY 10952. (914)362-3155. Fax: (914)362-2191. Art Director: Philip Denlinger. Estab. 1992. Monthly trade publication for healthcare executives. Circ. 85,000.
Illustration: Approached by 50 illustrators/year. Buys 3 illustrations/issue. Has featured illustrations by Theo Rudnak, David Wilcox, Debra Hardesty and Phill Sing. Features caricatures of politicians, charts & graphs, informational graphics, realistic and spot illustration. Prefers business subjects. Assignments for illustrations divided equally between well-known or name illustrators; experienced, but not well-known, illustrators; and new and emerging illustrators. Send postcard sample. Samples are filed. Will contact artist for portfolio review if interested. Rights purchased vary according to project. **Pays on acceptance**; $1,500-2,000 for color cover; $250-750 for color inside; $450 for spots. Finds illustrators through *American Showcase* and postcards.

MANAGEMENT REVIEW, 1601 Broadway, New York NY 10019-7420. (212)903-8058. Fax: (212)903-8452. E-mail: snewton@amanet.org. Art & Production Director: Seval Newton. Estab. 1921. Monthly company "business magazine for senior managers. A general, internationally-focused audience." 64-page 4-color publication. Circ. 80,000. Original artwork returned after publication. Tearsheets available.
Cartoons: Approached by 10-20 cartoonists/year. Buys 1-2 cartoons/issue. Prefers "business themes and clean drawings of minority women as well as men." Prefers double panel; washes and line drawings. Do not send originals. Selected

samples are filed. Will call for b&w or 4-color original when placed in an issue. Buys first rights. Pays $100 for b&w, $200 for color.

Illustration: Approached by 50-100 illustrators/year. Buys 10-20 illustrations/issue. Electronic chart and graph artists welcome. Works on assignment only. Has featured illustrations by Rob Schuster, Robert Neubecher and Paulette Bogan. Features charts & graphs, informational graphics, computer and spot illustration. Assigns 50% of illustrations to well-known or "name" illustrators; 25% to experienced, but not well-known illustrators; 25% to new and emerging illustrators. Prefers business themes and strong concepts. Considers airbrush, watercolor, collage, acrylic and oil. Electronic art (for Macintosh) can be sent via e-mail. Send query letter with printed samples, tearsheets and SASE. Will accept submissions on disk in Adobe Illustrator using EPS files, Adobe Photoshop, TIFF or JPEG files. Samples are filed. Calls back only if interested. To show a portfolio, mail printed samples and b&w tearsheets, photographs and slides or "drop off portfolio at the above address. Portfolio will be ready to pick up after two days." Rights purchased vary according to project, usually buys multiple usage rights. **Pays on acceptance**; $600-1,100 for color cover; $250-500 for color inside; $600-900 for 2-page spreads; $150-250 for spots.

Tips: "Send tearsheets; periodically send new printed material. The magazine is set on the Macintosh. Any digital illustration helps cut down scanning costs. Do good work. Adhere to deadlines. Be sensitive to revises. Be conceptual. Know the business and definitely read the articles."

MARTIAL ARTS TRAINING, 24715 Avenue Rockefeller, Valencia CA 91380-9018. (805)257-4066. Fax: (805)257-3028. E-mail: rainbow@rsabbs.com. Editor: Doug Jeffrey. Assistant Editor: Stacey Gallard. Estab. 1980. Bimonthly magazine on martial arts training. Circ. 25,000-35,000. Originals are returned at job's completion. Sample copies available; art guidelines available.

Cartoons: Approached by 1 cartoonist/year. Has featured illustrations by Jerry King. Features caricatures of celebrities. Prefers martial arts training; single panel with gagline. Send query letter with roughs and finished cartoons. Samples are not filed and are returned by SASE. Reports within 1 month. Buys all rights.

Tips: "Contact us! Send samples! Want timeliness, quality work and detailed work." Magazine has added a kids section.

MASSAGE MAGAZINE, 1315 W. Mallon Ave., Spokane WA 99201-2038. (509)536-4461. E-mail: robinf@massagem ag.com. Website: http://www.massagemag.com. Art Director: Robin Fontaine. Estab. 1986. Bimonthly trade magazine for practitioners and their clients in the therapeutic massage and allied healing arts and sciences (acupuncture, aromatherapy, chiropractic, etc.) Circ. 45,000. Art guidelines not available.

Illlustration: Not approached by enough illustrators/year. Buys 18-24 illustrations/year. Features medical illustration. Assigns 70% off illustrations to experienced, but not well-known illustrators; 30% to new and emerging illustrators. Themes or style range from full color spiritually-moving to business-like line art. Considers all media. All art must be scanable. Send postcard sample and query letter with printed samples or photocopies. Accepts disk-submitted artwork done in Freehand or Photoshop for use in QuarkXPress version 3.31. Reports back only if interested. Rights purchased vary according to project. Pays on publication; $250 minimum for b&w cover; $450 maximum for color cover; $35 minimum for b&w inside; $90 maximum for color inside. Finds illustrators through word of mouth and artist's submissions.

Tips: "I'm looking for quick, talented artists, with an interest in alternative healing arts and sciences."

N MEDICAL ECONOMICS COMPANY, Five Paragon Dr., Montvale NJ 07645. (201)358-7366. Art Director: Michael Velthaus. Art Coordinator: Jeanine Kalbostian. Estab. 1909. Publishes 22 health related publications and several annuals. Interested in all media, including electronic and traditional illustrations. Accepts previously published material. Originals are returned at job's completion. Uses freelance artists for "all editorial illustration in the magazines." 25% illustration and 100% freelance production work demand knowledge of QuarkXPress, Adobe Illustrator and Adobe Photoshop.

Cartoons: Prefers editorial illustration with medically related themes. Prefers single panel b&w line drawings and washes with gagline. Send query letter with finished cartoons. Material not filed is returned by SASE. Reports within 2 months. Buys all rights.

Illustration: Prefers all media including 3-D illustration. Needs editorial and medical illustration that varies, "but is mostly on the conservative side." Works on assignment only. Send query letter with résumé and samples. Samples not filed are returned by SASE. Reports only if interested. Publication will contact artist for portfolio review if interested. Buys one-time rights. **Pays on acceptance**; $1,000-1,500 for color cover; $200-600 for b&w, $250-800 for color inside.

MEDIPHORS, A Literary Journal of the Health Professions, P.O. Box 327, Bloomsburg PA 17815-0327. E-mail: mediphor@ptd.net. Website: http://www.mediphors.org. Editor: Eugene D. Radice, MD. Estab. 1993. Semiannual literary magazine/journal publishing short story, essay and poetry which broadly relate to medicine and health. Circ. 900. Sample copy and art guidelines for SASE with first-class postage; art guidelines also available on website.

Cartoons: Approached by 6 cartoonists/year. Buys 6-12 cartoons/issue. Prefers health/medicine related. Prefers single panel, humorous, b&w line drawings. Samples are returned by SASE. Reports back in 1 month. Buys first North American serial rights. Pays on publication; 2 publication copies.

Illustration: Approached by 6 illustrators/year. Buys 5 illustrations/issue. Features humorous and realistic illustration. Assigns 50% of if illustrations to experienced, but not well-known illustrators; 50% to new and emerging illustrators. Considers charcoal, collage, marker, pen & ink. Send query letter with photocopies and SASE. Samples are filed or

returned by SASE. Reports back in 1 month if interested. Buys first North American serial rights. Pays on publication; 2 copies of publication.

Tips: "We enjoy publishing work from beginning artists who would like to see their work published in a nationally-distributed magazine, but do not require cash payment."

N **THE MEETING PROFESSIONAL**, 4455 LBJ Freeway, Suite 1200, Dallas TX 75244. (972)702-3000. E-mail: jott@mpiweb.org. Website: http://www.mpiweb.org. Art Director: Joel W. Ott. Estab. 1980. Monthly 4-color company magazine written for professional meeting managers responsible for meeting planners. Circ. 30,000 Art guidelines for #10 SASE.

Illustration: Approached by 10 illustrators/year. Buys 3 illustrations/issue. Has featured illustrations by Bart Forbes. Features computer illustrations on business subjects. Prefers bright, contemporary feel—slightly abstract. Assigns 50% of illustrations to new and emerging illustrators; 25% each to well-known or name illustrators and experienced, but not well-known, illustrators. 75% of freelance illustration demands knowledge of Adobe Photoshop. Send postcard sample; "only very polished or unique promos, please." Samples are not returned. Reports back only if interested. Portfolio review not required. Buys one-time rights. Pays $75-300 for color cover; $25-100 for color inside, $50-150 for 2-page color spread. Finds illustrators through sourcebooks, word of mouth.

Tips: "A unique style or technique and a friendly, down-to-earth attitude could get you a lot of work with us. Consistent, deadline-driven professional person would be an asset. You have to think globally in the meeting planning industry."

☑ **MEETINGS IN THE WEST**, 550 Montgomery St., Suite 750, San Francisco CA 94111. (415)788-2005. Fax: (415)788-0301. Website: http://www.meetingsweb.com. Production Manager: Rebecca King. Production Assistants: Mike Stahlbrodt and Dominic Vacci. Monthly 4-color and b&w tabloid/trade publication for meeting planners covering the 14 western United States, plus western Canada and Mexico. Circ. 25,000.

Illustration: Approached by 5 illustrators/year. Buys 0-1 illustrations/issue. Has featured illustrations by Shari Warren, Beatrice Benjamin. Features computer illustration, humorous and spot illuatration. Prefers subjects portraying business subjects. Prefers watercolor—bright watercolor washes, colorful computer illustration. Assigns 20% of illustration to experienced, but not well-known illustrators; 80% to new and emerging illustrators. 100% of freelance illustration demands knowledge of Adobe Illustrator, Adobe Photoshop. Send postcard sample. Accepts Mac-compatible disk submissions. Samples are filed or returned by SASE. Will contact artist for portfolio review if interested. Buys first rights. Pays on publication; $700-1,000 for color cover; $50-300 for color inside. Finds illustrators through word of mouth, recommendations by colleagues, promo samples.

Tips: "We rely on our in-house production assistant's illustration talent on a regular basis. A few projects may be out-sourced, but the need is not very high."

MICHIGAN LIVING, 1 Auto Club Dr., Dearborn MI 48126. (313)336-1506. Fax: (313)336-1344. E-mail: michliving @aol.com. Editor: Ron Garbinski. Estab. 1918. Monthly magazine emphasizing travel and lifestyle. Circ. 1.1 million. Sample copies and art guidelines for SASE with first-class postage.

Illustration: Approached by 20 illustrators/year. Features natural history illustrations; realistic illustration; charts & graphs; and informational graphics. Assigns 50% of illustrations to experienced, but not well-known illustrators; 50% to new and emerging illustrators. Prefers travel related. Considers all media. Knowledge of Aldus FreeHand, Adobe Photoshop, QuarkXPress, Adobe Illustrator helpful, but not required. Send query letter with printed samples, photocopies, SASE, tearsheets and include e-mail address. Accepts disk submissions compatible with QuarkXPress 3.32. Samples are not filed and are not returned. Reports back in 6 weeks. Art director will contact artist for portfolio review of b&w and color final art, photographs, photostats, roughs, slides, tearsheets, thumbnails, transparencies if interested. Buys first North American serial rights or reprint rights. Pays $450 maximum for cover and inside; $400 maximum for spots. Finds illustrators through sourcebooks, such as *Creative Black Book*, word of mouth, submissions.

Tips: "Read our magazine, we need fast workers with quick turnaround."

N **MICROSOFT CERTIFIED PROFESSIONAL MAGAZINE**, 1500 Quail St., Newport Beach CA 92660. (949)225-4916. Fax: (949)863-1680. E-mail: mattcr@mcpmag.com. Website: http://www.mcpmag.com. Art Director: Matt Crane. Estab. 1993. Monthly 4-color trade publication for Windows NT professionals. Circ. 70,000.

Cartoons: Approached by 1-2 cartoonists/year. Buys 12 cartoons/year. Prefers technical illustrations. Prefers color washes. Send tearsheets. Samples are filed. Reports back in 1 month. Buys all rights. Pays on publication; $250-500 for color cartoons.

Illustration: Approached by 1-2 illustrators/year. Features charts & graphs, informational graphics, spot illustrations and computer illustration of business subjects. Assigns 50% of illustrations to experienced, but not well-known illustrators; 50% to new and emerging illustrators. 100% of freelance illustration demands knowledge of Adobe Illustrator and Adobe Photoshop. Send non-returnable samples and tearsheets. Accepts Mac-compatible disk submissions. Samples are

SASE MEANS SELF-ADDRESSED, STAMPED ENVELOPE. Send SASEs when requesting return of your samples.

filed. Reports back within 1 month. Portfolio review not required. Buys all rights. Pays $500 for spots.

MID-AMERICAN REVIEW, English Dept., Bowling Green State University, Bowling Green OH 43403. (419)372-2725. Editor-in-Chief: George Looney. Estab. 1980. Twice yearly literary magazine publishing "the best contemporary poetry, fiction, essays, and work in translation we can find. Each issue includes poems in their original language and in English." Circ. 700. Originals are returned at job's completion. Sample copies available for $5.
Illustration: Approached by 10-20 illustrators/year. Buys 1 illustration/issue. Considers pen & ink, watercolor, collage, charcoal and mixed media. Send query letter with brochure, SASE, tearsheets, photographs and photocopies. Samples are filed or are returned by SASE if requested by artist. Reports back within 3 months. Buys first rights. Pays on publication. Pays $50 when funding permits. Also pays in copies, up to 20.
Tips: "*MAR* only publishes artwork on its cover. We like to use the same artist for one volume (two issues)."

N MILITARY MARKET MAGAZINE, 6883 Commercial Dr., Springfield VA 22159-0210. (703)750-8680. Editor: Roger Hyneman. Monthly 4-color trade magazine emphasizing "the military's PX and commissary businesses for persons who manage and buy for the military's commissary and post exchange systems; also aimed at manufacturers, brokers and distributors"; contemporary design. Circ. 12,000. Simultaneous submissions OK. Original artwork not returned after publication.
Cartoons: Approached by 25 cartoonists/year. Buys 2 cartoons/issue. Interested in themes relating to "retailing/buying of groceries or general merchandise from the point of view of the store managers and workers." Prefers single panel b&w line drawings with or without gagline. Send finished cartoons. Samples returned by SASE. Reports in 6 months. Buys all rights. **Pays on acceptance**; $25 for b&w. Finds artists through word of mouth.
Tips: "We use freelance cartoonists only—*no* other freelance artwork." Do not "send us military-oriented cartoons. We want retail situations *only. No* bimbo cartoons."

MILLER FREEMAN, INC., 600 Harrison St., San Francisco CA 94107. (415)905-2200. Fax: (415)905-2236. E-mail: abrokering@mfi.com. Website: http://www.mfi.com. Graphics Operations Manager: Amy R. Brokering. Publishes 90 monthly and quarterly 4-color business and special-interest consumer and trade magazines serving the paper, travel, retail, real estate, sports, design, forest products, computer, music, electronics and healthcare markets. Circ. 20,000-150,000. Returns original artwork after publication.
Illustration: Approached by 1,000 illustrators/year. Uses freelancers occasionally for illustration of feature articles. Needs editorial, technical and medical illustration. No cartoons please. Buys numerous illustrations/year. Works on assignment only. 90% of freelance work demands knowledge of QuarkXPress, Adobe Illustrator or Adobe Photoshop. Send query letter with printed samples to be kept on file (or send e-mail inquiry before mailing printed samples, if preferred). Do not send photocopies or original work. Samples not filed are returned by SASE only. Reports back only if interested. "No phone queries, please." Negotiates rights purchased. **Pays on acceptance**.
Design: Needs freelancers for design, production, multimedia. Prefers local freelancers. Send query letter with brochure, résumé, SASE and tearsheets. Pays for design by the hour.

N MOBILE BEAT, P.O. Box 309, East Rochester NY 14445. (716)385-9920. Fax: (716)385-3637. E-mail: mobilebeat@aol.com. Website: http://www.mobilebeat.com. Editor: Robert Lindquist. Estab. 1991. Bimonthly magazine "of professional sound, lighting and karaoke." Circ. 18,000.
Cartoons: Buys 1 cartoon/issue. Prefers single panel with gagline. Send query lettery with finished cartoons. Samples are filed. Reports back within 1 month if interested. Buys one-time rights. Pays on publication; $100 minimum for b&w.
Illustration: Approached by 10-12 illustrators. Buys 6-8 illustrations/issue. Has featured illustrations by Robert Burger, Jeff Marinelli, Dan Sipple. Assigns 50% of illustrations to experienced but not well-known illustrators; 50% to new and emerging illustrators. 100% of freelance illustration demands knowledge of Adobe PageMaker, Adobe Photoshop, Adobe Illustrator and MacroMedia FreeHand. Send query letter with photocopies. Accepts disk submissions compatible with Adobe PageMaker, Adobe Photoshop, Adobe Illustrator and MacroMedia FreeHand. Samples are filed. Reports back within 1 month. Buys one-time rights. Pays on publication; $200-400 for b&w cover; $100 for b&w inside. Finds illustrators through agents, sourcebooks and submissions.
Tips: "Read our magazine."

MODERN DRUMMER, 12 Old Bridge Rd., Cedar Grove NJ 07009. (201)239-4140. Editor-in-Chief: Ronald Spagnardi. Art Director: Scott Bienstock. Monthly magazine for drummers, "all ages and levels of playing ability with varied interests within the field of drumming." Circ. 103,000. Previously published work OK. Original artwork returned after publication. Sample copy for $4.95.
Cartoons: Buys 3-5 cartoons/year. Interested in drumming themes; single and double panel. Prefers finished cartoons or roughs. Include SASE. Reports in 3 weeks. Buys first North American serial rights. Pays on publication; $5-25.
Tips: "We want strictly drummer-oriented gags."

N MODERN HEALTHCARE MAGAZINE, 740 Rush St., Chicago IL 60611. (312)649-5346. E-mail: balig@crain.com. Website: http://www.modernhealthcare.com. Art Director: Brad Alig. Estab. 1976. Weekly 4-color trade magazine on healthcare topics, geared to CEO's, CFO's, COO's etc. Circ. 80,000.
Illustration: Approached by 50 illustrators/year. Features caricatures of politicians, humorous illustration, charts &

graphs, informational graphics, medical illustration, spot illustrations and computer illustration. Assigns 60% of illustrations to well-known or "name" illustrators; 40% to experienced, but not well-known illustrators. 100% of freelance illustration demands knowledge of Adobe Illustrator, Adobe Photoshop, Aldus FreeHand. Send postcard sample and non-returnable printed samples. Accepts Mac or Windows-compatible disk submissions. Samples are filed. Reports back only if interested. Will contact artist for portfolio review if interested. Buys all rights. "Usually buy all rights for cover art. If it is a generic illustration not geared directly to our magazine, then we might buy only first rights in that case." **Pays on acceptance**; $400-450 for color cover; $50-150 for color inside. Finds illustrators through word of mouth and staff members.

Tips: "Keep sending out samples, someone will need your style. Don't give up!"

MODERN MATURITY, Dept. AM, 601 E Street NW, Washington DC 20049. Design Director: Cynthia Friedman. Estab. 1956. Bimonthly 4-color magazine emphasizing health, lifestyles, travel, sports, finance and contemporary activities for members 50 years and over. Circ. 22 million. Originals are returned after publication.

Illustration: Approached by 200 illustrators/year. Buys 40 freelance illustrations/issue. Works on assignment only. Considers digital, watercolor, collage, oil, mixed media and pastel. Samples are filed "if I can use the work." Do not send portfolio unless requested. Portfolio can include original/final art, tearsheets, slides and photocopies and samples to keep. Buys first rights. **Pays on acceptance**; $2,000 for color cover; $1,000 for color inside, full page; $500 for color ¼ page.

Tips: "We generally use people with strong conceptual abilities. I request samples when viewing portfolios."

N MODERN PLASTICS, 2 Penn Plaza, 5th Floor, New York NY 10121-2298. (212)904-3491. Art Director: Anthony Landi. Monthly trade journal emphasizing technical articles for manufacturers of plastic parts and machinery; 4-color with contemporary design. Circ. 65,000 domestic, 35,000 international. 20% of freelance work demands knowledge of Adobe Illustrator, QuarkXPress or Aldus FreeHand.

Illustration: Works with 4 illustrators/year. Buys 6 illustrations/year. Prefers airbrush, computer and conceptual art. Works on assignment only. Send brochure. Samples are filed. Does not report back. Call for appointment to show a portfolio of tearsheets, photographs, slides, color and b&w. Buys all rights. **Pays on acceptance**; $800-1,200 for color cover; $200-250 for color inside.

N MODERN REFORMATION MAGAZINE, 1716 Spruce St., Philadelphia PA 19103. (215)546-3696. Fax: (215)735-5133. E-mail: modref@alliancenet.org. Website: http://www.alliancenet.org. Design and Layout: Lori Cook. Production Editor: Irene Hetherington. Estab. 1991. Bimonthly b&w theological magazine from a reformational perspective. Circ. 10,000. Sample copies and art guidelines for 9×12 SASE and 5 first-class stamps.

Illustration: Buys 5 illustrations/issue. Has featured illustrations by Corey Wilkinson. Features charts & graphs, realistic, religious and spot illustration. Preferred subjects: religious. Prefers scratchboard, pen & ink, realism. Assigns 75% of illustrations to new and emerging illustrators; 25% to experienced, but not well-known illustrators. 25% of freelance illustration demands knowledge of Adobe Illustrator, Adobe Photoshop and QuarkXPress. Send query letter with photocopies. Accepts Mac-compatible disk submissions. Samples are filed. Will contact artist for portfolio review if interested. Buys one-time rights. **Pays on acceptance**; $150 minimum for b&w inside. Finds illustrators through artists' promo samples.

Tips: "Knowledge of theological issues helpful; quick turnaround and reliability a must."

N MODERN SALON, 400 Knightsbridge Pkwy., Lincolnshire IL 60069. (847)634-2600. Fax: (847)634-4379. Website: http://www.vancepublishing.com. Art Director: Robin Hicks. Estab. 1913. Monthly trade publication that "highlights new hairstyles, products and gives how-to info." Circ. 136,000.

Illustration: Approached by "tons" of illustrators/year. Buys 1-2 illustrations/issue. Has featured illustrations by Roberta Polfus, Magué Calanche. Features fashion illustration, spot illustrations and computer illustration of families, women, teens and collage/conceptual illustrations. Prefers clean lines, bright colors, texture. Assigns 90% of illustrations to experienced, but not well-known illustrators; 10% to new and emerging illustrators. Send postcard sample. Samples are filed. Reports back only if interested. Portfolio review not required. Buys one-time rights. Pays on publication; $300-700 for color inside. Pays $200 for spots. Finds illustrators through samples and word of mouth.

Tips: "I want an illustrator who is highly conceptual, easy to work with and get in touch with, and timely in regards to deadlines. We commission non-gritty, commercial-style illustrators with bright colors and highly stylized content."

MOM GUESS WHAT NEWSPAPER, 1725 L St., Sacramento CA 95814. (916)441-6397. E-mail: info@mgwnews.com. Website: http://www.mgwnews.com. Publisher/Editor: Linda Birner. Estab. 1978. Weekly newspaper "for gays/lesbians." Circ. 21,000. Sample copies for 10×13 SASE and 4 first-class stamps. Art guidelines for #10 SASE with first-class postage.

Cartoons: Approached by 15 cartoonists/year. Buys 5 cartoons/issue. Prefers gay/lesbian themes. Prefers single and multiple panel political, humorous b&w line drawings with gagline. Send query letter with photocopies and SASE. Samples are filed. Reports back only if interested. Rights purchased vary according to project. Pays on publication; $5-50 for b&w.

Illustration: Approached by 10 illustrators/year. Buys 3 illustrations/issue. Has featured illustrations by Andy Markley and Tim Brown. Features caricatures of celebrities; humorous, realistic and spot illustration. Assigns 50% of illustration to experienced, but not well-known illustrators; 50% to new and emerging illustrators. Prefers gay/lesbian themes.

Considers pen & ink. 50% of freelance illustration demands knowledge of Aldus PageMaker. Send query letter with photocopies. Samples are filed. Reports back only if interested. Art director will contact artist for portfolio review of b&w photostats if interested. Rights purchased vary according to project. Pays on publication; $100 for b&w or color cover; $10-100 for b&w or color inside; $300 for 2-page spreads; $25 for spots. Finds illustrators through word or mouth and artist's submissions.

Design: Needs freelancers for design and production. Prefers local design freelancers. 100% of freelance work demands knowledge of Aldus PageMaker 6.5 and Corel Draw. Send query letter with photocopies, phone art director.

Tips: "Send us copies of your ideas that relate to gays/lesbian issues, serious and humorous."

☑ MOMENT, 4710 41st St. NW, Washington DC 20016. (202)364-3300. Fax: (202)364-2636. Executive Editor: Suzanne Singer. Contact: Josh Rolnick, associate editor. Estab. 1973. Bimonthly Jewish magazine, featuring articles on religion, politics, culture and Israel. Circ. 65,000. Accepts previously published artwork. Originals returned at job's completion. Sample copies available for $4.50.

Cartoons: Uses reprints and originals. Prefers political themes relating to Middle East, Israel and contemporary Jewish life. Samples are filed. Reports back only if interested. Rights purchased vary according to project. Pays minimum of $30 for ¼ page, b&w and color.

Illustration: Buys 5-10 illustrations/year. Works on assignment only. Send query letter. Samples are filed. Reports back only if interested. Rights purchased vary according to project. Pays $30 for b&w, $225 for color cover; $30 for color inside (¼ page or less).

Tips: "We look for specific work or style to illustrate themes in our articles. Please know the magazine—read back issues!"

ℕ MONTANA MAGAZINE, P.O. Box 5630, Helena MT 59604. (406)443-2824. Fax: (406)443-5480. Editor: Beverly R. Magley. Estab. 1970. Bimonthly magazine covering Montana recreation, history, people, wildlife. Geared to Montanans. Circ. 40,000.

● Art director reports this magazine has rarely used illustration in the past, but would like to use more. Also, the magazine no longer accepts cartoons.

Illustration: Approached by 15-20 illustrators/year. Buys 1-2 illustrations/year. Prefers outdoors. Considers all media. Knowledge of Aldus PageMaker, Adobe Photoshop, Adobe Illustrator helpful but not required. Send query letter with photocopies. Accepts disk submissions combatible with Pagemaker 5.0. Send EPS files. Samples are filed and are not returned. Buys one-time rights. Pays on publication; $35-50 for b&w; $50-125 for color. Pays $35-50 for spots. Finds illustrators through submissions, word of mouth.

Tips: "We work with local artists usually because of convenience and turnaround."

ℕ THE MORGAN HORSE, Box 960, Shelburne VT 05482. (802)985-4944. Art Director: James Guertin. Emphasizes all aspects of Morgan horse breed including educating Morgan owners, trainers and enthusiasts on breeding and training programs; the true type of the Morgan breed, techniques on promoting the breed, how-to articles, as well as preserving the history of the breed. Monthly. Circ. 8,000. Accepts previously published material, simultaneous submissions. Original artwork returned after publication. Sample copy $4.

Illustration: Approached by 10 illustrators/year. Buys 2-5 illustrations/year. Uses artists mainly for editorial illustration and mechanical production. "Line drawings are most useful for magazine work. We also purchase art for promotional projects dealing with the Morgan horse—horses must look like *Morgans.*" Send query letter with samples and tearsheets. Accepts "anything that clearly shows the artist's style and craftsmanship" as samples. Samples are returned by SASE. Reports within 6-8 weeks. Call or write for appointment to show portfolio. Buys all rights or negotiates rights purchased. **Pays on acceptance;** $25-100 for b&w; $100-300 for color inside.

Tips: As trend sees "more of an effort on the part of art directors to use a broader style. Magazines seem to be moving toward more interesting graphic design. Our magazine design is a sophisticated blend of conservative and tasteful contemporary design. While style varies, the horses in our illustrations must be unmistakably Morgans."

MOTHER JONES, 731 Market St., Suite 600, San Francisco CA 94103. (415)665-6637. Fax: (415)665-6696. Webiste: http://www.motherjones.com. Assistant Art Director: Benjamin Shaykin. Estab. 1976. Bimonthly magazine. Focuses on investigative journalism, progressive politics and exposés. Circ. 144,500. Accepts previously published artwork. Originals returned at job's completion. Sample copies available. Freelance designers should be familiar with QuarkXPress, Adobe Photoshop and Adobe Illustrator.

Cartoons: Approached by 25 cartoonists/year. Prints one cartoon/issue (6/year). Prefers full page, multiple-frame color drawings. Send query letter with postcard-size sample or finished cartoons. Samples are filed or returned by SASE if requested by artist. Reports back to the artist only if interested. Buys first rights. Works on assignment only.

Illustration: Approached by hundreds of illustrators/year. Has featured illustrations by: Gary Baseman, Chris Ware, Juliette Borda and Gary Panter. Assigns 90% of illustrations to well-known or "name" illustrators; 5% to experienced, but not well-known illustrators; 5% to new and emerging illustrators. Works on assignment only. Considers all media. Send postcard-size sample or query letter with samples. Samples are filed or returned by SASE if requested by artist. Reports back to the artist only if interested. Portfolio should include photographs, slides and tearsheets. Buys first rights. Pays on publication; payment varies widely. Finds artists through illustration books; other magazines; word of mouth.

☑ **MS. MAGAZINE**, 20 Exchange Place, 22nd Floor, New York NY 10005. (212)509-2092. Art Department: Jennifer Walter. Estab. 1972. Bimonthly consumer magazine emphasizing feminist news, essays, arts. Circ. 150,000. Originals returned at job's completion. Art guidelines not available.

Cartoons: Approached by 50 cartoonists/year. Buys 3-4 cartoons/issue. Prefers women's issues. Prefers single panel political, humorous b&w line drawings. Send query letter with photocopied finished cartoons. "Never send originals." Samples sometimes filed or returned by SASE if included. Does not report back. Buys one-time rights. Pays $100 and up for b&w.

Illustration: Approached by hundreds of illustrators/year. Buys 10 illustrations/issue. Works on assignment only. "Work must reproduce well in 2-color." Considers all media. Send postcard-size sample or color copies. Samples sometimes filed and are not returned. Does not report back. Portfolio review by *Ms.* request only. Buys one time rights. Pays on publication. Finds artists through word of mouth, submissions and sourcebooks. "Absolutely no calls."

MUSHING, P.O. Box 149, Ester AK 99725-0149. (907)479-0454. Fax: (907)479-3137. E-mail: editor@mushing.com. Website: http://www.mushing.com. Publisher: Todd Hoener. Estab. 1988. Bimonthly "year-round, international magazine for all dog-powered sports, from sledding to skijoring to weight pulling to carting to packing. We seek to educate and entertain." Circ. 10,000. Photo/art originals are returned at job's completion. Sample copies available for $5. Art guidelines available upon request.

Cartoons: Approached by 20 cartoonists/year. Buys up to 1 cartoon/issue. Prefers humorous cartoons; single panel b&w line drawings with gagline. Send query letter with roughs. Samples are not filed and are returned by SASE if requested by artist. Reports back with 1-6 months. Buys first rights and reprint rights. Pays $25 for b&w and color.

Illustration: Approached by 20 illustrators/year. Buys 0-1 illustrations/issue. Prefers simple; healthy, happy sled dogs; some silhouettes. Considers pen & ink and charcoal. Send query letter with SASE and photocopies. Accepts disk submissions if Mac compatible. Send EPS or TIFF files with hardcopy. Samples are returned by SASE if requested by artist. Prefers to keep copies of possibilities on file and use as needed. Reports back within 1-6 months. Portfolio review not required. Buys first rights. Pays on publication; $150 for color cover; $25 for b&w and color inside; $25 for spots. Finds artists through submissions.

Tips: "Be familiar with sled dogs and sled dog sports. We're most open to using freelance illustrations with articles on dog behavior, adventure stories, health and nutrition. Illustrations should be faithful and/or accurate to the sport. Cartoons should be faithful and tasteful (e.g., not inhumane to dogs)."

MUTUAL FUNDS MAGAZINE, 2200 SW 10th St., Deerfield Beach FL 33442-8799. (954)421-1000. Fax: (954)570-8200. Website: http://www. mfmag.com. Art Director: Mary Branch. Estab. 1994. Monthly consumer magazine covering mutual funds. Circ. 750,000.

• Magazine was recently purchased by Time Inc.

Cartoons: Approached by 10 cartoonists/year. Buys 1 cartoon/issue. Prefers mutual fund themes. Prefers single panel, humorous, color washes, with gaglines. Send query with photocopies, tearsheets. Send non-returnable samples only. Samples are filed. Reports back only if interested. Buys first-time rights. Pays on publication; $150-400 for color.

Illustration: Approached by 100 illustrators/year. Assigns 50% of illustrations to well-known or "name" illustrators; 50% to experienced, but not well-known illustrators. Buys 10 illustrations/issue. Prefers detailed, colorful, pen & ink, wash. 20% of freelance illustration demands knowledge of any Mac based software. Send postcard sample or query letter with printed samples, photocopies and tearsheets. Send only non-returnable samples. "No cold calls, please." Reports back only if interested. Art director will contact artist for portfolio review of color final art, photographs, tearsheets, transparencies if interested. Buys one-time rights. Pays on publication; $400-1,500 for color cover; $350-2,000 for color inside; $150-250 for spots. Finds illustrators through sourcebooks, other magazines, direct mail.

Tips: "Look at *Mutual Funds* before you contact me. Know the product and see if you fit in. Be easy to communicate with, with quick turn around, flexible and traditional computer skills."

MY FRIEND, 50 St. Paul's Ave., Boston MA 02130-3491. (617)522-8911. Website: http://www.Internaturally.com. Contact: Graphic Design Dept. Director of Operations: Cheryl Hanenberg. Estab. 1979. Monthly Catholic magazine for kids, b&w with 4-color cover, containing information, entertainment, and Christian information for young people ages 6-12. Circ. 14,000. Originals returned at job's completion. Sample copies free for 9×12 SASE with first-class postage; art guidelines available for SASE with first-class postage.

Illustration: Approached by 60 illustrators/year. Buys 6 illustrations/issue; 60/year. Works on assignment only. Has featured illustrations by Terry Julien, Jack Hughes, Stephen J. King, Denis Thien and Elaine Garvin. Features realistic illustration; informational graphics; spot illustration. Assigns 10% of illustrations to well-known or "name" illustrators; 80% to experienced, but not well-known illustrators; 10% to new and emerging illustrators. Prefers humorous, realistic portrayals of children. Considers pen & ink, watercolor, airbrush, acrylic, marker, colored pencil, oil, charcoal, mixed media and pastel. Send query letter with résumé, SASE, tearsheets, photocopies. Accepts disk submissions compatible with Windows 3.1, Aldus PageMaker 5.0 or CorelDraw 5.0. Send TIFF files. Samples are filed or are returned by SASE if requested by artist. Reports back to the artist within 1-2 months only if interested. Portfolio review not required. Rights purchased vary according to project. Pays on publication; $200-250 for color cover; $50-100 for b&w inside; $75-125 for color inside; $150-175 for 2-page spreads; $25-50 for spots.

Design: Needs freelancers for design, production and multimedia projects. Design demands knowledge of Aldus PageMaker, Aldus FreeHand and CorelDraw 5.0. Send query letter with résumé, photocopies and tearsheets. Pays by project.

N THE MYSTERY REVIEW, P.O. Box 233, Colborne, Ontario K0K 1S0 Canada. (613)475-4440. Fax: (613)475-3400. E-mail: 71554.551@compuserve.com. Website: http://www:inline-online.com/mystery/. Editor: Barbara Davey. Estab. 1992. Quarterly literary magazine "for mystery readers." Circ. 5,000.
Illustration: Send query letter with photocopies and SASE. Asks disk submissions compatible with PageMaker 6.0 version for Windows." Samples are filed. Reports back only if interested. Negotiates rights purchased. Pays on publication; $50 maximum for b&w cover; $20 maximum for b&w inside. Finds illustrators through artist's submissions.
Design: Needs freelancers for design. Send query letter with photocopies.
Tips: "Take a look at our magazine—it's in bookstores."

N NA'AMAT WOMAN, 200 Madison Ave., New York NY 10016. (212)725-8010. Fax: (212)447-5187. Editor: Judith Sokoloff. Estab. 1926. Jewish women's magazine published 4 times yearly, covering a wide variety of topics that are of interest to the Jewish community, affiliated with NA'AMAT USA (a nonprofit organization). Originals are returned at job's completion. Sample copies available for $1.
Cartoons: Approached by 5 cartoonists/year. Buys 4-5 cartoons/year. Prefers political cartoons; single panel b&w line drawings. Send query letter with brochure and finished cartoons. Samples are filed or are returned by SASE if requested by artist. Reports back to the artist only if interested. Rights purchased vary according to project. Pays $50 for b&w.
Illustration: Approached by 20 illustrators/year. Buys 1-3 illustrations/issue. Works on assignment only. Considers pen & ink, collage, marker and charcoal. Send query letter with tearsheets. Samples are filed or are returned by SASE if requested by artist. Reports back to the artist only if interested. Publication will contact artist for portfolio review if interested. Portfolio should include b&w tearsheets and final art. Rights purchased vary according to project. Pays on publication; $150 for b&w cover; $50-75 for b&w inside. Finds artists through sourcebooks, publications, word of mouth, submissions.
Tips: "Give us a try! We're small, but nice."

N NAILPRO, 7628 Densmore Ave., Van Nuys CA 91406. (818)782-7328. Fax: (818)782-7340. E-mail: nailpro@nailpro.com. Website: http://www.nailpro.com. Art Director: Kim Lewis. Creative Director: Melissa Colton. Monthly trade magazine for the nail and beauty industry, audience: nail technicians. Circ. 50,000. Sample copies and art guidelines available.
Cartoons: Prefers subject matter related to nail industry. Prefers humorous color washes and b&w line drawings with or without gagline. Send query letter with samples. Reports back only if interested. Rights purchased vary according to project. Payment varies with projects.
Illustration: Approached by tons of illustrators. Buys 3-4 illustrations/issue. Has featured illustrations by Kelley Kennedy, Nick Bruhel and Kathryn Adams. Assigns 20% of illustrations to well-known or "name" illustrators; 70% to experienced, but not well-known illustrators; 10% to new and emerging illustrators. Prefers whimsical computer illustrations. Considers all media. 85% of freelance illustration demands knowledge of Adobe Photoshop 3.0, Adobe Illustrator 5.5 and QuarkXPress 3.32. Send postcard sample. Accepts disk submissions compatible with QuarkXPress 3.32, TIFFs, EPS files submitted on Zip, Syquest or CD (Mac format only). Send samples to attn: Art Director. Samples are filed. Reports back only if interested. Art director will contact artist for portfolio review of b&w, color, final art and tearsheets if interested. Buys first rights. Pays on publication; $350-400 for 2-page, full-color feataure spread; $300 for 1-page; $250 for ½ page. Pays $50 for spots. Finds illustrators through *Workbook*, samples sent in the mail, magazines.
Design: Needs freelancers for design, production and multimedia projects. Prefers local design freelancers only. 100% of freelance work demands knowledge of Adobe Photoshop 3.0, Adobe Illustrator 6.0 and QuarkXPress 3.32. Send query letter with printed samples and tearsheets.
Tips: "I like conceptual illustrators with a quick turnaround."

☑ THE NATION, 33 Irving Pl., New York NY 10003. (212)209-5400. Website: http://www.thenation.com. Art Director: Steven Brower. Estab. 1865. A weekly journal of "left/liberal political opinion, covering national and international affairs, literature and culture." Circ. 100,000. Originals are returned after publication upon request. Sample copies available. Art guidelines not available.
 ● The *Nation*'s Art Director works out of his design studio at Steven Brower Design, 18 E. 16th St., 7th Floor, New York NY 10003. You can send samples to *The Nation* or directly to him.
Illustration: Approached by 50 illustrators/year. Buys 3-4 illustrations/issue. Works with 25 illustrators/year. Has featured illustrators by Robert Grossman, Luba Lukora, Igor Kopelnitsky and Karen Caldecott. Buys illustrations mainly for spots and feature spreads. Works on assignment only. Considers pen & ink, airbrush, mixed media and charcoal pencil; b&w only. Send query letter with tearsheets and photocopies. "On top of a defined style, artist must have a strong and original political sensibility." Samples are filed or are returned by SASE. Reports back only if interested. Buys first rights. Pays $75-125 for b&w inside; $150 for color inside.

NATIONAL BUSINESS EMPLOYMENT WEEKLY, P.O. Box 300, Princeton NJ 08543-0300. (609)520-7311. Fax: (609)520-4309. E-mail: lnanton@wsj.com. Art Director: Larry Nanton. Estab. 1981. Weekly newspaper covering job search and career guidance for middle-senior level executives. Circ. 33,000. Originals returned at job's completion. Art guidelines available.
Cartoons: Buys 1 cartoon/issue. Subject must pertain to some aspect of job hunting; single panel b&w washes and line drawings with or without gagline. Send query letter with finished cartoons. Samples are not filed and are returned by SASE. Reports back to the artist only if interested. Buys first rights. Pays $50 for b&w.

Illustration: Approached by 24 illustrators/year. Buys 4 illustrations/issue. Works on assignment only. Has featured illustrations by Darren Gygi, Dennis Dittrich, Lael Henderson, Tim Foley and Patrick Arrasmith. Features humorous, realistic, computer and spot illustration. Assigns 50% of illustrations to experienced, but not well-known illustrators; 50% to new and emerging illustrators. Prefers b&w images and designs of people in all stages of the job search. Considers pen & ink, watercolor, airbrush and pencil. Send postcard sample or query letter with tearsheets. Samples are filed. Reports back to the artist only if interested. Portfolio review not required. Buys one-time rights and reprint rights. Pays on publication; $125 for b&w inside; $500 for 4-color cover, $150 for color inside.

Tips: "Artist should have a good imagination, nice sense of design and be competent in drawing people. Send only samples that you can live up to. Accept the terms of employment in exchange for the exposure."

⚃ NATIONAL DRAGSTER, 2220 E. Alosta Ave., Suite 101, Glendora CA 91740. Fax: (626)335-6651. E-mail: nhra@nhraonline.com. Website: http://www.nhra.com. Art Director: Jill Flores. Estab. 1959. Weekly drag racing b&w tabloid with 4-color cover and "tabazine" style design distributed to 85,000 association (NHRA) members. "The nation's leading drag racing weekly." Circ. 85,000. Accepts previously published artwork. Originals are not returned after publication. Sample copies available upon request. Art guidelines available.

Cartoons: Buys 5-10 cartoons/year. Prefers drag racing theme. Prefers single panel b&w line drawings and washes with gagline. Send query letter with samples of style. Samples are filed. Reports back only if interested. Negotiates rights purchased. Pays on publication; minimum $50 for b&w.

Illustration: Buys illustrations for covers, full-page special features and spots. Buys 10-20 illustrations/year. Style is modern creative image, line or wash, sometimes humorous, style of Don Weller. Needs editorial and technical illustration. Prefers drag racing-oriented theme, rendered in pen & ink, airbrush, mixed media, computer-generated or markers, with vibrant use of color. Send query letter with brochure showing art style, tearsheets, slides, transparencies, photostats or photocopies. Looks for realistic automotive renderings. Accepts disk submissions compatible with Mac except Aldus PageMaker files. Samples are filed. Reports back only if interested. Publication will contact artist for portfolio review if interested. Portfolio can include printed copies, tearsheets, photostats and photographs. Negotiates rights purchased. Pays on publication; $100 for b&w; up to $1,000 for color inside.

Design: Needs freelancers for design and production. Freelance work demands knowledge of Adobe Photoshop, Adobe Illustrator, Aldus FreeHand and QuarkXPress. Send query letter with photocopies, tearsheets, résumé, photographs, slides and transparencies. Pays by the project.

Tips: Looking for "bright colors, in a wide range of styles, techniques and mediums." Send "concept drawings, drag racing illustrations (actual cars, cut-aways, etc.). Send me samples that knock me out of my chair. Do not have to be drag racing-related, but should be automotive-related. I love to get samples."

NATIONAL ENQUIRER, Dept. AGDM, Lantana FL 33464. (561)586-1111, ext. 2274. Assistant Editor: Joan Cannata-Fox. A weekly tabloid. Circ. 3.8 million. Originals are returned at job's completion. Art guidelines available for SASE with first-class postage.

Cartoons: "We get 1,000-1,500 cartoons weekly." Buys 300 cartoons/year. Has featured cartoons by Edgar Argo, Harvey Bosch, Glenn Bernhardt, Earl Engelman, George Crenshaw, Goodard Sherman and Yahan Shirvanian. Prefers animal, family, husband/wife and general themes. Nothing political or off-color. Prefers single panel b&w line drawings and washes with or without gagline. Computer-generated cartoons are not accepted. Prefers to do own coloration. Send query letter with finished cartoons and SASE. Samples are not filed and are returned only by SASE. Reports back within 2-3 weeks. Buys first and one-time rights. Pays $300 for b&w plus $40 each additional panel.

Tips: "Study several issues to get a solid grasp of what we buy. Gear your work accordingly."

⚃ NATIONAL GARDENING, 180 Flynn Ave., Burlington VT 05401. (802)863-1308. Fax: (802)863-5962. E-mail: lindap@garden.org. Website: http://www.garden.org. Art Director: Linda Provost. Estab. 1980. Bimonthly magazine "specializing in all aspects of backyard gardening; environmentally conscious; fun and informal but accurate; a gardener-to-gardener network." 4-color design is "crisp but not slick, fresh but not avant-garde—colorful, informative, friendly, practical." Circ. 215,000. Sometimes accepts previously published artwork. Original artwork returned after publication. Sample copies available. 20% of freelance work demands knowledge of Adobe Illustrator, QuarkXPress, Aldus FreeHand, Adobe Photoshop or Fractal Painter.

Illustration: Approached by 200 illustrators/year. Buys 1-7 illustrations/issue. Works on assignment only. Needs editorial and technical illustration. Preferred themes or styles "range from botanically accurate how-to illustrations to less literal, more interpretive styles. See the magazine. We use all media." Style of Kim Wilson Eversz, Andrea Eberbach, Amy Bartlett Wright. Send postcard sample or sample sheet. Accepts disk submissions. Send EPS files. Samples are filed or returned by SASE if requested. Reports back only if interested "i.e. ready to assign work." Publication will contact artist for portfolio review if interested. Portfolio should include "your best work in your best form." Buys one-time rights. Pays within 30 days of acceptance; $50-350 for b&w, $100-700 for color inside; approximately $150 for spots. Finds artists through submissions/self-promotions and *American Showcase*.

Tips: "Send me a printed promotional four-color (stiff) sheet with your name, address, phone. Something I can see at a glance and file easily. We're interested in computer illustrations in *whatever* program. Artist should be able to help decode any computer problems that arise inputting into QuarkXPress and printing."

NATIONAL BUSINESS EMPLOYMENT WEEKLY

THE WALL STREET JOURNAL

October 11-17, 1998 ©1998 Dow Jones & Company, Inc. All Rights Reserved DOWJONES $3.95

Wallet Stuffers

How to increase your earnings in 1999

1998 Salary Review
Pay statistics for hundreds of jobs

Advertising special section: Franchise and Business Opportunities

©1999 Tim Foley Illustration

As a result of his direct mail marketing efforts, illustrator Tim Foley landed this cover illustration assignment with *National Business Employment Weekly*. He has since received further assignments from *NBEW* and many positive comments. Foley does one or two promotional mailings a year and advises artists to not give up hope if they don't immediately get a response from their marketing efforts. "Keep at it. I frequently get calls from direct mail pieces sent out five to ten years ago."

NATIONAL GEOGRAPHIC, 17th and M Streets NW, Washington DC 20036. (202)857-7000. Art Director: Chris Sloan. Estab. 1888. Monthly. Circ. 9 million. Original artwork returned 1 year after publication, but *National Geographic* owns the copyright.

• *National Geographic* receives up to 30 inquiries a day from freelancers. They report most are not appropriate to their needs. Please make sure you have studied several issues before you submit. They have a roster of artists they work with on a regular basis and it's difficult to break in, but if they like your samples they will file them for consideration for future assignments.

Illustration: Works with 20 illustrators/year. Contracts 50 illustrations/year. Interested in "full-color renderings of historical and scientific subjects. Nothing that can be photographed is illustrated by artwork. No decorative, design material. We want scientific geological cut-aways, maps, historical paintings." Works on assignment only. Send color copies, postcards, tearsheets, proofs or other appropriate samples. Art director will contact for portfolio review if interested. Samples are returned by SASE. **Pays on acceptance**; varies according to project.

Tips: "Do your homework before submitting to any magazine. We only use historical and scientific illustrations, ones that are very informative and very accurate. No decorative, abstract portraits."

☑ **THE NATIONAL NOTARY**, 9350 DeSoto Ave., Box 2402, Chatsworth CA 91313-2402. (818)739-4000. Fax: (818)700-1942 (Attn. Editorial Department). E-mail: publications@nationalnotary.org. Website: http://www.nationalnotary.org. Senior Editor: Conny Israelson. Emphasizes "notaries public and notarization—goal is to impart knowledge, understanding, and unity among notaries nationwide and internationally." Readers are notaries of varying primary occupations (legal, government, real estate and financial), as well as state and federal officials and foreign notaries. Bimonthly. Circ. 150,000. Original artwork not returned after publication. Sample copy $5.

• Also publishes *The Notary Bulletin*.

Cartoons: Approached by 5-8 cartoonists/year. Cartoons "must have a notarial angle"; single or multiple panel with gagline, b&w line drawings. Send samples of style. Samples not returned. Reports in 4-6 weeks. Call to schedule an appointment to show a portfolio. Buys all rights. Pays on publication; pay is negotiable.

Illustration: Approached by 3-4 illustrators/year. Uses about 3 illustrations/issue; buys all from local freelancers. Works on assignment only. Themes vary, depending on subjects of articles. 100% of freelance work demands knowledge of Adobe Illustrator, QuarkXPress or Aldus FreeHand. Send business card, samples and tearsheets to be kept on file. Samples not returned. Reports in 4-6 weeks. Call for appointment. Buys all rights. Negotiates pay; on publication.

Tips: "We are very interested in experimenting with various styles of art in illustrating the magazine. We generally work with Southern California artists, as we prefer face-to-face dealings."

☑ **NATIONAL REVIEW**, 215 Lexington Ave., New York NY 10016. (212)679-7330. Contact: Art Director. Emphasizes world events from a conservative viewpoint; bimonthly b&w with 4-color cover, design is "straight forward—the creativity comes out in the illustrations used." Originals are returned after publication. Uses freelancers mainly for illustrations of articles and book reviews, also covers.

Cartoons: Buys 17 cartoons/issue. Interested in "light political, social commentary on the conservative side." Send appropriate samples and SASE. Reports in 2 weeks. Buys first North American serial rights. Pays on publication; $50 for b&w.

Illustration: Buys 10 illustrations/issue. Especially needs b&w ink illustration, portraits of political figures and conceptual editorial art (b&w line plus halftone work). "I look for a strong graphic style; well-developed ideas and well-executed drawings." Style of Tim Bower, Jennifer Lawson, Janet Hamlin, Alan Nahigian. Works on assignment only. Send query letter with brochure showing art style or tearsheets and photocopies. No samples returned. Reports back on future assignment possibilities. Call for an appointment to show portfolio of final art, final reproduction/product and b&w tearsheets. Include SASE. Buys first North American serial rights. Pays on publication; $100 for b&w inside; $750 for color cover.

Tips: "Tearsheets and mailers are helpful in remembering an artist's work. Artists ought to make sure their work is professional in quality, idea and execution. Recent printed samples alongside originals help. Changes in art and design in our field include fine art influence and use of more halftone illustration." A common mistake freelancers make in presenting their work is "not having a distinct style, i.e., they have a cross sample of too many different approaches to rendering their work. This leaves me questioning what kind of artwork I am going to get when I assign a piece."

NATION'S RESTAURANT NEWS, 425 Park Ave., 6th Floor, New York NY 10022-3506. (212)756-5208. Fax: (212)756-5215. E-mail: mvila@nrn.com. Website: http://www.nrn.com. Art Director: Manny Vila. Design Associate: Maureen Smith. Estab. 1967. Weekly 4-color trade publication/tabloid. Circ. 100,000.

Illustration: Approached by 35 illustrators/year. Buys 15 illustrations/issue. Has featured illustrations by Stephen Sweny, Daryl Stevens, Elvira Regince, Garrett Kallenbach. Features computer, humorous and spot illustrations of business subjects in the food service industry. Prefers pastel and bright colors. Assigns 5% of illustrations to well-known or "name" illustrators; 70% to experienced, but not well-known illustrators; 25% to new and emerging illustrators. 20% of freelance illustration demands knowledge of Adobe Illustrator or Adobe Photoshop. Send postcard sample or other non-returnable samples, such as tearsheets. Accepts Windows-compatible disk submissions. Send EPS files. Samples are filed. Will contact artist for portfolio review if interested. Buys one-time rights. Pays on publication; $700-900 for b&w cover; $900-1,200 for color cover; $200-300 for b&w inside; $275-350 for color inside; $350 for spots. Finds illustrators through *Creative Black Book* and *LA Work Book*.

Tips: "Great imagination and inspiration are essential for one's uniqueness in a field of such visual awareness."

NATURAL HISTORY, American Museum of Natural History, Central Park West and 79th St., New York NY 10024. (212)769-5500. Editor: Bruce Stutz. Designer: Tom Page. Emphasizes social and natural sciences. For well-educated professionals interested in the natural sciences. Monthly. Circ. 400,000.
Illustration: Buys 23-25 illustrations/year; 25-35 maps or diagrams/year. Works on assignment only. Query with samples. Samples returned by SASE. Provide "any pertinent information" to be kept on file for future assignments. Buys one-time rights. Pays on publication; $200 and up for color inside.
Tips: "Be familiar with the publication. Always looking for accurate and creative scientific illustrations, good diagrams and maps."

NATURALLY MAGAZINE, P.O. Box 317, Newfoundland NJ 07435. (973)697-8313. Fax: (973)697-8313. E-mail: naturally@nac.net. Website: http://www.internaturally.com. Publisher/Editor: Bernard Loibl. Director of Operations: Cheryl Hanenberg. Estab. 1981. Quarterly magazine covering family nudism/naturism and nudist resorts and travel. Circ. 35,000. Sample copies for $6.50 and $2.50 postage; art guidelines for #10 SASE with first-class postage.
Cartoons: Approached by 10 cartoonists/year. Buys 3 cartoons/issue. Prefers nudism/naturism. Send query letter with finished cartoons. Samples are filed. Reports back only if interested. Buys one-time rights. Pays on publication. Pays $20-70.
Illustration: Approached by 10 illustrators/year. Buys 3 illustrations/issue. Prefers nudism/naturism. Considers all media. 20% of freelance illustration demands knowledge of Corel Draw. Contact only through artists' rep. Accepts disk submissions compatible with Corel Draw files or EPS files. Samples are filed. Reports back only if interested. Buys one-time rights. Pays on publication; $140 for cover; $70/page inside.

N: NATURE CONSERVANCY, 4245 N. Fairfax Dr., #100, Arlington VA 22203-1606. Fax: (703)841-9692. E-mail: kelly_johnson@tnc.org. Website: http://www.tnc.org. Director of Design, Photography and Production: Kelly Johnson. Estab. 1951. Bimonthly membership magazine of nonprofit conservation organization. "The intent of the magazine is to educate readers about broad conservation issues as well as to inform them about the Conservancy's specific accomplishments. The magazine is achievement-oriented without glossing over problems, creating a generally positive tone. The magazine is rooted in the Conservancy's work and should be lively, engaging and readable by a lay audience." Sample copies available.
Illustration: Approached by 100 illustrators/year. Buys 1-5 illustrations/issue. Considers all media. 10% of freelance illustration demands knowledge of Adobe Photoshop and/or Adobe Illustrator. Send query letter with photocopies and tearsheets. Samples are sometimes filed and are not returned. Reports back only if interested. Rights purchased vary according to project. **Pays on acceptance**. Payment varies. Finds illustrators through sourcebooks, magazines and submissions.

NERVE COWBOY, P.O. Box 4973, Austin TX 78765-4973. Editors: Joseph Shields and Jerry Hagins. Art Director: Mary Gallo. Estab. 1995. Biannual b&w literary journal of poetry, short fiction and b&w artwork. Sample copies for $4 postpaid. Art guidelines free for #10 SASE with first-class postage.
Illustration: Approached by 100 illustrators/year. Buys work from 10 illustrators/issue. Has featured illustrations by Wayne Hogan, Stepan Chapman, Bob Lavin, Andrea Dezso, David Hernandez, Julie McNeil. Features humorous illustration and creative b&w images. Prefers b&w. "Color will be considered if a b&w half-tone can reasonably be created from the piece." Assigns 40% of illustrations to well-known or "name" illustrators; 40% to experienced, but not well-known illustrators; 20% to new and emerging illustrators. Send printed samples, photocopies with a SASE. Samples are returned by SASE. Reports back within 3 months. Portfolio review not required. Buys first North American serial rights. Pays on publication; 3 copies of issue in which art appears on cover; or 1 copy if art appears inside.
Tips: "We are always looking for new artists with an unusual view of the world."

N: NETWORK COMPUTING, 600 Community Dr., Manhasset NY 11030. (516)562-5000. Fax: (516)562-7293. E-mail: editor@nwc.com. Website: http://www.networkcomputing.com. Administrative Assistant: Courtenay Kelley. Monthly trade magazine for those who professionally practice the art and business of networkology (a technology driver of networks). Circ. 220,000. Sample copies available. Contact art director for art guidelines.
Illustration: Approached by 30-50 illustrators/year. Buys 6-7 illustrations/issue. Considers all media. 60% of freelance illustration demands knowledge of Aldus FreeHand, Adobe Photoshop, Adobe Illustrator. Send postcard sample with follow-up sample every 3-6 months. Contact through artists' rep. Accepts disk submissions compatible with QuarkXPress 7.5/version 3.3. Send EPS files. Samples are returned. Reports back only if interested. Art director will contact artist for portfolio review of tearsheets if interested. Buys one-time rights. **Pays on acceptance**: $700-1,000 for b&w, $1,500-2,000 for color cover; $300 minimum for b&w, $350-500 for color inside. Pays $350-500 for spots. Finds illustrators through agents, sourcebooks, word of mouth, submissions.
Tips: "I like artists with a unique looking style—colorful but with one-two weeks turnaround."

N: NETWORK MAGAZINE, (formerly *LAN Magazine*), 600 Harrison St., San Francisco CA 94107. (415)905-2200. Fax: (415)905-2587. Website: http://www.networkmagazine.com. Design Editor: Nina Ellsworth. Estab. 1986. Monthly magazine covers local and wide area computer networks. Circ. 200,000.
Illustration: Approached by 30 illustrators/year. Buys 7 illustrations/issue. "Half freelancers work electronically, half by hand. Themes are technology-oriented, but artwork doesn't have to be." Considers all media, color. 50% of freelance illustration demands knowledge of Adobe Photoshop. Send postcard sample. Accepts disk submissions compatible with

Adobe Photoshop files on Mac formatted disks; "would recommend saving as JPEG (compressed) if you're sending a disk." Samples are filed. Reports back only if interested. "Will look at portfolios if artists are local (Bay area), but portfolio review is not necessary." **Pays on acceptance;** $250 minimum for inside. Finds illustrators through postcards in the mail, agencies, word of mouth, artist's submissions.

Tips: "Take a look at the magazine (available where most computer mags are sold and on our website); all work is color; prefer contrast, not monochrome. Usually give freelancer a week to turn art around. The magazine's subject matter is highly technical, but the art doesn't have to be (we use a lot of collage and hand-done work in addition to computer-assisted art.)"

☑ **NEVADA,** 401 N. Carson St., #100, Carson City NV 89701. (775)687-6158. Fax: (775)687-6159. Estab. 1936. Bimonthly magazine "founded to promote tourism in Nevada." Features Nevada artists, history, recreation, photography, gaming. Traditional, 3-column layout with large (coffee table type) 4-color photos. Circ. 130,000. Accepts previously published artwork. Originals are returned to artist at job's completion. Sample copies for $3.50. Art guidelines available.

Illustration: Approached by 25 illustrators/year. Buys 2 illustrations/issue. Works on assignment only. Send query letter with brochure, résumé and slides. Samples are filed. Reports back within 2 months. To show portfolio, mail 20 slides and bio. Buys one-time rights. Pays $35 minimum for inside illustrations.

N **NEW MOON: THE MAGAZINE FOR GIRLS AND THEIR DREAMS,** P.O. Box 3620, Duluth MN 55803-3620. (218)728-5507. Fax: (218)728-0314. E-mail: girl@newmoon.org. Website: http://www.newmoon.org. Managing Editors: Bridget Grosser and Deb Mylin. Estab. 1992. Bimonthly 4-color cover, 2-color inside consumer magazine. Circ. 25,000. Sample copies are $6.50.

Illustration: Buys 3-4 illustrations/issue. Has featured illustrations by Neverne Covington, Andrea Dwyer, Julie Paschkis, Wendy Morris. Features realistic illustrations, informational graphics and spot illustrations of children, women and girls. Prefers b&w, ink. Assigns 30% of illustrations to well-known or "name" illustrators; 30% to experienced, but not well-known illustrators; 30% to new and emerging illustrators. Send postcard sample or other non-returnable samples. Final work can be submitted on disk or as original artwork. Send EPS files at 300 dpi or greater, hi-res. Samples are filed. Reports back only if interested. Portfolio review not required. Buys one-time rights. Pays on publication; $400 maximum for color cover; $75 maximum for b&w inside. Finds illustrators through *Illustration Workbook* and samples.

Tips: "Be very familiar with the magazine and our mission. Women cover artists only. Men and women are welcome to submit black & white samples for inside."

N **NEW ORLEANS REVIEW,** Box 195, Loyola University, New Orleans LA 70118. (504)865-2294. E-mail: adamo@loyno.edu. Editor: Ralph Adamo. Journal of literature and the arts, b&w with 4-color cover. Published 4 times/year. Sample copy $10.

Illustration: Uses 1 illustration/issue. Cover: usually uses color, all mediums. Send query letter with résumé, photocopies, SASE and slides. Accepts disk submissions. Reports in 4 months.

THE NEW REPUBLIC, 1220 19th St. NW, Suite 600, Washington DC 20036. (202)331-7494. Contact: Art Director. Estab. 1914. Weekly political/literary magazine; political journalism, current events in the front section, book reviews and literary essays in the back; b&w with 4-color cover. Circ. 100,000. Original artwork returned after publication. Sample copy for $3.50. 50% of freelance work demands computer skills.

Illustration: Approached by 400 illustrators/year. Buys up to 5 illustrations/issue. Uses freelancers mainly for cover art. Works on assignment only. Prefers caricatures, portraits, 4-color, "no cartoons." Style of Vint Lawrence. Considers reflective or digital media. Send query letter with tearsheets. Samples returned by SASE if requested. Publication will contact artist for portfolio review if interested. Portfolio should include color photocopies. Rights purchased vary according to project. Pays on publication; up to $600 for color cover; $250 for b&w and color inside.

N **NEW TIMES LA,** 1950 Sawtelle, #200, Los Angeles CA 90025. (310)477-0403. Fax: (310)478-9873. Art Director: Mei Lisa Luther. Weekly alternative newspaper. Circ. 100,000. Sample copy and art guidelines available.

Cartoons: Approached by 15-20 cartoonists/year. Buys 3 cartoons/year. Prefers smart and unique styles. Prefers political, humorous b&w washes and line drawings with or without gaglines. Send query letter with finished cartoons and tearsheets. Samples are filed. Rights purchased vary according to project. **Pays on acceptance.**

Illustration: Approached by many illustrators/year. Buys 1-3 illustrations/issue. Considers all media. Send postcard sample or query letter with printed samples and tearsheets. Accepts disk submissions. Samples are filed. Portfolios may be dropped off every Wednesday, Thursday and Friday. Rights purchased vary according to project. **Pays on acceptance.**

Design: Needs freelancers for design. Prefers local design freelancers only.

NEW WRITER'S MAGAZINE, Box 5976, Sarasota FL 34277. (941)953-7903. E-mail: newriters@aol.com. Website: http://www.newriters.com. Editor/Publisher: George J. Haborak. Estab. 1986. Bimonthly b&w magazine. Forum "where all writers can exchange thoughts, ideas and their own writing. It is focused on the needs of the aspiring or new writer." Rarely accepts previously published artwork. Original artwork returned after publication if requested. Sample copies for $3; art guidelines for SASE with first-class postage.

Cartoons: Approached by 15 cartoonists/year. Buys 1-3 cartoons/issue. Features spot illustration. Assigns 20% of illustrations to experienced, but not well-known illustrators; 80% to new and emerging illustrators. Prefers cartoons "that reflect the joys or frustrations of being a writer/author"; single panel b&w line drawings with gagline. Send query

letter with samples of style. Samples are sometimes filed or returned if requested. Reports back within 1 month. Buys first rights. Pays on publication; $5 for b&w.

Illustration: Buys 1 illustration/issue. Works on assignment only. Prefers line drawings. Considers watercolor, mixed media, colored pencil and pastel. Send postcard sample. Samples are filed or returned if requested by SASE. Reports within 1 month. To show portfolio, mail tearsheets. Buys first rights or negotiates rights purchased. Pays $10 for spots. Payment negotiated.

THE NEW YORKER, 20 W. 43rd St., 16th Floor, New York NY 10036. (212)840-3800. E-mail (cartoons): bob@cartoo nbank.com. Website: http://www.cartoonbank.com. Emphasizes news analysis and lifestyle features.

Cartoons: Buys b&w cartoons. Receives 3,000 cartoons/week. Cartoon editor is Bob Mankoff, who also runs Cartoon Bank, a stock cartoon agency that features *New Yorker* cartoons. Accepts unsolicited submissions only by mail. Reviews unsolicited submissions every 1-2 weeks. Photocopies only, please. Include SASE. Strict standards regarding style, technique, plausibility of drawing. Especially looks for originality. Pays $575 minimum for cartoons. Contact cartoon editor.

Illustration: All illustrations are commissioned. Portfolios may be dropped off Wednesdays between 10-6 and picked up on Thursdays. Mail samples, no originals. "Because of volume of submissions we are unable to respond to all submissions." No calls please. Emphasis on portraiture. Contact illustration department.

Tips: "Familiarize yourself with *The New Yorker*."

NEWSWEEK, 251 W. 57th St., 15th Floor, New York NY 10019. (212)445-4000. Assistant Managing Editor/Design: Lynn Staley.

Illustration: Send postcard samples or other non-returnable samples. Portfolios may be dropped off at front desk Tuesday or Wednesday from 9 to 5.

☑ **NIGHTLIFE MAGAZINE**, (formerly *Long Island Update*), 990 Motor Pkwy., Central Islip NY 11722. (516)435-8890. Fax: (516)435-8925. Editor: Susan Weiner. Estab. 1979. Monthly consumer magazine covering events, entertainment and other consumer issues for general audience, ages 21-40, of New York area. Circ. 45,000. Originals returned at job's completion.

Illustration: Approached by 25-30 illustrators/year. Buys 1 illustration/issue. Considers watercolor. Send postcard sample or query letter with tearsheets. Samples filed. Reports back within 2 months. Portfolio review not required. Buys first rights. Pays on publication; $50-75 for color inside.

NORTH AMERICAN WHITETAIL MAGAZINE, 2250 Newmarket Pkwy., Suite 110, Marietta GA 30067. (770)953-9222. Fax: (770)933-9510. Editorial Director: Ken Dunwoody. Estab. 1982. Consumer magazine "designed for serious hunters who pursue whitetailed deer." 8 issues/year. Circ. 160,000. Accepts previously published artwork. Original artwork is returned at job's completion. Sample copies available for $3; art guidelines not available.

Illustration: Approached by 30 freelance illustrators/year. Buys 1-2 freelance illustrations/issue. Works on assignment only. Considers pen & ink and watercolor. Send postcard sample and/or query letter with brochure and photocopies. Samples are filed or are returned by SASE if requested by artist. Reports back only if interested. To show a portfolio, mail appropriate materials. Rights purchased vary according to project. Pays 10 weeks prior to publication; $25 minimum for b&w inside; $75 minimum for color inside.

NORTH CAROLINA LITERARY REVIEW, English Dept., East Carolina University, Greenville NC 27858-4353. E-mail: bauerm@mail.ecu.edu. Editor: Margaret Bauer. Estab. 1992. Annual literary magazine of art, literature, clulture having to do with NC. Circ. 2,000. Samples available; art guidelines for SASE with first-class postge.

Illustration: Considers all media. Send postcard sample or send query letter with printed samples, SASE and tearsheets. Send follow-up postcard sample every 2 months. Samples are not filed and are returned by SASE. Reports back within 2 months. Art director will contact artist for portfolio review of b&w, color slides and transparencies if interested. Rights purchased vary according to projects. Pays on publication; $100-250 for cover; $50-250 for inside. Pays $25 for spots. Finds illustrators through magazines and word of mouth.

Tips: "Read our magazine."

THE NORTHERN LOGGER & TIMBER PROCESSOR, Northeastern Loggers Association Inc., Box 69, Old Forge NY 13420. (315)369-3078. Editor: Eric A. Johnson. Trade publication (8½×11) with an emphasis on education. Focuses on methods, machinery and manufacturing as related to forestry. For loggers, timberland managers and processors of primary forest products. Monthly b&w with 4-color cover. Circ. 13,000. Previously published material OK. Free sample copy and guidelines available.

Cartoons: Buys 1 cartoon/issue. Receives 1 submission/week. Interested in "any cartoons involving forest industry situations." Send finished cartoons with SASE. Reports in 1 week. **Pays on acceptance**; $20 for b&w line drawings.

Illustration: Pays $20 for b&w cover.

Tips: "Keep it simple and pertinent to the subjects we cover. Also, keep in mind that on-the-job safety is an issue we like to promote."

NOTRE DAME MAGAZINE, 535 Grace Hall, Notre Dame IN 46556. (219)631-4630. Website: http://www.ND.EDU/ ~NDMAG. Art Director: Don Nelson. Estab. 1971. Quarterly 4-color university magazine that publishes essays on

cultural, spiritual and ethical topics, as well as news of the university for Notre Dame alumni and friends. Circ. 130,000. Accepts previously published artwork. Original artwork returned after publication.

Illustration: Approached by 40 illustrators/year. Buys 5-8 illustrations/issue. Has featured illustrations by Steve Madson, Joe Ciardiello, Mark Fisher and Terry Lacy. Assigns 20% of illustrations to well-known or "name" illustrators; 60% to experienced, but not well-known illustrators; 20% to new and emerging illustrators. Works on assignment only. Has featured illustrations by Carl Prescott, Terry Lacy, Mark Fisher, Joe Ciardiello, Steve Madson. Features editorial art only. Assigns 20% of illustrations to well-known or "name" illsutrators; 60% to experienced, but not well-known illustrators; 20% to new and emerging illustrators. Tearsheets, photographs, slides, brochures and photocopies OK for samples. Samples are returned by SASE if requested. "Don't send submissions—only tearsheets and samples." To show portfolio, mail published editorial art. Buys first rights. Pays $2,000 maximum for color covers; $150-400 for b&w inside; $200-700 for color inside; $75-150 for spots.

Tips: "Looking for noncommercial style editorial art by accomplished, experienced editorial artists. Conceptual imagery that reflects the artist's awareness of fine art ideas and methods is the kind of thing we use. Sports action illustrations not used. Cartoons not used. Learn to draw well, study art history, develop a style, limit use of color, create images that can communicate ideas."

NOW AND THEN, Box 70556 ETSU, Johnson City TN 37614-0556. (423)439-5348. Fax: (423)439-6340. E-mail: fischman@etsu.edu. Website: http://cass.etsu.edu/n&t/art.htm. Editor: Jane Harris Woodside. Estab. 1984. Magazine covering Appalachian issues and arts, published 3 times a year. Circ. 1,000. Accepts previously published artwork. Originals are returned at job's completion. Sample copies available for $5; art guidelines available.

Cartoons: Approached by 5 cartoonists/year. Prefers Appalachia issues, political and humorous cartoons; b&w washes and line drawings. Send query letter with brochure, roughs and finished cartoons. Samples not filed and are returned by SASE if requested by artist. Reports back within 4-6 months. Buys one-time rights. Pays $25 for b&w.

Illustration: Approached by 3 illustrators/year. Buys 1-2 illustrations/issue. Has featured illustrations by Nancy Jane Earnest, David M. Simon and Anthony Feathers. Features natural history; humorous, realistic, computer and spot illustration. Assigns 100% of illustrations to experienced, but not well-known illustrators. Prefers Appalachia, any style. Considers b&w or 2- or 4-color pen & ink, collage, airbrush, marker and charcoal. Freelancers should be familiar with Macromedia FreeHand, PageMaker or Adobe Photoshop. Send query letter with brochure, SASE and photocopies. Samples are not filed and are returned by SASE if requested by artist. Reports back within 4-6 months. Publication will contact artist for portfolio review if interested. Portfolio should include b&w tearsheets, slides, final art and photographs. Buys one-time rights. Pays on publication; $50-100 for color cover; $25 maximum for b&w inside.

Tips: "We have special theme issues. Illustrations have to have something to do with theme. Write for guidelines, enclose SASE."

NUGGET, Dugent Corp., 14411 Commerce Way, Suite 420, Miami Lakes FL 33016-1598. Editor: Christopher James. Illustration Assignments: Nye Willden. 4-color "eclectic, modern" magazine for men and women with fetishes. Published 13 times/year. Art guidelines for SASE with first-class postage.

Cartoons: Buys 5 cartoons/issue. Receives 50 submissions/week. Interested in "funny fetish themes." Black & white only for spots and for page. Prefers to see finished cartoons. Include SASE. Reports in 2 weeks. Buys first North American serial rights. Pays $75 for spot drawings; $125 for full page.

Illustration: Buys 2 illustrations/issue. Interested in "erotica, cartoon style, etc." Works on assignment only. Prefers to see samples of style. Send query letter with photocopies and tearsheets. Samples to be kept on file for future assignments. No samples returned. Publication will contact artist for portfolio review if interested. Buys first North American serial rights. Pays $300 for color inside; $75 for spots. Finds artists through submissions/self-promotions.

Tips: Especially interested in "the artist's anatomy skills, professionalism in rendering (whether he's published or not) and drawings which relate to our needs." Current trends include "a return to the 'classical' realistic form of illustration, which is fine with us because we prefer realistic and well-rendered illustrations."

N. NURSEWEEK, 1156-C Aster Ave., Sunnyvale CA 94086. (408)249-5877. Fax: (408)249-8204. E-mail: youngk@nurseweek.com. Website: http://www.nurseweek.com. Art Director: Young Kim. "*Nurseweek* is a biweekly 4-color tabloid mailed free to registered nurses in Los Angeles and Orange counties, the greater San Francisco Bay Area and 4 cities in Texas. Also publishes *Health Week*. Combined circulation of all publications is over 400,000. Bimonthly to every RN in California. *Nurseweek* provides readers with nursing-related news and features that encourage and enable them to excel in their work and that enhance the profession's image by highlighting the many diverse contributions nurses make. In order to provide a complete and useful package, the publication's article mix includes late-breaking news stories, news features with analysis (including in-depth bimonthly special reports), interviews with industry leaders and achievers, continuing education articles, career option pieces (Spotlight, Entrepreneur) and reader dialogue (Letters, Commentary, First Person)." Sample copy $3. Art guidelines not available. Needs computer-literate freelancers for production. 90% of freelance work demands knowledge of Quark, PhotoShop, Adobe Illustrator, Ventura/CorelDraw.

Illustration: Approached by 10 illustrators/year. Buys 1 illustration/year. Prefers pen & ink, watercolor, airbrush, marker, colored pencil, mixed media and pastel. Needs medical illustration. Send query letter with brochure, tearsheets, photographs, photocopies, photostats, slides and transparencies. Samples are not filed and are returned by SASE if requested by artist. Publication will contact artist for portfolio review if interested. Portfolio should include final art samples, photographs. Buys all rights. Pays on publication; $150 for b&w; $250 for color cover; $100 for b&w, $175 for color inside. Finds artists through sourcebooks.

Design: Needs freelancers for design. 90% of design demands knowledge of Adobe Photoshop 4.0, QuarkXPress 3.3 and Ventura 7.0. Prefers local freelancers. Send query letter with brochure, résumé, SASE and tearsheets. Pays for design by the project.

N **O&A MARKETING NEWS**, 559 S. Harbor Blvd., Suite A, Anaheim CA 92805. (714)563-9300. Fax: (714)563-9310. Website: http://www.kalpub.com. Editor: Kathy Laderman. Estab. 1966. Bimonthly b&w trade publication about the service station/petroleum marketing industry. Circ. 8,000. Sample copies for 11×17 SASE with 10 first-class stamps.
Cartoons: Approached by 10 cartoonists/year. Buys 1-2 cartoons/issue. Prefers humor that relates to service station industry. Prefers single panel, humorous, b&w line drawings. Send b&w photocopies, roughs or samples and SASE. Samples are returned by SASE. Reports back in 1 month. Buys one-time rights. **Pays on acceptance**; $12 for b&w.
Tips: "We run a cartoon (at least one) in each issue of our trade magazine. We're looking for a humorous take on business—specifically the service station/petroleum marketing/carwash/quick lube industry that we cover."

✓ **OFF DUTY MAGAZINE**, 3505 Cadillac, Suite 0-105, Costa Mesa CA 92626. Fax: (714)549-4222. E-mail: odutyedit@aol.com. Executive Editor: Tom Graves. Estab. 1970. Consumer magazine published 8 times/year "for U.S. military community worldwide." Sample copy for $8\frac{1}{2} \times 11$ SASE and 6 first-class stamps.
• There are three versions of *Off Duty Magazine*: U.S., Europe and the Pacific.
Illustration: Approached by 10-12 illustrators/year. Buys 2 illustrations/issue. Considers airbrush, colored pencil, marker, pastel, watercolor and computer art. Knowledge of Adobe Illustrator helpful but not required. Send query letter with printed samples. Samples are filed. Does not report back. Artist should wait for call about an assignment. Buys one-time rights. **Pays on acceptance;** negotiable for cover; $200-300 for color inside. Finds illustrators through previous work and word of mouth.
Tips: "We're looking for computer (Illustrator better than FreeHand, and/or Photoshop) illustrators for an occasional assignment."

THE OFFICIAL PRO RODEO SOUVENIR PROGRAM, 4565 Hilton Pkwy., Suite 205, Colorado Springs CO 80907. (719)531-0177. Fax: (719)531-0183. Publisher: Steve Rempelos. Estab. 1973. Annual 4-color souvenir program for PRCA rodeo events. "This magazine is purchased by rodeo organizers, imprinted with rodeo name and sold to spectators at rodeo events." Circ. 400,000. Originals are returned at job's completion. Sample copies available. Art guidelines not available.
Illustration: Works on assignment only. "We assign a rodeo event—50%-art, 50%-photos." Considers all media. Send query letter with brochure, résumé, SASE, tearsheets, photographs and photocopies. Samples are filed. Publication will contact artist for portfolio review if interested. Buys one-time rights. Pays on publication; $250 for color cover.
Tips: Finds artists through artists' submissions/self-promotions, sourcebooks, artists' agents and reps, and attending art exhibitions. "Know about rodeos and show accurate (not necessarily photo-realistic) portrayal of event. Artwork is used on the cover about 50 percent of the time. Freelancers get more work now because our office staff is smaller."

OHIO MAGAZINE, 62 E. Broad St., Columbus OH 43215. (614)461-5083. Art Director: Brooke Wenstrup. 10 issues/year emphasizing feature material of Ohio "for an educated, urban and urbane readership"; 4-color; design is "clean, with white-space." Circ. 90,000. Previously published work OK. Original artwork returned after publication. Sample copy $2.50; art guidelines not available.
Cartoons: Approached by 15 cartoonists/year. Buys 2 cartoons/year. Prefers b&w line drawings. Send brochure. Samples are filed or are returned by SASE. Reports back within 1 month. Buys one-time rights. Pays $50 for b&w and color.
Illustration: Approached by 70 illustrators/year. Buys 2 illustrations/issue. Works on assignment only. Has featured illustrations by David and Amy Butler and Chris O'Leary. Features charts & graphs; informational graphics; spot illustrations. Assigns 10% of illustrations to well-known or "name" illustrators; 80% to experienced, but not well-known illustrators; 10% to new and emerging illustrators. Considers pen & ink, watercolor, collage, acrylic, marker, colored pencil, oil, mixed media and pastel. 20% of freelance work demands knowledge of Adobe Illustrator, QuarkX-Press, Adobe Photoshop or Aldus FreeHand. Send postcard sample or brochure, SASE, tearsheets and slides. Accepts disk submissions. Send Mac EPS files. Samples are filed or are returned by SASE. Reports back within 1 month. Request portfolio review in original query. Portfolio should include b&w and color tearsheets, slides, photostats, photocopies and final art. Buys one-time rights. **Pays on acceptance**; $250-500 for color cover; $50-400 for b&w inside; $50-500 for color inside; $100-800 for 2-page spreads; $50-125 for spots. Finds artists through submissions and gallery shows.
Design: Needs freelancers for design and production. 100% of freelance work demands knowledge of Adobe Photoshop and QuarkXPress. Send query letter with tearsheets and slides.
Tips: "Use more of a fine art-style to illustrate various essays—like folk art-style illustrators. Please take time to look

SPECIAL MARKET INDEXES, identifying Licensing, Medical Illustration, Religious Art, Science Fiction/Fantasy Art, Sport Art, T-Shirts, Textiles, Wildlife Art and other categories are located in the back of this book.

at the magazine if possible before submitting."

OKLAHOMA TODAY MAGAZINE, 15 N. Robinson, Suite 100, Oklahoma City OK 73102. (405)521-2496. Fax: (405)522-4588. Website: http://www.oklahomatoday.com. Editor: Louisa McCune. Estab. 1956. Bimonthly regional, upscale consumer magazine focusing on all things that define Oklahoma and interest Oklahomans. Circ. 43,000. Accepts previously published artwork. Originals are returned at job's completion. Sample copies available with a SASE.
Illustration: Approached by 24 illustrators/year. Buys 5-10 illustrations/year. Has featured illustrations by Rob Silvers, Tim Jossel, Steven Walker and Cecil Adams. Features caricatures of celebrities; natural history; realistic and spot illustration. Assigns 10% of illustrations to well-known illustrators; 80% to experienced, but not well-known illustrators; 10% to new and emerging illustrators. Considers pen & ink, watercolor, collage, airbrush, acrylic, marker, colored pencil, oil, charcoal and pastel. 20% of freelance work demands knowledge of Aldus PageMaker, Adobe Illustrator and Adobe Photoshop. Send query letter with brochure, résumé, SASE, tearsheets and slides. Samples are filed. Reports back within days if interested; months if not. Portfolio review required if interested in artist's work. Portfolio should include b&w and color thumbnails, tearsheets and slides. Buys one-time rights. Pays $200-500 for b&w cover; $200-750 for color cover; $50-500 for b&w inside; $75-750 for color inside. Finds artists through sourcebooks, other publications, word of mouth, submissions and artist reps.
Tips: Illustrations to accompany short stories and features are most open to freelancers. "Read the magazine. Be willing to accept low fees at the beginning."

OLD BIKE JOURNAL, 1010 Summer St., Stamford CT 06905. (203)425-8777. Fax: (203)425-8775. Art Director: Jonas Land. Estab. 1989. Monthly international classic and collectible motorcycle magazine dedicated to classics of yesterday, today and tomorrow. Includes hundreds of classified ads for buying, selling or trading bikes and parts worldwide. Circ. under 100,000. Originals are returned at job's completion if requested. Sample copy $4 (US only). Art guidelines available. Computer-literate freelancers for illustration should be familiar with Adobe Photoshop, Adobe Illustrator or QuarkXPress.
Cartoons: Approached by 12 cartoonists/year. Buys 1-2 cartoons/issue. Prefers vintage motorcycling and humorous themes; single panel, b&w line drawings. Send query letter with copies of finished work. Samples are filed or are returned by SASE if requested by artist. Reports back within 1 month. Buys one-time rights. Pays $50 for b&w; $100 for color.
Illustration: Approached by 50-100 illustrators/year. Buys 1-5 illustrations/issue. Considers pen & ink, watercolor, airbrush, marker and colored pencil. Send query letter with brochure, SASE, tearsheets, photographs, photocopies, photostats, slides and transparencies. Samples are filed or are returned by SASE if requested. Reports back within 1 month. Call for appointment to show portfolio. Portfolio should include tearsheets, slides, photostats, photocopies and photographs. Buys one-time rights. Pays on publication; $25 for b&w; $100 for color.
Tips: "Send copies or photos of final art pieces. If they seem fit for publication, the individual will be contacted and paid upon publication. If not, work will be returned with letter. Often, artists are contacted for more specifics as to what might be needed."

THE OPTIMIST, 4494 Lindell Blvd., St. Louis MO 63108. (314)371-6000. E-mail: rennera@optimist.org. Website: http://www.optimist.org. Graphic Designer: Andrea Renner. 4-color magazine with 4-color cover that emphasizes activities relating to Optimist clubs in US and Canada (civic-service clubs). "Magazine is mailed to all members of Optimist clubs. Average age is 42; most are management level with some college education." Circ. 140,000. Sample copy for SASE; art guidelines not available.
Cartoons: Buys 2 or 3 cartoons/issue. Has featured cartoons by Martin Bucella, Randy Glasbergen, Randy Bisson. Assigns 75% of cartoons to experienced, but not well-known cartoonists; 25% to new and emerging cartoonists. Prefers themes of general interest: family-orientation, sports, kids, civic clubs. Prefers color single panel with gagline. No washes. Send query letter with samples. Send art on a disk if possible (Macintosh compatible). Submissions returned by SASE. Reports within 1 week. Buys one-time rights. **Pays on acceptance**; $30 for b&w; $40 for color.
Tips: "Send clear cartoon submissions, not poorly photocopied copies."

OPTIONS, P.O. Box 170, Irvington NY 10533. Contact: Wayne Shuster. E-mail: natway@aol.com. Estab. 1981. Bimonthly consumer magazine featuring erotic stories and letters, and informative items for gay and bisexual males and females. Circ. 60,000. Accepts previously published artwork. Originals are returned at job's completion. Sample copies available for $3.50 and 6×9 SASE with first-class postage; art guidelines available for SASE with first-class postage.
Cartoons: Approached by 10 cartoonists/year. Buys 5 cartoons/issue. Prefers well drawn b&w, ironic, humorous cartoons; single panel b&w line drawings with or without gagline. Send query letter with finished cartoons. Samples are not filed and are returned by SASE if requested by artist. Reports back within 3 weeks. Buys all rights. Pays $20 for b&w.
Illustration: Approached by 2-3 illustrators/year. Buys 2-4 illustrations/issue. Has featured illustrations by Jack Whitlow and Al Pierce. Features realistic and spot illustration. Assigns 100% of illustrations to experienced, but not well-known illustrators. Prefers gay male sexual situations. Considers pen & ink, airbrush b&w only. Also buys color or b&w slides (35mm) of illustrations. Send postcard sample. "OK to submit computer illustration—Adobe Photoshop 3.0 and Adobe Illustrator 5.0 (Mac)." Samples are not filed and are returned by SASE if requested by artist. Reports back to the artist

Using cut paper and amberlith, artist Steve Erspamer created these graphic illustrations for a journal of personal tributes to those who have died of AIDS. His work caught the attention of Jean Germano, art director at *Oregon Catholic Press*, who has since featured many of his illustrations in the quarterly liturgical music planner. Germano prefers to use artwork already created, on a one-time basis, as opposed to commissioned pieces and is drawn to art that is tasteful but not overly religious.

only if interested. Portfolio review not required. Buys all rights. Pays on publication; $50 for b&w inside. Finds artists through submissions.

OREGON CATHOLIC PRESS, 5536 NE Hassalo, Portland OR 97213-3638. (503)281-1191. Fax: (503)282-3486. E-mail: jeang@ocp.org. Website: http://www.ocp.org/. Art Director: Jean Germano. Estab. 1988. Quarterly liturgical music planner in both Spanish and English with articles, photos and illustrations specifically for but not exclusive to the Roman Catholic market.
- See *OCP*'s listing in the Book Publishers section to learn about this publisher's products and needs.

Illustration: Approached by 10 illustrators/year. Buys 20 illustrations/issue. Has featured illustrations by John August Swanson, Michael McGrath and Steve Erspamer. Assigns 50% of illustrations to experienced, but not well-known illustrators; 50% to new and emerging illustrators. Send query letter with printed samples, photocopies, SASE. Samples are filed or returned by SASE. Reports back within 2 weeks. Portfolio review not required. Rights purchased vary according to project. **Pays on acceptance**; $100-250 for color cover; $30-50 for b&w spot art or photo.

N **OREGON RIVER WATCH**, Box 294, Rhododendron OR 97049. (503)622-4798. Editor: Michael P. Jones. Estab. 1985. Quarterly b&w books published in volumes emphasizing "fisheries, fishing, camping, rafting, environment, wildlife, hiking, recreation, tourism, mountain and wilderness scenes and everything that can be related to Oregon's waterways. Down-home pleasant look, not polished, but practical—the '60s still live on." Circ. 2,000. Accepts previously published material. Original artwork returned after publication. Art guidelines for SASE with first-class postage.

Cartoons: Approached by 400 cartoonists/year. Buys 1-25 cartoons/issue. Cartoons need to be straightforward, about fish and wildlife/environmental/outdoor-related topics. Prefers single, double or multiple panel b&w line drawings, b&w or color washes with or without gagline. Send query letter with SASE, samples of style, roughs or finished cartoons. Samples are filed or are returned by SASE. Reports back within 2 months "or sooner—depending upon work load." Buys one-time rights. Pays in copies.

Illustration: Approached by 600 illustrators/year. Works with 100 illustrators/year. Buys 225 illustrations/year. Needs editorial, humorous and technical illustration related to the environment. "We need b&w pen & ink sketches. We look for artists who are not afraid to be creative, rather than those who merely go along with trends." Send query letter with brochure, résumé, photocopies, SASE, slides, tearsheets and transparencies. "Include enough to show me your true style." Samples not filed are returned by SASE. Reports back within 2 weeks. Buys one-time rights. Pays in copies. 20% of freelance work demands computer skills.

Design: Needs freelancers for design and production. Send brochure, photocopies, SASE, tearsheets, résumé, photographs, slides and transparencies. Pays in copies.

Tips: "Freelancers must be patient. We have a lot of projects going on at once but cannot always find an immediate need for a freelancer's talent. Being pushy doesn't help. I want to see examples of the artist's expanding horizons, as well as their limitations. Make it really easy for us to contact you. Remember, we get flooded with letters and will respond faster to those with a SASE."

N **ORLANDO MAGAZINE**, 260 Maitland Ave., Altamonte Springs FL 32701. (407)767-8338. Fax: (407)767-8348. E-mail: orlandomag@aol.com. Art Director: Jeanne Euker. Estab. 1946. "We are a 4-color monthly city/regional magazine covering the Central Florida area—local issues, sports, home and garden, business, entertainment and dining." Circ. 30,000. Accepts previously published artwork. Originals are returned at job's completion. Sample copies available.

Illustration: Buys 3-4 illustrations/issue. Has featured illustrations by T. Sirell, Rick Martin and Doug Nelson. Assigns 100% of illustrations to experienced, but not well-known illustrators. Works on assignment only. Needs editorial illustration. Send postcard, brochure or tearsheets. Samples are filed and are not returned. Reports back to the artist only if interested with a specific job. Portfolio review not required. Buys first rights, one-time rights or all rights (rarely). Pays on publication; $400 for color cover; $200-250 for color inside.

Design: Needs freelancers for design and production. Pays for design by the project.

Tips: "Send appropriate samples. Most of my illustration hiring is via direct mail. The magazine field is still a great place for illustration. Have several ideas ready after reading editorial to add to or enhance our initial concept."

THE OTHER SIDE, 300 W. Apsley St., Philadelphia PA 19144. (215)849-2178. Fax: (605)335-0368. Editors: Dee Dee and Doug Davidson. Art Director: Ellen Moore Osbourne. "We are read by Christians with a radical commitment to social justice and a deep allegiance to biblical faith. We try to help readers put their faith into action." Publication is 80% 4-color with 4-color cover. Published 6 times/year. Circ. 14,000. Accepts previously published artwork. Sample copy available for $4.50.

Cartoons: Approached by 20-30 cartoonists/year. Buys 12-15 cartoons/year on current events, human interest, social commentary, environment, economics, politics and religion; single and multiple panel. Pays on publication; $25 for b&w line drawings. "Looking for cartoons with a radical political perspective."

Illustration: Approached by 40-50 artists/year. Especially interested in original artwork in color. Send query letter with tearsheets, photocopies, slides, photographs and SASE. Reports in 6 weeks. Simultaneous submissions OK. Publication will contact artist for portfolio review if interested. Pays within 1 month of publication; $50-100 for 4-color; $30-50 for b&w line drawings and spots.

Tips: "We're looking for artists whose work shares our perspective on social, economic and political issues."

OUR STATE: DOWN HOME IN NORTH CAROLINA, 1915 Lenden St., Suite 200, Greensboro NC 27408. (336)286-0600. Fax: (336)286-0100. E-mail: mannmedia2@aol.com. Art Director: Jennifer Swafford. Estab. 1933. Monthly 4-color consumer magazine featuring travel, history and culture of North Carolina. Circ. 45,000. Art guidelines are free for #10 SASE with first-class posgate.

Illustration: Approached by 6 illustrators/year. Buys 12 illustrations/issue. Features "cartoon-y" maps. Preferred subjects: maps of towns in NC. "Prefers pastel and bright colors." Assigns 100% to new and emerging illustrators. 100% of freelance illustration demands knowledge of Adobe Illustrator. Send postcard sample or non-returnable samples. Samples are not filed and are not returned. Portfolio review not required. Buys one-time rights. Pays on publication; $250-600 for color cover; $50-350 for b&w inside; $50-350 for color inside; $50-350 for 2-page spreads. Finds illustrators through word of mouth.

OUTDOOR CANADA MAGAZINE, 340 Ferrier St., Suite 210, Markham, Ontario L3R 2Z5 Canada. Editor: James Little. 4-color magazine for Canadian outdoor enthusiasts and their families. Stories on fishing, camping, hunting, canoeing and wildlife. Readers are 81% male. Publishes 7 regular issues/year and a fishing special in February. Circ. 95,000. Art guidelines not available.

Illustration: Approached by 12-15 illustrators/year. Buys approximately 10 drawings/issue. Has featured illustrations by Malcolm Cullen, Stephen MacEachren and Jerzy Kolatch. Features humorous, computer and spot illustration. Assigns 90% to experienced, but not well-known illustrators; 10% to new and emerging illustrators. Uses freelancers mainly for illustrating features and columns. Uses pen & ink, acrylic, oil and pastel. Send postcard sample, brochure and tearsheets. Accepts disk submissions compatible with Adobe Illustrator 7.0. Send EPS, TIFF and PICT files. Buys first rights. Pays $150-300 for b&w inside; $100-500 for color inside; $500-700 for 2-page spreads; $150-300 for spots. Artists should show a representative sampling of their work. Finds most artists through references/word of mouth.

Design: Needs freelancers for multimedia. 20% of freelance work demands knowledge of Adobe Photoshop, Adobe Illustrator and QuarkXPress. Send brochure, tearsheets and postcards. Pays by the project.

Tips: "Meet our deadlines and our budget. Know our product. Fishing and hunting knowledge an asset."

OUTDOOR LIFE MAGAZINE, Dept. AGDM, 2 Park Ave., New York NY 10016. (212)779-5000. Contact: Art Director. Estab. 1897. Monthly magazine geared toward hunting, fishing and outdoor activities. Circ. 1,000,000. Original artwork is returned at job's completion. Sample copies not available.

Illustration: Works on assignment only. Send non-returnable tearsheets, or brochures. Samples are filed. Rights purchased vary according to project. **Pays on acceptance.**

OUTER DARKNESS (Where Nightmares Roam Unleashed), 1312 N. Delaware Place, Tulsa OK 74110. (918)832-1246. E-mail: outerdarknessmag@hotmail.com. Editor: Dennis Kirk. Estab. 1994. Quarterly digest/zine of horror and science fiction, poetry and art. Circ. 500. Sample copy for $3.95. Sample illustrations free for 6×9 SASE and 2 first-class stamps. Art guidelines free for #10 SASE with first-class postage.

Cartoons: Approached by 12 cartoonists/year. Buys 15 cartoons/year. Prefers horror/science fiction slant, but not necessary. Prefers single panel, humorous, b&w line drawings. Send query letter with b&w photocopies, samples, SASE. Samples are returned. Reports back within 2 weeks. Buys one-time rights. Pays on publication in contributor's copies.

Illustration: Approached by 10-12 illustrators/year. Buys 5-7 illustrations/issue. Has featured illustrations by Allen Koszowski, Jeff Ward, Terry Campbell, Lee Seed. Features realistic science fiction and horror illustrations. Prefers b&w, pen & ink drawings. Assigns 30% of illustrations to well-known or "name" illustrators; 50% to experienced, but not well-known illustrators; 20% to new and emerging illustrators. Send query letter with photocopies, SASE. Reports back within 2 weeks. Buys one-time rights. Pays on publication in contributor's copies. Finds illustrators through magazines and submissions.

Tips: "Send samples of your work, along with a cover letter. Let me know a little about yourself. I enjoy learning about artists interested in *Outer Darkness*. *Outer Darkness* is continuing to grow at an incredible rate. It's presently stocked in two out-of-state bookstores, and I'm working to get it into more. Plus, I plan on going full size within the next year. so *OD* is quickly moving through the ranks."

OVER THE BACK FENCE, 5311 Meadow Lane Court, Elyria OH 44035. (440)934-1812. Fax: (440)934-1816. E-mail: kbsaqert@centuryinter.net. Website: http://www.backfence.com. Creative Director: Rocky Alten. Estab. 1994. Quarterly consumer magazine emphasizing northern and southern Ohio topics. Circ. 15,000 (each regional version). Sample copies for $4; art guidelines free for #10 SASE with first-class postage.

Illustration: Features humorous and realistic illustration; informational graphics and spot illustration. Assigns 50% of illustration to experienced, but not well-known illustrators; 50% to new and emerging illustrators. Send query letter with photocopies, SASE and tearsheets. Ask for guidelines. Samples are occasionally filed or returned by SASE. Reports back within 1-3 months. Creative director will contact artist for portfolio review if interested. Buys one-time rights. Pays on publication, net 15 days; $100 for b&w and color covers; $25-100 for b&w and color inside; $25-200 for 2-page spreads; $25-100 for spots. Finds illustrators through word of mouth and submissions.

Tips: "Our readership enjoys our warm, friendly approach. The artwork we select will possess the same qualities."

THE OXFORD AMERICAN, P.O. Box 1156, Oxford MS 38655-1156. (601)236-1836. E-mail: oxam@watervalley.n et. Art Director: A. Newt Rayburn. Estab. 1992. Bimonthly literary magazine. "The Southern magazine of good writing." Circ. 30,000.

Illustration: Approached by many artists/year. Uses a varying number of illustrations/year. Considers all media. Send postcard sample of work. Samples are filed. Reports back only if interested. Art director will contact artist for portfolio review of final art and roughs if interested. Buys one-time rights. Pays on publication. Finds artists through word of mouth and submissions.

Tips: "See the magazine."

OXYGEN, 6465 Airport Rd., Mississauga, Ontario L4V 1E4 Canada. (905)678-7311. Fax: (905)678-9236. Contact: Pam Cottrell. Art Director: Robert Kennedy. Estab. 1997. Bimonthly consumer magazine. "Oxygen is a new magazine devoted to women's fitness, health and physique." Circ. 180,000.

Illustration: Buys 2 illustrations/issue. Has featured illustrations by Erik Blais, Ted Hammond and Lauren Sanders. Features caricatures of celebrities; charts & graphs; computer and realistic illustrations. Assigns 85% of illustrations to experienced, but not well-known illustrators; 15% to new and emerging illustrators. Prefers loose illustration, full color. Considers acrylic, airbrush, charcoal, collage, color washed, colored pencil, mixed media, pastel and watercolor. 50% of freelance illustration demands knowledge of Adobe Photoshop and QuarkXPress. Send query letter with photocopies and tearsheets. Samples are filed and are not returned. Reports back within 21 days. Buys all rights. **Pays on acceptance**; $1,000-2,000 for b&w and color cover; $50-500 for b&w and color inside; $100-1,000 for 2-page spreads. Finds illustrators through word of mouth and submissions.

Tips: "Artists should have a working knowledge of women's fitness. Study the magazine. It is incredible the amount of work that is sent that doesn't begin to relate to the magazine."

P.O.V., 56 W. 22nd St., 3rd Floor, New York NY 10010. Contact: Art Director. Estab. 1995. Monthly consumer magazine for men in their 20s. Circ. 300,000

Illustration: Prefers conceptual and cutting-edge style. Considers all media. Send postcard sample of work. Samples are filed. Does not report back. Art director will contact artist for portfolio review if interested. Finds artists through magazines, word of mouth, submissions, *American Illustration*.

PACIFIC YACHTING MAGAZINE, 300-780 Beatty St., Vancouver, British Columbia V6B 2M1 Canada. (604)606-4644. Fax: (604)687-1925. Editor: Duart Snow. Estab. 1968. Monthly 4-color magazine focused on boating on the West Coast of Canada. Power/sail cruising only. Circ. 25,000. Accepts previously published artwork. Original artwork returned at job's completion. Sample copies available for $3. Art guidelines not available.

Cartoons: Approached by 12-20 cartoonists/year. Buys 1 cartoon/issue. Boating themes only; single panel b&w line drawings with gagline. Send query letter with brochure and roughs. Samples are filed or are returned by SASE if requested by artist. Reports back within 1 month. Buys one-time rights. Pays $25-50 for b&w.

Illustration: Approached by 25 illustrators/year. Buys 6-8 illustrations/year. Boating themes only. Considers pen & ink, watercolor, airbrush, acrylic, colored pencil, oil and charcoal. Send query letter with brochure. Samples are filed or are returned by SASE if requested by artist. Reports back within 2 weeks only if interested. Call for appointment to show portfolio of appropriate samples related to boating on the West Coast. Buys one-time rights. Pays on publication; $300 for color cover; $50-100 for b&w inside; $100-150 for color inside; $25-50 for spots.

Tips: "Know boats and how to draw them correctly. Know and love my magazine."

PARABOLA MAGAZINE, 656 Broadway, New York NY 10012. (212)505-9037. Fax: (212)979-7325. Art Researcher: Miriam Faugno. Estab. 1974. Quarterly literary magazine of world myth, religious traditions and arts/comparative religion. Circ. 40,000. Sample copies available. Art guidelines for #10 SASE with first-class postage.

Illustration: Approached by 20 illustrators/year. Buys 4-6 illustrations/issue. Prefers traditional b&w-high contrast. Considers all media. Send postcard or query letter with printed samples, photocopies and SASE. Send follow-up postcard sample every 3 months. Accepts disk submissions. Samples are filed. Reports back only if interested. Buys one-time rights. Pays on publication (kill fee given for commissioned artwork only); $300 maximum for cover; $150 maximum for b&w inside. Pays $50-100 for spots. Finds illustrators through sourcebooks, magazines, word of mouth and artist's submissions.

Tips: "Familiarity with religious traditions and symbolism a plus."

PARADE MAGAZINE, 711 Third Ave., New York NY 10017. (212)450-7000. E-mail: ira_yoffe@parade.com. Director of Design: Ira Yoffe. Photo Editor: Miriam White-Lorentzen. Weekly emphasizing general interest subjects. Circ. 40 million (readership is 86 million). Original artwork returned after publication. Sample copy and art guidelines available. Art guidelines for SASE with first-class postage.

Illustration: Uses varied number of illustrations/issue. Works on assignment only. Send query letter with brochure, résumé, business card and tearsheets to be kept on file. Call or write for appointment to show portfolio. Reports only if interested. Buys first rights, occasionally all rights.

Design: Needs freelancers for design. 100% of freelance work demands knowledge of Adobe Photoshop, Adobe Illustrator, QuarkXPress. Prefers local freelancers. Send query letter with résumé. Pays for design by the project, by the day or by the hour depending on assignment.

Tips: "Provide a good balance of work."

⊠ PC MAGAZINE, One Park Ave., 4th Floor, New York NY 10016. (212)503-5222. Assistant to Art Director: Frieda Smallwood. Estab. 1983. Bimonthly consumer magazine featuring comparative lab-based reviews of current PC hardware and software. Circ. 1.2 million. Sample copies available.

Illustration: Approached by 100 illustrators/year. Buys 10-20 illustrations/issue. Considers all media. 50% of freelance illustration demands knowledge of Adobe Photoshop, Adobe Illustrator. Send postcard sample and/or printed samples, photocopies, tearsheets. Accepts disk submissions compatible with Adobe Photoshop or Adobe Illustrator. Samples are filed. Portfolios may be dropped on Wednesday and should include tearsheets and transparencies. **Pays on acceptance**. Payment negotiable for cover and inside; $300 for spots.

⊠ ⊕ THE PEAK, 15-B Temple St., Singapore 058562. Phone: (65)323 1119. Fax: (65)323 7776/323 7779. E-mail: mag_inc@pacific.net.sg. Editor: Kannan Chandran. Monthly 4-color consumer magazine.

Illustration: Approached by 20 illustrators/year. Buys 4 illustrations/issue. Has featured illustrations by local illustrators and students. Features charts & graphs, informational graphics, geographic/maps, humorous, medical and spot illustration. Preferred subjects: business and concept illustrations. Prefers pastel/bright/b&w, depends on subject. Assigns 80% of illustrations to new and emerging illustrators; 20% to experienced, but not well-known, illustrators. Send postcard sample and follow-up postcard; send non-returnable samples. Accepts Mac-compatible disk submissions. Samples are filed and are not returned. Will contact artist for portfolio review if interested. Rights purchased vary according to project. Pays $40-60 for b&w; $50-100 for color inside; $50 for spots.

Tips: "A sense of humor—where applicable—and a good interpretation of the subject matter are important."

☑ PEDIATRIC ANNALS, 6900 Grove Rd., Thorofare NJ 08086. (609)848-1000. Website: http://www.slackinc.com. Managing Editor: Shirley Strunk. Monthly 4-color magazine emphasizing pediatrics for practicing pediatricians. "Conservative/traditional design." Circ. 35,000. Considers previously published artwork. Original artwork returned after publication. Sample copies available; art guidelines available.

Illustration: Has featured illustrations by Peg Gerrity and John Paul Genco. Reatures realistic and medical illustration. Prefers "technical and conceptual medical illustration which relate to pediatrics." Considers watercolor, acrylic, oil, pastel and mixed media. Send query letter with brochure, tearsheets, slides and photographs to be kept on file. Publication will contact artist for portfolio review if interested. Buys one-time rights or reprint rights. Pays $250-700 for color cover. Finds artists through submissions/self-promotions and sourcebooks.

Tips: "Illustrators must be able to treat medical subjects with a high degree of accuracy. We need people who are experienced in medical illustration, who can develop ideas from manuscripts on a variety of topics, and who can work independently (with some direction) and meet deadlines. Non-medical illustration is also used occasionally. We deal with medical topics specifically related to children. Include color work, previous medical illustrations and cover designs in a portfolio. Show a representative sampling of work."

PENNSYLVANIA LAWYER, 100 South St., Harrisburg PA 17108-0186. (717)238-6715 ext. 241. Fax: (717)238-7182. Editor: Sherri Kimmel. Bimonthly association magazine "featuring nuts and bolts articles and features of interest to lawyers." Circ. 28,000. Sample copies for #10 SASE with first-class postage. Art guidelines available.

Cartoons: Approached by 2 cartoonists/year. Buys 1 cartoon/year. "No lawyer jokes." Send query letter with samples. Reports back within 1 month. Negotiates rights purchased. Pays on acceptance; $50 minimum.

Illustration: Approached by 30 illustrators/year. Buys 12 illustrations/year. Has featured illustrations by Greg Couch, Andrze Dudzinski and Hadi Farahani. Assigns 10% of illustrations to well-known or "name" illustrators; 60% to experienced, but not well-known illustrators; 30% to new and emerging illustrators. Considers all media. Send query letter with samples. Samples are filed or returned by SASE. Reports back within 2 weeks. Art director will contact artist for portfolio review if interested. Negotiates rights purchased. **Pays on acceptance**; $185-600 for color cover; $100-200 for b&w inside. Pays $25-50 for spots. Finds illustrators through word of mouth and artists' submissions.

Tips: "Artists must be able to interpret legal subjects. Art must have fresh, contemporary look. Read articles you are illustrating, provide three or more roughs in timely fashion."

PERSIMMON HILL, 1700 NE 63rd St., Oklahoma City OK 73111. (405)478-6404. Fax: (405)478-4714. Director of Publications: M.J. Van Deventer. Estab. 1970. Quarterly 4-color journal of Western heritage "focusing on both historical and contemporary themes. It features nonfiction articles on notable persons connected with pioneering the American West; art, rodeo, cowboys, flora and animal life; or other phenomena of the West of today or yesterday. Lively articles, well written, for a popular audience. Contemporary design follows style of *Architectural Digest* and *European Travel and Life*." Circ. 15,000. Original artwork returned after publication. Sample copy for $9.

Illustration: Approached by 75-100 illustrators/year. Buys 1-2 illustrations/issue. Works on assignment only. Prefers Western-related themes and pen & ink sketches. 50% of freelance work demands knowledge of Aldus PageMaker. Send query letter with tearsheets, SASE, slides and transparencies. Samples are filed or returned by SASE if requested. Publication will contact artist for portfolio review if interested. Portfolio should include original/final art, photographs or slides. Buys first rights. Requests work on spec before assigning job. Pay varies. Finds artists through word of mouth and submissions.

Tips: "We are a museum publication. Most illustrations are used to accompany articles. Work with our writers, or suggest illustrations to the editor that can be the basis for a freelance article or a companion story. More interest in the West means we have to provide more contemporary photographs and articles about what people in the West are doing today. Study the magazine first—at least four issues."

PET BUSINESS, 7L Dundas Circle, Greensboro NC 27407-1615. Editor: Rita Davis. Managing Editor: Alison Netsel. A monthly 4-color news magazine for the pet industry (retailers, distributors, manufacturers, breeders, groomers). Circ. 22,048. Accepts previously published artwork. Sample copy $5.
Illustration: Occasionally needs illustration for business-oriented cover stories. Features realistic illustrations. Prefers watercolor, pen & ink, acrylics and color pencil. Accepts Windows-compatible disk submissions. Send EPS files, 266 dpi. Portfolio review not required. Pays on publication; $100.
Tips: "Send two or three samples and a brief bio, only."

PHI DELTA KAPPAN, Box 789, Bloomington IN 47402. Website: http://www.pdkintl.org/kappan/kappan.htm. Design Director: Carol Bucheri. Emphasizes issues, policy, research findings and opinions in the field of education. For members of the educational organization Phi Delta Kappa and subscribers. Black & white with 4-color cover and "conservative, classic design." Published 10 times/year. Circ. 130,000. Include SASE. Reports in 2 months. "We return illustrations and cartoons after publication." Sample copy for $4.90 plus S&H. "The journal is available in most public and college libraries."
Cartoons: Approached by over 100 cartoonists/year. Looks for "finely drawn cartoons, with attention to the fact that we live in a multi-racial, multi-ethnic world."
Illustration: Approached by over 100 illustrators/year. Uses 1 4-color cover and spread and approximately 7 b&w illustrations/issue, all from freelancers who have worked on assignment. Features serious conceptual art; humorous, realistic, computer and spot illustraion. Prefers style of John Berry, Brenda Grannan, Mario Noche and Jen Sullivan. Most illustrations depict some aspect of the education process (from pre-kindergarten to university level), often including human figures. Send postcard sample. Samples returned by SASE. To show a portfolio, mail a few slides or photocopies with SASE. "We can accept computer illustrations that are Mac formatted (EPS or TIFF files. Adobe Photoshop 3.0 or Adobe Illustrator 6.0)." Buys one-time rights. Payment varies.
Tips: "We look for artists who can create a finely crafted image that holds up when translated onto the printed page. Our journal is edited for readers with master's or doctoral degrees, so we look for illustrators who can take abstract concepts and make them visual, often through the use of metaphor."

N PLANNING, American Planning Association, 122 S. Michigan Ave., Suite 1600, Chicago IL 60603. (312)431-9100. Editor and Publisher: Sylvia Lewis. Art Director: Richard Sessions. Monthly b&w magazine with 4-color cover for urban and regional planners interested in land use, housing, transportation and the environment. Circ. 30,000. Previously published work OK. Original artwork returned after publication, upon request. Free sample copy and artist's guidelines available. "Enclose $1 in postage for sample magazine—stamps only, no cash or checks, please."
Cartoons: Buys 2 cartoons/year on the environment, city/regional planning, energy, garbage, transportation, housing, power plants, agriculture and land use. Prefers single panel with gaglines ("provide outside of cartoon body if possible"). Include SASE. Reports in 2 weeks. Buys all rights. Pays on publication; $50 minimum for b&w line drawings.
Illustration: Buys 20 illustrations/year on the environment, city/regional planning, energy, garbage, transportation, housing, power plants, agriculture and land use. Send roughs and samples of style with SASE. Reports in 2 weeks. Buys all rights. Pays on publication; $250 maximum for b&w cover drawings; $100 minimum for b&w line drawings inside.
Tips: "Don't send portfolio. No corny cartoons. Don't try to figure out what's funny to planners. All attempts seen so far are way off base."

N PLAY STATION MAGAZINE, 150 North Hill Dr., #40, Brisbane CA 94005-1018. (415)468-4684, ext. 13. Fax: (415)468-4686. E-mail: ewang@imaginemedia.com. Website: http://www.imaginemedia.com. Art Director: Eugene Wang. Estab. 1997. Monthly 4-color consumer magazine focused on Play Station video game for preteens and up— "comic booky." Circ. 250,000. Free sample copies available.
Cartoons: Prefers multiple panel, humorous b&w line drawings; manga, comic book, image style. Send query letter with b&w and color photocopies and samples. Samples are filed. Reports back only if interested. Buys all rights. Pays on publication.
Illustration: Approached by 20-30 illustrators/year. Buys 24 illustrations/issue. Has featured illustrations by Joe Madureira, Art Adams, Adam Warren, Hajeme Soroyana, Royo, J. Scott Campbell and Travis Charest. Features comic-book style, computer, humorous, realistic and spot illustration. Preferred subject: video game characters. Prefers liquid! BAD@$$ computer coloring. Assigns 80% of illustrations to well-known or "name" illustrators; 10% each to experienced, but not well-known, illustrators and new and emerging illustrators. 50% of freelance illustration demands knowledge of Adobe Illustrator and Adobe Photoshop. Send postcard sample or non-returnable samples; send query letter with printed samples, photocopies and tearsheets. Accepts Mac-compatible disk submissions. Send TIFF files. Samples are not filed. Will contact artist for portfolio review if interested. Buys all rights. Pays on publication. Finds illustrators through magazines and word of mouth.
Tips: "If you are an artist, confident that your vision is unique, your quality is the best, ever seeing anew, ever evolving, send us samples!"

PLAYBOY MAGAZINE, 680 N. Lakeshore Dr., Chicago IL 60611. (312)751-8000. Managing Art Director: Kerig Pope. Estab. 1952. Monthly magazine. Circ. 3.5 million. Originals returned at job's completion. Sample copies available.
Cartoons: Cartoonists should contact Michelle Urry, Playboy Enterprises Inc., Cartoon Dept., 730 Fifth Ave., New

York NY 10019. "Please do not send cartoons to Kerig Pope!" Samples are filed or returned. Reports back within 2 weeks. Buys all rights.

Illustration: Approached by 700 illustrators/year. Buys 30 illustrations/issue. Prefers "uncommercial looking" artwork. Considers all media. Send postcard sample or query letter with slides and photocopies or other appropriate sample. Does not accept originals. Samples are filed or returned. Reports back within 2 weeks. Buys all rights. **Pays on acceptance**; $1,200/page; $2,000/spread; $250 for spots.

Tips: "No phone calls, only formal submissions of five pieces."

PN/PARAPLEGIA NEWS, 2111 E. Highland Ave., Suite 180, Phoenix AZ 85016-4702. (602)224-0500. Fax: (602)224-0507. E-mail: pvapub@aol.com. Website: http://www.pva.org/pn. Art Director: Susan Robbins. Estab. 1947. Monthly 4-color magazine emphasizing wheelchair living for wheelchair users, rehabilitation specialists. Circ. 27,000. Accepts previously published artwork. Original artwork not returned after publication. Sample copy free for large-size SASE with $3 postage.

Cartoons: Buys 3 cartoons/issue. Prefers line art with wheelchair theme. Prefers single panel b&w line drawings with or without gagline. Send query letter with finished cartoons to be kept on file. Material not kept on file is returned by SASE. Reports only if interested. Buys all rights. **Pays on acceptance**; $10 for b&w.

Illustration: Prefers wheelchair living or medical and financial topics as themes. 50% of freelance work demands knowledge of QuarkXPress, Adobe Photoshop or Adobe Illustrator. Send postcard sample. Accepts disk submissions compatible with Adobe Illustrator 7.0 or Photoshop 4.0. Send EPS of TIFF files. Samples not filed are returned by SASE. Publication will contact artist for portfolio review if interested. Portfolio should include final reproduction/product, color and b&w tearsheets, photostats, photographs. Pays on publication; $250 for color cover; $10 for b&w inside, $25 for color inside.

Tips: "When sending samples, include something that shows a wheelchair user. We have not purchased an illustration or used a freelance designer for several years. We do regularly purchase cartoons that depict wheelchair users."

POCKETS, Box 189, 1908 Grand Ave., Nashville TN 37202. (615)340-7333. E-mail: pockets@upperroom.org. Website: http://www.upperroom.org. Editor: Janet Knight. Devotional magazine for children 6-12. 4-color with some 2-color. Monthly except January/February. Circ. 100,000. Accepts previously published material. Original artwork returned after publication. Sample copy for SASE with 4 first-class stamps.

Illustration: Approached by 50-60 illustrators/year. Features humorous, realistic, computer and spot illustration. Assigns 5% of illustrations to well-known or "name" illustrators; 80% to experienced, but not well-known illustrators; 15% to new and emerging illustrators. Uses variety of styles; 4-color, 2-color, flapped art appropriate for children. Realistic, fable and cartoon styles. Send postcard sample, brochure, photocopies, SASE and tearsheets. Also open to more unusual art forms: cut paper, embroidery, etc. Samples not filed are returned by SASE. "No response without SASE." Reports only if interested. Buys one-time or reprint rights. **Pays on acceptance**; $600 flat fee for 4-color covers; $50-250 for b&w inside, $75-350 for color inside.

Tips: "Decisions made in consultation with out-of-house designer. Send samples to our designer: Chris Schechner, 3100 Carlisle Plaza, Suite 207, Dallas, TX 75204."

POLICY REVIEW, 214 Massachusetts Ave., Washington DC 20002. (202)608-6163. Fax: (202)608-6136. E-mail: polrev@heritage.org. Website: http://www.heritage.org. Estab. 1977. Bimonthly. Circ. 25,000. Sample copies free for #10 SASE with first-class postage.

Illustration: Approached by 40 illustrators/year. Buys 4-5 illustrations/issue. Has featured illustrations by Phil Foster, David Clark and Christopher Bing. Features caricatures of politicians, humorous, realistic, and conceptual spot illustration. Prefers b&w, conceptual work. Considers charcoal, collage and pen & ink. Send postcard sample. Accepts disk submissions compatible with QuarkXPress for PC; prefers TIFF or EPS files. Samples are filed. Reports back only if interested. Art director will contact artist for portfolio review if interested. Rights purchased vary according to project. Pays on publication; negotiable. Pays $100-200 for spots.

N POPULAR ELECTRONICS, 500 Bi-County Blvd., Farmingdale NY 11735-3931. (516)293-3900. Fax: (516)293-3115. E-mail: peeditor@gernsback.com. Website: http://www.gernsback.com. Editor: Konstantinos Karagiannis. Monthly consumer magazine "for the electronics consumer and hobbyist." Circ. 75,000. Sample copies available.

Cartoons: Approached by 40 cartoonists/year. Buys 2 cartoons/issue. Prefers electronics-related humor. Prefers single panel, humorous, b&w line drawings with or without gagline. Send query letter with finished cartoons. Samples are not filed and are returned by SASE. Reports back within 1 week. Buys all rights. **Pays on acceptance**; $25 for b&w.

N POPULAR SCIENCE, Dept. AM, Times Mirror Magazines, Inc., 2 Park Ave., New York NY 10016. (212)779-5000. E-mail: chris.garcia@tmm.com. Website: http://www.popsci.com. Art Director: Chris Garcia. "For the well-educated adult male, interested in science, technology, new products." Original artwork returned after publication. Art guidelines available.

Illustration: Uses 30-40 illustrations/issue. Has featured illustrations by Don Foley, P.J. Loughron, Andrew Grirds and Bill Duke. Assigns 50% of illustrations to well-known or "name" illustrators; 40% to experienced but not well-known illustrators; 10% to new and emerging illustrators. Works on assignment only. Interested in technical 4-color art and 2-color line art dealing with automotive or architectural subjects. Especially needs science and technological pieces as assigned per layout. Send postcard sample, photocopies or other non-returnable samples. Reports back only if interested.

Samples kept on file for future assignments. "After seeing portfolios, I photocopy or photostat those samples I feel are indicative of the art we might use." Reports whenever appropriate job is available. Buys first publishing rights.
Tips: "More and more scientific magazines have entered the field. This has provided a larger base of technical artists for us. Be sure your samples relate to our subject matter, i.e., no rose etchings, and be sure to include a tearsheet for our files. I don't really need a high end, expensive sample. All I need is something that shows the type of work you do. Look at our magazine before you send samples. Our illustration style is very specific. If you think you fit into the look of our magazine, send a sample for our files."

POTATO EYES, Box 76, Troy ME 04987. (207)948-3427. E-mail: potatoeyes@uninet.net. Co-Editor: Carolyn Page. Estab. 1988. Biannual literary magazine; b&w with 2-color cover. Design features "strong art showing rural places, people and objects in a new light of respect and regard. We publish people from all over the world." Circ. 800. Original artwork returned at job's completion. Sample copies available: $6 for back issues, $7.95 for current issue; art guidelines available for SASE with first-class postage.
 ● Also occasionally publishes *The Nightshade Short Story Reader*, same format, and three poetry chapbooks/year.
Illustration: Has featured illustrations by Vasily Kafanov, Linda S. Wingerter, Kathryn DiLego and Fernando Aguiar. Features realistic illustration. Assigns 60% of illustration to experienced, but not well-known illustrators; 40% to new and emerging illustrators. Prefers detailed pen & ink drawings or block prints, primarily realistic. No cartoons. Send query letter with photocopies. Samples are filed and are not returned. Reports back within 2 months. Acquires one-time rights. Requests work on spec before assigning job. Pays on publication; $50-100 for b&w or color cover; $25-50 for b&w inside. Spots are paid for in contributor's copies. "Our *Artist's & Graphic Designer's Market* listing has sent us hundreds of artists. The rest have come through word of mouth."
Tips: "We hope to utilize more black & white photography to complement the black & white artwork. An artist working with quill pens and a bottle of India ink could do work for us. A woodcarver cutting on basswood using 19th-century tools could work for us. Published artists include Soshanna Cohen, Lynn Foster Hill, David Kooharian and Vasily Kafanov. A Burbank artist, Kathryn DiLego, has done six color covers for us. We look for only the highest-quality illustration. If artists could read a sample issue they would save on time and energy as well as postage. A lot of what we receive in the mail is line drawing verging on cartoon and not particularly well done. We seek a look that is more fine art than flip art or clip art. If you are not a serious artist don't bother us, please."

POTPOURRI, A Magazine of the Literary Arts, P.O. Box 8278, Prairie Village KS 66208-0278. (913)642-1503. Fax: (913)642-3128. E-mail: potpourpub@aol.com. Art Director: Sophia Myers. Estab. 1989. Quarterly b&w literary magazine featuring short stories, poetry, essays on arts, illustrations. Circ. 3,000. Art guidelines free for SASE with first-class postage. Sample copy for $4.95.
Illustration: Approached by 20 illustrators/year. Buys 10-12 illustrations/issue. Has featured illustrations by M. Keating, E. Reeve, A. Olsen, T. Devine, D.J. Baker, D. Transue, S. Chapman, W. Philips, M. Larson, D. McMillion. Features caricatures of literary celebrities, computer and realistic illustrations. Prefers pen & ink. Assigns 100% of illustrations to new and emerging illustrators. Send query letter with printed samples, photocopies and SASE. Samples are filed. Reports back within 3 months. Portfolio review not required. Buys one-time and reprint rights. Pays on publication, in copies. Finds illustrators through sourcebooks, artists' samples, word of mouth.
Tips: "*Potpourri* seeks original illustrations for its short stories. Also open to submissions for cover illustration of well-known literary persons. Prefer clean, crisp black & white illustrations and quick turn-around. *Potpourri* has completed its tenth year of publication and offers artists an opportunity for international circulation/exposure."

POWER AND LIGHT, 6401 The Paseo, Kansas City MO 64131. (816)333-7000 ext. 2243. Fax: (816)333-4439. E-mail: bpostlewait@nazarene.org or mprice@nazarene.org. Editor: Beula Postlewait. Associate Editor: Melissa Hammer. Estab. 1992. "*Power and Light* is a weekly 8 page, 2- and 4-color story paper that focuses on the interests and concerns of the preteen (11- to 12-year-old). We try to connect what they learn in Sunday School with their daily lives." Circ. 40,000. Originals are not returned. Sample copies and art guidelines free for SASE with first-class postage.
Cartoons: Buys 1 cartoon/issue. Prefers humor for the preteen; single panel b&w line drawings with gagline. Send query letter with finished cartoon samples and SASE. Samples are filed or are returned by SASE if requested. Reports back within 3 months. Buys multi-use rights. Pays $15 for b&w.
Illustration: Buys 1 illustration/issue. Works on assignment only. Should relate to preteens. Considers acrylic, color washed, colored pencil, pen & ink, watercolor, airbrush, marker and pastel. Send query letter with samples and SASE. Accepts submissions on disk (write for guidelines). Samples are filed. Reports back only if interested. Art Director will contact artist for portfolio review if interested. Portfolio should include roughs, final art samples, black and white, color photographs. Buys all rights. Sometimes requests work on spec before assigning job. Pays on publication; $40 for b&w cover and inside; $75 for color cover and inside. Finds artists through submissions, word of mouth, magazines, WWW.
Tips: "Send a résumé, photographs or photocopies of artwork and a SASE to the office. A follow-up call is appropriate within the month. Adult humor is not appropriate. Keep in touch. Show us age-appropriate, color, quality or black & white materials. Know children."

■ **PRAIRIE JOURNAL TRUST**, P.O. Box 61203 Brentwood P.O., Calgary, Alberta T2L 2K6 Canada. E-mail: prairiejournal@iname.com. Estab. 1983. Biannual literary magazine. Circ. 600. Sample copies available for $8; art guidelines for SAE with IRCs only or on website.

Illustration: Approached by 8 illustrators/year. Buys 5 illustrations/issue. Has featured illustrations by C. Weiss, A. Peycha, B. Carlson, H. Spears, H. Love and P. Wheatley. Considers b&w only. Send query letter with photocopies. Samples are not filed and are returned by SASE if requested by artist. Reports back within 6 months. Portfolio review not required. Acquires first rights. Pays honorarium for b&w cover.

Tips: "Send copies only of work available for publication. We are very open to black & white artwork. Unsolicited art only; we do not commission work. Any level of experience welcome. Small honourarium paid if accepted."

PRAIRIE SCHOONER, 201 Andrews Hall, University of Nebraska, Lincoln NE 68588-0334. (402)472-3191. Fax: (402)472-9771. Editor: Hilda Raz. Managing Editor: Ladette Randolph. Estab. 1927. Quarterly b&w literary magazine with 2-color cover. "*Prairie Schooner*, now in its 72nd year of continuous publication, is called 'one of the top literary magazines in America' by *Literary Magazine Review*. Each of the four issues contains short stories, poetry, book reviews, personal essays, interviews or some mix of these genres. Contributors are both established and beginning writers. Readers live in all states in the U.S. and in most countries outside the U.S." Circ. 3,200. Original artwork is returned after publication. "We rarely have the space or funds to reproduce artwork in the magazine but hope to do more in the future." Sample copies for $5.

Illustration: Approached by 1-5 illustrators/year. Uses freelancers mainly for cover art. "Before submitting, artist should be familiar with our cover and format, 6×9, black and one color or b&w, vertical images work best; artist should look at previous issues of *Prairie Schooner*. Portfolio review not required. We are rarely able to pay for artwork; have paid $50 to $100."

Tips: Finds artists through word of mouth. "We're trying for some four-color covers."

THE PREACHER'S MAGAZINE, 10814 E. Broadway, Spokane WA 99206. (509)226-3464. Fax: (509)926-8740. Editor: Randal E. Denny. Estab. 1926. Quarterly trade journal "for pastors and other holiness preachers." Circ. 18,000.

Cartoons: Approached 4-5 cartoonists. Buys 5 cartoons/issue. Prefers single, double and multiple panel, humorous, b&w washes and line drawings with gagline. Send query letter with photocopies. Samples are filed or returned by SASE. Reports back within 1 month with SASE. Buys one-time rights. Pays on publication; $20-25 for b&w.

THE PRESBYTERIAN RECORD, 50 Wynford Dr., North York, Ontario M3C 1J7 Canada. (416)441-1111. E-mail: pcrecord@presbyterian.ca. Website: http://www.presbycan.ca/record. Production and Design: Tim Faller. Published 11 times/year. Deals with family-oriented religious themes. Circ. 60,000. Original artwork returned after publication. Simultaneous submissions and previously published work OK. Free sample copy and artists' guidelines for SASE with first-class postage.

Cartoons: Approached by 12 cartoonists/year. Buys 1-2 cartoons/issue. Interested in some theme or connection to religion. Send roughs and SAE (nonresidents include IRC). Reports in 1 month. Pays on publication; $25-50 for b&w.

Illustration: Approached by 6 illustrators/year. Buys 1 illustration/year on religion. Has featured illustrations by Ed Schnurr, Claudio Ghirardo and Chrissie Wysotski. Features humorous, realistic and spot illustration. Assigns 50% of illustrations to experienced, but not well-known illustrators; 50% to new and emerging illustrators. "We are interested in excellent color artwork for cover." Any line style acceptable—should reproduce well on newsprint. Works on assignment only. Send query letter with brochure showing art style or tearsheets, photocopies and photographs. Will accept computer illustrations compatible with QuarkXPress 3.32, Adobe Illustrator 8.0, Adobe Photoshop 5.0. Samples returned by SAE (nonresidents include IRC). Reports in 1 month. To show a portfolio, mail final art and color and b&w tearsheets. Buys all rights on a work-for-hire basis. Pays on publication; $50-100 for b&w cover; $100-300 for color cover; $25-80 for b&w inside; $25-60 for spots.

Tips: "We don't want any 'cute' samples (in cartoons). Prefer some theological insight in cartoons; some comment on religious trends and practices."

PRESBYTERIANS TODAY, 100 Witherspoon St., Louisville KY 40202. (502)569-5636. Fax: (502)569-8632. E-mail: today@pcusa.org. Website: http://www.pcusa.org/pcusa/today. Art Director: Linda Crittenden. Estab. 1830. 4-color; official church magazine emphasizing religious world news and inspirational features. Publishes 10 issues year. Circ. 85,000. Originals are returned after publication if requested. Some feature illustrations may appear on website. Sample copies for SASE with first-class postage.

Cartoons: Approached by 20-30 cartoonists/year. Buys 1-2 freelance cartoons/issue. Prefers general religious material; single panel. Send roughs and/or finished cartoons. Samples are filed or are returned. Reports back within 1 month. Rights purchased vary according to project. Pays $25, b&w.

Illustration: Approached by more than 50 illustrators/year. Buys 2-3 illustrations/issue, 30 illustrations/year from freelancers. Works on assignment only. Media varies according to need. Send query letter with slides or tearsheets. Samples are filed or are returned by SASE. Reports back only if interested. Buys one-time rights. Pays $150-350, cover; $80-250, inside.

PRISM INTERNATIONAL, Department of Creative Writing, U.B.C., Buch E462—1866 Main Mall, Vancouver, British Columbia V6T 1Z1 Canada. (604)822-2514. Fax: (604)822-3616. E-mail: prism@unixg.ubc.ca. Website: http://www.arts.ubc.ca/prism. Editors: Jeremiah Aherne and Natalie Meisner. Estab. 1959. Quarterly literary magazine. "We use cover art for each issue." Circ. 1,200. Original artwork is returned to the artist at the job's completion. Sample copies for $5, art guidelines for SASE with first-class postage.

Illustration: Approached by 20 illustrators/year. Buys 1 cover illustration/issue. Has featured illustrations by Scott

Bakal, Chris Woods, and Angela Grossman. Features representational and non-representational fine art. Assigns 50% of illustrations to experienced, but not well-known illustrators; 50% to new and emerging illustrators. "Most of our covers are full color; however, we try to do at least one black & white cover/year." Send postcard sample. Accepts submissions on disk compatible with CorelDraw 5.0 (or lower) or other standard graphical formats. Most samples are filed. Those not filed are returned by SASE if requested by artist. Reports back within 3 months. Portfolio review not required. Buys first rights. Pays on publication; $150 (Canadian) for b&w and color cover; $10 (Canadian) for b&w and color inside and 3 copies. Finds artists through word of mouth and going to local exhibits.

Tips: "We are looking for fine art suitable for the cover of a literary magazine. Your work should be polished, confident, cohesive and original. Send a postcard sample of your work. As with our literary contest, we will choose work which is exciting and which reflects the contemporary nature of the magazine."

PRIVATE PILOT, 265 S. Anita Dr., Suite 120, Orange CA 92868. (714)939-9991. Editorial Director: Bill Fedorko. Managing Editor: Amy Maclean. Estab. 1965. Monthly magazine for owners/pilots of private aircraft, student pilots and others aspiring to attain additional ratings and experience. Circ. 105,000. Receives 3 cartoons and 2 illustrations/week from freelance artists.

● Also publishes *Custom Planes*, a bimonthly magazine for homebuilders and restorers. Same guidelines apply.

Illustration: Works with 2 illustrators/year. Buys 10 illustrations/year. Uses artists mainly for spot art. Send query letter with photocopies, tearsheets and SASE. Accepts submissions on disk (call first). Reports in 3 months. Pays $50-500 for color inside. "We also use spot illustrations as column fillers." Buys 1-2 spot illustrations/issue. Pays $35/spot.

Tips: "Know the field you wish to represent; we specialize in general aviation aircraft, not jets, military or spacecraft."

✓ **PROCEEDINGS**, U.S. Naval Institute, 291 Wood Rd., Annapolis MD 21402-5035. Fax: (410)295-1049. Website: http://www.usni.org. Art Director: LeAnn Bauer. Monthly b&w magazine with 4-color cover emphasizing naval and maritime subjects. "*Proceedings* is an independent forum for the sea services." Design is clean, uncluttered layout, "sophisticated." Circ. 110,000. Accepts previously published material. Sample copies and art guidelines available.

Cartoons: Buys 23 cartoons/year from freelancers. Prefers cartoons assigned to tie in with editorial topics. Send query letter with samples of style to be kept on file. Material not filed is returned if requested by artist. Reports within 1 month. Negotiates rights purchased. Pays $25-50 for b&w, $50 for color.

Illustration: Buys 1 illustration/issue. Works on assignment only. Has featured illustrations by Tom Freeman, R.G. Smith and Eric Smith. Features humorous and realistic illustration; charts & graphs; informational graphics; computer and spot illustration. Needs editorial and technical illustration. "We like a variety of styles if possible. Do excellent illustrations and meet the requirement for military appeal." Prefers illustrations assigned to tie in with editorial topics. Send query letter with brochure, résumé, tearsheets, photostats, photocopies and photographs. Accepts submissions on disk (call production manager for details). Samples are filed or are returned only if requested by artist. Publication will contact artist for portfolio review if interested. Negotiates rights purchased. Sometimes requests work on spec before assigning job. Pays $50 for b&w inside, $50-75 for color inside; $150-200 for color cover; $25 minimum for spots. "Contact us first to see what our needs are."

Tips: "Magazines such as *Proceedings* that rely on ads from defense contractors will have rough going in the future."

Ⓝ PROFESSIONAL TOOL & EQUIPMENT NEWS AND BODYSHOP EXPO, 25401 Cabot Rd., Suite 209, Laguna Hills CA 92653. (949)830-7520. Fax: (949)830-7523. Publisher: Rudy Wolf. Estab. 1990. Bimonthly trade journals. "*PTEN* covers tools and equipment used in the automotive repair industry. *Bodyshop Expo* covers tools and equipment used in the automotive bodyshop industry." Circ. 110,000 for *Professional Tool*; 62,000 for *Bodyshop Expo*. Originals returned at job's completion. Sample copies for *Professional Tool* $5; for *Bodyshop Expo* $4. Art guidelines free for SASE with first-class postage.

Cartoons: Approached by 3 cartoonists/year. Buys 2 cartoons/issue. Prefers auto service and tool-related, single panel color washes with gaglines. Send query letter with finished cartoons. Samples are not filed and are returned by SASE if requested by artist. Reports back within 2 weeks. Buys one-time rights. Pays $50 for b&w.

Illustration: Approached by 3 illustrators/year. Buys 2 illustrations/issue. Works on assignment only. Considers pen & ink and airbrush. Send query letter with brochure and tearsheets. Samples are not filed and returned by SASE. Reports back within 2 weeks. To show a portfolio, mail thumbnails and roughs. Buys one-time rights. **Pays on acceptance**; $100-200 for b&w, $200-500 for color inside.

THE PROGRESSIVE, 409 E. Main St., Madison WI 53703. Website: http://www.progressive.org. Art Director: Patrick JB Flynn. Estab. 1909. Monthly b&w plus 4-color cover. Circ. 40,000. Originals returned at job's completion. Free sample copy and art guidelines.

Illustration: Works with 50 illustrators/year. Buys 10 b&w illustrations/issue. Has featured illustrations by S. Kroninger, S. Coe, B. Holland, M. Fisher, Gale, S. Goldenberg, J. Ciardiello, D. Johnson, H. Drescher, Jordon Isip, Melinda Beck, D. McLimans and M. Duffy. Features caricatures of politicians; humorous and political illustration. Assigns 40% of illustrations to well-known or "name" illustrators; 50% to experienced, but not well-known illustrators; 10% to new and emerging illustrators. Needs editorial illustration that is "smart, bold, expressive." Works on assignment only. Send query letter with tearsheets and/or photocopies. Samples returned by SASE. Reports in 6 weeks. Portfolio review not required. Pays $500 for b&w and color cover; $100-250 for b&w line or tone drawings/paintings/collage inside. Buys first rights.

Tips: Do not send original art. Send samples, postcards or photocopies and appropriate postage for materials to be

returned. "The successful art direction of a magazine allows for personal interpretation of an assignment."

PROGRESSIVE RENTALS, 9015 Mountain Ridge, Suite 220, Austin TX 78759-7252. (512)794-0095. Fax: (512)794-0097. E-mail: nferguson@apro-rto.com. Website: http://www.apro-rto.com. Art Director: Neil Ferguson. Estab. 1983. Bimonthly association publication for members of the Association of Progressive Rental Organizations, the national association of the rental-purchase industry. Circ. 5,000. Sample copies free for catalog-size SASE with first-class postage.
Illustration: Buys 3-4 illustrations/issue. Has featured illustrations by Barry Fitzgerald, Aletha Reppel, A.J. Garces, Edd Patton and Jane Marinsky. Features computer and conceptual illustration. Assigns 15% of illustrations to well-known or "name" illustrators; 70% to experienced, but not well-known illustrators; 15% to new and emerging illustrators. Prefers cutting edge; nothing realistic; strong editorial qualities. Considers all media. "Accepts computer-based illustrations (Adobe Photoshop, Adobe Illustrator). Send postcard sample, query letter with printed samples, photocopies or tearsheets. Accepts disk submissions. (Must be Photoshop-accessable EPS high-resolution [300 dpi] files or Illustrator files.) Samples are filed or returned by SASE. Reports back with 1 month if interested. Rights purchased vary according to project. Pays on publication: $300-400 for color cover; $200-300 for b&w, $250-350 for color inside; $75-125 for spots. Finds illustrators mostly through artist's submissions; some from other magazines.
Tips: "Illustrators who work for us must have a strong conceptual ability—that is, they must be able to illustrate for editorial articles dealing with business/management issues. We are looking for cutting-edge styles and unique approaches to illustration. I am willing to work with new, lesser-known illustrators."

N 🌐 **PROPERTY REVIEW**, 15-B Temple St., Singapore 058562. Phone: (65)323 1119. Fax: (65)323 7776/323 7779. E-mail: mag_inc@pacific.net.sg. Editor: Bee Ong. Estab. 1996. Monthly 4-color business magazine for the real estate industry. Circ. 20,000.
Illustration: Approached by 4-5 illustrators/year. Buys 0-1 illustration/issue. Features charts & graphs, informational graphics, computer, humorous and realistic illustration and illustrations that portray a storyline. Preferred subjects: business, real estate. Prefers witty and informative art. Send query letter with non-returnable printed samples. Samples are filed. Will contact artist for portfolio review if interested. Rights purchased vary according to project. Pays on publication, $90-150 for b&w cover; $50-100 for b&w inside. Finds illustrators through word of mouth, agencies and artists' queries.
Tips: "Wit and logic are most important. A pretty piece that says nothing or something abstract simply won't do."

PROTOONER, P.O. Box 2270, Daly City CA 94017-2270. (650)755-4827. Fax: (650)994-4131. E-mail: protooner@earthlink.net. Editor: Joyce Miller. Art Director: Ladd A. Miller. Editorial Assistant: Chris Patterson. Estab. 1995. Monthly trade journal for the professional cartoonist and gagwriter. Circ. 500+. Sample copy $5 U.S., $6 foreign. Art guidelines for #10 SASE with first-class postage.
Cartoons: Approached by tons of cartoonists/year. Buys 5 cartoons/issue. Prefers good visual humorous impact. Prefers single panel, humorous, b&w line drawings, with or without gaglines. Send query letter with roughs, SASE, tearsheets. "SASE a must!" Samples are filed. Reports back in 1 month. Buys reprint rights. **Pays on acceptance**; $25-35 for b&w cartoons; $15 cover/spots.
Illustration: Approached by 6-12 illustrators/year. Buys 3 illustrations/issue. Has featured illustrations by Randy Glasbergen, Dan Rosandich, Art McCourt, Chris Patterson and Dan Knauss. Assigns 50% off illustrations to well-known or "name" illustrators; 30% to experienced, but not well-known illustrators; 20% to new and emerging illustrators. Features humorous illustration; informational graphics; spot illustration. Prefers humorous, original. Avoid vulgarity. Considers pen & ink. 50% of freelance illustration demands computer knowledge. Query for programs. Send query letter with printed samples and SASE. Samples are filed. Reports back within 1 month. Buys reprint rights. **Pays on acceptance**; $20-30 for b&w cover. Pay for spots varies according to assignment.
Tips: "Pay attention to the magazine slant and SASE a must! Study sample copy before submitting. Request guidelines. Don't mail artwork not properly slanted!"

☑ **PSYCHOLOGY TODAY**, 49 E. 21st St., 11th Floor, New York NY 10010. (212)260-7210. Fax: (212)260-7445. Art Director: Barrie Goodman Lloyd. Estab. 1991. Bimonthly consumer magazine for professionals and academics, men and women. Circ. 350,000. Accepts previously published artwork. Originals returned at job's completion.
Illustration: Approached by 250 illustrators/year. Buys 5 illustrations/issue. Works on assignment only. Prefers psychological, humorous, interpersonal studies. Considers all media. Needs editorial, technical and medical illustration. 20% of freelance work demands knowledge of QuarkXPress or Adobe Photoshop. Send query letter with brochure, photostats and photocopies. Samples are filed and are not returned. Reports back only if interested. Buys one-time rights. Pays on publication; $200-500 for color inside; $50-350 for spots; cover negotiable.

N **PUBLIC CITIZEN NEWS**, (formerly *Public Citizen*), 1600 20th St., NW, Washington DC 20009. (202)588-1000. E-mail: bmentzin@citizen.org. Website: http://www.citizen.org. Editor: Bob Mentzinger. Bimonthly magazine emphasizing consumer issues for the membership of Public Citizen, a group founded by Ralph Nader in 1971. Circ. 100,000. Accepts previously published material. Sample copy available for 9×12 SASE with first-class postage.
Illustration: Buys up to 2 illustrations/issue. Assigns 33% of illustrations to well-known or "name" illustrators; 33% to experienced, but not well-known illustrators; 33% to new and emerging illustrators. Prefers contemporary styles in pen & ink. Send query letter with samples to be kept on file. Samples not filed are returned by SASE. Buys first rights or one-time rights. Pays on publication. Payment negotiable.

Tips: "Send several keepable samples that show a range of styles and the ability to conceptualize. Want cartoons that lampoon policies and politicians, especially on the far right of the political spectrum. Magazine was redesigned into a newspaper format in 1998."

☒ PUBLISH, 501 Second St., San Francisco CA 94107. (415) 978-3200. Fax: (415)975-2613. Website: http://www.publish.com. Contact: Art Director: Jean Zambelli. Estab. 1986. Monthly magazine focusing on publishing technology and graphic design. Circ. 95,000.
 ● This magazine has been honored with numerous awards for design and won a Maggie award for Best Magazine, Trade, in 1998.
Illustration: Approached by 50-200 illustrators/year. Buys 2-4 illustrations/issue. Has featured illustrations by James Yang, Jere Smith, Kim Stringfellow. Assigns 10% of illustrations to well-known or "name" illustrators; 80% to experienced, but not well-known illustrators; 10% to new and emerging illustrators. Considers all media. Send printed samples and photocopies. Accepts submissions on disk. Samples are filed and not returned. Reports back only if interested. Buys first North American serial rights or negotiates rights purchased. **Pays on acceptance**, $100-800 for color inside; $100-250 for spots. Finds artists through submissions, sourcebooks, word of mouth and illustration annuals.
Design: Needs freelancers for marketing and special publications occasionally. Prefers local design freelancers only. 100% of design/production demands knowledge of Adobe Photoshop and QuarkXPress. Send query letter with printed samples to Jean Zambelli, art director.
Tips: "Do not cold call. Send non-returnable samples. We usually select artists more on style than other factors."

QECE (QUESTION EVERYTHING CHALLENGE EVERYTHING), 406 Main St., #3C, Collegeville PA 19426. E-mail: qece@aol.com. Creative Director: Larry Nocella. Estab. 1996. Three times yearly b&w zine "encouraging a more questioning mentality." Circ. 450. Sample copies available for $3. Art guidelines free for #10 SASE with first class postage.
Cartoons: Buys 10 cartoons/year. Prefers subversive and bizarre single, double or multiple panel humorous, b&w line drawings. Send query letter with b&w photocopies and SASE. Samples are not filed; returned by SASE. Reports back within 1 month. Buys one-time rights. Pays on publication; $5 maximum or contributor copies.
Illustration: Approached by 12 illustrators/year. Buys 4 illustrations/issue. Has featured illustrations by Randy Moore, Kiel Stuart, GAK, Colin Develin, Steve Barr. Features charts & graphs, humorous and realistic illustrations; "anything that jolts the imagination." Prefers "intelligent rebellion." Prefers b&w line art. Assigns 100% of illustrations to new and emerging illustrators. Send query letter with bio (25 words or less), photocopies, SASE. Samples are not filed; returned by SASE. Reports back within 1 month. Portfolio review not required. Buys one-time rights. Pays on publication; $5 or 2 contributor copies for b&w cover. Finds illustrators through Internet, word of mouth.
Tips: "*QECE* offers you the artistic freedom you've always wanted. Send your most unique black & white creations—our 'gallery' centerfold has no theme other than printing the coolest (in our opinion) art we can get. Throw off your shackles and create what you want. Cartoonists, be subversive, but avoid common subjects, such as latest political scandal, etc. Be pro-activist, pro-action. Be free and question everything. Challenge everything."

QUEEN OF ALL HEARTS, 26 S. Saxon Ave., Bay Shore NY 11706. (516)665-0726. Fax: (516)665-4349. Managing Editor: Rev. Roger Charest. Estab. 1950. Bimonthly Roman Catholic magazine on Marian theology and spirituality. Circ. 2,500. Accepts previously published artwork. Sample copy available.
Illustration: Buys 1 or 2 illustrations/issue. Works on assignment only. Prefers religious. Considers pen & ink and charcoal. Send postcard samples. Samples are not filed and are returned by SASE if requested by artist. Buys one-time rights. **Pays on acceptance**; $50 minimum for b&w inside.
Tips: Area most open to freelancers is illustration for short stories. "Be familiar with our publication."

☑ ELLERY QUEEN'S MYSTERY MAGAZINE, 475 Park Ave. S., New York NY 10016. (212)686-7188. Fax: (212)686-7414. Senior Art Director: Victoria Green. Assistant Art Director: Shirley Chan Levi. All submissions should be sent to Shirley Chan Levi, assistant art director. Emphasizes mystery stories and reviews of mystery books. Art guidelines for SASE with first-class postage.
 ● Also publishes *Alfred Hitchcock Mystery Magazine*, *Analog* and Isaac Asimov's *Science Fiction Magazine*.
Cartoons: "We are looking for cartoons with an emphasis on mystery, crime and suspense."
Illustration: Prefers line drawings. All other artwork is done inhouse. Send SASE and tearsheets or transparencies. Accepts disk submissions. Reports within 3 months. **Pays on acceptance**; $1,200 for color covers; $125 for b&w and spots.

RACQUETBALL MAGAZINE, 1685 W. Uintah, Colorado Springs CO 80904-2921. (719)535-9648. Fax: (719)535-0685. E-mail: lmojer@racqmag.com. Website: http://www.racqmag.com. Director of Communications/Editor: Linda Mojer. Bimonthly publication of The United States Racquetball Association. "Distributed to members of USRA and industry leaders in racquetball. Focuses on both amateur and professional athletes." Circ. 50,000. Accepts previously published artwork. Originals returned at job's completion. Sample copies and art guidelines available.
Cartoons: Needs editorial illustration. Prefers racquetball themes. Send query letter with roughs. Samples are filed. Publication will contact artist for portfolio review if interested. Negotiates rights purchased. Pays $50 for b&w, $50 for color (payment negotiable).
Illustration: Approached by 5-10 illustrators/year. Usually works on assignment. Prefers racquetball themes. Freelanc-

ers should be familiar with Aldus PageMaker. Send postcard samples. Accepts disk submissions. Samples are filed. Publication will contact artist for portfolio review if interested. Negotiates rights purchased. Pays on publication; $200 for color cover; $50 for b&w, $50 for color inside (all fees negotiable).

RADIANCE, The Magazine for Large Women, P.O. Box 30246, Oakland CA 94604. Phone/fax: (510)482-0680. E-mail: radmag2@aol.com. Website: http://www.radiancemagazine.com. Publisher/Editor: Alice Ansfield. Estab. 1984. Quarterly consumer magazine "for women *all* sizes of large—encouraging them to live fully *now*." Covers health, media, fashion and politics. "A leading resource in the worldwide size acceptance movement." Circ. 14,000 and rising. Accepts previously published artwork. Original artwork returned at job's completion. Sample copy for $3.50 plus postage.

Cartoons: Approached by 200 cartoonists/year. Buys 3 cartoons/year. Wants empowering messages for large women, with humor and perspective on women's issues; single, double or multiple panel b&w or 2-color line drawings with gagline. "We'd like to see any format." Send query letter with brochure, roughs and finished cartoons or postcard-size sample. Samples are filed or are returned by SASE if requested by artist. Buys one-time rights. Pays $15-50 for b&w.

Illustration: Approached by 200 illustrators/year. Buys 3 illustrations/year. Features fashion, humorous and realistic illustration; informational graphics; spot illustration. Assigns 50% of illustrations to experienced, but not well-known illustrators; 50% to new and emerging illustrators. Considers pen & ink, watercolor, airbrush, acrylic, colored pencil, collage and mixed media. 10% of freelance works demands knowledge of Adobe Illustrator, QuarkXPress, Adobe Photoshop, Aldus FreeHand on Macintosh. Send postcard sample or query letter with brochure, photocopies, photographs, SASE and tearsheets. Samples are filed or are returned by SASE if requested by artist. Reports back in 3-4 months. Buys one-time rights. Pays on publication; $30-60 for b&w cover; $100 minimum for color cover.

Design: Needs freelancers for design, production, multimedia. 50% of freelance work demands knowledge of Adobe Photoshop, Adobe Illustrator, Aldus FreeHand, QuarkXPress. Send query letter with brochure, photocopies, SASE, tearsheets, résumé, photographs. Pays for design by the project; pay is negotiable.

Tips: "Read our magazine. Find a way to help us with our goals and message. We welcome new and previously published freelancers to our magazine. I'd recommend reading *Radiance* to get a feel for our design, work, editorial tone and philosophy. See if you feel your work could contribute to what we're doing and send us a letter with samples of your work or ideas on what you'd like to do!"

RAG MAG, Box 12, Goodhue MN 55027. (651)923-4590. Contact: Beverly Voldseth. Estab. 1982. Semiannual (spring and winter) b&w magazine emphasizing poetry, graphics, fiction and reviews for small press, writers, poets and editors. Circ. 300. Accepts previously published material. "Send no original art or photos—copies please." Sample copy $6; art guidelines available for SASE with first-class postage.

● Does not accept any work during June, July and August. Work received in those months will be returned unread.

Cartoons: Approached by 4-5 cartoonists/year. Acquires 2 cartoons/issue. Any theme or style. Prefers single panel or multiple panel b&w line drawings with gagline. Send only finished cartoons. Material returned in 2 months by SASE if unwanted. Reports within 2 months. Acquires first rights. Pays in copies only.

Illustration: Approached by up to 12 illustrators/year. Acquires 6 illustrations/issue. Has featured illustrations by Walt Philips, Kathryn DiLego, Nazly Botas, JoAnn E. Kitchel and Wayne Hogan. Any style or theme. Send camera-ready copy (3-6 pages of your best work). Samples and responses returned only by SASE. Reports within 1 month. Portfolio review not required. Acquires first rights. Pays in copies.

Tips: "I choose artwork for its own appeal—just as I choose the poems and short stories. I only take what's ready to be used on receipt. I return what I don't want. I don't hold anything in my files because I think artists should be sending their artwork around. And even if I like someone's artwork very much, I like to use new people. I do not want to see anything portraying violence. Be sure your name and address is somewhere on each submitted page of work."

RANGER RICK, 8925 Leesburg Pike, Vienna VA 22184. (703)790-4000. Website: http://www.nwf.org. Art Director: Donna D. Miller. Monthly 4-color children's magazine focusing on wildlife and conversation. Circ. 700,000. Art guidelines are free for #10 SASE with first-class postage.

Cartoons: Approached by 100-200 illustrators/year. Buys 4-6 illustrations/issue. Has featured illustrations by Danielle Jones, Jack Desrocher, John Dawson and Dave Clegg. Features computer, humorous, natural science and realistic illustrations. Preferred subjects: children, wildlife and natural world. Assigns 4% of illustrations to well-known or "name" illustrators; 95% to experienced, but not well-known illustrators; 1% to new and emerging illustrators. 50% of freelance illustration demands knowledge of Adobe Illustrator, Adobe Photoshop. Send query letter with printed samples, photocopies and SASE. Accepts Mac-compatible disk submissions. Samples are filed or returned by SASE. Reports back within 3 months. Will contact artist for portfolio review if interested. Buys one-time rights. Pays on publication; $50-250 for b&w inside; $150-800 for color inside; $1,000-2,000 for 2-page spreads; $350-450 for spots. Finds illustrators through Graphic Artists Guild, promotional samples, Guild of Natural Science Illustrators.

Tips: "Looking for new artists to draw animals using Illustrator, Photoshop and other computer drawing programs.

HUMOR & CARTOON markets are listed in the Humor & Cartoon Index located at the back of this book.

Submit an original game idea—hidden picture, maze, what's wrong here etc."

RAPPORT, 5265 Fountain Ave., Los Angeles CA 90029. (323)660-0433. Art Director: Crane Jackson. Estab. 1974. Bimonthly entertainment magazine featuring book and CD reviews; music focus is on jazz, some popular music. Circ. 52,000. Originals not returned.
Illustration: Approached by 12 illustrators/year. Buys 6 illustrations/issue. Works on assignment only. Prefers airbrush and acrylic. Send postcard sample and brochure. Samples are filed. Reports back within 2 months. Pays $100 for cover illustration; $50-100 for b&w inside; $100 for color inside.
Tips: "As a small publication, we try to pay the best we can. We do not want artists who have a fixed amount for payment when they see us. We give good exposure for artists who will illustrate our articles. If we find good artists, they'll get a lot of work, payment on receipt and plenty of copies of the magazine to fill their portfolios. Several artists have been recruited by book publishers who have seen their work in our magazine, which reviews more than 100 books from all publishers. We do not want artists who demand to be paid more. We are open to newcomers as well as established artists. Art for art's sake is disappearing from magazines. We'll suggest art to illustrate articles, or will supply article. Publication will contact artist when the proper article arises."

REAL PEOPLE MAGAZINE, 450 Seventh Ave., Suite 1701, New York NY 10123. (212)244-2351. Fax: (212)244-2367. E-mail: mrs-2@idt.net. Editor: Alex Polner. Estab. 1988. "Bimonthly 4-color and b&w entertainment magazine featuring celebrities and show business articles, profiles for men and women ages 35 and up." Circ. 100,000. Original artwork returned after publication. Sample copy for $3.50 plus postage; art guidelines not available.
Illustration: Buys 1-2 color illustrations/issue and 4-6 b&w/issue. Works on assignment only. Has featured illustrations by Brad Walker, Chris Sabatino, Matt Baier, Tina Marie, Tom La Baff and Chad Crowe. Features caricatures of celebrities and politicians, humorous and spot illustration. Assigns 25% of illustrations to experienced, but not well-known illustrators; 75% to new and emerging illustrators. Theme or style depends on the article. Prefers pen & ink, watercolor, acrylic and collage with strong concept and/or sense of humor. Send query letter with tearsheets. Samples are filed. Artist should follow up after initial query. Publication will contact artist for portfolio review if interested. Buys all publishing rights. Pays on publication; $150 for b&w inside; $250-300 for color inside; $75-100 for spots.
Tips: "We prefer illustration with a sense of humor. Show us range—both color and black & white."

REASON, 3415 S. Sepulveda Blvd., Suite 400, Los Angeles CA 90034-6064. (310)391-2245. Fax: (310)391-4395. E-mail: edreason@aol.com. Website: http://www.reason.com. Art Director: Barb Burch. Estab. 1969. Monthly consumer magazine of libertarian public policy—political, social and cultural issues. Circ. 55,000. Art guidelines not available.
Illustration: Buys 1-2 illustrations/issue. Considers all media. Send postcard sample. Samples are filed. Does not report back. Art director will contact artist for portfolio review if interested. Buys one-time rights. Pays on publication; $600-1,200 for color cover; $200 minimum for b&w inside.

☑ **REDBOOK MAGAZINE**, Redbook Art Dept., 224 W. 57th St., 6th Floor, New York NY 10019. (212)649-2000. Creative Director: Marilou Lopez. Monthly magazine "geared to married women ages 24-39 with young children and busy lives. Interests in fashion, food, beauty, health, etc." Circ. 7 million. Accepts previously published artwork. Original artwork returned after publication with additional tearsheet if requested.
Illustration: Buys 3-7 illustrations/year. "We prefer photo illustration for fiction and more serious articles, loose or humorous illustrations for lighter articles. Illustrations can be in any medium. Portfolio drop off any day, pick up 2 days later. To show a portfolio, mail work samples that will represent the artist and do not have to be returned. This way the sample can remain on file, and the artist will be called if the appropriate job comes up." Accepts fashion illustrations for fashion page. Send illustrations to the attention of Jennifer Madara, associate art director. Buys reprint rights or negotiates rights.
Tips: "Look at the magazine before you send anything, we might not be right for you. Generally, illustrations should look new, of the moment, intelligent."

☑ **REFORM JUDAISM**, 633 Third Ave., 6th Floor, New York NY 10017-6778. (212)650-4240. Managing Editor: Joy Weinberg. Estab. 1972. Quarterly magazine. "The official magazine of the Reform Jewish movement. It covers developments within the movement and interprets world events and Jewish tradition from a Reform perspective." Circ. 300,000. Accepts previously published artwork. Originals returned at job's completion. Sample copies available for $3.50.
Cartoons: Prefers political themes tying into editorial coverage. Send query letter with finished cartoons. Samples are filed. Reports back within 3-4 weeks. Buys first rights, one-time rights and reprint rights.
Illustration: Buys 8-10 illustrations/issue. Works on assignment. 10% of freelance work demands computer skills. Send query letter with brochure, résumé, SASE and tearsheets. Samples are filed. Reports back within 3-4 weeks. Publication will contact artist for portfolio review if interested. Portfolio should include tearsheets, slides and final art. Rights purchased vary according to project. **Pays on acceptance**; varies according to project. Finds artists through sourcebooks and artists' submissions.

N **RELIX MAGAZINE**, P.O. Box 94, Brooklyn NY 11229. (718)258-0009. Website: http://www.Relix.com. Publisher: Toni Brown. Estab. 1974. Bimonthly consumer magazine emphasizing the Grateful Dead and psychedelic music. Circ. 70,000. Does not accept previously published artwork.

Cartoons: Approached by 20 cartoonists/year. Prefers Grateful Dead-related humorous cartoons, single or multiple panel b&w line drawings. Send query letter with finished cartoons. Samples are not filed and are returned by SASE if requested by artist. Reports back to the artist only if interested. Pays $25-75 for b&w, $100-200 for color. Buys all rights.

Illustration: Approached by 100 illustrators/year. Buys multiple illustrations/issue. Prefers Grateful Dead-related. Considers pen & ink, airbrush and marker. Send query letter with SASE and photocopies. Samples are not filed and are returned by SASE if requested by artist. Reports back to the artist only if interested. Portfolio review not required. Buys all rights. Pays on publication; $75-150 for b&w, $100-200 for color cover; $15-75 for b&w inside; $15-25 for spots. Finds artists through word of mouth.

Tips: "Looking for skeleton artwork—happy, not gorey."

N THE REPORTER, Women's American ORT, 315 Park Ave. S., New York NY 10010. (212)505-7700. Fax: (212)674-3057. Editor: Aviva Patz. Estab. 1966. Quarterly organization magazine for Jewish women emphasizing Jewish and women's issues, lifestyle, education. *The Reporter* is the magazine of Women's ORT, a membership organization supporting a worldwide network of technical and vocational schools. Circ. 80,000. Original artwork returned at job's completion. Sample copies for SASE with first-class postage.

Illustration: Buys 1-5 illustrations/issue. Works on assignment only. Prefers contemporary art. Considers pen & ink, mixed media, watercolor, acrylic, oil, charcoal, airbrush, collage and marker. Send postcard sample or query letter with brochure, SASE and photographs. Samples are filed. Reports back to the artist only if interested. Rights purchased vary according to project. Pays on publication; $150 and up, depending on work.

N RESIDENT AND STAFF PHYSICIAN, 1065 Old Country Rd., #213, Westbury NY 11590. (516)883-6350. Executive Editor: Anne Mattarella. Monthly publication emphasizing hospital medical practice from clinical, educational, economic and human standpoints. For hospital physicians, interns and residents. Circ. 100,000.

Cartoons: Buys 3-4 cartoons/year from freelancers. "We occasionally publish sophisticated cartoons in good taste dealing with medical themes." Reports in 2 weeks. Buys all rights. **Pays on acceptance**; $25.

Illustration: "We commission qualified freelance medical illustrators to do covers and inside material. Artists should send sample work." Send query letter with brochure showing art style or résumé, tearsheets, photostats, photocopies, slides and photographs. Call or write for appointment to show portfolio of color and b&w final reproduction/product and tearsheets. **Pays on acceptance**; $800 for color cover; payment varies for inside work.

Tips: "We like to look at previous work to give us an idea of the artist's style. Since our publication is clinical, we require highly qualified technical artists who are very familiar with medical illustration. Sometimes we have use for nontechnical work. We like to look at everything. We need material from the *doctor's* point of view, *not* the patient's."

N RESTAURANT HOSPITALITY, 1100 Superior Ave., Cleveland OH 44114. (216)931-9942. Fax: (216)696-0836. E-mail: crobertoenton.com. Editor-in-Chief: Michael Sanson. Art Director: Christopher Roberto. Circ. 123,000. Estab. 1919. Monthly trade publication emphasizing "hands-on resturant management ideas and strategies." Readers are restaurant owners, chefs and food service chain executives.

Illustration: Approached by 150 illustrators/year. Buys 5-10 illustrations per issue (combined assigned and stock illustration.) Prefers food and business related illustration in a variety of styles. Illustrations should tie-in with the restaurant industry. Has featured illustrations by Mark Shaver, Paul Watson and Brian Raszka. Assigns 10% of illustrations to well-known or "name" illustrators; 60% to experienced, but not well-known illustrators; and 30% to new and emerging illustrators. Welcomes stock submissions. Send postcard samples and follow-up card every 3-6 motnhs. Buys one-time rights. **Pays on acceptance**; $400-500 full page; $300-350 quarter-page; $250-350 for spots.

Tips: "I like to work with illustrators who are trying new techniques. I particularly enjoy contemporary styles and themes that are exciting and relevant to our industry. If you have a website, please include your URL on your sample so I can view more of your work online."

N THE RETIRED OFFICER, 201 N. Washington St., Alexandria VA 22314. (703)549-2311. Art Director: M.L. Woychik. Estab. 1945. Four-color magazine for retired officers of the uniformed services; concerns current military/political affairs; recent military history, especially Vietnam and Korea; holiday anecdotes; travel; human interest; humor; hobbies; second-career job opportunities and military family lifestyle.

Illustration: Works with 9-10 illustrators/year. Buys 15-20 illustrations/year. Buys illustrations on assigned themes. (Generally uses Washington DC area artists.) Uses freelancers mainly for features and covers. Send samples.

Tips: "We look for artists who can take a concept and amplify it editorially."

N RHODE ISLAND MONTHLY, 280 Kinsley Ave., Providence RI 02903-4161. (401)421-2552. Fax: (401)831-5624. Art Director: Kate Adams. Estab. 1988. Monthly 4-color magazine which focuses on life in Rhode Island. Provides the reader with in-depth reporting, service and entertainment features and dining and calendar listings. Circ. 40,000. Accepts previously published artwork. Art guidelines not available.

• Also publishes a bride magazine, campus guide, tourism-related publications and health-related publications.

Illustration: Approached by 20 freelance illustrators/year. Buys 1-2 illustrations/issue. Works on assignment and sometimes on spec. Considers all media. Send query letter with SASE, tearsheets, photographs and slides. Samples are filed. Request portfolio review in original query. Publication will contact artist for portfolio review if interested. Portfolio should include b&w and color tearsheets. Buys one-time rights. Sometimes requests work on spec before assigning job.

Pays on publication; $150 for b&w, $250 minimum for color inside, depending on the job. Finds artists through word of mouth, submissions/self-promotions and sourcebooks.

Tips: "Ninety-five percent of our visual work is done by photographers. That's what works for us. We are glad to file illustration samples and hire people with appropriate styles at the appropriate time. I need to look at portfolios quickly. I like to know the illustrator knows a little bit about *RI Monthly* and has therefore edited his/her work down to a manageable amount to view in a short time."

RICHMOND MAGAZINE, 2500 E. Parham Rd., Suite 200, Richmond VA 23228. (804)261-0034. Fax: (804)261-1047. E-mail: tylerd@richmag.com. Website: http://www.richmag.com. Art Director: Tyler Darden. Assistant Art Director: Gwen Richlen. Graphic Artist: Arnel Reynon. Estab. 1980. Monthly 4-color regional consumer magazine focusing on Richmond lifestyles. Circ. 21,000. Art guidelines free for #10 SASE with first-class postage.

Cartoons: Approached by 20 cartoonists/year. Buys 5-10 cartoons/year. Prefers humorous, witty, Richmond-related, single panel, humorous color washes. Send query letter with color photocopies. Samples are filed and not returned. Reports back only if interested. Buys one-time rights. Pays on publication; $75-150 for b&w; $75-200 for color cartoons.

Illustration: Approached by 30 illustrators/year Buys 1-2 illustrations/issue. Has featured illustrations by Kelly Alder, Kerry Talbott, Joel Priddy. Features humorous, realistic, conceptional, medical and spot ilustrations. Assigns 75% of illustrations to experienced, but not well-known illustrators; 25% to new and emerging illustrators. Send postcard sample or query letter with photocopies, tearsheets or other non-returnable samples and SASE. Send follow-up postcard every 2 months. Accepts Mac-compatible disk submissions. Send EPS files. Samples are filed or returned by SASE. Will contact artist for portfolio review if interested. Pays $150-200 for b&w cover; $200-500 for color cover; $50-100 for b&w inside; $150-300 for color inside; $200-400 for 2-page spreads; $75 for spots. Finds illustrators through promo samples, word of mouth, regional soucebooks.

Tips: "Be dependable, on time and have strong concepts."

N: RISK MANAGEMENT, 655 Third Ave., 2nd Floor, New York NY 10017. (212)286-9292. Art Director: Craig Goldberg. "Updated redesign has more color and '90s graphics." Emphasizes the risk management and insurance fields; 4-color. Monthly. Circ. 11,600.

Illustration: Buys 5-8 freelance illustrations/issue. Uses artists for covers, 4-color inside and spots. Works on assignment only. Send card showing art style or tearsheets. Drop-off policy. To show a portfolio, mail original art and tearsheets. Printed pieces as samples only. Samples are returned only if requested. Buys one-time rights. Needs conceptual illustration. Needs computer-literate freelancers for illustration and production. 15% of freelance work demands computer literacy in Adobe Illustrator, Quark XPress or Photoshop.

Tips: When reviewing an artist's work, looks for "strong concepts, creativity and craftsmanship. Our current design uses more illustration and photography."

N: THE ROANOKER MAGAZINE, P.O. Box 21535, Roanoke VA 24018. (540)989-6138. E-mail: art@leisurepublishing.com. Website: http://www.theroanoker.com. Art Director: Joan Ramsay-Johnson. Estab. 1974. Monthly general interest magazine for the city of Roanoke, Virginia and the Roanoke valley. Circ. 10,000. Originals are returned. Art guidelines not available.

Illustration: Approached by 20-25 freelance illustrators/year. Buys 2-5 illustrations/year. Works on assignment only. Send query letter with brochure, tearsheets and photocopies. Samples are filed. Reports back only if interested. No portfolio reviews. Buys one-time rights. Pays on publication; $100 for b&w or color cover; $75 for b&w or color inside.

Tips: "Please *do not* call or send any material that needs to be returned."

ROCKFORD REVIEW, P.O. Box 858, Rockford IL 61105. Website: http://www.welcome.to/rwg. Editor: David Ross. Estab. 1971. Triquarterly literary magazine emphasizing literature and art which contain fresh insights into the human condition. Circ. 750. Sample copy for $5. Art guidelines free for SASE with first-class postage.

Illustration: Approached by 8-10 illustrators/year. Buys 1-2 illustrations/issue. Has featured illustrations by JP Henderson, Christine Schneider. Features humorous, computer and satirical illustration. Prefers satire/human condition. Considers pen & ink and marker. Needs computer-literate freelancers for illustration. Send query letter with photographs, SASE and photocopies. Samples are not filed and are returned by SASE. Reports back within 2 months. Portfolio review not required. Publication will contact artist for portfolio review if interested. Buys first rights. Pays on publication; 1 copy plus eligiblity for $25 Editor's Choice Prize (6 each year)—and guest of honor at summer party. Finds artists through word of mouth and submissions.

Tips: "If something people do makes you smile, go 'hmph' or shake your head, draw it and send it to us. We are starving for satire on the human condition."

ROLLING STONE MAGAZINE, 1290 Avenue of the Americas, New York NY 10104. Website: http://www.rollingstone.com. Estab. 1967. Bimonthly magazine. Circ. 1.4 million. Originals returned at job's completion. 100% of freelance design work demands knowledge of Adobe Illustrator, QuarkXPress and Adobe Photoshop. (Computer skills not necessary for illustrators).

Illustration: Approached by "tons" of illustrators/year. Buys approximately 4 illustrations/issue. Works on assignment only. Considers all media. Send postcard sample and/or query letter with tearsheets, photocopies or any appropriate sample. Samples are filed. Does not report back. Portfolios may be dropped off every Tuesday 10 a.m. and should include final art and tearsheets. Publication will contact artist for portfolio review if interested. Buys first and one-time

rights. **Pays on acceptance**; payment for cover and inside illustration varies; pays $300-500 for spots. Finds artists through word of mouth, *American Illustration, Communication Arts*, mailed samples and drop-offs.

N ☑ ROOM OF ONE'S OWN, Box 46160, Station D, Vancouver, British Columbia V6J 5G5 Canada. Website: http://www.islandnet.com/Room/enter. Contact: Editor. Estab. 1975. Quarterly literary journal. Emphasizes feminist literature for women and libraries. Circ. 1,000. Original artwork returned after publication if requested. Sample copy for $7; art guidelines for SASE (nonresidents include 3 IRCs).
Cartoons: Pays $25 minimum for b&w and color.
Illustration: Buys 3-5 illustrations/issue from freelancers. Prefers good b&w line drawings. Prefers pen & ink, then charcoal/pencil and collage. Send photostats, photographs, slides or original work as samples to be kept on file. Samples not kept on file are returned by SAE (nonresidents include IRC). Reports within 6 months. Buys first rights. Pays $25-50, b&w, color; on publication.

THE ROTARIAN, 1560 Sherman Ave., Evanston IL 60201. Editor-in-Chief: Willmon L. White. Art Director: F. Sanchez. Estab. 1911. Monthly 4-color publication emphasizing general interest, business and management articles. Service organization for business and professional men and women, their families and other subscribers. Accepts previously published artwork. Sample copy and editorial fact sheet available.
Cartoons: Approached by 14 cartoonists/year. Buys 5-8 cartoons/issue. Interested in general themes with emphasis on business, sports and animals. Avoid topics of sex, national origin, politics. Send query letter to Cartoon Editor, Charles Pratt, with brochure showing art style. Reports in 1-2 weeks. Buys all rights. **Pays on acceptance**; $100.
Illustration: Approached by 8 illustrators/year. Buys 10-20 illustrations/year; 7-8 humorous illustrations/year from freelancers. Uses freelance artwork mainly for covers and feature illustrations. Most editorial illustrations are commissioned. Send query letter to art director with photocopies or brochure showing art style. To show portfolio, artist should follow-up with a call or letter after initial query. Portfolio should include original/final art, final reproduction/product, color and photographs. Sometimes requests work on spec before assigning job. Buys all rights. **Pays on acceptance**; payment negotiable, depending on size, medium, etc.; $800-1,000 for color cover; $75-150 for b&w inside; $200-700 for color inside.
Tips: "Preference given to area talent. We're looking for a wide range of styles, although our subject matter might be considered somewhat conservative by those steeped in the avant-garde."

RUNNER'S WORLD, 33 E. Minor St., Emmaus PA 18098. (610)967-5171. Fax: (610)967-8883. Website: http://www.RUNNERSWORLD.com. Art Director: Ken Kleppert. Associate Director: Glenn Hughes. Estab. 1965. Monthly 4-color with a "contemporary, clean" design emphasizing serious, recreational running. Circ. 470,000. Accepts previously published artwork "if appropriate." Returns original artwork after publication. Art guidelines not available.
Illustration: Approached by hundreds of illustrators/year. Works with 50 illustrators/year. Buys average of 10 illustrations/issue. Has featured illustrations by Sam Hundley, Gil Eisner, Randall Enos and Katherine Adams. Features humorous and realistic illustration; charts & graphics; informational graphics; computer and spot illustration. Assigns 40% of illustrations to well-known or "name" illustrators; 40% to experienced, but not well-known illustrators; 20% to new and emerging illustrators. Needs editorial, technical and medical illustrations. "Styles include tightly rendered human athletes, graphic and cerebral interpretations of running themes. Also, *RW* uses medical illustration for features on biomechanics." No special preference regarding media, but appreciates electronic transmission. "No cartoons or originals larger than 11×14." Works on assignment only. 30% of freelance work demands knowledge of Adobe Illustrator, Adobe Photoshop or Aldus FreeHand. Send postcard samples to be kept on file. Accepts submissions on disk compatible with Adobe Illustrator 5.0. Send EPS files. Publication will contact artist for portfolio review if interested. Buys one-time international rights. Pays $1,800 maximum for 2-page spreads; $400 maximum for spots. Finds artists through word of mouth, magazines, submissions/self-promotions, sourcebooks, artists' agents and reps, and attending art exhibitions.
Tips: Portfolio should include "a maximum of 12 images. Show a clean presentation, lots of ideas and few samples. Don't show disorganized thinking. Portfolio samples should be uniform in size. Be patient!"

RURAL HERITAGE, 281 Dean Ridge Lane, Gainesboro TN 38562-5039. (931)268-0655. E-mail: editor@ruralheritage.com. Website: http://www.ruralheritage.com. Editor: Gail Damerow. Estab. 1976. Bimonthly farm magazine "published in support of modern-day farming and logging with draft animals." Circ. 4,000. Sample copy for $6 postpaid; art guidelines not available.
Cartoons: Approached by "not nearly enough" cartoonists/year. Buys 2 or more cartoons/issue. Prefers bold, clean, minimalistic draft animals and their relationship with the teamster. Prefers single panel, humorous, b&w line drawings with or without gagline. Send query letter with finished cartoons and SASE. Samples are not filed (unless we plan to use them—then we keep them on file until used) and are returned by SASE. Reports back within 2 months. Buys first North American serial rights or all rights very occasionally. Pays on publication; $10 for one-time rights; $20 for all rights.
Tips: "Know draft animals (horses, mules, oxen, etc.) well enough to recognize humorous situations intrinsic to their use or that arise in their relationship to the teamster."

SACRAMENTO MAGAZINE, 4471 D Street, Sacramento CA 95819. (916)452-6200. Fax: (916)452-6061. Website: http://www.sacmag.com. Art Director: Debbie Hurst. Estab. 1975. Monthly consumer lifestyle magazine with emphasis

on home and garden, women, health features and stories of local interest. Circ. 20,000. Accepts previously published artwork. Originals returned to artist at job's completion. Sample copies available.

Illustration: Approached by 100 illustrators/year. Buys 5 illustrations/year. Works on assignment only. Considers pen & ink, collage, airbrush, acrylic, colored pencil, oil, marker and pastel. Send postcard sample. Accepts disk submissions. Send EPS files. Samples are filed and are not returned. Publication will contact artist for portfolio review if interested. Portfolio should include b&w and color tearsheets and final art. Buys one-time rights. Pays on publication; $300-400 for color cover; $200-500 for b&w or color inside; $100-200 for spots. Finds artists through submissions.

Tips: Sections most open to freelancers are departments and some feature stories.

SACRAMENTO NEWS & REVIEW, 1015 20th St., Sacramento CA 95814. (916)498-1234. Fax: (916)489-7920. E-mail: donb@newsreview.com. Website: http://www.newsreview.com. Art Director: Don Button. Estab. 1989. "An award-winning black & white with 4-color cover alternative newsweekly for the Sacramento area. We combine a commitment to investigative and interpretive journalism with coverage of our area's growing arts and entertainment scene." Circ. 90,000. Occasionally accepts previously published artwork. Originals returned at job's completion. Art guidelines not available.

● Also publishes issues in Chico, CA and Reno, NV.

Illustration: Approached by 50 illustrators/year. Buys 1 illustration/issue. Works on assignment only. Features caricatures of celebrities and politicans; humorous, realistic, computer and spot illustrations. Assigns 5% of illustrations to well-known or "name" illustrators; 45% to experienced, but not well-known illustrators; 50% to new and emerging illustrators. For cover art, needs themes that reflect content. Send postcard sample or query letter with photocopies, photographs, SASE, slides and tearsheets. Accepts disk submissions compatible with Photoshop 4.0. Samples are filed. Publication will contact artist for portfolio review if interested. Portfolio should include tearsheets, slides, photocopies, photographs or Mac floppy disk. Buys first rights. **Pays on acceptance**; $75-150 for b&w cover; $150-300 for color cover; $20-75 for b&w inside; $10-40 for spots. Finds artists through submissions.

Tips: "Looking for colorful, progressive styles that jump off the page. Have a dramatic and unique style . . . not traditional or common."

SALES & MARKETING MANAGEMENT MAGAZINE, 355 Park Ave. S., New York NY 10010-1789. (212)592-6300. Fax: (212)592-6309. Website: http://www.salesandmarketing.com. Art Director: Victoria Beerman. Estab. 1918. Monthly 4-color trade magazine for sales and marketing executives. Circ. 65,000.

Cartoons: Approached by 10 cartoonists/year. Buys 12 cartoons/year. Prefers single panel, humorous b&w line drawings. Send b&w photocopies and SASE. Samples are filed or returned by SASE. Reports back only if interested. Buys reprint rights or rights purchased vary according to project. Pays on publication; $150.

Illustration: Approached by 250-350 illustrators/year. Buys 1-10 illustrations/issue. Has featured illustrations by Philip Burke, Robert Risko, William Duke, Richard Downs, Amanda Duffy, Harry Campbell, Brian Raszka, Tim Hussey, Katherine Streeter. Features caricatures of celebrities, charts & graphs, computer, humorous, realistic and spot illustrations. Prefers business subjects, men and women. Prefers hip, fresh styles—all media. Avoid standard "business-looking" work in favor of more current approaches. Assigns 25% of illustrations to well-known or "name" illustrators; 50% to experienced, but not well-known illustrators; 25% to new and emerging illustrators. 50% of freelance illustration demands knowledge of Adobe Illustrator or Adobe Photoshop. "Use illustrators that work in all media, so computer skills only necessary if that's how artist works." Send postcard, printed samples, photocopies or tearsheets. Accepts Mac-compatible disk submissions (Prefers printed samples). Samples are filed or returned by SASE. Will contact artist for portfolio review if interested. Buys first North American serial rights. Pays on publication; $800-1,100 for color cover; $650-1,000 full page color inside; $800-1,100 for 2-page spreads; $150-250 for spots. Finds illustrators through all sources, but prefers artist's promo samples.

Tips: "We like to use cutting-edge illustrators who can come up with creative solutions quickly and on time. It's exciting when the illustrators come up with an idea I never would have thought of myself!"

SAN FRANCISCO BAY GUARDIAN, 520 Hampshire St., San Francisco CA 94110. (415)255-3100. Website: http://www.sfbg.com. Art Director: Elyse Hochstadt. For "a young, liberal, well-educated audience." Circ. 157,000. Weekly newspaper; tabloid format, b&w with 4-color cover, "progressive design." Art guidelines not available.

Illustration: Has featured illustrations by Mark Matcho, John Veland, Barbara Pollack, Gabrielle Drinard and Gus D'Angelo. Features caricatures of politicans; humorous, realistic and spot illustration. Assigns 10% of illustrations to well-known or "name" illustrators; 60% to experienced, but not well-known illustrators; 30% to new and emerging illustrators. Weekly assignments given to local artists. Subjects include political and feature subjects. Preferred styles include contemporary, painterly and graphic line—pen and woodcut. "We like intense and we like fun." Artists who exemplify desired style include Tom Tommorow, George Rieman and Bonnie To. Pays on publication; $300-315 for b&w and color cover; $34-100 for b&w inside; $75-150 for color inside; $100-250 for 2-page spreads; $34-100 for spots.

Design: 100% of freelance work demands knowledge of Adobe Photoshop, Adobe Illustrator, QuarkXPress. Prefers diversified talent. Send query letter with photocopies, photographs and tearsheets. Pays for design by the project.

Tips: "Please submit samples and letter before calling. Turnaround time is generally short, so long-distance artists generally will not work out." Advises freelancers to "have awesome work—but be modest."

THE SATURDAY EVENING POST, Dept. AM, The Saturday Evening Post Society, 1100 Waterway Blvd., Indianapolis IN 46202. (317)636-8881. Estab. 1897. General interest, family-oriented magazine. Published 6 times/year. Circ. 500,000. Sample copy $4.

Cartoons: Cartoon Editor: Steven Pettinga. Buys about 35 cartoons/issue. Uses freelance artwork mainly for humorous fiction. Prefers single panel with gaglines. Receives 100 batches of cartoons/week. "We look for cartoons with neat line or tone art. The content should be in good taste, suitable for a general-interest, family magazine. It must not be offensive while remaining entertaining. We prefer that artists first send SASE for guidelines and then review recent issues. Political, violent or sexist cartoons are not used. Need all topics, but particularly medical, health, travel and financial." SASE. Reports in 1 month. Buys all rights. Pays on publication; $125 for b&w line drawings and washes, no pre-screened art.

Illustration: Art Director: Chris Wilhoite. Uses average of 3 illustrations/issue. Send query letter with brochure showing art style or résumé and samples. To show a portfolio, mail final art. Buys all rights, "generally. All ideas, sketchwork and illustrative art are handled through commissions only and thereby controlled by art direction. Do not send original material (drawings, paintings, etc.) or 'facsimiles of' that you wish returned." Cannot assume any responsibility for loss or damage. "If you wish to show your artistic capabilities, please send nonreturnable, expendable/sampler material (slides, tearsheets, photocopies, etc.)." Pays $1,000 for color cover; $175 for b&w, $450 for color inside.

Tips: "Send samples of work published in other publications. Do not send racy or too new wave looks. Have a look at the magazine. It's clear that 50 percent of the new artists submitting material have not looked at the magazine."

THE SCHOOL ADMINISTRATOR, %American Association of School Administrators, 1801 N. Moore St., Arlington VA 22209. (703)875-0753. Fax: (703)528-2146. E-mail: lgriffin@aasa.org. Website: http://www@aasa.org. Managing Editor: Liz Griffin. Monthly association magazine focusing on education. Circ. 18,000. Art guidelines available on website.

Cartoons: Approached by 8-10 editorial cartoonists/year. Buys 12 cartoons/year. Prefers editorial/humorous, b&w/color washes or b&w line drawings. "Humor should be appropriate to a CEO of a school system, not a classroom teacher." Send photocopies and SASE. Reports back only if interested. Buys one-time rights. **Pays on acceptance**.

Illustration: Approached by 60 illustrators/year. Buys 1-2 illustrations/issue. Has featured illustrations by Michael Gibbs, Ralph Butler and Danuta Jarecka. Features spot and computer illustrations. Preferred subjects: education K-12. Assigns 50% of illustrations to experienced, but not well-known illustrators; 50% to well-known or "name" illustrators. Considers all media. "Prefers illustrators who can take a concept and translate it into a simple powerful image and who can deliver art in digital form." Send non-returnable samples. Samples are filed and not returned. Reports back only if interested. Rights purchased vary according to project. Pays on publication; $400-650 for color cover. Finds illustrators through word of mouth, stock illustration source and Creative Sourcebook.

Tips: "Read our magazine. I like work that takes a concept and translates it into a simple, powerful image. Check out our website."

☑ **SCHOOL BUSINESS AFFAIRS**, 11401 N. Shore Dr., Reston VA 20190-4200. (703)478-0405. Fax: (703)478-0205. Publications Coordinator: Katherine Jones. Monthly trade publication for school business officials. Circ. 6,000. Accepts previously published artwork. Originals are returned at job's completion. Sample copies available; art guidelines not available.

Illustration: Buys 2 illustrations/issue. Prefers business-related themes. Send query letter with tearsheets. Accepts disk submissions compatible with IBM format; Adobe Illustrator 4.0. Samples are filed. Reports back to the artist only if interested. Portfolio review not required. Rights purchased vary according to project.

Tips: "Tell me your specialties, your style—do you prefer realistic, surrealistic, etc. Include range of works with samples."

THE SCIENCE TEACHER, 1840 Wilson, Arlington VA 22201-3000. (703)243-7100. Fax: (703)243-7177. Website: http://www.nsta.org/pubs/tst. Design Manager: Kim Alberto. Estab. 1958. Monthly education association magazine; 4-color with straightforward design. "A journal for high school science teachers, science educators and secondary school curriculum specialists." Circ. 27,000. Accepts previously published work. Original artwork returned at job's completion. Sample copies and art guidelines available.

Illustration: Approached by 75 illustrators/year. Buys 2 illustrations/issue. Works on assignment only. Has featured illustrations by Charles Beyl, Leila Cabib and Michael Teel. Features humorous and realistic illustration. Assigns most work to experienced, but not well-known illustrators. Considers pen & ink, airbrush, collage and charcoal. Needs conceptual pieces to fit specific articles. Send query letter with tearsheets and photocopies. Samples are filed. Publication will contact artist for portfolio review if interested. Buys one-time rights. Pays on publication; budget limited.

Tips: Prefers experienced freelancers with knowledge of the publication. "I have found a very talented artist through his own self-promotion, yet I also use a local sourcebook to determine artists' styles before calling them in to see their portfolios. Feel free to send samples, but keep in mind that we're busy, too. Please understand we don't have time to return samples or take calls."

N. SCRAP, 1325 G St. N.W., Suite 1000, Washington DC 20005-3104. (202)662-8547. Fax: (202)626-0947. E-mail: kentkiser@scrap.org. Website: http://www.scrap.org. Editor: Kent Kiser. Estab. 1987. Bimonthly 4-color trade publication that covers all aspects of the scrap recycling industry. Circ. 7,000.

Cartoons: "We haven't run cartoons yet but would reconsider for the right artists."

Illustration: Approached by 10 illustrators/year. Buys 3-4 illustrations/issue. Has featured illustrations by Scott Roberts, John Hersey, David Uhl and Steve Johnson. Features realistic illustrations, business/industrial/corporate illustrations and international/financial illustrations. Prefered subjects: business subjects. Assigns 90% of illustrations to experienced, but not well-known illustrators; 10% to new and emerging illustrators. Send postcard sample. Samples are filed. Reports back within 2 weeks. Portfolio review not required. Buys first North American serial rights. **Pays on acceptance**; $1,200-1,600 for color cover; $300-1,000 for color inside. Finds illustrators through creative sourcebook, mailed submissions, referrals from other editors, and "direct calls to artists whose work I see and like."

Tips: "We're always open to new talent and different styles. Our main requirement is the ability and willingness to take direction and make changes if necessary. No prima donnas, please. Send a postcard to let us see what you can do."

N SCREEN ACTOR, 5757 Wilshire Blvd., Los Angeles CA 90036. (323)954-1600. National Director of Communication: Katherine Moore. Estab. 1934. Quarterly trade journal; magazine format. Publishes the national and Hollywood "Call Sheet" newsletters, covering issues of concern to performers. Circ. 98,000. Accepts previously published work. Sample copies available.

☑ SCUBA TIMES MAGAZINE, 14110 Perdido Key Dr., Suite P2, Pensacola FL 32507. (850)492-7805. Fax: (850)492-7807. E-mail: scotbb@scubatimes.com. Website: http://www.scubatimes.com. Art Director: Scott Bieberich. Bimonthly magazine for scuba enthusiasts. Originals returned at job's completion. Editorial schedule is available.

Illustration: Approached by 10 illustrators/year. Buys 0-1 illustration/issue. Assigns 40% of illustrations to experienced, but not well-known illustrators; 60% to new and emerging illustrators. Considers all media, particularly interested in Photoshop digital collage techniques that compliment the contemporary design of the magazine. Send postcard sample or query letter with SASE and samples. Accepts disk submissions compatible with Windows. Send EPS or TIFF files. Samples are filed. Publication will contact artist for portfolio review if interested. Buys one-time rights. Pays on publication; $150 for color cover; $25-75 for b&w/color inside; $25-50 for spots. Finds artists through submissions and word of mouth.

Tips: "Be familiar with our magazine. Show us you can draw divers and their gear. Our readers will catch even the smallest mistake. Also a good thing to try would be to get an old issue and pick a story from either the advanced diving journal or the departments where we used a photo and show us how you would have used your art instead. This will show us your ability to conceptualize and your skill as an artist. Samples do not have to be dive-related to win assignments."

N SEA MAGAZINE, Box 17782 Cowan, Irvine CA 92614. Art Director: Jeffrey Fleming. Estab. 1908. Monthly 4-color magazine emphasizing recreational boating for owners or users of recreational powerboats, primarily for cruising and general recreation; some interest in boating competition; regionally oriented to 13 Western states. Circ. 55,000. Accepts previously published artwork. Return of original artwork depends upon terms of purchase. Sample copy for SASE with first-class postage.

● Also needs freelancers fluent in Quark and Photoshop for production.

Illustration: Approached by 20 illustators/year. Buys 10 illustrations/year mainly for editorial. Prefers pen & ink. Also considers airbrush, watercolor, acrylic and calligraphy. Send query letter with brochure showing art style. Samples are returned only if requested. Publication will contact artist for portfolio review if interested. Portfolio should include tearsheets and cover letter indicating price range. Negotiates rights purchased. Pays on publication; $50 for b&w; $250 for color inside (negotiable).

Tips: "We will accept students for portfolio review with an eye to obtaining quality art at a reasonable price. We will help start career for illustrators and hope that they will remain loyal to our publication."

☑ SEATTLE MAGAZINE, 701 Dexter Ave. N., Suite 101, Seattle WA 98109. (206)284-1750. Fax: (206)284-2550. Website: http://www.seattlemag.com. Art Director: Patrick Farabaugh. Estab. 1992. Monthly urban lifestyle magazine covering Seattle. Circ. 48,000. Call art director directly for art guidelines.

Illustration: Approached by hundreds of illustrators/year. Buys 2 illustrations/issue. Considers all media. "We can scan any type of illustration." Send postcard sample. Accepts disk submissions. Samples are filed. Reports back only if interested. Art director will contact artist for portfolio review of color, final art and transparencies if interested. Buys one-time rights. Sends payment on 15th of month of publication. Pays on publication; $150-1,100 for color cover; $50-400 for b&w; $50-1,100 for color inside; $50-400 for spots. Finds illustrators through agents, sourcebooks such as *Creative Black Book*, *LA Workbook*, online services, magazines, word of mouth, artist's submissions, etc.

Tips: "Good conceptual skills are the most important quality that I look for in an illustrator as well as unique skills."

SEEK, 8121 Hamilton Ave., Cincinnati OH 45231. (513)931-4050, ext. 365. Cartoon editor: Eileen H. Wilmoth. Emphasizes religion/faith. Readers are young adult to middle-aged adults who attend church and Bible classes. Quarterly in weekly issues. Circ. 45,000. Sample copy and art guidelines for SASE with first-class postage.

Cartoons: Approached by 6 cartoonists/year. Buys 8-10 cartoons/year. Buys "church or Bible themes—contemporary situations of applied Christianity." Prefers single panel b&w line drawings with gagline. Send finished cartoons, photocopies and photographs. Include SASE. Reports in 3-4 months. Buys first North American serial rights. **Pays on acceptance**; $30.

Illustration: Send b&w 8×10 glossy photographs.

SENIOR MAGAZINE, 3565 S. Higuera, San Luis Obispo CA 93401. (805)544-8711. Fax: (805)544-4450. Publisher: Gary Suggs. Estab. 1981. Monthly tabloid-sized magazine for people ages 40 and up. Circ. 300,000. Accepts previously published work. Original artwork returned at job's completion. Sample copies for SASE with first-class postage; art guidelines available for SASE.
Cartoons: Buys 1-2 freelance cartoons/issue. Prefers single panel with gagline. Send query letter with finished cartoons. Samples are filed. Reports back within 15 days. Pays $25 for b&w.
Illustration: Works on assignment only. "Would like drawings of famous people." Considers pen & ink. Send query letter with photostats. Samples are filed. Reports back within 15 days. Buys first rights or one-time rights. Pays on publication; $25 for b&w.

THE $ENSIBLE SOUND, 403 Darwin Dr., Snyder NY 14226. (716)833-0930. Fax: (716)833-0929 (5p.m.-9a.m.). E-mail: sensisound@aol.com. Publisher: John A. Horan. Editor: Karl Nehring. Bimonthly publication emphasizing audio equipment for hobbyists. Circ. 12,700. Accepts previously published material and simultaneous submissions. Original artwork returned after publication. Sample copy for $3.
Cartoons: Uses 4 cartoons/year. Prefers single panel, with or without gagline; b&w line drawings. Will accept material on mal-formatted disk or format via e-mail. Reports within 1 month. Negotiates rights purchased. Pays on publication; rate varies.
Tips: "Audio hobbyist material only please. We receive all types of material but never anything appropriate."

Ⓝ SHEEP! MAGAZINE, 128 E. Lake St., W., P.O. Box 10, Lake Mills WI 53551. (920)648-8285. Fax: (920)648-3770. Estab. 1980. A monthly publication covering sheep, wool and woolcrafts. Circ. 15,000. Accepts previously published work. Original artwork returned at job's completion.
Cartoons: Approached by 30 cartoonists/year. Buys 6-8 cartoons/issue. Considers all themes and styles. Prefers single panel with gagline. Send query letter with brochure and finished cartoons. Samples are returned. Reports back within 3 weeks. Buys first rights or all rights. Pays $15-25 for b&w; $50-100 for color.
Illustration: Approached by 10 illustrators/year. Buys 5 illustrations/year. Works on assignment only. Considers pen & ink, colored pencil, watercolor. Send query letter with brochure, SASE and tearsheets. Samples are filed or returned. Reports back within 3 weeks. To show a portfolio, mail thumbnails and b&w tearsheets. Buys first rights or all rights. **Pays on acceptance**; $45-75 for b&w, $75-150 for color cover; $45-75 for b&w, $50-125 for color inside.
Tips: "Demonstrate creativity and quality work."

SHEPHERD EXPRESS, 1123 N. Water St., Milwaukee WI 53202. (414)276-2222. Fax: (414)276-3312. Production Manager: Matthew Karshna. Estab. 1982. "A free weekly newspaper that covers news, entertainment and opinions that don't get covered in our daily paper. We are an alternative paper in the same genre as *LA Weekly* or New York's *Village Voice*." Circ. 58,000. Accepts previously published artwork. Sample copies free for SASE with first-class postage. Art guidelines not available.
Cartoons: Approached by 130 cartoonists/year. Buys 2-3 cartoons/issue. Prefers single panel, b&w line drawings. Send query letter with finished cartoon samples. Samples are filed. Reports back only if interested. Buys one-time rights. Pays $15 for b&w.
Illustration: Approached by 25 illustrators/year. Buys 1-2 illustrations/week. Works on assignment only. Considers pen & ink, watercolor, airbrush, acrylic, marker, colored pencil, oil, charcoal and pastel. Send query letter with tearsheets and photographs. Samples are not filed and are returned by SASE if requested by artist. Reports back within 3-4 weeks. Write for appointment to show portfolio of final art, b&w and color tearsheets and photographs. Buys one-time rights. Pays on publication; $35 for b&w cover; $50 for color cover; $30 for b&w inside.
Tips: "Freelance artists must be good and fast, work on tight deadlines and have a real grasp at illustrating articles that complement the print. I hate it when someone shows up unannounced to show me work. I usually turn them away because I can't take time from my work. It's better to schedule a showing."

SHOFAR, 43 Northcote Dr., Melville NY 11747. (516)643-4598. Managing Editor: Gerald H. Grayson. Estab. 1984. Monthly magazine emphasizing Jewish religious education published October through May—double issues December/January and April/May. Circ. 15,000. Accepts previously published artwork. Originals returned at job's completion. Sample copies free for 9 × 12 SASE and $1.01 in postage; art guidelines available.
Illustration: Buys 3-4 illustrations/issue. Works on assignment only. Send query letter with tearsheets. Reports back to the artist only if interested. Pays on publication; $25-100 for b&w cover; $50-150 for color cover.

SHOW BIZ NEWS AND MODEL NEWS, 244 Madison Ave., #393, New York NY 10016-2817. (212)969-8715. Publisher and Editor: John King. Estab. 1975. "Our newspaper is read by show people—models and the public—coast to coast." Circ. 300,000. Art guidelines available for $1.25. Accepts previously published artwork. Originals are returned at job's completion. Sample copies free for SASE with first-class postage.
Cartoons: Approached by 20 cartoonists/year. Buys 10 cartoons/issue. Prefers caricatures of show people and famous models; single or multiple panel b&w line drawings with gagline. Contact through artist rep or send query letter with finished cartoon samples. Samples are returned by SASE. Reports back within 10 days only if interested. Payment negotiable.
Illustration: Approached by 20-30 illustrators/year. Assigns 20% of illustrations to well-known or "name" illustrators; 30% to experienced, but not well-known illustrators; 50% to new and emerging illustrators. Buys 10 illustrations/year.

Artists sometimes work on assignment. Considers pen & ink, collage, airbrush, marker, colored pencil, charcoal and mixed media. Contact only through artist rep or send query letter with brochure, résumé, SASE, tearsheets, photographs and photocopies. Samples are filed or returned by SASE. Reports back within 10 days only if interested. Call or write to show a portfolio or mail appropriate materials: thumbnails, final art samples, b&w and color tearsheets and photographs. Buys first rights, one-time rights or reprint rights. Pays on publication.

Tips: "Keep up with the top cebebrities and models. Try to call and send data first. No drop-ins. Face shots are big."

SIGNS OF THE TIMES, 1350 N. King's Rd., Nampa ID 83687. (208)465-2592. Fax: (208)465-2531. E-mail: merste@pacificpress.com. Website: http://www.pacificpress.com. Art Director: Merwin Stewart. A monthly Seventh-day Adventist 4-color publication that examines contemporary issues such as health, finances, diet, family issues, exercise, child development, spiritual growth and end-time events. "We attempt to show that Biblical principles are relevant to everyone." Circ. 225,000. Original artwork returned to artist after publication. Art guidelines available for SASE with first-class postage.

● They accept illustrations traditionally produced or converted to electronic form on a 3.5″ optical disk, a 5.25″ removable hard disk cartridge, or a Zip disk.

Illustration: Buys 6-10 illustrations/issue. Works on assignment only. Has featured illustrations by Darren Thompson, Lars Justinen, Consuelo Udave and Terry Julien. Features realistic illustration. Assigns 10% of illustrations to well-known or "name" illustrators; 80% to experienced, but not well-known illustrators; 10% to new and emerging illustrators. Prefers contemporary "realistic, stylistic, or humorous styles (but not cartoons)." Considers any media. Send postcard sample, brochure, photographs, slides, tearsheets or transparencies. Samples are not returned. "Tearsheets or color photos (prints) are best, although color slides are acceptable." Samples are filed for future consideration and are not returned. Publication will contact artist for more samples of work if interested. Buys first-time North American publication rights. **Pays on acceptance** (30 days); $600-800 for color cover; $100-300 for b&w inside; $300-700 for color inside. Fees negotiable depending on needs and placement, size, etc. in magazine. Finds artists through submissions, sourcebooks, and sometimes by referral from other art directors.

Tips: "Most of the magazine illustrations feature people. Approximately 20 visual images (photography as well as artwork) are acquired for the production of each issue, half in black & white, half in color, and the customary working time frame is 3 weeks. Quality artwork and timely delivery are mandatory for continued assignments. It is customary for us to work with highly-skilled and dependable illustrators for many years." Advice for artists: "Invest in a good art school education, learn from working professionals within an internship, and draw from your surroundings at every opportunity. Get to know lots of people in the field where you want to market your work, and consistently provide samples of your work so they'll remember you. Then relax and enjoy the adventure of being creative."

THE SILVER WEB, P.O. Box 38190, Tallahassee FL 32315. E-mail: annkl9@mail.idt.net Publisher/Editor: Ann Kennedy. Estab. 1989. Semi-annual literary magazine. Subtitled "A Magazine of the Surreal." Circ. 2,000. Accepts previously published artwork. Originals returned at job's completion. Sample copies available for $7.20; art guidelines for SASE with first-class postage.

Illustration: Approached by 50-100 illustrators/year. Buys 15-20 illustrations/issue. Has featured illustrations by Scott Bagle, David Walters, Carlos Batts, Rodger Gerberding and Micahel Shores. Prefers works of the surreal, horrific or bizarre but not traditional horror/fantasy (dragons or monsters are not desired). Considers pen & ink, collage, charcoal and mixed media. Send query letter with samples and SASE. Samples are filed or returned by SASE if requested by artist. Reports back within 2 weeks. Publication will contact artist for portfolio review if interested. Rights purchased vary according to project. **Pays on acceptance**; $25-50 for color cover; $10-25 for b&w inside; $5-10 for spots.

Tips: "I am more interested in what an artist creates because it is in his heart—rather than work done to illustrate a certain story. I want to see what you create because you want to create it."

SKIPPING STONES, P.O. Box 3939, Eugene OR 97403-0939. (541)342-4956. E-mail: skipping@efn.org. Website: http://www.nonviolence.org/skipping. Editor: Arun Toké. Associate Editor: Rachel Knudson. Estab. 1988. Bimonthly b&w (with 4-color cover) consumer magazine. International nonprofit multicultural and nature education magazine for today's youth. Circ. 2,500. Art guidelines are free for SASE with first-class postage. Sample copy available for $5.

Cartoons: Prefers multicultural, social issues, nature/ecology themes. Prefers humorous, b&w washes and line drawings. Send b&w photocopies and SASE. Samples are filed or returned by SASE. Reports back within 3 months only if interested. Buys first rights and reprint rights. Pays on publication in copies.

Illustration: Approached by 100 illustrators/year. Buys 20-30 illustrations/issue. Has featured illustrations by Vidushi Avrati Bhatnagar, India; Inna Svjatova, Russia; Pam Logan, US. Features humorous illustration, informational graphics, natural history and realistic illustrations. Preferred subjects: children and teens. Prefers pen & ink. Assigns 20% of illustrations to experienced, but not well-known illustrators; 80% to new and emerging illustrators. Send non-returnable photocopies and SASE. Samples are filed or returned by SASE. Reports back within 3 months if interested. Portfolio review not required. Buys first rights, reprint rights. Pays on publication 1-5 copies. Finds illustrators through word of mouth, artists promo samples.

Tips: "We are a gentle, non-glossy, ad-free magazine not afraid to tackle hard issues. We are looking for work that challenges the mind, charms the spirit, warms the heart; handmade, non-violent, global, for youth 8-15 with multicultural/nature content. Please, no aliens or unicorns."

SKYDIVING MAGAZINE, 1725 N. Lexington Ave., DeLand FL 32724. (904)736-4793. Fax: (904)736-9786. E-mail: editor@skydivingmagazine.com. Website: http://emporium.turnpike.net/~skydiving.mag/index/.htm. Designer: Sue Clifton. Estab. 1979. "Monthly magazine on the equipment, techniques, people, places and events of sport parachuting." Circ. 14,200. Originals returned at job's completion. Sample copies available; art guidelines not available.
Cartoons: Approached by 10 cartoonists/year. Buys 2 cartoons/issue. Has featured cartoons by Craig Robinson. Prefers skydiving themes; single panel, with gagline. Send query letter with roughs. Samples are filed. Reports back within 2 weeks. Buys one-time rights. Pays $25 for b&w.

SLACK PUBLICATIONS, 6900 Grove Rd., Thorofare NJ 08086. (609)848-1000. Fax: (609)853-5991. E-mail: lbaker @slackinc.com. Creative Director: Linda Baker. Estab. 1960. Publishes 22 medical publications dealing with clinical and lifestyle issues for people in the medical professions. Circ. 13,000 Accepts previously published artwork. Originals returned at job's completion. Art guidelines not available.
Illustration: Approached by 50 illustrators/year. Buys 2 illustrations/issue. Works on assignment only. Features humorous and realistic illustration; charts & graphs; infomational graphics; medical, computer and spot illustration. "No cartoons." Assigns 5% of illustrations to well-known or "name" illustrators; 90% to experienced, but not well-known illustrators; 5% to new and emerging illustrators. Prefers watercolor, airbrush, acrylic, oil and mixed media. Send query letter with tearsheets, photographs, photocopies, slides and transparencies. Samples are filed and are returned by SASE if requested by artist. Reports back to the artist only if interested. To show a portfolio, mail b&w and color tearsheets, slides, photostats, photocopies and photographs. Negotiates rights purchased. Pays on publication; $200-400 for b&w cover; $400-600 for color cover; $100-200 for b&w inside; $100-350 for color inside; $50-150 for spots.
Tips: "Send samples."

SMALL BUSINESS TIMES AND EMPLOYMENT TIMES, 1123 N. Water St., Milwaukee WI 53202. (414)277-8181 and (414)277-8191. Fax: (414)277-8191. Website: http://www.biztimes.com. Art Director: Catherine Findley. Estab. 1995. Monthly b&w with 4-color cover and inside spread, regional publication for business owners. Circ. 25,000. Sample copies free for 10×13 SASE and $3 first-class stamps. Art guidelines are free for #10 SASE with first-class postage.
Illustration: Approached by 100 illustrators/year. Buys 5-10 illustrations/issue. Has featured illustrations by Keith Skeen, Matt Zumbo, Bill Dunlap. Features computer, humorous, realistic and b&w spot illustrations. Prefers business subjects in simpler styles that reproduce well on newsprint. Assigns 5% of illustrations to well-known or "name" illustrators; 20% to experienced, but not well-known illustrators; 75% to new and emerging illustrators. Send postcard sample and follow-up postcard every 6 months. Accepts Mac-compatible disk submissions. Send EPS or TIFF files. Samples are returned by SASE. Will contact artist for portfolio review if interested. Buys one-time rights. **Pays on acceptance**; $400-600 for color cover; $50-150 for b&w inside. Finds illustrators through word-of-mouth, *Black Book*, *Workbook*.
Tips: "Conceptual illustrators wanted! We're looking for simpler, black & white illustrations that communicate quickly."

☑ **THE SMALL POND MAGAZINE OF LITERATURE**, Box 664, Stratford CT 06615. Editor: Napoleon St. Cyr. Estab. 1964. Emphasizes poetry and short prose. Readers are people who enjoy literature—primarily college-educated. Usually b&w or 2-color cover with "simple, clean design." Published 3 times/year. Circ. 300. Sample copy for $4; art guidelines for SASE.
Illustration: Receives 50-75 illustrations/year. Acquires 1-5 illustrations/issue. Assigns 20% of illustrations to experienced, but not well-known illustrators; 80% to new and emerging illustrators. Has featured illustrations by Syd Weedon, Mal Gormley, Matthew Morgaine, Tom Herzberg and Jackie Peterson. Features humorous and spot illustrations. Assigns 20% of illustrations to experienced, but not well known illustrators; 80% to new and emerging illustrators. Uses freelance artwork mainly for covers, centerfolds and spots. Prefers "line drawings (inside and on cover) which generally relate to natural settings, but have used abstract work completely unrelated. Fewer wildlife drawings and more unrelated-to-wildlife material." Send query letter with finished art or production-quality photocopies, 2×3 minimum, 8×11 maximum. Include SASE. Publication will contact artist for portfolio review if interested. Pays 2 copies of issue in which work appears. Buys copyright in copyright convention countries. Finds artists through submissions.
Tips: "Need cover artwork, but inquire first or send for sample copy." Especially looks for "smooth clean lines, original movements, an overall impact. Don't send a heavy portfolio, but rather four to six black & white representative samples with SASE. Don't send your life's history and/or a long sheet of credits. Do not send a postcard with a beautiful work in full color. Black & white and 3-5 pieces, no postcards. Work samples are worth a thousand words." Advice to artists: "Peruse listings in *Artist's & Graphic Designer's Market* for wants and needs of various publications."

SOCIAL POLICY, 25 W. 43rd St., New York NY 10036. (212)642-2929. E-mail: socpol@igc.apc.org. Website: http://www.socialpolicy.org. Managing Editor: Audrey Gartner. Estab. 1970. The magazine about movements, emphasizes the human services—education, health, mental health, self-help, consumer action, voter registration, employment. Quarterly magazine for social action leaders, academics and social welfare practitioners. Black & white with 2-color cover. Circ. 5,000. Accepts simultaneous submissions. Original artwork returned after publication. Sample copy for $2.50.
Illustration: Approached by 10 illustrators/year. Works with 4 illustrators/year. Buys 6-8 illustrations/issue. Accepts b&w only, illustration "with social consciousness." Prefers pen & ink and charcoal/pencil. Send query letter with photocopies and tearsheets to be kept on file. Call for appointment to show portfolio, which should include b&w final

art, final reproduction/product and tearsheets. Reports only if interested. Buys one-time rights. Pays on publication; $100 for cover; $40 for b&w inside.

Tips: When reviewing an artist's work, looks for "sensitivity to the subject matter being illustrated."

SOLDIERS MAGAZINE, 9325 Gunston Rd., Suite S108, Ft. Belvoir VA 22060-5548. (703)806-4486. Fax: (703)806-4566. Editor-in-Chief: Lt. Col. Ray Whitehead. Monthly 4-color magazine that provides "timely and factual information on topics of interest to members of the Active Army, Army National Guard, Army Reserve and Department of Army civilian employees and Army family members." Circ. 225,000. Previously published material and simultaneous submissions OK. Samples available upon request.

Illustration: Buys 5-10 illustrations/year. Considers all media. Send query letter with photocopies of samples. Reports back only if interested. Illustrations should have a military or general interest theme. No portfolio review necessary. Buys all rights. **Pays on acceptance**. Pay varies by project.

Tips: "We are actively seeking new ideas and fresh humor, and are looking for new contributors. However, we require professional-quality material, professionally presented. We will not use anti-Army, sexist or racist material. We suggest you review recent back issues before submitting."

SOLIDARITY MAGAZINE, Published by United Auto Workers, 8000 E. Jefferson, Detroit MI 48214. (313)926-5291. E-mail: uawsolidarity@compuserve.com. Website: http:/www.uaw.org. Acting Editor: Dick Olson. Four-color magazine for "1.3 million member trade union representing U.S. workers in auto, aerospace, agricultural-implement, public employment and other areas." Contemporary design.

Cartoons: Carries "labor/political" cartoons. Pay varies.

Illustration: Works with 10-12 illustrators/year for posters and magazine illustrations. Interested in graphic designs of publications, topical art for magazine covers with liberal-labor political slant. Looks for "ability to grasp our editorial slant." Send postcard sample or tearsheets and SASE. Samples are filed. Pays $500-600 for color cover; $200-300 for b&w inside; $300-450 for color inside.

SONGWRITER'S MONTHLY, 332 Eastwood Ave., Feasterville PA 19053. Phone/fax: (215)953-0952. E-mail: a1foster@aol.com. Website: http://www.geocities.com/timessquare/labyrinth/1917. Editor/Publisher: Allen Foster. Estab. 1992. Monthly trade journal. "We are a cross between a trade journal and a magazine—our focus is songwriting and the music business." Circ. 2,500. Originals returned at job's completion with SASE. Sample copy and art guidelines free.

● *Songwriter's Monthly* currently hosts a live web radio show at http://www.mediabureau.com.

Cartoons: Approached by 24+ cartoonists/year. Buys 1 cartoon/issue. Has featured cartoons by Christopher Kent, Vern Dailey and Billy Mitchell. Cartoons must deal with some aspect of songwriting or the music business. Prefers single panel, humorous, b&w line drawings with or without gagline. Send query letter with finished cartoons. Samples are not filed and are returned by SASE if requested by artist. Reports back within 2-4 weeks. Buys one-time rights. Pays $10 for b&w.

Illustration: Has featured illustrations by W.C. Pope, Regina Lafay and Chris Sabatino. Assigns 50% of illustrations to experienced, but not well-known illustrators; 50% to new and emerging illustrators. Features humorous illustration. Prefers music themes. Considers pen & ink. Send query letter with SASE and photocopies. Samples are filed. Reports back within 2-4 weeks. Portfolio review not required. Buys one-time rights. **Pays on acceptance**; $10 for b&w inside; $10 for spots.

Tips: "Our primary needs are for artists who can find a creative way to illustrate articles dealing with songwriting concepts. We are black & white—please do not send color or color samples. A good single-panel cartoon on songwriting is the best way to get in our pages."

SOUTHERN ACCENTS MAGAZINE, 2100 Lakeshore Dr., Birmingham AL 35209. (205)877-6000. Fax: (205)877-6990. Art Director: Ann M. Carothers. Estab. 1977. Bimonthly consumer magazine emphasizing fine Southern interiors and gardens. Circ. 350,000.

Illustration: Buys 25 illustrations/year. Considers color washes, colored pencil and watercolor. Send postcard sample. Accepts disk submissions. Samples are returned. Reports back only if interested. Art director will contact artist for portfolio of final art, photographs, slides and tearsheets if interested. Rights purchased vary according to project. **Pays on acceptance** or pays on publication; $100-800 for color inside. Finds artists through magazines and sourcebook submissions.

SOUTHERN EXPOSURE, Box 531, Durham NC 27702. (919)419-8311. Fax: (919)419-8315. E-mail: editor@i4south.org. Editor: Chris Kromm. Estab. 1972. A quarterly magazine of Southern politics and culture emphasizing issues of importance to disenfranchised southern communities. Circ. 5,000. Accepts previously published artwork. Original artwork returned at job's completion. Sample copies available for $5. Guidelines available for SASE with first-class postage.

Illustration: Buys 2 freelance illustrations/issue. Send postcard sample or query letter with brochure, résumé, photographs and photocopies. Samples are nonreturnable. Pays $100 color cover; $25-50, b&w inside.

Tips: This company "prefers artists working in the South with southern themes, but please avoid stereotypes."

☑ **SPIDER**, P.O. Box 300, Peru IL 61354. Art Director: Anthony Jacobson. Estab. 1994. Monthly magazine "for children 6 to 9 years old. Literary emphasis, but also include activities, crafts, recipes and games." Circ. 95,000. Samples copies available; art guidelines for SASE with first-class postage.

Illustration: Approached by 800-1,000 illustrators/year. Buys 30-35 illustrations/issue. Has featured illustrations by Floyd Cooper, Jon Goodell and David Small. Features humorous and realistic illustration. Assigns 25% of illustrations to well-known or "name" illustrations; 50% to experienced, but not well-known illustrators; 25% to new and emerging illustrators. Prefers art featuring children and animals, both realistic and whimsical styles. Considers all media. Send query letter with printed samples, photocopies, SASE and tearsheets. Send follow-up every 4 months. Samples are filed or are returned by SASE. Reports back within 4-6 weeks. Buys first North American serial rights. **Pays on acceptance**; $750 minimum for cover; $150-250 for color inside. Pays $50-150 for spots. Finds illustrators through artists who've published work in the children's field (books/magazines); artist's submissions.

Tips: "Read our magazine, include samples showing children and animals and put your name, address and phone number on every sample. It's helpful to include pieces that take the same character(s) through several actions/emotional states. It's also helpful to remember that most children's publishers need artists who can draw children from many different racial and ethnic backgrounds."

THE SPIRIT OF WOMAN IN THE MOON, 1409 The Alameda, Cupertino CA 95126-2653. (408)279-6626. Fax: (408)279-6636. E-mail: womaninmoon@earthlink. Website: http://wwwwomaninthemoon.com. Publisher: Dr. SD. Adamz-Bogus. Estab. 1993. Quarterly magazine. "We are New Age and we like ghosts, healing, angel, good-feeling stories. We like moon poetry and planet/themes." Circ. 3,000. Sample copies for $5. "Please write for guidelines."

Cartoons: Buys 4 cartoons/issue. Prefers "New Age/wacky!" Prefers single panel, political, humorous, b&w washes with gagline. Send query letter with finished cartoons, photocopies or tearsheets. "We have a cartoon panel series called 'Omen'—we want anonymous contributors to it." Reports back only if interested. "We keep samples but answer written requests." Buys first and reprint rights. Pays on publication; $10-25 for b&w.

Illustration: Approached by 20 illustrators/year. Features women's fashion illustration; humorous illustration. Assigns 10% of illustrations to well-known or "name" illustrators; 80% to experienced, but not well-known illustrators; 10% to new and emerging illustrators. Prefers human drama/life's ironies/Egyptian/animals. Considers acrylic, airbrush, colored pencil, oil, pastel, pen & ink and watercolor. 50% of freelance illustration demands knowledge of Aldus PageMaker, Adobe Photoshop and QuarkXPress. Send postcard sample. Samples are filed and are not returned. Reports back only if interested. Art director will contact artist for portfolio review of b&w, photographs and tearsheets if interested. Buys all rights on completion. Pays $100-600 for b&w cover; $250-600 for color cover; $10-25 for spots. Finds illustrators through *Creative Black Book* and artist's submissions.

Design: Needs freelancers for design and production. This is our biggest need. Prefers local design freelancers only. 50% of freelance work demands knowledge of Aldus PageMaker, Adobe Photoshop and QuarkXPress. Send query letter with printed samples, photocopies and SASE.

Tips: "We look for a fast turnaround and an open personality. We need a part-time regular graphic artist who can work on layout and design of magazine every three months. We want a regular cover designer. Call if able to come in. Simply let us know you've seen the publication or write for one and tell us how your work fits our themes."

N̈ SPITBALL, The Literary Baseball Magazine, 5560 Fox Rd., Cincinnati OH 45239. (513)385-2268. Editor: Mike Shannon. Quarterly 2-color magazine emphasizing baseball exclusively, for "well-educated, literate baseball fans." Sometimes prints color material in b&w on cover. Returns original artwork after publication if the work is donated; does not return if purchases work. Sample copy for $2.

• *Spitball* has a regular column called "Brushes with Baseball" that features one artist and his work. Chooses artists for whom baseball is a major theme/subject. Prefers to buy at least one work from the artist to keep in its collection.

Cartoons: Prefers single panel b&w line drawings with or without gagline. Prefers "old fashioned *Sport Magazine/ New Yorker* type. Please, cartoonists . . . make them funny, or what's the point!" Query with samples of style, roughs and finished cartoons. Samples not filed are returned by SASE. Reports back within 1 week. Negotiates rights purchased. Pays $10, minimum.

Illustration: "We need two types of art: illustration (for a story, essay or poem) and filler. All work must be baseball-related; prefers pen & ink, airbrush, charcoal/pencil and collage. Interested artists should write to find out needs for specific illustration." Buys 3 or 4 illustrations/issue. Send query letter with b&w illustrations or slides. Target samples to magazine's needs. Samples not filed are returned by SASE. Reports back within 1 week. Negotiates rights purchased. **Pays on acceptance**; $20-40 b&w inside. Needs short story illustration.

Tips: "Usually artists contact us and if we hit it off, we form a long-lasting mutual admiration society. Please, you cartoonists out there, drag your bats up to the *Spitball* plate! We like to use a variety of artists."

N̈ SPORTS AFIELD, Hearst Magazines, 250 W. 55th, New York NY 10019. (212)649-4000. Fax: (212)581-3923. Website: http://www.sportsafield.com. Art Director: Beth Deeney. Estab. 1887. Monthly magazine. "*SA* is edited for outdoor enthusiasts with special interests in fishing and hunting. We are the oldest outdoor magazine and continue as the authority on all traditional sporting activities including camping, boating, hiking, fishing, mountain biking, rock climbing, canoeing, kayaking, rafting, shooting and wilderness travel." Sample copies available for 10×13 SASE. Art guidelines available for #10 SASE with first-class postage.

Cartoons: Buys 7-10 cartoons/issue. Prefers outdoors/hunting, fishing themes. Prefers single, double or multiple panel

humorous b&w and color washes or b&w line drawings with or without gagline. Send photocopies and SASE. Samples are filed. Reports back if interested. Buys first North American serial rights. Pays on publication.

Illustration: Buys 2-3 illustrations/issue. Prefers outdoor themes. Considers all media. Freelancers should be familiar with Adobe Photoshop, Adobe Illustrator, QuarkXPress. Send postcard sample or query letter with photocopies and tearsheets. Accepts disk submissions. Samples are filed. Reports back only if interested. Will contact for portfolio of b&w or color photographs, slides, tearsheets and transparencies if interested. Buys first North American serial rights. Pays on publication; negotiable. Finds illustrators through *Black Book*, magazines, submissions.

SPORTS 'N SPOKES, 2111 E. Highland Ave., Suite 180, Phoenix AZ 85016-4702. (602)224-0500. Fax: (602)224-0507. E-mail: snsmagaz@aol.com. Website: http://www.pva.org/sns. Art and Production Director: Susan Robbins. Published 8 times a year. Consumer magazine with emphasis on sports and recreation for the wheelchair user. Circ. 15,000. Accepts previously published artwork. Sample copies for 11×14 SASE and 6 first-class stamps.

Cartoons: Approached by 10 cartoonists/year. Buys 3-5 cartoons/issue. Prefers humorous cartoons; single panel b&w line drawings with or without gagline. Send query letter with finished cartoons. Samples are filed or returned by SASE if requested by artist. Reports back within 3 months. Buys all rights. **Pays on acceptance**; $10 for b&w.

Illustration: Approached by 10 illustrators/year. Works on assignment only. Considers pen & ink, watercolor and computer-generated art. 50% of freelance work demands knowledge of Adobe Illustrator, QuarkXPress or Adobe Photoshop. Send postcard sample or query letter with résumé and tearsheets. Accepts disk submissions compatible with Adobe Illustrator 7.0 or Photoshop 4.0. Send EPS or TIFF files. Samples are filed or returned by SASE if requested by artist. Reports back to the artist only if interested. Publication will contact artist for portfolio review if interested. Portfolio should include color tearsheets. Buys one-time rights and reprint rights. Pays on publication; $250 for color cover; $10 for b&w inside; $25 for color inside.

Tips: "We have not purchased an illustration or used a freelance designer for five years. We regularly purchase cartoons with wheelchair sports/recreation theme. Complete magazine redesign—begins with January '99 issue."

☑ **STEREOPHILE**, P.O. Box 5529, Sante Fe NM 87502. (505)982-2366. Fax: (505)989-8791. E-mail: bacan@petersonpub.com. Art Director: Natalie Baca. Estab. 1962. "We're the oldest and largest subject review high-end audio magazine in the country, approximately 220 pages/monthly." Circ. 80,000. Accepts previously published artwork.

Illustration: Approached by 50 illustrators/year. Buys 3-5 illustrations/issue. Works on assignment only. Features realistic illustration; charts & graphs; computer and spot illustration. Assigns 75% of illustrations to experienced, but not well-known illustrators; 25% to new and emerging illustrators. Interested in all media. Send query letter with brochure and tearsheets. Samples are filed. Reports back only if interested. Portfolio should include original/final art, tearsheets or other appropriate samples. Rights purchased vary according to project. Pays on publication; $150-1000 for color inside.

Tips: "Be able to turn a job in three to five days and have it look professional. Letters from previous clients to this effect help. Some knowledge of consumer electronics is helpful. Prefer electronic submissions, on disks or via e-mail/web."

☑ **STONE SOUP, The Magazine by Young Writers and Artists**, P.O. Box 83, Santa Cruz CA 95063. (831)426-5557. E-mail: editor@stonesoup.com. Website: http://www.stonesoup.com. Editor: Gerry Mandel. Bimonthly 4-color magazine with "simple and conservative design" emphasizing writing and art by children through age 13. Features adventure, ethnic, experimental, fantasy, humorous and science fiction articles. "We only publish writing and art by children through age 13. We look for artwork that reveals that the artist is closely observing his or her world." Circ. 20,000. Original artwork is returned after publication. Sample copies available for $4. Art guidelines for SASE with first-class postage.

Illustration: Buys 12 illustrations/issue. Prefers complete and detailed scenes from real life. Send query letter with photocopies. Samples are filed or are returned by SASE. Reports back within 1 month. Buys all rights. Pays on publication; $50 for color cover; $10-25 for b&w or color inside; $15-25 for spots.

Tips: "We accept artwork by children only, through age 13."

STRAIGHT, 8121 Hamilton Ave., Cincinnati OH 45231. (513)931-4050. Fax: (513)931-0950. Editor: Heather E. Wallace. Estab. 1950. Weekly Sunday school take-home paper for Christian teens ages 13-19. Circ. 35,000. Sample copies for #10 SASE with first-class postage; art guidelines not available.

Illustration: Approached by 40-50 illustrators/year. Buys 50-60 illustrations/year. Has featured illustrations by Keith Locke, Patrick Kelley and Randy Glasbergen. Features humorous and realistic illustration. Prefers realistic and cartoon. Considers pen & ink, watercolor, collage, airbrush, colored pencil and oil. Send postcard sample or tearsheets. Samples are filed. Reports back to the artist only if interested. Portfolio review not required. Buys all rights. **Pays on acceptance**; $150 for 1-page inside illustration; $325 for 2-page inside illustration. Finds artists through submissions, other publications and word of mouth.

Tips: Areas most open to freelancers are "realistic and cartoon illustrations for our stories and articles."

THE STRAIN, 1307 Diablo, Houston TX 77532-3004. (713)733-0338. Articles Editor: Alicia Adler. Estab. 1987. Monthly literary magazine and interactive arts publication. "The purpose of our publication is to encourage the interaction between diverse fields in the arts and (in some cases) science." Circ. 1,000. Accepts previously published artwork.

Original artwork is returned to the artist at the job's completion. Sample copy for $5 plus 9×12 SAE and 7 first-class stamps.

Cartoons: Send photocopies of finished cartoons with SASE. Samples not filed are returned by SASE. Reports back within 2 years on submissions. Buys one-time rights or negotiates rights purchased.

Illustration: Buys 2-10 illustrations/issue. "We look for works that inspire creation in other arts." Send work that is complete in any format. Samples are filed "if we think there's a chance we'll use them." Those not filed are returned by SASE. Publication will contact artist for portfolio review if interested. Portfolio should include final art or photographs. Negotiates rights purchased. Pays on publication; $10 for b&w, $5 for color cover; $10 for b&w inside; $5 for color inside.

[N] STRATEGIC FINANCE, (formerly *Management Accounting*), 10 Paragon Dr., Montvale NJ 07645. (800)638-4427. Website: http://www.imanet.org and http://www.strategicfinancemag.com. Assistant Publisher: Robert F. Randall. Production Manager: Lisa Nasuta. Estab. 1919. Monthly 4-color with a 3-column design emphasizing management accounting for management accountants, controllers, chief accountants and treasurers. Circ. 80,000. Accepts simultaneous submissions. Originals are returned after publication.

• This magazine has a new title, new design and broadened coverage. Robert Randall reports they will no longer publish cartoons, but will be using a lot more illustrations.

Illustration: Approached by 6 illustrators/year. Buys 10 illustrations/issue. Send non-returnable postcard samples. Prefers financial accounting themes.

[N] STRATTON MAGAZINE, 1148 Route 30, Dorset VT 05251-2038. (802)362-4059. Fax: (802)362-2048. Art Director: Jennifer Richardson. Estab. 1964. Quarterly 4-color free lifestyle magazine for resort area. Circ. 25,000.

Illustration: Approached by 2-4 illustrators/year. Buys 0-6 illustrations/issue. Has featured illustrations by Matthew Perry, John D'Alliard. Features humorous illustration, natural history illustration and realistic illustrations. Preferred subjects: nature. Assigns 85% to experienced, but not well-known illustrators; 15% to new and emerging illustrators. "We will do traditional separations from reflective art but if supplied electronically, should be in Illustrator or Photoshop. Send postcard samples. Send non-returnable samples. Accepts Mac-compatible disk submissions. Send EPS or TIFF files. Samples are filed. Reports back only if interested. Will contact artist for portfolio review if interested. Buys one-time rights. Rights purchased vary according to project. Pays on publication; $250-500 for color cover; $25-100 for b&w, $100-250 for color inside.

Tips: "We have an outstanding nationally known staff photographer who provides most of our visuals, but we turn to illustration when the subject requires it and budget allows. I would like to have more artists available who are willing to accept our small payment in order to build their books! We are fairly traditional so please do not send way-out samples."

STUDENT LAWYER, 750 N. Lake Shore Dr., Chicago IL 60611. (312)988-6042. E-mail: kulcm@staff.abanet.org. Art Director: Mary Anne Kulchawik. Estab. 1972. Trade journal, 4-color, emphasizing legal education and social/legal issues. *"Student Lawyer* is a legal affairs magazine published by the Law Student Division of the American Bar Association. It is not a legal journal. It is a features magazine, competing for a share of law students' limited spare time—so the articles we publish must be informative, lively, good reads. We have no interest whatsoever in anything that resembles a footnoted, academic article. We are interested in professional and legal education issues, sociolegal phenomena, legal career features, and profiles of lawyers who are making an impact on the profession." Monthly (September-May). Circ. 35,000. Original artwork is returned to the artist after publication.

Illustration: Approached by 20 illustrators/year. Buys 8 illustrations/issue. Has featured illustrations by Sean Kane, Jim Starr, Slug Signorino, Ken Wilson and Charles Stubbs. Features realistic, computer and spot illustration. Assigns 50% of illustrations to experienced, but not well-known illustrators; 50% to new and emerging illustrators. Needs editorial illustration with an "innovative, intelligent style." Works on assignment only. Needs computer-literate freelancers for illustration. Send postcard sample, brochure, tearsheets and printed sheet with a variety of art images (include name and phone number). Samples are filed or returned by SASE. Call for appointment to show portfolio of final art and tearsheets. Buys one-time rights. **Pays on acceptance**; $500-800 for color cover; $300-500 for b&w cover, $450-600 for color inside; $300-450 for b&w inside; $150-200 for spots.

Tips: "In your portfolio, show a variety of color and black & white, plus editorial work."

STUDENT LEADER MAGAZINE, P.O. Box 14081, Gainesville FL 32604-2081. (352)373-6907. Fax: (352)373-8120. E-mail: oxenpub@mindspring.com. Website: http://www.studentleader.com. Art Director: Jeff Riemersma. Estab. 1993. National college leadership magazine published 3 times/year. Circ. 100,000. Sample copies for 8½×11 SASE and 4 first-class stamps. Art guidelines for #10 SASE with 1 first-class stamp.

• Oxendine Publishing also publishes *Florida Leader Magazine* and *Florida Leader Magazine for High School Studends*.

Illustration: Approached by hundreds of illustrators/year. Buys 6 illustrations/issue. Considers all media. 10% of freelance illustration demands computer skills. Disk submissions must be PC-based, TIFF or EPS files. Samples are filed and are not returned. Reports back only if interested. Rights purchased vary according to project. Pays on publication; $125 for color inside. Finds illustrators through sourcebook and artist's submissions.

Tips: "We need responsible artists who complete projects on time and have a great imagination. Also must work within budget."

SUB-TERRAIN MAGAZINE, 204-A, 175 E. Broadway, Vancouver, British Columbia V5T 1W2 Canada. (604)876-8710. Fax: (604)879-2667. E-mail: subter@pinc.com. Website: http://www.anvilpress.com. Managing Editor: Brian Kaufman. Estab. 1988. Quarterly b&w literary magazine featuring contemporary literature of all genres. Art guidelines for SASE with first-class postage.
Cartoons: Prefers single panel cartoons. Samples are filed. Reports back within 6 months. Buys first North American serial rights. Pays in copies, except for covers; price negotiable.
Illustration: Assigns 50% of illustrations to experienced, but not well-known illustrators; 50% to new and emerging illustrators. Send query letter with photocopies. Samples are filed. Reports back within 6 months. Portfolio review not required. Buys first rights, first North American serial rights, one-time rights or reprints rights. Pays in copies, except for covers; price negobitale.
Tips: "Take the time to look at an issue of the magazine to get an idea of what work we use."

SUN VALLEY MAGAZINE, 112 E. Bullion St., Suite B, Hailey ID 83333. (208)788-0770. Fax: (208)788-3881. E-mail: svmag@micron.net. Website: http://www.sunvalleymag.com. Art Director: Britt Butler. Estab. 1971. Consumer magazine published 3 times/year "highlighting the activities and lifestyles of people of the Wood River Valley." Circ. 15,000. Sample copies available. Art guidelines free for #10 SASE with first-class postage.
Illustration: Approached by 10 illustrators/year. Buys 3 illustrations/issue. Prefers forward, cutting edge styles. Considers all media. 50% of freelance illustration demands knowledge of QuarkXPress. Send query letter with SASE. Accepts disk submissions compatible with Macintosh, QuarkXPress 3.3. Send EPS files. Samples are filed. Does not report back. Artist should call. Art director will contact artist for portfolio review of b&w, color, final art, photostats, roughs, slides, tearsheets and thumbnails if interested. Buys first rights. Pays on publication; $100-200 for b&w, $250-500 for color cover; $35-100 for b&w, $50-100 for color inside.
Tips: "Read our magazine. Send ideas for illustrations and examples."

SUNEXPERT, 1340 Centre St., Newton Center MA 02459. (617)641-0519. Fax: (617)641-9102. E-mail: jwk@cpg.com. Website: http://www.cpg.com. Art Director: John W. Kelley Jr. Senior Designer: Jerry Cogliano. Designer: Brad Dillman. Estab. 1989. Monthly 4-color trade publication. Circ. 105,000.
Illustration: Approached by 20-30 illustrators/year. Buys 15 illustrations/issue. Has featured illustrations by Paul Anderson, Chris Butler, Lynne Cannoy, Daniel C. O'Connor, Paul Zwolak and Tom Barrett. Features computer illustration, informational graphics and spot illustrations. Assigns 33.3% of illustration to well-known or "name" illustrators; 33.3% to experienced, but not well-known illustrators; 33.3% to new and emerging illustrators. Send postcard or other non-returnable samples and follow-up samples every 2 months. Accepts Mac-compatible disk submissions. Send EPS or TIFF files. Samples are filed. Will contact artist for portfolio review if interested. Rights purchased vary according to project. Pays on publication; $325-1,200 for color inside; $125 for spots.
Tips: "We like to give new artists a shot, those who are conceptual are looked at closely. Work should be conceptual because we deal in the high-tech arena. Since we buy at least 15 pieces each issue we alternate the talent every 4-6 months."

SUNSHINE MAGAZINE, 200 E. Las Olas Blvd., Ft. Lauderdale FL 33301. (305)356-4690. E-mail: gcarannante@sun-sentinel.com. Art Director: Greg Carannante. Estab. 1983. Consumer magazine; the Sunday magazine for the *Sun Sentinel* newspaper; "featuring anything that would interest an intelligent adult reader living on South Florida's famous 'gold coast.'" Circ. 350,000. Accepts previously published artwork. Original artwork returned to artist at the job's completion. Sample copies and art guidelines available.
Illustration: Approached by 100 illustrators/year. Buys 60-70 freelance illustrations/year. Works on assignment only. Has featured illustrations by Cary Henrie, Hungry Dog Studio and Janet Uram. Features caricatures of celebrities; humorous, realistic, computer and spot illustrations. Assigns 10% of illustrations to well-known or "name" ilustrators; 60% to experienced, but not well-known illustrators; 30% to new and emerging illustrators. Preferred themes and styles vary. Considers all color media. Send postcard sample. Will accept computer art—Quark/Photoshop interface. Samples are filed or are returned by SASE. Reports back to the artist only if interested. To show a portfolio, mail color cards, disks, tearsheets, photostats, slides and photocopies. Buys first rights. **Pays on acceptance**; $600-700 for color cover; $250-500 for color inside; $600-700 for 2-page spreads; $200-300 for spots.
Tips: Looking for stylized, colorful dramatic images "with a difference. Show me something stylistically different—but with fundamental quality."

TAMPA BAY MAGAZINE, 33761 Landmark Dr., Clearwater FL 34621. (727)791-4800. Editor: Aaron Fodiman. Estab. 1986. Bimonthly local lifestyle magazine with upscale readership. Circ. 35,000. Accepts previously published artwork. Sample copy available for $4.50. Art guidelines not available.
Cartoons: Approached by 30 cartoonists/year. Buys 6 cartoons/issue. Prefers single panel color washes with gagline.

 A CHECKMARK PRECEDING A LISTING indicates a change in either the address or contact information since the 1999 edition.

Send query letter with finished cartoon samples. Samples are not filed and are returned by SASE if requested. Buys one-time rights. Pays $15 for b&w, $20 for color.

Illustration: Approached by 100 illustrators/year. Buys 5 illustrations/issue. Prefers happy, stylish themes. Considers watercolor, collage, airbrush, acrylic, marker, colored pencil, oil and mixed media. Send query letter with photographs and transparencies. Samples are not filed and are returned by SASE if requested. To show a portfolio, mail color tearsheets, slides, photocopies, finished samples and photographs. Buys one-time rights. Pays on publication; $150 for color cover; $75 for color inside.

TAPPI JOURNAL, 15 Technology Pkwy., Norcross GA 30092. (770)446-1400. Fax: (770)209-7400. Website: http://www.tappi.org. Production Manager: Timothy Whelan. Monthly trade journal covering pulp and paper industry. Circ. 50,000. Sample copies available; art guidelines not available.

Illustration: Approached by 3 illustrators/year. Buys 1 illustration/year. Features realistic illustration; informational graphics; computer illustrations. Prefers pulp and paper/manufacturing and engineering themes. Considers all media. Knowledge of Adobe Photoshop, QuarkXPress, Adobe Illustrator helpful, but not required. Send query letter with printed samples. Send follow-up postcard sample every 3 months. Accepts disk submissions compatible with latest version of Photoshop, QuarkXPress. Send EPS. Reports back within 1 month. Buys all rights. **Pays on acceptance**; $1,000 maximum for color cover. Finds illustrators through word of mouth, magazines.

[N] TEACHERS IN FOCUS, FOCUS ON THE FAMILY, 8605 Explorer Dr., Colorado Springs CO 80920. (719)548-4582. Fax: (719)548-5860. E-mail: tifeditor@fotf.org. Website: http://www.family.org/cforum/teachersmag. Art Director/Senior Designer: John T. Sutton. Estab. 1992. Monthly 4-color trade publication for Christian teachers. Circ. 30,000. Sample copy online.

Illustration: Approached by 50 illustrators/year. Buys 12 illustrations/issue. Features computer and realistic illustration. Assigns 80% of illustrations to experienced, but not well-known illustrators; 10% each to well-known or "name" illustrators and new and emerging illustrators. 40% of freelance illustration demands knowledge of Adobe Photoshop. Send postcard sample and follow-up postcard every 6 months or send non-returnable printed samples, photocopies and tearsheets. Accepts Mac-compatible disk submissions. Samples are not filed and are not returned. Portfolio review not required. Buys first North American serial rights. **Pays on acceptance.** Pays $400-1,200 for color cover; $150-1,200 for color inside. Finds illustrators through magazines, word of mouth and promotional samples.

Tips "We need realistic illustrations and realistic distortion cartoons. It is best if you are up to speed on the computer."

TECHNICAL ANALYSIS OF STOCKS & COMMODITIES, 4757 California Ave. SW, Seattle WA 98116-4499. (206)938-0570. E-mail: cmorrison@traders.com. Website: http://www.Traders.com. Art Director: Christine Morrison. Estab. 1982. Monthly traders' magazine for stocks, bonds, futures, commodities, options, mutual funds. Circ. 52,000. Accepts previously published artwork. Sample copies available for $5. Art guidelines for SASE with first-class postage or on website.

Cartoons: Approached by 10 cartoonists/year. Buys 1 cartoon/issue. Prefers humorous cartoons, single panel b&w line drawings with gagline. Send query letter with finished cartoons. Samples are filed or are returned by SASE if requested by artist. Reports back within 3 weeks. Buys one-time rights and reprint rights. Pays $30 for b&w.

Illustration: Approached by 25 illustrators/year. Buys 6 illustrations/issue. Works on assignment only. Has featured illustrations by John English, Carolina Arentsen and Patrick Fitzgerald. Features humorous, realistic, computer (occasionally) and spot illustrations. Assigns 10% of illustrations to well-known or "name" illustrators; 60% to experienced, but not well-known illustrators; 30% to new and emerging illustrators. Send query letter with brochure, tearsheets, photographs, photocopies, photostats, slides. Accepts disks compatible with any Adobe products on TIFF or EPS files. Samples are filed or are returned by SASE if requested by artist. Reports back within 3 weeks. Publication will contact artist for portfolio review if interested. Portfolio should include b&w and color tearsheets, slides, photostats, photocopies, final art and photographs. Buys one-time rights and reprint rights. Pays on publication; $135-350 for color cover; $165-213 for color inside; $105-133 for b&w inside.

Tips: "Looking for creative, imaginative and conceptual types of illustration that relate to the article's concepts. Also caricatures with market charts and computers. Send a few copies of black & white and color work—with cover letter—if I'm interested I will call."

TECHNIQUES, 1410 King St., Alexandria VA 22314. (703)683-3111. Fax: (703)683-7424. E-mail: marlene@acteonline.org or jwelch@acteonline.org. Website: http://www.avaonline.org. Contact: Marlene Lozada. Art Director: Janelle Welch. Estab. 1924. Monthly 4-color technical and career education magazine. Circ. 45,000. Accepts previously published artwork. Originals returned at job's completion. Sample copies with 9×11 SASE and first-class postage. Art guidelines not available.

Cartoons: "We rarely use cartoons." Pays $100 for b&w, $200-300 for color.

Illustration: Approached by 50 illustrators/year. Buys 8 illustrations/year. Works on assignment only. Has featured illustrations by John Berry, Valerie Spain, Eric Westbrook, Becky Heavner and Bryan Leister. Features informational graphics; computer and spot illustrations. Assigns 60% of illustrations to well-known or "name" illustrators; 20% to experienced, but not well-known illustrators; 20% to new and emerging illustrators. Considers pen & ink, watercolor, colored pencil, oil and pastel. Needs computer-literate freelancers for illustration. "We use a lot of CD-ROM art." Send query letter with brochure and photographs. Samples are filed. Reports back within 3 weeks. Portfolio review not

required. Rights purchased vary according to project. Sometimes requests work on spec before assigning job. Pays on publication; $600-1,000 for color cover; $275-500 for color inside.

Tips: "Send samples. When we need an illustration we look through our files."

☑ 'TEEN MAGAZINE, 6420 Wilshire Blvd., Los Angeles CA 90048-5515. (323)782-2936. Fax: (323)782-2660. Associate Art Director: Yvonne Sakowski. Estab. 1960. Monthly consumer magazine "that focuses on fashion, beauty, entertainment and psychological issues important to the high school and college-age girl." Circ. 1,700,000.

Illustration: Approached by 100 illustrators/year. Buys 1-2 illustrations/issue. Considers all media. Send postcard sample or query letter with printed samples, photocopies, SASE and tearsheets. Samples are filed. Buys one-time rights. Pays on publication; $150-450 for color inside. Finds illustrators through *Creative Black Book*, *LA Workbook*, word of mouth and artist's submissions.

Design: Needs freelancers for design and production on occasion. Prefers local design freelancers only. 100% of freelance work demands knowledge of Adobe Photoshop, Adobe Illustrator and QuarkXPress. Send query letter with printed samples, photocopies, SASE and tearsheets.

☑ TENNIS, 810 7th Ave., 4th Floor, New York NY 10019. (212)636-2700. Fax: (212)636-2730. Website: http://www.tennis.com. Art Director: Robin Helman. For affluent tennis players. Monthly. Circ. 800,000.

Illustration: Works with 15-20 illustrators/year. Buys 50 illustrations/year. Uses artists mainly for spots and openers. Works on assignment only. Send query letter with tearsheets. Mail printed samples of work. **Pays on acceptance**; $400-800 for color.

Tips: "Prospective contributors should first look through an issue of the magazine to make sure their style is appropriate for us."

TEXAS MONTHLY, P.O. Box 1569, Austin TX 78767-1569. (512)320-6900. Fax: (512)476-9007. Art Director: D.J. Stout. Estab. 1973. Monthly general interest magazine about Texas. Circ. 350,000. Accepts previously published artwork. Originals are returned to artist at job's completion.

Illustrations: Approached by hundreds of illustrators/year. Works on assignment only. Considers all media. Send postcard sample of work or send query letter with tearsheets, photographs, photocopies. Samples are filed "if I like them," or returned by SASE if requested by artist. Publication will contact artist for portfolio review if interested. Portfolio should include tearsheets, photographs, photocopies. Buys one-time rights. Pays on publication; $1,000 for color cover; $800-2,000 for color inside; $150-400 for spots.

☒ THE TEXAS OBSERVER, 307 W. Seventh, Austin TX 78701. (512)477-0746. Fax: (512)474-1175. E-mail: editors@texasobserver.org. Contact: Editor. Estab. 1954. Biweekly b&w magazine emphasizing Texas political, social and literary topics. Circ. 10,000. Accepts previously published material. Returns original artwork after publication. Sample copy for SASE with postage for 2 ounces; art guidelines for SASE with first-class postage.

Cartoons: "Our style varies; content is political/satirical or feature illustrations." Also uses caricatures.

Illustration: Buys 4 illustrations/issue. Has featured illustrations by: Matt Weurker and Sam Hurt. Assigns 15% of illustrations to well-known or "name" illustrators; 75% to experienced, but not well-known illustrators; 10% to new and emerging illustrators. Needs editorial illustration with political content. "We only print b&w, so pen & ink is best; washes are fine." Send photostats, tearsheets, photocopies, slides or photographs to be kept on file. Samples not filed are returned by SASE. Reports within 1 month. Request portfolio review in original query. Buys one-time rights. Pays on publication; $50 for b&w cover; $25 for inside.

Tips: "No color. We use mainly local artists usually to illustrate features. We also require a fast turnaround. Humor scores points with us."

☑ THEMA, Box 8747, Metairie LA 70011-8747. (504)568-6268. E-mail: bothomos@juno.com. Website: http://www.litline.org. Editor: Virginia Howard. Estab. 1988. Triquarterly. Circ. 300. Sample copies are available for $8. Art guidelines for SASE with first-class postage.

> ● Each issue of *Thema* is based on a different, unusual theme, such as "Jogging on Ice." Upcoming themes and deadlines include "Toby Came Today" (November 1, 1999); "Addie hasn't been the same . . ." (March 1, 2000); and "Scraps" (July 1, 2000).

Cartoons: Approached by 10 cartoonists/year. Buys 1 cartoon/issue. Preferred themes are specified for individual issue (see Tips and Editorial Comment). Prefers humorous cartoons; b&w line drawings without gagline. Send query letter with finished cartoons. Samples are filed or are returned by SASE if requested by artist. Buys one-time rights. Pays $10 for b&w.

Illustration: Approached by 10 illustrators/year. Buys 1 illustration/issue. Has featured illustrations by Thezeus Sarris and Keith Peters. Features theme-related illustrations. Preferred themes are specified for target issue (see Tips and Editorial Comment). Considers pen & ink. Freelancers should be familiar with CorelDraw. Send query letter specifying target theme with photocopies, photographs and SASE. Samples are returned by SASE if requested by artist. Portfolio review not required. Buys one-time rights. **Pays on acceptance**; $25 for b&w cover; $10 for b&w inside; $5 for spots. Finds artists through word of mouth.

Tips: "Please be aware that *Thema* is theme-oriented—each issue based on a different theme. Don't submit anything unless you have one of our themes in mind. No theme—no chance of acceptance."

N THRASHER, 1303 Underwood Ave., San Francisco CA 94124. (415)822-3083. Fax: (415)822-8359. Website: http://www.thrashermagaine.com. Managing Editor: Jen Houghton. Estab. 1981. Monthly 4-color magazine. "*Thrasher* is the dominant publication devoted to the latest in extreme youth lifestyle, focusing on skateboarding, snowboarding, new music, videogames, etc." Circ. 200,000. Accepts previously published artwork. Originals returned at job's completi on. Sample copies for SASE with first-class postage. Art guidelines not available. Needs computer-literate freelancers for illustration. Freelancers should be familiar with Adobe Illustrator or Photoshop.

Cartoons: Approached by 100 cartoonists/year. Buys 2-5 cartoons/issue. Has featured illustrations by Mark Gonzales. Prefers skateboard, snowboard, music, youth-oriented themes. Assigns 100% of illustrations to new and emerging illustrators. Send query letter with brochure and roughs. Samples are filed and are not returned. Reports back to the artist only if interested. Rights purchased vary according to project. Pays $50 for b&w, $75 for color.

Illustrations: Approached by 100 illustrators/year. Buys 2-3 illustrations/issue. Prefers themes surrounding skateboard ing/skateboarders, snowboard/music (rap, hip hop, metal) and characters and commentary of an extreme nature. Prefers pen & ink, collage, airbrush, marker, charcoal, mixed media and computer media (Mac format). Send query letter with brochure, résumé, SASE, tearsheets, photographs and photocopies. Samples are filed. Publication will contact artist for portfolio review if interested. Portfolio should include b&w and color tearsheets, photocopies and photographs. Rights purchased vary according to project. Negotiates payment for covers. Sometimes requests work on spec before assigning job. Pays on publication; $75 for b&w, $100 for color inside.

Tips: "Send finished quality examples of relevant work with a bio/intro/résumé that we can keep on file and update contact info. Artists sometimes make the mistake of submitting examples of work inappropriate to the content of the magazine. Buy/borrow/steal an issue and do a little research. Read it. Desktop publishing is now sophisticated enough to replace all high-end prepress systems. Buy a Mac. Use it. Live it."

✓ TIKKUN MAGAZINE, 26 Fell St., San Francisco CA 94102. (415)575-1200. Fax: (415)575-1434. E-mail: magazine@tikkun.org. Website: http://www.tikkun.org. Editor: Michael Lerner. Managing Editor: Jo Ellen Green Kaiser. Estab. 1986. "A bimonthly Jewish critique of politics, culture and society. Includes articles regarding Jewish and non-Jewish issues, left-of-center politically." Circ. 70,000. Accepts previously published material. Original artwork returned after publication. Sample copies for $6 plus $2 postage or "call our distributor for local availability at (800)221-3148."

Illustration: Approached by 50-100 illustrators/year. Buys 0-8 illustrations/issue. Features realistic illustration. Assigns 90% of illustrations to experienced, but not well-known illustrators; 10% to new and emerging illustrators. Prefers line drawings. Send brochure, résumé, tearsheets, photostats, photocopies. Slides and photographs for color artwork only. Buys one-time rights. Do not send originals; unsolicited artwork will not be returned. "Often we hold onto line drawings for last-minute use." Pays on publication; $150 for color cover; $50 for b&w inside.

Tips: No "computer graphics, sculpture, heavy religious content. Read the magazine—send us a sample illustration of an article we've printed, showing how you would have illustrated it."

TIME, 1271 Avenue of the Americas, Rockefeller Center, New York NY 10020. (212)522-1212. Fax: (212)522-0536. Website: http://www.time.com. Deputy Art Director: Joe Zeff. Estab. 1923. Weekly magazine covering breaking news, national and world affairs, business news, societal and lifestyle issues, culture and entertainment. Circ. 4,096,000.

Illustration: Considers all media. Send postcard sample, printed samples, photocopies or other appropriate samples. Accepts disk submissions. Samples are filed. Reports back only if interested. Portfolios may be dropped off every Tuesday between 11 and 1. They may be picked up the following day, Wednesday, between 11 and 1. Buys first North American serial rights. Pay is negotiable. Finds artists through sourcebooks and illustration annuals.

N THE TOASTMASTER, 23182 Arroyo Vista, Rancho Santa Margarita CA 92688. (949)858-8255. Editor: Suzanne Frey. Estab. 1924. Monthly trade journal for association members. "Language, public speaking, communication are our topics." Circ. 170,000. Accepts previously published artwork. Originals returned at job's completion. Sample copies available.

Illustration: Buys 6 illustrations/issue. Works on assignment only. Prefers communications themes. Considers watercolor and collage. Send postcard sample. Accepts disk submissions. Samples are filed or returned by SASE if requested by artist. Reports back to the artist only if interested. Portfolio should include tearsheets and photocopies. Negotiates rights purchased. **Pays on acceptance**; $500 for color cover; $50-200 for b&w, $100-250 for color inside.

N TODAY'S CHRISTIAN WOMAN, 465 Gundersen Dr., Carol Stream IL 60188. (630)260-6200. Fax: (630)260-0114. Design Director: Gary Gnidovic. Estab. 1978. Bimonthly consumer magazine "for Christian women, covering all aspects of family, faith, church, marriage, friendship, career and physical, mental and emotional development from a Christian perspective." Circ. 309,848.

● This magazine is published by Christianity Today, Inc. which also publishes 12 other magazines. Gary Gndovic is also the art director for CTI's publication, *Book & Culture*.

Illustration: Approached by 30 illustrators/year. Buys 8 illustrations/issue. Considers all media. Send postcard sample or query letter with printed samples, photocopies, SASE and tearsheets. Send follow-up postcard sample every 6 months. Samples are filed. Reports back only if interested. Buys first rights. Pays $200-650 for color inside. Pays $250-350 for spots.

TODAY'S FIREMAN, Box 875108, Los Angeles CA 90087. Editor: Jayney Mack. Estab. 1960. Quarterly b&w trade tabloid featuring general interest, humor and technical articles and emphasizing the fire service. "Readers are firefight-

ers—items should be of interest to the fire service." Circ. 10,000. Accepts previously published material. Original artwork is not returned after publication.

Cartoons: Buys 12 cartoons/year from freelancers. Prefers fire-service oriented single panel with gagline; b&w line drawings. Send query letter with samples of style, roughs or finished cartoons. Reports back only if interested. Buys one-time rights. Pays $4.

Illustration: Send postcard sample or query letter with brochure. Pays $4-10 for b&w inside.

Design: Needs freelancers for design, production and multimedia. 50% of freelance work demands knowledge of Aldus FreeHand and QuarkXPress. Send query letter with SASE. Pays by the project.

Tips: "Everything should relate to the fire service."

TOLE WORLD, 1041 Shary Circle, Concord CA 94518. (510)671-9852. Editor: Judy Swager. Estab. 1977. Bimonthly 4-color magazine with creative designs for decorative painters. "*Tole* incorporates all forms of craft painting including folk art. Manuscripts on techniques encouraged." Circ. 90,000. Accepts previously published artwork. Original artwork returned after publication. Sample copies available; art guidelines available for SASE with first-class postage.

Illustrations: Buys illustrations mainly for step-by-step project articles. Buys 8-10 illustrations/issue. Prefers acrylics and oils. Considers alkyds, pen & ink, mixed media, colored pencil, watercolor and pastels. Needs editorial and technical illustration. Send query letter with photographs. Samples are not filed and are returned. Reports back about queries/submissions within 1 month. Pay is negotiable.

Tips: "Submissions should be neat, evocative and well-balanced in color scheme with traditional themes, though style can be modern."

TRAINS, P.O. Box 1612, 21027 Crossroads Circle, Waukesha WI 53187. (414)796-8776. Fax: (414)796-1778. E-mail: lzehner@kalmbach.com. Website: http://www.trains.com. Art Director: Lisa A. Zehner. Estab. 1940. Monthly magazine about trains, train companies, tourist RR, latest railroad news. Circ. 133,000. Art guidelines available.
● Published by Kalmbach Publishing. Also publishes *Classic Toy Trains*, *Astronomy*, *Finescale Modeler*, *Model Railroader* and *Model Retailer*.

Illustration: 100% of freelance illustration demands knowledge of Adobe Photoshop 3.0, Adobe Illustrator 5.5. Send query letter with printed samples, photocopies and tearsheets. Accepts disk submissions (opticals) or CDs, using programs above. Samples are filed. Art director will contact artist for portfolio review of color tearsheets if interested. Buys one-time rights. Pays on publication.

Tips: "Quick turnaround and accurately built files are a must."

TRAVEL IMPULSE, 9336 117th Street, Delta, British Columbia V4C 6B8 Canada. (604)951-3238. Fax: (604)951-8732. E-mail: travimp@ibm.net. Editor/Publisher: Susan M. Boyce. Copy Editor: Kim Applegate. Graphics Consultant: Craig Stuckless. Estab. 1984 (under name of Travel & Courier News). Quarterly consumer magazine about travel. "Our readers love to travel, in fact, they find it irresistable. We publish unusual, quirky destinations plus tips on how to get there inexpensively." Circ. 1,000. Sample copies available for $5. Art guidelines free for SASE with first-class Canadian postage or IRC.
● The editor told *AGDM* that she is actively searching for new freelance illustrators to help update the look of the magazine.

Cartoons: "We are considering cartoons but have not used them to this point. Query and we might be interested—single panel only."

Illustration: Buys 2-4 illustrations/issue. Features humorous illustration; charts & graphs. Assigns 25% of illustrations to new and emerging illustrators. Prefers "the allure of exotic destinations or the fun, playfulness of travel as themes." Considers all media especially charcoal, mixed media, pen & ink and photos. Send postcard sample, photocopies and tearsheets. Submission/queries with U.S. postage cannot be acknowledged or returned. Accepts disk submissions compatible with Adobe PageMaker 6.5. Samples are filed. Reports back within 8-10 weeks. Buys first and reprint rights. Pays on publication; $30 minimum for b&w cover; $50 mimimum for color cover; $10 minimum for b&w inside.

Tips: "We are changing the look of *Travel Impulse* so now is a good time to submit. Show us your playful side when submitting work."

TRAVEL PUBLISHING GROUP, 4100 NE 2nd Ave., #206, Miami FL 33157-3528. E-mail: miranda@travelpublishing.com and george@travelpublishing.com. Website: http://www.honeymoonmagazine.com. Creative Director: Miranda Newsom. Art Director (Adventure Journal): George Vasquez. Estab. 1994. Quarterly consumer magazines "focused on romantic travel, honeymoon and destination weddings." Circ. 200,000. Sample copies free for #10 SASE with first-class stamps; art guidelines not available.
● Publishes *Honeymoon Magazine* and *Adventure Journal*.

Illustration: Approached by 10-15 illustrators/year. Buys 2 illustrations/issue. Features caricatures of celebrities, charts & graphs and spot illustration. Assigns 10% of illustrations to well-known or "name" illustrators; 40% to experienced, but not well-known illustrators; 50% to new and emerging illustrators. Prefers tropical and romantic themes. Considers airbrush, collage, colored pencil, mixed media, oil, pastel and watercolor. 50% of freelance illustration demands knowledge of Adobe Photoshop, Adobe Illustrator, Aldus FreeHand and QuarkXPress. Send query letter with printed samples, postcards that show your style of illustration and photocopies. Accepts disk submissions. Must be Quark 3.3.2 comp and on Zip disk only. Samples are filed. Reports back within 2 months. Art director will contact artist for portfolio review of b&w, color, photographs, photostats, roughs, slides, tearsheets and thumbnails if interested. Buys first North

American serial, one-time and reprint rights. Pays on publication. Payment for spots negotiable. Finds illustrators through magazines and artist's submissions.

Design: Needs freelancers for design, production and multimedia projects. 100% of freelance work demands knowledge of Adobe Photoshop and QuarkXPress. Send query letter with printed samples, photocopies and tearsheets.

Tips: "We use quite a lot of freelance design and illustration."

TRIQUARTERLY, 2020 Ridge Ave., Evanston IL 60208-4302. (847)491-3490. Fax: (847)467-2096. Editor: Susan Hahn. Estab. 1964. Triquarterly literary magazine "dedicated to publishing writing and graphics which are fresh, adventurous, artistically challenging and never predictable." Circ. 5,000. Originals returned at job's completion. Sample copies for $5.

Illustration: Approached by 10-20 illustrators/year. Considers only work that can be reproduced in b&w as line art or screen for pages; all media; 4-color for cover. Send query letter with SASE, tearsheets, photographs, photocopies and brochure. Samples are filed or are returned by SASE. Reports back within 3 months (if SASE is supplied). Publication will contact artist for portfolio review if interested. Portfolio should include b&w and color thumbnails, tearsheets, slides, photostats, photocopies, final art and photographs. Buys first rights. Pays on publication; $300 for b&w/color cover; $20 for b&w inside.

[N] [□] TROIKA MAGAZINE, P.O. Box 1006, Weston CT 06883. (203)227-5377. Fax: (203)222-9332. E-mail: etroika@aol.com. Art Director: Minoru Morita. Estab. 1994. Quarterly literary magazine. *TROIKA* encourages readers to reflect on topics such as culture, science, the arts, parenting, the environment, business and politics. Circ. 120,000. Sample copies available.

Cartoons: Approached by 250 cartoonists/year. Buys 3 cartoons/issue. Prefers, single, double and multiple panel, political, humorous, b&w and color washes, b&w line drawings with gagline. Send query letter with photocopies. Samples are filed and are not returned. Reports back only if interested. Buys first North American serial rights. Pays on publication; $250.

Illustration: Approached by 1,000 illustrators/year. Buys 40 illustrations/issue. Considers all media. 50% of freelance illustration demands computer knowledge. Send postcard sample. Samples are filed and are not returned. Reports back only if interested. Art director will contact artist for portfolio review if interested. Buys first North American serial rights. Pays on publication; $1,000 for cover; $250-750 for inside. Pays $300-400 for spots. Finds illustrators through *Creative Black Book*, *LA Workbook*, on-line services, magazines, word of mouth, artist's submissions.

Design: Needs freelancers for design, production and multimedia projects. 100% of design demands knowledge of QuarkXPress. Send query letter with photocopies.

Tips: "We encourage freelancers to send in their work."

TRUE WEST, 205 W. Seventh, Suite 202, Stillwater OK 74076. (800)749-3369. Fax: (405)743-3374. E-mail: western @cowboy.net. Website: http://www.cowboy.net/western. Editor: Marc Huff. Monthly b&w magazine with 4-color cover emphasizing American Western history from 1830 to 1910. For a primarily rural and suburban audience, middle-age and older, interested in Old West history, horses, cowboys, art, clothing and all things Western. Circ. 65,000. Accepts previously published material and considers some simultaneous submissions. Original artwork returned after publication. Sample copy for $2; art guidelines for SASE and on website.

Cartoons: Approached by 10-20 cartoonists/year. Buys 1 cartoon/issue. Prefers western history theme. Prefers humorous cartoons, single or multiple panel. Send query letter with photocopies. Samples are filed or returned. Reports back within 2 weeks. Buys first rights. Pays $25-75 for b&w cartoons.

Illustration: Approached by 100 illustrators/year. Buys 5-10 illustrations/issue (2 or 3 humorous). Has featured illustrations by Gary Zaboly, Bob Bose Bell, Sparky Moore and Jack Jackson. Assigns 80% of illustrations to well-known or "name" illustrators; 10% to experienced, but not well-known illustrators; 10% to new and emerging illustrators. "Inside illustrations are usually, but not always, pen & ink line drawings; covers are Western paintings." 10% of freelance illustration demands knowledge of Adobe Photoshop, Adobe Illustrator and QuarkXPress. Send query letter with photocopies to be kept on file; "We return anything on request. For inside illustrations, we want samples of artist's line drawings. For covers, we need to see full-color transparencies." Reports back within 2 weeks. Publication will contact artist for portfolio review if interested. Buys one-time rights. Sometimes requests work on spec before assigning job. **"Pays on acceptance for new artists, on assignment for established contributors."** Pays $125-200 for color cover; $20-75 for b&w inside; and $20-25 for spots.

Tips: "We think the interest in Western Americana has moved in the direction of fine art, and we're looking for more material along those lines. Our magazine has an old-fashioned Western history design with a few modern touches. We use a wide variety of styles so long as they are historically accurate and have an old-time flavor. We must see samples demonstrating historically accurate details of the Old West. Our readers won't be fooled by bad art. Know your history!! Clothing, weapons, etc."

TURTLE MAGAZINE, For Preschool Kids, Children's Better Health Institute, 1100 Waterway Blvd., Box 567, Indianapolis IN 46206. (317)636-8881. Art Director: Bart Rivers. Estab. 1979. Emphasizes health, nutrition, exercise and safety for children 2-5 years. Published 8 times/year; 4-color. Original artwork not returned after publication. Sample copy for $1.75; art guidelines for SASE with first-class postage. Needs computer-literate freelancers familiar with Macromedia FreeHand and Adobe Photoshop for illustrations.

● Also publishes *Child Life*, *Children's Digest*, *Children's Playmate*, *US Kids*, *Humpty Dumpty's Magazine* and *Jack and Jill*.

Illustration: Approached by 100 illustrators/year. Works with 20 illustrators/year. Buys 15-30 illustrations/issue. Interested in "stylized, humorous, realistic and cartooned themes; also nature and health." Works on assignment only. Send query letter with good photocopies and tearsheets. Accepts disk submissions. Samples are filed or are returned by SASE. Reports only if interested. Portfolio review not required. Buys all rights. Pays on publication; $275 for color cover; $35-90 for b&w inside; $70-155 for color inside; $35-70 for spots. Finds most artists through samples received in mail.
Tips: "Familiarize yourself with our magazine and other children's publications before you submit any samples. The samples you send should demonstrate your ability to support a story with illustration."

✔ **TV GUIDE**, 1211 Sixth Ave., New York NY 10036. (212)852-7500. Fax: (212)852-7470. Art Director: Maxine Davidowitz. Estab. 1953. Weekly consumer magazine for television viewers. Circ. 11,800,000. Sample copies available.
Illustration: Approached by 200 illustrators/year. Buys 50 illustrations/year. Considers all media. Send postcard sample. Samples are filed. Art director will contact artist for portfolio review of color tearsheets if interested. Negotiates rights purchased. **Pays on acceptance**; $1,500-4,000 for color cover; $1,000-2,000 for full page color inside; $200-500 for spots. Finds artists through sourcebooks, magazines, word of mouth, submissions.

▟ **U. THE NATIONAL COLLEGE MAGAZINE**, 1800 Century Park E. #820, Los Angeles CA 90067-1511. (310)551-1381. Fax: (310)551-1659. E-mail: cmann@umagazine.com. Website: http://www.umagazine.com. Editor: Frances Huffman. Art Director: Chris Mann. Estab. 1986. Monthly consumer magazine of news, lifestyle and entertainment geared to college students. Magazine is for college students by college students. Circ. 1.5 million. Sample copies and art guidelines available for SASE with first-class postage or on website.
● This magazine won *Folio Magazine's* 1998 Editorial Excellence Award.
Cartoons: Approached by 25 cartoonists/year. Buys 2 cartoons/issue. Prefers college-related themes. Prefers humorous color washes, single or multiple panel with gagline. Send query letter with photocopies. Samples are filed and not returned. Reports back only if interested. Buys all rights. Pays on publication; $25 for color.
Illustration: Approached by 100 illustrators/year. Buys 10-20 illustrations/issue. Features caricatures of celebrities; humorous illustration; informational graphics; computer and spot illustration. Assigns 100% of illustrations to new and emerging illustrators. Prefers bright, light, college-related, humorous, color only, no b&w. Considers collage, color washed, colored pencil, marker, mixed media, pastel, pen & ink or watercolor. 20% of freelance illustration demands knowledge of Adobe Photoshop, Adobe Illustrator and QuarkXPress. Send query letter with photocopies and tearsheets. Samples are filed and are not returned. Reports back only if interested. Buys all rights. Pays on publication; $100 for color cover; $25 for color inside; $25 for spots. Finds illustrators through college campus newspapers and magazines.
Tips: "We need light, bright, colorful art. We accept art from college students only."

UNDERGROUND SURREALIST MAGAZINE, P.O. Box 382565, Cambridge MA 02238-2565. (617)789-4107. Website: http://fas-www.harvard.edu~cusimano/chickenlittle.html. Publisher: Mick Cusimano. Estab. 1987. Annual magazine featuring cartoons, social satire, 1-2 page comic stories and strips. Circ. 300. Sample copy for $3. Art guidelines available for SASE with first-class postage.
Cartoons: Approached by 20 cartoonists/year. Buys 10 cartoons/issue. Prefers multiple panel, humorous, b&w line drawings, with gaglines. Send query letter with photocopies. Samples are filed. Reports back in 1 month. Buys one-time rights. Pays 1 contributor's copy to cartoonist.

UNMUZZLED OX, 105 Hudson St., New York NY 10013. (212)226-7170. Editor: Michael Andre. Emphasizes poetry, stories, some visual arts (graphics, drawings, photos) for poets, writers, artists, musicians and interested others; b&w with 2-color cover and "classy" design. Circ. 18,000. Return of original artwork after publication "depends on work—artist should send SASE." Sample copy for $4.95 plus $1 postage.
Cartoons: Send query letter with copies. Reports within 10 weeks. No payment for cartoons.
Illustration: Uses "several" illustrations/issue. Themes vary according to issue. Send query letter and "anything you care to send" to be kept on file for possible future assignments. Reports within 10 weeks.
Tips: Magazine readers and contributors are "highly sophisticated and educated"; artwork should be geared to this market. "Really, *Ox* is part of New York art world. We publish art, not 'illustration.'"

▣ **UPSIDE**, 731 Market St., 2nd Floor, San Francisco CA 94103-2005. (415)589-5600. Fax: (415)589-4400. E-mail: rmerchan@upside.com. Website: http://www.upside.com. Art Director: Richard Merchán. Estab. 1990. Monthly trade publication covering the business aspects of the technology industry from an executive perspective. *Upside* interprets, examines and tracks emerging technology trends in a sophisticated, entertaining fashion. Circ. 150,000.
Cartoons: Approached by 100 cartoonists/year. Buys 12 cartoons/year. Prefers sophisticated business and technology themes. Send query letter with photocopies. Samples are filed. **Pays on acceptance**. Payment negotiable.
Illustration: Approached by 500 illustrators/year. Buys 7-8 illustrations/issue. Has featured illustrations by Vivienne Flesher, Jose Cruz, Ismael Roldan and Brian Raska. Features caricatures and portraiture of influential hi-tech business personalities, like Bill Gates, Andy Grove, Ted Turner, Larry Ellison; humorous illustration; realistic or stylistic illustrations of controversial hi-tech business subjects. "We tend to hit below the belt within reason." Prefers all styles and media. Art director chooses style to go with the varying tone and content of each article. Assigns 5% of illustrations to well-known or "name" illustrators; 55% to experienced, but not well-known illustrators; 40% to new and emerging

illustrators. Send postcard sample and follow-up postcard every 3 months. Accepts Mac-compatible disk submissions. Samples are filed. Reports back only if interested. Will review portfolios. Call to arrange drop-off. Buys first rights. Pays 30 days after acceptance; $1,200-1,500 for color cover (uses mostly photography for covers); $800-1,000 for color inside; $200-300 for spots. Finds illustrators through samples and source books.
Tips: "Frequency is very important when sending out samples to make sure art directors remember your name and associate you with a style. Create four different postcards and roate them throughout the year. If you have only one postcard sample just send the same one. Being an illustrator myself, I understand the commitment it takes to send out frequent samples. I tend to respect and reward those illustrators who send frequent samples because it demonstrates their commitment."

☑ **US KIDS: A WEEKLY READER MAGAZINE**, 1100 Waterway Blvd., Indianapolis IN 46202. (317)636-8881. Fax: (317)684-8094. Art Director: Talmadge Burdine. Estab. 1987. Magazine published 8 times/year focusing on health and fitness for kids 5-12 years old. Marketed through school systems. Circ. 250,000. Sample copy for $2.50. Art guidelines free for SASE with first-class postage.
Illustration: Approached by 120 illustrators/year. Buys 10-20 illustrations/issue. Use same artist on a series. Has featured illustrations by: George Sears, John Lupton, Ron Wheeler, John Blackford and Geoffrey Brittingham. Assigns 10% of illustrations to well-known or "name" illustrators; 70% to experienced but not well-known illustrators; 20% to new and emerging illustrators. Uses same artist on series. Prefers health, fitness, fun for kids, simple styles. Considers all media. 25% of freelance illustration demands knowledge of Adobe Photoshop, Adobe Illustrator, Aldus FreeHand and QuarkXPress. Send postcard sample or query letter with printed samples, photocopies, tearsheets. Send follow-up postcard sample every 4-6 months. Samples are filed. Reports back only if interested. Art director will contact artist for portfolio review of color, final art, tearsheets, transparencies. Include a sample with name and address to leave with art director. Buys all rights. Pays on publication; $70-190 for color inside. Pays $70-80 for spots. Finds illustrators through sourcebooks and submissions. Pays slightly more for electronic versions of illustrations (on disk and formatted for magazine use).
Tips: Work should be colorful and on the traditional side rather than wild and wacky. We center much of our magazine toweard good health and educational themes. You must be geared to children, positive in nature. Timing and need are biggest factors! Most illustration is "middle of road." Do not use much that is too avant-garde. Need for activity pages and/or pieces. With a new editor and art director on board our magazine is going to have a substantial face-lift. We also are gearing our magazine down to a younger audience. Though we will use other info, our thrust will be toward second and third grade age groups.

☑ **UTNE READER**, 1624 Harmon Place, Suite 330, Minneapolis MN 55403. (612)338-5040. Website: http://www.utne.com. Assistant Art Director: Victor Sanchez. Estab. 1984. Bimonthly digest of news and opinion with articles and reviews selected from independently published newsletters, magazines and journals. Regularly covers politics, international issues, the arts, science, education, economics and psychology. Circ. 260,644.
 • The art director for *Utne Reader* commissions illustrations from renowned illustrators like Brad Holland and Vivienne Flesher to enliven magazine's pages, but he is also open to new illustrators. However, newcomers must show consistency in conceptualizinig ideas, and provide evidence that they can meet deadlines.
Cartoons: Approached by 20 cartoonists/issue. Buys 4-5 cartoons/issue. Prefers single panel b&w line drawings with gagline. Send query letter with photocopies or other appropriate samples. Samples are filed and are returned. Reports back only if interested. Buys 60-day North American serial rights. Payment negotiable.
Illustration: Approached by "tons" of illustrators/year. Buys 20-25 illustrations per issue. Considers all media. Send postcard or other appropriate samples. Accepts submissions on disk. Samples are filed and are not returned. Reports back only if interested. Pays $1,500 for color cover; $175-1,000 for original color inside; and $175-200 for spots. Find artists through submissions, illustration annuals and soucebooks.
Tips: "Please send samples that are easy to open. Samples that take a lot of time to open are generally tossed."

VANITY FAIR, 350 Madison Ave., New York NY 10017. (212)880-8800. Fax: (212)880-6707. E-mail: vfmail@vf.com. Art Director: David Harris. Estab. 1983. Monthly consumer magazine. Circ. 1.1 million. Does not use previously published artwork. Original artwork returned at job's completion. 100% of freelance design work demands knowledge of QuarkXPress and Adobe Photoshop.
Illustration: Approached by "hundreds" of illustrators/year. Buys 3-4 illustrations/issue. Works on assignment only. "Mostly uses artists under contract."

☑ **VARBUSINESS**, Dept. AM, One Jericho Plaza, Wing A, Jericho NY 11753. (516)733-8550. E-mail: varbizart@cmp.com. Website: http://www.varbiz.com. Art Director: Dean Markadakis. Estab. 1985. Emphasizes computer business, for and about value added resellers. Biweekly 4-color magazine with an "innovative, contemporary, progressive, very creative" design. Circ. 105,000. Original artwork is returned to the artist after publication. Art guidelines not available.
Illustration: Approached by 100+ illustrators/year. Works with 30-50 illustrators/year. Buys 150 illustrations/year. Needs editorial illustrations. Style of Peter Hoey, Brian Kronin, Steve Dininno, Joel Nakamura, Robert Pizzo. Uses artists mainly for covers, full and single page spreads and spots. Works on assignment only. Prefers "digitally compiled, technically conceptual oriented art (all sorts of media)." Send postcard sample or query letter with tearsheets. Accepts disk submissions. Samples are filed or are returned only if requested. Reports back only if interested. Call or write for appointment to show portfolio, which should include tearsheets, final reproduction/product and slides. Buys one-time

rights. Pays on publication. Pays $1,000-1,500 for b&w cover; $1,500-2,500 for color cover; $500-850 for b&w inside; $750-1,000 for color inside; pays $300-600 for spots. 30-50% of freelance work demands knowledge of Adobe Photoshop and QPS Publishing.

Design: Also needs freelancers for design. 100% of design demands knowledge of Adobe Photoshop 4.0 and QuarkX-Press 3.31.

Tips: "Show printed pieces or suitable color reproductions. Concepts should be imaginative, not literal. Sense of humor sometimes important."

VEGETARIAN JOURNAL, P.O. Box 1463, Baltimore MD 21203-1463. (410)366-8343. E-mail: vrg@vrg.org. Website: http://www.vrg.org. Editor: Debra Wasserman. Estab. 1982. Bimonthly nonprofit vegetarian magazine that examines the health, ecological and ethical aspects of vegetarianism. "Highly educated audience including health professionals." Circ. 27,000. Accepts previously published artwork. Originals returned at job's completion upon request. Sample copies available for $3.

Cartoons: Approached by 4 cartoonists/year. Buys 1 cartoon/issue. Prefers humorous cartoons with an obvious vegetarian theme; single panel b&w line drawings. Send query letter with roughs. Samples are not filed and are returned by SASE if requested by artist. Reports back within 2 weeks. Rights purchased vary according to project. Pays $25 for b&w.

Illustration: Approached by 20 illustrators/year. Buys 6 illustrations/issue. Works on assignment only. Prefers strict vegetarian food scenes (no animal products). Considers pen & ink, watercolor, collage, charcoal and mixed media. Send query letter with photostats. Samples are not filed and are returned by SASE if requested by artist. Reports back within 2 weeks. Portfolio review not required. Rights purchased vary according to project. **Pays on acceptance**; $25-50 for b&w/color inside. Finds artists through word of mouth and job listings in art schools.

Tips: Areas most open to freelancers are recipe section and feature articles. "Review magazine first to learn our style. Send query letter with photocopy sample of line drawings of food."

N VENTURES, 105 S. Fifth St., Suite 100, Minneapolis MN 55402-9018. (612)338-4288. Fax: (612)373-0195. E-mail: jonathanh@corpreport.com. Art Director: Jonathan Hankin. Designer: Therese Rozeboom. Estab. 1998. Monthly 4-color consumer magazine. Circ. 25,000.

Illustration: Approached by 300 illustrators/year. Buys 5 illustrations/issue. Has featured illustrations by Victor Gad, Paul Stoddard, Charles Stubbs, Mark James and Hadi Farahani. Features computer, humorous and spot illustration. Preferred subject: business. Prefers work with strong graphical qualities, bright colors and with an ironic twist or sense of the bizarre. Assigns 80% of illustrations to experienced, but not well-known illustrators; 20% to new and emerging illustrators. Send postcard sample and follow-up postcard every 2 months or send non-returnable samples. Accepts Mac-compatible disk submissions. Send TIFF files; may send compressed JPEGs via e-mail. Samples are filed. Will contact artist for portfolio review if interested. Buys first rights. **Pays on acceptance.** Pays $600-1,000 for b&w, $600-1,200 for color cover; $150-400 for b&w, $200-600 for color inside. Pays $150 for spots. Finds illustrators through magazines, word of mouth and artists' promotional samples.

Tips: "We are looking for non-traditional business illustration. We have a lively and energetic publication which has a unique sense of humor. Illustrations submitted should exhibit these same qualities."

N VFW MAGAZINE, 406 W, 34th St., Suite 523, Kansas City MO 64111. (816)756-3390. Fax: (816)968-1169. Website: http://www.vfw.org. Art Director: Robert Widener. Estab. 1904. Monthly 4-color company magazine. Audience is military veterans of overseas campaigns. Articles cover items of interest to veterans and veterans issues. Circ. 1.8 million.

Illustration: Approached by 75 illustrators/year. Buys 1-2 illustrations/issue. Has featured illustrations by Tom Bookwalter, Paul Salmon and David Russell. Features caricatures of politicians, realistic illustrations and spot illustrations of military, military history and current events. "Style is most important, prefer realism." Assigns 10% of illustrations to well-known or "name" illustrators; 70% to experienced, but not well-known illustrators; 20% to new and emerging illustrators. 25% of freelance illustration demands knowledge of Adobe Photoshop. Send query letter with photocopies, SASE. Samples are returned by SASE. Reports back within 1 month. Reports back only if interested. Will contact artist for portfolio review if interested. Rights purchased vary according to project. **Pays on acceptance**; $400-1,000 for color cover; $250 maximum for b&w inside, $500 for color inside; $125 for spots.

Tips: "Illustrators who enjoy history, particularly military history, and have well-executed illustrations stand the best chance."

VIBE, 215 Lexington Ave., 6th Floor, New York NY 10016. (212)448-7300. Fax: (212)448-7400. E-mail: dshaw@vibe.com. Art Director: Dwayne Shaw. Estab. 1993. Monthly consumer magazine focused on music, urban culture. Circ. 450,000. Accepts previously published artwork. Originals returned at job's completion. Sample copies available.

Cartoons: Send postcard-size sample or query letter with brochure and finished cartoons. Samples are filed. Reports back to the artist only if interested. Buys one-time rights.

Illustration: Has featured illustrations by Dan Adel and Johanna Goodman. Assigns 50% of illustrations to well-known or "name" illustrators; 25% to experienced, but not well-known illustrators; 25% to new and emerging illustrators. Works on assignment only. Considers all media. Send postcard-size sample or query letter with photocopies. Samples are filed. Portfolios may be dropped off every Wednesday. Publication will contact artist for portfolio review of roughs, final art and photocopies if interested. Buys one-time or all rights. Finds artists through portfolio drop-off.

✓ **VIDEOMAKER MAGAZINE**, Box 4591, Chico CA 95927. (916)891-8410. Fax: (916)891-8443. E-mail: spiper @videomaker.com. Website: http://www.videomaker.com. Art Director: Samuel Piper. Monthly 4-color magazine for video camera users with "contemporary, stylish yet technical design." Circ. 150,000. Accepts previously published artwork. Original artwork returned at job's completion. 75% of freelance work demands knowledge of Adobe PageMaker, Adobe Illustrator, FreeHand and Photoshop.

Cartoons: Prefers technical illustrations with a humorous twist. Pays $30-200 for b&w, $200-800 for color.

Illustration: Approached by 30 illustrators/year. Buys 3 illustrations/issue. Has featured illustrations by Larry Burke-Weiner. Assigns 80% of illustrations to experienced, but not well-known illustrators; 20% to new and emerging illustrators. Works on assignment only. Likes "illustration with a humorous twist." Considers pen & ink, airbrush, colored pencil, mixed media, watercolor, acrylic, oil, pastel, collage, marker and charcoal. Needs editorial and technical illustration. Send postcard sample and/or query letter with photocopies, brochure, SASE and tearsheets. Samples are filed. Publication will contact artist for portfolio review. Portfolio should include thumbnails, tearsheets and photographs. Negotiates rights purchased. Sometimes requests work on spec before assigning job. Pays on publication; $30-800 for b&w inside; $50-1,000 for color inside; $30-50 for spots. Finds artists through submissions/self-promotions.

Design: Needs freelancers for design. Freelance work demands knowledge of Adobe PageMaker, Photoshop and FreeHand. Send query letter with brochure, photocopies, SASE, tearsheets. Pays by the project, $30-1,000.

Tips: "Read a previous article from the magazine and show how it could have been illustrated. The idea is to take highly technical and esoteric material and translate that into something the layman can understand. Since our magazine is mostly designed on desktop, we are increasingly more inclined to use computer illustrations along with conventional art. We constantly need people who can interpret our information accurately for the satisfaction of our readership. Wants artists with quick turnaround (21 days maximum). Magazine will have a 'new look' starting in March 1999 issue with a digital emphasis."

VISIONS—INTERNATIONAL, THE WORLD OF ILLUSTRATED POETRY, Black Buzzard Press, 1007 Ficklen Rd., Fredericksburg VA 22405. Editors: Bradley R. Strahan and Shirley Sullivan. Art Editor: Jerry Minor. Emphasizes literature and the illustrative arts for "well educated, very literate audience, very much into art and poetry." Published 3 times/year. Circ. 750. Original artwork returned after publication *only if requested*. Sample copy for $4.50 (latest issue $5.50); art guidelines for SASE with first-class postage.

Illustration: Approached by 40-50 illustrators/year. Has featured illustrations by Ursula Gill, Brad Ross and Kathleen Oettinger. Assigns 50% of illustrations to experienced, but not well-known illustrators; 50% to new and emerging illustrators. Acquires approximately 21 illustrations/issue. Needs poetry text illustration. Works on assignment only. Features realistic and spot illustration. Representational to surrealistic and some cubism. Black & white only. Send query letter with SASE and photocopies that clearly show artist's style and capability; no slides or originals. Samples not filed are returned by SASE. Reports within 2 months. Portfolio review not required. Acquires first rights. "For information of releases on artwork, please contact the editors at the above address." Pays in copies or up to $10. Finds new artists through editor or people submitting samples.

Tips: "Don't send slides. We might lose them. We don't use color, anyway. No amateurs. Send available unpublished black & white illustrations. We might even use one in an emergency."

WASHINGTON CITY PAPER, 2390 Champlain St. N.W., Washington DC 20009. (202)332-2100. E-mail: mail@washcp.com. Website: http://www.washingtoncitypaper.com. Art Director: Jandos Rothstein. Estab. 1980. Weekly tabloid "distributed free in D.C. and vicinity. We focus on investigative reportage and general interest stories with a local slant." Circ. 95,000. Art guidelines not available.

Cartoons: Prefers b&w line drawings. Send query letter with photocopies. Samples are not filed and are not returned. Reports back only if interested. Pays $25 minimum for b&w.

Illustration: Approached by 50-100 illustrators/year. Buys 2-8 illustrations/issue. Has featured illustrations by Michael Kupperman, Peter Kuper, Greg Heuston, Joe Rocco, Marcos Sorensen and Robert Meganck. Features caricatures of politicians; humorous illustration; informational graphics; computer and spot illustration. Considers all media, if the results do well in b&w. Send query letter with printed samples, photocopies or tearsheets. We occasionally accept Mac compatible files. Art director will contact artist for portfolio review of b&w, final art, tearsheets if interested. Buys first-rights. Pays on publication which is usually pretty quick; $150 minimum for b&w cover; $200 for color cover; $75 minimum for inside. Finds illustrators mostly through submissions.

Tips: "We are a good place for freelance illustrators, we use a wide variety of styles, and we're willing to work with beginning illustrators. We like illustrators who are good on concept and can work fast if needed. We don't use over polished 'clip art' styles. We also avoid cliché DC imagery such as the capitol and monuments."

Ⓝ **WASHINGTON FLYER MAGAZINE**, % The Magazine Group, 1707 L St. NW, Suite 350, Washington DC 20036. (202)331-9393. Art Director: Elaine Bradley. Estab. 1989. Bimonthly 4-color consumer magazine. "In-airport publication focusing on travel, transportation, trade and communications for frequent business and pleasure travelers." Circ. 180,000. Accepts previously published artwork. Original artwork is returned to the artist at the job's completion. Sample copies available. Art guidelines not available. Needs computer-literate freelancers for illustration. 20% of freelance work demands knowledge of QuarkXPress, Aldus FreeHand or Adobe Illustrator.

Illustration: Approached by 100 illustrators/year. Needs editorial illustration—"clear, upbeat, sometimes serious, positive, bright." Works on assignment only. Considers all media. Send query letter with brochure, tearsheets, photostats, photographs, slides, SASE, photocopies and transparencies. Samples are filed. Publication will contact artist for portfolio

review if interested. Portfolio should include color tearsheets, photostats, photographs, slides and color photocopies. Buys reprint rights or all rights. **Pays on acceptance**; $600 for color cover; $250 for color inside.

Tips: "We are very interested in reprint rights."

☑ **WASHINGTON PHARMACIST**, 1501 Taylor Ave. SW, Renton WA 98055-3139. (425)228-7171. Fax: (425)277-3897. E-mail: wspa@pharmcare.org. Website: http://www.pharmcare.org. Publications Director: Sheri Ray. Estab. 1959. Quarterly association trade magazine, b&w with 2- and 4-color covers, emphasizing pharmaceuticals, professional issues and management for pharmacists. Circ. 2,000. Accepts previously published artwork.

Cartoons: Approached by 15 cartoonists/year. Buys fewer than 5 cartoons/year. Themes vary. Send query letter with brochure and roughs. Samples are filed. Reports back only if interested. Rights purchased vary according to project. Pays $15 for b&w.

Illustration: Approached by 15 illustrators/year. Buys 2-5 illustrations/year. Send postcard sample or query letter with brochure. Publication will contact artist for portfolio review if interested. Rights purchased vary according to project. **Pays on acceptance**; $25-75 cover; $15-25 inside. Finds artists through submissions and word of mouth.

Ⓝ **WASHINGTONIAN MAGAZINE**, 1828 L St., NW, Suite 200, Washington DC 20036. (202)862-3528. E-mail: ttilden-smith@washingtonian.com. Website: http://www.washingtonian.com. Creative Director: Tessa Tilden-Smith. Associate Design Director: Eileen Crowson. Estab. 1965. Monthly 4-color consumer lifestyle and service magazine. Circ. 120,000. Sample copies free for #10 SASE with first-class posgate.

Illustration: Approached by 200 illustrators/year. Buys 2 illustrations/issue. Has featured illustrations by Michael Witte, John Kascht, Michael Paraskevas and Richard Thompson. Features caricatures of celebrities, caricatures of politicians, humorous illustration, realistic illustrations, spot illustrations, computer illustrations and photo collage. Preferred subjects: men, women and creative humorous illustration. Prefers light and bright colors. Assigns 20% of illustrations to well-known or "name" illustrators; 60% to experienced, but not well-known illustrators; 20% to new and emerging illustrators. 20% of freelance illustration demands knowledge of Adobe Photoshop. Send postcard sample and follow-up postcard every 6 months. Send non-returnable samples. Send query letter with tearsheets. Accepts Mac-compatible submissions. Send EPS or TIFF files. Samples are filed or returned by SASE. Reports back only if interested. Will contact artist for portfolio review if interested. Buys first rights. **Pays on acceptance**; $900-1,200 for color cover; $200-800 for b&w, $400-900 for color inside; $900-1,200 for 2-page spreads; $400 for spots. Finds illustrators through magazines, word of mouth, promotional samples, sourcebooks.

Tips: "We like caricatures that are fun, not mean and ugly. Want a well-developed sense of color, not just primaries."

☑ **WATERCOLOR MAGIC**, 1507 Dana Ave., Cincinnati OH 45207. (513)531-2690. Fax: (513)531-2902. E-mail: wcmedit@aol.com. Art Director: Dave Richmond. Editor: Ann Abbott. Estab. 1995. Quarterly 4-color consumer magazine to "help artists explore and master watermedia." Circ: 92,000. Art guidelines free for #10 SASE with first-class postage.

Illustration: Pays on publication. Finds illustrators through word of mouth, visiting art exhibitions, unsolicited queries, reading books.

Tips: "We are looking for watermedia artists who are willing to teach special aspects of their work and their techniques to our readers."

WEEKLY READER, (formerly *Weekly Reader/Secondary*), Weekly Reader Corp., 200 First Stamford Place, Stamford CT 06912. (203)705-3500. Contact: Sandra Forrest. Estab. 1928. Educational newspaper, magazine, posters and books. *Weekly Reader* has a newspaper format. The *Weekly Reader* emphasizes news and education for children 4-14. The philosophy is to connect students to the world. Publications are 4-color. Design is "clean, straight-forward." Accepts previously published artwork. Original artwork is returned at job's completion. Sample copies are available.

Illustration: Needs editorial and technical illustration. Style should be "contemporary and age level appropriate for the juvenile audience." Buys more than 50/week. Works on assignment only. Uses computer and reflective art. Send query letter with brochure, tearsheets, slides, SASE and photocopies. Samples are filed or are returned by SASE if requested by artist. Request portfolio review in original query. Payment is usually made within 3 weeks of receiving the invoice. Finds artists through artists' submissions/self-promotions, sourcebooks, agents and reps.

Tips: "Our primary focus is the children's marketplace; figures must be drawn well if style is realistic. Art should reflect creativity and knowledge of audience's needs. Our budgets are tight and we have very little flexibility in our rates. We need artists who can work with our budgets. Still seeking out artists of all styles—professionals!"

WESTART, P.O. Box 6868, Auburn CA 95604-6868. (530)885-0969. Editor: Martha Garcia. Estab. 1962. Semimonthly art magazine. *WestArt* serves fine artists and craftspeople on the West Coast. Readership includes art patrons, libraries, galleries and suppliers. It features news about current and upcoming gallery exhibitions, and covers painting, ceramics, sculpture, photography, and related visual arts activities. The "Time to Show" section lists fine art competitions, as well arts and crafts shows and festivals. Circ. 4,000. Originals returned at job's completion. Sample copies and art guidelines available.

● Does not buy cartoons or illustrations, but features the work of fine artists whose work is shown on the West Coast.

Tips: All art published by *WestArt*, including cartoons and illustrations, must be included in current or upcoming West Coast exhibitions. Artists should send for a free sample copy of *WestArt* and art guidelines before submitting any

information or artwork. When submitting information and artwork, a SASE is required for a response.

WESTWAYS, 3333 Fairview Rd., Costa Mesa CA 92808. (714)885-2396. Fax: (714)885-2335. Design: Eric Van Eyke. Estab. 1918. A bimonthly lifestyle and travel magazine. Circ. 3,000,000. Original artwork returned at job's completion. Sample copies and art guidelines available for SASE.
Illustration: Approached by 20 illustrators/year. Buys 2-6 illustrations/issue. Works on assignment only. Preferred style is arty-tasteful, colorful. Considers pen & ink, watercolor, collage, airbrush, acrylic, colored pencil, oil, mixed media and pastel. Send query letter with brochure, tearsheets and samples. Samples are filed. Reports back within 1-2 weeks only if interested. To show a portfolio, mail appropriate materials. Portfolio should include thumbnails, final art, b&w and color tearsheets. Buys first rights. Pays on publication; $250 minimum for color inside.

WILDLIFE ART, P.O. Box 390026, Edina MN 55439. (612)835-5353. Fax: (612)835-5554. Publisher: Robert Koenke. Estab. 1982. Bimonthly 4-color trade journal with award-winning design. Many two-page color art spreads. "The largest magazine in wildlife art originals, prints, duck stamps, artist interviews and industry information." Circ. 55,000. Accepts previously published artwork. Original artwork returned to artist at job's completion. Sample copy for $6; art guidelines for SASE with first-class postage.
 • Also publishes *Sculpture Forum* magazine, highlighting the best of three-dimensional artwork in all media.
Illustration: Approached by 100 illustrators/year. Works on assignment only. Prefers nature and animal themes. Considers pen & ink and charcoal. Send postcard sample or query letter. Accepts disk submissions compatible with Mac—QuarkXPress, Adobe Illustrator and Adobe Photoshop. Send EPS files. Samples are not filed and are returned by SASE if requested by artist. Reports back within 1 to 2 months. To show a portfolio, mail color tearsheets, slides and photocopies. Buys first rights. "We do not pay artists for illustration in publication material."
Tips: "Interested wildlife artists should send SASE, three to seven clearly-marked slides or transparencies, short biography and be patient! Also publish annually *1998 Art Collector's Edition*, now the seventh issue, the largest source book of wildlife artists' biographies, color reproductions, print prices and calendar of events for wildlife art shows. Sculptors, photographers, painters, scratchboard, and pastel artists are invited to participate in the volume. Write for packet."

WINDOWS NT MAGAZINE, 221 E. 29th St., Loveland CO 80538. (970)203-2732. Fax: (970)663-3714. E-mail: steve@duke.com. Creative Director: Steven Adams. Estab. 1995. Monthly technical publication for users of Windows NT. Circ. 150,000. Art guidelines not available.
Illustration: Buys 10-15 illustrations/issue. Has featured illustrations by A. Shachat, G. Horland, R. Magiera, V. GAD, E. Keleny, S. Liao, E. Yang and A. Baruffi. Features humorous, computer and spot illustration. Assigns 60% of illustrations to well-known or "name" illustrators; 20% to experienced, but not well-known illustrators; 10% to new and emerging illustrators. Considers all media. 80% of freelance illustration demands knowledge of Aldus FreeHand, Adobe Photoshop, Adobe Illustrator. Send postcard sample. Accepts 3.5″ floppy, 44-88-250mb SyQuest disk, optical disk and CD-ROM for Mac. Reports back only if interested. Art director will contact artist for portfolio review of tearsheets if interested. Rights purchased vary according to project. **Pays on acceptance**; $600-2,000 for color cover; $350-1,200 for color inside; $1,000-1,500 for 2-page spread; $125-450 for spots. Finds artists through the *Workbook* and samples.
Tips: "We're looking for illustrators who understand how to bring technical material to life, are professional and 'push the envelope' with their style and technique. Study the styles of artwork in the types of publication you would be interested in illustrating for and create a style similar or new that offers the art director a new choice."

WIRE JOURNAL INTERNATIONAL, 1570 Boston Post Rd., Guilford CT 06437. (203)453-2777. Contact: Art Director. Emphasizes the wire industry worldwide, members of Wire Association International, industry suppliers, manufacturers, research/developers, engineers, etc. Monthly 4-color. Circ. 12,500. Design is "professional, technical and conservative." Original artwork not returned after publication. Free sample copy and art guidelines.
Illustration: Illustrations are "used infrequently." Works on assignment only. Provide samples, business card and tearsheets to be kept on file for possible assignments. To submit a portfolio, call for appointment. Reports "as soon as possible." Buys all rights. Pay is negotiable; on publication. 85% of freelance work demands computer literacy in QuarkXPress and Photoshop.
Tips: "Show practical artwork that relates to industrial needs; and avoid bringing samples of surrealism, for example. Also, show a variety of techniques—and know something about who we are and the industry we serve."

WIRELESS REVIEW, 9800 Metcalf Ave., Overland Park KS 66212-2216. (913)967-7258. Fax: (913)967-1905. E-mail: cheri_jones@intertec.com. Website: http://www.wirelessreview.com. Art Director: Cheri Jones. Estab. 1998. Semimonthly 4-color trade publication covering cellular industry; readers include presidents of companies like Sprint PCS and AT&T. Circ. 30,000. Sample copies free for #10 SASE.
Illustration: Approached by 40 illustrators/year. Buys 3-12 illustrations/issue. Has featured illustrations by Jimmy Holder, Rick Nass and Daniel Vasconcellos. Features computer, humorous, realistic and spot illustration. Preferred subjects: business, men and women, cell phones, towers. Prefers watercolors, airbrush and computer-generated art. Assigns 80% of illustrations to experienced, but not well-known illustrators; 15% to new and emerging illustrators; 5% to well-known or "name" illustrators. Send non-returnable samples: printed samples, photocopies and tearsheets. Accepts Windows-compatible disk submissions, Zip only. Send EPS or TIFF files for PC. Samples are filed and returned by SASE. Reports back only if interested. Portfolio review not required. Buys one-time or reprint rights. Pays on publication. Pays $500-700 for color cover; $400-600 for color inside; $500-600 for 2-page color spread; $250 for spots. Finds

illustrators through *Creative Workbook*, *LA Black Book*, directory of illustration and the ispot.com.
Tips: "We are always open to new talent. Send tearsheets via mail on a regular basis. Assignments are given on a two-week turnaround basis; anything sent on a Zip disk saves time and money. We commonly use people in our illustrations with towers or phones; send samples incorporating people."

WISCONSIN REVIEW, Box 158, Radford Hall, University of Wisconsin-Oshkosh, Oshkosh WI 54901. (414)424-2267. Editor: Jonathan Wittman. Triquarterly review emphasizing literature (poetry, short fiction, reviews) and the arts. Black & white with 4-color cover. Circ. 2,000. Accepts previously published artwork. Original artwork returned after publication "if requested." Sample copy for $4; art guidelines available; for SASE with first-class postage.
Illustration: Uses 5-10 illustrations/issue. Assigns 10% of illustrations to well-known of "name" illustrators; 50% to experienced, but not well-known illustrators; 40% to new and emerging illustrators. "Cover submissions can be color, size 5½×8½ or smaller or slides. Submissions for inside must be b&w, size 5½×8½ or smaller unless artist allows reduction of a larger size submission. We are primarily interested in material that in one way or another attempts to elucidate, explain, discover or otherwise untangle the manifestly complex circumstances in which we find ourselves in this age." Send postcard sample, SASE and slides with updated address and phone number to be kept on file for possible future assignments. Send query letter with roughs, finished art or samples of style. Samples returned by SASE. Reports in 5 months. Pays in 2 contributor's copies. Finds artists mainly through sourcebooks, "but hopefully through word of mouth by artists who made it in."

☑ WISCONSIN TRAILS, Box 5650, Madison WI 53705. (608)231-2444. Art Director: Kathie Campbell. 4-color publication concerning travel, recreation, history, industry and personalities in Wisconsin. Published 6 times/year. Circ. 35,000. Previously published and photocopied submissions OK. Art guidelines for SASE.
Illustration: Buys 6 illustrations/issue. "Art work is done on assignment, to illustrate specific articles. All articles deal with Wisconsin. We allow artists considerable stylistic latitude." Send postcard samples or query letter with brochure, photocopies, SASE, tearsheets, résumé, photographs, slides and transparencies. Samples kept on file for future assignments. Indicate artist's favorite topics; name, address and phone number. Include SASE. Publication will contact artist for portfolio review if interested. Buys one-time rights on a work-for-hire basis. Pays on publication; $50-150 for b&w inside; $50-400 color inside. Finds artists through magazines, submissions/self-promotions, artists' agents and reps and attending art exhibitions.
Tips: Keep samples coming of new work.

☑ THE WITNESS, 7000 Michigan Ave., Detroit MI 48210-2872. (313)841-1967. Fax: (313)841-1951. E-mail: editor@thewitness.org. Website: http://www.thewitness.org. Co-Editors: Jeanie Wylie-Kellermann and Julie A. Wortman. Estab. 1917. Christian journal published 10 times/year "focusing on social justice issues. Episcopal roots—quirky, sometimes irreverent." Circ. 3,500. Sample copies free for 9½×12½ SASE and 4 first-class stamps.
Cartoons: Buys 10-12 cartoons/year. Prefers single panel, political, b&w line drawings. Send query letter with finished cartoons, photographs, photocopies, roughs or tearsheets. Samples are filed if suitable and are not returned. Reports back only if interested. Buys one-time rights. Pays on publication; $50 maximum for b&w cartoons.
Illustration: Approached by 20 illustrators/year. Buys 4 illustrations/issue. Has feataured illustrations by Dierdre Luzwick, Betty LaDuke and Robert McGovern. Features humorous, realistic and spot illustration. "Themes: social and economic justice, though we like to use art in unusual and surprising combination with story topics. Style: we appreciate work that is subtle, provocative, never sentimental." Send postcard sample or query letter with printed samples, photocopies and tearsheets. Accepts disk submissions compatible with WordPerfect 5.1. Samples are filed if suitable and are not returned. "We like to keep samples of artists' work on file, with permission to use in the magazine. We rarely commission original work; we prefer to select from existing artwork." Reports back only if interested. Buys one-time rights. Pays on publication; $100 maximum for b&w and color covers; $50 maximum for b&w and color inside.

☑ WOMENWISE, % BWHBC, P.O. Box 192, West Somerville MA 02144. (603)225-2739. Fax: (603)228-6255. E-mail: luitad@aol.com. Editor: Luita D. Spangler. Estab. 1978. Quarterly consumer magazine. "We are a feminist, pro-choice, pro-animal rights, health journal offering articles, book reviews, poetry and feminist analysis and news." Circ. 1,000. Sample copies available. Art guidelines available for SASE with first-class postage.
 ● Magazine is sponsored by The Boston Women's Health Book Collective, publishers of *Our Bodies, Ourselves*.
Illustration: Approached by 8-12 illustrators/year. Buys 40 illustrations/year. Has featured illustrations by Sudie Rakusin, Susan Bliss, Loy McWhirter and Susan Becker. Features natural history; realistic illustration; information graphics; medical illustration. Assigns 10% of illustrations to well-known or "name" illustrators; 70% to experienced, but not well-known illustrators; 20% to new andemerging illustrators. Prefers line drawings of women, marginalia. Considers pen & ink. Send query letter with photocopies. Samples are filed. Reports back in 1 month. Negotiates rights purchased. Pays on publication. Pays $15 and 1 year subscription for b&w cover; subscription and 5 portfolio copies for b&w inside.

☑ WONDER TIME, Nazarene Publishing House, 2923 Troost Ave., Kansas City MO 64109. (816)333-7000. Fax: (816)333-4439. Pre-Press Manager: Rayce Ratcliff. Associate Editor: Patty L. Craft. Estab. 1969. Weekly 4-color Sunday school "story paper" emphasizing inspiration and character-building material for first and second graders, 6-8 years old, for Sunday School curriculum. Circ. 40,000. Sample copies for SASE with 56¢ postage.
Illustration: Buys 1 illustration/issue. Works on assignment only. Send query letter with tearsheets or photocopies to

be kept on file. Buys all rights. **Pays on acceptance**; $40 for b&w; $75 for color.

Tips: "Include illustrations of six- to eight-year-old ethnic children in your portfolio. We use some full-color cartoons to illustrate our Bible-in-Action stories."

[N] WOODENBOAT MAGAZINE, Box 78, Brooklin ME 04616-0078. (207)359-4651. Fax: (207)359-8920. E-mail: dickg@woodenboat.com. Website: http://www.woodenboat.com. Art Director: Richard Gorski. Estab. 1974. Bimonthly magazine for wooden boat owners, builders and designers. Circ. 106,000. Previously published work OK. Sample copy for $4. Art guidelines free for SASE with first-class postage.

Illustration: Approached by 10-20 illustrators/year. Buys 2-10 illustrations/issue on wooden boats or related items. Has featured illustrations by Sam Manning and Kathy Bray. Assigns 10% of illustrations to well-known or "name" illustrators; 80% to experienced but not well-known illustrators; 10% to new and emerging illustrators. Send postcard sample or query letter with printed samples and tearsheets. Samples are filed. Does not report back. Artist should follow up with call. Pays on publication. "Rates vary, but usually $50-400 for spots."

Design: Needs freelancers for design and production. 100% of freelance work demands knowledge of Adobe Photoshop, Adobe Illustrator, QuarkXPress. Send query letter with tearsheets, résumé and slides. Pays by project.

Tips: "We work with several professionals on an assignment basis, but most of the illustrative material that we use in the magazine is submitted with a feature article. When we need additional material, however, we will try to contact a good freelancer in the appropriate geographic area."

[N] WORKFORCE, 245 Fischer Ave., B-2, Costa Mesa CA 92626. (714)751-1883. Fax: (714)751-4106. Production Director: Bob Dortch. Estab. 1922. Monthly trade journal for human resource business executives. Circ. 30,000. Sample copies available in libraries.

Illustration: Approached by 100 illustrators/year. Buys 10 illustrations/issue. Prefers business themes. Considers all media. 40% of freelance illustration demands knowledge of Adobe Photoshop, QuarkXPress and Adobe Illustrator. Send postcard sample. Send follow-up postcard sample every 3 months. Samples are filed and are not returned. Does not report back, artist should call. Art director will contact for portfolio review if interested. Rights purchased vary according to project. **Pays on acceptance**; $350-500 for color cover; $100-400 for b&w and/or color inside; $75-150 for spots. Finds artists through agents, sourcebooks such as *LA Workbook*, magazines, word of mouth and submissions.

Tips: "Read our magazine."

[✓] WRITER'S DIGEST, 1507 Dana Ave., Cincinnati OH 45207. E-mail: writersdig@fwpubs.com. Website: http://www.writersdigest.com. Art Director: Tricia Barlow. Editor: Melanie Rigney (for cartoons). Monthly magazine emphasizing freelance writing for freelance writers. Circ. 250,000. Original artwork returned after publication. Sample copy for $3. Art guidelines free for SASE with first-class postage.

● Submissions are also considered for inclusion in annual *Writer's Yearbook* and *Quarterly Fiction Writer*.

Cartoons: Buys 3 cartoons/issue. Theme: the writing life. Needs cartoons that deal with writers and the trials of writing and selling their work. Also, writing from a historical standpoint (past works), language use and other literary themes. Prefers single panel with or without gagline. Send finished cartoons. Material returned by SASE. Reports back within 1 month. Buys first rights or one-time rights. **Pays on acceptance**; $50-85 for b&w.

Illustration: Buys 3 spots and up to 4 feature illustrations per month. Has featured illustrations by Tim Cook, Sean Kane and Si Huynh. Assigns 20% of illustrations to well-known or "name" illustrators; 70% to experienced, but not well-known illustrators; 10% to new and emerging illustrators. Features: humorous, realistic, computer and spot illustration. Theme: the writing life. Prefers b&w line art. Works on assignment only. Send postcard or any printed/copied samples to be kept on file (limit size to 8½×11). Accepts Mac-formatted disk submissions. "EPS, PICT, TIFF or JPEG OK for viewing—for reproduction we need EPS." Buys one-time rights. **Pays on acceptance**; $500-1,000 for color cover; $100-500 for inside b&w.

Tips: "We're also looking for black & white spots of writing-related subjects. We buy all rights; $15-25/spot. I like having several samples to look at. Online portfolios are great."

[✓] WRITER'S YEARBOOK, 1507 Dana Ave., Cincinnati OH 45207. Submissions Editor: Dawn Simonds Ramirez. Annual publication featuring "the best writing on writing." Topics include writing and marketing techniques, business issues for writers and writing opportunities for freelance writers and people getting started in writing. Original artwork returned with 1 copy of the issue in which it appears. Sample copy $6.25. Affiliated with *Writer's Digest*. Cartoons submitted to either publication are considered for both.

Cartoons: Uses 3-6 cartoons in yearbook. "All cartoons must pertain to writing—its joys, agonies, quirks. All styles accepted, but high-quality art is a must." Prefers single panel, with or without gagline, b&w line drawings or washes. Send finished cartoons. Samples returned by SASE. Reports in 1-2 months. Buys first North American serial rights for one-time use. **Pays on acceptance**; $50 minimum for b&w.

Tips: "A cluttery style does not appeal to us. Send finished, not rough art, with clearly typed gaglines. Cartoons without gaglines must be particularly well-executed."

[N] WWWIZ MAGAZINE, 8840 Warner Ave., Suite 200, Fountain Valley CA 92708. (714)848-9600. Fax: (714)375-2493. E-mail: wwwiz@ix.netcom.com. Website: http://wwwiz.com. Managing Editor: Beth Krippner. Estab. 1995. Bimonthly magazine covering the World Wide Web. Circ. 900,000/year. Sample copies available. Must talk to editor for art guidelines.

Illustration: Illustrations bought/year varies. Prefers people-oriented art for cover. Considers digital. 90% of freelance illustration demands knowledge of Aldus PageMaker, Adobe Photoshop, Adobe Illustrator, Aldus FreeHand, QuarkXPress. "Versions: preferably latest or one back. Call office directly to discuss. Contact editor for details of disk submissions." Samples are filed and are returned on request. Reports back within 3 days. Art director will contact artist for portfolio review of final art and anything the artist deems important. Negotiates rights purchased. Finds illustrators through calls, walk-ins, word of mouth.

Design: Needs freelancers for multimedia. Prefers local design freelancers only. Phone art director.

Tips: "Read the magazine—WWWIZ is people-, business- and lifestyle-oriented."

XSESS LIVING, 3932 Wilshire Blvd., 212, Los Angeles CA 90010. (213)383-1091. Fax: (213)383-1093. E-mail: xsesscdzne@aol.com. Creative Director: Sean Perkin. Estab. 1993. Quarterly consumer magazine covering lifestyles, travel, entertainment and pop culture. Circ. 25,000. Sample copies for 10×12 SASE and $3 postage. Art guidelines available per assignment.

Cartoons: Approached by 20-30 cartoonists/year. Buys 3-4 cartoons/issue. Theme or style varies per issue/content. Prefers single panel, political, humorous, b&w and color washes and b&w line drawings. Send query letter with sample works. Samples are filed and are not returned. Reports back only if interested. Rights purchased vary according to project. Pays on publication; $50-250 for b&w, $100-500 for color.

Illustration: Approached by 20-30 illustrators/year. Buys 4-6 illustrations/issue. Themes or styles vary. Considers all media. 50% of freelance illustration demands knowledge of Adobe Photoshop, Adobe Illustrator and QuarkXPress. Send query letter with printed samples and photocopies. Samples are filed and are not returned. Reports back only if interested. Art director will contact artist for portfolio review if interested. Rights purchased vary according to project. Pays on publication; $50-250 for b&w, $100-500 for color inside. Pay for spots varies. Finds illustrators through word of mouth.

Design: Needs freelancers for design, production and multimedia projects. 100% of freelance design demands knowledge of Adobe Photoshop, Adobe Illustrator and QuarkXPress. Send query letter with printed samples, photocopies and tearsheets, phone art director.

XSESS MUSIC, 3932 Wilshire Blvd., Bldg. 212, Los Angeles CA 90010. (213)383-1091. Fax: (213)383-1093. Creative Director: Sean Perkin. Estab. 1993. Quarterly consumer magazine covering music.
 • See *Xsess Living* for submission information.

YACHTING MAGAZINE, 20 E. Elm St., Greenwich CT 06830. (203)625-4480. Fax: (203)625-4481. Website: http://www.yachtingnet.com. Art Director: Rana Bernhardt. Estab. 1907. Monthly magazine "with emphasis on high-end power and sail vessels. Gear and how-to also included." Circ. 132,000. Art guidelines not available.

Illustration: Approached by 75 illustrators/year. Buys 5 illustrations/issue. Features humorous illustration; charts & graphs; informational graphics; computer and spot illustration. Assigns 100% of illustrations to experienced, but not well-known illustrators. Prefers tech drawings. Considers all media. 30% of freelance illustration demands knowledge of Adobe Photoshop, Adobe Illustrator and QuarkXPress, all lates versions. Send postcard sample. Send follow-up postcard samle every 3 months. Accepts disk submissions compatible with QuarkXPress 7.5/version 3.3 send EPS files. Files accepted on Syquest 44,00 and ZIP and floppies. Samples are filed and are not returned. Reports back only if interested. Art director will contact artist for portfolio review of b&w, color tearsheets if interested. Buys first rights. Pays on publication; $250-450 for color inside; $450-600 for 2-page spreads; $150-350 for spots.

Design: Needs freelancers for design, production and multimedia projects, rarely. Prefers designers with experience in production. 100% of freelance work demands knowledge of Adobe Photoshop, Adobe Illustrator and QuarkXPress. Send query letter with printed samples and tearsheets.

Tips: "Read the magazine. I like clean, professional work done quickly and with little supervision. Have a presentable portfolio. Our subject is pretty slim, but we can see potential."

YM, Dept. AM, 375 Lexington Ave., New York NY 10017-5514. Contact: Art Director. A fashion magazine for teen girls between the ages of 14-21. Ten issues (monthly and 2 joint issues—June-July and December-January.) Original artwork returned at job's completion. Sample copies available.

Illustration: Buys 1-2 illustrations/issue. Buys 12-36 illustrations/year. Prefers funny, whimsical illustrations related to girl/guy problems, horoscopes and dreams. Considers watercolor, collage, acrylic, colored pencil, oil, charcoal, mixed media, pastel. Samples are filed or not filed (depending on quality). Samples are not returned. Reports back to the artist only if interested. Buys one-time rights. **Pays on acceptance** or publication. Offers one half of original fee as kill fee.

YOGA JOURNAL, 2054 University Ave., Berkeley CA 94704-1082. (510)841-9200. Fax: (510)644-3101. Website: http://www.yogajournal.com. Art Director: Jonathan Wieder. Estab. 1975. Bimonthly consumer magazine emphasizing health, consciousness, yoga, holistic healing, transpersonal psychology, body work and massage, martial arts, meditation and Eastern spirituality. Circ. 100,000. Originals returned at job's completion.

Illustration: Approached by 150 illustrators/year. Buys 8 illustrations/issue. Works on assignment only. Considers all media, including electronic (Mac). Send query letter with any reproductions. Accepts disk submissions compatible with Adobe Illustrator 5.5. Send EPS files. Samples are filed. Publication will contact artist for portfolio review if interested. Buys one-time rights. **Pays on acceptance**; $800-1,500 for color cover; $500-1,000 for b&w, $800-1,200 for color inside; $150-400 for spots.

Tips: "Send plenty of samples in a convenient form (i.e. 8½ × 11 color photocopies with name and phone number on each sample) that don't need to be returned. Tearsheets are always desirable."

☑ **YOU! MAGAZINE,** 29963 Mulholland Hwy., Agoura Hills CA 91301-3009. (818)991-1813. Fax: (818)991-2024. E-mail: youmag@earthlink.net. Website: http://www.youmagazine.com. Art Director: Louanne Tan. Estab. 1986. Magazine for Catholic and Christian high school and college youth, published 10 times/year. Circ. 375,000. Originals are not returned. Sample copies available for $2.98; art guidelines for SASE with first-class postage.

Cartoons: Approached by 30-40 cartoonists/year. Buys 2 cartoons/issue. Prefers Catholic youth, political and humorous cartoons; single or multiple panel b&w line drawings. Send query letter with brochure, roughs and finished cartoons. Samples are filed. Reports back to the artist only if interested. Rights purchased vary according to project. Pays $50 for b&w; $60 for color.

Illustration: Approached by 100 illustrators/year. Buys 20 illustrations/issue. Has featured illustrations by Mark Armstrong and Tony Calvello. Features fashion, humorous, realistic and computer illustrations. Prefers spiritual themes. Considers pen & ink, watercolor, collage, airbrush, acrylic, marker, oil, charcoal, mixed media, pastel and computer art. Needs computer-literate freelancers for design and illustration. 50% of freelance work demands computer knowledge of Adobe Illustrator, QuarkXPress, Adobe Photoshop or Aldus FreeHand. Send query letter with brochure, résumé, SASE, tearsheets, photographs, photocopies, slides and transparencies. Samples are filed. Request portfolio review in original query. Publication will contact artist for portfolio review if interested. Portfolio should include b&w thumbnails, tearsheets, slides, roughs, photocopies, final art and photographs. Rights purchased vary according to project. Pays on publication; $70 for b&w inside; $80 for color inside.

Tips: "Be creative and persistent. Express yourself with confidence by putting all your energy and talent with your creations. Love what you do!"

YOUR HEALTH, 5401 NW Broken Sound Blvd., Boca Raton FL 33487. (561)989-1176. Fax: (561)997-9210. E-mail: yhealth@aol.com. Website: http://www.yourhealthmag.com. Photo Editor: Judy Browne. Estab. 1960. Health and fitness magazine published 8 times a year for the general public. Circ. 50,000. Accepts previously published artwork. Originals returned at job's completion. Sample copies available; art guidelines available for SASE with first-class postage.

Cartoons: Approached by 30 cartoonists/year. Buys 5 cartoons/year. Prefers health and fitness humorous cartoons; b&w line drawings. Send query letter with roughs. Samples are filed. Reports back within 1 month. Buys one-time rights. Pays $50 for b&w/color.

Illustration: Approached by 100 illustrators/year. Buys 2 illustrations/issue. Has featured illustrations by Cathi Mingus, Michael Krone and Art Valero. Assigns 100% of illustrations to experienced, but not well-known illustrators. Prefers health and fitness themes. Considers all media. Send query letter with tearsheets, photographs and photocopies. Samples are filed. Reports back within 1 month. Publication will contact artist for portfolio review if interested. Portfolio should include any samples. Buys one-time rights. Pays on publication; $100-125 for b&w inside; $200-250 for color inside; $50-75 for spots. Finds artists through other publications.

Tips: Features and departments are both open to freelancers.

YOUR MONEY MAGAZINE, 8001 N. Lincoln Ave. 6th Floor, Skokie IL 60077. (847)763-9200. Corporate Art Director: Beth Ceisel. Estab. 1980. Bimonthly 4-color personal finance magazine. "Provides useful advice on saving, investing and spending. Design is accessible and reader-friendly." Circ. 500,000. Original artwork returned after publication. Art guidelines for SASE with first-class postage.

Illustration: Buys 15-20 illustrations/issue. Works on assignment only. "Editorial illustration is based upon specific needs of an article, therefore style, tone and content will vary." Needs computer-literate freelancers for illustration, charts/graphs. 65% of freelance work demands knowledge of Aldus FreeHand, Adobe Illustrator or Photoshop. Send postcard sample or tearsheets. Accepts disk submissions compatible with QuarkXPress, Adobe Illustrator, Adobe Photoshop. Samples not filed are returned by SASE. Publication will contact artist for portfolio review if interested. Portfolio dropoffs are departmentally reviewed on the second Monday of each month and returned the same week. Buys first rights or one-time rights. Sometimes requests work on spec before assigning job. Pays $300-800 for b&w, $300-1,000 for cover; $300-1,000 for color inside; $200-400 for spots. Finds artists through other magazines, submissions and sourcebooks.

Tips: "Show only your best work. Include tearsheets in portfolio. Computers are taking on a very important role in magazine publishing."

Posters & Prints

The companies listed in this section contract with artists to put a piece of artwork in print form. They pay for and supervise the production and marketing of work. Some run prints of pre-existing images, while others will ask you to create a new piece of art. The resulting work will either be an original print, a poster, a limited edition print or offset reproduction, depending on how it is produced and sold. Prints are published in limited editions, while posters and offset reproductions usually are not.

Posters and prints of your artwork can boost both your sales and visibility. You can sell your work all over the country at various galleries and commercial outlets. You or your gallery dealer can market more of your work to corporations, hotel chains and hospitals. The exposure you gain from prints will make your original paintings more valuable.

The following pages describe several ways to produce posters or prints. Each method has its advantages. It's a good idea to talk to several artists who have used each method before you make a decision, then choose a method that suits your own temperament and marketing skills.

The benefit of working with a publisher/distributor is that they take on the expense and duties of printing and marketing. (Some companies listed specialize in distribution only and do not publish. Only contact a distributor if you already have a published print.) Research art publishers thoroughly before you sign with them. Examine their catalogs to make sure the colors of prints are true and paper quality is high. Find out how they plan to market your work and what outlets it will be sold to before you sign a contract.

Find the best publishers for your work

Some listings in this section are **fine art presses**, others are more commercial. Read the listings carefully to determine if they create editions for the fine art market or for the **decorative market**. Explore your options in the sidebar on the next page.

Once you select a list of potential publishers, send for each publisher's catalog. Some publishers will not send their catalogs because they are too expensive, but you can often ask to see one at a local poster shop, print gallery, upscale furniture store or frame shop.

How to submit your work

To approach a publisher, send a brief query letter, a short bio, a list of galleries that represent your work and five to ten slides or whatever samples they specify in their listing. It helps to send printed pieces or tearsheets as samples, as these show publishers that your work reproduces well and that you have some understanding of the publication process.

UNDERSTANDING PRINT JARGON

- **Signing and numbering your editions.** Before you enter the print arena, you will need to know the proper method of signing and numbering your editions. You can observe how this is done by visiting galleries and museums and talking to fellow artists.

If you are creating a limited edition, with a specific set number of prints, all prints are numbered, such as 35/100. The largest number is the total number of prints in the edition; the smaller number is the number of the print. Some artists hold out 10% as artist's proofs and number them separately with AP after the number (such as 5/100 AP). Many artists sign and number their prints in pencil.

- **Original prints**. Original prints may be woodcuts, engravings, linocuts, mezzotints, etchings,

EXPLORE YOUR PRINTING OPTIONS

1. Working with a commercial poster manufacturer or art publisher. If you don't mind creating commercial images, and following current trends, the decorative market can be quite lucrative. On the other hand, if you should decide to work with a fine art publisher, you will have more control over the final image.

2. Working with a fine art press. Fine art presses differ from commercial presses in that press operators (usually artists themselves) work side by side with you to create the edition every step of the way, sharing their experience and knowledge of the printing process. You may be charged a fee for the time your work is on the press and for the expert advice of the printer.

3. Working at a co-op press. Instead of approaching an art publisher you can learn to make your own hand-pulled original prints—such as lithographs, monoprints, etchings or silk-screens. If there is a co-op press in your city, you can rent time on a printing press and create your own editions. It is rewarding to learn printing skills and have the hands-on experience. You also gain total control of your work. The drawback is you have to market your images yourself, by approaching galleries, distributors and other clients.

4. Self-publishing with a printing company. Several national printing concerns advertise heavily in artists' magazines, encouraging artists to publish their own work. If you are a savvy marketer, who understands the ins and outs of trade shows and direct marketing, this is a viable option. However it takes a large investment up front. You could end up with a thousand prints taking up space in your basement, or if you are a good marketer you could end up selling them all and making a much larger profit from your work than if you had gone through an art publisher or poster company.

5. Marketing through distributors. If you choose the self-publishing route, but don't have the resources to market your prints, distributors will market your work to outlets around the country in exchange for a percentage of sales. Distributors have connections with all kinds of outlets like retail stores, print galleries, framers, college bookstores and museum shops.

lithographs or serigraphs. What distinguishes them is that they are produced by hand by the artist (and consequently often referred to as hand-pulled prints). In a true original print the work is created specifically to be a print. Each print is considered an original because the artist creates the artwork directly on the plate, woodblock, etching stone or screen. Original prints are sold through specialized print galleries, frame shops and high-end decorating outlets, as well as fine art galleries.

• **Offset reproductions and posters.** Offset reproductions, also known as posters and image prints, are reproduced by photochemical means. Since plates used in offset reproductions do not wear out, there are no physical limits on the number of prints made. Quantities, however, may still be limited by the publisher in order to add value to the edition.

• **Giclée Prints.** As the new color-copier technology matures, inkjet fine art prints, also called giclée prints, are gaining respectability. Iris prints, images that are scanned into a computer and output on oversized printers, are even showing up in museum collections.

• **Canvas Transfers.** Canvas transfers are becoming increasingly popular. Instead of, and often in addition to, printing an image on paper, the publisher transfers your image onto canvas so the work has the look and feel of a painting. Some publishers market limited editions of 750 prints on paper, along with a smaller edition of 100 of the same work on canvas. The edition on paper might sell for $150 per print, while the canvas transfer would be priced higher, perhaps selling for $395.

PRICING CRITERIA FOR LIMITED EDITIONS AND POSTERS

Because original prints are always sold in limited editions, they command higher prices than posters (which usually are not numbered). Since plates for original prints are made by hand, and as a result can only withstand a certain amount of use, the number of prints pulled is limited by the number of impressions that can be made before the plate wears out. Some publishers impose their own limits on the number of impressions to increase a print's value. These limits may be set as high as 700 to 1,000 impressions, but some prints are limited to just 250 to 500, making them highly prized by collectors.

A few publishers buy work outright for a flat fee, but most pay on a royalty basis. Royalties for handpulled prints are usually based on retail price and range from 5 to 20 percent, while percentages for posters and offset reproductions are lower (from 2½ to 5 percent) and are based on the wholesale price. Be aware that some publishers may hold back royalties to cover promotion and production costs. This is not uncommon.

Prices for reproductions vary widely depending on the quantity available; the artist's reputation; the popularity of the image; the quality of the paper, ink and printing process. Since prices are lower than for original prints, publishers tend to select images with high-volume sales potential.

Negotiating your contract

As in other business transactions, ask for a contract and make sure you understand and agree to all the terms before you sign. Make sure you approve the size, printing method, paper, number of images to be produced and royalties. Other things to watch for include insurance terms, marketing plans, and a guarantee of a credit line or copyright notice.

Always retain ownership of your original work. Work out an arrangement in which you're selling publication rights only. You'll also want to sell rights only for a limited period of time. That way you can sell the image later as a reprint, or license it for other use (for example as a calendar or note card). If you are a perfectionist about color, make sure your contract gives you final approval of your print. Stipulate that you'd like to inspect a press proof prior to the print run.

MORE INDUSTRY TIPS

☑ **Research print outlets.** Visit galleries, frame shops, furniture stores and other retail outlets that carry prints to see where your art fits in. You may also want to visit designer showrooms and interior decoration outlets.

☑ **Find a niche.** Many artists do well in small, specialized niches. Limited edition prints with Civil War themes, for example, are avidly collected by Civil War enthusiasts. But to appeal to Civil War buffs, artists must do extensive research. Every detail, from weapons and foliage in battlefields, to the buttons on soldiers' uniforms, must be historically accurate. Signed limited editions are usually created in a print run of 950 or so and can average about $175-200; artist's proofs sell from between $195-250, with canvas transfers selling for $400-500. The original paintings from which images are taken often sell for thousands of dollars to avid collectors.

Sport art is another lucrative niche. There's a growing trend toward portraying sports figures from golf, tennis, football, basketball, racing (both sports car and horse racing) in prints which include both the artist's and the athlete's signatures. Movie stars from the 1940s and 50s (such as Humphrey Bogart, James Dean, Marilyn Monroe and Elvis) are also cult favorites.

☑ **Work in a series.** It is often easier to market a series of small prints exploring a single theme or idea than to market single images. A series of similar prints works well in long hospital corridors, office meeting rooms or restaurants. Also marketable are "paired" images. Hotels

often purchase two similar prints for each of their rooms.

☑ **Study trends.** If you hope to get published by a commercial art publisher or poster company, your work will have a greater chance of acceptance if you use popular colors and themes.

☑ **Attend trade shows.** Many artists say it's the best way to research the market and make contacts. Increasingly it has become an important venue for self-published artists to market their work.

☑ **Don't overlook the collectibles market.** If your artwork has wide appeal, and you are flexible, another option for you is the lucrative plates and collectibles market. You will be asked to adjust your work to fit into a circular format if it is chosen for a collectible plate, so be prepared to work with the company's creative staff to develop the final image. Consult the Greeting Cards, Gifts & Products section for companies specializing in collectibles.

For More Information

☑ Read industry publications, such as *Decor* magazine and *Art Business News* to get a sense of what sells in both markets.

☑ The Color Association of the United States (CAUS) is the association that tracks and discovers color trends for the industry. Each year CAUS publishes a report predicting color trends for the coming season. For more information contact Margaret Walsh, associate director of CAUS at (212)582-6884.

☑ To find out what trade shows are coming up in your area, check the event calendars in industry trade publications. Many shows, such as the Art Buyers Caravan, are scheduled to coincide with annual stationery or gift shows, so if you work in both the print and greeting card markets, be sure to take that into consideration. Remember, traveling to trade shows is considered a deductible business expense, so don't forget to save your receipts!

☑ Consult *Business and Legal Forms for Fine Artists* by Tad Crawford (Allworth Press) for sample contracts.

AARON ASHLEY, INC., 230 Fifth Ave., Suite 400, New York NY 10001. (212)532-9227. Fax: (212)481-4214. Art Director: Tim Nicoletti. Produces unlimited edition, offset reproduction fine art prints for distributors, decorators, frame shops, corporate curators, giftshops, museums and galleries. Clients: Freer Museum and Amon Carter.
Needs: Seeking decorative art for the designer and commercial markets. Considers oil, acrylic and watercolor paintings, mixed media and pastel. Prefers realistic or representational works. Artists represented include French-American Impressionists, Bierstadt, Russell Remington, Jacqueline Penney, Ron McKee, Carolyn Blish and Urania Christy Tarbot. Editions created by working from an existing painting or chrome or by collaborating with the artists. Approached by 150 artists/year. Publishes the work of 12 emerging, 12 mid-career and 50 established artists/year.
First Contact & Terms: Query with SASE and slides or photos. "Do not send originals." Samples are returned. Reports within 3 days. Company will contact artist for portfolio review of color photographs and transparencies if interested. Pays royalties or fee. Offers advance. Buys reprint rights. Requires exclusive representation for unlimited editions. Provides advertising and promotion.
Tips: Advises artists to attend Art Expo (industry trade show) held yearly in May in New York City.

ACTION IMAGES INC., 1892 First St., Suite 101, Highland Park, IL 60035. (847)763-9700. E-mail: actionim@aol.c om. Website: http://www.actionimagesinc.com. President: Tom Green. Estab. 1989. Art publisher of sport art. Publishes

limited edition prints, open edition posters as well as direct printing on canvas. Specializes in sport art prints for events such as the Super Bowl, World Series, Final Four, Indy 500 and NASCAR. Clients include galleries, distributors, sales promotion agencies. Current clients include E&J Gallo Winery, Duracell Battery, Coca Cola, AllSport.

Needs: Seeking sport art for posters and as promotional material for sporting events. Considers all media. Artists represented include Ken Call, Konrad Hack, George Gaadt and Alan Studt. Approached by approximately 25 artists/ year. Publishes the work of 1 emerging, 6 mid-career and 6 established artists/year.

First Contact & Terms: Send query letter with slides or color prints and SASE. Accepts submissions on disk compatible with Mac. Send EPS files. Samples are filed. Reports back only if interested. If interested in samples, will ask to see more of artist's work. Pays flat fee: $1,000-2,000. Buys exclusive reproduction rights. Often acquires original painting. Provides insurance while work is at firm and outbound in-transit insurance. Promotional services vary depending on project. Also needs designers. Prefers designers who own Macs. Designers send query letter and samples. Finds artists through recommendations from other artists, word of mouth and submissions.

Tips: "The trend seems to be moving away from superrealism toward more Impressionistic work. We like to work with artists who are knowledgable about the pre-press process. Sometimes artists don't understand that the colors they create in their studios will not reproduce the exact way they envision them. Greens are tough to reproduce accurately. When you finish an artwork, have a photographer shoot it and get a color print. You'll be surprised how the colors come out. For example, if you use dayglow colors, they will not show up well in the cromalin. When we hire an artist to create a piece, we need to know the cromalin print will come back with accurate colors. This can only occur when the artist understands how colors reproduce and plans his colors so the final version shows the intended color."

AEROPRINT, (AKA SPOFFORD HOUSE), South Shore Rd., Box 154, Spofford NH 03462. (603)363-4713. Owner: H. Westervelt. Estab. 1972. Art publisher/distributor handling limited editions (maximum 250 prints) of offset reproductions and unlimited editions for galleries and collectors. Clients: aviation art collectors.

Needs: Seeking creative art. Considers pen & ink, oil, acrylic, pastel, watercolor, tempera or mixed media. Prefers representational, event-oriented subject matter of historical nature. Artists represented include Merv Corning, Jo Kotula, Terry Ryan and Gil Cohen. Publishes the work of 1 emerging and 8 established artists/year. Distributes the work of 5 emerging and 32 established artists/year.

First Contact & Terms: To show a portfolio, mail color or b&w thumbnails, roughs, original/final art, photostats, tearsheets, slides, transparencies or final reproduction/product. Payment method is negotiated. Offers an advance. Negotiates rights purchased. Provides written contract and shipping from firm.

Tips: A common problem is "incomplete or undeveloped talent, prematurely presented for publishing or introduction to a project."

AFFORDABLE BLACK ART, 5146 Fourth Ave., Los Angeles CA 90043-1931. (323)299-8082. Fax: (323)290-0777. Owner: Pamela Miller. Estab. 1992. Publishes/distributes limited edition, fine art prints and posters. Clients: gift shops, bookstores and galleries. Current clients include: Deck The Walls and Picture This Framing.

Needs: Seeking art for the serious collector and lithographs for the wholesale market. Considers prints. Prefers African-American subjects. Artists represented include Brenda Joysmith, George E. Miller II, Jimi Claybrooks, Keith Mallett. Editions created by working from existing painting. Approached by 20 artists/year. Publishes the work of 2 emerging and 1 established artists/year. Distributes the work of 1-2 emerging and 14 established artists/year.

First Contact & Terms: Send résumé and tearsheets. Samples are filed or are returned by SASE. Reports back only if interested. Company will contact artist for portfolio review of final art (if not too large), tearsheets, sample print stock or prints. Pays 50% of 50% of retail. Negotiates rights purchased. Provides shipping from firm. "We refer to our file of submisisons which artists have sent through the year to find new talent."

Tips: "It is helpful if fine artists also have commercial art skills."

N: AFRICAN RICH TRADITION, 26871 Hobie Circle, #B-6, Murrieta CA 92562. (909)696-1990. Fax: (909)696-2011. Publisher: Lee Mathews. Estab. 1994. Art publisher and distributor. Publishes/distributes limited edition, unlimited edition, canvas transfers, fine art prints, offset reproduction, posters and sculpture. Clients: galleries, decorators, frame shops, distributors and gift shops.

Needs: Seeking creative, fashionable and decorative art for the serious collector, commercial market and designer market. Considers oil, acrylic, watercolor, mixed media, pen & ink and sculpture. Prefers African-American and family themes. Artists represented include Albert Fennell, Charles Bibbs, Keith Mallett and Dexter Griffin. Editions created by collaborating with the artist. Approached by 20 artists/year. Publishes work of 1-2 mid-career and 3 established artists/year. Distributes the work of 3 mid-career and 5 established artists/year.

First Contact & Terms: Send query letter with brochure, photographs, slides, tearsheets and transparencies. Samples are filed. Reports back only if interested. Company will contact artist for portfolio review if interested. Portfolio should include color photographs and tearsheets. Pays royalties of 10% or negotiates payment. Offers advance when appropriate. Rights purchased vary according to project. Requires exclusive representation of artist. Provides advertising, promotion and written contract. Finds artists through attending art exhibitions, word of mouth, watching art competitions and artists' submissions.

ALEXANDRE ENTERPRISES, P.O. Box 34, Upper Marlboro MD 20773. (301)627-5170. Fax: (301)627-5106. Artistic Director: Walter Mussienko. Estab. 1972. Art publisher and distributor. Publishes and distributes handpulled originals, limited editions and originals. Clients: retail art galleries, collectors and corporate accounts.

Needs: Seeking creative and decorative art for the serious collector and designer market. Considers oil, watercolor, acrylic, pastel, ink, mixed media, original etchings and colored pencil. Prefers landscapes, wildlife, abstraction, realism and impressionism. Artists represented include Cantin and Gantner. Editions created by collaborating with the artist. Approached by 30 artists/year. Publishes the work of 2 emerging, 2 mid-career and 3-4 established artists/year. Distributes the work of 2-4 emerging, 2 mid-career and 24 established artists/year.

First Contact & Terms: Send query letter with résumé, tearsheets and photographs. Samples are filed. Reports back within 4-6 weeks only if interested. Call to schedule an appointment to show a portfolio or mail photographs and original pencil sketches. Payment method is negotiated: consignment and/or direct purchase. Offers an advance when appropriate. Negotiates rights purchased. Provides promotion, a written contract and shipping from firm.

Tips: "Artist must be properly trained in the basic and fundamental principles of art and have knowledge of art history. Have work examined by art instructors before attempting to market your work."

ALPHABETICA/NORTHERN KNIGHTS FINE ART, (formerly Alphabetica), 1271 LaQuinta Dr., #4, Orlando FL 32809. (407) 240-1091. Fax: (407) 240-1951. E-mail: joanne@alphabetica.com or nwpublishing@mindspring.com. Art Directors: Joanne Fink and Kathy Anish. Estab. 1996. Publishes art prints.

Needs: Approached by 300 freelancers/year. Works with 50 freelancers/year. Buys 200 freelance designs and illustrations/year. Art guidelines free for SASE with first-class postage. Works on assignment only. Looking for high-end art. 20% of freelance design work demands knowledge of Adobe Photoshop, Adobe Illustrator and QuarkXPress.

First Contact & Terms: Designers send brochure photocopies, photographs, photostats, tearsheets and SASE. "No original art please." Samples are filed or returned by SASE. Reports back within 6 weeks. Company will contact artists for portfolio review if interested. Portfolio should include color final art, slides, tearsheets and transparencies. Rights purchased vary according to project. Pays "either royalties or a flat fee. The artist may choose." Finds freelancers through SURTEX, word of mouth and art societies.

Tips: "Read the trade magazines, *GSB, G&D, GN, Decor* and *Greetings Today.*"

AMERICAN VISION GALLERY, 625 Broadway, 4th Floor, New York NY 10012. (212)677-2559. Fax: (212)677-2253. President: Bruce Teleky. Estab. 1974. Art publisher and distributor. Publishes and distributes posters, fine art prints, unlimited editions and offset reproductions. Clients: galleries, frame shops, museum shops, decorators, corporate curators, giftshops. Current clients include Museum of Modern Art, The Studio Museum.

Needs: African-American and decorative art for the designer and commercial markets. Considers collage, oil, watercolor, pastel, pen & ink, acrylic. Prefers depictions of African-Americans, Carribean scenes or African themes. Artists represented include Romare Bearden, Jacob Lawrence and several Hatian artists.

First Contact & Terms: Send query letter with slides and brochure. Samples are returned by SASE if requested by artist. Reports back only if interested. Pays flat fee, $400-2,500 maximum, or royalties of 7-15%. Offers advance when appropriate. Rights purchased vary according to project. Interested in buying second rights (reprint rights) to previously published artwork.

Tips: "If you don't think you're excellent, wait until you have something excellent. Posters are a utility, they go somewhere specific, so images I use fit somewhere—over the couch, kitchen, etc."

ANGEL GRAPHICS, A Division of Angel Gifts, Inc., 903 W. Broadway, P.O. Box 530, Fairfield IA 52556. (515)472-5481. Fax: (515)472-7353. Website: http://www.angelgraphics.com. Project Manager: Julie Greeson. Estab. 1981. Publisher of wall decor art (photographic and graphic images) in mini poster (16×20) and smaller sizes and open edition art prints between 2×3 and 24×36. Clients: wholesale gift market, international, picture framers.

Needs: Folk art, especially humorous, country, florals, children, angels, Victorian images; ethnic (Hispanic, African-American including historical figures, African, Spanish, Native American); inspirational/religious, motivational (with and without quotes); fantasy (unicorns, wizards, etc.); western U.S., cowboys. Seeking detailed artwork, realistic subjects with broad appeal. Publishes up to 150 new subjects/year.

First Contact & Terms: Send query letter with photographs or duplicate slides and SASE. Do not send originals. Pays $150-600. Successful artists can make other arrangements. Works with artists to develop proper look.

Tips: "Send $7 for current catalog or $3 for most current supplement to see types of images we publish."

HERBERT ARNOT, INC., 250 W. 57th St., New York NY 10107. (212)245-8287. President: Peter Arnot. Vice President: Vicki Arnot. Art distributor of original oil paintings. Clients: galleries, design firms.

Needs: Seeking creative and decorative art for the serious collector and designer market. Considers oil and acrylic paintings. Has wide range of themes and styles—"mostly traditional/impressionistic, not modern." Artists represented include An He, Malva, Willi Bauer, Gordon, Yoli and Lucien Delarue. Distributes the work of 250 artists/year.

First Contact & Terms: Send query letter with brochure, résumé, business card, slides or photographs to be kept on file. Samples are filed or are returned by SASE. Reports within 1 month. Portfolios may be dropped off every Monday-

[N] MARKETS NEW TO THIS EDITION

Friday or mailed. Pays flat fee, $100-1,000. Provides promotion and shipping to and from distributor.
Tips: "Check colors currently in vogue."

ART A'LA CARTE, 25 Harveston, Mission Viejo CA 92692-5117. (949)455-0957. Director of Marketing: Debra Dalmand. Estab. 1975. Art publisher/distributor. Publishes handpulled originals, limited and unlimited editions, fine art prints, monoprints, photography, offset reproductions, posters, sculpture and copper reliefs. Clients include: galleries, interior designers, framers, architects, gift shops. Current clients include Intercontinental Art, Z Gallerie, Fast Frames.
Needs: Seeking creative, fashionable, decorative, trendsetting art for the serious collector, commercial and designer markets. Considers oil, acrylic, watercolor, mixed media, pastel, pen & ink and sculpture. Considers all themes and styles. Artists represented include Bruce Wood, Endrew Szasz, Guy Begin, Csaba Markus, Marton Varo. Editions created by collaborating with the artist and working from existing painting. Approached by 50 artists/year. Distributes the work of many artists/year.
First Contact & Terms: Send query letter with brochure, photocopies, photographs, résumé. Samples are filed or are returned by SASE. Artists should follow up with call or letter. Company will contact artist for portfolio review if interested. Negotiates payment: royalties from 10-33% or consignment basis: firm receives 50%. Rights vary according to project. Provides promotion. Finds artists through art exhibitions, submissions, art reps.
Tips: Recommends artists be "fast, productive, open minded and flexible."

☑ **ART BEATS, INC.**, P.O. Box 1469, Greenwich CT 06836-1469. (800)677-6947. Fax: (203)661-2480. Estab. 1983. Art publisher. Publishes and distributes open edition posters and gift/fine art cards. Clients: framers, galleries, gift shops. Current clients include Prints Plus, Intercontinental Art. Member of New York Graphic Society Publishing Group.
Needs: Seeking creative, fashionable and decorative art for the commercial and designer markets. Considers oil, watercolor, mixed media, pastel and acrylic. Art guidelines free for SASE with first-class postage. Approached by 1,000 artists/year. Publishes the work of 45 established artists/year.
First Contact & Terms: Send query letter with résumé, color correct photographs, transparencies and tearsheets. Samples are not filed and are returned by SASE if requested by artist. Reports back within 3 months. Publisher will contact artist for portfolio review if interested. Portfolio should include photostats, slides, tearsheets, photographs and transparencies; "no originals please." Pays royalties of 10% gross sales. No advance. Buys first rights, one-time rights or reprint rights. Provides promotion and written contract. Finds artists through art shows, exhibits, word of mouth and submissions.

ART BROKERS OF COLORADO, 2419 W. Colorado Ave., Colorado Springs CO 80904. (719)520-9177. Contact: Nancy Anderson. Estab. 1991. Art publisher. Publishes limited and unlimited editions, posters and offset reproductions. Clients: galleries, decorators, frame shops.
Needs: Seeking decorative art by established artists for the serious collector. Prefers oil, watercolor and acrylic. Prefers western theme. Editions created by collaborating with the artist. Approached by 20-40 artists/year. Publishes the work of 1-2 established artists/year.
First Contact & Terms: Send query letter with photographs. Samples are not filed and are returned by SASE. Reports back within 4-6 weeks. Company will contact artist for portfolio review of final art if interested. Pays royalties. Rights purchased vary according to project. Provides insurance while work is at firm.
Tips: Advises artists to attend all the trade shows and to participate as often as possible.

ART EMOTION CORP., 1758 S. Edgar, Palatine IL 60067. (847)397-9300. Fax: (847)397-9306. E-mail: gperez@artc om.com. Website: http://www.artemo.com. President: Gerard V. Perez. Estab. 1977. Art publisher and distributor. Publishes and distributes limited editions. Clients: corporate/residential designers, consultants and retail galleries.
Needs: Seeking decorative art. Considers oil, watercolor, acrylic, pastel and mixed media. Prefers representational, traditional and impressionistic styles. Artists represented include Garcia, Johnson and Sullivan. Editions created by working from an existing painting. Approached by 50-75 artists/year. Publishes and distributes the work of 2-5 artists/year.
First Contact & Terms: Send query letter with slides or photographs. "Supply a SASE if you want materials returned to you." Samples are filed. Does not necessarily report back. Pays royalties of 10%.
Tips: "Send visuals first."

🅽 **ART IMPRESSIONS, INC.**, 9035-A Eton Ave., Canoga Park CA 91304-1616. (818)700-8541. Fax: (818)718-5722. E-mail: artimpress@aol.com. Contact: Chelsea Fisher. Estab. 1990. Licensing agent. Clients: major manufacturers worldwide. Current clients include: Hasbro, Winn Devon, Mattel, American Greetings, Portal Publications, The Franklin Mint and Mead.
Needs: Seeking art for the commercial market. Considers oil, acrylic, mixed media, pastel and photography. Prefers proven themes like children, domestic animals, fantasy/fairies, nostalgia, floral; no abstract or "dark" themes. Artists represented include Schim Schimmel, Valerie Tabor-Smith, Susan Branch, Josephine Wall, Ron Burns and Ronda Ahrens. Approached by over 70 artists/year.
First Contact & Terms: Send query letter with photocopies, photographs, slides, transparencies or tearsheets and SASE. Accepts disk submissions but not preferred. Accepts CD-ROM only, must be PC-compatible; no Zip disk or Mac format. Samples are not filed and are returned by SASE. Reports back in 2 months. Company will contact artist

for portfolio review if interested. Artists are paid percentage of licensing revenues generated by their work. No advance. Requires exclusive representation of artist. Provides advertising, promotion, written contract and legal services. Finds artists through attending art exhibitions, word of mouth, publications and artists' submissions.

Tips: "Uplifting themes in fantasy art are doing well for us (fairies, angels, etc.) if not too religious. Children and domestic animals are always strong. Colors should be bright, and overall the work should not be too dark. You must have 6-12 images that work well together as a theme or series. You should have at least 30 images completed and be prolific enough to do at least 15 new ones per year." Computer skills not necessary.

ART IN MOTION, 800 Fifth Ave., Suite 150, Seattle WA 98104. Also 2000 Hartley Ave., Coquitlam, British Columbia V3K 6W5 Canada. (604)525-3900. Fax: (604)525-6166. E-mail: dstobart@artinmotion.com. President: Garry Peters. Licensing: David Jacobson. Art publisher and distributor. Publishes, licenses and distributes limited editions, original prints, offset reproductions and posters. Licenses all types of artwork for all industries including wallpaper, fabric, stationary and calendars. Clients: galleries, high-end gift shops, designers, distributors world wide and picture frame manufacturers. Art guidelines available to freelancers.

Needs: Seeking creative, fashionable and innovative art for the decorative art market. Considers oil, watercolor, acrylic and mixed media. Prefers decorative styles. Some artists represented include Sid Pickens, Shelley Heley, Marilyn Simandle, Fabricede Villeneure, Elaine Vollherbst and Janet Tava. Editions created by collaborating with the artist.

First Contact & Terms: Send query letter with brochure, tearsheets, slides, photographs and transparencies. Samples are filed or are returned by SASE if requested by artist. Reports back within 2 weeks if interested. "Artists are welcome to call for feedback." Call for appointment to show portfolio. Offers an advance when appropriate. Negotiates rights purchased. Requires exclusive representation of artist. Provides in-transit insurance, insurance while work is at firm, promotion and shipping to and from firm.

Tips: "We are looking for a few good artists; make sure you know your goals, and hopefully we can help you accomplish them, along with ours."

ART REPS, INC., 7 Hemlock Hill Rd., Upper Saddle River NJ 07458. (201)825-0028. Fax: (201)327-5278. President: Al Di Felice. Estab. 1988. Art publisher, distributor and gallery. Publishes/distributes limited and unlimited editions, canvas transfers and fine art prints. Clients: galleries, furniture stores, chains, etc.

Needs: Seeking decorative art for the commercial market. Media depends on subject matter. Artists represented include Patricia Rainey and Eleanor Seifert. Editions created by collaborating with the artist or working from an existing painting. Distributes the work of 2-4 emerging, 2 mid-career and 2 established artists/year.

First Contact & Terms: Send query letter with tearsheets, photocopies, slides and photographs. Samples are not filed and are returned by SASE. Reports back within 2 weeks. Company will contact artist for portfolio review if interested. Portfolio should include original/final art, b&w and color slides, transparencies and photographs. Pays royalties of 10% or works on consignment basis: firm receives 50% commission. Offers an advance when appropriate. Rights purchased vary according to project. Requires exclusive representation. Provides advertising, promotion and a written contract.

Tips: "Be realistic in analyzing your work. Publishers are primarily interested in top-notch work or specialty art."

ART RESOURCES INTERNATIONAL, LTD./BON ART, Fields Lane, Brewster NY 10509. (914)277-8888. Fax: (914)277-8602. E-mail: robin@fineartpublishes.com. Website: http://www.fineartpublishers.com. Vice President: Robin E. Bonnist. Estab. 1980. Art publisher. Publishes unlimited edition offset lithographs and posters. Does not distribute previously published work. Clients: galleries, department stores, distributors, framers worldwide.

Needs: Seeking fashionable and decorative art for the commercial market. Considers oil, acrylic, watercolor and mixed media. Art guidelines free for SASE with first-class postage. Artists represented include Carolyn Bucha, Barbara Wilson, Martin Wiscombe, Judy Hand, Lucy Davies and Ken Shotwell. Editions created by collaborating with the artist. Approached by hundreds of artists/year. Publishes the work of 15 emerging, 10 mid-career and 10 established artists/year.

First Contact & Terms: Send query letter with photocopies, photographs, tearsheets, slides and photographs to be kept on file. Samples returned by SASE only if requested. Portfolio review not required. Prefers to see slides or transparencies initially as samples, then reviews originals. Reports within 2 months. Appointments arranged only after work has been sent with SASE. Negotiates payment. Offers advance in some cases. Requires exclusive representation for prints/posters during period of contract. Provides advertising, in-transit insurance, insurance while work is at publisher, shipping from firm, promotion and a written contract. Artist owns original work. Finds artists through art and trade shows, magazines and submissions.

Tips: "Please submit decorative, fine quality artwork. We prefer to work with artists who are creative, professional and open to art direction." Advises artists to attend all art buyers caravan shows, and NEC Birmingham, England.

ART SOURCE, 210 Cochrane, Suite 3, Markham, Ontario L3R 8E6 Canada. (905)475-8181. Fax: (905)479-4966. President: Lou Fenninger. Estab. 1979. Poster company and distributor. Publishes/distributes handpulled originals, limited editions, unlimited edition, canvas transfers, fine art prints, monoprints, monotypes, offset reproduction and posters. Clients: galleries, decorators, frame shops, distributors, corporate curators, museum shops and giftshops.

Needs: Seeking creative, fashionable and decorative art for the designer market. Considers oil, acrylic, watercolor, mixed media, pastel and pen & ink. Editions created by collaborating with the artist and by working from an existing painting. Approached by 50 artists/year. Publishes work of 5 emerging, 5 mid-career and 10 established artists/year. Distributes the work of 5 emerging, 5 mid-career and 10 established artists/year.

First Contact & Terms: Send query letter with brochure, photocopies, photographs, photostats, résumé, SASE, slides,

tearsheets and transparencies. Accepts disk submissions compatible with standard Windows format. Samples are filed or returned by SASE. Reports back within 2 weeks. Portfolios may be dropped off every Monday and Tuesday. Artist should follow-up with letter after initial query. Company will contact artist for portfolio review if interested. Portfolio should include color photographs, photostats, roughs, slides, tearsheets, thumbnails and transparencies. Pays royalties of 6-12%, flat fee is optional. Payment is negotiable. Offers advance when appropriate. Negotiates rights purchased. Rights purchased vary according to project. Sometimes requires exclusive representation of artist. Provide advertising, promotion and written contract.

ARTHURIAN ART GALLERY, 4646 Oakton St., Skokie IL 60076-3145. Website: http://www.arthurart.com. Owner: George Aslanian and Art Sahagian. Estab. 1985. Art distributor and gallery. Handles limited editions, handpulled originals, bronze, watercolor, oil and pastel. Current clients include Gerald Ford, Nancy Reagan, White House collection and Dave Powers.
Needs: Seeking creative, fashionable and decorative art for the serious collector and commercial market. Artists represented include Robert Barnum, Nancy Fortunato, Art Sahagian and Christiana. Editions created by collaborating with the artist. Approached by 25-35 artists/year. Publishes and distributes the work of 5-10 emerging, 1-3 mid-career and 2-5 established artists/year.
First Contact & Terms: Send query letter with brochure showing art style and résumé, slides and prices. Samples not filed are returned by SASE. Reports within 30 days. Write for appointment to show portfolio of original/final art, final reproduction/product and color photographs. Pays flat fee of $25-2,500; royalties of 3-5%; or on a consignment basis (firm receives 25% commission). Rights purchased vary. Provides insurance while work is at firm, promotion and written contract.
Tips: Sees trend toward animal images and bright colors.

⃞N⃞ ARTS UNIQ' INC., 1710 S. Jefferson Ave., Box 3085, Cookeville TN 38502. (615)526-3491. Fax: (615)528-8904. E-mail: art@artsuniq.com. Website: http://www.artsuniq.com. Contact: Karen Davis. Licensing: Jane Randolph. Estab. 1985. Art publisher. Publishes limited and open editions. Licenses a variety of artwork for cards, throws, figurines, etc. Clients: art galleries, gift shops, furniture stores and department stores.
Needs: Seeking creative and decorative art for the designer market. Considers all media. Artists represented include Debbie Kingston Baker, D. Morgan, Gay Talbott and Carolyn Wright. Editions created by collaborating with the artist or by working from an existing painting.
First Contact & Terms: Send query letter with slides or photographs. Samples are filed or are returned by request. Reports back within 1-2 months. Pays royalties monthly. Requires exclusive representation rights. Provides promotion, framing and shipping from firm.

ARTVISIONS, 12117 SE 26th St., Suite 202A, Bellevue WA 98005-4118. (425)746-2201. E-mail: neilm@artvisions.com. Website: http://www.artvisions.com. Owner: Neil Miller. Estab. 1993. Markets include publishers, manufacturers and others who may require fine art. Fine art licensing of posters and prints. See listing in Artists' Reps.

BANKS FINE ART, 3316 Royal Lane, Dallas TX 75229-5061. (214)352-1811. Fax: (214)352-1667. E-mail: artman2@ix.netcom.com. Website: http://www.banksfineart.com. Owner: Bob Banks. Estab. 1980. Distributor, gallery of original oil paintings. Clients: galleries, decorators.
Needs: Seeking decorative, traditional and impressionistic art for the serious collector and the commercial market. Considers oil, acrylic. Prefers traditional and impressionistic styles. Artists represented include Joe Sambataro, Jan Bain, Marcia Banks, Eleanore Guinther. Approached by 100 artists/year. Publishes/distributes the work of 2 emerging, 7 mid-career, 3 established artists/year.
First Contact & Terms: Send photographs. Samples are returned by SASE. Reports back within 1 week. Offers advance. Rights purchased vary according to project. Provides advertising, in-transit insurance, insurance while work is at firm, promotion, shipping from firm, written contract.
Tips: Needs Paris street scenes. Advises artists entering the poster and print fields to attend Art Expo, the industry's largest trade event, held in New York City every spring. Also recommends reading *Art Business News*.

BENJAMANS ART GALLERY, 419 Elmwood Ave., Buffalo NY 14222. (716)886-0898. Fax: (716)886-0546. Licensing: Barry Johnson. Estab. 1970. Art publisher, distributor, gallery, frame shop and appraiser. Publishes and distributes handpulled originals, limited and unlimited editions, posters, offset reproductions and sculpture. Clients include P&B International.
Needs: Seeking decorative art for the serious collector. Considers oil, watercolor, acrylic and sculpture. Prefers art deco and florals. Artists represented include J.C. Litz, Jason Barr and Eric Dates. Editions created by collaborating with the artist. Approached by 20-30 artists/year. Publishes and distributes the work of 4 emerging, 2 mid-career and 1 established artists/year.
First Contact & Terms: Send query letter with SASE slides, photocopies, résumé, transparencies, tearsheets and/or photographs. Samples are filed or returned. Reports back within 2 weeks. Company will contact artist for portfolio review if interested. Pays on consignment basis: firm receives 30-50% commission. Offers advance when appropriate. Rights purchased vary according to project. Does not require exclusive representation of artist. Provides advertising, promotion, shipping to and from firm, written contract and insurance while work is at firm.
Tips: "Keep trying to join a group of artists and try to develop a unique style."

BENTLEY HOUSE FINE ART PUBLISHERS, Box 5551, 1410-J Lesnick Lane, Walnut Creek CA 94596. (925)935-3186. Fax: (925)935-0213. E-mail: alp@bentleyhouse.com. Website: http://www.bentleyhouse.com. Director: Mary Sher. Estab. 1986. Art publisher of open and limited editions of offset reproductions and canvas replicas; also agency (Art Licensing Properties) for licensing of artists' images worldwide. License florals, teddy bear, wildlife and Christmas images to appear on puzzles, tapestry products, doormats, stitchery kits, giftbags, greeting cards, mugs, tiles, wall coverings, resin and porcelain figurines, waterglobes and various other gift items. Clients: framers, galleries, distributors and framed picture manufacturers.

Needs: Seeking decorative fine art for the designer, residential and commercial markets. Considers oil, watercolor, acrylic, gouache, pastel, mixed media and photography. Artists represented include Barbara Mock, Carl Valente, Peggy Abrams, Mary Kay Krell, Richard Judson Zolan, Loren Entz, Charly Palmer and Tom Sierak. Editions created by collaborating with the artist or by working from an existing painting. Approached by 1,000 artists/year.

First Contact & Terms: Send query letter with brochure showing art style or résumé, advertisements, slides and photographs. Samples are filed or are returned by SASE if requested by artist. Reports back within 1 month. Pays royalties of 10% net sales for prints monthly plus 50 artist proofs of each edition. Pays 50% monies received from licensing. Obtains all reproduction rights. Usually requires exclusive representation of artist. Provides national trade magazine promotion, a written contract, worldwide agent representation, 5 annual trade show presentations, insurance while work is at firm and shipping from firm.

Tips: "Feel free to call and request guidelines. Bentley House is looking for experienced artists, with images of universal appeal. New imagery added to our line are contemporary, wildlife and African-American Art so we would particularly like to see that type of work from artists."

BERGQUIST IMPORTS INC., 1412 Hwy. 33 S., Cloquet MN 55720. (218)879-3343. Fax: (218)879-0010. E-mail: bbergqu106@aol.com. President: Barry Bergquist. Estab. 1948. Distributor. Distributes unlimited editions. Clients: gift shops.

Needs: Seeking creative and decorative art for the commercial market. Considers oil, watercolor, mixed media and acrylic. Prefers Scandinavian or European styles. Artists represented include Jacky Briggs, Dona Douma and Darlene Buchanan. Editions created by collaborating with the artist or by working from an existing painting. Approached by 20 artists/year. Publishes the work of 2-3 emerging, 2-3 mid-career and 2 established artists/year. Distributes the work of 2-3 emerging, 2-3 mid-career and 2 established artists/year.

First Contact & Terms: Send brochure, résumé and tearsheets. Samples are not filed and are returned. Reports back within 2 months. Artist should follow-up. Portfolio should include color thumbnails, final art, photostats, tearsheets and photographs. Pays flat fee: $50-300, royalties of 5%. Offers advance when appropriate. Negotiates rights purchased. Provides advertising, promotion, shipping from firm and written contract. Finds artists through art fairs.

Tips: Suggests artists read *Giftware News Magazine*.

BERKSHIRE ORIGINALS, P.O. Box 951, Eden Hill, Stockbridge MA 01263. (413)298-3691. Fax: (413)298-3583. Program Design Assistant: Stephanie Wilcox-Hughes. Estab. 1991. Art publisher and distributor of offset reproductions and greeting cards.

Needs: Seeking creative art for the commercial market. Considers oil, watercolor, acrylic, pastel and pen & ink. Prefers religious themes, but also considers florals, holiday and nature scenes.

First Contact & Terms: Send query letter with brochure showing art style or other art samples. Samples are filed or are returned by SASE if requested by artist. Reports within 1 month. Write for appointment to show portfolio of slides, color tearsheets, transparencies, original/final art and photographs. Pays flat fee; $50-500. Buys all rights.

Tips: "Good draftsmanship is a must, particularly with figures and faces. Colors must be harmonious and clearly executed."

BERNARD FINE ART, P.O. Box 1528, Historic Rt. 7A, Manchester Center VT 05255. (802)362-0373. Fax: (802)362-1082. Managing Director: Michael Katz. Art publisher. Publishes unlimited editions and posters. Clients: picture frame manufacturers, distributors, manufacturers, galleries and frame shops.

● This company also publishes a high-end poster line called Hope Street Editions.

Needs: Seeking creative, fashionable and decorative art for commercial and designer markets. Considers oil, watercolor, acrylic, pastel, mixed media and printmaking (all forms). Art guidelines free for SASE with first-class postage. Editions created by collaborating with the artist or by working form an existing painting. Artists represented include Erin Dertner, Sue Dreamer, Rusty Rust, Bill Bell, Shelly Rasche, Steven Klein and Michael Harrison. Approached by hundreds of artists/year. Publishes the work of 8-10 emerging, 10-15 mid-career and 100-200 established artists.

First Contact and Terms: Send query letter with brochure showing art style and/or résumé, tearsheets, photostats, photocopies, slides, photographs or transparencies. Samples are returned by SASE. Reports back within 2-8 weeks. Call or write for appointment to show portfolio of thumbnails, roughs, original/final art, b&w and color photostats, tearsheets, photographs, slides and transparencies. Pays royalty. Offers an advance when appropriate. Buys all rights. Usually requires exclusive representation of artist. Provides in-transit insurance, insurance while work is at firm, promotion, shipping from firm and a written contract. Finds artists through submissions, sourcebooks, agents, art shows, galleries and word of mouth.

Tips: "We look for subjects with a universal appeal. Some subjects that would be appropriate are landscapes, still lifes, wildlife, religious themes and florals. Please send enough examples of your work so we can see a true representation of style and technique"

BIG, (Division of the Press Chapeau), Govans Station, Box 4591, Baltimore City MD 21212-4591. Director: Elspeth Lightfoot. Estab. 1976. Supplier of original tapestries, sculptures, crafts and paintings to architects, interior designers, facility planners and corporate curators. Makes individual presentations to clients.
Needs: Seeking art for the serious and commercial collector and the designer market. "We distribute what corporate America hangs in its board rooms; highest quality traditional, landscapes, contemporary abstracts. But don't hesitate with unique statements, folk art or regional themes. In other words, we'll consider all categories as long as the craftsmanship is there." Prefers individual works of art. Art guidelines available free for SASE with first-class postage. Editions created by collaborating with the artist. Approached by 50-150 artists/year. Distributes the work of 10 emerging, 10 mid-career and 10 established artists/year.
First Contact & Terms: Send query letter with slides. Samples are filed or are returned by SASE. Reports back within 5 days. Request portfolio review in original query. Artist should follow up with letter after initial query. Pays $500-30,000. Payment method is negotiated (artist sets net pricing). Usually pays ⅓ at contract, ⅓ at commencement of work and ⅓ at work's completion. Does not require exclusive representation. Provides in-transit insurance, insurance while work is at firm, promotion, shipping to firm, and a written contract.

N: TOM BINDER FINE ARTS, 2218 Main St., Santa Monica CA 90405. (310)452-4095. Fax: (310)452-1260. E-mail: artman@loop.com. Website: http://www.artman.net. Owner: Tom Binder. Wholesaler of handpulled originals, limited editions and fine art prints. Clients: galleries and collectors.
Needs: Seeking art for the commercial market. Considers acrylic, mixed media, giclee and pop art. Artists represented include Alexander Chen, John Stango and Leo Posillico. Editions created by working from an existing painting.
First Contact & Terms: Send brochure, photographs, photostats, slides, transparencies and tearsheets. Accepts disk submissions if compatible with Adobe Illustrator 5.0. Samples are not filed and are returned by SASE. Does not report back; artist should contact. Offers advance when appropriate. Rights purchased vary according to project. Provides shipping. Finds artists through art fairs and World Wide Web.

THE BLACKMAR COLLECTION, P.O. Box 537, Chester CT 06412. (860)526-9303. Estab. 1992. Art publisher. Publishes offset reproduction and giclée prints. Clients: individual buyers.
Needs: Seeking creative art. "We are not actively recruiting at this time." Artists represented include DeLos Blackmar, Blair Hammond, Gladys Bates and Keith Murphey. Editions created by working from an existing painting. Approached by 24 artists/year. Publishes the work of 3 established artists/year. Provides advertising, in-transit insurance, insurance while work is at firm. Finds artists through personal contact.

BRINTON LAKE EDITIONS, Box 888, Brinton Lake Rd., Concordville PA 19331-0888. (610)459-5252. President: Lannette Badel. Estab. 1991. Art publisher, distributor, gallery. Publishes/distributes limited editions and canvas transfers. Clients: independent galleries and frame shops. Current clients include: over 100 galleries, mostly East Coast.
Needs: Seeking fashioniable art. Considers oil, acrylic, watercolor, mixed media and pastel. Prefers realistic landscape and florals. Artists represented include Gary Armstrong and Lani Badel. Editions created by collaborating with the artist. Approached by 20 artists/year. Publishes/distributes the work of 1 emerging and 1 established artist/year.
First Contact & Terms: Send query letter with samples. Samples are not filed and are returned. Reports back within 2 months. Company will contact artist for portfolio review of final art, photographs, slides, tearsheets and transparencies if interested. Negotiates payment. Rights purchased vary according to project. Requires exclusive representation of artist.
Tips: "Artists submitting must have good drawing skills no matter what medium used."

BROWN'S FINE ART & FRAMING, 630 Fondren Place, Jackson MS 39216. (601)982-4844 or (800)737-4844. Fax: (601)982-0030. E-mail: bffa@misnet.com. Website: http://www.brownsfineart.com. Contact: Joel Brown. Estab. 1965. Gallery/frame shop. Sells originals, limited editions, unlimited editions, fine art prints, monoprints, offset reproductions, posters, sculpture, and "original art by Mississippi artists." Current clients include: doctors, lawyers, accountants, insurance firms, general public, other frame shops and distributors, decorators and architects, local companies large and small.
Needs: Seeking creative, decorative and investment quality art for the serious collector, commercial and designer markets. Considers oil, acrylic, watercolor, mixed media, pastel, pen & ink and sculpture. Prefers landscapes, florals, unique, traditional and contemporary. Artists represented include Emmitt Thames, Sharon Richardson, Jackie Meena, "plus 30 other Mississippi artists."
First Contact & Terms: Call to make appointment to bring original work. Samples are returned. Request portfolio review of final art and originals in original query. Pays on consignment basis: firm receives 50% commission. Requires exclusive representation of artist. Provides advertising, in-transit insurance, insurance while work is at firm, promotion, shipping from our firm and all framing.
Tips: "Visit our website or e-mail us."

JOE BUCKALEW, 1825 Annwicks Dr., Marietta GA 30062. (800)971-9530. Fax: (770)971-6582. Contact: Joe Buckalew. Estab. 1990. Distributor. Distributes limited editions, canvas transfers, fine art prints and posters. Clients: 600-800 frame shops and galleries.
Needs: Seeking creative, fashionable, decorative art for the serious collector. Considers oil, acrylic and watercolor. Prefers florals, landscapes, Civil War and sports. Artists represented include B. Sumrall, R.C. Davis, F. Buckley, M.

Ganeck, D. Finley. Approached by 25-30 artists/year. Distributes work of 10 emerging, 10 mid-career and 50 established artists/year. Art guidelines free for SASE with first-class postage.

First Contact & Terms: Send sample prints. Accepts disk submissions. "Please call. Currently using a 460 commercial computer." Samples are filed or are returned. Does not report back. Artist should call. To show portfolio, artist should follow-up with call after initial query. Portfolio should include sample prints. Pays on consignment basis: firm receives 50% commission paid net 30 days. Provides advertising, shipping from firm and company catalog. Finds artists through ABC shows, regional art & craft shows, frame shops, other artists.

Tips: "Paint your own style."

CANADIAN ART PRINTS INC., 160-6551 Westminster Hwy., Richmond, British Columbia V3A 3E4 Canada. (604)276-4551. Fax: (604)276-4552. E-mail: sales@canadianartprints.com. Website: http://www.canadianartprints.com. Art Director: Dennis Tessier. Estab. 1965. Art Publisher/distributor. Publishes or distributes unlimited edition, fine art prints, posters and art cards. Clients: galleries, decorators, frame shops, distributors, corporate curators, museum shops, giftshops and manufacturing framers.

Needs: Seeking fashionable and decorative art for the commercial and designer markets. Considers oil, acrylic, watercolor, mixed media, pastel. Prefers florals, landscapes, decorative and still life. Artists represented include Jae Dougall, Philip Craig, Joyce Kamikura, Kiff Holland, Victor Santos, Dubravko Raos and Don Li-Leger. Editions created by collaborating with the artist and working from an existing painting. Approached by 300-400 artists/year. Publishes/distributes 10-15 emerging, 10 mid-career and 20 established artists/year.

First Contact & Terms: Send query letter with photographs, SASE, slides, tearsheets, transparencies. Samples are not filed and are returned by SASE. Reports back within 1 month. Will contact artist for portfolio review of photographs, slides or transparencies if interested. Pays range of royalties. Buys reprint rights or negotiates rights purchased. Provides advertising, in-transit insurance, insurance while work is at firm, promotion, shipping and contract. Finds artists through art exhibitions, art fairs, word of mouth, art reps, submissions.

Tips: "Keep up with trends by following decorating magazines."

CARMEL FINE ART PRODUCTIONS, LTD., 21 Stocker Rd., Verona NJ 07044. (800)951-1950. E-mail: carmelprod@aol.com. Website: http://carmelprod.com. Vice President Sales: Louise Perrin. Estab. 1995. Art publisher/distributor. Publishes/distributes handpulled originals, limited and unlimited edition fine art prints and offset reproduction. Clients: galleries, corporate curators, distributors, frame shops, decorators.

Needs: Seeking creative art for the serious collector, commercial and designer markets. Considers oil, acrylic, pastel. Prefers family-friendly abstract and figurative images. Artists represented include Melvin King, Jenik Cook, Laura Cooper, Adam Hicks, William Carter, G.L. Smothers, William Ward, William Calhoun, Jon Jones. Editions created by collaborating with the artist and working from an existing painting. Approached by 10-20 artists/year. Publishes the work of 2-3 emerging, 1 mid-career and 2-3 established artists/year.

First Contact & Terms: Send query letter with brochure, photographs. Samples are filed. Reports back within 1 month. Will contact artist for portfolio review of final art, roughs if interested. Rights purchased vary according to project. Provides advertising, promotion, shipping from firm and contract. Finds artists through established networks.

Tips: "Be true to your creative callings. Abstracts are being accepted by a wider audience."

CAVALIER GRAPHICS, 17197 Old Jefferson, Prairieville LA 70769. (225)673-4612. Fax: (225)673-9503. Partner: Al Cavalier. Estab. 1991. Poster company, art publisher and distributor. Publishes/distributes limited edition, unlimited edition, offset reproduction and posters. Clients: galleries, frame shops and distributors. "We have about 1,000 clients in over 35 states."

Needs: Seeking creative, fashionable and decorative art for the commercial and designer market. Considers oil, acrylic, watercolor and mixed media. Prefers decorative, floral, southern genre. Editions created by collaborating with the artist and working from an existing painting. Approached by 20-40 artists/year.

First Contact & Terms: Send query letter with brochure, photographs and tearsheets. Samples are not filed and are returned by SASE. Reports back within 3 weeks. Company will contact artist for portfolio review if interested. Portfolio should include color, final art, photographs and tearsheets. Pays royalties and negotiates payment or pays in merchandise. Rights purchased vary according to project. Provides advertising. Finds artists through art exhibition, art fairs, word of mouth and artists' submissions.

Tips: "Be aware of current color trends. Work in a series."

CHALK & VERMILION FINE ARTS, P.O. Box 5119, Greenwich CT 06831. (203)869-9500. Fax: (203)869-9520. Contact: Eric Dannemann. Estab. 1976. Art publisher. Publishes original paintings, handpulled serigraphs and lithographs, posters, limited editions and offset reproductions. Clients: 4,000 galleries worldwide.

Needs: Publishes decorative art for the serious collector and the commercial market. Considers oil, mixed media,

NEED HELP? For tips on finding markets and understanding listings, see our Quick-Start Guide in the front of this book.

acrylic and sculpture. Artists represented include Erte, Thomas McKnight, Alex Katz, Ludmilla Kondakova, Kerry Hallam, John Kiraly, Sally Caldwell Fisher, Fanny Brennan and Robert Williams. Editions created by collaboration. Approached by 200 artists/year.

First Contact & Terms: Send query letter with slides, résumé and photographs. Samples are filed or are returned by SASE if requested by artist. Reports back within 3 months. Publisher will contact artist for portfolio review if interested. Pay "varies with artist, generally fees and royalties." Offers advance. Negotiates rights purchased. Prefers exclusive representation of artist. Provides advertising, in-transit insurance, promotion, shipping to and from firm, insurance while work is at firm and written contract. Finds artists through exhibitions, trade publications, catalogs, submissions.

CIRRUS EDITIONS, 542 S. Alameda St., Los Angeles CA 90013. (213)680-3473. Fax: (213)680-0930. President: Jean R. Milant. Produces limited edition handpulled originals. Clients: museums, galleries and private collectors.

Needs: Seeking contemporary paintings and sculpture. Prefers abstract, conceptual work. Artists represented include Lari Pittman, Joan Nelson, John Millei, Charles C. Hill and Bruce Nauman. Publishes and distributes the work of 6 emerging, 2 mid-career and 1 established artists/year.

First Contact & Terms: Prefers slides as samples. Samples are returned by SASE.

CLASSIC COLLECTIONS FINE ART, 1 Bridge St., Irvington NY 10533. (914)591-4500. Fax: (914)591-4828. Acquisition Manager: Larry Tolchin. Estab. 1990. Art publisher. Publishes unlimited editions and offset reproductions. Clients: galleries, interior designers, hotels.

Needs: Seeking decorative art for the commercial and designer markets. Considers oil, acrylic, watercolor, mixed media and pastel. Prefers landscapes, still lifes, florals. Artists represented include Harrison Rucker, Henrietta Milan, Sid Willis and Charles Zhan. Editions created by collaborating with the artist and by working with existing painting. Approached by 100 artists/year. Publishes the work of 6 emerging, 6 mid-career and 6 established artists/year.

First Contact & Terms: Send slides and transparencies. Samples are filed. Reports back within 3 months. Company will contact artist for portfolio review if interested. Offers advance when appropriate. Buys first and reprint rights. Provides advertising, insurance while work is at firm and written contract. Finds artists through art exhibitions, fairs and competitions.

THE COLONIAL ART CO., 1336 NW First St., Oklahoma City OK 73106. (405)232-5233. E-mail: colonialart@aol.c om. Owner: Willard Johnson. Estab. 1919. Publisher and distributor of offset reproductions for galleries. Clients: retail and wholesale. Current clients include Osburns, Grayhorse and Burlington.

Needs: Artists represented include Felix Cole, Dennis Martin, John Walch and Leonard McMurry. Publishes the work of 2-3 emerging, 2-3 mid-career and 3-4 established artists/year. Distributes the work of 10-20 emerging, 30-40 mid-career and hundreds of established artists/year. Prefers realism and expressionism—emotional work.

First Contact & Terms: Send sample prints. Samples not filed are returned only if requested by artist. Publisher/ Distributor will contact artist for portfolio review if interested. Pays negotiated flat fee or royalties, or on a consignment basis (firm receives 33% commission). Offers an advance when appropriate. Does not require exclusive representation of the artist. Considers buying second rights (reprint rights) to previously published work.

Tips: "The current trend in art publishing is an emphasis on quality."

COLOR CIRCLE ART PUBLISHING, INC., P.O. Box 190763, Boston MA 02119. (617)437-1260. Fax: (617)437-9217. E-mail: t123@msn.com. Website: http://www.colorcircle.com. Estab. 1991. Art publisher. Publishes limited editions, unlimited editions, fine art prints, offset reproductions, posters. Clients: galleries, art dealers, distributors, museum shops. Current clients include: Deck the Walls, Things Graphics, Essence Art.

Needs: Seeking creative, decorative art for the serious collector, for the commercial market. Considers oil, acrylic, watercolor, mixed media, pastel, pen & ink. Prefers ethnic themes. Artists represented include Paul Goodnight, Essud Fungcap, Charly and Dorothea Palmer. Editions created by collaborating with the artist or by working from an existing painting. Approached by 12-15 artists/year. Publishes the work of 2 emerging, 1 mid-career artists/year. Distributes the work of 4 emerging, 1 mid-career artists/year.

First Contact & Terms: Send query letter with slides. Samples are filed or returned by SASE. Reports back within 2 months. Negotiates payment. Rights purchased vary according to project. Provides advertising, insurance while work is at firm, promotion, shipping from our firm and written contract. Finds artists through submissions, trade shows and word of mouth.

Tips: "We like to present at least two pieces by a new artist that are similar in either theme, treatment or colors."

COLVILLE PUBLISHING, 2909 Oregon Ct., #B2, Torrance CA 90503. (310)681-3700. Fax: (310)618-3710. Chairman: Christian Title. Licensing: Bill Dreyer. Estab. 1982. Art publisher. Publishes limited edition serigraphs and Iris graphics. Clients: art galleries, dealers and designers.

● Since our previous edition, this publisher has added a poster line which is open to a broad range of styles and subjects.

Needs: Seeking creative art for the serious collector. Considers oil on canvas. Considering high end product licensing only. Prefers impressionism and American Realism. Artists represented include John Powell, Henri Plisson and Don Hatfield. Publishes and distributes the work of a varying number of emerging, 2 mid-career and 4 established artists/ year.

First Contact & Terms: Send query letter with résumé, slides, photographs, transparencies, biography and SASE.

Samples are not filed. Reports back within 1 month. To show a portfolio, mail appropriate materials. Payment method and advances are negotiated. Prefers exclusive representation of artist. Provides in-transit insurance, insurance while work is at firm, promotion, shipping to and from firm and a written contract.
Tips: "Establish a unique style, look or concept before looking to be published."

COTTAGE EDITIONS, LTD., P.O. Box 335 Carmel CA 93921-0335. Managing Partner: George Goff. Estab. 1992. Art publisher and gallery with digital studio for creation of IRIS Giclée prints. Publishes /prints open and limited editions, canvas transfers, fine art prints, offset reproduction, posters, sculpture, original oils/watercolors. Clients: distributors, galleries, retail, chains, commercial framers, frame shops. Current clients include: Winn Devon Art Group, Image Conscious, International Graphics.
Needs: Creative, fashionable and decorative art for the serious collector, commercial and designer markets. Considers oil, acrylic, watercolor, mixed media, pastel, pen & ink, sculpture. Prefers all styles and themes. Artists represented include John Terelak, Tom Nicholas, Tom Browning, Gordon Wang. Editions created by collaborating with the artist or working from an existing painting.
First Contact & Terms: Send query letter with brochure, photographs, résumé, SASE, slides, transparencies. Samples are not filed and are returned by SASE. Reports back within 1 month. Company will contact artist for portfolio review of color, photographs, slides, tearsheets, transparencies if interested. Pays royalties of 5-10% (percentage paid to artist) or on consignment basis: firm receives 50% commission. Rights purchased vary according to project. Provides advertising, in-transit insurance, insurance while work is at firm, promotion, shipping from firm, written contract. Finds artists through submissions, art shows, exhibitions and fairs, word of mouth.
Tips: "Stress quality, be original."

CREATIF LICENSING CORP., 31 Old Town Crossing, Mount Kisco NY 10549-4030. (914)241-6211. E-mail: creatiflic@aol.com. Website: http://members.aol.com/creatiflic. Estab. 1975. Art licensing agency. Clients: manufacturers of gifts, stationery, bed and bath accessories, toys and home furnishings.
 ● Creatif posts submission guidelines on its web page. The company is also listed in the Greeting Cards, Gifts and Products section.
Needs: Seeking art for the commercial market. Considers oil, acrylic, watercolor, mixed media and pastel. Artists represented include Roger La Borde. Approached by hundreds of artists/year.
First Contact & Terms: Send query letter with 8½×11 color copies. Accepts disk submissions if compatible with Mac Adobe Photoshop 2.5. Samples are filed and are returned by SASE. Reports back within 1 month. Company will contact artist for portfolio review of color and photographs if interested. Pays royalties; varies depending on the experience and marketablity of the artist. Also varies advance structure depending on if the artwork is existing vs. new. Offers advance when appropriate. Negotiates licensing rights. "Artist retains all rights, we license rights to clients." Provides advertising, promotion, written contract, sales marketing and negotiating contracts. Finds artists through art fairs, word of mouth, art reps, sourcebooks and referrals.
Tips: "Be aware of current color trends and design with specific products in mind."

☑ **THE CREATIVE SOCIETY, INC.**, 1231-G Beacon Pkwy. E., Birmingham AL 35209. (205)414-8248. Fax: (205)414-8249. Contact: Finley Eversole. Estab. 1969. Art publisher. Publishes unlimited editions, canvas transfers, fine art prints. Clients: distributors, ready-framers, frame stores and decorators. Current clients include Pier I, Carolina Mirror.
Needs: Seeking creative art for the serious collector, commercial, ready-framed and designer markets. Considers oil, watercolor, acrylic, pastel, mixed media. Prefers animals, landscapes, impressionism, Indian and western. Artists represented include Mark Pettit, Monet, Maxfield Parrish. Editions created by working from an existing painting. Publishes the work of 1-2 mid-career artists/year.
First Contact & Terms: Send query letter with résumé, slides, photographs and photocopies. Samples are filed or are returned by SASE if requested by artist. Reports back only if interested. Company will contact artist for portfolio review if interested. Portfolio should include color photographs and transparencies. Pays royalties of 5-10%. Offers advance when appropriate. Provides advertising, promotion, shipping from firm and written contract.
Tips: Advises artists to attend Atlanta ABC show, which is the largest in the industry. "Work must be of very high quality with good sense of color, light and design. Artist should be willing to grow with young company. We only publish top quality art in traditional and 'new age' styles. Both require excellent color."

CROSS GALLERY, INC., 180 N. Center, P.O. Box 4181, Jackson Hole WY 83001. (307)733-2200. Fax: (307)733-1414. Director: Mary Schmidt. Estab. 1982. Art publisher and gallery. Publishes handpulled originals, limited and unlimited editions, offset reproductions and canvas reproductions. Also licenses a variety of products. Clients: wholesale and retail.
Needs: Seeking creative art for the serious collector. Considers oil, watercolor, mixed media, pastel, pen & ink, sculpture and acrylic. Prefers realism, contemporary, western and portraits. Artists represented include Penni Anne Cross, Val Lewis, Joe Geshick, Michael Chee, Andreas Goft and Kevin Smith. Editions created by collaborating with the artist or by working from an existing image. Approached by 100 artists/year.
First Contact & Terms: Send query letter with brochure, résumé, tearsheets, slides, photostats, photographs, photocopies and transparencies. Samples are not filed and are returned by SASE if requested by artist. Reports back within 2 days. Publisher will contact artist for portfolio review if interested. Portfolio should include b&w and color thumbnails,

roughs, final art, photostats, tearsheets, photographs, slides and transparencies. Pays royalties or on consignment basis (firm receives 33⅓% commission). No advance. Rights purchased vary according to project. Requires exclusive representation of artist. Provides advertising, insurance while work is at firm, promotion, shipping from firm and written contract.
Tips: "Be original."

CUPPS OF CHICAGO, INC., 831 Oakton St., Elk Grove IL 60007. (847)593-5655. Fax: (847)593-5550. President: Gregory Cupp. Estab. 1967. Art publisher and distributor of limited and open editions, offset reproductions and posters. Clients: galleries, frame shops, designers and home shows.
 • Pay attention to contemporary/popular colors when creating work for this design-oriented market.
Needs: Seeking creative and decorative art for the commercial and designer markets. Also needs freelance designers. Artists represented include Gloria Rose and Sonia Gil Torres. Editions created by collaborating with the artist or by working from an existing painting. Considers oil and acrylic paintings in "almost any style—only criterion is that it must be well done." Prefers individual works of art. Approached by 150-200 artists/year. Publishes and distributes the work of 25-50 emerging, 100 mid-career and 10 established artists/year.
First Contact & Terms: Send query letter with résumé, photographs, photocopies and tearsheets. Samples are filed or are returned by SASE if requested. Reports back only if interested. Company will contact artist for portfolio review of color photographs if interested. Negotiates payment. Rights purchased vary according to project. Provides advertising, promotion, shipping from firm, insurance while work is at firm.
Tips: This distributor sees a trend toward traditional and Victorian work.

✓ **DARE TO MOVE**, Dept. AGDM, 1132 S. 274th Place, Des Moines WA 98198. (253)946-7727. Fax: (253)946-7764. E-mail: wfpp@aol.com. President: Steve W. Sherman. Estab. 1987. Art publisher, distributor. Publishes/distributes limited editions, unlimited editions, canvas transfers, fine art prints, offset reproductions. Licenses aviation and marine art for puzzles, note cards, book marks, coasters etc. Clients: art galleries, aviation museums, frame shops and interior decorators.
 • This company has expanded from aviation-related artwork to work encompassing most civil service areas. Steve Sherman likes to work with artists who have been painting for 10-20 years. He usually starts off distributing self-published prints. If prints sell well, he will work with artist to publish new editions.
Needs: Seeking naval, marine, firefighter, civil service and aviation-related art for the serious collector and commercial market. Considers oil and acrylic. Artists represented include John Young, Ross Buckland, Mike Machat, James Dietz, Jack Fellows, John Barber, William Ryan, Patrick Haskett. Editions created by collaborating with the artist or working from an existing painting. Approached by 15-20 artists/year. Publishes the work of 1 emerging, 2-3 mid-career and established artists/year. Distributes the work of 9 emerging and 2-3 established artists/year.
First Contact & Terms: Send query letter with photographs, slides, tearsheets and transparencies. Samples are filed or sometimes returned by SASE. Artist should follow-up with call. Portfolio should include color photographs, transparencies and final art. Pays royalties of 20% commission of wholesale price. Buys one-time or reprint rights. Provides advertising, in-transit insurance, insurance while work is at firm, promotion, shipping from firm and written contract.
Tips: "Present your best work—professionally."

DAUPHIN ISLAND ART CENTER, 1406 Cadillac Ave., Box 699, Dauphin Island AL 36528. Phone/fax: (334)861-5701. Owner: Nick Colquitt. Estab. 1984. Wholesale producer and distributor of marine and nautical decorative art. Clients: West, Gulf and eastern coastline retailers.
Needs: Approached by 12-14 freelance artists/year. Works with 8-10 freelance artists/year. Prefers local artists with experience in marine and nautical themes. Uses freelancers mainly for wholesale items to be retailed. Also for advertising, brochure and catalog illustration, and design. 1% of projects require freelance design.
First Contact & Terms: Send query letter with brochure and samples. Samples not filed are returned only if requested by artist. Reports back within 3 weeks. To show portfolio, mail final reproduction/product. Pays for design and illustration by the finished piece. Considers skill and experience of artist and "retailability" when establishing payment. Negotiates rights purchased.
Tips: Advises artists to attend any of the Art Expo events, especially those held in Atlanta Merchandise Mart. Dauphin Island Art Center offers week-end seminar/workshops year-round on subject of making and marketing graphic art. Every inquiry is answered, promptly.

Ⓝ **DECORATIVE EXPRESSIONS, INC.**, 3595 Clearview Place, Atlanta GA 30340. (770)457-8008. Fax: (770)457-8018. President: Robert Harris. Estab. 1984. Distributor. Distributes original oils. Clients: galleries, designers, antique dealers.
Needs: Seeking creative and decorative art for the designer market. Styles range from traditional to contemporary to

 A CHECKMARK PRECEDING A LISTING indicates a change in either the address or contact information since the 1999 edition.

impressionistic. Artists represented include Henri Hess, J. Hovener, E. Payes, J. Ripoll, Barbera, Gerry Groeneveld, Peter VanBerkel, Cornelis LeMair, Pineda Bueno, Salvador Caballero, Ramon Pujol, Marteen Huisman and Roman Frances. Approached by 6 artists/year. Distributes the work of 2-6 emerging, 2-4 mid-career and 10-20 established artists/year.

First Contact & Terms: Send photographs. Samples are returned by SASE if requested by artist. Reports back to the artist only if interested. Portfolios may be dropped off every Monday. Portfolio should include final art and photographs. Negotiates payment. Offers advance when appropriate. Negotiates rights purchased. Requires exclusive representation of artist. Provides advertising, in-transit insurance, promotion and distribution through sale force and trade shows. Finds artists through word of mouth, exhibitions, travel.

Tips: "The design market is major source for placing art. We seek art that appeals to designers."

DELJOU ART GROUP, INC., (formerly Graphique du Jour, Inc.), 1710 Defoor Ave. NW, Atlanta GA 30318. (404)350-7190. Fax: (404)350-7195. President: Daniel Deljou. Estab. 1980. Art publisher, distributor and gallery of limited editions (maximum 250 prints), handpulled originals, monoprints/monotypes, sculpture, fine art prints and paintings on paper and canvas. Clients: galleries, designers, corporate buyers and architects. Current clients include Coca Cola, Xerox, Exxon, Marriott Hotels, General Electric, Charter Hospitals, AT&T and more than 3,000 galleries worldwide, "forming a strong network throughout the world."

Needs: Seeking creative, fine and decorative art for the designer market. Considers oil, acrylic, pastel, sculpture and mixed media. Artists represented include Lee White, Lyda Claire, Sergey Cherepakhin, Matt Lively, Alexa Kelemen, Ralph Groff, Yasharel, Chemiakin, Bika, Kamy Babak Emanuel and T.L. Lange. Editions created by collaborating with the artist. Approached by 300 artists/year. Publishes the work of 10 emerging, 20 mid-career artists/year and 20 established artists/year.

First Contact & Terms: Send query leter with photographs, slides, brochure, photocopies, tearsheets, SASE and transparencies. Samples not filed are returned only by SASE. Reports back within 1-24 weeks. Will contact artist for portfolio review if interested. Payment method is negotiated. Offers an advance when appropriate. Negotiates rights purchased. Requires exclusive representation. Provides promotion, a written contract and advertising. Finds artists through visiting galleries, art fairs, word of mouth, World Wide Web, art reps, submissions, art competitions and sourcebooks.

Tips: "We would like to add a line of traditional art with a contemporary flair. Earth-tone and jewel-tone colors are in. We need landscape artists, monoprint artists, strong figurative artists, strong abstracts and soft-edge abstracts. We are also beginning to publish sculptures and are interested in seeing slides of such. We have had a record year in sales, and have recently relocated into a brand new gallery, framing and studio complex."

[N] DEVON EDITIONS, 6015 6th Ave. S., Seattle WA 98108. (206)763-9544. Fax: (206)762-1389. Director of Production Development: Buster Morris. Estab. 1987. Art publisher and distributor. Publishes offset reproductions. Clients: architects, designers, specifiers, frame shops.

Needs: Seeking creative and decorative art for the designer market. Considers oil, watercolor, acrylics, pastels, mixed media and photography. "Open to a wide variety of styles." Editions created by collaborating with the artist or by working from an existing painting. Approached by 200 artists.

First Contact & Terms: Send query letter with slides, résumé, transparencies and photographs. Samples are filed or returned by SASE. Reports back within 6 weeks if SASE enclosed. To show portfolio, mail slides and transparencies. Pays flat fee or royalties and advance. Offers advance when appropriate. Buys first-rights or negotiates rights purchased. Provides in-transit insurance, promotion, shipping from firm, insurance while work is at firm and a written contract.

DIRECTIONAL PUBLISHING, INC., 2616 Commerce Circle, Birmingham AL 35210. (205)951-1965. Fax: (205)951-3250. President: David Nichols. Estab. 1986. Art publisher. Publishes limited and unlimited editions and offset reproductions. Clients: galleries, frame shops and picture manufacturers.

Needs: Seeking decorative art for the designer market. Considers oil, watercolor, acrylic and pastel. Prefers floral, sporting, landscapes and still life themes. Artists represented include A. Kamelhair, H. Brown, R. Lewis, L. Brewer, A. Nichols, D. Nichols, M.B. Zeitz and N. Raborn. Editions created by working from an existing painting. Approached by 50 artists/year. Publishes and distributes the work of 5-10 emerging, 5-10 mid-career and 3-5 established artists/year.

First Contact & Terms: Send query letter with slides and photographs. Samples are not filed and are returned by SASE. Reports back within 3 months. Pays royalties. Buys all rights. Provides in-transit insurance, insurance while work is at firm, promotion, shipping from firm and written contract.

Tips: "Always include SASE. Do not follow up with phone calls. All work published is first of all *decorative*. The application of artist designed borders to artwork can sometimes greatly improve the decorative presentation. We follow trends in the furniture/accessories market. Aged and antiqued looks are currently popular—be creative!"

DODO GRAPHICS, INC., 145 Cornelia St., P.O. Box 585, Plattsburgh NY 12901. (518)561-7294. Fax: (518)561-6720. Manager: Frank How. Art publisher of offset reproductions, posters and etchings for galleries and frame shops.

Needs: Considers pastel, watercolor, tempera, mixed media, airbrush and photographs. Prefers contemporary themes and styles. Prefers individual works of art, 16×20 maximum. Publishes the work of 5 artists/year.

First Contact & Terms: Send query letter with brochure showing art style or photographs and slides. Samples are filed or are returned by SASE. Reports back within 3 months. Write for appointment to show portfolio of original/final

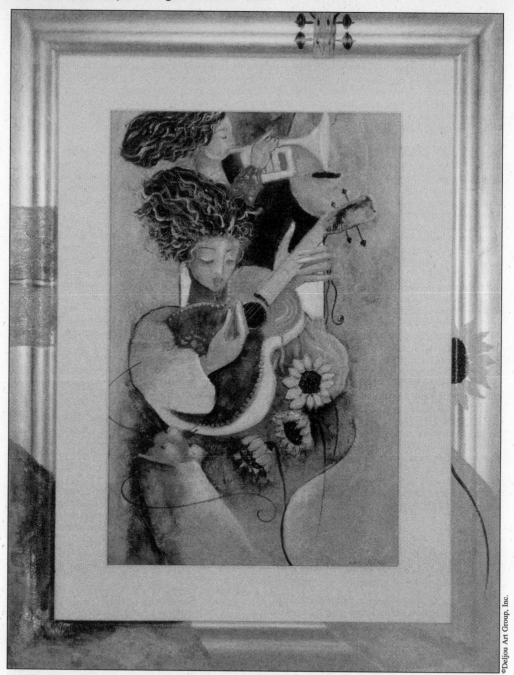

Lee White's stylized mixed media piece *Euphony 1* is one of a number of works by the prolific artist published by Deljou Art Group. White hooked up with Deljou Art by submitting slides and showing his portfolio. "The artist also has abstract art in the same style," says Daniel Deljou. "Our company is looking for anything new in two- or three-dimensional artwork. Technique is very important in today's art market; different but palatable, not too avant garde."

art and slides. Payment method is negotiated. Offers an advance when appropriate. Buys all rights. Requires exclusive representation of the artist. Provides written contract.

Tips: "Do not send any originals unless agreed upon by publisher."

EDELMAN FINE ARTS, LTD., 386 W. Broadway, Third Floor, New York NY 10012. (212)226-1198. Website: http://www.citysearch.com/nyc/heatheredelman. Vice President: H. Heather Edelman. Art distributor of original oil paintings. "We now handle watercolors, lithographs, serigraphs, sculpture and 'works on paper' as well as original oil paintings." Clients: galleries, dealers, consultants, interior designers and furniture stores worldwide.
- The president of Edelman Fine Arts says the mainstream art market is demanding traditional work with great attention to detail. She feels impressionism is still in vogue but with a coral, peach color tone with a Cortes, Couret or Turner feel. She says Renaissance large nudes, pictured in a typical scene, are being requested.

Needs: Seeking creative and decorative art for the serious collector and designer markets. Considers oil and acrylic paintings, watercolor, sculpture and mixed media. Especially likes Old World themes and impressionist style. Art guidelines free for SASE with first-class postage. Distributes the work of 150 emerging, 70 mid-career and 150 established artists.

First Contact & Terms: Send six 3×5 photos (no slides), résumé, tearsheets. Samples are filed. Portfolios may be dropped off every Monday-Thursday upon request. Portfolio should include original/final art and photographs. Reports as soon as possible. Pays royalties of 40% or works on consignment basis (20% commission). Buys all rights. Provides in-transit insurance, insurance while work is at firm, promotion and shipping from firm.

Tips: "Know what's saleable and available in the marketplace."

☑ **EDITIONS LIMITED GALLERIES, INC.**, 744 Alabama St., Suite 300, San Francisco CA 94110. (415)543-9811. Fax: (415)777-1390. Director: Todd Haile. Art publisher and distributor of limited edition graphics and fine art posters. Clients: galleries, framing stores, art consultants and interior designers.

Needs: Seeking creative art for the designer market. Considers oil, acrylic and watercolor painting, monoprint, monotype, photography and mixed media. Prefers landscape and abstract imagery. Editions created by collaborating with the artist or by working from an existing work.

First Contact & Terms: Send query letter with résumé, slides and photographs. Samples are filed or are returned by SASE. Reports back within 2 months. Publisher/distributor will contact artist for portfolio review if interested. Payment method is negotiated. Negotiates rights purchased.

Tips: "We deal both nationally and internationally, so we need art with wide appeal. No figurative or animals, please. When sending slides or photos, send at least six so we can see an overview of the work. We publish artists, not just images." Advises artists to attend Art Expo, New York City and Art Buyers Caravan, Atlanta.

ENCORE GRAPHICS & FINE ART, P.O. Box 812, Madison AL 35758. (800)248-9240. E-mail: jrandjr@hiwaay.net. Website: http://www.randenterprises.com. President: J. Rand, Jr. Estab. 1995. Poster company, art publisher, distributor. Publishes/distributes limited edition, unlimited edition, fine art prints, offset reproduction, posters. Clients: galleries, frame shops, distributors.

Needs: Creative art for the serious collector. Considers all media. Also needs freelance designers with computer experience. Prefers African American and abstract. Art guidelines available on company's website. Artists represented include C. Lewis Perez, Greg Gamble, Buck Brown, Mario Robinson, Lori Goodwin, Wyndall Coleman, T.H. Waldman, John Will Davis, Burl Washington, Henry Battle, Cisco Davis, Delbert Iron-Cloud and John Moore. Editions created by working from an existing painting. Approached by 15 artists/year. Publishing the work of 3 emerging artists, 1 mid-career artist/year. Distributes the work of 3 emerging, 2 mid-career and 3 established artists/year.

First Contact & Terms: Send photocopies, photographs, résumé, tearsheets. Samples are filed. Reports back only if interested. Company will contact artist for portfolio review of color, photographs, tearsheets if interested. Negotiates payment. Offers advance when appropriate. Requires exclusive representation of artist. Provides advertising, in-transit insurance, insurance while work is at firm, promotion, shipping from firm, written contract. Finds artists through the WWW and art exhibits.

Tips: "Prints of African-Americans with religious themes or children are popular now. Paint from the heart."

ESSENCE ART, 1708 Church St., Holbrook NY 11741-5918. (516)589-9420. E-mail: essenceart@aol.com. President: Mr. Jan Persson. Estab. 1989. Art publisher and distributor of posters, limited editions and offset reproductions. "All are African-American images." Licenses African American art on a case by case basis. Clients: galleries and framers. Current clients include Deck the Walls and Fast Frame.

Needs: Seeking artwork with creative expression and decorative appeal for the commercial market. Considers all media. Prefers African-American themes and styles. Artists represented include Dane Tilghman, Cal Massey, Brenda Joysmith, Carl Owens and Synthia Saint-James. Editions created by collaborating with artist or by working from an existing painting. Approached by 120 artists/year. Publishes and distributes the work of 6-20 emerging and up to 5 established artists/year.

First Contact & Terms: Send query letter with slides, photographs and transparencies. Samples are filed or are returned by SASE if requested by artist. Reports back within 2 months. Pays royalties of 20% or payment method negotiated. No advance. Provides insurance while work is at firm, promotion, shipping from firm and a written contract.

Tips: "We are looking for artwork with good messages; family-oriented art is popular. Follow the publisher's advice and be prompt."

"Mario A. Robinson is one of our premiere artists," says Jesse Rand, Jr. of Encore Graphics and Fine Art. Robinson's work in pastel entitled *Mother's Angel* "offers a positive message on the importance of family and religion." Encore Graphics specializes in publishing and distributing fine African-American art. Their audience reacted with overwhelming enthusiasm to the theme and the realism of the piece, Rand says. More samples of work by Robinson and other artists published by Encore can be found on their website at http://randenterprises.com.

ELEANOR ETTINGER INCORPORATED, 119 Spring St., New York NY 10012. (212)925-7474. Fax: (212)925-7734. President: Eleanor Ettinger. Estab. 1975. Art dealer of limited edition lithographs, limited edition sculpture and unique works (oil, watercolor, drawings, etc.).
Needs: Seeks classically inspired realistic work involving figurative, landscapes and still lifes for the serious collector. Considers oil, watercolor, acrylic, pastel, mixed media, pen & ink and pencil drawings. Prefers American realism.
First Contact & Terms: Send query letter with visuals (slides, photographs, etc.), a brief biography, résumé (including a list of exhibitions and collections) and SASE for return of the materials. Reports back within 3-4 weeks.

NANNY FAYE FINE ART, 408 N., Mountain Rd. PA 17112. (800)733-1144. Fax: (800)830-8640. E-mail: sales@nannyfaye.com. Website: http://www.nannyfaye.com. President: Wendy Augustine. Estab. 1990. Art publisher, distributor, wholesale framer/liscencing agent for gift industry. Publishes limited edition, unlimited edition, fine art prints, offset reproduction, posters. Clients: gift and furniture industry, retail catalogs, galleries and framers.
Needs: Seeking creative and decorative art for the commercial market; also folk, country, traditional, trends in the gift industry. Connsiders oil, acrylic, watercolor. Artists represented include Anna Krajewski, Alex Krajewski, Stewart Sherwood, Nancy Young, Clint Hansen, Barbara Appleyard, Catherine Simpson. Editions created by collaborating with the artist or working from an existing painting. Approached by 20-50 artists/year. Publishes the work of 1 emerging, 1-2 mid-career and 2-3 established artists/year.
First Contact & Terms: Send letter with brochure, photocopies, photographs, tearsheets and transparencies. Samples are filed or returned. Will contact for portfolio review of b&w, color, final art, photographs, tearsheets if interested. Payment negotiable. Offers advance when appropriate. Rights purchased vary according to project. Provides advertising, insurance while work is at firm, promotion. Also needs freelancers for design.

S.E. FEINMAN FINE ARTS LTD., 448 Broome St., New York NY 10013. (212)431-6820. Fax: (212)431-6495. President: Stephen E. Feinman. Estab. 1965. Art publisher/distributor, gallery. Publishes/distributes handpulled originals and fine art prints. Clients: galleries, designers.
Needs: Seeking creative art for the serious collector. Considers oil, acrylic, watercolor, pastel, original prints. Artists represented include Mikio Watanabe, Miljenko Bengez, Felix Sherman, Nick Kosciuk, Karine Boulanger. Approached

by hundreds of artists/year. Publishes/distributes the work of 1 emerging and 1 mid-career artist/year.

First Contact & Terms: Send photographs, résumé, SASE, slides. Samples are not filed and are returned by SASE. Reports back within 2 weeks. Company will contact artist for portfolio review of color, final art and photographs if interested. Pays on consignment basis; negotiable. Offers advance when appropriate. Rights purchased vary according to project. Provides insurance while work is at firm, promotion. Finds artists through reps, exhibitions, expos, sourcebooks and word of mouth.

Tips: "When making a presentation to a gallery it must be current work (even if it's sold) with the price that the artist wants fixed as part of the presentation."

☑ **FLYING COLORS, INC.**, 4117 Jefferson, Los Angeles CA 90066. (213)732-9994. Fax: (213)731-0969. E-mail: flyingcolors@artnet.net. Art Director: Lyle Siwkewich. Estab. 1993. Poster company and art publisher. Publishes unlimited edition, fine art prints, posters. Clients: galleries, frame shops, distributors, museum shops, giftshops, mail order, end-users, retailers, chains, direct mail.

Needs: Seeking decorative art for the commercial market. Considers oil, acrylic, watercolor, mixed media, pastel. Prefers multicultural, religious, inspirational wildlife, Amish, country, scenics, stilllife, american culture. Also needs freelancers for design. Prefers designers who own Mac computers. Artists represented include Greg Gorman, Deidre Madsen. Editions created by collaborating with the artist or by working from an existing painting. Approached by 200 artists/year. Publishes the work of 20 emerging, 5-10 mid-career, 1-2 established artists/year.

First Contact & Terms: Send photocopies, photographs, SASE, slides, transparencies. Accepts disk submissions if compatible with SyQuest, Dat, Jazzy, ZIP, QuarkXPress, Illustrator, Photoshop or FreeHand. Samples are filed or returned by SASE. Reports back only if interested. Artist should follow-up with call to show portfolio. Portfolio should include color, photographs, roughs, slides, transparencies. Negotiates payment. Offers advance when appropriate. Negotiates rights purchased, all rights preferred. Provides advertising, promotion, written contract. Finds artists through attending art exhibitions, art fairs, word of mouth, artists' submissions, clients, local advertisements.

Tips: "Ethnic and inspirational/religious art is very strong. Watch the furniture industry. Come up with themes, sketches and series of at least two pieces. Art has to work on 8×10, 16×20, 22×28, 24×36, greeting cards and other possible mediums."

FRONT LINE GRAPHICS, INC., 9808 Waples St., San Diego CA 92121. (619)552-0944. Fax: (619)552-0129. Creative Director: Benita Sanserino. Estab. 1981. Publisher of posters, prints, offset reproductions and unlimited editions. Clients: galleries, frame shops, gift shops and corporate curators.

Needs: Seeking creative and decorative art reflecting popular trends for the commercial and designer markets. Also needs freelancers for design. Considers oil, acrylic, pastel, pen & ink, watercolor and mixed media. Prefers contemporary interpretations of landscapes, seascapes, florals, abstracts and African-American subjects. Artists represented include Hannum, Graves, Van Dyke and Cacalono. Editions created by working from an existing painting or by collaborating with the artist. Approached by 300 artists/year. Publishes the work of 40 artists/year.

First Contact & Terms: Send query letter with brochure, photocopies, photographers, tearsheets and slides. Samples not filed are returned by SASE. Reports back within 4 weeks if interested. Company will contact artist for portfolio review of photographs and slides if interested. Payment method is negotiated; royalty based contracts. Requires exclusive representation of the artist. Provides advertising, promotion, written contract and insurance while work is at firm.

Tips: "Front Line Graphics is looking for artists who are flexible and willing to work to develop art that meets the specific needs of the print and poster marketplace. We actively seek out new art and artists on an ongoing basis."

FUNDORA ART GALLERY, 103400 Overseas Hwy., Key Largo FL 33037. (305)451-2200. Fax: (305)453-1153. E-mail: thomasfund@aol.com. Director: Manny Fundora. Estab. 1987. Art publisher/distributor/gallery. Publishes limited edition fine art prints. Clients: galleries, decorators, frameshops. Current clients include: Ocean Reef Club, Paul S. Ellison.

Needs: Seeking creative and decorative art for the serious collector. Considers oil, watercolor, mixed media. Prefers nautical, maritime, tropical. Artists represented include Tomas Fundora, Gaspel, Juan A. Carballo, Carlos Sierra. Editions created by collaborating with the artist and working from an existing painting. Approached by 15 artists/year. Publishes/distributes the work of 2 emerging, 1 mid-career and 3 established artists/year.

First Contact & Terms: Send query letter with brochure, photographs. Samples are filed. Will contact artist for portfolio review if interested. Pays royalties. Buys all rights. Requires exclusive representation of artist. Provides advertising and promotion. Also works with freelance designers.

Tips: "Trends to watch: Tropical sea and landscapes."

GALAXY OF GRAPHICS, LTD., 460 W. 34th St., New York NY 10001. (212)947-8989. E-mail: aacgog@aol.com. Art Directors: Colleen Buchweitz and Christine Pratti. Estab. 1983. Art publisher and distributor of unlimited editions. Licensing handled by Colleen Buchweitz. Clients: galleries, distributors, and picture frame manufacturers.

● Since our last edition, this publisher added a new size of 11×28 panels to its line.

Needs: Seeking creative, fashionable and decorative art for the commerical market. Artists represented include Glenna Kurz, Christa Keiffer, Ruane Manning and Carol Robinson. Editions created by collaborating with the artist or by working from an existing painting. Considers any media. "Any currently popular and generally accepted themes." Art guidelines free for SASE with first-class postage. Approached by several hundred artists/year. Publishes and distributes the work of 20 emerging and 20 mid-career and established artists/year.

First Contact & Terms: Send query letter with résumé, tearsheets, slides, photographs and transparencies. Samples are not filed and are returned by SASE. Reports back within 2 weeks. Call for appointment to show portfolio. Pays royalties of 10%. Offers advance. Buys rights only for prints and posters. Provides insurance while material is in house and while in transit from publisher to artist/photographer. Provides written contract to each artist.
Tips: "There is a trend of strong jewel-tone colors and spice-tone colors. African-American art very needed."

ROBERT GALITZ FINE ART, 166 Hilltop Court, Sleepy Hollow IL 60118. (847)426-8842. Fax: (847)426-8846. Owner: Robert Galitz. Estab. 1986. Distributor of handpulled originals, limited editions and watercolors. Clients: designers, architects, consultants and galleries—in major cities of seven states.
Needs: Seeking creative, fashionable and decorative art for the serious collector and commercial and designer markets. Considers all media. Prefers contemporary and representational imagery. Art guidelines free for SASE with first-class postage. Editions created by collaborating with the artist. Publishes the work of 1-2 established artists/year. Distributes the work of 100 established artists/year.
First Contact & Terms: Send query letter with slides and photographs. Samples are filed or are returned by SASE. Reports back within 1 month. Call for appointment to show portfolio of original/final art. Pays flat fee of $200 minimum, or pays on consignment basis (25-40% commission). No advance. Buys all rights. Provides a written contract.
Tips: Advises artists to attend an Art Expo event in New York City, Las Vegas, Miami or Chicago. Finds artists through galleries, sourcebooks, word of mouth, art fairs. "Be professional. I've been an art broker or gallery agent for 26 years and very much enjoy bringing artist and client together!"

GALLERIA FINE ARTS & GRAPHICS, 7305 Edgewater Dr., Unit C, Oakland CA 94621. (510)553-0228. Fax: (510)553-9130. Director: Thomas Leung. Estab. 1985. Art publisher/distributor. Publishes/distributes limited editions, unlimited editions, canvas transfers, fine art prints, offset reproductions, posters.
Needs: Seeking creative, decorative art for the serious collector and the commercial market. Considers oil, acrylic, watercolor. Artists represented include H. Leung and Thomas Leung. Editions created by collaborating with the artist or by working from an existing painting. Approached by 50 artists/year.
First Contact & Terms: Send query letter with photographs. Samples are filed. Reports back only if interested. Company will contact artist for portfolio review of color photographs, slides, transparencies if interested. Negotiates payment. Buy all rights. Requires exclusive representation of artist. Provides advertising, in-transit insurance, insurance while work is at firm, promotion, shipping to and from our firm, written contract.
Tips: "Color/composition/subject are important."

GALLERY GRAPHICS, 227 Main, P.O. Box 502, Noel MO 64854. (417)475-6191. Fax: (417)475-3542. E-mail: mdmiller@bestweb.net. Website: http://www.benmarl.com. Contact: Terri Galvin. Estab. 1980. Wholesale producer and distributor of prints, cards, sachets, stationery, calendars, framed art, stickers. Clients: frame shops, craft shops, florists, pharmacies and gift shops.
Needs: Seeking art with nostalgic look, country, Victorian, still lifes, people, children, angels, florals, landscapes, botanicals, animals—nothing too abstract or non-representational. Considers oil, watercolor, mixed media, pastel and pen & ink. 10% of editions created by collaborating with artist. 90% created by working from an existing painting.
First Contact & Terms: Send query letter with brochure showing art style and tearsheets. Designers send photographs, photocopies and tearsheets. Accepts disk submissions compatible with IBM or Mac. Samples are filed or are returned by SASE. Reports back within 2 months. To show portfolio, mail finished art samples, slides, color tearsheets. Pays flat fee: $300-500. Offers advance when appropriate. Can buy all rights or pay royalties of 5%. Provides insurance while work is at firm, promotion and a written contract. Also looking to outsource some projects with graphic designers.
Tips: "I wish artists would submit artwork on different subjects and styles. Some artists do certain subjects particularly well, but you don't know if they can do other subjects. Don't concentrate on just one area—do others as well. Don't limit yourself or you could be missing out on some great opportunities. Paint the world you live in."

GALLERY IN A VINEYARD, P.O. Box 549, Benmarl Vineyards, Marlboro NY 12542. (914)236-4265. E-mail: mdmiller@bestweb.net. Wesbsite: http://www.benmarl.com. Owner: Mark Miller. Art publisher, gallery and studio handling limited editions, offset reproductions, unlimited editions, handpulled originals, posters and original paintings and sculpture. Clients: galleries and collectors.
 ● The owner started out as a self-published artist but has expanded to consider work by other artists.
Needs: Considers any media. Prefers contemporary, original themes in illustrative style and has begun to add digital images. Publishes/distributes the work of 1-2 artists/year.
First Contact & Terms: Send appropriate samples. Samples are not filed and returned only if requested. Reports back within 3 weeks only if interested. Pays on consignment basis (firm receives 50% commission). Negotiates rights purchased. Provides a written contract.
Tips: "Subjects related to the 50s and 60s period of illustrative art are especially interesting. There seems to be a renewed interest in nostalgia. Paint the world you live in."

GAMBOA PUBLISHING, 208 E. Devonshire, Hemet CA 92543. (800)669-1368 or (909)766-6363. Fax: (909)925-5657. E-mail: gamboapublishing@juno.com. Website: http://www.gamboapublishing.com. Art Publisher/Distributor/Framer. Publishes lithographs, canvas transfers and serigraphs.
Needs: Seeking fine art for serious collectors and decorative art for the commercial market. Considers all media. Artists

represented include Gamboa, Joan Sanford.

First Contact & Terms: Send query letter with slides or other appropriate samples and SASE. Will accept submissions on disk or CD-ROM. Publisher will contact artist for portfolio review if interested.

GANGO EDITIONS, 351 NW 12th, Portland OR 97209. (503)223-9694. E-mail: gango@hevanet.com. Website: http://www.hevanet.com/gango. Contact: Artist Submissions. Licensing: Leesa Gango. Estab. 1982. Publishes posters. Licenses work already published in poster form. Clients: poster galleries, art galleries, contract framers and major distributors. Current clients include Bruce McGaw Graphics, Graphique de France, Image Conscious, Editions Limited and In Graphic Detail.

Needs: Seeking creative art for the commercial and designer markets. Considers, oil, watercolor, acrylic, pastel, mixed media and Poloroid transfers. Prefers still life, floral, abstract, landscape, folk art and some photography. Artists represented include Diane Pederson, Amy Melious, Michael Palmer, Randal Painter, Pamela Gladding, Alan Stephenson, Bill Kucha, Gregg Robinson and CW Potzz. Editions created by working from an existing painting or work. Publishes and distributes the work of emerging and established artists.

First Contact & Terms: Send query letter with slides and/or photographs. Samples returned by SASE. Artist is contacted by mail. Reports back within 6 weeks. Write for appointment to show portfolio or mail appropriate materials. Pays royalties of 10%. Requires exclusive representation of artist on posters only. Provides written contract.

Tips: "We are currently looking for contemporary landscapes and are always actively seeking new artists. We are eager to work with fresh ideas, colors and presentations. We like to see pairs. We also like to see classical, traditional works done in a unique style. Be aware of market trends."

GEME ART INC., 209 W. Sixth St., Vancouver WA 98660. (360)693-7772. Fax: (360)695-9795. Art Director: Merilee Will. Estab. 1966. Art publisher. Publishes fine art prints and reproductions in unlimited and limited editions. Clients: galleries, frame shops, art museums. Licenses designs.

Needs: Considers oil, acrylic, pastel, watercolor and mixed media. "We use a variety of styles from realistic to whimsical catering to "Mid-America art market." Artists represented include Lois Thayer, Crystal Skelley, Steve Nelson, Lary McKee, Susan Scheewe, Charles Freeman, Jeanné Flevotomas and Lael Nelson (plus many other artists).

First Contact & Terms: Send color slides, photos or brochure. Include SASE. Publisher will contact artist for portfolio review if interested. Simultaneous submissions OK. Payment on a royalty basis. Purchases all rights. Provides promotion, shipping from publisher and contract.

Tips: "We have added new sizes and more artists to our lines since last year."

GESTATION PERIOD, Box 2408, Columbus OH 43216-2408. (800)800-1562. President: Robert Richman. Estab. 1971. Importer and distributor of unlimited editions and posters. Clients: art galleries, framers, campus stores, museum shops, bookstores and poster oriented shops.

Needs: Seeking published creative art—especially fantasy, surrealism, innovative art and wildlife.

First Contact & Terms: Send query letter with résumé, tearsheets, pricing list and published samples. Samples are filed or returned by SASE. Reports back within 2 months. Negotiates rights purchased. Provides promotion.

Tips: "We do *not* publish. We are seeking pre-published open edition posters that will retail from $5-30."

GHAWACO INTERNATIONAL INC., P.O. Box 962, Guelph, Ontario N1H 6N1 Canada. (519)827-1732 or (888)769-ARTS. Fax: (519)827-1734 or (888)769-5505. E-mail: ghawaco@hotmail.com. Product Development: Kwasi Nyarko. Estab. 1994. Art publisher and distributor. Publishes/distributes limited edition, unlimited edition, canvas transfers and offset reproduction. Clients: museum shops, galleries, gift shops, frame shops, distributors, bookstores and other buyers.

Needs: Seeking contemporary ethnic art. Considers oil and acrylic. Prefers artwork telling the stories of peoples of the world. Emphasis on under-represented groups such as African and Aboriginal. Artists represented include Wisdom Kudowor, Ablade Glover and Kofi Agorsor. Editions created working from an existing painting. Publishes work of 1 emerging, 1 mid-career and 1 established artist/year. Also needs freelancers for design.

First Contact & Terms: Send query letter with brochure, photographs, résumé and SASE. Samples are filed. Reports back only if interested. Request portfolio review in original query. Company will contact artist for portfolio review if interested. Portfolio should include final art, photographs and slides. Pays royalties of up to 30% (net). Consignment basis: firm receives 50% commission or negotiates payment. Offers no advance. Negotiates rights purchased. Requires exclusive representation of artist. Provides advertising, insurance while work is at firm, promotion, shipping from our firm and written contract. Finds artists through referrals, word of mouth and art fairs.

Tips: "To create good works that are always trendy, do theme based compositions. Artists should know what they want to achieve in both the long and short term. Overall theme of artist must contribute to the global melting pot of styles."

GRAPHIQUE DE FRANCE, 9 State St., Woburn MA 01801. (781)935-3405. Website: http://www.graphiquedefrance. com. Contact: Katherine Pierce. Estab. 1979. Art publisher and distributor handling offset reproductions, posters, notecards, gift and stationery products, calendars and silkscreens. Clients: galleries, foreign distributors, museum shops, high end retailers. Art guidelines available via voicemail recording.

First Contact & Terms: Artwork may be submitted in the form of slides, transparencies or high-quality photocopies.

Please do not send original artwork. Please allow four to six weeks for response. SASE is required for any submitted material to be returned.

Tips: "It's best not to insist on speaking with someone at a targeted company prior to submitting work. Let the art speak for itself and follow up a few weeks after submitting."

RAYMOND L. GREENBERG ART PUBLISHING, P.O. Box 239, Circleville NY 10919-0239. (914)469-6699. Fax: (914)469-5955. E-mail: rlgap@pioneeris.net. Owner: Ray Greenberg. Licensing: Ray Greenberg. Estab. 1995. Art publisher. Publishes unlimited edition fine art prints for major framers and plaque manufacturers. Licenses inspirational, ethnic, Victorian, kitchen and bath artwork for prints for wall decor. Clients include Crystal Art Galleries, Impulse Designs.

Needs: Seeking decorative artwork in popular styles for the commercial and mass markets. Considers oil, acrylic, watercolor, mixed media, pastel and pen & ink. Prefers inspirational, ethnic, Victorian, nostalgic and religious themes. Art guidelines free for SASE with first-class postage. Artists represented include Leslie Triesch, Diane Viera, Robert Daley, Monicka Aranibar. Editions created by collaborating with the artist and/or working from an existing painting. Approached by 35 artists/year. Publishes 7 emerging, 13 mid-career and 5 established artists/year.

First Contact & Terms: Send query letter with photographs, slides, SASE; "any good, accurate representation of your work." Samples are filed or returned by SASE. Reports back within 6 weeks. Company will contact artist for portfolio review if interested. Pays flat fee: $50-200 or royalties of 5-7%. Offers advance against royalties when appropriate. Buys all rights. Prefers exclusive representation. Provides insurance, promotion, shipping from firm and contract. Finds artists through word-of-mouth.

Tips: "Versatile artists who are willing to paint for the market can do very well with us. Be flexible and patient."

N THE GREENWICH WORKSHOP, INC., One Greenwich Place, Shelton CT 06484. Contact: Artist Selection Committee. Art publisher and gallery. Publishes limited and open editions, offset productions, fine art lithographs, serigraphs, canvas reproductions and fine art porcelains and books. Clients: independent galleries in US, Canada and United Kingdom.

Needs: Seeking creative, fashionable and decorative art for the serious collector, commercial and designer markets. Considers oil, watercolor, mixed media, pastel and acrylic. Considers all but abstract. Artists represented include James C. Christensen, Howard Terpning, James Reynolds, James Bama, Bert Doolittle, Scott Gustafson, Braldt Bralds. Editions created by collaborating with the artist or by working from an existing painting. Approached by 100 artists/year. Publishes the work of 4-5 emerging, 15 mid-career and 25 established artists. Distributes the work of 4-5 emerging, 15 mid-career and 25 established artists/year.

First Contact & Terms: Send query letter with brochure, slides, photographs and transparencies. Samples are not filed and are returned. Reports back within 2-3 months. Publisher will contact artist for portfolio review if interested. Portfolio should include final art, tearsheets, photographs, slides and transparencies. Pays royalties. No advance. Rights purchased vary according to project. Requires exclusive representation of artist. Provides advertising, insurance while work is at firm, promotion, shipping to and from firm, and written contract. Finds artists through art exhibits, submissions and word of mouth.

☑ GREGORY EDITIONS, 12919 Southwest Freeway, Suite 170, Stafford TX 77477. (800)288-2724. Fax: (281)494-4755. E-mail: mleace@aol.com. President: Mark Eaker. Estab. 1988. Art publisher and distributor of originals, limited editions, serigraphs and bronze sculptures. Licenses variety art for Texture Touch™ canvas reproduction. Clients: Retail art galleries.

● Since our last edition, this publisher has broadened its scope of artwork to include a wider variety of styles.

Needs: Seeking contemporary, creative artwork. Considers oil and acrylic. Open to all subjects and styles. Artists represented include G. Harvey, JD Challenger, Stan Solomon, James Talmadge, Denis Paul Noyer, Liliana Frasca, Michael Young, James Christensen, Gary Ernest Smith, Douglas Hofmann, Alan Hunt, Joy Kirton-Smith, Nel Whatmore, Larry Dyke, Tom DuBois, Michael Jackson, Robert Heindel and sculptures by Ting Shao Kuang and JD Challenger. Editions created by working from an existing painting. Publishes and distributes the work of 5 emerging, 2 mid-career and 2 established artists/year.

First Contact & Terms: Send query letter with brochure or slides showing art style. Call for appointment to show portfolio of photographs and transparencies. Purchases paintings outright; pays percentage of sales. Negotiates payment on artist-by-artist basis based on flat negotiated fee per visit. Requires exclusive representation of artist. Provides in-transit insurance, insurance while work is at firm, promotion, shipping from firm and written contract.

N HADDAD'S FINE ARTS INC., 3855 E. Miraloma Ave., Anaheim CA 92806. President: Paula Haddad. Estab. 1953. Art publisher and distributor. Produces unlimited edition offset reproductions and posters. Clients: galleries, art stores, museum stores and manufacturers. Sells to the trade only—no retail.

SASE MEANS SELF-ADDRESSED, STAMPED ENVELOPE. Send SASEs when requesting return of your samples.

Needs: Seeking creative and decorative art for the commercial and designer markets. Prefers traditional, realism with contemporary flair; unframed individual works and pairs; all media. Editions created by collaborating with the artist or by working from an existing painting. Approached by 200-300 artists/year. Publishes the work of 10-15 emerging artists/year. Also uses freelancers for design. 20% of projects require freelance design. Design demands knowledge of QuarkXPress and Adobe Illustrator.

First Contact & Terms: Illustrators should send query letter with brochure, transparencies, slides, photos representative of work for publication consideration. Include SASE. Designers send query letter explaining skills. Reports back within 90 days. Publisher/distributor will contact artist for portfolio review if interested. Portfolio should include slides, roughs, final art, transparencies. Pays royalties quarterly, 10% of base net price. Rights purchased vary according to project. Provides advertising and written contract.

HADLEY HOUSE PUBLISHING, 11001 Hampshire Ave. S., Bloomington MN 55438. (612)943-5270. Fax: (612)943-8098. Director of Art Publishing: Lisa Laliberte Belak. Licensing: Lowell D. Thompson. Estab. 1974. Art publisher, distributor and 75 retail galleries. Publishes and distributes handpulled originals, limited and unlimited editions and offset reproductions. Licenses all types of flat art. Clients: wholesale and retail.

Needs: Seeking artwork with creative artistic expression and decorative appeal for the serious collector. Considers oil, watercolor, acrylic, pastel and mixed media. Prefers wildlife, florals, landscapes and nostalgic Americana themes and styles. Art guidelines free for SASE with first-class postage. Artists represented include Charles Wysocki, Charles White, James A. Meger, Olaf Wieghorst, Steve Hanks, Les Didier, Al Agnew, John Seerey-Lester, Darrell Bush, Dave Barnhouse, Michael Capser, Lesley Harrison, Nancy Howe, Steve Hamrick, Terry Redlin, Bryan Moon, Lynn Kaatz, John Ebner, Cha Ilyong and Linda Daniel. Editions created by collaborating with artist and by working from an existing painting. Approached by 200-300 artists/year. Publishes the work of 3-4 emerging, 15 mid-career and 8 established artists/year. Distributes the work of 1 emerging and 4 mid-career artists/year.

First Contact & Terms: Send query letter with brochure showing art style or résumé and tearsheets, slides, photographs and transparencies. Samples are filed or are returned. Reports back within 3-5 weeks. Call for appointment to show portfolio of slides, original final art and transparencies. Pays royalties. Requires exclusive representation of artist and/or art. Provides insurance while work is at firm, promotion, shipping from firm, a written contract and advertising through dealer showcase.

Tips: "Build a market for your originals by affiliating with an art gallery or two."

[N] [symbol] HEARTSTRINGS CREATIVE PUBLISHING LTD., 409-244 Wallace Ave., Toronto, Ontario M6H 1V7 Canada. (416)532-3922. Fax: (416)532-6351. E-mail: posters@heartstringscreative.com. President: Peter Pesic. Estab. 1975. Art publisher and distributor. Publishes/distributes canvas transfers and offset reproductions. Clients: galleries, frame shops, distributors and giftshops.

Needs: Seeking creative and decorative art for the commercial market. Prefers home decor that is warm and color sensitive. Looking for landscape, wildlife, seascape, sentimental-figurative, floral and contemporary mixed media utilizing architectural elements. Editions created by collaborating with the artist. Approached by 15-20 artists/year. Publishes work of 6 emerging, 3 mid-career and 2 established artists/year. Distributes the work of 6 emerging, 3 mid-career and 2 established artists/year. Also needs freelancers for design. Prefers designers who own a Mac computer.

First Contact & Terms: Send query letter with photocopies, photographs, slides and transparencies. Accepts disk submissions compatible with Mac and Power Mac. Samples are filed or returned by SASE. Reports back within 3 weeks. Company will contact artist for portfolio review if interested. Payment of royalties are negotiable. Offers advance when appropriate. Rights purchased vary according to project. Requires exclusive representation of artist. Provides advertising, insurance while work is at firm, promotion and written contract. Finds artists through art exhibitions, art fairs, word of mouth and artists' submissions.

Tips: "Wildlife is selling well. Be aware of current color trends. Work in a series."

[N] HOOF PRINTS, P.O. Box 1917, Dept. A & G., Lenox MA 01240. Phone/fax: (413)637-4334. Website: http://www.hoofprints.com. Proprietor: Judith Sprague. Estab. 1991. Mail order art retailer and wholesaler. Handles handpulled originals, limited and unlimited editions, offset reproductions, posters and engravings. Clients: individuals, galleries, tack shops and pet stores.

Needs: Considers only existing horse, dog, fox and cat prints.

First Contact & Terms: Send brochure, tearsheets, photographs and samples. Samples are filed. Will contact artist for portfolio review if interested. Pays per print. No advance. Provides advertising and shipping from firm. Finds artists through sourcebooks, magazine ads, word of mouth.

IMAGE SOURCE INTERNATIONAL, 12 Riverside Dr., Unit 2, Pembroke MA 02359. (781)829-0897. Fax: (781)829-0995. E-mail: pdownes@isiposters.com. Website: http://www.isiposters.com. Contact: Patrick Downes. Art Editor: Mario Testa. Estab. 1992. Poster company, art publisher, distributor, foreign distributor. Publishes/distributes unlimited editions, fine art prints, offset reproductions, posters. Clients: galleries, decorators, frame shops, distributors, architects, corporate curators, museum shops, gift shops, foreign distributors (Germany, Holland, Asia, South America).

● Image Source International is one of America's fastest-growing publishers.

Needs: Seeking fashionable, decorative art for the designer market. Considers oil, acrylic, pastel. Artists represented include Micarelli. Editions created by collaborating with the artist or by working from an existing painting. Approached

by hundreds of artists/year. Publishes the work of 6 emerging, 2 mid-career and 2 established artists/year. Distributes the work of 50 emerging, 25 mid-career, 50 established artists/year.

First Contact & Terms: Send query letter with brochure, photocopies, photographs, résumé, slides, tearsheets, transparencies, postcards. Samples are filed and are not returned. Reports back only if interested. Company will contact artist for portfolio review if interested. Pays flat fee "that depends on artist and work and risk." Buys all rights. Requires exclusive representation of artist.

Tips: Notes trends as sports art, neo-classical, nostalgic, oversize editions. "Think marketability."

IMAGES OF AMERICA PUBLISHING COMPANY, P.O. Box 608, Jackson WY 83001. (800)451-2211. Fax: (307)739-1199. E-mail: artsforthepark@bcissnet.com. Website: http://www.artfortheparks.com. Executive Director: Christopher Moran. Estab. 1990. Art publisher. Publishes limited editions, posters. Clients: galleries, frame shops, distributors, gift shops, national parks, natural history associations.

● This company publishes the winning images in the Art for the Parks competition which was created in 1986 by the National Park Academy of the Arts in cooperation with the National Park Foundation. The program's purpose is to celebrate representative artists and to enhance public awareness of the park system. The top 100 paintings tour the country and receive cash awards. Over $86,000 in prizes in all.

Needs: Seeking national park images. Considers oil, acrylic, watercolor, mixed media, pastel, pen & ink. Prefers nature and wildlife images from one of the sites administered by the National Park Service. Art guidelines available on company's website. Artists represented include Jim Wilcox, Linda Tippetts, Howard Hanson, Tom Antonishak, Steve Hanks. Editions created by collaborating with the artist. Approached by over 2,000 artists/year.

First Contact & Terms: Submit by entering the Arts for the Parks contest for a $40 entry fee. Entry form and slides must be postmarked by June 1 each year. Send for prospectus before April 1st. Samples are filed. Portfolio review not required. Pays flat fee of $50-50,000. Buy one-time rights. Provides advertising.

Tips: "All artwork selected must be representational of a National Park site."

IMPACT IMAGES, 4919 Windplay Dr., El Dorado Hills CA 95762. (916)933-4700. Fax: (916)933-4717. Owner: Benny Wilkins. Estab. 1975. Publishes unlimited edition posters. Clients: frame shops, museum and gift shops. Current clients inlcude Impulse Designs, Image Conscious, Prints Plus, Summit Art Inc. and Deck the Walls.

Needs: Seeking traditional and contemporary artwork. Considers oils, acrylics, pastels, watercolors, mixed media. Prefers contemporary, original themes, humor, fantasy, autos, animals, children, western, country, floral, golf, angels, inspirational, aviation, ethnic, wildlife and suitable poster subject matter. Prefers individual works of art. "Interested in licensed subject matter." Artists represented include Jonnie Chardon, Dan McMannis and Beatrix Potter. Publishes the work of 5 emerging, 25 mid-career and 15 established artists/year.

First Contact & Terms: Send query letter with brochure, tearsheets, photographs, slides and transparencies. Samples are not filed and are returned by SASE. Reports back within 1 month. Payment method is negotiated. Offers an advance when appropriate. Negotiates rights purchased. Does not require exclusive representation of the aritst. Provides written contract. Finds artists through art fairs, word of mouth and submissions.

Tips: "In the past we have been 'trendy' in our art; now we are a little more conservative and traditional."

N INNERSPACE ART PUBLISHING, 3277 Bluff Rd., Marietta GA 30062-4228. (770)977-3242 and (800)239-2682. Fax: (770)579-2906. E-mail: info@sotillo.com. Website: http://www.sotillo.com. National Sales Rep: Jaime Sotillo. Estab. 1990. Art publisher and distributor. Publishes/distributes handpulled originals, limited edition, canvas transfers, monoprints, monotypes, serigraphs, collagraphs, etchings and linocut prints. Clients: galleries, decorators, finer frame shops.

Needs: Seeking creative, fashionable and decorative art for the serious collector, commercial market and designer market. Considers oil, acrylic, mixed media and pastel. Prefers landscapes, abstracts, figuratives, florals and architecture. Artists represented include Rodney Martinez, M. Sotillo, Doug Smoak, LINDA and Tara Farineau. Editions created by collaborating with the artist and by working from an existing painting. Approached by 30-50 artists/year. Publishes work of 2 mid-career artists/year. Distributes the work of 10 emerging, 10 mid-career and 3 established artists/year.

First Contact & Terms: Send query letter with brochure, photographs, SASE, slides, tearsheets and transparencies. Accepts disk submissions. Send JPEG or GIF files. Samples are not filed and are returned by SASE. Reports back only if interested. Portfolio review not required. Pays on consignment basis: firm receives 25% commission. Negotiates payment. No advance. Buys all rights. Rights purchased vary according to project. Sometimes requires exclusive representation of artist. Provides advertising, insurance while work is at firm, promotion, shipping from our firm and written contract. Finds artists through artists' submissions, word of mouth and exhibitions.

Tips: "Landscapes and mature abstracts always sell. Be aware of current color trends, work in a series."

N INNOVATIVE ART, INC., 2 Kile Court, Munsey NY 10952-4531. (914)425-1400. Fax: (914)352-2168. Estab. 1985. Art publisher and distributor. Publishes/distributes limited edition, fine art prints and posters. Clients: wholesalers.

Needs: Seeking creative art. Considers mixed media. Prefers New Age. Artists represented include Thais Oiticia. Editions created by collaborating with the artist. Approached by 10 artists/year. Publishes work of 3 emerging artists/year. Distributes the work of 3 emerging artists/year. Also uses freelancers for design.

First Contact & Terms: Send query letter. Accepts disk submissions. Samples are filed. Reports back within 1 week. Portfolio may be dropped off. Portfolio should include color. Pays flat fee or royalties. Offers advance. Buys first rights. Provides advertising and promotion.

INSPIRATIONART & SCRIPTURE, INC., P.O. Box 5550, Cedar Rapids IA 52406. (319)365-4350. Fax: (319)861-2103. E-mail: charles@inspirationart.com. Website: http://www.inspirationart.com. Creative Director: Charles R. Edwards. Estab. 1993 (incorporated 1996). Produces Christian poster prints. "We create and produce jumbo-sized (24×36) posters targeted at pre-teens (10-14), teens (15-18) and young adults (18-30). A Christian message is contained in every poster. Some are fine art and some are very commercial. We prefer very contemporary images."

Needs: Approached by 150-200 freelance artist/year. Works with 10-15 freelancers/year. Buys 10-15 designs, photos, illustrations/year. Christian art only. Uses freelance artists for posters. Considers all media. Looking for "something contemporary or unusual that appeals to teens or young adults and communicates a Christian message." Art guidelines available for SASE with first-class postage. Catalog available for $3.

First Contact & Terms: Send query letter with photographs, slides, SASE or transparencies. Accepts submissions on disk (call first). Samples are filed or are returned by SASE. Reports back within 6 months. Company will contact artist for portfolio review if interested. Portfolio should include color roughs, final art, photographs and transparencies. "We need to see the artist's range. It is acceptable to submit 'secular' work, but we also need to see work that is Christian-inspired." Originals are returned at job's completion. Pays by the project, $50-250. Pays royalties of 5% "only if the artist has a body of work that we are interested in purchasing in the future." Rights purchased vary according to project.

Tips: "The better the quality of the submission, the better we are able to determine if the work is suitable for our use (slides are best). The more complete the submission (e.g., design, art layout, scripture, copy), the more likely we are to see how it may fit into our poster line. We do accept traditional work, but are looking for work that is more commercial and hip (think MTV with values). A poster needs to contain a Christian message that is relevant to teen and young adult issues and beliefs. Understand what we publish before submitting work. Artists can either purchase a catalog for $3 or visit our website to see what it is that we do. We are not simply looking for beautiful art, but rather we are looking for art that communicates a specific scriptural passage."

INTERCONTINENTAL GREETINGS LTD., 176 Madison Ave., New York NY 10016. (212)683-5380. Fax: (212)779-8564. Art Director: Nancy Hoffman. Estab. 1967. Sells reproduction rights of design to publisher/manufacturers. Handles offset reproductions, greeting cards, stationery and gift items. Clients: paper product, gift tin, ceramic and textile manufacturers. Current clients include: Franklin Mint, Scandecor, Verkerke, Simon Elvin, others in Europe, Latin America, Japan and Asia.

Needs: Seeking creative, fashionable and decorative art for the commercial and designer markets. Considers oil, watercolor, mixed media, pastel, acrylic, computer and photos. Approached by several hundred artists/year. Publishes the work of 30 emerging, 100 mid-career and 100 established artists/year. Also needs freelance design (not necessarily designers). 100% of freelance design demands knowledge of Adobe Photoshop, Adobe Illustrator and Painter. Prefers designers experienced in greeting cards, paper products and giftware.

First Contact & Terms: Send query letter with brochure, tearsheets, slides, photographs, photocopies and transparencies. Samples are filed or returned by SASE if requested by artist. Artist should follow-up with call. Portfolio should include color final art, photographs and slides. Pays flat fee, $30-500, or royalties of 20%. Offers advance when appropriate. Rights purchased vary according to project. Requires exclusive representation of artist, "but only on the artwork we represent." Provides promotion, shipping to firm and written contract. Finds artists through attending art exhibitions, word of mouth, sourcebooks or other publications and submissions.

Tips: Recommends New York Stationery Show held annually. "In addition to having good painting/designing skills, artists should be aware of market needs."

INTERNATIONAL GRAPHICS GMBH., Dieselstr. 7, 76344, Eggenstein Germany. 011(49)721-978-0612. Fax: (49)721-978-0678. E-mail: ig-team@t.online. President: Lawrence Walmsley. Estab. 1983. Poster company/art publisher/distributor. Publishes/distributes limited edition monoprints, monotypes, offset reproduction, posters, original paintings and silkscreens. Clients: galleries, framers, department stores, gift shops, card shops and distributors. Current clients include: Windsor Art and Balangier.

Needs: Seeking creative, fashionable and decorative art for the commercial and designer markets. Also seeking Americana art for our gallery clients. Considers oil, acrylic, watercolor, mixed media, pastel. Prefers landscapes, florals, still lifes. Art guidelines free for SASE with first-class postage. Artists represented include Ida, Janssen, Lilita, Bähr-Clemens, McCulloch, Barth, Mayer, Hecht. Editions created by working from an existing painting. Approached by 20-30 artists/year. Publishes the work of 4-5 emerging, 1-5 mid-career and 1-2 established artists/year. Distributes the work of 40-50 emerging, 10 mid-career, 2-3 established artists/year.

First Contact & Terms: Send query letter with brochure, photocopies, photographs, photostats, résumé, slides, tearsheets. Accepts disk submissions in Mac or Windows. Samples are filed and returned. Reports back within 1-2 months. Will contact artist for portfolio review if interested. Negotiates payment on basis of per piece sold arrangement. Offers advance when appropriate. Buys first rights. Provides advertising, promotion, shipping from our firm and contract. Also work with freelance designers. Prefers local designers only. Finds artists through exhibitions, word of mouth, submissions.

Tips: "Bright landscapes and still life pictures are good at the moment. Blues are popular—especially darker shades."

ISLAND ART, 6687 Mirah Rd., Saanichton, British Columbia V8M 1Z4 Canada. (250)652-5181. Fax: (250)652-2711. E-mail: islandart@islandart.com. Website: http://www.islandart.com. President: Myron D. Arndt. Estab. 1985. Art publisher and distributor. Publishes and distributes limited and unlimited editions, offset reproductions, posters and

art cards. Clients: galleries, department stores, distributors, gift shops. Current clients include: Disney, Host-Marriott, Ben Franklin.

Needs: Seeking creative and decorative art for the serious collector, commercial and designer markets. Considers oil, watercolor and acrylic. Prefers lifestyle themes/Pacific Northwest. Also needs designers. 10% of products require freelance design and demand knowledge of Adobe Photoshop. Art guidelines available on company's website. Artists represented include Sue Coleman and Lissa Calvert. Editions created by working from an existing painting. Approached by 100 artists/year. Publishes the work of 2 emerging, 2 mid-career and 2 established artists/year. Distributes the work of 4 emerging, 10 mid-career and 5 established artists/year.

First Contact & Terms: Send résumé, tearsheets, slides and photographs. Designers send photographs, slides or transparencies (do not send originals). Accepts submissions on disk compatible with Adobe Photoshop. Send EPS of TIFF files. Samples are not filed and are returned by SASE if requested by artist. Reports back within 3 months. Publisher/distributor will contact artist for portfolio review if interested. Portfolio should include color roughs, final art, slides and 4×5 transparencies. Pays royalties of 5-10%. Offers advance when appropriate. Buys reprint rights. Requires exclusive representation of artist. Provides insurance while work is at firm, promotion, shipping from firm, written contract, trade fair representation and Internet service. Finds artists through art fairs, referrals and submissions.

Tips: "Provide a body of work along a certain theme to show a fully developed style that can be built upon. We are influenced by our market demands. Please ask for our submission guidelines before sending work on spec."

N **☒** **JADEI GRAPHICS INC.**, 4943 McConnell Ave., Suite "W", Los Angeles CA 90066. E-mail: selrt@aol.com. Contact: Liz. Licensing: Allen Cathey. Poster company. Publishes limited edition, unlimited edition and posters. Licenses calendars, puzzles, etc.

Needs: Seeking creative, decorative art for the commercial market. Considers oil, acrylic, watercolor, mixed media and pen & ink. Approached by 50 artists/year. Also needs freelancers for design. Prefers local designers only.

First Contact & Terms: Send query letter with brochure, photocopies, photographs and slides. Accepts disk submissions. Samples are returned by SASE. Reports back only if interested. Company will contact artist for portfolio review of b&w, color, photographs, slides and transparencies. Negotiates payment. Offers advance. Rights purchased vary according to project. Provides advertising.

N **ARTHUR A. KAPLAN CO. INC.**, 460 W. 34th St., New York NY 10001. (212)947-8989. Fax: (212)629-4317. Art Directors: Colleen Buchweitz and Christine Pratli. Estab. 1956. Art publisher of unlimited editions of offset reproduction prints. Clients: galleries and framers.

Needs: Seeking creative and decorative art for the designer market. Considers all media. Artists represented include Lena Liu, Charles Murphy and Gloria Eriksen. Editions created by collaborating with artist or by working from an existing painting. Approached by 1,550 artists/year. Publishes and distributes the work of "as many good artists as we can find."

First Contact & Terms: Send résumé, tearsheets, slides and photographs to be kept on file. Material not filed is returned by SASE. Reports within 2-3 weeks. Call for appointment to show portfolio, or mail appropriate materials. Portfolio should include final reproduction/product, color tearsheets and photographs. Pays a royalty of 5-10%. Offers advance. Buys rights for prints and posters only. Provides insurance while work is at firm and in transit from plant to artist.

Tips: "We cater to a mass market and require fine quality art with decorative and appealing subject matter. Don't be afraid to submit work—we'll consider anything and everything."

LAWRENCE UNLIMITED, 8721 Darby Ave., Northridge CA 91324. (818)349-4120. Fax: (818)349-0450. Owner: Lawrence. Estab. 1966. Art publisher, distributor and manufacturer. Publishes and/or distributes hand-pulled originals and offset reproductions. Clients: furniture stores, designers, commercial markets.

Needs: Seeking artwork with creative expression, fashionableness and decorative appeal for the commercial and designer markets. Considers watercolor, mixed media, pastel, pen & ink and intaglio, monotype. Artists represented include Jeanne Down, Nancy Cowan and M. Duval. Editions created by collaborating with the artist. Approached by 20 artists/year. Distributes the work of 4 emerging and 2 mid-career artists/year. Also needs freelancers for design.

First Contact & Terms: Send query letter with brochure showing art style, photocopies, résumé, transparencies, tearsheets and photographs. Samples are not filed and are returned. Reports back within 2 weeks. Call for appointment to show portfolio. Portfolio should include roughs, final art, tearsheets and photographs. Pays flat fee. Offers advance when appropriate. Negotiates rights purchased. Provides promotion.

Tips: "Have pricing in mind for distributing and quantity."

LESLI ART, INC., Box 6693, Woodland Hills CA 91365. (818)999-9228. E-mail: artlesli@aol.com. President: Stan Shevrin. Estab. 1965. Artist agent handling paintings for art galleries and the trade.

Needs Considers oil paintings and acrylic paintings. Prefers realism and impressionism—figures costumed, narrative content, landscapes, still lifes and florals. Maximum size 36×48, unframed. Works with 20 artists/year.

First Contact & Terms: Send query letter with photographs and slides. Samples not filed are returned by SASE. Reports back within 1 month. To show portfolio, mail slides and color photographs. Payment method is negotiated. Offers an advance. Provides national distribution, promotion and written contract.

Tips: "Considers only those artists who are serious about having their work exhibited in important galleries throughout

the United States and Europe. Never stop learning about your craft."

LESLIE LEVY FINE ART PUBLISHING, INC., 1505 N. Hayden, Suite J10, Scottsdale AZ 85257. (602)945-8491. Fax: (602)945-8104. E-mail: leslevy@ix.netcom.com. Director of Marketing: Gary Massey. Licensing: Laura Levy. Estab. 1976. Art publisher of posters. "Our publishing customers are mainly frame shops, galleries, designers, framed art manufacturers, distributors and department stores. Currently works with over 10,000 clients."
- Leslie Levy has added a licensing division, Leslie Levy Creative Art Licensing. The division will license calendar notecards and other paper goods, puzzles, book illustrations and covers, CD covers, china, fabric designs, gifts, menus, etc. Laura Levy directs the program.

Needs Seeking creative and decorative art for the residential, hospitality, health care, commercial and designer markets. Artists represented include: Steve Hanks, Doug Oliver, Robert Striffolino, Kent Wallis, Cyrus Afsary, Raymond Knaub, Terry Isaacs, Doug West, Patricia Hunter, Jean Crane and many others. Considers oil, acrylic, pastel, watercolor, tempera, mixed media and photography. Prefers art depicting florals, landscapes, wildlife, farm scenes, Americana and figurative works. Approached by hundreds of artists/year. Publishes the work of 2 new, 2 mid-career and 2 established artists/year.

First Contact & Terms: Send query letter with résumé, slides or photos. Samples are filed or returned by SASE. Reports back within 6 weeks. "Portfolio will not be seen unless interest is generated by the materials sent in advance." Please do not send limited editions, transparencies or original works. Pays royalties quarterly based on wholesale price. Insists on acquiring reprint rights for posters. Requires exclusive representation of the artist for the image being published. Provides advertising, promotion, written contract and insurance while work is at firm. "Please, don't call us. After we review your materials, we will contact you or return materials within 6-8 weeks.

Tips: "We are looking for floral, figurative, landscapes, wildlife, abstract art, and any art of exceptional quality. Please, if you are a beginner do not go through the time and expense of sending materials. Also we publish no copycat art." Advises artists to attend the Art Buyers Caravan, an annual trade show held in Atlanta, Georgia or Galeria, New York.

LIPMAN PUBLISHING, 76 Roxborough St. W., Toronto, Ontario M5R 1T8 Canada. (800)561-4260. E-mail: lipman@passport.ca. Owner: Louise Lipman. Estab. 1976. Art publisher. Publishes unlimited editions, offset reproductions and posters. Clients: wholesale framers, distributors, hospitality. Current clients include: Pier One, Bombay, Spiegel.

Needs: Seeking decorative art for the commercial and designer markets. Considers all 2-dimensional media. Prefers garden, kitchen, landscape, floral themes. Art guidelines available. Artists represented include William Buffett, Anna Pugh and Donald Farnsworth. Editions created by collaborating with the artist or by working from an existing painting.

First Contact & Terms: Send slides, photographs, photocopies or any low-cost facsimile. Samples are filed and not returned. Reports back within a few weeks. Publisher will contact artist for portfolio review if interested. Portfolio should include color thumbnails, photographs and slides. Pays royalties of 10%. Negotiates rights purchased. Requires exclusive representation of artist. Provides advertising, promotion and written contract.

Tips: "There's a trend to small pictures of garden-, kitchen-, and bathroom-related material. Be willing to take direction."

LOLA LTD./LT'EE, 1811 Egret St. SW, S. Brunswick Islands, Ocean Isle Beach NC 28470. (910)754-8002. Owner: Lola Jackson. Distributor of limited editions, offset reproductions, unlimited editions, handpulled originals, antique prints and etchings. Clients: art galleries, architects, picture frame shops, interior designers, major furniture and department stores, industry and antique gallery dealers.
- This distributor also carries antique prints, etchings and original art on paper and is interested in buying/selling to trade.

Needs: Seeking creative and decorative art for the commercial and designer markets. "Handpulled graphics are our main area." Also considers oil, acrylic, pastel, watercolor, tempera or mixed media. Prefers unframed series, 30×40 maximum. Artists represented include White, Brent, Jackson, Mohn, Baily, Carlson, Coleman. Approached by 100 artists/year. Publishes the work of 5 emerging, 5 mid-career and 5 established artists/year. Distributes the work of 40 emerging, 40 mid-career and 5 established artists/year.

First Contact & Terms: Send query letter with sample. Samples are filed or are returned only if requested. Reports back within 2 weeks. Payment method is negotiated. "Our standard commission is 50% less 50% off retail." Offers an advance when appropriate. Provides insurance while work is at firm, shipping from firm and written contract.

Tips: "We find we cannot sell b&w only; red, orange and yellow are also hard to sell unless included in abstract subjects. Best colors: emerald, mauve, pastels, blues. Leave wide margins on prints. Send all samples before end of May each year as our main sales are targeted for summer."

LONDON CONTEMPORARY ART, 6950 Phillips Hwy., Suite 51, Jacksonville FL 32216. (904)296-4982. Fax: (904)296-4943. Website: http://www.artcom.com/lca/. Estab. 1978. Art publisher. Publishes limited editions. Clients: art galleries, dealers, distributors, furniture stores and interior designers.

Needs: Seeking art for the commercial market. Prefers figurative, landscapes, some abstract expressionism. Artists represented include Roy Fairchild, David Dodsworth, Janet Treby, Alexander Ivanov and Csaba Markus. Editions created by working from an existing painting. Approached by hundreds of artists/year. Publishes the work of 1-10 emerging, 1-10 mid-career and 20 established artists/year. Distributes the work of 1-10 emerging, 1-10 mid-career, 20-50 established artists/year.

First Contact & Terms: Send brochure, résumé, tearsheets, photographs and photocopies. Samples are filed or returned by SASE. Publisher/distributor will contact artist for portfolio review if interested. Portfolio should include final

art, tearsheets and photographs. Negotiates payment. Rights purchased vary according to project. Provides advertising, in-transit insurance, insurance while work is at firm, promotion, shipping from firm and written contract. Finds artists through attending art exhibitions and art fairs, word of mouth and submissions.

Tips: Recommends artists read *Art Business News* and *U.S. Art.* "Pay attention to color trends and interior design trends. Artists need discipline and business sense and must be productive."

MACH 1, INC., P.O. Box 7360, Chico CA 95927. (916)893-4000. Fax: (916)893-9737. E-mail: marketing@mach_1.com. Website: http://www.mach1.com. Vice President Marketing: Paul Farsai. Estab. 1987. Art publisher. Publishes unlimited and limited editions and posters. Clients: museums, galleries, frame shops and mail order customers. Current clients include the Smithsonian Museum, the Intrepid Museum, Deck the Walls franchisers and Sky's The Limit.

Needs: Seeking creative and decorative art for the commercial and designer markets. Considers mixed media. Prefers aviation related themes. Artists represented include Jarrett Holderby and Jay Haiden. Editions created by collaborating with the artist or by working from an existing painting. Publishes the work of 2-3 emerging, 2-3 mid-career and 2-3 established artists/year.

First Contact & Terms: Send query letter with résumé, slides and photographs. Samples are not filed and are returned. Reports back within 1 month. To show a portfolio, mail slides and photographs. Pays royalties. Offers an advance when appropriate. Requires exclusive representation of the artist. Provides promotion, shipping to and from firm and a written contract.

Tips: "Find a good publisher."

MAIN FLOOR EDITIONS, 4943 McConnell Ave., Los Angeles CA 90066. (310)823-5686. Fax: (310)823-4399. Art Director: Allen Cathey. Estab. 1996. Poster company, art publisher and distributor. Publishes/distributes limited edition, unlimited edition and posters. Clients: distributors, retail chain stores, gallery, frame shops, O.E.M. framers.

Needs: Seeking creative, fashionable and decorative art for the commercial and designer markets. Considers oil, acrylic, watercolor, mixed media, pastel and photography. Artists represented include Allayn Stevens, Inka Zlin and Peter Colvin. Editions created by collaborating with the artist or by working from an existing painting. Approached by 100 artists/year. Publishes work of 30 emerging, 15 mid-career and 10 established artists/year. Distributes the work of 5 emerging, 3 mid-career and 2 established artists/year. Also needs freelancers for design.

First Contact & Terms: Send query letter with brochure, photocopies, photographs and tearsheets. Samples are filed and are not returned. Reports back within 6 months only if interested. Company will contact artist for portfolio review if interested. Portfolio should include photographs, slides and tearsheets. Pays flat fee $300-700; royalties of: 10%. Offers advance when appropriate. Negotiates rights purchased. Requires exclusive representation of artist. Finds artists through art fairs, sourcebooks and word of mouth.

Tips: "Follow catalog companies—colors/motifs."

MARGIEART, 39 Fairway Dr., Bluffton SC 29910-5702. (843)757-2445. E-mail: margieart2@aol.com. Vice President, Marketing: Sheryl Inglefield. Estab. 1993. Distributor. Distributes limited editions, unlimited editions, fine art prints, offset reproductions, posters. Clients: galleries, frame shops.

● This publisher is currently seeking abstracts, landscapes and florals.

Needs: Seeking creative, fashionable, decorative art for the commerical and designer markets. Considers oil, acrylic, watercolor, mixed media, pastel, pen & ink. Artists represented include Guy Begin, Tom Sierak, Karen Vernon, Susanne Lawrence and Richard Zucco. Editions created by working from an existing painting. Approached by 10-20 artists/year. Distributes the work of 6-8 emerging, 12-15 mid-career and 2-3 established artists/year.

First Contact & Terms: Send query letter with brochure, photographs, SASE, tearsheets. Samples are not filed and are returned by SASE. Reports back within 6-8 weeks. Company will contact artist for portfolio review of color photographs if interested. Pays on consignment basis: firm receives 50% commission. Rights purchased vary according to project. Provides promotion, shipping from our firm, written contract. Finds artists through attending art exhibitions, art fairs, word of mouth, other publications, submissions.

Tips: "Check with several galleries and framing shops regarding image, size and price before printing to be sure your art print is in line with the markets demand. Art prints that require oversized matting and framing are rarely purchased for inventory by galleries or framing shops."

MARLBORO FINE ART & PUBL., LTD., 10 Gristmill Rd., Howell NJ 07731. Phone/fax: (732)972-9044. E-mail: charlin15@aol.com. Website: http://www.art-smart.com/mfa. Estab. 1996. Art publisher/distributor. Publishes/distributes limited and unlimited edition offset reproductions and posters. Clients: galleries, decorators, frame shops, distributors, architects, corporate curators, museum shops, giftshops. Current clients include: Paloma, H&M Gallery, Charray Art.

 A CHECKMARK PRECEDING A LISTING indicates a change in either the address or contact information since the 1999 edition.

Needs: Publishes/distributes creative, fashionable and decorative art for the commercial market. Considers acrylic, watercolor, mixed media, pastel, pen & ink. Prefers multicultural themes. Artists represented include Anthony Armstrong, Khalil Bey, Hosa Anderson, Harry Davis, William Buffet, Alex Corbbrey, Mario A. Robinson, Ophie Lawrence, James Ghetters, Jr. and Peggy Van Buren. Editions created by collaborating with the artist and working from an existing painting. Approached by 15-20 artists/year. Publishes 1-2 emerging, 2 established artists/year. Distributes the work of 5-10 emerging, 5 mid-career artists/year. Also needs sculptors, pay rate negotiable.

First Contact & Terms: Send query letter with brochure, photocopies, photographs, photostats, slides, transparencies. Samples are not filed and are returned. Reports back within days. Will contact artist for portfolio review if interested. Royalties paid monthly. Offers advance when appropriate. Rights purchased vary according to project. Provides advertising, promotion, shipping from firm and contract. Finds artists through the web, trade publications.

Tips: "Do your own thing—if it feels right—go for it!"

BRUCE MCGAW GRAPHICS, INC., 389 W. Nyack Rd., West Nyack NY 10994. (914)353-8600. Fax: (914)353-3155. E-mail: 75300.2226@compuserve.com. Acquisitions: Martin Lawlor. Clients: poster shops, galleries, I.D., frame shops.

- Bruce McGaw Graphics introduced a new collection of limited edition serigraphs and lithographs in March, 1999 to compliment its fine art poster collection.

Needs: Artists represented include Betsy Cameron, Yuriko Takata, Art Wolfe, Diane Romanello, Romero Britto, Jacques Lamy, Peter Sculthorpe, Peter Kitchell, Bob Timberlake, Bernie Horton and P.G. Gravele. Publishes the work of 10 emerging and 20 established artists/year.

First Contact & Terms: Send slides, transparencies or any other visual material that shows the work in the best light. "We review all types of 2-dimensional art with no limitation on media or subject. Review period is 1 month, after which time we will contact you with our decision. If you wish the material to be returned, enclose a SASE. Contractual terms are discussed if work is accepted for publication."

Tips: "Simplicity is very important in today's market (yet there still needs to be 'a story' to the image). Form and palette are critical to our decision process. We have a tremendous need for decorative pieces, especially new abstracts, landscapes, and florals. Environmental images which feature animals and decorative still life images are very popular, and much needed as well. There are a lot of prints and posters being published into the marketplace these days. Market your best material! There are a number of important shows—the largest American shows being Art Expo, New York (March) and the Atlanta A.B.C. Show (September)."

☑ **MIXED-MEDIA, LTD.**, 3585 E. Patrick Lane, #800, Las Vegas NV 89120. (702)796-8282. Fax: (702)794-0292. E-mail: mmlasveg@aol.com. Contact: Brad Whiting. Estab. 1969. Distributor of posters. Clients: galleries, frame shops, decorators, hotels, architects and department stores.

Needs: Considers posters only. Artists represented include Adams, Behrens, Erte, Kimble, McKnight and many others. Distributes the work of hundreds of artists/year.

First Contact & Terms: Send finished poster samples. Samples not returned. Negotiates payment method and rights purchased.

Tips: "We have been in business for over 26 years. The style of artists and their art have changed through the years. Just because we may not accept one thing today, does not mean we will not accept it tomorrow. Don't give up!"

N̄ MODARES ART PUBLISHING, 8840 Seventh Ave. N., Golden Valley MN 55427. (800)896-0965. Fax: (612)513-1357. President: Mike Modares. Estab. 1993. Art publisher, distributor, also framed art distribution. Publishes/distributes limited edition, unlimited edition, canvas transfers, monoprints, monotypes, offset reproduction and posters. Clients: galleries, decorators, frame shops, distributors, architects, corporate curators, museum shops and giftshops.

Needs: Seeking creative and decorative art for the commercial and designer market. Considers oil, acrylic, watercolor mixed media and pastel. Prefers realism and impressionism. Artists represented include Tim Hansel, Derk Mayen, and Michael Schofield. Editions created by collaborating with the artist or working from an existing painting. Approached by 10-50 artists/year. Distributes the work of 10-30 emerging artists/year. Also needs freelancers for design.

First Contact & Terms: Send query letter with brochure, photographs, photostats, slides and transparencies. Samples are not filed and are returned. Reports back within 3-5 days. Portfolio may be dropped off every Monday, Tuesday and Wednesday. Artist should follow-up with a call. Portfolio should include color, final art, photographs, photostats, thumbnails. Payment negotiated. Offers advance when appropriate. Buys one-time rights and all rights. Sometimes requires exclusive representation of artist. Provide advertising, in-transit insurance, insurance while work is at firm, promotion, shipping from our firm and written contract. Finds artists through attending art exhibitions, art fairs and word of mouth.

N̄ MODERNART EDITIONS, 276 Fifth Ave., Suite 205, New York NY 10001. (212)779-0700, ext. 251. Contact: Mary Mizerany. Estab. 1973. Art publisher and distributor of "top of the line" open edition posters and offset reproductions. Clients: galleries and custom frame shops worldwide.

Needs: Seeking decorative art for the commercial and designer markets. Considers oil, watercolor, mixed media, pastel and acrylic. Prefers fine art landscapes, abstracts, representational, still life, decorative, collage, mixed media. Size: 16×20. Artists represented include Carol Ann Curran, Diane Romanello, Pat Woodworth, Chuck Huddleston, Penny Feder and Neil Faulkner. Editions created by collaboration with the artist or by working from an existing painting. Approached by 200 artists/year. Publishes the work of 10-15 emerging artists/year. Distributes the work of 100 emerging artists/year.

First Contact & Terms: Send postcard size sample of work, contact through artist rep, or send query letter with slides, photographs, brochure, photocopies, résumé, photostats, transparencies. Reports within 6 weeks. Request portfolio review in original query. Publisher/distributor will contact artist for portfolio review if interested. Portfolio should include color photostats, photographs, slides and trasparencies. Pays flat fee of $200-300 or royalties of 10%. Offers advance against royalties. Provides insurance while work is at firm, shipping to firm and written contract.
Tips: Advises artists to attend Art Expo New York City and Atlanta ABC.

MORIAH PUBLISHING, INC., 23500 Mercantile Rd., Unit B, Beechwood OH 44122. (216)595-3131. Fax: (216)595-3140. E-mail: rouven@moriahpublishing.com. Website: http://www.moriahpublishing.com. Contact: Rouven R. Cyncynatus. Estab. 1989. Art publisher and distributor of limited editions. Licenses wildlife and nature on all formats. Clients: wildlife art galleries.
Needs: Seeking artwork for the serious collector. Editions created by working from an existing painting. Approached by 100 artists/year. Publishes the work of 6 and distributes the work of 15 emerging artists/year. Publishes and distributes the work of 10 mid-career artists/year. Publishes the work of 30 and distributes the work of 10 established artists/year.
First Contact & Terms: Send query letter with brochure showing art style, slides, photocopies, résumé, photostats, transparencies, tearsheets and photographs. Reports back within 2 months. Write for appointment to show portfolio or mail appropriate materials: rough, b&w, color photostats, slides, tearsheets, transparencies and photographs. Pays royalties. No advance. Buys reprint rights. Requires exclusive representation of artist. Provides in-transit insurance, promotion, shipping to and from firm, insurance while work is at firm, and a written contract.
Tips: "Artists should be honest, patient, courteous, be themselves, and make good art."

MULTIPLE IMPRESSIONS, LTD., 128 Spring St., New York NY 10012. (212)925-1313. Fax: (212)431-7146. President: Elizabeth Feinman. Estab. 1972. Art publisher and gallery. Publishes handpulled originals. Clients: young collectors, established clients, corporate, mature collectors.
Needs: Seeking creative art for the serious collector. Considers oil, watercolor, mixed media and printmaking. Prefers figurative, abstract, landscape. Editions created by collaborating with the artist. Approached by 300 artists/year. Promotes the work of 1 emerging, 1 mid-career and 1 established artist/year.
First Contact & Terms: Send query letter with slides and transparencies. Samples are not filed and are returned by SASE. To show a portfolio, send transparencies. Pays flat fee. Offers advance when appropriate. Requires exclusive representation of artist.

N **MUNSON GRAPHICS,** 111 E. Palace Ave., Santa Fe NM 87501. (505)424-4112. Fax: (505)424-6338. Website: http://www.munsongraphics.com. President: Michael Munson. Estab. 1997. Poster company, art publisher and distributor. Publishes/distributes limited edition, fine art prints and posters. Clients: galleries, museum shops, gift shops and frame shops.
Needs: Seeking creative art for the serious collector and commercial market. Considers oil, acrylic, watercolor and pastel. Artists represented include O'Keeffe, Baumann, Nieto, Abeyta. Editions created by working from an existing painting. Approached by 75 artists/year. Publishes work of 3-5 emerging, 3-5 mid-career and 3-5 established artists/year. Distributes the work of 5-10 emerging, 5-10 mid-career and 5-10 established artists/year.
First Contact & Terms: Send query letter with slides and transparencies. Samples are not filed and are returned. Reports back within 1 month. Company will contact artist for portfolio review if interested. Negotiates payment. Offers advance. Rights purchased vary according to project. Provides written contract. Finds artists through art exhibitions, art fairs, word of mouth and artists' submissions.

MUSEUM EDITIONS WEST, 4130 Del Rey Ave., Marina Del Rey CA 90292. (310)822-2558. Fax: (310)822-3508. E-mail: jordanarts@aol.com. Director: Grace Yee. Poster company, distributor, gallery. Distributes unlimited editions, canvas transfers, posters. Clients: galleries, decorators, frame shops, distributors, architects, corporate curators, museum shops, giftshops. Current clients include: San Francisco Modern Art Museum and The National Gallery, etc.
Needs: Seeking creative, fashionable art for the commercial and designer markets. Considers oil, acrylic, watercolor, pastel. Prefers landscape, floral, abstract. Artists represented include John Botzy and Carson Gladson. Editions created by working from an existing painting. Approached by 150 artists/year. Publishes/distributes the work of 5 mid-career and 20 established artists/year. Also needs freelancers for design.
First Contact & Terms: Send query letter with brochure, photocopies, photographs, résumé, SASE, slides, tearsheets, transparencies. Samples are not filed and are returned by SASE. Reports back within 3 months. Company will contact artist for portfolio review of photographs, slides, tearsheets and transparencies if interested. Pays royalties of 8-10%. Offers advance when appropriate. Rights purchased vary according to project. Provides advertising, insurance while work is at firm, promotion, shipping from firm, written contract. Finds artists through art exhibitions, art fairs, word of mouth, submissions.
Tips: "Look at our existing catalog for samples."

NATIONAL WILDLIFE GALLERIES/artfinders.com, 11000-33 Metro Parkway, Fort Myers FL 33912. (941)939-2425, (800)382-5278. Fax (941)936-2788. E-mail: art@artlithos.com. Website: http://www.artlithos.com and www.artfinders.com. Contact: David H. Boshart. Publisher/distributor of wildlife art
• This publisher also owns National Art Publishing Corp. but the two are separate entities. National Wildlife Galleries was established in 1990, when National Art Publishing Corp. acquired Peterson Prints.

Needs: Seeking paintings, graphics, posters for the fine art and commercial markets. Specializes in wildlife art. Artists represented include Larry Barton, Bill Burkett and Guy Coheleach.
First Contact & Terms: Send query letter, slides and SASE. Publisher will contact for portfolio review if interested.

NEW YORK GRAPHIC SOCIETY, P.O. Box 1469, Greenwich CT 06836-1469. (203)661-2400. President: Richard Fleischmann. Vice President: Owen Hickey. Estab. 1925. Publisher of offset reproductions, posters. Clients: galleries, frame shops and museums shops. Current clients include Deck The Walls, Ben Franklin, Prints Plus.
Needs: Considers oil, acrylic, pastel, watercolor, mixed media and colored pencil drawings. Publishes reproductions, posters. Publishes and distributes the work of numerous emerging artists/year. Art guidelines free with SASE. Response to submissions in 90 days.
First Contact & Terms: Send query letter with transparencies or photographs. All submissions returned to artists by SASE after review. Pays flat fee or royalty. Offers advance. Buys all print reproduction rights. Provides in-transit insurance from firm to artist, insurance while work is at firm, promotion, shipping from firm and a written contract; provides insurance for art if requested. Finds artists through submissions/self promotions, magazines, visiting art galleries, art fairs and shows.
Tips: "We publish a broad variety of styles and themes. We actively seek all sorts of fine decorative art."

NOTTINGHAM FINE ART, 73 Gebig Rd., W. Nottingham NH 03291-0073. Phone/fax: (603)942-7089. President: Robert R. Lemelin. Estab. 1992. Art publisher, distributor. Publishes/distributes handpulled originals, limited editions, fine art prints, monoprints, monotypes, offset and digital reproductions. Clients: galleries, frame shops, architects.
Needs: Seeking creative, fashionable, decorative art for the serious collector. Considers oil, acrylic, watercolor, mixed media, pastel. Prefers sporting, landscape, floral, creative, musical and lifestyle themes. Artists represented include Edward Gordon, Roger Blum, Barbie Tidwell, Judith Hall, Christina Martuccelli, Monique Parry, Ronald Parry, Arthur Miller and Kathleen Cantin. Editions created by collaborating with the artist or by working from an existing painting. Approached by 10 artists/year.
First Contact & Terms: Send query letter with brochure, photographs, slides. Samples are filed or returned by SASE. Reports back within 2 months. Company will contact artist for portfolio review of color photographs, slides and transparencies if interested. Pays in royalties. Rights purchased vary according to project. Requires exclusive representation of artist. Provides advertising, insurance while work is at firm, promotion, shipping from firm, written contract. Finds artists through art fairs, submissions and referrals from existing customers.
Tips: "If you don't have a marketing plan developed or $5,000 you don't need, don't self-publish. We look for artists with consistent quality and a feeling to their work."

NOUVELLES IMAGES INC., 860 Canal St., Stamford CT 06902. (203)969-0509. Fax: (203)969-0889. E-mail: nouvelles.images@snet.net. Website: http://www.nouvellesimages.com. Director: E. Nicholas Boulard. Estab. 1987. Publishes open edition, fine art prints and posters. Also publishes greeting cards, note cards, postcards and calendars. Clients: galleries, decorators, frame shops, etc. Current clients include all the 12,000 framers in the U.S.
Needs: Seeking creative and decorative art for the commercial and designer markets. Considers oil. Prefers classic to contemporary. Art guidelines free for SASE with first-class postage. Artists represented include Haring, Hopper, Kandinsky, Matisse, Dufy, Klee and Feininger. Edition created by collaborating with the artist or by working from an existing artwork. Approached by 50 artists/year. Publishes the work of 12 emerging and a few established artists/year. Also needs freelancers for design
First Contact & Terms: Send query letter with photographs, résumé, slides and transparencies. Samples are returned when requested. Company will contact artist for portfolio review of b&w and color if interested. Pays royalties. Offers advance when appropriate. Rights purchased vary according to project. Provides advertising, promotion and written contract. Finds artists through connections, research and artists' circles.
Tips: "Please do not send anything that is original or irreplaceable, and please include a self-addressed envelope for all material that you would like to have returned you."

☑ **NOVA MEDIA INC.**, 1724 N. State, Big Rapids MI 49307. Phone/fax: (616)796-4637. E-mail: trund@nov.com. Website: http://www.nov.com. Editor: Tom Rundquist. Estab. 1981. Poster company, art publisher, distributor. Publishes/distributes limited editions, unlimited editions, fine art prints, posters. Current clients: various galleries.
Needs: Seeking creative art for the serious collector. Considers oil, acrylic. Prefers expressionism, impressionism, abstract. Editions created by collaborating with the artist or by working from an existing painting. Approached by 14 artists/year. Publishes/distributes the work of 2 emerging, 2 mid-career and 1 established artists/year. Also needs freelancers for design. Prefers local designers.
First Contact & Terms: Send query letter with photographs, résumé, SASE, slides, tearsheets. Samples are returned by SASE. Reports back within 2 weeks. Request portfolio review in original query. Company will contact artist for portfolio review of color photographs, slides, tearsheets if interested. Pays royalties of 10% or negotiates payment. No advance. Rights purchased vary according to project. Provides promotion.
Tips: Predicts colors will be brighter in the industry.

☑ **OAK TREE ART AGENCY**, Division of Cupps of Chicago Inc., P.O. Box 1180, Dewey AZ 86327. (520)771-2577. Fax: (520)771-9977. Manager: William F. Cupp. Estab. 1989. Art publisher, distributor. Publishes/distributes

limited editions, unlimited editions, canvas transfers, offset reproductions, licensing around the world. Clients: galleries, frame shops, distributors.

Needs: Seeking creative, decorative art for the commercial and designer markets. Considers oil, acrylic, mixed media. Interested in ethnic art. Artists represented include Jorge Tarallo Braun. Editions created by working from an existing painting.

First Contact & Terms: Send brochure, photographs, SASE, slides. "Must have SASE or will not return." Reports back only if interested. Company will contact artist for portfolio review of transparencies if interested. Pays flat fee. No advance. Rights purchased vary according to project. Provides advertising, insurance while work is at firm, shipping from firm.

✓ **OLD GRANGE GRAPHICS**, 40 Scitico Rd., Somersville CT 06072. (800)282-7776. Fax: (800)437-3329. E-mail: ogg@denunzio.com. President: Art Ernst. Estab. 1976. Distributor/canvas transfer studio. Publishes/distributes canvas transfers, posters. Clients: galleries, frame shops, museum shops, publishers, artists.

Needs: Seeking decorative art for the commercial and designer markets. Considers lithographs. Prefers prints of artworks that were originally oil paintings. Editions created by working from an existing painting. Approached by 100 artists/year.

First Contact & Terms: Send query letter with brochure. Samples are not filed and are returned. Reports back within 1 month. Will contact artist for portfolio review of tearsheets if interested. Negotiates payment. Rights purchased vary according to project. Provides promotion and shipping from firm. Finds artists through art publications.

Tips: Recommends Galeria, Artorama and ArtExpo shows in New York and *Decor, Art Trends, Art Business News* and *Picture Framing* as tools for learning the current market.

✓ **OLD WORLD PRINTS, LTD.**, 2601 Floyd Ave., Richmond VA 23220-4305. (804)213-0600. Fax: (804)213-0700. E-mail: owprints@erols.com. President: John Wurdeman. Estab. 1973. Art publisher and distributor of primarily open edition hand printed reproductions of antique engravings and all subject matter of color printed art. Clients: retail galleries, frame shops and manufacturers.

 • Old World Prints reports the top-selling art in their 2,500-piece collection includes botanical and decorative prints.

Needs: Seeking traditional and decorative art for the commercial and designer markets. Specializes in handpainted prints. Considers "b&w (pen & ink or engraved) art which can stand by itself or be hand painted by our artists or originating artist." Prefers traditional, representational, decorative work. Editions created by collaborating with the artist. Distributes the work of more than 1,000 artists.

First Contact & Terms: Send query letter with brochure showing art style or résumé and tearsheets and slides. Samples are filed. Reports back within 6 weeks. Write for appointment to show portfolio of photographs, slides and transparencies. Pays flat fee of $100/piece and royalties of 10% of profit. Offers an advance when appropriate. Negotiates rights purchased. Provides in-transit insurance, insurance while work is at firm, promotion, shipping from firm and a written contract. Finds artists through word of mouth.

Tips: "We are a specialty art publisher, the largest of our kind in the world. We reproduce only black & white engraving, pen & ink and b&w photogravures. All of our pieces are handpainted."

OPUS ONE PUBLISHING, P.O. Box 1469, Greenwich CT 06836-1469. (203)661-2400. Fax: (203)661-2480. Publishing Director: James Munro. Estab. 1970. Art Publisher. Publishes open editions, offset reproductions, posters.

 • Opus One was formerly a part of Scandecor. It is now a division of New York Graphic Society Publishing Group.

Needs: Seeking creative, fashionable and decorative art for the commercial and designer markets. Considers all media. Art guidelines free for SASE with first-class postage. Artists represented include Kate Frieman, Jack Roberts, Jean Richardson, Richard Franklin, Lee White. Approached by 100 artists/year. Publishes the work of 20% emerging, 20% mid-career and 60% established artists.

First Contact & Terms: Send brochure, tearsheets, slides, photographs, photocopies, transparencies. Samples are not filed and are returned. Reports back within 1 month. Artist should follow up with call after initial query. Portfolio should include final art, slides, transparencies. Negotiates payment. Offers advance when appropriate. Rights purchased vary according to project.

Tips: "Please attend the Art Expo New York City trade show."

Ⓝ **PALATINO EDITIONS/CALDWELL SNYDER GALLERY**, 228 Grant Ave., 5th Floor, San Francisco CA 94108. Fax: (415)392-4609. Contact: Acquisitions Director. Estab. 1983. Art publisher of handpulled originals, limited editions, fine art prints, monoprints, monotypes, posters and originals. Clients: galleries, decorators, frame shops and corporate curators.

Needs: Seeking decorative art for serious collectors and the commercial market; original, interesting art for art galleries. Considers oil, acrylic, watercolor and mixed media. Prefers landscapes, figuratives, some abstract and realism. Artists represented include Thomas Pradzynski, Manel Anoro and Regina Saura. Editions created by collaborating with the artist and by working from an existing painting. Approached by 500-2,500 artists/year. Publishes/distributes the work of 1 emerging artist and 2 mid-career artists/year.

First Contact & Terms: Send query letter with brochure, photographs, résumé, slides, transparencies, tearsheets and SASE; send only visual material including exhibition catalog. Samples are not filed and are returned by SASE. Reports

back within 3-4 weeks. Company will contact artist for portfolio review of final art if interested. Payment to be determined. Rights purchased vary according to project. Requires exclusive representation of artist. Provides advertising, in-transit insurance/return, insurance while work is at firm, promotion, shipping from our firm, written contract and marketing and public relations efforts, established gallery network for distribution. Finds artists through art exhibitions, art fairs, word of mouth, art reps, sourcebooks, artists' submissions and watching art competitions.

Tips: "We prefer to set trends. We are looking for innovation and original thought and aesthetic. Know your market and be familiar with printing techniques and what works best for your work."

☑ **PALM DESERT ART PUBLISHERS**, 74-350 Allessandro Dr., Suite A-Z, Palm Desert CA 92260. (888)360-9046. Fax: (760)346-2470. President: Hugh Pike. Marketing Director: Sandy Mitchell. Estab. 1996. Art Publisher. Publishes handpulled originals and limited edition fine art prints. Clients: galleries, art dealers, designers, frame shops, art consultants.

● Palm Desert Art Inc. owns and operates retail art galleries, frame shops, a fine art publishing division and an open edition publishing division selling framed art to gift market and furniture stores.

Needs: Seeking creative, fashionable and decorative art for the commercial and designer markets. Considers oil, acrylic, watercolor, mixed media, pastel, pen & ink and collage. Prefers landscapes, florals, figures, interiors, architecture, contemporary abstract, wildlife. Artists represented include Patricia Nix, Elyse, Sandra Bierman, Christine Comyn, Ali Golkar, Barbara Cleary and Dino Paravano. Editions created by collaborating with the artist and working from an existing painting. Publish or wholesale to retail market.

First Contact & Terms: Send query letter with brochure, photocopies, photographs, résumé, SASE, tearsheets, exhibition list, significant corporate collectors or private collectors. Samples are filed or returned by SASE. Artist should call to set up appointment. Company will arrange for portfolio review if interested. Negotiates payment. Individual compensation packages are developed. Offers advance when appropriate. Negotiates rights purchased. Usually requires exclusive representation of artist unless a previous agreement binds the artist to a limited contract. Provides advertising, in-transit insurance, insurance while work is at firm, promotion, contract and sometimes shipping. Finds artists through art exhibitions, art fairs, word of mouth.

Tips: "Subscribe to 2-3 trade magazines and read them every month. Stay attuned to color trends that emerge first in fashion and home decor. Watch in business reports for popular trends—these dictate imagery. All of these, plus be prolific, consistant and try to develop a business sense when approaching galleries and publishers. Have realistic income expectations. It makes no difference if artist has computer skills—we would rather have an artist who can produce 40 originals a year!! Don't be afraid to self-promote! An artists' enthusiasm and conviction in their work is contagious!— It also makes for great PR material! The World Wide Web can be detrimental to exclusive agreements with retail art galleries in certain geographical areas—But—it's a great promotional tool and info source!"

⧄ PALOMA EDITIONS, 9808 Waples St., San Diego CA 92121-2921. (619)552-0347. Publisher: Kim A. Butler. Art publisher/distributor of limited and unlimited editions, fine art prints, offset reproductions and posters, notecards, greeting cards and tapestries. Specializes in African-American art. Clients include galleries, specialty shops, retail chains, framers, distributors, museum shops.

Needs: Seeking creative and decorative art for the commercial and designer market. Considers all media. Prefers African-American art. Artists represented include Dexter Griffin, Alonzo Saunders, Jerry Logans, Bruni, Evita, Keith Mollett, Charles Bibbs. Editions created by working from existing painting. Approached by hundreds of artists/year. Publishes the work of 4 emerging, 2 mid-career and 3 established artists/year. Distributes the work of 10 emerging, 25 mid-career and 6 established artists/year.

First Contact & Terms: Send query letter with brochure, photocopies, photographs, tearsheets and/or transparencies. Samples are returned by SASE, only if requested. Reports back within 2 months, only if interested. Publisher will contact for portfolio review of color final art, photographs, tearsheets and transparencies if interested. Payment negotiable, royalties vary. Offers advance when appropriate. Negotiates rights purchased. Requires exclusive representation of artist. Provides advertising, promotion, shipping and written contract. Also needs designers. Prefers designers who own IBM PCs. Freelance designers should be experienced in QuarkXPress, Photoshop, FreeHand. Finds artists through art shows, magazines and referrals.

Tips: "African-American art is hot! Read the trade magazines and watch the furniture and fashion industry. Keep in mind that your work must appeal to a wide audience. Just because you sold an original to one person doesn't mean 500 other people want to own it. It is helpful if fine artists also have basic design skills so they can present their artwork complete with border treatments."

PANACHE EDITIONS LTD, 234 Dennis Lane, Glencoe IL 60022. (847)835-1574. President: Donna MacLeod. Estab. 1981. Art publisher and distributor of offset reproductions and posters. Clients: galleries, frame shops, domestic and international distributors. Current clients are mostly individual collectors.

Needs: Considers acrylic, pastel, watercolor and mixed media. "Looking for contemporary compositions in soft pastel color palettes; also renderings of children on beach, in park, etc." Artists represented include Bart Forbes, Peter Eastwood and Carolyn Anderson. Prefers individual works of art and unframed series. Publishes and distrubutes work of 1-2 emerging, 2-3 mid-career and 1-2 established artists/year.

First Contact & Terms: Send query letter with brochure showing art style or photographs, photocopies and transparencies. Samples are filed. Reports back only if interested. To show portfolio, mail roughs and final reproduction/product. Pays royalties of 10%. Negotiates rights purchased. Requires exclusive representation of artist. Provides in-transit

insurance, insurance while work is at firm, promotion, shipping to and from firm and written contract.

Tips: "We are looking for artists who have not previously been published [in the poster market] with a strong sense of current color palettes. We want to see a range of style and coloration. Looking for a unique and fine art approach to collegiate type events, i.e., Saturday afternoon football games, Founders Day celebrations, homecomings, etc. We do not want illustrative work but rather an impressionistic style that captures the tradition and heritage of one's university. We are very interested in artists who can render figures."

PARADISE PRINTS, INC., 223 S. Main St., Livingston MT 59047. (406)222-5974. Fax: (406)222-5820. E-mail: paradise@wtp.net. Website: http://www.wildwestart.com. President: David C. Lewis. Distributor/gallery dealing in sales of existing limited edition prints. Licensing: Diana Burton. Licenses wildlife, western, angling, scenic, inspirational art for various media/output ("we have used artwork for CD and cassette covers, booklets and J cards also").

- Also see listing in Galleries. If you self-publish your own prints consider the option of selling them through distributor/galleries, such as this one. Paradise Prints inhabits a 3,200 sq. ft. facility on main street in downtown Livingston. The gallery employs a sales force of six full-time and two part-time sales persons. They also sell prints through their website. According to the company's president, gross sales in 1997 topped one-half million.

Needs: Considers all types of prints to sell in gallery and through www. Prefers framed limited edition prints of realistic portrayals of scenic sites throughout the US and the world, especially National Parks, waterfalls, wildlife, angling, scenic, Americana, inspirational, religious, angel, New Age, classical, baroque art—preferably oil, acrylic and photography. No modern art, psychedelic art or nudism.

First Contact & Terms: Send clear slides of published prints. Negotiates payment. 25% of consignment in most cases, includes gallery, internet sales, prints and T-shirts.

Tips: "For our market, realism is the key, as well as intense detail work. We also provide internet artist services for $250 setup for web page plus $25 per image and return postage for images."

PENNY LANE PUBLISHING INC., 1791 Dalton Dr., New Carlisle OH 45344. (937)849-1101. Fax: (937)849-9666. Art Coordinator: Theresa Slivinski. Estab. 1993. Art publisher. Publishes limited editions, unlimited editions, offset reproductions. Clients: galleries, frame shops, distributors, decorators.

Needs: Seeking creative, decorative art for the commercial market. Considers oil, acrylic, watercolor, mixed media, pastel. Artists represented include Linda Spivey, Becca Barton, Cindy Sampson, Annie LaPoint, Jon Q. Wright, Jay Zinn. Editions created by collaborating with the artist or working from an existing painting. Approached by 40 artists/year. Publishes the work of 3-4 emerging, 18 mid-career and 18 established artists/year.

First Contact & Terms: Send query letter with brochure, résumé, photographs, slides, tearsheets. Samples are filed or returned by SASE. Reports back within 2 weeks. Company will contact artist for portfolio review of color, final art, photographs, slides, tearsheets if interested. Pays royalties. Buys first rights. Requires exclusive representation of artist. Provides advertising, shipping from firm, promotion, written contract. Finds artists through art exhibitions, art fairs, submissions, decorating magazines.

Tips: Advises artists to be aware of current color trends and work in a series.

☑ **PGM ART WORLD**, 18 Orchard Terrace, Bristol VT 05443. (802)453-3733. Fax: (802)453-6680. Website: http://www.pgm-art-world.de. General Manager: Petra Nihsen. Estab. 1995. (German office established 1969.) International fine art publisher, distributor, gallery. Publishes/distributes limited and unlimited edition, offset reproductions, posters. Clients: world-wide supplier of galleries, framers, distributors, decorators.

- This publisher's main office is in Germany. PGM publishes more than 300 images and distributes more than 6,000 images in Europe and Asia. The company also operates four galleries in Munich. General manager Petra Nihsen requests that artists living in North America send samples to the Bristol Vermont office. Artists resideing outside of North America should send samples to PGM's main office: PGM Artworld, Carl-von-Linde-Str. 33, 85748 Garching, Germany. Phone 011-49-89-3292381. Fax: 011-49-89-3207745. Publishing Manager: Andrea Kuborn.

Needs: Seeking creative, fashionable and decorative art for the commercial and designer markets. Considers oil, acrylic, watercolor, mixed media, pastel, pen & ink. Considers any well accomplished work of any theme or style. Artists represented include Renato Casaro, Diane French-Gaugush Hundertwasser, Fred Hunt, Patricia Nix, Nina Nolte, Roy Schallenberg. Editions created by working from an existing painting. Approached by 100 artists/year. Publishes the work of 25 artists/year.

First Contact & Terms: Send query letter with photographs, résumé, SASE, slides, transparencies. Samples are not filed and are returned by SASE. Reports back within 3 months. Will contact artist for portfolio review if interested. Pays royalties; negotiable. Does not require exclusive representation of artist. Provides advertising, promotion, written contract.

Tips: "Get as much exposure as possible! Advises artists to attend ABC shows, Art Expo and Galeria for exposure. Advises artists to read *Art World News* and *Art Trends*. The world wide web is very important (like a gallery online)."

N T **THE PICTURE CO.**, 497 Edison Court, Unit H, Cordelia CA 94585. (707)863-8334. Fax: (707)864-3830. Poster company, art publisher, distributor, gallery and custom framer. Publishes/distributes limited edition, unlimited edition, canvas transfers, fine art prints, offset reproduction and posters. Clients: galleries, decorators, frame shops and corporations.

Needs: Seeking creative, fashionable and decorative art for the commercial market. Considers oil, acrylic, watercolor,

mixed media, pastel, pen & ink and sculpture. Artists represented include Guan and Kohler. Editions created by collaborating with the artist and by working from an existing painting. Approached by 10 artists/year. Publishes work of 1 emerging, 3 mid-career and 2 established artists/year. Also needs freelancers for design. Prefers local designers only.
First Contact & Terms: Send query letter with brochure, photocopies, photographs, résumé and tearsheets. Samples are filed and not returned. Reports back within 2 weeks only if interested. Company will contact artist for portfolio review if interested. Portfolio should include b&w, color, final art, photostats, photographs and tearsheets. Pays on consignment basis: firm receives 40% commission. No advance. Buys first rights. Provides advertising, promotion and framing. Finds artists through art fairs.

 PORTER DESIGN—EDITIONS PORTER, The Old Estate Yard, Newton St. Loe, Bath, Somerset BA2 9BR, England. (01144)1225-874250. Fax: (01144)1225-874251. US Address: 38 Anacapa St., Santa Barbara CA 93101. (805)568-5433. (805)568-5435. Partners: Henry Porter, Mary Porter. Estab. 1985. Publishes limited and unlimited editions and offset productions and hand-colored reproductions. Clients: international distributors, interior designers and hotel contract art suppliers. Current clients include Devon Editions, Top Art, Harrods and Bruce McGaw.
Needs: Seeking fashionable and decorative art for the designer market. Considers watercolor. Prefers 16th-19th century traditional styles. Artists represented include Alexandra Churchill, Caroline Anderton, Victor Postolle, Joseph Hooker and Adrien Chancel. Editions created by working from an existing painting. Approached by 10 artists/year. Publishes and distributes the work of 10-20 established artists/year.
First Contact & Terms: Send query letter with brochure showing art style or résumé and photographs. Accepts disk submissions compatible with QuarkXPress on Mac. Samples are filed or are returned. Reports back only if interested. To show portfolio, mail photographs. Pays flat fee or royalties. Offers an advance when appropriate. Negotiates rights purchased.

PORTFOLIO GRAPHICS, INC., 4060 S. 500 W., Salt Lake City UT 84123. (801)266-4844. Fax: (801)263-1076. E-mail: info@portfoliographics.com. Website: http://www.portfoliographics.com. Creative Director: Kent Barton. Estab. 1986. Publishes and distributes limited editions, unlimited editions and posters. Clients: galleries, designers, poster distributors (worldwide) and framers. Licensing: All artwork is available for license for large variety of products. Portfolio Graphics works with a large licensing firm who represents all of their imagery.
Needs: Seeking creative, fashionable and decorative art for commercial and designer markets. Considers oil, watercolor, acrylic, pastel, mixed media and photography. Publishes 30-50 new works/year. Art guidelines free for SASE with first-class postage. Artists represented include Dawna Barton, Ovanes Berberian, Del Gish, Michael Coleman and Kent Wallis. Editions created by working from an existing painting or transparency.
First Contact & Terms: Send query letter with résumé, biography, slides and photographs. Accepts disk submissions compatible with Adobe Illustrator and QuarkXPress. Send TIFF (preferred) or EPS files. Samples are not filed. Reports back within months. To show portfolio, mail slides, transparencies and photographs with SASE. Pays $100 advance against royalties of 10%. Buys reprint rights. Provides promotion and a written contract.
Tips: "We are currently adding 50 new images to our binder catalog and we'll continue to add new supplemental pages twice yearly. We find artists through galleries, magazines, art exhibits, submissions. We're looking for a variety of artists and styles/subjects." Advises artists to attend Art Expo New York City and Art Buyer Caravan (at various locations throughout the year).

POSNER FINE ART, 117 Fourth St., Manhattan Beach CA 90266. (310)260-8858. Fax: (310)260-8860. E-mail: posart1@aol.net. Director: Judith Posner. Estab. 1994. Art distributor and gallery. Distributes fine art prints, monoprints, sculpture and paintings. Clients: galleries, frame shops, distributors, architects, corporate curators, museum shops. Current clients include: Arthur Andersen Co.
Needs: Seeking creative art for the serious collector and commercial market. Considers oil, acrylic, watercolor, mixed media, sculpture. Prefers very contemporary style. Artists represented include John Bose, Soja Kim, David Hockney, Robert Indiana. Editions created by collaborating with the artist. Approached by hundreds of artists/year. Distributes the work of 5-10 emerging, 5 mid-career and 200 established artists/year. Art guidelines free for SASE with first-class postage.
First Contact & Terms: Send slides. "Must enclose self-addressed stamped return envelope." Samples are filed or returned. Reports back within a few weeks. Pays on consignment basis: firm receives 50% commission. Buys one-time rights. Provides advertising, promotion, insurance while work is at firm. Finds artists through art fairs, word of mouth, submissions, attending exhibitions, art reps.
Tips: "Know color trends of design market. Look for dealer with same style in gallery."

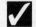

**FOR EXPLANATIONS OF THESE SYMBOLS,
SEE THE INSIDE FRONT AND BACK COVERS OF THIS BOOK.**

POSTER PORTERS, P.O. Box 9241, Seattle WA 98109-9241. (206)286-0818. Fax: (206)286-0820. E-mail: posterport ers@compuserve.com. Marketing Director: Mark Simard. Art publisher/distributor/gift wholesaler. Publishes/distributes limited and unlimited edition, posters and art T-shirts. Clients: galleries, decorators, frame shops, distributors, corporate curators, museum shops, giftshops. Current clients include: Prints Plus, W.H. Smith, Smithsonian, Nordstrom.
Needs: Publishes/distributes creative art for regional commercial and designer markets. Considers oil, watercolor, pastel. Prefers regional, whimsical art. Artists represented include Beth Logani, Carolin Oltman, Jean Castaline, M.J. Johnson. Art guidelines free for SASE with first-class postage. Editions created by collaborating with the artist, working from an existing painting. Approached by 144 artists/year. Publishes the work of 2 emerging, 2 mid-career and 1 established artist/year. or Distributes the work of 50 emerging, 25 mid-career, 20 established artists/year.
First Contact & Terms: Send photocopies, SASE, tearsheets. Accepts disk submissions. Samples are filed or returned by SASE. Will contact artist for Friday portfolio drop off. Pays flat fee: $225-500; royalties of 5%. Offers advance when appropriate. Buys all rights. Provides advertising, promotion, contract. Also works with freelance designers. Prefers local designers only. Finds artists through exhibition, art fairs, through art reps, submissions.
Tips: "Be aware of what is going on in the interior design sector. Be able to take criticism. Be more flexible."

POSTERS INTERNATIONAL, 1200 Castlefield Ave., Toronto, Ontario M6B 1G2 Canada. (416)789-7156. Fax: (416)789-7159. E-mail: info@postersintl.com. Website: http://www.postersintl.com/~posters. President: Esther Cohen. Licensing: Richie Cohen. Estab. 1976. Poster company, art publisher. Publishes fine art posters. Licenses any kind of painting or photography for notecards, wrapping paper and gift bags. Clients: galleries, decorators, distributors, hotels, restaurants etc., in U.S., Canada and International. Current clients include: Holiday Inn and Bank of Nova Scotia.
Needs: Seeking creative, fashionable art for the commercial market. Considers oil, acrylic, watercolor, mixed media, b&w and color photography. Prefers landscapes, florals, collage, architecturals, classical (no figurative). Artists represented include Elizabeth Berry, Catherine Hobart, Fenwick Bonnell, Julie McCarroll. Editions created by collaborating with the artist or by working from an existing painting. Approached by 100 artists/year. Art guidelines free for SASE with first-class postage or IRC.
First Contact & Terms: Send query letter with brochure, photographs, slides, transparencies. Samples are filed or returned by SASE. Reports back within 1-2 months. Company will contact artist for portfolio review of photographs, photostats, slides, tearsheets, thumbnails, transparencies if interested. Pays flat fee or royalties of 10%. Offers advance when appropriate. Rights purchased vary according to project. Requires exclusive representation of artist for posters. Provides advertising, promotion, shipping from firm, written contract. Finds artists through art fairs, art reps, submissions.
Tips: "Be aware of current color trends—work in a series (of two). Visit poster shops to see what's popular before submitting artwork."

THE PRESS CHAPEAU, Govans Station, Box 4591, Baltimore City MD 21212-4591. Director: Elspeth Lightfoot. Estab. 1976. Publishes original prints only, "in our own atelier or from printmaker." Clients: architects, interior designers, corporations, institutions and galleries.
Needs: Considers original handpulled etchings, lithographs, woodcuts and serigraphs. Prefers professional, highest museum-quality work in any style or theme. "Suites of prints are also viewed with enthusiasm." Prefers unframed series. Also needs sculpture. Art guidelines for SASE with first-class postage.
First Contact & Terms: Send query letter with slides. Samples not filed are returned by SASE. Reports back within 5 days. Write for appointment to show portfolio of slides. Payment method is negotiated. Offers advance. Purchases 51% of edition or right of first refusal. Does not require exclusive representation. Provides insurance, promotion, shipping to and from firm and a written contract. Finds artists through agents.
Tips: "Our clients are interested in investment quality original handpulled prints. Your résumé is not as important as the quality and craftsmanship of your work."

PRESTIGE ART INC., 3909 W. Howard St., Skokie IL 60076. (847)679-2555. E-mail: prestige@prestigeart.com. Website: http://www.prestigeart.com. President: Louis Schutz. Estab. 1960. Publisher/distributor/art gallery. Represents a combination of 18th and 19th century work and contemporary material. Publishes and distributes handpulled originals, limited and unlimited editions, canvas transfers, fine art prints, offset reproductions, posters, sculpture. Licenses artwork for note cards, puzzles, album covers and posters. Clients: galleries, decorators, architects, corporate curators.
 • Company president Louis Shutz now does consultation to new artists on publishing and licensing their art in various mediums.
Needs: Seeking creative and decorative art. Considers oil, acrylic, mixed media, sculpture, glass. Prefers figurative art, impressionism, surrealism/fantasy, photo realism. Artists represented include Jean-Paul Avisse. Editions created by collaborating with the artist or by working from an existing painting. Approached by 15 artists/year. Publishes the work of 2 emerging and 2 established artists/year. Distributes the work of 5 emerging and 100 established artists/year.
First Contact & Terms: Send query letter with résumé and tearsheets, photostats, slides, photographs and transparencies. Accepts IBM compatible disk submissions. Samples are not filed and are returned by SASE. Reports back only if interested. Company will contact artist for portfolio review of tearsheets if interested. Pays flat fee. Offers an advance when appropriate. Rights purchased vary according to project. Provides insurance in-transit and while work is at firm, advertising, promotion, shipping from firm and written contract.
Tips: "Be professional. People are seeking better quality, lower-sized editions, less numbers per edition—1/100 instead of 1/750."

PRIME ART PRODUCTS, 5772 N. Ocean Shore Blvd., Palm Coast FL 32137. (904)445-3851. Fax: (904)445-6057. Owner: Dee Abraham. Estab. 1990. Art publisher, distributor. Publishes/distributes limited editions, unlimited editions, fine art prints, offset reproductions. Clients include: galleries, specialty giftshops, interior design and home accessory stores.

Needs: Seeking art for the commercial and designer markets. Considers oil, acrylic, watercolor. Prefers realistic wildlife, magnolias and shore birds. Artists represented include Robert Binks, James Harris, Keith Martin Johns, Christi Mathews, Art LaMay and Barbara Klein Craig. Editions created by collaborating with the artist or by working from an existing painting. Approached by 30 artists/year. Publishes the work of 1-2 emerging artists/year. Distributes the work of many emerging and 4 established artists/year.

First Contact & Terms: Send photographs, SASE and tearsheets. Samples are filed or returned by SASE. Reports back within 5 days. Company will contact artist for portfolio review if interested. Negotiates payment per signature. Offers advance when appropriate. Rights purchased vary according to project. Finds artists through submissions and small art shows.

☑ **PROGRESSIVE EDITIONS**, 37 Sherbourne St., Toronto, Ontario M5A 2P6 Canada. (416)860-0983. Fax: (416)367-2724. E-mail: peart@interlog.com. Website: http://www.progressiveeditions.com. President: Mike Havers. Estab. 1982. Art publisher. Publishes handpulled originals, limited edition fine art prints and monoprints. Clients: galleries, decorators, frame shops, distributors.

Needs: Seeking creative and decorative art for the serious collector and designer market. Considers oil, acrylic, watercolor, mixed media, pastel. Prefers figurative, abstract, landscape and still lifes. Artists represented include Eric Waugh, Issa Shojaei, Doug Edwards, Marsha Hammel. Editions created by working from an existing painting. Approached by 100 artists/year. Publishes the work of 4 emerging, 10 mid-career, 10 established artists/year. Distributes the work of 10 emerging, 20 mid-career, 20 established artists/year.

First Contact & Terms: Send query letter with photographs, slides. Samples are not filed and are returned. Reports back within 1 month. Will contact artist for portfolio review if interested. Negotiates payment. Offers advance when appropriate. Negotiates rights purchased. Requires exclusive representation of artist. Provides advertising, in-transit insurance, insurance while work is at firm, promotion, shipping and contract. Finds artists through exhibition, art fairs, word of mouth, art reps, sourcebooks, submissions, competitions.

Tips: "Develop organizational skills."

RIGHTS INTERNATIONAL GROUP, 463 First St., #3C, Hoboken NJ 07030. (201)963-3123. Fax: (201)420-0679. E-mail: hazaga@aol.com. Contact: Robert Hazaga. Estab. 1996. Agency for cross licensing. Represents artists for licensing into publishing, stationery, giftware, home furnishing. Clients: galleries, decorators, frame shops, distributors, giftware manufacture, stationery, poster, limited editions publishers, home furnishing manufacturers. Clients include: Scandecor, Nobleworks, Studio Oz, New York Graphic Society, Editions Ltd.

• This company is also listed in the Greeting Card, Gifts & Products section.

Needs: Seeking creative, decorative art for the commercial and designer markets. Also looking for textile art. Considers oil, acrylic, watercolor, mixed media, pastel. Prefers commercial style. Artists represented include Gillian Campbell, Camille Pzrewodek, Possi, Planet Art Group, Warabe Aska. Approached by 50 artists/year.

First Contact & Terms: Send brochure, photocopies, photographs, SASE, slides, tearsheets, transparencies. Accepts disk submissions compatible with Adobe Illustrator. Samples are not filed and are returned by SASE. Reports back within 2 months. Company will contact artist for portfolio review if interested. Negotiates payment.

RINEHART FINE ARTS, INC., 250 W. 57th St., Suite 1716, New York, NY 10107. (212)399-8958. Fax: (212)399-8964. E-mail: rinepit@aol.com. Website: http://www.rinehartfinearts.com. Poster publisher. President: Harriet Rinehart. Licenses 2D artwork for posters. Clients include galleries, decorators, frame shops, corporate curators, museum shops, gift shops and substantial overseas distribution.

• This publisher represents established artists such as Howard Behrens, Linnea Pergola, Victo Shvaiko, Sally Caldwell Fisher and Thomas McKnight.

Needs: Seeking creative, fashionable and decorative art. Considers oil, acrylic, watercolor, mixed media, pastel and pen & ink. Artists represented include Howard Behren, Thomas McKnight, Tadashi Asoma, André Bourrié. Editions created by collaborating with the artist or working from an existing painting. Approached by 30-40 artists/year. Publishes the work of 2 emerging, 2 mid-career, 2 established artists/year.

First Contact & Terms: Send query letter with photographs, SASE, slides, tearsheets, transparencies or "whatever the artist has which represents artist." Samples are not filed. "Reviews within 90 days and returned." Reports back within 3 months. Portfolio review not required. Pays royalties of 8-10%. Offers advance. Rights purchased vary according to project. Provides advertising, promotion, written contract and substantial overseas exposure.

Tips: "Read *Home Furnishings News*. Work in a series. Attend trade shows."

🌐 ☑ **FELIX ROSENSTIEL'S WIDOW & SON LTD.**, 33-35 Markham St., London SW3 3NR England. (44)171-352-3551. Fax: (44)171-351-5300. Contact: Mrs. Lucy McDowell. Licensing: Miss Justine Egan. Estab. 1880. Publishes handpulled originals, limited edition, canvas transfers, fine art prints and offset reproductions. Licenses all subjects on any quality product.

Needs: Seeking decorative art for the serious collector and the commercial market. Considers oil, acrylic, watercolor, mixed media and pastel. Prefers art suitable for homes or offices. Artists represented include Spencer Hodge, Claire

ROBERT MAGAW · THE GATES OF DAWN

©1996 Robert Magaw

Robert Magaw's piece *Gates of Dawn* is one of a number of the artist's paintings carried by Rinehart Fine Arts, Inc. "I chose the piece because my instinct told me it felt right," says Harriet Rinehart of Rinehart Fine Arts. "The artist submitted slides, we got to know each other over several months, he did several additional paintings based on what I liked and didn't like. I picked *Gates of Dawn* from about six similar paintings."

Burton, Ray Campbell and Richard Aykerman. Editions created by collaborating with the artist or by working from an existing painting. Approached by 200-500 artists/year.
First Contact & Terms: Send query letter with photographs. Samples are not filed and are returned by SAE. Reports back within 2 weeks. Company will contact artist for portfolio review of final art and transparencies if interested. Negotiates payment. Offers advance when appropriate. Rights purchased vary according to project.

SAGEBRUSH FINE ART, 285 West 2855, South, Salt Lake City UT 84115. (801)466-5136. Fax: (801)466-5048. Art Review Coordinator: Robyn Marshall. Estab. 1991. Art publisher. Publishes fine art prints and offset reproductions. Clients: frame shops, distributors, corporate curators and chain stores.
Needs: Seeking decorative art for the commercial and designer markets. Considers oil, acrylic, watercolor and photography. Prefers traditional themes and styles. Editions created by collaborating with the artist or by working from an existing painting. Approached by 200 artists/year. Publishes the work of 20 emerging artists/year.
First Contact & Terms: Send SASE, slides and transparencies. Samples are not filed and are returned by SASE. Reports back within 3 weeks. Company will contact artist for portfolio review if interested. Pays royalties of 10% or negotiates payment. Offers advance when appropriate. Rights purchased vary according to project. Provides advertising, promotion, shipping from firm and written contract.

ST. ARGOS CO., INC., 11040 W. Hondo Pkwy., Temple City CA 91780. (626)448-8886. Fax: (626)579-9133. Manager: Paul Liang. Estab. 1987. Produces Christmas decorations, including ornaments; also giftwrap, boxes, bags, cards and puzzles.
Needs: Approached by 3 artists/year. Works with 2 freelance artists/year. Prefers artists with experience in Victorian or country style. Uses freelance artists mainly for design. Submit seasonal material 6 months in advance.
First Contact & Terms: Send query letter with résumé and slides. Samples are filed. Will contact artist for portfolio review if interested. Portfolio should include color samples. Pays royalties of 7.5%. Negotiates rights purchased.

☑ **SCAFA ART PUBLISHING CO. INC.**, (formerly Scafa-Tornabene Art Publishing Co. Inc.), 276 Fifth Ave., Suite 205, New York NY 10001. (212)779-0700, ext. 256. Fax: (212)779-3135. Art Coordinator and licensing: Elaine Citron. Produces unlimited edition offset reproductions. Clients: framers, commercial art trade and manufacturers worldwide. Licenses florals, still lifes, landscapes, animals, religious, etc. for placemats, puzzles, textiles, furniture, cassette/CD covers.

Needs: Seeking decorative art for the wall decor market. Considers unframed decorative paintings, posters, photos and drawings. Prefers pairs and series. Artists represented include T.C. Chiu, Jack Sorenson, Kay Lamb Shannon and Marianne Caroselli. Editions created by collaborating with the artist and by working from a pre-determined subject. Approached by 100 artists/year. Publishes and distributes the work of dozens of artists/year. "We work constantly with our established artists, but are always on the lookout for something new."

First Contact & Terms: Send query letter first with slides or photos and SASE. Reports in about 3-4 weeks. Pays $200-350 flat fee for some accepted pieces. Royalty arrangements with advance against 5-10% royalty is standard. Buys only reproduction rights. Provides written contract. Artist maintains ownership of original art. Requires exclusive publication rights to all accepted work.

Tips: "Do not limit your submission. We are interested in seeing your full potential. Please be patient. All inquiries will be answered."

☒ **SCHIFTAN INC.**, 1300 Steel Rd. W, Suite 4, Morrisville PA 19067. (215)428-2900 or (800)255-5004. Fax: (215)295-2345. President: Harvey S. Cohen. Estab. 1903. Art publisher, distributor. Publishes/distributes unlimited editions, fine art prints, offset reproductions, posters and hand-colored prints. Clients: galleries, decorators, frame shops, architects, wholesale framers to the furniture industry.

Needs: Seeking fashionable, decorative art for the commercial market. Considers watercolor, mixed media. Prefers traditional, landscapes, botanicals, wild life, Victorian. Editions created by collaborating with the artist. Approached by 15-20 artists/year. Also needs freelancers for design.

First Contact & Terms: Send query letter with transparencies. Samples are not filed and are returned. Reports back within 1 week. Company will contact artist for portfolio review of final art, roughs, transparencies if interested. Pays flat fee or royalties. Offers advance when appropriate. Negotiates rights purchased. Provides advertising, written contract. Finds artists through art exhibitions, art fairs, submissions.

SCHLUMBERGER GALLERY, P.O. Box 2864, Santa Rosa CA 95405. (707)544-8356. Fax: (707)538-1953. Owner: Sande Schlumberger. Estab. 1986. Art publisher, distributor and gallery. Publishes and distributes limited editions, posters, original paintings and sculpture. Clients: collectors, designers, distributors, museums, galleries, film and television set designers. Current clients include: Bank of America Collection, Fairmont Hotel, Editions Ltd., Sonoma Cutrer Vineyards, Dr. Robert Jarvis Collection.

Needs: Seeking decorative art for the serious collector and the designer market. Prefers trompe l'oeil, realist, architectural, figure, portrait. Artists represented include Charles Giulioli, Deborah Deichler, Susan Van Camden, Aurore Carnera, Borislav Satijnac, Robert Hughes, Fletcher Smith. Editions created by collaborating with the artist or by working from an existing painting. Approached by 50 artists/year.

First Contact & Terms: Send query letter with tearsheets and photographs. Samples are not filed and are returned by SASE if requested by artist. Publisher/Distributor will contact artist for portfolio review if interested. Portfolio should include color photographs and transparencies. Negotiates payment. Offers advance when appropriate. Rights purchased vary according to project. Provides advertising, in-transit insurance, insurance while work is at firm, promotion, shipping to and from firm, written contract and shows. Finds artists through exhibits, referrals, submissions and "pure blind luck."

Tips: "Strive for quality, clarity, clean lines and light even if the style is impressionistic. Bring spirit into your images. It translates!"

☑ **SEGAL FINE ART**, 4760 Walnut St., #100, Boulder CO 80301. (800)999-1297. (303)939-8930. Fax: (303)939-8969. E-mail: sfineart@aol.com. Artist Liason: Amanda Vanderbrook. Estab. 1986. Art publisher. Publishes limited editions. Clients: galleries.

Needs: Seeking creative and fashionable art for the serious collector and commercial market. Considers oil, watercolor, mixed media and pastel. Artists represented include Lu Hong, Sassone, Scott Jacobs and Ting Shao Kuang. Editions created by working from an existing painting. Publishes limited edition serigraphs, mixed media pieces and posters. Publishes and distributes the work of 1 emerging artist/year. Publishes the work of 7 and distributes the work of 3 established artists/year.

First Contact & Terms: Send query letter with slides, résumé and photographs. Samples are not filed and are returned by SASE. Reports back in 2 months. To show portfolio, mail slides, color photographs, bio and résumé. Offers advance when appropriate. Negotiates payment method and rights purchased. Requires exclusive representation of artist. Provides promotion.

Tips: Advises artists to attend New Trends Expos and Art Expo in New York and California or Art Buyers Caravan.

☒ **SIDE ROADS PUBLICATIONS**, 177 NE 39th St., Miami FL 33137. (305)438-8828. Fax: (305)576-0551. E-mail: sideropub@aol.com. Estab. 1998. Art publisher and distributor of handpulled originals and limited editions. Clients: galleries, decorators and frame shops.

Needs: Seeking creative art for the commercial market. Considers oil, acrylic, mixed media and sculpture. Open to all

themes and styles. Artists represented include Clemeus Briels. Editions created by working from an existing painting. Also needs freelancers for design.

First Contact & Terms: Send query letter with brochure, photographs, résumé, slides and SASE. Samples are filed or returned by SASE. Company will contact artist for portfolio review if interested. Payment on consignment basis. Rights purchased vary according to project. Requires exclusive representation of artist. Provides advertising and promotion. Finds artists through art exhibitions and artists' submissions.

SIERRA SUN EDITIONS, 5090 Robert J. Mathews Pkwy., Suite 2, El Dorado Hills CA 95762. (916)933-2228. Fax: (916)933-6224. Art Director: Ravel Buckley. Art publisher, distributor. Publishes/distributes handpulled originals, limited editions, unlimited editions, canvas transfers, fine art prints, offset reproductions. Clients: galleries, decorators, frame shops, distributors, architects, corporate curators, museum shops, gift-shops, and sports memorabilia and collectibles stores. Current clients include: Sports Legacy, Field of Dreams, Deck the Walls and Sports Forum.

Needs: Seeking creative, fashionable, decorative art for the serious collector, commercial and designer markets. "We publish/distribute primarily professional team sports art—i.e., celebrity athletes of major leagues—National Football League, Major League Baseball. Considers oil, acrylic, watercolor, mixed media, pastel. Artists represented include Daniel M. Smith, Stephen Holland, Vernon Wells, Eric Franchimon. Rick Rush, Ryan Fritz, Samantha Wendell, Terry Crews. Editions created by collaborating with the artist or by working from an existing painting. Approached by 60 artists/year. Publishes the work of 1-2 emerging, 2-3 mid-career and 7 established artists/year. Distributes the work of 3-8 emerging, 3-8 mid-career and 4-8 established artists/year.

First Contact & Terms: Send query letter with brochure, résumé, SASE, slides, tearsheets, photographs. Samples are filed or returned by SASE. Reports back within 1-3 months. Company will contact artist for portfolio review of color, final art, thumbnails, transparencies if interested. Pays royalties of 10-20%; or on a consignment basis: firm receives 20-40% commission for sale of originals. Negotiates payment regarding licensing of works. Offers advance when appropriate. May require exclusive representation of artist. Provides advertising, promotion, shipping from firm, written contract, trade shows, gallery shows. Finds artists through word of mouth, art trade shows, gallery owners.

Tips: "Painting likenesses of celebrity athletes and the human body in action must be accurate if your style is photo real or realism. We seek strong concepts that can continue in repetitive series. Freedom of expression, artistic creativity and painterly techniques are acceptable and sought after in sports art."

SIGNATURE SERIES BY ANGEL GRAPHICS, 903 W. Broadway, P.O. Box 530, Fairfield IA 52556. (515)472-5481. Fax: (515)472-7353. Website: http://www.angelgraphicsinc.com. Project Manager: Julie Greeson. Estab. 1996. Art publisher. Publishes mid to high end open edition art prints in standard sizes between 2×3 and 24×36. Clients include U.S. and international picture framers and galleries.

Needs: Needs all types of currently popular subjects. Art guidelines available for SASE with first-class postage. Best trends include "den art" (golf, sports etc.), Hispanic subjects (churches, slice of life); African-American (especially religious content and leisure); gardens, florals, fruit; whimsical folk art; tropical, nostalgic. Needs high quality, detailed art work, both realistic and stylized. Uses 100-150 new images/year. "We follow trends in the art world."

First Contact & Terms: Send photographs, SASE and duplicate slides. Do not send originals. Pays by the project, $150-600. Competitive pricing and terms.

Tips: "Include expected contract terms in cover letter. Send $3 for current catalog or $10 for catalog and 22×28 print sample."

SJATIN BV, P.O. Box 4028, 5950 AA Belfeld/Holland. 3177 475 1998. Fax: 31774 475 1965. E-mail: art@sjatin.nl. Vice President: Monique van den Hurk. Estab. 1977. Art publisher. Publishes handpulled originals, limited editions, unlimited editions, fine art prints, offset reproductions, greeting cards. Licenses romantic art to appear on placemats, notecards, stationery, photo albums, posters, puzzles and gifts. Clients: furniture stores, department stores. Current clients include: Karstadt (Germany), Morres Meubel-Hulst (Holland), Prints Plus (USA).

● Sjatin actively promotes worldwide distribution for artists they sign.

Needs: Seeking decorative art for the commercial market. Considers oil, acrylic, watercolor, mixed media, pastel. Prefers romantic themes, florals, landscapes/garden scenes, women. Artists represented include Willem Haenraets, Peter Motz, Reint Withaar. Editions created by collaborating with the artist or by working from an existing painting. Approached by 50 artists/year. "We work with 20 artists only, but publish a very wide range from cards to oversized prints and we sell copyrights."

First Contact & Terms: Send brochure and photographs. Reports back only if interested. Company will contact artist for portfolio review of color photographs (slides) if interested. Negotiates payment. Offers advance when appropriate. Buys all rights. Provides advertising, promotion, shipping from firm and written contract (if requested).

Tips: "Follow the trends in interior decoration; look at the furniture and colors. I receive so many artworks that are

MARKET CONDITIONS are constantly changing! If you're still using this book and it is 2001 or later, buy the newest edition of *Artist's & Graphic Designer's Market* at your favorite bookstore or order directly from Writer's Digest Books (1-800-289-0963).

beautiful and very artistic, but are not commercial enough for reproduction. I need designs which appeal to many many people, worldwide such as flowers, gardens, interiors and kitchen scenes. I do not wish to receive graphic art. Artists entering the poster/print field should attend the I.S.F. Show in Birmingham, Great Britain or the ABC show in Atlanta."

SOHO GRAPHIC ARTS WORKSHOP, 433 W. Broadway, Suite 5, New York NY 10012. (212)966-7292. Director: Xavier H. Rivera. Estab. 1977. Art publisher, distributor and gallery. Publishes and distributes limited editions.
Needs: Seeking art for the serious collector. Considers prints. Editions created by collaborating with the artist or working from an existing painting. Approached by 10-15 artists/year.
First Contact & Terms: Send résumé. Reports back within 2 weeks. Artist should follow-up with letter after initial query. Portfolio should include slides and 35mm transparencies. Negotiates payment. No advance. Buys first rights. Provides written contract.

☑ ⊕ **JACQUES SOUSSANA GRAPHICS**, 37 Pierre Koenig St., Jerusalem 91041 Israel. Phone: 972-2-6782678. Fax: 972-2-6782426. E-mail: jsgraphics@hotmail.com. Estab. 1973. Art publisher. Publishes handpulled originals, limited editions, sculpture. Clients: galleries, decorators, frame shops, distributors, architects. Current clients include: Rozembaum Galleries, Royal Beach Hotel, Moriah Gallery.
Needs: Seeking decorative art for the serious collector and designer market. Considers oil, watercolor and sculpture. Artists represented include Calman Shemi. Editions created by collaborating with the artist. Approached by 20 artists/year. Publishes/distributes the work of 5 emerging, 3 mid-career and 2 established artists/year.
First Contact & Terms: Send query letter with brochure, slides. To show portfolio, artist should follow-up with letter after initial query. Portfolio should include color photographs.

SPORT'EN ART, 1015 W. Jackson St., Sullivan IL 61951-1058. (217)728-2361. E-mail: sportart@moultrie.com. Large publisher/distributor of limited edition prints and posters featuring sports images. Contact: Dan Harshman.
Needs: Artists represented include Harry Antis, Carole Bourdo, Roger Cruwys, Louis Frisino, Rob Leslie, Richard Sloan.
First Contact & Terms: Send query letter with slides and SASE. Publisher will contact for portfolio review if interested.

☑ **SPORTS ART INC**, Dept. AM, N. 1675 Powers Lake Rd., Powers Lake WI 53159. (800)552-4430. Fax: (414)279-9831. E-mail: ggg-golfgifts@encnet.net. President: Dean Chudy. Estab. 1989. Art publisher and distributor of limited and unlimited editions, offset reproductions and posters. Clients: over 2,000 active art galleries, frame shops and specialty markets.
Needs: Seeking artwork with creative artistic expression for the serious collector and the designer market. Considers oil, watercolor, acrylic, pastel, pen & ink and mixed media. Prefers sports themes. Artists represented include Ken Call, Anne Peyton, Tom McKinney and Terrence Fogarty. Editions created by collaborating with the artist or working from an existing painting. Approached by 150 artists/year. Publishes the work of 2 emerging and 4 mid-career artists/year. Distributes the work of 30 emerging, 60 mid-career and 30 established artists/year.
First Contact & Terms: Send query letter with brochure showing art style or résumé, tearsheets, SASE, slides and photographs. Accepts submissions on disk. Samples are filed or returned by SASE if requested by artist. To show a portfolio, mail thumbnails, slides and photographs. Pays royalties of 10%. Offers an advance when appropriate. Negotiates rights purchased. Sometimes requires exclusive representation of the artist. Provides promotion and shipping from firm.
Tips: "We are interested in generic sports art that captures the essence of the sport as opposed to specific personalities."

Ⓝ SULIER ART PUBLISHING AND DESIGN RESOURCE NETWORK, 111 Conn Terrace, Lexington KY 40508-3205. (606)259-1688. Fax: (606)252-6858. Estab. 1969. Art Director: Neil Sulier. Art publisher and distributor. Publishes and distributes handpulled originals, limited and unlimited editions, posters, offset reproductions and originals. Clients: designers.
Needs: Seeking creative, fashionable and decorative art for the serious collector and the commercial and designer markets. Considers oil, watercolor, mixed media, pastel and acrylic. Prefers impressionist. Artists represented include Judith Webb, Neil Sulier, Eva Macie, Neil Davidson, William Zappone, Zoltan Szabo, Henry Faulconer, Mariana McDonald. Editions created by collaborating with the artist or by working from an existing painting. Approached by 20 artists/year. Publishes the work of 5 emerging, 30 mid-career and 6 established artists/year. Distributes the work of 5 emerging artists/year.
First Contact & Terms: Send query letter with brochure, slides, photocopies, résumé, photostats, transparencies, tearsheets and photographs. Samples are filed or are returned. Reports back only if interested. Request portfolio review in original query. Artist should follow up with call. Publisher will contact artist for portfolio review if interested. Portfolio should include slides, tearsheets, final art and photographs. Pays royalties of 10%, on consignment basis or negotiates payment. Offers advance when appropriate. Negotiates rights purchased (usually one-time or all rights). Provides in-transit insurance, promotion, shipping to and from firm, insurance while work is at firm and written contract.

SUMMERFIELD EDITIONS, 2019 E. 3300 S., Salt Lake City UT 84109. (801)484-0700. Fax: (801)485-7172. Website: http://www.artsparts.com. Contact: Kelly Omana. Publishes limited editions, fine art prints, posters. Clients: galleries, decorators, frame shops and gift shops.
Needs: Seeking decorative art for the designer market. Considers oil, acrylic, watercolor, mixed media and pastel.

Prefers traditional themes. Artists represented include Karen Christensen, Ann Cowdell and Pat Enk. Editions created by collabortaing with the artist or by working from an existing painting. Approached by 24 artists/year. Samples are not filed and are not returned. Reports back only if interested. Company will contact artists for portfolio review of color sample; "good presentation of work." Negotiates payment. Offers advance when appropriate. Rights purchased vary according to project; prefers all rights. Provides advertising and written contract. Finds artists through art exhibitions, art fairs, word of mouth.

Tips: Sees trend toward "sporting themes without being cute; rich colors. Artwork should come from the heart."

⟨N⟩ SUNSET MARKETING, 5908 Thomas Dr., Panama City Beach FL 32408. (850)233-6261. Fax: (850)233-9169. Website: http://www.sunsetartprints.com. Sales Marketing: Michelle A. Holland. Estab. 1986. Art publisher and distributor of unlimited editions, canvas transfers and fine art prints. Clients: galleries, decorators, frame shops, distributors and corporate curators. Current clients include: Paragon, Propac, Uttermost, Lieberman's and Bruce McGaw.

Needs: Seeking fashionable and decorative art for the commercial and designer market. Considers oil, acrylic, watercolor art and home decor furnishings. Artists represented include Steve Butler, Merri Paltinian, Van Martin and Barbara Shipman. Editions created by collaborating with the artist. Approached by 20-30 artists/year. Publishes the work of 3-5 emerging and 7 established artists/year.

First Contact & Terms: Send query letter with brochure, photocopies and photographs. Samples are filed. Company will contact artist for portfolio review of color final art, roughs and photographs if interested. Requires exclusive representation of artist.

SYRACUSE CULTURAL WORKERS, P.O. Box 6367, Syracuse NY 13217. (315)474-1132. Fax (315)475-1277. E-mail: scw@syrculturalworkers.org. Website: http://www.syrculturalworkers.org. Art Director: Karen Kerney. Produces posters, notecards, postcards, greeting cards, T-shirts and calendars that are feminist, multicultural, lesbian/gay allied, racially inclusive and honor elders and children.

 • See listing in Greeting Cards, Gifts and Products section. This organization has added a new poster size, 12×36, to its line.

Needs: Art guidelines free for SASE with first-class postage and also available on company's website.

First Contact & Terms: Pays flat fee, $85-400; royalties of 6% of gross sales.

✓ JOHN SZOKE EDITIONS, (formerly John Szoke Graphics, Inc.), 164 Mercer St., New York NY 10012. (212)219-8300. Executive Vice President: Tom Beadle. Produces limited edition handpulled originals for galleries, museums and private collectors.

 • In December 1998, this publisher announced a new name and corporate logo to reflect their current strength as a publisher of limited-edition prints. The company has established a separate staff to handle licensing projects and also acquired the license to market limited-edition prints and sculptures created from images of classic Universal Studios films.

Considers: Original artwork for limited-edition prints, mostly in middle price range, by up-and-coming artists. Artists represented include James Rizzi, Jean Richardson, Tadashi Asoma, Amos Yaskil, Scott Sandell, Norman Laliberté and others. Publishes the work of 2 emerging, 10 mid-career and 2 established artists/year. Distributes the work of 10 emerging, 10 mid-career and 5 established artists/year.

First Contact & Terms: Send slides with SASE. Request portfolio review in original query. Reports within 1 week. Charges commission, negotiates royalties or pays flat fee. Provides promotion and written contract.

⟨N⟩ TAHARAA FINE ART, P.O. Box 3171, Kailua-Kona HI 96745. (808)331-0770. Fax: (808)331-0702. Website: http://Taharaafineart.com. Owner: Neil Stein. Estab. 1998. Art publisher of handpulled originals, limited editions and giclees. Clients: all wholesale—galleries, decorators, etc. Current clients include: Pacific Fine Art and Atlantis Gallery & Frames.

Needs: Seeking creative and decorative art for the serious collector and the commercial and designer markets. Considers oil, acrylic, watercolor, mixed media and pastel. "We prefer tropical themes or styles but will accept any wonderful art." Artists represented include Marian Berger and R.G. Finney. Editions created by collaborating with the artist and by working from an existing painting. Approached by 30 artists/year. Publishes 2 established artists/year.

First Contact & Terms: Send query letter with brochure, photographs, résumé, slides and transparencies. Artist should follow up with call after initial query. Samples are filed or returned. Company will contact artist for portfolio review of color photographs if interested. Negotiates payment and rights purchased. Usually requires exclusive representation of artist. Provides advertising, in-transit insurance, insurance while work is at firm, promotion, shipping and written contract.

⟨N⟩ TAKU GRAPHICS, 3291 Douglas Hwy., Juneau AK 99801. (907)586-3291. Fax: (907)586-1240. E-mail: takuart@eagle.ptialaska.net. Website: http://www.takugraphics.com. Owner: Adele Hamey. Estab. 1991. Distributor. Distributes handpulled originals, limited edition, unlimited edition, fine art prints, offset reproduction, posters, hand-painted silk ties, paper cast and bead jewelry. Clients: galleries and gift shops.

Needs: Seeking art from Alaska and the Pacific Northwest exclusively. Considers oil, acrylic, watercolor, mixed media, pastel and pen & ink. Prefers regional styles and themes. Artists represented include JoAnn George, Ann Miletich, Brenda Schwartz and Barry Herem. Editions created by working from an existing painting. Approached by 10-20 artists/year. Distributes the work of 12 emerging, 6 mid-career and 4 established artists/year.

The Alternative Alphabet Poster for Little and Big People

Karen Kerney created *The Alternative Alphabet Poster for Little and Big People* in QuarkXPress for Syracuse Cultural Workers. The piece features "words ranging from basic elements of a child's life to concepts likely to be met with puzzlement, enjoyment or wonder" . . . from Africa and Bicycle to Yoga and Zzzzz. "The artwork is often playful, always vivid and expressive," says a SCW representative. "The richness of the colors is inviting and there is a great deal of thought evident in the details of many of the squares. Overall the poster is beautiful and intriguing."

First Contact & Terms: Send query letter with brochure, photographs and tearsheets. Samples are not filed and are returned. Reports back within 1 month. Company will contact artist for portfolio review if interested. Pays on consignment basis: firm receives 30% commission. No advance. Requires exclusive representation of artist. Provides advertising, insurance while work is at firm, promotion, sales reps, trade shows and mailings. Finds artists through word of mouth.

BRUCE TELEKY INC., 625 Broadway, 4th Floor, New York, NY 10012. (800)835-3539 or (212)677-2559. Fax: (212)677-2253. Publisher/Distributor. President: Bruce Teleky. Clients include galleries, manufacturers and other distributors.
Needs: Works from existing art to create open edition posters or works with artist to create limited editions. Artists represented include Romare Bearden, Faith Ringgold, Joseph Reboli, Barbara Appleyard, Norman Rockwell, Gigi Boldon and Daniel Pollera.
First Contact & Terms: Send query letter with slides, transparencies, postcard or other appropriate samples and SASE. Publisher will contact artist for portfolio review if interested. Payment negotiable.

TOP ART, 9863 Pacific Heights Blvd., San Diego CA 92121. (619)554-0102. Fax: (619)554-0309. President: Keith Circosta. Estab. 1991. Publishes offset reproductions and posters. Clients: galleries, decorators, frame shops, distributors, architects, corporate curators, museum shops, giftshops, national retail chains.
Needs: Seeking decorative art for the commercial and designer markets. Considers oil, acrylic, watercolor, mixed media and pastel. Prefers florals, landscapes, coastals, abstracts and classical styles. Editions created by collaborating with the artist or by working from an existing painting. Approached by 100 artists/year. Publishes the work of 5 emerging, 10 mid-career and 15 established artists/year.
First Contact & Terms: Send photographs, slides, tearsheets and transparencies. Samples are filed. Reports back only if interested in 1 month. Company will contact artist for portfolio review of color, final art, photographs, slides and transparencies if interested. Rights purchased vary according to project. Provides advertising, insurance while work is at firm and promotion.

N TRIAD ART GROUP, 73 Wynnewood Lane, Stamford CT 06903. (203)329-3895. Fax: (203)329-3896. President: Greg Bloch. Art publisher/distributor of handpulled originals, limited editions and sculpture. Clients: galleries.
Needs: Seeking artwork for the serious collector and the commercial market. Considers oil, acrylic, watercolor, mixed media and pastel. Prefers representational themes and styles. Artists represented include Royo and Cartmell. Editions created by collaborating with the artist and by working from an existing painting. Approached by 50 artists/year. Publishes/distributes the work of 1 emerging artist, 1 mid-career artist and 1 established artist/year.
First Contact & Terms: Send query letter with brochure, photographs, slides, transparencies and SASE. Samples are not filed and are returned by SASE. Company will contact artist for portfolio review of photographs and transparencies if interested. Pays royalties or pays on consignment basis. Offers advance when appropriate. Rights purchased vary according to project. Requires exclusive representation of artist. Provides advertising, in-transit insurance, insurance while work is at firm, promotion, shipping and written contract. Finds artists through art exhibitions and fairs, word of mouth, World Wide Web, art reps, sourcebooks and other publications, artists' submissions and watching art competitions.

UMOJA FINE ARTS, 16250 Northland Dr., Suite 104, Southfield MI 48075. (800)469-8701. E-mail: info@umojafinearts.com. Website: http://www.umojafinearts.com. Estab. 1995. Art publisher and distributor specializing in African-American posters, graphics, painting and sculpture. President: Ian Grant.
Needs: Seeking fine art and decorative images and sculpture for the serious collector as well as the commercial market. Artists include Lazarus Bain, Jeff Clark, Joe Dobbins, Marcus Glenn, David Haygood, Annie Lee, Jimi Claybrooks, Joe Dobbins Sr., Ivan Stewart. Editions created by collaborating with the artist. Approached by 40-50 artists/year. Publishes the work of 1-2 emerging, 1-2 mid-career and 1 established artists/year. Distributes the work of 2-3 emerging, 2-3 mid-career and 2 established artists/year.
First Contact & Terms: Send query letter with slides and SASE. Samples are filed. Reports back only if interested in 1 month. Publisher will contact for portfolio review if interested. Buys all rights. Requires exclusive representation of artist. Provides advertising, insurance while work is at firm and written contract.

N UNIVERSAL PUBLISHING, 821 E. Ojai Ave., Ojai CA 93023. (805)640-0057. Fax: (805)640-0059. E-mail: milgallery@aol.com. Vice President: Andrew Wilkey. Estab. 1967. Art publisher and distributor. Publishes/distributes limited edition, unlimited edition, canvas transfers, fine art prints, offset reproduction and posters. Clients: galleries and mail order. Current clients include: The Soldier Factory and Virginia Bader Fine Art.
Needs: Seeking creative, fashionable and decorative art. Considers oil, acrylic, watercolor and pen & ink. Prefers aviation, maritime, landscape and wildlife. Artists represented include Robert Taylor and Nicolas Trudgian. Editions created by collaborating with the artist or by working from an existing painting. Approached by 10 artists/year. Publishes work of 1 emerging, 1 mid-career and 1 established artist/year. Distributes the work of 1 emerging, 1 mid-career and 1 established artist/year.
First Contact & Terms: Send query letter with photographs, slides, tearsheets and transparencies. Samples are not filed and are returned. Reports back within 2 days. Company will contact artist for portfolio review if interested. Portfolio should include photographs, tearsheets and transparencies. Payment negotiable. Buys all rights. Requires exclusive

©JoAnn George

"The Tlingit and Haida indian tribes of the Northwest Coast are made up of many clans," explains JoAnn George. "This painting represents an 'elan mother' who holds the knowledge of her clan—its songs, dances, legends and protocol." George's oil painting titled *Wrapped in Legend*, which she self-published, is distributed by Taku Graphics. To promote her work and the work of their other artists, Taku advertises in *Decor*, does 10-12 mailings a year, and hires sales reps throughout the Pacific Northwest.

representation of artist. Provides advertising, promotion and written contract. Finds artists through word of mouth.
Tips: "Get to know us via our catalogs."

☑ **VARGAS FINE ART PUBLISHING, INC.**, Southgate at Washington Business Park. 9700 M.L. King, Jr. Hwy., Suite D, Lanham MD 20706. (301)731-5175. Fax: (301)731-5712. E-mail: vargasfineart@erols.com. President: Elba Vargas. Estab. 1987. Art publisher and worldwide distributor of serigraphs, limited and open edition offset reproductions, etchings, sculpture, music boxes, keepsake boxes, ceramic art tiles, art magnets, art mugs, collector plates, calendars, canvas transfers and figurines. Clients: galleries, frame shops, museums, decorators, movie sets and TV.
Needs: Seeking creative art for the serious collector and commercial market. Considers oil, watercolor, acrylic, pastel pen & ink and mixed media. Prefers ethnic themes. Artists represented include Joseph Holston, Kenneth Gatewood, Tod Haskin Fredericks, Betty Biggs, Charles Bibbs, Sylvia Walker, Ted Ellis, Leroy Campbell, William Tolliver, Sylvia Walker, Paul Goodnight, Wayne Still and Paul Aiyuzie. Approached by 100 artists/year. Publishes/distributes the work of about 80 artists.
First Contact & Terms: Send query letter with résumé, slides and/or photographs. Samples are filed. Reports back only if interested. To show portfolio, mail photographs. Payment method is negotiated. Requires exclusive representation of the artist.
Tips: "Continue to hone your craft with an eye towards being professional in your industry dealings."

🌐 **VERKERKE REPRODUKTIES NV**, Wiltonstraat 36, 3905 KW Veenendaal, The Netherlands. (31)318 569200. Fax: (31)318 569209. Art Director: A. Hazenberg. Licensing: Mr. Paul Muschert. Estab. 1957. Publishes limited edition, unlimited edition, fine art prints, offset reproductions, posters, greeting cards and limited edition handpainted frames. Licenses: various types of artwork for books, puzzles, textile, stationary, graphics. Clients: galleries, decorators, frame shops, distributors, architects, corporate curators, museum shops and giftshops. Current clients include Prints Plus, Image Source.
Needs: Seeking creative, fashionable and decorative art for the commercial and designer markets. Considers oil, acrylic, watercolor, mixed media, pastel, pen & ink and photography. Prefers all figurative and abstract art, also photography. Artists represented include Charles Bell, Ralph Goings, H. Leyng, Kim Anderson, Oadoor, Rosina Wachtmeister, Alex. Editions created by collaborating with the artist or by working from an existing painting.
First Contact & Terms: Send brochure, photocopies, photographs, tearsheets and transparencies. "Images can be supplied in EPS or TIFF formats, using Adobe Photoshop, Adobe Illustrator or QuarkXPress. Text can be supplied in QuarkXPress, WordPerfect, MS-Word or ASCII files." Samples are filed or returned. Reports back within 6 weeks. Company will contact artist for portfolio review if interested. Pays royalties of 8-10%. Offers advance. Rights purchased vary according to project. Provides advertising, insurance while work is at firm, promotion, written contract and world-wide distribution of prints. Finds artists through attending art exhibitions, art fairs, word of mouth, World Wide Web, through art reps, sourcebooks, submissions and watching art competitions.
Tips: "Make a concise presentation (do not try to show everything) which is clear and handy to review."

▓ **VIBRANT FINE ART**, 3444 Hillcrest Dr., Los Angeles CA 90016. (213)766-0818. Fax: (213)737-4025. Art Director: Phyliss Stevens. Licensing: Tom Nolen. Estab. 1990. Art publisher and distributor. Publishes and distributes fine art prints, limited and unlimited editions and offset reproductions. Licenses ethnic art to appear on ceramics, gifts, textiles, miniature art, stationery and note cards. Clients: galleries, designers, giftshops, furniture stores and film production companies.
Needs: Seeking decorative and ethnic art for the commercial and designer markets. Considers oil, watercolor, mixed media and acrylic. Prefers African-American, Native-American, Latino themes. Artists represented include Sonya A. Spears, Van Johnson, Momodou Ceesay, William Crite and Darryl Daniels. Editions created by collaborating with the artist or by working from an existing painting. Approached by 40 artists/year. Publishes the work of 5 emerging, 5 mid-career and 2 established artists/year. Distributes the work of 5 emerging, 5 mid-career and 2 established artists/year. Also needs freelancers for design. 20% of products require design work. Designers should be familiar with Adobe Illustrator and Mac applications. Prefers local designers only.
First Contact & Terms: Send query letter with brochure, tearsheets and slides. Samples are filed or are returned by SASE. Publisher/distributor will contact artist for portfolio review if interested. Portfolio should include color tearsheets, photographs, slides and biographical sketch. Pays royalties of 10%. Rights purchased vary according to project. Provides advertising, insurance while work is at firm, promotion, written contract and shipping from firm. Finds artists through art exhibitions, referrals, sourcebooks, art reps, submissions.
Tips: "Ethnic art is hot. The African-American art market is expanding. I would like to see more submissions from artists that include slides of ethnic imagery, particularly African-American, Latino and Native American. We desire contemporary cutting edge, fresh and innovative art. Artists should familiarize themselves with the technology involved in the printing process. They should posess a commitment to excellence and understand how the business side of the art industry operates."

N **VLADIMIR ARTS USA INC.**, 2504 Sprinkle Rd., Kalamazoo MI 49001. (616)383-0032. Fax: (616)383-1840. E-mail: vladimir@vladimirarts.com. Website: http://www.vladimirarts.com. Art publisher, distributor and gallery. Publishes/distributes handpulled originals, limited edition, unlimited edition, canvas transfers, fine art prints, monoprints, monotypes, offset reproduction and posters. Clients: galleries, decorators, frame shops, distributors, architects, corporate

curators, museum shops, giftshops and West Point military market. Current clients include: Pharmacia/Upjohn, Stryker Industries, Marks Collection and Stephan Studios.

Needs: Seeking creative, fashionable and decorative art for the serious collector, commercial market and designer market. Considers oil, acrylic, watercolor, mixed media, pastel, pen & ink and sculpture. Artists represented include Hongmin Zou and Paul Steucke. Editions created by collaborating with the artist. Approached by 30 artists/year. Publishes work of 1-2 emerging, 1 mid-career and 1-2 established artists/year. Distributes work of 1-2 emerging, 1 mid-career and 1-2 established artists/year.

First Contact & Terms: Send query letter with brochure, photocopies, photographs and tearsheets. Accepts disk submissions compatible with Adobe Illustrator 5.0 for Windows 95. Samples are filed and not returned. Reports back only if interested. Company will contact artist for portfolio review if interested. Portfolio should include b&w, color, fine art, photographs and roughs. Negotiates payment. No advance. Buys all rights. Provides advertising, promotion and shipping from our firm. Finds artists through attending art exhibitions, art fairs, word of mouth, World Wide Web, art reps, sourcebooks, artists' submissions and watching art competitions.

Tips: "The industry is growing in diversity of color. There are no limits."

WANDA WALLACE ASSOCIATES, P.O. Box 436, Inglewood CA 90306-0436. (310)419-0376. Website: http://www.sensorium.com. President: Wanda Wallace. Estab. 1980. Art publisher, distributor, gallery and consultant for corporations, businesses and residential. Publishes handpulled originals, limited and unlimited editions, canvas transfers, fine art prints, monotypes, posters and sculpture. Clients: decorators, galleries, distributors.

Needs: Seeking art by and depicting African-Americans. Considers oil, acrylic, watercolor, mixed media, pastel, pen & ink and sculpture. Prefers traditional, modern and abstract styles. Artists represented include Alex Beaujour, Dexter, Aziz, Momogu Ceesay, Charles Bibbs, Betty Biggs, Tina Allen, Adrian Won Shue. Editions created by collaborating with the artist or by working from an existing painting. Approached by 100 artists/year. Publishes/distributes the work of 10 emerging, 7 mid-career and 3 established artists/year.

First Contact & Terms: Send query letter with brochure, photocopies, photographs, tearsheets and transparencies. Samples are filed and are not returned. Reports back only if interested. Company will contact artist for portfolio review of color, final art, photographs and transparencies. Pays on consignment basis: firm receives 50% commission or negotiates payment. Offers advance when appropriate. Buys all rights. Requires exclusive representation of artist. Provides advertising, promotion, shipping from firm and written contract.

Tips: "African-American art is very well received. Depictions that sell best are art by black artists. Be creative, it shows in your art. Have no restraints."

N WATERLINE PUBLICATIONS, INC., 51 Melcher St., Boston MA 02210. (617)695-2601. E-mail: tgc@waterline.com. Website: http://www.waterlineart.com. Contact: Tomas Chiginsky. Estab. 1984. Art publisher of limited editions, note cards and art posters. Clients: galleries, framers, gift shops, card shops, furniture stores and distributors overseas.

● This publisher is located in a 13,000-ft. loft in Ft. Point Channel, one of New England's largest art communities.

Needs: Seeking creative and decorative art. Considers all media, including oil, watercolor, acrylic, pastel and mixed media. Open to all categories of artwork. Artists represented include Susan Martinelli, Brian Bergeron and Mary Beth Baxter. Publishes botanicals, American folk art and decorative art. All publications are created from original artwork supplied by the artist. Publishes a maximum of 12 artists/year.

First Contact & Terms: Send query letter with slides, printed samples or transparencies of artwork. Do not send originals unless they are requested. Samples are filed unless otherwise specified. All artwork sent in will be reviewed. Send SASE to have samples returned. Reports back within 2 months. Provides written contract to be signed and agreed upon by publisher and artist. Royalties are paid based on sales of the item. Promotes published art through catalogs, advertising, trade shows and sales reps.

Tips: "Read current trade magazines, home decor magazines and art publications to pick up on latest trends in the market. Watch for trends not only in the art industry, but in home furnishing and fashion—they are all influenced by one another. Classic imagery has always been our strongest selling items as trends change." Advises artists to attend Art Expo New York, Atlanta Gift Show, High Point furniture market.

✓ WEBSTER FINE ART LTD., 1185 Tall Tree Rd., Clemmons NC 27012. (336)712-0900. Fax: (336)712-0974. Design Director/Artist/Computer Specialist: Cecilia T. Myrick. Art publisher/distributor. Estab. 1987. Publishes unlimited editions and fine art prints. Clients: galleries, frame shops, distributors, giftshops.

Needs: Considers oil, acrylic, watercolor, pastel, pen & ink, mixed media. "Seeking creative artists that can take directions; decorative, classic, traditional, fashionable, realistic, impressionistic, landscape, artists who know the latest trends." Artists represented include Janice Brooks, Lorraine Rossi, Fiona Butler, Jan Pashley. Editions created by collaborating with the artist.

First Contact & Terms: Send query letter with brochure, photocopies, photographs, slides, tearsheets, transparencies and SASE. Samples are filed or returned by SASE. Reports back within 1 month. Company will contact artist for portfolio review if interested. Negotiates payment. Offers advance when appropriate. Buys all or reprint rights. Finds artists by word of mouth, attending art exhibitions and fairs, submissions and watching art competitions.

Tips: "Check decorative home magazines—*Southern Accents, Architectural Digest, House Beautiful,* etc.—for trends. Understand the decorative art market."

THE WHITE DOOR PUBLISHING COMPANY, P.O. Box 427, New London MN 56273. (320)796-2209. Fax: (320)796-2968. President: Mark Quale. Estab. 1988. Art publisher. Publishes limited editions, offset reproductions. Clients: 1,000 galleries (authorized dealer network).

Needs: Seeking creative art for the commercial market. Considers oil, acrylic, watercolor, mixed media, pastel. Prefers "traditional" subject matter. Artists represented include Charles L. Peterson, Morten Solberg, Jan Martin McGuire, Greg Alexander, Dan Mieduch and D. Edward Kucera. Editions created by collaborating with the artist or by working from an existing painting. Approached by 250 artists/year. Publishes the work of 2-3 emerging, 2-3 mid-career and 4-6 established artists/year.

First Contact & Terms: Send photographs, SASE, slides, tearsheets, transparencies. Samples are not filed and are returned by SASE. Reports back within 2 weeks. Company will contact artist for portfolio review of color photographs, slides, transparencies. Pays royalties. Buys one-time and reprint rights. Requires exclusive representation of artist. Provides advertising, in-transit insurance, insurance while work is at firm, shipping to and from firm, written contract. Finds artists through attending art exhibitions, word of mouth, submissions and art publications.

Tips: "Nostalgia and images reflecting traditional values are good subjects. Versatility not important. Submit only the subjects and style you love to paint."

WHITEGATE FEATURES SYNDICATE, 71 Faunce Dr., Providence RI 02906. (401)274-2149. Website: http://www.whitegatefeatures.com. Talent Manager: Eve Green.

• This syndicate is looking for fine artists and illustrators. See listing in Syndicates section for information on their needs.

First Contact & Terms: "Please send (non-returnable) slides or photostats of fine arts works. We will call if a project suits your work." Pays royalties of 50% if used to illustrate for newspaper or books.

Tips: "We also work with collectors of fine art and we are starting a division that will represent artists to galleries."

WILD APPLE GRAPHICS, LTD., 5264 US Route 4, Woodstock VT 05091-9600. (802)457-3003. Fax: (802)457-3214. E-mail: wildapple@aol.com. Website: http://www.wildapple.com. Artist Relations: Patty Hasson. Director of Licensing: Deborah Legget. Estab. 1990. Art publisher and distributor of open edition prints. Licenses fine art representing over 20 artists for paper products, decorative accessories, kitchen textiles, floor coverings and many others. Clients: frame shops, interior designers, furniture companies and framed picture manufacturers. Current clients include Pier 1, Bombay, Neiman Marcus and stores selling decorative accessories.

Needs: Seeking decorative art for the commercial and designer markets. Considers all 2D media. Artists represented include Warren Kimble, Nancy Pallan, Deborah Schenck, David Carter Brown, Isabelle de Borchgrane, Cheri Blum, Carol Endres and Beatrix Potter. Fine art prints created by working from an existing painting or by collaborating with the artist. Approached by 2,000 artists/year. Publishes the work of 10-20 artists/year.

First Contact & Terms: Send query letter with résumé and slides, photographs or transparencies that represent a broad range of artwork. Samples are returned by SASE. Reports back within 1 month. Negotiates payment method and rights purchased. Provides in-transit insurance, insurance while work is at firm, promotion, shipping to and from firm and a written contract. Finds artists through art fairs, museums, galleries and submissions.

Tips: "Don't be trendy. We seek decorative images that will have broad appeal and can stay on walls for a long time. Frightening/destructive, full nudity or deeply religious images are not suitable for our markets. Be aware that techniques have to be tight enough to reproduce well."

WILD WINGS INC., S. Highway 61, Lake City MN 55041. (612)345-5355. Fax: (612)345-2981. Merchandising Manager: Sara Koller. Estab. 1968. Art publisher, distributor and gallery. Publishes and distributes limited editions and offset reproductions. Clients: retail and wholesale.

Needs: Seeking artwork for the commercial market. Considers oil, watercolor, mixed media, pastel and acrylic. Prefers fantasy, military, golf, variety and wildlife. Artists represented include David Maass, Lee Kromschroeder, Ron Van Gilder, Robert Abbett, Michael Sieve and Persis Clayton Weirs. Editions created by working from an existing painting. Approached by 300 artists/year. Publishes the work of 36 artists/year. Distributes the work of numerous emerging artists/year.

First Contact & Terms: Send query letter with slides and résumé. Samples are filed and held for 6 months then returned. Reports back within 3 weeks if uninterested or 6 months if interested. Publisher will contact artist for portfolio review if interested. Pays royalties for prints. Accepts original art on consignment and takes 40% commission. No advance. Buys first-rights or reprint rights. Requires exclusive representation of artist. Provides in-transit insurance, promotion, shipping to and from firm, insurance while work is at firm and a written contract.

☑ WINDSOR ART & MIRROR CO., INC., 4444 Ayers Ave., Vernon CA 90023. (323)415-5720. Fax: (323)415-5734. President: Pauline Raschella. Estab. 1970. Manufacturer of decorative framed artwork and mirrors for retail stores.

Needs: Seeking original fine artwork, watercolor, oils, acrylics, limited edition prints, serigraphs, monoprints to produce as prints and sell as original art.

First Contact & Terms: Send query letter and SASE with photographs, slides and brochure showing art style. Samples not filed are returned only if requested. Pays for design and illustration by the project, $300-1,000. Considers complexity of project when establishing payment.

WINN DEVON ART GROUP, 6015 Sixth Ave. S., Seattle WA 98108. (206)763-9544. Fax: (206)762-1389. Vice President Product Develop: Buster Morris. Estab. 1976. Art publisher and wholesaler. Publishes limited editions and posters. Clients: mostly trade, designer, decorators, galleries, poster shops. Current clients include: Pier 1, Z Gallerie, Intercontinental Art, Chamton International, Bombay Co.

Needs: Seeking decorative art for the designer market. Considers oil, watercolor, mixed media, pastel, pen & ink and acrylic. Artists represented include Buffet, de Claviere, Dench, Gunn, Hayslette, Horning, Hall, Wadlington, Singley, Schaar. Editions created by working from an existing painting. Approached by 300-400 artists/year. Publishes and distributes the work of 0-3 emerging, 3-8 mid-career and 8-10 established artists/year.

First Contact & Terms: Send query letter with brochure, slides, photocopies, résumé, photostats, transparencies, tearsheets or photographs. Samples are returned by SASE if requested by artist. Reports back within 4-6 weeks. Publisher will contact artist for portfolio review if interested. Portfolio should include "whatever is appropriate to communicate the artist's talents." Pay varies. Offers advance when appropriate. Rights purchased vary according to project. Provides written contract. Finds artists through attending art exhibitions, agents, sourcebooks, publications, submissions.

Tips: Advises artists to attend Art Expo New York City, ABC Atlanta. "I would advise artists to attend just to see what is selling and being shown, but keep in mind that this is not a good time to approach publishers/exhibitors with your artwork."

Book Publishers

The best way to understand the size of the book publishing market is to visit one of the large "superstores" like Barnes & Noble, Borders or Waldenbooks. Notice how many titles are on the shelves. Each book must compete with all the others for the public's attention.

Artwork for book covers must grab readers' attention and make them want to pick up the book. Secondly, it must show at a glance what type of book it is and who it is meant to appeal to. In addition, the cover has to include basic information such as title, the author's name, the publisher's name, blurbs and price.

The interior of a book is important, too. Designers create the page layouts that direct us through the text and illustrators create artwork to complement the story. This is particularly important in children's books and textbooks. Many publishing companies hire freelance designers with computer skills to design interiors on a contract basis. Look within each listing for the subheading Book Design, to find the number of jobs assigned each year, and how much is paid per project. Look under the Needs heading to find out what computer software the company uses. If you work with compatible software, your chances of winning an assignment increase.

Finding your best markets

Within the first paragraph of each listing, we describe the type of books each publisher specializes in. This may seem obvious, but submit only to publishers who specialize in the type of book you want to illustrate or design. There's no use submitting to a publisher of literary fiction if you want to illustrate for children's picture books.

The publishers in this section are just the tip of the iceberg. You can find additional publishers by visiting bookstores and libraries and looking at covers and interior art. When you find covers you admire, write down the name of the books' publishers in a notebook. If the publisher is not listed in *Artist's & Graphic Designer's Market*, go to your public library and ask to look at a copy of *Literary Market Place*, also called *LMP*, published annually by Bowker. The cost of this large directory is prohibitive to most freelancers, but you should become familiar with it if

LEARNING INDUSTRY TERMS

- ☑ **Mass market** books are sold in supermarkets, newsstands, drugstores, etc. They include paperbacks by popular authors like Stephen King.
- ☑ **Trade books** are the hardcovers and paperbacks found only in bookstores and libraries. The paperbacks are larger than those on the mass market racks. They are printed on higher quality paper, and feature matte-paper jackets.
- ☑ **Textbooks** feature plenty of illustrations, photographs, and charts to explain their subjects. They are also more likely to need freelance designers.
- ☑ **Small press** books are books produced by a small, independent publisher. Many are literary or scholarly in theme, and often feature fine art on the cover.
- ☑ **Backlist titles** or **reprints** refer to publishers' titles from past seasons that continue to sell year after year. These books are often updated and republished with freshly designed covers to make them more attractive to readers.

you plan to work in the industry. Though it won't tell you how to submit to each publisher, it does give art directors' names. The book also has a section featuring the winners of the year's book awards, including awards for book design.

How to submit

Send one to five nonreturnable samples along with a brief letter and a SASE. Never send originals. Most art directors prefer samples $8\frac{1}{2} \times 11$ or smaller that can fit in file drawers. Bulky submissions are considered a nuisance. After sending your initial introductory mailing, you should follow-up with postcard samples every few months to keep your name in front of art directors.

Getting paid

Payment for design and illustration varies depending on the size of the publisher, the type of project and the rights bought. Most publishers pay on a per-project basis, although some publishers of highly illustrated books (such as children's books) pay an advance plus royalties. A few very small presses may only pay in copies.

Illustrating for children's books

Working in children's books requires a specific set of skills. You must be able to draw the same characters in a variety of action poses and situations. Like other publishers, many children's publishers are expanding their product lines to include multimedia projects (CD-ROM and software). A number of children's publishers are listed in this book, but *Children's Writer's & Illustrator's Market*, published by Writer's Digest Books (800)289-0963, is a valuable resource if you enter this field.

For More Information

If you decide to focus on book publishing, you'll need to become familiar with *Publishers Weekly*, the trade magazine of the industry. It will keep you abreast of new imprints, publishers that plan to increase their title selection, and the names of new art directors. You should also look for articles on book illustration and design in *HOW* and other graphic design magazines. Book designers like Lorraine Louie, Lucille Tenazas and Chip Kidd are regularly featured, as are cover illustrators like Gary Kelley. To find out about one of the innovators of book design, read *Wendell Minor: Art for the Written Word* edited by Wendell Minor and Florence Friedman Minor (Harvest Books). Other great books to browse through are *Jackets Required: An Illustrated History of American Book Jacket Design, 1920-1950*, by Steven Heller and Seymour Chwast (Chronicle Books), which offers nearly 300 examples of book jackets, and *Covers & Jackets! What the Best-Dressed Books & Magazines are Wearing*, by Steven Heller and Anne Fink (PCB Intl. Inc.). While you're at the library, read the Insider Reports in the Book Publishers section of past editions of *Artist's & Graphic Designer's Market*. And don't forget to check Websites for Artists on page 683.

Book Publishing Niche: The Adventure Gaming Industry
by Tricia Waddell

Why are we talking about games in the book publishers section? Because games such as roleplaying games (e.g., *Dungeons & Dragons®*), miniature games, trading card games, board games, and play-by-mail games are all part of the adventure game industry and rely heavily on books. Adventure games are played by hobby enthusiasts who devote significant time and skill mastering often complex games. Game companies produce a host of player guides, adventure campaign books and reference books for designing characters, in addition to spin-off novels and products based on the game, all chock-full of art. Art directors at game companies rely heavily on freelance artists for illustrations and graphic design for book cover and interior art, in addition to related game accessories, publications, merchandise and marketing materials.

Adventure games range in artistic styles and genres. Historical games and war games reflect period styles from feudal Japan to World War II. Roleplaying games such as *Dungeons & Dragons®* use fantasy art and medieval settings. Other roleplaying games showcase various styles including science fiction, cyberpunk, horror, Japanimation and Gothic. Collectible card games such as *Magic: the Gathering®* use fantasy art with a supernatural twist. Art directors look for artists who can create accurate figure drawings, dynamic compositions and depict both real and imaginary environments. Black and white line art is most often used in book or game interior illustrations, while four-color work is used for game and book covers, card game art and related products.

Artists wanting to break into this market should research companies and product lines to ensure their submissions match in style and genre. Adventure games are usually sold through game, comic or hobby shops, with popular titles and novels sold in mass-market bookstores. To learn more about the gaming industry and meet art directors directly for portfolio reviews, attend one of the many gaming conventions held in cities across the U.S. The two major conventions are the Origins International Game Expo and Fair held annually in Columbus, Ohio, and Gen Con, held annually in Milwaukee, Wisconsin. To see the work of other artists in the science fiction and fantasy genre, check out *Spectrum: The Best in Contemporary Fantastic Art* (Underwood Books). This annual sourcebook of artists is often used as a talent resource by art directors. To learn more about freelancing for a game company, see the Insider Report with Jon Schindehette, Senior Art Director of the book division at Wizards of the Coast on page 275. To find contact information and art submission guidelines for game companies, look for market listings under the Science Fiction/Fantasy category in the Special Markets Index on page 689 and check out the following resources and industry websites.

- **RPGnet** http://rpg.net
 Information on the roleplaying gaming industry with links to dozens of game companies.
- **Game Manufacturers Association** http://www.gama.org
 Links to GAMA members which include the majority of adventure gaming companies and distributors. GAMA also publishes a free membership directory with contact information.
- **The Academy of Gaming Arts & Design** http://www.gama.org/academy/academy.html
 Publishes a free directory of game industry professionals.
- **Game Publishers Association** http://rpg.net/gpa
 Provides links to GPA members, an association of small game companies.
- **The Games Quarterly Catalog**
 An industry bible with complete listings of every hobby game product in print, by manufacturer, along with contact information for manufacturers and distributors. Contact Matthews-Simmons Marketing, 5575D Arapahoe Road, Boulder, CO 80303. (303)786-9727.

Tricia Waddell is the production editor for *Artist's & Graphic Designer's Market*.

insider report

Down-to-earth advice on entering the other-worldly market of roleplaying games

He can transport you to exotic planets, magical kingdoms and distant realms. Enter the many worlds of Jon Schindehette, senior art director for the book division of Wizards of the Coast and subsidiary TSR, Inc., publishers of roleplaying games and related fantasy and science fiction novels and products. From legendary heroes to strange alien species, it's Schindehette's job to make fantastic characters and epic worlds come to life and leap off the book cover into the imagination of millions of readers.

Jon Schindehette

Roleplaying games took the world by storm in the mid-1970s, becoming popular with TSR's *Dungeons & Dragons*® game. The basis of the game is for players to take on the identities of imaginary characters and act out an adventure, writing the script as they go along. Now a billion-dollar industry, roleplaying games have created many spinoff products based on the characters and worlds created in the game genre, including bestselling fantasy and science fiction novels, magazines, computer games and merchandise. With a strong emphasis on visual design, the illustration and graphics featured on these products have showcased the top creative talent working in the science fiction and fantasy genre.

One of the largest roleplaying and hobby game companies in the world, Wizards of the Coast and its subsidiary companies TSR, Inc. and Five Rings Publishing Group, publish an average of 40 books and 45-50 game products a year. Schindehette works with a sizable in-house art department and dozens of freelance artists to maintain the unique visual look of several book lines. "We call ourselves 'Spine Design' and have approximately 45 in-house visual staff. We have on staff Rich Kaalaas, our creative director, 12 art directors, 17 graphic designers, 8 illustrators, 3 cartographers and 1 sculptor. We're bigger than most advertising firms."

JON SCHINDEHETTE

Title: Senior Art Director
Company: Wizards of the Coast

Roleplaying games have a very loyal fan base and fans expect the integrity of the game settings and characters to be maintained when they are translated into novels. "Because of our loyal fan base, we have very defined worlds and very defined

intellectual properties and brand lines," Schindehette says. "One of the challenges I enjoy is working with recurring characters and worlds. This provides a definite sense of history with our product lines. It helps freelancers, because they a have a huge scope of back material to pull from for references and content issues."

Schindehette works with several book series based on successful game lines that each maintain a distinctive look and feel. Book lines based on the medieval fantasy setting of TSR's *Advanced Dungeons & Dragons*® game include the *Dragonlance* novel series, *Forgotten Realms* series, *Planescape* series, *Greyhawk* series and *Ravenloft* series. Newer book lines include a science fiction book line based on the science fiction games *Alternity* and *Stardrive*, in addition to fiction and nonfiction books based on Wizards of the Coast's popular trading card game, *Magic: The Gathering.*® "Certain lines have very defined characters," explains Schindehette. "Our *Dragonlance* line, which is probably one of our most well-known book lines, has very defined characters which were generated through the game genre. We're looking for interesting ways to reinterpret how they look, the way they interact with each other, the setting, all that fun stuff. Some of our other lines, such as *Alternity* and *Stardrive*, are built around a world and don't have established characters per se. So a lot of the characters in the books are brand new. We flesh them out. It's a collaboration between myself, the illustrators and the authors that gets the whole process jiving to make the vision that will be detailed in the book come to life on the cover."

From fire-breathing dragons to mysterious dark angels, these compelling book illustrations by Todd Lock and Brom evoke the emotion and artistic skill Jon Schindehette looks for in freelance artists.

Schindehette uses freelancers for illustration and graphic design and looks for a broad range of skills and styles. "I look for different things in different lines. Our *Dragonlance* line, for instance, tends to be very tight, very detail oriented. For some of our other lines, we're looking for a looser, more fun look. Some of our stuff can be dark and moody, abstract and conceptual. I want to have a really broad range to choose from and have filing cabinets full of illustrators' stuff just for that purpose."

Fortunately for Schindehette, there is no shortage of freelance artists wanting to work with him. On average, he gets 10-15 submissions a day. "I sort through the pile once a week and determine whose skills meet our standards. Then I sort them by three criteria. First, does the work fit a particular brand line or product line we're using right now? If it doesn't, since we know what we're doing several years ahead, is it something we can use a year or two from now? If so, we hold those guys. And third, if it's technically correct but not something we use often, we might use the artist on an occasional basis for an editorial piece in one of the magazines or for a spot illustration in a corporate catalog. Then I make the art directors of the different lines aware that we found an artist to consider for future use."

Game conventions also provide an opportunity for freelance artists to show their portfolio to Schindehette and other art directors from game companies. Held in cities around the country, the big national conventions, GenCon in Milwaukee and Origins International Game Expo & Fair in Columbus, Ohio, draw tens of thousands of fans. "At some conventions I'll look at 20-30 portfolios a day, and at others I'll see over 150 a day. I like to be there for the more aspiring guys who want critiques. They're looking for real feedback instead of just a nice little form letter that says, 'Sorry we're not using your type of work at the moment.'"

In addition to artistic talent, Schindehette looks for freelancers with strong communication skills and the ability to meet deadlines. "Because we use a lot of freelancers, we communicate a lot by phone. I need to be able to discuss exactly what I'm looking for, what the tone is, what the look is, who the characters are, what they're wearing. And I need them to be able to communicate any questions back to me. I like illustrators who are very conceptual. I'm an art director, not an art dictator. I want them to take the characters I want, take the tone, the look, the feel, and give me three or four sketches back and offer me several different interpretations."

Schindehette recommends that freelancers interested in breaking into this market have a familiarity with the genre and do their homework. "A third of the submissions I get everyday are so completely inappropriate for my company that I can't use them. Whether it's my company or anyone else's, research who it is. Get on the Web, find out what they do, look at their product lines, go to the stores, look at what they've done and where they're going. Then call before you send to them, that way you can tailor your portfolio better and I get a better idea of what you can do in my genre, what you can actually offer me. If you can get your foot in the door, your style may end up defining a line. You may develop a valuable relationship there."

—*Tricia Waddell*

insider report

Passion, research and strong presentation: Keys to published comic books

Comic book artist Gary Francis is a soft-spoken man with a kind face and a quick wit. But this gentle facade masks an amazingly dark imagination that comes to life on the pages of the comic books he writes and illustrates, pages where blood trickles from the lips of crumbling nymphet statues and a lone vampire battles his way through a surreal dreamscape called Madness Prime. Francis says he finds material for his dark tales "from the primal side of the human subconscious."

Gary Francis

The writer/illustrator of 12 comic books, Francis has been drawing since childhood. "My dad used to take me out and buy a comic every time he'd bring me home from the babysitter, so I associate comics with my dad." Later, comic books helped a six-year-old Francis deal with the death of his father, part of the reason he takes his art so seriously. "Once you do a comic book you have no idea where it's going to end up in the world and whose lives it's going to touch."

Professional comic book publishing first touched Francis's life when he was in college. "A couple of the other guys, who were in the graphics program, were getting published and they asked me whether I'd like to write one," he says. Watching the more experienced comic book artists helped Francis learn the trade and their encouragement led him to start illustrating his own ideas. Though he planned to self-publish his first book, he decided to submit it to an independent comic book publisher first.

Francis sent his proposal for *Young Dracula: Diary of a Vampire* to Caliber Press, now called Caliber Comics, the publishers of *The Crow*. "I sent the packet out on Thursday and I got a yes reply on Tuesday." Francis signed a contract to do three issues for 60 percent of the royalties. Besides Caliber Comics, Francis has also been published by Arrow Manga and Boneyard Press, all independent comics companies who publish mostly black and white books. "I'm really interested in black and white as an evolving art form," he says. "The story lines and writing tend to be of a higher to be of a

GARY FRANCIS

Comic Book: Young Dracula: Diary of a Vampire
Publishers: Arrow Manga, Caliber Comics, Boneyard Press

higher gauge than in color books. It's where the most creative things happen. It's grittier. It's closer to the asphalt."

Francis chose to send his first comic submission to Caliber because of his respect for "the damaged emotional content" of *The Crow*. He suggests you begin your journey into comic book publishing by choosing several companies you like and researching their submission guidelines on the Internet. (For links to many publishers' guidelines, see the How-To Guide to Comics, http://www.teleport.com/~ennead/ampersand/howto_main.html.)

Once you've selected a potential publisher, send a query letter detailing your idea. If the publisher is interested he will ask for more. Your submission packet should include a synopsis of the book's plot, suggestions about how the book should be marketed and several pages of panel-to-panel artwork. Independent publishers will also expect you to find writers with whom to collaborate if you don't plan to do the writing yourself.

Collaboration is a crucial part of crafting a comic book, Francis says. "When you start at the beginning, you write a script or plot, which basically says what's going

Francis has penned stories for several publishers featuring his take on the early years of a certain Transylvanian Count. The above layout is from *Prayer of the Vampire*, published by Boneyard Press, but he also created *Diary of a Vampire*, published by Caliber Comics. While Francis did the writing and inside illustrations for *Prayer of the Vampire*, he collaborated with artist David Hutchison who created the cover painting, inks and lettering.

to happen in all the little boxes. That goes off to the penciler who breaks the story down into panels. Then it goes to the inker who adds all the special effects and usually sets the mood. After the inker, it may go back to the writer, who'll write the dialogue for the individual boxes if it wasn't included with the plot, or it will go off to the letterer." Francis has learned to write, pencil and ink. "You really have to be well-rounded in the independent and underground markets," he says. The more steps an individual artist can complete the faster the publishing process goes.

Before you take your first steps toward publication, Francis suggests showing your artwork to a comic book retailer. "Ask him if it's marketable. The retailer is usually the oracle of what's going on in the industry; he has to keep on top of things and most of the marketing is coming directly to him." A comic book salesperson will also be able to suggest other artists and publishers you may enjoy and find instructive.

Though Francis hasn't been able to quit his day job yet, he doesn't get discouraged about the slow process of building a fan base and getting his name out. He doesn't do it for the money and he warns against having that attitude. Do it because "it's your love, it's your passion," he says. "Comic books have to continually evolve and it's your duty to help in that process. You're giving back the thing you got from comics when you were in junior high or high school or college or whenever you discovered them. They're like no other art form in the world."

—*Megan Lane*

☑ **AAIMS PUBLISHERS**, 11000 Wilshire Blvd., P.O. Box 241777, Los Angeles CA 90024-9577. (213)968-1195. Fax: (323)931-7217. E-mail: aaimspub@aol.com. Director of Art: Nancy Freeman. Estab. 1969. Publishes hardcover, trade and mass market paperback originals and textbooks. Publishes all types of fiction and nonfiction. Publishes 17 titles/year. Recent titles include *A Message from Elvis*, by Harry McKinzie; and *USMC Force Recon: A Black Hero's Story*, by Amankwa Adeduro. Book catalog for SASE.
Needs: Uses freelancers for jacket/cover design and illustration. Also for text illustration, multimedia projects and direct mail and book catalog design. Works on assignment only. 80% of freelance work requires knowledge of Microsoft Word and WordPerfect. 7% of titles require freelance art direction.
First Contact & Terms: Send query letter with SASE, photographs and photocopies. Samples are filed or are returned by SASE. Portfolio should include thumbnails and roughs. Sometimes requests work on spec before assigning a job. Buys all rights. Originals are not returned. Pays by the project, negotiated.
Book Design: Assigns 5 freelance design jobs/year and 5 freelance art direction projects/year. Pay varies for design.
Jackets/Cover: Assigns 17 freelance design and 7 freelance illustration jobs/year. Pay varies for design.
Tips: "Looking for design and illustration that is appropriate for the general public. Book design is becoming smoother, softer and more down to nature with expression of love of all—humanity, animals and earth."

A&B PUBLISHERS GROUP, 1000 Atlantic Ave., Brooklyn NY 11238. (718)783-7808. Fax: (718)783-7267. Art Director: Maxwell Taylor. Estab. 1992. Publishes trade paperback originals and reprints. Types of books include comic books, history, juvenile, preschool and young adult. Specializes in history. Publishes 15 titles/year. Recent titles include: *Gospel of Barnabas* and *What They Never Told You in History Class.* 70% require freelance illustration; 25% require freelance design. Catalog available.
● A&B Publishers Group will be venturing into the printing of calendars.
Needs: Approached by 36 illustrators and 12 designers/year. Works with 8 illustrators and 2 designers/year. Prefers local illustrators experienced in airbrush and computer graphics. Uses freelancers mainly for "book covers and insides." 85% of freelance design demands knowledge of Adobe Photoshop, Adobe Illustrator and QuarkXPress. 60% of freelance design demands knowledge of Photoshop, Illustrator, QuarkXPress and Fractal Design Painter. 20% of titles require freelance art direction.
First Contact & Terms: Designers send query letter with photocopies. Illustrators send postcard sample, photocopies,

photographs, photostats, printed samples, slides and tearsheets. Send follow-up postcard sample every 4 months. Accepts disk submissions from designers compatible with QuarkXPress, Photoshop and Illustrator. Send EPS and TIFF files. Samples are filed. Reports back within 2 months if interested. Portfolio review required. Portfolio should include artwork portraying children, animals, perspective, anatomy and transparencies. Rights purchased vary according to project.

Book Design: Assigns 8 freelance design jobs/year. Pays by the hour, $15-65 and also a flat fee.

Jackets/Covers: Assigns 12 freelance design jobs and 21 illustration jobs/year. Pays by the project, $250-1,200. Prefers "computer generated titles, pen & ink and watercolor or airbrush for finish."

Text Illustration: Assigns 12-25 freelance illustration jobs/year. Pays by the hour, $8-25 or by the project $800-2,400 maximum. Prefers "airbrush or watercolor that is realistic or childlike, appealing to young schoolage children." Finds freelancers through word of mouth, submissions, NYC school of design.

Tips: "I look for artists who are knowledgeable about press and printing systems—from how color reproduces to how best to utilize color for different presses."

✓ ACROPOLIS BOOKS, INC., 747 Sheridan Blvd., #8C, Lakewood CO 80214-2562. (303)231-9923. Fax: (303)235-0492. E-mail: acropolisbooks@worldnet.att.net. Website: http://www.Acropolisbooks.com. Vice President Sales and Marketing: Carol Core. Imprints include I-Level and Awakening. Publishes hardcover originals and reprints, trade paperback originals and reprints. Types of books include mysticism and spiritual. Specializes in books of higher consciousness. Publishes 10 titles/year. Recent titles include: *The Foundation of Mysticism*, by Joel Goldsmith; and *Invisible Leadership*, by Robert Rabbin. 30% require freelance design. Catalog available.

Needs: Approached by 15 illustrators and 10 designers/year. Works with 5-6 illustrators and 2-3 designers/year. Knowledge of Adobe Photoshop and QuarkXPress useful in freelance illustration and design.

First Contact & Terms: Designers send brochure and résumé. Illustrators send query letter with photocopies and résumé. Samples are filed. Reports back within 2 months. Will contact artist for portfolio review if interested. Buys all rights.

Book Design: Assigns 3-4 freelance design jobs/year. Pays by the project.

Jackets/Covers: Assigns 3-4 freelance design jobs/year. Pays by the project.

Tips: "We are looking for people who are familiar with our company and understand our focus."

ℕ ALFRED PUBLISHING CO., INC., 16320 Roscoe Blvd., Box 10003, Van Nuys CA 91410-0003. (818)891-5999. Fax: (818)891-2182. Website: http://www.alfredpub.com. Art Director: Ted Engelbart. Estab. 1922. Book publisher. Publishes trade paperback originals. Types of books include instructional, juvenile, young adult, reference and music. Specializes in music books. Publishes approximately 300 titles/year. Recent titles include *Blues Guitar for Beginners*; *Anthology of Baroque Keyboard Music*; and *Music for Little Mozarts*.

Needs: Approached by 40-50 freelancers/year. Works with 10 freelance illustrators and 5 designers/year. "We prefer to work directly with artist—local, if possible." Uses freelancers mainly for cover art, marketing material, book design and production. Also for jacket/cover and text illustration. Works on assignment only.

First Contact & Terms: Send résumé, SASE and tearsheets. "Photocopies are fine for line art." Samples are filed. Reports back only if interested. "I appreciate paid reply cards." To show portfolio, include "whatever shows off your work and is easily viewed." Originals are returned at job's completion.

Jackets/Covers: Assigns 20 freelance design and 25 illustration jobs/year. Pays by the project, $300-800. "We generally prefer fairly representational styles for covers, but anything upbeat in nature is considered."

Text Illustration: Assigns 15 freelance illustration jobs/year. Pays by the project, $350-2,500. "We use a lot of line art for b&w text, watercolor or gouache for 4-color text."

✓ ALLYN AND BACON INC., College Division, 160 Gould St., Needham MA 02494. (781)455-1200. Fax: (781)455-1378. Art Director: Linda Knowles. Publishes more than 300 hardcover and paperback textbooks/year. 60% require freelance cover designs. Subject areas include education, psychology and sociology, political science, theater, music and public speaking.

Needs: Designers must be strong in book cover design and contemporary type treatment. 50% of freelance work demands knowledge of Adobe Illustrator, Adobe Photoshop and Aldus FreeHand.

Jackets/Covers: Assigns 100 design jobs and 2-3 illustration jobs/year. Pays for design by the project, $300-750. Pays for illustration by the project, $150-500. Prefers sophisticated, abstract style in pen & ink, airbrush, charcoal/pencil, watercolor, acrylic, oil, collage and calligraphy. "Always looking for good calligraphers."

Tips: "Keep stylistically and technically up to date. Learn *not* to over-design: read instructions and ask questions. Introductory letter must state experience and include at least photocopies of your work. If I like what I see, and you can stay on budget, you'll probably get an assignment. Being pushy closes the door. We primarily use designers based in the Boston area."

THE AMERICAN BIBLE SOCIETY, 1865 Broadway, New York NY 10023. Fax: (212)408-1305. Assistant Director, Product Development: Christina Murphy. Estab. 1868. Company publishes religious products including Bibles/New Testaments, portions, leaflets, calendars and bookmarks. Additional products include religious children's books, posters, seasonal items, teaching aids, audio casettes, videos and CD-ROMs. Specializes in contemporary applications to the Bible. Publishes 80 titles/year. Recent titles include: *Translators to the Reader: The Original Preface of the King James Version of 1611 Revisited*. 25% requires freelance illustration; 90% requires freelance design. Book catalog free by request.

Needs: Approached by 50-100 freelancers/month. Works with 10 freelance illustrators and 20 designers/year. Uses freelancers for jacket/cover illustration and design, text illustration, book design and children's activity books. 90% of freelance work demands knowledge of Adobe Illustrator, QuarkXPress, Adobe Photoshop. Works on assignment only. 5% of titles require freelance art direction.

First Contact & Terms: Send postcard samples of work or send query letter with brochure and tearsheets. Samples are filed and/or returned. **Please do not call.** Reports back within 1-2 months. Product Design will contact artist for portfolio review if additional samples are needed. Portfolio should include final art and tearsheets. Buys all rights. Finds artists through artists' submissions, *The Workbook* (by Scott & Daughters Publishing) and *RSVP Illustrator*.

Book Design: Assigns 3-5 freelance interior book design jobs/year. Pays by the project, $350-1,000 depending on work involved.

Jackets/Covers: Assigns 60-80 freelance design and 20 freelance illustration jobs/year. Pays by the project, $350-2,000.

Text Illustration: Assigns several freelance illustration jobs/year. Pays by the project.

Tips: "Looking for contemporary, multicultural artwork/designs and good graphic designers familiar with commercial publishing standards and procedures. Have a polished and professional-looking portfolio or be prepred to show polished and professional-looking samples."

AMERICAN JUDICATURE SOCIETY, 180 N. Michigan, Suite 600, Chicago IL 60601-7401. (312)558-6900, ext. 119. Fax: (312)558-9175. E-mail: drichort@ajs.org. Website: http://www.ajs.org. Editor: David Richert. Estab. 1913. Publishes journals and books. Specializes in courts, judges and administration of justice. Publishes 5 titles/year. 75% requires freelance illustration. Catalog available free for SASE.

Needs: Approached by 20 illustrators and 6 designers/year. Works with 3-4 illustrators and 1 designer/year. Prefers local designers. Uses freelancers mainly for illustration. 100% of freelance design demands knowledge of Aldus Page-Maker, Aldus FreeHand, Adobe Photoshop and Adobe Illustrator. 10% of freelance illustration demands knowledge of Aldus PageMaker, Aldus FreeHand, Adobe Photoshop and Adobe Illustrator.

First Contact & Terms: Designers send query letter with photocopies. Illustrators send query letter with photocopies and tearsheets. Send follow-up postcard every 3 months. Samples are not filed and are returned by SASE. Reports back within 1 month. Will contact artist for portfolio review of photocopies, roughs and tearsheets if interested. Buys one-time rights.

Book Design: Assigns 1-2 freelance design jobs/year. Pays by the project, $500-1,000.

Text Illustration: Assigns 10 freelance illustration jobs/year. Pays by the project, $75-375.

AMHERST MEDIA, INC., P.O. Box 586, Amherst NY 14226. (716)874-4450. Fax: (716)874-4508. Publisher: Craig Alesse. Estab. 1974. Company publishes trade paperback originals. Types of books include instructional and reference. Specializes in photography, how-to. Publishes 30 titles/year. Recent titles include *Wedding Photographer's Handbook*, by Robert Hurth. 20% require freelance illustration; 80% require freelance design. Book catalog free for 9×12 SAE with 3 first-class stamps.

Needs: Approached by 12 freelancers/year. Works with 3 freelance illustrators and 3 designers/year. Uses freelance artists mainly for illustration and cover design. Also for jacket/cover illustration and design and book design. 80% of freelance work demands knowledge of QuarkXPress or Adobe Photoshop. Works on assignment only.

First Contact & Terms: Send brochure, résumé and photographs. Samples are filed. Reports back only if interested. Art Director will contact artist for portfolio review if interested. Portfolio should include slides. Rights purchased vary according to project. Originals are returned at job's completion. Finds artists through word of mouth.

Book Design: Assigns 12 freelance design jobs/year. Pays for design by the hour $25 minimum; by the project $1,650.

Jackets/Covers: Assigns 12 freelance design and 4 illustration jobs/year. Pays $200-1200. Prefers computer illustration (QuarkXPress/Adobe Photoshop).

Text Illustration: Assigns 12 freelance illustration job/year. Pays by the project. Prefers computer illustration (QuarkX-Press).

ANDREWS McMEEL PUBLISHING, 4520 Main, Kansas City MO 64111-7701. (816)932-6600. Fax: (816)932-6781. E-mail: tlynch@amuniversal.com. Website: http://www.andrewsmcmeel.com. Art Director: Tim Lynch. Assistant Art Director: Julie Herren. Estab. 1972. Publishes hardcover originals and reprints; trade paperback originals and reprints. Types of books include biography, cookbooks, history, humor, instructional, juvenile, nonfiction, reference, religious, self help, travel. Specializes in cartoon/humor books. Publishes 200 titles/year. Recent titles include: *Far Side*, *Dilbert*, *Jenny Jones My Story*, *Landing on My Feet*. 10% requires freelance illustration; 80% requires freelance design.

Needs: Approached by 100 illustrators and 10 designers/year. Works with 15 illustrators and 25 designers/year. Prefers freelancers experienced in book jacket design. 100% of freelance design demands knowledge of Adobe Illustrator, Adobe Photoshop, QuarkXPress. 100% of freelance illustration demands knowledge of traditional art skills: printing, watercolor etc.

First Contact & Terms: Designers send query letter with printed samples. Illustrators send query letter with printed samples or contact through artists' rep. Accepts Mac-compatible disk submissions. Samples are filed and not returned. Reports back only if interested. Portfolio review not required. Rights purchased vary according to project. Finds freelancers mostly through sourcebooks and samples sent in by freelancers.

Book Design: Assigns 60 freelance design jobs/year. Pays by the project, $600-3,000.

Jackets/Covers: Assigns 60 freelance design jobs and 20 illustration jobs/year. Pays for design $600-3,000.

Tips: "We want designers who can read a manuscript and design a concept for the best possible cover. Communicate well and be flexible with design."

APPALACHIAN MOUNTAIN CLUB BOOKS, 5 Joy St., Boston MA 02108. (617)523-0636. Fax: (617)523-0722. Website: http://www.outdoors.org. Production: Elisabeth L. Brady. Estab. 1876. Publishes trade paperback originals and reprints. Types of books include adventure, instructional, nonfiction, travel. Specializes in hiking guidebooks. Publishes 7-10 titles/year. Recent titles include: *White Mountain Guide, 26th ed*; *Nature Walks in New Jersey*; and *Backcountry Skiing Adventures*. 5% requires freelance illustration; 100% requires freelance design. Book catalog free for #10 SAE with 1 first-class stamp.

Needs: Approached by 5 illustrators and 2 designers/year. Works with 1 illustrator and 2 designers/year. Prefers local freelancers experienced in book design. 100% of freelance design demands knowledge of Aldus FreeHand, Adobe Photoshop, QuarkXPress. 100% of freelance illustration demands knowledge of Aldus FreeHand, Adobe Illustrator.

First Contact & Terms: Designers send postcard sample or query letter with photocopies. Illustrators send postcard sample. Accepts Mac-compatible disk submissions. Samples are not filed and are not returned. Will contact artist for portfolio review of book dummy, photocopies, photographs, tearsheets, thumbnails if interested. Negotiates rights purchased. Finds freelancers through professional recommendation (word of mouth).

Book Design: Assigns 10-12 freelance design jobs/year. Pays for design by the project, $1,500-2,000.

Jackets/Covers: Assigns 10-12 freelance design jobs and 1 illustration job/year. Pays for design by the project.

ARJUNA LIBRARY PRESS, 1025 Garner St., D, Space 18, Colorado Springs CO 80905-1774. Director: Count Prof. Joseph A. Uphoff, Jr. Estab. 1979. Company publishes trade paperback originals and monographs. Types of books include experimental fiction, fantasy, horror, nonfiction and science fiction. Specializes in surrealism and metamathematics. Publishes 1 or more titles/year. Recent titles include *The Promethean and Epimethean Continuum of Art*, by Professor Shlomo Giora Shoham. 100% require freelance illustration. Book catalog available for $1.

- Count Professor Joseph A. Uphoff, Jr. who is Editor-in-Chief of The Journal Of Regional Criticism, will have a brief biographical sketch in *Outstanding People Of The 20th Century* to be published in mid-1999 by The International Biographical Center, Cambridge, England.

Needs: Approached by 1-2 freelancers/year. Works with 1-2 freelance illustrators/year. Buys 1-2 freelance illustrations/year. Uses freelancers for jacket/cover and text illustration.

First Contact & Terms: Send query letter with brochure, résumé, SASE, tearsheets, slides, photographs and photocopies. Samples are filed. Reports back if interested. Portfolio review not required. Originals are not returned.

Book Design: Pays contributor's copy and "royalties by agreement if work becomes profitable."

Jackets/Covers: Pays contributor's copy and "royalties by agreement if work becomes profitable."

Text Illustration: Pays contributor's copy and "royalties by agreement if work becomes profitable."

Tips: "Although color illustrations are needed for dust jackets and paperback covers, because of the printing cost, most interior book illustrations are black and white. It is a valuable skill to be able to make a color image with strong values of contrast that will transcribe positively into black and white. In terms of publishing and computer processing, art has become information. There is yet an Art that presents the manifestation of the object as being a quality. This applies to sculpture, ancient relics, and anything with similar material value. These things should be treated with respect; curatorial values will always be important."

ART DIRECTION BOOK CO. INC., 456 Glenbrook Rd., Glenbrook CT 06906. (203)353-1441. Fax: (203)353-1371. Art Director: Doris Gordon. Publishes hardcover and paperback originals on advertising design and photography. Publishes 12-15 titles/year. Titles include disks of *Scan This Book* and *Most Happy Clip Art*; book and disk of *101 Absolutely Superb Icons* and *American Corporate Identity #11*. Book catalog free on request.

Needs: Works with 2-4 freelance designers/year. Uses freelancers mainly for graphic design.

First Contact & Terms: Send query letter to be filed, and arrange to show portfolio of 4-10 tearsheets. Portfolios may be dropped off Monday-Friday. Samples returned by SASE. Buys first rights. Originals are returned to artist at job's completion. Advertising design must be contemporary. Finds artists through word of mouth.

Book Design: Assigns 8 freelance design jobs/year. Pays $350 maximum.

Jackets/Covers: Assigns 8 freelance design jobs/year. Pays $350 maximum.

ARTEMIS CREATIONS, 3395-2J Nostrand Ave., Brooklyn NY 11229. (718)648-8215. E-mail: artemispub@aol.com. President: Shirley Oliveira. Estab. 1992. Publishes trade paperback originals, audio tapes and periodicals. Types of books include erotica, experimental fiction, fantasy, horror, humor, new age, nonfiction and religious. Specializes in powerful women. Publishes 2-4 books, 4 journals and novellas/year. 10% require freelance illustration and design.

Needs: Black & white line art, fantasy, fetishism.

First Contact & Terms: Designers send query letter with photocopies, photographs, résumé and tearsheets. Illustrators

NEED HELP? For tips on finding markets and understanding listings, see our Quick-Start Guide in the front of this book.

send photocopies, résumé, SASE and tearsheets. Accepts disk submissions compatible with PC only. Samples are filed and are returned by SASE. Reports back within 1 day. Rights purchased vary according to project.

Book Design: Pays by the project.

Jackets/Covers: Pays for design by the project $200 maximum. Pays for illustration by the project $8 maximum for b&w line art.

Text Illustration: Finds freelancers through magazines and word of mouth.

Tips: "Artists should follow instructions."

ARTIST'S & GRAPHIC DESIGNER'S MARKET, Writer's Digest Books, 1507 Dana Ave., Cincinnati OH 45207. E-mail: artdesign@fwpubs.com. Editor: Mary Cox. Annual hardcover directory of markets for designers, illustrators and fine artists. Buys one-time rights.

Needs: Buys 35-45 illustrations/year. "I need examples of art that have been sold to the listings in *Artist's & Graphic Designer's Market*. Look through this book for examples. The art must have been freelanced; it cannot have been done as staff work. Include the name of the listing that purchased or exhibited the work, what the art was used for and, if possible, the payment you received. Bear in mind that interior art is reproduced in black and white, so the higher the contrast, the better."

First Contact & Terms: Send printed piece, photographs or tearsheets. "Since *Artist's & Graphic Designer's Market* is published only once a year, submissions are kept on file for the upcoming edition until selections are made. Material is then returned by SASE if requested." Pays $50 to holder of reproduction rights and free copy of *Artist's & Graphic Designer's Market* when published.

✓ **ASSOCIATION OF COLLEGE UNIONS INTERNATIONAL**, One City Centre, 120 W. Seventh St., Suite 200, Bloomington IN 47404-3925. (812)855-8550. Fax: (812)855-0162. E-mail: kcarnaha@indiana.edu. Website: http://www.acui.web.oxc. Interim Production Manager: Kelly Carnahan. Estab. 1914. Professional education association. Publishes hardcover and trade paperback originals. Specializes in multicultural issues, creating community on campus, union and activities programming, managing staff, union operations, and professional and student development.

● This association also publishes a magazine (see Magazines section for listing). Note that most illustration and design are accepted on a volunteer basis. This is a good market if you're just looking to build or expand your portfolio.

Needs: "We are a volunteer-driven association. Most people submit work on that basis." Uses freelancers mainly for illustration. Works on assignment only.

First Contact & Terms: Send query letter with tearsheets. Samples are filed. Reports back to the artist only if interested. Negotiates rights purchased. Originals are returned at job's completion.

Book Design: Assigns 2 freelance design jobs/year.

Tips: Looking for color transparencies of college student union activities.

✓ **ATHENEUM BOOKS FOR YOUNG READERS**, 1230 Avenue of the Americas, New York NY 10020. (212)698-2781. Designer/Art Assistant: Andrea Levy. Imprint of Simon & Schuster. Imprint publishes hardcover originals, picture books for young kids, nonfiction for ages 8-12. Types of books include biography, fantasy, historical fiction, history, instructional, nonfiction, and reference for preschool, juvenile and young adult. Publishes 400 titles/year. Recent titles include: *Shiloh Season*, *Summertime Song* and *Plains Warrior*. 100% requires freelance illustration; 15% requires freelance design. Book catalog free by request.

Needs: Approached by hundreds of freelance artists/year. Works with 40-60 freelance illustrators and 3-5 designers/year. Buys 40 freelance illustrations/year. "We are interested in artists of varying media and are trying to cultivate those with a fresh look appropriate to each title." 90% of freelance work demands knowledge of Adobe Illustrator 7.0, QuarkXPress 3.31 and Adobe Photoshop 4.0. Works on assignment only.

First Contact & Terms: Send postcard sample of work or send query letter with tearsheets, résumé and photocopies. Samples are filed. Portfolios may be dropped off every Thursday between 9 a.m. and noon. Art Director will contact artist for portfolio review if interested. Portfolio should include final art if appropriate, tearsheets and folded & gathered sheets from any picture books you've had published. Rights purchased vary according to project. Originals are returned at job's completion. Finds artists through submissions, magazines ("I look for interesting editorial illustrators"), word of mouth.

Book Design: Assigns 2-5 freelance design jobs/year. Pays by the project, $750-1,500.

Jackets/Covers: Assigns 1-2 freelance design and 20 freelance illustration jobs/year. Pays by the project, $1,200-1,800. "I am not interested in generic young adult illustrators."

Text Illustration: Pays by the project, $500-2,000.

N ✓ **ATLAS GAMES**, P.O. Box 131233, Roseville MN 55113-1233. (651)638-0077. Fax: (651)638-0084. E-mail: atlasgames@aol.com. Website: http://www.atlas-games.com. President: John Nephew. Publishes roleplaying game books, game/trading cards and board games. Main style/genre of games: fantasy, horror, historical (medieval). Uses freelance artists mainly for b&w interior illustrations. Publishes 8 titles or products/year. Game/product lines include: *Ars Magica*, *Over the Edge*, *Once Upon A Time*, *Lunch Money*, *Cults Across America* and *Unknown Armies*. 100% requires freelance illustration; 5% requires freelance design. Request art guidelines by mail or on website.

Needs: Approached by 100 illustrators and 10 designers/year. Works with 6 illustrators and 1 designer/year. 100% of freelance design demands knowledge of Adobe Photoshop and QuarkXPress.

First Contact & Terms: Illustrators send 6-12 printed samples, photocopies, photographs or tearsheets. Samples are filed. Reports back within 2 months. Will contact artist for portfolio review if interested. Negotiates rights purchased. Finds freelancers through submissions and referrals.

Visual Design: Assigns 1 freelance design job/year.

Book Covers/Posters/Cards: Assigns 4 illustration jobs/year. Pays $200-300 for cover art. Pays for design by the project, $100-300.

Text Illustration: Assigns 20 freelance text illustration jobs/year. Pays by the full page, $40-50. Pays by the half page, $20-25.

Tips: "Please include a SASE."

AUGSBURG FORTRESS PUBLISHERS, Box 1209, 100 S. Fifth St., Suite 700, Minneapolis MN 55402. (612)330-3300. Contact: Director of Design, Design Services. Publishes hard cover and paperback Protestant/Lutheran books (90 titles/year), religious education materials, audiovisual resources, periodicals. Recent titles include *Ecotheraphy*, by Howard Clinebell; and *Thistle*, by Walter Wangerin.

Needs: Uses freelancers for advertising layout, design, illustration and circulars and catalog cover design. Freelancers should be familiar with QuarkXPress 3.31, Adobe Photoshop 3.0 and Adobe Illustrator 5.0.

First Contact & Terms: "Majority, but not all, of our freelancers are local." Works on assignment only. Reports back on future assignment possibilities in 5-8 weeks. Call, write or send brochure, flier, tearsheet, good photocopies and 35mm transparencies; if artist is not willing to have samples filed, they are returned by SASE. Buys all rights on a work-for-hire basis. May require designers to supply overlays on color work.

Jackets/Covers: Uses designers primarily for cover design. Pays by the project, $600-900. Prefers covers on disk using QuarkXPress.

Text Illustration: Negotiates pay for 1-, 2- and 4-color. Generally pays by the project, $25-500.

Tips: Be knowledgeable "of company product and the somewhat conservative contemporary Christian market."

N: ✦ AVALANCHE PRESS, LTD., P.O. Box 100852, Birmingham AL 35210-0852. (205)957-0017. Fax: (205)957-0016. E-mail: avlchpress@aol.com. Website: http://www.avalanchepress.com. Art Director: Brien J. Miller. Estab. 1993. Publishes roleplaying game books, game/trading cards, posters/calendars and board games. Main style/ genre of games: science fiction, fantasy, humor, Victorian, historical, military and mythology. Uses freelance artists for "most everything." Publishes 14 titles or products/year. Game/product lines include: *Airlines* and *Great War at Sea*. 70% requires freelance illustration; 10% requires freelance design; 20% requires freelance art direction.

Needs: Approached by 50 illustrators and 150 designers/year. Works with 4 illustrators and 1 designer/year. Prefers local illustrators. Prefers freelancers experienced in professional publishing. 90% of freelance design demands knowledge of Adobe Illustrator. 30% of freelance illustration demands knowledge of PageMaker and QuarkXPress.

First Contact & Terms: Send query letter with résumé and SASE. Send printed samples and photographs. Send Mac format submissions via SyQuest or floppy disk. Samples are not filed and are not returned. Will contact artist for portfolio review if interested. Buys all rights.

Visual Design: Assigns 8-12 freelance design and 1-4 art direction projects/year. Pays by the project.

Book Covers/Posters/Cards: Assigns 10-12 illustration jobs/year. Pays by the project.

Tips: "We need people who want to work with us and have done their homework. Study our product lines and do not send us blanket, mass-mailed queries."

AVON BOOKS, 1350 Avenue of the Americas, New York NY 10019. (212)261-6888. Fax: (212)261-6925. Art Director: Tom Egner. Estab. 1941. Publishes hardcover, trade and mass market paperback originals and reprints. Types of books include adventure, biography, cookbooks, fantasy, history, horror, humor, juvenile, mainstream fiction, New Age, nonfiction, romance, science fiction, self-help, travel, young adult. Specializes in romance, mystery, upscale fiction. Publishes 400-450 titles/year. Recent titles include: *Love Me Forever*, by Johanna Lindsey; *Sanctuary*, by Faye Kellerman. 85% requires freelance illustration; 10% requires freelance design.

Needs: Approached by 150 illustrators and 25 designers/year. Works with 125 illustrators and 5-10 designers/year. Prefers freelancers experienced in illustration. Uses freelancers mainly for illustration. 80% of freelance design and 5% of freelance illustration demands knowledge of Adobe Photoshop, Adobe Illustrator and QuarkXPress.

First Contact & Terms: Designers send query letter with slides, tearsheets, transparencies. Illustrators send postcard sample and/or query letter with printed samples, slides, tearsheets and transparencies. Accepts disk submissions from designers, not illustrators, compatible with QuarkXPress 7.5, version 3.3. Send EPS files. Samples are filed or returned. Reports back within days if interested. Portfolios may be dropped off every Thursday. Will contact for portfolio review of slides and transparencies of work in all genres if interested. Rights purchsed vary according to project.

Book Design: Assigns 25 freelance design jobs/year. Pays by the project, $700-1,500.

Jackets/Covers: Assigns 25 freelance design jobs and 325 illustration jobs/year. Pays for design by the project, $700-1,500. Pays for illustration by the project, $1,000-5,000. Prefers all mediums.

BAEN BOOKS, Box 1403, Riverdale NY 10471. (718)548-3100. Website: http://baen.com. Publisher: Jim Baen. Editor: Toni Weisskopf. Estab. 1983. Publishes science fiction and fantasy. Publishes 84-96 titles/year. Titles include: *A Boy and His Tank*, by Leo Frankowski; and *Four and Twenty Blackbirds*, by Mercedes Lackey. 75% requires freelance illustration; 80% requires freelance design. Book catalog free on request.

First Contact & Terms: Approached by 500 freelancers/year. Works with 10 freelance illustrators and 3 designers/

year. 50% of work demands computer skills. Designers send query letter with résumé, color photocopies, tearsheets (color only) and SASE. Illustrators send query letter with color photocopies, SASE, slides and tearsheets. Samples are filed. Originals are returned to artist at job's completion. Buys exclusive North American book rights.

Jackets/Covers: Assigns 64 freelance design and 64 illustration jobs/year. Pays by the project—$200 minimum, design; $1,000 minimum, illustration.

Tips: Wants to see samples within science fiction, fantasy genre only. "Do not send black & white illustrations or surreal art. Please do not waste our time and your postage with postcards. Serious submissions only."

☑ BANDANNA BOOKS, 319-B Anacapa St., Santa Barbara CA 93101. Fax: (805)564-3278. E-mail: bandanna@b andannabooks.com. Website: http://www.bandannabooks.com. Publisher: Sasha Newborn. Estab. 1981. Publishes non-fiction trade paperback originals and reprints. Types of books include classics and self-help books for college freshmen. Publishes 3 titles/year. Recent titles include *Benigna Machiavelli*, by Charlotte Perkins Gilman; *Italian for Opera Lovers*; and *Don't Panic: The Procrastinator's Guide to Writing an Effective Term Paper*, by Steven Posusta.

● We have focused on college freshmen, their teachers, their parents—with special interest in distance learning, independent study, writing and learning disabilities.

Needs: Approached by 150 freelancers/year. Uses illustrators mainly for b&w woodblock or scratchboard and pen & ink art. Also for cover and text illustration.

First Contact & Terms: Send postcard sample or query letter with samples. Samples are filed and are returned by SASE only if requested. Reports back within 2 months if interested. Originals are not returned. To show portfolio mail thumbnails and sample work. Considers project's budget when establishing payment.

Jackets/Covers: Pays by the project, $50-200.

Text Illustration: Pays by the project, $50-200. Prefers b&w.

Tips: "Include at least five samples in your submission. Make sure samples are generally related to our topics published. We're interested in work that is innovative without being bizarre, quality without looking too 'slick' or commercial. Simplicity is are important. We are not interested in New Age or fantasy work. Book illustration does not have to be center stage; some of the finest work blends into the page, or is ornamental."

☑ BEDFORD/ST. MARTIN'S, (formerly Bedford Books of St. Martin's Press), 75 Arlington St., Boston MA 02116. (617)426-7440. Fax: (617)426-8582. Advertising and Promotion Manager: Hope Tompkins; Art Director: Donna Dennison. Estab. 1981. Publishes college textbooks. English, history, political science and communications. Publishes 40 titles/year. Recent titles include *A Writer's Reference, Fourth Edition*; *The Bedford Handbook*, Fifth Edition; *The American Promise*; *Literature and Its Writers*. Books have "contemporary, classic design." 5% require freelance illustration; 90% require freelance design.

Needs: Approached by 25 freelance artists/year. Works with 2-4 illustrators and 6-8 designers/year. Buys 2-4 illustrations/year. Prefers artists with experience in book publishing. Uses freelancers mainly for cover and brochure design. Also for jacket/cover and text illustration and book and catalog design. 75% of design work demands knowledge of Adobe PageMaker, QuarkXPress, MacromediaFreeHand, Adobe Photoshop or Adobe Illustrator.

First Contact & Terms: Send query letter with brochure, tearsheets and SASE. Samples are filed or are returned by SASE if requested by artist. Reports back only if interested. Request portfolio review in original query. Art Director will contact artists for portfolio review if interested. Portfolio should include roughs, original/final art, color photostats and tearsheets. Rights purchased vary according to project. Interested in buying second rights (reprint rights) to previously published work. Originals are returned at job's completion.

Jackets/Covers: Assigns 40 design jobs and 2-4 illustration jobs/year. Pays by the project. Finds artists through magazines, self-promotion and sourcebooks. Contact: Donna Dennison.

Tips: "Regarding book cover illustrations, we're usually interested in buying reprint rights for artistic abstracts or contemporary, multicultural scenes and images of writers and writing-related scenes (i.e. desks with typewriters, paper, open books, people reading, etc.)."

ROBERT BENTLEY PUBLISHERS, 1734 Massachusetts Ave., Cambridge MA 02138-1804. (617)547-4170. Website: http://www.rb.com. Publisher: Michael Bentley. Publishes hardcover originals and reprints and trade paperback originals—reference books. Specializes in automotive technology and automotive how-to. Publishes 20 titles/year. Recent titles include *Jeep Owner's Bible* and *Unbeatable BMW*. 50% require freelance illustration; 50% require freelance design and layout. Book catalog for 9×12 SAE.

Needs: Works with 5-10 illustrators and 15-20 designers/year. Buys 1,000 illustrations/year. Prefers artists with "technical illustration background, although a down-to-earth, user-friendly style is welcome." Uses freelancers for jacket/cover illustration and design, text illustration, book design, page layout, direct mail and catalog design. Also for multimedia projects. 100% of design work requires computer skills. Works on assignment only.

First Contact & Terms: Send query letter with résumé, SASE, tearsheets and photocopies. Accepts disk submissions.

 A CHECKMARK PRECEDING A LISTING indicates a change in either the address or contact information since the 1999 edition.

Samples are filed. Reports in 3-5 weeks. To show portfolio, mail thumbnails, roughs and b&w tearsheets and photographs. Buys all rights. Originals are not returned.

Book Design: Assigns 10-15 freelance design and 20-25 illustration jobs/year. Pays by the project.

Jackets/Covers: Pays by the project.

Text Illustration: Prefers Adobe Illustrator files.

Tips: "Send us photocopies of your line artwork and résumé."

[N] [icon] BINARY ARTS CORP., 1321 Cameron St., Alexandria VA 22314. (703)549-4999. Fax: (703)549-6210. E-mail: manderson@puzzles.com. Website: http://puzzles.com. Graphic Design Director: Marty Anderson. Estab. 1985. Publishes graphic novels, game/trading cards, newsletter, board games, grid games and puzzles. Main style/genre of games: science fiction, fantasy, humor and education. Uses freelance artists mainly for illustration. Publishes 7-10 titles or products/year. Game/product lines include: *Grid Games*, *Illusions* and *Stacking Puzzles*. 100% requires freelance illustration; 50% requires freelance design.

Needs: Approached by 20 illustrators and 20 designers/year. Works with 5 illustrators and 3 designers/year. Sometimes prefers local illustrators. Prefers freelancers experienced in Illustrator, Freehand, Quark. 100% of freelance design demands knowledge of Adobe Illustrator, Aldus FreeHand, Adobe Photoshop and QuarkXPress. 100% of freelance illustration demands knowledge of Adobe Illustrator and Aldus FreeHand.

First Contact & Terms: Send self-promotion postcard sample and follow-up postcard. Illustrators send 10-20 printed samples and tearsheet. Accepts disk submissions in Mac format. Send via CD or Zip as EPS, TIFF, GIF or JPEG files. Samples are filed. Reports back only if interested. Will contact artist for portfolio review if interested. Buys all rights. Finds freelancers through referrals, *Black Book* etc.

Visual Design: Assigns 20 freelance design jobs/year.

Book Covers/Posters/Cards: Assigns 5 freelance design jobs and 5 illustration jobs/year. Pays for illustration by the project

[N] BOOK DESIGN, Box 193, Moose WY 83012. Art Director: Robin Graham. Specializes in hardcover and paperback originals of nonfiction, natural history. Publishes more than 3 titles/year. Recent titles include *Tales of the Wolf*, *Wildflowers of the Rocky Mountains*, *Mattie: A Woman's Journey West*, *Teton Skiing* and *Bonney's Guide to Jackson's Hole*.

Needs: Works with 20 freelance illustrators and 10 designers/year. Works on assignment only. "We are looking for top-notch quality only." 90% of freelance work demands knowledge of Aldus PageMaker and Aldus FreeHand.

First Contact & Terms: Send query letter with "examples of past work and one piece of original artwork which can be returned." Samples not filed are returned by SASE if requested. Reports back within 20 days. Originals are not returned. Write for appointment to show portfolio. Negotiates rights purchased.

Book Design: Assigns 6 freelance design jobs/year. Pays by the project, $50-3,500.

Jackets/Covers: Assigns 2 freelance design and 4 illustration jobs/year. Pays by the project, $50-3,500.

Text Illustration: Assigns 26 freelance jobs/year. Prefers technical pen illustration, maps (using airbrush, overlays etc.), watercolor illustration for children's books, calligraphy and lettering for titles and headings. Pays by the hour, $5-20, or by the project, $50-3,500.

BROOKS/COLE PUBLISHING COMPANY, 511 Forest Lodge Rd., Pacific Grove CA 93950. (408)373-0728. Website: http://www.brookscole.com. Art Director: Vernon T. Boes. Art Editor: Lisa Torri. Estab. 1967. Specializes in hardcover and paperback college textbooks on mathematics, chemistry, earth sciences, physics, computer science, engineering and statistics. Publishes 100 titles/year. 85% requires freelance illustration. Books are bold, contemporary textbooks for college level.

Needs: Works with 25 freelance illustrators and 25 freelance designers/year. Uses freelance artists mainly for interior illustration. Uses illustrators for technical line art and covers. Uses designers for cover and book design and text illustration. Also uses freelance artists for jacket/cover illustration and design. Works on assignment only.

First Contact & Terms: Send query letter with brochure, résumé, tearsheets and photographs. Samples are filed or are returned by SASE. Art Director will contact artist for portfolio review if interested. Portfolio should include roughs, tearsheets, final reproduction/product, photographs, slides and transparencies. Considers complexity of project, skill and experience of artist, project's budget and turnaround time in determining payment. Negotiates rights purchased. Not interested in second rights to previously published work unless first used in totally unrelated market. Finds illustrators and designers through word of mouth, magazines, submissions/self promotion, sourcebooks, and agents.

Book Design: Assigns 70 design and many illustration jobs/year. Pays by the project, $500-2,000.

Jackets/Covers: Assigns 90 design and many illustration jobs/year. Pays by the project, $500-1,500.

Text Illustration: Assigns 85 freelance jobs/year. Prefers ink/Macintosh. Pays by the project, $20-2,000.

Tips: "Provide excellent package in mailing of samples and cost estimates. Follow up with phone call. Don't be pushy. Would like to see abstract and applied photography/illustration; single strong, memorable bold images."

[N] [icon] [icon] THE BUREAU FOR AT-RISK YOUTH, 135 Dupont St., P.O. Box 760, Plainview NY 11803-0760. (516)349-5520. Fax: (516)349-5521. E-mail: info@at-risk.com. Website: http://www.at-risk.com. Editor-in-Chief: Sally Germain. Estab. 1991. Publishes CD-ROMs, booklets, pamphlets, posters, video programs, curriculum and educational resources for educators, counselors, children, parents and others who work with youth. Publishes 20-50 titles/year. Recent titles include: *Teen Talk* Prevention Pamphlet Series, *Human Relations* CD-ROM series, *Do the Right Thing*

CD-ROM series, *Warning Signs* poster series and *Mentoring Works!* curriculum. 30% requires freelance illustrations; 75% requires freelance design. Free Catalog of Resources available with $1.70 in stamps.

Needs: Works with 4 illustrators/year and 6 designers/year. Prefers local designers/illustrators, but not required. Prefers freelancers experienced in educational/youth materials. Freelance design demands knowledge of Adobe Photoshop and QuarkXPress. Illustration demands knowledge of Adobe Illustrator, Adobe Photoshop and QuarkXPress.

First Contact & Terms: Send query letter with photocopies and SASE. Accepts Mac-compatible disk submissions. Send EPS files. Samples are filed. Reports back only if interested; will return materials if SASE sent and requested. Portfolio review not required initially. Rights purchased vary according to project. Finds freelancers through word of mouth and networking.

Jackets/Covers: Payment either by hour or by project, but depends on specific project.

N ▪ CACTUS GAME DESIGN, INC., 1553 S. Military Hwy., Suite 101, Chesapeake VA 23320. (757)366-9907. Fax: (757)366-9913. E-mail: cactusrob@aol.com. Website: http://ww.cactusmarketing.com. Art Director: Rob Anderson. Estab. 1995. Publishes comic books, game/trading cards, posters/calendars, CD-ROM/online games and board games. Main style/genre of games: science fiction, fantasy and Biblical. Uses freelance artists mainly for illustration. Publishes 2-3 titles or products/year. Game/product lines include: *Redemption CCG*, *Game of Scattergories Bible Edition*, *Bible Outburst*, *Angel War* comics and *Saints of Virtue* (CD-ROM game). 100% requires freelance illustration; 100% requires freelance design.

Needs: Approached by 50 illustrators and 5 designers/year. Works with 20 illustrators and 1 designer/year. Prefers freelancers experienced in fantasy and Biblical art. 100% of freelance design demands knowledge of Corel Draw, Adobe Photoshop and QuarkXPress.

First Contact & Terms: Send query letter with résumé and photocopies. Accepts disk submissions in Windows format. Send via CD, floppy disk, Zip as TIFF, GIF or JPEG files. Samples are filed. Reports back only if interested. Portfolio review not required. Rights purchased vary according to project. Finds freelancers through submission packets and word of mouth.

Visual Design: Assigns 100-150 freelance design jobs/year. Pays for design by the hour, $20.

Book Covers/Posters/Cards: Pays for illustration by the project, $25-250. "Artist must be aware of special art needs associated with Christian retail environment."

Tips: "We like colorful action shots."

✔ CANDLEWICK PRESS, 2067 Massachusetts Ave., Cambridge MA 02140. (617)661-3330. Associate Art Director: Ann Stolt. Estab. 1992. Imprints include Walker Books, London. Publishes hardcover, trade paperback and mass market paperback originals. Publishes biography, history, humor, juvenile, young adult. Specializes in children's books. Publishes 170 titles/year. Recent titles include: *Westandia* and the *Maisy* books. 100% requires freelance illustration. Book catalog not available.

Needs: Approached by 400 illustrators and 30 designers/year. Works with 170 illustrators and 1-2 designers/year. 100% of freelance design demands knowledge of Adobe Photoshop, Adobe Illustrator or QuarkXPress.

First Contact & Terms: Designers send query letter with résumé. Illustrators send query letter with photocopies. Accepts non-returnable disk submissions from illustrators. Samples are filed and are not returned. Will contact artist for portfolio review of artwork of characters in sequence, tearsheets if interested. Buys all rights or rights purchased vary according to project.

Text Illustration: Finds illustrators through agents, sourcebooks, word of mouth, submissions.

Tips: "We generally use illustrators with prior trade book experience."

N CANDY CANE PRESS, Ideals Publications Inc., 535 Metroplex Dr., Suite 250, Nashville TN 37211. (615)781-1420. Fax: (615)781-1447. E-mail: pingry103@aol.com. Designer: Eve DeGrie. Publisher: Patricia Pingry. Estab. 1996. Publishes hardcover and trade paperback originals. Types of books include children's picture books, juvenile and preschool. Publishes 10 titles/year. Recent titles include *The Story of Easter* (boardbook) and *Barefoot Days: Poems of Childhood*. 100% requires freelance illustration; 25% requires freelance design.

Needs: Works with 10 illustrators/year. 100% of freelance design demands knowledge of Adobe Photoshop and QuarkXPress.

First Contact & Terms: Designers and illustrators send postcard sample or query letter with photocopies and SASE. Portfolio review not required. Negotiates rights purchased; rights purchased vary according to project. Finds freelancers through agents, networking events sponsored by graphic arts organizations, sourcebooks and illustration annuals, design magazines and word of mouth.

Book Design: Assigns 6 freelance design jobs/year. Pays by the project.

Jackets/Covers: Pays by the project.

Tips: "We are looking for multicultural people and art with some humor and different styles."

▪ CARTWHEEL BOOKS, Imprint of Scholastic, Inc., 555 Broadway, New York NY 10012-3999. Art Director: Edith T. Weinberg. Estab. 1990. Publishes mass market and trade paperback originals. Types of books include children's picture books, instructional, juvenile, preschool, novelty books. Specializes in books for very young children. Publishes 100 titles/year. 100% requires freelance illustration; 25% requires freelance design; 5% requires freelance art direction. Book catalog available for SAE with first-class stamps.

Needs: Approached by 500 illustrators and 50 designers/year. Works with 75 illustrators, 5 designers and 3 art directors/

year. Prefers local designers. 100% of freelance design demands knowledge of QuarkXPress.

First Contact & Terms: Designers send query letter with printed samples, photocopies, SASE. Illustrators send postcard sample or query letter with printed samples, photocopies and follow-up postcard every 2 months. Samples are filed. Reports back within 1 month. Will contact artist for portfolio review of artwork portraying children and animals, artwork of characters in sequence, tearsheets if interested. Rights purchased vary according to project. Finds freelancers through submissions on file, reps.

Book Design: Assigns 10 freelance design and 2 art direction projects/year. Pays for design by the hour, $30-50; art direction by the hour, $35-50.

Text Illustration: Assigns 200 freelance illustration jobs/year. Pays by the project, $500-10,000.

Tips: "I need to see cute fuzzy animals, young, lively kids, and/or clear depictions of objects, vehicles and machinery."

CCC PUBLICATIONS, 9725 Lurline Ave., Chatsworth Park CA 91311. (818)718-0507. Fax: (818)718-0655. Editorial Director: Cliff Carle. Estab. 1984. Company publishes trade paperback originals and manufactures accessories (T-shirts, mugs, caps). Types of books include self-help and humor. Specializes in humor. Publishes 50 titles/year. Recent titles include *The Better Half*, by Randy Glasbergen; and *Golfaholics*, by Bob Zahn. 90% require freelance illustration; 90% require freelance design. Book catalog free for SAE with $1 postage.

Needs: Approached by 200 freelancers/year. Works with 20-30 freelance illustrators and 10-20 designers/year. Buys 100 freelance illustrations/year. Prefers artists with experience in humorous or cartoon illustration. Uses freelancers mainly for color covers and b&w interior drawings. Also for jacket/cover and book design. 80% of design and 50% of illustration demands computer skills.

First Contact & Terms: Send query letter with samples, résumé, SASE. Samples are filed or are returned by SASE if requested by artist. Reports back only if interested. Art Director will contact artist for portfolio review if interested. Portfolio should include b&w and color samples. Rights purchased vary according to project. Finds artists through agents and unsolicited submissions.

Book Design: Assigns 30 freelance design jobs/year. Pay negotiated based on artist's experience and notoriety.

Jackets/Covers: Assigns 30 freelance design and 30 illustration jobs/year. Pay negotiated on project by project basis.

Text Illustration: Assigns 30 freelance illustration jobs/year. Pay negotiated.

Tips: First-time assignments are usually b&w text illustration; cover illustration is given to "proven" freelancers. "Sometimes we offer royalty points and partial advance. Also, cartoon characters should have 'hip' today look. Be original"

CELO VALLEY BOOKS, 346 Seven Mile Ridge Rd., Burnsville NC 28714. Production Manager: Diana Donovan. Estab. 1987. Publishes hardcover originals and trade paperback originals. Types of books include biography, juvenile, mainstream fiction and nonfiction. Publishes 3-5 titles/year. Recent titles include: *Quaker Profiles*. 5% require freelance illustration.

Needs: Approached by 5 illustrators/year. Works with 1 illustrator every 3 years. Prefers local illustrators. Uses freelancers mainly for working with authors during book design stage.

First Contact & Terms: Illustrators send query letter with photocopies. Send follow-up postcard every year. Samples are filed. Reports back only if interested. Negotiates rights purchased.

Jackets/Covers: Assigns 1 freelance job every 3 years or so. Pay negotiable. Finds freelancers mostly through word of mouth.

Tips: "Artist should be able to work with authors to fit ideas to production."

THE CENTER FOR WESTERN STUDIES, Box 727, Augustana College, Sioux Falls SD 57197. (605)336-4007. Website: http://inst.angie.edu/CWS/. Managing Editor: Harry F. Thompson. Estab. 1970. Publishes hardcover originals and trade paperback originals and reprints. Types of books include western history. Specializes in history and cultures of the Northern Plains, especially Plains Indians, such as the Sioux and Cheyenne. Publishes 2-3 titles/year. Recent titles include *What It Took: A History of the USGS Eros Data Center*; and *The Lizard Speaks: Essays on the Writings of Frederick Manfred*. 75% require freelance design. Books are conservative, scholarly and documentary. Book catalog free by request.

Needs: Approached by 4 freelancers/year. Works with 1-2 freelance designers and 1-2 illustrators/year. Uses freelancers mainly for cover design. Also for book design and text illustration. 25% of freelance work demands knowledge of QuarkXPress. Works on assignment only.

First Contact & Terms: Send query letter with résumé, SASE and photocopies. Samples are filed. Request portfolio review in original query. Reports back only if interested. Portfolio should include roughs and final art. Sometimes requests work on spec before assigning a job. Rights purchased vary according to project. Originals are not returned. Finds illustrators and designers through word of mouth and submissions/self promotion.

Book Design: Assigns 1-2 freelance design jobs/year. Pays by the project, $500-750.

Jackets/Covers: Assigns 1-2 freelance design jobs/year. Pays by the project, $250-500.

Text Illustration: Pays by the project, $100-500.

Tips: "We are a small house, and publishing is only one of our functions, so we usually rely on the work of graphic artists with whom we have contracted previously. Send samples."

CENTERSTREAM PUBLISHING, P.O. Box 17878, Anaheim Hills CA 92807. (714)779-9390. E-mail: centerstrm@ aol.com. Production: Ron Middlebrook. Estab. 1978. Publishes audio tapes and hardcover originals. Types of books

include history, self help, music history and instruction. Publishes 10-20 titles/year. Recent titles include: *Essential Blues Guitar, 300 Fiddle Tunes, Irish and American Fiddle Tunes for Harmonica, Jazz Saxophone* (video) and *Hawaiian Ukulele, The Early Methods*. 100% requires freelance illustration. Book catalog free for 6×9 SAE with 2 first-class stamps.

Needs: Approached by 12 illustrators/year. Works with 3 illustrators/year.

First Contact & Terms: Illustrators send postcard sample or tearsheets. Accepts Mac-compatible disk submissions. Samples are not filed and are returned by SASE. Reports back only if interested. Buys all rights or rights purchased vary according to project.

Tips: "Publishing is a quick way to make a slow buck."

CHARLESBRIDGE PUBLISHING, 85 Main St., Watertown MA 02472. E-mail: books@charlesbridge.com. Website: http://www.charlesbridge.com. Senior Editor: Harold Underdown. Estab. 1980. Publishes hardcover and softcover children's trade picture books: nonfiction and a small fiction line. Publishes 25 titles/year. Recent titles include *Counting Is for the Birds*, by Frank Mazzola and *Turn of the Century*, by Ellen Jackson. Books are "realistic art picture books depicting people, outdoor places and animals."

Needs: Works with 5-10 freelance illustrators/year. "Specializes in detailed, color realism, although other styles are gladly reviewed."

First Contact & Terms: Send résumé, tearsheets and photocopies. Samples not filed are returned by SASE. Reports back only if interested. Originals are not returned. Considers complexity of project and project's budget when establishing payment. Buys all rights.

Text Illustration: Assigns 5-10 jobs/year. Pays by the project: flat fee or royalty with advance.

N ⬛ CHATHAM PRESS, INC., P.O. Box A, Old Greenwich CT 06870. (203)531-7755. Art Director: Arthur G.D. Mark. Estab. 1971. Publishes hardcover originals and reprints, trade paperback originals and reprints. Types of books include coffee table books, cookbooks, history, nonfiction, self help, travel, western, political, Irish and photographic. Publishes 12 titles/year. Recent titles include: *Exploring Old Cape Cod* and *Photographers of New England*. 5% requires freelance illustration; 5% requires freelance design; 5% requires freelance art direction. Book catalog free for 7×10 SASE with 4 first-class stamps.

Needs: Approached by 16 illustrators and 16 designers/year. Works with 2 illustrators, 2 designers and 2 art directors/year. Prefers local illustrators and designers.

First Contact & Terms: Send query letter with photocopies and SASE. Samples are not filed and are returned by SASE. Reports back within 2 months. Will contact artist for portfolio review if interested. Negotiates rights purchased. Finds freelancers through word of mouth and individual contacts.

Jackets/Covers: Assigns 4 freelance design jobs and 1 illustration job/year. Pays for design by the project. Pays for illustration by the project.

Tips: "We accept and look for contrast (black & whites rather than grays), simplicity in execution, and immediate comprehension (i.e., not cerebral, difficult-to-quickly-understand) illustrations and design. We have one tenth of a second to capture our potential customer's eyes—book jacket—art must help us do that."

CHELSEA HOUSE PUBLISHERS, 1974 Sproul Rd., Suite 204, Broomall PA 19008-0914. (610)353-5166, ext. 186. Fax: (610)353-5191. Art Director: Sara Davis. Estab. 1973. Publishes hardcover originals and reprints. Types of books include biography, history, juvenile, reference, young adult. Specializes in young adult literary books. Publishes 150 titles/year. Recent titles include: *Women Writers of English & Their Works, Overcoming Adversity* (series includes Tim Allen, Roseanne, Bill Clinton). 85% requires freelance illustration; 30% requires freelance design; 10% requires freelance art direction. Book catalog not available.

Needs: Approached by 100 illustrators and 50 designers/year. Works with 25 illustrators, 10 designers, 5 art directors/year. Prefers freelancers experienced in Macintosh computer for design. 100% of freelance design demands knowledge of Adobe Photoshop, QuarkXPress. 20% of freelance illustration demands knowledge of Adobe Illustrator, Adobe Photoshop, QuarkXPress.

First Contact & Terms: Designers send query letter with non-returnable printed samples, photocopies. Illustrators send postcard sample and follow-up postcard every 3 months. Accepts Mac-compatible disk submissions. Samples are filed and are not returned. Will contact artist for portfolio review if interested. Buys first rights. Finds freelancers through networking, submissions, agents and *American Showcase*.

Book Design: Assigns 25 freelance design and 5 art direction projects/year. Pays for design by the hour, $15-35; for art direction by the hour, $25-45.

Jackets/Covers: Assigns 50 freelance design jobs and 150 illustration jobs/year. Prefers oil, acrylic. Pays for design by the hour, $25-35. Pays for illustration by the project, $650-850. Prefers portraits that capture close likeness of a person.

Tips: "Most of the illustrations we purchase involve capturing an exact likeness of a famous or historical person. Full color only, no black & white line art. Please send non-returnable samples only."

CHERUBIC PRESS, P.O. Box 5036, Johnstown PA 15904-5036. (814)535-4300. E-mail: cherubicpr@aol.com. Website: http://members.aol.com/cherubicpr/index.html. Senior Editor: Juliette Gray. Art Coordinator: William Morgan. Estab. 1995. Publishes quality hardcover collections and paperback originals. Publishes specialty cookbooks, instructional, juvenile, New Age, preschool picture books, ethnic and self-help. Specializes in "anything that uplifts, inspires

or is self-help." Publishes 3-6 titles/year. Recent titles include *Storybook of Native American Wisdom*, by Donna Clovis; and *Cherubic's Classic Storybook*, by 30 different authors. 90% require freelance illustration; 10% require freelance design. Book catalog free for 4×9½ SASE with 2 first-class stamps.

Needs: Approached by 50 freelancers/year. Works with 30 freelance illustrators and 1-2 designers/year. Commissions 50-90 illustrations/year. Uses freelancers mainly for illustrating children's picture books. Also for jacket/cover design and illustration and text illustration. Works on assignment only.

First Contact & Terms: Send query letter with résumé, SASE and photocopies. Samples are filed or returned by SASE. Reports back within 1-2 months. Will contact for portfolio review if interested. Buys first/all rights.

Jackets/Covers: Assigns 3-4 freelance design and 3-4 illustration jobs/year. Pays by the project, $100 minimum.

Text Illustration: Assigns 50-90 freelance illustration jobs/year. Pays by the project, $100 minimum.

Tips: "Cherubic Press is small so we can't pay big bucks but we can get you published and on your way! Show us your style—send photocopies of your pen & ink, pencil or charcoal portraits capturing the expressions of children and their parents, grandparents. We need to see emotion on the subjects' faces and in their body postures. Also send a few other examples such as animals, a house, 'whatever,' so we get the feeling of your work. Always send pen and ink examples of your work since this is the medium we use the most."

☑ **CHICAGO REVIEW PRESS**, Dept. AGDM, 814 N. Franklin, Chicago IL 60610. (312)337-0747. Fax: (312)337-5985. E-mail: crp@ipgbook.com. Website: http://www.ipgbook.com. Art Director: Joan Sommers. Editor: Cynthia Sherry. Publishes hardcover and paperback originals. Specializes in trade nonfiction: how-to, travel, cookery, popular science, Midwest regional. Publishes 12 titles/year. Recent titles include *Leonardo Da Vinci for Kids*; *The Hemingway Cookbook*; and *Classical Kids*. 30% require freelance illustration; 100% require jacket cover design.

• This press has two new imprints. Lawrence Hill Books publishes titles of black interest and Acappella Books covers the performing arts.

Needs: Approached by 50 freelancers/year. Works with 15 freelance illustrators and 5 designers/year. Uses freelancers for jacket/cover illustration and design, text illustration. 100% of design and 10% of illustration demand knowledge of QuarkXPress, Adobe Photoshop and Adobe Illustrator.

First Contact & Terms: Call or send postcard sample or query letter with résumé and color tearsheets. Samples are filed or are returned by SASE. Art Director will contact artist for portfolio review if interested. Call for appointment to show portfolio of tearsheets, final reproduction/product and slides. Considers project's budget when establishing payment. Buys one-time rights. Finds artists through magazines, submissions/self promotions, sourcebooks and galleries.

Jackets/Covers: Assigns 10 freelance design and 10 illustration jobs/year. Pays by project, $500-1,000.

Text Illustration: Pays by the project, $500-3,000.

Tips: "Our books are interesting and innovative. Design and illustration we use is sophisticated, above average and unusual. Fine art has become very marketable in the publishing industry."

◆ **CHILDREN'S BOOK PRESS**, 246 First St., Suite 101, San Francisco CA 94105. (415)995-2200. Fax: (415)995-2222. E-mail: cbookpress@cbookpress.org. Assistant Production Editor: Laura Atkins. Estab. 1975. Publishes hardcover originals and trade paperback reprints. Types of books include juvenile. Specializes in multicultural. Publishes 4-6 titles/year. Recent titles include: *Going Back Home* and *In My Family*. 100% requires freelance illustration and design. Catalog free for 9×6 SASE with 55¢ first-class stamps.

Needs: Approached by 100 illustrators and 20 designers/year. Works with 4-6 illustrators and 3 designers/year. Prefers local designers experienced in QuarkXPress (designers) and previous children's picture book experience (illustrators). Uses freelancers for 32-page picture book design. 100% of freelance design demands knowledge of Adobe Photoshop, Adobe Illustrator and QuarkXPress.

First Contact & Terms: Designers send query letter with brochure, photocopies, photostats, résumé, bio, SASE and tearsheets. Illustrators send postcard sample or query letter with photocopies, photographs, printed samples, résumé, SASE and tearsheets. Reports back within 4-6 months if interested or if SASE is included. Will contact artist for portfolio review if interested. Buys all rights.

Book Design: Assigns 4-6 freelance design jobs/year. Pays by the project.

Text Illustration: Assigns 4-6 freelance illustration jobs/year. Pays royalty.

Tips: "We look for a multicultural experience. We are especially interested in the use of bright colors and non-traditional instructive approach."

CIRCLET PRESS, INC., 1770 Massachusetts Ave., #278, Cambridge MA 02140. (617)864-0492. Fax: (617)864-0663. E-mail: circlet-info@circlet.com. Website: http://www.circlet.com. Publisher: Cecilia Tan. Estab. 1992. Company publishes trade paperback originals. Types of books include science fiction and fantasy. Specializes in erotic science fiction/fantasy. Publishes 8-10 titles/year. Recent titles include: *Sex Magick*, edited by Cecilia Tan; and *The Drag Queen of Elfland*, by Lawrence Schimel. 100% require freelance illustration. Book catalog free for business size SAE with 1 first-class stamp.

• The publisher is currently seeking cover art for anthologies to be published in late 1999 and 2000. Titles include *Wired Hard: Erotica for a Gay Universe*, *Dreams of Dominance*, *Upon a Dungeon* and *Sextopia*.

Needs: Approached by 50-100 freelancers/year. Works with 4-5 freelance illustrators/year. Prefers freelancers with experience in science fiction illustration. Uses freelancers for cover art. Needs computer-literate freelancers for illustration. 100% of freelance work demands knowledge of QuarkXPress or Photoshop. Works on assignment only. 10% of titles require freelance art direction.

First Contact & Terms: Send query letter with color photocopies pitching an idea for specific upcoming books. List of upcoming books available for 33¢ SASE or on website. Ask for "Artists Guidelines." Samples are filed. Reports back only if interested. Portfolio review not required. Buys one-time rights or reprint rights. Originals are returned at job's completion. Finds artists through art shows at science fiction conventions and submission samples. "I need to see human figures well-executed with sensual emotion. No tentacles or gore! Photographs, painting, computer composites all welcomed."

Book Design: Assigns 2-4 freelance design jobs/year. Pays by the project, $100-200.

Jackets/Covers: Assigns 2-4 freelance illustration jobs/year. Pays by the project, $15-100. Now using 4-color and halftones.

Tips: "Follow the instructions in this listing: Don't send me color samples on slides. I have no way to view them. Any jacket and book design experience is also helpful. I prefer to see a pitch idea for a cover aimed at a specific title, a way we can use an image that is already available to fit a theme."

CITY & COMPANY, 22 W. 23rd St., New York NY 10010. (212)366-1988. Fax: (212)242-0415. Publisher: Helene Silver. Estab. 1994. Publishes hardcover originals and trade paperback originals. Types of books include reference. Specializes in New York subjects. Publishes 10-15 titles/year. Recent titles include: *Shop NY: Downtownstyle* and *New York Chocolate Lover's Guide*. 100% require freelance illustration; 100% require freelance design. Catalog available.

Needs: Approached by 25 illustrators and 10 designers/year. Works with 5 illustrators and 2 designers/year. Prefers local freelancers experienced in Quark. Uses freelancers mainly for illustration and design. 100% of freelance design demands knowledge of Adobe Photoshop, Adobe Illustrator and QuarkXPress. 10% of freelance illustration demands computer knowledge.

First Contact & Terms: Illustrators send postcard sample or query letter with photocopies, photographs, photostats, résumé and tearsheets. Samples are filed. Reports back only if interested. Will contact artist for portfolio review of book dummy, photocopies, photographs, photostats and tearsheets. Buys reprint rights.

Book Design: Assigns 10 freelance design jobs/year. Pays by the project, $750-1,500.

Jackets/Covers: Assigns 10 freelance design jobs/year. Pays for design and illustration by the project, $750-1,500.

Text Illustration: Assigns 10 freelance illustration jobs/year. Pays by the project, $250-500. Finds freelancers through agents.

Tips: "Look at our books before sending samples—we have a definite look."

☑ **CLARION BOOKS,** 215 Park Ave., 10th Floor, New York NY 10003. (212)420-5800. Website: http://www.hmco.com/trade/. Imprint of Houghton Mifflin Company. Imprint publishes hardcover originals and trade paperback reprints. Specializes in picture books, chapter books, middle grade novels and nonfiction, including historical and animal behavior. Publishes 60 titles/year. Recent titles include: *Piggie Pie!*, by Margie Palatini, illustrated by Howard Fine. 90% requires freelance illustration. Book catalog free for SASE.

● Publisher of *The Midwife's Apprentice*, by Karen Cushman, 1996 Newberry Award Winner and *Golem*, by David Wisniewski, 1997 Caldecott Award Winner.

Needs: Approached by "countless" freelancers. Works with 48 freelance illustrators/year. Uses freelancers mainly for picture books and novel jackets. Also for jacket/cover and text illustration.

First Contact & Terms: Send query letter with tearsheets and photocopies. Samples are filed "if suitable to our needs." Reports back only if interested. Portfolios may be dropped off every Monday. Art Director will contact artist for portfolio review if interested. Rights purchased vary according to project. Originals are returned at job's completion.

Text Illustration: Assigns 48 freelance illustration jobs/year. Pays by the project.

Tips: "Be familiar with the type of books we publish before submitting. Send a SASE for a catalog or look at our books in the bookstore. Send us children's book-related samples."

CLEIS PRESS, P.O. Box 14684, San Francisco CA 94114. (415)575-4700. Fax: (415)575-4703. E-mail: fdcleis@aol. Website: http://www.cleispress.com. Art Director: Frederique Delacoste. Estab. 1979. Publishes trade paperback originals and reprints. Types of books include comic books, experimental and mainstream fiction, nonfiction and self help. Specializes in lesbian/gay. Publishes 18 titles/year. Recent titles include: *Sexually Speaking: Collected Sex Writings*, by Gore Vidal. 100% requires freelance design. Book catalog free for SAE with 2 first-class stamps.

Needs: Works with 4 designers/year. Prefers local illustrators. Freelance design demands knowledge of Adboe Illustrator, Adobe Photoshop, QuarkXPress.

First Contact & Terms: Designers send postcard sample and follow-up postcard every 6 months or query letter with photocopies. Illustrators send postcard sample or query letter with printed samples, photocopies. Accepts Mac-compatible disk submissions. Send EPS or TIFF files. Samples are filed and are not returned. Will contact artist for portfolio review if interested.

Book Design: Assigns 17 freelance design jobs/year. Pays for design by the project, $500.

Jackets/Covers: Pays for design by the project, $500.

☑ **CLIFFS NOTES INC.,** Box 80728, Lincoln NE 68501. E-mail: linnea@cliffs.com. Website: http://www.cliffs.com. Contact: Linnea Fredrickson. Publishes educational books. Titles include *Cliffs SAT I Preparation Guide* and *Quick Review Microbiology*.

First Contact & Terms: Approached by 30 freelance artists/year. Works on assignment only. Samples returned by

SASE. Reports back on future assignment possibilities. Send brochure, flier and/or résumé. Originals are not returned. Buys all rights.

Text Illustration: Uses technical illustrators for mathematics, science, miscellaneous.

COFFEE HOUSE PRESS, 27 N. Fourth St., Minneapolis MN 55401-1718. (612)338-0125. Fax: (612)338-4004. E-mail: kelly@coffeehousepress.org. Website: http://www.coffeehousepress.org. Design & Production Manager: Kelly Kofron. Publishes hardcover and trade paperback originals. Types of books include experimental and mainstream fiction and poetry. Publishes 14 titles/year. Recent titles include: *Our Sometime Sister, Sacred Vows* and *How to Accomodate Men*. 15% requires freelance illustration. Book catalog free for SASE.

Needs: Approached by 20 illustrators and 10 designers/year. Works with 4 illustrators/year. Prefers freelancers experienced in book covers.

First Contact & Terms: Designers send query letter with photocopies. Illustrators send postcard sample and/or photocopies and printed samples. After introductory mailing send follow-up postcard samples every 6 months. Samples are filed. Will contact artist for portfolio review if interested. Rights purchased vary according to project.

Jackets/Covers: Assigns 5 freelance illustration jobs/year. Pays for illustration by the project, $200-550.

Text Illustration: Finds illustrators through sourcebooks, word of mouth, self promos.

Tips: "We are nonprofit and may not be able to provide full market value for artwork and design. However, we can provide national exposure and excellent portfolio pieces, and allow for generous creative license."

⚏ COLONY PUBLISHING, LTD., 302 Cheswick Lane, Richmond VA 23229-7660. (804)740-8459. E-mail: rbbook@aol.com. Contact: Raymond L. Berry. Estab. 1996. Publishes mass market paperback originals. Type of books: humor books for family audiences. Recent titles include: *Who Says Football Isn't Funny?* and *CATS-and more cats*. 60% requires freelance illustration; 40% requires freelance design.

Needs: Approached by 8-10 illustrators/year. Prefers freelancers experienced in mass market paperbacks. 100% of freelance design/illustration demands knowledge of Adobe Photoshop, Aldus PageMaker, QuarkXPress and original art, book design and 4-color process work.

First Contact & Terms: Designers and illustrators send query letter with photocopies; send no sample that has to be returned. Will contact artist for portfolio review if interested. Buys all rights. Finds freelancers through local printing and suppliers' trade references.

Book Design: Pays for design and art direction by the project.

Jackets/Covers: Pays for design and illustration by the project. Prefers cartoonists, illustrators, book designers with successful record/mass market paperbacks.

Text Illustration: Pays by the project.

Tips: "We need book designers, illustrators experienced in humor for a series of original mass market paperbacks. Thorough knowledge of type and four-color work a must. A later series will need top cartoonists."

⚏ CORWIN PRESS, INC., 2455 Teller Rd., Thousand Oaks CA 91320-2218. (805)499-9734. Fax: (805)499-0871. Website: http://www.corwinpress.com. Contact: Senior Graphic Designer. Estab. 1990. Imprint of Sage Publications Co. Publishes hardcover originals and textbooks. Types of books include professional/scholarly. Specializes in educational books aimed at administrators of schools and districts and for teacher reference. Publishes 70 titles/year. Recent titles include *Learning through Real-World Problem Solving*, by Nancy G. Nagel and *Going Against the Grain*, by Elizabeth Aaronsohn. Book catalog free by request.

Needs: Just beginning to seek outside freelance help. Prefers local artists with experience in direct mail marketing and book design. Uses freelancers for jacket/cover illustration and design, and book, direct mail and catalog design. Freelancers should be familiar with Aldus PageMaker or CorelDraw. (We operate in IBM environment only.) Works on assignment only.

First Contact & Terms: Send query letter with résumé and 2-3 samples. Reports back within 2-4 weeks. To show portfolio, mail photographs. Buys all rights. "Return of originals at job's completion is negotiable."

Book Design: Pays by the project, $200 minimum.

Tips: "We can work long distance; but the talent pool within this area is huge, so the odds favor artists who can stop by for a visit."

COUNCIL FOR EXCEPTIONAL CHILDREN, 1920 Association Dr., Reston VA 20191-1589. (703)620-3660. Fax: (703)620-2521. E-mail: cecpubs@cec.sped.org. Website: http://www.cec.sped.org. Senior Director for Publications: Ms. Jean Boston. Education Specialist: Ms. Susan Bergert. Estab. 1922. Publishes audio tapes, CD-ROMs, paperback originals. Specializes in professional development/instruction. Recent titles include: *IEP Team Guide* and *Publish and Flourish*. Publishes 10 titles/year. Book catalog available.

Needs: Prefers local illustrators, designers and art directors. Prefers freelancers experienced in education. Some freelance illustration demands knowledge of PageMaker, QuarkXPress.

First Contact & Terms: Send query letter with printed samples, SASE. Accepts Windows-compatible disk submissions or TIFF files. Samples are not filed and are returned by SASE. Will contact artist for portfolio review showing book dummy and roughs if interested. Buys all rights.

⚏ COUNCIL FOR INDIAN EDUCATION, 2032 Woody Dr., Billings MT 59102. (406)652-7598. E-mail: hapcie@aol.com. Editor: Hap Gilliland. Estab. 1970. Publishes trade paperback originals. Types of books include contemporary

fiction, historical fiction, instruction, adventure, biography, pre-school, juvenile, young adult and history. Specializes in Native American life and culture. Titles include *Voices of Native America* and *Kamache and the Medicine Bead*. Look of design is realistic, Native American style. 50% require freelance illustration. Book catalog free for #10 SASE.

Needs: Approached by 35 freelance artists/year. Works with 1-2 illustrators/year. Buys 5-15 illustrations/year. Uses freelancers for illustrating children's books. Works on assignment only.

First Contact & Terms: Send query letter with SASE and photocopies. Samples are filed. Reports back within 2 months. Buys one-time rights. Originals returned at job's completion.

Text Illustration: Assigns 1-3 freelance illustration jobs/year. Prefers realistic pen & ink.

Tips: "We are a small nonprofit organization publishing on a very small budget to aid Indian education. Contact us only if you are interested in illustrating for $5 per illustration."

THE COUNTRYMAN PRESS (Division of W.W. Norton & Co., Inc.), Box 748, Woodstock VT 05091. (802)457-4826. E-mail: countrymanpress@wwnorton.com. Prepress Manager: Fred Lee. Production Editor: Cristen Brooks. Estab. 1976. Book publisher. Publishes hardcover originals and reprints, and trade paperback originals and reprints. Types of books include history, travel, nature and recreational guides. Specializes in recreational (biking/hiking) guides. Publishes 35 titles/year. Recent titles include *Reading the Forested Landscape* and *Connecticut, An Explorer's Guide*. 10% require freelance illustration; 60% require freelance cover design. Book catalog free by request.

Needs: Works with 4 freelance illustrators and 7 designers/year. Uses freelancers for jacket/cover and book design. Works on assignment only. Prefers working with computer-literate artists/designers within New England/New York with knowledge of Adobe PageMaker, Adobe Photoshop, Adobe Illustrator, QuarkXPress or Aldus FreeHand.

First Contact & Terms: Send query letter with appropriate samples. Samples are filed. Reports back to the artist only if interested. To show portfolio, mail best representations of style and subjects. Negotiates rights purchased.

Book Design: Assigns 10 freelance design jobs/year. Pays for design by the project, $500-1,200.

Jackets/Covers: Assigns 10 freelance design jobs/year. Pays for design $400-1,000.

Text Illustration: Assigns 2 freelance illustration jobs/year.

CRC PRODUCT SERVICES, 2850 Kalamazoo Ave. SE, Grand Rapids MI 49560. (616)224-0780. Fax: (616)224-0834. Website: http://www.crcna.org/cr/crop/croparte.htm. Art Director: Dean Heetderks. Estab. 1866. Publishes hardcover and trade paperback originals and magazines. Types of books include instructional, religious, young adult, reference, juvenile and preschool. Specializes in religious educational materials. Publishes 8-12 titles/year. 85% requires freelance illustration.

Needs: Approached by 30-45 freelancers/year. Works with 12-16 freelance illustrators/year. Prefers freelancers with religious education, cross-cultural sensitivities. Uses freelancers for jacket/cover and text illustration. Works on assignment only. 5% requires freelance art direction.

First Contact & Terms: Send query letter with brochure, résumé, tearsheets, photographs, photocopies, photostats, slides and transparencies. Illustration guidelines are available on website. Samples are filed. Request portfolio review in original query. Portfolio should include thumbnails, roughs, finished samples, color slides, tearsheets, transparencies and photographs. Buys one-time rights. Originals are returned at job's completion.

Jackets/Covers: Assigns 2-3 freelance illustration jobs/year. Pays by the project, $200-1,000.

Text Illustration: Assigns 50-100 freelance illustration jobs/year. Pays by the project, $75-100. "This is high-volume work. We publish many pieces by the same artist."

Tips: "Be absolutely professional. Know how people learn and be able to communicate a concept clearly in your art."

CREATIVE WITH WORDS PUBLICATION, P.O. Box 223226, Carmel CA 93922. E-mail: cwwpub@usa.net. Website: http://members.triped.com/~CreateWithWords. Editor-in-Chief: Brigitta Geltrich. Nature Editor: Bert Hower. Estab. 1975. Publishes mass market paperback originals. Types of books include adventure, children's picture books, history, humor, juvenile, preschool, travel, young adult and folklore. Specializes in anthologies. Publishes 12-14 titles/year. Recent titles include: *Let's have Fun* and *We are Writers, Too!* Book catalog free for 8½ × 11 SAE with 2 oz firt-class postage.

Needs: Approached by 12-20 illustrators/year. Works with 6 illustrators/year. Prefers freelancers experienced in b&w drawings. Does not want computer art.

First Contact & Terms: Send postcard sample and follow-up postcard every 3 months, or query letter with printed samples, photocopies, SASE. Samples are filed or returned by SASE. Reports back within 2 weeks if SASE was enclosed. Will contact artist for portfolio review if interested. Buys one-time rights and sometimes negotiates rights purchased.

Book Design: Assigns 12-14 freelance design jobs/year. Pays for design by the project, $2-20 a sketch.

Jackets/Covers: Assigns 12-14 illustration jobs/year. Pays for illustration by the project, $2-20 a sketch. Prefers folkloristic themes, general-public appeal.

Text Illustration: Assigns 12-14 freelance illustration jobs/year. Pays by the project, $2-20. Prefers b&w sketches.

Tips: "We aim for a folkloristic slant in all of our publications. Therefore, we always welcome artists who weave this slant into our daily lives for a general (family) public. We also like to have the meanings of a poem or prose expressed in the sketch."

N CROSS CULTURAL PUBLICATIONS, INC., P.O. Box 506, Notre Dame IN 46556. Estab. 1980. Imprint is Cross Roads Books. Company publishes hardcover and trade paperback originals and textbooks. Types of books include

biography, religious and history. Specializes in scholarly books on cross-cultural topics. Publishes 10 titles/year. Recent titles include *Zero: Reflections About Nothing*, by Sarah Voss; *Feminism and Love*, by Ruth Whitney; and *Connections and Disconnections*, by Tim Cooney and Beth Predy. Book catalog free for SASE.

Needs: Approached by 25 freelancers/year. Works with 2 freelance illustrators/year. Prefers local artists only. Uses freelance artists mainly for jacket/cover illustration.

First Contact & Terms: Send query letter with résumé and photocopies. Samples are not filed and are not returned. Reports back only if interested. Art Director will contact artist for portfolio review if interested. Portfolio should include b&w samples. Rights purchased vary according to project. Originals are not returned. Finds artists through word of mouth.

Jackets/Covers: Assigns 4-5 freelance illustration jobs/year. Pays by the project.

Tips: First-time assignments are usually book jackets.

THE CROSSING PRESS, P.O. Box 1048, Freedom CA 95019. (408)722-0711. Fax: (408)722-2749. E-mail: knarita@crossingpress.com. Website: http://www.crossingpress.com. Art Director: Karen Narita. Estab. 1966. Publishes audio tapes, trade paperback originals and reprints. Types of books include nonfiction and self help. Specialties in natural healing, New Age spirituality, cookbooks. Publishes 50 titles/year. Recent titles include: *The Optimum Nutrition Bible*; *Nature's Aphrodisiacs* and *A Little Book of Love Magic*.

Needs: Freelance illustrators, photographers, artists and designers welcome to submit samples. Prefers designers experienced in Quark, Photoshop and Book Text design.

First Contact & Terms: Send query letter with printed samples, photocopies, SASE if materials are to be returned. Accepts Mac-compatible disk submissions. Samples are filed or returned by SASE. Will contact artist for portfolio review if interested. Rights purchased vary according to project. Finds freelancers through submissions, promo mailings, *Directory of Illustration*, *California Image*, *Creative Black Book*.

Tips: "We look for artwork that is expressive, imaginative, colorful, textural—abstract or representational—appropriate as cover art for books on natural healing or New Age spirituality. We also are interested in artists/photographers of prepared food for cookbooks."

JONATHAN DAVID PUBLISHERS, 68-22 Eliot Ave., Middle Village NY 11379. (718)456-8611. Fax: (718)894-2818. E-mail: jondavpub@aol.com. Website: http://www.JonathanDavidOnline.com. Production Coordinator: Fiorella de Lima. Estab. 1948. Company publishes hardcover and paperback originals. Types of books include biography, religious, young adult, reference, juvenile and cookbooks. Specializes in Judaica. Publishes 25 titles/year. Recent titles include *Great Jewish Quotations* and *The New Baseball Catalog*. 50% require freelance illustration; 75% require freelance design. Book catalog free by request.

Needs: Approached by numerous freelancers/year. Works with 5 freelance illustrators and 5 designers/year. Prefers freelancers with experience in book jacket design and jacket/cover illustration. 100% of design and 5% of illustration demands computer literacy. Works on assignment only.

First Contact & Terms: Designers send query letter with résumé and photocopies. Illustrators send postcard sample and/or query letter with photocopies, résumé. Samples are filed. Production Coordinator will contact artist for portfolio review if interested. Portfolio should include color final art and photographs. Buys all rights. Originals are not returned. Finds artists through submissions.

Book Design: Assigns 15-20 freelance design jobs/year. Pays by the project.

Jackets/Covers: Assigns 15-20 freelance design and 4-5 illustration jobs/year. Pays by the project.

Tips: First-time assignments are usually book jackets, mechanicals and artwork.

DAW BOOKS, INC., 375 Hudson St., 3rd Floor, New York NY 10014-3658. (212)366-2096. Fax: (212)366-2090. Art Director: Betsy Wollheim. Estab. 1971. Publishes hardcover and mass market paperback originals and reprints. Specializes in science fiction and fantasy. Publishes 72 titles/year. Recent titles include: *This Alien Shore*, by C.S. Friedman; and *Mountain of Black Glass*, by Tad Williams. 50% require freelance illustration. Book catalog free by request.

Needs: Works with several illustrators and 1 designer/year. Buys more than 36 illustrations/year. Works with illustrators for covers. Works on assignment only.

First Contact & Terms: Send postcard sample or query letter with brochure, résumé, tearsheets, transparencies, photocopies, photographs and SASE. "Please don't send slides." Samples are filed or are returned by SASE only if requested. Reports back about queries/submissions within 2-3 days. Originals returned at job's completion. Call for appointment to show portfolio of original/final art, final reproduction/product and transparencies. Considers complexity of project, skill and experience of artist and project's budget when establishing payment. Buys first rights and reprint rights.

Jacket/Covers: Pays by the project, $1,500-8,000. "Our covers illustrate the story."

THE MULTIMEDIA INDEX preceding the General Index in the back of this book lists markets seeking freelancers with multimedia, animation and CD-ROM skills.

Tips: "We have a drop-off policy for portfolios. We accept them on Tuesdays, Wednesdays and Thursdays and report back within a day or so. Portfolios should contain science fiction and fantasy color illustrations *only*. We do not want to see anything else. Look at several dozen of our covers."

⊞ ALDINE DE GRUYTER, NEW YORK, 200 Saw Mill R. Rd., Hawthorne NY 10532. (914)747-0110. Production Manager: Anne Obuck. Estab. 1978. Imprint of Walter de Gruyter Inc. Publishes scholarly books and graduate level textbooks (cloth and paper dual editions). Specializes in sociology. Publishes 15-20 titles/year. 0% requires illustration; 100% requires freelance design. Book catalog free on request.
Needs: Works with 2 designers/year. Prefers local freelancers experienced in scholarly covers and jackets. Design demands knowledge of Adobe Illustrator and QuarkXPress, "or subject to prior discussion. Strong typographic skills essential."
First Contact & Terms: Designers send photocopies, résumé. Samples are filed. Will contact artist for portfolio review of printed samples if interested.
Jackets/Covers: Assigns 15-20 design jobs/year. Pays by the project; negotiable.
Tips: "Looking for somewhat witty, but always intelligent approach to dealing with sometimes nonexciting sociology titles. Strong typpgraphic experience essential. Adaptation to 2-color discipline. Good use of color."

⊞ DEATH'S EDGE GAMES, 3906 Grace Ellen Dr., Columbia MO 65202-1739. E-mail: cclark@socket.net. Art Director: Thomas Thurman. Estab. 1993. Publishes roleplaying game books. Main style/genre of games: mythology and fantasy. Uses freelance artists mainly for interior art. Publishes 2-3 titles or products/year. Game/product lines include: *Inferno, Out of the Abyss, Gods of Hell, Battle Dragons, Arcanum, Bestiary* and *Lexicon*. 50% requires freelance illustration.
Needs: Approached by 3-4 illustrators and 0-1 designer/year. Works with 1-2 illustrators/year. Prefers freelancers experienced in b&w line art with good comic book background.
First Contact & Terms: Send query letter with résumé and photocopies. Send 1 sample. Samples are filed. Reports back within weeks. Will contact artist for portfolio review if interested. Rights purchased vary according to project. Finds freelancers through conventions and word of mouth.
Visual Design: Assigns 1-2 freelance design jobs/year. Pays for design by the project, $20-600.

DOMINIE PRESS, INC., 1949 Kellogg Ave., Carlsbad CA 92008-6582. (760)431-8000. Fax: (760)431-8777. E-mail: info@dominie.com. Website: http://www.dominie.com. C.E.O.: Ray Yuen. Editors: Bob Rowland and Carlos Byfield. Estab. 1975. Publishes textbooks. Types of books include children's picture books, juvenile, nonfiction, preschool, textbooks and young adult. Specializes in educational textbooks. Publishes 180 titles/year. Recent titles include: *The Day Miss Francine Got Skunked* and *Marine Life Series*. 90% requires freelance illustration; 50% requires freelance design; 30% requires freelance art direction. Book catalog free for 9×12 SASE with $2 postage.
Needs: Approached by 50 illustrators and 50 designers/year. Works with 35 illustrators, 10 designers and 2 art directors/year. Prefers local designers and art directors. Prefers freelancers experienced in children's books and elementary textbooks. 100% of freelance design demands knowledge of Adobe Illustrator, Adobe Photoshop, Aldus FreeHand, Aldus PageMaker, PageMaker and Quark XPress.
First Contact & Terms: Designers send printed samples and tearsheets. Illustrators send query letter with printed samples and tearsheets. Samples are not filed and are returned by SASE. Reports back in 6 months only if interested. Will contact artist for portfolio review if interested. Portfolio should include book dummy, photocopies, photographs, roughs, tearsheets, thumbnails, transparencies. Buys all rights.
Book Design: Assigns 25 freelance designs and 5 freelance art direction projects/year. Pays by the project.
Jackets/Covers: Assigns 30 freelance design jobs and 150 illustration jobs/year.
Text Illustration: Assigns 150 freelance illustration jobs/year. Pays by the project.

DUTTON CHILDREN'S BOOKS, Penguin Putnam Inc., 375 Hudson St., New York NY 10014. Art Director: Sara Reynolds. Publishes hardcover originals. Types of books include children's picture books, juvenile, preschool, young adult. Publishes 60-80 titles/year. 75% require freelance illustration.
First Contact & Terms: Send postcard sample, printed samples, tearsheets. Samples are filed or returned by SASE. Will contact artist for portfolio review if interested. Portfolios may be dropped off every Tuesday and picked up by end of the day.
Jackets/Covers: Pays for illustration by the project $1,000-1,800.

⊞ THE ECCO PRESS, 100 W. Broad St., Hopewell NJ 08525. (609)466-4748. Fax: (609)466-4706. E-mail: eccopress@snip.net. Website: http://www.eccopress.com. Cover Coordinator: Ms. Fairfax Hutter. Production Manager: Michael Siebert. Estab. 1972. Publishes hardcover and trade paperback originals and reprints. Types of books include biography, cookbooks, experimental and mainstream fiction, poetry, nonfiction and travel. Specializes in literary fiction, poetry and cookbooks. Publishes 60 titles/year. Recent titles include: *Essential Tales of Chekhov, Feeding the Ghosts, Dream Mistress, Skating to Antarctica, Wide Open, Poet's Choice Essential Haiku* and *Midnight Magic*. 10% requires freelance illustration; 100% requires freelance design.
Needs: Approached by 40 illustrators and 60 designers/year. Works with 2 illustrators and 20 designers/year. Prefers freelancers experienced in book jacket design and interior book design. 100% of freelance design demands knowledge of QuarkXPress. 80% of freelance illustration demands knowledge of Adobe Photoshop.

First Contact & Terms: Designers and illustrators send postcard sample or query letter with photocopies and tear-sheets. Accepts Mac-compatible disk submissions. Some samples filed, most not kept and not returned. Will contact artist for portfolio review if interested; portfolios may be dropped off every week, Monday through Saturday, and can be picked up the following week. Portfolio should include photocopies and tearsheets. Rights purchased vary according to project. Finds freelancers through word of mouth, sourcebooks, design magazines and browsing bookstores.
Book Design: Pays for design by the project.
Jackets/Covers: Assigns 60 freelance design jobs and 1 illustration job/year. Pays by the project, $500-1,000 for design, $200-500 for illustration. "We prefer sophisticated and hip experienced designers."
Tips: "Artists' work should be true to the book. The best designers read the manuscript or part of the manuscript. Artwork should reflect the content of the book and be original and eye-catching. Submit designs in QuarkXPress for Mac on Zip disks. Ask questions. Jacket type should be readable."

EDEN STUDIOS, INC., 15 Ledgewood Dr., Albany NY 12205. (518)435-1128. Fax: (518)435-1120. E-mail: edenprod@aol.com. Website: http://www.edenstudios.net. Art Director: George Vasilakos. Estab. 1997. Publishes roleplaying game books, game/trading cards, graphic novels. Main style/genre of games: Japanimation, gothic punk, horror, science fiction, cyberpunk, military, aliens and governmental conspiracies. Uses freelance artists mainly for roleplaying games. Publishes 6 titles or products/year. Game/product lines include: *Conspiracy X* roleplaying game, *Abduction* card game, *Witchcraft* roleplaying game. 80% requires freelance illustration; 20% requires freelance design. Art guidelines available on website.
Needs: Approached by 20 illustrators and 5 designers/year. Works with 5 illustrators and 2 designers/year. Prefers freelancers experienced in grayscale/line art illustration. 100% of freelance design and illustration demands knowledge of Adobe Illustrator, Adobe Photoshop, QuarkXPress.
First Contact & Terms: Send self-promotion postcard sample, résumé and SASE. Illustrators send photocopies. Send 3 samples. Accepts disk submissions in Mac format. Send via CD or Zip as JPEG files at 100 dpi. Samples are filed. Reports back only if interested. Portfolio review not required. Buys all rights. Finds freelancers through submissions, conventions and referrals.
Book Covers/Posters/Cards: Assigns 6 freelance design jobs and 6 illustration jobs/year. Prefers photo imagery and paintings. Pays for illustration by the project, $300-500.
Text Illustration: Pays by the full page, $75-150. Prefers photorealistic art.
Tips: Submit work for the type of genre of games we produce."

EDITORIAL CARIBE, INC., P.O. Box 14100, Nashville TN 37214. (615)391-3937, ext. 2376. E-mail: production@editorialcaribe.com. Website: http://editorialcsribe.com. Production Manager: Sam Rodriguez. Publishes hardcover originals, trade paperback originals and reprints and mass market paperback originals and reprints. Types of books include self-help and religious. Specializes in commentary series and Bibles. Publishes 60 titles/year. Recent titles include: *Renuevame* and *Cuidado con los extremos!* 90% requires freelance illustration; 100% requires freelance design. Book catalog free by request.
Needs: Approached by 10 freelance artists/year. Works with 12-18 illustrators and 12 designers/year. Buys 20 freelance illustrations/year. Uses freelancers mainly for cover design. Also uses freelance artists for jacket/cover illustration. 100% of freelance design and 40% of illustration demands knowledge of Adobe Photoshop and Adobe Illustrator. Works on assignment only.
First Contact & Terms: Designers send query letter with brochure. Illustrators send postcard sample and/or brochure. Samples are filed. Reports back within 2 weeks. Artist should follow up with call and/or letter after initial query. Requests work on spec before assigning job. Buys all rights. Interested in buying second rights (reprint rights) to previously published work. Originals not returned. Finds artists through word of mouth, submissions and work already done.
Book Design: Assigns 15 design jobs/year. Pays by the project, $300-1,000.
Jackets/Covers: Assigns 40 design and 40 illustration jobs/year. Pays by the project, $400-700.
Tips: "Show creativity at a reasonable price. Keep in touch with industry and know what is out in the marketplace. Visit a large book store. Be flexible and get to know the target market."

ELCOMP PUBLISHING, INC., 4650 Arrow Highway #E-6, Montclair CA 91763. (909)626-4070. Fax: (909)624-9574. E-mail: 70414.1170@compuserve.com. Website: http://www.clipshop.com. President: Winfried Hofacker. Estab. 1979. Publishes mass market paperback originals and CD-ROMs. Types of books include reference, textbooks, travel and computer. Specializes in computer and software titles. Publishes 2-3 titles/year. Recent titles include: *Bio's*, *CD-ROM* and *Unix*. 90% require freelance illustration; 90% require freelance design. Catalog free for 2 first-class stamps.
Needs: Approached by 2 illustrators and 2 designers/year. Works with 1 illustrator and 1 designer/year. Prefers freelancers experienced in cartoon drawing and clip art drawing. Uses freelancers mainly for clip art drawing. 10% of freelance design demands knowledge of Adobe Photoshop. 10% of freelance illustration demands knowledge of Adobe Photoshop and Adobe Illustrator.
First Contact & Terms: Designers send photocopies. Illustrators send photocopies, printed sample and follow-up postcard samples every 2 months. Accepts disk submissions compatible with EPS files for Windows. Samples are returned. Reports back within 6 weeks. Art director will contact artist for portfolio review if interested.
Book Design: Pays for design by the project, $20-50.
Jackets/Covers: Pays for design by the project, $10-50. Pays for illustration by the project, $10-20.

Text Illustration: Pays by the project, $10-20.

EDWARD ELGAR PUBLISHING INC., 6 Market St., Northampton MA 01060. (413)584-5551. Fax: (413)584-9933. E-mail: kwight@e-elgar.com. Website: http://www.e-elgar.co.uk. Promotions Manager: Katy Wight. Publishing Assistant: Michaela Cahillane. Estab. 1986. Publishes hardcover originals and textbooks. Types of books include instructional, nonfiction, reference, textbooks, academic monographs and references in economics. Publishes 200 titles/year. Recent titles include: *Who's Who in Economics, Third Edition* and *Teaching Economics to Undergraduates*.
● This publisher uses only freelance designers. Its academic books are produced in the United Kingdom. Direct Marketing material is done in U.S. There is no call for illustration.
Needs: Approached by 2-4 designers/year. Works with 2 designers/year. Prefers local designers. Prefers freelancers experienced in direct mail and academic publishing. 100% of freelance design demands knowledge of Adobe Photoshop, QuarkXPress.
First Contact & Terms: Designers send query letter with printed samples. Accepts Mac-compatible disk submissions. Samples are filed. Will contact artist for portfolio review if interested. Buys one-time rights or rights purchased vary according to project. Finds freelancers through word of mouth, local sources i.e. phone book, newspaper, etc.

ESCAPE VENTURES, INC., 4400 N. Scottsdale Rd., Suite 9-332, Scottsdale AZ 85251-3300. E-mail: info@ev.com. Website: http://ev.com. Creative Director: Robert Finkbeiner. Estab. 1982. Publishes roleplaying game books, CD-ROM/online games, board games, graphic novels and miniatures. Genres include science fiction, fantasy and humor. Produces 2 titles/year. Produces *Gatewar* RPG lines. 25% requires freelance illustration. Art guidelines available on website.
Needs: Approached by 24 illustrators and 2 designers/year/ Works with 3 illustrators/year. Prefers freelancers experienced in computer art generation. 100% of freelance design and illustration demands knowledge of Adobe Illustrator, Adobe Photoshop and QuarkXPress.
First Contact & Terms: Send self-promotion postcard sample and product release form. Request 1 sample/photocopy. Samples are filed. Will contact artist for portfolio review if interested. Negotiates rights purchased. Rights purchased vary according to project. Pays by the project. Finds freelancers through submission packets, promotional postcards, conventions, word of mouth and referrals.

M. EVANS AND COMPANY, INC., 216 E. 49th St., New York NY 10016. (212)688-2810. Fax: (212)486-4544. Managing Editor: Rik Schell. Estab. 1956. Publishes hardcover and trade paperback originals. Types of books include contemporary fiction, biography, health and fitness, history, self-help and cookbooks. Specializes in general nonfiction. Publishes 30 titles/year. Recent titles include: *Dr. Atkins' New Diet Revolution*, by Robert C. Atkins; and *Terrorism In the 20th Century*, by Jay Robert Nash. 5% requires freelance illustration and design.
Needs: Approached by "too many" freelancers/year. Works with approximately 3 freelance illustrators and designers/year. Prefers local artists. Uses freelance artists mainly for jacket/cover illustration. Also for text illustration and jacket/cover design. Works on assignment only.
First Contact & Terms: Send query letter with brochure and résumé. Samples are filed. Art Director will contact artist for portfolio review if interested. Portfolio should include original/final art and photographs. Rights purchased vary according to project. Originals are returned at job's completion upon request.
Book Design: Assigns 10 freelance jobs/year. Pays by project, $200-500.
Jackets/Covers: Assigns 20 freelance design jobs/year. Pays by the project, $600-1,200.
Text Illustration: Pays by the project, $50-500.

FACTS ON FILE, 11 Penn Plaza, New York NY 10001-2006. (212)967-8800. Fax: (212)896-4204. Website: http://www.factsonfile.com. Art Director: Cathy Rincon. Estab. 1940. Publisher of school, library and trade books, CD-ROMs and OnFiles. Types of reference and trade books include science, history, biography, language/literature/writing, pop culture, biography, self-help. Specializes in general reference. Publishes 150 titles/year. Recent titles include *Ellis Island Interviews, The Quotable Lawyer* and *The Complete Motorcycle Book*. 10% require freelance illustration. Book catalog free by request.
Needs: Approached by 100 freelance artists/year. Works with 5 illustrators and 25 designers/year. Uses freelancers mainly for jacket and direct mail design. Needs computer-literate freelancers for design and illustration. Demands knowledge of Macintosh and IBM programs. Works on assignment only.
First Contact & Terms: Send query letter with SASE, tearsheets and photocopies. Samples are filed. Reports back only if interested. Call to show a portfolio, which should include thumbnails, roughs, color tearsheets, photographs and comps. Rights purchased vary. Originals returned at job's completion.
Jackets/Covers: Assigns 50 freelance design jobs/year. Pays by the project, $500-1,000.
Tips: "Our books range from straight black and white to coffee-table type four-color. We're using more freelancers for technical, computer generated line art—charts, graphs, maps. We're beginning to market some of our titles in CD-Rom and online format; making fuller use of desktop publishing technology in our production department."

F&W PUBLICATIONS INC., 1507 Dana Ave., Cincinnati OH 45207. Art Director: Clare Finney. Imprints: Writers Digest Books, North Light Books, Betterway Books, Story Press. Publishes 120 books annually for writers, artists and photographers, plus selected trade (lifestyle, home improvement) titles. Recent titles include: *Creative Nonfiction, The*

Best of Portrait Painting and *Perfect Wood Finishing Made Easy.* Books are heavy on type-sensitive design.
Needs: Works with 10-20 freelance illustrators and 5-10 designers/year. Uses freelancers for jacket/cover design and illustration, text illustration, direct mail and book design. Works on assignment only.
First Contact & Terms: Send nonreturnable photocopies of printed work to be kept on file. Art director will contact artist for portfolio review if interested. Interested in buying second rights (reprint rights) to previously published illustrations. "We like to know where art was previously published." Finds illustrators and designers through word of mouth and submissions/self promotions.
Book Design: Pays by the project, $500-1,000.
Jackets/Covers: Pays by the project, $500-850.
Text Illustration: Pays by the project, $100 minimum.
Tips: "Don't call. Send appropriate samples we can keep. Clearly indicate what type of work you are looking for."

FANTAGRAPHICS BOOKS, INC., 7563 Lake City Way, Seattle WA 98115. (206)524-1967. Fax: (206)524-2104. E-mail: fbicomix@fantagraphics.com. Website: http://www.fantagraphics.com. Publisher: Gary Groth. Estab. 1976. Publishes hardcover and trade paperback originals and reprints. Types of books include contemporary, experimental, mainstream, historical, humor and erotic. "All our books are comic books or graphic stories." Publishes 100 titles/year. Recent titles include: *Love & Rockets, Hate, Eightball, Acme Novelty Library, JIM* and *Naughty Bits.* 10% requires freelance illustration. Book catalog free by request.
Needs: Approached by 500 freelancers/year. Works with 25 freelance illustrators/year. Must be interested in and willing to do comics. Uses freelancers for comic book interiors and covers.
First Contact & Terms: Send query letter addressed to submissions editor with résumé, SASE, photocopies and finished comics work. Samples are not filed and are returned by SASE. Reports back to the artist only if interested. Call or write for appointment to show portfolio of original/final art and b&w samples. Buys one-time rights or negotiates rights purchased. Originals are returned at job's completion. Pays royalties.
Tips: "We want to see completed comics stories. We don't make assignments, but instead look for interesting material to publish that is pre-existing. We want cartoonists who have an individual style, who create stories that are personal expressions."

FARRAR, STRAUS & GIROUX, INC., 19 Union Square W., New York NY 10003. (212)741-6900. Art Director: Susan Mitchell. Book publisher. Estab. 1946. Publishes hardcover and trade paperback originals and trade paperback reprints. Publishes nonfiction and fiction. Publishes 200 titles/year. 20% require freelance illustration; 40% freelance design.
Needs: Works with 12 freelance designers and 3-5 illustrators/year. Uses artists for jacket/cover and book design.
First Contact & Terms: Send postcards, samples, tearsheets and photostats. Samples are filed and are not returned. Reports back only if interested. Originals are returned at job's completion. Call or write for appointment to show portfolio of photostats and final reproduction/product. Portfolios may be dropped off every Wednesday before 2 p.m. Considers complexity of project and budget when establishing payment. Buys one-time rights.
Book Design: Assigns 40 freelance design jobs/year. Pays by the project, $300-450.
Jackets/Covers: Assigns 20 freelance design jobs/year and 10-15 freelance illustration jobs/year. Pays by the project, $750-1,500.
Tips: The best way for a freelance illustrator to get an assignment is "to have a great portfolio."

☑ **FILMS FOR CHRIST**, 1832 S. McDonald, Suite 103, Meza AZ 85210. E-mail: mail@eden.org. Website: http://www.eden.org. Contact: Paul S. Taylor. Number of employees: 10. Motion picture producer and book publisher. Audience: educational, religious and secular. Produces and distributes motion pictures, videos and books.
• Design and computer work are done inhouse. Will work with out-of-town illustrators.
Needs: Works with 1-5 freelance illustrators/year. Works on assignment only. Uses illustrators for books, catalogs and motion pictures. Also for storyboards, animation, cartoons, slide illustration and ads.
First Contact & Terms: Send query letter with résumé, photocopies, slides, tearsheets or snapshots. Samples are filed or are returned by SASE. Reports in 1 month. All assignments are on a work-for-hire basis. Originals are not returned. Considers complexity of project and skill and experience of artist when establishing payment.

☑ **FIRST BOOKS, INC.**, P.O. Box 578147, Chicago IL 60657. (773)276-5911. Website: http://www.firstbooks.com. President: Jeremy Solomon. Estab. 1988. Publishes trade paperback originals. Publishes 4-5 titles/year. Recent titles include: *Gay USA*, by George Hobica. 100% require freelance illustration.
Needs: Uses freelancers mainly for interiors and covers.
First Contact & Terms: Designers send "any samples you want to send and SASE but no original art, please!" Illustrators send query letter with a few photocopies or slides. Samples are filed or returned by SASE. Reports back within 1 month. Rights purchased vary according to project.
Book Design: Payment varies per assignment.
Tips: "We're a small outfit—keep that in mind when sending in samples."

N: FOCUS PUBLISHING, 1375 Washington Ave., Bemidji MN 56601. (218)759-9817. Fax: (218)751-2183. E-mail: focus@paulbunyan.net. Website: http://www.paulbunyan.net/Focus. Vice President: Jan Haley. Estab. 1993. Publishes hardcover originals, trade paperback originals and reprints. Types of books include juvenile, religious and young

adult. Specializes in Christian, children. Publishes 3-4 titles/year. Recent titles include: *Keeper of the Light* and *J. Rooker, Manatee*. 25% requires freelance illustration. Catalog available.

Needs: Approached by 1-2 illustrators/year. Works with 1-2 illustrators/year. Prefers local designers. Uses freelancers mainly for children's titles.

First Contact & Terms: Illustrators send query letter with photocopies, résumé, SASE and tearsheets. Samples are filed and are returned by SASE. Reports back within 2 months. Will contact artist for portfolio review of photocopies, roughs and tearsheets if interested. Negotiates rights purchased.

Text Illustration: Assigns 1-2 freelance illustration jobs/year. Pays negotiable. Finds freelancers through sourcebooks—NY Artist Guild and submissions on file.

FOREIGN SERVICES RESEARCH INSTITUTE/WHEAT FORDERS, Box 6317, Washington DC 20015-0317. (202)362-1588. Director: John E. Whiteford Boyle. Specializes in paperback originals of modern thought, nonfiction and philosophical poetry.

Needs: Works with 2 freelancers/year. Freelancers should understand the principles of book jacket design. Works on assignment only.

First Contact & Terms: Send query letter to be kept on file. Reports within 15 days. Originals not returned. Considers project's budget when establishing payment. Buys first rights or reprint rights.

Book Design: Assigns 1-2 freelance jobs/year. Pays by the hour, $25-35 average.

Jackets/Covers: Assigns 1-2 freelance design jobs/year. Pays by the project, $250 minimum.

Tips: "Submit samples of book jackets designed for and accepted by other clients. Include SASE, please."

FORT ROSS INC., 269 W. 259 St., Riverdale NY 10471-1921. (718)884-1042. Fax: (718)884-3373. E-mail: ftross@ix.netcom.com. Website: http://pw1.netcom/~ftross. Executive Director: Dr. Vladimir P. Kartsev. Represents leading Russian publishing companies in the US and Canada. Estab. 1992. Hardcover originals, mass market paperback originals and reprints, and trade paperback reprints. Works with adventure, children's picture books, fantasy, horror, romance, science fiction and western. Specializes in romance, science fiction, mystery. Publishes 1,000 titles/year. Recent titles include: translations of Deepak Chopra Books, Patricia Kajan and Catherine Creel's novels in Eastern Europe. 100% requires freelance illustration. Book catalog not available.

- "Since 1996 we have introduced a new generation of outstanding Russian book illustrators and designers to the American and Canadian publishing world."

Needs: Approached by 100 illustrators/year. Works with 40 illustrators/year. Prefers freelancers experienced in romance, science fiction, fantasy, mystery cover art.

First Contact & Terms: Illustrators send query letter with printed samples, photocopies, SASE, tearsheets. Accepts Windows or Mac-compatible disk submissions. Send EPS files. Samples are filed. Will contact artist for portfolio review if interested. Buys secondary rights. Finds freelancers through agents, networking events, sourcebooks, *Creative Black Book*, *RSVP*.

Book Design: Assigns 5 freelance design and 5 freelance art direction projects/year. Pays by the project, $300-500.

Jackets/Covers: Buys about 1,000 illustrations/year. Pays for illustration by the project, $100-200 for secondary rights (for each country). Prefers experienced romance, mystery, science fiction, fantasy cover illustrators.

Tips: "Fort Ross is the best place for experienced cover artists to sell secondary rights for their images in Russia, countries of the former USSR and Eastern Europe."

FORWARD MOVEMENT PUBLICATIONS, 412 Sycamore St., Cincinnati OH 45202. (513)721-6659. Fax: (513)721-0729. E-mail: forward.movement@msn.com. Website: http://www.forwardmovement.org. Associate Director: Sally B. Sedgwick. Estab. 1934. Publishes trade paperback originals. Types of books include religious. Publishes 24 titles/year. Recent titles include *Praying with Cancer*, by Sherry Hunt; *Then Joy Breaks Through*, by George Benson. 17% require freelance illustration. Book illustration is usually suggestive, not realistic. Book catalog free for SAE with 3 first-class stamps.

Needs: Works with 2-4 freelance illustrators and 1-2 designers/year. Uses freelancers mainly for illustrations required by designer. "We also keep original clip art-type drawings on file to be paid for as used."

First Contact & Terms: Send query letter with tearsheets, photographs, photocopies and slides. Samples are sometimes filed. Art Director will contact artist for portfolio review if interested. Sometimes requests work on spec before assigning a job. Interested in buying second rights (reprint rights) to previously published work. Rights purchased vary according to project. Originals sometimes returned at job's completion. Finds artists mainly through word of mouth.

Jackets/Covers: Assigns 1-4 freelance design and 6 illustration jobs/year. Pays by the project, $25-175.

Text Illustration: Assigns 1-4 freelance jobs/year. Pays by the project, $10-200; pays $5-25/picture. Prefers pen & ink.

Tips: We need clip art. If you send clip art, include fee you charge for use.

FULCRUM PUBLISHING, 350 Indiana St., Suite 350, Golden CO 80401. (303)277-1623. Fax: (303)279-7111. Associate Publisher: Jay Staten. Estab. 1986. Book and calendar publisher. Publishes hardcover originals and trade paperback originals and reprints. Types of books include biography, Native American, reference, history, self help, teacher resource books, travel, humor, gardening and nature. Specializes in history, nature, teacher resource books, travel, Native American and gardening. Publishes 50 titles/year. Recent titles include: *Sex in Your Garden*, by Angela

Overy; and *The Colorado Guide, 4th Edition*, by Bruce Caughey and Dean Winstanley. 15% requires freelance illustration; 85% requires freelance design. Book catalog free by request.

Needs: Approached by 50 freelancers/year. Works with 4 freelance illustrators and 6 designers/year. Uses freelancers mainly for cover and interior illustrations for gardening books and images for calendars. Also for other jacket/covers, text illustration and book design. Works on assignment only.

First Contact & Terms: Send query letter with tearsheets, photographs, photocopies and photostats. Samples are filed. Reports back to artist only if interested. To show portfolio, mail b&w photostats. Buys one-time rights. Originals are returned at job's completion.

Book Design: Assigns 25 freelance design and 6 illustration jobs/year. Pays by the project, $350-2,000.

Jackets/Covers: Assigns 20 freelance design and 4 illustration jobs/year. Pays by the project.

Text Illustration: Assigns 10 freelance design and 1 illustration jobs/year. Pays by the project.

Tips: Previous book design experience a plus.

GALISON BOOKS/MUDPUPPY PRESS, 28 W. 44th, New York NY 10036. (212)354-8840. Fax: (212)391-4037. Design Director: Gina Manola. Publishes coffee table books. Specializes fine art, botanicals. Publishes 120 titles/year. 50% requires design.
 • Also has listing in greeting cards, gifts and products section.

Needs: Approached by 10 illustrators/year. Works with 50 illustrators and 20 designers/year. Some freelance design demands knowledge of Adobe Photoshop, Adobe Illustrator and QuarkXPress.

First Contact & Terms: Designers send brochure, photocopies, SASE, slides, tearsheets. Illustrators send photocopies, printed samples, tearsheets. Samples are filed or returned SASE. Will contact artist for portfolio review if interested. Rights purchased vary according to project.

GALLOPADE PUBLISHING GROUP/CAROLE MARSH FAMILY CD-ROM, 200 Northlake Dr., Peachtree City GA 30269. (770)631-4222 or (800)536-2438. Contact: Art Department. Estab. 1979. Publishes hardcover and trade paperback originals, textbooks and interactive multimedia. Types of books include contemporary fiction, western, instructional, mystery, biography, young adult, reference, history, humor, juvenile and sex education. Publishes 1,000 titles/year. Titles include: *Alabama Jeopardy* and *A Trip to the Beach* (CD-ROM). 20% requires freelance illustration; 20% requires freelance design.

Needs: Works almost exclusively with paid or unpaid interns. Company selects interns from applicants who send nonreturnable samples, résumé and internship availability. Interns work on an initial unpaid project, anything from packaging and book covers to multimedia and book design. Students can receive credit and add commercial work to their portfolio. Prefers artists with Macintosh experience.

First Contact & Terms: Send non-returnable samples only. Usually buys all rights.

GAYOT PUBLICATIONS, 5900 Wilshire Blvd., Los Angeles CA 90036. (323)965-3529. Fax: (323)936-2883. E-mail: gayots@aol.com. Website: http://www.gayot.com. Publisher: Alain Gayot. Estab. 1986. Publishes trade paperback originals. Types of books include travel. Publishes 8 titles/year. Recent titles include: *The Best of London*, *The Best of San Francisco*, *The Best of Chicago* and *The Best of Hawaii*. 100% requires freelance design. Catalog available.

Needs: Approached by 30 illustrators and 2 designers/year. Works with 3 designers/year. Prefers local designers. 100% of freelance design demands knowledge of Aldus PageMaker, Adobe Photoshop, Adobe Illustrator and QuarkXPress.

First Contact & Terms: Designers send query letter with brochure, photocopies and résumé. Send follow-up postcard every 6 months. Accepts disk submissions compatible with Mac, any program. Samples are filed. Reports back only if interested. Will contact artist for portfolio review if interested. Rights purchased vary according to project.

Book Design: Pays by the hour or by the project.

Jackets/Covers: Assigns 40 freelance design jobs/year. Pays for design by the hour. Pays for illustration by the project, $800-1,200.

Tips: "We look for rapidity, flexibility, eclecticism and an understanding of the travel guide business."

GEM GUIDES BOOK CO., 315 Cloverleaf Dr., Suite F, Baldwin Park CA 91706. (626)855-1611. Fax: (626)855-1610. Editor: Kathy Mayerski. Estab. 1964. Book publisher and wholesaler of trade paperback originals and reprints. Types of books include earth sciences, western, instructional, travel, history and regional (western US). Specializes in travel and local interest (western Americana). Publishes 7 titles/year. Recent titles include: *Florida's Geological Treasures*, by Iris Tracy Comfort; and *Destination: Phoenix*, by Dorothy Tegeler. 75% requires freelance illustration and design. Book catalog free for SASE.

Needs: Approached by 24 freelancers/year. Works with 3 designers/year. Uses freelancers mainly for covers. Also for text illustration and book design. 100% of freelance work demands knowledge of Aldus PageMaker 5.0, Aldus FreeHand 4.0, Appleone Scanner and Omnipage Professional. Works on assignment only.

First Contact & Terms: Send query letter with brochure, résumé and SASE. Samples are filed. Editor will contact artist for portfolio review if interested. Requests work on spec before assigning a job. Buys all rights. Originals are not returned. Finds artists through word of mouth and "our files."
Book Design: Assigns 6 freelance design jobs/year. Pays by the project.
Jackets/Covers: Pays by the project.
Text Illustration: Assigns 2 freelance jobs/year. Pays by the project.

GENERAL PUBLISHING GROUP, 2701 Ocean Park Blvd. #140, Santa Monica CA 90405-5200. (310)314-4000. Fax: (310-314-8080. E-mail: genpub@aol.com. Production Director: Trudihope Schlomowitz. Estab. 1993. Publishes hardcover and trade paperback originals and reprints. Publishes biography, coffee table books, cookbooks and retrospectives. Specializes in entertainment and pop culture. Publishes 50 titles/year. Recent titles include: *Leg, Havens II, Thierry Mugler, Israel at Fifty* and *CBS: The First Fifty Years.* 25% require freelance design. Catalog available free for 8½ × 11 SASE with 1 first-class stamp.
Needs: Works with 2 local freelance designers/year. Uses freelancers mainly for design, layout, production. 100% of freelance design demands knowledge of Adobe Photoshop, Adobe Illustrator 6.0 and QuarkXPress 3.32.
First Contact & Terms: Send query letter with brochure, photographs, photocopies, photostats, resume, printed samples, tearsheets and SASE. Accepts disk submissions compatible with QuarkXPress, Adobe Photoshop and Adobe Illustrator (TIFF, EPS files). Samples are filed and are not returned. Will contact artist for portfolio review of artwork portraying entertainment subjects, photocopies, photographs, photostats, roughs and tearsheets. Rights purchased vary according to project. Finds artists through portfolio reviews, recommendations, *LA Times* employment ads and *Art Center Alumni Bulletin.*
Book Design: Assigns 2 book design jobs/year. Pays by the hour, $15-25.
Jackets/Covers: Assigns 2 design jobs/year. Pays by the hour $15-25 for design and illustration.

 GIBBS SMITH, PUBLISHER, P.O. Box 667, Layton UT 84041. (801)544-9800. Fax: (801)544-5582. E-mail: info@gibbs-smith.com. Website: http://www.gibbs-smith.com. Editorial Director: Madge Baird. Estab. 1969. Imprints include Peregrine Smith Books. Company publishes hardcover and trade paperback originals and textbooks. Types of books include children's picture books, coffee table books, cookbooks, humor, juvenile, nonfiction textbooks, western. Specializes in interior design. Publishes 50 titles/year. Recent titles include: *Mexican Country Style, The Log Home Book* and *Cooking On a Stick.* 10% requires freelance illustration; 100% requires freelance design. Book catalog free for 8½ × 11 SASE with $1.24 postage.
Needs: Approached by 250 freelance illustrators and 50 freelance designers/year. Works with 5 freelance illustrators and 20 designers/year. Prefers local art directors. Prefers freelancers experienced in layout of photographic nonfiction. Uses freelancers mainly for cover design and book layout, cartoon illustration, children's book illustration. 100% of freelance design demands knowledge of QuarkXPress. 70% of freelance illustration demands knowledge of Adobe Photoshop, Adobe Illustrator and Aldus FreeHand.
First Contact & Terms: Designs send postcard sample and query with photocopies and tearsheets. Illustrators send printed samples and photocopies. Samples are filed. Reports back only if interested. Finds freelancers through submission packets and illustration annuals.
Book Design: Assigns 50 freelance design jobs/year. Pays by the project, $8-12/page.
Jackets/Covers: Assigns 50-60 freelance design jobs and 5 illustration jobs/year. Pays for design by the project, $500-800. Pays for illustration by the project.
Text Illustration: Assigns 1 freelance illustration job/year. Pays by the project.

GLENCOE/McGRAW-HILL PUBLISHING COMPANY, 3008 W. Willow Knolls Rd., Peoria IL 61615. (309)689-3200. Fax: (309)689-3211. Contact: Ardis Parker, Design and Production Manager, and Art and Photo Editors. Specializes in secondary educational materials (hardcover, paperback, filmstrips, software), in industrial and computer technology, home economics and family living, social studies, career education, etc. Publishes more than 100 titles/year.
Needs: Works with over 30 freelancers/year. 60% of freelance work demands knowledge of Adobe Illustrator, QuarkXPress or Adobe Photoshop. Works on assignment only.
First Contact & Terms: Send query letter with brochure, résumé and "any type of samples." Samples not filed are returned if requested. Reports back in weeks. Originals are not returned; works on work-for-hire basis with rights to publisher. Considers complexity of the project, skill and experience of the artist, project's budget, turnaround time and rights purchased when establishing payment. Buys all rights.
Book Design: Assigns 30 freelance design jobs/year. Pays by the project.

Jackets/Covers: Assigns 50 freelance design jobs/year. Pays by the project.
Text Illustration: Assigns 50 freelance jobs/year. Pays by the hour or by the project.
Tips: "Try not to cold call and never drop in without an appointment."

N GLOBE PEQUOT PRESS, 6 Business Park Rd., P.O. Box 833, Old Saybrook CT 06475-0833. (860)395-0440. Fax: (860)395-3069. E-mail: sdamato@globe-pequot.com. Website: http://www.globe-pequot.com. Production Director: Kevin Lynch. Estab. 1947. Publishes hardcover and trade paperback originals and reprints. Types of books include (mostly) travel, kayak, outdoor, cookbooks, instruction, self-help and history. Specializes in regional subjects: New England, Northwest, Southeast bed-and-board country inn guides. Publishes 150 titles/year. 20% require freelance illustration; 75% require freelance design. Recent titles include *N.Y. Neighborhoods*, by Eleanor Berman; *Positively Connecticut*, by Diane Smith; *Legendary Lighthouses*, by John Grant; revision of *Basic Essential* series. Design of books is "classic and traditional, but fun." Book catalog available.
Needs: Works with 10-20 freelance illustrators and 15-20 designers/year. Uses freelancers mainly for cover and text design and production. Also for jacket/cover and text illustration and direct mail design. Needs computer-literate freelancers for production. 100% of design and 75% of illustration demand knowledge of QuarkXPress 3.32, Adobe Illustrator 6.02 or Adobe Photoshop 4. Works on assignment only.
First Contact & Terms: Send query letter with résumé, photocopies and photographs. Accepts disk submissions compatible with QuarkXPress 3.32, Adobe Illustrator 6.02 or Adobe Photoshop 4. Samples are filed and not returned. Request portfolio review in original query. Artist should follow up with call after initial query. Art Director will contact artist for portfolio review if interested. Portfolio should include roughs, original/final art, photostats, tearsheets and dummies. Requests work on spec before assigning a job. Considers complexity of project, project's budget and turn-around time when establishing payment. Buys all rights. Originals are not returned. Finds artists through word of mouth, submissions, self promotion and sourcebooks.
Book Design: Pays by the hour, $20-28 for production; or by the project, $400-600 for cover design.
Jackets/Covers: Prefers realistic style. Pays by the hour, $20-35; or by the project, $500-1,000.
Text Illustration: Prefers pen & ink line drawings. Pays by the project, $25-150.
Cover Illustration: Pays by the project $500-700 for color.
Tips: "Our books are being produced on Macintosh computers. We like designers who can use the Mac competently enough that their design looks as if it *hasn't* been done on the Mac."

N GOLD RUSH GAMES, P.O. Box 2531, Elk Grove CA 95759-2531. Phone/fax: (916)684-9443. E-mail: goldrushg @aol.com. Website: http://members.aol.com/goldrushg. President: Mark Arsenault. Estab. 1992. Publishes roleplaying game books, newsletter. Main style/genre of games: science fiction, fantasy, historical (16th century Japan) and superheroes. Uses freelance artists mainly for full color covers and b&w interior book illustrations. Publishes 4-6 titles or products/year. Game/product lines include: *San Angelo: City of Heroes (Champions Campaign Setting)*, *Sengoku: Chanbara Roleplaying in Feudal Japan* and miscellaneous roleplaying games. 100% requires freelance illustration; 50% requires freelance design; 25% requires freelance art direction. Art guidelines free for SASE with 2 first-class stamps. Art guidelines available on website.
Needs: Approached by 50 illustrators and 25 designers/year. Works with 10 illustrators and 2 designers/year. 100% of freelance design demands knowledge of Adobe Illustrator, PageMaker, Adobe Photoshop. 50% of freelance illustration demands knowledge of Adobe Photoshop.
First Contact & Terms: Send query letter with SASE. Illustrators send printed samples and photocopies. Accepts disk submissions in Windows format. Send via floppy disk, Jaz, Zip or e-mail as TIFF or JPEG files at 100-200 dpi "or Zip compression OK. Stuff it, no LZW compressed Zip files." Samples are filed. Reports back within 3 months. Reports back only if interested. Will contact artist for portfolio review if interested. Portfolio should include artwork portraying superheroes and historical Japanese (16th century), b&w, color photocopies. Buys first and reprint rights. Finds freelancers through submissions packets, conventions and referrals.
Visual Design: Assigns 2 freelance design and 2 art direction projects/year. Pays for design by the project, $100-500; for art direction by the project, $100-300.
Book Covers/Posters/Cards: Assigns 2 freelance design jobs and 6 illustration jobs/year. Pays for illustration by the project, $250-1,000; royalties of 2-3%. Prefers multicultural portrayal of characters, detailed backgrounds.
Text Illustration: Assigns 12 freelance illustrations jobs/year. Pays by the full page, $75-150. Pays by the half page, $35-75.
Tips: "We need reliable freelance artists and designers who can meet deadlines. We prefer a mix of 'action' and 'mood' illustrations. Historical accuracy for Japanese art a must."

N GOLDEN BOOKS, (formerly Western Publishing Co., Inc.), 888 Seventh Ave., New York NY 10106. (212)547-6700. Fax: (212)371-1091. Creative Director: Paula Darmofal. Senior Art Director: Tracy Tyler (mass market). Art Directors: Amelia Carling (trade) and Mark Kaplan (young adult). Printing company and publisher. Imprint is Golden Books. Publishes preschool, juvenile, young adult and adult nature guides. Specializes in picture books themed for infant to 8-year-olds. Publishes 250 titles/year. Titles include *I Love Christmas*, *Walt Disney's Lion King*; *Walt Disney's A Bugs Life*; *Family Storytime Books*; *Totally Amazing* Series; and *A Family Treasury of Little Golden Books* and other film releases, 100% require freelance illustration. Book catalog free by request.
Needs: Approached by several hundred artists/year. Works with approximately 100 illustrators/year. Very little freelance design work. Most design is done in-house. Buys enough illustration for 200 plus new titles, approximately 70% being

licensed character books. Artists must have picture book experience; illustrations are generally full color but b&w art is required for coloring and activity books. Uses freelancers for picture books, color and activity books for young children and leveled readers, and for young adult covers and interiors. Traditional illustration as well as digital illustration is accepted, although digital is preferred.

First Contact & Terms: Send query letter with SASE and tearsheets. Samples are filed or are returned by SASE if requested by artist. Portfolio drop-off on Thursdays. Will look at original artwork and/or color representations in portfolios, but please do not send original art through the mail. Royalties or work for hire according to project.

Jackets/Covers: All design done in-house. Makes outright purchase of cover illustrations.

Text Illustration: Assigns approximately 250 freelance illustration jobs/year. Payment varies.

Tips: "We are open to a wide variety of styles. However, illustrations that have strong bright colors and mass market appeal featuring appealing multicultural children will get strongest consideration."

GOOSE LANE EDITIONS LTD., 469 King St., Fredericton, New Brunswick E3B 1E5 Canada. (506)450-4251. E-mail: gooselane@nb.aibn.com. Art Director: Julie Scriver. Estab. 1958. Publishes trade paperback originals of poetry, fiction and nonfiction. Types of books include biography, cookbooks, fiction, reference and history. Publishes 10-15 titles/year. 10% requires freelance illustration. Titles include: *A Guide to Animal Behavior* and *Pete Luckett's Complete Guide to Fresh Fruit and Vegetables*. Books are "high quality, elegant, generally with full-color fine art reproduction on cover." Book catalog free for SAE with Canadian first-class stamp or IRC.

Needs: Approached by 3 freelancers/year. Works with 1-2 illustrators/year. Only works with freelancers in the region. Works on assignment only.

First Contact & Terms: Send query letter with résumé, reproductions and SASE. Illustrators may send postcard samples. Samples are filed or are returned by SASE. Reports back in 2 months.

Book Design: Pays by the project, $400-1,200.

Jackets/Covers: Assigns 1 freelance design job and 2-3 illustration jobs/year. Pays by the project, $200-500.

Text Illustration: Assigns 1 freelance illustration job/year. Pays by the project, $300-1,500.

GOSPEL LIGHT PUBLICATIONS, 2300 Knoll Dr., Ventura CA 93003. (805)644-9721. Fax: (805)644-4729. Art Director: B. Fisher. Estab. 1932. Book publisher. Publishes hardcover, trade paperback and mass market paperback originals. Types of books include instructional, preschool, juvenile, young adult, reference, self-help and history. Specializes in Christian issues. Publishes 30 titles/year. Recent titles include: *Victory Over the Darkness*, by Neil Anderson; and *Bible Verse Coloring Pages*. 25% requires freelance illustration; 10% requires freelance design. Book catalog available for SASE.

Needs: Approached by 300 artists/year. Works with 10 illustrators and 4 designers/year. Buys 10 illustrations/year. Uses freelancers mainly for jacket/cover illustration and design. Also for text illustration, direct mail, book and catalog design. 100% of freelance design and 50% of illustration requires knowledge of QuarkXPress, Adobe Illustrator and Adobe Photoshop. Works on assignment only.

First Contact & Terms: Send SASE, tearsheets, photographs and samples. Samples are filed or are returned by SASE if requested by artist. Reports back to the artist only if interested. Art Director will contact artist for portfolio review if interested. Portfolio should include color photostats, tearsheets, photographs, slides or transparencies. Negotiates rights purchased. Originals are returned to artist at job's completion.

Book Design: Assigns 4 freelance design and 5 illustration jobs/year. Pays by the project.

Jackets/Covers: Assigns 5 freelance design and 5 freelance illustration jobs/year. Accepts all types of styles and media for jacket/cover design and illustration. Pays by the project.

Text Illustration: Assigns 6 freelance design and 8 illustration jobs/year. Pays by the project.

THE GRADUATE GROUP, P.O. Box 370351, W. Hartford CT 06137-0351. (860)233-2330. President: Mara Whitman. Estab. 1967. Publishes trade paperback originals. Types of books include instructional and reference. Specializes in internships and career planning. Publishes 35 titles/year. Recent titles include *New Internships for 1998*, by Robert Whitman and *Careers in Law Enforcement*, by Lt. Jim Nelson. 10% require freelance illustration and design. Book catalog free by request.

Needs: Approached by 20 freelancers/year. Works with 1 freelance illustrator and 1 designer/year. Prefers local freelancers only. Uses freelancers for jacket/cover illustration and design; direct mail, book and catalog design. 5% of freelance work demands computer skills. Works on assignment only.

First Contact & Terms: Send query letter with brochure and résumé. Samples are not filed. Reports back only if interested. Write for appointment to show portfolio.

GRAYWOLF PRESS, 2402 University Ave., St. Paul MN 55114. (612)641-0077. Fax: (612)641-0036. E-mail: czarnie c@graywolfpress.org. Website: http://www.graywolfpres.org. Executive Editor: Anne Czarniecki. Estab. 1974. Publishes hardcover originals, trade paperback originals and reprints of literary classics. Specializes in novels, nonfiction, memoir, poetry, essays and short stories. Publishes 16 titles/year. Recent titles include: *Otherwise*, by Jane Kenyon; *Nola*, by Robin Hemley; *Central Square*, by George Packer; *Crossing the Expendable Landscape*, by Bettina Drew. 100% require freelance design. Books use solid typography, strikingly beautiful and well-integrated artwork. Book catalog free by request.

• Graywolf is recognized as one of the finest small presses in the nation.

Needs: Approached by 50 freelance artists/year. Works with 5 designers/year. Buys 20 illustrations/year (existing art

only). Prefers artists with experience in literary titles. Uses freelancers mainly for cover design. Also for direct mail and catalog design. Works on assignment only.

First Contact & Terms: Send query letter with résumé and photocopies. Samples are returned by SASE if requested by artist. Executive Editor will contact artist for portfolio review if interested. Portfolio should include b&w, color photostats and tearsheets. Negotiates rights purchased. Interested in buying second rights (reprint rights) to previously published work. Originals are returned at job's completion. Pays by the project. Finds artists through submissions and word of mouth.

Jackets/Covers: Assigns 16 design jobs/year. Pays by the project, $800-1,200. "We use existing art—both contemporary and classical—and emphasize fine typography."

Tips: "Have a strong portfolio of literary (fine press) design."

☑ 🏆 **GREAT QUOTATIONS PUBLISHING,** 1967 Quincy Court, Glendale Heights IL 60139. (630)582-2800. Fax: (630)582-2813. Design Editor: Cheryl Henderson. Estab. 1985. Imprint of Greatime Offset Printing. Company publishes hardcover, trade paperback and mass market paperback originals. Types of books include humor, inspiration, motivation and books for children. Specializes in gift books. Publishes 50 titles/year. Recent titles include *Only a Sister Could Be Such a Good Friend* and *Words From the Coach*. 50% requires freelance illustration and design. Book catalog available for $2 with SASE.

Needs: Approached by 100 freelancers/year. Prefers local artists. Uses freelancers to illustrate and/or design books and catalogs. 50% of freelance work demands knowledge of QuarkXPress and Adobe Photoshop. Works on assignment only.

First Contact & Terms: Send letter of introduction and a maximum of 3 samples. Only samples measuring 8½ × 11 will be considered. Name, address and telephone number should be clearly displayed on the front of the sample. All appropriate samples will be placed in publisher's library. Design Editor will contact artist under consideration, as prospective projects become available. Rights purchased vary according to project.

Book Design: Assigns 35 freelance design jobs/year. Pays by the project, $300-3,000.

Jackets/Covers: Assigns 15 freelance design jobs/year and 15 illustration jobs/year. Pays by the project, $300-3,000.

Text Illustration: Assigns 20 freelance illustration jobs/year. Pays by the project, $100-1,000.

Tips: "We're looking for bright, colorful cover design on a small size book cover (around 6 × 6). Outstanding humor or motivational titles will be most in demand."

GROUP PUBLISHING BOOK PRODUCT, (formerly Group Publishing—Book & Curriculum Division), 1515 Cascade Ave., Loveland CO 80539. (970)669-3836. Fax: (970)669-1994. Website: http://www.grouppublishing.com. Art Directors (for interiors): Jeff Spencer, Jean Bruns, Kari Monson and Randy Kady. Webmaster: Ray Tollison. Company publishes books, Bible curriculum products (including puzzles, posters, etc.), clip art resources and audiovisual materials for use in Christian education for children, youth and adults. Publishes 35-40 titles/year. Recent titles include: *The Dirt on Learning, Group's Hands-On Bible Curriculum, Real Life Bible Curriculum, Group's Treasure Hunt Bible Adventure Vacation Bible School,* and *Faith Bible Curriculum.*

● This company also produces magazines. See listing in Magazines section for more information.

Needs: Uses freelancers for cover illustration and design. 100% of design and 50% of illustration demand knowledge of QuarkXPress 3.32-4.0, Macromedia Freehand 8.0, Adobe Photoshop 5.0, Adobe Illustrator 7.0. Occasionally uses cartoons in books and teacher's guides. Uses b&w and color illustration on covers and in product interiors.

First Contact & Terms: Contact Jeff Storm, Marketing Art Director, if interested in cover design or illustration. Contact Jeff Spencer if interested in book and curriculum interior illustration and design. Send query letter with nonreturnable b&w or color photocopies, slides, tearsheets or other samples. Accepts disk submissions. Samples are filed, additional samples may be requested prior to assignment. Reports back only if interested. Rights purchased vary according to project.

Jackets/Covers: Assigns minimum 15 freelance design and 10 freelance illustration jobs/year. Pays for design, $250-1,200; pays for illustration, $250-1,200.

Text Illustration: Assigns minimum 30 freelance illustration jobs/year. **Pays on acceptance**: $40-200 for b&w (from small spot illustrations to full page). Fees for color illustration and design work vary and are negotiable. Prefers b&w line or line and wash illustrations to accompany lesson activities.

Tips: "We prefer contemporary, nontraditional styles appropriate for our innovative and upbeat products and the creative Christian teachers and students who use them. We seek experienced designers and artists who can help us achieve our goal of presenting biblical material in fresh, new and engaging ways. Submit design/illustration on disk. Self promotion pieces help get you noticed. Have book covers/jackets, brochure design, newsletter or catalog design in your portfolio. Include samples of Bible or church-related illustration."

🔳 ❧ 🏆 **GUARDIANS OF ORDER,** P.O. Box 25016, Stone Road Mall Post Office, 435 Stone Rd., Guelph, Ontario N1G 4T4 Canada. (519)821-7174. Fax: (519)821-7635. E-mail: mark@guardiansorder.on.ca. Website: http://www.guardiansorder.on.ca. Art Director: Mark C. MacKinnon. Estab. 1997. Publishes roleplaying game books. Main style/genre of games: Japanimation. Uses freelance artists mainly for books and posters. Publishes 6 titles or products/year. Game/product lines include: *The Sailor Moon Role-Playing Game and Resource Book* and *Big Eyes, Small Mouth.* 50% requires freelance illustration; 50% requires freelance design.

Needs: Approached by 10 illustrators and 5 designers/year. Works with 5 illustrators and 2 designers/year. Prefers local illustrators. Prefers local designers. Prefers local freelancers. Prefers freelancers experienced in color, CG and line art.

100% of freelance design demands knowledge of Adobe Illustrator, Adobe Photoshop and QuarkXPress. 50% of freelance illustration demands knowledge of Adobe Photoshop.

First Contact & Terms: Send query letter with résumé, business card. Illustrators send printed samples, photocopies and disk submissions. Send 6-10 samples. Accepts disk submissions in Mac format. Send via floppy disk or e-mail as JPEG files at 200 dpi. Samples are filed. Reports back only if interested. Portfolio review not required. Buys first or reprint rights. Finds freelancers through submission packets and conventions.

Visual Design: Pays for design by the project.

Text Illustration: Assigns 6-10 freelance illustration jobs/year. Pays by the project. Prefers characters with backgrounds, scenic art, and/or technical illustrations.

Tips: "We need fast workers, with quick turnaround."

GUERNICA EDITIONS, P.O. Box 117, Station P, Toronto, Ontario M5S 2S6 Canada. (416)657-8885. Fax: (416)657-8885. E-mail: 102026.1331@compuserve.com. Website: http://ourworld.compuserve.com/homepages/Guerni ca. Publisher/Editor: Antonio D'Alfonso. Editors: Joseph Pivato, Ken Scambray, Pasquale Verdicchio. Estab. 1978. Book publisher and literary press specializing in translation. Publishes trade paperback originals and reprints. Types of books include contemporary and experimental fiction, biography and history. Specializes in ethnic/multicultural writing and translation of European and Quebecois writers into English. Publishes 16-20 titles/year. Recent titles include *Fascism and the Italians of Montreal*, by Filippo Salvatore (artist: Cesare Oliva); *Pillars of Lace*, edited by Marisa De Franceschi (artist: Hono Lulu); and *A House on the Piazza*, by Kenny Marotta (artist: Vince Mancuso). 40-50% require freelance illustration. Book catalog available for SAE; nonresidents send IRC.

Needs: Approached by 6 freelancers/year. Works with 6 freelance illustrators/year. Uses freelancers mainly for jacket/cover illustration.

First Contact & Terms: Send query letter with résumé, SASE (or SAE with IRC), tearsheets, photographs and photocopies. Samples are filed or are returned by SASE if requested by artist. Reports back only if interested. To show portfolio, mail photostats, tearsheets and dummies. Buys one-time rights. Originals are not returned at job completion.

Jackets/Covers: Assigns 10 freelance illustration jobs/year. Pays by the project, $150-200.

Tips: "We really believe that the author should be aware of the press they work with. Try to see what a press does and offer your own view of that look. We are looking for strong designers. We have three new series of books, so there is a lot of place for art work."

HARLAN DAVIDSON, INC., 773 Glenn Ave., Wheeling IL 60090-6000. (847)541-9720. Fax: (847)541-9830. E-mail: harlandavidson@harlandavidson.com. Website: http://www.harlandavidson.com. Production Manager: Lucy Herz. Imprints include Forum Press and Crofts Classics. Publishes textbooks. Types of books include biography, classics in literature, drama, political science and history. Specializes in US and European history. Publishes 6-15 titles/year. Recent titles include: *America's Civil War*. 20% requires freelance illustration; 20% requires freelance design. Catalog available.

Needs: Approached by 2 designers/year. Works with 1-2 designers/year. 100% of freelance design demands knowledge of Adobe Photoshop.

First Contact & Terms: Designers send query letter with brochure and résumé. Samples are filed or are returned by SASE. Reports back within 2 weeks. Portfolio review required from designers. Will contact artist for portfolio review of book dummy if interested. Buys all rights.

Book Design: Assigns 3 freelance design jobs/year. Pays by the project, $500-1,000.

Jackets/Covers: Assigns 3 freelance design jobs/year. Pays by the project, $500-1,000. Finds freelancers through networking.

Tips: "Have knowledge of file preparation for electronic prepress."

HARMONY HOUSE PUBLISHERS—LOUISVILLE, P.O. Box 90, Prospect KY 40059. (502)228-4446. Fax: (502)228-2010. Art Director: William Strode. Estab. 1980. Publishes hardcover books. Specializes in general books, cookbooks and education. Publishes 20 titles/year. Titles include *Sojourn in the Wilderness* and *Christmas Collections*. 10% require freelance illustration.

Needs: Approached by 10 freelancers/year. Works with 2-3 freelance illustrators/year. Prefers freelancers with experience in each specific book's topic. Uses freelancers mainly for text illustration. Also for jacket/cover illustration. Usually works on assignment basis.

First Contact & Terms: Send query letter with brochure, résumé, SASE and appropriate samples. Samples are filed or are returned. Reports back only if interested. "We don't usually review portfolios, but we will contact the artist if the query interests us." Buys one-time rights. Returns originals at job's completion. Assigns several freelance design and 2 illustration jobs/year. Pays by the project.

HARVEST HOUSE PUBLISHERS, 1075 Arrowsmith, Eugene OR 97402. (541)343-0123. Fax: (541)342-6410. Cover Director: Barbara Sherrill. Specializes in hardcover and paperback editions of adult fiction and nonfiction, children's books, gift books and youth material. Publishes 100-125 titles/year. Recent titles include *Pretense*; *The Very Best Christmas Ever*; *With New Eyes*; and *A Garden Full of Love*. Books are of contemporary designs which compete with the current book market.

Needs: Works with 4-5 freelance illustrators and 7-8 freelance designers/year. Uses freelance artists mainly for cover art. Also uses freelance artists for text illustration. Works on assignment only.

First Contact & Terms: Send query letter with brochure, résumé, tearsheets and photographs. Art Director will contact artist for portfolio review if interested. Requests work on spec before assigning a job. Originals may be returned at job's completion. Buys all rights. Finds artists through word of mouth and submissions/self-promotions.
Book Design: Pays by the project.
Jackets/Covers: Assigns 100-125 design and less than 10 illustration jobs/year. Pays by the project.
Text Illustration: Assigns 5 jobs/year. Pays by the project.

☑ ▣ **HAY HOUSE, INC.**, P.O. Box 5100, Carlsbad CA 92018-5100. (800)654-5126. Art Director: Christy Salinas. Publishes hardcover originals and reprints, trade paperback originals and reprints, audio tapes, CD-ROM. Types of book include New Age, astrology, metaphysics, psychology and gift books. Specializes in self-help. Publishes 100 titles/year. Recent titles include *You Can Heal Your Life*, *The Western Guide to Feng Shui* and *Heal Your Body A-Z* and *New York Times* bestseller *Adventures of a Psychic*. 40% require freelance illustration; 30% require freelance design. Book catalog free on request.
 • Hay House is also looking for people who design for the gift market.
Needs: Approached by 20 freelance illustrators and 5 freelance designers/year. Works with 10 freelance illustrators and 2-5 freelance designers/year. Uses freelancers mainly for cover design and illustration. 80% of freelance design demands knowledge of Adobe Photoshop, Adobe Illustrator, QuarkXPress. 20% of titles require freelance art direction.
First Contact & Terms: Designers send photocopies (color), résumé, SASE "if you want your samples back." Illustrators send photocopies. "We accept TIFF and EPS images compatible with the latest versions of QuarkXPress, Adobe Photoshop and Adobe Illustrator. Samples are filed or are returned by SASE. Art director will contact artist for portfolio review of printed samples or original artwork if interested. Buys all rights. Finds freelancers through word of mouth, submissions.
Book Design: Assigns 10 freelance design jobs/year; 10 freelance art direction projects/year.
Jacket/Covers: Assigns 20 freelance design jobs and 20 illustration jobs/year. Pays for design by the project, $800-1,200. Payment for illustration varies for covers.
Text Illustration: Assigns 10 freelance illustration jobs/year.
Tips: "We look for freelancers with experience in graphic design, desktop publishing, printing processes, production and illustrators with fresh and whimsical styles."

☑ **HEARTLAND SAMPLERS, INC.**, 3255 Spring St. NE, Minneapolis MN 55413. (612)379-8029. Fax: (612)378-4835. Art Director: Mark Johnson. Estab. 1987. Book publisher. Types of products include perpetual calendars, books and inspirational gifts. Publishes 50 titles/year. 100% requires freelance illustration and design. Book catalog for SAE with first-class postage.
Needs: Approached by 4 freelancers/year. Works with 10-12 freelance illustrators and 2-4 designers/year. Prefers freelancers with experience in the gift and card market. Uses freelancers for illustrations; jacket/cover illustration and design; direct mail, book and catalog design.
First Contact & Terms: Send query letter with brochure, résumé, SASE, tearsheets, photographs and photocopies. Samples are filed or are returned by SASE if requested by artist. Art Director will contact artist for portfolio review if interested. Portfolio should include thumbnails, roughs, 4-color photographs and dummies. Sometimes requests work on spec before assigning a job. Rights purchased vary according to project.
Book Design: Assigns 12 freelance design jobs/year. Pays by the project, $35-300.
Jackets/Covers: Assigns 15-40 freelance design jobs/year. Prefers watercolor, gouache and acrylic. Pays by the project, $50-350.
Text Illustration: Assigns 2 freelance design jobs/year. Prefers watercolor, gouache and acrylic. Pays by the project, $50-200.

HEAVEN BONE PRESS, Box 486, Chester NY 10918. (914)469-9018. E-mail: heavenbone@aol.com. President/Editor: Steve Hirsch. Estab. 1987. Book and magazine publisher of trade paperback originals. Types of books include poetry and contemporary and experimental fiction. Publishes 4-6 titles/year. Recent titles include *Fountains of Gold*, by Wendy Vig and Jon Anderson. Design of books is "off-beat, eclectic and stimulating." 80% require freelance illustration. Book catalog available for SASE.
 • This publisher often pays in copies. Approach this market if you're seeking to build your portfolio and are not concerned with payment. The press also publishes *Heaven Bone* magazine for which illustrations are needed.
Needs: Approached by 10-12 freelancers/year. Works with 3-4 freelance illustrators. Uses freelancers mainly for illustrations. Needs computer-literate freelancers for illustration. 5% of work demands knowledge of QuarkXPress, Aldus FreeHand, Adobe Illustrator or Photoshop.
First Contact & Terms: Send query letter with brochure, tearsheets, photostats, photographs and slides. Samples are filed or returned by SASE. Reports back within 3 months. To show portfolio, mail finished art, photostats, tearsheets, photographs and slides. Rights purchased vary according to project. Originals are returned at job's completion.
Book Design: Assigns 1-2 freelance design jobs/year. Prefers to pay in copies, but has made exceptions.
Jackets/Covers: Prefers to pay in copies, but has made exceptions. Enjoys pen & ink, woodcuts, b&w drawings and front and back outside covers in 4-color process.
Text Illustration: Assigns 1-2 freelance design jobs/year.
Tips: "Know our specific needs, know our magazine and be patient."

🌐 **HEMKUNT PUBLISHERS LTD.**, A-78 Naraina Indl. Area Ph.I, New Delhi 110028 India. Phone: 011-91-11 579-2083, 579-0032 or 579-5079. Fax: 611-3705. Website: http://www.gen.com/knowindia/indianbooks/hemkunt.htm. Chief Executive: Mr. G.P. Singh. Director Marketing: Aruinder Singh. Director Production: Deepinder Singh. Specializes in educational text books, illustrated general books for children and also books for adults. Subjects include religion and history. Publishes 30-50 new titles/year. Recent titles include *Tales of Birbal and Akbar*, by Vernon Thomas.
Needs: Works with 30-40 freelance illustrators and 3-5 designers/year. Uses freelancers mainly for illustration and cover design. Also for jacket/cover illustration. Works on assignment only.
First Contact & Terms: Send query letter with résumé and samples to be kept on file. Prefers photographs and tearsheets as samples. Samples not filed are not returned. Art Director will contact artist for portfolio review if interested. Requests work on spec before assigning a job. Originals are not returned. Considers complexity of project, skill and experience of artist and project's budget when establishing payment. Buys all rights. Interested in buying second rights (reprint rights) to previously published artwork.
Book Design: Assigns 40-50 freelance design jobs/year. Payment varies.
Jackets/Covers: Assigns 30-40 freelance design jobs/year. Pays $20-50.
Text Illustration: Assigns 30-40 freelance jobs/year. Pays by the project.

🆕 **HERALDIC GAMES DESIGN**, 1013 W. Virginia Ave., Peoria IL 61604. (305)686-0845. E-mail: heraldic@aol.com. Website: http://members.aol.com/heraldic. Owner: Keith L. Sears. Estab. 1993. Publishes roleplaying game books. Main style/genre of games: science fiction, cyberpunk, fantasy, Victorian, horror. Uses freelance artists mainly for b&w interior illustrations. Publishes 2 titles or products/year. 100% requires freelance illustration.
First Contact & Terms: Accepts disk submissions in Windows format. Send via CD, floppy disk, Zip or e-mail as TIFF, GIF or JPEG files. Samples are filed. Portfolio review not required. Negotiates rights purchased. Finds freelancers through e-mail and submission packets.
Text Illustration: Assigns 2 freelance text illustration jobs/year. Pays 5% royalty.

👤 **HIPPOCRENE BOOKS INC.**, 171 Madison Ave., Suite 1602, New York NY 10016. (212)685-4371. Fax: (212)779-9338. E-mail: hippocre@ix.netcom.com. Website: http://www.hippocrenebooks.com. Managing Editor: Carol Chitnis. Estab. 1971. Publishes hardcover originals and trade paperback reprints. Types of books include biography, cookbooks, history, nonfiction, reference, travel, dictionaries, foreign language, bilingual. Specializes in dictionaries, cookbooks, love poetry. Publishes 60 titles/year. Recent titles include: *Hippocrene Children's Illustrated Foreign Language Dictionaries*, *Longing For a Kiss: Love Poems From Many Lands* and *Russia: An Illustrated History*. 10% requires freelance illustration. Book catalog free for 9×12 SAE with 4 first-class stamps.
Needs: Approached by 10 illustrators and 5 designers/year. Works with 3 illustrators and 1 designer/year. Prefers local freelancers experienced in line drawings.
First Contact & Terms: Designers send query letter with photocopies, SASE, tearsheets. Illustrators send postcard sample and follow-up postcard every 4-6 months. No disk submissions. Samples are filed. Will contact artist for portfolio review if interested. Portfolio should include photocopies of artwork portraying "love" poetry subjects. Buys one-time rights. Finds freelancers through promotional postcards and suggestion of authors.
Jackets/Covers: Assigns 2 freelance design and 4 freelance illustration jobs/year. Pays by the project, $200-500.
Text Illustration: Assigns 4 freelance illustration jobs/year. Pays by the project, $250-1,700. Prefers freelancers who create drawings/sketches for love or poetry books.
Tips: "We prefer traditional illustrations appropriate for gift books."

HOLCOMB HATHAWAY, PUBLISHERS, 6207 N. Cattle Track Rd., Scottsdale AZ 85250. (602)991-7881. Fax: (602)991-4770. E-mail: sales@hh-pub.com. Production Director: Gay Pauley. Estab. 1997. Publishes textbooks. Specializes in education, communication. Publishes 10 titles/year. Recent titles include: *The Agricultural Marketing System*. 50% requires freelance cover illustration; 10% requires freelance design. Book catalog not available.
Needs: Approached by 15 illustrators and 15 designers/year. Works with 3 illustrators and 10 designers/year. Prefers freelancers experienced in cover design, typography, graphics. 100% of freelance design and 50% of freelance illustration demands knowledge of Adobe Photoshop, Adobe Illustrator, QuarkXPress.
First Contact & Terms: Send query letter with brochure. Illustrators send postcard sample. Will contact artist for portfolio review of photocopies and tearsheets if interested. Rights purchased vary according to project.
Book Design: Assigns 3 freelance design jobs/year. Pays for design by the project, $500-1,500.
Jackets/Covers: Assigns 10 design jobs/year. Pays by the project, $250-1,000. Pays for cover illustration by the project.
Text Illustration: Assigns 2 freelance illustration jobs/year. Pays by the piece. Prefers computer illustration. Finds freelancers through word of mouth, submissions.
Tips: "It is helpful if designer has experience with college textbook design and good typography skills."

🆕 **HOLIDAY HOUSE**, 425 Madison Ave., New York NY 10017. (212)688-0085. Editor-in-Chief: Regina Griffin. Art Director: Claire Counihan. Specializes in hardcover children's books. Publishes 50 titles/year. 75% require illustration. Recent titles include *Rum-A-Tum-Tum*, by Angela Shelf Medearis; *The Moon Book*, by Gail Gibbons; and *The True Tale of Johnny Appleseed*, illustrated by Kimberly Bulcken Root.
Needs: Only accepts art suitable for children and young adults. Works on assignment only.
First Contact & Terms: Send query letter with photocopies and SASE. Samples are filed or are returned by SASE.

Request portfolio review in original query. Reports back only if interested. Originals are returned at job's completion. Finds artists through submissions and agents.

Jackets/Covers: Assigns 5-10 freelance illustration jobs/year. Pays by the project, $900-1,200.

Text Illustrations: Assigns 5-10 freelance jobs/year. Pays royalty.

HOLLOW EARTH PUBLISHING, P.O. Box 1355, Boston MA 02205-1355. (603)433-8735. Fax: (603)433-8735. E-mail: hep2@aol.com. Publisher: Helian Yvette Grimes. Estab. 1983. Company publishes hardcover, trade paperback and mass market paperback originals and reprints, textbooks, electronic books and CD-ROMs. Types of books include contemporary, experimental, mainstream, historical and science fiction, instruction, fantasy, travel and reference. Specializes in mythology, photography, computers (Macintosh). Publishes 5 titles/year. Titles include *Norse Mythology*, *Legend of the Niebelungenlied*. 50% require freelance illustration; 50% require freelance design. Book catalog free for #10 SAE with 1 first-class stamp.

Needs: Approached by 250 freelancers/year. Prefers freelancers with experience in computer graphics. Uses freelancers mainly for graphics. Also for jacket/cover design and illustration, text illustration, book design and multimedia projects. 100% of freelance work demands knowledge of Adobe Illustrator, QuarkXPress, Adobe Photoshop, Aldus FreeHand, Director or rendering programs. Works on assignment only.

First Contact & Terms: Send e-mail queries only. Reports back within 1 month. Art Director will contact artist for portfolio review if interested. Portfolio should include color thumbnails, roughs, tearsheets and photographs. Buys all rights. Originals are returned at job's completion. Finds artists through submissions and word of mouth.

Book Design: Assigns 12 book and magazine covers/year. Pays by the project, $100 minimum.

Jackets/Covers: Assigns 12 freelance design and 12 illustration jobs/year. Pays by the project, $100 minimum.

Text Illustration: Assigns 12 freelance illustration jobs/year. Pays by the project, $100 minimum.

Tips: Recommends being able to draw well. First-time assignments are usually article illustrations; covers are given to "proven" freelancers.

HENRY HOLT BOOKS FOR YOUNG READERS, 115 W. 18th St., 6th Floor, New York NY 10011. (212)886-9200. Fax: (212)645-5832. Art Director: Martha Rago. Estab. 1866. Imprint of Henry Holt and Company, Inc. Imprint publishes hardcover and trade paperback originals and reprints. Types of books include juvenile, preschool and young adult. Specializes in picture books and young adult nonfiction and fiction. Publishes 75-100 titles/year. 100% requires freelance illustration. Book catalog free by request.

Needs: Approached by 1,300 freelancers/year. Works with 30-50 freelance illustrators and designers/year. Uses freelancers for jacket/cover and text illustration. Works on assignment only.

First Contact & Terms: Send postcard sample of work or query letter with tearsheets, photostats and SASE. Samples are filed or returned by SASE if requested by artist. Reports back within 1-3 months if interested. Portfolios may be dropped off every Thursday. Art Director will contact artist for portfolio review if interested. Portfolio should include photostats, final art, roughs and tearsheets. "Anything artist feels represents style, ability and interests." Rights purchased vary according to project. Originals are returned at job's completion. Finds artists through word of mouth, artists' submissions and attending art exhibitions.

Jackets/Covers: Assigns 20-30 freelance illustration jobs/year. Pays $800-1,000.

Text Illustration: Assigns 30-50 freelance illustration jobs/year. Pays $5,000 minimum.

:N: HOMESTEAD PUBLISHING, Box 193, Moose WY 83012. Phone/fax: (307)733-6248. Contact: Art Director. Estab. 1980. Publishes hardcover and paperback originals. Types of books include art, biography, history, guides, photography, nonfiction, natural history, and general books of interest. Publishes more than 30 titles/year. Recent titles include *Tales of the Wolf*, *Wildflowers of the Rocky Mountains*, *The Ape & The Whale*, *Never Too Late For Love*, *Rocky Mountain Wildlife* and *Robert E. Lee: A Portrait*. 75% requires freelance illustration. Book catalog free for SAE with 4 first-class stamps.

Needs: Works with 20 freelance illustrators and 10 designers/year. Prefers pen & ink, airbrush, charcoal/pencil and watercolor. 25% of freelance work demands knowledge of Aldus PageMaker or Aldus FreeHand. Works on assignment only.

First Contact & Terms: Send query letter with printed samples to be kept on file or write for appointment to show portfolio. For color work, slides are suitable; for b&w, technical pen, photostats. "Include one piece of original artwork to be returned." Samples not filed are returned by SASE only if requested. Reports back within 10 days. Rights purchased vary according to project. Originals are not returned.

Book Design: Assigns 6 freelance design jobs/year. Pays by the project, $50-3,500.

Jackets/Covers: Assigns 2 freelance design and 4 illustration jobs/year. Pays by the project, $50-3,500.

Text Illustration: Assigns 50 freelance illustration jobs/year. Prefers technical pen illustration, maps (using airbrush, overlays, etc.), watercolor illustrations for children's books, calligraphy and lettering for titles and headings. Pays by the hour, $5-20 or by the project, $50-3,500.

Tips: "We are using more graphic, contemporary designs and looking for the best quality."

HONOR BOOKS, 2448 E. 81st St., Suite 4800, Tulsa OK 74137. (918)496-9007. E-mail: dianew@honorbooks.com. Creative Director: Diane Whisner. Estab. 1991. Publishes hardcover originals, trade paperback originals, mass market paperback originals and gift books. Types of books include biography, coffee table books, humor, juvenile, motivational, religious and self help. Specializes in inspirational and motivational. Publishes 60-70 titles/year. Recent titles include:

God's Little Instruction Book and *Treasury of Virtues*. 40% require freelance illustration; 90% require freelance design.

Needs: Works with 4 illustrators and 10 designers/year. Prefers illustrators experienced in line art; designers experienced in book design. Uses freelancers mainly for design and illustration. 100% of freelance design demands knowledge of Aldus FreeHand, Adobe Photoshop, Adobe Illustrator and QuarkXPress. 20% of freelance illustration demands knowledge of Aldus FreeHand, Adobe Photoshop and Adobe Illustrator. 15% of titles rquire freelance art direction.

First Contact & Terms: Designers send query with with brochure, photocopies and tearsheets. Illustrators send query letter with printed samples and tearsheets. Send follow-up postcard every 3 months. Accepts disk submissions compatible with QuarkXPress or EPS files. Samples are filed. Reports back within 3 weeks. Request portfolio review in original query. Will contact artist for portfolio review of book dummy, photographs, roughs and tearsheets if interested. Rights purchased vary according to project.

Book Design: Assigns 60 freelance design jobs/year. Pays by the project, $300-1,800.

Jackets/Covers: Assigns 60 freelance design jobs and 30 illustration jobs/year. Pays for design by the project, $700-2,400. Pays for illustration by the project, $400-1,500.

Text Illustration: Pays by the project. Finds freelancers through *Creative Black Book*, word of mouth, conventions and submissions.

Tips: "Artist should be knowledgeable of CBA/general interest market and digital prepress."

HOUGHTON MIFFLIN COMPANY, Children's Book Department, 222 Berkeley St., Boston MA 02116. (617)351-5000. Website: http://www.hmco.com. Art Director: Bob Kosturko. Estab. 1880. Company publishes hardcover originals. Types of books include juvenile, preschool and young adult. Publishes 60-70 titles/year. 100% requires freelance illustration; 10% requires freelance design.

Needs: Approached by 400 freelancers/year. Works with 50 freelance illustrators and 10 designers/year. Prefers artists with interest in or experience with children's books. Uses freelance illustrators mainly for jackets, picture books. Uses freelance designers primarily for photo essay books. 100% of freelance design work demands knowledge of QuarkXPress, Adobe Photoshop and Adobe Illustrator.

First Contact & Terms: Send postcard sample of work or send query letter with tearsheets, photographs, slides, photocopies and/or transparencies and SASE. Do not send originals! Samples are filed or returned by SASE. Reports back within 1-2 months. Art director will contact artist for portfolio review if interested. Portfolio should include printed books, book dummy, slides, transparencies, roughs and tearsheets. Rights purchased vary according to project. Works on assignment only. Finds artists through sourcebooks, word of mouth, submissions.

Book Design: Assigns 10-20 freelance design jobs/year. Pays by the project.

Jackets/Covers: Assigns 12 freelance illustration jobs/year. Pays by the project.

Text Illustration: Assigns up to 50 freelance illustration jobs/year. Pays by the project.

☑ HOWELL PRESS, INC., 1713-2D Allied Lane, Charlottesville VA 22903. (804)977-4006. Fax: (804)971-7204. E-mail: howellpres@aol.com. Website: http://www.howellpress.com. President: Ross Howell. Estab. 1985. Company publishes hardcover and trade paperback originals. Types of books include history, coffeetable books, cookbooks, gardening and transportation. Publishes 9-10 titles/year. Recent titles include *The Burning*, by John Heatwole; *Sprint Car Racing*, by Bill Holder; and *Virginia's Past Today*, by Chiles T.A. Larson. 80% require freelance illustration and design. Book catalog free by request.

Needs: Approached by 15-20 freelancers/year. Works with 1-2 freelance illustrators and 1-2 designers/year. "It's most convenient for us to work with local freelance designers." Uses freelancers mainly for graphic design. Also for jacket/cover, direct mail, book and catalog design. 100% of freelance work demands knowledge of Aldus PageMaker, Adobe Illustrator, Adobe Photoshop or QuarkXPress.

First Contact & Terms: Designers send query letter with résumé, SASE, slides and tearsheets. Illustrators send query letter with résumé, photocopies, SASE and tearsheets. Samples are filed and are returned by SASE if requested by artist. Art Director will contact artist for portfolio review if interested. Portfolio should include color tearsheets and slides. Negotiates rights purchased. Originals are returned at job's completion. Finds artists through submissions.

Book Design: Assigns 9-10 freelance design jobs/year. Pays for design by the hour, $15-25; by the project, $500-5,000.

☑ HUMANICS LIMITED, P.O. Box 7400, Atlanta GA 30357. (404)874-2176. Fax: (404)874-1976. E-mail: humanics@mindspiring.com. Website: http://www.humanicspub.com. Acquisitions Editor: W. Arthur Bligh. Estab. 1976. Publishes trade paperback originals and educational activity books. Publishes 5 titles/year. Recent titles include *Sexual Styles*; *The Tao of Design*; *The Millenium Myth* and *The Tao of Living on Purpose*. Learning books are workbooks with 4-color covers and line art within; trade paperbacks are 6×9 with 4-color covers. Book catalog for 9×12 SASE. Specify which imprint when requesting catalog: Learning or trade paperbacks.

● No longer publishes children's fiction or picture books.

First Contact & Terms: Send query letter with résumé, SASE and photocopies. Samples are filed or are returned by SASE if requested by artist. Rights purchased vary according to project. Originals are not returned.

Book Design: Pays by the project.

Jackets/Covers: Pays by the project.

Text Illustration: Pays by the project.

IDEALS CHILDREN'S BOOKS, 1501 County Hospital Rd., Nashville TN 37218. (615)254-2480. Fax: (615)254-2405. Editor: Laura Rader. Estab. 1940. Imprint of Hambleton-Hill Publishing, Inc. Publishes hardcover originals, trade paperback originals and reprints, mass market paperback originals and reprints. Types of books include children's picture books, juvenile and preschool. Specializes in fiction and nonfiction for children aged 3-10. Publishes 40 titles/year. Recent titles include: *The Littlest Uninvited One*, by Charles Tazewell; *Just Right*, by Alan Osmond; and *Outside*. 100% require freelance illustration; 5% require freelance design.

Needs: Approached by 400 illustrators/year. Works with 30 illustrators and 2 designers/year. Prefers freelancers experienced in picture book illustration. Uses freelancers mainly for picture book illustration. 100% of freelance design demands knowledge of Adobe Photoshop, Adobe Illustrator and QuarkXPress.

First Contact & Terms: Designers send query letter with photocopies and résumé. Illustrators send postcard sample or query letter with photocopies, photographs, printed samples, résumé and tearsheets. Send follow-up postcard every 3-6 months. Samples are filed. Reports back only if interested. Portfolio review not required. Buys all rights.

Book Design: Assigns 2-4 freelance design jobs/year. Pays by the project.

Jackets/Covers: Assigns 2-4 freelance design jobs and 40 illustration jobs/year. Pays for design and illustration by the project.

Text Illustration: Assigns 40 freelance illustration jobs/year. Pays by the project. Finds freelancers through agents, submissions and sourcebooks.

Tips: "Primarily, we look for quality and consistency of character development. It is helpful if artist has some knowledge of the printing and scanning processes."

☑ **IDEALS PUBLICATIONS INC.**, 535 Metroplex Dr., Suite 250, Nashville TN 37211. (615)333-0478. Fax: (615)781-1447. Editor: Michelle Burke. Art Director: Eve DeGrie. Publisher: Patricia Pinery. Estab. 1944. Imprints include Candy Cane Press. Company publishes hardcover originals and *Ideals* magazine. Specializes in nostalgia and holiday themes. Publishes 5-7 book titles and 6 magazine issues/year. Recent titles include *Barefoot Days* and *The Legend of Sleepy Hollow*. 100% requires freelance illustration; 30% requires freelance design. Guidelines free for #10 SASE with 1 first-class stamp.

Needs: Approached by 100 freelancers/year. Works with 10-12 freelance illustrators and 1-3 designers/year. Prefers freelancers with experience in illustrating people, nostalgia, botanical flowers. Uses freelancers mainly for flower borders (color), people and spot art. Also for text illustration, jacket/cover and book design. Works on assignment only.

First Contact & Terms: Send query letter with tearsheets and SASE. Samples are filed or returned by SASE. Reports back only if interested. Buys all rights. Finds artists through submissions.

Book Design: Assigns 3 freelance design jobs/year.

Jackets/Covers: Assigns 3 freelance design jobs/year.

Text Illustration: Assigns 75 freelance illustration jobs/year. Pays by the project, $125-400. Prefers oil, watercolor, gouache, colored pencil or pastels.

Tips: "Looking for illustrations with unique perspectives, perhaps some humor, that not only tells the story but draws the reader into the artist's world."

INCENTIVE PUBLICATIONS INC., 3835 Cleghorn Ave., Nashville TN 37215. (615)385-2934. E-mail: incentiv@nashville.net. Website: http://www.nashville.net/~incentiv/. Art Director: Marta Johnson Drayton. Specializes in supplemental teacher resource material, workbooks and arts and crafts books for children K-8. Publishes 15-30 titles/year. Recent titles include *Character Education Series* (4 books) and *Multicultural Plays*. 40% require freelance illustration. Books are "cheerful, warm, colorful, uncomplicated and spontaneous."

Needs: Works with 3-6 freelance illustrators and 1-2 designers/year. Uses freelancers mainly for covers and text illustraion. Also for promo items (occasionally). Works on assignment only, primarily with local artists. 10% of design work demands knowledge of Adobe Illustrator, QuarkXPress, Adobe Photoshop or Aldus FreeHand.

First Contact & Terms: Designers send query letter with photocopies and SASE. Illustrators send query letter with photocopies, SASE and tearsheets. Samples are filed. Samples not filed are returned by SASE. Art Director will contact artist for portfolio review if interested. Portfolio should include original/final art, photostats, tearsheets and final reproduction/product. Sometimes requests work on spec before assigning a job. Considers complexity of project, project's budget and rights purchased when establishing payment. Buys all rights. Originals are not returned.

Jackets/Covers: Assigns 4-6 freelance illustration jobs/year. Prefers 4-color covers in any medium. Pays by the project, $200-350.

Text Illustration: Assigns 4-6 freelance jobs/year. Black & white line art only. Pays by the project, $175-1,250.

Tips: "We look for a warm and whimsical style of art that respects the integrity of the child. We sell to parents and teachers. Art needs to reflect specific age children/topics for immediate association of parents and teachers to appropriate books."

INNER TRADITIONS INTERNATIONAL, One Park St., Rochester VT 05767. (802)767-3174. Fax: (802)767-3726. Website: http://www.InnerTraditions.com. Art Director: Peri Champine. Estab. 1975. Publishes hardcover originals and trade paperback originals and reprints. Types of books include self-help, psychology, esoteric philosophy, alternative medicine and art books. Publishes 60 titles/year. Recent titles include: *Traditional Reiki for Our Times* and *The Complete I Ching*. 50% requires freelance illustration; 50% requires freelance design. Book catalog free by request.

Needs: Works with 8-9 freelance illustrators and 10-15 freelance designers/year. 100% of freelance design demands

knowledge of QuarkXPress, Adobe Illustrator, Aldus FreeHand and Adobe Photoshop. Buys 30 illustrations/year. Uses freelancers for jacket/cover illustration and design. Works on assignment only.

First Contact & Terms: Send query letter with résumé, SASE, tearsheets, photocopies, photographs and slides. Accepts disk submissions. Samples filed if interested or are returned by SASE if requested by artist. Reports back to the artist only if interested. To show portfolio, mail tearsheets, photographs, slides and transparencies. Rights purchased vary according to project. Originals returned at job's completion. Pays by the project.

Jackets/Covers: Assigns approximately 32 design and 26 illustration jobs/year. Pays by the project.

INSTRUCTIONAL FAIR • TS DENISON, Imprint of Ideal Instructional Fair Publishing Group. Parent company: Tribune Education. Box 1650, Grand Rapids MI 49501. (616)363-1290. Fax: (616)363-2156. Website: http//.www.instructionalfair.com. Creative Director: Annette Hollister-Papp. Also 9601 Newton Ave. S., Minneapolis MN 55431, attn: Art Director: Darcy Bell-Myers. Also P.O. Box 128, Rt. 1, Hwy. 94 S., Carthage IL 62321, Attn: Jeff VanKanegan, Art Director (middle school division). Other imprints include: In Celebration™, Ideal School Supply, Living & Learning and LDA. Publishes hardcover originals, softcover reproducibles and teacher resources. Types of books include children's picture books, history, instructional, preschool, reference, religious and textbooks (reproducibles). Also software, stickers and classroom decorations. Specializes in supplemental educational materials. Publishes 300 titles/year (500/year for all imprints). 50% requires freelance illustration. Book catalog free for 9 × 12 SASE with 2 first-class stamps.

• Because this company has three divisions be sure to submit materials to all directors.

Needs: Approached by 100-150 freelancers/year. Works with 20-40 freelancers/year. Full-color and blackline art. Prefers freelancers experienced in computer-generated art, as well as traditional illustrations in oils, acrylics, watercolors and markers. 10% of freelance illustration demands knowledge of Adobe Illustrator and Adobe Photoshop.

First Contact & Terms: Send postcard sample and query letter with printed samples, tearsheets, photocopies and SASE. Samples are filed (if interested) or are returned by SASE. Reports back within 1-2 months if interested. Will contact artist for portfolio review if interested. Portfolio should include artwork portraying children and animals, photocopies, photographs, tearsheets and thumbnails. Buys all rights. Finds freelancers through submission packets, postcards, agents and word of mouth.

Book Design: Assigns 100-200 freelance design jobs/year. Pays by the project, price determined by project.

Jackets/Covers: Assigns 100 illustration jobs/year. Pays by the project, $350-500. "Design determined by project. All educational materials are realistic, cartoon or humorous."

Test Illustration: Assigns 50-100 freelance illustration jobs/year. Pays by the project, $20-45 per page. Prefers smooth black line, pen/brush and ink.

Tips: "We are looking for freelance illustrators who are self-motivated, deadline oriented, multiculturally aware, have an enthusiastic approach to design, can conceptualize quickly, ask relevant questions and have a willingness to take creative chances while accepting directions."

INTERCULTURAL PRESS, INC., 374 U.S. Route 1, Yarmouth ME 04096. (207)846-5168. Fax: (207)846-5181. E-mail: books@interculturalpress.com. Website: http://www.interculturalpress.com. Production Manager: Patty Topel. Estab. 1982. Company publishes paperback originals. Types of books include text and reference. Specializes in intercultural and multicultural. Publishes 12 titles/year. Recent titles include *The Color of Words*, by Philip Herbst; *Host Family Survival Kit*, by Nancy King and Ken Huff; and *Our Soul to Keep*, by George Henderson. 10% require freelance illustration. Book catalog free by request.

Needs: Approached by 20 freelancers/year. Works with 2-3 freelance illustrators/year. Prefers freelancers with experience in trade books, multicultural field. Uses freelancers mainly for jacket/cover design and illustration. 80% of freelance work demands knowledge of Aldus PageMaker or Adobe Illustrator. "If a freelancer is conventional (i.e., not computer driven) they should understand production and pre-press."

First Contact & Terms: Send query letter with brochure, tearsheets, résumé and photocopies. Samples are filed or are returned by SASE if requested by artist. Does not report back. Will contact artist for portfolio review if interested. Portfolio should include b&w final art. Buys all rights. Originals are not returned. Finds artists through submissions and word of mouth.

Jackets/Covers: Assigns 6 freelance illustration jobs/year. Pays by the project, $300-500.

Text Illustration: Assigns 1 freelance illustration job/year. Pays "by the piece depending on complexity." Prefers b&w line art.

Tips: First-time assignments are usually book jackets only; book jackets with interiors (complete projects) are given to "proven" freelancers. "We look for artists who have flexibility with schedule and changes to artwork. We appreciate an artist that will provide artwork that doesn't need special attention by pre-press in order for it to print properly. For black & white illustrations keep your lines crisp and bold. For color illustrations keep your colors pure and saturated to keep them from reproducing 'muddy.' "

IRON CROWN ENTERPRISES, P.O. Box 1605, Charlottesville VA 22902. (804)295-3918. Fax: (804)977-6987. E-mail: askice@aol.com. Art Director: Jessica Ney-Grimm. Assistant Art Director: Jason O. Hawkins. Estab. 1980. Company publishes fantasy roleplaying games, supplements, collectible card games and mass market board games and card games. Specializes in fantasy in a variety of genres. Publishes 25-50 titles/year. Recent titles include: *Runout the Guns!*, *Middle-earth: The Balrog*, *Fluxx* and *Pyramidis*. 100% require freelance illustration; 50% require freelance design. Book catalog free by request.

Needs: Approached by 120 freelancers/year. Works with 75 freelance illustrators and 4 designers/year. Buys 1,500

freelance illustrations/year. Prefers freelancers with experience in fantasy illustration and sci-fi illustration; prefers local freelancers for book design. Uses freelancers mainly for full color cover art, full color art for collectible trading cards, b&w interior illustration. Also for jacket/cover and text illustration and page design for interior. 5% of freelance work demands knowledge of QuarkXPress and Adobe Photoshop.

First Contact & Terms: Send query letter with photographs and photocopies. Samples are filed or returned by SASE if requested by artist. Reports back within 4 months. Assistant Art Director will contact artist for portfolio review if interested. Portfolio should include photographs, slides and tearsheets. Buys all rights. Originals are returned at job's completion. Finds artists through submissions.

Book Design: Assigns 20-30 freelance design jobs/year. Pays by the hour, $8.

Jackets/Covers: Assigns 25-50 freelance illustration jobs/year. Pays by the hour, $15. Prefers paintings for cover illustrations, QuarkXPress for cover design.

Text Illustration: Assigns 25-50 freelance jobs/year. Pays per published page. Prefers pen & ink.

Tips: "Send me 6-12 samples of your current work and present it neatly. I choose artists who thrive on team brainstorming in the creative endeavor and who reliably make deadlines."

ITP NELSON, 1120 Birchmount Rd., Scarborough, Ontario M1K 5G4 Canada. (416)752-9100 ext. 343. Fax: (416)752-7144. E-mail: acluer@nelson.com. Creative Director: Angela Cluer. Estab. 1931. Company publishes hardcover originals and reprints and textbooks. Types of books include instructional, juvenile, preschool, reference, high school math and science, primary spelling, textbooks and young adult. Specializes in a wide variety of education publishing. Publishes 150 titles/year. Recent titles include: *Marketing Our Environment: A Canadian Perspective*, *Language Arts K-6* and *The Learning Equation: Mathematics 9*. 70% requires freelance illustration; 25% requires freelance design. Book catalog free by request.

Needs: Approached by 50 freelancers/year. Works with 30 freelance illustrators and 10-15 designers/year. Prefers Canadian artists, but not a necessity. Uses freelancers for jacket/cover design and illustration, text illustration and book design. Also for multimedia projects. 100% of design and illustration demands knowledge of Adobe Illustrator, QuarkXPress and Adobe Photoshop. Works on assignment only.

First Contact & Terms: Designers send query letter with tearsheets and résumé. Illustrators send postcard sample, brochure and tearsheets. Accepts disk submissions. Samples are filed. Art Director will contact artist for portfolio review if interested. Portfolio should include book dummy, transparencies, final art, tearsheets and photographs. Rights purchased vary according to project. Originals usually returned at job's completion. Finds artists through *American Showcase*, *Creative Source*, submissions, designers' suggestions (word of mouth).

Book Design: Assigns 15 freelance design jobs/year. Pays by the project, $800-1,200 for interior design, $800-1,200 for cover design.

Jackets/Covers: Assigns 15 freelance design and 40 illustration jobs/year. Pays by the project, $800-1,300.

Text Illustration: Pays by the project, $30-450.

JALMAR PRESS/INNERCHOICE PUBLISHING, 24426 S. Main St., Suite 702, Carson CA 90745. (310)816-3085. Fax: (310)816-3092. E-mail: blwjalmar@worldnet.att.net. Website: http://www.ierc.com. President: Bradley L. Winch. Project and Production Director: Cathy Zippi. Estab. 1971. Publishes books emphasizing healthy self-esteem, character building, emotional intelligence, nonviolent communication, peaceful conflict resolution, stress management and whole brain learning. Publishes 6-10 titles/year. Recent titles include *Talking With Kids*, by David Cowan and S. Palomares; *Peaceful Classroom in Action*, by Naomi Drew. Books are contemporary, yet simple.

• Jalmar has developed a new line of books to help counselors, teachers and other caregivers deal with the 'tough stuff' including violence, abuse, divorce, AIDS, low self-esteem, the death of a loved one, etc.

Needs: Works with 3-5 freelance illustrators and 5 designers/year. Uses freelancers mainly for cover design and illustration. Also for direct mail and book design. Works on assignment only.

First Contact & Terms: Send query letter with brochure showing art style. Samples not filed are returned by SASE. Artist should follow up after initial query. 80% of freelance work demands knowledge of Adobe Photoshop, Adobe Illustrator and QuarkXPress. Buys all rights. Considers reprints but prefers original works. Considers complexity of project, budget and turnaround time when establishing payment.

Book Design: Pays by the project, $200 minimum.

Jackets/Covers: Pay by the project, $200 minimum.

Text Illustration: Pays by the project, $15 minimum.

Tips: "Portfolio should include samples that show experience. Don't include 27 pages of 'stuff.' Stay away from the 'cartoonish' look. If you don't have any computer design and/or illustration knowledge—get some! If you can't work on computers, at least understand the process of using traditional artwork with computer generated film. For us to economically get more of our product out (with fast turnaround and a minimum of rough drafts), we've gone exclusively to computers for total book design; when working with traditional artists, we'll scan their artwork and place it within the computer-generated document."

JAMSA PRESS, 3301 Allen Pkwy., Houston TX 77019. (713)525-4676. Fax: (713)525-4670. Website: http://www.jamsa.com. Content Manager: Kong Cheung. Estab. 1993. Publishes trade paperback originals and CD-ROMs. Types of books include computers. Specializes in computers, internet and programming. Publishes 20 titles/year. Recent titles include: *1001 Windows 98 Tips*; *Rescued by Personal Computers* and *Visual Basic Programmer's Library*. 20% require freelance illustration. Catalog available.

Needs: Approached by 5 illustrators and 5 designers/year. Works with 3 illustrators and 3 designers/year. Prefers local freelancers experienced in Adobe Illustrator and Adobe Photoshop. Uses freelancers mainly for cover design. 100% of freelance design demands knowledge of Aldus PageMaker, Adobe Photoshop and Adobe Illustrator. 100% of freelance illustration demands knowledge of Aldus PageMaker, Adobe Photoshop and Adobe Illustrator.

First Contact & Terms: Designers send query letter with brochure. Illustrators send query letter with printed samples. Send follow-up postcard every 3 months. Samples are filed and are not returned. Reports back within 1 month. Will contact artist for portfolio review if interested. Buys all rights.

Jackets/Covers: Assigns 20 freelance design jobs and 5 illustration jobs/year. Pays $800-1,000/project.

Text Illustration: Assigns 5 freelance illustration jobs/year.

Tips: "We look for professionalism and references."

[N] JOLLY ROGER GAMES, 4402 County Lake Dr., Charleston IL 61920. (217)348-5625. E-mail: jolly.roger1@adv ant.net. Website: http://www.rr1.net/users/vashnaar/jollyroger. President: Jim Dietz. Estab. 1997. Publishes roleplaying game books, board games and produces miniatures. Main style/genre of games: science fiction, fantasy, historical (US Civil War, WWII). Uses freelance artists mainly for inside and cover art. Publishes 4-8 titles or products/year. Game/ product lines include: *Nation on Trial, Maul of Trial, Swashbuckler, Fire Brigade* and *Orcs at the Gates.* 100% requires freelance illustration; 100% requires freelance design.

Needs: Approached by 3 illustrators and 1 designer/year. Works with 3 illustrators and 1 designer/year. 100% of freelance design and illustration demands knowledge of Adobe Illustrator, Corel Draw, PageMaker, QuarkXPress.

First Contact & Terms: Send query letter with résumé and SASE. Illustrators send printed samples and photocopies. Samples are not filed and are returned by SASE. Reports back within 1 week, "if there is a SASE." Portfolio review not required. Rights purchased vary according to project. Finds freelancers through referrals, direct contact—especially at conventions.

Visual Design: Assigns 4-8 freelance design and 4-8 art direction projects/year. Pays for design by the project, $150-500. Pays for art direction by the project, $50-500.

Book Covers/Posters/Cards: Assigns 4-8 freelance design jobs and 4-8 illustration jobs/year. Pays for illustration and design by the project, $250-750.

Text Illustration: Assigns 2-3 freelance illustrations jobs/year. Pays by the project, $25-200.

Tips: "Meet the deadlines given. Be flexible regarding contract terms. Previous experience is not important—the 'feel' of the work is."

JUDSON PRESS, Imprint of American Baptist Board of Education & Publication, P.O. Box 851, Valley Forge PA 19482-0851. Fax: (610)768-2441. Website: http://www.judsonpress.com. Estab. 1824. Publishes hardcover originals and reprints, trade paperback originals and reprints. Types of books: religious. Specializes in pastoral aid, church school curriculum. Publishes 30 titles/year. Book catalog available. Call 800-4-JUDSON for catalog.

First Contact & Terms: Send postcard sample or other printed samples. Accepts Windows-compatible disk submissions. Samples are filed and not returned. Reports back only if interested. Portfolio review not required. Buys all rights or negotiates rights purchased. Finds freelancers through watching for samples in mail. "We use most designers and illustrators for years."

Jackets/Covers: Assigns 10 freelance design jobs and 10 illustration jobs/year.

Text Illustration: Assigns 10 freelance illustration jobs/year.

KAEDEN BOOKS, P.O. Box 16190, Rocky River OH 44116. (216)356-0030. Fax: (216)356-5081. Website: http://www.kaeden.com. Vice President Creative/Production: Dennis Graves. Estab. 1989. Publishes textbooks. Types of books include juvenile and preschool. Specializes in learning-to-read books. Publishes 50-100 titles/year. 90% require freelance illustration; 10% require freelance design. Book catalog available upon request.

Needs: Approached by 100-200 illustrators/year. Works with 10-20 illustrators/year. Prefers freelancers experienced in juvenile/humorous illustration and children's books. Uses freelancers mainly for story illustration. 10% of freelance illustrations demands knowledge of Adobe Illustrator, QuarkXPress and CorelDraw 8.

First Contact & Terms: Designers send query letter with brochure and résumé. Illustrators send postcard sample or query letter with photocopies, photographs, printed samples, tearsheets and résumé. Samples are filed or returned only by request. Reports back only if interested. Art director will contact artist for portfolio review if interested. Buys all rights.

Jackets/Covers: Assigns 50-100 illustration jobs/year. Pays by the project, $75-200 per page. Looks for a variety of styles.

Text Illustration: Assigns 50-100 jobs/year. Pays by the project, $50-200 per page. "We accept all media, though most of our books are watermedia."

Tips: "We look for professional level drawing and rendering skills, plus the ability to interpret a juvenile story. There is a tight correlation between text and visual in our books, plus a need for attention to detail."

KAMEHAMEHA SCHOOLS PRESS, 1887 Makuakane St., Honolulu HI 96817-1887. Fax: (808)842-8875. E-mail: kspress@ksbe.edu. Website: http://www.ksbe.edu/pubs/KSPress/catalog.html. Contact: Henry Bennett. Publishes hardcover originals and reprints, trade paperback originals and reprints and textbooks. Types of books include biography, Hawaiian culture and history, instruction, juvenile, nonfiction, preschool, reference, textbooks and young adult. Publishes

3-5 titles/year. Recent titles include: *From the Mountains to the Sea* and *Kamehameha IV: Alexander Liholiho*. 25% require freelance illustration; 5% require freelance design. Catalog available.

Needs: Approached by 3-5 illustrators and 5-10 designers/year. Works with 2-3 illustrators and 1-2 designers/year. Prefers local freelancers knowledgeable in Hawaiian culture. Uses freelancers mainly for b&w line illustration. 100% of freelance design demands knowledge of QuarkXPress.

First Contact & Terms: Designers send query letter with photocopies of book design. Illustrators send query letter with photocopies. Samples are filed. Reports back only if interested. Will contact artist for portfolio review of roughs and tearsheets if interested. Portfolio should include artwork portraying Hawaiian cultural material. Buys all rights.

Book Design: Assigns 1-3 freelance design jobs/year. Pays by the project.

Jackets/Covers: Assigns 1-3 freelance design jobs and 1-3 illustration jobs/year. Pays for design and illustration by the project.

Text Illustration: Assigns 1-3 freelance illustration jobs/year. Pays by the project. Finds freelancers through word of mouth and submissions.

Tips: "We require our freelancers to be extremely knowledgeable in accurate and authentic presentation of Hawaiian-culture images."

KAR-BEN COPIES, INC., 6800 Tildenwood Lane, Rockville MD 20852. Fax: (301)881-9195. E-mail: karben@aol.c om. Website: http://www.karben.com. Editor: Madeline Wikler. Estab. 1975. Company publishes hardcovers and paperbacks on juvenile Judaica. Publishes 6-8 titles/year. Recent titles include *The Magic of Kol Nidre*, by Bruce Siegel; *Once Upon a Shabbos*, by Jacqueline Jules; and *Terrible, Terrible*, by Robin Bernstein. Books contain "colorful illustrations to appeal to young readers." 100% require freelance illustration. Book catalog free on request.

Needs: Uses 10-12 freelance illustrators/year. Uses freelancers mainly for book illustration. Also for jacket/cover design and illustration, book design and text illustration.

First Contact & Terms: Send query letter with photostats, brochure or tearsheets to be kept on file or returned. Samples not filed are returned by SASE. Reports within 2 weeks only if SASE included. Originals are returned at job's completion. Sometimes requests work on spec before assigning a job. Considers skill and experience of artist and turnaround time when establishing payment. Pays by the project, $500-3,000 average, or advance plus royalty. Buys all rights. Considers buying second rights (reprint rights) to previously published artwork.

Tips: Send samples showing active children, not animals or still life. Don't send original art. "Look at our books and see what we do. We are using more full-color as color separation costs have gone down."

B. KLEIN PUBLICATIONS INC., P.O. Box 6578, Delray Beach FL 33482. (561)496-3316. Fax: (561)496-5546. Editor: Bernard Klein. Estab. 1955. Publishes reference books, such as the *Guide to American Directories*. Publishes approximately 15-20 titles/year. 25% require freelance illustration. Book catalog free on request.

Needs: Works with 1-3 freelance illustrators and 1-3 designers/year. Uses freelancers for jacket design and direct mail brochures. 25% of titles require freelance art direction.

First Contact & Terms: Submit résumé and samples. Pays $50-300.

KRUZA KALEIDOSCOPIX INC., Box 389, Franklin MA 02038. (508)528-6211. Editor: J.A. Kruza. Estab. 1980. Publishes hardcover and mass market paperback originals. Types of books include adventure, biography, juvenile, reference and history. Specializes in children's books for ages 3-10 and regional history for tourists and locals. Publishes 12 titles/year. Titles include: *Lighthouse Handbook for New England*. 75% requires freelance illustration.

Needs: Approached by 150 freelancers/year. Works with 8 freelance illustrators/year. Uses freelancers for magazine editorial. Also for text illustration. Works on assignment only.

First Contact & Terms: Send query letter with brochure, tearsheets, photostats and SASE. Samples are filed or returned by SASE. Reports back to the artist only if interested. Buys all rights.

Book Design: Pays by the project.

Text Illustration: Assigns 30 freelance illustration jobs/year. Pays $50-100/illustration. Prefers watercolor, airbrush, pastel, pen & ink.

Tips: "Submit sample color photocopies of your work every five or six months. We're looking to fit an illustrator together with submitted and accepted manuscripts. Each manuscript calls for different techniques."

PETER LANG PUBLISHING, INC., 275 Seventh Ave., 28th Floor, New York NY 10001. Website: http:// www.peterlang.com. Production Manager: Lisa Dillon. Publishes humanities textbooks and monographs. Publishes 300 titles/year. Book catalog not available, "but visit website."

Needs: Works with a small pool of designers/year. Prefers local designers experienced in scholarly book covers. Prefers freelancers experienced in scholarly book covers. Most covers will be 2 colors and black. 100% of freelance design demands knowledge of Adobe Illustrator, Adobe Photoshop and QuarkXPress.

First Contact & Terms: Send query letter with printed samples, photocopies and SASE. Accepts Windows-compatible and Mac-compatible disk submissions. Samples are filed. Reports back only if interested. Will contact artist for portfolio review if interested. Finds freelancers through referrals.

Jackets/Covers: Assigns 100 freelance design jobs/year. Only accepts Quark electronic files. Pays for design by the project; $150 for comp; $150 for cover.

LAREDO PUBLISHING CO., 8907 Wilshire Blvd. 102, Beverly Hills CA 90211. (310)358-5288. Fax: (310)358-5282. E-mail: larpub@aol.com. Art Director: Silvana Cervera. Estab. 1991. Publishes juvenile, preschool textbooks. Specializes in Spanish texts educational/readers. Publishes 16 titles/year Recent titles include *Barriletes, Kites.* 30% require freelance illustration; 30% require freelance design. Book catalog free on request.

Needs: Approached by 10 freelance illustrators and 2 freelance designers/year. Works with 2 freelance designers/year. Uses freelancers mainly for book development. 100% of freelance design demands knowledge of Adobe Photoshop, Adobe Illustrator, QuarkXPress. 20% of titles require freelance art direction.

First Contact & Terms: Designers send query letter with brochure, photocopies. Illustrators send photocopies, photographs, résumé, slides, tearsheets. Samples are not filed and are returned by SASE. Reports back only if interested. Portfolio review required for illustrators. Art director will contact artist for portfolio review if interested. Portfolio should include artwork portraying children, book dummy, photocopies, photographs, tearsheets. Buys all rights or negotiates rights purchased.

Book Design: Assigns 5 freelance design jobs/year. Pays for design by the project.

Jacket/Covers: Pays for illustration by the project, page.

Text Illustration: Pays by the project, page.

☑ **LEE & LOW BOOKS**, 95 Madison Ave., New York NY 10016-7801. (212)779-4400. Website: http://www.leeandlow.com. Senior Editor: Louise May. Publisher: Philip Lee. Estab. 1991. Book publisher. Publishes hardcover originals and reprints for the juvenile market. Specializes in multicultural children's books. Publishes 8-10 titles/year. First list published in spring 1993. Recent titles include: *Confetti: Poems for Children*, by Pat Mora; and *In Daddy's Arms I Am Tall*, by Javaka Steptoe. 100% requires freelance illustration and design. Book catalog available.

Needs: Approached by 100 freelancers/year. Works with 6-10 freelance illustrators and 1-3 designers/year. Uses freelancers mainly for illustration of children's picture books. 100% of design work demands computer skills. Works on assignment only.

First Contact & Terms: Contact through artist rep or send query letter with brochure, résumé, SASE, tearsheets, photocopies and slides. Samples are filed. Art Director will contact artist for portfolio review if interested. Portfolio should include b&w and color tearsheets, slides and dummies. Rights purchased vary according to project. Originals are returned at job's completion.

Book Design: Pays by the project.

Text Illustration: Pays by the project.

Tips: "We want an artist who can tell a story through pictures and is familiar with the children's book genre. Lee & Low Books makes a special effort to work with writers and artists of color and encourages new voices. We prefer filing samples that feature children."

🆕 **LEISURE BOOKS/LOVE SPELL**, Divisions of Dorchester Publishing Co., Inc., 276 Fifth Ave., Suite 1008, New York NY 10001. (212)532-1054. E-mail: dorkcarlon@aol.com. Director of Publishing: Katherine Carlon. Estab. 1970. Specializes in paperback, originals and reprints, especially mass market category fiction—realistic historical romance, western, adventure, horror. Publishes 170 titles/year. Recent titles include: *Chase the Wind*, by Madeline Baker; and *Savage Shadows*, by Cassie Edwards. 90% requires freelance illustration.

Needs: Works with 24 freelance illustrators and 6 designers/year. Uses freelancers mainly for covers. "We work with freelance art directors; editorial department views all art initially and refers artists to art directors. We need highly realistic, paperback illustration; oil or acrylic. No graphics, fine art or photography." Works on assignment only.

First Contact & Terms: Send samples by mail. Accepts disk submissions from illustrators on SyQuest or Zip disks compatible with Adobe Photoshop 3.0. No samples will be returned without SASE. Reports only if samples are appropriate and if SASE is enclosed. Call for appointment to drop off portfolio. Portfolios may be dropped off Monday-Thursday. Sometimes requests work on spec before assigning a job. Considers complexity of project and project's budget when establishing payment. Usually buys first rights, but rights purchased vary according to project. Interested in buying second rights (reprint rights) to previously published work "for contemporary romance and westerns only." Originals returned at job's completion.

Jackets/Covers: Pays by the project.

Tips: "Talented new artists are welcome. Be familiar with the kind of artwork we use on our covers. If it's not your style, don't waste your time and ours."

LIBRARIES UNLIMITED/TEACHER IDEAS PRESS, Box 6633 Englewood CO 80155-6633. (303)770-1220. Fax: (303)220-8843. E-mail: lu-marketing@lu.com. Website: http://www.lu.com. Contact: Publicity Department. Estab. 1964. Specializes in hardcover and paperback original reference books concerning library science and school media for librarians, educators and researchers. Also specializes in resource and activity books for teachers. Publishes more than 60 titles/year. Book catalog free by request.

Needs: Works with 4-5 freelance artists/year.

First Contact & Terms: Designers send query letter with brochure, résumé and photocopies. Illustrators send query letter with photocopies. Samples not filed are returned only if requested. Reports within 2 weeks. Considers complexity of project, skill and experience of artist, and project's budget when establishing payment. Buys all rights. Originals not returned.

Text Illustration: Assigns 2-4 illustration jobs/year. Pays by the project, $100 minimum.

Jackets/Covers: Assigns 4-6 design jobs/year. Pays by the project, $350 minimum.

Tips: "We look for the ability to draw or illustrate without overly loud cartoon techniques. Freelancers should have the ability to use two-color effectively, with screens and screen builds. We ignore anything sent to us that is in four-color. We also need freelancers with a good feel for typefaces."

LIPPINCOTT WILLIAMS & WILKINS, (formerly Williams & Wilkins Book Division). Parent company: Wolters Kluwer. 351 W. Camden St., Baltimore MD 21201-2436. (410)528-4267. Fax: (410)361-8015. E-mail: mfernand@lww.com. Senior Design Coordinator: Mario Fernandez. Estab. 1890. Publishes audio tapes, CD-ROMs, hardcover originals and reprints, textbooks, trade paperbook originals and reprints. Types of books include instructional and textbooks. Specializes in medical publishing. Publishes 400 titles/year. Recent titles include: *Principles of Medical Genetics-2nd Edition, Communication Development: Foundations Processes and Clinical Applications*. 100% requires freelance design.
Needs: Approached by 20 illustrators and 20 designers/year. Works with 10 illustrators and 30 designers/year. Prefers freelancers experienced in medical publishing. 100% of freelance design demands knowledge of Adobe Illustrator, Adobe Photoshop, QuarkXPress.
First Contact & Terms: Send query letter with printed samples and tearsheets. Accepts Mac-compatible disk submissions. Send EPS or TIFF files. Reports back only if interested. Will contact artist for portfolio review if interested. Buys all rights. Finds freelancers through submission packets, word of mouth.
Book Design: Assigns 150 freelance design jobs/year. Pays by the project, $350-5,000.
Jackets/Covers: Assigns 150 freelance design jobs/year. Pays for design by the project, $350-5,000. Prefers medical publishing experience.
Text Illustration: Assigns 150 freelance illustration jobs/year. Pays by the project, $350-500. Prefers freelancers with medical publishing experience.
Tips: "We're looking for freelancers who are flexible and have extensive clinical and textbook medical publishing experience. Designers must be proficient in Quark, Illustrator and Photoshop and completely understand how design affects the printing (CMYK 4-color) process."

N ☩ LITURGY TRAINING PUBLICATIONS, An agency of the Roman Catholic Archdiocese of Chicago, 1800 N. Hermitage, Chicago IL 60622. (773)486-8970. Fax: (773)486-7094. Contact: Design Manager. Estab. 1964. Publishes hardcover originals and trade paperback originals and reprints. Types of books include children's picture books, instruction (ritual books) and religious. Publishes 50 titles/year. Recent titles include: *The Winter Saints, The Sunday Lectionary, Eucaristic Prayer at Sunday Mass* and *Confirmation, a Parish Celebration*. 60% requires freelance illustration; 3-5% requires freelance design. Book catalog free by request.
Needs: Approached by 10 illustrators and 2-4 designers/year. Works with 10-15 illustrators and 2-4 designers/year. Prefers local designers. 90% of freelance design demands knowledge of Adobe Illustrator, Adobe Photoshop and QuarkXPress. 2% of freelance illustration demands knowledge of Adobe Photoshop.
First Contact & Terms: Designers and illustrators should send postcard sample or send query letter with printed samples, photocopies and tearsheets. Accepts Mac-compatible disk submissions (Quark only). Send EPS or TIFF files. Samples are filed and not returned. Will contact for portfolio review if interested. Rights purchased vary according to project.
Book Design: Assigns 4-5 freelance design jobs/year.
Jackets/Covers: Assigns 3-4 freelance design jobs and 20-30 illustration jobs/year. Pays for design by the hour.
Text Illustration: Assigns 15-20 freelance illustration jobs/year. Pays by the project. Prefers illustrators who are good in b&w or 2-color.
Tips: "One of our books was in the AIGA 50 Best Books of the Year show a couple of years ago. Sometimes illustrators who have done religious topics for others have a hard time working with us because we do not want sentimental or traditional religious art. We look for sophisticated, daring, fine art-oriented illustrators and artists. Those who work in a more naturalistic manner need to be able to portray various nationalities well. We never use cartoons."

N LOOMPANICS UNLIMITED, P.O. Box 1197, Port Townsend WA 98368. (360)385-2230. Fax: (360)385-7785. E-mail: loompseditor@olympus.net. Website: http://www.loompanics.com. Chief Editor: Vanessa McGrady. Estab. 1973. Publishes mass market paperback originals and reprints, trade paperback originals and reprints. Types of books include nonfiction, crime, police science, illegal drug manufacture, self-sufficiency and survival. Specializes in how-to with an edge. Publishes 25 titles/year. Recent titles include: *Advanced Techniques of Clandestine Psychedelic & Amphetamine Manufacture, How to Drink as Much as You Want and Live Longer* and *Beat the System: Freedom Afloat and on Wheels*. 75% requires freelance illustration. Book catalog available for $5.
Needs: Approached by 10 illustrators/year. Works with 10 illustrators and 2 designers/year. Prefers freelancers experienced in action drawing, cartoons, precision/botany.
First Contact & Terms: Send query letter with printed samples, photocopies and SASE. Samples are returned by SASE. Reports back only if interested. Will contact artist for portfolio review if interested. Buys one-time rights. Usually works with freelancers publisher has worked with in the past.
Book Design: Assigns 1 freelance design job/year. Pays for design by the project.
Jackets/Covers: Assigns 10 freelance design jobs and 15 illustration jobs/year. Pays for design and illustration by the project. Prefers creative illustrators willing to work with controversial and unusual material.
Text Illustration: Assigns 50 freelance illustration jobs/year.
Tips: "Please do not call us. We develop good, long-lasting relationships with our illustrators, who are used to our 'we're-not-sure-what-we-want-but-we'll-know-it-when-we-see-it' approach."

"In this book, my goal was to create an all-encompassing sense of the ancient yet very contemporary words of the psalms," says artist Linda Ekstrom of her work in *The Psalter*. "Rather than illustrate particular passages, I wanted the art to provide a place of pause and a space for reflection for the one reading or praying the psalms." Ekstrom used a monotype method to illustrate the book published by Liturgy Training Publications.

©Linda Ekstrom. Reprinted with permission of Liturgy Training Publications

☑ LOWELL HOUSE, a division of NTC Contemporary Publishing Group, Inc., 202 Avenue of the Stars, Suite 300, Los Angeles CA 90067. (310)552-7555. Fax: (310)552-7573. Senior Designer: Treesha Runnells. Production Director: Bret Perry. Estab. 1987. Types of books include adventure, fantasy, history, horror, instructional, juvenile, nonfiction, preschool, reference, young adult, educational/workbooks. Specializes in workbooks, activity books, craft. Publishes 100 titles/year. Recent titles include: *60 Super Simple Friendship Crafts*, *Draw Future Worlds*, *The First-Timer's Guide to Science Fair Projects*, *Gifted & Talented Series®*, and *Gradebooster Series*. 90% requires freelance illustration; 10% requires freelance design. Book catalog free for 9 × 12 SAE with $1.24 first-class stamps.
Needs: Approached by 80 illustrators and 20 designers/year. Works with 40 illustrators and 10 designers/year. Prefers freelancers experienced in children's illustration. 100% of freelance design demands knowledge of Adobe Illustrator, Adobe Photoshop, QuarkXPress. 10% of freelance illustration demands knowledge of Adobe Illustrator, Adobe Photoshop.
First Contact & Terms: Designers send query letter with printed samples. Illustrators send postcard sample, printed samples, tearsheets. Accepts Mac-compatible disk submissions. Samples are filed or returned. Will contact artist for portfolio review if interested. Buys all rights. Finds freelancers through sourcebooks, illustrator annuals, mailings, word of mouth.
Book Design: Assigns 6-10 freelance design jobs/year. Pays for design by the project, $500-2,000.
Jackets/Covers: Assigns 40-50 freelance illustration jobs/year. Pays for illustration by the project, $100-1,500. Prefers vibrant colors and compositions that engage the viewer.
Text Illustration: Assigns 40-50 freelance illustration jobs/year. Pays by the project, $100-4,000. Prefers clean lines and consistency, both of which are necessary when working on juvenile educational workbooks.

☑ MACMILLAN COMPUTER PUBLISHING, 201 W. 103rd St., Indianapolis IN 46290. (317)581-3500. Website: http://www.mcp.com. Operations Specialist: Jay Corpus. Imprints include Que, New Riders, Sams, Hayden, Adobe Press, Que Education, Training, Macmillan Technical Publishing, Webster's New World, Arco and Brady Games.

Company publishes instructional computer books. Publishes 800 titles/year. 5-10% requires freelance illustration; 3-5% requires freelance design. Book catalog free by request with SASE.

Needs: Approached by 100 freelancers/year. Works with 20+ freelance illustrators and 10 designers/year. Buys 100 freelance illustrations/year. Uses freelancers for jacket/cover illustration and design, text illustration, direct mail and book design. 50% of freelance work demands knowledge of Aldus PageMaker, QuarkXPress, Aldus FreeHand, Adobe Illustrator and Adobe Photoshop. Finds artists through agents, sourcebooks, word of mouth, submissions and attending art exhibitions.

First Contact & Terms: Send query letter with brochure, tearsheets, photostats, résumé, photographs, slides, photocopies or transparencies. Samples are filed or returned by SASE if requested by artist. Art Director will contact artist for portfolio review if interested. Portfolio should include final art, photographs, photostats, roughs, slides, tearsheets and transparencies. Rights purchased vary according to project.

Book Design: Assigns 10 freelance design jobs/year. Pays by the project, $1,000-4,000.

Jackets/Covers: Assigns 15 freelance design and 25+ illustration jobs/year. Pays by the project, $1,000-3,000.

Text Illustration: Pays by the project.

N ☒ MAPEASY, INC., P.O. Box 80, 54 Industrial Rd., Wainscott NY 11975. (516)537-6213. Fax: (516)537-4541. E-mail: chrhar@aol.com. Website: http://mapeasy.com. Production: Chris Harris. Estab. 1990. Publishes maps. 100% requires freelance illustration; 25% requires freelance design. Book catalog not available.

Needs: Approached by 15 illustrators and 10 designers/year. Works with 3 illustrators and 1 designer/year. Prefers local freelancers. 100% of freelance design and illustration demands knowledge of Adobe Illustrator, Adobe Photoshop, QuarkXPress and Painter.

First Contact & Terms: Send query letter with photocopies. Accepts Mac-compatible disk submissions. Samples are filed. Reports back only if interested. Will contact artist for portfolio review if interested. Portfolio should include photocopies. Finds freelancers through ads and referrals.

Text Illustration: Pays by the hour, $45 maximum. Prefers freelancers who care create colorful maps.

☑ McCLANAHAN BOOK CO., 23 W. 26th St., New York NY 10010. (212)725-1515. Senior Art Director: Dawn Beard. Estab. 1990. Publishes educational mass retail books. Types of books include board books, novelty books, activity books, sticker books, flash cards, paperback picture books. Audience is infant to 12-year-olds. Publishes approximately 60 titles/year. Recent titles include: *50 Animal Mothers and Babies*, *Volcanoes and Other Earth Wonders*, *Trains* and *Dino Trackers*.

Needs: Approached by 1,000 illustrators and 75 designers/year. Works with 35 illustrators and 10 designers/year. Works with 35 illustrators and 10 designers/year. All design is electronic using Quark, Illustrator, Photoshop.

First Contact & Terms: Send photocopies, printed samples and tearsheets. Accepts disk submissions. Samples are filed if appropriate. Will contact for portfolio review of artwork only if interested in artist's work. Buys all rights. Finds freelancers through word of mouth and submissions.

Book Design: Pays for design by the hour, $25.

Jackets/Covers: Pays for design/illustration by the project, $500-1,000.

Text Illustration: Assigns 60 freelance illustration jobs/year. Pays $3,000-20,000 for books (24-96 pages).

Tips: "Illustration must be appropriate for mass market children's books."

N MCGRAW HILL HIGHER EDUCATION GROUP, 2460 Kerper Blvd., Dubuque IA 52001. (319)588-1451. Fax: (319)589-2955. Contact: Art Director. Estab. 1944. Publishes hardbound and paperback college textbooks. Produces more than 200 titles/year. 10% require freelance design; 70% require freelance illustration.

Needs: Works with 15-25 freelance designers and 30-50 illustrators/year. Uses freelancers for advertising. 90% of freelance work demands knowledge of Aldus PageMaker, Adobe Illustrator, QuarkXPress, Adobe Photoshop or Aldus FreeHand. Works on assignment only.

First Contact & Terms: Prefers color 35mm slides and color or b&w photocopies. Send query letter with brochure, résumé, slides and/or tearsheets. "Do not send samples that are not a true representation of your work quality." Reports back in 1 month. Accepts disk submissions. Samples returned by SASE if requested. Reports back on future assignment possibilities. Buys all rights. Pays $35-350 for b&w and color promotional artwork. Pays half contract for unused assigned work.

Book Design: Assigns 100-140 freelance design jobs/year. Uses artists for all phases of process. Pays by the project. Payment varies widely according to complexity.

Jackets/Covers: Assigns 100-140 freelance design jobs and 20-30 illustration jobs/year. Pays $1,700 for 4-color cover design and negotiates pay for special projects.

Text Illustration: Assigns 75-100 freelance jobs/year. Considers b&w and color work. Prefers computer-generated, continuous tone, some mechanical line drawings; ink preferred for b&w. Pays $30-500.

Tips: "In the field, there is more use of color. There is need for sophisticated color skills—the artist must be knowlegeable about the way color reproduces in the printing process. Be prepared to contribute to content as well as style. Tighter production schedules demand an awareness of overall schedules. *Must* be dependable."

MEDIA ASSOCIATES-ARKIVES PRESS, P.O. Box 46, Wilton CA 95693. (800)373-1897. Fax: (916)682-7090. E-mail: ed@arkives.com. Website: http://www.arkives.com. Editor-in-Chief: Phil Wycliff. Estab. 1968. Imprint of Media Associates. Imprints include Arkives Press and Epona Books. Publishes hardcover originals and reprints, trade paperback

originals and reprints, audio tapes and CD-ROMs. Types of books include biography, coffee table books, cookbooks, history, new age, nonfiction and self help. Specializes in archaeology, Irish history and rock and roll. Publishes 12 titles/year. Recent titles include: *Kurt Cobian—Beyond Nirvana* and *Grateful Dead: Garcia*. 50% require freelance illustration; 50% require freelance design. Catalog free for 5 first class stamps or 1 priority mail stamp.

Needs: Approached by 100 illustrators and 100 designers/year. Works with 10 illustrators and 3 designers/year. Prefers freelancers experienced in book design. Uses freelancers mainly for book design, children's illustrations and special contributions depending upon style. 100% of freelance design and illustration demands knowledge of most Adobe products.

First Contact & Terms: Designers send query letter with brochure, photocopies, photographs, photostats, résumé, SASE, slides, tearsheets and transparencies. Illustrators send query letter with photocopies, photographs, photostats, printed samples, résumé, SASE, slides, tearsheets and transparencies. "Be creative." Send follow-up postcard every 6 months. Accepts disk submissions compatible with MAC/OS files only. "One sample is filed—the one we think is the best example." The rest are returned by SASE. Reports back in 6 weeks if interested. Will contact artist for portfolio review of book dummy if interested. Rights purchased vary according to project.

Book Design: Assigns 3-6 freelance design jobs/year. Pays by arrangement.

Jackets/Covers: Assigns 10 freelance design jobs and 10 illustration jobs/year. Pay for design and illustration open to negotiations.

Text Illustration: Assigns 3-6 freelance illustration jobs/year. Pay open to negotiation. Celtic themes preferred. "We do not work with agents—we have had good luck with university references and art schools."

Tips: "We prefer someone who is an enthusiastic book collector and antiquarian as well as an avid book reader."

☑ **MERLYN'S PEN**, P.O. Box 910, East Greenwich RI 02818. (401)885-5175. Fax: (401)885-5222. E-mail: merlynspen@aol.com. Website: http://www.merlynspen.com. President: R.J. Stahl. Estab. 1985. Imprints include The American Teen Writer Series. Publishes hardcover originals, trade paperback originals, textbooks, audio tapes and magazines. Types of books include young adult—most are by teen authors. Publishes 10 titles/year. Recent titles include: *Taking Off*, *Eighth Grade*, *Sophomores*. 100% requires freelance illustration and design. Catalog free.

Needs: Approached by 5 illustrators and 5 designers/year. Works with 10 illustrators/year. Prefers freelancers experienced in design and typography and illustration. Uses freelancers mainly for book jackes and magazine articles. 100% of freelance design demands knowledge of Adobe Photoshop, Adobe Illustrator and QuarkXPress.

First Contact & Terms: Designers send query letter with brochure, photocopies, SASE and tearsheets. Illustrators send postcard sample, photocopies and printed samples. Send follow-up postcard every 3 months. Accepts disk submissions compatible with QuarkXPress 7.5. Samples are filed and are not returned. Reports back only if interested. Will contact artist for portfolio review if interested. Portfolio should include artwork portraying teens, sci-fi, real life and story illustrations. Rights purchased vary according to project.

Book Design: Assigns 2 freelance design jobs/year. Pays by the project, $250-1,000.

Jackets/Covers: Assigns 10 freelance design and 10 illustration jobs/year. Pays for design by the hour, $20-50 or by the project, $250-1,000. Pays for illustration by the project, $400-600.

Text Illustration: Assigns 50 freelance illustration jobs/year. Pays by the project, $100-250. Prefers pen and ink, scratchboard, watercolor, tempera and oil. Finds freelancers through Rhode Island School of Design.

Tips: "We look for professionalism and unique points of view."

MILKWEED EDITIONS, 430 First Ave. N., Suite 400, Minneapolis MN 55401. (612)332-3192. Fax: (612)332-6248. Website: http://www.milkweed.org. Managing Editor: Beth Olson. Production Assistant: Anja Welsh. Estab. 1979. Publishes hardcover and trade paperback originals and trade paperback reprints of contemporary fiction, poetry, essays and children's novels (ages 8-13). Publishes 16-18 titles/year. Recent titles include *Treasure of Panther Peak*, by Aileen Kilgore Henderson; *Thirst*, by Ken Kalfus; *Welcome to Your Life*, edited by David Haynes and Julie Landsman; and *Eating Bread and Honey*, by Pattiann Rogers. Books have "colorful quality" look. Book catalog available for SASE with $1.50.

Needs: Approached by 150 illustrators/year. Works with 10 illustrators and designers/year. Buys 100 illustrations/year. Prefers artists with experience in book illustration. Prefers freelancers experienced in color and b&w. Uses freelancers mainly for jacket/cover illustration and text illustration. 100% of freelance design demands knowledge of Adobe Illustrator, Adobe Photoshop and QuarkXPress. Needs computer-literate freelancers for design. Works on assignment only. 80% requires freelance illustration; 100% requires freelance design; 10% requires freelance art direction.

First Contact & Terms: Send query letter with résumé, SASE and tearsheets. Samples are filed. Editor will contact artists for portfolio review if interested. Portfolio should include best possible samples. Rights purchased vary according to project. Interested in buying second rights (reprint rights) to previously published work. Originals are returned at job's completion. Finds artists through word of mouth, submissions and "seeing their work in already published books."

Book Design: Assigns 14-16 freelance design jobs/year. Pays for design and art direction by the project.

Jackets/Covers: Assigns 14-16 illustration jobs and 5 design jobs/year. Pays by the project, $250-800 for design. "Prefer a range of different media—according to the needs of each book."

Text Illustration: Assigns 3 jobs/year. Pays by the project. Prefers various media and styles.

Tips: "Show quality drawing ability, narrative imaging and interest—call back. Design and production are completely computer-based. Budgets have been cut so any jobs tend to neccesitate experience."

MITCHELL LANE PUBLISHERS, INC., 17 Matthew Bathon Court, Elkton MD 21921-3669. (410)392-5036. Fax: (410)392-4781. E-mail: mitchelllane@dpnet.net. Website: http://www.angelfire.com/biz/mitchelllane. Publisher: Barbara Mitchell. Estab. 1993. Publishes hardcover and trade paperback originals. Types of books include biography. Specializes in multicultural biography for young adults. Publishes 15-17 titles/year. Recent titles include: *Rafael Palmeiro: At Home With the Baltimore Orioles*; *Famous People of Hispanic Heritage*. 50% requires freelance illustration; 10% requires freelance design.

Needs: Approached by 20 illustrators and 5 designers/year. Works with 2 illustrators/year. Prefers freelancers experienced in illustrations of people.

First Contact & Terms: Send query letter with printed samples, photocopies. Samples are not filed and are not returned. Will contact artist for portfolio review if interested. Buys all rights.

Jackets/Covers: Prefers realistic portrayal of people.

MODERN LANGUAGE ASSOCIATION, 10 Astor Place, New York NY 10003-6981. (212)475-9500. Fax: (212)477-9863. Marketing Coordinator: Kathleen Hansen. Estab. 1883. Non-profit educational association. Publishes hardcover and trade paperback originals, trade paperback reprints and textbooks. Types of books include instructional, reference and literary criticism. Specializes in language and literature studies. Publishes 10-15 titles/year. Recent titles include *The MLA Style Manual*, 2nd edition, by Joseph Gibaldi; and *The Story of Ernestine*, by Marie Riccoboni. 5-10% require freelance design. Book catalog free by request.

Needs: Approached by 5-10 freelancers/year. Works with 2-3 freelance designers/year. Prefers freelancers with experience in academic book publishing and textbook promotion. Uses freelancers mainly for jackets and book design. 100% of freelance work demands knowledge of QuarkXPress. Works on assignment only.

First Contact & Terms: Send query letter with brochure. Reports back to the artist only if interested. To show portfolio, mail finished art samples and tearsheets. Originals returned at job's completion if requested.

Book Design: Assigns 1-2 freelance design jobs/year. Payment "depends upon complexity and length."

Jackets/Covers: Assigns 3-4 freelance design jobs/year. Pays by the project, $750-1,500.

Tips: "Most freelance designers with whom we work produce our marketing jackets rather than our books. We are interested in seeing samples only of pieces related to publishing. We do not use illustrations for any of our publications."

MONDO PUBLISHING, One Plaza Rd., Greenvale NY 11548. (516)484-7812. Fax: (516)484-7813. Website: http://www.mondopub.com. Senior Editor: Louise May. Estab. 1992. Publishes hardcover and trade paperback originals and reprints and audio tapes. Types of books include juvenile. Specializes in fiction, nonfiction. Publishes 75 titles/year. Recent titles include *Lucy Takes a Holiday*, by Salvatore Murdocca; *Rainbows of the Sea*, by Meredith Thomas; and *Who Likes It Hot*, by May Garelick. Book catalog free for 9 × 12 SASE with $1.47 postage.

Needs: Approached by 12 illustrators and 5 designers/year. Works with 40 illustrators and 10 designers/year. Prefers freelancers experienced in children's hardcovers and paperbacks, plus import reprints. Uses freelancers mainly for illustration, art direction, design. 100% of freelance design demands knowledge of Adobe Photoshop, Adobe Illustrator, QuarkXPress. 67% of titles require freelance art direction.

First Contact & Terms: Send query letter with photocopies, printed samples and tearsheets. Samples are filed. Will contact for portfolio review if interested. Portfolio should include artist's areas of expertise, photocopies, tearsheets. Rights purchased vary according to project. Finds freelancers through agents, sourcebooks, illustrator shows, submissions, recommendations of designers and authors.

Book Design: Assigns 40 jobs/year. Pays by project.

Text Illustration: Assigns 45-50 freelance illustration jobs/year. Pays by project.

MOREHOUSE PUBLISHING GROUP, P.O. Box 1321, Harrisburg PA 17105. (717)541-8130. Fax: (717)541-8128. Website: http://www.morehousegroup.com. Managing Editor: Christine Finnegan. Estab. 1884. Company publishes trade paperback and hardcover originals and reprints. Books are religious. Specializes in spirituality, religious history, Christianity/contemporary issues. Publishes 60 titles/year. Recent titles include *Blessed Paradoxes*, by Barbara Catherine Cratton, illustrated by Dee Schenck Rhodes; and *Jenny's Prayer*, by Annette Grossman, illustrated by Mary Anne Lard. Book catalog free by request.

Needs: Works with 7-8 illustrators and 7-8 designers/year. Prefers freelancers with experience in religious (particularly Christian) topics. Uses freelancers for book design and formatting. Freelancers should be familiar with Adobe Illustrator, QuarkXPress and Adobe Photoshop. Also uses original art—all media. Works on assignment only.

First Contact & Terms: Send query letter with résumé and photocopies. "Show samples particularly geared for our 'religious' market." Samples are filed or are returned. Reports back only if interested but returns slides/transparencies that are submitted. Portfolio review not required. Usually buys one-time rights. Originals are returned at job's completion. Finds artists through freelance submissions, *Literary Market Place* and mostly word of mouth.

Book Design: Assigns 15 freelance design jobs/year. Pays hourly or by the page.

Text Illustration: Assigns 5 freelance illustration jobs/year for children's books.

Tips: "Prefer using freelancers who are located in central Pennsylvania and are available for meetings when necessary. We also have a special need for freelancers to design and format text pages."

NBM PUBLISHING CO., 185 Madison Ave., Suite 1504, New York NY 10016. (212)545-1223. Website: http://www.nbmpub.com. Publisher: Terry Nantier. Publishes graphic novels for an audience of 18-34 year olds. Types of

© Dee Schenck Rhodes

Blessed Paradoxes, from Morehouse Publishing, is a book of images inspired by the Beatitudes illustrated in oils by Dee Schenck Rhodes. "As I struggled to find images for each Beatitude, I found myself constantly dividing the paper into two sections," says Rhodes. "The two parts of each blessing wouldn't come together into one image. I began to see that the Beatitudes described two distinct Kingdoms, requiring a series of paired images depicting the Kingdom of the World and the Kingdom of Heaven." The result was eight full-color paintings along with eight smaller black and white images.

books include adventure, fantasy, mystery, science fiction, horror and social parodies. Recent titles include *Jack the Ripper*, by Rick Geary; and *Kafka Stories*, by Peter Kuper. Circ. 5,000-10,000.

Needs: Approached by 60-70 freelancers/year. Works with 2 freelance designers/year. Uses freelancers for lettering, paste-up, layout design and coloring. Prefers pen & ink, watercolor and oil for graphic novels submissions.

First Contact & Terms: Send query letter with résumé and samples. Samples are filed or are returned by SASE. Reports back within 2 weeks. To show portfolio, mail photocopies of original pencil or ink art. Originals are returned at job's completion.

Tips: "We are interested in submissions for graphic novels. We do not need illustrations or covers only! No submissions via e-mail!"

NEWSTAR MEDIA, INC., (formerly Dove Books), 8955 Beverly Blvd., Los Angeles CA 90048. (310)786-1600. Fax: (310)247-2924. Website: http://www.doveaudio.com. Creative Director: Rick Penn-Kraus. Estab. 1985. Imprints include Dove Audio, Dove Kids. Publishes hardcover, trade paperback and mass market paperback originals, hardcover reprints, audio tapes and CD-ROM. Types of books and audios include biography, cookbooks, experimental fiction, humor, New Age, nonfiction, religious and self help. Specializes in biography, business, current events, lifestyle. Pub-

lishes 15 titles/year. Recent titles include *Chosen By Fate*; and *Mile High Club*. 40% require freelance illustration; 25% require freelance design. Book catalog free.

Needs: Approached by 60 illustrators and 20 designers/year. Works with 20 illustrators and 20 designers/year. Prefers local designers. 100% of freelance design demands knowledge of Adobe Photoshop, Adobe Illustrator or QuarkXPress. 15% of freelance illustration demands knowledge of Adobe Photoshop or Adobe Illustrator.

First Contact & Terms: Designers send photocopies, résumé, SASE, tearsheets. Illustrators send postcard sample or query letter with SASE and tearsheets. Samples are filed or returned by SASE. Portfolios may be dropped off every Thursday or art director will contact artist for portfolio review of photocopies, tearsheets, thumbnails or transparencies if interested. Finds freelancers through promo cards, *Workbook*.

Book Design: Assigns 13 jobs/year. Pays by the project.

Jackets/Covers: Assigns 5 design and 7 illustration jobs/year. Pays by project.

Tips: "I look for artists and designers who are flexible and willing to go the extra mile. Good communication is also essential. Be professional. Show a concise, great portfolio. Send me a great postcard to put up on my wall as a reminder."

NORTHLAND PUBLISHING, Box 1389, Flagstaff AZ 86002. (520)774-5251. Fax: (520)774-0592. E-mail: design@northlandpub.com. Website: http://www.northlandpub.com. Contact: Jennifer Schaber. Estab. 1958. Company publishes hardcover and trade paperback originals. Types of books include western, juvenile, natural history, Native American art and cookbooks. Specializes in Native American, Western Americana. Publishes 25 titles/year. Recent titles include *Swimming Lessons*, by Betsy Jay; and *The Worrystone*, by Marianna Dengler. 50% requires freelance illustration; 25% requires freelance design. Book catalog free for 9×12 SASE ($2.13 postage).

Needs: Approached by 40-50 freelancers/year. Works with 5-10 freelance illustrators and 4-6 designers/year. Buys 140 freelance illustrations/year. Prefers freelancers with experience in illustrating children's titles. Uses freelancers mainly for children's books. Also for jacket/cover design and illustration, text illustration and book design. 100% of freelance work demands knowledge of Adobe Illustrator, QuarkXPress or Adobe Photoshop. Works on assignment only.

First Contact & Terms: Send query letter with résumé, SASE, tearsheets, slides and transparencies. Samples are filed or are returned by SASE if requested by artist. Will contact artist for portfolio review if interested. Portfolio should include color tearsheets and transparencies. Rights purchased vary according to project. Originals are returned at job's completion. Finds artists mostly through submissions.

Book Design: Assigns 4-6 freelance design jobs/year. Pays by the project, $500-4,500.

Jackets/Covers: Assigns 4-6 freelance design and 5-10 illustration jobs/year. "We prefer realistic, more representational styles in any medium."

Text Illustration: Assigns 5-10 freelance illustration jobs/year. Pays by the project, $1,000-6,000. Royalties are preferred—gives cash advances against royalties. "We prefer more realistic, representational styles in any medium."

Tips: "Creative presentation and promotional pieces filed."

NORTHWORD PRESS, 5900 Green Oak Dr., Minnetonka MN 55343. (612)936-4700. Fax: (612)933-1456. Editorial Director: Barbara Harold. Estab. 1984. Book publisher; imprint of Creative Publishing International, Inc. Publishes hardcover originals and reprints and trade paperback originals and reprints. Types of books include juvenile, adult, coffee table books, children's, travel, natural histories and nature guides. Specializes in nature, wildlife and environmental. Publishes about 25 titles/year. Recent titles include *Chased by the Light*, *Brother Wolf*, *Trout Country*, and *Dear Children of the Earth*. 30% require freelance illustration; 20% require freelance design. Book catalog free by request.

Needs: Works with 3-4 illustrators and 1-2 designers/year. "We commission packages of 30-40 illustrations for 3-4 titles/year, with covers. Most books are illustrated with photos." Prefers artists with experience in wildlife art. Uses freelancers mainly for illustration. Works on assignment only.

First Contact & Terms: Send query letter with brochure, SASE, tearsheets, photographs, photocopies, photostats, slides and transparencies. "No originals, and make sure they fit in standard-size folders." Samples are filed or are returned by SASE. Reports back only if interested. "I prefer samples mailed and will call to contact the artist if I want to see a portfolio." Negotiates rights purchased. Originals returned at job's completion "unless we purchase all rights."

Text Illustration: Assigns 4-6 illustration jobs/year. Pays by the project, $50-2,000. Any medium accepted.

Tips: "Must be serious and realistic art; no cartoons."

NOVALIS PUBLISHING, INC., 49 Front St. E., 2nd Floor, Toronto, Ontario M53 1B3 Canada. (416)363-3303. Fax: (416)363-9409. E-mail: novalis@interlog.com. Director of Sales & Marketing: Lauretta Santarossa. Publicity Coordinator: Kathy Shaidle. Estab. 1936. Publishes hardcover, mass market and trade paperback originals and textbooks. Primarily religious. Publishes 30 titles/year. Recent titles include: *Fergie the Frog* series, *On Our Way With Jesus* (sacramental preparation textbook). 100% requires freelance illustration; 25% requires freelance design; and 25% require freelance art direction. Free book catalog available.

 SPECIAL COMMENTS within listings by the editor of *Artist's & Graphic Designer's Market* are set off by a bullet.

Needs: Approached by 4 illustrators and 4 designers/year. Works with 3-5 illustrators and 2-4 designers/year. Prefers local freelancers experienced in graphic design and production. 100% of freelance work demands knowledge of Adobe Illustrator, Adobe Photoshop, Aldus PageMaker, PageMaker, QuarkXPress.

First Contact & Terms: Send postcard sample or query letter with printed samples, photocopies, tearsheets. Samples are filed or returned on request. Will contact artist for portfolio review if interested. Rights purchased vary according to project; negotiable.

Book Design: Assigns 10-20 freelance design and 2-5 art direction projects/year. Pays for design by the hour, $25-40.

Jackets/Covers: Assigns 5-10 freelance design and 2-5 illustration jobs/year. Prefers b&w, ink, woodcuts, linocuts, varied styles. Pays for design by the project, $100-800, depending on project. Pays for illustration by the project, $100-800, depending on project. Pays for illustration by the project, $100-600.

Text Illustration: Assigns 2-10 freelance illustration jobs/year. Pays by the project, $100 minimum, depending on project.

Tips: "We look for dynamic design incorporating art and traditional, non-traditional, folk etc. with spiritual, religious, Gospel, biblical themes—mostly Judaeo-Christian."

NTC/CONTEMPORARY PUBLISHING GROUP, Parent company: Tribune Company. 4255 W. Touhy Ave., Lincolnwood IL 60646-1975. (847)679-5500. Fax: (847)679-6388. E-mail: ntcpub@tribune.com. Directors: Kim Bartko, trade; Ophelia Chambliss, education. Estab. 1961. Imprints include Masters Press, Lowell House, Contemporary Books, Country Roads Press, Keats Publishing Peter Bedrick Books and Quilt Digest Press. Book publisher. Publishes hardcover and trade paperback originals, audio tapes, CD-ROMs, textbooks and trade paperpack reprints. Types of books include cookbooks, humor, instructional, coffee table books, juvenile, nonfiction, reference, textbooks, travel, sports, parenting, fitness, business, foreign language, reference and self-help. Publishes 800 titles/year. Recent titles include: *Sammy's Season*, *Chase's Calendar* and *Unbelievably Good Deals*. 20-25% requires freelance illustration; 20-30% requires freelance design. Book catalog not available.

Needs: Approached by 75 illustrators and 20 designers/year. Works with 30 illustrators and 10 designers/year. Prefers freelancers experienced in book/editorial illustration or design. 100% of design demands knowledge of Adobe Illustrator, Adobe Photoshop and QuarkXPress. 40% of illustration demands knowledge of QuarkXPress, Adobe Photoshop, Adobe Illustrator, Aldus FreeHand and PageMaker.

First Contact & Terms: Designers send query letter with printed samples, photocopies, SASE and tearsheets. Illustrators send postcard sample or query letter with printed samples, photocopies, SASE and tearsheets. Accepts Mac-compatible disk submissions. Send EPS files. Samples are filed. Reports back only if interested. Will contact artist for portfolio review if interested. Rights purchased vary according to project. Finds artists through samples, sourcebooks and annuals, *Workbook*, *Showcase*, *Illustrators* and *Directory of Illustration*.

Book Design: Assigns 20 freelance design jobs/year. Pays by the project.

Jackets/Covers: Assigns 40-50 freelance design and 40 illustration jobs/year. Pays by the project.

Text Illustration: Assigns 30 freelance jobs/year. Pays by the project.

Tips: "We publish a wide variety of nonfiction titles and textbooks. We welcome promotional samples in editorial (not too commercial) styles. We keep samples on file."

OCTAMERON PRESS, 1900 Mount Vernon Ave., Alexandria VA 22301. Website: http://www.octameron.com. Editorial Director: Karen Stokstod. Estab. 1976. Specializes in paperbacks—college financial and college admission guides. Publishes 10-15 titles/year. Titles include *College Match* and *The Winning Edge*.

Needs: Approached by 25 freelancers/year. Works with 1-2 freelancers/year. Works on assignment only.

First Contact & Terms: Send query letter with brochure showing art style or résumé and photocopies. Samples not filed are returned if SASE included. Considers complexity of project and project's budget when establishing payment. Rights purchased vary according to project.

Jackets/Covers: Works with 1-2 designers and illustators/year on 15 different projects. Pays by the project, $300-700.

Text Illustration: Works with variable number of artists/year. Pays by the project, $35-75. Prefers line drawings to photographs.

Tips: "The look of the books we publish is friendly! We prefer humorous illustrations."

OREGON CATHOLIC PRESS, 5536 NE Hassalo, Portland OR 97213-3638. (503)281-1191. Fax: (503)282-3486. E-mail: jeang@ocp.org. Website: http://ocp.org/. Art Director: Jean Germano. Division estab. 1997. Types of books include religious and liturgical books specifically but not exclusively to, the Roman Catholic market. Publishes 2-5 titles/year. Recent titles include: *More Stories and Songs of Jesus*, and *Singing on the Move*. 30% requires freelance illustration; 100% requires freelance art direction. Book catalog available for 9×12 SAE with first-class stamps.

- Oregon Catholic Press (OCP Publications) is a nonprofit publishing company, producing music and liturgical publications used in parishes throughout the United States, Canada, England and Australia. A piece written by one of their composers was sung at Princess Diana's funeral. This publisher also has listings in the Magazine and Record Labels sections. Recently acquired Pastoral Press.

Tips: "I am always looking for appropriate art for our projects. We tend to use work already created, on a one-time use basis, as opposed to commissioned pieces. I look for tasteful, not overtly religious art. Our book division is a new division. We anticipate 2-3 new books per year."

N OREGON STATE UNIVERSITY PRESS, 101 Waldo Hall, Corvallis OR 97331-6407. Managing Editor: Jo Alexander. Estab. 1961. Publishes hardcover and trade paperback originals and reprints and textbooks. Types of books include biography, history, nonfiction, reference, textbooks and western. Specializes in scholarly and regional trade. Publishes 15 titles/year. Recent titles include: *Mammals of the Pacific Northwest*, *American Nature Writing 1999* and *Plants of the Oregon Coastal Dunes*. 5% requires freelance illustration; 90% requires freelance design of cover, jacket. Book catalog for 8×11 SASE with 2 first-class stamps.

Needs: Approached by 20 illustrators and 20 designers/year. Works with 2 illustrators and 5 designers/year. Prefers freelancers experienced in computer skills. 100% of freelance design demands knowledge of one or more: Adobe Illustrator, Adobe Photoshop, Aldus FreeHand, Aldus PageMaker, PageMaker and QuarkXPress.

First Contact & Terms: Designers send query letter with printed samples or reference to website where we can view work. Accepts Mac-compatible disk submissions. Send TIFF files. Samples are filed. Reports back only if interested. Portfolio review not required. Rights purchased vary according to project. Finds freelancers through submission packets and personal referrals.

Book Design: Assigns 15 freelance design jobs/year. Pays by the project, $500-1,000.

Jackets/Covers: Assigns 15 freelance design jobs/year. Computer design essential. Pays by the project, $500 minimum.

OTTENHEIMER PUBLISHERS, INC., 5 Park Center Court #300, Owings Mills MD 21117. (410)902-9100. Fax: (410)902-7210. Contact: Art Director. Estab. 1890. Book producer. Specializes in mass market and trade, hardcover, pop and paperback originals—cookbooks, children's, encyclopedias, dictionaries, novelty and self-help. Publishes 200 titles/year. Titles include: *Ancient Healing Secrets* and *Santa's Favorite Sugar Cookies*. 80% requires freelance illustration.

Needs: Works with 100 illustrators and 3 freelance designers/year. Prefers professional graphic designers and illustrators. 100% of design demands knowledge of the latest versions of Adobe Illustrator, QuarkXPress and Adobe Photoshop.

First Contact & Terms: Designers send résumé, client list, photocopies or tearsheets to be kept on file. Illustrators send postcard sample and/or photocopies, tearsheets and client list. Accepts disk submissions from designers, not illustrators. Samples not filed are returned by SASE. Reports back only if interested. Call or write for appointment to show portfolio. No unfinished work or sketches. Considers complexity of project, project's budget and turnaround time when establishing payment. Buys all rights. Originals are returned at job's completion. No phone calls.

Book Design: Assigns 20-40 design jobs/year. Pays by the project, $500-4,000.

Jackets/Covers: Assigns 25 design and 25 illustration jobs/year. Pays by the project, $500-1,500, depending upon project, time spent and any changes.

Text Illustration: Assigns 30 jobs/year, both full color media and b&w line work. Prefers graphic approaches as well as very illustrative. "We cater more to juvenile market." Pays by the project, $500-10,000.

Tips: Prefers "art geared towards children—clean work that will reproduce well. I also look for the artist's ability to render children/people well. We use art that is realistic, stylized and whimsical but not cartoony. The more samples, the better. Take schedules seriously. Maintain a sense of humor."

N ✦ THE OVERMOUNTAIN PRESS, Sabre Industries, Inc., P.O. Box 1261, Johnson City TN 37605. (423)926-2691. Fax: (423)929-2464. E-mail: archer@planetc.net. Senior Editor: Elizabeth L. Wright. Estab. 1970. Publishes hardcover and trade paperback originals and reprints. Types of books include biography, children's picture books, cookbooks, history and nonfiction. Specializes in regional nonfiction (Appalachian). Publishes 20 titles/year. Recent titles include: *Appalachian ABC's*, *Lost Heritage*, *Our Living Heritage*, *Ten Friends* and *The Book of Kings: A History of Bristol TN/VA's Founding Family*. 20% requires freelance illustration. Book catalog free for 3 first-class stamps.

Needs: Approached by 10 illustrators/year. Works with 3 illustrators/year. Prefers local illustrators, designers and art directors. Prefers freelancers experienced in children's picture books. 100% of freelance design and illustration demands knowledge of Adobe Photoshop and QuarkXPress.

First Contact & Terms: Illustrators send query letter with printed samples. Samples are filed. Will contact artist for portfolio review including artwork and photocopies portraying children/kids' subjects if interested. Rights purchased vary according to project.

Jackets/Covers: Assigns 5-10 illustration jobs/year. Considers any medium and/or style. Pays by the project, royalty only, no advance. Prefers children's book illustrators.

Text Illustration: Assigns 2 freelance illustration jobs/year. Pays by the project, royalty only. Considers any style, medium, color scheme or type of work.

Tips: "We are starting a file of children's book illustrators. At this time we are not 'hiring' freelance illustrators. We are collecting names, addresses, numbers and samples of those who would be interested in having an author contact them about illustration."

RICHARD C. OWEN PUBLICATIONS INC., P.O. Box 585, Katonah NY 10536. (914)232-3903. Fax: (914)232-3977. Art Director: Janice Boland. Estab. 1986. Company publishes children's books. Types of books include juvenile fiction and nonfiction. Specializes in books for 5-, 6- and 7-year-olds. Publishes 20-23 titles/year. Recent titles include: *Dogs at School*; *Raveh's Gift*; *My Little Brother Ben*. 100% require freelance illustration.

• "We are building a collection of books for third grade children and continue to seek quality art."

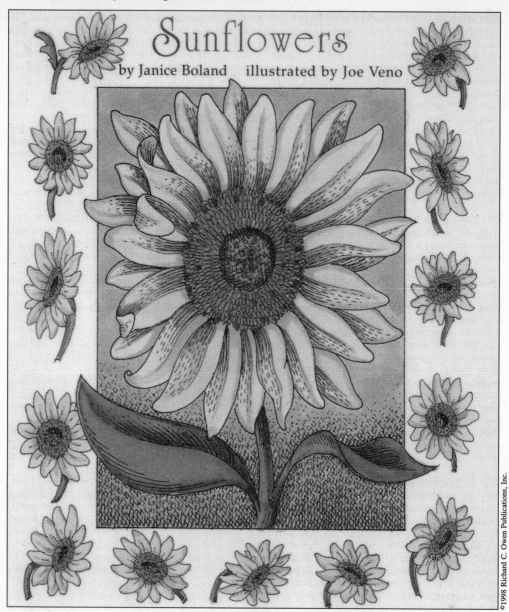

Illustrator Joe Veno rendered this cover of *Sunflowers*, published by Richard C. Owen Publications, in airbrush and acrylics. Veno finds markets such as this book publisher through about four mailings per year, advertising in *Black Book*, and using an art rep. "Try different approaches to illustration and design," Veno advises. "And learn to use the computer."

Needs: Approached by 200 freelancers/year. Works with 20-40 freelance illustrators/year. Prefers freelancers with experience in children's books. Uses freelancers for jacket/cover and text illustration. Works on assignment only.

First Contact & Terms: First request guidelines. Send samples of work (color brochure, tearsheets and photocopies). Samples are filed. Art director will contact artist if interested. Buys all rights. Original illustrations are returned at job's completion.

Text Illustration: Assigns 20-40 freelance illustration jobs/year. Pays by the project, $1,000-3,000 for a full book; $25-100 for spot illustrations.

Tips: "Show adequate and only best samples of work. Send varied work—but target the needs of the individual publisher. Send color work—no slides. Be persistent—keep file updated. Be willing to work with the art director. All our books have a trade book look. Art should capture the child reader."

OXFORD UNIVERSITY PRESS, English as a Second Language (ESL), 198 Madison Ave., 9th Floor, New York NY 10016. Website: http://www.oup-usa.org. Art Buyers: Tracy A. Hammond and Alexandra F. Rockafeller. Chartered by Oxford University. Estab. 1478. Specializes in fully illustrated, not-for-profit, contemporary textbooks emphasizing English as a second language for children and adults. Also produces wall charts, picture cards, CDs and cassettes. Recent titles include *Hotline*, *Tiny Talk* and various Oxford Picture Dictionaries.

Needs: Approached by 1,000 freelance artists/year. Works with 100 illustrators and 8 designers/year. Uses freelancers mainly for interior illustrations of exercises. Also uses freelance artists for jacket/cover illustration and design. Some need for computer-literate freelancers for illustration. 20% of freelance work demands knowledge of QuarkXPress or Adobe Illustrator. Works on assignment only.

First Contact & Terms: Send query letter with brochure, tearsheets, photostats, slides or photographs. Samples are filed. Art Buyer will contact artist for portfolio review if interested. Artists work from detailed specs. Considers complexity of project, skill and experience of artist and project's budget when establishing payment. Artist retains copyright. Originals are returned at job's completion. Finds artists through submissions, artist catalogs such as *Showcase*, *Guild Book*, etc. occasionally from work seen in magazines and newspapers, other illustrators.

Jackets/Covers: Pays by the project, $750 minimum.

Text Illustration: Assigns 500 jobs/year. Uses black line, half-tone and 4-color work in styles ranging from cartoon to realistic. Greatest need is for natural, contemporary figures from all ethnic groups, in action and interaction. Pays for text illustration by the project, $45/spot, $2,500 maximum/full page.

Tips: "Please wait for us to call you. You may send new samples to update your file at any time. We would like to see more natural, contemporary, nonwhite people from freelance artists. Art needs to be fairly realistic and cheerful. We do appreciate verve and style—we don't do stodgy texts."

■ PAULINE BOOKS & MEDIA, 50 St. Pauls Ave., Boston MA 02130-3491. (617)522-8911. Fax: (617)541-9805. Website: http://www.pauline.org. Contact: Graphic Design Dept. Estab. 1932. Book publisher. "We also publish a children's magazine and produce audio and video cassettes." Publishes hardcover and trade paperback originals and reprints and textbooks. Also electronic books and software. Types of books include instructional, biography, preschool, juvenile, young adult, reference, history, self-help, prayer and religious. Specializes in religious topics. Publishes 20 titles/year. Art guidelines available. Sample copies for SASE with first-class postage.

Needs: Approached by 50 freelancers/year. Works with 10-20 freelance illustrators/year. Also needs freelancers for multimedia projects. 65% of freelance work demands knowledge of Aldus PageMaker, Illustrator, Photoshop, etc.

First Contact & Terms: Send query letter with résumé, SASE, tearsheets and photocopies. Accepts disk submissions compatible with Windows 95, Mac. Send EPS, TIFF, GIF or TARGA files. Samples are filed or are returned by SASE. Reports back within 1-3 months only if interested. Rights purchased vary according to project. Originals are returned at job's completion.

Jackets/Covers: Assigns 1-2 freelance illustration jobs/year. Pays by the project.

Text Illustration: Assigns 3-10 freelance illustration jobs/year. Pays by the project.

☑ ✦ PAULIST PRESS, 997 Macarthur Blvd., Mahwah NJ 07430. (201)825-7300. Fax: (201)825-8345. Managing Editor: Maria Maggi. Estab. 1869. Company publishes hardcover and trade paperback originals and textbooks. Types of books include biography, juvenile and religious. Specializes in academic and pastoral theology. Publishes 95 titles/year. 5% requires freelance illustration; 5% requires freelance design.

Needs: Works with 10-12 freelance illustrators and 15-20 designers/year. Prefers local freelancers. Uses freelancers for juvenile titles, jacket/cover and text illustration. 10% of freelance work demands knowledge of QuarkXPress. Works on assignment only.

First Contact & Terms: Send query letter with brochure, résumé and tearsheets. Samples are filed. Reports back only if interested. Portfolio review not required. Negotiates rights purchased. Originals are returned at job's completion if requested.

Book Design: Assigns 10-12 freelance design jobs/year.

Jackets/Covers: Assigns 90 freelance design jobs/year. Pays by the project, $400-800.

Text Illustration: Assigns 3-4 freelance illustration jobs/year. Pays by the project.

PEACHPIT PRESS, INC., 1249 Eighth St., Berkeley CA 94710. (510)524-2178. Fax: (510)524-2221. Estab. 1986. Book publisher. Types of books include instruction and computer. Specializes in desktop publishing and Macintosh topics. Publishes 50-60 titles/year. Recent titles include: *HTML 4: Visual Quickstart Guide*; *The Windows 98 Bible*; and *The Little iMac Book*. 50% requires freelance design. Book catalog free by request.

Needs: Approached by 50-75 artists/year. Works with 4 freelance designers/year. Prefers artists with experience in computer book cover design. Uses freelance artists mainly for covers, fliers and brochures. Also uses freelance artists for direct mail and catalog design. Works on assignment only.

First Contact & Terms: Send query letter with résumé, photographs and photostats. Samples are filed. Reports back to the artist only if interested. Call for appointment to show a portfolio of original/final art and color samples. Buys all rights. Originals are not returned at job's completion.

Book Design: Pays by the project, $500-2,000.

Jackets/Covers: Assigns 40-50 freelance design jobs/year. Pays by the project, $1,000-7,000.

N ☐ PEACHTREE PUBLISHERS, 494 Armour Circle NE, Atlanta GA 30324. (404)876-8761. Fax: (404)875-2578. Website: http://www.peachtree-online.com. Art Director/Production Manager: Loraine Balcsik. Associate Production Manager: Melanie McMahon. Estab. 1977. Publishes hardcover and trade paperback originals. Types of books include children's picture books, history for young adults, humor, juvenile, preschool, self help, travel, young adult. Specializes in children's and young adult titles. Publishes 20-24 titles/year. Recent titles include: *All Star Sports Story Series*; *The Library Dragon*; *Older but Wilder*; *Sunsets of Miss Olivia Wiggins*; and *13 Monsters Who Should Be Avoided*. 90-100% requires freelance illustration; .5% requires freelance design. Call for catalog.

Needs: Approached by 750 illustrators and 200 designers/year. Works with 4-5 illustrators and 1-2 designers/year. Prefers local illustrators. Prefers local designers. Prefers fine art painterly style in children's and young adult books. Freelance design demands knowledge of Aldus PageMarker, QuarkXPress.

First Contact & Terms: Illustrators send query letter with photocopies, SASE, tearsheets. "Prefer not to receive samples from designers at this time since most is done in-house." Accepts Mac-compatible disk submissions but not preferred. Samples are filed and are returned by SASE. Reports back only if interested. Will contact artist for portfolio review if interested. Rights purchased vary according to project. Finds freelancers through submission packets, agents and sourcebooks, including *Black Book Directory of Illustration*.

Jackets/Covers: Assigns 18-20 illustration jobs/year. Prefers acrylic, watercolor, or a mixed media on flexible material. Pays for design by the project.

Text Illustration: Assigns 4-6 freelance illustration jobs/year. Pays by the project.

Tips: "We are a small, high-quality house with a limited number of new titles per season, therefore each book must be a jewel. We expect the illustrator to bring creative insights which expand the readers' understanding of the storyline through visual clues not necessarily expressed within the text itself."

☐ PEN NOTES, INC., 61 Bennington Ave., Freeport NY 11520-3919. (516)868-5753. Fax: (516)868-8441. E-mail: pennotes@worldnet.att.net. Website: http://www.PenNotes.com. President: Lorette Konezny. Produces learning books for children ages 3 and up. Clients: Bookstores, toy stores and parents.

Needs: Prefers New York artists with book or advertising experience. Works on assignment only. Each year assigns 1-2 books (with 24 pages of art) to freelancers. Uses freelancers for children's illustration, P-O-P display and design and mechanicals for catalog sheets for children's books. 100% of freelance design and up to 50% of illustration demands computer skills. Prefers knowledge of press proofs on first printing. Prefers imaginative, realistic style with true perspective and color. 100% of titles require freelance art direction.

First Contact & Terms: Designers send brochure, résumé, SASE, tearsheets and photocopies. Illustrators send sample with brochure, résumé and tearsheets. Samples are filed. Call or write for appointment to show portfolio or mail final reproduction/product, color and b&w tearsheets and photostats. Pays for design by the hour, $15-36; by the project, $60-125. Pays for illustration by the project, $60-500/page. Buys all rights.

Tips: "Work must be clean, neat and registered for reproduction. The style must be geared for children's toys. Looking for realistic/cartoon outline with flat color. You must work on deadline schedule set by printing needs. Must have full range of professional and technical experience for press proof. All work is property of Pen Notes, copyright property of Pen Notes."

N ☐ PEREGRINE, 83 Boston Ave., Toronto, Ontario M4M 2T8 Canada. (416)461-9884. Fax: (416)461-4031. E-mail: peregrine@ican.net. Website: http://home.ican.net/~peregrine. Creative Director: Kevin Davies. Estab. 1993. Publishes roleplaying game books, audio music, and produces miniatures supplements. Main style/genre of games: science fiction, cyberpunk, mythology, fantasy, military, horror and humor. Uses freelance artists mainly for interior art (b&w, greyscale) and covers (color). Publishes 1-4 titles or products/year. Game/product lines include: *Murphy's World* (roleplaying game), *Bob, Lord of Evil* (roleplaying game), *Adventure Areas* (miniatures supplements), *Adventure Audio*. 90% requires freelance illustration; 10% requires freelance design. Art guidelines available on website.

Needs: Approached by 20 illustrators and 2 designers/year. Works with 5 illustrators/year. Prefers freelancers experienced in anatomy, structure, realism, cartoon and greyscale. 100% of freelance design demands knowledge of Adobe Illustrator, Adobe Photoshop and QuarkXPress.

First Contact & Terms: Send self-promotion photocopy and follow-up postcard every 6-9 months. Send query letter with résumé, business card. Illustrators send photocopies and tearsheets. Send 5-10 samples. Accepts disk submissions in Mac format. Send via CD, floppy disk, Jaz, Zip, e-mail or website as EPS, TIFF or JPEG files at 72-100 dpi (samples), finished work at 300 dpi. Only use Jaz or Zip for finished work, not samples. Samples are filed and are not returned. Reports back only if interested. Portfolio review not required. Rights purchased vary according to project. Finds freelancers through conventions, internet and word of mouth.

Book Covers/Posters/Cards: Assigns 1-2 illustration jobs/year. Pays for illustration by the project.

Text Illustration: Assigns 5-10 illustration jobs/year (greyscale/b&w). Pays by the full page, $50-100. Pays by the half page $10-25. "Price varies with detail of image required and artist's reputation."

Tips: "Check out our existing products. Make sure at least half of the samples submitted reflect the art styles we're currently publishing. Other images can be provided to demonstrate your range of capability."

PERFECTION LEARNING CORPORATION, COVER-TO-COVER, 10520 New York Ave., Des Moines IA 50322-3775. (515)278-0133. Fax: (515)278-2980. E-mail: rmesser@plconline.com. Website: http://www.plconline.com. Art Director: Randy Messer. Senior Designer: Deb Bell. Estab. 1927. Publishes audio tapes, hardcover originals and reprints, mass market paperback originals and reprints, educational resources, trade paperback originals and reprints,

careers, health, high general interest/low reading level, multicultural, nature, science, social issues, sports. Specializes in high general interest/low reading level and Lit-based teacher resources. Publishes 50-75 titles/year. Recent titles include: *Sagebrush*; *Spirit of the Wild West*; *The Best Sign*; *Fight in the Fields*; by Cesar Chavez; and *Shatter With Words*, by Langston Hughes. 50% requires freelance illustration.

• Perfection Learning Corporation has had several books nominated for awards including *Iditarod*, nominated for a Golden Kite award and *Don't Bug Me*, nominated for an ALA-YALSA award.

Needs: Approached by 200 illustrators and 10-20 designers/year. Works with 20-30 illustrators/year. Prefers local designers and art directors. Prefers freelancers experienced in cover illustration and interior spot—4-color and b&w. 100% of freelance design demands knowledge of QuarkXPress.

First Contact & Terms: Illustrators send postcard or query letter with printed samples, photocopies, SASE, tearsheets. Accepts Mac-compatible disk submissions. Send EPS. Samples are filed or returned by SASE. Reports back only if interested. Portfolio review not required. Rights purchased vary according to project. Finds freelancers through tearsheet submissions, illustration annuals, phone calls, artists' reps.

Jackets/Covers: Assigns 30-40 freelance illustration jobs/year. Pays for illustration by the project, $250-750, depending on project. Prefers illustrators with conceptual ability.

Text Illustration: Assigns 10-20 freelance illustration jobs/year. Pays by the project. Prefers freelancers who are able to draw multicultural children and good human anatomy.

Tips: "We look for good conceptual skills, good anatomy, good use of color. Our materials are sold through schools for classroom use—they need to meet educational standards."

PETER PAUPER PRESS, INC., 202 Mamaroneck Ave., White Plains NY 10601. (914)681-0144. Fax: (914)681-0389. E-mail: pauperp@aol.com. Contact: Creative Director. Estab. 1928. Company publishes hardcover small format illustrated gift books and photo albums. Specializes in friendship, love, celebrations, holidays, topics of interest to women. Publishes 72 titles/year. Recent titles include *First Aid for a Mother's Soul*, illustrated by C. James Frazier; *Shop 'til You Drop*, illustrated by Paula Brinkman; and *You're A Beary Special Friend*, illustrated by Karen Anagnost. 100% require freelance illustration; 100% require freelance design.

• Peter Pauper has significantly increased its pay for illustration and now relies 100% on freelance illustration and design.

Needs: Approached by 75-100 freelancers/year. Works with 15-20 freelance illustrators and 3-5 designers/year. Uses freelancers for jacket/cover and text illustration. 100% of freelance design demands knowledge of QuarkXPress. Works on assignment only.

First Contact & Terms: Send query letter with brochure, résumé, SASE, photographs, tearsheets or photocopies. Samples are filed or are returned by SASE. Reports back within 1 month with SASE. Art Director will contact artist for portfolio review if interested. Portfolio should include book dummy, final art, photographs and photostats. Rights purchased vary according to project. Originals are returned at job's completion. Finds artists through submissions, gift and card shows.

Book Design: Assigns 65 freelance design jobs/year. Pays by the project, $500-2,500.

Jackets/Covers: Assigns 65 freelance design and 40 illustration jobs/year. Pays by the project, $800-1,200.

Text Illustration: Assigns 65 freelance illustration jobs/year. Pays by the project, $1,000-2,800.

Tips: "Knowledge of the type of product we publish is extremely helpful in sorting out artists whose work will click for us. We are most likely to have a need for up-beat works aimed at women."

PIPPIN PRESS, 229 E. 85th St., Gracie Station Box 1347, New York NY 10028. (212)288-4920. Fax: (908)225-1562. Publisher: Barbara Francis. Estab. 1987. Company publishes hardcover juvenile originals. Publishes 4-6 titles/year. Recent titles include *Abigail's Drums*, *The Spinner's Daughter*, *The Sounds of Summer* and *Windmill Hill*. 100% require freelance illustration; 50% require freelance design. Book catalog free for SAE with 2 first-class stamps.

Needs: Approached by 50-75 freelance artists/year. Works with 6 freelance illustrators and 2 designers/year. Prefers artists with experience in juvenile books for ages 4-10. Uses freelance artists mainly for book illustration. Also uses freelance artists for jacket/cover illustration and design and book design.

First Contact & Terms: Send query letter with résumé, tearsheets, photocopies. Samples are filed "if they are good" and are not returned. Reports back within 2 weeks. Portfolio should include selective copies of samples and thumbnails. Buys all rights. Originals are returned at job's completion.

Book Design: Assigns 3-4 freelance design jobs/year.

Text Illustration: All text illustration assigned to freelance aritsts.

Tips: Finds artists "through exhibits of illustration and looking at recently published books in libraries and bookstores."

PLAYERS PRESS, Box 1132, Studio City CA 91614. Associate Editor: Jean Sommers. Specializes in plays and performing arts books. Recent titles include *Principles of Stage Combat*; *Theater Management*; and *The American Musical Theatre*.

Needs: Works with 3-15 freelance illustrators and 1-3 designers/year. Uses freelancers mainly for play covers. Also for text illustration. Works on assignment only.

First Contact & Terms: Send query letter with brochure showing art style or résumé and samples. Samples are filed or are returned by SASE. Request portfolio review in original query. Art Director will contact artist for portfolio review if interested. Portfolio should include thumbnails, final reproduction/product, tearsheets, photographs and "as much information as possible." Sometimes requests work on spec before assigning a job. Buys all rights. Considers buying

second rights (reprint rights) to previously published work, depending on usage. "For costume books this is possible."

Book Design: Pays by the project, rate varies.

Jackets/Covers: Pays by the project, rate varies.

Text Illustration: Pays by the project, rate varies.

Tips: "Supply what is asked for in the listing and don't waste our time with calls and unnecessary cards. We usually select from those who submit samples of their work which we keep on file. Keep a permanent address so you can be reached."

CLARKSON N. POTTER, INC., Imprint of Crown Publishers. Parent company: Random House, 201 E. 50th St., 5th Floor, New York NY 10022. (212)572-6165. Fax: (212)572-6181. Website: http://www.randomhouse.com. Art Director: Marysarah Quinn. Publishes hardcover originals and reprints. Types of books include biography, coffee table books, cookbooks, history, gardening, crafts, decorating. Specializes in lifestyle (cookbooks, gardening, decorating). Publishes 60 titles/year. Recent titles include: *Martha Stewart's Healthy Quick Cook*, *Moosewood Restaurant's Low-fat Favorites*, *Spirit of African Design*. 20% requires freelance illustration; 65% requires freelance design.

Needs: Works with 10-15 illustrators and 30 designers/year. Prefers freelancers experienced in illustrating food in traditional styles and mediums and designers with previous book design experience. 100% of freelance design demands knowledge of Adobe Illustrator, Adobe Photoshop, QuarkXPress.

First Contact & Terms: Send postcard sample or query letter with printed samples, photocopies, tearsheets. Prefers not to receive disk submissions. Samples are filed and are not returned. Will contact artist for portfolio review if interested or portfolios may be dropped off any day. Leave for 2-3 days. Negotiates rights purchased. Finds freelancers through submission packets, promotional postcards, sourcebooks and illustration annuals, previous books.

Book Design: Assigns 30 freelance design jobs/year.

Jackets/Covers: Assigns 30 freelance design and 15 illustration jobs/year. Pays for design by the project.

Text Illustration: Assigns 15 freelance illustration jobs/year.

Tips: "We no longer have a juvenile books department. We do not publish books of cartoons or humor. We look at a wide variety of design styles. We look at mainly traditional illustration styles and mediums and are always looking for unique food illustrations."

PRAKKEN PUBLICATIONS, INC., 3970 Varsity Dr., Box 8623, Suite 1, Ann Arbor MI 48107. (734)975-2800. Fax: (734)975-2787. Production and Design Manager: Sharon Miller. Estab. 1934. Imprints include The Education Digest, Tech Directions. Company publishes textbooks, educator magazines and reference books. Specializes in vocational, technical, technology and education. Publishes 2 magazines and 2 new book titles/year. Titles include: *High School-to-Employment Transition*, *Exploring Solar Energy, II: Projects in Solar Electricity* and *Technology's Past*. Book catalog free by request.

Needs: Rarely uses freelancers. 50% of freelance work demands knowledge of Adobe PageMaker. Works on assignment only.

First Contact & Terms: Send samples. Samples are filed or are returned by SASE if requested by artist. Reports back only if interested. Art Director will contact artist for portfolio review if interested. Portfolio should include b&w and color final art, photostats and tearsheets.

PRE-EMPTIVE PRODUCTS, DEVELOPING HEARTS SYSTEMS, 2048 Elm St., Stratford CT 06615. (203)378-6725. Fax: (203)380-0456. E-mail: berquist@ntplx.net. President: Tom Berquist. Estab. 1985. Publishes children's picture books.

Needs: Approached by 15-20 freelancers/year. Works with 3-5 freelancers/year. Buys 20-30 freelance designs and illustrations/year. Considers art, acrylic and watercolor. Looking especially for short, wordless books for infants.

First Contact & Terms: Designers and cartoonists send query letter with photocopies. Samples are filed and are not returned. Reports back only if interested. Rights purchased vary according to project. Pays royalties of 3-5% for original art. Finds freelancers through word of mouth.

PRENTICE HALL COLLEGE DIVISION, 445 Hutchinson Ave., Columbus OH 43235. (614)841-3700. Fax: (614)841-3645. Website: http://www.pearson.com. Associate Design Director: Karrie Converse-Jones. Imprint of Pearson Education. Specializes in college textbooks in education and technology. Publishes 300 titles/year. Recent titles include: *Exceptional Children*, by Heward and *Electronics Fundamentals*, by Floyd.

Needs: Approached by 25-40 freelancers/year. Works with 30 freelance illustrators/year. Uses freelancers mainly for interior textbook design. 100% of freelance design and 70% of illustration demand knowledge of QuarkXPress 3.32, Aldus FreeHand 8.0, Adobe Illustrator 7.0 or Adobe Photoshop 5.0.

First Contact & Terms: Send query letter with résumé and tearsheets; sample text designs on disk in Mac format. Accepts submissions on disk in Mac files only (not PC) in software versions stated above. Samples are filed and portfolios are returned. Reports back within 30 days. Rights purchased vary according to project. Originals are returned at job's completion.

Book Design: Pays by the project, $500-2,500.

Text Illustration: Assigns 70 text designs/year.

Tips: "Send a style that works well with our particular disciplines. All text designs are produced with a computer, but the textbook should be appealing to the student-reader whether 1-color, 2-color or 4-color."

PRIDE & IMPRINTS, 7419 Ebbert Dr. SE, Port Orchard WA 98367. (360)769-7174. E-mail: pridepblsh@aol.com. Website: http://members.aol.com/pridepblsh/pride.html. Senior Editor: Ms. Cris Newport. Estab. 1989. Publishes audio tapes, CD-ROMs, trade paperback originals. Types of books include children's picture books, experimental and mainstream fiction, fantasy, history, juvenile, nonfiction, science fiction, young adult. Specializes in genre fiction. Publishes 8-10 titles/year. Recent titles include: *Queen's Champion: The Legend of Lancelot Retold*, *The Best Thing*, *Caruso the Mouse*. 80% requires freelance illustration. Book catalog available for $2.

Needs: Approached by 100 illustrators/year. Works with 20 illustrators/year. Prefers freelancers experienced in all media, pen & ink, watercolor.

First Contact & Terms: Illustrators send for guidelines first and include SASE. Then send query letter with printed samples, photocopies, SASE, tearsheets. Samples are filed. Reports back within 2 months. Will contact artist for portfolio review of photocopies of artwork portraying characters, landscapes if interested. Buys first rights. Finds freelancers through *Creative Black Book*, submissions.

Book Design: Assigns 10-15 illustration jobs/year. Pays for illustration by the project, $500-2,000.

Tips: "Artists must be able to work on a deadline. Be flexible in working with a variety of authors. Be willing to work with all types of people. Be willing to revise. We offer 10-15% royalty and our books never go out of print. We need illustrators for adult books as well as children's."

N. PULSAR GAMES, INC., 9413 San Miguel Dr., Indianapolis IN 46250. (317)841-8992. Fax: (317)585-8106. E-mail: info@pulsargamesinc.com. Website: http://www.pulsargamesinc.com. Art Director: Ray Hedman. Estab. 1997. Publishes roleplaying game books, posters/calendars, newsletter. Main style/genre of games: science fiction, fantasy and comic book. Uses freelance artists mainly for illustration. Publishes 2 titles or products/year. Game/product lines include: *Blood of Heroes* and *Project Pulsar*. 100% requires freelance illustration. Art guidelines available on website.

Needs: Approached by 30 illustrators and 10 designers/year. Works with 10 illustrators and 3 designers/year. Prefers freelancers experienced in comic book style and sci-fi genre. 100% of freelance design demands knowledge of Adobe Photoshop, QuarkXPress, PageMaker and Acrobat. 20% of freelance illustration demands knowledge of Adobe Illustrator, Adobe Photoshop, Aldus FreeHand, QuarkXPress and PageMaker.

First Contact & Terms: Send self-promotion postcard sample and follow-up postcard every 3 months. Send query letter with résumé, business card, SASE and product release form. Illustrators send printed samples, photocopies, photographs and slides. Send 8-10 samples. Accepts disk submissions in Windows or Mac format. Send via CD, floppy disk, Zip or e-mail as EPS, TIFF, GIF or JPEG files at 150 dpi. Samples are filed and are not returned. Reports back only if interested. Will contact artist for portfolio review if interested. Portfolio should include artwork portraying comic book and sci-fi characters and settings, b&w, color, photocopies, final art and roughs. Negotiates rights purchased and rights purchased vary according to project. Finds freelancers through submission packets, promotional postcards, conventions, word of mouth and referrals.

Visual Design: Assigns 2-3 freelance design jobs/year. Pays for design by the project.

Book Covers/Posters/Cards: Assigns 5-10 illustration jobs/year. Prefers pencils, pen & ink, colored inks, watercolor and oils. Pays for illustration by the project or royalties.

Text Illustration: Assigns 2-3 illustration jobs/year. Pays by the project.

Tips: "Be fast, but slow enough to be detail oriented. Be persistant and show all your favored media."

PULSE-FINGER PRESS, Box 488, Yellow Springs OH 45387. Contact: Orion Roche or Raphaello Farnese. Publishes hardbound and paperback fiction, poetry and drama. Publishes 5-10 titles/year.

Needs: Prefers local freelancers. Works on assignment only. Uses freelancers for advertising design and illustration. Pays $25 minimum for direct mail promos.

First Contact & Terms: Send query letter. "We can't use unsolicited material. Inquiries without SASE will not be acknowledged." Reports back in 6 weeks; reports on future assignment possibilities. Samples returned by SASE. Send résumé to be kept on file. Artist supplies overlays for all color artwork. Buys first serial and reprint rights. Originals are returned at job's completion.

Jackets/Covers: "Must be suitable to the book involved; artist must familiarize himself with text. We tend to use modernist/abstract designs. Try to keep it simple, emphasizing the thematic material of the book." **Pays on acceptance**; $25-100 for b&w jackets.

Tips: "We do most of our work in-house; otherwise, we recruit from the rich array of talent in the colleges and universities in our area. We've used the same people—as necessary—for years; so it's very difficult to break into our line-ups. We're receptive, but our needs are so limited as to preclude much of a market."

G.P. PUTNAM'S SONS, PHILOMEL BOOKS, PAPERSTAR BOOKS, 345 Hudson St., New York NY 10014. (212)951-8733. Art Director, Children's Books: Cecilia Yung. Assistant to Art Director: Gina Casquarelli. Publishes hardcover and paperback juvenile books. Publishes 100 titles/year. Free catalog available.

Needs: Works on assignment only.

First Contact & Terms: Provide flier, tearsheet, brochure and photocopy or stat to be kept on file for possible future assignments. Samples are returned by SASE. "We take drop-offs on Tuesday mornings. Please call in advance with the date you want to drop of your portfolio."

Jackets/Covers: "Uses full-color paintings, realistic painterly style."

Text Illustration: "Uses a wide cross section of styles for story and picture books."

QUITE SPECIFIC MEDIA GROUP LTD., 260 Fifth Ave., New York NY 10001. (212)725-5377. Estab. 1967. Publishes hardcover originals and reprints, trade paperback reprints and textbooks. Specializes in costume, fashion, theater and performing arts books. Publishes 12 titles/year. 10% requires freelance illustration; 60% requires freelance design.

● Imprints of Quite Specific Media Groupo Ltd. include Drama Publishers, Costume & Fashion Press, By Design Press, Entertainment Pro and Jade Rabbit.

Needs: Works with 2-3 freelance designers/year. Uses freelancers mainly for jackets/covers. Also for book, direct mail and catalog design and text illustration. Works on assignment only.

First Contact & Terms: Send query letter with brochure and tearsheets. Samples are filed. Reports back to the artist only if interested. Rights purchased vary according to project. Originals not returned. Pays by the project.

N. RAINBOW BOOKS, P.O. Box 261129, San Diego CA 92196. (619)271-7600. Fax: (619)578-4795. E-mail: rbbooks@adnc.com. Creative Director: Sue Miley. Estab. 1979. Publishes trade paperback originals. Types of books include religious books, reproducible Sunday School books for children ages 3-12 and Bible teaching books for children and adults. Specializes in reproducible Sunday School and Bible teaching books. Publishes 20 titles/eyar. Recent titles include: *The Un-Halloween Book*, *Instant Bible Lessons for Preschoolers*, *My Bible Journal*, *Big Puzzles for Little Hands* and *Gobble Up the Bible*. Book catalog for SASE with 2 first-class stamps.

Needs: Approached by hundreds of illustrators and 50 designers/year. Works with 5-10 illustrators and 5-10 designers/year. 100% of freelance design and illustration demands knowledge of Adobe Illustrator, Adobe Photoshop and QuarkX-Press.

First Contact & Terms: Send query letter with printed samples, SASE and tearsheets. Samples are filed or returned by SASE. Reports back only if interested. Will contact artist for portfolio review if interested. Finds freelancers through samples sent and personal referrals.

Book Design: Assigns 25 freelance design jobs/year. Pays for design by the project, $350 minimum. Pays for art direction by the project, $350 minimum.

Jackets/Covers: Assigns 25 freelance design jobs and 25 illustration jobs/year. "Prefers computer generated-high energy style with bright colors appealing to kids." Pays for design and illustration by the project, $350 minimum. "Prefers designers/illustrators with some biblical knowledge.".

Text Illustration: Assigns 50 freelance illustration jobs/year. Pays by the project, $450 minimum. "Prefers black & white line art, preferably computer generated with limited detail yet fun."

Tips: "We look for illustrators and designers who have some Biblical knowledge and excel in working with a fun, colorful, high-energy style that will appeal to kids and parents alike. Designers must be well versed in Quark, Adobe Illustrator and Photoshop, know how to visually market to kids and have wonderful conceptual ideas!"

RAINBOW BOOKS, INC., P.O. Box 430, Highland City FL 33846-0430. (941)648-4420. Fax: (941)648-4420. E-mail: naip@aol.com. Media Buyer: Betsy A. Lampe. Estab. 1979. Company publishes hardcover and trade paperback originals. Types of books include instruction, adventure, biography, travel, self help, religious, reference, history and cookbooks. Specializes in nonfiction, self help and how-to. Publishes 20 titles/year. Recent titles include *Radio Music Live: 1920-1950 A Pictorial Gamut*; *Learning Disabilities 101: A Primer For Parents*.

● Rainbow Books now publishes mystery fiction.

Needs: Approached by hundreds of freelance artists/year. Works with 5 illustrators/year. Prefers freelancers with experience in book cover design and line illustration. Uses freelancers for jacket/cover illustration and design and text illustration. Needs computer-literate freelancers for design, illustration and production. 90% of freelance work demands knowledge of Aldus PageMaker, Aldus FreeHand or CorelDraw. Works on assignment only.

First Contact & Terms: Send brief query, tearsheets, photographs and book covers or jackets. Samples are not returned. Reports back within 2 weeks. Art Director will contact artist for portfolio review if interested. Portfolio should include b&w and color tearsheets, photographs and book covers or jackets. Rights purchased vary according to project. Originals are returned at job's completion.

Jackets/Covers: Assigns 10 freelance illustration jobs/year. Pays by the project, $250-1,000.

Text Illustration: Pays by the project. Prefers pen & ink or electronic illustration.

Tips: "Nothing Betsy Lampe receives goes to waste. After consideration for Rainbow Books, Inc., artists/designers are listed free in her newsletter (Publisher's Report), which goes out to over 500 independent presses (quarterly). Then, samples are taken to the art department of a local school to show students how professional artists/designers market their work. Send samples (never originals), be truthful about the amount of time needed to complete a project, learn to use the computer. Study the competition (when doing book covers), don't try to write cover copy, learn the publishing business (attend small press seminars, read books, go online, make friends with the lcoal sales reps of major book manufacturers). Pass along what you learn."

RANDOM HOUSE VALUE PUBLISHING, 201 E. 50th St., New York NY 10022. E-mail: gpapadopoulos@random house.com. Art Director: Gus Papadopoulos. Imprint of Random House, Inc. Other imprints include Wings, Gramercy and Crescent. Imprint publishes hardcover, trade paperback and reprints, and trade paperback originals. Types of books include adventure, coffee table books, cookbooks, fantasy, historical fiction, history, horror, humor, instructional, mainstream fiction, New Age, nonfiction, reference, religious, romance, science fiction, self-help, travel and western. Specializes in contemporary authors' work. Recent titles include: work by John Saul, Mary Higgins Clark, Tom Wolfe, Dave Barry and Michael Chrichton (all omnibuses). 80% requires freelance illustration; 50% requires freelance design.

Needs: Approached by 50 freelancers/year. Works with 30-40 freelance illustrators and 15-20 designers/year. Uses freelancers mainly for jacket/cover illustration and design for fiction and romance titles. 100% of design and 50% of illustration demands knowledge of Adobe Illustrator, QuarkXPress, Adobe Photoshop and Aldus FreeHand. Works on assignment only.

First Contact & Terms: Designers send résumé and tearsheets. Illustrators send postcard sample, brochure, résumé and tearsheets. Accepts disk submissions compatible with Adobe Illustrator and Adobe Photoshop. Samples are filed. Request portfolio review in original query. Art Director will contact artist for portfolio review if interested. Portfolio should include tearsheets. Buys first rights. Originals are returned at job's completion. Finds artists through *American Showcase*, *Workbook*, *The Creative Illustration Book*, artist's reps.

Book Design: Pays by the project.

Jackets/Covers: Assigns 20-30 freelance design and 40 illustration jobs/year. Pays by the project, $500-1,500.

Tips: "Study the product to make sure styles are similar to what we have done: new, fresh, etc."

RED DEER PRESS, 56 Ave. & 32nd St., Box 5005, Red Deer Alberta T4N 5H5 Canada. (403)342-3321. Fax: (403)357-3639. E-mail: vmix@admin.rdc.ab.ca. Managing Editor: Dennis Johnson. Estab. 1975. Book publisher. Publishes hardcover and trade paperback originals. Types of books include contemporary and mainstream fiction, fantasy, biography, preschool, juvenile, young adult, humor and cookbooks. Specializes in contemporary adult and juvenile fiction, picture books and natural history for children. Recent titles include *On Tumbledown Hill* and *The Strongest Man This Side of Cremona*. 100% require freelance illustration; 30% require freelance design. Book catalog available for SASE with first-class postage.

Needs: Approached by 50-75 freelance artists/year. Works with 10-12 freelance illustrators and 2-3 freelance designers/year. Buys 100+ freelance illustrations/year. Prefers artists with experience in book and cover illustration. Also uses freelance artists for jacket/cover and book design and text illustration. Works on assignment only.

First Contact & Terms: Send query letter with résumé, tearsheets, photographs and slides. Samples are filed. Reports back within 4-6 months. To show a portfolio, mail b&w slides and dummies. Rights purchased vary according to project. Originals returned at job's completion.

Book Design: Assigns 3-4 design and 6-8 illustration jobs/year. Pays by the project.

Jackets/Covers: Assigns 6-8 design and 10-12 illustration jobs/year. Pays by the project, $300-1,000 CDN.

Text Illustration: Assigns 3-4 design and 4-6 illustration jobs/year. Pays by the project. May pay advance on royalties.

Tips: Looks for freelancers with a proven track record and knowledge of Red Deer Press. "Send a quality portfolio, preferably with samples of book projects completed."

REGNERY PUBLISHING INC., Parent company: Eagle Publishing Inc., One Massachusetts Ave. NW, Washington DC 20001. (202)216-0601. Fax: (202)216-0612. E-mail: mwalker@eaglepub.com. Art Director: Marja Walker. Estab. 1947. Publishes hardcover originals and reprints, trade paperback originals and reprints. Types of books include biography, coffee table books, cookbooks, history, humor, instructional, nonfiction and self help. Specializes in nonfiction. Publishes 24 titles/year. Recent titles include: *Murder In Brentwood* and *The Arthritis Cure Cookbook*. 20-50% requires freelance design. Book catalog available for SASE.

Needs: Approached by 20 illustrators and 20 designers/year. Works with 6 designers/year. Prefers local illustrators and designers. Prefers freelancers experienced in Mac, QuarkXPress and Photoshop. 100% of freelance design demands knowledge of QuarkXPress. 50% of freelance illustration demands knowledge of Adobe Photoshop, QuarkXPress.

First Contact & Terms: Send postcard sample and follow-up postcard every 6 months. Accepts Mac-compatible disk submissions. Send TIFF files. Samples are filed. Will contact artist for portfolio review if interested. Finds freelancers through *Workbook*, networking and submissions.

Book Design: Assigns 5-10 freelance design jobs/year. Pays for design by the project; negotiable.

Jackets/Covers: Assigns 5-10 freelance design and 1-5 illustration jobs/year. Pays by the project; negotiable.

Tips: "We welcome designers with knowledge of Mac platforms . . . and the ability to design 'bestsellers' under extremely tight guidelines and deadlines!"

RIO GRANDE PRESS, 4320 Canyon, Suite A12, Amarillo TX 79109. Editor/Publisher: Rosalie Avara. Estab. 1989. Small press. Publishes trade paperback originals. Types of books include poetry journal and anthologies. Publishes 7 titles/year. Recent titles include *Winter's Gems VIII*, Anthology, by R. Avara; and *The Story Shop VII*, Anthology, by R. Avara. 95% require freelance illustration; 90% require freelance design. Book catalog for SASE with first-class postage. Artist guidelines available.

Needs: Approached by 30 freelancers. Works with 5-6 freelance illustrators and 1 designer/year. Prefers freelancers with experience in spot illustrations for poetry and b&w cartoons about poets, writers, etc. Uses freelancers for jacket/cover illustration and design and text illustration.

First Contact & Terms: Designers send query letter and cover designs with résumé. Illustrators send tearsheets, photocopies and/or examples of small b&w drawings and SASE. Samples are filed. Reports back within 1 month. To show portfolio, mail roughs, finished art samples and b&w tearsheets. Buys first rights or one-time rights. Originals are not returned.

Book Design: Assigns 3 freelance illustration jobs/year. Pays by the project; $5 or copy.

Jackets/Covers: Assigns 3 freelance designs and 4 illustration jobs/year. Pays by the project, $5; or copy.

Text Illustration: Assigns 4 freelance illustration jobs/year. Prefers small b&w line drawings to illustrate poems. Pays by the project; $5 or copy.

Tips: "We are currently seeking cover designs for *The Story Shop VII* (short stories) and *Summer's Treasures VII*, *Winter's Gems IX* (poetry anthologies). Send copies of very small b&w drawings of everyday objects, nature, animals, seasonal drawings, small figures and/or faces with emotions expressed. Pen & ink preferred."

ROWMAN & LITTLEFIELD PUBLISHERS, INC., Parent company: University Press of America, 4720 Boston Way, Suite A, Lanham MD 20706. (301)731-9534. Fax: (301)459-3464. E-mail: ghenry@univpress.com. Art Director: Giséle Byrd Henry. Estab. 1975. Publishes hardcover originals and reprints, trade paperback originals and reprints. Types of books include biography, history, nonfiction, reference, self help, textbooks. Specializes in nonfiction trade. Publishes 150 titles/year. 100% of titles require freelance design. Does not use freelance illustrations. Book catalog not available.

Needs: Approached by 10 designers/year. Works with 20 designers/year. Prefers freelancers experienced in typographic design, Photoshop special effects. 100% of freelance design demands knowledge of Adobe Photoshop and QuarkXPress.

First Contact & Terms: Designers send query letter with printed samples, photocopies, tearsheets, SASE. Accepts Mac-compatible disk submissions. Send TIFF files. Samples are filed or returned by SASE. Reports back only if interested. Portfolio review not required. Buys all rights. Finds freelancers through submission packets and word of mouth.

Jackets/Covers: Assigns 150 freelance design jobs/year. Prefers postmodern, cutting-edge design and layering, filters and special Photoshop effects. Pays for design by the project $500-1,100. Prefers interesting "on the edge" typography. Must be experienced book jacket designer.

Tips: "All our designers must work on a Mac platform, and all files imported into Quark. Proper file set up is essential. Looking for cutting edge trade nonfiction designers who are creative and fluent in all special effect software."

SAUNDERS COLLEGE PUBLISHING, Public Ledger Bldg., Suite 1250, 150 S. Independence Mall West, Philadelphia PA 19106. (215)238-5500. E-mail: cbleistine@saunderscollege.com. Website: http://www.hbcollege.com. Manager of Art & Design: Carol Bleistine. Imprint of Harcourt Brace College Publishers. Company publishes textbooks. Specializes in sciences. Publishes 20 titles/year. 100% require freelance illustration; 20% require freelance design. Book catalog not available.

Needs: Approached by 10-20 freelancers/year. Works with 10-20 freelance illustrators and 10-20 designers/year. Prefers local freelancers with experience in hard sciences (biology, chemistry, physics, math, etc.). Uses freelancers mainly for design of text interiors, covers, page layout. Also for jacket/cover and text illustration. Needs computer-literate freelancers for design and illustration. 100% of freelance work demands knowledge of Adobe Illustrator, QuarkXPress, Adobe Photoshop and Aldus FreeHand. Works on assignment only.

First Contact & Terms: Send query letter with brochure, résumé, tearsheets, photographs, photocopies or color copies. Samples are filed or returned by SASE if requested by artist. Request portfolio review in original query. Art Director will contact artist for portfolio review if interested. Portfolio should include book dummy, final art, photographs, roughs, slides, tearsheets and transparencies. Buys all rights. Finds artists through sourcebooks, word of mouth and submissions.

Books Design: Assigns 5-10 freelance design jobs/year. Pays by the project.

Jackets/Covers: Assigns 5-10 freelance design and 1-2 illustration jobs/year. Pays by the project.

Text Illustration: Assigns 30 freelance illustration jobs/year. Pays by the project or per figure. Prefers airbrush reflective; electronic art, styled per book requirements—varies.

SCHOLARLY RESOURCES INC., 104 Greenhill Ave., Wilmington DE 19805-1897. (302)654-7713. Fax: (302)654-3871. E-mail: edit@scholarly.com. Website: http://www.scholarly.com. Marketing Manager: Toni Moyer. Managing Editor: Carolyn J. Travers. Estab. 1972. Publishes textbooks and trade paperback originals. Types of books include history, reference and textbooks. Publishes 40 titles/year. 60% requires freelance illustration; 80% requires freelance design. Book catalog free.

Needs: Works with 3 illustrators and 8 designers/year. Prefers freelancers experienced in book design. 100% of freelance design demands knowledge of PageMaker and Quark XPress.

First Contact & Terms: Designers and illustrators send query letter with printed samples, photocopies, tearsheets and SASE. Accepts Mac-compatible disk submissions. Samples are filed. Reports back only if interested. Will contact artist for portfolio review if interested. Buys all rights. Finds freelancers through submission packets and networking events.

Book Design: Assigns 12 freelance design jobs/year. Pays by the project, $200-800.

Jackets/Covers: Assigns 30 freelance design jobs/year. Pays by the project, $350-1,250.

☑ SCHOLASTIC INC., 555 Broadway, New York NY 10012. Website: http://www.scholastic.com. Creative Director: David Saylor. Specializes in paperback originals of young adult, biography, classics, historical and contemporary teen. Publishes 250 titles/year. Titles include *Goosebumps*, *Animorphs* and *Baby-sitters Club*. 80% require freelance illustration. Books have "a mass-market look for kids."

Needs: Approached by 100 freelancers/year. Works with 75 freelance illustrators and 2 designers/year. Prefers local freelancers with experience. Uses freelancers mainly for mechanicals. Also for jacket/cover illustration and design and book design. 40% of illustration demand knowledge of QuarkXPress, Adobe Illustrator, Adobe Photoshop.

First Contact & Terms: Designers send query letter with résumé and tearsheets. Illustrators send postcard sample and tearsheets. Accepts disk submissions compatible with Mac. Samples are filed or are returned only if requested, with

SASE. Art Director will contact artist for portfolio review if interested. Considers complexity of project and skill and experience of artist when establishing payment. Originals are returned at job's completion. Finds artists through word of mouth, *American Showcase*, *RSVP* and Society of Illustrators.

Book Design: Pays by the project, $2,000 and up.

Jackets/Covers: Assigns 200 freelance illustration jobs/year. Pays by the project, $2,000-5,000.

Text Illustration: Pays by the project, $1,500-2,500.

Tips: "In your portfolio, show tearsheets or proofs only of printed covers. Illustrators should research the publisher. Go into a bookstore and look at the books. Gear what you send according to what you see is being used."

SCHOOL GUIDE PUBLICATIONS, 210 North Ave., New Rochelle NY 10801. (800)433-7771. Fax: (914)632-3412. E-mail: info@schoolguides.com. Website: http://www.schoolguides.com. Art Director: Melvin Harris. Assistant Art Director: Tory Ridder. Estab. 1935. Types of books include reference and educational directories. Specializes in college recruiting publications. Recent titles include: *School Guide*, *Graduate School Guide*, *College Transfer Guide*, *Armed Services Veterans Education Guide* and *College Conference Manual*. 25% requires freelance illustration; 75% requires freelance design.

Needs: Approached by 10 illustrators and 10 designers/year. Prefers local freelancers. Prefers freelancers experienced in book cover and brochure design. 100% of freelance design and illustration demands knowledge of Adobe Illustrator, Adobe Photoshop, QuarkXPress.

First Contact & Terms: Send query letter with printed samples. Accepts Mac-compatible disk submissions. Send EPS files. Samples are filed. Reports back only if interested. Will contact artist for portfolio review if interested. Rights purchased vary according to project. Finds freelancers through word of mouth.

Book Design: Assigns 4 freelance design and 4 art direction projects/year.

Jackets/Covers: Assigns 8 freelance design jobs/year.

Tips: "We look for an artist/designer to create a consistent look for our publications and marketing brochures."

SEAL PRESS, 3131 Western Ave., #410, Seattle WA 98121. Website: http://www.sealpress.com. Production: Lee Damsky. Estab. 1976. Publishes hardcover originals, trade paperback originals and reprints. Types of books include multicultural fiction, outdoor writing, popular culture, self-help and women's studies. Specializes in writing by women authors only. Publishes 15 titles/year. Recent titles include: *Adiós Barbie: Young Women Write About Body Image*, *Beyond the Limbo Silence*, *No Mountain Too High: A Triumph Over Breast Cancer* and *Real Girl/Real World: Tools for Finding Your True Self*. 100% requires freelance design. Book catalog free upon request.

Needs: Works with 10 designers/year. Prefers local designers. Prefers freelancers experienced in book cover design. 100% of freelance design demands knowledge of Adobe Photoshop, PageMaker or QuarkXPress.

First Contact & Terms: Designers send query letter with printed samples. "We like to view portfolios on designer's website." Samples are filed. Reports back only if interested. Portfolio review not required if available online. Buys first rights. Finds freelancers through recommendations, other presses and submissions.

Book Design: Assigns 15 freelance design projects/year. Pays for design by the project, $600-800.

Tips: "Please review our website or catalog before submitting samples or querying."

SOMERVILLE HOUSE USA, (formerly Somerville House Books Limited), Partner company: Penguin Putnam, Inc. 3080 Yonge St., Suite 5000, Toronto, Ontario M4N 3N1 Canada. (416)488-5938. Fax: (416)488-5506. E-mail: sombooks@goodmedia.com. Website: http://www.sombooks.com. Creative Director: Jane Somerville. Associate Publisher: Trevor Dayton. Estab. 1983. Publishes mass market and trade paperback originals. Types of books include juvenile. Publishes 20-30 titles/year. Recent titles include: *Megalodon*, *Chew On This!*, *Time Capsule for the 21st Century*, *Ice Age Bones & Books* and *Eye to Eye*™ series. 100% requires freelance illustration, design and art direction. Book catalog free for sufficient Canadian postage, or visit website.

Needs: Approached by 50 illustrators and 50 designers/year. Works with 20 illustrators, 10 designers and 10 art directors/year. Prefers local freelancers. 100% of freelance design demands knowledge of Adobe Illustrator, Adobe Photoshop and QuarkXPress. 25% of freelance illustration demands knowledge of Adobe Illustrator and QuarkXPress.

First Contact & Terms: Designers send postcard sample and follow-up postcard every year. Illustrators send query letter with printed samples, photocopies and tearsheets. Samples are filed. Reports back only if interested. Will contact artist for portfolio review of portfolio if interested. Rights purchased vary according to project. Finds freelancers through design community and various publications.

Book Design: Assigns 30 freelance design and 30 freelance art direction projects/year. Pays by the project.

Jackets/Covers: Assigns 30 freelance design and 30 illustration jobs/year.

Text Illustration: Assigns 30 freelance illustration jobs/year. Pays by the project.

SOUNDPRINTS, 353 Main Ave., Norwalk CT 06851-1552. (203)846-2274. Fax: (203)846-1776. Website: http://www.soundprints.com. Art Director: Diane H. Kanzler. Editorial Assistant: Stephanie Smith. Designer: Scott Findlay. Estab. 1989. Company publishes hardcover originals. Types of books include juvenile. Specializes in wildlife, worldwide habitats and history. Publishes 14 titles/year. Recent titles include *Through Tsavo*, by Schuyler Bull; *Flying Squirrel at Acorn Place*, by Barbara Gaines Winkelman; and *Humpback Goes North*, by Darice Bailer. 100% require freelance illustration. Book catalog free for 9 × 12 SAE with $1.21 postage.

- 1998 Parents' Choice Recommended: *Through Tsavo*; 1998 Parents' Choice Approved: *Deer Mouse at Old Farm Road*, *Humpback Goes North*, *Bluestem Horizon*, *Song of La Selva* and *Handshake in Space*.

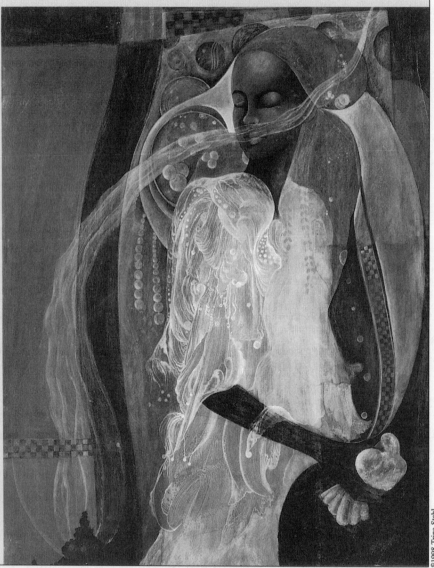

Freelance designer Trina Stahl created this cover image for the Seal Press book *Beyond the Limbo Silence*. "We loved her use of the painting, her choice of colors and elegant type treatment," says Lee Damskey of Seal Press. "We wanted a cover that would evoke the experience of a young Afro-Caribbean woman in the United States, and would be appropriate for a literary coming-of-age novel." Damskey had a query letter and samples of Stahl's work on file. "When we needed new freelance designers, we called her for an interview. She's done many successful covers for Seal Press."

Needs: Works with 10 freelance illustrators/year. Prefers freelancers with experience in realistic wildlife illustration and children's books. Heavy visual research required of artists. Uses freelancers for illustrating children's books (cover and interior).

First Contact & Terms: Send query letter with tearsheets, résumé, slides and SASE. Samples are filed or returned by SASE if requested by artist. Reports back within 1 month. Art Director will contact artist for portfolio review if interested. Portfolio should include color final art and tearsheets. Rights purchased vary according to project. Originals are returned at job's completion. Finds artists through agents, sourcebooks, reference, unsolicited submissions. Do not e-mail art samples.

Text Illustration: Assigns 14 freelance illustration jobs/year.

Tips: "Wants realism, not cartoons. Animals illustrated are not anthropomorphic. Artists who love to produce realistic, well-researched wildlife and habitat illustrations, and who care deeply about the environment, are most welcome."

[N] SOURCEBOOKS, INC., 121 N. Washington, Suite 2, Naperville IL 60540. (630)961-3900. Fax: (630)961-2168. Estab. 1987. Company publishes hardcover and trade paperback originals and ancillary items. Types of books include humor, New Age, nonfiction, preschool, reference, self-help and gift books. Specializes in business books and gift books. Publishes 50 titles/year. Recent titles include: *We Interrupt This Broadcast*, by Joe Garner; and *Mother Voices*, edited by Traci Dyer. Book catalog free for SASE with 4 first-class stamps.

Needs: Uses freelancers mainly for ancillary items, journals, jacket/cover design and illustration, text illustration, direct mail, book and catalog design. 100% of design and 25% of illustration demand knowledge of QuarkXPress 3.31, Adobe Photoshop 3.04 and Adobe Illustrator 6.0. Works on assignment only.

First Contact & Terms: Designers send query letter with photocopies. Illustrators send postcard sample. Accepts disk submissions compatible with Adobe Illustrator 6.0, Adobe Photoshop 3.0. Send EPS files. Reports back only if interested. Request portfolio review in original query. Negotiates rights purchased.

Book Design: Pays by the project.

Jackets/Covers: Pays by the project.

Text Illustration: Pays by the project.

Tips: "We have expanded our list tremendously and are, thus, looking for a lot more artwork. We have terrific distribution in retail outlets and are looking to provide more great-looking material."

THE SPEECH BIN, INC., 1965 25th Ave., Vero Beach FL 32960. (561)770-0007. Fax: (561)770-0006. Senior Editor: Jan J. Binney. Estab. 1984. Publishes textbooks and educational games and workbooks for children and adults. Specializes in tests and materials for treatment of individuals with all communication disorders. Publishes 20-25 titles/year. Recent titles include *Artic Pic*, by Denise Grigas; and *What Is Dementia*, by Mary Jo Santo Pietro. 5% require freelance illustration; 50% require freelance design. Book catalog available for 8½ × 11 SAE with $1.48 postage.

Needs: Works with 8-10 freelance illustrators and 2-4 designers/year. Buys 1,000 illustrations/year. Work must be suitable for handicapped children and adults. Uses freelancers mainly for instructional materials, cover designs, game-boards, stickers. Also for jacket/cover and text illustration. Occasionally uses freelancers for catalog design projects. Works on assignment only.

First Contact & Terms: Send query letter with brochure, SASE, tearsheets and photocopies. Samples are filed or are returned by SASE if requested by artist. Reports back to the artist only if interested. Do not send portfolio; query only. Usually buys all rights. Considers buying second rights (reprint rights) to previously published work. Finds artists through "word of mouth, our authors and submissions by artists."

Book Design: Pays by the project.

Jackets/Covers: Assigns 10-12 freelance design jobs and 10-12 illustration jobs/year. Pays by the project.

Text Illustration: Assigns 6-10 freelance illustration jobs/year. Prefers b&w line drawings. Pays by the project.

[✓] SPINSTERS INK, 3241 Columbus Ave. S., Minneapolis MN 55407-2030. (612)827-6177. Fax: (612)827-4417. E-mail: liz@spinsters-ink.com. Website: http://www.spinsters-ink.com. Production Manager: Liz Tufte. Estab. 1978. Company publishes trade paperback originals and reprints. Types of books include contemporary fiction, mystery, biography, young women, reference, history of women, humor and feminist. Specializes in "fiction and nonfiction that deals with significant issues in women's lives from a feminist perspective." Publishes 6 titles/year. Recent titles include *Turnip Blues*, by Helen Campbell (novel); *A Woman Determined*, by Jean Swallow (novel); and *Closed in Silence*, by Jean Drury (mystery). 50% require freelance illustration; 100% require freelance design. Book catalog free by request.

Needs: Approached by 24 freelancers/year. Works with 2-3 freelance illustrators and 2-3 freelance designers/year. Buys 2-6 freelance illustrations/year. Prefers artists with experience in "portraying positive images of women's diversity." Uses freelance artists for jacket/cover illustration and design, book and catalog design. 100% of freelance work demands knowledge of Adobe Illustrator, Adobe Photoshop, QuarkXPress or Adobe PageMaker. Works on assignment only.

First Contact & Terms: Designers send query letter with résumé. Illustrators send postcard sample with photocopies and SASE. Accepts submissions on disk compatible with PageMaker 6.5 or QuarkXPress. Samples are filed or are returned by SASE if requested by artist. Reports back within 6 weeks. Art Director will contact artist for portfolio review if interested. Portfolio should include b&w and color thumbnails, final art and photographs. Buys first rights. Originals are returned at job's completion. Finds artists through word of mouth and submissions.

Jackets/Covers: Assigns 6 freelance design and 2-6 freelance illustration jobs/year. Pays by the project, $200-1,000. Prefers "original art with appropriate type treatment, b&w to 4-color. Often the entire cover is computer-generated, with scanned image. Our production department produces the entire book, including cover, electronically."

Text Illustration: Assigns 0-6 freelance illustrations/year. Pays by the project, $75-150. Prefers "b&w line drawings or type treatment that can be converted electronically. We create the interior of books completely using desktop publishing technology on the Macintosh."

Tips: "We're always looking for freelancers who have experience portraying images of diverse women, with current technological experience on the computer."

[N] STEMMER HOUSE PUBLISHERS, INC., 2627 Caves Rd., Owings Mills MD 21117. (410)363-3690. Fax: (410)363-8459. E-mail: stemmerhouse@home.com. Website: http://www.stemmer.com. President: Barbara Holdridge. Specializes in hardcover and paperback nonfiction, art books, juvenile and design resource originals. Publishes 10 titles/ year. Recent titles include: *Ask Me If I'm a Frog* and *The Rainforest Encyclopedia*. Books are "well illustrated." 10% requires freelance design; 75% requires freelance illustration.

Needs: Approached by more than 50 freelancers/year. Works with 4 freelance illustrators and 1 designer/year. Works on assignment only.

First Contact & Terms: Designers send query letter with brochure, tearsheets, SASE, photocopies. Illustrators send postcard sample or query letter with brochure, photocopies, photographs, SASE, slides and tearsheets. Do not send original work. Material not filed is returned by SASE. Call or write for appointment to show portfolio. Reports in 6 weeks. Works on assignment only. Originals are returned to artist at job's completion on request. Negotiates rights purchased.

Book Design: Assigns 1 freelance design and 4 illustration projects/year. Pays by the project, $300-2,000.

Jackets/Covers: Assigns 4 freelance design jobs/year. Prefers paintings. Pays by the project, $300-1,000.

Text Illustration: Assigns 3 freelance jobs/year. Prefers full-color artwork for text illustrations. Pays by the project on a royalty basis.

Tips: Looks for "draftmanship, flexibility, realism, understanding of the printing process." Books are "rich in design quality and color, stylized while retaining realism; not airbrushed. We prefer non-computer. Review our books. Propose a strong picture-book manuscript with your illustrations."

STOREY BOOKS, Schoolhouse Rd., Pownal VT 05261. Art Director (covers): Meredith Maker. Art Director (text): Cynthia McFarland. Estab. 1982. Publishes hardcover and trade paperback originals. Publishes: cookbooks, instructional, self help, animal, gardening, crafts, building, herbs, natural healthcare. Publishes 50 titles/year. Recent titles include *Papermaking with Plants*; *Making Herbal Dream Pillows*; *The Backyard Birdhouse Book*; and *Natural Stonescapes*. 50% requires freelance illustration; 10% requires freelance design; 50% require freelance cover/jacket design.

Needs: Approached by 100 illustrators and 30 designers/year. Works with 10 designers/year. Prefers local freelancers (but not necessary). Text freelancers must be experienced in book design and building. 100% of freelance design demands knowledge of QuarkXPress. Knowledge of Adobe Illustration or Adobe Photoshop a plus.

First Contact & Terms: Send query letter with printed samples, photocopies, SASE (if wish returned), tearsheets. Samples are filed or returned by SASE. Will contact artist for portfolio review if interested. Buys one-time rights or all rights. Finds freelancers through submission packets, ABA (BookExpo).

Book Design: Assigns 5 freelance designs/year. Pays for design by the project, $500-3,000.

Jackets/Covers: Assigns 25 freelance design jobs/year. Pays for design by the project, $250-1,000. Prefers strong type treatment, fresh looking, graphic appeal.

Tips: "Storey Books are filled with how-to illustrations, tips, sidebars and charts. Storey covers are fresh, readable and clean."

[N] SWAMP PRESS, 323 Pelham Rd., Amherst MA 01002. Owner: Ed Rayher. Estab. 1977. Publishes trade paperback originals. Types of books include poetry. Specializes in limited letterpress editions. Publishes 2 titles/year. Recent titles include: *Scripture of Venus* and *Tightrope*. 75% requires freelance illustration. Book catalog not available.

Needs: Approached by 10 illustrators/year. Works with 2 illustrators/year. Prefers freelancers experienced in single and 2-color woodblock/linotype illustration.

First Contact & Terms: Illustrators send query letter with photocopies and SASE. Accepts Mac-compatible disk submissions. Samples are filed or returned by SASE. Reports back in 2 months. Rights purchased vary according to project.

Jackets/Covers: Pays for illustration by the project, $20-50.

Text Illustration: Assigns 2 freelance illustration jobs/year. Pays by the project, $20-50 plus copies. Prefers knowledge of letterpress.

Tips: "We are a small publisher of limited edition letterpress printed and hand-bound poetry books. We use fine papers, archival materials and original art."

TEHABI BOOKS, INC., 1201 Camino del Mar, Suite 100, Del Mar CA 92014. (619)481-7600. Fax: (619)481-3247. E-mail: nancy@tehabi.com. Website: http://www.tehabi.com. Managing Editor: Nancy Cash. Estab. 1992. Publishes softcover, hardcover, trade. Specializes in design and production of large-format, visual books. Works hand-in-hand with publishers, corporations, institutions and nonprofit organizations to identify, develop, produce and market high-quality visual books for the international market place. Produces lifestyle/gift books; institutional books; corporate-sponsored books and CD-ROMs. Publishes 10 titles/year. Recent titles include *Still Wild/Always Wild*, by Susan Zwinger; *Boston Celtics—Fifty Years*, by George Sullivan; and *Titanic, Legacy of the World's Greatest Ocean Liner*, by Susan Wels.

Needs: Approached by 50 freelancers/year. Works with 75-100 freelance photographers and illustrators and 3 designers/year. Freelance designers should be familiar with Aldus PageMaker, Adobe Illustrator, QuarkXPress, Adobe Photoshop, Aldus FreeHand and 3-D programs. Works on assignment only. 3% of titles require freelance art direction.

First Contact & Terms: Send query letter with résumé, samples. "Give a followup call." Rights purchased vary according to project. Finds artists through sourcebooks, publications and submissions.

Text Illustration: Pays by the project, $100-10,000.

THISTLEDOWN PRESS LTD., 633 Main St., Saskatoon, Saskatchewan S7H 0J8 Canada. (306)244-1722. Fax: (306)244-1762. E-mail: thistle@sk.sympatico.ca. Website: http://www.thistledown.sk.ca. Director, Production: Allan Forrie. Estab. 1975. Publishes trade and mass market paperback originals. Types of books include contemporary and experimental fiction, juvenile, young adult and poetry. Specializes in poetry creative and young adult fiction. Publishes 10-12 titles/year. Titles include *The Blue Jean Collection*; *The Big Burn*, by Lesley Choyce; and *The Crying Jesus*, by R.P. MacIntyre. Book catalog for SASE.

Needs: Approached by 25 freelancers/year. Works with 8-10 freelance illustrators/year. Prefers local Canadian freelancers. Uses freelancers for jacket/cover illustration. Uses only Canadian artists and illustrators for its title covers. Works on assignment only.

First Contact & Terms: Designers send query letter with résumé and photocopies. Illustrators send postcard samples. Samples are filed or are returned by SASE. Reports back to the artist only if interested. Call for appointment to show portfolio of original/final art, tearsheets, photographs, slides and transparencies. Buys one-time rights.

Jackets/Covers: Assigns 10-12 illustration jobs/year. Prefers painting or drawing, "but we have used tapestry—abstract or expressionist to representational." Also uses 10% computer illustration. Pays by the project, $250-600.

Tips: "Look at our books and send appropriate material. More young adult and adolescent titles are being published, requiring original cover illustration and cover design. New technology (Adobe Illustrator, Photoshop) has slightly altered our cover design concepts."

TORAH AURA PRODUCTIONS/ALEF DESIGN GROUP, 4423 Fruitland Ave., Los Angeles CA 90058. (213)585-7312. Fas: (213)585-0327. E-mail: misrad@torahaura.com. Website: http://www.torahaura.com. Art Director: Jane Golub. Estab. 1981. Publishes hardcover and trade paperback originals, textbooks. Types of books include children's picture books, cookbooks, juvenile, nonfiction and young adult. Specializes in Judaica titles. Publishes 15 titles/year. Recent titles include: *The Bonding of Isaac, Two Cents and a Milk Bottle, Mark Stark's Amazing Jewish Cookbook*. 85% requires freelance illustration. Book catalog free for 9×12 SAE with 10 first-class stamps.

Needs: Approached by 50 illustrators and 20 designers/year. Works with 25 illustrators/year.

First Contact & Terms: Illustrators send postcard sample and follow-up postcard every 6 months, printed samples, photocopies. Accepts Windows-compatible disk submissions. Samples are filed. Will contact artist for portfolio review if interested. Rights purchased vary according to project. Finds freelancers through submission packets.

Jackets/Covers: Assigns 6-24 illustration jobs/year. Pays by the project.

TREEHAUS COMMUNICATIONS, INC., 906 W. Loveland Ave., P.O. Box 249, Loveland OH 45140. (513)683-5716. Fax: (513)683-2882. Website: http://www.treehaus1.com. President: Gerard Pottebaum. Estab. 1973. Publisher. Specializes in books, periodicals, texts, TV productions. Product specialties are social studies and religious education.

Needs: Approached by 12-24 freelancers/year. Works with 12 freelance illustrators/year. Prefers freelancers with experience in illustrations for children. Works on assignment only. Uses freelancers for all work. Also for illustrations and designs for books and periodicals. 5% of work is with print ads. Needs computer-literate freelancers for illustration.

First Contact & Terms: Send query letter with résumé, transparencies, photocopies and SASE. Samples sometimes filed or are returned by SASE if requested by artist. Reports back within 1 month. Art Director will contact artist for portfolio review if interested. Portfolio should include final art, tearsheets, slides, photostats and transparencies. Pays for design and illustration by the project. Rights purchased vary according to project. Finds artists through word of mouth, submissions and other publisher's materials.

TRIUMPH BOOKS, 601 LaSalle St., Suite 500, Chicago IL 60605. (312)939-3330. Fax: (312)663-3557. E-mail: triumphbks@aol.com. Estab. 1990. Publishes hardcover originals and reprints, trade paperback originals and reprints. Types of books include biography, coffee table books, humor, instructional, reference, sports. Specializes in sports titles. Publishes 50 titles/year. 5% requires freelance illustration; 60% requires freelance design. Book catalog free for SAE with 2 first-class stamps.

Needs: Approached by 5 illustrators and 5 designers/year. Works with 2 illustrators and 8 designers/year. Prefers freelancers experienced in book design. 100% of freelance design demands knowledge of Adobe Photoshop, PageMaker, QuarkXPress.

First Contact & Terms: Send query letter with printed samples, SASE. Accepts Mac-compatible disk submissions. Send TIFF files. Samples are filed or returned by SASE. Will contact artist for portfolio review if interested. Buys all rights. Finds freelancers through word of mouth, organizations (Chicago Women in Publishing), submission packets.

Book Design: Assigns 20 freelance design jobs/year. Pays for design by the project.

Jackets/Covers: Assigns 30 freelance design and 2 illustration jobs/year. Pays for design by the project. Prefers simple, easy-to-read, in-your-face cover treatment.

Tips: "Most of our interior design requires a fast turnaround. We do mostly one-color work with occasional two-color and four-color jobs. We like a simple, professional design."

TROLL COMMUNICATIONS, (formerly Troll Associates), Publishing Division, 100 Corporate Dr., Mahwah NJ 07430. (201)529-4000. Publisher: Roy Wandelmaier. Specializes in hardcovers and paperbacks for juveniles (6- to 14-year-olds). Publishes more than 100 titles/year. 30% require freelance design and illustrations.
Needs: Works with 30 freelancers/year. Prefers freelancers with 2-3 years of experience. Works on assignment only.
First Contact & Terms: Send query letter with brochure/flier, résumé and tearsheets or photostats. Samples returned by SASE only if requested. Reports in 1 month. Considers complexity of project, skill and experience of artist, budget and rights purchased when establishing payment. Buys all rights or negotiates rights purchased. Originals usually not returned at job's completion.

N: TSR, INC., a subsidiary of Wizards of the Coast, P.O. Box 707, Renton WA 98057. (425)226-6500. Website: http://www.wizards.com. Contact: Art Submissions. Estab. 1975. Produces games, books and calendars. "We produce the *Dungeons & Dragons*® roleplaying game and the game worlds and fiction books that support it."
 ● See Insider Report with TSR's Senior Art Director Jon Schindehette on page 275. Also see listing for *Wizards of the Coast.*
Needs: Art guidelines free with SASE or on website. Works on assignment only. Uses freelancers for book and game covers and interiors and trading card game art. Considers any media. "Artists interested in cover work should show us tight, action-oriented 'realistic' renderings of fantasy or science fiction subjects in oils or acrylics."
First Contact & Terms: "Send cover letter with contact information and 6-10 pieces, color copies or copies of black & white work. Do not send originals—they will be returned without review. If you wish to have your portfolio returned, send a SASE."
Tips: Finds artists through submissions, reference from other artists and by viewing art on display at the annual Gencon® Game Fair in Milwaukee, Wisconsin. "Be familiar with the adventure game industry in general and our products in particular. Make sure pieces in portfolio are tight, have good color and technique."

N: TWENTY-FIRST CENTURY BOOKS/A DIVISION OF MILLBROOK PRESS, INC., 2 Old New Milford Rd., Brookfield CT 06804. (203)740-2220. Fax: (203)775-5643. Art Director: Judie Mills. Estab. 1986. Publishes hardcover originals. Types of books include juvenile, young adult and nonfiction for school and library market. Specializes in biography, social studies, drug education and science. Publishes 25-38 titles/year. 60% requires freelance illustration.
Needs: Approached by up to 10 freelance artists/year. Works with 3-10 freelance illustrators/year. Buys 100-200 freelance illustrations/year. Prefers artists with experience in realistic narrative illustration. Uses freelance artists mainly for jacket/cover and text illustration. Works on assignment only.
First Contact & Terms: Send query letter with tearsheets and any non-returnable samples. Samples are filed. Reports back only if interested. Write to schedule an appointment to show portfolio or mail tearsheets. Rights purchased vary according to project. Originals returned at job's completion.
Book Design: Assigns 5-20 freelance illustration jobs/year.
Jackets/Covers: Assigns 10-15 freelance illustration jobs/year. Pays by the project.
Text Illustration: Assigns 10-20 freelance illustration jobs/year. Pays by the project.
Tips: "Be competent, with a professional manner and a style that fits the project."

N: TWIN PEAKS PRESS, P.O. Box 129, Vancouver WA 98666. Fax: (360)696-3210. Design Department: Victoria Nova. Estab. 1982. Company publishes hardcover, trade and mass market paperback reprints, trade paperback and mass market paperback originals. Types of books include instruction, travel, self help, reference, humor and cookbooks. Specializes in how-to. Publishes 6 titles/year. Book catalog available for $5.
First Contact & Terms: Send query letter with SASE. Samples are not filed and are not returned. Portfolio review not required.

N: TWO BEARS PRESS, 2130 Mountain Blvd., Suite 103, Oakland CA 94611. (510)530-5340. E-mail: twobears@sl ip.net. Publisher: A. Craig Leth. Editor-in-Chief: Cristina Salat. Estab. 1998. Publishes hardcover originals and mass market and trade paperback reprints. Types of books include children's picture books and coffee table books. "Two Bears Press publishes high-quality, full-color, 32-40-page crossover picture books aimed for ages 8-80 based on substantive social themes." Currently publishes 1-2 titles/year, moving toward 3-6 titles/year. Recent titles include: *The Great Animal Race* and *The Symbol of Two Bears.* 90-100% requires freelance illustration; 50% requires freelance design; 25% requires freelance art direction. Book catalog free for SASE.
Needs: Approached by 50-500 illustrators and 50 designers/year. Works with 2-6 illustrators and 1-3 designers/year. Prefers but not limited to local illustrators, designers and art directors. Prefers freelancers experienced in creation of fine art work; collaborative creation under deadline. 100% of freelance design demands knowledge of Adobe Illustrator, Adobe Photoshop, PageMaker and QuarkXPress.
First Contact & Terms: Send query letter with printed samples, photocopies, tearsheets and SASE. Samples are filed. Will contact artist for portfolio review if interested. Portfolio should include photocopies—high-quality color repros preferred—and tearsheets if available. Portfolio content varies by project; send SASE for current artist guidelines. Negotiates rights purchased; rights purchased vary according to project. Finds freelancers through submission packets, networking events, word of mouth and organizations, e.g., Society of Children's Book Writers & Illustrators, Wildlife Artists Society, etc.
Book Design: "Generally we work with artist/designers to co-create the look of each book. Often artist/designer is one individual, working with our in-house staff." Terms negotiated in artist contract if applicable.

Jackets/Covers: Cover art done by book illustrator.
Text Illustration: Assigns 2-6 freelance illustration jobs/year. Pays by the project. "As a new, small press we offer modest advances coupled with higher than industry standard royalty rates and the opportunity to participate in the co-creation of book design. We also are committed to providing tailored marketing plans for each project that include active participation by both author and illustrator. Specific illustration needs vary by project, but we always prefer fine art work with personal flair suitable for a 'classic.' "
Tips: "Two Bears Press looks for art that lifts off the page and brings an expanded life to each text; art that is entertaining yet suitable to accompany substantive social themes in a high-quality crossover picture book aimed for both children and adults. We are committed to working with a diverse pool of artists and authors and maintain a diverse in-house staff. Additionally, we will launch a multicultural imprint early in the millennium. A portion of proceeds from each book is donated to a charity that matches the book's social theme. Though artist pay is modest at this time, we are committed to providing an invigorating work experience and to keeping our books in print indefinitely . . . thus we aim for classics!"

N TYNDALE HOUSE PUBLISHERS, INC., Box 80, 351 Executive Dr., Wheaton IL 60189. (630)668-8300. E-mail: talinda-ziehr@tyndale.com. Website: http://www.tyndale.com. Art Buyer: Talinda M. Ziehr. Vice President, Production: Joan Major. Specializes in hardcover and paperback originals on "Christian beliefs and their effect on everyday life." Publishes 200 titles/year. 50% require freelance illustration. Books have "classy, highly-polished design and illustration."
Needs: Approached by 50-75 freelance artists/year. Works with 30-40 illustrators and cartoonists/year.
First Contact & Terms: Send query letter, tearsheets and/or slides. Samples are filed or are returned by SASE. Reports back only if interested. Considers complexity of project, skill and experience of artist, project's budget and rights purchased when establishing payment. Negotiates rights purchased. Originals are returned at job's completion except for series logos.
Jackets/Covers: Assigns 40 illustration jobs/year. Prefers progressive but friendly style. Pays by the project.
Text Illustrations: Assigns 10 jobs/year. Prefers progressive but friendly style. Pays by the project.
Tips: "Only show your best work. We are looking for illustrators who can tell a story with their work and who can draw the human figure in action when appropriate." A common mistake is "neglecting to make follow-up calls. Be able to leave fileable sample(s). Be available; by friendly phone reminders, sending occasional samples. Schedule yourself wisely, rather than missing a deadline."

✓ UAHC PRESS, 633 Third Ave., New York NY 10017. (212)249-0100. Director of Publications: Stuart L. Benick. Produces books and magazines for Jewish school children and adult education. Recent titles include *Purim*, by Camille Kress; and *Who Knows Ten*, by Molly Cone.
Needs: Approached by 20 freelancers/year.
First Contact & Terms: Send samples or write for interview. Include SASE. Reports within 3 weeks.
Jackets/Covers: Pays by the project, $250-600.
Text Illustration: Pays by the project, $150-200.
Tips: Seeking "clean and catchy" design and illustration.

N THE UNIVERSITY OF ALABAMA PRESS, Box 870380, Tuscaloosa AL 35487-0380. (205)348-5180 or (205)348-1591. Fax: (205)348-9201. E-mail: rcook@uapress.ua.edu. Website: http://www.uapress.ua.edu. Production Manager: Rick Cook. Designer: Shari Degraw. Specializes in hardcover and paperback originals and reprints of academic titles. Publishes 40 titles/year. Recent titles include: *Alabama Railroads*, by Wayne Cline; and *Steinbeck and the Environment*, edited by Beegel, Shillinglow and Tiffney. 5% requires freelance design.
Needs: Works with 1-2 freelancers/year. Requires book design experience, preferably with university press work. Works on assignment only. 100% of freelance design demands knowledge of Mac PageMaker 6.0, Macromedia FreeHand 8.0, Adobe Photoshop 5.0, QuarkXPress and Illustrator.
First Contact & Terms: Send query letter with résumé, tearsheets and slides. Accepts disk submissions if compatible with Macintosh versions of above programs; provided that a hard copy that is color accurate is also included. Samples not filed are returned only if requested. Reports back within a few days. To show portfolio, mail tearsheets, final reproduction/product and slides. Considers project's budget when establishing payment. Buys all rights. Originals are not returned.
Book Design: Assigns several freelance jobs/year. Pays by the project, $300 minimum.
Jackets/Covers: Assigns 1-2 freelance design jobs/year. Pays by the project, $300 minimum.
Tips: Has a limited freelance budget. "We often need artwork that is abstract or vague rather than very pointed or focused on an obvious idea. For book design, our requirements are that they be classy and for the most part conservative."

✓ ▢ UNIVERSITY OF OKLAHOMA PRESS, 1005 Asp Ave., Norman OK 73019. (405)325-5111. Fax: (405)325-4000. E-mail: gcarter@ou.edu. Website: http://www.ou.edu/oupress. Design Manager: Gail Carter. Estab. 1927. Company publishes hardcover and trade paperback originals and reprints and textbooks. Types of books include biography, coffee table books, history, nonfiction, reference, textbooks, western. Specializes in western/Indian nonfiction. Publishes 100 titles/year. 75% requires freelance illustration (for jacket/cover). 5% requires freelance design. Book catalog free by request.
Needs: Approached by 15-20 freelancers/year. Works with 40-50 freelance illustrators and 4-5 designers/year. "We

cannot commission work, must find existing art." Uses freelancers mainly for jacket/cover illustrations. Also for jacket/cover and book design. 25% of freelance work demands knowledge of Aldus PageMaker, Adobe Illustrator, QuarkXPress, Adobe Photoshop, Aldus FreeHand, CorelDraw and Ventura.

First Contact & Terms: Send query letter with brochure, résumé and photocopies. Samples are filed. Does not report back. Artist should contact us 1 month after submission. Design Manager will contact artist for portfolio review if interested. Portfolio should include book dummy and photostats. Buys reprint rights. Originals are returned at job's completion. Finds artists through submissions, attending exhibits, art shows and word of mouth.

Book Design: Assigns 4-5 freelance design jobs/year. Pays by the project.

Jackets/Covers: Assigns 4-5 freelance design jobs/year. Pays by the project.

☑ ▣ **UNIVERSITY OF PENNSYLVANIA PRESS**, 4200 Pine St., Philadelphia PA 19104-4011. (215)898-1675. Fax: (215)898-0404. E-mail: cgross@pobox.upenn.edu. Art Director: Carl Gross. Design Coordinator: Madelyn Testa. Estab. 1920. Publishes audio tapes, CD-ROMs and hardcover originals. Types of books include biography, history, nonfiction, landscape architecture, art history, anthropology, literature and regional history. Publishes 70 titles/year. Recent titles include: *Historic Houses of Philadelphia, Bookleggers and Smuthounds, The Landscape Approach of Bernard Lassus, Renaissance Culture in the Everyday* and *Tough Girls.* 90% requires freelance design. Book catalog free for 8½×11 SASE with 5 first-class stamps.

Needs: Works with 7 designers/year. 100% of freelance work demands knowledge of Adobe Illustrator, Adobe Photoshop, Aldus FreeHand and QuarkXPress.

First Contact & Terms: Designers send query letter with photocopies. Illustrators send postcard sample. Accepts Mac-compatible disk submissions. Samples are not filed and are returned. Will contact artist for portfolio review if interested. Portfolio should include book dummy and photocopies. Rights purchased vary according to project. Finds freelancers through submission packets and word of mouth.

Book Design: Assigns 10 freelance design jobs/year. Pays by the project, $600-1,000.

Jackets/Covers: Assigns 60 freelance design jobs/year. Pays by the project, $500-1,000.

▣ **J. WESTON WALCH PUBLISHING**, 321 Valley St., Portland ME 04102. (207)772-2846. Fax: (207)774-7167. Website: http://www.walch.com. Art Director: Linwood N. Houghton. Estab. 1927. Company publishes supplementary educational books and other material (video, software, audio, posters, cards, games, etc.). Types of books include instructional and young adult. Specializes in all middle and high school subject areas. Recent titles include: Graphic Organizers for: English classes, science classes, and social studies classes, Using the Internet to Investigate Math. Publishes 100 titles/year. 15-25% require freelance illustration. Book catalog free by request.

Needs: Approached by 70-100 freelancers/year. Works with 10-20 freelance illustrators and 5-10 designers/year. Prefers local freelancers only. Uses freelancers mainly for text and/or cover illustrations. Also for jacket/cover design.

First Contact & Terms: Send tearsheets, SASE and photocopies. Samples are filed or returned by SASE. Accepts disk submissions compatible with Adobe Photoshop, QuarkXPress, Aldus FreeHand or Framemaker. Art Director will contact artist for portfolio review if interested. Portfolio should include final art, roughs and tearsheets. Buys one-time rights. Originals are returned at job's completion. Finds artists through submissions, reviewing with other art directors in the local area.

Jackets/Covers: Assigns 10-15 freelance design and 10-20 illustration jobs/year. Pays by the project, $300-1,500.

Text & Poster Illustration: Pays by the project, $300-4,000.

Tips: "Show a facility with taking subject matter appropriate for middle and high school curriculums and presenting it in a new way."

WARNER BOOKS INC., 1271 Avenue of the Americas, New York NY 10020. (212)522-7200. Vice President and Creative Director of Warner Books: Jackie Meyer. Publishes mass market paperbacks and adult trade hardcovers and paperbacks. Publishes 300 titles/year. Recent titles include: *WASP Cookbook* and *The Winner.* 20% requires freelance design; 80% requires freelance illustration.

● Others in the department are Diane Luger, Flamur Tonuzi, Don Puckey, Chris Standish, Carolyn Lechter and Rachel McClain. Send them mailers for their files as well.

Needs: Approached by 500 freelancers/year. Works with 75 freelance illustrators and photographers/year. Uses freelancers mainly for illustration and handlettering. Works on assignment only.

First Contact & Terms: Do not call for appointment or portfolio review. Mail samples only. Send brochure or tearsheets and photocopies. Samples are filed or are returned by SASE. Art Director will contact artist for portfolio review if interested. Negotiates rights purchased. Considers buying second rights (reprint rights) to previously published work. Originals are returned at job's completion (artist must pick up). "Check for most recent titles in bookstores." Finds artists through books, mailers, parties, lectures, judging and colleagues.

Jackets/Covers: Pays for design and illustration by the project. Uses all styles of jacket illustrations.

Tips: Industry trends include "graphic photography and stylized art." Looks for "photorealistic style with imaginative and original design and use of eye-catching color variations. Artists shouldn't talk too much. Good design and art should speak for themselves."

Ⓝ **WEBB RESEARCH GROUP**, Box 314, Medford OR 97501. (541)664-5205. Website: http://pnorthwestbooks.com. Owner: Bert Webber. Estab. 1979. Publishes hardcover and trade paperback originals. Types of books include biography, reference, history and travel. Specializes in the history and development of the Pacific Northwest and the

Oregon Trail. Recent titles include *Dredging for Gold*, by Bert Webber; and *Top Secret*, by James Martin Davis and Bert Webber. 5% require freelance illustration. Book catalog for SAE with 2 first-class stamps.

Needs: Approached by more than 30 freelancers/year, "most artists waste their and our time." Uses freelancers for localizing travel maps and doing sketches of Oregon Trail scenes. Also for jacket/cover and text illustration. Works on assignment only.

First Contact & Terms: Send query letter with SASE and photocopied samples of the artists' Oregon Trail subjects. "We will look only at subjects in which we are interested—Oregon history, development and Oregon Trail. No wildlife or scenics." Samples are not filed and are only returned by SASE if requested by artist. Reports back to the artist only if interested and SASE is received. Portfolios are not reviewed. Rights purchased vary according to project. Originals often returned at job's completion.

Jackets/Covers: Assigns about 10 freelance design jobs/year. Payment negotiated.

Text Illustration: Assigns 6 freelance illustration jobs/year. Payment negotiated.

Tips: "Freelancers negatively impress us because they do not review our specifications and send samples unrelated to what we do. We do not want to see 'concept' examples of what some freelancer thinks is 'great stuff.' If the subject is not in our required subject areas, do not waste samples or postage or our time with unwanted heavy mailings. We, by policy do not, will not, will never, respond to postal card inquiries. Most fail to send SASE thus submissions go into the ashcan, never looked at, for the first thing we consider with unsolicited material is if there is a SASE. Time is valuable for artists and for us. Let's not waste it."

WEIGL EDUCATIONAL PUBLISHERS LTD., 1902 11th St. SE, Calgary, Alberta T2G 3G2 Canada. (403)233-7747. Fax: (403)233-7769. E-mail: calgary@weigl.com. Contact: Senior Editor. Estab. 1979. Textbook publisher catering to juvenile and young adult audience. Specializes in social studies, science-environmental, life skills, multicultural and Canadian focus. Publishes 15 titles/year. Titles include *The Untamed World* series; *Living Science*; *Science@work*; *Twentieth Century Canada*; and *Women In Profile* series. 20-40% require freelance illustration. Book catalog free by request.

Needs: Approached by 50-60 freelancers/year. Works with 2-3 illustrators/year. Prefers freelancers with experience in children's text illustration in line art/watercolor. Uses freelancers mainly for text illustration. Also for direct mail design. Freelancers should be familiar with PageMaker 5.0, Illustrator and Photoshop 3.0.

First Contact & Terms: Send query letter with brochure, résumé, SASE, tearsheets, photographs, photocopies ("representative samples of quality work"). Samples are returned by SASE if requested by artist. Reports back to the artist only if interested. Write for appointment to show portfolio of original/final art (small), b&w photostats, tearsheets and photographs. Rights purchased vary according to project.

Text Illustration: Assigns 5-10 freelance illustration jobs/year. Pays by the hour, $20-60. Prefers line art and watercolor appropriate for elementary and secondary school students.

SAMUEL WEISER INC., Box 612, York Beach ME 03910. (207)363-4393. Fax: (207)363-5799. E-mail: email@weis erbooks.com. Website: http://www.weiserbooks.com. Vice President: B. Lundsted. Specializes in hardcover and paperback originals, reprints and trade publications on metaphysics/oriental philosophy/esoterica. Publishes 24 titles/year. Recent titles include *Karma*; *Destiny & Your Career*, by Nanette Hucknall; and *Intuition*, by Judee Gee. "We use visionary art or nature scenes." Publishes 20 titles/year. Catalog available for SASE.

Needs: Approached by approximately 25 artists/year. Works with 10-15 illustrators and 2-3 designers/year. Uses freelancers for jacket/cover design and illustration. 80% of design and 40% of illustration demand knowledge of Adobe Illustrator, Adobe Photoshop and QuarkXPress.

First Contact & Terms: Designers send query letter with résumé, photocopies and tearsheets. Illustrators send query letter with photocopies, photographs, SASE and tearsheets. "We can use art or photos. I want to see samples I can keep." Samples are filed or are returned by SASE only if requested by artist. Reports back within 1 month only if interested. Originals are returned to artist at job's completion. To show portfolio, mail tearsheets, color photocopies or slides. Considers complexity of project, skill and experience of artist, project's budget, turnaround time and rights purchased when establishing payment. Buys one-time nonexclusive rights. Finds most artists through references/word-of-mouth, portfolio reviews and samples received through the mail.

Jackets/Covers: Assigns 20 design jobs/year. Prefers airbrush, watercolor, acrylic and oil. Pays by the project, $100-500.

Tips: "Send me color copies of work—something we can keep in our files. Stay in touch with phone numbers. Sometimes we get material and suddenly can use it and can't because we can't find the photographer or artist! We're interested in buying art that we use to create a cover, or in artists with professional experience with cover film—who can work from inception of design to researching/creating image to type design; we work with old-fashioned mechanicals, film and disk. Don't send us drawings of witches, goblins and demons, for that is not what our field is about. You should know something about us before you send materials."

WHITE MANE PUBLISHING COMPANY, INC., 63 W. Burd St., P.O. 152, Shippensburg PA 17257. (717)532-2237. Fax: (717)532-7704. Vice President: Harold Collier. Estab. 1987. Publishes hardcover originals and reprints, trade paperback originals and reprints. Types of books include biography, history, juvenile, nonfiction, religious, self help and young adult. Publishes 70 titles/year. 10% requires freelance illustration; 50% requires freelance design. Book catalog free with SASE.

Needs: Approached by 5 illustrators and 5 designers/year. Works with 2 illustrators and 2 designers/year.

First Contact & Terms: Illustrators and designers send query letter with printed samples. Samples are filed. Reports back only if interested. Will contact artist for portfolio review if interested. Rights purchased vary according to project. Finds freelancers through submission packets and postcards.

Jackets/Covers: Assigns 10 freelance design jobs and 2 illustration jobs/year. Pays for design by the project.

ALBERT WHITMAN & COMPANY, 6340 Oakton, Morton Grove IL 60053-2723. Editor: Kathleen Tucker. Art Director: Scott Piehl. Specializes in hardcover original juvenile fiction and nonfiction—many picture books for young children. Publishes 25 titles/year. Recent titles include: *Two of Everything*, by Lily Toy Hong; and *Do Pirates Take Baths*, by Kathy Tucker. 100% requires freelance illustration. Books need "a young look—we market to preschoolers mostly."

Needs: Prefers working with artists who have experience illustrating juvenile trade books. Works on assignment only.

First Contact & Terms: Illustrators send postcard sample and tearsheets. "One sample is not enough. We need at least three. Do *not* send original art through the mail." Accepts disk submissions. Samples are not returned. Reports back "if we have a project that seems right for the artist. We like to see evidence that an artist can show the same children and adults in a variety of moods, poses and environments." Rights purchased vary. Original work returned at job's completion.

Cover/Text Illustration: Cover assignment is usually part of text illustration assignment. Assigns 25-30 freelance jobs/year. Prefers realistic and semi-realistic art. Pays by flat fee or royalties.

Tips: Especially looks for "an artist's ability to draw people, especially children and the ability to set an appropriate mood for the story."

WILLIAMSON PUBLISHING, P.O. Box 185, Charlotte VT 05445. (802)425-2102. E-mail: susan@williamsonbooks.com. Website: http://www.williamsonbooks.com. Editorial Director: Susan Williamson. Estab. 1983. Publishes trade paperback originals. Types of books include juvenile, children's nonfiction (science, history, the arts), preschool, folktales and educational. Specializes in children's active hands-on learning. Publishes 15 titles/year. Recent titles include: *Monarch Magic* and *Mexico: Past & Present*. Book catalog free for 8½×11 SASE with 5 first-class stamps.

Needs: Approached by 150 illustrators and 20 designers/year. Works with 10 illustrators and 5 designers/year. 100% of freelance design demands computer skills. "We especially need illustrators with a vibrant black & white style—and with a sense of humor evident in illustrations."

First Contact & Terms: Designers send query letter with brochure, photocopies, résumé, SASE. Illustrators send postcard sample and/or query letter with photocopies, résumé and SASE. Samples are filed. Reports back only if interested.

Book Design: Pays for design and illustration by the project.

Tips: "We are actively seeking freelance illustrators and book designers to support our growing team. We are looking for mostly black & white and some 4-color illustration—everything from step-by-step how-to (always done with personality as opposed to technical drawings) to full-page pictorial interpretation with folk tales. Go to the library and look up several of our books in our four series. You'll immediately see what we're all about. Then do a few samples for us. If we're excited about your work, you'll definitely hear from us."

WILSHIRE BOOK CO., 12015 Sherman Rd., North Hollywood CA 91605. (818)765-8579. E-mail: mpowers@mpowers.com. Website: http://www.mpowers.com. President: Melvin Powers. Company publishes trade paperback originals and reprints. Types of books include biography, humor, instructional, New Age, psychology, self help, inspirational and other types of nonfiction. Publishes 25 titles/year. Recent titles include *Think Like a Winner!*, *The Princess Who Believed in Fairy Tales*, and *The Knight in Rusty Armor*. 100% require freelance design. Catalog for SASE with first-class stamps.

Needs: Uses freelancers mainly for book covers, to design cover plus type. Also for direct mail design. "We need graphic design ready to give to printer. Computer cover designs are fine."

First Contact & Terms: Send query letter with fee schedule, tearsheets, photostats, photocopies (copies of previous book covers). Portfolio may be dropped off every Monday-Friday. Portfolio should include book dummy, slides, tearsheets, transparencies. Buys first, reprint or one-time rights. Interested in buying second rights (reprint rights) to previously published work. Negotiates payment.

Book Design: Assigns 25 freelance design jobs/year.

Jackets/Covers: Assigns 25 cover jobs/year.

Ⓝ ▣ THE H.W. WILSON COMPANY, 950 University Ave., Bronx NY 10452-4224. (718)588-8400. Fax: (718)538-2716. E-mail: lamos@hwwilson.com. Website: http://www.hwwilson.com. Art Director: Lynn Amos. Estab. 1898. Publishes CD-ROMs, hardcover originals and web databases. Types of books include reference. Specializes in periodical indexing, abstracting and full text. Publishes 45 titles/year. Recent titles include: *Radical Change: Books for Youth in a Digital Age* and *Wilson Biographies Plus*. 8% requires freelance design. Book catalog not available.

Needs: Approached by 20 illustrators and 5 designers/year. Works with 1 illustrator and 5 designers/year. Prefers freelancers experienced in brochure and direct mail design and book design. 100% of freelance design demands knowledge of Adobe Illustrator, Adobe Photoshop and QuarkXPress.

First Contact & Terms: Designers send query letter with photocopies. Illustrators send postcard sample and follow-up postcard every year. Accepts Mac-compatible disk submissions. Samples are filed or returned by SASE. Reports back only if interested. Will contact artist for portfolio review if interested. Rights purchsed vary according to project. Finds freelancers usually through word of mouth, sometimes postcard mailings.

Book Design: Assigns 3 freelance design jobs/year. Pays for design by the project.
Jackets/Covers: Assigns 2 freelance design jobs and 1 illustration job/year.

☑ **WISDOM PUBLICATIONS INC.**, 199 Elm St., Somerville MA 02144. (617)776-7416. Fax: (617)776-7841. E-mail: info@wisdompubs.org. Website: http://www.wisdompubs.org. Production Manager: Paul Miller. Publisher: Timothy McNeill. Estab. 1989. Publishes hardcover and trade paperback originals. Types of books include biography, religious, self help. Specializes in Buddhism. Publishes 14 titles/year. Recent titles include: *The Good Heart: A Buddhist Perspective on the Teachings of Jesus.* 10% requires freelance illustration; 70% requires freelance design; 50% requires freelance art direction. Book catalog free for SAE with 3 first-class stamps.
Needs: Approached by 20 illustrators/year and 10 designers/year. Works with 4 illustrators/year; 6 designers/year; 2 art directors/year. Prefers local freelancers experienced in computer-based design (Macs). 100% of freelance design demands knowledge of Adobe Illustrator, Adobe Photoshop, QuarkXPress.
First Contact & Terms: Send query letter with printed samples. Will contact artist for portfolio review of examples of book covers if interested. Rights purchased vary according to project. Finds freelancers through networking.
Book Design: Assigns 8 freelance design and art direction projects/year.
Jackets/Covers: Assigns 8 freelance design jobs and 6 illustration jobs/year. Prefers sophisticated or traditionsl styles.
Text Illustration: Assigns 4 freelance illustration jobs/year.
Tips: "Specialize in Buddhist books. Most utilize Buddhist art. Some East-West titles are narrated by Western art."

WIZARDS OF THE COAST, P.O. Box 707, Renton WA 98057. (425)204-7289. Website: http://www.wizards.com. Attn: Artist Submissions. Estab. 1990.
 ● See Insider Report with Senior Art Director Jon Schindehette on page 275. Also see listing for subsidiary TSR, Inc.
Needs: Prefers freelancers with with experience in fantasy art. Art guidelines available for SASE or on website. Works on assignment only. Uses freelancers mainly for cards, posters, books. Considers all media. Looking for fantasy, science fiction portraiture art. 100% of design demands knowledge of Adobe Photoshop, Adobe Illustrator, Aldus FreeHand, QuarkXPress. 30% of illustration demands computer skills.
First Contact & Terms: Illustrators send query letter with 6-10 non-returnabale full color or b&w pieces. Accepts submissions on disk. Samples are filed or returned by SASE. "We do not accept original artwork." Will contact for portfolio review if interested. Portfolios should include color, finished art or b&w pieces, photographs and tearsheets. Rights purchased vary according to project. Pays for design by the project, $300 minimum. Payment for illustration and sculpture depends on project. Finds freelancers through conventions, submissions and referrals.
Tips: "Remember who your audience is. Not everyone does 'babe' art."

■ **WORD PUBLISHING**, 545 Marriott Dr., Suite 750, Nashville TN 37214. Fax: (615)902-3206. E-mail: twilliams @thomasnelson.com. Website: http://www.wordpublishing.com. Executive Art Director: Tom Williams. Estab. 1951. Imprints include Word Bibles. Company publishes hardcover, trade paperback and mass market paperback originals and reprints; audio; and video. Types of books include biography, fiction, nonfiction, religious, self-help and sports biography. "All books have a strong Christian content—including fiction." Publishes 85 titles/year. Recent titles include *Storm Warning*, by Billy Graham; *Just Like Jesus*, by Max Lucado and *Power, Money, and Sex*, by Deion Sanders. 30-35% require freelance illustration; 100% require freelance design.
Needs: Approached by 1,500 freelancers/year. Works with 20 freelance illustrators and 30 designers/year. Buys 20-30 freelance illustrations/year. Uses freelancers mainly for book cover and packaging design. Also for jacket/cover illustration and design and text illustration. 100% of design and 5% of illustration demand knowledge of Adobe Illustrator, QuarkXPress and Adobe Photoshop. Works on assignment only.
First Contact & Terms: Send query letter with SASE, tearsheets, photographs, photocopies, photstats, "whatever shows artist's work best." Accepts disk submissions, but not preferred. Samples are returned by SASE. Art Director will contact artist for portfolio review if interested. Portfolio should include tearsheets and transparencies. Purchases first rights. Originals are returned at job's completion. Finds artists through agents, *Creative Illustration Book, American Showcase, Workbook, Directory of Illustration.*
Jacket/Covers: Assigns 85 freelance design and 20-30 freelance illustration jobs/year. Pays by the project $1,200-5,000. Considers all media—oil, acrylic, pastel, watercolor, mixed.
Text Illustration: Assigns 10 freelance illustration jobs/year. Pays by the project $75-250. Prefers line art.
Tips: "Please do not phone. I'll choose artists who work with me easily and accept direction and changes gracefully. Meeting deadlines is also extremely important. I regret to say that we are not a good place for newcomers to start. Experience and success in jacket design is a must for our needs and expectations. I hate that. How does a newcomer start? Probably with smaller companies. Beauty is still a factor with us. Our books must not only have shelf-appeal in bookstores, but coffee table appeal in homes."

WRIGHT GROUP PUBLISHING INC., Parent company: The Chicago Tribune, 19201 120th Ave. NE, Bothell WA 98011. (425)486-8011. Website: http://www.wrightgroup.com. Art Directors: Debra Lee and Patty Andrews. Publishes educational children's books. Types of books include children's picture books, history, nonfiction, preschool, educational reading materials. Specializes in education pre K-8. Publishes 50 titles/year. 100% requires freelance illustration; 5% requires freelance design.
Needs: Approached by 100 illustrators and 10 designers/year. Works with 50 illustrators and 2 designers/year. Prefers

local designers and art directors. Prefers freelancers experienced in children's book production. 100% of freelance design demands knowledge of Adobe Photoshop, Aldus FreeHand, PageMaker, QuarkXPress.

First Contact & Terms: Send query letter with printed samples, color photocopies and follow-up postcard every 6 months. Samples are filed or returned. Will contact artist for portfolio review if interested. Buys all rights. Finds freelancers through submission packets, agents, sourcebooks, word of mouth..

Book Design: Assigns 2 freelance design and 2 freelance art direction projects/year. Pays for design by the hour, $20-25.

Text Illustration: Assigns 50 freelance illustration jobs/year. Pays by the project, $3,000-3,800.

Tips: "Illustrators will have fun and enjoy working on our books, knowing the end result will help children learn to love to read."

☑ ❖ ▣ **WUERZ PUBLISHING LTD.**, 895 McMillan, Winnipeg, Manitoba R3M 0T2 Canada. (204)956-0308. Fax: (204)956-5053. E-mail: swuerz@wuerzpubl.mb.ca. Website: http://www.mbnet.mb.ca/~swuerz. Director: Steve Wuerz. Estab. 1989. Publishes trade paperback originals, textbooks and CD-ROMs. Types of books include native, science and textbooks. Publishes 12 titles/year.

First Contact & Terms: Designers send query letter with brochure. Illustrators send postcard sample or query letter with photocopies. Samples are not filed and are returned only if requested. Will contact artist for portfolio review if interested. Rights purchased vary according to project.

Jackets/Covers: Pays by the project; payment negotiable on quote or bid basis.

Text Illustration: Pays by the project; negotiable on quote or bid basis, $25-1,000.

☑ **YE GALLEON PRESS**, Box 25, Fairfield WA 99012. (509)283-2422. Editorial Director: Teresa Ruggles. Estab. 1937. Publishes hardcover and paperback originals and reprints. Types of books include rare Western history, Indian material, antiquarian shipwreck and old whaling accounts, and town and area histories. Publishes 20 titles/year. 10% requires freelance illustration. Book catalog for SASE.

First Contact & Terms: Works with 2 freelance illustrators/year. Query with samples and SASE. No advance. Pays promised fee for unused assigned work. Buys book rights.

Text Illustration: Buys b&w line drawings (pen & ink) of a historical nature; prefers drawings of groups with facial expressions and some drawings of sailing and whaling vessels. Pays for illustration by the project, $7.50-35.

ZOLAND BOOKS, INC., 384 Huron Ave., Cambridge MA 02138. (617)864-6252. Design Director: Lori Pease. Estab. 1987. Publishes hardcover and trade paperback originals and reprints. Types of books include literary fiction, biography, travel, poetry, fine art and photography. Publishes 10-12 titles/year. Recent titles include: *In The Pond*, by Ha Jin; and *Boyne's Lassie*, by Dick Wimmer. Books are of "quality manufacturing with full attention to design and production." 10% requires freelance illustration; 80% requires freelance design. Book catalog with an oversized SASE.

Needs: Works with 2 freelance illustrators and 6 freelance designers/year. Buys 3 illustrations/year. Uses freelancers mainly for book and jacket design. Also for jacket/cover illustration and catalog design. 100% of design work demands knowledge of Aldus PageMaker or QuarkXPress. Works on assignment only.

First Contact & Terms: Send query letter with brochure, résumé, tearsheets, photocopies or photostats. Samples are filed or are returned by SASE if requested by artist. Design Director will contact artist for portfolio review if interested. Rights purchased vary according to project. Originals are returned at job's completion.

Book Design: Assigns 10-12 jobs/year. Pays by the project, $750 minimum.

Jacket/Covers: Assigns 10-12 design and 1-3 freelance illustration jobs/year. Pays by the project, $750 minimum.

Artist's & Graphic Designer's Market Success Stories

BY MARY COX

The best part of my job is hearing from you, the readers of *Artist's & Graphic Designer's Market*. Your letters and e-mails really make my day—and inspire me to work harder on each new edition.

Last year's edition was the first to showcase *Artist's & Graphic Designer's Market* success stories. The response to the new section was wonderful. Many of you sent in new success stories and offered additional tips on how you use this book to sell your work. Throughout the year, as I spoke with artists and attended art events, I ran across more success stories than I could possibly print here.

Selling your work to a listing in this book is not the only kind of success story I'm after. Your fellow artists would enjoy hearing lessons you've learned from *mistakes* you've made, as well. (I guess "enjoy" isn't exactly the right word, but it *is* often reassuring to know other artists make mistakes, too.) Failures can be successes if you learn from them. Do any of you have long-term goals or dreams? Share them with me! I'll love to add you to my "I knew them when" file.

If you'd like to share a success, a successful "failure" or a far-off dream, drop me a line with some samples. You could see your work in this spot next year!

The contacts beyond the contacts

I have to admit, sometimes mail sits in my "in" box for a day before I have time to get to it, but **Jim Hunt**'s envelope was so inviting, I opened it right away. Hunt had taken the time to draw a cartoon "teaser"—an India ink bottle (on its side, with a pool of ink) on the envelope. Inside was an issue of *The Dairyman Magazine* featuring a two-page spread of his lively cartoon style, and a friendly letter:

> I thought I'd drop you a note to let you know how following up on a listing in *AGDM* can lead to bigger things. A few years ago I sent a sample package to the art director at *The Dairyman Magazine* in California (I like to contact "mid-sized" publications . . . less competition translates into more work). The art director, Ed Fuentes, was very receptive and I produced a few illustrations for him. Some time had passed and I hadn't heard from him, so I called to check in and discovered he had moved on to *Variety*. I got his number, called to say "hi" and we picked up where we had left off. Ed mentioned he had kept me in mind for some work and lo and behold I got an assignment shortly thereafter. This to me is the true value of your book, the contacts BEYOND the contacts. I've also had several clients ask me to forward additional samples to other art directors.

When I called Hunt to ask permission to use his tip in *AGDM*, he generously offered more tips to boost response rates. Hunt has had great results by sending what he calls his "intro e-mails" to art directors. "I prefer to contact art directors initially through e-mail (when possible) so the *AGDM* listings with e-mail addresses are the first ones I highlight." Here is the text of the e-mail message he sends:

I am interested in mailing some samples to you for your freelance file. But in the meantime, some examples of my work can be seen at http://www.jimhuntillustration.com.
Shall I mail some samples?
Thanks for your time and consideration.

Jim Hunt

Hunt purposefully keeps his message short because time is valuable to art directors. "Also, attaching my portfolio page web address allows them to quickly check out my work (as opposed to attaching file images). The final and most important item is the next to last sentence. Asking whether or not I should send anything (assuming they just looked at my work) allows me to find out: A) They have no interest (saves me time and postage); B) They don't need samples, they'll just bookmark my site, which means I'll send them a postcard each month to keep my work under their nose; or (my personal favorite) C) They want samples. They like what they've seen so far."

The last response is exactly what the art director at *National Business Employment Weekly* wrote in a reply to Hunt's e-mail. "I immediately sent samples to him (which is important in keeping my 'quick turnaround' reputation. Within days I received an agreement form specifying terms and payment for assigned work."

Jim Hunt

Jim Hunt drew this two-page layout for an article in *The Dairyman*, a magazine listing he found in *AGDM*.

Since Hunt prefers to target his work directly to individuals who might use it, this approach is now his primary promotional outlet. His website is getting some hits, too. I urge you to visit it, not only to see his wonderful cartoons, but to see how easy his pages are to navigate.

The power of listening

A box full of successes arrived from **Alison Jerry**. The Hoboken, New Jersey artist shipped a box full of products she has worked on for the gift industry. It was amazing to see everything she has done—plush pastel baby toys, wrapping paper, giftbags, photo albums and my favorite—colorful Mexican fiesta-themed paper plates. Jerry's colors are really bright and fun.

Jerry writes, "I have been using *Artist's & Graphic Designer's Market* for the past eight years and always recommend it to my friends. I have gotten many great clients from the listings. The ones, so far, that have been the best are Papel Giftware and Recycled Paper Greetings."

Jerry described how she orginated her "Little Tails" line for Papel Giftware. "I called the art director, introduced myself, gave her my background, asked what her needs were. I really took the time to get to know the company to analyze their needs and what I could bring to the table."

Alison Jerry

Jerry must have sounded professional and confident when she called the art director. But most importantly, she *listened*. Later, pouring over catalogs from the company, Jerry realized Papel could use more baby-related items. She sat at her drawing board and came up with an idea for an entire baby line that would include frames, teddy bears, rattles, banks, globes, photo albums and other gift items. After executing the artwork, she sent some samples to Papel and made an appointment to give a presentation of her idea to art directors. Working on the line was a real challenge, says Jerry. "It was a great experience. Papel is a great company to work with."

After analyzing her client's needs, Alison Jerry came up with the idea for "Little Tails," a line of baby-related gifts for Papel Giftware.

Jerry also sings the praises of other clients. "I did a children's line including several Valentine, Christmas and Halloween cards for Recycled Paper Greetings. They are always a pleasure to work with." What's next on the horizon? Jerry enthusiastically describes a project she just finished for Papel Giftware—a line of collectible claydough Santa Claus ornaments, with a folk art flair, called the "Heart Felt Santa" line. I recently had the chance to see several of her charming Santa ornaments. From the look of them, they are destined to be bestsellers! (There wasn't enough time for us to show them here, but look for a photo in next year's edition.)

From Happy Meals to licensing deals

Scott Nelson's letterhead tickles my funny bone! It sports a really fun logo with "Scott Nelson & Son" scrawled in whimsical script at the top. It's clear that "son" refers to one-year old Collin, shown at right with his dad. Nelson writes, "I'd like to thank you for making such a wonderful book for artists. I can honestly say I'm one of those rags-to-riches (although I'm not rich) stories." Nelson has been using *AGDM* for the last seven years. "My main market now is greeting cards. Thanks to your book, I have received freelance assigments from Paramount, American Greetings, Current, Burgoyne and Amberley. Amberley said I was the first artist they'd ever used outside the state of Ohio."

Looking through the packet of Nelson's promotional samples, cards and brochures I could see that Nelson has three distinct styles which he markets separately. He creates highly detailed illustrations,

Scott Nelson and son Collin

Scott Nelson's promotional samples and greeting card designs abound with silly wide-eyed bears, grinning kitty cats and grocery-cart pushing dogs. The Easter card featuring the funny bear was published by Paper Rainbow Press, for their "Mad Hatter" line.

©Scott Nelson

realistic caricatures and whimsical cartoons. His cards feature funny animal characters which he's just beginning to license.

I called Nelson at his Millbury, Massachusetts studio. In his Matt Damon-sound-alike voice, he spoke enthusiastically about the evolution of his career from a part-time effort while he supported himself managing a McDonald's to the full-time adventure he lives today. He loves working out of his home and spending time with Collin. In fact, Collin actually helped him get an assignment. Once when Nelson called an art director, she was just about to tell him she didn't have any assignments for him when she heard Collin babbling in the background. The baby talk made her laugh. Instead of hanging up, she ended up giving Nelson an assignment!

Nelson's studio is in the basement of his house. By keeping his home office entirely separate from the rest of the house Nelson can deduct office expenses from his income tax. While he doesn't miss his old job, Nelson says working at McDonald's was a great experience and he draws on his managerial regimen to help him manage his time. He keeps all his jobs straight by posting them to a board behind his drawing table. Oh yes, one of his long-term goals is to see his licensed characters on a McDonald's Happy Meal box!

You've got to keep moving "like a shark"

While in New York City this fall visiting publishers and galleries, I attended the Graphic Artists Guild's Illustration Marketplace, a trade show for illustrators. I walked from table to table chatting with artists and admiring the amazing array of styles. One of the artists I chatted with was **Barbara Griffel**, whose specialty is fashion illustration. Barbara read my name tag and told me she uses *Artist's & Graphic Designer's Market* as one of her strategies to sell her work. I was so impressed with her marketing material at the show, I arranged to meet with her to find out some of her marketing secrets. The next morning we met outside Macy's department store and walked across the street to Andrew's Coffee Shop. There, over cappuccinos and muffins, Griffel shared her marketing philosophy.

Barbara Griffel

Photo by Steven Griffel

Marketing your work has to be a constant effort, according to Griffel. "You've got to keep it moving—like a shark. If you send out 50 samples, and you only get one response, you can't dwell on the ones who didn't respond. One response is great! That new client might end up giving you a lot of work!" As we talked, Griffel kept emphasizing artists have to stay positive and just keep sending work out. "So often I mail art directors my samples and never hear back from them. But months, even years later, the wierdest things happen. I'll get a call out of the blue from an art director I've never mailed to. Invariably, when I trace it back, I find out my new client got my name from one of those art directors on my mailing list who never used me. That's when I remind myself, 'Ah! So sending out all those samples really does work, after all!' "

Wherever she goes, Griffel's radar homes in on possible markets. Once in a store, she spotted the magazine *Threads* and decided her work would be perfect for the publication. She sent mailings to the art director for *three years* before finally getting that first assigment from *Threads*. That connection helped her even further years later when the former art director of *Threads* moved to *Creative Home Owner Press* and contacted Griffel for more work.

As I examined the various postcard samples Griffel sends out, I noticed she has more than one style, but something about her samples projects a unified image for her work. I couldn't put my finger on it until Griffel pointed out her trick: in addition to her name and phone number, she adds a tag line, "Impress them with your great taste." She also includes her signature in

Barbara Griffel specializes in fashion illustration. She markets her sophisticated work to book publishers, magazines and the fashion industry.

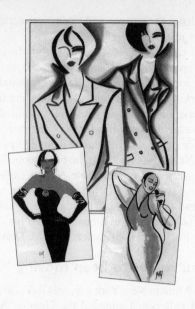

©Barbara Griffel

bold black strokes printed on every sample. Griffel got the idea of using a tag line and other consistent elements from the book *Guerrilla Marketing for the Home-Based Business* by Jay Levinson and Seth Godin (Houghton-Mifflin). "When you think of any successful corporation or product, such as Coca-Cola, a distinct image comes to mind. They always keep the same set of colors and the same logo—and they usually have a tag line." It works for corporate America and the same strategy can work for you, says Griffel. Another tip: for the holidays, Griffel sends out special hand-painted envelopes to her top clients. The extra effort she puts into her samples helps art directors identify her name with her work.

Griffel reveals that fashion illustrators, in particular, really have to dig for work. According to Griffel, there used to be a consistent market in newspaper advertising for fashion illustrators, but now photography plays a much larger role in print ads for the industry. One technique Griffel uses for finding clients is to take out an ad in *Women's Wear Daily* classified section under "situation wanted." Though sometimes the ads get no response, she says the few responses she has gotten have resulted in great clients. Her small classified ads attract fashion manufacturers and fashion designers who don't have the time or the expertise to illustrate large presentations. Even if an ad doesn't always attract work, at less than $100 Griffel considers it a small investment in her business, and "it's a tax deduction." Another powerful tool Griffel recommends is getting together with artists who do the same type of work you do. Griffel is a member of Fashion Art Source, an organization of New York, New Jersey and Connecticut fashion illustrators founded five years ago. The group sponsors symposiums on fashion illustration and trips to museums and other sources of inspiration. It's a great way to network with peers and exchange job leads, says Griffel.

Instant passion! Thriving on "the daily drama"

Another gorgeous packet came from **Vicki Nelson**, who enclosed printed samples and color copies of her work in a shiny white folder. She wrote:

> Enclosed is a postcard I printed from an idea included in last year's *AGDM*. Because of this mailing, I have signed a contract with Felix Rosentiels Widow and Son, Limited. They are publishing six of my images into prints to be marketed and distributed by their company. Other companies I have worked with are Painted Hearts and Friends, Northern Cards and Landmark, all of which were found through *AGDM*.

When I called Vicki to congratulate her, we talked for a long time. I found out she has back editions of *Artist's & Graphic Designer's Market* from the last ten years—an artist after my own heart. To find new companies, Nelson frequents greeting card stores, and poster and fine art print stores. "I looked on the backs of cards and posters for the names of the companies who published and distributed work I like. Then I read more about those companies in *AGDM*. It's important to look for similarity in your own works. Does the company's published pieces have the same feel, the same sense of style? Don't send fire-eating dragons to a company that publishes rose petals and wine themes. It wastes your time and money and theirs. But don't limit yourself either. If you think you'll fit in, give it a try."

Vicki Nelson

Nelson has praise for publishers she found through *AGDM*. "The first year I freelanced for Painted Hearts & Friends, I made $11,000 from that company alone. Landmark has added to that income by finding multiple uses for my fine art images: a calendar, published and distributed in Hong Kong; a Christmas card for Neiman Marcus Co.; and a Korean War veterans' greeting card. And Northern Cards has been very pleasant and easy to work with and very prompt on payments."

Nelson reads *AGDM* two to three times a week for an hour or more. "I make notes to myself about what to follow through on when I'm in the marketing mode. After all, if I don't make time for painting, I'll have nothing to market!"

Nelson has been in love with art all her life. "Five seconds after putting paint to paper I was hooked. Addicted. Instant passion! I loved every oozle, every watermark—the texture of the paper, the weight of the brush in my hand. It was and still is a daily drama." Nelson teaches watercolor and is represented by several galleries in the Northwest.

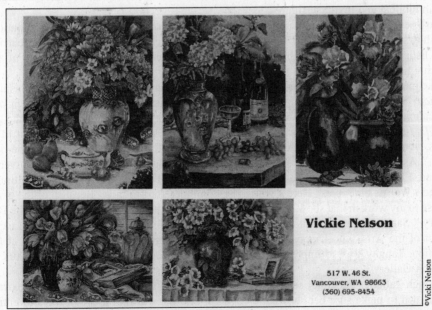

Vickie Nelson

517 W. 46 St.
Vancouver, WA 98663
(360) 695-8454

©Vicki Nelson

Vicki Nelson had this postcard sample of her work printed after seeing another artist's postcard in the 1998 edition of *AGDM*.

Like toppling dominoes

She's been reviewed in the *Washington Post* and *Art Papers*. Her work has been seen in dozens of group shows and solo exhibitions, and now we are happy to show the exciting work

"Eve and the Snake," acrylic on canvas, 43 × 36, was part of a one-person show of Mary Nash's work at Stetson University, Duncan Gallery of Art.

of **Mary Nash** in *Artist's & Graphic Designer's Market*. Nash is a painter who lives in Vienna, Virginia. Her work has been hailed as "visionary" by critics. Her paintings are vibrant and full of layers of meaning. Though she has a Masters in Fine Arts, Nash calls her work a "folk hybrid." It is often compared to Outsider art, and like Outsider art, Nash's bright paintings often contain biblical and mythical figures.

Nash sent me a folder containing newspaper and magazine reviews, opening invitations for past shows, slides and her artist's statement. She also included a very impressive curriculum vitae, listing her education, exhibitions, awards, honors, lectures and a bibliography of articles featuring her art.

Like many fine artists, Nash uses *AGDM* in conjunction with other arts publications like *Art Calendar* and *Art Papers* to help her find potential venues for her art. "If I read in another publication that a certain gallery is looking for artists for a group show, I'll look up the gallery in *AGDM* to get a better feel for the gallery." Once you start getting your work out in group shows, your career gains momentum, says Nash. "It really is a great example of the domino effect." As a result of a mailing she sent to the Duncan Gallery of Art at Stetson University in DeLand, Florida, five of her pen and ink drawings were curated into a group exhibition there entitled "Worlds on Paper." Here's where the dominoes start to fall. "Because of the excellent reponse to my work in that show, I was later offered a solo showing of my paintings at the Duncan Gallery." Sarah Tanguy, the Curator-in-Residence at the Emerson Gallery for the McLean (VA) Project of the Arts, who happened to be traveling to Florida, stopped by the show at Nash's invitation. Tanguy was so impressed that she offered to curate a show of Nash's work at the Emerson Gallery.

Though galleries generally send press releases and invitations, Nash takes some extra steps on her own to make sure her shows are covered. She likes to find creative ways to entice the press to write about her work. "I'll make a list of all the newspapers and local magazines and fax them to let them know about the show. When I'm wording the fax, I try to think of creative

ways to get their attention." Sometimes she calls up arts writers and says, "The show's really going to be great and I think it's something your readers would like to know about." Usually, if she calls five or six papers, a couple of them cover the show. Lots of little things add up to your professional image, says Nash. "I print out slide labels rather than write them and I always get professional slides made, even though it's costly. When I get dupes made, I load them into the projector to make sure they were duplicated correctly." Nash worked hard to perfect her promotional package. "I took two weeks out of my life and refined every single piece in my promotional folder." That two weeks paid off. Now when she needs to add something, she just makes copies for her promotional packages so she can send submissions at a moment's notice. Sure, Nash would have much rather used that two weeks for painting. Putting together slides, making copies and stapling articles together is a hassle. But she says, "I prefer to look at obstacles as challenges. I like to find my way around them."

She's a real card!

In the 1999 edition of this book, we included a reply card to find out more about *AGDM* readers. One of the first cards I received was from **Audrey Johnson** of St. Louis, Missouri. I recognized the name because I had read about her in Mark Heath's newletter, *Encouraging Rejection*. Like so many artists who filled out reply cards, Johnson checked all three categories— graphic designer, illustrator and fine artist. She's also a writer who writes her own gag-lines for her card designs. Johnson buys both *AGDM* and *Writer's Market*, our sister publication. "I send in the order forms bound into the book so I'll can get my next edition earlier than everybody else!" In the article in *Encouraging Rejection*, Johnson described how she got into freelancing: "I had four kids, two in diapers and a husband who traveled five days a week. I wanted to do something that would keep my brain from turning into putty, something I could do at home, something that was creative and something that did not require a large investment." After following the advice in a *Writer's Market* article about studio cards, she began submitting her card

Audrey Johnson's humor can be zany or simply gentle enough to elicit warm smiles.

ideas. "The first two months I got a lot of rejections but the third month I sold ideas to Paramount. Bingo!" When the editor asked how much I charged I had no idea, so of course I was paid the minimum." After 30 years in the business, Johnson has a much better idea of how to negotiate payments. She recently sold card ideas to Paramount and Amberley Greetings "just bought 50 designs at one pop!" The Amberley line will be called "Audrey" cards. Johnson excitedly told me she will even have her own "spinner" (that's greeting card lingo for those spinning display racks in stores.) More great news is that she's just had two of her paintings accepted in a juried show sponsored by the St. Louis Artist's Guild. It is a true delight to talk to Johnson. When I asked her how she finds the time to do so much, she laughed and said "You should see my house! You have to move a cat to sit down!"

Nancy Drew-It's remarkable career

With a name like "Nancy Drew-It!" on the return address line you can be sure I opened the big white envelope right away, just out of curiosity. Inside I found a friendly letter from

Nancy Arkell's wacky characters perfectly match the messages in her cards. The above cards were created for "Krack Ups," a division of Comstock Card; Off the Wall, a division of West Graphics; and "The Comedy Shoppe," a division of Magic Moments.

©West Graphics, Comstock Cards, Magic Moments

Nancy Arkell, an artist from Nanaimo, British Columbia. She writes: "A few years ago, while out shopping with my mother, I came across *Artist's & Graphic Designer's Market* at a local bookstore. At my mother's urging, I bought the book . . . and soon was to undergo a remarkable career transformation!"

Arkell had always wanted to create greeting cards. She sent her work and ideas to several companies listed in *AGDM*. "I was delighted to hear from West Graphic's Brian Fearon a few weeks later with the news that one of my designs was accepted. I'm happy to say I haven't looked back since! With the help of your annual book I have had dozens of cards published." Arkell has worked with Magic Moments, West Graphics, Designer Greetings, Comstock Cards, Brazen Images and Gibson Greetings.

Besides getting assignments through *AGDM*, Arkell illustrates personalized greeting cards to individuals and companies locally. She started her "Nancy Drew-It" company last year. "My favorite part of my career is the thrill when a design is accepted, and the pride and accomplishment I feel when the companies send me the finished products for my portfolio." Nancy was a finalist in the 1998 Athena awards, a Canadian businesswomen's award.

Portrait of persistance

I originally received a letter from **Michael Bennett** last October, notifying me that a listing had not been prompt in paying him, even after several follow-up letters. I got on the phone to Bennett immediately. (If something sounds amiss, I need to investigate to determine if I should remove the listing from the book.) During our conversation, Bennett spoke mostly about the many positive experiences he has had through *AGDM*, and the art directors who treated him fairly. I asked if I could see some of his work, and a few days later I received a packet from him and realized what a great talent he is. Looking at Bennett's work, I saw many faces I recognized immediately— Jimmy Stewart, John Wayne, Gary Cooper, David Copperfield, Mother Teresa and John F. Kennedy. I also saw portayals of nature—landscapes, flying geese, butterflies, flowers and mountains. My favorites were the stamps he created of JFK for a listing he found in *AGDM*.

Bennett's tale of how he won an assignment from Inspiration Art & Scripture is a lesson in true persistance! "I had done a pastel sketch of Mother Teresa and decided one more time to send a photo of my latest religious piece to Inspiration Art. I had been sending artwork to them for five years with no success when finally they called me and offered me a price for the Mother Teresa piece without even seeing the original. I was flabbergasted! They offered me $400 for the sketch or royalites for it and I accepted the royalty route, which should bring in more revenue in the long run. The poster was published with a prayer of St. Francis of Assisi underneath the sketch. It sells in Christian stores across the country for $10."

I don't know how Bennett manages to produce so much work, since he spends most of his time teaching at Park View Middle School in Yucaipa, California. I can imagine, however, that he must be a great inspiration to his students.

Michael Bennett created this stunning sheet of of nine different stamps honoring President John F. Kennedy for IGPC, a company that listed in a past edition of *Artist's & Graphic Designer's Market*. The collectible stamps were not issued through the United States Post Office, but for the tiny nation of Maldives. The stamps were written up in the April 1998 edition of *Global Stamp News*, a magazine for stamp collectors.

Be a sleuth!

Bev Jozwiak of Vancouver, Washington writes, "Painting watercolors has been a part of my life for what seems like forever. I have had gallery representation for about the last ten years, but decided I wanted my work to be seen by a larger audience than my originals could cover. I've become a pretty good sleuth. I regularly go into card and print shops to check for markets where I think my style would fit. If I find something of interest I look for the name of the company who printed it, then check it out in my *AGDM* to see if it is listed. Usually it is. Then I read the requirements to send my work to that company, and I'm off and running."

To date Jozwiak has freelanced for two card companies, Painted Hearts & Friends and Concord Litho Group, and had a calendar printed by Landmark that went worldwide. Although Hallmark does not accept freelance work, they purchased the rights to her calendar from Landmark.

"Each company works differently and you need to be flexible," says Jozwiak. "Painted Hearts & Friends pays five percent royalties and keeps the pieces you do for them. Concord Litho pays a flat fee anywhere from $200-800 a piece and have returned the originals for me to sell to my galleries. Landmark and Hallmark paid me royalties of eight percent, and didn't need the originals at all; they printed from slides."

Jozwiak says working with these companies has been profitable and fun. She is now in the process of sleuthing for a print company.

So many success stories, so little time!

Honestly, I still have a lot of success stories to report, but alas we've got to save *some* space for listings! One last success story is so good, I'll let you read it in the artist's own words. Be sure to pay special attention to how Steve Verriest saves money through bulk mailings. Until next year, happy sleuthing! Your most wonderful clients could be the ones you haven't mailed to yet!

I wish we could show these cards in color because Bev Jozwiak's colorful brushstokes really enliven these wonderful cards she created for Painted Hearts & Friends.

Diary of a career launch
by Steven Verriest

Steve Verriest

It wasn't until I told myself, "Forget the client: make art for Steven Verriest" that I found my personal style and realized that people were affected by my art. Of course, the client is a necessary evil, but after I am given the details of an assignment, I approach the project as if I am painting for myself.

In the '90s I worked as everything from creative director to art schlep, prostituting my skills for money. I would sell clients on my style of illustration for anything that came along—book covers, catalogs, annual reports and stuff. These jobs allowed me to explore my illustration styles without having to worry about where my next fast food combo meal was coming from.

At my day job I was able to create a jumbo portfolio of published illustration. I began bombarding every contest out there with my art. I felt ready. Apparently the judges didn't feel the same way. However, I continued entering contests like a mindless drone, never thinking I might actually win

In my second attempt to get out on my own, I picked a dozen of my best published pieces and put them in really cool handmade portfolios. I produced a couple dozen of them and mailed them to some of my favorite illustration representatives. When I had no takers, I realized the reps weren't going to take me on until I sold to prestigious clients. I needed to dog my way as my own rep. That's when I got tough and began to rain money and time into an aggressive marketing campaign.

After painting a ton of illustrations I thought were ready, I suppressed my urge to overnight my work in a brown paper bag. I designed a graphic identity that would showcase my illustration as high-end work. This consisted of some four-color printed samples, a four-color business card, two-color letterhead, two-color mailing labels, and a killer website (www.yourartslave.com). I put most of my money into four-color process printing on glossy card stock plus varnish. However, I cut costs where I could without sacrificing quality. I printed a bunch of $8\frac{1}{2} \times 11$ illustration samples at the same time to cut down on costs. I found some black 9×12 envelopes and glued my business cards to them as a return address. I also included a cover letter printed on my two-color letterhead with a business card attached. I cut my postage in half by sending everything by bulk mail. Every month or two, I sent between one and four samples so art directors were bombarded with my art.

At that point, even though I had received almost no feedback and certainly no assignments, I was still very excited about exploring my style and getting it out there. One of the things that kept me going was something Mary Cox, editor of *Artist's & Graphic Designer's Market* told me. She said, "Steve, I'll bet you there are some art

directors out there who are putting your work in a file. They'll call you when something comes up." She was right; the jobs started rolling in. I started getting calls from really cool art directors.

Since I began my campaign, I received three illustration assignments from my self-promotion mailer. *Aspire* magazine hired me to create a full-page color illustration for their feature article, "Making Life Rich Without Any Money." *Sacramento News & Review* hired me to do a color cover illustration to go with their feature article, "Psychotic Relationships from Hell," and *Brutarian* commissioned a full-page illustration for "Doors," a piece of fiction. I have received many e-mails and letters from representatives and art directors who like my style and are keeping a file of my work. A rep I respect is interested in promoting my work. When I finally won an award in *HOW* magazine's annual self-promotion competition, I realized how far I have come since I launched my aggressive campaign.

After launching his direct mail campaign, the assignments finally started coming in for budding illustrator Steven Verriest. He created this cover for *Sacramento News & Review*.

Bulk Mailing Tips from Steve Verriest

You have to have at least 200 pieces of mail to do a bulk mailing. All pieces must be identical in weight and size. The post office will help you every step of the way. It costs $80 for a permit number that is valid for one year. Then you have to buy a $50 roll of 10-cent bulk mail stamps and stick them on your letters. Next you have to presort the entire mailing by zip code. It's slightly more involved than that, so ask your friendly post office clerk for specifics. But believe me, the time I spent more than made up for the money I saved. After my first bulk mail, the others were cake.

Galleries

Do you have a full body of work to show (at least 30 artworks)? Is the work consistent in style? Do you have a track record of exhibiting in group shows? Then you may be ready for gallery representation. You don't have to move to New York City to find a gallery. Whether you live in a small town or a big city, the easiest galleries to try first are the ones closest to you. It's much easier to begin developing a reputation within a defined region. New artists rarely burst onto the scene on a national level.

The majority of galleries will be happy to take a look at your slides. If they feel your artwork doesn't fit their gallery, most will gently let you know, often steering you toward a more appropriate one. Whenever you meet rejection (and you will), tell yourself it's all part of being an artist.

Follow the rules

1. **Never walk into a gallery without an appointment**. When we ask gallery directors for pet peeves they always discuss the talented newcomer walking into the gallery with paintings in hand. Send a polished package of about 8 to 12 neatly labeled, mounted slides of your work submitted in plastic slide sheet format (refer to the listings for more specific information on each gallery's preferred submission method).
2. **Seek out galleries that show the type of work you create.** Since you'll probably be approaching galleries in your region first, visit galleries before you send. Browse for a while and see what type of work they sell. Do you like the work? Is it similar to yours in quality and style? What about the staff? Are they friendly and professional? Do they seem to know about the artists the gallery handles? Do they have convenient hours? When submitting to galleries outside your city, if you can't manage a personal visit before you submit, read the listing carefully to make sure you understand what type of work is shown in that gallery and get a feel for what the space is like. Ask a friend or relative who lives in that city to check out the gallery for you.
3. **Attend openings.** You'll have a chance to network and observe how the best galleries promote their artists. Sign each gallery's guest book or ask to be placed on galleries' mailing lists. That's also one good way to make sure the gallery sends out professional mailings to prospective collectors.

Your long-term goal: showing in multiple galleries

Most successful artists show in several galleries. Once you have achieved representation on a local level, you are ready to broaden your scope by querying galleries in other cities. You may decide to concentrate on galleries in surrounding states, becoming a "regional" artist. Some artists like to have an East Coast and a West Coast gallery.

What should I charge?

A common question of beginning artists is "What do I charge for my paintings?" There are no hard and fast rules. The better known you become, the more people will pay for your work. Though you should never underprice your work, you must take into consideration what people are willing to pay. Also keep in mind that you must charge the same amount for a painting sold in a gallery as you would for work sold from your studio. If you plan to sell work from your studio, or from a website or other galleries, be upfront with your gallery. Work out a commission

All Galleries Are Not Alike

As you search for the perfect gallery, it's important to understand the different types of spaces and how they operate. The route you choose depends on your needs, the type of work you do, your long term goals, and the audience you're trying to reach.

☑ **Retail or commercial galleries.** The goal of the retail gallery is to sell and promote artists while turning a profit. Retail galleries take a commission of 40 to 50 percent of all sales.

☑ **Co-op galleries.** Co-ops exist to sell and promote artists' work, but they are run by artists. Members exhibit their own work in exchange for a fee, which covers the gallery's overhead. Some co-ops also take a small commission of 20 to 30 percent to cover expenses. Members share the responsibilities of gallery-sitting, sales, housekeeping and maintenance.

☑ **Rental galleries.** The gallery makes its profit primarily through renting space to artists and consequently may not take a commission on sales (or will take only a very small commission). Some rental spaces provide publicity for artists, while others do not. Showing in this type of gallery is risky. Rental galleries are sometimes thought of as "vanity galleries" and, consequently they do not have the credibility other galleries enjoy.

☑ **Nonprofit galleries.** Nonprofit spaces will provide you with an opportunity to sell work and gain publicity, but will not market your work aggressively, because their goals are not necessarily sales-oriented. Nonprofits normally take a small commission of 20 to 30 percent.

☑ **Museums.** Don't approach museums unless you have already exhibited in galleries. The work in museums is by established artists and is usually donated by collectors or purchased through art dealers.

☑ **Art consultancies.** Generally, art consultants act as liaisons between fine artists and buyers. Most take a commission on sales (as would a gallery). Some maintain small gallery spaces and show work to clients by appointment.

For More Information

To develop a sense of various galleries and how to approach them, look to the myriad of art publications that contain reviews and articles. A few such publications are *ARTnews, Art in America, The New Art Examiner* and regional publications such as *ARTweek* (West Coast), *Southwest Art, Dialogue* and *Art New England*. Lists of galleries can be found in *Art in America's Guide to Galleries, Museums and Artists* and *Art Now, U.S.A.'s National Art Museum and Gallery Guide*. *The Artist's Magazine* and *Art Calendar* are invaluable resources for artists and feature dozens of helpful articles about dealing with galleries.

arrangement that feels fair to both of you and everybody wins. For "rules of thumb" about pricing and gallery commissions, see sidebar above.

Juried shows, competitions and other outlets

As you submit your work and get feedback you might find out your style hasn't developed enough to grab a gallery's interest. It may take months, maybe years, before you find a gallery to represent you. But don't worry, there are plenty of other venues to show in until you are accepted in a commercial gallery. If you get involved with your local art community, attend

KNOW WHO'S WHO IN THE GALLERY

It's important to understand the different roles of gallery personnel. Galleries are comprised of many people, each with their own distinct personality. It's these people who will be your partners in developing your art career. Treat them with respect and consideration, and expect that they will treat you the same.

Here is a list of titles and duties in a typical gallery.

OWNER OR ART DEALER

The person with ultimate control of a gallery is the owner (or owners). This person is also called an art dealer.

GALLERY DIRECTOR

The owner might or might not be the same person as the gallery director. The gallery director decides which artists to exhibit, when to have shows and so on. The gallery director is also responsible for the sales staff. You might find the gallery director on the floor of the gallery or in a separate office.

SALES STAFF

The sales staff works directly with collectors and other visitors to the gallery. You will find them on the floor of the gallery. Their responsibility is, obviously, to sell art. Get to know the sales staff, because they can tell you about the art and artists represented, as well as giving background information on the gallery. When I am showing with a gallery, I make a point of becoming friends with the salespeople because they are the ones who will be selling my art.

SERVICE STAFF

Larger galleries have various assistants, a receptionist, assistant to the director, maintenance crew and so on. Be friendly with everyone. In one way or another they all help sell your art.

STABLE OF ARTISTS

The last members of the gallery personnel are the stable of artists, the artists whose work is represented by the gallery. When I choose a new gallery, I always talk with one of the artists who is already represented by them. I ask how these people are to work with—Are they honest? Are they aggressive about promoting and selling their artists' work? Do they work hard for all their artists?

Excerpted from *How To Get Started Selling Your Art*, copyright © 1996 by Carole Ketchen.
Used with permission of North Light Books.

openings, read the arts section of your local paper, you'll see there are hundreds of opportunities right in your city.

Enter group shows and competitions every chance you get. Go to the art department of your local library and check out the bulletin board, then ask the librarian to steer you to regional arts magazines like *Art Calendar*, that list "calls to artists" and other opportunities to exhibit your work. Well-known painter Dean Mitchell gained the attention of galleries, curators and collectors through this strategy. It's a great way to get noticed. (Read how he did it on page 364.) Join a co-op gallery and show your work in a space run by artists for artists.

Another opportunity to show your work is through local restaurants and retail shops that show the work of local artists. Ask the manager how you can show your work. Become an active member in an arts group. It's important to get to know your fellow artists. And since art groups often mount exhibitions of their members' work you'll have a way to show your work until you find a gallery to represent you.

Competitions: A valuable marketing opportunity for your art

I grew up in a poor rural community in the Florida panhandle. If opportunity knocked, it was in the guise of the foreman of the local cannery. Art was certainly not considered a way to make a living. However, I had one great advantage. I was brought up by my grandmother, a wonderful woman who believed in my dream.

My grandmother taught me to believe in myself and to accept rejection as a challenge. And in the early days I sure got my share of challenges. I was turned down by many shows and publications. I used rejections to make myself examine my work critically—to try to see it through the eyes of a judge.

Dean Mitchell

Today, young artists often tell me, "My work is not ready. I will begin entering shows when I'm sure I'm ready." To them, I say the time is now. You are often your own harshest critic. It is easier to tell yourself you are not ready, than face the fear of rejection. Everyone faces the same fear. You just have to meet it head on.

When your work is not accepted, or doesn't win a prize, you can learn from the experience. When I was a teenager a friend brought me a notice about the Bay Annual, a multimedia show in Panama City. My first reaction was, "No, I'm not ready for this. Artists from all over the panhandle enter this show." But, with a little encouragement, I decided to enter. And I won a prize. Since that time I have won hundreds of awards and built a national reputation, but I will always remember how scary entering that first show was. Everyone faces the same fear. You just have to meet it head on.

DEAN MITCHELL

Occupation: Fine artist
Resides in: Overland Park, KS

Another complaint I hear from other artists is, "Entering competitions is expensive. I can't afford it." The truth is you can't afford not to enter. In

the early years after college I lived in a one-room studio apartment and sometimes spent money on entry fees and framing that I desperately needed for necessities. But eventually it paid off. Even when prize money began coming in and my work began selling well, I continued to live frugally. Now, without having to worry about keeping the wolf from the door, I can exercise much more freedom in my work.

Juried shows and competitions are one of my most valuable marketing tools. Yes, marketing. I know many artists are not comfortable with the idea of their work, the very window on their soul, as a product to be marketed. But, you must sell, or you must get a real job. I want to support myself by being a full-time working artist, therefore, marketing is part of my job. Marketing really means making the public aware of your work and establishing a value for it. That's why shows and competitions are so great. They provide an opportunity to present your work to art experts and the media as well as to the art buying public. Most art purchasers are not artist themselves,

THE ART
of
DEAN MITCHELL

The Early Years.

©Dean Mitchell

Mitchell chose the image of Rowena to grace the cover of his self-published art book. "She was already very old when I met her, but she was full of life and energy," says Mitchell. "I knew I had to paint her. When I was invited to enter the Hubbard Exhibit, I knew this was what I had been waiting for. Rowena captured the hearts of the viewers and judges, as she had captured mine."

and many are intimidated by the process of selecting a painting. Awards give your work credibility. The fact that your paintings have won awards is reassuring to the potential buyer.

Enter as many shows as you can, even when it means sacrificing something else in favor of entry fees. Obviously, you can't enter them all, so choose carefully. Deciding which shows to enter is a personal decision, but there are some basic guidelines I use. Don't restrict yourself to your city or region. Choose shows across the country. Local viewers and judges may become over-accustomed to your work. It loses impact. You need fresh audiences, and your particular genre may be more popular in some areas than others. Choosing widespread shows also builds your reputation nationally rather than regionally. I also look for shows that encourage a wide range of images. You may paint flowers, but stay away from shows that cater exclusively to floral images. Don't categorize yourself.

Study catalogs from previous shows if you can get them, and consider the judges. I like to enter shows judged by artists whose work I admire. However, never make the mistake of painting for the judge. This is a terrible mistake. When you stop painting what you want to paint, what you feel, you lose the spiritual quality of your work.

Mitchell's oil painting entitled *Since My Youth* typifies his artistic reflection on the journey of his life. "Each painting reveals a personal perception on the things, places and people who have touched my life." A prolific artist, Mitchell creates works in many media including pencil, watercolor, egg tempera, pastel, pen & ink and acrylic. He won the Arts in the Parks bronze medal in 1988 and 1989. Additional awards include the Ogden Pleissner Award from the American Watercolor Society and the Grumbacher Gold Medal from the Allied Artists.

©Dean Mitchell

Once you have decided on a show, the selection of entries deserves careful consideration. In most cases the juror's first reaction to your work is going to come from a one-inch representation on film. Your most brilliant painting will fall flat if it is presented in the form of a fuzzy, poorly lit slide. Invest in a good camera and proper lighting, or a good photographer. You may find one willing to trade photography for a painting.

Picture your slides being slapped on a light table and scanned with a loupe. They must have instant impact. Composition is never more important than when your work is being viewed in this tiny format. I study the work of abstract and non-objective painters to learn more about form, color and space. Although my genre is realism, there is often a hint of the abstract or the unreal in my use of form and space. For entries I like pieces that combine loose and tight techniques. The loose areas have a lot of initial impact to grab the juror's attention; subtlety and detail will hold the interest when the final judge comes face-to-face with the painting.

Sometimes my best work is not my most salable. These intensely emotional pieces might not do well in a gallery, but in a competition they are seen by art experts who are looking at the quality of the work rather than selecting a pretty picture for the living room.

Remember that your framing is part of the package, part of the image you are presenting of your work and yourself. Expensive framing is nice if you can afford it, but simple metal frames are perfectly acceptable. Stay away from shoddy wooden or plastic frames. Mats should be neutral, well-cut and clean.

Win or lose, the benefits of entering shows are many. Winning brings recognition, prize money, media attention—and buyers. Rejection brings the impetus to reexamine what you are doing. But, just because a piece was turned down, or didn't win, don't assume that it is not good. Judges are human. Individual preferences and biases enter into their decisions. That doesn't mean the decisions are bad, or unfair. Art is all about individuality. Technique can be judged objectively, but the essence, the soul, of a painting is very personal. Don't expect everyone to respond to your work in the same way. It comes back to believing in yourself. So learn from your rejections, but don't be discouraged by them.

Sometimes people say to me, "You've made a name for yourself now, so why do you keep entering shows?" Shows keep me aware of what other artists are doing and force me to constantly reexamine my own work. And the public has a short memory; artists need to keep their work in front of the public. Besides, entering shows is fun, and I like getting something in the mail besides bills.

Many artists are afraid to market themselves because it is too "commercial." I find discussions about what's commercial and what's fine art tiresome. There's nothing more commercial than an art auction. If you don't sell, you can't affort to paint. Financial success opens doors for you and gives you the freedom to reach your true creative potential as an artist. Venture out and continue to grow.

Only you can make success happen.

—*Dean Mitchell, with Anne Ake*

Galleries: an artist's marketplace

Choosing a gallery, or galleries, is an important marketing decision for an artist. Ideally you want to establish a long-term relationship with a gallery that is genuinely committed to advancing your career. I have never been willing to sign an exclusive contract with any gallery. I want to stay in control of my career, and I will not be told what to paint. Many galleries will try to dictate what you should produce. "Barns are big this year, paint a lot of old barns." Well, I have to be concerned with selling my work, but I am more concerned with what I will leave behind when I'm gone. So, I stay away from galleries that want me to tell me what to paint.

Although I never let the market dictate to me what or how to paint, I do make an effort to produce a wide range of images and to maintain a wide range of prices. Working in various media allows me flexibility. When I was just starting out and it was important to sell things quickly, watercolor allowed me to be more prolific. Now that I am more financially stable, I have the freedom to devote a lot of time and effort to large oils that may not sell immediately. I can afford to hold these pieces until the right buyer comes along, and if he never does I can enjoy them as part of my personal collection.

You should also consider the amount of wall space a gallery is willing to give you. You are better off as a primary artist in a smaller, less well-known gallery, than stuffed in a bin in the back room of a large gallery. My first gallery experience was Bay Art and Frame in Panama City. I will never forget the support I got from the owners, Zolton and Vicki Bush, when I was a young college student selling paintings to pay my way through college. I still show there and ship many exhibit pieces back to the Bushes to be framed. This kind of gallery relationship can be a real boon to your career.

—Dean Mitchell with Ann Ake

Alabama

ART GALORE!, 3322 S. Memorial Pkwy. 109, Huntsville AL 35801. (256)882-9040. E-mail: artgalor@b17.com. Website: http://www.b17.com. Owner: Charles Hayes. Retail gallery. Estab. 1994. Represents 41 emerging, mid-career and established artists/year. Exhibited artists include Chuck Long and Anita Hoodless. Sponsors 9 shows/year. Average display time 3 months. Open all year; Tuesday-Friday, 11-5; Saturday, 1-5. 600 sq. ft. 100% of space for gallery artists. Clientele: local. 90% private collectors, 10% corporate collectors. Overall price range: $50-5,000; most work sold at $100-500.
 • Art Galore! is now primarily an Internet gallery, and is not looking for artists who want traditional gallery space. Open to web gallery exhibit submissions.
Media: Considers all media and all types of prints. Most frequently exhibits watercolor, oil and acrylic.
Style: Exhibits all styles and genres. Prefers landscapes, florals and portraits.
Terms: Accepts work on consignment (25% commission). Retail price set by the artist. Gallery provides promotion. Artist pays shipping costs. Prefers artwork framed.
Submissions: Send query letter with slides and photographs. Call for appointment to show portfolio of photographs and slides. Replies in 2 weeks. Finds artist's through submissions.
Tips: "Include painting dimensions."

ARTISANS, P.O. Box 256, Mentone AL 35984. (205)634-4037. Fax: (256)634-4057. E-mail: artisans@folkartisans.com. Website: http://www.folkartisans.com. Partner: Matt Lippa. Retail gallery. Estab. 1986. Represents 4-10 emerging, mid-career and established artists/year. Exhibited artists include Melanie McGinnis and Marilyn Dorsey. Average display time 1 month. Open all year; Monday-Saturday, 9-6. Located in rural AL near downtown; 1,500 sq. ft.; Website gallery. Clientele: upscale. 99% private collectors, 1% corporate collectors. Overall price range: $200-5,000; most work sold at $500-1,000.
 • Works mainly with Internet exhibits. Will either buy rights or negotiate with artist.
Media: Considers all media except craft and installation. Considers all types of prints. Most frequently exhibits mixed media, sculpture and acrylic.
Style: Exhibits primitivism, folk art and outsider art. Prefers folk-untrained, outsider art and prison art.
Terms: Accepts work on consignment (35% commission or arranged net). Retail price set by the gallery and the artist.

Gallery provides promotion and contract. Shipping costs are shared.
Submisisons: Send query letter with résumé, photographs and artist's statement. Call for appointment to show portfolio of photographs. Replies in 1 week.
Tips: "We're not looking for artists at this time."

CORPORATE ART SOURCE, 2960-F Zelda Rd., Montgomery AL 36106. (334)271-3772. E-mail: ca5jb@mindsprin g.com. Owner: Jean Belt. Retail gallery and art consultancy. Estab. 1985. Interested in mid-career and established artists. "I don't represent artists, but keep a slide bank to draw from as resources." Exhibited artists include: Beau Redmond and Dale Kenington. Open Monday-Friday, 10-5. Located in exclusive shopping center; 1,000 sq. ft. Clientele: corporate upscale, local. 20% private collectors, 80% corporate collectors. Overall price range: $100-250,000. Most work sold at $500-5,000.
Media: Considers all media and all types of prints. Most frequently exhibits oil/acrylic paintings on canvas, pastel and watercolor. Also interested in sculpture.
Style: Exhibits expressionism, painterly abstraction, Impressionism and realism. Genres include landscapes, abstract and architectural work.
Terms: Artwork is accepted on consignment (50% commission). Retail price set by artist. Gallery provides contract, shipping costs from gallery. Prefers artwork unframed.
Submissions: Send query letter with résumé, slides or photographs and SASE. Call for appointment to show portfolio of slides and photographs. Replies in 6 weeks.
Tips: "Always send several photos (or slides) of your work. An artist who sends a letter and one photo and says 'write for more info' gets trashed. We don't have time to respond unless we feel strongly about the work—and that takes more than one sample."

N EASTERN SHORE ART CENTER, 401 Oak St., Fairhope AL 36532. (334)928-2228. E-mail: esac@mindspring .com. Website: http://www.fairhope.com/esac/. Executive Director: B.G. Hinds. Museum. Estab. 1957. Exhibits emerging, mid-career and established artists. Average display time 1 month. Open all year. Located downtown; 8,000 sq. ft. of galleries.
 ● Artists applying to Eastern Shore should expect to wait at least a year for exhibits.
Media: Considers all media and prints.
Style: Exhibits all styles and genres.
Terms: Accepts works on consignment (25% commission). Retail price set by artist. Gallery provides insurance, promotion and contract. Prefers artwork framed.
Submissions: Send query letter with résumé and slides. Write for appointment to show portfolio of originals and slides.
Tips: "Conservative, realistic art is appreciated more and sells better."

LEON LOARD GALLERY OF FINE ARTS, 2781 Zelda Rd., Montgomery AL 36106. (800)270-9017. Fax: (334)270-0150. Gallery Director: Barbara Smith. Retail gallery. Estab. 1989. Represents about 70 emerging, mid-career and established artists/year. Exhibited artists include Paige Harvey and Pete Beckman. Sponsors 4 shows/year. Average display time 3 months. Open all year; Monday-Friday, 9-4:30; weekends by appointment. Located in upscale suburb; cloth walls. 45% of space for special exhibitions; 45% of space for gallery artists. Clientele: local community—many return clients. 80% private collectors, 20% corporate collectors. Overall price range: $100-75,000; most work sold at $500-3,000.
Media: Considers oil, acrylic, watercolor, pastel, pen & ink, drawing, mixed media, collage, paper, sculpture, ceramics, fiber and glass. Most frequently exhibits oil on canvas, acrylic on canvas and watercolor on paper.
Style: Exhibits all styles and all genres. Prefers Impressionism, realism and abstract.
Terms: Accepts work on consignment. Retail price set by the gallery and the artist. Gallery provides insurance, promotion and contract. Shipping costs are shared. Prefers artwork unframed.
Submissions: Send query letter with résumé, slides, bio and photographs. Portfolio should include photographs and slides. Replies in 2 weeks. Files bios and slides.

MAYOR'S OFFICE FOLK ART GALLERY, 5735 Hwy. 431, P.O. Box 128, Pittsview AL 36871. (334)855-3568. Owner: Frank Turner. Wholesale gallery. Estab. 1994. Represents 5-6 emerging, mid-career and established artists/year. Exhibited artists include: Buddy Snipes, Butch Anthony, John Henry Toney, Ned Berry, Rocky Wade and Roger Miller. Average display time 6 months. Open all year; by chance or appointment. Located in rural community on main highway; 800-1,000 sq. ft.; folk/outsider art only. 75% of space for gallery artists. Clientele: tourists, upscale collectors, dealers. 50% private collectors (wholesale). Overall price range: $60-1,000; most work sold at $60-150.
Media: Considers oil, acrylic, watercolor, pastel, pen & ink, drawing, mixed media, collage, paper, sculpture, fiber and glass; considers all types of prints. Most frequently exhibits oil, house paint and wood.
Style: Exhibits: expressionism and primitivism. (It's folk art—you name it and they do it.)
Terms: Buys outright. Retail price set by the gallery and the artist. Gallery provides promotion; shipping costs are shared.
Submissions: Accepts only artists from east Alabama and west Georgia. Prefers folk/outsider only—must be "unique and true." Call to show portfolio of photographs and original art. Finds artists through word of mouth, referrals by other artists and submissions.
Tips: "No craft items. Art must be true—straight from the heart and mind of the artist."

☑ **MOBILE MUSEUM OF ART**, P.O. Box 8426, Mobile AL 36689-0426. (334)343-2667. E-mail: jbs@mobilemuseumofart.com. Director: Joe Schenk. Clientele: tourists and general public. Sponsors 6 solo and 12 group shows/year. Average display time 6-8 weeks. Interested in emerging, mid-career and established artists. Overall price range: $100-5,000; most artwork sold at $100-500.

Media: Considers all media and all types of visual art.

Style: Exhibits all styles and genres. "We are a general fine arts museum seeking a variety of style, media and time periods." Looking for "historical significance."

Terms: Accepts work on consignment (20% commission). Retail price set by artist. Exclusive area representation not required. Gallery provides insurance, promotion, contract; shipping costs are shared. Prefers framed artwork.

Submissions: Send query letter with résumé, brochure, business card, slides, photographs, bio and SASE. Write to schedule an appointment to show a portfolio, which should include slides, transparencies and photographs. Replies only if interested within 3 months. Files résumés and slides. All material is returned with SASE if not accepted or under consideration.

Tips: "Be persistent—but friendly!"

RENAISSANCE GALLERY, INC., 431 Main Ave., Northport AL 35476. (205)752-4422. Owners: Judy Buckley and Kathy Groshong. Retail gallery. Estab. 1994. Represents 25 emerging, mid-career and established artists/year. Exhibited artists include: Mary Lou Liberty, John Wagnon and Sharon Yavis. Sponsors 12 shows/year. Average display time 6 months. Open all year; Monday-Saturday, 11-4:30. Located in downtown historical district; 1,000 sq. ft.; historic southern building. 25% of space for special exhibitions; 75% of space for gallery artists. Clientele: tourists and local community. 95% private collectors; 5% corporate collectors. Overall price range: $65-3,000; most work sold at $100-900.

Media: Considers oil, acrylic, watercolor, pastel, pen & ink, mixed media, sculpture, ceramics and leaded glass; types of prints include woodcuts, etchings and monoprints. No mass produced reproductions. Most frequently exhibits oil, acrylic and watercolor.

Style: Exhibits: painterly abstraction, Impressionism, photorealism, realism, imagism and folk-whimsical. Genres include florals, portraits, landscapes, Americana and figurative work. Prefers: realism, imagism and abstract.

Terms: Accepts work on consignment (50% commission). Retail price set by the artist. Gallery provides promotion; shipping costs are shared. Prefers artwork framed. "We are not a frame shop."

Submissions: Prefers only painting, pottery and sculpture. Send query letter with slides or photographs. Write for appointment to show portfolio of photographs and sample work. Replies only if interested within 1 month. Files artists slides/photographs, returned if postage included. Finds artists through referrals by gallery artists.

Tips: "Do your homework. See the gallery before approaching. Make an appointment to discuss your work. Be open to suggestions, not defensive. Send or bring decent photos. Have work that is actually available, not already given away or sold. Don't bring in your first three works. You should be comfortable with what you are doing, past the experimental stage. You should have already produced many works of art (zillions!) before approaching galleries."

MARCIA WEBER/ART OBJECTS, INC., 1050 Woodley Rd., Montgomery AL 36106. (334)262-5349. Fax: (334)567-0060. E-mail: weberart@mindspring.com. Website: http://weberart.home.mindspring.com. Owner: Marcia Weber. Retail, wholesale gallery. Estab. 1991. Represents 21 emerging, mid-career and established artists/year. Exhibited artists include: Woodie Long, Jimmie Lee Sudduth. Sponsors 6 shows/year. Open all year except July by appointment only. Located in Old Cloverdale near downtown in older building with hardwood floors in section of town with big trees and gardens. 100% of space for gallery artists. Clientele: tourists, upscale. 90% private collectors, 10% corporate collectors. Overall price range: $300-20,000; most work sold at $300-4,000.

● This gallery owner specializes in the work of self-taught, folk, or outsider artists. Many artists shown generally "live down dirt roads without phones," so a support person first contacts the gallery for them. Marcia Weber moves the gallery to New York's Soho district 3 weeks each winter and routinely shows in the Atlanta area.

Media: Considers all media except prints. Must be original one-of-a-kind works of art. Most frequently exhibits acrylic, oil, found metals, found objects and enamel paint.

Style: Exhibits genuine contemporary folk/outsider art and some Southern antique original works.

Terms: Accepts work on consignment (variable commission) or buys outright. Gallery provides insurance, promotion and contract if consignment is involved. Prefers artwork unframed so the gallery can frame it.

Submissions: Folk/outsider artists usually do not contact dealers. If they have a support person or helper, who might write or call. Send query letter with photographs, artist's statement. Call or write for appointment to show portfolio of photographs, original material. Finds artists through word of mouth, other artists and "serious collectors of folk art who want to help an artist get in touch with me." Gallery also accepts consignments from collectors.

Tips: "One is not a folk artist or outsider artist just because their work resembles folk art. They have to *be* folks or live outside mainstream America to create folk art or outsider art. Prefers artists committed to full-time creating.

Alaska

DECKER/MORRIS GALLERY, (formerly Stonington Gallery), 621 W. Sixth Ave., Anchorage AK 99501-2127. (907)272-1489. Fax: (907)272-5395. Manager: Don Decker. Retail gallery. Estab. 1983. Interested in emerging, mid-

career and established artists. Represents 50 artists. Sponsors 15 solo and group shows/year. Average display time 3 weeks. Clientele: 90% private collectors, 10% corporate clients. Overall price range: $100-5,000; most work sold at $500-1,000.

Media: Considers oil, acrylic, watercolor, pastel, mixed media, collage, works on paper, sculpture, ceramic, craft, fiber, glass and all original handpulled prints. Most frequently exhibits oil, mixed media and all types of craft.

Style: Exhibits all styles. "We have no pre-conceived notions as to what an artist should produce." Specializes in original works by artists from Alaska and the Pacific Northwest. "We are the only source of high-quality crafts in the state of Alaska. We continue to generate a high percentage of our sales from jewelry and ceramics, small wood boxes and bowls and paper/fiber pieces. We push the edge to avante garde."

Terms: Accepts work on consignment (50% commission). Retail price set by artist. Exclusive area representation required. Gallery provides insurance, promotion.

Submissions: Send letter of introduction with résumé, slides, bio and SASE.

Tips: Impressed by "high quality ideas/craftsmanship—good slides."

Arizona

[N] ARIZONA STATE UNIVERSITY ART MUSEUM, Nelson Fine Arts Center and Matthews Center, Arizona State University, Tempe AZ 85287-2911. (602)965-ARTS. Website: http://asuam.fa.asu.edu/homepage.htm. Director: Marilyn Zeitlin. Museum. Estab. 1950. Represents mid-career and established artists. Sponsors 12 shows/year. Average display time 2 months. Open all year. Located downtown Tempe ASU campus. Nelson Fine Arts Center features award-winning architecture, designed by Antoine Predock. "The Matthews Center, located in the center of campus, features the Experimental Gallery, showing contemporary art that explores challenging materials, subject matter and/or content."

Media: Considers all media. Greatest interests are contemporary art, crafts, and work by Latin American and Latin artists.

Submissions: "Interested artists should submit slides to the director or curators."

Tips: "With the University cutbacks, the museum has scaled back the number of exhibitions and extended the average show's length. We are always looking for exciting exhibitions that are also inexpensive to mount."

SUZANNE BROWN GALLERIES, 7160 Main St., Scottsdale AZ 85251. (602)945-8475. Director: Ms. Linda Corderman. Retail gallery and art consultancy. Estab. 1962. Interested in established artists. Represents 60 artists. Exhibited artists include Merrill Mahaffey, Howard Post, Ed Mell and Nelson Boren. Sponsors 6 solo and 2 group shows/year. Average display time 2 weeks. Located in downtown Scottsdale. Clientele: valley collectors, tourists, international visitors. 80% private collectors; 20% corporate clients. Overall price range: $500-30,000; most work sold at $1,000-10,000.

• Though focus is mainly on contemporary interpretations of Southwestern themes, gallery shows work of artists from all over the country. Director is very open to 3-dimensional work.

Media: Considers oil, acrylic, watercolor, pastel, drawings, mixed media, collage, sculpture, ceramic, craft, glass, lithographs, monoprints and serigraphs. Most frequently exhibits oil, acrylic and watercolor.

Style: Exhibits realism, painterly abstraction and postmodern works; will consider all styles. Genres include landscapes, florals and Southwestern and Western themes. Prefers contemporary Western, Southwestern and realism. Likes "contemporary American art, specializing in art of the 'New West.' Our galleries exhibit realistic and abstract paintings, drawings and sculpture by American artists.

Terms: Accepts work on consignment. Retail price set by the gallery and the artist. Exclusive area representation required. Gallery provides insurance, promotion and contract; gallery pays for shipping costs from gallery. Prefers framed artwork.

Submissions: Send query letter with résumé, brochure, slides, photographs, bio and SASE. Replies in 2 weeks. All material is returned with SASE. No appointments are made.

Tips: "Include a complete slide identification list, including availability of works and prices. The most common mistakes are presenting poor reproductions."

JOAN CAWLEY GALLERY, LTD., 7135 E. Main St., Scottsdale AZ 85251. (602)947-3548. Fax: (602)947-7255. E-mail: joanc@jcgltd.com. Website: http://www.jcgltd/com. President: Joan M. Cawley. Retail gallery and print publisher. Estab. 1974. Represents 20 emerging, mid-career and established artists/year. Exhibited artists include: Carol Grigg, Adin Shade. Sponsors 5-10 shows/year. Average display time 2-3 weeks. Open all year; Monday-Saturday, 10-5; Thursday, 7-9. Located in art district, center of Scottsdale; 2,730 sq. ft. (about 2,000 for exhibiting); high ceilings, glass frontage and interesting areas divided by walls. 50% of space for special exhibitions; 75% of space for gallery artists. Clientele: tourists, locals. 90% private collectors. Overall price range: $100-12,000; most work sold at $3,500-5,000.

Media: Considers all media except fabric or cast paper; all graphics. Most frequently exhibits acrylic on canvas, watercolor, pastels and chine colle.

Style: Exhibits expressionism, painterly abstraction, Impressionism. Exhibits all genres. Prefers Southwestern and contemporary landscapes, figurative, wildlife.

Terms: Accepts work on consignment (50% commission.) Gallery provides insurance, promotion and contract; shipping

costs are shared. Prefers artwork framed.

Submissions: Prefers artists from west of Mississippi. Send query letter with bio and at least 12 slides or photos. Call or write for appointment to show portfolio of photographs, slides or transparencies. Replies as soon as possible.

Tips: "We are a contemporary gallery in the midst of traditional Western galleries. We are interested in seeing new work always." Advises artists approaching galleries to "check out the direction the gallery is going regarding subject matter and media. Also always make an appointment to meet with the gallery personnel. We always ask for a minimum of five to six paintings on hand. If the artist sells for the gallery we want more but a beginning is about six paintings."

EL PRESIDIO GALLERY, 7000 E. Tanque Verde Rd., Tucson AZ 85715. (520)733-0388. E-mail: presidio@dakotaco m.net. Director: Henry Rentschler. Retail gallery. Estab. 1981. Represents 30 artists; emerging, mid-career and established. Sponsors 5-6 group shows/year. Average display time 2 months. Located at upscale Santa Fe Square Shopping Plaza; 7,000 sq. ft. of exhibition space. Accepts mostly artists from the West and Southwest. Clientele: locals and tourists. 80% private collectors, 20% corporate clients. Overall price range: $500-20,000; most artwork sold at $1,000-5,000.

Media: Considers oil, acrylic, watercolor, mixed media, works on paper, sculpture, ceramic, glass, egg tempera, pastel and original handpulled prints. Most frequently exhibits oil, watercolor and acrylic.

Style: Exhibits Impressionism, expressionism, realism, photorealism and painterly abstraction. Genres include landscapes, Southwestern, Western, wildlife and figurative work. Prefers realism, representational works and representational abstraction.

Terms: Accepts work on consignment (50% commission). Retail price set by the gallery and the artist. Exclusive area representation required. Gallery provides insurance, promotion and contract; artist pays for shipping. Prefers framed artwork.

Submissions: Send query letter with résumé, brochure, slides, photographs with sizes and retail prices, bio and SASE. Call or write to schedule an appointment to show a portfolio, which should include originals, slides, transparencies and photographs. A common mistake is artists overpricing their work. Replies in 2 weeks.

Tips: "Work hard. Have a professional attitude. Be willing to spend money on good frames."

ELEVEN EAST ASHLAND INDEPENDENT ART SPACE, 11 E. Ashland, Phoenix AZ 85004. (602)257-8543. Director: David Cook. Estab. 1986. Represents emerging, mid-career and established artists. Exhibited artists include Erastes Cinaedi, Frank Mell, David Cook, Vernita N. Cognita, Ron Crawford and Mark Dolce. Sponsors 1 juried, 1 invitational and 13 solo and mixed group shows/year. Average display time 3 weeks. Located in "two-story old farm house in central Phoenix, off Central Ave." Overall price range: $100-5,000; most artwork sold at $100-800.

 ● An anniversary exhibition is held every year in April and is open to national artists. Work must be submitted by March. Work will be for sale, and considered for permanent collection and traveling exhibition. Also sponsors an "Adults Only" show.

Media: Considers all media. Most frequently exhibits photography, painting, mixed media and sculpture.

Style: Exhibits all styles, preferably contemporary. "This is a non-traditional proposal exhibition space open to all artists excluding Western and Southwest styles (unless contemporary style)."

Terms: Accepts work on consignment (25% commission); rental fee for space covers 1 month. Retail price set by artist. Artist pays for shipping.

Submissions: Accepts proposal in person or by mail to schedule shows 6 months in advance. Send query letter with résumé, brochure, business card, 3-5 slides, photographs, bio and SASE. Call or write for appointment to show portfolio of slides and photographs. Be sure to follow through with proposal format. Replies only if interested within 1 month. Samples are filed or returned if not accepted or under consideration.

Tips: "Be yourself, avoid hype and commercial glitz. Be ready to show, sincere and have a positive attitude. Our space is somewhat unique as I deal with mostly new and emerging artists. The main thing I look for is confidence, workmanship and presentation. Don't be afraid to approach exhibition opportunities. Avoid trade/craft type shows. Be willing to be involved with exhibiting and promoting your work. Avoid gaudy presentation."

☑ MESA CONTEMPORARY ARTS, (formerly Galeria Mesa), 155 N. Center, Box 1466, Mesa AZ 85211-1466. (602)644-2056. Fax: (602)644-2901. E-mail: robert_schultz@ci.mesa.az.us. Website: http://www.mesaarts.com. Owned and operated by the City of Mesa. Estab. 1981. Exhibits the work of emerging, mid-career and established artists. "We only do national juried shows and curated invitationals. We are an exhibition gallery, NOT a commercial sales gallery." Sponsors 8 shows/year. Average display time 4-6 weeks. Closed August. Located downtown; 3,600 sq. ft., "wood floors, 14′ ceilings and monitored security." 100% of space for special exhibitions. Clientele: "cross section of Phoenix metropolitan area." 95% private collectors, 5% gallery owners. "Artists selected only through national juried exhibitions." Overall price range: $100-10,000; most artwork sold at $200-400.

Media: Considers all media including sculpture, painting, printmaking, photography, fibers, glass, wood, metal, video, ceramics, installation and mixed.

Style: Exhibits all styles and genres. Interested in seeing contemporary work.

Terms: Charges 25% commission. Retail price set by artist. Gallery provides insurance, promotion and contract; pays for shipping costs from gallery. Requires framed artwork.

Submissions: Send a query letter or postcard with a request for a prospectus. After you have reviewed prospectus, send up to 8 slides. "We do not offer portfolio review. Artwork is selected through national juried exhibitions." Files

slides and résumés. Finds artists through gallery's placement of classified ads in various art publications, mailing news releases and word of mouth.

Tips: "Scout galleries to determine their preferences before you approach them. Have professional quality slides. Present only your very best work in a professional manner."

SCHERER GALLERY, Hillside, 671 Hwy. 179, Sedona AZ 86336. (520)203-9000. Fax: (520)203-0643. Owners: Tess Scherer and Marty Scherer. Retail gallery. Estab. 1968. Represents over 30 mid-career and established artists. Interested in seeing the work of emerging artists. Exhibited artists include Tamayo, Hundertwasser, Friedlaender, Delaunay, Calder and Barnet. Sponsors 4 solo and 3 group shows/year. Average display time 2 months. Open daily 10-6. 1,200 sq. ft.; 25% of space for special exhibitions; 75% for gallery artists. Clientele: upscale, local community and international collectors. 90% private collectors, 10% corporate clients. Overall price range: $1,000-20,000; most artwork sold at $5,000-10,000.
- This gallery moved from New Jersey to Arizona in 1997. Owners say "after 30 years in New Jersey we headed for a warmer climate. So far, we love it here."

Media: Considers non-functional glass sculpture; paintings and other works on paper including hand-pulled prints in all mediums; and kaleidoscopes.

Style: Exhibits color field, minimalism, surrealism, expressionism, modern and post modern works. Looking for artists "with a vision. Work that shows creative handling of the medium(s) and uniqueness to the style—'innovation,' 'enthusiasm.' " Specializes in handpulled graphics, art-glass and kaleidoscopes.

Terms: Accepts work on consignment (50% commission). Retail price set by artist. Exclusive area representation required. Gallery provides insurance, promotion and contract; shipping costs are shared.

Submissions: Send query letter, résumé, bio, at least 12 slides (no more than 30), photographs and SASE. Follow up with a call for appointment to show portfolio. Replies in 2-4 weeks.

Tips: "Persevere! Don't give up!" Considers "originality and quality of the work."

 TRAILSIDE FINE ART GALLERIES, 7330 Scottsdale Mall, Scottsdale AZ 85251. (602)945-7751. Fax: (602)946-9025. Contact: Joan M. Griffith. Retail gallery. Estab. 1963. Represents/exhibits approximately 75 emerging, mid-career and established artists/year. Exhibited artists include G. Harvey and Clyde Aspevig. Sponsors 10-12 shows/year. Average display time 2 weeks. Open all year; Monday-Saturday, 10-5:30. Located in downtown Scottsdale Old Town; approximately 5,500 sq. ft. 100% of space for gallery artists. Clientele: tourists, upscale, local community and international. 75% private collectors, 25% corporate collectors. Overall price range: $5,000-100,000; most work sold at $5,000-50,000.
- Trailside Americana has a second location at P.O. Box 1149, Jackson WY 83001.

Media: Considers oil, pen & ink, acrylic, drawing, sculpture, watercolor, mixed media and pastel. Does not consider prints. Most frequently exhibits oils, bronzes and watercolors.

Style: Exhibits realism and Impressionism. Genres include florals, Western, wildlife, Southwestern, landscapes, Americana and figurative work. Prefers Western art, landscapes and Impressionism.

Terms: Artwork is accepted on consignment and there is a 33⅓% commission. Retail price set by gallery and artist.

Submissions: Send query letter with résumé, slides and bio. Call for appointment to show portfolio of photographs, slides and transparencies. Usually replies only if interested within 2 weeks. Files brochures. Finds artists through referrals, word of mouth and artists' submissions.

WILDE-MEYER GALLERY, 4142 North Marshall Way, Scottsdale AZ 85251. (602)945-2323. Fax: (602)941-0362. Co-owner: Betty Wilde. Retail/wholesale gallery and art consultancy. Estab. 1983. Represents/exhibits 40 emerging, mid-career and established artists/year. Exhibited artists include Linda Carter-Holman and Jacqueline Rochester. Sponsors 5-6 shows/year. Average display time 1-12 months rotating. Open all year; Monday-Saturday, 9-6; Sunday, 12-4. Located in downtown Scottsdale in the heart of Art Walk; 3,000 sq. ft.; 20% of space for special exhibitions; 80% of space for gallery artists. Clientele: upscale tourists: local community. 50% private collectors, 50% corporate collectors. Overall price range: $1,000-20,000; most work sold at $1,500-5,000.

Media: Considers all media and all types of prints. Most frequently exhibits original oil/canvas, mixed media and originals on paper.

Style: Exhibits primitivism, painterly abstraction, figurative, landscapes, all styles. All genres. Prefers contemporary artwork.

Terms: Accepts work on consignment (50% commission). Retail price set by gallery and artist. Insurance and promotion shared 50/50 by artist and gallery. Artist pays for shipping costs.

Submissions: Send query letter with résumé, slides, bio, photographs, SASE, business card, reviews and prices. Write for appointment to show portfolio of photographs, slides, bio and prices. Replies only if interested within 4-6 weeks.

● **SPECIAL COMMENTS** within listings by the editor of *Artist's & Graphic Designer's Market* are set off by a bullet.

Files all material if interested. Finds artists through word of mouth, referrals by artists and artists' submissions.
Tips: "Just do it."

Arkansas

AMERICAN ART GALLERY, 724 Central Ave., Hot Springs National Park AR 71901. (501)624-0550. Website: http://411web.com/A/americanartgallery/. Retail gallery. Estab. 1990. Represents 22 emerging, mid-career and established artists. Exhibited artists include Jimmie Tucek and Jimmie Leach. Sponsors 12 shows/year. Average display time 1 month. Open all year. Located downtown; 4,000 sq. ft.; 40% of space for special exhibitions. Clientele: private, corporate and the general public. 85% private collectors, 15% corporate collectors. Overall price range: $50-12,000; most work sold at $350-800.
Media: Considers oil, acrylic, watercolor, pastel, pen & ink, sculpture, ceramic, photography, original handpulled prints, woodcuts, wood engravings, lithographs and offset reproductions. Most frequently exhibits oil, wood sculpture and watercolor.
Style: Exhibits all styles and genres. Prefers realistic, abstract and impressionistic styles; wildlife, landscapes and floral subjects.
Terms: Accepts work on consignment (40% commission). Retail price set by gallery and the artist. Gallery provides promotion and contract; artist pays for shipping. Offers customer discounts and payment by installments. Prefers artwork framed.
Submissions: Prefers Arkansas artists, but shows 5-6 others yearly. Send query letter with résumé, 8-12 slides, bio and SASE. Call or write for appointment to show portfolio of originals and slides. Reports in 6 weeks. Files copy of résumé and bio. Finds artists through agents, by visiting exhibitions, word of mouth, various art publications and sourcebooks, submissions/self promotions and art collectors' referrals.
Tips: "We have doubled our floor space and have two floors which allows us to separate the feature artist from the regular artist. We have also upscaled the quality of artwork exhibited. Our new gallery is located between two other galleries. It's a growing art scene in Hot Springs."

THE ARKANSAS ARTS CENTER, P.O. Box 2137, Little Rock AR 72203. (501)372-4000. Fax: (501)375-8053. Curator of Art: Brian Young. Curator of Decorative Arts: Alan DuBois. Museum art school, children's theater and traveling exhibition service. Estab. 1930s. Exhibits the work of emerging, mid-career and established artists. Sponsors 25 shows/year. Average display time 6 weeks. Open all year. Located downtown; 10,000 sq. ft.; 60% of space for special exhibitions.
Media: Most frequently exhibits drawings and crafts.
Style: Exhibits all styles and all genres.
Terms: Retail price set by the artist. "Work in the competitive exhibitions (open to artists in Arkansas and six surrounding states) is for sale; we usually charge 10% commission."
Submissions: Send query letter with samples, such as photos or slides.
Tips: Write for information about exhibitions for emerging and regional artists, and various themed exhibitions.

ARKANSAS STATE UNIVERSITY FINE ARTS CENTER GALLERY, P.O. Drawer 1920, State University AR 72467. (870)972-3050. E-mail: csteele@aztec.astate.edu. Website: http://www.astate.edu/docs/acad/cf2/art. Chair, Department of Art: Curtis Steele. University—Art Department Gallery. Estab. 1968. Represents/exhibits 3-4 emerging, mid-career and established artists/year. Sponsors 3-4 shows/year. Average display time 1 month. Open fall, winter and spring; Monday-Friday, 10-4. Located on university campus; 1,600 sq. ft.; 60% of time devoted to special exhibitions; 40% to faculty and student work. Clientele: students/community.
Media: Considers all media. Considers all types of prints. Most frequently exhibits painting, sculpture and photography.
Style: Exhibits conceptualism, photorealism, neo-expressionism, minimalism, hard-edge geometric abstraction, painterly abstraction, postmodern works, realism, Impressionism and pop. "No preference except quality and creativity."
Terms: Exhibition space only; artist responsible for sales. Retail price set by the artist. Gallery provides insurance, promotion and contract; shipping costs are shared. Prefers artwork framed.
Submissions: Send query letter with résumé, slides and SASE. Portfolio should include photographs, transparencies and slides. Replies only if interested within 2 months. Files résumé. Finds artists through call for artists published in regional and national art journals.
Tips: "Show us 20 slides of your best work. Don't overload us with lots of collateral materials (reprints of reviews, articles, etc.). Make your vita as clear as possible."

CANTRELL GALLERY, 8206 Cantrell Rd., Little Rock AR 72207. (501)224-1335. E-mail: cgallery@aristotle.net. Website: http://www.befound.com/bargainart/. President: Helen Scott; Director: Cindy Huisman. Wholesale/retail gallery. Estab. 1970. Represents/exhibits 75 emerging, mid-career and established artists/year. Exhibited artists include Boulanger, Dali, G. Harvey, Warren Criswell, N. Scolt and Robin Morris. Sponsors 8-10 shows/year. Average display time 1 month. Open all year; Monday-Saturday, 10-5. Located in the strip center; 3,500 sq. ft.; "we have several rooms and different exhibits going at one time." Clientele: collectors, retail, decorators. Overall price range: $100-10,000; most work sold at $250-3,000.

Media: Considers oil, acrylic, watercolor, pastel, pen & ink, drawing, mixed media, collage, paper, sculpture, woodcut, engraving, lithograph, wood engraving, mezzotint, serigraphs, linocut, etching. Most frequently exhibits etchings, water-color, mixed media, oils and acrylics.

Style: Exhibits eclectic work, all genres.

Terms: Gallery provides insurance and promotion; shipping costs are shared. Prefers artwork unframed.

Submissions: Send query letter with résumé, 5 photos and bio. Write for appointment to show portfolio of originals. Replies in 2 months. Files all material. Finds artists through agents, by visiting exhibitions, word of mouth, art publications and sourcebooks, artists' submissions.

Tips: "Be professional. Be honest. Place a retail price on each piece, rather than only knowing what 'you need to get' for the piece. Don't spread yourself too thin—in any particular area—only show in one gallery."

DUCK CLUB GALLERY, 2333 N. College, Fayetteville AR 72703. (501)443-7262. Vice President-Secretary: Frances Sego. Retail gallery. Estab. 1980. Represents mid-career and established artists. May be interested in seeing the work of emerging artists in the future. Exhibited artists include Terry Redlin, Jane Garrison and Linda Cullers. Displays work "until it sells." Open all year; Monday-Friday, 10-5:30; Saturday, 10-4. Located midtown; 1,200 sq. ft. 100% of space for gallery artists. Clientele: tourists, local community, students "we are a university community." 80% private collectors, 20% corporate collectors. Overall price range: $50-400; most work sold at $50-200.

Media: Considers all media including wood carved decoys. Considers engravings, lithographs, serigraphs, etchings, posters. Most frequently exhibits limited edition and open edition prints and poster art.

Style: Exhibits and styles and genres. Prefers: wildlife, local art and landscapes.

Terms: Buys outright for 50% of retail price (net 30 days). Retail price set by the artist. Gallery provides insurance and promotion; artist pays for shipping. Prefers artwork unframed.

Submissions: Send query letter with brochure, photographs and business card. Write for appointment to show portfolio. Finds artists through word of mouth, referrals by other artists, visiting art fairs and exhibitions, submissions, referrals from customers.

GALLERY FOUR INC., 11330 Arcade Dr., Little Rock AR 72212-4084. (501)224-4090. E-mail: mmargo7421@aol.com. Owner: Michael Margolis. Retail gallery. Estab. 1985. Open all year; Tuesday-Friday, 10-5:30; Saturday, 10-5; also by appointment. Located in West Little Rock; 650 sq. ft. Clientele: upscale-local. 100% private collectors. Overall price range: $50-750; most work sold at $100-350.

Media: Considers all media and all types of prints. Most frequently exhibits watercolor, pastel and oil-acrylic.

Style: Exhibits all styles and all genres. Prefers Impressionism, wildlife and portrait.

Terms: Accepts work on consignment (40% commission). Retail price set by the gallery and the artist. Gallery provides insurance, promotion and contract. Artist pays shipping costs. Prefers artwork unframed.

Submissions: Send query letter with brochure, business card and 2-3 slides. Call for appointment to show portfolio of slides. Replies in 1 week. Files name, address, phone and type of artwork and sizes. Finds artists through word of mouth and artist's submissions.

Tips: "Ask! Don't be afraid to ask for gallery representation. We're all human. 'No' is just a word. It's a numbers game. Don't stop until you find a gallery that will give you a chance. We all started somewhere—didn't we?"

SOUTH ARKANSAS ARTS CENTER, 110 E. Fifth, El Dorado AR 71730. (870)862-5474. Fax: (870)862-4921. Executive Director: Linda Boydsten. Nonprofit gallery. Estab. 1963. Exhibits the work of 50 emerging, mid-career and established artists. Exhibited artists include George Price and Dee Ludwig. Sponsors 15 shows/year. Average display time 1 month. Open all year. Located "in the middle of town; 3,200 sq. ft." 60% of space for special exhibitions. 100% private collectors. Overall price range: $50-1,500; most work sold at $200-300.

Media: Considers all media and prints. Most frequently exhibits watercolor, oil and mixed media.

Style: Exhibits all styles.

Terms: Accepts work on consignment (25% commission). Retail price set by the artist. Gallery provides insurance and promotion; contract and shipping may be negotiated. Prefers artwork framed.

Submissions: Send query with slides, photographs, SASE and "any pertinent materials." Only after a query, call to schedule an appointment to show a portfolio. Portfolio should include originals and artist's choice of work. Replies in 2 weeks. Files materials unless artist requests return. "Keeping something on file helps us remember your style."

Tips: "We exhibit a wide variety of works by local, regional and national artists. We have facilities for 3-D works."

California

N BOEHM GALLERY, Palomar College, 1140 W. Mission Rd., San Marcos CA 92069-1487. (760)744-1150 ext. 2304. Fax: (760)744-8123. Gallery Director: Harry E. Bliss. Nonprofit gallery. Estab. 1966. Represents/exhibits mid-career artists. May be interested in seeing the work of emerging artists in the future. Generally exhibits 30 or more artists/year in solo and group exhibitions, supplemented with faculty, student work. Exhibited artists include top illustrators, crafts people, painters and sculptors. Sponsors 6 shows/year. Average display time 4-5 weeks. Open fall and spring semester; Tuesday 10-4; Wednesday-Thursday 10-7; Friday-Saturday 10-2; closed Sunday, Monday and school holidays. Located on the Palomar College campus in San Marcos; 2,000 sq. ft.; 100% of space for special exhibitions. Clientele:

regional community, artists, collectors and students. "Prices range dramatically depending on exhibition type and artist . . . $25 for student works to $10,000 for paintings, drawings, oils and installational sculptural works."

Media: Considers all media. Considers all types of prints. Most frequently exhibits installation art, painting, sculpture, glass, illustration, quilts, ceramics, furniture design and photography.

Style: Exhibits all styles. Styles vary. Exhibits primarily group exhibits based on either a medium or theme or genre.

Terms: If artwork is sold, gallery retains 10% gallery "donation." Gallery provides insurance and promotion.

Submissions: Accepts primarily artists from Southern California. Send query letter with résumé, slides, reviews and bio. Call or write for appointment to show portfolio of photographs and slides. Replies in 2-3 months. Files artist bio and résumé. Finds artists through "artist network, other reviewed galleries, or university visits or following regional exhibitions, and referrals from other professional artists and crafts people."

Tips: Advises artists to show "Clear focus for art exhibition and good slides. Lucid, direct artist statement. Be willing to take part in group exhibits—we have very few strictly 'solo' shows and then only for very prominent artists. Be professional in your contacts and presentations and prompt or meeting deadlines for response. Have a unified body of work which is identifiable as your expression."

COAST GALLERIES, Big Sur, Pebble Beach, CA; Hana, HI. Mailing address: P.O. Box 223519, Carmel CA 93922. (408)625-4145. Fax: (408)625-3575. Owner: Gary Koeppel. Retail gallery. Estab. 1958. Represents 300 emerging, mid-career and established artists. Sponsors 3-4 shows/year. Open all year. Located in both rural and resort hotel locations; 3 separate galleries—square footage varies, from 900-3,000 sq. ft. "The Hawaii galleries feature Hawaiiana; our Big Sur gallery is constructed of redwood water tanks and features Central California Coast artists and imagery." 100% of space for special exhibitions. Clientele: 90% private collectors, 10% corporate collectors. Overall price range: $25-60,000; most work sold at $400-4,000.

● They enlarged their Big Sur Coast Gallery and added a 100-seat restaurant.

Media: Considers all media; engravings, lithographs, posters, etchings, wood engravings and serigraphs. Most frequently exhibits bronze sculpture, limited edition prints, watercolor and oil on canvas.

Style: Exhibits Impressionism and realism. Genres include landscapes, marine and wildlife.

Terms: Accepts work on consignment (50% commission), or buys outright for 40% of retail price (net 30 days.) Retail price set by gallery. Gallery provides insurance, promotion and contract; artist pays for shipping. Requires artwork framed.

Submissions: Accepts only artists from Hawaii for Maui galleries; coastal and wildlife imagery for California galleries; interested in Central California Coast imagery for Pebble Beach gallery. Send query letter with résumé, slides, bio, brochure, photographs, SASE, business card and reviews. Write for appointment to show portfolio of photographs, slides and transparencies. Replies in 2 weeks.

PATRICIA CORREIA GALLERY, 2525 Michigan Ave., Bergamot Station #E2, Santa Monica CA 90404. (310)264-1760. (310)264-1762. E-mail: correia@earthlink.net. Website: http://www.correiagallery.com. Director: Patricia Correia. Retail gallery. Estab. 1991. Represents 12-15 emerging, mid-career and established artists. Exhibited artists include Steve V. Correia and Steve Schauer. Sponsors 8 shows/year. Average display time 6 weeks. Open all year. 80% of space for special exhibitions; 20% of space for gallery artists. Clientele: upper middle class, young. 90% private collectors, 10% corporate collectors. Overall price range: $100-20,000; most work sold at $1,000-5,000.

● Located in fashionable Bergamot Station, arts district surrounded by other interesting galleries.

Media: Considers all media.

Style: Exhibits contemporary art.

Terms: Accepts work on consignment (50% commission). Retail price set by gallery and artist. Gallery provides insurance, promotion, contract and shipping costs from gallery.

Submissions: Submit for juried exhibition; upon request or referral.

Tips: "The role as a dealer is different in contemporary time. It is as helpful for the artist to learn how to network with museums, press and the art world, as well as the gallery doing the same. It takes creative marketing on both parts."

CREATIVE GROWTH ART CENTER GALLERY, 355 24th St., Oakland CA 94612. (510)836-2340. Fax: (510)836-0769. E-mail: creativg@dnai-com. Executive Director: Irene Ward Brydon. Nonprofit gallery. Estab. 1978. Represents 100 emerging and established artists; 100 adults with disabilities work in our adjacent studio. Exhibited artists include Dwight Mackintosh, Nelson Tygart. Sponsors 10 shows/year. Average display time 5 weeks. Open all year; Monday-Friday, 10-4. Located downtown; 1,200 sq. ft.; classic large white room with movable walls, track lights; visible from the street. 25% of space for special exhibitions; 75% of space for gallery artists. Clientele: private and corporate collectors. 90% private collectors, 10% corporate collectors. Overall price range: $50-4,000; most work sold at $100-250.

● This gallery concentrates mainly on the artists who work in an adjacent studio, but work from other regional or national artists may be considered for group shows. Only outsider and brut art are shown. Brut art is like Brut champagne—raw and undistilled. Most of the artists have not formally studied art, but have a raw talent that is honest and real with a strong narrative quality.

Media: Considers oil, acrylic, watercolor, pastel, pen & ink, drawing, mixed media, collage, paper, sculpture, ceramics, fiber, woodcuts, engravings, lithographs, wood engravings, mezzotints, serigraphs, linocuts and etchings. Most frequently exhibits (2-D) drawing and painting, (3-D) sculpture, hooked rug/tapestries.

Style: Exhibits expressionism, primitivism, color field, naive, folk art, brut. Genres include landscapes, florals and

figurative work. Prefers brut/outsider, contemporary, expressionistic.

Terms: Accepts work on consignment (40% commission). Retail price set by the gallery. Gallery provides insurance, promotion and contract; artist pays shipping costs to and from gallery. Prefers artwork framed.

Submissions: Prefers only brut, naive, outsider; works by adult artists with disabilities. Send query letter with résumé, slides, bio. Write for appointment to show portfolio of photographs and slides. Replies only if interested. Files slides and printed material. Finds artists through agents, by visiting exhibitions, word of mouth, various art publications and sourcebooks, submissions and networking.

Tips: "Peruse publications that feature brut and expressionistic art (example: *Raw Vision*)."

CUESTA COLLEGE ART GALLERY, P.O. Box 8106, San Luis Obispo CA 93403-8106. (805)546-3202. Fax: (805)546-3904. E-mail: miacross@bass.cuesta.cc.ca.us. Website: http://www.thegrid.net/fine.arts/gallery.html. Director: Marta Peluso. Nonprofit gallery. Estab. 1965. Exhibits the work of emerging, mid-career and established artists. Exhibited artists include Italo Scanga and JoAnn Callis. Sponsors 5 shows/year. Average display time 4½ weeks. Open all year. Space is 750 sq. ft.; 100% of space for special exhibitions. Overall price range: $250-5,000; most work sold at $400-1,200.

Media: Considers all media and all types of prints. Most frequently exhibits painting, sculpture and photography.

Style: Exhibits all styles, mostly contemporary.

Terms: Accepts work on consignment (20% commission). Retail price set by artist. Customer discounts and payment by installment are available. Gallery provides insurance, promotion and contract; shipping costs are shared. Prefers artwork framed.

Submissions: Send query letter with résumé, slides, bio, brochure, SASE and reviews. Call for appointment to show portfolio. Replies in 6 months. Finds artists mostly by reputation and referrals, sometimes through slides.

Tips: "We have a medium budget, thus cannot pay for extensive installations or shipping. Present your work legibly and simply. Include reviews and/or a coherent statement about the work. Don't be too slick or too sloppy."

N DEL MANO GALLERY, 11981 San Vicente Blvd., W. Los Angeles CA 90049. (310)476-8508; or 33 E. Colorado Blvd., Pasadena CA 91105. (818)793-6648. Assistant Director: Chris Drosse. Retail gallery. Estab. 1973. Represents 300+ emerging, mid-career and established artists. Interested in seeing the work of emerging artists working in wood, glass, ceramics, fiber and metals. Los Angeles gallery location deals heavily in turned and sculpted wood, showing work by David Ellsworth, William Hunter and Ron Kent. Pasadena gallery location has a special exhibition space for furniture and home accessories. Each gallery hosts approximately 5 exhibitions per year. Average display time 2-6 months. Open 7 days a week in Pasadena; L.A. location open Tuesday-Sunday. Galleries located in Brentwood (a scenic corridor) and Old Pasadena (a business district). Space is 3,000 sq. ft. in each gallery. 25% of space for special exhibitions; 75% of space for gallery artists. Clientele: professionals and affluent collectors. 20% private collectors, 5% corporate collectors. Overall price range: $50-20,000; most work sold at $250-5,000.

Media: Considers contemporary art in craft media—ceramics, glass, jewelry, wood, fiber. No prints. Most frequently exhibits wood, glass, ceramics, fiber, metal and jewelry.

Style: Exhibits all styles and genres.

Terms: Accepts work on consignment (50% commission) or 30 days net. Retail price set by gallery and artist. Customer discounts and payment by installment are available. 10-mile exclusive area representation required. Gallery provides insurance, promotion and shipping costs from gallery. Prefers artwork framed.

Submissions: Send query letter with résumé, slides, bio and prices. "Please contact Chris Drosse for details." Portfolio should include slides, price list, artist's statement and bio."

SOLOMON DUBNICK GALLERY, 2131 Northrop Ave., Sacramento CA 95825. (916)920-4547. Fax: (916)923-6356. Director: Shirley Dubnick. Retail gallery and art consultancy. Estab. 1981. Represents/exhibits 20 emerging, mid-career and established artists/year. "Must have strong emerging record of exhibits." Exhibited artists include Jerald Silva and Gary Pruner. Sponsors 11-12 shows/year. Average display time 1 month. Open all year; Tuesday-Saturday, 11-6 or by appointment. Located in suburban area on north side of Sacramento; 7,000 sq. ft.; large space with outside sculpture space for large scale, continued exhibition space for our stable of artists, besides exhibition space on 1st floor. Movable walls for unique artist presentations. 75% of space for special exhibitions; 25% of space for gallery artists. Clientele: upscale, local, students, national and international clients due to wide advertising of gallery. 80% private collectors, 20% corporate collectors. Overall price range: $500-50,000; most work sold at $2,000-10,000.

Media: Considers oil, pen & ink, paper, acrylic, drawing, sculpture, watercolor, mixed media, ceramics, pastel and photography. Considers original prints produced only by artists already represented by gallery. Most frequently exhibits painting, sculpture and works on paper.

Style: Exhibits all styles (exhibits very little abtract paintings unless used in landscape). Genres include landscapes, figurative and contemporary still life. Prefers figurative, realism and color field.

Terms: Accepts work on consignment (50% commission). Commission may differ on certain sculpture. Retail price set by the gallery with artist concerns. Gallery provides insurance, promotion and contract; shipping costs are shared (large scale delivery to and from gallery is paid for by artist). Prefers artwork framed.

Submissions: Accepts only artists from Northern California with invited artists outside state. Send query letter with résumé, slides, photographs, reviews, bio and SASE. Call for appointment to show portfolio of photographs, transparencies and slides. Replies only if interested within 3-4 weeks. Files all pertinent materials. Finds artists through word of mouth, referrals by other artists, art fairs, advertising in major art magazines and artists' submissions.

Tips: "Be professional. Do not bring work into gallery without appointment with Director or Assistant Director. Do not approach staff with photographs of work. Be patient."

[N] ELECTRIC AVE/SHARON TRUAX FINE ART, 1625 Electric Ave., Venice CA 90291. Phone/fax: (310)396-3162. E-mail: meta_arts@earthlink.net. Contact: Sharon Truax. *A Meta-Arts Space.* Estab. 1987. Exhibitions and projects by emerging and established artists. Visioning and workshops—Healing Through Art. Open all year by appointment. 1,500 sq. ft. warehouse; "clean viewing space with 30 ft. ceiling, and intimate salon-viewing area opening to garden." 60% of space for special exhibitions. Clientele: 70% private collectors, 30% corporate collectors. Overall price range: $1,000-125,000; most work sold at $5,000-18,000.
Media: Considers all media. Most frequently exhibits painting.
Style: Exhibits painterly abstraction, minimalism and constructivism. Genres include landscape, "eclectic venue."
Submissions: "Open to unique projects." Send query letter and include only materials which don't need to be returned. Portfolio review requested if interested in artist's work. Finds artists through word of mouth, other artists and artists' submissions.

[N] GALLERY EIGHT, 7464 Girard Ave., La Jolla CA 92037. (619)454-9781. Director: Ruth Newmark. Retail gallery with focus on craft. Estab. 1978. Represents 100 emerging and mid-career artists. Interested in seeing the work of emerging artists. Exhibited artists include Philip Moulthrop, Yoshiro Ikeda and Ken Loeber. Sponsors 6 shows/year. Average display time 6-8 weeks. Open all year; Monday-Saturday, 10-5. Located downtown; 1,200 sq. ft.; slightly post-modern. 25% of space for special exhibitions; 100% of space for gallery artists. Clientele: upper middle class, mostly 35-60 in age. Overall price range: $5-5,000; most work sold at $25-150.
Media: Considers ceramics, metal, wood, craft, fiber and glass. Most frequently exhibits ceramics, jewelry, other crafts.
Terms: Accepts work on consignment (50% commission) or buys outright for 50% of retail price (net 30 days). Retail price set by the gallery and the artist. Gallery provides insurance, promotion and shipping costs from gallery; artist pays shipping costs to gallery.
Submissions: Send query letter with résumé, slides, photographs, reviews and SASE. Call or write for appointment to show portfolio of photographs and slides. Replies in 1-3 weeks. Files "generally only material relating to work by artists shown at gallery." Finds artists by visiting exhibitions, word of mouth, various art publications and sourcebooks, submissions, through agents, and juried fairs.
Tips: "Make appointments. Do not just walk in and expect us to drop what we are doing to see work."

GREENLEAF GALLERY, 20315 Orchard Rd., Saratoga CA 95070. (408)867-3277. Owner: Janet Greenleaf. Director: Chris Douglas. Collection and art consultancy and advisory. Estab. 1979. Represents 45 to 60 emerging, mid-career and established artists. By appointment only. "Features a great variety of work in diverse styles and media. We have become a resource center for designers and architects, as we will search to find specific work for all clients." Clientele: professionals, collectors and new collectors. 50% private collectors, 50% corporate clients. Prefers "very talented emerging or professional full-time artists—already established." Overall price range: $400-15,000; most artwork sold at $500-8,000.
Media: Considers oil, acrylic, watercolor, pastel, mixed media, collage, works on paper, sculpture, glass, original handpulled prints, lithographs, serigraphs, etchings and monoprints.
Style: Deals in expressionism, neo-expressionism, minimalism, Impressionism, realism, abstract work or "whatever I think my clients want—it keeps changing." Traditional, landscapes, florals, wildlife, figurative and still lifes.
Terms: Artwork is accepted on consignment. "The commission varies." Artist pays for shipping or shipping costs are shared.
Submissions: Send query letter, résumé, 6-12 photographs (but slides OK), bio, SASE, reviews and "any other information you wish." Call or write to schedule an appointment for a portfolio review, which should include originals. If does not reply, the artist should call. Files "everything that is not returned. Usually throw out anything over two years old." Finds artists through visiting exhibits, referrals from clients, or artists, submissions and self promotions.
Tips: "Send good photographs with résumé and ask for an appointment. Send to many galleries in different areas. It's not that important to have a large volume of work. I would prefer to know if you are full time working artist and have representation in other galleries."

JUDITH HALE GALLERY, 2890 Grand Ave., P.O. Box 884, Los Olivos CA 93441-0884. (805)688-1222. Fax: (805)688-2342. Owner: Judy Hale. Retail gallery. Estab. 1987. Represents 70 mid-career and established artists. Exhibited artists include Neil Boyle, Susan Kliewer, Karl Dempwolf, Alice Nathan, Larry Bees and Joyce Birkenstock. Sponsors 4 shows/year. Average display time 6 months. Open all year. Located downtown; 2,100 sq. ft.; "the gallery is eclectic and inviting, an old building with six rooms." 20% of space for special exhibitions which are regularly rotated and rehung. Clientele: homeowners, tourists, decorators, collectors. Overall price range: $100-5,000; most work sold at $500-2,000.
- This gallery specializes in western artwork and California landscape, with focus on original work instead of prints. They are moving toward established-known artists.
Media: Considers oil, acrylic, watercolor, pastel, sculpture, engravings and etchings. Most frequently exhibits watercolor, oil, acrylic and sculpture.
Style: Exhibits Impressionism and realism. Genres include landscapes, florals, western and figurative work. Prefers figurative work, western, florals, landscapes, structure. No abstract or expressionistic.

Terms: Accepts work on consignment (40% commission). Retail price set by artist. Offers payment by installments. Gallery arranges reception and promotion; artist pays for shipping. Prefers artwork framed.

Submissions: Send query letter with 10-12 slides, bio, brochure, photographs, business card and reviews. Call for appointment to show portfolio of photographs. Replies in 2 weeks. Files bio, brochure and business card.

Tips: "Create a nice portfolio. See if your work is comparable to what the gallery exhibits. Do not plan your visit when a show is on; make an appointment for future time. I like 'genuine' people who present quality with fair pricing. Rotate artwork in a reasonable time, if unsold. Bring in your best work, not the 'seconds' after the show circuit."

LINCOLN ARTS, 540 F St., P.O. Box 1166, Lincoln CA 95648. (916)645-9713. Fax: (916)645-3945. E-mail: lincarts@ psyber.com. Website: http://www.lincolnarts.org. Executive Director: Jeanne-Marie Fritts. Nonprofit gallery and alternative space area coordinator. Estab. 1986. Represents 100 emerging, mid-career and established artists/year. 400 members. Exhibited artists include Bob Arneson, Tommie Moller. Sponsors 19 shows/year (9 gallery, 9 alternative and 1 major month-long ceramics exhibition). Average display time 5 weeks. Open all year; Tuesday-Saturday, 10-6, or by appointment. Located in the heart of downtown Lincoln; 900 sq. ft.; housed in a 1926 bungalow overlooking beautiful Beermann Plaza. "Our annual 'Feats of Clay®' exhibition is held inside the 125-year-old Gladding McBean terra cotta factory." 70% of space for gallery artists. 90% private collectors, 10% corporate collectors. Overall price range: $90-7,000; most work sold at $150-2,000.

Media: Considers all media including linocut prints. Most frequently exhibits ceramics and mixed media.

Style: Exhibits all styles, all genres.

Terms: Accepts work on consignment (30% commission). "Membership donation (min. $25) is encouraged but not required." Retail price set by the artist. Gallery provides promotion; artist pays shipping costs to and from gallery. Prefers artwork framed.

Submissions: Send query letter with résumé, slides or photographs, bio and SASE. Call or write for appointment to show portfolio of originals (if possible) or photographs or slides. Replies in 1 month. Artist should include SASE for return of slides/photos. Files bio, résumé, review notes. "Scheduling is done minimum one year ahead in August for following calendar year. Request prospectus for entry information for Feats of Clay© exhibition." Finds artists through visiting exhibitions, word of mouth, art publications and sourcebooks and submissions.

LIZARDI/HARP GALLERY, P.O. Box 91895, Pasadena CA 91109. (626)791-8123. Fax: (626)791-8887. E-mail: lizardiharp@carmlink.net. Director: Grady Harp. Retail gallery and art consultancy. Estab. 1981. Represents 15 emerging, mid-career and established artists/year. Exhibited artists include Christopher James, John Nava, Craig Attebery, Miguel Condé, Don Bachardy, Stephen De Staebler, Stephen Douglas, Curtis Wright, Jan Saether, Ruprecht von Kaufmann and Erik Olson. Sponsors 9 shows/year. Average display time 1 month. Open all year; Tuesday-Saturday. 80% private collectors, 20% corporate collectors. Overall price range: $900-80,000; most work sold at $2,000-15,000.

- Director reports gallery has "more emphasis on representation art now as I am curating shows and writing more about this area."

Media: Considers oil, acrylic, watercolor, pastel, pen & ink, drawing, mixed media, sculpture, installation, photography, woodcuts, lithographs, serigraphs and etchings. Most frequently exhibits works on paper and canvas, sculpture, photography.

Style: Exhibits representational art. Genres include landscapes, figurative work—both portraiture and narrative. Prefers figurative, landscapes and experimental.

Terms: Accepts work on consignment (50% commission). Retail price set by the gallery and the artist. Gallery provides insurance, promotion, contract; artist pays shipping costs.

Submissions: Send query letter with artist's statement, résumé, 20 slides, bio, photographs, SASE and reviews. Write for appointment to show portfolio of photographs, slides and transparencies. Replies in 3-4 weeks. Files "all interesting applications." Finds artists through studio visits, group shows, submissions.

Tips: "Timelessness of message is a plus (rather than trendy). Our emphasis is on quality or craftsmanship, evidence of originality . . . and maturity of business relationship concept." Artists are encouraged to send an "artist's statement with application and at least one 4×5 or print along with 20 slides."

N ⚑ JOHN NATSOULAS GALLERY, 140 "F" St., Davis CA 95616. (530)756-3938. Fax: (530)756-3961. Website: http://www.natsoulas.com. Contact: Director. Retail gallery and art consultancy. Represents 30 artists; emerging and established. Exhibited artists include Roy Deforest and Robert Arneson. Sponsors 10 shows/year. Average display time 6 weeks. Open all year. Located: downtown, 5 blocks from U.C.-Davis; 4,000 sq. ft. 70% of space for special exhibitions. 75% private collectors, 25% corporate collectors. Overall price range: $100-45,000; most work sold at $1,000-15,000.

Media: Considers oil, acrylic, watercolor, pastel, drawing, mixed media, collage, sculpture, ceramic, glass and original handpulled prints. Most frequently exhibits ceramic, oil and mixed media on paper.

Style: Exhibits expressionism, color field, realism, abstract expression and "ceramic funk." Genres include "Bay area figurative work." Prefers figurative, abstract and realist works.

Terms: Artwork is accepted on consignment (50-60% commission). Retail price set by the gallery. Gallery provides insurance and promotion; shipping costs are shared. Prefers artwork framed.

Submissions: Accepts primarily artists from California. Send query letter with SASE and all information available. Write to schedule an appointment to show a portfolio, which should include all pertinent information. Replies in 6-8 weeks. Files "only work to be represented."

ORLANDO GALLERY, 14553 Ventura Blvd., Sherman Oaks CA 91403. Website: http://artscencal.com. Co-Directors: Robert Gino and Don Grant. Retail gallery. Estab. 1958. Represents 30 emerging, mid-career and established artists. Sponsors 22 solo shows/year. Average display time is 1 month. Accepts only California artists. Overall price range: up to $35,000; most artwork sold at $2,500.
Media: Considers oil, acrylic, watercolor, pastel, pen & ink, drawings, mixed media, collage, works on paper, sculpture, ceramic and photography. Most frequently exhibits oil, watercolor and acrylic.
Style: Exhibits painterly abstraction, conceptualism, primitivism, Impressionism, photorealism, expressionism, neo-expressionism, realism and surrealism. Genres include landscapes, florals, Americana, figurative work and fantasy illustration. Prefers Impressionism, surrealism and realism. Interested in seeing work that is contemporary. Does not want to see decorative art.
Terms: Accepts work on consignment. Retail price set by artist. Offers customer discounts and payment by installments. Exclusive area representation required. Gallery provides insurance and promotion; artist pays for shipping.
Submissions: Send query letter, résumé and 12 or more slides. Portfolio should include slides and transparencies. Finds artists through submissions.
Tips: "Be inventive, creative and be yourself."

PALO ALTO ART CENTER, (formerly Palo Alto Cultural Center), 1313 Newell Rd., Palo Alto CA 94303. (650)329-2366. Director: Linda Craighead. Municipal visual arts center. Estab. 1971. Exhibits the work of regional and nationally known artists in group and solo exhibitions. Interested in established artists or emerging/mid-career artists who have worked for at least 3 years in their medium. Overall price range: $150-20,000; most artwork sold at $200-3,000.
Media: Considers oil, acrylic, watercolor, pastel, pen & ink, drawings, sculpture, ceramic, fiber, photography, mixed media, collage, glass, installation, decorative art (i.e., furniture, hand-crafted textiles, etc.) and original handpulled prints. "All works on paper must be suitably framed and behind plexiglass." Most frequently exhibits ceramics, painting, photography and fine arts and crafts.
Style: "Our gallery specializes in contemporary and historic art."
Terms: Accepts work for exhibition (10% commission). Accepts fine crafts on consignment for The Gallery Shop (40% commission). Retail price is set by gallery representation and the artist. Exclusive area representation not required. Center provides insurance, promotion and contract; artist pays for shipping.
Submissions: Send query letter, résumé, slides, business card and SASE.

[N] THE MARY PORTER SESNON GALLERY, Porter College, UCSC, Santa Cruz CA 95064. (831)459-3606. Fax: (831)459-3535. Director: Pamela Bailey. Associate Director: Bridget Barnes. University gallery, nonprofit. Estab. 1971. Features new and established artists. Sponsors 4-6 shows/year. Average display time 4-6 weeks. Open September-June; Tuesday-Saturday, noon-5. Located on campus; 1,000 sq. ft. 100% of space for changing exhibitions. Clientele: academic and community-based. "We are not a commercial gallery. Visitors interested in purchasing work are put in direct contact with artists."
Media: Considers all media.
Style: Exhibits experimental, conceptually-based work.
Terms: Gallery provides insurance, promotion, shipping costs to and from gallery and occasional publications.
Submissions: Send query letter with résumé, slides, statement, SASE and reviews. Replies only if interested within 6 months. "Material is retained for committee review and returned in SASE."

[N] POSNER FINE ART, 117 Fourth St., Manhattan Beach CA 90266. (310)260-8858. Fax: (310)260-8860. E-mail: posartl@aol.com. Website: http://www.artla.com. Director: Judith Posner. Retail gallery and art publisher. Estab. 1994. Represents 200 emerging, mid-career and established artists. Sponsors 5 shows/year. Average display time 6 weeks. Open all year, Tuesday-Saturday, 10-6; Sunday, 12-5 or by appointment. Clientele: upscale and collectors. 50% private collectors, 50% corporate collectors. Overall price range: $25-50,000; most work sold at $500-10,000.
Media: Considers oil, acrylic, watercolor, pastel, mixed media, collage, works on paper, sculpture, ceramics, original handpulled prints, engravings, etchings, lithographs, posters and serigraphs. Most frequently exhibits paintings, sculpture and original prints.
Style: Exhibits painterly abstraction, minimalism, Impressionism, realism, photorealism, pattern painting and hard-edge geometric abstraction. Genres include florals and landscapes. Prefers abstract, trompe l'oeil, realistic.
Terms: Accepts work on consignment (50% commission). Retail price set by the gallery. Customer discount and payment by installments. Gallery provides insurance and promotion; shipping costs are shared. Prefers artwork unframed.
Submissions: Send query letter with résumé, slides and SASE. Portfolio should include slides. Replies only if interested in 2 weeks. Finds artists through submissions and art collectors' referrals.
Tips: "We are looking for images for our new venture which is poster publishing. We will do a catalog. We pay a royalty on posters created."

NEED HELP? For tips on finding markets and understanding listings, see our Quick-Start Guide in the front of this book.

N TOWER GALLERY, 484 Howe Ave., Sacramento CA 95825. (916)924-1001. Fax: (916)924-1350. Director: Alan Dismuke. Retail gallery. Estab. 1983. Represents emerging and established artists. Exhibited artists include Gregory Kondos, Michael Parkes, Pradzynski. Sponsors 10-12 shows/year. Open all year, 7 days a week. Located near downtown; 5,000 sq. ft. Occasionally uses 25% of space for special exhibitions. 90% private collectors, 10% corporate collectors. Overall price range: $20-5,000.
Media: Considers oil, acrylic, watercolor, pastel, mixed media, lithograph, serigraphs and posters. Most frequently exhibits serigraphs.
Style: Exhibits all styles. Genres include landscapes and figurative work.
Terms: Accepts work on consignment (50% commission) or buys outright for 50% of retail price (net 60 days). Retail price set by the gallery. Gallery provides insurance and promotion.
Submissions: Send query letter with slides, photographs and SASE. Replies only if interested within 2 weeks.

N THE WING GALLERY, 13632 Ventura Blvd., Sherman Oaks CA 91423. (818)981-WING and (800)422-WING. Fax: (818)981-ARTS. E-mail: wingallery@aol.com. Website: http://www.winggallery.com. Director: Robin Wing. Retail gallery. Estab. 1974. Represents 100+ emerging, mid-career and established artists. Exhibited artists include Doolittle and Wysocki. Sponsors 6 shows/year. Average display time 2 weeks-3 months. Open all year. Located on a main boulevard in a charming freestanding building, carpeted; separate frame design area. 80% of space for special exhibitions. Clientele: 90% private collectors, 10% corporate collectors. Overall price range: $50-50,000; most work sold at $150-5,000.
Media: Considers oil, acrylic, watercolor, pen & ink, drawings, sculpture, ceramic, craft, glass, original handpulled prints, offset reproductions, engravings, lithographs, monoprints and serigraphs. Most frequently exhibits offset reproductions, watercolor and sculpture.
Style: Exhibits primitivism, Impressionism, realism and photorealism. Genres include landscapes, Americana, Southwestern, Western, wildlife and fantasy.
Terms: Accepts work on consignment (40-50% commission). Retail price set by gallery and artist. Sometimes offers customer discounts and payment by installments. Gallery provides insurance, promotion and contract; shipping costs are shared. Prefers unframed artwork.
Submissions: Send query letter with résumé, slides, bio, brochure, photographs, SASE, reviews and price list. "Send complete information with your work regarding price, size, medium, etc., and make an appointment before dropping by." Portfolio reviews requested if interested in artist's work. Replies in 1-2 months. Files current information and slides. Finds artists through agents, by visiting exhibitions, word of mouth, various publications, submissions, and referrals.
Tips: Artists should have a "professional presentation" and "consistent quality."

Los Angeles

N SHERRY FRUMKIN GALLERY, 2525 Michigan Ave., #T-1, Santa Monica CA 90404-4011. (310)453-1850. Fax: (310)453-8370. Retail gallery. Estab. 1990. Represents 20 emerging, mid-career and established artists. Interested in seeing the work of emerging artists. Exhibited artists include Ron Pippin, David Gilhooly and James Strombotne. Sponsors 11 shows/year. Average display time 1 month. Open all year; Tuesday-Saturday, 10:30-5:30. Located in the Bergamot Station Arts Center; 3,000 sq. ft. in converted warehouse with 16 ft. ceilings, skylights. 25% of space for special exhibitions; 75% of space for gallery artists. Clientele: upscale, creative arts, i.e. directors, actors, producers. 80% private collectors, 20% corporate collectors. Overall price range: $1,000-25,000; most work sold at $2,000-5,000.
Media: Considers oil, acrylic, mixed media, collage, pen & ink, sculpture, ceramic and installation. Most frequently exhibits assemblage sculpture, paintings and photography.
Style: Exhibits expressionism, neo-expressionism, conceptualism, painterly abstraction and postmodern works. Prefers expressionism, painterly abstraction and postmodern.
Terms: Accepts work on consignment (50% commission). Retail price set by gallery and artist. Offers payment by installments. Gallery provides insurance and promotion. Prefers artwork framed.
Submissions: Send query letter with résumé, slides, reviews and SASE. Portfolio review requested if interested in artist's work. Portfolio should include slides and transparencies. Replies in 1 month. Files résumé and slides.
Tips: "Present a coherent body of work, neatly and professionally presented. Follow up, but do not become a nuisance."

N GALLERY 825, LA Art Association, 825 N. La Cienega Blvd., Los Angeles CA 90069. (310)652-8272. Fax: (310)652-9251. Contact: Cynthia Peters. Nonprofit gallery. Estab. 1925. Exhibits emerging, mid-career and established artists. "Artists must be local LA residents." Interested in seeing the work of emerging artists. Approximately 300 members. Sponsors 10 shows/year. Average display time 5-6 weeks. Open all year; Tuesday-Saturday, 12-5. Located in Beverly Hills/West Hollywood. 25% of space for special exhibitions (2 rooms); 75% for gallery artists (2 large main galleries). Clientele: set decorators, interior decorators, general public. 90% private collectors.
Media: Considers all media and original handpulled prints. "All serious work. No crafts." Most frequently exhibits mixed media, oil/acrylic and watercolor.
Style: All styles.
Terms: Requires $75 annual membership fee plus entry fees or 12 hours volunteer time. Retail price set by artist.

Gallery provides promotion. "No shipping allowed." Accepts only artists from LA area. "Artists must apply via jury process held at the gallery 2 times per year." Phone for information.
Tips: "No commercial work (e.g. portraits/advertisements)."

[N] [🏛] LOS ANGELES MUNICIPAL ART GALLERY, Barnsdall Art Park, 4804 Hollywood Blvd., Los Angeles CA 90027. (213)485-4581. E-mail: cadmag@earthlink.net. Contact: Mary Oliver. Curators: Noel Korten and Scott Canty. Nonprofit gallery. Estab. 1971. Interested in emerging, mid-career and established artists. Sponsors 5 solo and group shows/year. Average display time 2 months. 10,000 sq. ft. Accepts primarily Southern California artists.
Media: Considers oil, acrylic, watercolor, pastel, pen & ink, drawings, contemporary sculpture, ceramic, fiber, photography, craft, mixed media, performance art, video, collage, glass, installation and original handpulled prints.
Style: Exhibits contemporary works only. "We organize and present exhibitions which primarily illustrate the significant developments and achievements of living Southern California artists. The gallery strives to present works of the highest quality in a broad range of media and styles. Programs reflect the diversity of cultural activities in the visual arts in Los Angeles."
Terms: Gallery provides insurance, promotion and contract. This is a curated exhibition space, not a sales gallery.
Submissions: Send query letter, résumé, brochure, slides and photographs. Slides and résumés are filed. Submit slides to Scott Canty or Mary Oliver, Cultural Affairs Dept., Slide Registry, %the gallery at the above address. Finds artists through submissions to slide registry.
Tips: "No limits—contemporary only."

SYLVIA WHITE CONTEMPORARY ARTISTS' SERVICES, 2022 B Broadway, Santa Monica CA 90404. (310)828-6200. E-mail: artadvice@aol.com. Website: http://www.sylviawhite.com. Owner: Sylvia White. Retail gallery, art consultancy and artist's career development services. Estab. 1979. Represents 20 emerging, mid-career and established artists. Interested in seeing work of emerging artists. Exhibited artists include Martin Mull, John White. Sponsors 12 shows/year. Average display time 1 month. Open all year; Tuesday-Saturday, 11-6. Located in downtown Santa Monica; 2,000 sq. ft.; 100% of space for special exhibitions. Clientele: upscale. 50% private collectors, 50% corporate collectors. Overall price range: $1,000-10,000; most work sold at $3,000.
 • Sylvia White also has a location in Soho in New York City.
Media: Considers all media, including photography. Most frequently exhibits painting and sculpture.
Style: Exhibits all styles, including painterly abstraction and conceptualism.
Terms: Retail price set by gallery and artist. Gallery provides insurance, promotion and contract. Artist pays for shipping costs.
Submissions: Send query letter with résumé, slides, bio and SASE. Portfolio should include slides.

San Francisco

AUROBORA PRESS, 147 Natoma St., San Francisco CA. (415)546-7880. Fax: (415)546-7881. E-mail: monotype@aurobora.com. Website: http://www.aurobora.com. Directors: Michael Dunev and Michael Liener. Retail gallery and fine arts press. Invitational Press dedicated to the monoprint and monotype medium. Estab. 1991. Represents/exhibits emerging, mid-career and established artists. Exhibited artists include William T. Wiley and Charles Arnoldi. Sponsors 10 shows/year. Average display time 4-6 weeks. Open all year; Monday-Saturday, 11-5. Located south of Market—Yerba Buena; 1,000 sq. ft.; turn of the century firehouse—converted into gallery and press area. Clientele: collectors, tourists and consultants. Overall price range: $1,200-6,000; most work sold at $1,500-4,000.
 • Aurobora Press invites artists each year to spend a period of time in residency working with Master Printers.
Media: Publishes monotypes.
Terms: Retail price set by gallery and artist. Gallery provides promotion.
Submissions: By invitation only.

J.J. BROOKINGS GALLERY, 669 Mission St., San Francisco CA 94025. (415)546-1000. Website: http://www.jjbrookings.com. Director: Timothy Duran. Retail gallery. Estab. 1970. Of artists represented 15% are emerging, 25% are mid-career and 60% are established. Exhibited artists include Ansel Adams, Robert Motherwell, Richard Diebenkorn, Bill Barrett, Katherine Chang-Liu, Lisa Gray, Misha Grodin, Bruce Dorfman, Eduardo Chillida, Sandy Skoglund and James Crable. Sponsors 6-7 shows/year. Average display time 40 days in rotation. Open all year; Tuesday-Saturday, 10-6; Sunday, 11-5. Located next to San Francisco MOMA and Moscone Center; 7,500 sq. ft.; 60% of space for special exhibitions. Clientele: collectors and private art consultants. 60% private collectors, 10% corporate collectors, 30% private art consultants. Overall price range: $1,000-125,000; most work sold at $2,000-8,000. Works with architects and designers for site-specific commissions—often in the $4,000-$60,000 range.
Media: Considers oil, acrylic, sculpture, watercolor, mixed media, pastel, collage, photography, original handpulled prints, woodcuts, wood engravings, linocuts, engravings, mezzotints, etchings, lithographs and serigraphs. Most frequently exhibits high-quality paintings, prints, sculpture and photography.
Style: Exhibits primarily abstract work. Genres include landscapes, florals, figurative work and city scapes.
Terms: Retail price set by gallery and artist. Gallery provides insurance, promotion, contract and shipping costs from gallery; artist pays for shipping costs to gallery.

Submissions: Prefers "intellectually mature artists who know quality and who are professional in their creative and business dealings. Artists can no longer be temperamental." Send query letter with résumé, minimum of 20 current slides, bio, brochure, photographs, SASE, business card and reviews. Replies if interested within 2-3 months; if not interested, replies in a few days.

Tips: "First, determine just how unique or well crafted or conceived your work really is. Secondly, determine your market—who would want this type of art and especially your type of art; then decide what is the fair price for this work and how does this price fit with the price for similar work by artists of similar stature. Lastly, have a well thought-out presentation that shows consistent work and/or consistent development over a period of time. We want artists with an established track record and proven maturity in artistic vision. Bill Vouksonovich only creates 7-10 pieces a year, but at prices from $13,000-20,000 and he has a waiting list. Katherine Chang Liu creates 300-400 works a year, has an established international network of dealers and sells at $700-4,000. You need a sufficient number of works for a dealer to see the growth of your vision and technique, but, depending on the artist, this could be ten pieces over five years or twenty pieces over two years because the artist has yet to ground himself."

N CATHARINE CLARK GALLERY, 49 Geary St., #2FL, San Francisco CA 94108-5705. (415)399-1439. Fax: (415)399-0675. E-mail: morphos@cclarkgallery.com. Website: http://www.cclarkgallery.com. Owner/Director: Catharine Clark. Retail gallery. Estab. 1991. Represents 10 emerging and mid-career artists. Curates 5-12 shows/year. Average display time 4-6 weeks. Open all year. Located downtown San Francisco; 2,000 sq. ft. 90% of space for special exhibitions; 10% of space for gallery artists. Clientele: 95% private collectors, 5% corporate collectors. Overall price range: $200-300,000; most work sold at $800-2,200.

Media: Considers oil, acrylic, mixed media, collage, sculpture, installation, photography, woodcuts, wood engravings, linocuts, engravings, mezzotints, etchings, photography, lithographs and new genres. Most frequently exhibits painting, sculpture, installation and new genres.

Style: Exhibits all styles and genres.

Terms: Accepts work on consignment (50% commission). Retail price set by gallery and artist. Offers customer payment by installments. Gallery provides insurance, promotion and contract; shipping costs are shared. Prefers artwork framed.

Submissions: Send query letter with slides, bio, reviews and SASE. Reviews in December and August.

EBERT GALLERY, 49 Geart St., San Francisco CA 94108. (415)296-8405. E-mail: dickebert@sprynet.com. Website: http://www.ebertgallery.com. Owner: Dick Ebert. Retail gallery. Estab. 1989. Represents 24 established artists "from this area." Interested in seeing the work of emerging artists. Sponsors 11-12 shows/year. Average display time 1 month. Open all year; Tuesday-Friday, 10:30-5:30; Saturday, 11-5. Located downtown near bay area; 600 sq. ft.; one room which can be divided for group shows. 85% of space for special exhibitions; 15% of space for gallery artists. Clientele: collectors, tourists, art students. 80% private collectors. Overall price range: $500-20,000; most work sold at $500-8,000.

Media: Considers oil, acrylic, watercolor, pastel, pen & ink, drawing, mixed media, collage, paper, sculpture, glass, photography, woodcuts, engravings, mezzotints, etchings and encostic. Most frequently exhibits acrylic, oils and pastels.

Style: Exhibits expressionism, painterly abstraction, Impressionism and realism. Genres include landscapes, figurative work, all genres. Prefers landscapes, abstract, realism. "Smaller work to 4×5—no larger."

Terms: Accepts work on consignment (50% commission). Retail price set by the artist. Gallery provides promotion. Shipping costs are shared. Prefers artwork framed.

Submissions: San Francisco Bay Area artists only. Send query letter with résumé and slides. Finds artists through referral by professors or stable artists.

Tips: "You should have several years of practice as an artist before approaching galleries. Enter as many juried shows as possible."

N INTERSECTION FOR THE ARTS, 446 Valencia, San Francisco CA 94103. (415)626-2787. E-mail: intrsect@wenet.net. Website: http://www.wenet.net/~intrsect. Program Director: Kevin B. Chen. Alternative space and nonprofit gallery. Estab. 1980. Exhibits the work of 10 emerging and mid-career artists/year. Sponsors 8 shows/year. Average display time 6 weeks. Open all year. Located in the Mission District of San Francisco; 840 sq. ft.; gallery has windows at one end and cement pillars betwen exhibition panels. 100% of space for special exhibitions. Clientele: 100% private collectors.

• This gallery supports emerging and mid-career artists who explore experimental ideas and processes. Interdisciplinary, new genre, video performance and installation is encouraged.

Media: Considers oil, pen & ink, acrylic, drawings, watercolor, mixed media, installation, collage, photography, site-specific installation, video installation, original handpulled prints, woodcuts, lithographs, posters, wood engravings, mezzotints, linocuts and etchings.

Style: Exhibits all styles and genres.

Terms: Retail price set by artist. Customer discounts and payment by installment are available. Gallery provides promotion; shipping costs are shared. Prefers artwork unframed.

Submissions: Send query letter with résumé, 20 slides, reviews, bio, clippings and SASE. Portfolio review not required. Replies within 6 months only if interested and SASE has been included. Files slides.

Tips: "Create proposals which consider the unique circumstances of this location, utilizing the availability of the theater and literary program/resources/audience."

MUSEUM WEST FINE ARTS & FRAMING, INC., 170 Minna, San Francisco CA 94105. (415)546-1113. Director: Tim Duran. Assistant Manager: Susan Pitcher. Retail gallery. Represents/exhibits 14 emerging artists/year. Sponsors 8-11 shows/year. Average display time 6 weeks. Open all year; Monday-Saturday. Located downtown next to San Francisco Museum of Modern Art; 3,500 sq. ft.; 30% of space for special exhibitions. Clientele: upscale tourists, art consultants, sophisticated corporate buyers, private collectors. Overall price range: $200-8,000; most work sold at $500-2,500.

● This gallery has a second location in Palo Alto. All submissions should be directed to Tim Duran in San Francisco.

Media: Considers all media except fabric. No installation work.

Style: Exhibits expressionism, painterly abstraction, Impressionism and realism. Genres include abstract; expressionistic landscapes, cityscapes; and some figurative.

Terms: Artwork is accepted on consignment (50% commission). Retail price set by the gallery and artist. Gallery provides insurance, promotion and contract; shipping costs are shared or negotiated.

Submissions: No sexually explicit or politically-oriented art. Send query letter with résumé, slidesheet of 20 current slides, bio, brochure, photographs, SASE, business card and and reviews. Write for appointment to show portfolio of photographs, slides and transparencies. Replies in 6-8 weeks. Files all material if interested. Finds artists through open studios, mailings, referrals by other artists and collectors.

Tips: "Since we work with a lot of younger or non-established artists from all over the country we do not expect extensive museum representation. We look for artists who are serious enough about their work to stay with it, yet we understand that their main source of income may not be from art. We do expect a professional presentation package. We reserve the right to pick and choose or simply say 'no' to a new, but unresolved body of work. We want images of current work, not work sold three years ago and no longer available. Be prepared for rejection. It's not necessarily a reflection on the work but that it is not productive for either the gallery or artist to show work that does not fit in with the general focus of the gallery. One of the biggest mistakes an artist can make is to send a slide package indicating numerous styles. Dealers view this as artist being unfocused and therefore unprofessional."

N OLGA DOLLAR GALLERY, 210 Post St., 2nd Fl., San Francisco CA 94108. (415)398-2297. Fax: (415)398-2788. E-mail: odgallery@aol.com. Retail gallery. Estab. 1989. Represents sixty emerging, mid-career and established artists. Exhibited artists include Francesca Sundsten and David Dornan. Sponsors 16 shows/year. Average display time 6 weeks. Open all year; Tuesday-Saturday 10:30-5:30. Located downtown; 2,400 sq. ft. 50% of space for special exhibitions; 50% of space for gallery artists. Clientele: young-established. 50% private collectors, 50% corporate collectors. Overall price range: $300-15,000; most work sold at $3,000-7,000.

Media: Considers oil, pen & ink, paper, acrylic, drawing, sculpture, watercolor, mixed media, installation, pastel, collage, mezzotints, etchings, lithographs. Most frequently exhibits paintings, work on paper and sculpture.

Style: Exhibits painterly abstraction, realism, surrealism, imagism. Genres include landscapes and figurative work.

Terms: Accepts work on consignment (50% commission). Retail price set by gallery and artist. Gallery provides insurance, promotion, contract, shipping costs from gallery. Prefers artwork framed.

Submissions: Send query letter with résumé, slides, bio. Write for appointment to show portfolio of slides. Replies in 1 month.

Tips: "Investigate the gallery's direction to see whether or not your work is appropriate. Send a complete slide submission including a résumé, slide identification sheet, prices and a SASE."

SAN FRANCISCO ART COMMISSION GALLERY & SLIDE REGISTRY, 401 Van Ness, Civic Center, San Francisco CA 94102. (415)554-6080. Fax: (415)252-2595. E-mail: sfacgallery@telis.org. Website: http://thecity.sfsu.edu/sfac/. Director: Rupert Jenkins. Nonprofit municipal gallery; alternative space. Estab. 1983. Exhibits work of approximately 150 emerging and mid-career artists/year; 400-500 in Slide Registry. Sponsors 7 indoor group shows/year; 3 outdoor site installations/year. Average display time 5 weeks (indoor); 3 months (outdoor installations). Open all year. Located at the Civic Center; 1,000 sq. ft. (indoor), 4,500 sq. ft. (outdoor); City Site lot across the street from City Hall and in the heart of the city's performing arts complex. 100% of space for special exhibitions. Clientele: cross section of San Francisco/Bay Area including tourists, upscale, local and students. Sales are minimal.

● A newly renovated exhibition space opened in January, '96. The program continues with window installations, site specific projects, the Artists' Slide Registry, artists' talks and special projects.

Media: Considers all media. Most frequently exhibits installation, mixed media, sculpture/3-D, painting, photography.

Style: Exhibits all styles. Prefers cutting-edge, contemporary works.

Terms: Accepts artwork on consignment (20% commission). Retail price set by artist. Gallery provides insurance, promotion and contract; artist pays for shipping.

Submissions: Accepts only artists residing in one of nine Bay Area counties. Write for guidelines to join the slide registry to automatically receive calls for proposals and other exhibition information. Do not send unsolicited slides.

Tips: "The Art Commission Gallery serves as a forum for exhibitions which reflect the aesthetic and cultural diversity of contemporary art in the Bay Area. Temporary installations in the outdoor lot adjacent to the gallery explore alternatives to traditional modes of public art. Gallery does not promote sale of art, as such, but will handle sale of available work if a visitor wishes to purchase it. Exhibit themes, artists, and selected works are recommended by the Gallery Director to the San Francisco Art Commission for approval. Gallery operates for the benefit of the public as well as the artists. It is not a commercial venue for art."

Colorado

N THE BOULDER MUSEUM OF CONTEMPORARY ART, 1750 13th St., Boulder CO 80302. (303)443-2122. Fax: (303)447-1633. E-mail: bmoca@indra.net. Website: http://www.BMOCA.org. Contact BAC Board of Directors: Exhibitions Committee. Nonprofit gallery. Estab. 1972. Exhibits the work of emerging, mid-career and established artists. Sponsors 10 shows/year. Average display time is 6 weeks. "Ideal downtown location in a beautiful, historically-landmarked building."

Media: Considers all media.

Style: Exhibits contemporary, abstract, experimental, figurative, non-representational works.

Submissions: Accepts work by invitation only, after materials have been reviewed by Exhibitions Committee. Send query letter, artist statement, résumé, approximately 20 high-quality slides and SASE. Portfolio review requested if interested in artist's work. Reports within 6 months. Press and promotional material, slides and Boulder Museum of Contemporary Art history are filed.

N FIRST PEOPLES GALLERY, 556 Adams Ave., Parkway Place, Silverthorne CO 80498. (970)513-8038 or (888)663-3900. Fax: (970)513-8053. E-mail: indianart@internetmci.com. Director: Victoria Torrez Kneemeyer. Retail gallery. Estab. 1992. Represents 30 mid-career and established artists/year. Interested in seeing the work of emerging North American Native and Southwestern artists. Exhibited artists include Tim Nicola, Dan Lomahaftewa, Pablo Luzardo and Raymond Nordwall. Sponsors 5 shows/year. Average display time 6 weeks. Open all year; Tuesday-Sunday, 11-6. Located in Summit City—Colorado's playground. Space is 2,000 sq. ft. (new construction) in ski resort location. 60% of space for special exhibitions; 40% of space for gallery artists. Clientele: collectors, walk-in traffic, tourists. 30% private collectors, 10% corporate collectors. Overall price range: $100-1,000 (40%), $1,000-15,000 (10%); most work sold at $3,000 (50%).

Media: Considers oil, acrylic, watercolor, pastel, pen & ink, mixed media, sculpture, pottery (coiled, traditional style only) and Cape Dorset Soapstone sculpture. Most frequently exhibits oil and acrylic, Northwest Coast woodcarvings, pottery.

Style: Only North American Native fine art paintings. Exhibits expressionism, painterly abstraction and traditional (figurative) realism by Mexican style artists, Southwest artists (Art Deco, Kiowa), who work in Santa Fe school, Jalisco and other local styles. Genres includes Southwestern, portraits and figurative work. Prefers expressionism, painterly abstraction and realism.

Terms: Accepts work on consignment (40-50% commission) or buys outright for 50% of retail price (net 30 days). Retail price set by the gallery and the artist. Gallery provides insurance, promotion and contract; artist pays shipping costs to gallery. Prefers artwork framed in wood.

Submissions: Accepts only artists native to North America. Send query letter with résumé, slides, bio, brochure, price list, list of exhibitions, business card and reviews. Call for appointment to show portfolio. Replies in 3-4 weeks. Replies if interested within 1 week. Files entire portfolio. Finds artists through exhibits, submissions, publications and Indian markets.

Tips: "Send artist statement, bio and profile describing work and photos/slides. First Peoples Gallery accepts only North American Native art and a minimum of ten pieces."

FOOTHILLS ART CENTER, 809 15th St., Golden CO 80401. (303)279-3922. Fax: (303)279-9470. Executive Director: Carol Dickinson. Nonprofit gallery. Estab. 1968. Exhibits approximately 600 established artists/year in invitational and competitive juried shows. Sponsors 9 shows/year. Average display time 6 weeks. Open all year; daily (except major holidays); Monday-Saturday, 9-4; Sunday, 1-4. Located downtown; 5 self-contained spaces (under one roof) 2,232 sq. ft. "We are housed in a National Historic Register building of classic Gothic/Victorian design—a church linked to a parsonage and remodeled into modern gallery interior spaces." 100% of space for special exhibitions. 90% private collectors, 10% corporate collectors. Overall price range: $100-30,000; most work sold at $1,500-2,000. Foothill's director urges artists to call or write for prospecti on how to enter their two national shows.

Media: Considers all media and all types of prints (size limitations on sculpture). Most frequently exhibits watermedia and mixed media, sculpture and clay.

Style: Exhibits all genres. Prefers figurative, realism, Impressionism and contemporary-experimental.

Terms: Accepts work on consignment (35% commission). Retail price set by the artist. Gallery provides insurance, promotion and contract; shipping costs are shared. Prefers artwork framed.

Submissions: "The exhibition schedule offers opportunities to nationwide artists primarily through the biennial North American Sculpture Exhibition (May/June—competitive, juried, catalog, $15,000 in awards) and the annual Rocky Mountain National Watermedia Exhibition (August/September; juried, slide entries and small fee required, $15,000 in awards, catalog published)."

Tips: "Artists often include too much variety when multiple slides are submitted, with the result that jurors are unable to discern a recognizable style or approach, or artists submit poor photography or slides."

E.S. LAWRENCE GALLERY, 516 E. Hyman Ave., Aspen CO 81611. (970)920-2922. Fax: (970)920-4072. E-mail: esl@sopris.net. Website: http://www.eslawrence.com. Director: Kert Koski. Retail gallery. Estab. 1988. Represents emerging, mid-career and established artists. Exhibited artists include Zvonimir Mihanovic, Graciela Rodo Boulanger,

Steve Hanks and Chiu Tak Hak. Sponsors 2 shows/year. Open all year; daily 10-10. Located downtown. 100% of space for gallery artists. 95% private collectors, 5% corporate collectors.

Media: Considers oil, acrylic, watercolor, pastel, mixed media, sculpture, glass, lithograph and serigraphs. Most frequently exhibits oil, acrylic, watercolor and bronzes.

Style: Exhibits expressionism, Impressionism, photorealism and realism. Genres include landscapes, florals, Americana, figurative work. Prefers photorealism, Impressionism, expressionism.

Terms: Accepts artwork on consignment. Retail price set by the gallery and the artist. Gallery provides insurance, promotion and contract; artist pays shipping costs to and from gallery "if not sold." Prefers artwork framed.

Submissions: Send query letter with résumé, slides and photographs. Write for appointment to show portfolio of photographs, slides and reviews. Replies in 1 month. Finds artists through agents, visiting exhibitions, word of mouth, art publications and artists' submissions.

Tips: "We are always willing to look at submissions. We are only interested in originals above $2,000 retail price range. Not interested in graphics."

MAGIDSON FINE ART, 525 E. Cooper Ave., Dept. AM, Aspen CO 81617. (970)920-1001. Fax: (970)925-6181. E-mail: art@magidson.com. Website: http://www.magidson.com. Owner: Jay Magidson. Retail gallery. Estab. 1990. Represents 50 emerging, mid-career and established artists. Exhibited artists include Annie Leibovitz, Andy Warhol. Sponsors 5 shows/year. Average display time 3 months. Open all year; December 15-April 15, 10-9 daily; June 15-September 15, 10-9; rest of the year, Tuesday-Sunday, 10-6. Located in central Aspen; 800 sq. ft.; exceptional window exposure; free hanging walls; 12 ft. ceilings. 50% of space for special exhibitions; 50% of space for gallery artists. Clientele: emerging and established collectors. 95% private collectors, 5% corporate collectors. Overall price range: $1,200-75,000; most work sold at $2,500-7,500.

Media: Considers oil, acrylic, watercolor, pastel, pen & ink, drawing, mixed media, collage, paper, sculpture, ceramics, fiber, photography, woodcut, engraving, lithograph, wood engraving, serigraphs, linocut and etching. Most frequently exhibits oil/acrylic on canvas, photography and sculpture.

Style: Exhibits painterly abstraction, surrealism, color field, photorealism, hard-edge geometric abstraction and realism; all genres. Prefers pop, realism and unique figurative (colorful and imaginative).

Terms: Accepts work on consignment (40-60% commission). Retail price set by the gallery. Gallery provides insurance, promotion and shipping costs from gallery; artist pays shipping costs to gallery. Prefers artwork framed.

Submissions: Send query letter with slides, bio, photographs and SASE. Call for appointment to show portfolio of photographs, slides, "never originals!" Replies only if interested in 1 month. Files slides, "bios on artists we represent." Finds artists through recommendations from other artists, reviews in art magazines, museum shows, gallery shows.

Tips: "I prefer photographs over slides. No elaborate artist statements or massive résumés necessary."

PINE CREEK ART GALLERY, 2419 W. Colorado Ave., Colorado Springs CO 80904. (719)633-6767. Website: http://www.pcagallery.com. Owner: Nancy Anderson. Retail gallery. Estab. 1991. Represents 10+ established artists. Exhibited artists include Lorene Lovell, Karen Noles, Kirby Sattler, Chuck Mardosz and Don Grzybowski. Sponsors 2-4 shows/year. Average display time 1 month. Open all year Monday-Saturday, 10-6; Sunday, 11-5. 2,200 sq. ft.; in a National Historic District. 30% of space for special exhibitions. Clientele: middle to upper income. Overall price range: $30-5,000; most work sold at $100-500.

Media: Considers most media, including bronze, pottery and all types of prints.

Style: Exhibits all styles and genres.

Terms: Accepts artwork on consignment (40% commission). Retail price set by gallery and artist. Gallery provides insurance, promotion and shipping costs from gallery. Prefers artwork "with quality frame only."

Submissions: No fantasy or abstract art. Prefer experienced artists only—no beginners. Send query letter with 6-12 slides and photographs. Call or write for appointment to show portfolio or originals, photographs, slides and tearsheets. Replies in 2 weeks.

Tips: "Make sure your presentation is professional. We like to include a good variety of work, so show us more than one or two pieces."

SANGRE DE CRISTO ARTS CENTER AND BUELL CHILDREN'S MUSEUM, 210 N. Santa Fe Ave., Pueblo CO 81003. (719)543-0130. Fax: (719)543-0134. E-mail: artctr@ris.net. Curator of Visual Arts: Jennifer Cook. Nonprofit gallery and museum. Estab. 1972. Exhibits emerging, mid-career and established artists. Sponsors 20 shows/year. Average display time 10 weeks. Open all year. Free to the public. Located "downtown, right off Interstate I-25"; 16,000 sq. ft.; six galleries, one showing a permanent collection of western art; changing exhibits in the other five. Also a new 10,000 sq. ft. children's museum with changing, interactive exhibits. Clientele: "We serve a 19-county region and attract 200,000 visitors yearly." Overall price range for artwork: $50-100,000; most work sold at $50-2,500.

Media: Considers all media.

Style: Exhibits all styles. Genres include southwestern, regional and contemporary.

Terms: Accepts work on consignment (30% commission). Retail price set by artist. Gallery provides insurance, promotion, contract and shipping costs. Prefers artwork framed.

Submissions: "There are no restrictions, but our exhibits are booked into 2001 right now." Send query letter with slides. Write or call for appointment to show portfolio of slides. Replies in 2 months.

☑ **TREASURE ALLEY**, 713 Main, Alamosa CO 81101-2326. Partners: Carol Demlo and Melody Johnson. Retail gallery and specialty gift shop. Estab. 1995. Represents regional artwork. Open all year. Located in the southern Rocky Mountains in the hub of the San Luis Valley; gallery includes a historic walk-in vault. Overall price range: $40-400.
Media: Considers oil, acrylic, watercolor, pastel, pen & ink, drawings, mixed media, works on paper, sculpture, ceramic, glass posters, linocuts and etchings. Most frequently exhibits watercolor, oil, ceramics and pastels.
Style: Genres include landscapes, florals, southwestern and still lifes. Prefers realism, Impressionism and color field.
Terms: Accepts work on consignment (35% commission). Retail price set by gallery. Customer discounts and payment by installment available. Gallery provides insurance and promotion; artist pays for shipping. Prefers artwork framed.
Submissions: Send query letter with résumé, 3 slides of each work, brochure, photographs and SASE for return. Finds artists through visiting exhibitions and referrals.
Tips: Have at least 20-25 good pieces before approaching galleries. You should have a complete portfolio including current and past work.

Connecticut

Ⓝ ARTWORKS GALLERY, 233 Pearl St., Hartford CT 06103. (203)247-3522. Website: http://www.artworksgaller y.org. Executive Director: Judith Green. Cooperative nonprofit gallery. Estab. 1976. Exhibits 200 emerging, mid-career and established artists. Interested in seeing the work of emerging artists. 50 members. Sponsors 13 shows/year. Average display time 1 month. Open Wednesday-Friday, 11-5; Saturday, 12-3. Closed in August. Located in downtown Hartford; 1,300 sq. ft.; large, first floor, store front space. 20% of space for special exhibitions; 80% of space for gallery artists. Clientele: 80% private collectors, 20% corporate collectors. Overall price range: $200-5,000; most work sold at $200-1,000.
Media: Considers all media and all types of prints. Most frequently exhibits oil on canvas, photography and sculpture. No crafts or jewelry.
Style: Exhibits all styles and genres, especially contemporary.
Terms: Co-op membership fee plus a donation of time. There is a 30% commission. Retail price set by artist. Offers customer discounts and payment by installments. Gallery provides insurance, promotion and contract. Artist pays for shipping costs. Prefers artwork framed. Accepts only artists from Connecticut for membership. Accepts artists from New England and New York for juried shows.
Submissions: Send query letter with résumé, slides, bio and $10 application fee. Call for appointment to show portfolio of slides. Replies in 1 week.
Tips: Finds artists through visiting exhibitions, various art publications and sourcebooks, artists' submissions, art collectors' referrals, but mostly through word of mouth and juried shows.

MONA BERMAN FINE ARTS, 78 Lyon St., New Haven CT 06511. (203)562-4720. Fax: (203)787-6855. E-mail: mbfineart@snet.net. Director: Mona Berman. Art consultancy. Estab. 1979. Represents 100 emerging and mid-career artists. Exhibited artists include Tom Hricko, David Dunlop, Pierre Pardlanac and S. Wind-Greenbain. Sponsors 1 show/ year. Open all year by appointment. Located near downtown; 1,400 sq. ft. Clientele: 5% private collectors, 95% coporate collectors. Overall price range: $200-20,000; most artwork sold at $500-5,000.
Media: Considers all media except installation. Shows very little sculpture. Considers all limited edition prints except posters and photolithography. Most frequently exhibits works on paper, painting, relief and ethnographic arts.
Style: Exhibits most styles. Prefers abstract, landscape and transitional. No figurative, little still life.
Terms: Accepts work on consignment (50% commission; net 30 days). Retail price is set by gallery and artist. Customer discounts and payment by installment are available. Gallery provides insurance; artist pays for shipping. Prefers artwork unframed.
Submissions: Send query letter, résumé, "about 20 slides," bio, SASE, reviews and "price list—retail only at stated commission." Portfolios are reviewed only after slide submission. Replies in 1 month. Slides and reply returned only if SASE is included. Finds artists through word of mouth, art publications and sourcebooks, submissions and self-promotions and other professionals' recommendations.
Tips: "Please understand that we are not a gallery, although we do a few exhibits. We are primarily art consultants. We continue to be busy selling high-quality art and related services to the corporate, architectural and design sectors. Read our listings then you don't have to call first. A follow-up call is certainly acceptable after you have sent your package."

Ⓝ MARTIN CHASIN FINE ARTS L.L.C., 1125 Church Hill Rd., Fairfield CT 06432. (203)374-5987. Fax: (203)372-3419. Owner: Martin Chasin. Retail gallery. Estab. 1985. Represents 40 mid-career and established artists. Interested in seeing the work of emerging artists. Exhibited artists include Katherine Ace and David Rickert. Sponsors 8 shows/year. Average display time 3 weeks. Open all year. Located downtown; 1,000-1,500 sq. ft. 50% of space for special exhibitions. Clientele: "sophisticated." 40% private collectors; 30% corporate collectors. Overall price range: $1,500-10,000; most work sold at $3,000-5,000.
Media: Considers oil, acrylic, watercolor, pastel, pen & ink, drawings, paper, woodcuts, wood engravings, engravings, mezzotints, etchings, lithographs, pochoir and serigraphs. "No sculpture." Most frequently exhibits oil on canvas, etchings/engravings and pastel.

Style: Exhibits expressionism, neo-expressionism, color field, Impressionism and realism. Genres include landscapes, Americana, portraits. Prefers landscapes, seascapes, ships/boating scenes and sporting action. Particularly interested in realistic art.

Terms: Accepts work on consignment (30-50% commission). Retail price set by artist. Offers payment by installments. Gallery provides insurance, promotion and shipping costs from gallery. Prefers artwork unframed.

Submissions: Send query letter with résumé, slides, bio, price list and SASE. Call or write for appointment to show portfolio of slides and photographs. Replies in 3 weeks. Files future sales material. Finds artists through exhibitions, "by artists who write to me and send good slides or transparencies. Send at least 10-15 slides showing all genres of art you produce. Omit publicity sheets and sending too much material."

Tips: "The art scene is less far-out, fewer avant-garde works are being sold. Clients want artists with a solid reputation."

CONTRACT ART, INC., P.O. Box 520, Essex CT 06426. (203)767-0113. Fax: (203)767-7247. President: K. Mac Thames. In business approximately 30 years. "We contract artwork for blue-chip businesses." Represents emerging, mid-career and established artists. Assigns site-specific commissions to artists based on client needs, theme and preferences. Showroom is open all year to corporate art directors, architects and designers. 1,600 sq. ft.. Clientele: 98% commercial. Overall price range: $500-500,000.

Media: Considers all art media and all types of prints.

Terms: Pays for design by the project, negotiable; 50% up front. Rights purchased vary according to project.

Submissions: Send query letter with résumé, slides, bio, brochure, photographs and SASE. If local, write for appointment to show portfolio; otherwise, mail appropriate materials, which should include slides and photographs. "Show us a good range of what you can do. Also, keep us updated if you've changed styles or media." Replies in 1 week. Files all samples and information in registry library.

Tips: "We exist mainly to solicit commissioned artwork for specific projects."

SILVERMINE GUILD GALLERY, 1037 Silvermine Rd., New Canaan CT 06840. (203)966-5617. Fax: (203)972-7236. Director: Vincent Baldassano. Nonprofit gallery. Estab. 1922. Represents 268 emerging, mid-career and established artists/year. Sponsors 20 shows/year. Average display time 1 month. Open all year; Tuesday-Saturday, 11-5; Sunday, 1-5. 5,000 sq. ft. 95% of space for gallery artists. Clientele: tourist, upscale. 40% private collectors, 10% corporate collectors. Overall price range: $250-10,000; most work sold at $1,000-2,000.

Media: Considers all media and all types of prints. Most frequently exhibits paintings, sculpture and ceramics.

Style: Exhibits all styles.

Terms: Accepts work on consignment (50% commission). Co-op membership fee plus donation of time (50% commission.) Retail price set by the gallery and the artist. Gallery provides insurance, promotion and contract; shipping costs are shared. Prefers artwork framed.

Submissions: Send query letter.

✔ **SMALL SPACE GALLERY**, Arts Council of Greater New Haven, 70 Audubon St., New Haven CT 06510. (203)772-2788. Fax: (203)772-2262. E-mail: arts.council@snet.net. Director: Helen Herzig. Alternative space. Estab. 1985. Interested in emerging artists. Sponsors 10 solo and group shows/year. Average display time: 1 month. Open to Arts Council artists only (Greater New Haven). Overall price range: $35-3,000.

Media: Considers all media.

Style: Exhibits all styles and genres. "The Small Space Gallery was established to provide our artist members with an opportunity to show their work. Particularly those who were just starting their careers. We're not a traditional gallery, but an alternative art space."

Terms: AAS Council requests 10% donation on sale of each piece. Retail price set by artist. Exclusive area representation not required. Gallery provides insurance (up to $10,000) and promotion.

Submissions: Send query letter with résumé, brochure, slides, photographs and bio. Call or write for appointment to show portfolio of originals, slides, transparencies and photographs. Replies only if interested. Files publicity, price lists and bio.

Delaware

N **DELAWARE ART MUSEUM ART SALES & RENTAL GALLERY**, 2301 Kentmere Parkway, Wilmington DE 19806. (302)571-9590 ext. 550. Fax: (302)571-0220. Director, Art Sales & Rental: Alice B. Hupfel. Nonprofit retail gallery, art consultancy and rental gallery. Estab. 1975. Represents 50-100 emerging artists. Open all year; Tuesday-Saturday, 9-4 and Sunday 10-4. Located seven minutes from the center of Wilmington; 1,200 sq. ft.; "state-of-the-art gallery and sliding racks." Clientele: 40% private collectors; 60% corporate collectors. Overall price range: $500-12,000; most work sold at $1,500-2,500.

Media: Considers all media and all types of prints except posters and reproductions.

Style: Exhibits all styles.

Terms: Accepts artwork on consignment (20% commission). Rental fee for artwork covers 2 months. Retail price set by artist and consigning gallery. Gallery provides insurance while on premises and contract. Artist pays shipping costs. Artwork must be framed.

Submissions: "No submissions now—I will obtain work through galleries."

DELAWARE CENTER FOR THE CONTEMPORARY ARTS, 103 E. 16th St., Wilmington DE 19801. (302)656-6466. Fax: (302)656-6944. Director: Steve Lanier. Nonprofit gallery. Estab. 1979. Exhibits the work of emerging, mid-career and established artists. Sponsors 30 solo/group shows/year of both national and regional artists. Average display time is 1 month. 2,000 sq. ft.; 19 ft. ceilings. Overall price range: $50-10,000; most artwork sold at $500-1,000.
Media: Considers all media, including contemporary crafts.
Style: Exhibits contemporary, abstract, figurative, conceptual, representational and non-representational, painting, sculpture, installation and contemporary crafts.
Terms: Accepts work on consignment (35% commission). Retail price is set by the gallery and the artist. Exclusive area representation not required. Gallery provides insurance and promotion; shipping costs are shared.
Submissions: Send query letter, résumé, slides and/or photographs and SASE. Write for appointment to show portfolio. Seeking consistency within work as well as in presentation. Slides are filed. Submit up to 20 slides with a corresponding slide sheet describing the work (i.e. media, height by width by depth), artist's name and address on top of sheet and title of each piece in the order in which you would like them reviewed.

MICHELLE'S OF DELAWARE, 831 North Market St., Wilmington DE 19801. (302)655-3650. Fax: (302)655-3650. Art Director: Raymond Bullock. Retail gallery. Estab. 1991. Represents 18 mid-career and established artists/year. May be interested in seeing the work of emerging artists in the future. Exhibited artists include: William Tolliver and Joseph Holston. Sponsors 8 shows/year. Average display time 1-2 weeks. Open all year; Saturday-Sunday, 11-5 and 1-5 respectively. Located in Market Street Mall (downtown); 2,500 sq. ft. 50% of space for special exhibitions. Clientele: local community. 97% private collectors; 3% corporate collectors. Overall price range: $300-20,000; most work sold at $1,300-1,500.
Media: Considers oil, acrylic, watercolor, pastel, pen & ink, mixed media, collage and sculpture; types of prints include woodcuts, lithographs, mezzotints, serigraphs, linocuts and etchings. Most frequently exhibits acrylic, watercolor, pastel and oil.
Style: Exhibits: Cubism. Exhibits all genres. Prefers: jazz, landscapes and portraits.
Terms: Retail price set by the artist. Gallery provides insurance and contract; shipping costs are shared. Prefers artwork framed.
Submissions: Send slides. Write for appointment to show portfolio of artwork samples. Replies only if interested within 1 month. Files bio. Finds artists through art fairs and exhibitions.
Tips: "Use conservation materials to frame work."

District of Columbia

N AARON GALLERY, 1717 Connecticut Ave. NW, Washington DC 20009. (202)234-3311. Manager: Annette Aaron. Retail gallery and art consultancy. Estab. 1970. Represents 35 emerging, mid-career and established artists. Sponsors 10 shows/year. Average display time is 3-6 weeks. Open all year. Located on Dupont Circle; 2,000 sq. ft. Clientele: private collectors and corporations. Overall price range: $100 and up; most artwork sold at $2,000-10,000.
Media: Considers oil, acrylic, watercolor, mixed media, collage, paper, sculpture, ceramic and installation. Most frequently exhibits sculpture, paintings and works on paper.
Style: Exhibits expressionism, painterly abstraction, imagism, color field, post-modern works, impressionism, realism and photorealism. Genres include florals. Most frequently exhibits abstract expressionism, figurative expressionism and post-modern works.
Terms: Accepts work on consignment (50% commission). Retail price set by gallery and artist. Sometimes offers payment by installment. Exclusive area representation required. Gallery provides promotion and contract; artist pays for shipping.
Submissions: Send query letter, résumé, slides or photographs, reviews and SASE. Slides and photos should be labeled with complete information—dimensions, title, media, address, name and phone number. Portfolio review requested if interested in artist's work. Portfolio should include photographs and, if possible, originals. Slides, résumé and brochure are filed. Finds artists through visiting exhibitions, word of mouth, submissions, self-promotions, art collector's referrals.
Tips: "We visit many studios throughout the country."

ATLANTIC GALLERY OF GEORGETOWN, 1055 Thomas Jefferson St. NW, Washington DC 20007. (202)337-2299. Fax: (202)333-4467. E-mail: vsmith2299@aol.com. Director: Virginia Smith. Retail gallery. Estab. 1976. Represents 10 mid-career and established artists. Exhibited artists include John Stobart, Tim Thompson, John Gable, Frits Goosen and Robert Johnson. Sponsors 5 solo shows/year. Average display time is 2 weeks. Open all year. Located downtown; 700 sq. ft. Clientele: 70% private collectors, 30% corporate clients. Overall price range: $100-20,000; most artwork sold at $300-5,000.
Media: Considers oil, watercolor and limited edition prints.

Style: Exhibits realism and Impressionism. Prefers realistic marine art, florals, landscapes and historic narrative leads.
Terms: Accepts work on consignment (40% commission). Retail price set by gallery and artist. Exclusive area representation required. Gallery provides insurance, promotion and contract; artist pays for shipping.
Submissions: Send query letter, résumé and slides. Portfolio should include originals and slides.

BIRD-IN-HAND BOOKSTORE & GALLERY, 323 7th St. SE, Box 15258, Washington DC 20003. (202)543-0744. Fax: (202)547-6424. E-mail: chrisbih@aol.com. Director: Christopher Ackerman. Retail gallery. Estab. 1987. Represents 30 emerging artists. Exhibited artists include Susan Nees, Lise Drost, Marylee by the River and Julianne Marcoux. Sponsors 6 shows/year. Average display time 6-8 weeks. Located on Capitol Hill at Eastern Market Metro; 300 sq. ft.; space includes small bookstore, art and architecture. "Most of our customers live in the neighborhood." Clientele: 100% private collectors. Overall price range: $75-1,650; most work sold at $75-350.
Media: Considers original handpulled prints, woodcuts, wood engravings, artists' books, linocuts, engravings, etchings. Also considers small paintings. Prefers small prints.
Terms: Accepts work on consignment (50% commission). Retail price set by gallery. Gallery provides insurance, promotion and contract; shipping costs are shared.
Submissions: Send query letter with résumé, 10-12 slides and SASE. Write for appointment to show portfolio of originals and slides. Interested in seeing tasteful work. Replies in 1 month. Files résumé; slides of accepted artists.
Tips: "The most common mistake artists make in presenting their work is dropping off slides/samples without SASE and without querying first. We suggest a visit to the gallery before submitting slides. We show framed and unframed work of our artists throughout the year as well as at time of individual exhibition. Also, portfolio/slides of work should have a professional presentation, including media, size, mounting, suggested price."

N: ROBERT BROWN GALLERY, 2030 R St., NW, Washington DC 20009. (202)483-4383. Fax: (202)483-4288. Website: http://www.artline.com. Director: Robert Brown. Retail gallery. Estab. 1978. Represents emerging, mid-career and established artists. Exhibited artists include Joseph Solman, Oleg Kudryashov. Sponsors 6 shows/year. Average display time 6 weeks. Open all year; Tuesday-Friday, 12-5; Saturday, 12-6. Located in Dupont Circle area; 600 sq. ft.; English basement level on street of townhouse galleries. 100% of space for gallery artists. Clientele: local, national and international. Overall price range: $500-20,000.
Media: Considers oil, acrylic, watercolor, pen & ink, drawing, mixed media, collage, paper, photography, woodcut, engraving, lithograph, wood engraving, mezzotint, serigraphs, linocut and etching. Most frequently exhibits works on paper, prints, paintings.
Style: Exhibits all styles.
Terms: Accepts work on consignment (50% commission). Retail price set by the gallery and the artist by agreement. Gallery provides insurance and promotion. Prefers artwork framed.
Submissions: Send query letter with slides, bio, brochure, SASE and any relevant information. No originals. Write for appointment to show portfolio of originals. "Will return information/slides without delay if SASE provided." Files "only information on artists we decide to show." Finds artists through exhibitions, word of mouth, artist submissions.

DE ANDINO FINE ARTS, 2450 Virginia Ave. NW, Washington DC 20037. (202)861-0638. Fax: (202)659-1899. Director: Jean-Pierre de Andino. Retail gallery and art consultancy. Estab. 1988. Represents/exhibits 4 mid-career and established artists/year. May be interested in seeing the work of emerging artists in the future. Exhibited artists include Sam Gilliam and Rainer Fetting. Sponsors 2 shows/year. Open all year by appointment only. Located downtown; 1,800 sq. ft.; discreet, private gallery in established upscale downtown neighborhood. Clientele: upscale. 60% private collectors, 20% corporate collectors. Overall price range: $1,000-100,000; most work sold at $15,000-50,000.
Media: Considers all media and types of prints. Most frequently exhibits painting, sculpture and conceptual work.
Style: Exhibits conceptualism, neo-expressionism, minimalism, color field, hard-edge geometric abstraction and surrealism. All genres. Prefers minimal, conceptual and color field.
Terms: Artwork is accepted on consignment and there is a 50% commission or is bought outright for a percentage of the retail price; net 60 days. Retail price set by the gallery. Gallery provides promotion. Artist pays for shipping costs. Prefers artwork framed.
Submissions: Send query letter with résumé, slides, bio and SASE. Write for appointment to show portfolio of slides and transparencies. Replies in 1-2 months.
Tips: Finds artists through referrals. "Work is a constant, do not stop."

DISTRICT OF COLUMBIA ARTS CENTER (DCAC), 2438 18th St. NW, Washington DC 20009. (202)462-7833. Fax: (202)328-7099. E-mail: dcarts98@aol.com. Website: dcartscenter.org. Executive Director: B. Stanley. Nonprofit gallery and performance space. Estab. 1989. Exhibits emerging and mid-career artists. Sponsors 7-8 shows/year. Average display time 1-2 months. Open Wednesday-Thursday, 2-6; Friday-Sunday, 2-10; and by appointment. Located "in Adams Morgan, a downtown neighborhood; 132 running exhibition feet in exhibition space and a 52-seat theater." Clientele: all types. Overall price range: $200-10,000; most work sold at $600-1,400.
Media: Considers all media including fine and plastic art. "No crafts." Most frequently exhibits painting, sculpture and photography.
Style: Exhibits all styles. Prefers "innovative, mature and challenging styles."
Terms: Accepts artwork on consignment (30% commission). Artwork only represented while on exhibit. Retail price

© Josephine Grant

Watercolor artist Josephine Grant visited galleries in the Washington, D.C. area and felt work shown by the Atlantic Gallery of Georgetown was compatible with her style. Her in-person research paid off: Grant's work was exhibited in a show entitled "Interiors in Watercolor" at the Atlantic Gallery, and her serene painting, *November Sun, Tourneferie, France*, which appeared on the invitation to the exhibition, sold for $1,200—before the opening.

set by the gallery and artist. Offers payment by installments. Gallery provides promotion and contract; artist pays for shipping. Prefers artwork framed.

Submissions: Send query letter with résumé, slides, bio and SASE. Portfolio review not required. Replies in 2 months.

Tips: "We strongly suggest the artist be familiar with the gallery's exhibitions, and the kind of work we show: strong, challenging pieces that demonstrate technical expertise and exceptional vision. Include SASE if requesting reply and return of slides!"

FOXHALL GALLERY, 3301 New Mexico Ave. NW, Washington DC 20016. (202)966-7144. Website: http://www.washingtonpost.com/yp/foxhallgallery. Director: Jerry Eisley. Retail gallery. Represents emerging and established artists. Sponsors 6 solo and 6 group shows/year. Average display time 3 months. Overall price range: $500-20,000; most artwork sold at $1,500-6,000.

Media: Considers oil, acrylic, watercolor, pastel, sculpture, mixed media, collage and original handpulled prints (small editions).

Style: Exhibits contemporary, abstract, impressionistic, figurative, photorealistic and realistic works and landscapes.

Terms: Accepts work on consignment (50% commission). Retail price set by gallery and artist. Customer discounts and payment by installment are available. Exclusive area representation required. Gallery provides insurance.

Submissions: Send résumé, brochure, slides, photographs and SASE. Call or write for appointment to show portfolio. Finds artists through agents, by visiting exhibitions, word of mouth, various art publications and sourcebooks, artists' submissions, self promotions and art collectors' referrals.

Tips: To show in a gallery artists must have "a complete body of work—at least 30 pieces, participation in a juried show and commitment to their art as a profession."

SPECTRUM GALLERY, 1132 29th St. NW, Washington DC 20007. (202)333-0954. Contact: Elizabeth Nader. Retail/cooperative gallery. Estab. 1966. Exhibits the work of 29 mid-career artists. Sponsors 10 solo and 2 group shows/year. Average display time 1 month. Accepts only artists from Washington area. Open year round. Located in Georgetown. Clientele: 80% private collectors, 20% corporate clients. Overall price range: $50-5,000; most artwork sold at $450-1,200.

Media: Considers oil, acrylic, watercolor, pastel, pen & ink, drawings, mixed media, collage, works on paper, sculpture, ceramic, fiber, woodcuts, mezzotints, etchings, lithographs and serigraphs. Most frequently exhibits acrylic, watercolor and oil.

Style: Exhibits Impressionism, realism, minimalism, painterly abstraction, pattern painting and hard-edge geometric abstraction. Genres include landscapes, florals, Americana, portraits and figurative work.

Terms: Co-op membership fee plus donation of time; 35% commission. Retail price set by artist. Sometimes offers payment by installment. Exclusive area representation not required. Gallery provides promotion and contract.

Submissions: Artists must live in the Washington area because of the cooperative aspect of the gallery. Bring actual painting at jurying; application forms needed to apply. "Come into gallery and pick up application form."

TOUCHSTONE GALLERY, 406 Seventh St. NW, Washington DC 20004. (202)347-2787. Director: Craig Kittner. Cooperative gallery. Estab. 1976. Interested in emerging, mid-career and established artists. Represents over 30 artists. Sponsors 20 solo and numerous group shows/year. Average display time 1 month. Located in the Seventh Street Gallery District in Penn Quarter; second floor of a building that is home to 5 other art galleries; main exhibition space features 2 solo exhibits, 3 smaller exhibit spaces feature monthly members shows. Clientele: 90% private collectors, 10% corporate clients. Overall price range: $100-6,000. Most artwork sold at $400-1,500.

Media: Considers all media. Most frequently exhibits paintings, sculpture and photography.

Style: Exhibits all styles and genres. "We show contemporary art from the Washington DC area."

Terms: Donation of time, monthly fee of $100 and 40% commission. Retail price set by artist. Exclusive area representation not required. Prefers framed artwork.

Submissions: Send query letter with SASE for jurying information. Artists are juried by actual work at monthly meetings. Artists are juried in by the member artists. A majority of positive votes is required for acceptance. Voting is by secret ballot. The most common mistake artists make in presenting their work is "showing work from each of many varied periods in their careers."

Tips: "Artists who approach a co-op gallery should be aware that acceptance makes them partial owners of the gallery. They should be willing to work for the gallery's success."

TROYER FITZPATRICK LASSMAN GALLERY, 1710 Connecticut Ave. NW, Washington DC 20009. (202)328-7189. Fax: (202)667-8106. Retail gallery. Estab. 1983. Represents 22 emerging, mid-career and established artists/year; 30 emerging, mid-career and established photographers. Exhibited artists include: Mindy Weisel and Willem de Looper. Sponsors 6 shows/year. Average display time 7 weeks. Open all year except August; Tuesday-Friday, 11-5; Saturday-12-5. Located on Dupont Circle; 1,000 sq. ft.; townhouse. Overall price range: $500-10,000.

Media: Considers oil, paper, acrylic, sculpture, watercolor, mixed media, pastel, collage and photography. Most frequently exhibits paintings, photography and sculpture.

Style: Exhibits neo-expressionism, painterly abstraction, surrealism, all styles.

Terms: Accepts work on consignment (50% commission). Gallery provides insurance and promotion; artist pays for shipping.

Submissions: Accepts only Mid-Atlantic artists. Send query letter with résumé, slides and bio. Call for appointment

to show portfolio of photographs, transparencies and slides. Files slides. Finds artists through word of mouth, referrals by other artists, visiting art fairs and exhibitions and submissions.

☑ **WASHINGTON PRINTMAKERS GALLERY**, 1732 Connecticut Ave. NW, Washington DC 20009. (202)332-7757. Director: Pam Hoyle. Cooperative gallery. "We trade shows internationally." Estab. 1985. Exhibits 3 emerging and mid-career artists/year. Exhibited artists include Betty MacDonald, Tanya Matthews and Jenny Freestone. Sponsors 12 exhibitions/year. Average display time 1 month. Open all year; Tuesday-Thursday, 12-6; Friday, 12-9; Saturday-Sunday, 12-5. Located downtown in Dupont Circle area. 100% of space for gallery artists. Clientele: varied. 90% private collectors, 10% corporate collectors. Overall price range: $50-900; most work sold at $200-400.
Media: Considers only all types of original prints, hand pulled by artist. Most frequently exhibits etchings, lithographs, serigraphs.
Style: Considers all styles and genres. Prefers expressionism, abstract, realism.
Terms: Co-op membership fee plus donation of time (35% commission). Retail price set by artist. Gallery provides promotion; artist pays shipping costs.
Submissions: Send query letter. Call for appointment to show portfolio of original prints and slides. Replies in 1 month.
Tips: "There is a bimonthly jury for prospective new members. Call to find out how to present work. We are especially interested in artists who exhibit a strong propensity for not only the traditional conservative approaches to printmaking, but also the looser, more daring and innovative experimentation in technique."

Florida

Ⓝ AMBROSINO GALLERY, 3095 S.W. 39th Ave., Miami FL 33146. (305)445-2211. Fax: (305)444-0101. E-mail: ambrosino@earthlink.net. Director: Genaro Ambrosino. Retail gallery. Estab. 1991. Represents 22 contemporary artists/year. Exhibited artists include: William Cordova and Hilla Lulu Lin. Sponsors 8 shows/year. Average display time 6 weeks. Open Wednesday-Friday, 11-5; Saturday 12-5, or by appointment. Closed July or August. Located in southwest Miami; 10,000 sq. ft.; warehouse space. Clientele: local, upscale. 90% private collectors, 10% corporate collectors. Overall price range: $1,000-40,000; most work sold at $1,500-10,000.
Media: Considers oil, paper, fiber, acrylic, drawing, sculpture, mixed media, installation, collage, photography and video/film. Most frequently exhibits painting, photography and installation.
Style: Exhibits conceptualism, minimalism, painterly abstraction and postmodern works.
Terms: Accepts work on consignment (50% commission). Buys outright for 50% of retail price. Retail price set by the artist. Gallery provides insurance and promotion. Prefers artwork framed.
Submissions: Accepts contemporary art only. Send query letter with résumé, slides, photographs and SASE. Call for appointment to show portfolio of photographs and slides. Replies in 2 weeks. Files photos and catalogs.
Tips: "Common artists' mistakes include not calling in advance for appointment, submitting poor-quality images, not inquiring beforehand about type of work shown at the gallery, not including SASE for reply."

Ⓝ ATLANTIC CENTER FOR THE ARTS, INC., 1414 Arts Center Ave., New Smyrna Beach FL 32168. (904)427-6975. Contact: Program Director. Nonprofit interdisciplinary artists-in-residence program. Estab. 1979. Represents established artists. Interested in seeing the work of emerging artists. Exhibited artists include Alex Katz, Wm. Wegman, Janet Fish, Mel Chin. Sponsors 5-6 shows/year. Located on secluded bayfront—3½ miles from downtown; 100 sq. ft.; building made of cedar wood, 30 ft. ceiling, skylights. Clientele: local community, art patrons. "Most work is not sold—interested parties are told to contact appropriate galleries."
 • This location accepts applications for residencies only, but they also run Harris House of Atlantic Center for the Arts, which accepts Florida artists only for exhibition opportunities. Harris House is located at 214 S. Riverside Dr., New Smyrna Beach FL 32168. (904)423-1753.
Media: Most frequently exhibits paintings/drawings/prints, video installations, sculpture, photographs.
Style: Contemporary.
Terms: "Provides insurance, shipping costs, etc. for exhibiting Master Artists' work."
Submissions: Exhibits only Master Artists in residence. Call for more information.

AUTHORS/OPUS 71 GUESTHOUSE, (formerly Opus 71 Galleries), 725 White St., Key West FL 33040. (305)294-7381 or (800)898-6909. E-mail: lionxsx@aol.com. Co-Directors: Charles Z. Candler III and Gary R. Johnson. Retail and wholesale gallery, alternative space, art consultancy and salon style organization. Estab. 1969. Represents 50 (25-30 on regular basis) emerging, mid-career and established artists/year. Open all year; appointment only on weekdays, most weekend afternoons without appointment. Clientele: upscale, local, international and regional. 75% private collec-

SASE MEANS SELF-ADDRESSED, STAMPED ENVELOPE. Send SASEs when requesting return of your samples.

tors; 25% corporate collectors. Overall price range: $200-85,000; most work sold at $500-5,000
• This gallery is a division of The Leandros Corporation. Other divisions include Opus 71 Galleries and the Alexander project.
Media: Considers oil, acrylic, pastel, pen & ink, drawing, mixed media, collage, sculpture and ceramics; types of prints include woodcuts and wood engravings. Most frequently exhibits oils or acrylic, bronze and marble sculpture and pen & ink or pastel drawings.
Style: Exhibits: expressionism, neo-expressionism, primitivism, painterly abstraction, surrealism, conceptualism, minimalism, color field, postmodern works, Impressionism, photorealism, hard-edge geometric abstraction, realism and imagism. Exhibits all genres. Prefers: figural, objective and nonobjective abstraction and realistic bronzes.
Terms: Accepts work on consignment or buys outright. Retail price set by "consulting with the artist initially." Gallery provides insurance (with limitations), promotion and contract; artist pays for shipping. Prefers artwork framed.
Submissions: Telephone call is important. Call for appointment to show portfolio of photographs and actual samples. "We will not look at slides." Replies in 2 weeks. Files résumés, press clippings and some photographs. "Artists approach us from a far flung area. We currently have artists from about ten states and three foreign countries. Most come to us. We approach only a handful of artists annually."
Tips: "Know yourself . . . be yourself . . . ditch the jargon. Quantity of work available not as important as quality, and the fact that the presenter is a working artist. We don't want hobbyists."

BOCA RATON MUSEUM OF ART, 801 W. Palmetto Park Rd., Boca Raton FL 33486. (561)392-2500. Fax: (561)391-6410. Executive Director: George S. Bolge. Museum. Estab. 1950. Represents established artists. 2,500 members. Exhibits change every 2 months. Open all year; Tuesday, Thursday-Friday, 10-4; Wednesday, 10-9. Located one mile east of I-95 on Palmetto Park Road in Boca Raton; 3,000 sq. ft.; three galleries—one shows permanent collection, two are for changing exhibitions. 66% of space for special exhibitions.
Media: Considers all media.
Submissions: "Contact executive director, in writing."
Tips: "Photographs of work of art should be professionally done if possible. Before approaching museums, an artist should be well-represented in solo exhibitions and museum collections. Their acceptance into a particular museum collection, however, still depends on how well their work fits into that collection and how well it fits with the goals and collecting policies of that museum."

N ALEXANDER BREST MUSEUM/GALLERY, 2800 University Blvd., Jacksonville University, Jacksonville FL 32211. (904)745-7371. Fax: (904)745-7375. Director: David Lauderdale. Museum. Estab. 1970. Sponsors group shows of various number of artists. Average display time 6 weeks. Open all year; Monday-Friday, 9-4:30; Saturday, 12-5. "We close 2 weeks at Christmas and University holidays." Located in Jacksonville University, near downtown; 1,600 sq. ft.; 11½ foot ceilings. 50% of space for special exhibitions. "As an educational museum we have few if any sales. We do not purchase work—our collection is through donations."
Media: "We rotate style and media to reflect the curriculum offered at the institution. We only exhibit media that reflect and enhance our teaching curriculum. (As an example we do not teach bronze casting, so we do not seek such artists.)."
Style: Exhibits expressionism, neo-expressionism, primitivism, painterly abstraction, surrealism, all styles, primarily contemporary.
Terms: Retail price set by the artist. Gallery provides insurance and promotion; artist pays shipping costs to and from gallery. "The art work needs to be ready for exhibition in a professional manner."
Submissions: Send query letter with résumé, slides, brochure, business card and reviews. Write for appointment to show portfolio of slides. "Replies fast when not interested. Yes takes longer." Finds artists through visiting exhibitions and submissions.
Tips: "Being professional impresses us. But circumstances also prevent us from exhibiting all artists we are impressed with."

✓ CAPITOL COMPLEX EXHIBITION PROGRAM, Division of Cultural Affairs, The Capitol, Tallahassee FL 32399-0250. (850)487-2980. Fax: (904)922-5259. E-mail: sshaughnessy@mail.dos.state.fl.us. Website: http://www.dos. state.fl.us. Arts Administrator: Sandy Shaughnessy. Exhibition spaces (6 galleries). Represents 20 emerging, mid-career and established artists/year. Sponsors 20 shows/year. Average display time 3 months. Open all year; Monday-Friday, 8-5; Saturday-Sunday, 8:30-4:30. "Exhibition spaces include 22nd Floor Gallery, Cabinet Meeting Room, Secretary of State's Reception Area, Old Capitol-Gallery, the Florida Supreme Court and The Governor's Office Hallway."
Media: Considers all media and all types of prints. Most frequently exhibits oil, watercolor and acrylic.
Style: Exhibits all genres.
Terms: Free exhibit space—artist sells works. Retail price set by the artist. Gallery provides insurance; artist pays for shipping to and from gallery.
Submissions: Accepts only artists from Florida. Send query letter with résumé, 20 slides, artist's statement and bio.

DUNCAN GALLERY OF ART, Campus Box 8252, Stetson University, DeLand FL 32720-3756. (904)822-7266. Fax: (904)822-7268. E-mail: cnelson@stetson.edu. Website: www.stetson.edu/departments/art. Gallery Director: Dan Gunderson. Nonprofit university gallery. Represents emerging, mid-career and established artists. Sponsors 6-8 shows/year. Average display time 6 weeks. Open all year except during university holidays and breaks; Monday-Friday, 10-4; Saturday and Sunday, 1-4. Located in the heart of the Stetson University campus, which is adjacent to downtown;

2,400 sq. ft. in main gallery; 144 cu. ft. in glass display cases in foyer; in 100+-year-old, recently renovated building with Neo-Classical trappings and 16-foot ceilings. 95% of space for special exhibitions. Clientele: students, faculty, community members. 99% private collectors, 1% corporate collectors. Overall price range: $100-35,000.
Media: Considers all media and all types of prints. Most frequently exhibits paintings, ceramics and sculpture.
Style: Exhibits all styles, all genres.
Terms: Accepts work on consignment (20% commission). Retail price set by the artist. Gallery provides insurance and promotion; shipping costs are shared. Prefers artwork framed.
Submissions: "Exhibiting artists tend to be from the Southeast, but there are no restrictions." Send query letter with résumé, 20 slides, SASE and proposal. Write for appointment to show portfolio of originals, photographs, slides or transparencies. Replies in 3-4 months. Files slides, postcards, résumés. Finds artists through proposals, visiting exhibitions and word of mouth.
Tips: "Contact us; we'll be happy to provide our requirements."

N FRIZZELL CULTURAL CENTRE GALLERY, 10091 McGregor Blvd., Ft. Myers FL 33919. (941)939-2787. Fax: (941)939-0794. E-mail: arts@artinlee.org. Website: http://www.artinlee.org. Contact: Exhibition committee. Non-profit gallery. Estab. 1979. Represents emerging, mid-career and established artists. 800 members. Sponsors 12 shows/year. Average display time 1 month. Open all year; Monday-Saturday, 9-5. Located in Central Lee County—near downtown; 1,400 sq. ft.; high ceiling, open ductwork—ultra modern and airy. Clientele: local to national. 90% private collectors, 10% corporate collectors. Overall price range: $200-100,000; most work sold at $500-5,000.
Media: Considers all media and all types of print. Most frequently exhibits oil, sculpture, watercolor, print, drawing and photography.
Style: Exhibits all styles, all genres.
Terms: Retail price set by the artist. Prefers artwork framed. Only 30% commission, no shipping fees.
Submissions: Send query letter with slides, bio and SASE. Write for appointment to show portfolio of photographs and slides. Replies in 3 months. Files "all material unless artist requests slides returned." Finds artists through visiting exhibitions, word of mouth and artists' submissions.

THE HANG-UP, INC., 45 S. Palm Ave., Sarasota FL 34236. (813)953-5757. President: F. Troncale. Manager: Lynlee Troncale. Retail gallery. Estab. 1971. Represents 25 emerging and mid-career artists. Sponsors 6 shows/year. Average display time 1 month. Open all year. Located in arts and theater district downtown; 1,700 sq. ft.; "high tech, 10 ft. ceilings with street exposure in restored hotel." 50% of space for special exhibitions. Clientele: 75% private collectors, 25% corporate collectors. Overall price range: $500-5,000; most artwork sold at $500-1,000.
Media: Considers oil, acrylic, watercolor, mixed media, collage, works on paper, sculpture, original handpulled prints, lithographs, etchings, serigraphs and posters. Most frequently exhibits painting, graphics and sculpture.
Style: Exhibits expressionism, painterly abstraction, surrealism, Impressionism, realism and hard-edge geometric abstraction. All genres. Prefers abstraction, Impressionism, surrealism.
Terms: Accepts artwork on consignment (50% commission). Retail price set by artist. Sometimes offers customer discounts and payment by installment. Gallery provides insurance, promotion and contract; shipping costs are shared. Prefers unframed work. Exhibition costs shared 50/50.
Submissions: Send résumé, brochure, slides, bio and SASE. Write for appointment to show portfolio of originals and photographs. "Be organized and professional. Come in with more than slides; bring P.R. materials, too!" Replies in 1 week.

N KENDALL CAMPUS ART GALLERY, MIAMI-DADE COMMUNITY COLLEGE, 11011 SW 104 St., Miami FL 33176-3393. (305)237-2322. Fax: (305)237-2901. Interim Director: Lilia Fontana. College gallery. Estab. 1970. Represents emerging, mid-career and established artists. Exhibited artists include Komar and Melamid. Sponsors 10 shows/year. Average display time 3 weeks. Open all year except for 2 weeks at Christmas and 3 weeks in August. Located in suburban area, southwest of Miami; 3,000 sq. ft.; "space is totally adaptable to any exhibition." 100% of space for special exhibitions. Clientele: students, faculty, community and tourists. "Gallery is not primarily for sales, but sales have frequently resulted."
Media: Considers all media, all types of original prints. "No preferred style or media. Selections are made on merit only."
Style: Exhibits all styles and genres.
Terms: "Purchases are made for permanent collection; buyers are directed to artist." Retail price set by artist. Gallery provides insurance and promotion; arrangements for shipping costs vary. Prefers artwork framed.
Submissions: Send query letter with résumé, slides, bio, brochure, SASE, and reviews. Write for appointment to show portfolio of slides. "Artists commonly make the mistake of ignoring this procedure." Replies in 2 weeks. Files résumés and slides (if required for future review).
Tips: "Present good-quality slides of works which are representative of what will be available for exhibition."

☑ KOUCKY GALLERY, 4330 Gulfshore Blvd. N., #306, Naples FL 34102. (813)261-8988. Fax: (813)261-8576. E-mail: nrkoucky@aol.com. Owners: Chuck and Nancy. Retail gallery. Focus is on contemporary American artists and craftsmen. Estab. 1986. Represents/exhibits 175 emerging, mid-career and established artists/year. Exhibited artists include Daniel Meyer and Jack Dowd. Sponsors 6 shows/year. Open all year; Monday-Saturday. Located in the Village

on Venetian Bay. Clientele: upscale international, resort. 98% private collectors, 2% corporate collectors. Overall price range: $14-35,000; most work sold at $85-900.

• Koucky Gallery also has a location in Charlevoix, Michigan.

Media: Considers all media. Most frequently exhibits sculpture, painting, jewelry and designer crafts.

Style: Exhibits expressionism, painterly abstraction, Impressionism, contemporary works and imagism.

Terms: Artwork is accepted on consignment. Retail price set by the artist. Gallery provides insurance. Artist pays shipping costs. Prefers artwork framed.

Submissions: Accepts only US artists. Send query letter with at least 6 slides, photographs, bio and SASE. Call for appointment to show portfolio of photographs. "Replies slowly." Finds artists through word of mouth.

Tips: "Send portfolio and résumé with retail prices and SASE. Then call for appointment. Follow up is required, we're so busy we might not have time to follow up. Don't show up in the middle of our busy season and expect to be represented or even seen."

A LAUREL ART GALLERY, 2112 Crystal Dr., Ft. Myers FL 33907. (941)278-0489. Fax: (941)482-6879. E-mail: alaurelart@cyberstreet.com. Website: www.alaurelart.com. Retail gallery. Estab. 1990. Represents 6 emerging artists/year. Exhibited artists include Ch Vaurina and G. Valtier. Sponsors 2 shows/year. Average display time 6 weeks. Open all year; 11-4. 6,000 sq. ft.. 75% of space for special exhibitions. Clientele: tourists and upscale. 10% private collectors. Overall price range: $1,000-10,000; most work sold at $3,000.

Media: Considers oil and acrylic.

Style: Exhibits: Impressionism. Genres include landscapes and still lifes.

Terms: Accepts work on consignment (50% commission). Retail price set by the gallery. Gallery provides promotion; artist pays for shipping.

Submissions: Send résumé, brochure and 12 slides. Call for appointment to show portfolio of photographs.

Tips: You should have completed a body of work of approximately 200 works before approaching galleries.

N J. LAWRENCE GALLERY, 1435 Highland Ave., Melbourne FL 32935. (407)259-1492. Fax: (407)259-1494. Director/Owner: Joseph L. Conneen. Retail gallery. Estab. 1980. Represents 65 mid-career and established artists. Exhibited artists include Wayne Sessions and Mari Conneen. Sponsors 10 shows/year. Average display time 3 weeks. Open all year. "Centrally located downtown in a turn-of-the-century bank building in the antique and business district; 2,000 sq. ft.; five individual gallery rooms." 50% of space for special exhibitions. Clientele: 80% private collectors, 20% corporate collectors. Overall price range: $2,000-150,000; most work sold at $2,000-15,000.

Media: Considers oil, acrylic, watercolor, pastel, sculpture, ceramic, glass, original handpulled prints, mezzotints, lithographs and serigraphs. Most frequently exhibits oil, watercolor and silkscreen.

Style: Exhibits expressionism, painterly abstraction, Impressionism, realism, photorealism and hard-edge geometric abstraction; all genres. Prefers realism, abstraction and hard-edge works.

Terms: Accepts work on consignment (50% commission). Retail price set by gallery. Customer discounts and payment by installment are available. Gallery provides insurance and promotion; artist pays for shipping.

Submissions: Prefers résumés from established artists. Send résumé, slides and SASE. Write for appointment to show portfolio of originals and slides.

Tips: "The most common mistake artists make is not making appointments and not looking at the gallery first to see if their work would fit in. The gallery scene is getting better. The last three years have been terrible."

MIAMI ART MUSEUM, 101 W. Flagler St., Miami FL 33130. (305)375-3000. Fax: (305)375-1725. Director: Suzanne Delehany. Museum. Estab. 1984. Exhibitions include emerging, mid-career and established artists. Average display time 2 months. Open all year; Tuesday-Friday, 10-5; Saturday and Sunday, noon-5 pm. Located downtown; cultural complex designed by Philip Johnson. 16,000 sq. ft. for exhibitions.

Media: Considers all media.

Style: Has exhibited international art of the Western Hemisphere since 1945; large scale traveling exhibitions, retrospective of internationally known artists.

Submissions: Accepts only artists nationally and internationally recognized. Send query letter with résumé, slides, bio, brochure, photographs, SASE and reviews. Replies in 2-3 months.

Tips: Finds artists through visiting exhibitions, word of mouth, art publications and artists' submissions.

✓ NEW RIVER GALLERY, (formerly Apropos Art Gallery, Inc.), 1016 E. Las Olas Blvd., Ft. Lauderdale FL 33301. (954)524-2100. Fax: (954)524-1817. Director: Lisa Aruta. Retail and wholesale gallery. Represents/exhibits 20th Century masters and contemporary art. Interested in seeing the work of emerging artists. Sponsors 65 shows/year. Average display time 3 months. Open all year; Monday-Sunday, 10-7. Located downtown, Main Blvd.; 4,000 sq. ft.; newly remodeled, wood floors, high ceiling. 90% of space for gallery artists. Clientele: tourists, upscale, local community. 100% private collectors. Overall price range: $1,000-150,000.

Media: Considers all media except pastel and wood. Considers woodcut, engraving, lithograph, wood engraving, mezzotint, serigraphs, linocut and etching. Most frequently exhibits oil and acrylic painting.

Style: Exhibits expressionism, conceptualism, photorealism, neo-expressionism, painterly abstract, realism, surrealism and imagism. Genres include figurative work. Prefers figurative, surrealism, expressionism and Impressionism.

Terms: Artwork is accepted on consignment and there is up to a 50% commission. Retail price set by the gallery and the artist. Gallery provides insurance, promotion and contract; shipping costs are shared. Prefers artwork framed.

Submissions: Send query letter with résumé, slides, reviews, bio, SASE and detail/wholesale price list. Gallery will contact artist if interested. Portfolio should include photographs and slides. Replies in 1-2 months. Finds artists through word of mouth, referrals by other artists, visiting art fairs and exhibitions and artists' submissions.
Tips: "Keep your portfolio updated and complete."

NUANCE GALLERIES, 720 S. Dale Mabry, Tampa FL 33609. (813)875-0511. Owner: Robert A. Rowen. Retail gallery. Estab. 1981. Represents 70 emerging, mid-career and established artists. Sponsors 3 shows/year. Open all year. 3,000 sq. ft. "We've reduced the size of our gallery to give the client a more personal touch. We have a large extensive front window area."
Media: Specializing in watercolor, original mediums including sculpture.
Style: "Majority of the work we like to see are realistic landscapes, escapism pieces, bold images, bright colors and semitropical subject matter. Our gallery handles quite a selection and it's hard to put us into any one class."
Terms: Accepts work on consignment (50% commission). Retail price set by gallery and artist. Offers customer discounts and payment by installments. Gallery provides insurance and contract; shipping costs are shared.
Submissions: Send query letter with slides and bio. SASE if want slides/photos returned. Portfolio review requested if interested in artist's work.
Tips: "Be professional; set prices (retail) and stick with them. There are still some artists out there that are not using conservation methods of framing. As far as submissions we would like local artists to come by to see our gallery and get the idea what we represent. Tampa has a healthy growing art scene and the work has been getting better and better. But as this town gets more educated it is going to be much harder for up-and-coming artists to emerge."

PARADISE ART GALLERY, 1359 Main St., Sarasota FL 34236. (941)366-7155. Fax: (941)366-8729. Website: http://www.paradisegallery.com. President: Gudrún Newman. Retail gallery, art consultancy. Represents hundreds of emerging, mid-career and established artists/year. May be interested in seeing the work of emerging artists in the future. Exhibited artists include: John Lennon, Hessam, Sabzi, Britto. Open all year; Monday-Saturday, 10-10; Sunday by appointment. Located in downtown Sarasota; 2,500 sq. ft. 50% of space for special exhibitions. Clientele: tourists, upscale. 90% private collectors, 10% corporate collectors. Overall price range: $500-30,000; most work sold at $1,000.
Media: Considers all media. Most frequently exhibits serigraphs, acrylics, 3-D art.
Style: Exhibits all styles. Prefers contemporary, pop.
Terms: Accepts work on consignment (50% commission). Buys outright for 50-70% of retail price (net 30-60 days). Retail price set by the gallery. Gallery provides promotion and contract; shipping costs are shared. Prefers artwork framed.
Submissions: Send query letter with résumé, brochure, photographs, artist's statement and bio. Call for appointment to show portfolio of photographs. Replies in 2-3 weeks.

PASTA FINE ART (PROFESSIONAL ARTISTS OF ST. AUGUSTINE) GALLERY INC., 214 Charlotte St., St. Augustine FL 32084. (904)824-0251. Director/Vice President: Jean W. Troemel. Cooperative nonprofit gallery. Estab. 1984. Represents 17 emerging, mid-career and established artists/year. 17 artist members. Exhibited artists include Jean W. Troemel. Continuous exhibition of members' work plus a featured artist each month. Average display time 2 months. Open all year; Monday-Friday, 10:30-4; Saturday and Sunday, 10-5. Located downtown—"South of The Plaza"; 1,250 sq. ft.; a 100-year-old building adjoining a picturesque antique shop and located on a 400-year-old street in our nation's oldest city. 100% of space for gallery artists. Clientele: tourists and visitors. 100% private collectors. "We invite two guest artists for two month exhibitions. Same conditions as full membership."
Overall price range: $10-3,000; most work sold at $10-800.
 • This gallery reports that their clients are looking for larger paintings.
Media: Considers oil, acrylic, watercolor, pastel, pen & ink, drawing, mixed media, collage, sculpture, ceramics, photography, alkyd, serigraphs and mono prints. Most frequently exhibits watercolor, oil and alkyd.
Style: Exhibits expressionism, primitivism, painterly abstraction, Impressionism and realism. Genres include landscapes, florals, portraits and figurative work. Prefers Impressionism and realism.
Terms: Co-op membership fee (30% commission). Retail price set by the artist. Gallery provides insurance, promotion and contract; artist pays shipping costs to and from gallery.
Submissions: Accepts only artists from Northeast Florida. Work must be no larger than 60 inches. Send query letter with résumé, 5 slides or photographs, bio, brochure, and SASE. Call or write for appointment to show portfolio of originals, photographs and brochures. "New members must meet approval of a committee and sign a 4-month contract with the 1st and 4th month paid in advance." Replies only if interested within 2 weeks. Finds artists through visiting exhibitions, word of mouth, artists' submissions.
Tips: "We can tell when artists are ready for gallery representation by their determination to keep producing and improving regardless of negative sales plus individual expression and consistent good workmanship. They should have up to ten works—large pieces, medium sizes and small pieces—in whatever medium they choose. Every exhibited artwork should have a bio of the artist on the books."

☑ **PENSACOLA MUSEUM OF ART**, 407 S. Jefferson, Pensacola FL 32501. (850)432-6247. Website: http://www.artsnwfl.org/pma. Director: Linda Nolan Ph.D. Nonprofit museum. Estab. 1954. Interested in emerging, mid-career and established artists. Sponsors 18 exhibitions/year. Average display time: 6-8 weeks. Open all year. Located

in the historic district; renovated 1906 city jail. Clientele: 90% private collectors; 10% corporate clients. Overall price range: $200-20,000; most work sold at $500-3,000.

- This museum has guidelines for submitting work. Write to Curator of Exhibitions for "Unsolicited Exhibition Policy" guidelines.

Media: Considers all media. Most frequently exhibits painting, sculpture, photography, glass and new-tech (i.e. holography, video art, computer art etc.).

Style: Exhibits neo-expressionism, realism, photorealism, surrealism, minimalism, primitivism, color field, postmodern works, imagism; all styles and genres.

Terms: Retail price set by museum and artist. Exclusive area representation not required. Museum provides insurance and promotion costs.

Submissions: Send query letter with résumé, at least 3 slides, SASE and/or videotape. "A common mistake of artists is making impromptu drop-ins." Files guides and résumé.

Tips: Looks for "skill and expertise and a broad selection of definitive works."

RENNER STUDIOS, INC., 4056 S.W. Moore St., Palm City FL 34990, (561)287-1855. Fax: (561)287-0398. Gallery Director/Owner: Ron Renner. Retail gallery. Estab. 1989. Represents 6 emerging and established artists/year. Exhibited artists include Simbari and Ron Renner. Sponsors 4 shows/year. Average display time 1 month. Open all year; Monday-Saturday, 10-6. Located in rural area, barn studios and showroom; 1,200 sq. ft.; 50% of space for special exhibitions; 50% of space for gallery artists. Clientele. 90% private collectors, 10% corporate collectors. Overall price range: $750-250,000; most work sold at $7,500-10,000.

Media: Considers oil, pen & ink, acrylic, drawing, watercolor, mixed media, pastel, collage, photography, engravings, etchings, lithographs and serigraphs. Most frequently exhibits oil on canvas/linen, acrylic on canvas, serigraphs.

Style: Exhibits expressionism, Impressionism, action painting. Genres include Mediterranean seascapes. Prefers abstract expressionism, Impressionism and drawings.

Terms: Artwork is accepted on consignment (50% commission). Retail price set by the gallery. Gallery provides insurance, promotion, contract; shipping costs are shared. Prefers artwork framed.

Submissions: Send query letter with résumé, slides, bio and SASE. Write for appointment to show portfolio of slides. Replies only if interested within 3 weeks. Files bio, résumé, photos and slides. Finds artists through submissions and visits to exhibits.

Tips: "Keep producing, develop your style, take good pictures for slides of your work."

SANTE FE TRAILS GALLERY, 1429 Main St., Sarasota FL 34236. (813)954-1972. E-mail: sftgallery@aol.com. Website: http://www.eltallerpublishing.com. Owner: Beth Segreti. Retail gallery. Emphasis is on Native American and contemporary Southwestern art. Estab. 1990. Represents/exhibits 25 emerging, mid-career and established artists/year. May be interested in seeing the work of emerging artists in the future. Exhibited artists include Amado Peña and R.C. Gorman. Sponsors 5-6 shows/year. Average display time 1 month. Open all year; Tuesday-Saturday, 10-5. Located downtown; 1,000 sq. ft.; 100% of space for special exhibitions featuring gallery artists. Clientele: tourists, upscale and local community. 100% private collectors. Overall range: $35-12,000; most work sold at $500-1,500.

Media: Considers all media, etchings, lithographs, serigraphs and posters. Most frequently exhibits lithographs, mixed media and watercolor.

Style: Prefers Southwestern. "Southwestern art has made a dramatic increase in the past few months. This could be the start of another seven-year cycle."

Terms: Artwork is accepted on consignment (50% commission), or is bought outright for 50% of the retail price. Retail price set by the gallery and the artist. Gallery provides promotion. Shipping costs are shared. Artist pays for shipping costs to gallery. Prefers artwork unframed.

Submissions: Send query letter with résumé, slides or photographs, bio and SASE. Write for appointment to show portfolio of photographs, slides and transparencies. Replies only if interested within 2 weeks. Finds artists through word of mouth, referrals by other artists and submissions.

Tips: "Make an appointment. No walk-ins!!"

Georgia

ABSTEIN GALLERY, 558 14th St. NW, Atlanta GA 30318. (404)872-8020. Fax: (404)872-2518. Gallery Director: Paul E. Abstein. Retail gallery. Estab. 1973. Represents/exhibits 40 emerging, mid-career and established artists/year. Exhibited artists include Eva Carter and Elsie Dresch. Sponsors 3 shows/year. Average display time 1-2 months. Open all year; Monday-Friday, 8:30-5:30; Saturday, 10-4. Located midtown; 5,000 sq. ft.; 2 story glass block window and interior glass wall. 100% of space for gallery artists. Clientele: interior designers, Atlanta and surrounding city homeowners. 50% private collectors, 50% corporate collectors. Overall price range: $100-12,000; most work sold at $1,000-5,000.

Media: Considers all media and all types of prints. Most frequently exhibits oil on canvas, pastel and watercolor, ceramics.

Style: Exhibits expressionism, conceptualism, photorealism, minimalism, color field, hard-edge geometric abstraction,

painterly abstraction, postmodern works, realism, surrealism, Impressionism and imagism. All genres. Prefers abstract figurative, landscapes and abstraction.

Terms: Artwork is accepted on consignment and there is a 50% commission. Retail price set by the artist. Gallery provides insurance, promotion and contract. Artist pays for shipping costs. Prefers artwork unframed (paper art acetate-wrapped).

Submissions: Send query letter with résumé, slides, photographs, bio and SASE. "We will contact them once we see slides." Replies in 2 weeks. Files artist bio.

Tips: "Try to visit galleries where you wish to submit to see if the work would be suitable."

ARIEL GALLERY, 75 Bennett St., NW, Atlanta GA 30309. (404)352-5753. Contact: Director. Cooperative gallery. Estab. 1984. Represents 20 emerging, mid-career and established artists/year. 18 members. Exhibited artists include Mark Allen Henderson, Susan Sisk and Georgia Nagle. Sponsors 8 shows/year. Average display time 6 weeks. Open all year; Tuesday-Saturday, 11-5. Located in midtown; 914 sq. ft. Clientele: upscale, urban. 80% private collectors, 20% corporate collectors. Overall price range: $25-6,000; most work sold at $250-1,500.

Media: Considers all media, all types of prints. Most frequently exhibits paintings, sculpture and fine crafts.

Style: Exhibits primitivism, painterly abstraction and pattern painting. Prefers semi-abstract or abstract.

Terms: Accepts work on consignment (40% commission) or Co-op membership fee plus a donation of time (10% commission). Retail price set by the artist. Gallery provides promotion and contract. "Prefers hand delivery."

Submissions: Accepts only member artists from Atlanta area. "Some work taken on consignment. Members must live within 50-mile radius of Atlanta." Send query letter with résumé, slides or photographs, and bio. "Applicants for membership are considered at meeting on first Monday of each month." Portfolio should include originals (if possible), photographs or slides. Replies in 2 months. Finds artists through visiting exhibitions, word of mouth, submissions, local advertising in arts publications.

Tips: "Talk with membership chairman or exhibition director and get details. We're approachable and less formal than most."

COASTAL CENTER FOR THE ARTS, INC., 2012 Demere Rd., St. Simons Island GA 31522. Phone/fax: (912)634-0404. Director: Mittie B. Hendrix. Nonprofit regional art center. Estab. 1947. Represents over 150 emerging, mid-career and established artists/year. Sponsors 15 shows/year. Average display time 3 weeks. Open all year; Monday-Saturday, 9-5. Located on main thoroughfare; 9,000 sq. ft.; 6 large galleries, 1 small built for display. "We do not hang multiple paintings on wall, but display as in a museum. 90% for special exhibitions. Clientele: tourists, upscale, local community, students. Overall price range: $ 25-7,000; most work sold at $300 minimum.

Media: Considers all media and all types of prints. Most frequently exhibits paintings, sculpture, pottery.

Style: Exhibits all styles and genres. Prefers neo-Impressionism, realism, superrealism.

Terms: Accepts work on consignment (30-40% commission). Gallery consults the artist about retail price. Gallery provides promotion and contract; artist pays for shipping. Prefers artwork framed or shrink-wrapped for bins.

Submissions: Send query letter with at least 12 slides, bio, SASE. Write for appointment to show portfolio of photographs. "We have limited clerical staff but reply ASAP." Finds artists through word of mouth, other artists' recommendations.

Tips: "Don't overframe. Be honest and realistic. Don't be too sensitive. We want to see you succeed so we try to give helpful constructive critique if needed. Most of our artists are not prolific, but we would like to have a minimum of three for selection by patrons. For a show, you need 20-25, according to size."

ANN JACOB GALLERY, 3261 Roswell Rd. NE, Atlanta GA 30305. (404)262-3399. Director: Yvonne J. Spiotta. Retail gallery. Estab. 1968. Represents 35 emerging, mid-career and established artists/year. Sponsors 4 shows/year. Open all year; Monday-Saturday 10-9; Sunday 12-5:30. Located midtown; 1,600 sq. ft. 100% of space for special exhibitions; 100% of space for gallery artists. Clientele: private and corporate. 80% private collectors, 20% corporate collectors.

Media: Considers oil, acrylic, watercolor, sculpture, ceramics, craft and glass. Most frequently exhibits paintings, sculpture and glass.

Style: Exhibits all styles, all genres.

Terms: Accepts work on consignment (50% commission). Retail price set by the gallery and the artist. Gallery provides promotion; artist pays shipping costs.

Submissions: Send query letter with résumé, slides, bio, brochure, photographs and SASE. Write for appointment. Replies in 2 weeks.

RAYMOND LAWRENCE GALLERY, 75 Bennett St., Suite M1, Atlanta GA 30309. (404)352-5058. Fax: (404)352-2979. Director of Sales and Marketing: Sophia Nakis . Estab. 1998. Represents 25 emerging, mid-career and established artists. Exhibited artists include Edgar Sanchez Cumbas and David Pettrow. Sponsors 11 exhibits/year. Average display time 1 month. Open all year: Tuesday-Friday, 11-5; Saturday, 12-5; Sundays and Mondays by appointment. Located in Buckhead; 6,800 sq. ft.; "European flair, architecture is pristine and unique." Clients include tourists, upscale, local community, students, designers, other artists and collectors. 90% of sales are to private collectors, 10% to corporate collectors. Overall price range $700-25,000; most work sold at $3,00-8,000.

Media: Considers oil, acrylic, pen & ink, drawing, mixed media, collage, sculpture, installation and photography. No prints. Most frequently exhibits mixed media, oil and sculpture.

Style: Considers all styles. Genres include landscapes and figurative work. Most frequently exhibits figurative, abstract and representational styles.

Terms: Artwork is accepted on consignment and there is a 50% commission. Retail price set by the gallery and the artist. Gallery provides promotion and contract. Accepted work should be framed.

Submissions: Artist needs 2 review submission requirement forms. Call gallery and they will send on fax. Send query letter with résumé, slides, bio, brochure, artist's statement and SASE. Write for appointment for portfolio review including slides. Replies in 1 month. Slides, résumé, bio and statement are filed. Finds artists through submissions, advertising and word of mouth.

Tips: "Common mistakes made by artists when submitting to our gallery: no SASE; not a solid body of work, need to see continuity and/or development."

TRINITY GALLERY, 315 E. Paces Ferry Rd., Atlanta GA 30305. (404)237-0370. Fax: (404)240-0092. E-mail: trinitygallery@mindspring.com. Website: http://www.artatlanta.com/trinitygallery. President: Alan Avery. Retail gallery and corporate sales consultants. Estab. 1987. Represents/exhibits 67 mid-career and established artists and old masters/year. Exhibited artists include Frederick Hart, Adrian Arleo and David Fraley. Sponsors 6 shows/year. Average display time 1 month. Open all year; Tuesday-Friday, 10-6; Saturday, 11-5 and by appointment. Located mid-city; 6,700 sq. ft.; 25-year-old converted restaurant. 50-60% of space for special exhibitions; 40-50% of space for gallery artists. Clientele: upscale, local, regional, national and international. 70% private collectors, 30% corporate collectors. Overall price range: $300-100,000; most work sold at $1,500-5,000.

● Gallery has a second location at 47 Forsyth, The Healey Building, Atlanta GA 30303. (404)659-0084.

Media: Considers all media and all types of prints. Most frequently exhibits painting, sculpture and work on paper.

Style: Exhibits expressionism, conceptualism, color field, painterly abstraction, postmodern works, realism, impressionism and imagism. Genres include landscapes, Americana and figurative work. Prefers realism, abstract and figurative.

Terms: Artwork is accepted on consignment (negotiable commission), or it is bought outright for a negotiable price. Retail price set by gallery. Gallery pays promotion and contract. Shipping costs are shared. Prefers artwork framed.

Submissions: Send query letter with résumé, at least 20 slides, bio, prices, medium, sizes and SASE. Reviews every 6 weeks.

Tips: Finds artists through word of mouth, referrals by other artists and artists' submissions. "Be as complete and professional as possible in presentation. We provide submittal process sheets listing all items needed for review. Following this sheet is important."

VESPERMANN GLASS GALLERY, 2140 Peachtree Rd., Atlanta GA 30309. (404)350-9698. Fax: (404)350-0046. Owner: Seranda Vesperman. Managers: David Alfrey, Tracey Lofton. Retail gallery. Estab. 1984. Represents 200 emerging, mid-career and established artists/year. Sponsors 4-5 shows/year. Average display time 1 month. Open all year; Monday-Saturday, 10-6 and holiday hours. Located between Mid-town and Buckhead; 2,500 sq. ft.; features contemporary art glass. Overall price range: $100-10,000; most work sold at $200-2,000.

Media: Considers glass and craft.

Style: Exhibits contemporary.

Terms: Accepts work on consignment (50% commission). Buys outright for 50% of retail price (net 30 days). Retail price set by the gallery and the artist. Gallery provides insurance, promotion and contract; shipping costs are shared.

Submissions: Send query letter with résumé, slides, bio. Write for appointment to show portfolio of photographs, transparencies and slides. Replies only if interested within 2 weeks. Files slides, résumé, bio.

Hawaii

▣ COAST GALLERIES, Located in Hana, Hawaii. Also in Big Sur and Pebble Beach, California. Mailing address: P.O. Box 223519, Carmel CA 93922. (408)625-4145. Fax: (408)625-3575. E-mail: gmk@mbay.net. Website: http://www.coastgalleries.com or http://www.hanacoastgallery.com. Owner: Gary Koeppel.

● Coast Galleries are located in both Hawaii and California. See listing in San Francisco section for information on the galleries' needs and submission policies.

HANA COAST GALLERY, Hotel Hana-Maui, P.O. Box 565, Hana Maui HI 96713. (808)248-8636. Fax: (808)248-7332. E-mail: 72162.261@compuserve.com. Website: http://www.hanacoast.com. Managing Director: Patrick Robinson. Retail gallery and art consultancy. Estab. 1990. Represents 75 mid-career and established artists. May consider emerging artists in the future. Sponsors 12 group shows/year. Average display time 1 month. Open all year. Located in the Hotel Hana-Maui at Hana Ranch; 3,000 sq. ft.; "an elegant ocean-view setting in one of the top small luxury resorts in the world." 20% of space for special exhibitions. Clientele: ranges from very upscale to highway traffic walk-ins. 85% private collectors, 15% corporate collectors. Overall price range: $150-50,000; most work sold at $1,500-25,000.

Media: Considers oil, acrylic, watercolor, pastel, mixed media, collage, works on paper, sculpture, ceramic, craft, fiber, glass, photography, original handpulled prints, engravings, lithographs, pochoir, wood engravings, mezzotints, serigraphs and etchings. Most frequently exhibits oil, watercolor and Japanese woodblock/old master etchings.

Style: Exhibits expressionism, primitivism, painterly abstraction, postmodern works, Impressionism and realism. Genres include landscapes, florals, portraits, figurative work and Hawaiiana. Prefers landscapes, florals and figurative work.

"We display very painterly Hawaiian landscapes. Master-level craftwork, particularly turned-wood bowls and smaller jewelry chests. We are *the* major gallery featuring Hawaiian crafts/furniture."

Terms: Accepts artwork on consignment (50% commission). Retail price set by gallery and artist. Gallery provides insurance, promotion and shipping costs from gallery. Framed artwork only.

Submissions: Accepts only full-time Hawaii resident artists. Send query letter with résumé, slides, bio, brochure, photographs, SASE and reviews. Write for appointment to show portfolio after query and samples submitted. Portfolio should include originals, photographs, slides and reviews. Replies only if interested within 1 week. If not accepted at time of submission, all materials returned.

Tips: "Know the quality level of art in our gallery and know that your own art would be companionable with what's being currently shown. We represent artists instead of just being 'picture sellers.' "

☑ MAYOR'S OFFICE OF CULTURE AND THE ARTS, 530 S. King, #404, Honolulu HI 96813. (808)523-4674. Fax: (808)527-5445. Acting Director: Peter Radulovic. Local government/city hall exhibition areas. Estab. 1965. Exhibits group shows coordinated by local residents. Sponsors 50 shows/year. Average display time 3 weeks. Open all year; Monday-Friday, 7:45-4:30. Located at the civic center in downtown Honolulu; 3 galleries—courtyard (3,850 sq. ft.), lane gallery (873 sq. ft.), 3rd floor (536 sq. ft.); Mediterranean-style building, open interior courtyard. "City does not participate in sales. Artists make arrangements directly with purchaser."

Media: Considers all media and all types of prints. Most frequently exhibits oil/acrylic, photo/print and clay.

Terms: Gallery provides promotion; local artists deliver work to site. Prefers artwork framed.

Submissions: "Local artists are given preference." Send query letter with résumé, slides and bio. Write for appointment to show portfolio of slides. "We maintain an artists' registry for acquisition review for the art in City Buildings Program."

Tips: "Selections of exhibitions are made through an annual application process. Have a theme or vision for exhibit. Plan show at least one year in advance."

QUEEN EMMA GALLERY, 1301 Punchbowl St., Honolulu HI 96813. (808)547-4397. Fax: (808)547-4646. E-mail: efukuda@queens.org. Website: http://www.queens.org. Director: Masa Morioka Taira. Nonprofit gallery. Estab. 1977. Exhibits the work of emerging, mid-career and established artists. Average display time is 4-5½ weeks. Weekend and holiday hours: 8 a.m.-12 p.m. Located in the main lobby of The Queen's Medical Center; "intimate ambiance allows close inspection." Clientele: M.D.s, staff personnel, hospital visitors, community-at-large. 90% private collectors. Overall price range: $50-5,000.

• The display wall space in this gallery has been expanded with the addition of a 32′ × 8′ panel along corridor outside gallery. There is a second addition of 15¾″ × 8′ fabric—wrapped panels in public dining room. Hours: 6 a.m.-8 p.m. daily including Saturday, Sunday and holidays.

Media: Considers all media. "Open to innovation and experimental work appropriate to healing environment."

Style: Exhibits contemporary, abstract, Impressionism, figurative, primitive, non-representational, photorealism, realism and neo-expressionism. Specializes in humanities-oriented interpretive, literary, cross-cultural and cross-disciplinary works. Interested in folk art, miniature works and ethnic works. "Our goal is to offer a variety of visual expressions by regional artists. Subject matter and aesthetics appropriate for audience in a healthcare facility is acceptable." Interested in seeing "progressive, honest, experimental works with artist's personal interpretation."

Terms: Accepts work on consignment (30% commission). Retail price set by artist. Accepts payment by installments. Exclusive area representation not required. Gallery provides promotion and contract.

Submissions: Send query letter with résumé, brochure, business card, 24 slides (including at least 12 slides or current work intended to show), photographs and SASE. Wishes to see a portfolio or 4 × 5 full color prints with a brief proposal or statement or proposed body of works. Preference given to artists with Hawaii connections. Include prices, title and medium information. Artists found through direct inquiries, referral by art professionals, news media publicity.

Tips: "Pound the pavement. Get exposure. Enter as many juried shows as you can. Build your portfolio. Show professionalism, integrity, preparation, new direction and readiness to show. Be honest. Adhere to basics. We look for professional appearance of materials submitted, i.e., curriculum vita, proposal, artworks, photographic materials, slides, etc. Portfolio should be representative of your style with current works and/or works-in-progress. We regret the gallery is not equipped to handle and show larger format paintings, large or heavy sculptures and craft objects, etc."

Ⓝ THE VILLAGE GALLERY, 120 Dickenson St., Lahaina HI 96761. (808)661-4402. Fax: (808)661-4403. E-mail: village@t-link.net. Owner/Manager: Lynn Shue. Retail gallery. Estab. 1970. Represents 100 artists. Interested in emerging and established artists. Sponsors 10 solo and 4 group shows/year. Average display time varies. "We now have 3 locations: 120 Dickenson St., (main); 180 Dickenson St. (contemporary); Ritz-Carlton-Kapalua." Clientele: tourists, return visitors, those with a second home in Hawaii, 85% private collectors, 15% corporate clients. Overall price range: $10-10,000; most work sold at $800-3,000.

Media: Considers oil, acrylic, watercolor, pastel, pen & ink, drawings, mixed media, collage, works on paper, sculpture, ceramic, fiber and glass. Most frequently exhibits oil, watercolor and mixed media.

Style: Exhibits Impressionism, realism, color field and painterly abstraction. Genres include landscapes, florals, figurative work; considers all genres. Prefers Impressionism, painterly abstraction and realism.

Terms: Accepts work on consignment (50% commission). Retail price set by gallery and artist. Offers payment by installments. Exclusive area representation required. Shipping costs are shared. Prefers artwork framed.

Submissions: Send query letter with résumé, slides, and photographs. Write to schedule an appointment to show a

portfolio, which should include originals, slides and photographs. Replies in 2 weeks. All material is returned if not accepted or under consideration.

Tips: "Galleries today must have a broader selection, sizes and price ranges."

VOLCANO ART CENTER GALLERY, P.O. Box 104, Hawaii National Park HI 96718. (808)967-7511. Fax: (808)967-8512. Gallery Director: Natalie Pfeifer. Nonprofit gallery to benefit arts education; nonprofit organization. Estab. 1974. Represents 200 emerging, mid-career and established artists/year. 1,400 member organization. Exhibited artists include Dietrich Varez and Brad Lewis. Sponsors 25 shows/year. Average display time 1 month. Open all year; daily 9-5 except Christmas. Located Hawaii Volcanoes National Park; 3,000 sq. ft.; in the historic 1877 Volcano House Hotel. 15% of space for special exhibitions; 90% of space for gallery artists. Clientele: affluent travelers from all over the world. 95% private collectors, 5% corporate collectors. Overall price range: $20-28,000; most work sold at $50-400.

Media: Considers all media, all types of prints. Most frequently exhibits wood, mixed media, ceramics and glass.

Style: Exhibits expressionism, neo-expressionism, primitivism and painterly abstraction. Prefers traditional Hawaiian, contemporary Hawaiian and contemporary fine crafts.

Terms: "Artists must become Volcano Art Center members." Accepts work on consignment (50% commission). Retail price set by the gallery. Gallery provides promotion and contract; artist pays shipping costs to gallery.

Submissions: Prefers only work relating to the area or by Hawaiian artists. Call for appointment to show portfolio. Replies only if interested within 1 month. Files "information on artists we represent."

[N] WAILOA CENTER, 200 Piopio St., Hilo HI 96720. (808)933-0416. Fax: (808)933-0417. Director: Mrs. Pudding Lassiter. Nonprofit gallery and museum. Focus is on propigation of Hawaiian culture. Estab. 1968. Represents/exhibits 300 emerging, mid-career and established artists. Interested in seeing work of emerging artists. Sponsors 60 shows/year. Average display time 1 month. Open all year; Monday-Friday, 8-4:30. Located downtown; 10,000 sq. ft.; 3 exhibition areas: main gallery and two local airports. Clientele: tourists, upscale, local community and students. Overall price range: $25-25,000; most work sold at $1,500.

Media: Considers all media and all types of prints. Most frequently exhibits mixed media.

Style: Exhibits all styles. "We cannot sell, but will refer buyer to seller." Gallery provides promotion. Artist pays for shipping costs. Prefers artwork framed.

Submissions: Send query letter with résumé, slides, photographs and reviews. Call for appointment to show portfolio of photographs and slides. Replies in 3 weeks. Finds artists through word of mouth, referrals by other artists, visiting art fairs and exhibitions, submissions.

Tips: "We welcome all artists, and try to place them in the best location for the type of art they have. Drop in and let us review what you have."

Idaho

[N] THE GALLERY, 507 Sherman Ave., Coeur d'Alene ID 83814. Phone/fax: (208)667-2898. E-mail: tgallery@dmi.n et. Website: http://www.artshowcase.com. Owners: Skip and Debbie Peterson. Retail gallery. Estab. 1982. Represents 30 emerging, mid-career and established artists. Exhibited artists include Jo Simpson, William Voxman and Donna Yde. Sponsors 4 shows/year. Average display time 3 months. Open all year. Located "in main business district downtown;" 2,500 sq. ft.; antique and rustic. 30% of space for special exhibitions. Clientele: middle to upper income. 82% private collectors, 18% corporate collectors. Overall price range: $100-1,400; most work sold at $500.

• The Gallery has a second location at The Gallery Plaza Shops, Sherman Ave., Coeur D'Alene ID 83814. Phone: (208)667-7852.

Media: Considers all media.

Style: Exhibits all styles. Genres include landscapes, florals, Western, wildlife and portraits. Prefers contemporary styles.

Terms: Accepts artwork on consignment (40% commission). Retail price set by gallery and artist. Gallery provides insurance, promotion and contract; artist pays for shipping. Prefers artwork framed.

Submissions: Send query letter with bio, photographs, SASE and business card. Write for appointment to show portfolio of originals and photographs. Replies within 2 weeks only if interested. Files all material for 6 months.

Tips: "The Gallery now has a complete custom frame shop with 223 years experience in framing."

[✓] KNEELAND GALLERY, P.O. Box 2070, Sun Valley ID 83353. (208)726-5512. Fax: (208)726-7495. (800)338-0480. E-mail: gallery@micron.net. Director: Kelly Daluiso. Retail gallery, art consultancy. Estab. 1981. Represents 40 emerging, mid-career and established artists/year. Exhibited artists include: Ovanes Berberian, Steven Lee Adams. Sponsors 9 shows/year. Average display time 3 weeks. Open all year; Monday-Saturday, 10-5. Located downtown; 2,500 sq. ft.; features a range of artists in several exhibition rooms. 50% of space for special exhibitions; 50% of space for gallery artists. Clientele: tourist, seasonal, local, upscale. 95% private collectors, 5% corporate collectors. Overall price range: $200-25,000; most work sold at $1,000-2,000.

Media: Considers all media and all types of prints. Most frequently exhibits oil, acrylic, watercolor.

Style: Exhibits expressionism, realism. Genres include landscapes, florals, figurative work. Prefers landscapes-realism,

© Dietrich Varez

Painter Dietrich Varez's oil painting of a woman performing the art of lauhala weaving shows an important component of Hawaiian village life, explains Natalie Pfeifer, director of the Volcano Art Center Gallery. The Gallery represents over 350 artists in all media, mostly from the islands of Hawaii. Varez, a founding member of the Volcano Art Center, sells enough work through the Gallery to allow him to be a full time artist. To promote his work he sends out catalogs of his art on request. "Creating on a daily basis is a process every artist should allow himself to do," says Varez. "There is nothing like it!"

expressionism, abstraction.

Terms: Accepts work on consignment (50% commission). Retail price set by the artist. Gallery provides insurance, promotion and contract; shipping costs are shared. Prefers artwork framed.

Submissions: Send query letter with résumé, slides, photographs, artists' statement, bio, SASE. Write for appointment to show portfolio of photographs and slides. Replies in 1-2 months. Files photo samples/business cards. Finds artists through submissions and referrals.

N POCATELLO ART CENTER GALLERY & SCHOOL, 401½ N. Main, Pocatello ID 83204. (208)232-0970. Nonprofit gallery featuring work of artist/members. Estab. 1970. Represents approximately 60 emerging, mid-career and established artists/year. 130 members. Exhibited artists include: Carol Myers, Ruth Kreitzer-Sauerbreit and Barbara Ruffridge. Sponsors 6 shows/year. Average display time 2 months. Open all year; Monday-Friday, 10-4 (varies occasionally). Located downtown in "Old Town"; 400 sq. ft. We hold classes, feature all levels of artists and are a gathering place for artists. Clientele: tourists, local community, students and artists. 100% private collectors. Overall price range: $25-1,000; most work sold at $25-300.

Media: Considers oil, acrylic, watercolor, pastel, pen & ink, drawing, mixed media, collage, paper, sculpture, ceramics, craft, fiber, glass and photography; types of prints include woodcuts, engravings, wood engravings, serigraphs, linocuts and etchings. Most frequently exhibits watercolor, oil and pastel.

Style: Exhibits: Expressionism, neo-expressionism, primitivism, painterly abstraction, surrealism, minimalism, Impressionism, photorealism, hard-edge geometric abstraction, realism and imagism. Exhibits all genres. Prefers: Impressionism, realism and painterly abstraction.

Terms: Co-op membership fee plus donation of time. Donations-monetary. Retail price set by the artist. Gallery provides promotion; hand delivered works only. Prefers artwork framed.

Submissions: Accepts only artists from Southeast Idaho. Memberships open to all artists and persons interested in the visual arts. Send query letter or visit gallery. Finds artists through word of mouth, referrals by other artists, visiting art fairs and exhibitions.

Tips: "Have work ready to hang."

N THE POTTER'S CENTER, 110 Ellen, Boise ID 83714. (208)378-1112. Fax: (208)378-8881. Owner: Scott Brown. Retail gallery. Estab. 1976. Represents 25 mid-career artists/year. Interested in seeing the work of emerging artists. Exhibited artists include: Liz James and Julie Wawirka. Sponsors 6 shows/year. Average display time 6 weeks. Open all year; Tuesday-Friday, 10-5:30; Saturday, 12-4. 800 sq. ft. exhibition space. Clientele: tourists and local community. Overall price range: $10-200; most work sold at $50-75.

Media: Considers ceramics. Most frequently exhibits ceramics.

Terms: Accepts work on consignment (40% commission). Retail price set by the artist. Gallery provides promotion; shipping costs are shared.

Submissions: Accepts only artists from Idaho. Prefers only ceramics. Send query letter with slides or photographs. Call for appointment to show portfolio of photographs. Replies in 1-2 weeks. Finds artists through word of mouth.

Tips: An artist is ready for gallery representation when they have "a body of work over time that shows control of medium and a personal approach to create their style."

ANNE REED GALLERY, P.O. Box 597, Ketchum ID 83340. (208)726-3036. Fax: (208)726-9630. E-mail: annereed@micron.net. Website: http://www.annereedgallery.com. Director: Joy Kaspurys. Retail Gallery. Estab. 1980. Represents mid-career and established artists. Exhibited artists include Howard Ben Tre, Jun Kaneko, Robert Kelly, Libby Wadsworth and Andrew Young. Sponsors 8 exhibitions/year. Average display time 1 month. Open all year. Located in the Walnut Avenue Mall. 10% of space for special exhibitions; 90% of space for gallery artists. Clientele: 80% private collectors, 20% corporate collectors.

Media: Most frequently exhibits sculpture, wall art and photography.

Style: Exhibits expressionism, abstraction, conceptualism, Impressionism, photorealism, realism. Prefers contemporary.

Terms: Accepts work on consignment (50% commission). Retail price set by gallery and artist. Sometimes offers customer discounts and payment by installment. Gallery provides insurance, promotion, contract and shipping costs from gallery. Prefers artwork framed.

Submissions: Send query letter with résumé, 40 slides, bio and SASE. Call or write for appointment to show portfolio of originals (if possible), slides and transparencies. Replies in 2 months. Finds artists through word of mouth, exhibitions, publications, submissions and collector's referrals.

Tips: "Please send only slides or other visuals of current work accompanied by updated résumé. Check gallery representation prior to sending visuals. Always include SASE."

✓ THE ROLAND GALLERY, Sun Valley Rd. & East Ave., P.O. Box 221, Ketchum ID 83340. (208)726-2333. Fax: (208)726-6266. E-mail: rolandart1@aol.com. Owner: Roger Roland. Retail gallery. Estab. 1990. Represents 100 emerging, mid-career and established artists. Sponsors 8 shows/year. Average display time 1 month. Open all year; daily 11-5. 800 sq. ft. 50% of space for special exhibitions; 50% of space for gallery artists. Clientele: 75% private collectors, 25% corporate collectors. Overall price range: $10-10,000; most work sold at $500-1,500.

Media: Considers oil, pen & ink, paper, fiber, acrylic, sculpture, glass, watercolor, mixed media, ceramic, installation, pastel, collage, craft and photography, engravings, mezzotints, etchings, lithographs. Most frequently exhibits glass, paintings and jewelry.

Style: Considers all styles and genres.
Terms: Accepts work on consignment (50% commission) or buys outright for 50% of the retail price (net 30 days). Retail price set by artist. Gallery provides insurance, promotion, shipping costs from gallery. Prefers artwork framed.
Submissions: Send query letter with résumé, slides, bio, brochure, photographs, SASE, business card and reviews. Write for appointment to show portfolio of photographs, slides and transparencies. Replies only if interested within 2 weeks.

Illinois

ARTCO, INCORPORATED, 3148 RFD, Long Grove IL 60047. (847)438-8420. Fax: (847)438-6464. E-mail: smbm04b@prodigy.com. President: Sybil Tillman. Retail and wholesale gallery, art consultancy and artists' agent. Estab. 1970. Represents 60 mid-career and established artists. Interested in seeing the work of emerging artists. Exhibited artists include Ed Paschke and Gary Grotey. Open all year; daily and by appointment. Located "2 blocks outside of downtown Long Grove; 7,200 sq. ft.; unique private setting in lovely estate and heavily wooded area." 50% of space for special exhibitions. Clientele: upper middle income. 65% private collectors, 20% corporate collectors. Overall price range: $500-20,000; most work sold at $2,000-5,000.
Media: Considers paper, sculpture, fiber, glass, original handpulled prints, woodcuts, engravings, pochoir, wood engravings, mezzotints, linocuts, etchings and serigraphs. Most frequently exhibits originals and signed limited editions "with a small number of prints."
Style: Exhibits all styles, including expressionism, abstraction, surrealism, conceptualism, postmodern works, Impressionism, photorealism and hard-edge geometric abstraction. All genres. Likes American contemporary and Southwestern styles.
Terms: Accepts artwork on consignment. Retail prices set by gallery. Customer discounts and payment by installment are available. Gallery provides promotion and contract; artist pays for shipping.
Submissions: Send query letter with résumé, slides, transparencies, bio, brochure, photographs, SASE, business card and reviews. Replies in 2-4 weeks. Files materials sent. Portfolio review required. Finds artists through agents, by visiting exhibitions, word of mouth, various art publications and sourcebooks, submissions/self-promotions and art collectors' referrals.
Tips: "We prefer established artists but will look at all new art."

ARTHURIAN GALLERY, 4646 Oakton, Skokie IL 60076. (847)674-7990. Owner: A. Sahagian. Retail/wholesale gallery and art consultancy. Estab. 1987. Represents/exhibits 60-80 emerging, mid-career and established artists/year. Interested in seeing the work of emerging artists. Exhibited artists include Christana-Fortunato. Sponsors 3-4 shows/year. Average display time 4-6 weeks. Open all year; Monday-Sunday, 10-4. Located on main street of Skokie; 1,600 sq. ft. 80-100% of space for gallery artists. 5-10% private collectors, 5-10% corporate collectors. Overall price range: $50-3,000; most work sold at: $200-2,000.
Media: Considers all media and all types of prints. Most frequently exhibits oil, water color, acrylic and pastel.
Style: Exhibits expressionism, painterly abstraction, surrealism, all styles. All genres. Prefers Impressionism, abstraction and realism.
Terms: Artwork is accepted on consignment (35% commission). Retail price set by the gallery and the artist. Gallery provides insurance and promotion. Artist pays for shipping costs. Prefers artwork framed.
Submissions: Send query letter with résumé, slides and SASE. Include price and size of artwork. Call or write for appointment to show portfolio of photographs, slides and transparencies. Replies in 2 weeks. Finds artists through word of mouth, referrals by other artists, visiting art fairs and exhibitions, submissions.
Tips: "Be persistent."

FREEPORT ARTS CENTER, 121 N. Harlem Ave., Freeport IL 61032. (815)235-9755. Fax: (815)235-6015. Director: Becky Connors. Estab. 1975. Interested in emerging, mid-career and established artists. Sponsors 9 solo and group shows/year. Open Tuesdays, 10-6; Wednesday-Sunday, 10-5. Clientele: 30% tourists; 60% local; 10% students. Average display time 7 weeks.
Media: Considers all media and prints.
Style: Exhibits all styles and genres. "We are a regional museum serving Northwest Illinois, Southern Wisconsin and Eastern Iowa. We have extensive permanent collections and 8-9 special exhibits per year representing the broadest possible range of regional and national artistic trends. Some past exhibitions include 'Gifts for the Table,' 'Art Bytes: An Introduction to Computer Art,' 'Au Naturel: American Wildlife Art,' and 'Midwestern Romanticism.' "
Terms: Gallery provides insurance and promotion; shipping costs are shared. Prefers artwork framed.
Submissions: Send query letter with résumé, slides, SASE, brochure, photographs and bio. Replies in 3-4 months. Files résumés.
Tips: "The Exhibition Committee meets three times each year to review the slides submitted."

GALESBURG CIVIC ART CENTER, 114 E. Main St., Galesburg IL 61401. (309)342-7415. E-mail: artcenter@missl ink.net. Contact: Julie Layer. Nonprofit gallery. Estab. 1923. Exhibits emerging, mid-career and established artists. 400 members. Sponsors 11 shows/year. Average display time 1 month. Located downtown; 1,400 sq. ft. "We have 2 gallery

spaces: 1 exhibition gallery and 1 consignment gallery." Overall price range: $50-1,000; most artwork sold at $50-300.
Media: Considers oil, acrylic, watercolor, pastel, mixed media, works on paper, sculpture, ceramic, fiber, glass, photography, original handpulled prints.
Style: Exhibits expressionism, painterly abstraction, color field, postmodern works, realism, all styles. Interested in seeing and quality 2- and 3-D work."
Terms: Accepts work on consignment (40% commission). Retail price set by artist. Gallery provides insurance and promotion; artist pays for shipping. Framed artwork only.
Submissions: Accepts primarily artists from Midwest. Send query letter with résumé, slides and bio. Call for appointment to show portfolio, which should include slides. "No unsolicited samples, please." Replies in 3 months.

GROVE ST. GALLERY, 919 Grove St., Evanston IL 60201. (847)866-7340. E-mail: botti@bottistudio.com. Website: http://www.bottistudio.com. Gallery Director: Chris or George. Retail gallery. Estab. 1889. Represents 15 emerging and established artists. Sponsors 6 solo and 5 group shows/year. Average display time 1 month. Clientele: 60% private collectors, 40% corporate clients. Overall price range: $500-25,000; most work sold at $2,500-10,000.
 • Gallery has two new locations: State Street Gallery in Sarasota FL and Lerner Gallery in Encinitas, CA.
Media: Considers oil, acrylic, watercolor, pastel, glass and serigraphs. Most frequently exhibits oil.
Style: Exhibits Impressionism. Genres include landscapes, florals, Southwestern and Western themes and figurative work. Prefers Mediterranean landscapes, florals and Southwestern/Western works.
Terms: Accepts work on consignment. Retail price set by artist. Exclusive area representation required. Gallery provides partial insurance and promotion; shipping costs are shared. Prefers artwork framed.
Submissions: Send query letter with résumé, slides, brochure, photographs and bio. Call or write for appointment to show portfolio of originals, slides, transparencies and photographs. Replies in 3 weeks. Files photographs or slides. All material is returned if not accepted or under consideration.

PRESTIGE ART GALLERIES, 3909 W. Howard, Skokie IL 60076. (847)679-2555. E-mail: prestige@prestigeart.com. Website: http://www.prestigeart.com. President: Louis Schutz. Retail gallery. Estab. 1960. Exhibits 100 mid-career and established artists/year. Interested in seeing the work of emerging artists. Exhibited artists include Jean Paul Avisse. Sponsors 4 shows/year. Average display time 4 months. Open all year; Saturday and Sunday, 11-5; Monday-Wednesday, 10-5. Located in a suburb of Chicago; 3,000 sq. ft. 20% of space for special exhibitions; 50% of space for gallery artists. Clientele: professionals. 20% private collectors, 10% corporate collectors. Overall price range: $100-100,000; most work sold at $1,500-2,000.
Media: Considers oil, acrylic, mixed media, paper, sculpture, ceramics, craft, fiber, glass, lithographs and serigraphs. Most frequently exhibits paintings, glass and fiber.
Style: Exhibits surrealism, New Age visionary, Impressionism, photorealism and realism. Genres include landscapes, florals, portraits and figurative work. Prefers landscapes, figurative-romantic and floral.
Terms: Accepts work on consignment (50% commission). Retail price set by the gallery and the artist. Gallery provides insurance, promotion and contract; shipping costs are shared. Prefers artwork framed.
Submissions: Send query letter with résumé, slides, bio, SASE and prices/sizes. Call for appointment to show portfolio of photographs. Replies in 2 weeks. "Returns all material if SASE is included."

Chicago

ARTEMISIA GALLERY, 700 N. Carpenter, Chicago IL 60622. (312)226-7323. E-mail: artemisi@enteract.com. Website: http://www.enteract.com/~artemisi. Gallery Coordinator: Clodagh Kenny. Presidents: Ellie Wallace and Susan Senserman. Cooperative and nonprofit gallery/alternative space run by women artists. Estab. 1973. 14 active members, 15 associate members. Sponsors 60 solo shows/year. Average display time 4 weeks. Interested in emerging and established artists. Overall price range: $150-10,000; most work sold at $600-2,500.
Media: Considers all traditional media including craft, installation, performance and new technologies.
Terms: Rental fee for space; rental fee covers 1 month. Retail price set by artist. Exclusive area representation not required. Artist pays for shipping and announcement cards.
Submissions: Send query letter with résumé, statement, 10 slides, slide sheet and SASE. Portfolios reviewed each month. Replies in 6 weeks. All material is returned if not accepted or under consideration if SASE is included.
Tips: "Send clear, readable slides, labeled and marked 'top' or with red dot in lower left corner."

[N] BEACON STREET GALLERY & THEATRE, 1145 W. Wilson, Chicago IL 60640. (773)769-4284. Contact: Susan Field. Nonprofit gallery/alternative space. Estab. 1983. Exhibits 30 emerging artists. Interested in seeing the work of emerging artists. Exhibited artists include Patricia Murphy and Eugene Pine. Sponsors 18 shows/year. Average display time 6 weeks. Open in fall and spring. 4,000 and 1,000 sq. ft. 50% of space for special exhibitions; 25% of space for gallery artists. Clientele: 20% private collectors, 20% corporate collectors. Overall price range $100-5,000.
 • Gallery also has a space at 15 S. 6th St., Geneva, IL 60134 for exhibitions and performances. Phone: (630)232-2728.
Media: Considers oil, acrylic, watercolor, pastel, drawings, paper, installation, photography, woodcuts and engravings. Most frequently exhibits oil, installation and crafts.

Style: Exhibits primitivism, painterly abstraction, conceptualism, minimalism and imagism. Prefers abstract and folk ethnic.
Terms: Accepts work on consignment (40% commission). Gallery provides insurance promotion and contract; artist pays for shipping or costs are shared. Prefers artwork framed.
Submissions: Send query letter with résumé, slides and bio. Write for appointment to show portfolio of slides. Replies only if interested once a year. Files résumé and slides.

BERET INTERNATIONAL GALLERY, 1550 N. Milwaukee St., Chicago IL 60622. (773)489-6518. Fax: (773)342-5012. Director: Ned Schwartz. Alternative space. Estab. 1991. Represents 20 emerging, mid-career and established artists/year. Exhibited artists include Jno Cook and Dennis Kowalski. Sponsors 8 shows/year. Average display time 5 weeks. Open all year; Thursday, 1-5; Friday and Saturday, 1-5; or by appointment. Located near north west Chicago, Bucktown; 2,500 sq. ft.; shows conceptual art, mechanical sculpture. 100% of space for special exhibitions; backrooms for gallery artists. Clientele: "serious art intellectuals." 90% private collectors, 10% corporate collectors. Overall price range: $25-5,000.
Style: Exhibits conceptualism.
Terms: Accepts work on consignment (40% commission). Retail price set by the gallery and the artist. Gallery provides insurance, promotion and contract; artist pays shipping costs to and from gallery.
Submissions: "All art has strong social relevance. No decorative craft." Send query letter with slides, photographs and SASE. Call or write for appointment. Files résumé, 10-20 slides and photos. Finds artists through visiting exhibitions, submissions.
Tips: "Be familiar with the art that the gallery exhibits. Basically artists should not send any submissions unless they are familiar with the gallery."

CAIN GALLERY, 111 N. Marion St., Oak Park IL 60301. (708)383-9393. Owners: Priscilla and John Cain. Retail gallery. Estab. 1973. Represents 75 emerging, mid-career and established artists. "Although we occasionally introduce unknown artists, because of high overhead and space limitations, we usually accept only artists who are somewhat established, professional and consistently productive." Sponsors 6 solo shows/year. Average display time 6 months. Open all year. Recent move triples space, features an on-site interior design consultant. Clientele: 80% private collectors, 20% corporate clients. Overall price range: $100-6,000; most artwork sold at $500-1,000.
Media: Considers oil, acrylic, watercolor, mixed media, collage, sculpture, crafts, ceramic, woodcuts, engravings, mezzotints, etchings, lithographs and serigraphs. Most frequently exhibits acrylic, watercolor and serigraphs.
Style: Exhibits Impressionism, realism, surrealism, painterly abstraction, imagism and all styles. Genres include landscapes, florals, figurative work. Prefers Impressionism, abstraction and realism. "Our gallery is a showcase for living American artists—mostly from the Midwest, but we do not rule out artists from other parts of the country who attract our interest. We have a second gallery in Saugatuck, Michigan, which is open during the summer season. The Saugatuck gallery attracts buyers from all over the country."
Terms: Accepts artwork on consignment. Retail price set by artist. Sometimes offers customer payment by installment. Exclusive area representation required. Gallery provides insurance, promotion, contract and shipping costs from gallery. Prefers artwork framed.
Submissions: Send query letter with résumé and slides. Portfolio review requested if interested in artist's work. Portfolio should include originals and slides. Finds artists through visiting exhibitions, word of mouth, submissions/self-promotions and art collectors' referrals.
Tips: "We are now showing more fine crafts, especially art glass and sculptural ceramics. The most common mistake artists make is amateurish matting and framing."

CHICAGO CENTER FOR THE PRINT & POSTER, 1509 W. Fullerton, Chicago IL 60614. (312)477-1585. Fax: (312)477-1851. E-mail: rkasvin@prints-posters.com. Website: http://www.prints-posters.com. Owner/Director: Richard H. Kasvin. Retail gallery. Estab. 1979. Represents 100 mid-career and established artists/year. Interested in seeing the work of emerging artists. Exhibited artists include Hiratsuka, J. Buck, David Bumbeck, Scott Sandel, Armin Hoffmann and Herbert Leupin. Sponsors 5-6 shows/year. Average display time 4-6 weeks. Open all year; Tuesday-Saturday, 11-7; Sunday, 12-5. Located in Lincoln Park, Chicago; 2,500 sq. ft. "We represent works on paper, Swiss graphics and European Vintage Posters." 40% of space for special exhibitions; 60% of space for gallery artists. 90% private collectors, 10% corporate collectors. Overall price range: $300-3,000; most work sold at $500-1,300.
Media: Considers mixed media, paper, woodcuts, engravings, lithographs, wood engravings, mezzotints, serigraphs, linocuts, etchings and vintage posters. Most frequently exhibits prints and vintage posters.
Style: Exhibits all styles. Genres include landscapes and figurative work. Prefers abstract, figurative and landscape.
Terms: Accepts work on consignment (50% commission) or buys outright for 40-60% of the retail price (30-60 days). Retail price set by the gallery and the artist. Gallery provides promotion; shipping costs are shared. Prefers artwork unframed.
Submissions: Send query letter with résumé, slides and photographs. Write for appointment to show portfolio of originals, photographs and slides. Files everything. Finds new artists through agents, by visiting exhibitions, word of mouth, art publications and sourcebooks, submissions.

CIRCA GALLERY, 1800 W. Cornelia Ave., Chicago IL 60657. (773)935-1854. E-mail: richardelange@hotmail.com. Website: http://www.fota.com. Director: Richard E. Lange. Alternative space, art consultancy, rental gallery. Estab.

1992. Represents 12 emerging artists/year. Exhibited artists include Tor Dettwiler. Sponsors 10 shows/year. Average display time 1 month. Open all year; Friday evenings; Saturday afternoon; or by appointment. Located 7 miles northwest of downtown Chicago; 700 sq. ft.; placed in 1910 Ice House factory, 14 ft. ceilings, brick walls. 50% of space for special exhibitions; 50% of space for gallery artists. Clientele: local community, students. 90% private collectors, 10% corporate collectors. Overall price range: $100-1,500; most work sold at $100-500.

Media: Considers all media except installation and all types of prints. Most frequently exhibits photography, paintings and sculpture.

Style: Exhibits expressionism, conceptualism, photorealism, minimalism, pattern painting, color field, hard-edge geometric abstraction, painterly abstraction, postmodern works, realism and surrealism. Exhibits all genres. Prefers cutting edge, figurative and abstract.

Terms: Accepts work on consignment (20% commission). There is a rental fee for space. Retail price set by the artist. Gallery provides promotion and contract; artist pays for shipping. Prefers artwork framed.

Submissions: Send query letter with résumé, business card, 12 slides, photographs, artist's statement, bio and SASE. Call or write for appointment to show portfolio of photographs and slides. Replies in 2 weeks. Files slides. Finds artists through visiting art fairs, word of mouth, friends, local listings.

Tips: Looks for "the artist's professional attitude towards working with us in a collaborative effort!"

Ⓝ COLUMBIA COLLEGE CHICAGO CENTER FOR BOOK AND PAPER ARTS, 218 S. Wabash, 7th Floor, Chicago IL 60604. Director: Marilyn Sward. (312)431-8612. Fax: (312)986-8237. Nonprofit gallery. Estab. 1994. Exhibits artists' books, paper art, fine binding and paper sculpture. Sponsors 8 shows/year. Average display time 6 weeks. Open Monday-Friday, 9-5; some weekends; closed August. Located in downtown Chicago, 1 block from the Art Institute; 1,200 sq. ft.; natural light; track lighting; grey carpet; white walls. 100% of space for special exhibitions. Clientele: local community, students. 90% private collectors, 10% corporate collectors. Overall price range: $100-10,000.

● Two organizations, Paper Press and Artists Book Works, merged to form this center.

Media: Considers drawing, mixed media, collage, paper, sculpture, craft, fiber, installation and photography. "Everything we show relates to books and/or paper." Most frequently exhibits book arts/paper, installation, typography, design and calligraphy.

Style: Exhibits all styles and genres.

Terms: Accepts work on consignment (40% commission). Retail price set by the artist. "Some artists donate work." Gallery provides insurance; shipping costs are shared.

Submissions: Send query letter with résumé, bio and slides for possible inclusion in group exhibitions. "We rarely, if ever, showcase the work of a single artist. The exhibition committee meets four times/year. We have a slide registry. There is a $10 fee. We find new artists through the slide registry, recommendations from other artists and our annual national open call for entries."

CONTEMPORARY ART WORKSHOP, 542 W. Grant Place, Chicago IL 60614. (773)472-4004. Director: Lynn Kearney. Nonprofit gallery. Estab. 1949. Interested in emerging and mid-career artists. Average display time is 4½ weeks "if it's a show, otherwise we can show the work for an indefinite period of time." Open Tuesday-Friday, 12:30-5:30. Clientele: art-conscious public. 75% private collectors, 25% corporate clients. Overall price range: $300-5,000; most artwork sold at $1,000 "or less."

● This gallery also offers studios for sculptors, painters and fine art crafts on month to month arrangement, and open space for sculptors.

Media: Considers oil, acrylic, mixed media, works on paper, sculpture, installations and original handpulled prints. Most frequently exhibits paintings, sculpture and works on paper and fine art furniture.

Style: "Any high-quality work" is considered.

Terms: Accepts work on consignment (33% commission). Retail price set by gallery or artist. "Discounts and payment by installments are seldom and only if approved by the artist in advance." Exclusive area representation not required. Gallery provides insurance and promotion.

Submissions: Send query letter with résumé, slides and SASE. Slides and résumé are filed. "First we review slides and then send invitations to bring in a portfolio based on the slides." Finds artists through call for entries in arts papers; visiting local BFA, MFA exhibits; referrals from other artists, collectors.

Tips: "Looks for a professional approach and a fine art school degree (or higher). Artists a long distance from Chicago will probably not be considered."

CORTLAND-LEYTEN GALLERY, 815 N. Milwaukee Ave., Chicago IL 60622. (312)733-2781. E-mail: leyten@aol.com. Director: S. Gallas. Retail gallery. Estab. 1984. Represents 6 emerging artists/year. Exhibited artists include Martin Geese, Wayne Bertola, Joseph Fontana. Sponsors 4 shows/year. Average display time 1 month. Open all year; Saturday, 12:30-5; Sunday, 12:30-3; and by appointment. Located in River West area near downtown; 2,000 sq. ft. 50% of space for special exhibitions; 50% of space for gallery artists. Clientele: upscale. 75% private collectors, 25% corporate collectors.

Media: Considers oil, pen & ink, acrylic, drawing, sculpture, mixed media, ceramics, collage, craft, engravings and lithographs. Most frequently exhibits sculpture, oil, mixed media.

Style: Exhibits all styles and all genres. Prefers figurative, oil.

Terms: Accepts work on consignment (50% commission). Retail price set by the gallery. Gallery provides insurance,

promotion and contract; artist pays for shipping. Prefers artwork framed.

Submissions: Accepts local artists only. Send query letter with résumé, slides, bio. Write for appointment to show portfolio of slides. Replies only if interested within 2 weeks. Files slides, résumés. Finds artists through word of mouth, submissions.

DIX ART MIX, 2068 N. Leavitt, Chicago IL 60647. Phone/fax: (773)384-5142. Website: http://www.fota.com. Director: Thomas E. Prerk. Retail gallery, alternative space, art consultancy. Estab 1998. Represents 35 emerging artists and 12 consignment artists/year. Exhibited artists include Anne Leuck amd Kevin Orth. Sponsors 6 shows/year. Average display time 1 month. Open all year. Friday and Sunday evenings; Saturday afternoons by appointment. Clientele: local community—many diverse groups. 90% private collectors, 10% corporate collectors. Overall price range $100-2,000; most work sold at $200-500.

Media: Considers all media and all types of prints. Most frequently exhibits paintings, photography, mixed media, glass, jewelry, pottery, sculpture and consignment art.

Style: Exhibits neoexpressionism, conceptualism, street art, environmental/cultural, painterly abstraction and surrealism. Prefers conceptualism, mixed media, pop art, avant garde.

Terms: Accepts work on consignment (15-25% commissions) and/or rental fee for space. The rental fee covers 1 month; there is a per event price. Prices of artwork set by artist. Gallery provides promotion and contract; artist pays for shipping. Prefers artwork framed.

Submissions: Send query letter with résumé, business card, 3 or more slides, photographs, artist's statment, bio and SASE. Call for appointment to show portfolio of photographs and slides. Replies in 1 month. files color photocopies. Finds artists through visiting shows/openings, referrals and word of mouth.

ROBERT GALITZ FINE ART, 166 Hilltop Court, Sleepy Hollow IL 60118. (847)426-8842. Fax: (847)426-8846. Owner: Robert Galitz. Wholesale representation to the trade. Makes portfolio presentations to corporations. Estab. 1986. Represents 40 emerging, mid-career and established artists. Exhibited artists include Marko Spalatin and Jack Willis. Open by appointment. Located in far west suburban Chicago.

Media: Considers oil, acrylic, watercolor, mixed media, collage, ceramic, fiber, original handpulled prints, engravings, lithographs, pochoir, wood engravings, mezzotints, serigraphs and etchings. "Interested in original works on paper."

Style: Exhibits expressionism, painterly abstraction, surrealism, minimalism, impressionism and hard-edge geometric abstraction. Interested in all genres. Prefers landscapes and abstracts.

Terms: Accepts artwork on consignment (variable commission) or artwork is bought outright (25% of retail price; net 30 days). Retail price set by artist. Customer discounts and payment by installment are available. Gallery provides promotion and shipping costs from gallery. Prefers artwork unframed only.

Submissions: Send query letter with SASE and submission of art. Portfolio review requested if interested in artist's work. Files bio, address and phone.

Tips: "Do your thing and seek representation—don't drop the ball!—Keep going—don't give up!"

GALLERY E.G.G. (EARTH GODDESS GROUP), 1474 W. Hubbard St., 2nd Floor, Chicago IL 60622. (312)666-0553. Fax: (312)666-0553. Directors: Analisa Leppanen and Marianne Taylor-Leppanen. Nonprofit gallery, alternative space and museum. Estab. 1993. Represents 10 emerging, mid-career and established artists/year. Exhibited artists include James Mesplé, Maureen Warren. Sponsors 8 shows/year. Average display time 6 weeks. Open all year; varying hours (call ahead). Located in West Loop, 3,000 sq. ft.; large loft space in industrial building. 50% for rotating exhibit, 50% for permanent collection/museum. Clientele: varied. 100% private collectors. Overall price range: $300-10,000; most work sold at $300-2,000.

● Gallery E.G.G. is a member of West Loop Gate Arts Council.

Media: Considers all media except glass and craft, and all types of prints. Most frequently exhibits sculpture, assemblage, oil and acrylic.

Style: Exhibits abstract, naturalism, primitivism, surrealism. Genres include environmental and spiritual.

Terms: Accepts work on consignment (30% commission). Buys outright for permanent collection for 70% of retail price. For group shows, there is a participation fee of $35. Retail price set by the gallery and the artist. Gallery provides insurance, promotion and contract; artists pays for shipping. Prefers paintings unframed; drawings, watercolors, etc. framed. For 1-4 person shows, artists/gallery split cost of promotion.

Submissions: Send query letter with résumé, brochure, 10-20 slides, artists's statement, SASE. Call for appointment to show portfolio of photographs and slides. Replies in 2 months. Files "anything the artist wants me to keep, otherwise slides and photos are returned in a SASE. I advertise thematic shows, but I find many artists through word of mouth and referrals by other artists."

Tips: "Develop a focused and consistent body of work of about 20-30 works, then research those galleries that seem to show that type of work. We are interested in environmental and spiritual artwork, work that expresses a reverence for the earth, as well as artwork that uses found or recycled objects. Call for themes of upcoming shows."

GALLERY 312, 312 N. May St., Suite 110, Chicago IL 60607. (312)942-2500. Fax: (312)942-0574. E-mail: gall312@m egsinet.com. Nonprofit gallery which benefits the Peach Club—working with children at risk. Estab. 1994. Exhibits established artists. Interested in seeing the work of emerging artists only for special shows. Exhibited artists include Harry Callahan, Michiko Itatani, Leon Golub, Ray K. Metzker, Jed Fielding, Joseph Jachna, Joseph Sterling, Charles Swedlund, John Heward, Sylvia Safdie and Yasuhiro Ishimoto. Sponsors 6 shows/year. Average display time 6 weeks.

Open all year; Tuesday-Saturday, 11-5. Located in Fulton/Randolph Market District; 7,200 sq. ft.; 28 ft. ceiling. Gallery is in restored boiler room of large warehouse. 100% of space for special exhibitions. Clientele: "museum-goers," educators, artists, collectors, students. 50% private collectors, 50% corporate collectors. Overall price range: $2,000-75,000; most work sold at $5,000-15,000.
Media: Considers oil, acrylic, drawing, mixed media, sculpture, installation, photography, video. Considers woodcuts and linocuts. Most frequently exhibits oil on canvas, photography, sculpture and museum exhibits on loan.
Style: Exhibits conceptualism, minimalism, color field, postmodern. Prefers contemporary, abstract, book paper art.
Terms: Accepts work on consignment (50% commission). Retail price set by gallery. Gallery provides insurance, promotion and contract; artist pays for shipping. Prefers paper and photographs framed; canvas etc. unframed.
Submissions: Send query letter with résumé, brochure, business card, slides, photographs, reviews, artists' statement, bio and SASE. Write for appointment to show portfolio of transparencies. Replies in 6-8 weeks. Files catalogs. Finds artists through referrals by other galleries, museums, guest curators and submissions.

N GWENDA JAY GALLERY, 704 N. Wells, Chicago IL 60610. (312)664-3406. Fax: (312)664-3388. E-mail: gwendajay@rivernorth.net. Website: http://www.gwendajay.com. President: Gwenda Jay Gombrich. Director: Dan Addington. Retail gallery. Estab. 1988. Represents 25 mainly mid-career artists, but emerging and established, too. Exhibited artists include painters Mark Perlman, Ron Clayton and Howard Hersh and sculptor Bruce Beasley. Sponsors 8 shows/year. Average display time 5 weeks. Open all year; Tuesday-Friday, 10-5; Saturday, 11-5. Located in River North area; 2,000 sq. ft.; "intimate, warm feeling loft-type space"; 60% of space for 1-2 person and group exhibitions. Clientele: "all types—budding collectors to corporate art collections." 75% private collectors; 10% corporate collectors. Overall price range: $500-5,000; most artwork sold at $2,000.
Media: Considers all media except large-scale sculptures; types of prints include lithographs and mezzotints. Most frequently exhibits paintings, monotypes and "prints by big name artists."
Style: Exhibits lyrical and organic abstraction, romanticism, poetic architectural classicism. Genres include landscapes abstraction or representational imagery. Styles are contemporary with traditional elements or classical themes.
Terms: Accepts work on consignment (50% commission). Retail price set by the gallery and the artist. Offers customer discounts and payment by installments. Gallery provides insurance and promotion; shipping costs are shared.
Submissions: Send query letter with résumé, slides, bio, reviews, artists' statement and SASE. No unsolicited appointments. Replies in 3 months. Finds artists through visiting exhibitions, referrals and submissions.
Tips: "Please send slides with résumé and SASE first. We will reply and schedule an appointment once slides have been reviewed if we wish to see more. Please be familiar with the gallery's style." Looking for "consistent style and dedication to career. There is no need to have work framed excessively. The work should stand well on its own, initially."

N CARL HAMMER GALLERY, 200 W. Superior, Chicago IL 60610. (312)266-8512. Fax: (312)266-8510. Director/Owner: Carl Hammer. Estab. 1979. Represents/exhibits emerging, mid-career and established artists. Exhibited artists include Hollis Sigler and Henry Darger. Sponsors 8 shows/year. Average display time 4-6 weeks. Open all year. Located at River North, downtown; 1,500 sq. ft. Clientele: local, upscale, tourists and students. Overall price range: $600-50,000; most work sold at $3,000-7,000.
Media: Considers all media, woodcut, lithography, wood engraving, serigraphy and etching. Most frequently exhibits works on canvas, sculpture and works on paper.
Style: Prefers contemporary figurative art. "Pioneer in the field of outsider art."
Terms: Artwork is accepted on consignment and there is a commission. Artwork is bought outright for a percentage of the retail price. Retail price set by the gallery. Gallery provides insurance, promotion and contract; shipping costs are shared.
Submissions: Send query letter with résumé, slides, bio and SASE. Replies in 1 month. Files slides if interested.
Tips: Finds artists through word of mouth, self discovery and referrals.

ILLINOIS ART GALLERY, Suite 2-100, 100 W. Randolph, Chicago IL 60601. (312)814-5322. Fax: (312)814-3471. E-mail: jstevens@museum.state.il.us. Website: http://www.museum.state.il.us. Assistant Administrator: Jane Stevens. Museum. Estab. 1985. Exhibits emerging, mid-career and established artists. Sponsors 6-7 shows/year. Average display time 7-8 weeks. Open all year. Located "in the Chicago loop, in the James R. Thompson Center designed by Helmut Jahn." 100% of space for special exhibitions.
Media: All media considered, including installations.
Style: Exhibits all styles and genres, including contemporary and historical work.
Terms: "We exhibit work, do not handle sales." Gallery provides insurance and promotion; artist pays for shipping. Prefers artwork framed.
Submissions: Accepts only artists from Illinois. Send résumé, 10 high quality slides, bio and SASE.

ILLINOIS ARTISANS PROGRAM, James R. Thompson Center, 100 W. Randolph St., Chicago IL 60601. (312)814-5321. Fax: (312)814-3891. Director: Ellen Gantner. Four retail shops operated by the nonprofit Illinois State Museum Society. Estab. 1985. Represents over 1,000 artists; emerging, mid-career and established. Average display time 6 months. "Accepts only juried artists living in Illinois." Clientele: tourists, conventioneers, business people, Chicagoans. Overall price range: $10-5,000; most artwork sold at $25-100.
Media: Considers all media. "The finest examples in all media by Illinois artists."
Style: Exhibits all styles. "Seeks contemporary, traditional, folk and ethnic arts from all regions of Illinois."

Terms: Accepts work on consignment (50% commission). Retail price set by gallery and artist. Sometimes offers customer discounts. Exclusive area representation not required. Gallery provides promotion and contract.
Submissions: Send résumé and slides. Accepted work is selected by a jury. Résumé and slides are filed. "The finest work can be rejected if slides are not good enough to assess." Portfolio review not required. Finds artists through word of mouth, requests by artists to be represented and by twice-yearly mailings to network of Illinois crafters announcing upcoming jury dates.

KLEIN ART WORKS, 400 N. Morgan, Chicago IL 60622. (312)243-0400. Fax: (312)243-6782. E-mail: info@kleinart. com. Website: http://www.kleinart.com. Director: Paul Klein and Joelle Rabion. Retail gallery. Estab. 1981. Represents 20 emerging, mid-career and established artists. Interested in seeing the work of emerging artists. Exhibited artists include Sam Gilliam and Stephanie Weber. Sponsors 10 shows/year. Average display time 5 weeks. Open all year. Located in industrial section of downtown; 4,500 sq. ft.; spacious, with steel floors, no columns and outdoor sculpture garden. 80% of space for special exhibitions; 20% of space for gallery artists. Clientele: 75% private collectors, 25% corporate collectors. Overall price range: $1,000-50,000; most artwork sold at $2,000-10,000.
Media: Considers oil, acrylic, mixed media, sculpture, ceramic, installation and photography. Most frequently exhibits painting and sculpture.
Style: Exhibits abstraction.
Terms: Accepts work on consignment (50% commission). Retail price set by gallery and artist. Gallery provides insurance, promotion and contract; shipping costs are shared.
Submissions: Send query letter with résumé, slides, bio, reviews and SASE. Replies in 2-6 weeks.

KUNSTWERK GALERIE, 1800 W. Cornelia Ave., #106A, Chicago IL 60657. (773)935-1854. Fax: (773)384-5142. Website: http://www.fota.com. Director: Thomas E. Frerk. Retail gallery, alternative space, art consultancy. Estab. 1993. Represents 12 emerging artists/year. Exhibited artists include Colin Lambides and Doug Birkenheuer. Sponsors 6 shows/year. Average display time 1 month. Open all year; Friday evenings, Saturday afternoons by appointment. Located 7 miles northwest of downtown Chicago; 500 sq. ft.; well-lighted, 14 ft. ceilings, located in old factory, lots of brick wall and dry wall to show. Clientele: local community—many diverse groups. 90% private collectors, 10% corporate collectors. Overall price range: $100-2,000; most work sold at $200-500.
Media: Considers all media and all types of prints. Most frequently exhibits paintings, photography, mixed media, sculpture and installation art.
Style: Exhibits neoexpressionism, conceptualism, street art, environmental/cultural, painterly abstraction and surrealism. Prefers conceptualism, mixed media, pop art and avant garde.
Terms: Accepts work on consignment (25% commission) and/or rental fee for space. The rental fee covers 1 month; there is a per event price. Price set per artist. Gallery provides promotion and contract; artist pays for shipping. Prefers artwork framed.
Submissions: Send query letter with résumé, business card, 3 or more slides, photographs, artist's statement, bio, SASE. Call for appointment to show portfolio of photographs and slides. Replies in 1 week. Files color photocopies. Finds artists through visiting shows/openings, referrals and word of mouth.
Tips: "Let gallery dealer know why you are approaching his or her gallery as opposed to another. You should have a body of work of at least six pieces."

PETER MILLER GALLERY, 740 N. Franklin St., Chicago IL 60610-3518. (312)951-0252. Co-Director: Natalie R. Domchenko. Retail gallery. Estab. 1979. Represents 15 emerging, mid-career and established artists. Sponsors 9 solo and 3 group shows/year. Average display time is 1 month. Clientele: 80% private collectors, 20% corporate clients. Overall price range: $500-20,000; most artwork sold at $5,000 and up.
Media: Considers oil, acrylic, mixed media, collage, sculpture, installations and photography. Most frequently exhibits oil and acrylic on canvas and mixed media.
Style: Exhibits abstraction, conceptual and realism.
Terms: Accepts work on consignment (50% commission). Retail price set by gallery and artist. Exclusive area representation required. Insurance, promotion and contract negotiable.
Submissions: Send slides and SASE. Slides, show card are filed.
Tips: Looks for "classical skills underlying whatever personal vision artists express. Send a sheet of 20 slides of work done in the past 18 months with a SASE."

NORTHERN ILLINOIS UNIVERSITY ART GALLERY IN CHICAGO, 215 W. Superior, 3rd Floor, Chicago IL 60610. (312)642-6010. Fax: (312)642-9635. Website: http://www.vpa.niu.edu/museum. Executive Director: Peggy Doherty. Nonprofit university gallery. Estab. 1984. Exhibits emerging, mid-career and established artists. Sponsors 6 shows/year. Average display time 6-7 weeks. Closed August. Located in Chicago gallery area (near downtown); 1,656 sq. ft. 100% of space for special exhibitions. Overall price range: $100-50,000.
Media: Considers all media.
Style: Exhibits all styles and genres. Interested in seeing contemporary styles.
Terms: "No charge to artist and no commission." Retail price set by artist. Gallery provides insurance and promotion; shipping costs are shared, depending on costs. Prefers artwork framed.
Submissions: Send query letter with résumé, slides, SASE, reviews and statement. Replies "ASAP." Files résumés, bios, statements and paperwork.

Tips: "Always include SASE. Work for exhibition is rarely selected at the first viewing."

SOUTHPORT GALLERY, 3755 N. Southport, Chicago IL 60613. (312)327-0372. Owner: Donna Wolfe. Retail gallery. Estab. 1988. Represents 3 artists. Interested in emerging artists. Sponsors 5 solo shows/year. Average display time 2 months. Accepts only artists from Chicago. Located near Wrigley Field and Music Box Theatre. Clientele: neighborhood people as well as the theater crowd. Overall price range: $100-1,000; "we do exhibit and sell work for over $1,000."

Media: Considers oil, acrylic, watercolor, pen & ink, drawings, mixed media, collage, sculpture and photography. Most frequently exhibits watercolor, oil, pen & ink and etchings.

Style: Exhibits Impressionism, realism, photorealism, surrealism, primitivism, color field, painterly abstraction and figurative work. Prefers realism, surrealism and photorealism. "Ideally, we seek emerging artists, offering them the opportunity to exhibit their work under standards that require it to be presented in a very professional manner. More established artists have found Southport gallery to be the perfect place to have an exhibit of their etchings, drawings or smaller works that fit within our price range."

Terms: Accepts work on consignment (40% commission). Retail price set by gallery and artist. Exclusive area representation not required. Gallery provides promotion and contract, opening reception and announcements. Prefers artwork framed.

Submissions: Send query letter with résumé, at least 5 slides, brochure, photographs, business card and bio. Call for appointment to show portfolio of originals, slides and photographs. Replies only if interested within 3 weeks. Files résumé, bio and photos.

Tips: "Keep in mind our general price range and the fact that our gallery is small and therefore not suitable for exhibits of entirely large pieces (60×64). Qualities we look for include enthusiasm, professionalism and pride, plus a body of work of at least 20-25 pieces. Present a fair representation of strong work and be secure about the way you present it. Presentation is extremely important."

SUBURBAN FINE ARTS CENTER, 1913 Sheridan Rd., Highland Park IL 60035-2607. (708)432-1888. Executive Director: Ann Rosen. Nonprofit gallery. Estab. 1960. Represents "hundreds" of emerging, mid-career and established artists/year. 2,200 members. Sponsors 12 shows/year. Average display time 1 month. Open all year, Monday-Saturday, 9-5. Located downtown, in Highland Park, a suburb of Chicago; 7,000 sq. ft.; spacious, light and airy. 20% of space for special exhibitions; 20% of space for gallery artists. Clientele: vast array. 100% private collectors. Overall price range: $20-30,000; most work sold at $100.

Media: Considers all media and all types of prints. Most frequently exhibits painting and photography.

Style: Exhibits all styles, all genres. Prefers expressionism, conceptualism and contemporary.

Terms: Accepts work on consignment (20% commission). Retail price set by the artist. Gallery provides insurance, promotion and contract; artist pays shipping costs to and from gallery. Prefers artwork framed.

Submissions: Send query letter with résumé, slides and bio. Call or write for appointment to show portfolio of slides. Replies in 1 week. Files résumé, bio, artist statement.

Tips: "Prepare slides well, along with well written proposal. Talent counts more than quantity."

VALE CRAFT GALLERY, 230 W. Superior St., Chicago IL 60610. (312)337-3525. Fax: (312)337-3530. Owner: Peter Vale. Retail gallery. Estab. 1992. Represents 100 emerging, mid-career artists/year. Exhibited artists include Liz Mamorsky and John Kevern. Sponsors 7 shows/year. Average display time 2 months. Open all year; Monday-Friday, 10:30-5:30; Saturday, 11-5; Sunday, 12-4; first Fridays and openings with hours expanded to 8 p.m. Located in River North gallery district near downtown; 2,100 sq. ft.; lower level of prominent gallery building; corner location with street-level windows provides great visibility. 40% of space for special exhibitions; 60% of space for gallery artists. Clientele: private collectors, tourists, people looking for gifts, people furnishing and decorating their homes. 50% private collectors, 5% corporate collectors. Overall price range: $50-2,000; most work sold at $100-500.

Media: Considers paper, sculpture, ceramics, craft, fiber, glass, metal, wood and jewelry. Most frequently exhibits fiber wall pieces, jewelry, glass, ceramic sculpture and mixed media.

Style: Exhibits contemporary craft. Prefers decorative, colorful and natural or organic.

Terms: Accepts work on consignment (50% commission). Retail price set by the artist. Gallery provides insurance, promotion, contract and shipping costs from gallery; artist pays shipping costs to gallery.

Submissions: Accepts only artists from US. Only craft media. Send query letter with résumé, 10-20 slides (including slides of details), bio or artist's statement, photographs, record of previous sales, SASE and reviews if available. Call for appointment to show portfolio of originals and photographs. Replies in 2 months. Files résumé (if interested). Finds artists through submissions, art and craft fairs, publishing a call for entries, artists' slide registry and word of mouth.

Tips: "Call ahead to find out if the gallery is interested in showing the particular type of work you do; send professional slides and statement about the work or call for an appointment to show original work. Try to visit the gallery ahead of time to find out if your work fits into the gallery's focus. I would suggest you have completed at least ten pieces in a body of work before approaching galleries."

SONIA ZAKS GALLERY, 311 W. Superior St., Suite 207, Chicago IL 60610. (312)943-8440. Fax: (312)943-8489. Director: Sonia Zaks. Retail gallery. Represents 25 emerging, mid-career and established artists/year. Sponsors 10 solo shows/year. Average display time is 1 month. Overall price range: $500-15,000.

Media: Considers oil, acrylic, watercolor, drawings, sculpture.

Style: Specializes in contemporary paintings, works on paper and sculpture. Interested in narrative work.
Terms: Accepts work on consignment. Retail price is set by gallery and artist. Exclusive area representation required. Gallery provides insurance and contract.
Submissions: Send query letter with 20 slides.
Tips: "A common mistake some artists make is presenting badly-taken and unmarked slides. Artists should write to the gallery and enclose a résumé, about one dozen well-marked slides and a SASE."

Indiana

ARTLINK, 437 E. Berry St., Suite 202, Fort Wayne IN 46802-2801. (219)424-7195. Executive Director: Betty Fishman. Nonprofit gallery. Estab. 1979. Exhibits emerging and mid-career artists. 585 members. Sponsors 9 shows/year. Average display time 5-6 weeks. Open all year. Located 4 blocks from central downtown, 2 blocks from Art Museum and Theater for Performing Arts; in same building as a cinema theater, dance group and historical preservation group; 1,600 sq. ft. 100% of space for special exhibitions. Clientele: "upper middle class." Overall price range: $100-500; most artwork sold at $200.
 • Publishes a quarterly newsletter, *Genre*, which is distributed to members. Includes features about upcoming shows, profiles of members and other news. Some artwork shown at gallery is reproduced in b&w in newsletter. Send SASE for sample and membership information.
Media: Considers all media, including prints. Prefers work for annual print show and annual photo show, sculpture and painting.
Style: Exhibits expressionism, neo-expressionism, painterly abstraction, conceptualism, color field, postmodern works, photorealism, hard-edge geometric abstraction; all styles and genres. Prefers imagism, abstraction and realism. "Interested in a merging of craft/fine arts resulting in art as fantasy in the form of bas relief, photo/books, all experimental media in nontraditional form."
Terms: Accepts work on consignment only for exhibitions (35% commission). Retail price set by artist. Gallery provides insurance, promotion and contract; shipping costs are shared. Prefers framed artwork.
Submissions: Send query letter with résumé, no more than 6 slides and SASE. Reviewed by 14-member panel. Replies in 2-4 weeks. "Jurying takes place three times per year unless it is for a specific call for entry. A telephone call will give the artist the next jurying date."
Tips: "Call ahead to ask for possibilities for the future and an exhibition schedule for the next two years will be forwarded." Common mistakes artists make in presenting work are "bad slides and sending more than requested—large packages of printed material. Printed catalogues of artist's work without slides are useless." Sees trend of community-wide cooperation by organizations to present art to the community.

THE FORT WAYNE MUSEUM OF ART SALES AND RENTAL GALLERY, 311 E. Main St., Ft. Wayne IN 46802. (219)422-6467. E-mail: fwma@art-museum-ftwayne.org. Website: http://www.art-museum-ftwayne.org. Gallery Coordinator: Vanessa Freygang. Retail and rental gallery. Estab. 1983. Represents emerging, mid-career and established artists who reside within a 150 mile radius of Fort Wayne. Clientele: 25% private collectors, 75% corporate clients. Overall price range: $15-4,500; most artwork sold at $250-1,000.
Media: Considers oil, acrylic, watercolor, pastel, pen & ink, photography, mixed media, collage, original handpulled prints and computer-generated art.
Style: "We try to show the best regional artists available. We jury by quality, not salability." Exhibits Impressionism, expressionism, realism, photorealism and painterly abstraction. Genres include landscapes, florals, Americana, Southwestern, Western and wildlife. Prefers landscapes, abstractions and florals. "We do not do well with works that are predominantly figures."
Terms: Accepts work on consignment (40% commission). Retail price set by artist. Exclusive area representation not required. Gallery provides insurance, promotion and contract; artist pays for shipping.
Submissions: Send query letter with résumé, brochure, 3-8 slides, photographs, bio and SASE. Slides and résumés are filed.
Tips: "Our Club Art seems to be selling quite a bit of merchandise. 'Clever' art at moderate prices sells well in our gift shop."

[N] GREATER LAFAYETTE MUSEUM OF ART, 101 S. Ninth St., Lafayette IN 47901. (317)742-1128. E-mail: glma@glmart.org. Website: http://dcwi.com/~glma. Executive Director: Gretchen A. Mehring. Museum. Estab. 1909. Exhibits 100 emerging, mid-career and established artists from Indiana and the midwest. 1,340 members. Sponsors 14 shows/year. Average display time 10 weeks. Located 6 blocks from city center; 3,318 sq. ft.; 4 galleries. Clientele: 50% private collectors, 50% corporate collectors (audience includes Purdue University faculty, students and residents of Lafayette/West Lafayette and nine-county area). Most work sold at $500-1,000.
Media: Considers all media. Most frequently exhibits paintings, prints and sculpture.
Style: Exhibits all styles. Genres include landscapes, still life, portraits, abstracts, non-objective and figurative work.
Terms: Accepts work on consignment (35% commission). Retail price set by artist. Gallery provides insurance, promotion and contract; artist pays for shipping. Prefers artwork framed.
Submissions: Send query letter with résumé, slides, artist's statement and letter of intent. Write for appointment to

show portfolio of slides. "Send good-quality, clearly labeled slides, and include artist's statement, please!" Files artists' statement, résumé. Slides are returned to artists.

Tips: "Indiana artists specifically encouraged to apply."

INDIANAPOLIS ART CENTER, 820 E. 67th St., Indianapolis IN 46220. (317)255-2464. Fax: (317)254-0486. E-mail: inartctr@inetdirect.net. Website: www.indplsartcenter.org. Director of Exhibitions and Artist Services: Julia Moore. Nonprofit art center. Estab. 1934. Prefers emerging artists. Exhibits approximately 100 artists/year. 1,800 members. Sponsors 15-20 shows/year. Average display time 5 weeks. Open Monday-Friday, 9-10; Saturday, 9-3; Sunday, 12-3. Located in urban residential area; 2,560 sq. ft. in 3 galleries; "Progressive and challenging work is the norm!" 100% of space for special exhibitions. Clientele: mostly private. 90% private collectors, 10% corporate collectors. Overall price range: $50-15,000; most work sold at $100-5,000. Also sponsors annual Broad Ripple Art Fair in May.

Media: Considers all media and all types of original prints. Most frequently exhibits painting, sculpture installations and fine crafts.

Style: All styles. Interested in figurative work. "In general, we do not exhibit genre works. We do maintain a referral list, though." Prefers postmodern works, installation works, conceptualism.

Terms: Accepts work on consignment (35% commission). Commission is in effect for 3 months after close of exhibition. Retail price set by artist. Gallery provides insurance, promotion, contract; artist pays for shipping. Prefers artwork framed.

Submissions: "Special consideration for IN, OH, MI, IL, KY artists." Send query letter with résumé, minimum of 20 slides, SASE, reviews and artist's statement. Replies in 5-6 weeks. Season assembled in January.

Tips: "Research galleries thoroughly—get on their mailing lists, and visit them in person at least twice before sending materials. Always phone to get the gallery's preferred timing and method of viewing new work, and adhere to these preferences. Find out the 'power structure' of the targeted galleries and use it to your advantage. Most artists need to gain experience exhibiting in smaller or non-profit spaces before approaching a gallery—work needs to be of consistent, dependable quality. Have slides done by a professional if possible. Stick with one style—no scattershot approaches. Have a concrete proposal with installation sketches (if it's never been built). We book two years in advance—plan accordingly. Do not call. Put me on your mailing list one year before sending application so I can be familiar with your work and record—ask to be put on my mailing list so you know the gallery's general approach. It works!"

N **MIDWEST MUSEUM OF AMERICAN ART**, 429 S. Main St., Elkhart IN 46516. (219)262-3603. Director: Jane Burns. Curator: Brian D. Byrn. Museum. Estab. 1978. Represents mid-career and established artists. May be interested in seeing the work of emerging artists in the future. Sponsors 10-12 shows/year. Average display time 5-6 weeks. Open all year; Tuesday-Friday 11 to 5; Saturday and Sunday 1-4. Located downtown; 1,000 sq. ft. temporary exhibits; 10,000 sq. ft. total; housed in a renovated neoclassical style bank building; vault gallery. 10% for special exhibitions. Clientele: general public.

Media: Considers all media and all types of prints.

Style: Exhibits all styles, all genres.

Terms: Acquired through donations. Retail price set by the artist "in those cases when art is offered for sale." Gallery provides insurance, promotion and contract; artist pays shipping costs to and from gallery. Prefers artwork framed.

Submissions: Accepts only art of the Americas, professional artists 18 years or older. Send query letter with résumé, slides, bio, reviews and SASE. Write for appointment to show portfolio of slides. Replies in 6 months. Files résumé, bio, statement. Finds artists through visiting exhibitions, submissions, art publications.

Tips: "Keep portfolio updated."

RUSCHMAN GALLERY, 948 N. Alabama St., Indianapolis IN 46202. (317)634-3114. Director: Mark Ruschman. Retail gallery. Estab. 1985. Represents 40 emerging and mid-career artists/year. Sponsors 10 shows/year. Average display time 1 month. Open all year; Tuesday-Saturday, 11-5. Located downtown—near Northeast side; 1,800 sq. ft.; two gallery showrooms which allow solo and group exhibitions to run concurrently. 100% of space for gallery artists. Clientele: local individual and corporate collectors. 60% private collectors, 40% corporate collectors. Overall price range: $500-30,000; most work sold at $1,000-4,000.

Media: Considers all media (including all types of prints small editions) except large run prints and posters. Most frequently exhibits painting, sculpture, textile.

Style: Exhibits all styles. Prefers abstract, landscape, figurative.

Terms: Accepts work on consignment (40-50% commission). Retail price set by the gallery and the artist. Gallery provides promotion and contract; gallery pays shipping costs to gallery; artist pays for shipping from gallery. Prefers artwork framed.

Submissions: Send query letter with résumé, slides, bio, SASE. Call for appointment to show portfolio of slides, bio. Replies in 3 weeks. Files referrals by other artists and submissions.

Iowa

ARTS FOR LIVING CENTER, P.O. Box 5, Burlington IA 52601-0005. Located at Seventh & Washington. (319)754-8069. Fax: (319)754-4731. Executive Director: Lois Rigdon. Nonprofit gallery. Estab. 1974. Exhibits the work of mid-

career and established artists. May consider emerging artists. 425 members. Sponsors 10 shows/year. Average display time 3 weeks. Open all year; Tuesday-Friday, 12-5; weekends, 1-4. Located in Heritage Hill Historic District, near downtown; 2,500 sq. ft.; "former sanctuary of 1868 German Methodist church with barrel ceiling, track lights." 35% of space for special exhibitions. Clientele: 80% private collectors, 20% corporate collectors. Overall price range: $25-1,000; most work sold at $75-500.

Media: Considers all media and all types of prints. Most frequently exhibits watercolor, intaglio and sculpture.

Style: Exhibits all styles.

Terms: Accepts work on consignment (25% commission). Retail price set by artist. Gallery provides insurance, promotion and contract; artist pays for shipping. Prefers artwork framed.

Submissions: Send query letter with résumé, slides, bio, brochure, photographs, SASE and reviews. Call or write for appointment to show portfolio of slides and gallery experience verification. Replies in 1 month. Files résumé and photo for reference if interested.

CORNERHOUSE GALLERY AND FRAME, 2753 First Ave. SE, Cedar Rapids IA 52402. (319)365-4348. Fax: (319)365-1707. Director: Janelle McClain. Retail gallery. Estab. 1976. Represents 150 emerging, mid-career and established artists. Exhibited artists include John Preston, Grant Wood and Stephen Metcalf. Sponsors 3 shows/year. Average display time 1 month. Open all year; Monday-Friday, 9:30-5:30; Saturday, 9:30-4. 3,000 sq. ft.; "converted 1907 house with 3,000 sq. ft. matching addition devoted to framing, gold leafing and gallery." 25% of space for special exhibitions. Clientele: "residential/commercial, growing collectors." 80% private collectors. Overall price range: $50-20,000; most artwork sold at $200-2,000.

Media: Considers oil, acrylic, watercolor, pastel, drawings, mixed media, collage, works on paper, sculpture, ceramic, fiber, glass, original handpulled prints, woodcuts, wood engravings, linocuts, engravings, mezzotints, jewelry, etchings, lithographs and serigraphs. Most frequently exhibits oil, acrylic, original prints and ceramic works.

Style: Exhibits all styles. Genres include florals, landscapes, figurative work. Prefers regionalist/midwestern subject matter. Exhibits only original work—no reproductions.

Terms: Accepts work on consignment (45% commission) or artwork is bought outright for 50% of retail price (net 30 days). Retail price set by artist and gallery. Gallery provides insurance, promotion and shipping costs from gallery. Prefers artwork unframed.

Submissions: Prefers only Midwestern artists. Send résumé, 20 slides, photographs and SASE. Portfolio review requested if interested in artist's work. Replies in 1 month. Files résumé and photographs. Finds artists through word of mouth, submissions/self promotions and art collectors' referrals. Do not stop in unannounced.

Tips: "Send a written letter of introduction along with five representative images and retail prices. Ask for a return call and appointment. Once appointment is established, send a minimum of 20 images and résumé so it can be reviewed before appointment. Do not approach a gallery with only a handful of works to your name. I want to see a history of good-quality works. I tell artists they should have completed at least 50-100 high-quality works with which they are satisfied. An artist also needs to know which works to throw away!"

▓N▓ GUTHART GALLERY & FRAMING, 506 Clark St., Suite A, Charles City IA 50616. (515)228-5004. Owner: John R. Guthart. Retail gallery and art consultancy. Estab. 1992. Represents 12 emerging, mid-career and established artists. Exhibited artists include: John Guthart and Steve Schiller. Average display time is 2 months. Open all year; Monday-Saturday, 10-5, and by appointment. Located downtown—close to art center and central park. 700 sq. ft. 50% of space for special exhibitions; 50% of space for gallery artists. Clientele: tourists, upscale, local community and students. 80% private collectors, 20% corporate collectors. Overall price range: $25-10,000; most work sold at $200-800.

Media: Considers all media. Considers all types of prints. Most frequently exhibits watercolors, oils and prints.

Style: Exhibits expressionism, primitivism, painterly abstraction, surrealism, postmodernism, Impressionism and realism. Exhibits all genres. Prefers florals, wildlife and architectural art.

Terms: Accepts artwork on consignment (30% commission) or buys outright for 50% of retail price (net 30 days). Retail price set by gallery. Gallery provides insurance and promotion. Shipping costs are shared. Prefers artwork framed.

Submissions: Send query letter with résumé, slides and brochure. Write for appointment to show portfolio of photographs and slides. Replies only if interested in 2 weeks. Files résumé, letter and slides. Finds artists through word of mouth, referrals, submissions and visiting art fairs and exhibitions.

KAVANAUGH ART GALLERY, 131 Fifth St., W. Des Moines IA 50265. (515)279-8682. Fax: (515)279-7609. E-mail: kagallery@aol.com. Director: Carole Kavanaugh. Retail gallery. Estab. 1990. Represents 25 mid-career and established artists/year. May be interested in seeing the work of emerging artists in the future. Exhibited artists include Kati Roberts, Don Hatfield, Dana Brown, Gregory Steele, August Holland, Ming Feng and Larry Guterson. Sponsors 3-4 shows/year. Averge display time 3 months. Open all year; Monday-Saturday, 10-5. Located in Old Town shopping area; 2,800 sq. ft. 70% private collectors, 30% corporate collectors. Overall price range: $300-20,000; most work sold at $800-3,000.

Media: Considers all media and all types of prints. Most frequently exhibits oil, acrylic and pastel.

Style: Exhibits color field, Impressionism, realism, florals, portraits, western, wildlife, southwestern, landscapes, Americana and figurative work. Prefers landscapes, florals and western.

Terms: Accepts work on consignment (50% commission). Retail price set by the artist. Gallery provides insurance, promotion and contract. Shipping costs are shared. Prefers artwork unframed.

Submissions: Send query letter with résumé, bio and photographs. Portfolio should include photographs. Replies in 2-3 weeks. Files bio and photos. Finds artists through word of mouth, referrals by other artists, visiting art fairs and exhibitions, artist's submissions.
Tips: "Get a realistic understanding of the gallery/artist relationship by visiting with directors. Be professional and persistent."

[N] WALNUT STREET GALLERY, 301 S.W. Walnut St., Ankeny IA 50021. (515)964-9434. Fax: (515)964-9438. E-mail: walnutst@dwx.com. Website: http://www.quikpage.com/w/walnutstgalry/. President: Patty Brewbaker. Retail gallery. Estab. 1982. Represents 50 emerging, mid-career and established artists/year. Exhibited artists include Larry Zach and Terry Redlin. Sponsors 1 show/year. Average display time 6 months. Open all year; Monday-Thursday, 9-7; Friday, 9-5; Saturday, 9-4. Located downtown; 1,500 sq. ft.; renovated building. 25% of space for special exhibitions. Clientele: local community and suburbs. Overall price range: $100-500; most work sold at $250-300.
Media: Considers all media and all types of prints. Most frequently exhibits watercolor, acrylic and oil.
Style: Exhibits: expressionism, Impressionism and realism. Genres include florals, wildlife, landscapes and Americana. Prefers: Impressionism, realism and expressionism.
Terms: Buys outright for 50% of retail price (net 30 days). Retail price set by the artist. Gallery provides promotion; gallery pays shipping. Prefers artwork unframed.
Submissions: Send query letter with brochure and photographs. Write for appointment to show portfolio of photographs. Replies only if interested within 3 weeks. Files all material. Finds artists through visiting art fairs and recommendations from customers.

Kansas

[N] THE COLLECTIVE GALLERY, 3121 SW Huntoon St., Topeka KS 66604-1662. (785)234-4254. E-mail: thecolgal@aol.com. Website: http://www.members.aol.com/thecolgal/thecollective.html. President: Phil Jones. Cooperative gallery. Estab. 1988. Approached by 25 artists/year. Represents 30 emerging, mid-career and established artists. Exhibited artists include members of the gallery and artists by invitation once a year. Sponsors 12 exhibits/year. Average display time 1 month. Open all year: Wednesday-Friday, 12-4; Saturday, 10-5. "Located in an older, charming, small shopping area with one other gallery, a floral shop and furniture store which draw a creative clientele. The exhibition space is long and narrow with white walls, two levels, lots of street exposure." Clients include local community, students, tourists, upscale. 5% of sales are to corporate collectors. Overall price range: $25-2,000; most work sold at $400.
Media: Considers all media; types of prints include engravings, etchings, linocuts, lithographs, mezzotints, serigraphs and woodcuts. Most frequently exhibits paintings, works on paper, ceramics, fiber and glass.
Style: Considers all styles.
Terms: Artwork is accepted on consignment and there is a 40% commission. Co-op membership fee plus donation of time required; 30% commission. Retail price set by the artist. Gallery provides insurance, promotion and contract. Accepted work should be framed, mounted or matted. Does not require exclusive representation locally.
Submissions: Call or write to arrange a personal interview to show portfolio of photographs and slides or send query letter with résumé, artist's statement, photographs, slides and SASE. Returns material with SASE. Replies within 2 months if interested. Finds artists through word of mouth, art exhibits, submissions, art fairs, portfolio reviews and referrals by other artists.
Tips: "Please send typed résumé, artist's statement and a couple slides or photographs that best represent work. We will contact artist for additional information if the work fits into our gallery. Our collectors are usually interested in mats and papers not yellowing or changing colors. Professional presentation important."

GALLERY XII, 412 E. Douglas, Suite A, Wichita KS 67202. (316)267-5915. Consignment Committee: Diane Curtis. Cooperative nonprofit gallery. Estab. 1977. Represents 50 mid-career and established artists/year and 20 members. Average display time 1 month. Open all year; Monday-Saturday, 10-4. Located in historic Old Town which is in the downtown area; 1,300 sq. ft.; historic building. 20% of space for special exhibitions; 80% of space for gallery artists. Clientele: private collectors, corporate collectors, people looking for gifts, tourists. Overall price range: $10-2,000.
Media: Considers all painting and drawing media, artists' prints (no mechanical reproductions), weaving, sculpture, ceramics, jewelry.
Style: Exhibits abstract, Impressionism, realism, etc.
Terms: Only accepts 3-D work on consignment (35% commission). Co-op membership screened and limited. Annual exhibition fee, 15% commission and time involved. Artist pays shipping costs to and from gallery.
Submissions: Limited to local artists or those with ties to area. Work juroed from slides.

PHOENIX GALLERY TOPEKA, 2900-F Oakley Dr., Topeka KS 66614. (913)272-3999. Owner: Kyle Garcia. Retail gallery. Estab. 1990. Represents 60 emerging, mid-career and established artists/year. Exhibited artists include Dave Archer, Louis Copt, Nagel, Phil Starke, Robert Berkeley Green and Raymond Eastwood. Sponsors 6 shows/year. Average display time 6 weeks-3 months. Open all year, 7 days/week. Located downtown; 2,000 sq. ft. 100% of space for special exhibitions; 100% of space for gallery artists. Clientele: upscale. 75% private collectors, 25% corporate collectors. Overall price range: $500-20,000.

Media: Considers all media and engravings, lithographs, woodcuts, mezzotints, serigraphs, linocuts, etchings and collage. Most frequently exhibits oil, watercolor, ceramic and artglass.

Style: Exhibits expressionism and Impressionism, all genres. Prefers regional, abstract and 3-D type ceramic; national glass artists. "We find there is increased interest in original work and regional themes."

Terms: Terms negotiable. Retail price set by the gallery and the artist. Prefers artwork framed.

Submissions: Call for appointment to show portfolio of originals, photographs and slides.

Tips: "We are scouting [for artists] constantly."

TOPEKA & SHAWNEE COUNTY PUBLIC LIBRARY GALLERY, 1515 W. Tenth, Topeka KS 66604-1374. (913)231-0527. Fax: (913)233-2055. E-mail: lpeters@tscpl.lib.ks.us. Website: http://www.tscpl.org. Gallery Director: Larry Peters. Nonprofit gallery. Estab. 1976. Exhibits emerging, mid-career and established artists. Sponsors 8-9 shows/year. Average display time 1 month. Open all year; Monday-Saturday, 9-6; Sunday, 2-6. Closed summer Sundays. Located 1 mile west of downtown; 1,200 sq. ft.; security, track lighting, plex top cases; recently added two moveable walls. 100% of space for special exhibitions. Overall price range: $150-5,000.

● As AGDM went to press, this gallery was temporarily closed for construction to be completed in 2000/2001. They are not accepting submissions until 2001.

Media: Considers oil, fiber, acrylic, sculpture, glass, watercolor, mixed media, ceramic, pastel, collage, metal work, woodcuts, wood engravings, linocuts, engravings, mezzotints, etchings, lithographs. Most frequently exhibits ceramic, oil and watercolor.

Style: Exhibits neo-expressionism, painterly abstraction, postmodern works and realism. Prefers painterly abstraction, realism and neo-expressionism.

Terms: Artwork accepted or not accepted after presentation of portfolio/résumé. Retail price set by artist. Gallery provides insurance; artist pays for shipping costs. Prefers artwork framed.

Submissions: Usually accepts only artists from KS, MO, NE, IA, CO, OK. Send query letter with résumé and 12-24 slides. Call or write for appointment to show portfolio of slides. Replies in 1-2 months. Files résumé. Finds artists through visiting exhibitions, word of mouth and submissions.

Tips: "Find out what each gallery requires from you and what their schedule for reviewing artists' work is. Do not go in unannounced. Have good quality slides—if slides are bad they probably will not be looked at. Have a dozen or more to show continuity within a body of work. Your entire body of work should be at least 50-100 pieces. Competition gets heavier each year. Looks for originality."

[N] EDWIN A. ULRICH MUSEUM OF ART, Wichita State University, Wichita KS 67260-0046. (316)689-3664. Fax: (316)689-3898. E-mail: knaub@twsuvm.uc.twsu.edu. Director: Donald E. Knaub. Museum. Estab. 1974. Represents mid-career and established artists. Sponsors 7 shows/year. Average display time 6-8 weeks. Open daily, 12-5; closed major holidays. Located on campus; 6,732 sq. ft.; high ceilings, neutral space. 75% of space for special exhibitions.

Media: Considers sculpture, installation, neon-light, new media.

Style: Exhibits conceptualism and new media.

Submissions: Send query letter with résumé, slides and SASE. Write for appointment to show portfolio of slides, transparencies and statement of intent. Replies only if interested within 6 weeks. Finds artists through word of mouth and art publications.

WICHITA ART MUSEUM STORE SALES GALLERY, 619 Stackman Dr., Wichita KS 67203. (316)268-4975. Fax: (316)268-4980. Manager/Buyer: Mark Fisher. Nonprofit retail and consignment gallery. Estab. 1963. Exhibits 150 emerging and established artists. Sponsors 4 group shows/year. Average display time is 6 months. 1,228 sq. ft. Accepts only artists from expanded regional areas. Clientele: tourists, residents of city, students. 75% private collectors, 25% corporate clients. Overall price range: $25-2,500; most work sold at $25-800.

Media: Considers oil, acrylic, watercolor, pastel, mixed media, collage, works on paper, sculpture, ceramic, fiber, glass and original handpulled prints.

Style: Exhibits organic/abstraction, Impressionism, expressionism and realism. Genres include landscapes, florals, portraits and figurative work. Most frequently exhibits realism and Impressionism.

Terms: Accepts work on consignment (40% commission). Retail price set by artist. Exclusive area representation not required. Gallery provides insurance and contract.

Submissions: Send query letter with résumé. Resumes and brochures are filed.

Tips: "Framing and proper matting very important. Realism and Impressionism are best sellers. Landscapes and florals most popular. We are constantly looking for and exhibiting new artists. We have a few artists who have been with us for many years but our goal is to exhibit the emerging artist."

Kentucky

BROWNSBORO GALLERY, 4802 Brownsboro Center, Louisville KY 40207. (502)893-5209. Owner: Leslie Spetz. Retail gallery. Estab. 1990. Represents 20-25 emerging, mid-career and established artists. Exhibited artists include Tarleton Blackwell and Michaele Ann Harper. Sponsors 9-10 shows/year. Average display time 5 weeks. Open all year; Tuesday-Friday, 10-5; Saturday, 10-3; closed Sunday and Monday. Located on the east end (right off I-71 at I-264);

1,300 sq. ft.; 2 separate galleries for artist to display in give totally different feelings to the art; one is a skylight room. 85% of space for gallery artists. Clientele: upper income. 90% private collectors, 10% corporate collectors. Overall price range; $100-2,500; most work sold at $800-1,000.

Media: Considers oil, acrylic, watercolor, pastel, pen & ink, drawing, mixed media, collage, paper, sculpture, ceramics, fiber, glass, installation, photography, woodcuts, engravings and etchings. Most frequently exhibits oil, mixed (oil or watercolor pastel) and watercolor.

Style: Exhibits painterly abstraction, all styles, color field, postmodern works, Impressionism, photorealism and realism. Genres include landscapes, Americana and figurative work. Prefers landscape, abstract and collage/contemporary.

Term: Accepts work on consignment (40% commission). Retail price set by the gallery and the artist. Gallery provides insurance, promotion, contract and shipping costs from gallery; artist pays shipping costs to gallery. Prefers artwork framed.

Submissions: Send query letter with résumé, at least 10 slides, bio, price list and SASE. Call for appointment to show portfolio of photographs and slides. Replies only if interested within 3-4 weeks. Finds artists through word of mouth and submissions, "sometimes by visiting exhibitions."

Tips: "Check the spaces out before approaching galleries to see how comfortable they are. Check out and agree to whatever contract the gallery may have and honor it. Have a body of work of at least 25-30, so if a show would be available they would know that there was enough work."

CAPITAL GALLERY OF CONTEMPORARY ART, 314 Lewis, Frankfort KY 40601. (502)223-2649. Owner: Ellen Glasgow. Retail gallery, art consultancy. Estab. 1981. Represents 20-25 emerging, mid-career and established artists/year. Exhibited artists include Kathleen Kelly, Robert Kipniss. Sponsors 8 shows/year. Average display time 1-2 months. Open all year; Tuesday-Saturday, 10-5. Located downtown, historic district; 1,200 sq. ft.; historic building, original skylights, vaults, turn-of-century. 50% of space for special exhibitions; 50% of space for gallery artists. 60% private collectors; 40% corporate collectors. Overall price range: $30-10,000; most work sold at $300-3,000.

Media: Considers all media except photography; all prints except posters. Most frequently exhibits oil paintings, watercolor, fine printmaking.

Style: Exhibits all styles and genres. Prefers landscapes, floral/figurative, works on paper.

Terms: Accepts work on consignment (40% commission). Retail price set by the artist. Gallery provides insurance and promotion; shipping costs are shared. Prefers artwork framed.

Submissions: Send query letter with résumé, slides, photographs, bio, SASE. Write for appointment to show portfolio of photographs and slides. Replies in 2-4 weeks. Files bios, cards.

Tips: "Visit the gallery first."

CENTRAL BANK GALLERY, 300 W. Vine St., Lexington KY 40507. (606)253-6135. Fax: (606)253-6069. Curator: John Irvin. Nonprofit gallery. Estab. 1985. Interested in seeing the work of emerging artists. Represented more than 1,000 artists in the past 10 years. Exhibited artists include Arturo Sandoval and John Tuska. Sponsors 12 shows/year. Average display time 3 weeks. Open all year; Monday-Friday, 9-4:30. Located downtown. 100% of space for special exhibitions. Clientele: local community. 100% private collectors. Overall price range: $100-5,000; most work sold at $350-500.

● Central Bank Gallery considers Kentucky artists only.

Media: Considers all media. Most frequently exhibits oils, watercolor, sculpture.

Style: Exhibits all styles. "Please, no nudes."

Terms: Retail price set by the artist "100% of proceeds go to artist." Gallery provides insurance and promotion; artist pays for shipping.

Submissions: Call or write for appointment.

Tips: "Don't be shy, call me. We pay 100% of the costs involved once the art is delivered."

KENTUCKY ART & CRAFT GALLERY, 609 W. Main St., Louisville KY 40202. (502)589-0102. Fax: (502)589-0154. Retail Marketing Director: Marcie Warner. Retail gallery operated by the private nonprofit Kentucky Art & Craft Foundation, Inc. Estab. 1984. Represents more than 400 emerging, mid-career and established artists. Exhibiting artists include Arturo Sandoval, Stephen Powell and Rude Osolnik. Sponsors 10-12 shows/year. Open all year. Located downtown in the historic Main Street district; 5,000 sq. ft.; a Kentucky tourist attraction located in a 120-year-old cast iron building. 33% of space for special exhibitions. Clientele: tourists, the art-viewing public and schoolchildren. 10% private collectors, 5% corporate clients. Overall price range: $3-20,000; most work sold at $25-500.

Media: Considers mixed media, metal, glass, clay, fiber, wood and stone.

Terms: Accepts work on consignment (50% commission). Retail price set by artist. Gallery provides insurance, promotion, contract and shipping costs from gallery.

Submissions: Contact gallery for jury application and guidelines first; then send completed application, résumé and 5 samples. Replies in 2-3 weeks. "If accepted, we file résumé, slides, signed contract, promotional materials and PR about the artist."

Tips: "The artist must live or work in a studio within the state of Kentucky."

LOUISVILLE VISUAL ART ASSOCIATION, Suite 275, Louisville Galleria, Louisville KY 40202. (502)581-1445. E-mail: louvsart.org. Gallery Manager: Janice Emery. Nonprofit sales and rental gallery. Estab. 1990. Represents 80+ emerging, mid-career and established regional artists. Average display time 3 months. Open all year; Monday-Friday,

11:30-3:30 and by appointment. Located downtown; 1,500 sq. ft. 10% of space for special exhibitions; 90% of space for gallery artists. Clientele: all ages and backgrounds. 50% private collectors, 50% corporate collectors. Overall price range: $300-4,000; most work sold at $300-1,000.

• Headquarters for LVAA are at 3005 Upper River Rd.; LVAA Sales and Rental Gallery is at #275 Louisville Galleria (Fourth and Liberty).

Media: Considers oil, acrylic, watercolor, pastel, pen & ink, drawing, mixed media, collage, paper, sculpture, ceramics, craft (on a limited basis), fiber, glass, photography, woodcuts, engravings, lithographs, wood engravings, mezzotints, serigraphs, linocuts, etchings and some posters. Most frequently exhibits oil, acrylic, watercolor, sculpture and glass.
Style: Exhibits contemporary, local and regional visual art, all genres.
Terms: Accepts work on consignment (40% commission). Membership is suggested. Retail price set by the artist. Gallery provides insurance, promotion and contract (nonexclusive gallery relationship). Artist pays shipping costs to and from gallery. Accepts framed or unframed artwork. Artists should provide necessary special displays. (Ready-to-hang is advised with or without frames.)
Submissions: Accepts only artists from within a 400-mile radius, or former residents or those trained in Kentucky (university credentials). Send query letter with résumé, slides, bio and reviews. Write for appointment to show portfolio of slides. Replies only if interested within 4-6 weeks. Files up to 20 slides (in slide registry), bio, résumé, brief artist's statement, reviews, show announcement. Finds artists through visiting exhibitions, word of mouth, art publications and submissions.
Tips: "If the artist has a reasonable number of works and has prepared slides/résumé/artist statement, we take a serious look at their potential. The quality must be a factor, however early development is not considered a drawback when viewing work. Strength of ideas and artistic ability are first and foremost in our selection criteria. Sophisticated use of materials is considered."

MAIN AND THIRD FLOOR GALLERIES, Northern Kentucky University, Nunn Dr., Highland Heights KY 41099. (606)572-5148. Fax: (606)572-5566. Gallery Director: David Knight. University galleries. Program established 1975; new main gallery in fall of 1992; renovated third floor gallery fall of 1993. Represents emerging, mid-career and established artists. Sponsors 10 shows/year. Average display time 1 month. Open Monday-Friday, 9-9; Saturday, Sunday, 1-5; closed major holidays and between Christmas and New Years. Located in Highland Heights, KY, 8 miles from downtown Cincinnati; 3,000 sq. ft.; two galleries—one small and one large space with movable walls. 100% of space for special exhibitions. 90% private collectors, 10% corporate collectors. Overall price range; $25-50,000; most work sold at $25-2,000.
Media: Considers all media and all types of prints. Most frequently exhibits painting, printmaking and photography.
Style: Exhibits all styles, all genres.
Terms: Proposals are accepted for exhibition. Retail price set by the artist. Gallery provides insurance, promotion and contract; shipping costs are shared. Prefers artwork framed "but we are flexible."
Submissions: Send query letter with résumé, slides, bio, photographs, SASE and reviews. Write for appointment to show portfolio of originals, photographs and slides. Submissions are accepted in December for following academic school year. Files résumés and bios. Finds artists through agents, visiting exhibitions, word of mouth, art publications, sourcebooks and submissions.

YEISER ART CENTER INC., 200 Broadway, Paducah KY 42001-0732. (502)442-2453. E-mail: yacenter@sunsix.infi .net. Website: http://www.yeiser.org. Executive Director: Dan Carver. Nonprofit gallery. Estab. 1957. Exhibits emerging, mid-career and established artists. 450 members. Sponsors 8-10 shows/year. Average display time 6-8 weeks. Open all year. Located downtown; 1,800 sq. ft.; "in historic building that was farmer's market." 90% of space for special exhibitions. Clientele: professionals and collectors. 90% private collectors. Overall price range: $200-8,000; most artwork sold at $200-1,000.
Media: Considers all media except installation. Prints considered include original handpulled prints, woodcuts, wood engravings, linocuts, mezzotints, etchings, lithographs and serigraphs. Most frequently exhibits oil, acrylic and mixed media.
Style: Exhibits all styles. Genres include landscapes, florals, Americana and figurative work. Prefers realism, Impressionism and abstraction.
Terms: Accepts work on consignment (35% commission). Retail price set by artist. Gallery provides insurance and promotion; shipping costs are shared. Prefers artwork framed.
Submissions: Send résumé, slides, bio, SASE and reviews. Replies in 1 month.
Tips: "Do not call. Give complete information about the work: media, size, date, title, price. Have good-quality slides of work, indicate availability and include artist statement. Presentation of material is important."

ZEPHYR GALLERY, 610 E. Market St., Louisville KY 40202. (502)585-5646. Directors: Patrick Donley, Peggy Sue Howard. Cooperative gallery and art consultancy with regional expertise. Estab. 1987. Exhibits 18 emerging and mid-career artists. Exhibited artists include C. Radtke, K. Malloy, Kocka, R. Stagg, G. Smith, J. Deamer, W. Smith, P. Manion. Sponsors 11 shows/year. Average display time 1 month. Open all year. Located downtown; approximately 1,800 sq. ft. Clientele: 25% private collectors, 75% corporate collectors. Most work sold at $200-2,000.
Media: Considers all media. Considers only small edition handpulled print work by the artist. Most frequently exhibits painting, photography and sculpture.
Style: Exhibits individual styles.

Terms: Co-op membership fee plus donation of time (25% commission). Must live within 50 mile radius of Louisville. Prefers artwork framed. No glass.

Submissions: No functional art (jewelry, etc.). Send query letter with résumé and slides. Call for appointment to show portfolio of slides; may request original after slide viewing. Replies in 6 weeks. Files slides, résumés and reviews (if accepted). Submissions accepted for January 15 and June 15 review.

Tips: "Submit well-organized slides with slide list. Include professional résumé with notable exhibitions."

Louisiana

BATON ROUGE GALLERY, INC., 1442 City Park Ave., Baton Rouge LA 70808-1037. (504)383-1470. Director: Kathleen Pheney. Cooperative gallery. Estab. 1966. Exhibits the work of 50 emerging, mid-career and established artists. 300 members. Sponsors 12 shows/year. Average display time 1 month. Open all year. Located in the city park pavilion; 1,300 sq. ft. Overall price range: $100-10,000; most work sold at $50-100.
 ● Every Sunday at 4 p.m. the gallery hosts a spoken word series featuring literary readings of all genres. We also present special performances including dance, theater and music.

Media: Considers oil, acrylic, watercolor, pastel, video, drawing, mixed media, collage, paper, sculpture, ceramic, fiber, glass, installation, photography, woodcuts, engravings, lithographs, pochoir, wood engravings, mezzotints, serigraphs, linocuts and etchings. Most frequently exhibits painting, sculpture and glass.

Style: Exhibits all styles and genres.

Terms: Co-op membership fee plus donation of time. Gallery takes 33% commission. Retail price set by artist. Artist pays for shipping. Artwork must be framed.

Submissions: Membership and guest exhibitions are selected by screening committee. Send query letter for application. Call for appointment to show portfolio of slides.

Tips: "The screening committee screens applicants in March and October each year. Call for application to be submitted with portfolio and résumé."

CASELL GALLERY, 818 Royal St., New Orleans LA 70116. (800)548-5473. Title/Owner-Directors: Joachim Casell. Retail gallery. Estab. 1970. Represents 20 mid-career artists/year. Exhibited artists include J. Casell and Don Picou. Sponsors 2 shows/year. Average display time 10 weeks. Open all year; 10-6. Located in French Quarter; 800 sq. ft. 25% of space for special exhibitions. Clientele: tourists and local community. 20-40% private collectors, 10% corporate collectors. Overall price range: $100-1,200; most work sold at $300-600.

Media: Considers all media, wood engravings, etchings, lithographs, serigraphs and posters. Most frequently exhibits pastel and pen & ink drawings.

Style: Exhibits Impressionism. All genres including landscapes. Prefers pastels.

Terms: Artwork is accepted on consignment (50% commission). Retail price set by the artist. Gallery provides promotion and pays for shipping costs. Prefers artwork unframed.

Submissions: Accepts only local area and southern artists. Replies only if interested within 1 week.

EARTHWORKS FINE ART GALLERY, 1424 Ryan, Lake Charles LA 70601. (318)439-1430. Fax: (318)439-1441. Owner: Ray Fugatt. Retail gallery. Estab. 1989. Represents 10-12 emerging, mid-career and established artists. Exhibited artists include Robert Rucker and Lian Zhen. Sponsors 3 shows/year. Average display time 1 month. Open all year. Located downtown; 4,000 sq. ft.; "a remodeled 50-year-old, art-deco designed grocery building." 40% of space for special exhibitions. Overall price range: $100-15,000; most work sold at $500-8,000.

Media: Considers oil, acrylic, watercolor, pen & ink, drawings, mixed media, sculpture, ceramic, glass, original hand-pulled prints, woodcuts, etchings and "any repros by artist; no photo lithos." Most frequently exhibits oil, acrylic and watercolor.

Style: Exhibits expressionism, Impressionism, realism and photorealism. Genres include landscapes, florals, Americana, Southwestern, Western, wildlife and figurative works.

Terms: 90% of work accepted on consignment (40% commission); 10% bought outright for 50% of the retail price (net 30 days). Exclusive area representation required. Retail price set by artist. Gallery provides insurance, promotion, contract and shipping costs from gallery. Prefers artwork framed.

Submissions: Send query letter with résumé and slides. Call or write for appointment to show portfolio of originals and slides. Replies in 2-4 weeks. Files résumés.

Tips: "Have a body of work available that shows the range of uniqueness of your talent."

GALLERY OF THE MESAS, 2010-12 Rapides Ave., Alexandria LA 71301. (318)442-6372. E-mail: wayne@popalex 1.linknet.net. Website: http://www.gallerymesas.com. Artist/Owner: C.H. Jeffress. Retail and wholesale gallery and artist studio. Focus is on southwest and Native American art. Estab. 1975. Represents 4-6 established artists. Exhibited artists include John White, Charles H. Jeffress, Atkinson and Mark Snowden. Open all year; Tuesday-Friday, 11-5. Located on the north edge of town; 2,500 sq. ft. Features new canvas awnings, large gold letters on brick side of buildings. Clientele: 95% private collectors, 5% corporate collectors. Overall price range: $165-3,800.

Media: Considers original handpulled prints, watercolor, intaglio, lithographs, serigraphs, Indian jewelry, sculpture,

ceramics and drums. Also exhibits Hopi-carved Katchina dolls. Most frequently exhibits serigraphs, inkless intaglio, collage and lithographs.

Style: Exhibits realism. Genres include landscapes, southwestern and figurative work. Most frequently exhibits landscapes.

Submissions: Handles only work of well-known artists in southwest field. Owner contacts artists he wants to represent.

Tips: "Visit galleries to see if your work 'fits in' with others in the gallery. Present strictly professional work. You should create at least 3-4 works per year, with a body of at least 30 works."

ANTON HAARDT GALLERY, 2714 Coliseum St., New Orleans LA 70130. (504)897-1172. Website: http://www.ant on.art.com. Owner: Anton Haardt. Retail gallery. Estab. 1987. Represents 25 established, self-taught artists. Exhibited artists include Mose Tollirer, Sybil Gibson. Open all year by appointment only. Located in New Orleans—Garden District, Montgomery—downtown; 1,000 sq. ft. 100% of space for gallery artists. Clientele: collectors, upscale. 50% private collectors, 50% corporate collectors. Overall price range: $200-10,000; most work sold at $300-1,000.

Media: Considers oil, pen & ink, paper, acrylic, drawing, sculpture, watercolor, mixed media, pastel and collage. Most frequently exhibits paint, pen & ink, mixed media.

Style: Exhibits primitivism, folk art. Prefers folk art.

Terms: Price set by the gallery. Gallery provides promotion; shipping costs to gallery. Prefers artwork unframed.

Submissions: Accepts only artists from the South (mainly). Must be self-taught—untrained. Send query letter with slides, bio. Call for appointment to show portfolio of photographs and slides. Replies in 2 months. Finds artists through word of mouth, newspaper and magazine articles.

Tips: "I have very strict requirements for absolute purist form of self-taught artists."

HILDERBRAND GALLERY, P.O. Box 15061, New Orleans LA 70175. (504)895-3312. Fax: (504)897-3905. Director: Clint Hilderbrand. Retail gallery and art consultancy. Estab. 1991. Represents/exhibits 22 emerging, mid-career and established artists/year. Exhibited artists include Walter Rutkowski, Massimo Boccuni, Robert Tanner and Lew Thomas. Average display time 1 month. Open Tuesday-Saturday, 11-5. Located uptown; 2,300 sq. ft.; 12′ walls; pitch open ceiling with exposed steel beams/skylites. 70% of space for special exhibitions; 30% of space for gallery artists. Clientele: collectors, museum and corporate. 70% private collectors, 30% corporate collectors. Overall price range: $500-40,000; most work sold at $500-3,500.

● The Gallery features independent films every other Thursday and performance art Friday through Sunday in its 65 person theater. Call for schedule.

Media: Considers all media, woodcuts, linocuts, engravings, mezzotints and etchings. Most frequently exhibits oil, glass/steel, photography and motion pictures.

Style: Considers all styles. Genres include landscapes, Americana and figurative work. Prefers nontraditional landscapes, conceptualist and abstract figurative.

Terms: Artwork is accepted on consignment (50% commission). Retail price set by the gallery. Gallery provides insurance, limited promotion and contract. Artist pays for shipping costs. Prefers artwork framed.

Submissions: Send query letter with résumé, brochure, slides, reviews, bio and SASE. Replies in 1 month. Finds artists through submissions, studio visits and exhibitions.

LE MIEUX GALLERIES, 332 Julia St., New Orleans LA 70130. (504)522-5988. Fax: (504)522-5682. President: Denise Berthiaume. Retail gallery and art consultancy. Estab. 1983. Represents 30 mid-career artists. Exhibited artists include Shirley Rabe Masinter and Kathleen Sidwell. Sponsors 7 shows/year. Average display time 6 months. Open all year. Located in the warehouse district/downtown; 1,400 sq. ft. 20-75% of space for special exhibitions. Clientele: 75% private collectors; 25% corporate clients.

Media: Considers oil, acrylic, watercolor, pastel, drawings, mixed media, works on paper, sculpture, ceramic, glass and egg tempera. Most frequently exhibits oil, watercolor and drawing.

Style: Exhibits Impressionism, neo-expressionism, realism and hard-edge geometric abstraction. Genres include landscapes, florals, wildlife and figurative work. Prefers landscapes, florals and paintings of birds.

Terms: Accepts work on consignment (50% commission). Retail price set by artist. Exclusive area representation required. Gallery provides promotion and contract; artist pays for shipping.

Submissions: Accepts only artists from the Southeast. Send query letter with SASE, bio, brochure, résumé, slides and photographs. Write for appointment to show portfolio of originals. Replies in 3 weeks. All material is returned if not accepted or under consideration.

Tips: "Send information before calling. Give me the time and space I need to view your work and make a decision;

**FOR EXPLANATIONS OF THESE SYMBOLS,
SEE THE INSIDE FRONT AND BACK COVERS OF THIS BOOK.**

you cannot sell me on liking or accepting it; that I decide on my own."

STONE AND PRESS GALLERIES, 238 Chartres St., New Orleans LA 70130. (504)561-8555. Fax: (504)561-5814. Owner: Earl Retif. Retail gallery. Estab. 1988. Represents/exhibits 20 mid-career and established artists/year. Interested in seeing the work of emerging artists. Exhibited artists include Carol Wax and Benton Spruance. Sponsors 9 shows/year. Average display time 1 month. Open all year; Monday-Saturday, 10:30-5:30. Located in historic French Quarter; 1,200 sq. ft.; in historic buildings. 50% of space for special exhibitions; 50% of space for gallery artists. Clientele: collectors nationwide also tourists. 90% private collectors, 10% corporate collectors. Overall price range: $50-10,000; most work sold at $400-900.
Media: Considers all drawing, pastel and all types of prints. Most frequently exhibits mezzotint, etchings and lithograph.
Style: Exhibits realism. Genres include Americana, portraits and figurative work. Prefers American scene of '30s and '40s and contemporary mezzotint.
Terms: Artwork is accepted on consignment (50% commission). Retail price set by the gallery and the artist. Gallery provides insurance, promotion and contract; shipping costs are shared. Prefers artwork unframed.
Submissions: Send query letter with résumé, slides and SASE. Write for appointment to show portfolio of photographs. Replies in 3 weeks.
Tips: Finds artists through word of mouth and referrals of other artists.

Maine

BIRDSNEST GALLERY, 12 Mt. Desert St., Bar Harbor ME 04609. (207)288-4054. Owner: Barbara Entzminger. Retail gallery. Estab. 1972. Represents 40 mid-career and established artists/year. Interested in seeing the work of emerging artists. Exhibited artists include Rudolph Colao and Tony Van Hasselt. Sponsors 6-9 shows/year. Average display time 1-6 months. Open May 15-October 30; daily 10-9; Sundays, 12-9. Located downtown, opposite Village Green; 4,800 sq. ft.; good track lighting, 5 rooms. 10% of space for special exhibitions; 90% of space for gallery artists. Clientele: tourists, summer residents, in-state collectors. 80% private collectors, 20% corporate collectors. Overall price range: $100-30,000; most work sold at $250-1,600.
Media: Considers all media except functional items and installations; types of prints include woodcuts, engravings, lithographs, wood engravings, mezzotints, serigraphs, linocuts and etchings. Original prints only, no reproductions. Most frequently exhibits oils, watercolors and serigraphs/etchings.
Style: Exhibits: expressionism, neo-expressionism, painterly abstraction, Impressionism, photorealism, realism and imagism from traditional to semi-abstract. Genres include florals, wildlife, landscapes, figurative work and seascapes. Prefers: Impressionism and traditional, contemporary realism and semi-abstract work.
Terms: Accepts work on consignment (50% commission). Retail price set by the artist. Gallery provides limited insurance and promotion; artist pays shipping. Gallery prefers artwork to be delivered and picked up; does not ship from gallery. Prefers artwork framed, matted and shrinkwrapped.
Submissions: Accepts only artists who paint in the Northeast. Prefers only oils and watercolor. Send query letter with résumé, 12 slides or photographs, bio, brochure, SASE and reviews. Call or write for appointment to show portfolio of photographs, slides. Final decision for acceptance of artwork is from the original. Replies only if interested with 1 month. Files photographs and bio. Finds artists through word of mouth, referrals by other artists and submissions.
Tips: "Test yourself by exhibiting in outdoor art shows. Are you winning awards? Are you winning awards and sell well? You should have 6 to 12 paintings before approaching galleries."

☑ **DUCKTRAP BAY TRADING COMPANY**, 28 Bayview St., Camden ME 04843. (207)236-9568. Fax: (207)236-6203. E-mail: info@ducktrapbay.com. Website: http://www.ducktrapbay.com. Owners: Tim and Joyce Lawrence. Retail gallery. Estab. 1983. Represents 200 emerging, mid-career and established artists/year. Exhibited artists include: Ward Huber, Rudy Miller, Grace Ellis, Maris Shepherd, Tim Thompson, Michael Wilson and Peter Sculthorpe. Open all year; Monday-Saturday, 9-5. Located downtown waterfront; small, 20×30. 100% of space for gallery artists. Clientele: tourists, upscale. 70% private collectors, 30% corporate collectors. Overall price range: $250-18,000; most work sold at $500-2,500.
Media: Considers watercolors, oil, acrylic, pastel, pen & ink, drawing, paper, sculpture and bronze; and carvings. Types of prints include lithographs. Most frequently exhibits woodcarvings, watercolor, acrylic and bronze.
Style: Exhibits: realism. Genres include nautical, wildlife and landscapes. Prefers: marine and wildlife.
Terms: Accepts work on consignment (40% commission) or buys outright for 50% of the retail price (net 30 days). Retail price set by the artist. Gallery provides insurance and minimal promotion; artist pays for shipping. Prefers artwork framed or shrinkwrapped.
Submissions: Send query letter with 10-20 slides or photographs. Call or write for appointment to show portfolio of photographs. Files all material. Finds artists through word of mouth, referrals by other artists and submissions.
Tips: "Find the right gallery and location for your subject matter. Have at least eight to ten pieces or carvings or three to four bronzes."

N **THE GALLERY ON CHASE HILL**, P.O. Box 2786, 10 Chase Hill Rd., Kennebunkport ME 04046. (207)967-0049. Fax: (207)967-8477. E-mail: spain@biodeford.com. Contact: Francesca Spain. Retail gallery. Estab. 1995. Repre-

sents 24 emerging and mid-career artists/year. Exhibited artists include: Sally Caldwell Fisher and Edward Gordon. Sponsors 8 shows/year. Average display time 4-6 weeks. Open all year; 7 days May-December and weekends in winter. 1,600 sq. ft.; "historic sea captain's house." 50% of space for special exhibitions; 50% of space for gallery artists. Clientele: tourists, upscale and local community. 85% private collectors; 15% corporate collectors. Overall price range: $300-20,000; most work sold at $500-5,000.

Media: Considers all media except photography and sculpture. Most frequently exhibits oil, acrylic and watercolor.

Style: Exhibits: primitivism, Impressionism, photorealism and realism. Genres include florals, landscapes and Americana. Prefers: landscape photorealism, landscape realism and primitivism.

Terms: Accepts work on consignment (60% commission). Retail price set by the artist. Gallery provides insurance and promotion; artist pays for shipping. Prefers artwork framed.

Submissions: Prefers Northeast United States. Send query letter with résumé, slides, bio, brochure, photographs, SASE, business card, reviews and artist's statement. Write for appointment to show portfolio of photographs, slides and transparencies. Replies in 2 weeks. Files résumé, photos and bio. Finds artist through word of mouth and referrals by other artists.

N **GOLD/SMITH GALLERY**, 63 Commercial St., BoothBay Harbor ME 04538. (207)633-6252. Owner: Karen Vander. Retail gallery. Estab. 1974. Represents 30 emerging, mid-career and established artists. Exhibited artists include John Vander and John Wissemann. Sponsors 6 shows/year. Average display time 6 weeks. Open May-December; Monday-Saturday, 10-6; Sunday, 12-5. Located downtown across from the harbor. 1,500 sq. ft.; traditional 19th century house converted to contemporary gallery. 75% of space for special exhibitions; 25% of space for gallery artists. Clientele: residents and visitors. 90% private collectors, 10% corporate collectors. Overall price range: $350-5,000; most work sold at $350-1,500.

● Artists creating traditional and representational work should try another gallery. The work shown here is strong, self-assured and abstract.

Media: Considers oil, acrylic, watercolor, pastel, pen & ink, drawing, mixed media, collage, paper, sculpture, photography, woodcuts, engravings, lithographs, wood engravings, mezzotints, serigraphs, linocuts and etchings. Most frequently exhibits acrylic and watercolor.

Style: Exhibits expressionism, painterly abstraction "emphasis on nontraditional work." Prefers expressionist and abstract landscape.

Terms: Commission negotiated. Retail price set by the artist. Gallery provides insurance and promotion; artist pays shipping costs to and from gallery. Prefers artwork framed.

Submissions: No restrictions—emphasis on artists from Maine. Send query letter with slides, bio, photographs, SASE, reviews and retail price. Write for appointment to show portfolio of originals. Replies in 2 weeks. Artist should write the gallery.

Tips: "Present a consistent body of mature work. We need 12 to 20 works of moderate size. The sureness of the hand and the maturity interest of the vision are most important."

GREENHUT GALLERIES, 146 Middle St., Portland ME 04101. (207)772-2693. Fax: (207)772-2758. President: Peggy Greenhut Golden. Retail gallery. Estab. 1990. Represents/exhibits 20 emerging and mid-career artists/year. Sponsors 6-9 shows/year. Exhibited artists include: Alison Goodwin and Connie Hayes. Average display time 3 weeks. Open all year; Monday-Friday, 10-5:30; Saturday, 10-5. Located in downtown-Old Port; 3,000 sq. ft. with neon accents in interior space. 60% of space for special exhibitions. Clientele: tourists and upscale. 55% private collectors, 10% corporate collectors. Overall price range: $500-8,000; most work sold at $600-3,000.

Media: Most frequently exhibits oil paintings, acrylic paintings and mixed media.

Style: Exhibits contemporary realism. Prefers landscape, seascape and abstract.

Terms: Artwork is accepted on consignment (50% commission). Retail price set by the gallery and artist. Gallery provides insurance and promotion. Artists pays for shipping costs. Prefers artwork framed.

Submissions: Accepts only artists from Maine or New England area with Maine connection. Send query letter with slides, reviews, bios and SASE. Call for appointment to show portfolio of slides. Replies in 1 month. Finds artists through word of mouth, referrals by other artists, visiting art fairs and exhibitions and submissions.

Tips: "Visit the gallery and see if you feel your work fits in."

N **JAMESON GALLERY & FRAME**, 305 Commercial St., Portland ME 04101. (207)772-5522. Fax: (207)774-7648. E-mail: jamesib@maine.rr.com. Gallery Director: Martha Gilmartin. Retail gallery, custom framing, restoration, appraisals, consultation. Estab. 1992. Represents 20 emerging, mid-career and established artists/year. Exhibited artists include Ronald Frontin, Jon Marshall and W. Charles Nowell. Sponsors 6 shows/year. Average display time 6 weeks. Open all year; Monday-Saturday, 10-6; Holiday season Monday-Sunday, 10-6. Located on the waterfront in the heart of the shopping district; 1,800 sq. ft. 50% of space for special exhibitions; 50% of space for gallery artists. Clientele: local community, tourists, upscale. 80% private collectors, 20% corporate collectors. Overall price range: $150-25,000; most work sold at $500-3,000.

Media: Considers all media including woodcuts, engravings, wood engravings, mezzotints, linocuts and lithographs and serigraphs only if gallery carries original work. Most frequently exhibits oil, watercolor and fine woodworking.

Style: Exhibits: Impressionism, photorealism and realism. Genres include florals, landscapes and still life. Prefers: still lifes and landscapes (Dutch Masters influence) and florals (Impressionistic).

Terms: Depends on each contract. Retail price set by the gallery. Gallery provides insurance, promotion and contract;

artist pays for shipping costs. Prefers artwork unframed. Artist may buy framing contract with gallery.

Submissions: Send query letter with résumé, slides, bio, photographs, statement about why they want to show at the gallery and SASE. Gallery will contact for appointment to show portfolio of photographs and sample work. Returns only with SASE. Files name, address and bio. Finds artists through exhibits and artists approaching gallery.

✓ **STEIN GALLERY CONTEMPORARY GLASS**, 195 Middle St., Portland ME 04101. (207)772-9072. Contact: Anne Stein. Retail gallery. Represents 95 emerging, mid-career and established artists. Open all year. Located in "old port" area. 100% of space for gallery artists.

Media: Considers glass only.

Terms: Retail price set by the artist. Gallery provides insurance and promotion.

Submissions: Send query letter with résumé and slides.

UNIVERSITY OF MAINE MUSEUM OF ART, 109 Carnegie Hall, Orono ME 04469. (207)581-3255. Fax: (207)581-3083. The Museum of Art hosts an annual calendar of exhibitions and programs featuring contemporary artists and ideas in a variety of traditional and non-traditional media, as well as exhibitions organized from the permanent collection. The permanent collection has grown to over 5,600 works of art. Included in the collection are works by artists such as Ralph Blakelock, Georges Braque, Mary Cassatt, Honore Daumier, George Inness, Diego Rivera, Pablo Picasso and Giovanni Battista Piranesi. In addition, each year the Museum organizes The Vincent Hartgen Traveling Exhibition Program: Museums by Mail, a statewide effort that circulates more than 50 exhibitions, drawn from the permanent collection. This program reaches hundreds of institutions such as schools, libraries, town halls and hospitals throughout the state.

Media: Considers all media and all types of prints.

Style: Exhibits all styles and genres.

Terms: Gallery provides insurance and promotion; shipping costs are shared. Prefers artwork framed.

Submissions: Send query letter with résumé, slides, bio and reviews. Write for appointment to show portfolio of originals and slides. Replies in 1 month. Files bio, slides, if requested, and résumé.

Maryland

ARTEMIS, INC., 4715 Crescent St., Bethesda MD 20816. (301)229-2058. Fax: (301)229-2186. E-mail: sjtropper@aol. com. Owner: Sandra Tropper. Retail and wholesale dealership and art consultancy. Represents more than 100 emerging and mid-career artists. Does not sponsor specific shows. Clientele: 40% private collectors, 60% corporate clients. Overall price range: $100-10,000; most artwork sold at $1,000-3,000.

Media: Considers oil, acrylic, watercolor, mixed media, collage, works on paper, sculpture, ceramic, craft, fiber, glass, installations, woodcuts, engravings, mezzotints, etchings, lithographs, pochoir, serigraphs and offset reproductions. Most frequently exhibits prints, contemporary canvases and paper/collage.

Style: Exhibits Impressionism, expressionism, realism, minimalism, color field, painterly abstraction, conceptualism and imagism. Genres include landscapes, florals and figurative work. "My goal is to bring together clients (buyers) with artwork they appreciate and can afford. For this reason I am interested in working with many, many artists." Interested in seeing works with a "finished" quality.

Terms: Accepts work on consignment (50% commission). Retail price set by dealer and artist. Exclusive area representation not required. Gallery provides insurance and contract; shipping costs are shared. Prefers unframed artwork.

Submissions: Send query letter with résumé, slides, photographs and SASE. Write to schedule an appointment to show a portfolio, which should include originals, slides, transparencies and photographs. Indicate net and retail prices. Replies only if interested within 1 month. Files slides, photos, résumés and promo material. All material is returned if not accepted or under consideration.

Tips: "Many artists have overestimated the value of their work. Look at your competition's prices."

Ⓝ SHERYL LEONARD GALLERIES, 11325 Seven Locks Rd., Potomac MD 20854. E-mail: sherylleonard@world net.att.net. Website: http://www.cnd7.com/slg/slg.htm. Owner: Lenny Porges. For profit gallery. Estab. 1995. Approached by 12 artists/year. Represents 25 artists emerging, mid-career and established artists. Exhibited artists include: Eng Tay (etchings) and Rober Le Mar (oils). Sponsors 6 exhibits/year. Average display time 3 weeks. Open all year; Monday-Friday, 10-6:30; Saturday, 10-6. Clients include: local community and upscale. 10% of sales are to corporate collectors. Overall price range: $300-3,000; most work sold at $800.

Media: Considers acrylic, ceramics, collage, craft, fiber, glass, mixed media, oil, paper, sculpture and watercolor. Most frequently exhibits oils. Considers engravings, etchings, lithographs and mezzotints.

Style: Considers all styles. Most frequently exhibits Impressionism, painterly abstraction, neo-expressionism. Considers all genres.

Making Contact & Terms: Artwork is accepted on consignment. Retail price set by the gallery. Gallery provides insurance, promotion and contract. Accepted work should be mounted. Requires exclusive representation locally.

Submissions: Write to arrange a personal interview to show portfolio of slides or mail portfolio for review. Returns material with SASE. Replies in 2 weeks. Files slides. Finds artists through word of mouth, art exhibits, art fairs and referrals by other artists.

Tips: "Only present archival quality materials."

LOBBY FOR THE ARTS GALLERY, Cumberland Theatre, 101 Johnson St., Cumberland MD 21502. Exhibitions Director: Shirley Giarritta. Alternative space. Estab. 1989. Sponsors 6 shows/year. Average display time 3 weeks. Open June-October; Tuesday-Sunday, 1-7 during performances in artists Equity Theatre. Located in downtown area; 600 sq. ft.; museum-standard lighting. 100% of space for special exhibitions. 95% private collectors, 5% corporate collectors. Overall $100-2,000; most work sold at $1,000.
Media: Considers all media, 2 and 3 dimensional. All genres.
Terms: Artwork is accepted on consignment (25% commission). Retail price set by the artist. Gallery provides promotion and contract. Artwork must be ready to hang.
Submissions: Accepts only artists who are able to have work hand-picked up. Send résumé, at least 10 slides and bio. Include SASE; all materials returned by June 1st of each year. "All replies made once a year in April, submission deadline is March 1." Finds artists solely through submissions.
Tips: "Slides must be of the highest quality. Organization of packet is important. Use clips, staples, folders, etc. Slides should be of recent work. Use professional quality matts, frames, bases to show work off at its best! Follow entry directions. Call if you need assistance. Have a fairly large body of work (depending on media that could mean 50 paintings or 6 sculptures of marble, etc.)"

N MARIN-PRICE GALLERIES, 7022 Wisconsin Ave., Chevy Chase MD 20815. (301)718-0622. President: F.J. Marin-Price. Retail/wholesale gallery. Estab. 1992. Represents/exhibits 25 established painters and 10 sculptors/year. Exhibited artists include Joseph Sheppard. Sponsors 24 shows/year. Average display time 3 weeks. Open Monday-Sunday, 11-8. 4,000 sq. ft. 50% of space for special exhibitions; 50% of space for gallery artists. Clientele: upscale. 90% private collectors, 10% corporate collectors. Overall price range: $3,000-25,000; most work sold at 5,000-8,000.
• This gallery has three locations, one in downtown Washington DC; one in the Georgetown and one in suburb of Chevy Chase.
Media: Considers oil, drawing, watercolor and pastel. Most frequently exhibits oil, watercolor and pastels.
Style: Exhibits expressionism, photorealism, neo-expressionism, primitivism, realism and Impressionism. Genres include landscapes, florals, Americana and figurative work.
Terms: Retail price set by the gallery and the artist. Gallery provides insurance, promotion and contract. Artist pays for shipping costs. Prefers artwork framed.
Submissions: Prefers only oils. Send query letter with résumé, slides, bio and SASE. Replies in 3-6 weeks.
Tips: Finds artists through research, from clients visiting studios. "We do well with established artists and totally unknown artists, better than mid-career. If you are just starting out, keep your prices as low as you can tolerate them."

MARLBORO GALLERY, 301 Largo Rd., Largo MD 20772. (301)322-0965. Coordinator: Tom Berault. Nonprofit gallery. Estab. 1976. Interested in emerging, mid-career and established artists. Sponsors 4 solo and 4 group shows/year. Average display time 1 month. Seasons for exhibition: September-May. 2,100 sq. ft. with 10 ft. ceilings and 25 ft. clear story over 50% of space—track lighting (incandescent) and daylight. Clientele: 100% private collectors. Overall price range: $200-10,000; most work sold at $500-700.
Media: Considers all media. Most frequently exhibits acrylics, oils, photographs, watercolors and sculpture.
Style: Exhibits expressionism, neo-expressionism, realism, photorealism, minimalism, primitivism, painterly abstraction, conceptualism and imagism. Exhibits all genres. "We are open to all serious artists and all media. We will consider all proposals without prejudice."
Terms: Accepts artwork on consignment. Retail price set by artist. Exclusive area representation not required. Gallery provides insurance. Artist pays for shipping. Prefers artwork ready for display.
Submissions: Send query letter with résumé, slides, SASE, photographs, artist's statement and bio. Portfolio review requested if interested in artist's work. Portfolio should include slides and photographs. Replies every 6 months. Files résumé, bio and slides. Finds artists through word of mouth, visiting exhibitions and submissions.
Tips: Impressed by originality. "Indicate if you prefer solo shows or will accept inclusion in group show chosen by gallery."

N MEREDITH GALLERY, 805 N. Charles St., Baltimore MD 21201. (410)837-3575. Contact: President. Retail gallery. Estab. 1977. Represents emerging, mid-career and established artists. Clientele: commercial and residential. Exhibits the work of 4-6 individuals and 5-7 groups/year. Average display time is 2 months. Overall price range: $200-5,000; most artwork sold under $2,000.
Media: Considers ceramic, glass and artist-designed furniture. Specializes in contemporary American crafts and artist-designed furniture.
Terms: Accepts work on consignment. Retail price is set by gallery and artist. Exclusive area representation required. Gallery provides insurance, promotion and contract; shipping costs are shared.
Submissions: Send query letter, résumé, slides, SASE and price list. Files materials "if we are interested." Indicate pricing information.
Tips: Looks for "excellent craftsmanship, innovative design and quality in your field. Economy has slowed sales down, yet there is still a definite interest among clientele in viewing new work."

[N] MONTPELIER CULTURAL ARTS CENTER, 12826 Laurel-Bowie Rd., Laurel MD 20708. (301)953-1993. Fax: (301)206-9682. Director: Richard Zandler. Alternative space, nonprofit gallery, public arts center. Estab. 1979. Exhibits 1,000 emerging, mid-career, established artists/year. Sponsors 24 shows/year. Average display time 1 month. Open all year; 7 days/week, 10-5. Located midway between Baltimore and Washington on 80 acre estate; 2,500 sq. ft. (3 galleries): cathedral ceilings up to 32'. 85% of space for special exhibitions; 15% of space for gallery artists. Clientele: diverse, general public. Overall price range: $50-50,000; most work sold at $200-300.
Media: Considers oil, pen & ink, paper, fiber, acrylic, drawing, sculpture, glass, watercolor, mixed media, ceramic, installation, pastel, collage, craft, photography, media arts, performance and mail art. Also considers all types of prints.
Style: Exhibits all styles and genres.
Terms: Special exhibitions only. 25% commission on sales during show. Retail price set by artist. Offers customer discount (seniors and members). Gallery provides insurance, promotion, contract and shipping costs from gallery. Prefers artwork framed.
Submissions: "Different shows target different media, theme and region. Call first to understand programs." Send résumé, slides and SASE. Replies only if interested within 8 months. Files résumés and cover letters. Slides are returned.
Tips: Finds artists through visiting exhibitions and artists' submissions.

ROMBRO'S ART GALLERY, 1805 St. Paul St., Baltimore MD 21202. (410)962-0451. Retail gallery, rental gallery. Estab. 1984. Represents 3 emerging, mid-career and established artists/year. May be interested in seeing the work of emerging artists in the future. Exhibited artists include Dwight Whitley and Judy Wolpert. Sponsors 4 shows/year. Average display time 3 months. Open all year; Tuesday-Saturday, 9-5; closed August. Located in downtown Baltimore; 3,500 sq. ft. Clientele: upscale, local community. Overall price range: $350-15,000.
Media: Considers oil, acrylic, watercolor, pastel, pen & ink, drawing, mixed media, collage, paper, sculpture and ceramics. Considers all types of prints. Most frequently exhibits oil, pen & ink, lithographs.
Style: Exhibits expressionism, painterly abstraction, color field, postmodern works, hard-edge geometric abstraction. Genres include florals and figurative work. Prefers florals and figurative.
Terms: Accepts work on consignment (50% commission) or buys outright for 35% of the retail price; net 45 days. Rental fee for space ($650). Retail price set by the gallery and the artist. Gallery provides promotion and contract; artist pays for shipping costs to gallery. Prefers artwork framed.
Submissions: Send query letter with résumé, brochure, slides and artist's statement. Write for appointment to show portfolio of slides. Files slides. Finds artists through visiting exhibitions.

STEVEN SCOTT GALLERY, 515 N. Charles St., Baltimore MD 21201. (410)752-6218. Director: Steven Scott. Retail gallery. Estab. 1988. Represents 15 mid-career and established artists/year. May be interested in seeing the work of emerging artists in the future. Exhibited artists include Hollis Sigler, Gary Bukovnik. Sponsors 6 shows/year. Average display time 2 months. Open all year; Tuesday-Saturday, 12-6. Located downtown; 1,200 sq. ft.; white walls, grey carpet—minimal decor. 80% of space for special exhibitions; 20% of space for gallery artists. 80% private collectors, 20% corporate collectors. Overall price range: $300-15,000; most work sold at $1,000-7,500.
Media: Considers oil, acrylic, watercolor, pastel, pen & ink, drawing, mixed media, collage, paper and photography. Considers all types of prints. Most frequently exhibits oil, prints and drawings.
Style: Exhibits expressionism, neo-expressionism, surrealism, postmodern works, photorealism, realism and imagism. Genres include florals, landscapes and figurative work. Prefers florals, landscapes and figurative.
Terms: Retail price set by the gallery and the artist. Gallery provides insurance, promotion and contract; shipping costs are shared. Prefers artwork unframed.
Submissions: Accepts only artists from US. Send query letter with résumé, brochure, slides, photographs, reviews, bio and SASE. Call for appointment to show portfolio of photographs and slides. Replies in 2 weeks.
Tips: "Don't send slides which are unlike the work we show in the gallery, i.e. abstract or minimal."

Massachusetts

[N] CLARK WHITNEY GALLERY, 25 Church St., Lenox MA 01240. (413)637-2126. Director: Ruth Kochta. Retail gallery. Estab. 1983. Represents 25 emerging, mid-career and established artists/year. Exhibited artists include Ross Barbera, Suzanne Howes-Stevens and Stanley Marcus. Sponsors 5 shows/year. Average display time 1 month. Open Thursday-Monday, 11-5; closed January and February. Located downtown; 800 sq. ft. "My gallery is in historic Lenox Village in the Berkshire Mountains. It is located in an area very rich in culture, i.e., classical music, dance, opera, Shakespeare, etc." 60% of space for special exhibitions; 100% of space for gallery artists. 90% private collectors, 10% corporate collectors. Overall price range: $200-8,000; most work sold at $200-5,000.
Media: Considers oil, acrylic, mixed media, sculpture, glass and conceptual assemblage. Most frequently exhibits oils, sculpture (bronze, steel, stone) and acrylics.
Style: Exhibits expressionism, neo-expressionism, surrealism, postmodern works, Impressionism, realism and imagism. Genres include landscapes, florals and figurative work. Prefers realistic figures in an environment, large scale landscapes and semi-abstracts.
Terms: Accepts work on consignment (40% commission). Retail price set by the artist. Gallery provides insurance. "We do not get involved in shipping." Prefers artwork framed.

Submissions: Accepts only artists who live within 3 hours driving time from Lenox. Send query letter with slides, bio, SASE and price range. Call for appointment to show portfolio of photographs or slides. Replies in 2 weeks. Files bio and copies of slides.
Tips: "I search for uniqueness of concept combined with technical competence."

✓ **DE HAVILLAND FINE ART**, 66 Charles St., #522, Boston MA 02114. (617)728-4900. Fax: (617)728-4494. Website: http://www.artexplorer.com. Contact: Gallery Manager. Corporate art dealer. Estab. 1989. Represents 20 emerging New England artists. Sponsors 2 shows/year. Average display time 1 month. Clientele: 70% private collectors, 90% corporate collectors. Overall price range: $200-7,000.
Media: Considers oil, acrylic, watercolor, pastel, mixed media and sculpture. Most frequently exhibits oil/acrylic, watercolor/pastel and mixed media.
Style: Exhibits painterly abstraction, Impressionism and realism. Genres include landscapes, florals and abstracts. Prefers realism and painterly abstraction.
Terms: Accepts artwork on consignment (50% commission). Retail price set by the gallery and artist. Sometimes offers customer discounts. Gallery provides promotion and contract; artist pays for shipping. Prefers artwork framed.
Submissions: Send query letter with résumé, slides, and SASE. "We represent emerging and established artists who reside in New England." Replies in 1 month. Files résumé.
Tips: Looks for "maturity of visual expression and professionalism."

N FITCHBURG ART MUSEUM, 185 Elm St., Fitchburg MA 01420. (508)345-4207. Fax: (508)345-2319. Collections Curator: Anja Chávez. Museum. Estab. 1925. Represents emerging, mid-career and established artists. Sponsors 5 shows/year. Average display time 7 weeks. Open all year; Tuesday-Saturday, 11-4; Sunday, 1-4. Located downtown; 700 sq. ft.; large contemporary galleries—high ceilings. 100% of new wing for special exhibitions.
Media: Considers all media and all types of prints.
Style: Considers all genres.
Terms: Gallery provides insurance and promotion. Artwork should be framed.
Submissions: Send query letter with résumé, slides, bio, SASE and reviews. "We don't review portfolios." Replies June-August only. Files all material sent. Finds artists through agents, visiting exhibitions and word of mouth.
Tips: Looks for "consistency in selection of work submitted. Photos also are helpful in some cases."

THE FREYDA GALLERY, 28 Main St., Rockport MA 01966. (978)546-9828. Owner: Freyda M. Craw. Retail gallery. Represents/exhibits mid-career and established artists. Exhibited artists include David L. Millard, Rudy Colao, Sue Daly, Theresa Golia Pergal, Joan Rademacher, Ron Straka and Freyda (Chickasaw-Choctaw). Sponsors ongoing group show and 1 special show/year. Average display time 9 months. Open March through December; Monday-Saturday, 9-5; Sunday, 1-5 (summer); Saturday-Sunday 1-5 (spring and fall). Located downtown. Clientele: tourist, beginning and experienced collectors. 50% private collectors. Overall price range: $200-8,000; most work sold at $200-4,000.
Media: Exhibits oil, watercolor and acrylic.
Style: Exhibits primarily traditional, representational art. Genres include landscapes, florals, seascapes and abstracts. Current interests: photorealism and works by Native American artists of traditional and nontraditional subject matter.
Terms: Artwork is accepted on consignment and there is a 40% commission. Retail price set by the gallery and the artist. Gallery provides promotion and contract. Shipping costs are shared. Prefers artwork framed.
Submissions: Interested in established artists only as evidenced by membership in national juried art associations and exhibitions in major juried art shows. Regional gallery exclusivity required. Send query letter with résumé, slides, reviews, bio and SASE. Write for appointment to show portfolio of slides. Replies only if interested within 1 month. Files artist's résumé and bio if future interest. Finds artists through referrals by other artists, exhibitions and artists' submissions.
Tips: Artist's work should demonstrate "Consistency in quality and style of work but evidence of continued maturity and refinement without loss of creativity. The gallery is located in an art colony which creates a highly competitive market and knowledgeable buyers. An artist needs a distinctive and appealing style with great color sense to compete."

GALLERY NAGA, 67 Newbury St., Boston MA 02116. (617)267-9060. E-mail: mail@gallerynaga.com. Website: http://www.gallerynaga.com. Directors: Arthur Dion and Virginia Anderson. Retail gallery. Estab. 1977. Represents 30 emerging, mid-career and established artists. Exhibited artists include Robert Ferrandini and George Nick. Sponsors 10 shows/year. Average display time 1 month. Open Tuesday-Saturday 10-5:30. Gallery Naga is open the first Thursday each of month until 7 p.m. Closed August. Located on "the primary street for Boston galleries; 1,500 sq. ft.; housed in an historic neo-gothic church." Clientele: 90% private collectors, 10% corporate collectors. Overall price range: $500-40,000; most work sold at $2,000-10,000.
Media: Considers oil, acrylic, mixed media, sculpture, photography, studio furniture and monotypes. Most frequently exhibits painting and furniture.
Style: Exhibits expressionism, painterly abstraction, postmodern works and realism. Genres include landscapes, portraits and figurative work. Prefers expressionism, painterly abstraction and realism.
Terms: Accepts work on consignment (50% commission). Retail price set by gallery and artist. Gallery provides insurance and promotion; artist pays for shipping. Prefers artwork framed.
Submissions: "Not seeking submissions of new work at this time."
Tips: "We focus on Boston and New England artists. We exhibit the most significant studio furnituremakers in the

country. Become familiar with a gallery to see if your work is appropriate before you make contact."

[N] KAJI ASO STUDIO/GALLERY NATURE AND TEMPTATION, 40 St. Stephen St., Boston MA 02115. (617)247-1719. Fax: (617)247-7564. Administrator: Kate Finnegan. Nonprofit gallery. Estab. 1975. Represents 40-50 emerging, mid-career and established artists. 35-45 members. Exhibited artists include Kaji Aso and Katie Sloss. Sponsors 10 shows/year. Average display time 3 weeks. Open all year; Tuesday, 1-8; Wednesday-Saturday, 1-5; and by appointment. Located in city's cultural area (near Symphony Hall and Museum of Fine Arts); "intimate and friendly." 30% of space for special exhibitions; 70% of space for gallery artists. Clientele: urban professionals and fellow artists. 80% private collectors, 20% corporate collectors. Overall price range: $150-8,000; most work sold at $150-1,000.
Media: Considers oil, acrylic, watercolor, pastel, pen & ink, drawing, ceramics and etchings. Most frequently exhibits watercolor, oil or acrylic and ceramics.
Style: Exhibits painterly abstraction, Impressionism and realism.
Terms: Co-op membership fee plus donation of time (35% commission). Retail price set by the artist. Gallery provides promotion; artist pays shipping costs to and from gallery. Prefers artwork framed.
Submissions: Send query letter with résumé, slides, bio, photographs and SASE. Write for appointment to show portfolio of originals, photographs, slides or transparencies. Does not reply; artist should contact. Files résumé. Finds artists through advertisements in art publications, word of mouth, submissions.

LE PETIT MUSÉE, (formerly Le Petit Musé of Wordplay), P.O. Box 556, Housatonic MA 01236. (413)274-9913. E-mail: indearts@aol.com. Owner: Sherry Steiner. Estab. 1991. "Specializes in vintage and contemporary small works of art of extraordinary merit." Interested in the work of emerging artists. Exhibited artists include Roy Interstate and Felicia Zumakoo. Average display time 1-2 months. Clientele: tourists, upscale local. 70% private, 30% corporate collectors. Overall price range: $100. Le Petit Musé places art at various locations throughout Berkshire County.
Media: Considers all media except craft. Considers wood engravings, engravings, mezzotints, lithographs and serigraphs. Most frequently exhibits paintings, drawings, photographs, mixed media.
Style: Exhibits all styles. Prefers postmodern works, realism and imagism.
Terms: Artwork is accepted on consignment (50% commission). Retail price set by the gallery. Gallery provides partial promotion. Artist pays for shipping costs. Framed art only. Artists need to carry their own insurance.
Submissions: Send 10 slides, photographs, reviews, bio and SASE. Replies in 1 week. Finds artists through word of mouth, referrals and submissions.
Tips: Advises artists to "submit adequate information on work. Send clear photos or slides and label each."

LICHTENSTEIN CENTER FOR THE ARTS/BERKSHIRE ARTISANS GALLERY, 28 Renne Ave., Pittsfield MA 01201. (413)499-9348. E-mail: berkart@taconic.net. Website: http://www.berkart@berkshirenet. Artistic Director: Daniel M. O'Connell. Nonprofit gallery, alternative space exhibiting juried shows. Estab. 1976. Represents/exhibits emerging, mid-career and established artists. Exhibited artists include: Thomas Patti and Rapheal Soyer. Sponsors 8 shows/year. Average display time 6 weeks. Open Monday-Friday, 11-5. Located in downtown Pittsfield, 2,400 sq. ft.; historic brownstone, high oak ceilings, north light, wood floors. 100% of space for special exhibitions of gallery artists. 35% private collectors, 10% corporate collectors. Overall price range: $150-20,000; most work sold at $150-20,000.
Media: Considers all media. Most frequently exhibits painting, drawing/prints, sculpture/glass.
Style: Exhibits all styles and genres. Juried exhibitions, public murals. Considers multimedia exhibitions' photorealistic murals.
Terms: "We exhibit juried works at 20% commission." Retail price set by the artist. Gallery provides insurance, promotion and contract. Artist pays for shipping costs.
Submissions: Send query letter with résumé, slides, photographs, reviews, bio and SASE. Does not reply. Artist should send 20 slides with résumé and SASE only. No entry fee.
Tips: "We are usually booked solid for exhibitions 3-5 years ahead of schedule." Advises artists to "develop professional, leather bound portfolio in duplicate with up to 20 slides, résumé, exhibit listings and SASE. Make sure photos in your portfolios are professionally done and send only recent information on résumé."

R. MICHELSON GALLERIES, 132 Main St., Northampton MA 01060. (413)586-3964. Also 25 S. Pleasant St., Amherst MA 01002. (413)253-2500. E-mail: rm@michaelson.com. Website: http://www.rmichelson.com. Owner: R. Michelson. Retail gallery. Estab. 1976. Represents 30 emerging, mid-career and established artists/year. Exhibited artists include Barry Moser and Leonard Baskin. Sponsors 6 shows/year. Average display time 1 month. Open all year; Monday-Saturday, 10-6; Sunday, 12-5. Located downtown; Northampton gallery has 3,500 sq. ft.; Amherst gallery has 1,800 sq. ft. 50% of space for special exhibitions. Clientele: 80% private collectors, 20% corporate collectors. Overall price range: $100-75,000; most artwork sold at $1,000-25,000.
Media: Considers all media and all types of prints. Most frequently exhibits oil, egg tempera, watercolor and lithography.
Style: Exhibits Impressionism, realism and photorealism. Genres include florals, portraits, wildlife, landscapes, Americana and figurative work.
Terms: Accepts work on consignment (commission varies). Retail price set by gallery and artist. Customer discounts and payment by installment are available. Gallery provides promotion; shipping costs are shared.
Submissions: Prefer Pioneer Valley artists. Send query letter with résumé, slides, bio, brochure and SASE. Write for appointment to show portfolio. Replies in 3 weeks. Files slides.

[N] **NIELSEN GALLERY**, 179 Newbury St., Boston MA 02116. (617)266-4835. Fax: (617)266-0480. Owner/Director: Nina Nielsen. Retail gallery. Estab. 1963. Represents 25 emerging, mid-career and established artists/year. Exhibited artists include Joan Snyder and John Walker. Sponsors 8 shows/year. Average display time 3-5 weeks. Open all year; closed in August. Located downtown; 2,500 sq. ft.; brownstone with 2 floors. 100% of space for gallery artists. 80% private collectors, 20% corporate collectors. Overall price range: $1,000-100,000; most work sold at $5,000-20,000.
Media: Considers contemporary painting, sculptures, prints, drawings and mixed media work.
Style: Exhibits all styles.
Terms: Retail price set by the gallery and the artist. Gallery provides insurance and promotion.
Submissions: Send query letter with slides. Replies in 2 months. Finds artists through word of mouth, referrals by other artists, visiting art fairs and exhibitions, submissions.

[N] **PEPPER GALLERY**, 38 Newbury St., Boston MA 02116. (617)236-4497. Fax: (617)236-4497. Director: Audrey Pepper. Retail gallery. Estab. 1993. Represents 20 emerging, mid-career and established artists/year. Exhibited artists include Ben Frank Moss, Nancy Friese, Phyllis Berman, Harold Reddicliffe, Marja Liamko, Daphne Cinfar, Damon Lehrer, Michael V. David, Edith Vonnegut and Kahn/Selesnick. Sponsors 9 shows/year. Average display time 6 weeks. Open all year; Tuesday-Saturday, 10-5. Located downtown, Back Bay; 700 sq. ft. 80% of space for special exhibitions. Clientele: private collectors, museums, corporate. 70% private collectors, 15% corporate collectors, 15% museum collectors. Overall price range: $275-15,000; most work sold at $800-7,000.
Media: Considers oil, watercolor, pastel, drawing, mixed media, glass, woodcuts, engravings, lithographs, mezzotints, etchings and photographs. Most frequently exhibits oil on canvas, lithos/etchings and photographs.
Style: Exhibits contemporary representational paintings, prints, drawings and photographs.
Terms: Accepts work on consignment (50% commission). Retail price set by the gallery and the artist. Gallery provides insurance and contract.
Submissions: Send query letter with résumé, slides, bio, SASE and reviews. Call for appointment to show portfolio of originals, photographs, slides and transparencies. Replies in 2 months. Finds artists through exhibitions, word of mouth, open studios and submissions.

✓ **PIERCE GALLERIES, INC.**, 721 Main St., Rt. 228, Hingham MA 02043. (781)749-6023. Fax: (781)749-6685. President: Patricia Jobe Pierce. Retail and wholesale gallery, art historians, appraisers and consultancy. Estab. 1968. Represents 12 established artists. May consider emerging artists in the future. Exhibited artists include Michael Keane, Joseph McGurt, Bernard Corey, John P. Osborne, R.L. Trotter, Stephen Gjerston, Joseph Fontaine, Geetesh and Kahlil Gibran. Sponsors 8 shows/year. Average display time 1 month. Open all year. Hours by appointment only. Located "in historic district on major road; 3,800 sq. ft.; historic building with high ceilings and an elegant ambiance." 100% of space for special exhibits. Overall price range: $1,500-400,000; most work sold at $1,500-100,000.
Media: Considers oil, acrylic, watercolor, pastel, pen & ink, drawings and sculpture. Does not consider prints. Most frequently exhibits oil, acrylic and watercolor.
Style: Exhibits expressionism, neo-expressionism, surrealism, Impressionism, realism, photorealism and social realism. All genres and subjects, including landscapes, florals, Americana, western, wildlife and figurative work. Prefers Impressionism, expressionism and super realism.
Terms: Often buys artwork outright for 50% of retail price; sometimes accepts on consignment (20-33% commission). Retail price set by artist, generally. Sometimes offers customer discounts and payment by installment. Gallery provides insurance and promotion; contract and shipping costs may be negotiated.
Submissions: Send query letter with résumé, slide sheets of 10 slides and SASE. Gallery will contact if interested for portfolio review. Portfolio should include photos or slides of originals. Replies in 48 hours. Files material of future interest.
Tips: Finds artists through referrals, portfolios/slides "sent to me or I see the work in a show or magazine. I want to see consistent, top quality work and techniques—not a little of this, a little of that. Please supply three prices per work: price to dealer buying outright, price to dealer for consigned work and a retail price. The biggest mistake artists make is that they sell their own work (secretly under the table) and then expect dealers to promote them! If a client can buy art directly from an artist, dealers don't want to handle the work. Artists should have a body of work of around 300 pieces before approaching galleries. Expand your breadth and show a new vital dimension."

PUCKER GALLERY, INC., 171 Newbury St., Boston MA 02116. (617)267-9473. Fax: (617)424-9759. Director: Bernard Pucker. Retail gallery. Estab. 1967. Represents 30 emerging, mid-career and established artists. Exhibited artists include modern masters such as Picasso, Chagall, Braque, and Samuel Bak and Brother Thomas. Sponsors 8 shows/year. Average display time 4-5 weeks. Open all year. Located in the downtown retail district. 5% of space for special exhibitions. Clientele: private clients from Boston, all over the US and Canada. 90% private collectors, 10% corporate clients. Overall price range: $20-200,000; most artwork sold at $5,000-20,000.
Media: Considers all media. Most frequently exhibits paintings, prints and sculpture.
Style: Exhibits all styles. Genres include landscapes and figurative work.
Terms: Terms of representation vary by artist, "usually it is consignment." Retail price set by gallery. Gallery provides promotion; artist pays shipping. Prefers artwork unframed.
Submissions: Send query letter with résumé, slides, bio and SASE. Write for appointment to show portfolio of originals and slides. Replies in 3 weeks. Files résumés.

JUDI ROTENBERG GALLERY, 130 Newbury St., Boston MA 02116. (617)437-1518. E-mail: jrgal@tiac.net. Website: http://www.fine-arts-unlimited.com/g4.htm. Retail gallery. Estab. 1964. Represents 14 emerging, mid-career and established artists. Average display time 3-4 weeks. Open all year. Located in the Back Bay; 1,400 sq. ft. 100% of space for special exhibitions. Overall price range: $800-19,000; most work sold at $1,200-7,000.

Media: Considers all media. Most frequently exhibits oil, watercolor and acrylic.

Style: Exhibits expressionism, painterly abstraction and postmodern works. Genres include landscapes and florals. Prefers expressionism and postmodernism.

Terms: Accepts artwork on consignment (50% commission). Retail price set by the gallery and artist. Gallery provides insurance, promotion and contract; artist pays shipping costs. Prefers artwork framed.

Submissions: Send query letter with résumé, slides, bio and photographs, reviews and SASE. Write for appointment to show portfolio of photographs. Replies only if interested.

Tips: "Please send SASE otherwise slides cannot be returned. Also send a consistent body of work that hangs well together."

N: SIGNATURE AND THE GROHE GALLERY, 24 North St., Dock Square, Boston MA 02109. (617)227-4885. Fax: (617)723-5898. Director: Kelly Welton. Retail gallery. Estab. 1978. Represents 600 emerging, mid-career and established artists/year. Exhibited artists include Josh Simpson, Jana Vgone. Sponsors 6 shows/year. Average display time 1 month. Open all year; Monday-Saturday, 10-8; Sunday, 12-6. Located downtown; 1,900 sq. ft. 30% of space for special exhibitions; 30% of space for gallery artists. Clientele: tourists, upscale. 10% private collectors, 10% corporate collectors. Overall price range: $30-9,000; most work sold at $100 minimum.

Media: Considers paper, fiber, sculpture, glass, watercolor, mixed media, ceramics and craft. Most frequently exhibits glass, clay, mixed media.

Style: Exhibits all styles.

Terms: Accepts work on consignment (50% commission). Buys outright for 50% of retail price (net 30 days). Price set by the artist. Gallery provides insurance, promotion, contract; shipping costs are shared. Prefers artwork framed.

Submissions: Send query letter with résumé, slides, artist's statement, bio and SASE. Write for appointment to show portfolio of photographs or slides. Replies in 3 weeks.

Tips: "Include price sheets."

THE SOCIETY OF ARTS AND CRAFTS, 175 Newbury St., Boston MA 02116. (617)266-1810. E-mail: societycraft@earthlink.net. Website: http://www.societyofcrafts.org. Also, second location at 101 Arch St., Boston MA 02110. (617)345-0033. Executive Director: Beth Ann Gerstein. Retail gallery with for-sale exhibition space. Estab. 1897. Represents 300 emerging, mid-career and established artists. 600 members. Sponsors 12 exhibitions/year (in the 2 gallery spaces). Average display time 6-8 weeks. Open all year; main: Monday-Saturday, 10-6; Sunday 12-5; second: Monday-Friday, 10-6. "The Society is the oldest nonprofit craft organization in America." 50% of space for special exhibitions; 50% of space for gallery artists. Clientele: corporate, collectors, students, interior designers. 85% private collectors, 15% corporate collectors. Overall price range: $2.50-6,000; most work sold at $100-300.

Media: Considers mixed media, metals, paper, sculpture, ceramics, wood, fiber and glass. Most frequently exhibits wood, clay and metal.

Style: Exhibits contemporary American crafts in all mediums, all genres.

Terms: Accepts work on consignment (50% commission). "Exhibiting/gallery artists can become members of the Society for $25 membership fee, annual." Retail price set by the artist; "if assistance is needed, the gallery will suggest." Prefers artwork framed.

Submissions: Accepts only artists residing in the US. Send query letter with résumé, no more than 10 slides, bio, brochure, SASE, business card and reviews. Portfolio should include slides or photos (if slides not available). Replies in 6 weeks. Files résumés (given out to purchaser), reviews, visuals. Finds artists through networking with artists and other craft organizations, trade shows (ACC Philadelphia, Springfield, Rosen Baltimore), publications (*Niche, American Craft*) and various specialty publications (*Metalsmith, Sculpture, American Woodworking*, etc.), collectors, other galleries, general submissions.

N: WORCESTER CENTER FOR CRAFTS GALLERIES, 25 Sagamore Rd., Worcester MA 01605. (508)753-8183. Fax: (508)797-5626. E-mail: craftcenter@worcester.org. Website: http://www.craftcenter.worcester.org. Executive Director: M. Attwood. Nonprofit rental gallery. Dedicated to promoting artisans and American crafts. Estab. 1856. Represents/exhibits 180 emerging, mid-career and established artists/year. May be interested in seeing the work of emerging artists in the future. Exhibited artists include Simon Pearce (glass) and Russell Spillman (ceramics). Sponsors 20 shows/year. Open all year; Monday-Saturday 10-5. Located at edge of downtown; 2,205 sq. ft. (main gallery); track lighting, security. Overall price range: $20-400; most work sold at $65-100.

Media: Considers all media except paintings and drawings. Most frequently exhibits wood, metal, fiber, ceramics, glass and photography.

Style: Exhibits all styles.

Terms: Artwork is accepted on consignment (40% commission). Retail price set by the artist. Gallery provides insurance, promotion and contract. Shipping costs are shared.

Submissions: Call for appointment to show portfolio of photographs and slides. Replies in 1 month.

Michigan

THE ART CENTER, 125 Macomb Place, Mount Clemens MI 48043. (810)469-8666. Fax: (810)469-4529. Executive Director: Jo-Anne Wilkie. Nonprofit gallery. Estab. 1969. Represents emerging, mid-career and established artists. 500 members. Sponsors 10 shows/year. Average display time 1 month. Open all year except July and August; Tuesday-Friday, 11-5; Saturday, 9-2. Located in downtown Mount Clemens; 1,300 sq. ft. The Art Center is housed in the historic Carnegie Library Building, listed in the State of Michigan Historical Register. 100% of space for special exhibitions. Clients include: private and corporate collectors. Overall price range: $5-1,000; most work sold at $50-500.
Media: Considers oil, acrylic, watercolor, pastel, pen & ink, drawing, mixed media, collage, paper, sculpture, ceramics, photography, jewelry, metals, craft, fiber, glass, all types of printmaking. Most frequently exhibits oils/acrylics, watercolor, ceramics and mixed media.
Style: Exhibits all styles, all genres.
Terms: The Art Center receives a 30% commission on sales of original works; 50% commission on prints.
Submissions: Send query letter with good reviews, 12 or more professional slides and a professional artist biography. Send photographs or slides and résumé with SASE for return. Finds artists through submissions, queries, exhibit announcements, word of mouth and membership.
Tips: "Join The Art Center as a member, call for placement on our mailing list, enter the Michigan Annual Exhibition."

N ART CENTER OF BATTLE CREEK, 265 E. Emmett St., Battle Creek MI 49017. (616)962-9511. Director: Don Desmett. Estab. 1948. Represents 150 emerging, mid-career and established artists. 90% private collectors, 10% corporate clients. Represents 150 artists. Exhibition program offered in galleries, usually 3-4 solo shows each year, two artists' competitions, and a number of theme shows. Also offers Michigan Artworks Shop featuring work for sale or rent. Average display time 1-2 months. "Three galleries, converted from church—handsome high-vaulted ceiling, arches lead into galleries on either side. Welcoming, open atmosphere." Overall price range: $20-1,000; most work sold at $20-300.
Media: Considers oil, acrylic, watercolor, pastel, pen & ink, drawings, mixed media, collage, works on paper, sculpture, ceramic, craft, fiber, glass, photography and original handpulled prints.
Style: Exhibits painterly abstraction, minimalism, Impressionism, photorealism, expressionism, neo-expressionism and realism. Genres include landscapes, florals, Americana, portraits and figurative work. Prefers Michigan artists.
Terms: Accepts work on consignment (40% commission). Retail price set by artist. Exclusive area representation not required. Gallery provides insurance, promotion and contract; artist pays for shipping.
Submissions: Michigan artists receive preference. Send query letter, résumé, brochure, slides and SASE. Slides returned; all other material is filed.
Tips: "Contact Art Center before mailing materials. We are working on several theme shows with groupings of artists."

N ARTS EXTENDED GALLERY, INC., 1553 Woodward, 212, Detroit MI 48226. Director: Dr. C.C. Taylor. Retail, nonprofit gallery, educational 501C3 space and art consultancy. Estab. 1959. Represents/exhibits many emerging, mid-career and established artists. Exhibited artists include: Michael Kelly Williams and Samuel Hodge. Sponsors 10 shows/year. Average display time 4-6 weeks. Open all year; Wednesday-Saturday, 12-5. Located downtown; 1,000 sq. ft.; 3 small comfortable spaces inside the historic David Whitney Bldg. 75% of space for special exhibitions. Clients include tourists, upscale, local community. 80% of sales are to private collectors, 20% corporate collectors. Overall price range: $150-1,200 up; most work sold at $200-300 (for paintings—craft items are considerably less).
 ● Gallery also sponsors art classes and exhibits outstanding work produced there.
Media: Considers all media, woodcuts, engravings, linocuts, etchings and monoprints. Most frequently exhibits painting, fibers and photographs.
Style: "The work which comes out of the community we serve is varied but rooted in realism, ethnic symbols and traditional designs/patterns with some exceptions."
Terms: Artwork is accepted on consignment and there is a 33⅓% commission or artwork is bought outright for 50% of the retail price. Retail price set by the gallery and the artist. Gallery provides insurance, promotion and contract; shipping costs are shared. Prefers artwork framed or ready to install.
Submissions: Send query letter with résumé, slides, photographs and reviews. Call for appointment to show a portfolio of photographs, slides and bio. Replies in 2-3 weeks. Files biographical materials sent with announcements, catalogs, résumés, visual materials to add to knowledge of local artists, letters, etc.
Tips: "Our work of recruiting local artists is known and consequently artists beginning to exhibit or seeking to expand are sent to us. Many are sent by relatives and friends who believe that ours would be a logical place to inquire. Study sound technique—there is no easy way or scheme to be successful. Work up to a standard of good craftsmanship and honest vision. Come prepared to show a group of artifacts. Have clearly in mind a willingness to part with work and understand that market moves fairly slowly."

N ARTS MIDLAND: GALLERIES & SCHOOL, of the Midland Center for the Arts, 1801 W. St. Andrews, Midland MI 48640. (517)631-3250. Director: B.B. Winslow. Nonprofit visual art gallery and school. Estab. 1956. Exhibits emerging, mid-career and established artists. Sponsors 20 shows/year. Average display time 2 months. Open all year, 7 days a week, 10-6. Located in a cultural center; "an Alden B. Dow design." 100% of space for special exhibitions.

Media: Considers all media and all types of prints.

Style: Exhibits all styles and genres.

Terms: "Exhibited art may be for sale" (30% commission). Retail price set by the artist. Gallery provides insurance, promotion and contract; shipping costs are shared. Artwork must be exhibition ready.

Submissions: Send query letter with résumé, slides, bio, SASE and proposal. Write to schedule an appointment to show a portfolio, which should include slides, photographs and transparencies. Replies only if interested as appropriate. Files résumé, bio and proposal.

JESSE BESSER MUSEUM, 491 Johnson St., Alpena MI 49707. (517)356-2202. Chief of Resources: Robert E. Haltiner. Nonprofit gallery. Estab. 1962. Interested in emerging and established artists. Sponsors 5 solo and 16 group shows/year. Average display time 1 month. Prefers but not limited to northern Michigan artists. 80% of sales are to private collectors, 20% corporate clients. Overall price range: $10-2,000; most artwork sold at $50-250.

Media: Considers oil, acrylic, watercolor, pastel, pen & ink, drawings, mixed media, collage, works on paper, sculpture, ceramic, craft, fiber, glass, installation, photography, original handpulled prints and posters. Most frequently exhibits prints, watercolor and acrylic.

Style: Exhibits hard-edge geometric abstraction, color field, painterly abstraction, pattern painting, primitivism, Impressionism, photorealism, expressionism, neo-expressionism, realism and surrealism. Genres include landscapes, florals, Americana, portraits, figurative work and fantasy illustration.

Terms: A 20% commission on sales is charged by the museum..

Submissions: Send query letter, résumé, brochure, slides and photographs to Robert E. Haltiner. Write for appointment to show portfolio of slides. Letter of inquiry and brochure are filed. Finds artists through word of mouth, art publications and sourcebooks, artists' submissions, self-promotions, art collectors' referrals and through visits to art fairs and festivals.

Tips: "Make sure you submit good quality slides with necessary information on them—title, media, artist, size."

N DE GRAAF FORSYTHE GALLERIES, INC., Park Place No. 4, 403 Water St. on Main, Saugatuck MI 49453. (616)857-1882. Fax: (616)857-3514. Director: Tad De Graaf. Retail gallery and art consultancy. Estab. 1950. Represents/exhibits 18 established artists/year. May be interested in seeing emerging artists in the future. Exhibited artists include: Stefan Davidek and C. Jagdish. Average display time 3-4 weeks. Open May-December; Monday-Saturday, 11-5; Sunday, 1-5. Located in center of town, 1,171 sq. ft.; adjacent to two city parks. 60% of space for gallery artists. Clients include: upscale. 50% of sales are to private collectors; 10% corporate collectors. Overall price range: $500-50,000; most work sold at $2,000-5,000.

Media: Considers all media except photography and crafts. Most frequently exhibits sculpture, paintings and tapestry.

Style: Exhibits all styles.

Terms: Artwork is accepted on consignment and there is a 50% commission. Retail price set by the gallery and the artist. Gallery provides promotion. Shipping costs are shared.

Submissions: Accepts only artists with endorsements from another gallery or museum. Send query letter with résumé, brochure, slides, photographs, reviews, bio and SASE. Write for appointment to show portfolio. Replies in 2 months, or if interested 3 weeks. Files résumé if possible future interest.

N DETROIT REPERTORY THEATRE LOBBY GALLERY, 13103 Woodrow Wilson, Detroit MI 48238. (313)868-1347. Fax: (313)868-1705. Gallery Director: Gilda Snowden. Alternative space, nonprofit gallery, theater gallery. Estab. 1965. Represents emerging, mid-career and established artists. Exhibited artists include Sabrina Nelson, Renee Dooley and Shirley Woodson. Sponsors 4 shows/year. Average display time 6-10 weeks. Exhibits November through June; Thursday-Friday, 8:30-11:30 pm; Saturday-Sunday, 7:30-10:30. Located in midtown Detroit; 750 sq. ft.; features lobby with a wet bar and kitchen; theatre. 100% of space for special exhibitions. Clientele: theatre patrons. 100% private collectors. Overall price range: $50-500; most work sold at $125-300.

Media: Considers oil, acrylic, watercolor, pastel, pen & ink, drawing, mixed media, collage and paper. "Must be two-dimensional; no facilities for sculpture." Most frequently exhibits painting, photography and drawing.

Style: Exhibits all styles, all genres. Prefers figurative painting, figurative photography and collage.

Terms: "No commission taken by gallery; artist keeps all revenues from sales." Retail price set by the artist. Gallery provides insurance and promotion (catalog, champagne reception); artist pays shipping costs to and from gallery. Prefers artwork framed.

Submissions: Accepts only artists from Metropolitan Detroit area. Prefers only two dimensional wall work. Artists install their own works. Send query letter with résumé, slides, bio and SASE. Write for appointment to show portfolio of slides, résumé and bio. Replies in 3 months.

Tips: Finds artists through word of mouth and visiting exhibitions.

✓ GALLERY SHOP: BIRMINGHAM BLOOMFIELD ART CENTER, 1516 S. Cranbrook Rd., Birmingham MI 48009. (248)644-0866. Fax: (248)644-7904. Nonprofit gallery shop. Estab. 1962. Represents emerging, mid-career and established artists. Sponsors ongoing exhibition. Open all year; Monday-Saturday, 9-5. Suburban location. 100% of space for gallery artists. Clientele: upscale, local. 100% private collectors. Overall price range: $50-2,000.

Media: Considers all media. Most frequently exhibits glass, jewelry and ceramics.

Style: Exhibits all styles.

Terms: Accepts work on consignment (30% commission). Retail price set by the artist. Gallery provides promotion and contract; artist pays for shipping costs to gallery.

Submissions: Send query letter with résumé, brochure, slides, photographs, reviews, artist's statement, bio, SASE; "as much information as possible." Files résumé, bio, brochure, photos.

Tips: "We consider the presentation of the work (framing, matting, condition) and the professionalism of the artist."

N KOUCKY, 325 Bridge St., Charlevoix MI 49720. (616)547-2228. Fax: (616)547-2455. Owners: Chuck and Nancy. Retail gallery.
• This gallery has two locations (Michigan and Naples, Florida). See its listing in the Florida section for information about the galleries' submissions policies as well as media and style needs.

KRASL ART CENTER, 707 Lake Blvd., St. Joseph MI 49085. (616)983-0271. Fax: (616)983-0275. Director: Dar Davis. Retail gallery of a nonprofit arts center. Estab. 1980. Clients include community residents and summer tourists. Sponsors 30 solo and group shows/year. Average display time is 1 month. Interested in emerging and established artists.

Media: Considers oils, acrylics, watercolor, pastels, pen & ink, drawings, mixed media, collage, paper, sculpture, ceramics, crafts, fibers, glass, installations, photography and performance.

Style: Exhibits all styles. "The works we select for exhibitions reflect what's happening in the art world. We display works of local artists as well as major traveling shows from SITES. We sponsor sculpture invitationals and offer holiday shows each December."

Terms: Accepts work on consignment (35% commission). Retail price is set by artist. Sometimes offers customer discounts. Exclusive area representation required. Gallery provides insurance, promotion, shipping and contract.

Submissions: Send query letter, résumé, slides, and SASE. Call for appointment to show portfolio of originals.

N PEWABIC POTTERY, 10125 E. Jefferson, Detroit MI 48214. (313)822-0954. Fax: (313)822-6266. E-mail: pewabic@pewabic.com. Website: http://www.pewabic.com. Director of Exhibitions: Carrie Bennett. Nonprofit gallery, ceramics only. Estab. 1981. Represents 80 emerging, mid-career and established artists/year. Sponsors 10 shows/year. Average display time 6 weeks. Open all year; Monday-Saturday, 10-6; 7 days during holiday. Located 3 miles east of downtown Detroit; historic building (1906). 50% of space for special exhibitions; 50% of space for gallery artists. Clients include: tourists, ceramic collectors. 98% of sales are to private collectors, 2% corporate collectors. Overall price range: $15-1,500; most work sold at $50-100.

Media: Considers ceramics, mixed media, ceramic jewelry.

Style: Exhibits utilitarian and sculptural clay.

Terms: Accepts work on consignment (50% commission). Retail price set by the artist. Gallery provides insurance and promotion; shipping costs are shared.

Submissions: Prefers only ceramics. Send query letter with résumé, slides, artist's statement and SASE. Write for appointment to show portfolio of slides. Replies in 1-3 months. Finds artists through word of mouth, referrals by other artists, visiting art fairs and exhibitions, submissions.

Tips: "Avoid sending poor-quality slides."

▼ SAPER GALLERIES, 433 Albert Ave., East Lansing MI 48823. Phone/fax: (517)351-0815. E-mail: rsaper812@aol.com. Website: http://home.aol.com/RSaper812. Director: Roy C. Saper. Retail gallery. Estab. in 1978 as 20th Century Fine Arts; in 1986 designed and built new location and name. Displays the work of 100 artists; mostly mid-career, and artists of significant national prominence. Exhibited artists include: Picasso, Peter Max and Rembrandt. Sponsors 2 shows/year. Average display time 6 weeks. Open all year. Located downtown; 5,700 sq. ft.; "We were awarded *Decor* magazine's Award of Excellence for gallery design." 50% of space for special exhibitions. Clients include students, professionals, experienced and new collectors. 80% of sales are to private collectors, 20% corporate collectors. Overall price range: $30-140,000; most work sold at $500-15,000.

Media: Considers oil, acrylic, watercolor, pastel, drawings, mixed media, collage, paper, sculpture, ceramic, craft, glass and original handpulled prints. Considers all types of prints except offset reproductions. Most frequently exhibits intaglio, serigraphy and sculpture. "Must be of highest quality."

Style: Exhibits expressionism, painterly abstraction, surrealism, postmodern works, Impressionism, realism, photorealism and hard-edge geometric abstraction. Genres include landscapes, florals, southwestern and figurative work. Prefers abstract, landscapes and figurative. Seeking artists who will continue to produce exceptional work.

Terms: Accepts work on consignment (negotiable commission); or buys outright for negotiated percentage of retail price. Retail price set by gallery and artist. Offers payment by installments. Gallery provides insurance, promotion and contract; shipping costs are shared. Prefers artwork unframed (gallery frames).

Submissions: Send query letter with bio or résumé, brochure and 6-12 slides or photographs and SASE. Call for appointment to show portfolio of originals or photos of any type. Replies in 1 week. Files any material the artist does not need returned. Finds artists mostly through NY Art Expo.

Tips: "Present your very best work to galleries which display works of similar style, quality and media. Must be outstanding, professional quality. Student quality doesn't cut it. Must be great. Be sure to include prices and SASE."

PERRY SHERWOOD GALLERY, 200 Howard St., Petoskey MI 49770. (616)348-5079. Fax: (616)348-5057. Director: Zalmon Sherwood. Retail gallery. Estab. 1993. Represents 25 emerging, mid-career and established artists/year. Sponsors 4 shows/year. Average display time 6 weeks. Open all year; Monday-Saturday, 10-6; Sunday, 12-4. Located in downtown historic district; 3,000 sq. ft. 25% of space for special exhibitions; 75% of space for gallery artists. Clients

include tourists and upscale. 80% of sales are to private collectors, 20% corporate collectors. Overall price range: $800-25,000; most work sold at $2,000-5,000.

● Perry Sherwood Gallery has a second location at 24-A N. Blvd. of the Presidents, Sarasota FL 34236. (941)388-5334. Fax: (941)388-5253. Estab. 1996. Located in southwest Florida Gulf resort; 2,000 sq. ft.

Media: Considers oil, glass, watercolor, ceramics, pastel and photography. Most frequently exhibits oil painting, sculptural glass and ceramics.

Style: Exhibits realism and Impressionism. Genres include florals, landscapes and figurative work.

Terms: Accepts work on consignment (50% commission). Retail price set by the artist. Gallery provides insurance, promotion and contract; artist pays for shipping. Prefers artwork framed.

Submissions: Send query letter with résumé, slides, photographs, reviews, artist's statement and SASE. Call for appointment to show portfolio of photographs and slides. Replies in 3 weeks. Finds artists through word of mouth, referrals by other artists, visiting art fairs and exhibitions, submissions.

[N] SWORDS INTO PLOWSHARES, Peace Center, 33 E. Adams, Detroit MI 48226. (313)963-7575. Fax: (313)965-4328. Executive Director: James W. Bristah. Nonprofit gallery. "Our theme is 'World Peace.'" Estab. 1985. Represents 250-300 emerging, mid-career and established artists/year. Sponsors 4-6 shows/year. Average display time 2½ months. Open all year; Tuesday, Thursday, Saturday, 11-3; second Saturday, 12-2. Located in downtown Detroit in the Theater District; 2,881 sq. ft.; 1 large gallery, 2 small galleries. 100% of space for special exhibitions. Clients include walk-in, church, school and community groups. 100% of sales are to private collectors. Overall price range: $75-6,000; most work sold at $75-700.

Media: Considers all media. Considers all types of prints. "We have a juried show every two years for Ontario and Michigan artists about our theme. The juries make the selection of 2- and 3-dimensional work."

Terms: Accepts work on consignment (25% commission). Retail price set by the artist. Gallery provides insurance and promotion; shipping costs from gallery.

Submissions: Accepts artists primarily from Michigan and Ontario. Send query letter with statement on how other work relates to our theme. Replies in 2 months. Finds artists through lists of Michigan Council of the Arts, Windsor Council of the Arts.

Minnesota

ART OPTIONS GALLERY, 132 E. Superior St., Duluth MN 55802. (218)727-8723. President: Sue Pavlatos. Retail gallery. Estab. 1988. Represents 35 mid-career artists/year. Sponsors 4 shows/year. Average display time 1 month. Open all year; Tuesday-Friday, 10:30-5; Monday and Saturday, 10:30-2. Located downtown. Clients include tourists and local community. 70% of sales are to private collectors, 30% corporate collectors. Overall price range: $50-1,000; most work sold at $300.

Media: Considers all media and all types of prints. Most frequently exhibits watercolor, mixed media and oil.

Style: Exhibits all styles and genres. Prefers: landscape, florals and Americana.

Terms: Accepts work on consignment (40% commission). Retail price set by the artist. Gallery provides insurance and promotion; artist pays for shipping. Prefers artwork framed.

Submissions: Send query letter with résumé, slides and bio. Write for appointment to show portfolio of slides. Replies in 2 weeks. Files bio and résumé. Finds artists through word of mouth.

Tips: "Paint or sculpt as much as you can. Work, work, work. You should have at least 50-100 pieces in your body of work before approaching galleries."

[N] EIGHT BROADWAY ART GALLERY, 8 Broadway, Grand Marais MN 55604. (218)387-9079. Contact: Nita Anderson. Retail, rental gallery and working studios. Estab. 1991. Represents 12-18 emerging, mid-career and established artists. Exhibits artists include Nita Anderson and Nedetta Buchheit. Sponsors 6 shows/year. Average display time 3 months. Open all year; 10-8. Located downtown; 1,500 sq. ft. 40% of space for special exhibitions; 60% of space for gallery artists. Clientele: tourists, local, upscale. 85% private collectors, 15% corporate collectors. Overall price range: $30-4,500; most work sold at $80-600.

Media: Considers oil, acrylic, watercolor, pastel, pen & ink, drawing, mixed media, paper, sculpture, ceramics, glass and photography. Considers all types of prints. Most frequently exhibits oil, watercolor and wood.

Style: Exhibits expressionism, primitivism, painterly abstraction, conceptualism, Impressionism, hard-edge geometric abstraction and realism. Genres include florals, portraits, wildlife, landscapes, Americana and political. Prefers realism, Impressionism and expressionism.

Terms: Accepts work on consignment (30% commission) or buys outright for 60% of retail price. Rental fee for space; minimum 5 months rental. Retail price set by the gallery. Gallery provides promotion and contract. Shipping costs are shared. Prefers artwork framed.

Submissions: Send query letter with résumé, bio, photographs and artist's statement. Write for appointment to show portfolio of photographs. Replies only if interested within 2 months. Finds artists through visiting art fairs and exhibitions, artist's submissions and artist presenting themselves by visiting the gallery.

Tips: "Leave enough information on where and how to be contacted and when."

FLANDERS CONTEMPORARY ART, 400 N. First Ave., Minneapolis MN 55401. (612)344-1700. Fax: (612)344-1643. Director: Douglas Flanders. Retail gallery. Estab. 1972. Represents emerging, mid-career and established artists. Exhibited artists include: Jim Dine and David Hockney. Sponsors 8 shows/year. Average display time 6 weeks. Open all year; Tuesday-Saturday 10-5. Located in downtown warehouse district; 2,600 sq. ft.: 17′ ceilings. Clients include private, public institutions, corporations, museums. Price range starts as low as $85. Most work sold at $9,500-55,000.
Media: Considers all media and original handpulled prints. Most frequently exhibits sculpture, paintings and various prints; some photography.
Style: Exhibits all styles and genres. Prefers abstract expressionism, Impressionism and post-Impressionism.
Terms: Accepts work on consignment (50% commission). Gallery provides insurance, promotion and contract; shipping costs are shared. Prefers artwork framed.
Submissions: Send query letter with résumé, 20 slides, bio and SASE. Write for appointment to show portfolio of slides. Replies in 1 week.
Tips: "Include a statement about your ideas and artwork."

N GROVELAND GALLERY, 25 Groveland Terrace, Minneapolis MN 55403. (612)377-7800. Fax: (612)377-8822. Director: Sally Johnson. Retail gallery. Estab. 1973. Represents 25-30 mid-career artists/year. Interested in seeing the work of emerging artists. Exhibited artists include: Mike Lynch and Rod Massey. Sponsors 7 shows/year. Average display time 6 weeks. Open all year; Tuesday-Friday, 12-5; Saturday, 12-4. Located downtown in Kenwood neighborhood; 500 sq. ft.; in historic mansion, built in 1894 by F.B. Long. 100% of space for gallery artists. Clients include corporations, individuals and museums. 65% of sales are to private collectors; 35% corporate collectors. Overall price range: $500-15,000; most work sold at $1,000-2,000.
Media: Considers oil, acrylic, watercolor, pastel, pen & ink and drawing; types of prints include woodcuts, lithographs and etchings. Most frequently exhibits oil, pastel and watercolor.
Style: Exhibits: realism. Genres include landscapes and still life. Prefers: landscape, still life and cityscapes.
Terms: Accepts work on consignment (50% commission). Retail price set by the gallery and artist. Gallery provides promotion; shipping costs are shared. Prefers artwork framed.
Submissions: Accepts only artists from the Midwest. No photography or sculpture. Send query letter with résumé, slides, bio and SASE. Replies in 2 months.

ICEBOX QUALITY FRAMING & GALLERY, 2401 Central Ave. NE, Minneapolis MN 55418. (612)788-1790. E-mail: icebox@bitstream.net. Fine Art Representative: Howard Christopherson. Retail gallery and alternative space. Estab. 1988. Represents emerging and mid-career artists. Sponsors 4-7 shows/year. Average display time 1-2 months. Open all year. Intimate, black-walled space.
Media: Considers photography and all fine art.
Style: Exhibits: any thought-provoking artwork.
Terms: "Exhibit expenses and promotional material paid by the artist along with a sliding scale commission." Gallery provides promotion.
Submissions: Accepts predominantly Minnesota artists but not exclusively. Send 20 slides, materials for review, letter of interest and reasons you would like to exhibit at Icebox.
Tips: "Be more interested in the quality and meaning in your artwork than in a way of making money. Do not give up, but do not start too early."

N MIKOLS RIVER STUDIO INC., 707 Hwy. 10, Elk River MN 55330. (612)441-0437. Contact: Tony Mikols. Retail gallery. Estab. 1985. Represents 12 established artists/year. Exhibited artists include: Terry Redlin. Sponsors 2 shows/year. Open all year; 6 days, 9-6. Located in downtown; 1,100 sq. ft. 10% of space for special exhibitions; 50% of space for gallery artists. Overall price range: $230-595.
Media: Considers watercolor, sculpture and photography; types of prints include lithographs. Most frequently exhibits paper.
Style: Genres include florals, portraits and wildlife. Prefers: wildlife, florals and portraits.
Terms: Accepts work on consignment (30% commission) or buys outright for 50% of retail price (net on receipt). Retail price set by the gallery. Gallery provides insurance; gallery pays for shipping.
Submissions: Accepts only artists from the Midwest. Prefers only wildlife. Send photographs. Artist's portfolio should include photographs. Replies only if interested within 2 weeks. Files wildlife material. Finds artists through word of mouth.
Tips: "Don't bug me by phone."

N MODARES PUBLISHING & DISTRIBUTION, 8840 Seventh Ave. N., Golden Valley MN 55427. (612)513-1305. Fax: (612)513-1357. Wholesale gallery. Estab. 1994. Represents 3 mid-career artists/year. Exhibited artists include: Jim Hause, Paul Kropf and Derk Hause. Sponsors 2 shows/year. Open all year; Monday-Friday, 9-5. 10,000 sq. ft. plus 50% of spare warehouse. 20% of space for special exhibitions; 30% of space for gallery artists. Clients include galleries and frame shops.
Media: Considers all media and all types of prints. Most frequently exhibits limited, lithography and serigraphs.
Style: Exhibits: expressionism, painterly abstraction, postmodern works, Impressionism and realism. Genres include florals, western, wildlife, southwestern, landscapes and Americana.
Terms: Retail price is set by the artist. Gallery provides promotion and contract; gallery pays for shipping. Prefers

artwork unframed.

Submissions: Send query letter with brochure and photographs. Call for appointment to show portfolio of photographs and brochures. Replies only if interested with 3-5 weeks.

THE CATHERINE G. MURPHY GALLERY, The College of St. Catherine, 2004 Randolph Ave., St. Paul MN 55105. (612)690-6637. Fax: (612)690-6024. Curator: Kathleen M. Daniels. Nonprofit gallery. Estab. 1973. Represents emerging, mid-career and nationally and regionally established artists. "We have a mailing list of 1,000." Sponsors 5 shows/year. Average display time 4-5 weeks. Open September-June; Monday-Friday, 8-8; Saturday, 12-6; Sunday, 12-6. Located in the Visual Arts Building on the college campus of the College of St. Catherines; 1,480 sq. ft.
 ● This gallery also exhibits art historical and didactic shows of visual significance. Gallery shows 75% women's art since it is an all-women's undergraduate program.
Media: Considers all media and all types of prints.
Style: Exhibits: Considers all styles.
Terms: Artwork is loaned for the period of the exhibition. Gallery provides insurance. Shipping costs are shared. Prefers artwork framed.
Submissions: Send query letter with artist statement and checklist of slides (title, size, medium, etc.), résumé, slides, bio and SASE. Write for appointment to show portfolio. Replies in 4-6 weeks. Files résumé and cover letters.

PINE CONE GALLERY INC., 130 W. Front St., Pequot Lakes MN 56472. (218)568-8239. President: Robert Kargel. Retail gallery. Estab. 1983. Represents 400 at any time and currently representing 50 emerging, mid-career and established artists/year. Exhibited artists include: Russell Norberg, Rose Edin, Thomas Philabaum, Peter Vanderlaan and David Ahrendt. Sponsors 3 shows/year. Average display time 1 month. Open all year; 10-5:30. Located downtown; 4,000 sq. ft. 20% of space for special exhibitions; 50% of space for gallery artists. Clients include tourists. 90% of sales are to private collectors, 10% corporate collectors. Overall price range: $295-12,000; most work sold at $1,000-2,500.
Media: Considers oil, acrylic, watercolor, pastel, collage, paper, sculpture, ceramics, fiber, glass and wood; types of prints include woodcuts, engravings, lithographs and serigraphs. Most frequently exhibits watercolor, wood sculpture and glass sculpture.
Style: Exhibits: surrealism, Impressionism and realism. Genres include florals, wildlife and landscapes. Prefers: landscape, florals and wildlife.
Terms: Accepts work on consignment (45% commission) or buys outright for 50% of retail price (net 30 days). Retail price set by the gallery. Gallery provides promotion; shipping costs are shared. Prefers artwork framed.
Submissions: Send query letter with résumé and 9 slides. Write for appointment to show portfolio of photographs and slides. Replies in 1-2 weeks. Files any that are of present or future interest. Finds artists through word of mouth and other artists.
Tips: "Submit a range of talent; do not overprice."

☑ **C. G. REIN GALLERIES**, In the Galleria, 3205 Galleria, Edina MN 55435. (612)927-4331. Fax: (612)927-5276. E-mail: gallery@cgrein.com. Website: http://www.cgrein.com. Director: Trish ReinCowle. Retail gallery. Estab. 1974. Represents 25-30 emerging, mid-career and established artists. Exhibited artists include: Alexandra Nechita and John Richen. Sponsors 4 shows/year. Average display time 2½ weeks. Open all year. Located southwest of downtown; 4,500 sq. ft.; "broad, open space, high ceilings." 40% of space for special exhibitions. Clients include mid-to upper-income, business executives. 50% of sales are to private collectors; 50% corporate collectors. Overall price range: $800-5,000 + ; most work sold at $2,000-3,000.
Media: Considers oil, acrylic, watercolor, pastel, mixed media, collage, sculpture, and original handpulled prints. Most frequently exhibits painting, sculpture and mixed-media "No photography or ceramics at this time."
Style: Exhibits: expressionism, neo-expressionism, painterly abstraction, color field, postmodern works and Impressionism. Genres include landscapes and figurative work. Prefers neo-expressionism, painterly abstraction and semi-abstract figurative sculpture.
Terms: Accepts artwork on consignment. Retail price set by the artist with director. Gallery provides insurance, promotion and contract; artist pays for shipping. Prefers artwork framed.
Submissions: Send query letter with résumé, slides, brochure, photographs and bio. Write to schedule an appointment to show a portfolio, which should include slides and transparencies. Replies in 2-4 weeks.
Tips: "Send a stamped return envelope. Develop a style that is recognizable as unique and your own. We look for work in all sizes, including quite large."

JEAN STEPHEN GALLERIES, 917 Nicollet Mall, Minneapolis MN 55402. (612)338-4333. Directors: Steve or Jean Danko. Retail gallery. Estab. 1987. Represents 12 established artists. Interested in seeing the work of emerging artists. Exhibited artists include: Jiang, Hart and Max. Sponsors 2 shows/year. Average display time 4 months. Open all year; Monday-Saturday, 10-6. Located downtown; 2,300 sq. ft. 15% of space for special exhibitions; 85% of space for gallery artists. Clients include upper income. 90% of sales are to private collectors, 10% corporate collectors. Overall price range: $600-12,000; most work sold at $1,200-2,000.
Media: Considers oil, acrylic, pastel, pen & ink, drawing, mixed media, collage, paper, sculpture, ceramics, woodcuts, engravings, lithographs, wood engravings, mezzotints, serigraphs, linocuts and etchings. Most frequently exhibits serigraphs, stone lithographs and sculpture.
Style: Exhibits: expressionism, neo-expressionism, surrealism, minimalism, color field, postmodern works and Impres-

sionism. Genres include landscapes, southwestern, portraits and figurative work. Prefers Chinese contemporary, abstract and Impressionism.

Terms: Accepts work on consignment (50% commission). Retail price set by the gallery. Gallery provides insurance and contract; artist pays shipping costs to and from gallery.

Submissions: Send query letter with résumé, slides and bio. Call for appointment to show portfolio of originals, photographs and slides. Replies in 1-2 months. Finds artists through art shows and visits.

Mississippi

BROWN'S FINE ART & FRAMING, INC., 630 Fondren Place, Jackson MS 39216. (800)737-4844. Fax: (601)982-0030. E-mail: bffa@misnet.com. Website: http://www.brownsfineart.com. Manager of Operations: Joel Brown. Retail gallery. Estab. 1965. Represents 30 emerging, mid-career and established artists/year. Exhibited artists include: Emmitt Thames and Sharon Richardson. Sponsors 6-8 shows/year. Average display time 1 month. Open all year; Monday-Friday, 9-5:30; Saturday, 10-4. Located in the Woodland Hills/Fondren business district; 10,000 total sq. ft.; one of the first specifically designed art gallery/picture framing in the country. 60% of space for special exhibitions. Clients include locals, tourists, etc. 50% of sales are to private collectors, 50% corporate collectors. Overall price range: $200-30,000; most work sold at $1,000-2,000.

Media: Considers oil, acrylic, watercolor, pastel, pen & ink, drawing, mixed media, collage, sculpture and ceramics. Most frequently exhibits oil, watercolor and pastel.

Style: Exhibits: expressionism, painterly abstraction, Impressionism and realism. Genres include florals and landscapes. Prefers: landscapes, floral and contemporary abstracts.

Terms: Accepts work on consignment (50% commission). Retail price set by the gallery and artist. Gallery provides promotion. Prefers artwork unframed. "We do all of our own framing at no expense to artist."

Submissions: Prefers only Mississippi artists. Send query letter with résumé, slides, bio and artist's statement. Call for appointment to show portfolio of actual work. Replies immediately. Files résumé, samples, slides and bio. Finds artists through artists who come to us who wish to be represented by us. We do not solicit.

Tips: "Be original. Take what you have learned from school and others who may have taught you, and come up with your own innovations and style. Paint everyday. Don't make the mistakes of dressing slovenly, not showing up on time, not looking around our gallery before initial contact, not having a bio or résumé and having a bad attitude."

CARTMELL GALLERY AND FRAME, (formerly Cartmell Gallery), 609 22nd Ave., Meridian MS 39301. (601)485-1122. Fax: (601)485-5559. Manager: Deborah Martin. Retail gallery. Estab. 1993. Represents 8 emerging, mid-career and established artists/year. Exhibited artists include: Greg Cartmell, Les Green, Joel Callahan, Mikki Senkarik and Malcolm Allen. Sponsors 6 shows/year. Average display time 2-3 weeks. Open all year; Monday-Friday, 10-5. Located downtown; 2,500 sq. ft. Clientele: tourists, upscale. 75% private collectors, 25% corporate collectors. Overall price range: $50-10,000; most work sold at $50-1,000.

Media: Considers all media and all types of prints. Most frequently exhibits oils, watercolor, pastel.

Style: Exhibits: expressionism, painterly abstraction, Impressionism, realism. Prefers: Impressionism, expressionism and painterly abstraction.

Terms: Accepts work on consignment (33% commission) or buys outright for 50% of retail price (net 30 days). Retail price set by the artist. Gallery provides insurance, promotion and contract; artists pays for shipping costs to gallery. Prefers artwork framed.

Submissions: Send query letter with résumé, bio, brochure, photographs, SASE and artist's statement. Call for appointment to show portfolio of photographs. Replies in 2-3 weeks. Files résumé and photographs. Finds artists through word of mouth, referrals by other artists, art fairs and exhibitions, submissions and national magazine advertising.

Tips: "Have good quality photographs or slides taken of your work before submitting to galleries."

HILLYER HOUSE INC., 207 E. Scenic Dr., Pass Christian MS 39571. (601)452-4810. Owners: Katherine and Paige Reed. Retail gallery. Estab. 1970. Represents emerging, mid-career and established artists: 19 artists, 34 potters, 46 jewelers, 10 glass-blowers. Interested in seeing the work of emerging artists. Exhibited artists include: Barbara Quigley and Patt Odom. Sponsors 24 shows/year. Average display time 2 months. Open Monday-Saturday 10-5; Sunday 12-5. Open all year. Located beachfront-middle of CBD historic district; 1,700 sq. ft. 50% of space for special exhibitions; 50% of space for gallery artists. Clients include visitors to the Mississippi Gulf Coast (80%), private collectors (20%). Overall price range: $25-700; most work sold at $30-150; paintings $250-700.

● Hillyer House has special exhibitions in all areas.

Media: Considers oil, watercolor, pastel, mixed media, sculpture (metal fountains), ceramic, craft and jewelry. Most frequently exhibits watercolor, pottery and jewelry.

Style: Exhibits: expressionism, imagism, realism and contemporary. Genres include aquatic/nautical. Prefers: realism, Impressionism and expressionism.

Terms: Accepts work on consignment (35% commission); or artwork is bought outright for 50% of the retail price (net 30 days). Retail price set by gallery or artist. Gallery provides promotion and contract; artist pays for shipping. Prefers artwork framed.

Submissions: Send query letter with résumé, slides, bio, brochure, photographs, SASE and reviews. Call or write for

appointment to show portfolio of originals and photographs. Replies only if interested within 3 weeks. Files photograph and bio. (Displays photo and bio with each person's art.)

Tips: "Work must be done in last nine months. Watercolors sell best. Make an appointment. Looking for artists with a professional attitude and approach to work. Be sure the work submitted is in keeping with the nature of our gallery."

Missouri

N CENTRAL MISSOURI STATE UNIVERSITY ART CENTER GALLERY, 217 Clark St., Warrensburg, MO 64093. (660)543-4498. Fax: (660)543-8006. Gallery Director: Morgan Gallatin. University Gallery. Estab. 1984. Exhibits emerging, mid-career and established artists. Sponsors 11 exhibitions/year. Average display time 1 month. Open Monday, Wednesday, Thursday and Friday, 8-5; Tuesday, 8-7; Saturday, 10-2; Sunday, 1-5. Open during academic year. Located on the University campus. 3,778 sq. ft. 100% of space is devoted to special exhibitions. Clientele: local community, students.

Media: Considers all media and all styles.

Terms: No commission: "We are primarily an education gallery, not a sales gallery." Gallery provides insurance. Shipping costs are shared. Prefers artwork framed.

Submissions: Send query letter with résumé, slides, bio, photographs, SASE. Write for appointment to show portfolio of photographs and slides. Replies in 6 months. Finds artists through The Greater Midwest International Art Competition sponsored by the Gallery.

✓ BYRON COHEN GALLERY FOR CONTEMPORARY ART, (formerly Byron Cohen Lennie Berkowitz), 2020 Baltimore, Kansas City MO 64108. (816)421-5665. Fax: (816)421-5775. E-mail: byroncohen@aol.com. Website: http://www.artnet.com/cohen.html. Owner: Byron Cohen. Retail gallery. Estab. 1994. Represents emerging and established artists. Exhibited artists include: Squeak Carnwath. Sponsors 6-7 shows/year. Average display time 7 weeks. Open all year; Thursday-Saturday, 11-5. Located downtown; 1,500 sq. ft.; 100% of space for gallery artists. 90% of sales are to private collectors, 10% corporate collectors. Overall price range: $300-42,000; most work sold at $2,000-7,000.

Media: Considers all media. Most frequently exhibits painting, works on paper and sculpture.

Style: Exhibits: Considers all styles. Prefers contemporary painting and sculpture, contemporary prints, contemporary ceramics.

Terms: Accepts work on consignment (50% commission.) Retail price set by the gallery and the artist. Gallery provides insurance, promotion and contract; shipping costs are shared. Prefers artwork framed.

Submissions: Send query letter with résumé, slides, artist's statement and bio. Write for appointment to show portfolio of photographs, transparencies and slides. Files slides, bio and artist's statement. Finds artists through word of mouth, referrals by other artists, visiting art fairs and exhibitions.

FINE ARTS RESOURCES, 11469 Olive St., #266, St. Louis MO 63141. Phone/fax: (314)432-5824. E-mail: mikeb@surfnet2000.com. President: R. Michael Bush. Art consultancy, broker. Estab. 1986. Represents over 50 emerging, mid-career and established artists. Interested in seeing the work of emerging artists. Open all year; by appointment only. Located in suburb. Clients include commercial/residential. 25% of sales are to private collectors, 75% corporate collectors. Overall price range: $150-10,000; most work sold at $1,000-3,000.

Media: Considers oil, pen & ink, paper, acrylic, drawing, sculpture, glass, watercolor, pastel and all types of prints. Most frequently exhibits oil, acrylic and sculpture.

Terms: Artwork is accepted on consignment (40% commission). Retail price set by the gallery and the artist. Shipping costs are shared. Prefers artwork framed.

Submissions: Send query letter with résumé, 7-10 slides and bio. Write for appointment to show portfolio of slides. Replies only if interested within 2 weeks.

N FORUM FOR CONTEMPORARY ART, 3540 Washington Ave., St. Louis MO 63103. (314)535-4660. Fax: (314)535-1226. E-mail: forum@inlink.com. Website: http://www.forumart.org. Executive Director/Curator: Elizabeth Wright Millard. Nonprofit gallery, museum. Estab. 1980. Exhibits emerging, mid-career and established artists. Interested in seeing the work of emerging artists. Sponsors 8-10 shows/year. Average display time 2 months. Open all year; Tuesday-Saturday 10-5. Located mid-town, Grand Center; 4,000 sq. ft.; urban, spare space. 95% of space for special exhibitions. Clients include local community, students.

Media: Considers all media. Most frequently exhibits installation, multi-media, performance, time arts and photography.

Style: Exhibits: Considers all styles. Genres include cutting edge, contemporary.

Terms: Gallery provides insurance, promotion and shipping costs.

Submissions: Only interested in contemporary work. Send query letter with résumé, slides and SASE. Write for appointment to show portfolio of slides. Replies in 6 months. Finds artists through referrals from other artists and galleries or museums.

Tips: "Do not submit unless your work fits the 'alternative' contemporary criteria of the museum. We look at our overall exhibition schedule and determine what kind of work we have not shown recently. If the artist is not experienced in exhibiting with a museum, we work closely with them to establish a high level of professionalism"

N **GALERIE BONHEUR**, 10046 Conway Rd., St. Louis MO 63124. (314)993-9851. Fax: (314)993-9260. E-mail: gbonheur@aol.com. Owner: Laurie Carmody. Private retail and wholesale gallery. Focus is on international folk art. Estab. 1980. Represents 60 emerging, mid-career and established artists/year. Exhibited artists include: Milton Bond and Justin McCarthy. Sponsors 6 shows/year. Average display time 1 year. Open all year; by appointment. Located in Ladue (a suburb of St. Louis); 1,500 sq. ft.; art is displayed all over very large private home. 75% of sales to private collectors. Overall price range: $25-25,000; most work sold at $50-1,000.
 • Galerie Bonheur also has a location at 9243 Clayton Rd., Ladue, MO.
Media: Considers oil, acrylic, watercolor, pastel, pen & ink, drawing, mixed media, collage, paper, sculpture, ceramics and craft. Most frequently exhibits oil, acrylic and metal sculpture.
Style: Exhibits: expressionism, primitivism, Impressionism, folk art, self-taught, outsider art. Genres include landscapes, florals, Americana and figurative work. Prefers genre scenes and figurative.
Terms: Accepts work on consignment (50% commission) or buys outright for 50% of retail price. Retail price set by the gallery and the artist. Gallery provides promotion; artist pays shipping costs to and from gallery. Prefers artwork framed.
Submissions: Prefers only self-taught artists. Send query letter with bio, photographs and business card. Write for appointment to show portfolio of photographs. Replies only if interested within 6 weeks. Finds artists through agents, visiting exhibitions, word of mouth, art publications and sourcebooks and submissions.
Tips: "Be true to your inspirations. Create from the heart and soul. Don't be influenced by what others are doing; do art that you believe in and love, and are proud to say is an expression of yourself."

✓ **GOMES GALLERY OF SOUTHWESTERN ART**, 7513 Forsyth, Clayton MO 63105. (314)725-1808. Fax: (314)725-2870. E-mail: artgal1@aol.com. Website: http://www.icon-stl.net/gomes/. Director: Carla Patton. Retail gallery. Estab. 1985. Represents 80 emerging, mid-career and established artists. Exhibited artists include R.C. Gorman and Frank Howell. Sponsors 5 shows/year. Average display time 4 months. Open all year; Monday-Thursday, 10-6; Friday and Saturday, 10-8; Sunday, 11-4. Located "downtown, across from the Ritz Carlton; 3,600 sq. ft.; total Southwestern theme, free covered parking." 35% of space for special exhibition during shows. Free standing display wall on wheels. Clientele: tourists, local community. 96% private collectors, 4% corporate collection. Overall price range: $100-15,000; most work sold at $1,200-2,000.
 • This gallery reports that business is up 10%.
Media: Considers all media and all types of prints. Most frequently exhibits stone lithos, originals and serigraphs.
Style: Exhibits all styles. Genres include landscapes, western, wildlife and southwestern. Prefers western/southwestern themes and landscapes.
Terms: Accepts artwork on consignment (50% commission); or buys outright for 40-50% of retail price (net 10-30 days). Retail price set by gallery and artist. Customer payment by installment is available. Gallery provides insurance, promotion and contract; shipping costs are shared.
Submissions: Prefer, but not limited to Native American artists. Send query letter with slides, bio, medium, price list, brochure and photographs. Portfolio review requested if interested in artist's work. Portfolio should include originals, slides, photographs, transparencies and brochure. Replies in 2-3 weeks; artist follow-up encouraged. Files bio.
Tips: "Send complete package the first time you submit. Include medium, size and cost or retail. Submit until you have succeeded in obtaining representation at 8-10 galleries, without duplication in a specific city or region. Promote co-op advertising with your galleries."

THE JAYNE GALLERY, 108 W. 47th St., Kansas City MO 64112. (816)561-5333. Fax: (816)561-8402. E-mail: cjnkc@jaynegallery.net. Website: http://www.jaynegallery.com. Owners: Ann Marie Jayne and Clint Jayne. Retail gallery. Represents/exhibits over 40 emerging, mid-career and established artists/year. Exhibited artists include: Jim Rabby and Robert Striffolino. Sponsors 4-6 shows/year. Average display time 3 weeks. Open all year; Monday-Saturday, 10-7; Thursday, 10-6; Sunday, 12-5. 2,000 sq. ft. in outdoor gallery located on The Plaza, a historic shopping district featuring Spanish architecture such as stucco buildings with red tile roofs, ornate towers and beautiful courtyards. 100% of space is devoted to the work of gallery artists. 40% of sales are to out-of-town clients; 60% Kansas City metro and surrounding communities. Overall price range: $500-5,000; most work sold at $1,500-3,700.
Media: Considers all media and all types of prints by artists whose original work is handled by gallery. Most frequently exhibits paintings—all media, ceramics, glass and other fine crafts.
Style: Exhibits: Considers all styles. Genres include landscapes and figurative work. Prefers: Impressionism, expressionism and abstraction.
Terms: Artwork is accepted on consignment (50% commission). Retail price set by the artist. Gallery provides insurance, promotion and contract; shipping costs are shared. Requires artwork framed.
Submissions: Accepts only artists from US. Send query letter with résumé, brochure, business card, slides, photographs, reviews, bio, SASE and price list. Write for appointment to show portfolio of photographs, transparencies, slides of available work. Replies in 6-8 weeks; if interested within 2 weeks. Files résumé, any visuals that need not be returned. Finds artists through referrals, travel, art fairs and exhibitions.
Tips: "Visit galleries to see if your work 'fits' with gallery's look, vision, philosophy, or visit the website to get a feel for the gallery."

N **SHERRY LEEDY CONTEMPORARY ART**, 2004 Baltimore Ave., Kansas City MO 64108. (816)474-1919. Director: Sherry Leedy. Retail gallery. Estab. 1985. Represents 50 mid-career and established artists. May be interested

in seeing the work of emerging artist in the future. Exhibited artists include: Dale Chihuly, Theodore Waddell. Sponsors 20 shows/year. Average display time 6 weeks. 10,000 sq. ft. of exhibit area in 3 galleries. Clients include established and beginning collectors. 80% of sales are to private collectors, 20% corporate clients. Price range: $50-100,000; most work sold at $3,500-35,000.

Media: Considers all media and one of a kind or limited edition prints; no posters. Most frequently exhibits painting, ceramic sculpture and glass.

Style: Exhibits: Considers all styles.

Terms: Accepts work on consignment (50% commission). Retail price set by gallery. Sometimes offers customer discounts and payment by installment. Exclusive area representation required. Gallery provides insurance, promotion; shipping costs are shared. Prefers artwork framed.

Submissions: Send query letter, résumé, good slides, prices and SASE. Write for appointment to show portfolio of originals, slides and transparencies. Bio, vita, slides, articles, etc. are filed if they are of potential interest.

Tips: "We pursue artists that are of interest to us—usually recommended by other artists, galleries and museums. We also find out about artists through their direct inquiries to us—they are usually directed to us by other atists, collectors, museums, etc. Allow three months for gallery to review slides."

LYSOGRAPHICS FINE ART, 722 S. Meramec, St. Louis MO 63105. (314)726-6140. Owner: Esther Lyss. Retail and wholesale gallery. Estab. 1971. Represents emerging, mid-career and established artists. Open all year by appointment. Located mid-town. Clientele: corporate and upper end.

Media: Considers all media and all types of prints.

Style: Exhibits all styles and genres.

Terms: Retail price set by gallery and/or artist. Prefers artwork unframed.

Submissions: Send query letter with résumé, slides, brochure, photographs, business card, reviews, bio and SASE. Call or write for appointment to show portfolio. Replies in 2-3 weeks. Files all material sent with query.

Tips: "I am always happy to speak with artists. I am a private dealer and specialize in helping my clients select works for their home or office."

MORTON J. MAY FOUNDATION GALLERY, Maryville University, 13550 Conway, St. Louis MO 63141. (314)576-9300. E-mail: nrice@maryville.edu. Director: Nancy N. Rice. Nonprofit gallery. Exhibits the work of 6 emerging, mid-career and established artists/year. Sponsors 10 shows/year. Average display time 1 month. Open all year. Located on college campus. 10% of space for special exhibitions. Clients include college community. Overall price range: $100-4,000.

• The gallery is long and somewhat narrow, therefore it is inappropriate for very large 2-D work. There is space in the lobby for large 2-D work but it is not as secure.

Media: Considers oil, acrylic, watercolor, pastel, pen & ink, drawings, mixed media, collage, works on paper, sculpture, ceramic, fiber, installation, photography, original handpulled prints, woodcuts, engravings, lithographs, wood engravings, mezzotints, linocuts and etchings. Exhibits all genres.

Terms: Artist receives all proceeds from sales. Retail price set by artist. Gallery provides insurance and promotion; artist pays for shipping. Prefers framed artwork.

Submissions: Prefers St. Louis area artists. Send query letter with résumé, slides, bio, brochure and SASE. Portfolio review requested if interested in artist's work. Portfolio should include slides, photographs and transparencies. Replies only if interested within 3 months. Finds artists through referrals by colleagues, dealers, collectors, etc. "I also visit group exhibits especially if the juror is someone I know and or respect."

Tips: Does not want "hobbyists/crafts fair art." Looks for "a body of work with thematic/aesthetic consistency."

THE SOURCE FINE ARTS, 4137 Pennsylvania, Kansas City MO 64111. (816)931-8282. Fax: (816)913-8283. Owner: Denyse Ryan Johnson. Retail gallery. Estab. 1985. Represents/exhibits 50 mid-career artists/year. Exhibited artists include: Jack Roberts and John Gary Brown. Sponsors 3-4 openings, monthly shows/year. Open all year; Monday-Friday, 9-5; Saturday, 11-4. Located in midtown Westport Shopping District; 2,000 sq. ft. 50% of space for special exhibitions. Clients include tourists and upscale. 60% of sales are to private collectors, 40% corporate collectors. Overall price range: $200-6,500; most work sold at $1,000-4,500.

Media: Considers all media except photography. Most frequently exhibits oil, acrylic, mixed media, ceramics and glass.

Style: Exhibits: expressionism, minimalism, color field, hard-edge geometric abstraction, painterly abstraction and Impressionism. Genres include landscapes. Prefers: non-objective, abstraction and Impressionism.

Terms: Artwork is accepted on consignment (50% commission). Retail price set by the gallery. Gallery provides insurance, promotion and contract; shipping costs are shared.

Submissions: Prefers Midwest artists with exhibit, sales/gallery record. Send query letter with résumé, brochure, business card, 8-12 slides, photographs, reviews and SASE. Call for appointment to show portfolio of photographs, slides and transparencies. Replies in 1 month. Files slides and résumé. Finds artists through word of mouth, referrals by other artists, visiting art fairs and exhibitions and artists' submissions. Reviews submissions in January and July.

Tips: Advises artists who hope to gain gallery representation to "visit the gallery to see what media and level of expertise is represented. If unable to travel to a gallery outside your region, review gallery guides for area to find out what styles the gallery shows. Prior to approaching galleries, artists need to establish an exhibition record through group shows. When you are ready to approach galleries, present professional materials and make follow-up calls."

Montana

ARTISTS' GALLERY, 111 S. Grand, #106, Bozeman MT 59715. (406)587-2127. Chairperson: Justine Heisel. Retail and cooperative gallery. Estab. 1992. Represents the work of 20 emerging and mid-career artists, 20 members. Sponsors 12 shows/year. Average display time 3 months. Open all year; Tuesday-Saturday, 10-5. Located near downtown; 900 sq. ft.; located in Emerson Cultural Center with other galleries, studios, etc. Clients include tourists, upscale, local community and students. 100% of sales are to private collectors. Overall price range: $35-600; most work sold at $100-300.

Media: Considers oil, acrylic, watercolor, pastel, pen & ink, drawing, mixed media, collage, paper, sculpture, ceramics and glass, woodcuts, engravings, linocuts and etchings. Most frequently exhibits oil, watercolor and ceramics.

Style: Exhibits: painterly abstraction, Impressionism, photorealism and realism. Exhibits all genres. Prefers realism, Impressionism and western.

Terms: Co-op membership fee plus donation of time (20% commission). Rental fee for space; covers 1 month. Retail price set by the artist. Gallery provides promotion; artist pays for shipping costs to gallery. Prefers artwork framed.

Submissions: Artists must be able to fulfill "sitting" time or pay someone to sit. Send query letter with résumé, slides, photographs, artist's statement and actual work. Write for appointment to show portfolio of photographs and slides. Replies in 2 weeks.

CORBETT GALLERY, Box 339, 459 Electric Ave. B, Bigfork MT 59911. (406)837-2400. E-mail: corbett@digisys.n et. Director: Jean Moore. Retail gallery. Estab. 1993. Represents 20 mid-career and established artists. Exhibited artists include: Greg Beecham. Sponsors 2 shows/year. Average display time 3 weeks. Open all year; Sunday-Friday, 10-8 summer, 10-5 winter. Located downtown; 2,800 sq. ft. Clients include tourists and upscale. 90% of sales are to private collectors. Overall price range: $250-10,000; most work sold at $2,400.

Media: Considers all media; types of prints include engravings, lithographs, serigraphs and etchings. Most frequently exhibits oil, watercolor and acrylic.

Style: Exhibits: photorealism. Genres include western, wildlife, southwestern and landscapes. Prefers: wildlife, landscape and western.

Terms: Accepts work on consignment (40% commission). Retail price set by the artist. Gallery provides insurance, promotion and contract. Shipping costs are shared. Prefers artwork framed.

Submissions: Send query letter with slides, brochure and SASE. Call for appointment to show portfolio of photographs or slides. Replies in 1 week. Files brochures and bios. Finds artists through art exhibitions and referrals.

Tips: "Don't show us only the best work, then send mediocre paintings that do not equal the same standard."

[N] CUSTER COUNTY ART CENTER, Box 1284, Water Plant Rd., Miles City MT 59301. (406)232-0635. Executive Director: Mark Browning. Nonprofit gallery. Estab. 1977. Interested in emerging and established artists. 90% of sales are to private collectors, 10% corporate clients. Sponsors 8 group shows/year. Average display time is 6 weeks. Overall price range: $200-10,000; most artwork sold at $300-500.

 ● The galleries are located in the former water-holding tanks of the Miles City WaterWorks. The underground, poured concrete structure is listed on the National Register of Historic Places. It was constructed in 1910 and 1924 and converted to its current use in 1976-77.

Media: Considers all media and original handpulled prints. Most frequently exhibits painting, sculpture and photography.

Style: Exhibits: painterly abstraction, conceptualism, primitivism, Impressionism, expressionism, neo-expressionism and realism. Genres include landscapes, western, portraits and figurative work. "Our gallery is seeking artists working with traditional and non-traditional Western subjects in new, contemporary ways." Specializes in western, contemporary and traditional painting and sculpture.

Terms: Accepts work on consignment (30% commission). Retail price is set by gallery and artist. Exclusive area representation not required. Gallery provides insurance, promotion and contract; shipping expenses are shared.

Submissions: Send query letter, résumé, brochure, slides, photographs and SASE. Write for appointment to show portfolio of originals, "a statement of why the artist does what he/she does" and slides. Slides and résumé are filed.

HARRIETTE'S GALLERY OF ART, 510 First Ave. N., Great Falls MT 59405. (406)761-0881. Owner: Harriette Stewart. Retail gallery. Estab. 1970. Represents 20 artists. Exhibited artists include: Don Begg, Larry Zabel, Frank Miller, Arthur Kober, Richard Luce, Susan Guy, J. Schoonover, Johnye Cruse and Lee Cable. Sponsors 1 show/year. Average display time 6 months. Open all year. Located downtown; 1,000 sq. ft. 100% of space for special exhibitions. 90% of sales are to private collectors, 10% corporate collectors. Overall price range: $100-10,000; most artwork sold at $200-750.

Media: Considers oil, acrylic, watercolor, pastel, pencils, pen & ink, mixed media, sculpture, original handpulled prints, lithographs and etchings. Most frequently exhibits watercolor, oil and pastel.

Style: Exhibits: expressionism. Genres include wildlife, landscape, floral and western.

Terms: Accepts work on consignment (33⅓% commission); or outright for 50% of retail price. Retail price set by gallery and artist. Sometimes offers customer discounts and payment by installment. Gallery provides promotion; "buyer pays for shipping costs." Prefers artwork framed.

Submissions: Send query letter with résumé, slides, brochure and photographs. Portfolio review requested if interested

in artist's work. "Have Montana Room in the largest Western Auction in U.S.—The Charles Russell Auction, in March every year—looking for new artists to display."

Tips: "Proper framing is important."

☑ **HOCKADAY MUSEUM OF ART**, (formerly Hockaday Center for the Arts), P.O. Box 83, Kalispell MT 59903. (406)755-5268. E-mail: hockaday@bigsky.net. Website: http://www.hockadaymuseum.org. Director: Joan Baucus. Museum. Estab. 1968. Exhibits emerging, mid-career and established artists. Interested in seeing the work of emerging artists. 500 members. Exhibited artists include: Theodore Waddell, Dale Chihuly and David Shaner. Sponsors approximately 15 shows/year. Average display time 2 months. Open year round. Located 2 blocks from downtown retail area; 2,650 sq. ft.; historic 1906 Carnegie Library Building with new (1989) addition; wheelchair access to all of building. 50% of space for special exhibitions. Overall price range $500-35,000.

Media: Considers all media, plus woodcuts, wood engravings, linocuts, engravings, mezzotings, etchings, lithographs and serigraphs. Most frequently exhibits painting (all media), sculpture/installations (all media), photography and original prints.

Style: Exhibits all styles and genres. Prefers: contemporary art (all media and styles), historical art and photographs and traveling exhibits. "We are not interested in wildlife art and photography, mass-produced prints or art from kits."

Terms: Accepts work on consignment (40% commission). Also houses permanent collection: Montana and regional artists acquired through donations. Sometimes offers customer discounts and payment by installment to museum members. Gallery provides insurance, promotion and contract; shipping costs are shared. Prefers artwork framed.

Submissions: Send query letter with résumé, slides, bio, reviews and SASE. Portfolio should include b&w photographs and slides (20 maximum). "We review *all* submitted portfolios once a year, in spring." Finds artists through submissions and self-promotions.

Tips: "Present yourself and your work in the best possible professional manner. Art is a business. Make personal contact with the director, by phone or in person. You have to have enough work of a style or theme to carry the space. This will vary from place to place. You must plan for the space. A good rule to follow is to present 20 completed works that are relative to the size of space you are submitting to. As a museum whose mission is education we choose artists whose work brings a learning experience to the community."

INDIAN UPRISING GALLERY, 111 S. Grand Ave. #104, Bozeman MT 59715. (406)586-5831. Fax: (406)587-5998. E-mail: indianuprising@mcn.net. Retail gallery. Estab. 1991. Represents 75 emerging, mid-career and established artists/year. Exhibited artists include: Sam English, Bruce Contway, Rance Hood, Frank Shortey and Gale Running Wolf. Sponsors 4 shows/year. Average display time 1 month. Open all year; 10-5. Located in Emerson Cultural Center; 500 sq. ft. 100% of space for gallery artists. 25% of sales are to private collectors.

● Indian Uprising Gallery has three new locations: 47214 Gallatin Rd., Big Sky, Montana 59716, (406)586-3851; 1169 Sheridan Ave., Cody, Wyoming 82414, (307)587-1132; and RUA Plácido de Sousa Vieira #3, Alte 8100-Loulé, Algarue, Portugal.

Media: Considers all media. Most frequently exhibits fine, contemporary and traditional tribal.

Style: Exhibits all styles and genres.

Terms: Accepts work on consignment (20% commission) or buys outright for 50% of retail price (net 30 days). Retail price set by the gallery. Gallery provides insurance, promotion and contract; shipping costs are shared. Prefers artwork framed.

Submissions: Accepts only Native artists from northern US. Send résumé, slides, bio and artist's statement. Write for appointment to show portfolio of photographs. Replies in 2 weeks. Finds artists through visiting museums art shows for Indian art.

Ⓝ **LEWISTOWN ART CENTER**, 801 W. Broadway, Lewistown MT 59457. (406)538-8278. Nonprofit gallery and gift shop. Estab. 1971. Represents emerging, mid-career and established artists. Sponsors 12 shows/year. Average display time 1 month. Open all year. Located in historic Courthouse Square; 1,075 sq. ft. (3 separate galleries: 400 sq. ft in one, 425 sq. ft. in another, approximately 250 sq. ft. in the last); historical stone bunk house—1897 and historical carriage house same era. Clients include business/professional to agriculture. 75% of sales are to private collectors, 25% corporate collectors. Overall price range: $45-1,200; most work sold at $200-400.

● Though the Lewistown Art Center is in Montana, its interests in art are much broader than might be expected.

Media: Considers oil, acrylic, watercolor, pastel, pen & ink, drawings, mixed media, sculpture, ceramic, fiber and glass; all types of prints on consignment only.

Style: Exhibits: expressionism, primitivism, conceptualism, postmodern works, Impressionism and realism. All genres.

Terms: Accepts work on consignment (30% commission). Retail price set by gallery and artist. Sometimes offers customer discounts and payment by installment. Gallery provides insurance, promotion and contract; artist pays for shipping. Prefers artwork framed.

Submissions: First send query letter with slides and bio. Then later send brochure and reviews. Replies in 2 weeks. Finds artists through word of mouth, artists' submissions, traveling shows and visiting and chatting with artists.

Tips: "Located in the center of Montana, between Great Falls and Billings, the LAC serves Montanans within a 100-mile radius."

LIBERTY VILLAGE ARTS CENTER, 400 S. Main, Chester MT 59522. (406)759-5652. Contact: Director. Nonprofit gallery. Estab. 1976. Represents 12-20 emerging, mid-career and established artists/year. Sponsors 6-12 shows/year.

Average display time 6-8 weeks. Open all year; Tuesday-Friday, 12-4; Sunday, 12-4. Located near a school; 1,000 sq. ft.; former Catholic Church. Clients include tourists and local community. 100% of sales are to private collectors. Overall price range: $100-2,500; most work sold at $250-500

Media: Considers all media; types of prints include woodcuts, lithographs, mezzotints, serigraphs, linocuts and pottery. Most frequently exhibits paintings in oil, water, acrylic, b&w photos and sculpture assemblages.

Style: Exhibits: Considers all styles. Prefers: contemporary and historic

Terms: Accepts work on consignment (30% commission) or buys outright for 40% of retail price. Retail price set by the gallery. Gallery provides insurance and promotion; shipping costs are shared. Prefers artwork framed or unframed.

Submissions: Send query letter with slides, bio and brochure. Artists portfolio should include slides. Replies only if interested within 3-12 months. Artist should cross us off their list. Files everything. Finds artists through word of mouth and seeing work at shows.

Tips: "Artists make the mistake of not giving us enough information and permission to pass information on to other galleries."

MISSOURI RIVER GALLERY, 201 N. Main St., Three Forks MT 59752. (406)285-4462. E-mail: missriverg@aol.com. Owner: Amber. Retail gallery and frame shop. Estab. 1995. Represents 10 emerging, mid-career and established artists/year. Exhibited artists include: Zabel, Dooley, N. Glazier, Rob DuBois and Tim Cox. Open all year; Monday-Saturday, 10-5. Located north end of town on Main; 1,000 sq. ft.; homestyle. 50% of space for special exhibitions; 50% of space for gallery artists. Overall price range: $10-2,000; most work sold at $75-300.

Media: Considers all media and all types of prints. Most frequently exhibits limited edition prints, oil colors and sculpture.

Style: Exhibits: Considers all styles. Genres include florals, western, wildlife, southwestern and landscapes. Prefers: western, Victorian and wildlife.

Terms: Accepts work on consignment (30% commission). Retail price set by the artist. Prefers artwork unframed.

Submissions: Send brochure, photographs and business card. Call for appointment. Does not reply. Artist should call. Finds artists through magazines and art fairs.

PARADISE PRINTS, INC., 223 S. Main St., Livingston MT 59047. (406)222-5974. Fax: (406)222-5820. E-mail: paradise@wtp.net. Website: http://www.wildwestart.com. President: David C. Lewis. Retail gallery. Estab. 1994. Represents 30 emerging, mid-career and established artists/year. Exhibited artists include: Tim Cox and Manuel Manzanarez. Sponsors 12 shows/year in gallery and 40 shows/year throughout the West. Average display time 2-3 weeks. Open all year; Monday-Saturday, 8:30-5:30; Sunday by appointment. Located downtown Livingston; 3,200 sq. ft. 25% of space for special exhibitions; 75% of space for gallery artists. Clients include local community, tourists and in-state interest. 85% of sales are to private collectors, 15% corporate collectors. Overall price range: $50-5,000; most work sold at $130-275. "We have 25 artists currently on the Internet and are adding more monthly. We provide low-cost web pages for artists throughout the West. (We currently get about 200 hits a day on our site.)"

Media: Considers all media and all types of prints. Most frequently exhibits limited-edition, framed, wildlife art prints; limited-edition, framed western art prints; open-edition, framed, wildlife art prints.

Style: Exhibits: photorealism and realism. Genres include florals, portraits, western, wildlife, landscapes, limited edition framed angling art prints, open edition angel Renaissance art prints, Americana and New Age.

Terms: Accepts work on consignment (25% commission). Retail price set by the gallery. Gallery provides insurance, promotion and contract. Artist pays shipping costs. Prefers artwork framed.

Submissions: Prefers limited-edition prints. Send query letter with résumé, brochure, business card, reviews, artist's statement and bio. Call for appointment to show portfolio of photographs. Files artist's brochures. Finds artists through word of mouth, visiting art fairs and exhibitions and through publications.

THE WADE GALLERY, 116 N. Main St., Livingston MT 59047. Phone/fax: (406)222-0404. E-mail: simonsez@sunrise.alpinet.net. Owner: Kelly Wade. Retail gallery and custom frame shop. Estab. 1986. Represents 15-20 emerging, mid-career and established artists/year. Exhibited artists include: Russell Chatham and Bruce Park. Sponsors 4 exhibitions/year. Average display time 1 month. Open all year; Tuesday-Saturday, 10-5. Located downtown; 1,200 sq. ft.; newly remodeled, individual alcoves to showcase artists. Clients include tourists, upscale and local. 90% of sales are to private collectors, 10% corporate collectors. Overall price range: $50-20,000; most work sold at $100-1,500.

Media: Considers all media including jewelry. Considers all types of original prints. Most frequently exhibits pastel, watercolor and oil.

Style: Exhibits: realism, Impressionism and historic photos. Genres include portraits, wildlife and landscapes. Prefers: Impressionism, realism and historic photos.

Terms: Accepts work on consignment (40% commission). Retail price set by the artist. Gallery provides insurance, promotion and contract. Shipping costs are shared. Prefers artwork framed.

Submissions: Accepts only artists from Yellowstone area. Prefers original art. No limited edition reproductions. Send query letter with résumé, brochure, 20 slides, photographs, artist's statement, bio, SASE in January and February only. Write for appointment to show portfolio of photographs, slides and transparencies. Replies in 1 month. Finds artists through word of mouth, referrals and artist submissions.

Tips: "Please don't drop in unannounced and want to show me your work!"

Nebraska

CARNEGIE ARTS CENTER, P.O. Box 375, 204 W. Fourth St., Alliance NE 69301. (308)762-4571. Gallery Director: Gretchen Garwood. Nonprofit gallery. Estab. 1993. Represents 300 emerging, mid-career and established artists/year. 90 members. Exhibited artists include: Rose Edin. Sponsors 12 shows/year. Average display time 1 month. Open all year; Tuesday-Saturday, 10-4; Sunday, 1-4. Located downtown; 2,346 sq. ft.; renovated Carnegie library built in 1911. Clients include tourists, upscale, local community and students. 90% of sales are to private collectors, 10% corporate collectors. Overall price range: $10-500; most work sold at $10-75.
Media: Considers all media and all types of prints. Most frequently exhibits watercolor, oil and silver jewelry.
Style: Exhibits all styles and genres. Prefers western, florals and Americana.
Terms: Accepts work on consignment (35% commission). Retail price set by the artist. Gallery provides promotion. Shipping costs are shared. Prefers artwork framed.
Submissions: Accepts only quality work. Send query. Write for appointment to show portfolio review of photographs, slides or transparencies. Replies only if interested within 1 month. Files résumé and contracts. Finds artists through word of mouth, referrals by other artists, visiting art fairs and exhibitions and artist's submissions.

N GALLERY 72, 2709 Leavenworth, Omaha NE 68105-2399. (402)345-3347. Director: Robert D. Rogers. Retail gallery and art consultancy. Estab. 1972. Interested in emerging, mid-career and established artists. Represents 10 artists. Sponsors 4 solo and 4 group shows/year. Average display time is 3 weeks. Clients include individuals, museums and corporations. 75% of sales are to private collectors, 25% corporate clients. Overall price range: $750 and up.
Media: Considers oil, acrylic, watercolor, pastel, pen & ink, drawings, mixed media, collage, sculpture, ceramic, installation, photography, original handpulled prints and posters. Most frequently exhibits paintings, prints and sculpture.
Style: Exhibits: hard-edge geometric abstraction, color field, minimalism, Impressionism and realism. Genres include landscapes and figurative work. Most frequently exhibits color field/geometric, Impressionism and realism.
Terms: Accepts work on consignment (commission varies), or buys outright. Retail price is set by gallery or artist. Gallery provides insurance; shipping costs and promotion are shared.
Submissions: Send query letter with résumé, slides and photographs. Call to schedule an appointment to show a portfolio, which should include originals, slides and transparencies. Vitae and slides are filed.
Tips: "It is best to call ahead and discuss whether there is any point in sending your material."

HAYDON GALLERY, 335 N. Eighth St., Suite A, Lincoln NE 68508. (402)475-5421. Fax: (402)472-9185. E-mail: ap63142@mail.itec.net. Director: Anne Pagel. Nonprofit project of the Nebraska Art Association in support of Sheldon Memorial Art Gallery and Sculpture Garden, UNL. Estab. 1984. Exhibits 100 mid-career and established artists. Exhibited artists include: Karen Kunc, Stephen Dinsmore, Ernest Ochsner, Jane Pronko, Tom Rierden and Susan Puelz. Sponsors 12 shows/year. Average display time 1 month. Open all year; Monday-Saturday, 10-5. Located in Historic Haymarket District (downtown); 2,500 sq. ft. 55% of space for special exhibitions. Clients include collectors, corporate, residential, architects and interior designers. 75% of sales are to private collectors, 25% corporate collectors. Overall price range: $75-20,000; most work sold at $500-3,000.
Media: Considers all media and all types of original prints. Most frequently exhibits paintings, mixed media and original prints.
Style: Exhibits: Considers all styles. Genres include landscapes, abstracts, still lifes and figurative work. Prefers: contemporary realism, nonrepresentational work in all styles.
Terms: Accepts work on consignment (45% commission). Retail price set by gallery and artist. Offers customer discounts and payment by installments. Gallery provides insurance, promotion, contract; artist pays for shipping.
Submission: Accepts primarily midwest artists. Send query letter with résumé, slides, reviews and SASE. Portfolio review requested if interested in artist's work. Portfolio should include originals, photographs or slides. Replies only if interested within 1 month (will return slides if SASE enclosed). Files slides and other support information. Finds artists through submissions, regional educational programs, visiting openings and exhibitions and news media.
Tips: "Professionalism and seriousness of artist and probability of a long-term working relationship are important. Don't think of galleries as taking commissions on your work. Look at it this way: You hire a gallery to do a service for you—one that will not cost a dime unless the gallery succeeds. If you are not satisfied with that service, you can go elsewhere. If you are satisfied, respect the relationship by being ethical, professional and accommodating."

N NOYES ART GALLERY, 119 S. Ninth, Lincoln NE 68508. (402)475-1061. Director: Julia Noyes. Cooperative and rental gallery, alternative space. Estab. 1994. Represents 48 emerging, mid-career and established artists/year. Exhibited artists include: Faridun Negmat-Zoda and Julia Noyes. Sponsors 12 shows/year. Average display time 1 month. Open all year; Monday-Saturday, 10-5; in November and December open 7 days a week. Located downtown Haymarket area; 1,200 sq. ft. downstairs, 300 upstairs; great location, quaint; above gallery we have 8 studios and a classroom; This was a gallery for 25 years before we bought it. ⅓ of space for special exhibitions; ⅔ of space for gallery

artists. Clients include upscale and local community. 20% of sales are to private collectors; 5% corporate collectors. Overall price range: $10-3,000; most work sold at $200-600.

Media: Considers all media and all types of prints except posters. Most frequently exhibits watercolor, acrylic, mixed media and pottery.

Style: Exhibits: expressionism, neo-expressionism, primitivism, painterly abstraction, surrealism, impressionism, photorealism, pattern painting, realism and imagism. Exhibits all genres. Prefers: impressionistic, realistic and abstraction.

Terms: Accepts work on consignment (30% commission) or co-op membership fee plus donation of time (10% commission). There is a rental fee for space. Retail price set by the gallery. Gallery provides promotion and contract; shipping costs are shared. Prefers artwork framed.

Submissions: Send résumé, slides, photographs, SASE and artist's statement. Call for appointment to show portfolio of photographs or slides. Replies in 1-2 months. Replies only if interested within 1 month. Files potential exhibit. Finds artists through word of mouth, referrals by other artists, visiting art fairs and exhibitions, submissions and art associations.

Tips: "Artists should make an appointment, be professional and organized. Their biggest mistake is that 'they want too much time.' "

WAREHOUSE GALLERY, 381 N. Walnut St., Grand Island NE 68801. (308)382-8589. Owner: Virginia Rinder. Retail gallery and custom framing. Estab. 1971. Represents 25-30 emerging artists/year. Exhibited artists include: Doug Johnson and Cindy Duff. Sponsors 3 shows/year. Average display time 1 month. Open all year; Monday-Friday, 10-5; Saturday, 10-3. Located in old downtown; 900 sq. ft.; old tin ceilings and skylights. 50% of space for special exhibitions. Clients include upscale and local community. Overall price range: $150-2,000; most work sold at $200-300.

Media: Considers oil, acrylic, watercolor, pastel, pen & ink, mixed media, collage, sculpture, ceramics, fiber, glass and photography; types of prints include woodcuts, wood engravings, serigraphs and linocuts. Most frequently exhibits watercolor, oil, acrylic and pastel.

Style: Exhibits: realism. Genres include florals and landscapes. Prefers: landscapes, florals and experimental.

Terms: Accepts work on consignment (40% commission). Retail price set by the artist. Gallery provides insurance, promotion and contract; artist pays for shipping. Prefers artwork framed.

Submissions: Accepts only artists from the Midwest. Send query letter with résumé, slides, photographs and SASE. Write for appointment to show portfolio of photographs or slides. Replies only if interested within 3 weeks. Finds artists through referrals by other artists, art fairs and exhibitions.

ADAM WHITNEY GALLERY, 8725 Shamrock Rd., Omaha NE 68114. (402)393-1051. Manager: Linda Campbell. Retail gallery. Estab. 1986. Represents 350 emerging, mid-career and established artists. Exhibited artists include: Richard Murray, Debra May, Dan Boylan, Ken and Kate Andersen, Scott Potter, Phil Hershberger and Brian Hirst. Average display time 3 months. Open all year; Monday-Saturday, 10-5. Located in countryside village; 5,500 sq. ft. 40% of space for special exhibitions. Overall price range: $150-10,000.

Media: Considers oil, paper, fiber, acrylic, sculpture, glass, watercolor, mixed media, ceramic, installation, pastel, collage, craft, jewelry. Most frequently exhibits glass, jewelry, 2-dimensional works.

Style: Exhibits all styles and genres.

Terms: Accepts work on consignment (50% commission). Retail price set by gallery and artist. Gallery provides insurance, promotion and contract; shipping costs are shared. Prefers artwork framed.

Submissions: Send query letter with résumé, slides, photographs and reviews. Call or write for appointment to show portfolio of originals, photographs and slides. Files résumé, slides, reviews.

Nevada

ART ENCOUNTER, 3979 Spring Mountain Rd., Las Vegas NV 89102. (702)227-0220. Fax: (702)227-3353. E-mail: rod@artencounter.com. Director: Rod Maly. Retail gallery. Estab. 1992. Represents 100 emerging and established artists/year. Exhibited artists include: Hermon Adams. Sponsors 4 shows/year. Open all year; Tuesday-Friday, 10-6; Saturday and Monday, 12-5. Located near the famous Las Vegas strip; 6,000 sq. ft. 20% of space for special exhibitions; 80% of space for gallery artists. Clients include upscale tourists and locals. 95% of sales are to private collectors, 5% corporate collectors. Overall price range: $200-20,000; most work sold at $400-600.

Media: Considers all media and all types of prints. Most frequently exhibits watercolor, oil and acrylic.

Style: Exhibits all styles and genres.

Terms: Rental fee for space; covers 6 months. Retail price set by the gallery and artist. Gallery provides promotion and contract; artist pays for shipping. Prefers artwork framed.

Submissions: Send 5-10 slides, photographs and SASE. Write for appointment to show portfolio of photographs or

 MARKETS NEW TO THIS EDITION

slides. Replies only if interested within 2 weeks. Files artist bio and résumé. Finds artists by advertising in the *Artist's Magazine, American Artist*, art shows and word of mouth.
Tips: "Poor visuals and no SASE are common mistakes."

N 🏛 ARTIST'S CO-OP OF RENO, 627 Mill St., Reno NV 89502. (702)322-8896. Cooperative nonprofit gallery. Estab. 1966. 20 emerging, mid-career and established artists. Sponsors 6 shows/year. Average display time 6 months. Exhibits 12 feature shows/year and quarterly all-gallery change of show. Open all year; Monday-Sunday, 11-4. Located in fringes of downtown; 1,000 sq. ft. in historic, turn of century "French laundry" building. 10% of space for special exhibitions; 90% of space for gallery artists. Clients include tourists, upscale and local community. 90% of sales are to private collectors, 10% corporate collectors. Overall price range: $50-400; $50-200.
Media: Considers all media. Does not sell prints. Most frequently exhibits watercolor, oil and mixed media.
Style: Exhibits: conceptualism, photorealism, color field, realism and imagism. Genres include western, landscapes, florals, wildlife, Americana, portraits, southwestern and figurative work. Prefers florals, landscapes and Americana.
Terms: There is Co-op membership fee plus a donation of time. There is a 15% commission. Retail price set by the artist. Gallery provides promotion. Artist pays for shipping costs from gallery. Prefers art framed.
Submissions: Accepts only artists from northern Nevada. Send query letter with résumé, slides, photographs, reviews and bio. Call for appointment to show portfolio. Finds artists through word of mouth and artists' visits.
Tips: "We are very small and keep our gallery at 20 local artists."

N CONTEMPORARY ARTS COLLECTIVE, 103 E. Charlesten Blvd., Las Vegas NV 89104. (702)382-3886. Website: http://www.contemporary.artscollective.org. Director: Diane Bush. Alternative space, nonprofit gallery. Estab. 1989. Represents emerging and mid-career artists, 250 members. Exhibited artists include: Mary Warner and Marilee Hortt. Sponsors 9 shows/year. Average display time 5 weeks. Open all year; Tuesday-Saturday, 12-5. Located downtown; 710 sq. ft. Clients include tourists, local community and students. 75% of sales are to private collectors, 25% corporate collectors. Overall price range: $250-2,000; most work sold at $400.
Media: Considers all media and all types of prints. Most frequently exhibits painting, photography and mixed media.
Style: Exhibits: conceptualism, only group shows of contemporary fine art. Genres include all contemporary art/all media. Artist pays shipping costs. Prefers artwork unframed. Finds artists through entries.
Tips: "We only show group shows that are self curated, or curated by outside curators. Groups need to be three to four artists or more. Annual guidelines are sent out in November for next coming year. We are looking for experimental and innovative work."

NEVADA MUSEUM OF ART, E.L. Wiegand Gallery, 160 W. Liberty St., Reno NV 89501. (775)329-3333. Fax: (775)329-1541. E-mail: art@nma.reno.nv.us. Website: http://nevadaart.org. Curator: Diane Deming. Museum. Estab. 1931. Hosts 8-12 exhibitions/year. Average display time: 6-8 weeks. Open all year. Located downtown in business district. 80% of space for special exhibitions. "NMA is a nonprofit private art museum. Museum curates individual and group exhibitions and has active acquisition policy related to the mission of the institution."
Media: Considers all media.
Style: Exhibits all styles and genres.
Terms: Acquires art "by committee following strict acquisition guidelines per the mission of the institution."
Submissions: Send query letter with slides. Write to schedule an appointment to show a portfolio.

GENE SPECK'S SILVER STATE GALLERY, 719 Plumas St., Reno NV 89509. (702)324-2323. Fax: (702)324-5425. Owner: Carolyn Barnes. Retail gallery. Estab. 1989. Represents 10-15 emerging, mid-career and established artists/year. Exhibited artists include: Gene Speck and Mary Lee Fulkerson. Sponsors 15-20 shows/year. Average display time 2-4 weeks. Closed for the month of January. Open Monday-Saturday, 11-6; Sunday, 12-5. Located within walking distance of downtown; 700 sq. ft.; refurbished brick house from 1911, charming garden patio. 50% of space for special exhibitions; 50% of space for gallery artists. Clients include tourists, upscale, local community and students. 80% of sales are to private collectors, 20% corporate collectors. Overall price range $20-5,500; most work sold at $100-2,000.
Media: Considers oil, acrylic, watercolor, pastel, pen & ink, paper, ceramics, fiber, jewelry and glass. Most frequently exhibits oils, fiber and watercolor.
Style: Exhibits: realism. Genres include western, wildlife, southwestern, landscapes and Americana.
Terms: Accepts work on consignment (30% commission). Retail price set by the artist. Gallery provides insurance, promotion and contract. Shipping costs are shared. Prefers artwork framed.
Submissions: Accepts only local artists. Send query letter with résumé, brochure, slides, photographs, artist's statement and bio. Call or write for appointment to show portfolio of photographs. Replies only if interested within 3 weeks. Finds artists through word of mouth and referrals by other artists.

STUDIO WEST, 8447 W. Lake Mead, Las Vegas NV 89128. (702)228-1901. Fax: (702)228-1622. Manager: Sharon Darcy. Retail gallery, framing. Estab. 1994. Represents 20 mid-career and established artists/year. May be interested in seeing the work of emerging artists in the future. Exhibited artists include: Thomas Kinkade and Robert Bateman. Sponsors 2 shows/year. Average display time 1 month. Open all year; Monday-Friday, 10-6; Saturday, 10-5. 1,200 sq. ft.; pueblo style architecture. 50% of space for special exhibitions; 50% of space for gallery artists. Clients include local community. 90% of sales are to private collectors, 10% corporate collectors. Overall price range: $100-1,200; most work sold at $700.

Media: Considers all media and all types of prints. Most frequently exhibits watercolor, paper and oil.

Style: Exhibits all styles and genres. Prefers landscape, wildlife and florals.

Terms: Accepts work on consignment (40% commission). Buys outright for 50% of the retail price. Retail price set by the artist. Gallery provides insurance, promotion and contract. Artists pays shipping costs.

Submissions: Send query letter with photographs. Call or write for appointment to show portfolio of photographs. Replies only if interested with 1 month. Files bio photos. Finds artists through word of mouth, referrals by other aritsts, visiting art fairs and exhibitions and artist's submissions.

N WASHOE TRADING POST THE GALLERY, 455 N. Hwy. 395, Carson City NV 89704. (702)849-9595. Fax: (702)849-2546. Owner: Joseph Santana. Retail gallery. Estab. 1991. Represents 70 emerging and established artists/year. Exhibited artists include: Mark Hopkins. Sponsors 12 shows/year. Average display time 1 month. Open all year; Monday-Saturday, 9-5; Sunday, 10-5. Located on main highway; 2,000 sq. ft. Clients include tourists and upscale. Most work sold at $25-1,000.

Media: Considers all media except installation; woodcuts, lithographs, wood engravings, serigraphs and etchings. Most frequently exhibits clay-ceramics, bronzes and acrylics.

Style: Exhibits: primitivism and Native American. Genres include western, southwestern and Americana. Prefers Native American, primitive, southwestern and/or western.

Terms: Accepts work on consignment (50% commission). Retail price set by the gallery and the artist. Gallery provides insurance and promotion. Shipping costs are shared. Prefers artwork framed.

Submissions: The art must fit gallery's standards. Send query letter with résumé, photographs, artist's statement and bio. Write for appointment to show portfolio of photographs and bio. Replies only if interested within 1-2 months.

New Hampshire

DOWNTOWN ARTWORKS, P.O. Box 506, Plymouth NH 03264. (603)536-8946. Fax: (603)536-1876. Manager: Ruth Preston. Retail and nonprofit gallery. Estab. 1991. Represents 30 emerging artists/year. 30 members. Exhibited artists include: Cam Sinclair. Sponsors 10 shows/year. Average display time 3 weeks. Open all year; Monday-Friday, 9-5; Saturday, 9-2. Located downtown Plymouth; 600 sq. ft. 25% of space for special exhibitions; 25% of space for gallery artists. Clients include tourists and locals. Overall price range: $50-2,000; most work sold at $150-250

Media: Considers all media and all types of prints (limited edition). Most frequently exhibits oil, watercolor and mixed.

Style: Exhibits: photorealism. Genres include florals, wildlife and landscapes. Prefers: landscapes, florals and wildlife.

Terms: Accepts work on consignment (30% commission). Rental fee for space $30 for 1 month. Retail price set by the artist. Gallery provides insurance, promotion, contract, patron's list and tax information; artist pays for shipping. Prefers artwork framed.

Submissions: Accepts only artists from New Hampshire. Send business card and artist's statement. Call for appointment to show portfolio of photographs. Replies in 1 month. Finds artists by going to exhibitions and shows.

Tips: "Work should not be poorly framed and artists should not be unsure of price range."

MCGOWAN FINE ART, INC., 10 Hills Ave., Concord NH 03301. (603)225-2515. Fax: (603)225-7791. E-mail: mcgowanfa@aol.com or mcgowan@ici.net. Website: http://www.mcgowanfineart.com. Gallery Director: Sarah Hardy. Owner/Art Consultant: Mary McGowan. Retail gallery and art consultancy. Estab. 1980. Represents emerging, mid-career and established artists. Sponsors 4 shows/year. Average display time 1 month. Located just off Main Street. 75-100% of space for special exhibitions. Clients include residential and corporate. Most work sold at $125-9,000.

Media: Considers oil, acrylic, watercolor, pastel, mixed media, collage, works on paper, sculpture, woodcuts, wood engravings, linocuts, engravings, mezzotints, etchings, lithographs and serigraphs. Most frequently exhibits limited edition prints, monoprints and oil/acrylic.

Style: Exhibits: painterly abstraction, landscapes, etc.

Terms: Accepts work on consignment (50% commission). Retail price set by artist. Gallery provides insurance and promotion; negotiates payment of shipping costs. Prefers artwork unframed.

Submissions: Send query letter with résumé, 5-10 slides and bio. Replies in 1 month. Files materials.

Tips: "Be professional. I am interested in the number of years you have been devoted to art. Are you committed? Do you show growth in your work?"

THE OLD PRINT BARN—ART GALLERY, RR2, P.O. Box 978, Winona Rd., Meredith NH 03253-0978. (603)279-6479. Fax: (603)279-1337. Director: Sophia Lane. Retail gallery. Estab. 1976. Represents 90-100 mid-career and established artists/year. May be interested in seeing the work of emerging artists in the future. Exhibited artists include: Michael McCurdy, Ryland Loos and Joop Vegter. Sponsors 3-4 shows/year. Average display time 3-4 months. Open daily 10-5 (except Columbus Day to Thanksgiving Day, Christmas and New Years). Located in the country; over 4,000 sq. ft. May to October; remodeled antique 19th century barn; winters smaller quarters in 1790 home. 30% of space for special exhibitions; 70% of space for gallery artists. Clients include tourists and local. 99% of sales are to private collectors. Overall price range: $10-18,000; most work sold at $200-900

Media: Considers oil, watercolor, pastel, pen & ink, drawing and photography; types of prints include woodcuts,

engravings, lithographs, wood engravings, mezzotints, serigraphs, linocuts and etchings. Most frequently exhibits all works of art on paper.

Style: Exhibits: realism. Genres include florals, wildlife, landscapes and Americana. Prefers: landscapes, wildlife and antique engravings.

Terms: Accepts work on consignment. Retail price set by the gallery and artist. Gallery provides promotion; shipping costs are shared. Prefers artwork unframed but shrink-wrapped with 1 inch on top for clips so work can hang without damage to image or mat.

Submissions: Prefers only works of art on paper. No abstract or abstract work. Send query letter with résumé, brochure, 10-12 slides and artist's statement. Title, medium and size of artwork must be indicated, clearly on slide label. Call or write for appointment to show portfolio of photographs. Replies in a few weeks. Files query letter, statements, etc. Finds artists through word of mouth, referrals of other artists, visiting art fairs and exhibitions and submissions.

Tips: "Show your work to gallery owners in as many different regions as possible. Most gallery owners have a feeling of what will sell in their area. I certainly let artists know if I feel their images are not what will move in this area."

☑ **SHARON ARTS CENTER/KILLIAN GALLERY**, 457 Route 123, Sharon NH 03458. (603)924-7256. Fax: (603)924-6074. E-mail: sharonarts@sharonarts.org. Website: http://www.sharonarts.org. Curator of Exhibits: Randall Hoel. Nonprofit gallery. Estab. 1947. Represents 5-7 invitationals, 140 juried, 180 members emerging, mid-career and established artists/year. 1,030 members. Sponsors 8 shows/year. Average display time 6 weeks. Open all year; Monday-Saturday, 10-5; Sunday, 12-5. Located in a woodland setting; 1,000 sq. ft. Part of an arts center with a school of art and crafts and a crafts gallery shop. 87% of space for special exhibitions; 13% of space for gallery artists. Clients include tourist, local and regional. 85% of sales are to private collectors, 15% corporate collectors. Overall price range: $200-10,000; most work sold at $200-700.

Media: Considers all media and all types of prints including computer generated. Most frequently exhibits fine arts, crafts and historical.

Style: Exhibits: expressionism, primitivism, painterly abstraction, surrealism, postmodern works, impressionism, photo-realism, realism and imagism. Exhibits all genres. Prefers: representation, Impressionism and abstractions.

Terms: Accepts work on consignment (40% commission). Retail price set by the artist. Gallery provides insurance, promotion and contract; artist pays for shipping. Prefers artwork framed.

Submissions: Send query letter with résumé, slides, bio, photographs and reviews. Call for appointment to show portfolio of photographs or slides. Replies in 1-2 months. Files résumé, sample slides or photos. Send copies. Finds artists through visiting exhibitions, submissions and word of mouth.

Tips: "Artists shouldn't expect to exhibit right away. We plan exhibits 18 months in advance."

THORNE-SAGENDORPH ART GALLERY, Keene State College, Wyman Way, Keene NH 03435-3501. (603)358-2720. Director: Maureen Ahern. Nonprofit gallery. Estab. 1965. Represents emerging, mid-career and established artists. 600 members. Exhibited artists include: Jules Olitski and Fritz Scholder. Sponsors 5 shows/year. Average display time 4-6 weeks. Open Monday-Saturday, 12-4; Thursday and Friday evenings till 7. Follows college schedule. Located on campus; 4,000 sq. ft.; climate control, security. 50% of space for special exhibitions. Clients include local community and students.

Media: Considers all media and all types of prints.

Style: Exhibits: Considers all styles.

Terms: Accepts work on consignment (30% commission). Retail price set by the artist. Gallery provides insurance, promotion and contract; shipping costs are shared. Prefers artwork framed.

Submissions: Artist's portfolio should include photographs and transparencies. Replies only if interested within 2 months. Files all material.

New Jersey

☑ **ARC-EN-CIEL**, 64 Naughright Rd., Long Valley NJ 07853. (908)876-9671. Owner: Ruth Reed. Retail gallery and art consultancy. Estab. 1980. Exhibited artists include: Andre Pierre, Petian Savain, Alexander Gregoire, Shalomda Safed, Wilmino Domond, Micius Stephane, Gerard Valcin and Seymore Bottex. 50% of sales are to private collectors, 50% corporate clients. Average display time is 6 weeks-3 months. Open by appointment only. Represents emerging, mid-career and established artists. Overall price range: $150-158,000; most artwork sold at $250-2,000.

Media: Considers oil, acrylic, wood carvings, sculpture. Most frequently exhibits acrylic, painted iron, oil.

Style: Exhibits minimalism and primitivism. "I exhibit country-style paintings, native art from around the world. The art can be on wood, iron or canvas."

Terms: Accepts work on consignment (50% commission). Retail price is set by gallery and artist. Customer discounts and payment by installment are available. Exclusive area representation required. Gallery provides promotion; shipping costs are shared.

Submissions: Send query letter, photographs and SASE. Portfolio review requested if interested in artist's work. Photographs are filed. Finds artists through word of mouth and art collectors' referrals.

N BARRON ARTS CENTER, 582 Rahway Ave., Woodbridge NJ 07095. (908)634-0413. Director: Stephen J. Kager. Nonprofit gallery. Estab. 1977. Interested in emerging, mid-career and established artists. Sponsors several solo and group shows/year. Average display time is 1 month. Clients include culturally minded individuals mainly from the central New Jersey region. 80% of sales are to private collectors, 20% corporate clients. Overall price range: $200-5,000.

Media: Considers oil, acrylic, watercolor, pastel, pen & ink, drawings, mixed media, collage, works on paper, sculpture, ceramic, craft, fiber, glass, installation, photography, performance and original handpulled prints. Most frequently exhibits acrylic, photography and mixed media.

Style: Exhibits: painterly abstraction, Impressionism, photorealism, realism and surrealism. Genres include landscapes and figurative work. Prefers painterly abstraction, photorealism and realism.

Terms: Accepts work on consignment. Retail price set by artist. Exclusive area representation not required. Gallery provides insurance, promotion and contract; artist pays for shipping.

Submissions: Send query letter, résumé and slides. Call for appointment to show portfolio. Résumés and slides are filed.

Tips: Most common mistakes artists make in presenting their work are "improper matting and framing and poor quality slides. There's a trend toward exhibition of more affordable pieces—pieces in the lower end of price range."

N BLACKWELL ST. CENTER FOR THE ARTS, P.O. Box 808, Denville NJ 07834. (973)316-0857. E-mail: wblakeart@nac.net. Website: http://www.blackwell-st-artists.org. Director: Annette Hanna. Nonprofit group. Estab. 1983. Exhibits the work of approximately 15 or more emerging and established artists. Sponsors 3-4 group shows/year. Average display time 1 month. Overall price range $100-5,000; most work sold at $150-350.

Media: Considers oil, acrylic, watercolor, pastel, pen & ink, drawings, mixed media, collage, paper, sculpture, ceramics, photography, egg tempera, woodcuts, wood engravings, linocuts, engravings, mezzotints, etchings, lithographs and serigraphs. Most frequently exhibits oil, photography and pastel.

Style: Exhibits all styles and genres. Prefers painterly abstraction, realism and photorealism.

Terms: Membership fee plus donation of time; 20% commission. Retail price set by artist. Sometimes offers payment by installments. Exclusive area representation not required. Artist pays for shipping. Prefers artwork framed.

Submissions: Send query letter with résumé, brochure, slides photographs, bio and SASE. Call or write for appointment to show portfolio of originals and slides. Replies in 1 month. Files slides of accepted artists. All material returned if not accepted or under consideration.

Tips: "Show one style of work and pick the best—less is more. Slides and/or photos should be current work. Enthusiasm and organization are big pluses!"

MABEL SMITH DOUGLASS LIBRARY, Douglass College, New Brunswick NJ 08901. (732)932-9407. Fax: (732)932-6667. E-mail: olin@rci.rutgers.edu. Website: http://www.libraries.rutgers.edu/rulib/abtlib/dglsslib/gen/events/was.htm. Curator: Ferris Olin. Alternative exhibition space for exhibitions of works by women artists. Estab. 1971. Represents/exhibits 5-7 emerging, mid-career and established artists/year. Interested in seeing the work of emerging artists. Sponsors 5-7 shows/year. Average display time 5-6 weeks. Open September-June; Monday-Sunday approximately 12 hours a day. Located on college campus in urban area; lobby-area of library. Clients include students, faculty and community.

Media: Considers all media.

Style: Exhibits all styles and genres.

Terms: Retail price by the artist. Gallery provides insurance, promotion and arranges transportation. Prefers artwork framed.

Submissions: Exhibitions are curated by invitation. Portfolio should include 5 slides. Finds artists through referrals.

GALMAN LEPOW ASSOCIATES, INC., 1879 Old Cuthbert Rd., #12, Cherry Hill NJ 08034. (609)354-0771. Contact: Judith Lepow. Art consultancy. Estab. 1979. Represents emerging, mid-career and established artists. Open all year. 1% of sales are to private collectors, 99% corporate collectors. Overall price range: $300-20,000; most work sold at $500-5,000.

Media: Considers oil, acrylic, watercolor, pastel, mixed media, collage, paper, sculpture, ceramic, craft, fiber, glass, photography, original handpulled prints, woodcuts, engravings, lithographs, pochoir, wood engravings, mezzotints, linocuts, etchings, and serigraphs.

Style: Exhibits: painterly abstraction, Impressionism, realism, photorealism, pattern painting and hard-edge geometric abstraction. Genres include landscapes, florals and figurative work.

Terms: Accepts artwork on consignment (40-50% commission). Retail price set by artist. Gallery provides insurance; shipping costs are shared. Prefers artwork unframed.

Submissions: Send query letter with résumé, slides and SASE. Call for appointment to show portfolio of originals, slides and transparencies. Replies in 3 weeks. Files "anything we feel we might ultimately show to a client."

N DAVID GARY LTD. FINE ART, 158 Spring St., Millburn NJ 07041. (973)467-9240. Fax: (973)467-2435. Director: Steve Suskauer. Retail and wholesale gallery. Estab. 1971. Represents 17-20 mid-career and established artists. Exhibited artists include: John Talbot and Marlene Lenker. Sponsors 3 shows/year. Average display time 3 weeks. Open all year. Located in the suburbs; 2,000 sq. ft.; high ceilings with sky lights. Clients include "upper income." 70% of

sales are to private collectors, 30% corporate collectors. Overall price range: $250-25,000; most work sold at $1,000-15,000.

Media: Considers oil, acrylic, watercolor, drawings, sculpture, pastel, woodcuts, engravings, lithographs, wood engravings, mezzotints, linocuts, etchings and serigraphs. Most frequently exhibits oil, original graphics and sculpture.

Style: Exhibits: primitivism, painterly abstraction, surrealism, Impressionism, realism and collage. All genres. Prefers Impressionism, painterly abstraction and realism.

Terms: Accepts artwork on consignment (50% commission). Retail price set by gallery and artist. Gallery services vary; artist pays for shipping. Prefers artwork unframed.

Submissions: Send query letter with résumé, photographs and reviews. Call for appointment to show portfolio of originals, photographs and transparencies. Replies in 1-2 weeks. Files "what is interesting to gallery."

Tips: "Have a basic knowledge of how a gallery works, and understand that the gallery is a business."

N KEARON-HEMPENSTALL GALLERY, 536 Bergen Ave., Jersey City NJ 07304. (201)333-8855. Fax: (201)333-8488. E-mail: khgallery@aol.com. Director: Suzann McKiernan. Retail gallery. Estab. 1981. Represents emerging, mid-career and established artists. Exhibited artists include: Dong Sik-Lee, Mary Buondies, Jesus Rivera, Stan Mullins, Linda Marchand, Bracha Guy, Elizabeth Bisbing and Kamil Kubik. Sponsors 3 shows/year. Average display time 2 months. Open all year; Monday-Friday, 10-3; closed July and August. Located on a major commercial street; 150 sq. ft.; brownstone main floor, ribbon parquet floors, 14 ft. ceilings, ornate moldings, traditional. 60% of space for special exhibitions; 40% of space for gallery artists. Clients include local community and corporate. 60% of sales are to private collectors, 40% corporate collectors. Overall price range: $200-8,000; most work sold at $1,500-2,500.

Media: Considers oil, acrylic, watercolor, pastel, drawing, mixed media, collage, paper, sculpture, fiber, glass, installation, photography, engravings, lithographs, serigraphs, etchings and posters. Most frequently exhibits mixed media painting, photography and sculpture.

Style: Prefers figurative expressionism and realism.

Terms: Accepts work on consignment (50% commission). Retail price set by the gallery. Gallery provides promotion; artist pays for shipping. Prefers artwork framed.

Submissions: Send query letter with résumé, slides, bio, brochure, SASE, reviews, artist's statement, price list of sold work. Write for appointment to show portfolio of photographs and slides. Replies in 6 weeks. Files slides and résumés. Finds artists through art exhibitions, magazines (trade), submissions.

Tips: "Be sure to include any prior show listings with prices for sold work and have an idea of marketing."

N LANDSMAN'S GALLERY & PICTURE FRAMING, 401 S. Rt. 30, Magnolia NJ 08049. (609) Fine Art. Fax: (609)784-0334. Owner: Howard Landsman. Retail gallery and art consultancy. Estab. 1965. Represents/exhibits 25 emerging, mid-career and established artists/year. Interested in seeing the work of emerging artists. Open all year; Tuesday-Saturday, 9-5. Located in suburban service-oriented area; 2,000 sq. ft. "A refuge in an urban suburban maze." Clients include upscale, local and established. 50% of sales are to private collectors, 50% corporate collectors. Overall price range: $100-10,000; most work sold at $300-1,000.

Media: Considers all media and all types of prints. Most frequently exhibits serigraphs, oils and sculpture.

Style: Exhibits all styles and genres. Gallery provides insurance, promotion and contract. Artist pays for shipping costs. Prefers artwork framed.

Terms: Artwork is accepted on consignment (50% commission). Retail price set by artist. Gallery provides insurance, promotion, contract. Artist pays shipping costs. Prefers artwork framed.

Submissions: Send query letter with slides, photographs and reviews. Write for appointment to show portfolio of photographs and slides. Files slides, bios and résumé. Finds artists through word of mouth, referrals by other artists, visiting art fairs and exhibitions and submissions.

MARKEIM ART CENTER, Lincoln Ave. and Walnut St., Haddonfield NJ 08033. Phone/fax: (609)429-8585. Executive Director: Danielle Reich. Nonprofit gallery. Estab. 1956. Represents emerging, mid-career and established artists. 150 members. Sponsors 8-10 shows/year, both on and off site. Average display time 6-8 weeks. Open all year; Monday-Friday 8-3. Located downtown; 600 sq. ft. 75% of space for special exhibitions; 20% of space for gallery artists. Overall price range: $85-5,000.

Media: Considers all media. Must be original. Most frequently exhibits paintings, photography and sculpture.

Style: Exhibits all styles and genres.

Terms: Work not required to be for sale (20% commission taken if sold.) Retail price set by the artist. Gallery provides promotion and contract. Artwork must be ready to hang.

Submissions: Send query letter with résumé, slides, bio/brochure, photographs, SASE, business card, reviews and artist's statement. Write for appointment to show portfolio of photographs and slides. Files slide registry.

THE NOYES MUSEUM OF ART, Lily Lake Rd., Oceanville NJ 08231. (609)652-8848. Fax: (609)652-6166. Curator of Collections and Exhibitions: Stacy Smith. Museum. Estab. 1982. Exhibits emerging, mid-career and established artists. Sponsors 15 shows/year. Average display time 6 weeks to 3 months. Open all year; Wednesday-Sunday, 11-4. 9,000 sq. ft.; "modern, window-filled building successfully integrating art and nature; terraced interior central space with glass wall at bottom overlooking Lily Lake." 75% of space for special exhibitions. Clients include rural, suburban,

urban mix; high percentage of out-of-state vacationers during summer months. 100% of sales are to private collectors. "Price is not a factor in selecting works to exhibit."
Media: All types of fine art, craft and folk art.
Style: Exhibits all styles and genres.
Terms: Accepts work on consignment (10% commission). "Artwork not accepted solely for the purpose of selling; we are a nonprofit art museum." Retail price set by artist. Gallery provides insurance. Prefers artwork framed.
Submissions: Send query letter with résumé, slides, photographs and SASE. "Letter of inquiry must be sent; then museum will set up portfolio review if interested." Portfolio should include originals, photographs and slides. Replies in 1 month. "Materials only kept on premises if artist is from New Jersey and wishes to be included in New Jersey Artists Resource File or if artist is selected for inclusion in future exhibitions."

☑ **POLO GALLERY**, 276 Old River Rd., Edgewater NJ 07020. (201)945-8200. Fax: (201)224-0150. Director: Mark A. Polo. Retail gallery, art consultancy. Estab. 1993. Represents 250 emerging, mid-career and established artists/year. Exhibited artists include: Christian Hal, Itzak Benshalom, Alice Harrison, Tobias Weissman, Judy Lyons Schneider, Jim Wilson and Ross Brown. Sponsors 6 shows/year. Average display time 6-8 weeks. Open all year; Tuesday-Sunday, 1:30-6; Friday, 1:30-7. Located downtown, Shadyside section; 1,100 sq. ft.; Soho atmosphere in burgeoning art center. 70% of space for special exhibitions; 30% of space for gallery artists. Clients include tourists-passersby, private clientele, all economic strata. 90% of sales are to private collectors, 10% corporate collectors. Overall price range: $80-18,000; most work sold at $350-4,000.
Media: Considers all media and all types of prints. Most frequently exhibits oil, sculpture, works on paper.
Style: Exhibits all styles and genres. Prefers realism, painterly abstraction, conceptual.
Terms: Accepts work on consignment (50% commission). Retail price set by the gallery and the artist. Gallery provides promotion and contract; artist pays for shipping or costs are shared.
Submissions: Send query letter with résumé slides, bio, artist's statement, assumed price list. Call or write for appointment to show portfolio of slides and b&w prints for newspapers. Replies in 2 months. Artist should call if no contact. Files future show possibilities.
Tips: Common mistakes artists make are not labeling slides, not including price list, and sending slides of unavailable work.

QUIETUDE GARDEN GALLERY, 24 Fern Rd., East Brunswick NJ 08816. (732)257-4340. Fax: (732)257-1378. E-mail: quietude24@aol.com. Websites: http://www.sculpture-art.com and www.artnet.com/quietude.html. Owner: Sheila Thau. Retail/wholesale gallery and art consultancy. Estab. 1988. Represents 85 emerging, mid-career and established artists/year. Exhibited artists include: Tom Blatt and Nora Chavooshian. Open April 27-November 8; Friday, Saturday and Sunday, by appointment. Located in a suburb; 4 acres; unique work exhibited in natural and landscaped, wooded property—each work in its own environment. 25% of space for special exhibitions; 75% of space for gallery artists. Clients include upper middle class, private home owners and collectors, small corporations. 75% of sales are to private collectors, 25% corporate collectors. Overall price range: $2,000-50,000; most work sold at $10,000-20,000.
Media: Considers "only sculpture suitable for outdoor (year-round) display and sale." Most frequently exhibits metal (bronze, steel), ceramic and wood.
Style: Exhibits all styles.
Terms: Accepts work on consignment. Retail price set by the artist. Gallery provides insurance, promotion and contract; artist pays shipping costs to and from gallery.
Submissions: Send query letter with résumé, slides, bio, photographs, SASE and reviews. Write for appointment to show portfolio of photographs, slides and bio. Replies in 2 weeks. Files "slides, bios of artists who we would like to represent or who we do represent." Finds artists through word of mouth, publicity on current shows and ads in art magazines.
Tips: "Always looking for different 'voices' to enhance range in the gallery."

▧ **SERAPHIM FINE ARTS GALLERY**, Dept. AM, 19 Engle St., Tenafly NJ 07020. (201)568-4432. Directors: E. Bruck and M. Lipton-Rigolosi. Retail gallery. Represents 150 emerging, mid-career and established artists. 90% of sales are to private collectors, 10% corporate clients. Overall price range: $700-17,000; most work sold at $2,000-5,000.
Media: Considers oil, acrylic, watercolor, drawings, collage, sculpture and ceramic. Most frequently exhibits oil, acrylic and sculpture.
Style: Exhibits: Impressionism, realism, photorealism, painterly abstraction and conceptualism. Considers all genres. Prefers Impressionism, realism and figure painting. "We are located in New Jersey, but we function as a New York gallery. We put together shows of artists who are unique. We represent fine contemporary artists and sculptors."
Terms: Accepts work on consignment. Retail price set by gallery and artist. Exclusive area representation required. Gallery provides insurance and promotion. Prefers framed artwork.
Submissions: Send query letter with résumé, slides and photographs. Portfolio should include originals, slides and photographs. Replies in 2-4 weeks. Files slides and bios.
Tips: Looking for "artistic integrity, creativity and an artistic ability to express self." Notices a "return to interest in figurative work."

BEN SHAHN GALLERIES, William Paterson University, 300 Pompton Rd, Wayne NJ 07470. (973)720-2654. Director: Nancy Einreinhofer. Nonprofit gallery. Estab. 1968. Interested in emerging and established artists. Sponsors 5 solo

and 10 group shows/year. Average display time is 6 weeks. Clients include college, local and New Jersey metropolitan-area community.

• The gallery specializes in contemporary art and encourages site-specific installations. They also have a significant public sculpture collection and welcome proposals.

Media: Considers all media.

Style: Specializes in contemporary and historic styles, but will consider all styles.

Terms: Accepts work for exhibition only. Gallery provides insurance, promotion and contract; shipping costs are shared.

Submissions: Send query letter with résumé, brochure, slides, photographs and SASE. Write for appointment to show portfolio. Finds artists through submissions, referrals and exhibits.

WALKER-KORNBLUTH ART GALLERY, 7-21 Fair Lawn Ave., Fair Lawn NJ 07410. (201)791-3374. Director: Sally Walker. Retail gallery. Estab. 1965. Represents 20 mid-career and established artists/year. Exhibited artists include Stuart Shils, Larry Horowitz and Richard Segalman. Sponsors 8 shows/year. Open Tuesday-Saturday, 10-5:30; Sunday, 1-5; closed August. 2,000 sq. ft., 1920's building (brick), 2 very large display windows. 75% of space for special exhibitions; 25% of space for gallery artists. Clientele: mostly professional and business people. 85% private collectors, 15% corporate collectors. Overall price range: $400-45,000; most work sold at $1,000-4,000.

Media: Considers all media except installation. Considers all types of original prints (no limited edition prints). Most frequently exhibits oil, watercolor, pastel and monoprints.

Style: Exhibits: painterly abstraction, Impressionism, realism, landscapes, figurative work. Prefers painterly realism, Impressionism.

Terms: Accepts work on consignment (40-50% commission). Retail price set by the gallery and the artist. Gallery provides insurance and promotion; shipping costs are shared. Prefers artwork framed.

Submissions: "We don't usually show local artists." Send query letter with résumé, slides, reviews and SASE. Write for appointment to show portfolio of transparencies and slides. Files slides. Finds artists through word of mouth, referrals by other artists, visiting exhibitions and submissions.

Tips: "If you've never shown in a commercial gallery, please don't send slides. Have some idea of the kind of work we show; submitting inappropriate work is a waste of everyone's time."

WYCKOFF GALLERY, 648 Wyckoff Ave., Wyckoff NJ 07481. (201)891-7436. Director: Sherry Cosloy. Retail gallery. Estab. 1980. Interested in emerging, mid-career and established artists. Sponsors 1-2 solo and 4-6 group shows/year. Average display time 1 month. Clients include collectors, art lovers, interior decorators and businesses. 75% of sales are to private collectors, 25% corporate clients. Overall price range: $250-10,000; most artwork sold at $500-3,000.

Media: Considers oil, acrylic, watercolor, pastel, pen & ink, pencil, mixed media, sculpture, ceramic, collage and limited edition prints. Most frequently exhibits oil, watercolor and pastel.

Style: Exhibits: contemporary, abstract, traditional, impressionistic, figurative, landscape, floral, realistic and neo-expressionistic works.

Terms: Accepts work on consignment. Retail price set by gallery or artist. Gallery provides insurance and promotion.

Submissions: Send query letter with résumé, slides and SASE. Résumé and biography are filed.

Tips: Sees trend toward "renewed interest in traditionalism and realism."

New Mexico

THE ALBUQUERQUE MUSEUM, 2000 Mountain Rd. NW, Albuquerque NM 87104. (505)243-7255. Curator of Art: Ellen Landis. Nonprofit museum. Estab. 1967. Interested in emerging, mid-career and established artists. Sponsors mostly group shows. Average display time is 3-6 months. Located in Old Town (near downtown).

Media: Considers all media.

Style: Exhibits all styles. Genres include landscapes, florals, Americana, western, portraits, figurative and nonobjective work. "Our shows are from our permanent collection or are special traveling exhibitions originated by our staff. We also host special traveling exhibitions originated by other museums or exhibition services."

Submissions: Send query letter, résumé, slides, photographs and SASE. Call or write for appointment to show portfolio.

Tips: "Artists should leave slides and biographical information in order to give us a reference point for future work or to allow future consideration."

ART CENTER AT FULLER LODGE, 2132 Central Ave., Los Alamos NM 87544. (505)662-9331. Director: Gloria Gilmore-House. Nonprofit gallery and retail shop for members. Estab. 1977. 388 members. Sponsors 9 shows/year. Average display time 5 weeks. Open all year. Located downtown; 3,400 sq. ft. 90% of space for special exhibitions. Clients include local, regional and international visitors. 99% of sales are to private collectors, 1% corporate collectors. Overall price range: $50-1,200; most artwork sold at $30-300.

Media: Considers all media.

Style: Exhibits all styles and genres.

Terms: Accepts work by member artists on consignment (30% commission). Retail price set by the artist. Gallery provides insurance and promotion; artist pays for shipping. "Work should be in exhibition form (ready to hang)."

Submissions: "Prefer the unique." Send query letter with résumé, slides, bio, brochure, photographs, SASE and reviews. Files "résumés, etc.; slides returned only by SASE."

Tips: "We put on juried competitions, guild exhibitions and special shows throughout the year. Send SASE for prospectus and entry forms."

BENT GALLERY AND MUSEUM, 117 Bent St., Box 153, Taos NM 87571. (505)758-2376. Owner: Otto Noeding. Retail gallery and museum. Estab. 1961. Represents 15 emerging, mid-career and established artists. Exhibited artists include E. Martin Hennings, Joseph Sharp, Herbert Dunton and Leal Mack. Open all year. Located 1 block off of the Plaza; "in the home of Charles Bent, the first territorial governor of New Mexico." 95% of sales are to private collectors, 5% corporate collectors. Overall price range: $100-10,000; most work sold at $500-1,000.

Media: Considers oil, acrylic, watercolor, pastel, pen & ink, drawings, sculpture, original handpulled prints, woodcuts, engravings and lithographs.

Style: Exhibits: Impressionism and realism. Genres include traditional, landscapes, florals, southwestern and western. Prefers: Impressionism, landscapes and western works. "We continue to be interested in collectors' art: deceased Taos artists and founders works."

Terms: Accepts work on consignment (33⅓-50% commission). Retail price set by gallery and artist. Artist pays for shipping. Prefers artwork framed.

Submissions: Send query letter with brochure and photographs. Write for appointment to show portfolio of originals and photographs. Replies if applicable.

Tips: "It is best if the artist comes in person with examples of his or her work."

N DARTMOUTH STREET GALLERY, 3011 Monte Vista Ave., Albuquerque NM 87106. (505)266-7751. Fax: (505)266-0005. E-mail: jc@dsq-art.com. Website: http://www.dsq-art.com. Owner: John Cacciatore. Retail gallery. Estab. 1992. Represents/exhibits 25 mid-career and established artists/year. Exhibited artists include: Angus Macpherson and Nancy Kuzikowski. Sponsors 6 shows/year. Average display time 2 months. Open all year; Monday-Saturday, 11-5:30. Located near University of New Mexico; 3,000 sq. ft. 80% of space for special exhibitions; 20% of space for gallery artists. Clients include tourists, upscale, local community and corporate. 80% of sales are to private collectors, 20% corporate collectors. Overall price range $35-50,000; most work sold at $3,000-10,000.

Media: Considers all media except ceramic. Also considers tapestry. Most frequently exhibits acrylic or oil on canvas, works on paper.

Style: Exhibits hard-edge geometric abstraction, painterly abstraction, postmodern works, realism and impressionism. Genres include landscapes, southwestern and figurative work. Prefers landscapes, abstracts and figures.

Terms: Artwork is accepted on consignment (50% commission). Retail price set by the artist. Gallery provides insurance, promotion and contract; shipping costs are shared.

Submissions: Send query letter with résumé, brochure, slides, photographs, bio and SASE. Portfolio should include slides. Replies in 1 month.

Tips: "Have persistence. Visit our website, call or e-mail for details."

✓ IAC CONTEMPORARY ART/FISHER GALLERY, P.O. Box 11222, Albuquerque NM 87192-0222. (505)292-3675. E-mail: iac1@unm.edu. Website: http://www.iac1.freeservers.com. Broker/Gallery Owner: Michael F. Herrmann. Gallery, art consultancy. Estab. 1992. Represents emerging, mid-career and established artists from website. Coordinates studio visits for small groups and individuals. Represented artists include Michelle Cook, Vincent Distasio, Jeanette Entwisle and Lynn Fero. Overall price range: $250-40,000; most work sold at $800-7,000.

Media: Considers all media. Most frequently exhibits acrylics on canvas.

Style: Exhibits painterly abstraction, postmodern works and surrealism. Genres include figurative work.

Terms: Artwork is accepted on consignment (50% commission). "Fees vary depending on event, market, duration." Retail price set by collaborative agreement with artist. Artist pays shipping costs. Prefers artwork framed.

Submissions: Send query letter with résumé, brochure, business card, slides, photographs, reviews, bio and SASE. Call or write for appointment to show portfolio. Replies in 1 month.

Tips: "I characterize the work we show as Fine Art for the *Non*-McMainstream. We are always interested in seeing new work. We look for a strong body of work and when considering emerging artists we inquire about the artist's willingness to financially commit to their promotion. A website is essential today and it's much easier, at least initially, than slides. When sending slides, don't send a query letter, but always include a SASE."

EDITH LAMBERT GALLERY, 300 Galisteo St., 2nd Floor, Santa Fe NM 87501. (505)984-2783. Fax: (505)983-4494. E-mail: elbuyart@nets.com. Website: http://www.elg.com. Contact: Director. Retail gallery. Estab. 1986. Represents 30 emerging and mid-career artists. Exhibited artists include: Karen Yank, Deborah Edwards and Margaret Nes. Sponsors 4 shows/year. Average display time 3 weeks. Open Monday-Saturday, hours vary. Located in "downtown Santa Fe, south of the river. Parking available behind building." 20% of space for special exhibitions. 95% of sales are to private collectors. Overall price range: $100-4,500; most artwork sold at $500-2,600.

Media: Considers oil, acrylic, watercolor, pastel, mixed media, collage, works on paper, ceramic, mixed metal sculpture. Most frequently exhibits pastel, oil and mixed metal sculpture.

Style: Exhibits: expressionism, neo-expressionism and painterly abstraction. Genres include landscapes, southwestern and figurative work. No portraits or "animal" paintings.

Terms: Accepts work on consignment (50% commission). Exclusive area representation required. Retail price set by

gallery. Sometimes offers customer discounts and payment by installments. Provides insurance, promotion and contract; shipping costs are shared. Prefers framed artwork.

Submissions: Send query letter with résumé, 1 full sheet of slides, bio, SASE and reviews. Call for an appointment to show portfolio, which should include originals and slides. Replies only if interested within 1 month. Finds artists through visiting exhibitions, word of mouth, various art publications and sourcebooks, artists' submissions and art collectors' referrals.

Tips: Looks for "consistency, continuity in the work; artists with ability to interact well with collectors and have a commitment to their career."

THE LEWALLEN CONTEMPORARY GALLERY, 129 W. Palace Ave., Santa Fe NM 87501. (505)988-8997. Fax: (505)989-8702. Assistant Director: Craig Leibelt. Retail gallery. Represents 75 emerging, mid-career and established artists/year. Exhibited artists include: Tom Palmore, John Fincher. Sponsors 7 shows/year. Average display time 3-4 weeks. Open all year; Monday-Saturday, 9:30-5:30; Sunday 12-5:30 (summer); Tuesday-Saturday, 9:30-5; (winter). Located downtown; 10,000 sq. ft.; varied gallery spaces; upstairs barrel-vaulted ceiling with hardwood floors. 25-30% of space for special exhibitions; 75-70% of space for gallery artists. Clients include a "broad range—from established well-known collectors to those who are just starting." 95% of sales are to private collectors, 5% corporate collectors. Overall price range: $650-350,000; most work sold at $1,500-15,000.

Media: Considers oil, acrylic, mixed media, sculpture and installation, lithograph and serigraphs. Most frequently exhibits oil, mixed media and acrylic/sculpture.

Style: Exhibits: surrealism, minimalism, postmodern works, photorealism, hard-edge geometric abstraction and realism. Genres include landscapes, southwestern and western. Prefers realism/photorealism, postmodern works and minimalism.

Terms: Accepts work on consignment (50% commission). Retail price set by the gallery and the artist. Gallery provides insurance, promotion, contract and shipping costs from gallery; artist pays shipping costs to gallery. Prefers artwork framed.

Submissions: Prefers only "artists from the western United States but we consider all artists." Send query letter with résumé, slides or photographs, reviews and bio. "Artist must include self-addressed, stamped envelope if they want materials returned." Call for appointment to show portfolio of originals, photographs, slides or transparencies. Replies in 2 months. Finds artists through visiting exhibitions, various art magazines and art books, word of mouth, other artists and submissions.

N̶ MICHAEL McCORMICK GALLERY, 106-C Paseo del Pueblo Norte, Taos NM 87571. (505)758-1372. E-mail: michaelm@laplaza.org. Retail gallery. Estab. 1983. Represents 10 emerging and established artists. Provides 3 solo and 1 group show/year. Average display time 6 weeks. 90% of sales are to private collectors, 10% corporate clients. Overall price range: $1,500-85,000; most work sold at $3,500-10,000.

Media: Considers oil, acrylic, watercolor, pastel, pen & ink, drawings, mixed media, collage, works on paper, sculpture, ceramic, photography, wood engravings, linocuts, engravings, mezzotints, etchings, lithographs, pochoir, serigraphs and posters. Most frequently exhibits oil, pottery and sculpture/stone.

Style: Exhibits: Impressionism, neo-expressionism, surrealism, primitivism, painterly abstraction, conceptualism and postmodern works. Genres include landscapes and figurative work. Interested in work that is "classically, romantically, poetically, musically modern." Prefers figurative work, lyrical Impressionism and abstraction.

Terms: Accepts work on adjusted consignment (approximately 50% commission). Retail price set by gallery and artist. Customer discounts and payment by installment are available. Exclusive area representation required. Gallery provides promotion and contract; artist pays for shipping. Prefers artwork framed.

Submissions: Send query letter with résumé, brochure, slides, photographs, bio and SASE. Portfolio review requested if interested in artist's work. Replies in 4-7 weeks. Finds artists usually through word of mouth and artists traveling through town.

Tips: "Send a brief, concise introduction with several color photos. During this last year there seems to be more art and more artists but fewer sales. The quality is declining based on mad, frantic scramble to find something that will sell."

MAYANS GALLERIES, LTD., 601 Canyon Rd., Santa Fe NM 87501; also at Box 1884, Santa Fe NM 87504. (505)983-8068. Fax: (505)982-1999. E-mail: arte4@aol.com. Website: http://www.artnet.com/mayans.html. Contact: Johanna Saretzki or Ava Hu. Retail gallery and art consultancy. Estab. 1977. Represents 10 emerging, mid-career and established artists. Sponsors 2 solo and 2 group shows/year. Average display time 1 month. Clientele: 70% private collectors, 30% corporate clients. Overall price range: $350 and up; most work sold at $500-7,500.

Media: Considers oil, acrylic, watercolor, pastel, pen & ink, drawings, mixed media, sculpture, photography and original handpulled prints. Most frequently exhibits oil, photography, and lithographs.

Style: Exhibits 20th century American and Latin American art. Genres include landscapes and figurative work."

Terms: Accepts work on consignment. Retail price set by gallery and artist. Exclusive area representation required.

Submissions: Send query letter (or e-mail first), résumé, business card and SASE. Discourages the use of slides. Prefers 2 or 3 snapshots or color photocopies which are representative of body of work. Files résumé and business card.

Tips: "Currently seeking contemporary figurative work and still life with strong color and technique. Gallery space can accomodate small-scale work comfortably."

NEW DIRECTIONS GALLERY, 107-B N. Plaza, Taos NM 87571. Phone/fax: (505)758-2771. Director/Owner: Cecelia Torres. Assistant Director: Ann Liebert. Retail gallery. Estab. 1988. Represents/exhibits 12 emerging, mid-career and established artists. Interested in seeing work of emerging artists. Exhibited artists include: Maye Torres and Larry Bell. Sponsors 1-3 shows/year. Average display time 1 month. Open all year; Monday-Sunday, 10-5. Located in North Plaza; 1,100 sq. ft.. 25-33⅓% of space for special exhibitions; 66-75% of space for gallery artists. 100% of sales are to private collectors. Overall price range: $150-32,000; most work sold at $900-12,000.
Media: Considers all original media except craft. Considers woodcut, etching, lithograph, serigraphs and posters. Most frequently exhibits original mixed media/collage, acrylic or oil on canvas, sculpture-bronze.
Style: Exhibits: expressionism, minimalism, hard-edge geometric abstraction, painterly abstraction and postmodern works. Prefers: non-objective, highly stylized and expressive.
Terms: Artwork is accepted on consignment (40% commission). Retail price set by the artist. Gallery and artist split promotion. Prefers artwork framed.
Submissions: Accepts only artists from Taos. Call or come in to gallery for appointment to show portfolio of photographs. Replies in weeks. Files only "material I'm seriously considering."
Tips: "I'm always looking."

ROSWELL MUSEUM AND ART CENTER, 100 W. 11th St., Roswell NM 88201. (505)624-6744. Fax: (505)624-6765. Website: http://www.roswellmuseum.org. Director: Laurie J. Rufe. Museum. Estab. 1937. Represents emerging, mid-career and established southwestern artists. Sponsors 7-9 shows/year. Average display time 2-4 months. Open all year; Monday-Saturday, 9-5; Sunday and holidays, 1-5. Closed Thanksgiving, Christmas Eve, Christmas and New Year's Day. Located downtown; 40,000 sq. ft.; specializes in Southwest. 50% of space for special exhibitions; 50% of space for gallery artists.
Media: Considers all media and all types of prints but posters. Most frequently exhibits painting, prints and sculpture.
Style: Exhibits: Considers all styles. Prefers: southwestern but some non-SW for context.
Terms: Accepts work on consignment (20% commission). Retail price set by the artist. Gallery provides insurance, promotion and shipping costs to and from gallery. Prefers artwork framed.
Submissions: Accepts only artists from southwest or SW genre. Send query letter with résumé, slides, bio, brochure, photographs, SASE and reviews. Write for appointment to show portfolio of photographs, slides and transparencies. Replies in 1 week. Files "all material not required to return."
Tips: Looks for "southwest artists or artists consistently working in southwest genre." Advises artists to "make an appointment well in advance. Be on time. Be prepared. Don't bring a truckload of paintings or sculpture. Have copies of résumé and transparencies for filing. Be patient. We're presently scheduling shows two years in advance."

SHIDONI GALLERY, P.O. Box 250, Tesuque NM 87574. (505)988-8001. Fax: (505)984-8115. Owner: T.C. Hicks. Retail gallery, art consultancy and sculpture garden. Estab. 1971. 80% of sales are to private collectors, 20% corporate clients. Represents 100 emerging, mid-career and established artists. Exhibited artists include Bill Weaver and Frank Morbillo. "Located five miles north of Santa Fe; sculpture gardens are eight and a half acres."Open all year; Monday-Saturday, 9-5. Overall price range: $400-150,000; most artwork sold at $1,800-15,000.
Media: Considers all media primarily indoor and outdoor sculpture. Most frequently exhibits cast bronze, fabricated sculpture.
Style: Exhibits all styles. Genres include wildlife and figurative work. "The ideal artwork is new, exciting, original, unpretentious and honest. We seek artists who are totally devoted to art, who display a deep passion for the process of making art and who are driven by a personal and spiritual need to satisfy an inventive mind." Interested in seeing a full range of artworks. Sculpture: varies from classical-traditional to figurative and non-objective.
Terms: Accepts work on consignment. Retail price is set by artist. Exclusive area representation required. Gallery provides insurance and contract; artist pays for shipping.
Submissions: Send query letter, résumé, slides, bio, photographs and SASE. Call to schedule an appointment to show a portfolio, which should include slides and transparencies, résumé, catalogs, clippings, dimensions and prices. Slides and résumés are filed in registry. "Please indicate your interest in leaving your slides and résumé in the registry." The most common mistakes artists make in presenting their work is failing to show up for an appointment, having inadequate or poor slides and apologizing for their work. Replies only if interested in 6 weeks.
Tips: Looks for "continuity, focus for subject matter."

New York

ADIRONDACK LAKES CENTER FOR THE ARTS, Route 28, Blue Mountain Lake NY 12812. (518)352-7715. E-mail: alca@telnet.net. Director: Ellen C. Bütz. Nonprofit gallery in multi-arts center. Estab. 1967. Represents 107 emerging, mid-career and established artists/year. Sponsors 6-8 summer shows/year. Average display time 1 month. Open Monday-Friday, 10-4; July and August daily. Located on Main Street next to Post Office; 176 sq. ft.; "pedestals and walls are white, some wood and very versatile." Clients include tourists, summer owners and year-round residents. 90% of sales are to private collectors, 10% corporate collectors. Overall price range: $100-10,000; most work sold at $100-1,000.
Media: Considers all media and all types of prints. Most frequently exhibits paintings, sculpture, wood and fiber arts.

Style: Exhibits all styles. Genres include landscapes, Americana, wildlife and portraits. Prefers landscapes, wildlife and folk art/crafts (quilts).

Terms: Accepts work on consignment (30% commission). Retail price set by the artist. Gallery provides insurance, contract; shares promotion. Prefers artwork framed.

Submissions: Send query letter with slides or photos and bio. Annual reviews of submissions each February; selections complete by April 1. Files "slides, photos and bios on artists we're interested in." Reviews submissions once/year. Finds artists through word of mouth, art publications and artists' submissions.

ALBANY CENTER GALLERIES, 23 Monroe St., Albany NY 12210. (518)462-4775. Nonprofit gallery. Estab. 1977. Represents/exhibits emerging, mid-career and established artists. May be interested in seeing work of emerging artists in the future. Presents 12 exhibitions of 6 weeks each year. Exhibited artists include: Leigh Wen, David Coughtry, Regis Brodie, Harry Orlyk, Martin Benjamin, Sue Rees, David Miller, Robert Cartmell and Benigna Chilla. Selects 12 shows/year. Average display time 6 weeks. Located downtown; 9,000 sq. ft.; "excellent well-lit space." 100% of space for gallery artists. Clients include tourists, upscale, local community and students. 2% of sales are to private collectors. Overall price range: $250-5,000; most work sold at $800-1,200.

Media: Considers all media and prints except posters. Most frequently exhibits oil, sculpture and photography.

Style: Exhibits all styles and genres. Prefers: painterly abstraction, representational, sculpture and ceramics.

Terms: Artwork is accepted on consignment (30% commission). Retail price set by the artist. Gallery provides insurance, promotion, contract, reception and sales. Artist pays for shipping costs. Prefers artwork framed.

Submissions: Accepts only artists from within a 75 mile radius of Albany (the Mohawk-Hudson area). Send query letter with résumé, slides, reviews, bio and SASE. Call for appointment to show portfolio of photographs, slides and transparencies. Replies only if interested within 1 week. Files slides, résumés, etc. Finds artists through visiting exhibitions, submissions.

ART DIALOGUE GALLERY, One Linwood Ave., Buffalo NY 14209-2203. (716)885-2251. Director: Donald James Siuta. Retail gallery, art consultancy. Estab. 1985. Represents 550 emerging, mid-career and established artists/year. Exhibited artists include: Catherine Burchfield Parker, Alberto Rey, Raymond A Massey. Sponsors 14 shows/year. Average display time 4-6 weeks. Open all year; Tuesday-Friday, 11-5; Saturday, 11-3. Located in downtown Buffalo/Allentown District; 1,200 sq. ft. 80% of space for special exhibitions; 20% of space for gallery artists. Clients include young professionals and collectors. 60% of sales are to private collectors, 20% corporate collectors. Overall price range: $100-25,000; most work sold at $300-500.

• The gallery recently added an additional 800 sq. ft. of exhibition space.

Media: Considers oil, acrylic, watercolor, pastel, pen & ink, drawing, mixed media, collage, paper, sculpture, ceramics, glass, photography and all types of prints. Most frequently exhibits oil painting, watercolor and mixed media.

Style: Prefers: realism, abstract and cutting edge.

Terms: Accepts work on consignment (40% commission). Retail price set by the gallery. "Artwork is insured from time of delivery to set pick-up date. Artists pay for promotion-invitations, etc." Artist pays shipping costs. Prefers artwork framed for shows, unframed for stacks.

Submissions: Accepts only artists from western New York, southern Ontario. Send query letter with résumé, full sheet of slides (work that is available only), bio, photographs, SASE, reviews, artist's statement. Call or write for appointment to show portfolio of slides. Files slides and résumés. Finds artists through word of mouth, referrals by artists, visiting art fairs and exhibitions and submissions.

Tips: "Enter as many juried exhibits as you can. Even if an artist can only supply us with one or two works a year, we will show his work as long as it is good. We hope this attitude will encourage more work more often if it sells."

ARTFORMS, 5 New Karner Rd., Guilderland NY 12084. (518)464-3355. Fax: (518)464-3358. President: Gary Weitzman and Jan Reiss-Weitzman. Retail gallery and art consultancy featuring fine art and art glass. Estab. 1997. Represents 10-20 emerging, mid-career and established artists. Exhibited artists include: Jane Bloodgood-Abrams, Thom O'Connor, John Stockwell and John Burchetta. Open all year. Located 2.5 miles west of the Adirondack Northway. Clients include banking, industry and healthcare. Overall price range: $50-5,000; most work sold at $500-2,000.

Media: Considers oil, acrylic, watercolor, pastel, mixed media, glass, sculpture, ceramic, fiber, original handpulled prints.

Style: Exhibits: expressionism, painterly abstraction, minimalism, color field, postmodern works, impressionism, realism. Prefers low edition sizes in multiples.

Terms: Accepts artwork on consignment (40% commission); or buys outright for 50% of retail price (net 30 days). Retail price set by gallery, sometimes with artist's input. Gallery provides insurance and promotion; shipping costs are shared. Prefers artwork unframed.

Submissions: Send query letter with résumé, slides, photographs and bio. Call or write for appointment to show portfolio of originals. Replies in 1-3 months. Files materials of artists represented or previously sold.

Tips: "Try to visit the gallery first to see if we are compatible with you and your work."

BURCHFIELD-PENNEY ART CENTER, Buffalo State College, 1300 Elmwood Ave., Buffalo NY 14222. (716)878-6012. Website: http://www.buffalostate.edu/~burchfld. Director: Ted Pietrzak. Nonprofit. Estab. 1966. Interested in emerging, mid-career and established artists who have lived in western New York State. Sponsors solo and group shows.

Average display time 2-3 months. Clients include urban and suburban adults, college students, corporate clients, all ages in touring groups.

Media: Considers all media, folk, craft and performance art, architecture and design.

Style: Exhibits: contemporary, abstract, Impressionism, primitivism, non-representational, photorealism, realism, neo-expressionism and post-pop works. Genres include figurative and landscape. "We show both contemporary and historical work by Western New York artists, Charles Burchfield and his contemporaries. The museum is not oriented toward sales."

Terms: Accepts work (craft) on consignment for gallery shop (50% commission). Retail price set by gallery and artist. Exclusive area representation not required. Gallery provides insurance, promotion and contract; shipping costs are shared.

Submissions: Send query letter, résumé, slides and photographs. Files biographical materials about artist, work, slides and photos, etc.

Tips: "Keep us on your mailing list. Send invitations to shows elsewhere. Send new slides periodically. We have annual exhibitions for emerging artists and include newer artists regularly in group shows."

CEPA (CENTER FOR EXPLORATORY AND PERCEPTUAL ART), 617 Main St. #201, Buffalo NY 14203.

(716)856-2717. Fax: (716)856-2720. E-mail: cepa@aol.com. Website: http://cepa.buffnet.net. Director/Curator: Robert Hirsch. Alternative space and nonprofit gallery. Interested in emerging, mid-career and established artists. Sponsors 5 solo and 1 group show/year. Average display time 4-6 weeks. Open fall, winter and spring. Office and underground hours are Monday-Friday, 10-5. Passageway Gallery is open Monday-Sunday 9-9. Clients include artists, students, photographers and filmmakers. Prefers photographically related work.

- *Ruins in Reverse* is a multi-site project including gallery exhibitions and installations, satellite exhibitions, public art projects, publication and educational components exploring how photography has been used as a means of critiquing/subverting historical notions. In this project issues of multiple time frames and virtual spaces challenges conceptions of single line narrative history.

Media: Installation, photography, film, mixed media, computer imaging and digital photography.

Style: Contemporary photography. "CEPA provides a context for understanding the aesthetic, cultural and political intersections of photo-related art as it is produced in our diverse society." Interested in seeing "conceptual, installation, documentary and abstract work."

Terms: Accepts work on consignment (25% commission).

Submissions: Call first regarding suitability for this gallery. Send query letter with résumé, 20 numbered slides, SASE, brochure, slides, bio and artist's statement. Call or write for appointment to show portfolio of slides and photographs. Replies in 6 weeks.

Tips: "It is a policy to keep slides and information in our file for indefinite periods. Grant writing procedures require us to project one and two years into the future. Provide a concise and clear statement to give staff an overview of your work."

CHAPMAN ART CENTER GALLERY, Cazenovia College, Cazenovia NY 13035. (315)655-9446. Fax: (315)655-

2190. Website: http://www.cazcollege.edu. Director: John Aistars. Nonprofit gallery. Estab. 1978. Interested in emerging, mid-career and established artists. Sponsors 8-9 shows/year. Average display time is 3 weeks. Clients include the greater Syracuse community. Overall price range: $50-3,000; most artwork sold at $100-200.

Media: Considers oil, acrylic, watercolor, pastel, pen & ink, drawings, sculpture, ceramic, fiber, photography, craft, mixed media, collage, glass and prints.

Style: Exhibits all styles. "Exhibitions are scheduled for a whole academic year at once. The selection of artists is made by a committee of the art faculty in early spring. The criteria in the selection process is to schedule a variety of exhibitions every year to represent different media and different stylistic approaches; other than that, our primary concern is quality. Artists are to submit to the committee by March 1 a set of slides or photographs and a résumé listing exhibitions and other professional activity."

Terms: Retail price set by artist. Exclusive area representation not required. Gallery provides insurance and promotion; works are usually not shipped.

Submissions: Send query letter, résumé, 10-12 slides or photographs.

Tips: A common mistake artists make in presenting their work is that the "overall quality is diluted by showing too many pieces. Call or write and we will mail you a statement of our gallery profiles."

JAMES COX GALLERY AT WOODSTOCK, 4666 Rt. 212, Willow NY 12495. (914)679-7608. Fax: (914)679-

7627. E-mail: jcoxgal@ulster.net. Retail gallery. Estab. 1990. Represents 30 mid-career and established artists. Exhibited artists include: Richard Segalman and Mary Anna Goetz. Represents estates of 7 artists including James Chapin, Margery Ryerson and Winold Reiss. Sponsors 5 shows/year. Average display time 1 month. Open all year; Monday-Friday, 10-5. Elegantly restored Dutch barn. 50% of space for special exhibitions. Clients include New York City and tourists, residents of 50 mile radius. 95% of sales are to private collectors. Overall price range: $500-50,000; most work sold at $3,000-10,000.

Media: Considers oil, watercolor, pastel, drawing and sculpture. Considers "historic Woodstock, fine prints." Most frequently exhibits oil paintings, watercolors, sculpture.

Style: Exhibits: Impressionism, realism. Genres include landscapes and figurative work. Prefers: expressive or evocative realism, painterly landscapes and stylized figurative sculpture.

Terms: Accepts work on consignment (40% commission). Retail price set by the artist. Gallery provides promotion; artist pays shipping costs to and from gallery. Prefers artwork framed.
Submissions: Prefers only artists from New York region. Send query letter with résumé, slides, bio, brochure, photographs, SASE and business card. Replies in 3 months. Files material on artists for special, theme or group shows.
Tips: "Be sure to enclose SASE—be patient for response. Include information on present pricing structure."

N: DARUMA GALLERIES, 1007 Broadway, Woodmere NY 11598. (516)569-5221. Owner: Linda Tsuruoka. Retail gallery. Estab. 1980. Represents about 25-30 emerging and mid-career artists. Exhibited artists include: Christine Amarger, Eng Tay, Dorothy Rice, Joseph Dawley, Seymour Rosenthal, Kamil Kubick and Nitza Flantz. Sponsors 2-3 shows/year. Average display time 1 month. Open all year. Located on the main street; 1,000 sq. ft. 100% of sales are to private collectors. Overall price range: $150-5,000; most work sold at $250-1,000.
Media: Considers watercolor, pastel, pen & ink, drawings, mixed media, collage, woodcuts, linocuts, engravings, mezzotints, etchings, lithographs and serigraphs. Most frequently exhibits etchings, lithographs and woodcuts.
Style: Exhibits all styles and genres. Prefers scenic (not necessarily landscapes), figurative and Japanese woodblock prints. "I'm looking for beach, land and sea scapes; sailing; pleasure boats."
Terms: 40% commission for originals; 50% for paper editions. Retail price set by the gallery (with input from the artist). Sometimes offers customer discounts and payment by installments. Artist pays for shipping to and from gallery. Prefers unframed artwork.
Submissions: Send query letter with résumé, bio and photographs. Call for appointment to show portfolio of originals and photographs. Replies "quickly." Files bios and photo examples. Finds artists through agents, visiting exhibitions, word of mouth, various art publications and sourcebooks, submissions/self-promotions and art collectors' referrals.
Tips: "Bring good samples of your work and be prepared to be flexible with the time needed to develop new talent. Have a competent bio, presented in a professional way. Use good materials. Often artists have nice images but they put them on cheap, low-quality paper which creases and soils easily. Also, I'd rather see work matted in acid-free mats alone, rather than cheaply framed in old and broken frames."

N: ESMAY FINE ART (formerly Shoestring Gallery), 1855 Monroe Ave., Rochester NY 14618. (716)271-3886. Website: http://www.pg1.com/shoestring/. Manager: Julie Rowe. Retail gallery. Estab. 1968. Represents 100 emerging, mid-career and established artists/year. Exhibited artists include: Lynn Shaler, Ruth Vaughan. Sponsors 9 shows/year. Average display time 1 month. Open all year; Monday-Friday, 9-5; Saturday, 10-5; Tuesday and Thursday until 6pm. Located in a suburb on edge of city; 1,600 sq. ft. 30% of space for special exhibitions; 80% of space for gallery artists. Clients include local community. 25% of sales are to corporate collectors. Overall price range: $50-4,000; most work sold at $500-2,000.
Media: Considers oil, acrylic, watercolor, pastel, mixed media, collage, paper, ceramics, glass, woodcuts, engravings, lithographs, wood engravings, mezzotints, serigraphs, linocuts and etchings. Most frequently exhibits watercolor, oil and fine prints.
Style: Exhibits expressionism, Impressionism, pattern painting and realism. Genres include florals, landscapes, figurative work, still life, interiors. Prefers Impressionism, realism, abstract expressionism.
Terms: Accepts work on consignment (50% commission). Retail price set by the artist. Gallery provides promotion and contract; shipping costs are shared. Prefers artwork framed.
Submissions: Send query letter with slides, bio, photographs and SASE. Replies in 1 month. Files letter of query. Finds artists through submissions, local exhibitions and art fairs.
Tips: "Be sure to include enough information about the work, particularly pricing."

N: GALLERY NORTH, 90 N. Country Rd., Setauket NY 11733. (516)751-2676. Fax: (516)751-0180. Website: http://www.gallerynorth.usrc.net. Director: Marjorie Taylor-Thomas. Not-for-profit gallery. Estab. 1965. Exhibits the work of emerging, mid-career and established artists from Long Island. Sponsors 9 shows annually. Average display time 4-5 weeks. Open all year. Located 1 mile from the State University at Stony Brook; approximately 1,600 sq. ft.; "in a renovated Victorian house." 85% of space for special exhibitions. Clients include university faculty and staff, Long Island collectors and tourists. Overall price range: $100-10,000; mostly $2-3,000.
Media: Considers all media and original handpulled prints, frequent exhibits of paintings, prints and fine crafts, especially jewelry and ceramics.
Style: Prefers abstract and representational contemporary artists.
Terms: Accepts work on consignment (50% commission). Retail price set by gallery and artist. Gallery provides insurance, promotion and contract; shipping costs are shared. Requires well-framed artwork.
Submissions: Send query letter with résumé, slides, bio, SASE and reviews. Portfolio review requested if interested in artist's work. Portfolio should include framed originals. Replies in 1-2 months. Files slides and résumés when considering work for exhibition. Finds artists from other exhibitions, slides and referrals.
Tips: "If possible artists should visit to determine whether their work is compatible with overall direction of the gallery. A common mistake artists make is that slides are not fully labeled as to size medium, top and price."

THE GRAPHIC EYE GALLERY OF LONG ISLAND, 301 Main St., Port Washington NY 11050. (516)883-9668. Cooperative gallery. Estab. 1974. Represents 25 artists. Sponsors solo, 2-3 person and 4 group shows/year. Average display time: 1 month. Interested in emerging and established artists. Overall price range: $35-7,500; most artwork sold at $500-800.

Media: Considers mixed media, collage, works on paper, pastels, photography, paint on paper, woodcuts, wood engravings, linocuts, engravings, mezzotints, etchings, lithographs, serigraphs, and monoprints.
Style: Exhibits Impressionism, expressionism, realism, primitivism and painterly abstraction. Considers all genres.
Terms: Co-op membership fee plus donation of time. Retail price set by artist. Offers payment by installments. Exclusive area representation not required. Prefers framed artwork.
Submissions: Send query letter with résumé, SASE, slides and bio. Portfolio should include originals and slides. "When submitting a portfolio, the artist should have a body of work, not a 'little of this, little of that.' " Files historical material. Finds artists through visiting exhibitions, word of mouth, artist's submissions and self-promotions.
Tips: "Artists must produce their *own* work and be actively involved. We have a competitive juried art exhibit annually. Open to all artists who work on paper."

GUILD HALL MUSEUM, 158 Main St., East Hampton NY 11937. (516)324-0806. Fax: (516)324-2722. Curator: Lisa Panzera. Assistant Curator: Heather Dimon. Museum. Estab. 1931. Represents emerging, mid-career and established artists. Sponsors 6-10 shows/year. Average display time 6-8 weeks. Open all year; Wednesday-Sunday, 11-5. 500 running feet; features artists who live and work on eastern Long Island. 85% of space for special exhibitions.
Media: Considers all media and all types of prints. Most frequently exhibits painting, prints and sculpture.
Style: Exhibits all styles and genres.
Terms: Artwork is donated or purchased. Gallery provides insurance and promotion. Prefers artwork framed.
Submissions: Accepts only artists from eastern Long Island. Send query letter with résumé, slides, bio, brochure, SASE and reviews. Write for appointment to show portfolio of originals and slides. Replies in 2 months.

HALLWALLS CONTEMPORARY ARTS CENTER, 2495 Main St., Suite 425, Buffalo NY 14214-2103. (716)835-7362. E-mail: hallwall@pce.net. Alternative space. Estab. 1974. Exhibits the work of emerging artists. 1,000 members. Past exhibited artists include Heidi Kumao, Judith Jackson and Tom Huff. Sponsors 10 shows/year. Average display time 6 weeks. Open all year. Located in north Buffalo; "three galleries, very flexible space." 100% of space for special exhibitions.
 • Hallwalls supports the creation and presentation of new work in the visual, media, performing and literary arts. The gallery looks for work which "challenges and extends the boundaries of various art forms."
Media: Considers all media.
Style: Exhibits all styles and genres. "Contemporary cutting edge work which challenges traditional cultural and aesthetic boundaries."
Terms: Retail price set by artist. Hallwalls takes a voluntary 15% commission on sales. Gallery provides insurance.
Submissions: Send query letter with résumé, slides, bio, brochure, photographs, SASE and reviews. Write for appointment to show portfolio of slides. Replies only if interested. Files slides, résumé, statement and proposals.
Tips: "Slides are constantly reviewed for consideration in group shows and solo installations by the staff curators and guest curators. It is recommended that artists leave slides on file for at least a year. We are showing more work by artists based in areas other than NYC and Buffalo."

ISLIP ART MUSEUM, 50 Irish Lane, East Islip NY 11730. (516)224-5402. Director: M.L. Cohalan. Nonprofit museum gallery. Estab. 1973. Interested in emerging and mid-career artists. Sponsors 14 group shows/year. Average display time is 6 weeks. Clients include contemporary artists from Long Island, New York City and abroad.
Media: Considers oil, acrylic, watercolor, pastel, pen & ink, drawings, mixed media, collage, works on paper, sculpture, ceramic, craft, fiber, glass, installation, photography, performance and original handpulled prints. Most frequently exhibits installation, oil and sculpture.
Style: Exhibits: Considers all styles, emphasis on experimental. Genres include landscapes, Americana, portraits, figurative work and fantasy illustration. "We consider many forms of modern work by artists from Long Island, New York City and abroad when organizing exhibitions. Our shows are based on themes, and we only present group exhibits. Museum expansion within the next two years will allow for one and two person exhibits to occur simultaneously with the ongoing group shows."
Terms: Gallery provides insurance, promotion, contract and shipping.
Submissions: Send résumé, brochure, slides and SASE. Slides, résumés, photos and press information are filed. The most common mistake artists make in presenting their work is that "they provide little or no information on the slides they have sent to the museum for consideration."

KIRKLAND ART CENTER, E. Park Row, P.O. Box 213 Clinton NY 13323-0213. (315)853-8871. E-mail: kac@borg.com. Contact: Director. Nonprofit gallery. Estab. 1960. Interested in emerging, mid-career and established artists. Sponsors 4 solo and 6 group shows/year. Average display time is 1 month. Clients include general public and art lovers. 99% of sales are to private collectors, 1% corporate clients. Overall price range: $60-4,000; most artwork sold at $200-1,200.
Media: Considers oil, acrylic, watercolor, pastel, pen & ink, drawings, mixed media, collage, works on paper, sculpture, ceramic, craft, fiber, glass, installation, photography, performance art and original handpulled prints. Most frequently exhibits watercolor, oil/acrylic, prints, sculpture, drawings, photography and fine crafts.
Style: Exhibits: painterly abstraction, conceptualism, Impressionism, photorealism, expressionism, realism and surrealism. Genres include landscapes, florals and figurative work.
Terms: Accepts work on consignment (25% commission). Retail price set by artist. Exclusive area representation not required. Gallery provides insurance, promotion and contract; artist pays for shipping.

Submissions: Send query letter, résumé, slides, slide list and SASE.

Tips: "Shows are getting very competitive—artists should send us slides of their most challenging work, not just what is most saleable. We are looking for artists who take risks in their work and display a high degree of both skill and imagination. It is best to call or write for instructions and more information."

LEATHERSTOCKING GALLERY, 52 Pioneer St., P.O. Box 446, Cooperstown NY 13326. (607)547-5942. (Gallery), (607)547-8044 (Publicity). Publicity: Dorothy V. Smith. Retail nonprofit cooperative gallery. Estab. 1968. Represents emerging, mid-career and established artists. 45 members. Sponsors 1 show/year. Average display time 3 months. Open in the summer (mid-June to Labor Day); daily 11-5. Located downtown Cooperstown; 300-400 sq. ft. 100% of space for gallery artists. Clients include varied locals and tourists. 100% of sales are to private collectors. Overall price range: $25-500; most work sold at $25-100.

Media: Considers oil, acrylic, watercolor, pastel, pen & ink, drawing, mixed media, collage, paper, sculpture, ceramics, craft, photography, handmade jewelry, woodcuts, engravings, lithographs, wood engravings, mezzotints, serigraphs, linocuts and etchings. Most frequently exhibits watercolor, oil and crafts.

Style: Exhibits: Impressionism and realism, all genres. Prefers landscapes, florals and American decorative.

Terms: Co-op membership fee, a donation of time plus 10% commission. Retail price set by the artist. Gallery provides insurance, promotion and contract; artist pays shipping costs from gallery if sent to buyer. Prefers artwork framed.

Submissions: Accepts only artists from Otsego County; over 18 years of age; member of Leatherstocking Brush & Palette Club. Replies in 2 weeks. Finds artists through word of mouth locally; articles in local newspaper.

Tips: "We are basically non-judgmental (unjuried). You just have to live in the area!"

MILLENNIUM GALLERY, 62 Park Place, East Hampton NY 11937. (516)329-2288. Fax: (516)329-2294. Director: Dr. Jon-Henri Bonnard. Retail gallery. Estab. 1994. Represents 15 emerging, mid-career and established artists/year. Exhibited artists include: Yoland Merchant, David Tyndall, Vince Brandi and Janet Culbertson. Sponsors 12 shows/year. Average display time 3-4 weeks. Open all year; 7 days a week. 1,200 sq. ft. 90% for special exhibitions. Clientele: tourists, upscale. Most work sold at $400-20,000.

Media: Considers all media, woodcuts and engravings. Most frequently exhibits oil/canvas, pastel/paper, sculpture.

Style: Exhibits: expressionism, painterly abstraction, conceptualism, Impressionism, realism. Genres include landscapes and figurative work. Prefers realism, expressionism, conceptualism.

Terms: Accepts work on consignment (50% commission). Retail price set by the gallery. Gallery provides insurance, promotion and contract; artist pays for shipping. Prefers artwork framed.

Submissions: Accepts only artists from east end of Long Island. Send query letter with slides, bio, photographs. Call for appointment to show portfolio of photographs. Replies only if interested within 2 weeks.

OXFORD GALLERY, 267 Oxford St., Rochester NY 14607. (716)271-5885. Fax: (716)271-2570. Website: http://www.oxfordgallery.com. Director: Lisa Pietrangeli. Retail gallery. Estab. 1961. Represents 70 emerging, mid-career and established artists. Sponsors 10 shows/year. Average display time 1 month. Open all year; Tuesday-Friday, 12-5; Saturday, 10-5; and by appointment. Located "on the edge of downtown; 1,000 sq. ft.; large gallery in a beautiful 1910 building." Overall price range: $100-30,000; most work sold at $1,000-2,000.

Media: Considers oil, acrylic, watercolor, pastel, pen & ink, drawings, mixed media, collage, paper, sculpture, ceramic, fiber, original handpulled prints, woodcuts, engravings, lithographs, wood engravings, mezzotints, serigraphs, linocuts and etchings.

Styles: All styles.

Terms: Accepts artwork on consignment (50% commission). Retail price set by gallery and artist. Gallery provides promotion and contract.

Submissions: Send query letter with résumé, slides, bio and SASE. Replies in 2-3 months. Files résumés, bios and brochures.

Tips: "Have professional slides done of your artwork. Have a professional résumé and portfolio. Do not show up unannounced and expect to show your slides. Either send in your information or call to make an appointment. An artist should have enough work to have a one-man show (20-30 pieces). This allows an artist to be able to supply more than one gallery at a time, if necessary. It is important to maintain a strong body of available work."

PORT WASHINGTON PUBLIC LIBRARY, One Library Dr., Port Washington NY 11050. (516)883-4400. Fax: (516)883-7927. Chair, Art Advisory Council: Eric Pick. Nonprofit gallery. Estab. 1970. Represents 10-12 emerging, mid-career and established artists/year. 23 members. Exhibited artists include: Frank Stella, Robert Dash. Sponsors 10-12 shows/year. Average display time 1 month. Open all year; Monday-Friday, 9-9; Saturday, 9-5; Sunday, 1-5. Located midtown, 972 sq. ft. Overall price range: up to $100,000.

Media: Considers all media and all types of prints.

Style: Exhibits all styles.

Terms: Price set by the artist. Gallery provides insurance and promotion.

Submissions: Send query letter with résumé, slides, bio, SASE. Replies in 1 month. Artist should call library. Finds artists through word of mouth, referrals by other artists, visiting art fairs and exhibitions and submissions.

PRAKAPAS GALLERY, One Northgate 6B, Bronxville NY 10708. (914)961-5091 or (914)961-5192. Private dealers. Estab. 1976. Represents 50-100 established artists/year. Exhibited artists include: Leger and El Lissitsky. Located in

suburbs. Clients include institutions and private collectors. Overall price range: $500-500,000.
Media: Considers all media with special emphasis on photography.
Style: Exhibits all styles. "Emphasis is on classical modernism."
Submissions: Finds artists through word of mouth, referrals by other artists, visiting art fairs and exhibitions.

✔ PRINT CLUB OF ALBANY, 140 N. Pearl St., P.O. Box 6578, Albany NY 12206. (518)432-9514. President: Martin S. Gnacik. Nonprofit gallery and museum. Estab. 1933. Exhibits the work of 70 emerging, mid-career and established artists. Sponsors 1 show/year. Average display time 6 weeks. Located in downtown arts district. "We currently have a small space and hold exhibitions in other locations." 90% of sales are to private collectors, 10% corporate collectors.
Media: Considers original handpulled prints.
Style: Exhibits all styles and genres. "No reproductions."
Terms: Accepts work on consignment from members. Membership is open internationally. "We welcome donations (of artists' works) to the permanent collection." Retail price set by artist. Customer discounts and payment by installment are available. Gallery provides promotion. Artist pays for shipping. Prefers artwork framed.
Submissions: Prefers prints. Send query. Write for appointment to show portfolio of slides. Replies in 1 week.
Tips: "We are a nonprofit organization of artists, collectors and others. Artist members exhibit without jury. We hold member shows and the Triannual National Open Competitive Exhibitions. We commission an artist for an annual print each year. Our shows are held in various locations. We are planning a museum (The Museum of Prints and Printmaking) and building. We also collect artists' papers, etc. for our library."

PYRAMID ARTS CENTER, 302 N. Goodman St., Rochester NY 14607. (716)461-2222. Fax: (716)461-2223. Director: Elizabeth McDade. Nonprofit gallery. Estab. 1977. Exhibits 200 emerging, mid-career and established artists/year. 400 members. Sponsors 20 shows/year. Average display time 2-6 weeks. Open 11 months. Business hours Wednesday-Friday, 10-5; gallery hours, Thursday-Sunday 12-5. Located in museum district of Rochester; 1,500 sq. ft.; features 3 gallery spaces. 80% of space for special exhibitions. Clients include artists, curators, collectors, dealers. 90% of sales are to private collectors, 10% corporate collectors. Overall price range: $25-15,000; most work sold at $40-500.
 • Gallery strives to create a forum for challenging, innovative ideas and works.
Media: Considers all media, video, film, dance, music, performance art, computer media; all types of prints including computer, photo lithography.
Style: Exhibits all styles and genres.
Terms: During exhibition a 25% commission is taken on sold works. Retail price set by the artist. Gallery provides insurance, promotion and contract; shipping costs are shared, "depending upon exhibition, funding and contract." Prefers artwork framed.
Submissions: Includes regional national artists and alike in thematic solo/duo exhibitions. Send query letter with résumé and slides. Call for appointment to show portfolio of originals and slides. "We have a permanent artist archive for slides, bios, résumés and will keep slides in file if artist requests." Finds artists through national and local calls for work, portfolio reviews and studio visits.
Tips: "Present slides that clearly and accurately reflect your work. Label slides with name, title, medium and dimensions. Be sure to clarify intent and artistic endeavor. Proposals should simply state the artist's work. Documentation should be accompanied by clear, concise script."

ROCKLAND CENTER FOR THE ARTS, 27 S. Greenbush Rd., West Nyack NY 10994. (914)358-0877. Fax: (914)358-0971. Website: http://www.rocklandartcenter.org. Executive Director: Julianne Ramos. Nonprofit gallery. Estab. 1972. Exhibits emerging, mid-career and established artists. 1,500 members. Sponsors 6 shows/year. Average display time 6 weeks. Open September-May. Located in suburban area; 2,000 sq. ft.; "contemporary space." 100% of space for special exhibitions. 100% of sales are to private collectors. Overall price range: $500-50,000; most artwork sold at $1,000-5,000.
Media: Considers oil, acrylic, watercolor, pastel, pen & ink, mixed media, sculpture, ceramic, fiber, glass and installation. Most frequently exhibits painting, sculpture and craft.
Style: Exhibits all styles and genres.
Terms: Accepts work on consignment (33% commission). Retail price set by artist. Gallery provides insurance, promotion and shipping costs to and from gallery. Prefers artwork framed.
Submissions: "Proposals accepted from curators only. No one-person shows. Artists should not apply directly." Replies in 2 months.
Tips: "Artist may propose a curated thematic show of three or more artists. Request curatorial guidelines. Unfortunately for artists, the trend is toward very high commissions in commercial galleries. Nonprofits like us will continue to hold the line."

THE SCHOOLHOUSE GALLERIES, Owens Rd., Croton Falls NY 10519. (914)277-3461. Fax: (914)277-2269. Director: Lee Pope. Retail gallery. Estab. 1979. Represents 30 emerging and mid-career artists/year. Exhibited artists include: Joseph Keiffer and Allen Whiting. Average display time 1 month. Open all year; Wednesday-Sunday, 1-5. Located in a suburban community of New York City; 1,200 sq. ft.; 70% of space for special exhibitions; 30% of space for gallery artists. Clients include residential, corporate, consultants. 50% of sales are to private collectors, 50% corporate collectors. Overall price range: $75-6,000; most work sold at $350-2,000.

Media: Considers oil, acrylic, watercolor, pastel, pen & ink, drawing, mixed media, collage, paper, sculpture, ceramics, fiber and photography, all types of prints. Most frequently exhibits paintings, prints and sculpture.

Style: Exhibits: expressionism, painterly abstraction, Impressionism and realism. Genres include landscapes. Prefers: Impressionism and painterly abstraction.

Terms: Accepts work on consignment (40% commission). Retail price set by the artist. Gallery provides insurance and promotion; shipping costs are shared. Prefers artwork on paper, unframed.

Submissions: Send query letter with slides, photographs and SASE. We will call for appointment to view portfolio of originals. Replies in 2 months. Files slides, bios if interested. Finds artists through visiting exhibitions and referrals.

SCHWEINFURTH MEMORIAL ART CENTER, 205 Genesee St., Auburn NY 13021. (315)255-1553. E-mail: smac@relex.com. Museum. Estab. 1981. Represents emerging, mid-career and established artists. Sponsors 15 shows/year. Average display time 2 months. Closed in January. Located on the outskirts of downtown; 7,000 sq. ft.; large open space with natural and artificial light.

• Schweinfurth has an AA Gift Shop featuring handmade arts and crafts, all media, for which they're looking for work.

Media: Considers all media, all types of prints.

Style: Exhibits all styles and genres.

Terms: Retail price set by the artist. Gallery provides insurance and promotion; artist pays for shipping costs. Artwork must be framed and ready to hang.

Submissions: Accepts artists from central New York. Send query letter with résumé, slides and SASE.

[N] CHARLES SEMOWICH FINE ARTS, 242 Broadway, Rensselaer NY 12144. (518)449-4756. E-mail: semowich @webtv.net. Website: http://members.tripod.com/~rensselaer/index-2.html. Owner: Charles Semowich. Private art gallery. Estab. 1985. Open all year; by appointment. Located downtown. Clients include dealers. 20% of sales are to private collectors. Overall price range: $200-800.

Media: Considers all media and all types of prints.

Style: Exhibits all styles and genres, mostly deceased artists.

Terms: Buys outright for 50% of retail price. Retail price set by the gallery.

Submissions: Write for appointment.

BJ SPOKE GALLERY, 299 Main St., Huntington NY 11743. (516)549-5106. Cooperative and nonprofit gallery. Estab. 1978. Exhibits the work of 24 emerging, mid-career and established artists. Sponsors 2-3 invitationals and juried shows/year. Average display time 1 month. Open all year. "Located in center of town; 1,400 sq. ft.; flexible use of space—3 separate gallery spaces." Generally, 66% of space for special exhibitions. Overall price range: $300-2,500; most work sold at $900-1,600. Artist is eligible for a 2-person show every 18 months. Entire membership has ability to exhibit work 11 months of the year.

• Sponsors annual national juried show. Deadline December. Send SASE for prospectives.

Media: Considers all media except crafts, all types of printmaking. Most frequently exhibits paintings, prints and sculpture.

Style: Exhibits all styles and genres. Prefers painterly abstraction, realism and expressionism.

Terms: Co-op membership fee plus donation of time (25% commission). Monthly fee covers rent, other gallery expenses. Retail price set by artist. Payment by installment is available. Gallery provides promotion and publicity; artists pay for shipping. Prefers artwork framed; large format artwork can be tacked.

Submissions: For membership, send query letter with résumé, high-quality slides, bio, SASE and reviews. For national juried show send SASE for prospectus and deadline. Call or write for appointment to show portfolio of originals and slides. Files résumés; may retain slides for awhile if needed for upcoming exhibition.

Tips: "Send slides that represent depth and breadth in the exploration of a theme, subject or concept. They should represent a cohesive body of work."

New York City

[✓] A.I.R. GALLERY, 40 Wooster St., Floor 2, New York NY 10013-2229. (212)966-0799. Website: http://www.airnyc .org. Director: Dena Muller. Cooperative nonprofit gallery, alternative space to advance the status of women artists and provide a sense of community. Estab. 1972. Represents/exhibits emerging, mid-career and established women artists. 20 New York City members; 15 National Affiliates. Sponsors 15 shows/year. Average display time 3 weeks. Open all year except late summer; Tuesday-Saturday, 11-6. Located in Soho; 1,600 sq. ft., 11'8" ceiling; the end of the gallery

[N] MARKETS NEW TO THIS EDITION

which faces the street is entirely windows. 20% of space for special exhibitions; 80% of space for gallery artists. Clients include art world professionals, students, artists, local community, tourists. Overall price: $500-15,000; most work sold at $1,000-5,000.

> • A.I.R. has both New York City members and members across the United States. They show emerging artists in their Gallery II program which is open to all artists interested in a one-time exhibition. Please specify whether you are applying for membership, Gallery II or both.

Media: Considers all media and all types of prints.

Style: Exhibits all styles and genres.

Terms: 15% commission. Retail price set by the artist. Gallery provides limited promotion (i.e., Gallery Guide listing). Artist pays for shipping costs. Prefers artwork framed.

Submissions: Membership and exhibitions are open to women artists. Send query letter with résumé, 10-20 slides and SASE. Replies in 2 months. Files no material unless an artist is put on the waiting list for membership. Finds artists through word of mouth, referrals by other artists, suggestions by past and current members.

Tips: "Look at a lot of art. Develop a relationship with a potential gallery by engaging in the work they show. Know what they like."

N **THE ART ALLIANCE**, 98 Greene St., New York NY 10012. (212)274-1704. Fax: (212)274-1682. E-mail: artallny@ix.netcom.com. Website: http://www.artspace2000. President: Leah Poller. Artist agent, curator and consultant. Estab. 1989. Represents 15 mid-career and established artists/year. Exhibited artists include: Bernardo Torrens, Mario Murua. Sponsors 3-5 in gallery, 10 in outside spaces/year. Average display time 1 month. Open Wednesday-Saturday, 11-5 or by appointment. Closed July and August. Located in Soho loft; 1,200 sq. ft. 70% of space for special exhibitions; 30% of space for gallery artists. Clients include international, corporate and major collectors. 80% of sales are to private collectors, 20% corporate collectors. Curates for large, prestigious public spaces. Overall price range: $1,500-75,000; most work sold at $10,000-20,000.

Media: Considers oil, acrylic, watercolor, pastel, pen & ink, drawing, mixed media, collage and sculpture. Most frequently exhibits oil, sculpture and drawing.

Style: Exhibits: expressionism, neo-expressionism, surrealism and realism. Prefers realism—figurative, sculpture—figurative, expressionism/neo-expressionism.

Terms: Accepts work on consignment (50% commission). Retail price set by the artist. Gallery provides insurance, promotion. Requires artwork framed.

Submissions: Prefers non-American artists; does not accept emerging artists. Send query letter with artist's statement, 10 slides, bio and SASE. Write for appointment to show portfolio of slides and artist statement. Replies in 1 month. Finds artists through art fairs, other artists.

Tips: "Ask for catalogs on my artists to see quality, bios. Don't send images without calling gallery."

N **ART DIRECTORS CLUB GALLERY**, 250 Park Ave. S., New York NY 10003-1402. (212)674-0500. Fax: (212)460-8506. Website: http://www.adcny.org. Executive Director: Myrna Davis. Nonprofit gallery. Exhibits groups in the field of visual communications (advertising, graphic design, publications, art schools). Estab. 1986. Exhibits emerging and professional work; 10-12 shows/year. Average display time 1-4 weeks. Closed August; Monday-Friday, 10-6. Located in Flatiron district; 3,500 sq. ft.; two galleries street level and lower level. 100% of space for special exhibitions. Clients include professionals, students.

Media: Considers all media and all types of prints. Most frequently exhibits posters, printed matter, photos, paintings and 3-D objects.

Style: Genres include graphic design, publication and advertising design and illustration.

Terms: There is a rental fee for space or gallery invites groups to show.

Submissions: Submissions are through professional groups. Group rep should send reviews and printed work. Replies within a few months.

N **ARTISTS SPACE**, 38 Greene St., 3rd Floor, New York NY 10013. (212)226-3970. Fax: (212)966-1434. Website: http://www.artistsspace.org. Curator: Jenelle Porter. Nonprofit gallery, alternative space. Estab. 1973. Exhibits emerging artists. Sponsors 4-5 shows/year. Average display time 6-8 weeks. Open Tuesday-Saturday, 10-6. Located in Soho; 5,000 sq. ft. 100% of space for special exhibitions.

Media: Considers all media.

Terms: "All curated shows selected by invitation." Gallery provides insurance and promotion.

Submissions: Send query letter with 10 slides and SASE. Portfolio should include slides.

Tips: "Choose galleries carefully, i.e., look at work represented and decide whether or not it is an appropriate venue."

ASIAN AMERICAN ARTS CENTRE, 26 Bowery, New York NY 10013. (212)233-2154. Fax: (212)766-1287. E-mail: aaartsctr@aol.com. Executive Director: Robert Lee. Nonprofit gallery. Estab. 1974. Exhibits the work of emerging and mid-career artists; 600 artists in archives file. Sponsors 4 shows/year. Average display time 4-6 weeks. Open September through June. Located in Chinatown; 1,800 sq. ft.; "a gallery and a research facility." 100% of space for special exhibitions. Overall price range: $500-10,000; most work sold at $500-3,000.

Media: Considers all media and all types of prints. Prefers paintings, installation and mixed media.

Style: Exhibits all styles and genres. Focuses on contemporary Asian, Asian American and American artists with strong Asian influences.

Terms: Suggests a donation of 20% of the selling price. Retail price set by the artist. Gallery provides insurance and promotion. Shipping costs are shared. Prefers artwork framed.

Submissions: Send query letter with résumé and slides. Will call artists if interested. Portfolio should include slides. Replies only if interested within 6-8 weeks. Files slides.

✓ **BLUE MOUNTAIN GALLERY**, 121 Wooster St., New York NY 10012. (212)941-9753. Fax: (212)274-9051. Website: http://www.artincontext.org/new_york/blue_mountain_gallery/. Director: Marcia Clark. Artist-run cooperative gallery. Estab. 1980. Exhibits 27 mid-career artists. Sponsors 13 solo and 1 group shows/year. Display time is 3 weeks. "We are located on the second floor of a loft building in Soho. We share our floor with two other well-established cooperative galleries. Each space has white partitioning walls and an individual floor-plan." Clients include art lovers, collectors and artists. 90% of sales are to private collectors, 10% corporate clients. Overall price range: $100-8,000; most work sold at $100-4,000.

Media: Considers painting, drawing and sculpture.

Style: "The base of the gallery is figurative but we show work that shows individuality, commitment and involvement with the medium."

Terms: Co-op membership fee plus donation of time. Retail price set by artist. Exclusive area representation not required. Gallery provides insurance, some promotion and contract; artist pays for shipping.

Submissions: Send name and address with intent of interest and sheet of 20 good slides. "We cannot be responsible for material return without SASE." Finds artists through artists' submissions and referrals.

Tips: "This is a cooperative gallery: it is important to represent artists who can contribute actively to the gallery. We look at artists who can be termed local or in-town more than out-of-town artists and would choose the former over the latter. The work should present a consistent point of view that shows individuality. Expressive use of the medium used is important also."

 BROADWAY WINDOWS, New York University, 80 Washington Square E., New York NY 10003. Viewing address: Broadway at E. 10th St. (212)998-5751. Fax: (212)998-5752. E-mail: bwaywinds@nyu.edu. Website: http://www.nyu.edu/pages/galleries. Directors: Marilynn Karp and Ruth D. Newman. Nonprofit gallery. Estab. 1984. Interested in emerging and established artists. On view to vehicular and pedestrian traffic 24 hours a day. "We do not formally represent any artists. We are operated by New York University as a nonprofit exhibition space whose sole purpose is to showcase artwork and present it to a new ever-growing art-interested public." Sponsors 9 solo shows/year. Average display time is 5 weeks. Clients include the metropolitan public.

Media: Considers all media. "We are particularly interested in site-specific installations."

Style: "No thematic restrictions or aesthetic restrictions are applied. We are interested in a tremendous range of style, approach and media."

Terms: Accepts work on consignment (20% commission). Retail price set by artist. Exclusive area representation not required. Gallery provides insurance, promotion and contract; artist pays for shipping.

Submissions: Send query letter, résumé, slides, photographs and SASE. "Proposals are evaluated once annually in response to an ad calling for proposals. Jurors look for proposals that make the best use of the 24-hour space."

Tips: "Often artists do not provide the visual evidence that they could produce the large scale artwork the Windows' physical structure dictates. And, in general, their installation proposals lack details of scale and substance."

☒ BROOKLYN BOTANIC GARDEN—STEINHARDT CONSERVATORY GALLERY, 1000 Washington Ave., Brooklyn NY 11225. (718)622-4433, ext. 223. Fax: (718)622-7839. E-mail: trishlindemann@bbg.org. Website: http://www.bbg.org. Director of Adult Education and Public Programs: Trish Lindemann. Nonprofit botanic garden gallery. Estab. 1988. Represents emerging, mid-career and established artists. 20,000 members. Sponsors 10-12 shows/year. Average display time 4-6 weeks. Open all year; Tuesday-Sunday, 10-4. Located near Prospect Park and Brooklyn Museum; 1,200 sq. ft.; part of a botanic garden, gallery adjacent to the tropical, desert and temperate houses. Clients include BBG members, tourists, collectors. 100% of sales are to private collectors. Overall price range: $75-7,500; most work sold at $75-500.

Media: Considers all media and all types of prints. Most frequently exhibits watercolor, oil and photography.

Style: Exhibits all styles. Genres include landscapes, florals and wildlife.

Terms: Accepts work on consignment (20% commission). Retail price set by the artist. Gallery provides insurance, promotion and contract; artist pays shipping costs to and from gallery. Prefers artwork framed.

Submissions: Work must have botanical, horticultural or environmental theme. Send query letter with résumé, slides, bio, brochure, photographs, SASE, business card and reviews in May, June, July or August for review in September. Write for appointment to show portfolio of slides.

Tips: "Artists' groups contact me by submitting résumé and slides of artists in their group. We favor seasonal art which echoes the natural events going on in the garden. Large format, colorful works show best in our multi-use space."

BRUSHSTROKES FINE ART GALLERY, 4612 13th Ave., Brooklyn NY 11219. (718)972-0682. Fax: (718)972-3642. Director: Sam Pultman. Retail gallery. Estab. 1993. Represents 15 emerging, mid-career and established artists/year. Exhibited artists include: Elena Flerova, Itshak Holtz, Anton Rosenberg and Zvi Malnovitzer. Sponsors 2 shows/year. Average display time 1 month. Open all year; Sunday and Monday, 11-6:30; Tuesday by appointment; Wednesday-Thursday, 11-6:30; Friday, 11-1:30; Closed Saturday. 1,100 sq. ft. "We're one of the only sources for fine art Judaica."

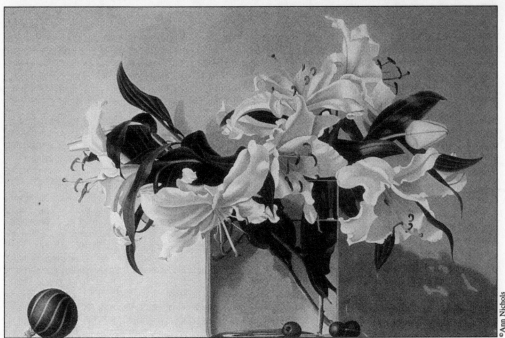

©Ann Nichols

This work by Ann Nichols appeared in her show at the Brooklyn Botanic Garden Steinhardt Conservatory Gallery. The artist, who worked in oil on gessoed masonite, sought to create a feel of "quiet elegance" and "a sense of tension compositionally resolved through asymmetrical balance." Nichols advises other artists to stick with a recognizable style in their work and enter juried shows. "Competitions help you build up your résumé and see how your work 'stacks up' against other artists."

100% of space for gallery artists. Clients include upscale. 100% of sales are to private collectors. Overall price range: $1,000-75,000; most work sold at $15,000-30,000.

Media: Considers oil, acrylic, watercolor, pastel, pen & ink, drawing. Considers all types of prints. Most frequently exhibits oil, acrylic, pastel.

Style: Exhibits: surrealism, Impressionism, realism. Genres include florals, portraits, landscapes, Judaic themes. Prefers: realism, Impressionism, surrealism.

Terms: Accepts work on consignment. Retail price set by the gallery. Gallery provides promotion; artist pays for shipping costs to gallery. Prefers artwork unframed.

Submissions: "No abstract art please." Send query letter with 10 slides, bio, brochure, photographs. Call for appointment to show portfolio of photographs. Replies only if interested within 1 week. Finds artists through word of mouth, referrals by other artists, submissions.

N CLAUDIA CARR GALLERY, 478 W. Broadway #2, New York NY 10012. (212)673-5518. Fax: (212)673-0123. E-mail: claudiacarr@erols.com. For profit gallery. Estab. 1995. Approached by 120 artists/year. Represents emerging, mid-career and established artists. Sponsors 10 exhibits/year. Average display time 4-6 weeks. Open Wednesday-Saturday, 11-5:30; closed Sunday, Christmas, New Year's and mid-July-August. "Soho gallery, second floor, small, intimate space." Clients include local community, tourists, upscale. 15% of sales are to corporate collectors. Overall price range: $300-6,000; most work sold at $1,500-2,000.

Media: Considers acrylic, paper, pastel, collage, pen & ink, mixed media, drawing, oil and watercolor. No prints. Most frequently exhibits drawing, painting on paper and monotype.

Style: Exhibits painterly abstraction, minimalism, geometric abstraction and other styles. Most frequently exhibits painterly abstraction and minimal. Genres include figurative work and landscapes.

Terms: Artwork is accepted on consignment (50% commission). Retail price set by the gallery and the artist. Gallery provides insurance and promotion. Accepted work should be framed, mounted or matted. Requires exclusive representation locally.

Submissions: Write to arrange a personal interview to show portfolio of photographs, transparencies, slides and other material or send query letter with bio, résumé, photocopies, photographs, slides and SASE. Returns material with SASE. Replies in 2 months. Files materials if interested. Finds artists through word of mouth and referrals by other artists.

Tips: "Write a cover letter, include biographical information, make certain to include a SASE. Be professional."

N CERES, 584 Broadway, Room 306, New York NY 10012. (212)226-4725. Administrator: Olive H. Kelsey. Women's cooperative and nonprofit, alternative gallery. Estab. 1984. Exhibits the work of emerging, mid-career and established artists. 56 members. Sponsors 11-14 shows/year. Average display time 1 month. Open all year; Tuesday-Saturday, 12-6. Located in Soho, between Houston and Prince Streets; 2,000 sq. ft. 30% of space for special exhibitions; 70% of space for gallery artists. Clients include artists, collectors, tourists. 85% of sales are to private collectors, 15% corporate collectors. Overall price range, $300-10,000; most work sold at $350-1,200.
Media: All media considered.
Style: All genres. "Work concerning politics of women and women's issues; although *all* work will be considered, still strictly women's co-op."
Terms: Co-op membership fee plus donation of time. Retail price set by artist. Gallery provides insurance; artists pays for shipping.
Submissions: Prefers women from tri-state area; "men may show in group/curated shows." Write with SASE for application. Replies in 1-3 weeks.
Tips: "Artist must have the ability to be a responsible gallery member and participant."

N CHINA 2000 FINE ART, 5 E. 57th St., New York NY 10022. (212)558-1198. Fax: (212)588-1882. Owners: Karen and Leon Wender. Retail gallery. Estab. 1980. Represents established artists. Exhibited artists include: Zhu Qizhan, Qi Baishi. Sponsors 4-5 shows/year. Average display time 1 month. Open all year; Monday-Saturday, 10-5. Located on the upper east side of New York City; 1,500 sq. ft. 90% of space for special exhibitions. Clients include private collectors, museums. 95% of sales are to private collectors, 5% corporate collectors. Overall price range: $5,000-250,000.
Media: Considers watercolor, Chinese ink and color on paper. Most frequently exhibits Chinese ink and color on paper.
Style: Exhibits: traditional and contemporary Chinese painting. Genres include landscapes, florals, wildlife and portraits. Prefers landscapes, flowers, portraits (nonfigurative).
Terms: Retail price set by the gallery. Costs to be arranged.
Submissions: Accepts only artists from China living in US. Send query letter with SASE, bio and photographs. Call for appointment to show portfolio of originals and photographs. Replies only if interested within 2 weeks.

CITYARTS, INC., 525 Broadway, Suite 700, New York NY 10012. (212)966-0377. Fax: (212)966-0551. Executive Director: Tsipi Ben-Haim. Art consultancy, nonprofit public art organization. Estab. 1968. Represents 500 emerging, mid-career and established artists. Sponsors 4-8 projects/year. Average display time varies. "A mural or public sculpture will last up to 15 years." Open all year; Monday-Friday, 10-5. Located in Soho; "the city is our gallery. CityArts's 200 murals are located in all 5 boroughs on NYC. We are funded by foundations, corporations, government and membership ('Friends of CityArts')."
Media: Considers oil, acrylic, drawing, sculpture, mosaic and installation. Most frequently exhibits murals (acrylic), mosaics and sculpture.
Style: Exhibits all styles and all genres.
Terms: Artist receives a flat commission for producing the mural or public art work. Retail price set by the gallery. Gallery provides insurance, promotion, contract, shipping costs.
Submissions: "We prefer New York artists due to constant needs of a public art work created in the city." Send query letter with SASE. Call for appointment to show portfolio of originals, photographs and slides. Replies in 1 month. "We reply to original query with an artist application. Then it depends on commissions." Files application form, résumé, slides, photos, reviews. Finds artists through recommendations from other art professionals.
Tips: "We look for artists who are dedicated to making a difference in people's lives through art."

AMOS ENO GALLERY, 594 Broadway, Suite 404, New York NY 10012. (212)226-5342. Director: Jane Harris. Nonprofit and cooperative gallery. Estab. 1973. Exhibits the work of 34 members/year. Sponsors 16 shows/year. Average display time 3 weeks. Open all year. Located in Soho; about 1,000 sq. ft.; "excellent location."
Media: Considers oil, acrylic, watercolor, pastel, pen & ink, drawings, mixed media, collage, works on paper, sculpture, fiber, glass, installation and photography and video.
Style: Exhibits a range of styles.
Terms: Co-op membership fee (20% commission). Retail price set by the gallery and the artist. Artist pays for shipping.
Submissions: Send query letter with SASE for membership information.

STEPHEN E. FEINMAN FINE ARTS LTD., 448 Broome St., New York NY 10012. (212)925-1313. Contact: S.E. Feinman. Retail/wholesale gallery. Estab. 1972. Represents 20 emerging, mid-career and established artists/year. Exhibited artists include: Mikio Watanabe, Johnny Friedlaender, Andre Masson, Felix Sherman, John Axton, Miljenko and Bengez. Sponsors 4 shows/year. Average display time 10 days. Open all year; Monday-Sunday, 12-6. Located in Soho; 1,000 sq. ft. 100% of space for gallery artists. Clients include prosperous middle-aged professionals. 90% of sales are to private collectors, 10% corporate collectors. Overall price range, $300-20,000; most work sold at $1,000-2,500.
Media: Considers oil, acrylic, watercolor, pastel, pen & ink, drawing, mixed media, sculpture, woodcuts, engravings, lithographs, mezzotints, serigraphs, linocuts and etchings. Most frequently exhibits mezzotints, aquatints and oils. Looking for artists that tend toward abstract-expressionists (watercolor/oil or acrylic) in varying sizes.
Style: Exhibits painterly abstraction and surrealism, all genres. Prefers abstract, figurative and surrealist.
Terms: Mostly consignment but also buys outright for % of retail price (net 90-120 days). Retail price set by the

gallery. Gallery provides insurance, promotion, contract and shipping costs from gallery; artist pays shipping costs to gallery. Prefers artwork unframed.
Submissions: Send query letter with résumé, slides and photographs. Replies in 2-3 weeks.
Tips: Currently seeking artists of quality who see a humorous bent in their works (sardonic, ironic) and are not pretentious. "Artists who show a confusing presentation drive me wild. Artists should remember that dealers and galleries are not critics. They are merchants who try to seduce their clients with aesthetics. Artists who have a chip on their shoulder or an 'attitude' are self-defeating. A sense of humor helps!"

FIRST STREET GALLERY, 560 Broadway, #402, New York NY 10012. (212)226-9127. Contact: Members Meeting. Cooperative gallery. Estab. 1964. Represents emerging and mid-career artists. 30 members. Sponsors 10-13 shows/year. Average display time 1 month. Open Tuesday-Saturday, 11-6. Closed in August. Located in the heart of Soho Art District; 2,100 sq. ft.; good combination natural/artificial light, distinguished gallery building. 100% of space for gallery artists. Clients include collectors, consultants, retail. 50% of sales are to private collectors, 50% corporate collectors. Overall price range: $500-40,000; most work sold at $1,000-3,000.
 • First Street sponsors an open juried show each spring with a well-recognized figurative artist as judge. Contact them for details.
Media: Considers oil, acrylic, watercolor, pastel, drawing, prints. Considers prints "only in connection with paintings." Most frequently exhibits oil on canvas and works on paper.
Style: Exhibits: realism. Genres include landscapes and figurative work. "First Street's reputation is based on showing figurative/realism almost exclusively."
Terms: Co-op membership fee plus a donation of time (no commission). "We occasionally rent the space in August for $4,500/month." Retail price set by the artist. Artist pays shipping costs to and from gallery.
Submissions: "We accept figurative/representational work." Send query letter with résumé, slides, bio and SASE. "Artists' slides reviewed by membership at meetings once a month—call gallery for date in any month. We need to see original work to accept a new member." Replies in 1-2 months.
Tips: "Before approaching a gallery make sure they show your type of work. Physically examine the gallery if possible. Try to find out as much about the gallery's reputation in relation to its artists (many well-known galleries do not treat artists well). Show a cohesive body of work with as little paperwork as you can, no flowery statements, the work should speak for itself. You should have enough work completed in a professional manner to put on a cohesive-looking show."

FISCHBACH GALLERY, 24 W. 57th St., New York NY 10019. (212)759-2345. Director: Lawrence DiCarlo. Retail gallery. Estab. 1960. Represents 30 emerging, mid-career and established artists. Sponsors 12 shows/year. Average display time 1 month. Open all year. Located in midtown; 3,500 sq. ft. 80% of space for special exhibitions. Clients include private, corporate and museums. 70% of sales are to private collectors, 30% corporate collectors. Overall price range: $3,000-300,000; most work sold at $10,000-20,000.
Media: Considers oil, acrylic, watercolor, pastel, pen & ink and drawings. Interested in American contemporary representational art; oil on canvas, watercolor and pastel.
Style: Exhibits: contemporary American realism. Genres include landscapes, florals, figurative work and still lifes. Prefers landscapes, still lifes and florals.
Terms: Accepts artwork on consignment (50% commission). Retail price set by gallery. Gallery provides promotion and shipping costs from gallery.
Submissions: Send query letter with résumé, slides, bio and SASE. Portfolio should include slides. Replies in 1 week.
Tips: "No videotapes—slides only with SASE. All work is reviewed."

FOCAL POINT GALLERY, 321 City Island, Bronx NY 10464. (718)885-1403. Artist/Director: Ron Terner. Retail gallery and alternative space. Estab. 1974. Interested in emerging and mid-career artists. Sponsors 2 solo and 6 group shows/year. Average display time 3-4 weeks. Clients include locals and tourists. Overall price range: $175-750; most work sold at $300-500.
Media: Most frequently exhibits photography. Will exhibit painting and etching and other material by local artists only.
Style: Exhibits all styles and genres. Prefers figurative work, landscapes, portraits and abstracts. Open to any use of photography.
Terms: Accepts work on consignment (30% commission). Exclusive area representation required. Customer discounts and payment by installment are available. Gallery provides promotion. Prefers artwork framed.
Submissions: "Please call for submission information. Do not include résumés. The work should stand by itself. Slides should be of high quality."
Tips: "Be nice. (Personality helps.)"

GALLERY HENOCH, 80 Wooster, New York NY 10012. (212)966-6360. Director: George Henoch Shechtman. Retail gallery. Estab. 1983. Represents 40 emerging and mid-career artists. Exhibited artists include Daniel Greene and Max Ferguson. Sponsors 10 shows/year. Average display time 3 weeks. Closed August. Located in Soho; 4,000 sq. ft. 50% of space for special exhibitions. 95% of sales are to private collectors, 5% corporate clients. Overall price range: $3,000-40,000; most work sold at $10,000-20,000.
Media: Considers oil, acrylic, watercolor, pastel, pen & ink, drawings, and sculpture. Most frequently exhibits painting, sculpture, drawings and watercolor.
Style: Exhibits: photorealism and realism. Genres include still life, cityscapes and figurative work. Prefers landscapes,

cityscapes and still lifes.

Terms: Accepts work on consignment (50% commission). Retail price set by gallery. Gallery provides insurance and promotion; shipping costs are shared. Prefers artwork framed.

Submissions: Send query letter with 12-15 slides, bio and SASE. Portfolio should include slides and transparencies. Replies in 3 weeks.

Tips: "We suggest artists be familiar with the kind of work we show and be sure their work fits in with our styles."

GALLERY JUNO, 568 Broadway, Suite 604B, New York NY 10012. (212)431-1515. Fax: (212)431-1583. Gallery Director: June Ishihara. Retail gallery, art consultancy. Estab. 1992. Represents 18 emerging artists/year. Exhibited artists include: Pierre Jacquemon, Kenneth McIndoe and Otto Mjaanes. Sponsors 8 shows/year. Average display time 6 weeks. Open all year; Tuesday-Saturday, 11-6. Located in Soho; 1,000 sq. ft.; small, intimate space. 50% of space for special exhibitions; 50% of space for gallery artists. Clients include corporations, private, design. 20% of sales are to private collectors, 80% corporate collectors. Overall price range: $600-10,000; most work sold at $2,000-5,000.

Media: Considers oil, acrylic, watercolor, pastel, pen & ink, drawing, mixed media. Most frequently exhibits painting and works on paper.

Style: Exhibits: expressionism, neo-expressionism, painterly abstraction, pattern painting and abstraction. Genres include landscapes. Prefers: contemporary modernism and abstraction.

Terms: Accepts work on consignment (50% commission). Retail price set by the gallery and the artist. Gallery provides insurance and promotion; artist pays shipping costs. Prefers artwork framed.

Submissions: Send query letter with résumé, slides, bio, photographs, SASE, business card and reviews. Write for appointment to show portfolio of originals/photographs and slides. Replies in 3 weeks. Files slides, bio, photos, résumé. Finds artists through visiting exhibitions, word of mouth and submissions.

GALLERY 10, 7 Greenwich Ave., New York NY 10014. (212)206-1058. E-mail: marcia@gallery10.com. Website: http://www.gallery10.com. Director: Marcia Lee Smith. Retail gallery. Estab. 1972. Open all year. Represents approximately 150 emerging and established artists. 100% of sales are to private collectors. Overall price range: $24-1,000; most work sold at $50-300.

Media: Considers ceramic, craft, glass, wood, metal and jewelry.

Style: "The gallery specializes in contemporary American crafts."

Terms: Accepts work on consignment (50% commission); or buys outright for 50% of retail price (net 30 days). Retail price set by gallery and artist.

Submissions: Call or write for appointment to show portfolio of originals, slides, transparencies or photographs.

 GOLDSTROM GALLERY, 560 Broadway, Suite 303, New York NY 10012 (212)941-9175. Owner: Manquie Goldstrom. Retail gallery. Estab. 1970. Represents 14 artists; emerging and established. Sponsors 15 solo and 4 group shows/year. Average display time 2-3 weeks. Located in SoHo, "in a clean, medium space in a good location." 90% of sales are to private collectors, 10% corporate clients. Overall price range: $650-300,000.

Media: Considers oil, acrylic, drawings, mixed media, collage, works on paper, sculpture, ceramic and photography.

Style: Exhibits all styles and genres, both emerging artists and secondary market.

Terms: Accepts work on consignment (50% commission) or buys outright (50% retail price). Retail price set by gallery and artist. Exclusive area representation required.

Submissions: Send query letter with well-marked, clear slides and SASE. Replies in 1 month. All material is returned if not accepted or under consideration.

Tips: "Please come into gallery, look at our stable of work, and see first if your work fits our aesthetic."

O.K. HARRIS WORKS OF ART, 383 W. Broadway, New York NY 10012. Director: Ivan C. Karp. Commercial exhibition gallery. Estab. 1969. Represents 55 emerging, mid-career and established artists. Sponsors 50 solo shows/year. Average display time 3 weeks. Open fall, winter, spring and early summer. "Four separate galleries for four separate one-person exhibitions. The back room features selected gallery artists which also change each month." 90% of sales are to private collectors, 10% corporate clients. Overall price range: $50-250,000; most work sold at $12,500-100,000.

Media: Considers all media. Most frequently exhibits painting, sculpture and photography.

Style: Exhibits: realism, photorealism, minimalism, abstraction, conceptualism, photography and collectibles. Genres include landscapes, Americana but little figurative work. "The gallery's main concern is to show the most significant artwork of our time. In its choice of works to exhibit, it demonstrates no prejudice as to style or materials employed. Its criteria demands originality of concept and maturity of technique. It believes that its exhibitions have proven the soundness of its judgment in identifying important artists and its pertinent contribution to the visual arts culture."

Terms: Accepts work on consignment (50% commission). Retail price set by gallery. Customer discounts and payment by installment are available. Exclusive area representation required. Gallery provides insurance and limited promotion. Prefers artwork ready to exhibit.

Submissions: Send query letter with 1 sheet of slides (20 slides) "labeled with size, medium, etc." and SASE. Replies in 1 week.

Tips: "We suggest the artist be familiar with the gallery's exhibitions, and the kind of work we prefer to show. Always include SASE." Common mistakes artists make in presenting their work are "poor, unmarked photos (size, material, etc.), submissions without return envelope, inappropriate work. We affiliate about one out of 10,000 applicants."

N SALLY HAWKINS GALLERY, 448 W. Broadway, 1st Floor, New York NY 10012. (212)477-5699. Managing Director: Sally Hawkins. Retail gallery. Estab. 1983. Represents 6 emerging artists. Exhibited artists include: Grace Group-Pillard and Bill Schiffer. Sponsors 6-8 shows/year. Average display time 5-6 weeks. Open all year. Located in Soho; 500 sq. ft.; "intimate space." 100% of space for special exhibitions. Clients include international. 80% of sales are to private collectors, 10% corporate collectors. Overall price range: $1,000-12,000.
Media: Considers all media and photography prints. Most frequently exhibits painting, small sculpture and photography.
Style: Exhibits: conceptualism, modern and postmodern works.
Terms: Accepts artwork on consignment (50% commission). Retail price set by gallery and artist. Gallery provides insurance and promotion; artist pays for shipping. Prefers artwork unframed.
Submissions: Send query letter with résumé, slides, bio and SASE. Write for appointment to show portfolio of slides and transparencies. Replies in 1 month. Files work of interest.

N PAT HEARN GALLERY, 530 W. 22nd St., New York NY 10011. (212)727-7366. Fax: (212)727-7467. Directors: Pat Hearn and Leslie Nolen. Retail gallery. Estab. 1983. Represents 8-10 emerging, mid-career and established artists/ year. Exhibited artists include Mary Heilman, Renée Green. Sponsors 7 shows/year. Average display time 5-6 weeks. Open all year; Wednesday-Sunday, 11-6. Located Chelsea; 2,500 sq. ft.; natural light, clean uninterrupted space. Generally 100% of space for gallery artists. Clientele: all types. 95% private collectors, 5% corporate collectors. Overall price range: $1,000-40,000; most work sold at $6,000-18,000.
Media: Considers all media including video and all types of prints.
Style: Exhibits expressionism, conceptualism, minimalism, color field, postmodern works and video, text, all genres.
Terms: Accepts work on consignment (50% commission). Retail price set by the gallery and the artist. Gallery provides promotion; shipping costs are shared ("this varies").
Submissions: Send query letter with slides and SASE. Portfolio should include slides. Replies in 1-2 months. Files bio only if interested. Finds artists through visiting exhibitions, word of mouth.

N HELLER GALLERY, 420 W. 14th St., New York NY 10014. (212)414-4014. Fax: (212)414-2636. Director: Douglas Heller. Retail gallery. Estab. 1973. Represents/exhibits emerging, mid-career and established artists. Exhibited artists include: Bertil Vallien and Robin Grebe. Sponsors 11 shows/year. Average display time 3 weeks. Open all year; Tuesday-Saturday, 11-6; Sunday, 12-5. Located in Soho; 4,000 sq. ft.; classic Soho Cast Iron landmark building. 65% of space for special exhibitions; 35% of space for gallery artists. Clients include serious private collectors and museums. 80% of sales are to private collectors, 10% corporate collectors and 10% museum collectors. Overall price range: $1,000-45,000; most work sold at $3,000-10,000.
Media: Glass and wood sculpture. Most frequently exhibits glass, glass and mixed media and wood.
Style: Geometric abstraction and figurative.
Terms: Artwork is accepted on consignment (50% commission). Retail price set by the artist. Gallery provides insurance and limited promotion; shipping costs are shared.
Submission: Send query letter with résumé, slides, photographs, reviews, bio and SASE. Call or write for appointment to show portfolio of photographs, slides and résumé. Replies in 2-4 weeks. Files information on artists represented by the gallery. Finds artists through word of mouth, referrals by other artists, visiting art fairs and exhibitions and submissions.

JEANETTE HENDLER, 55 E. 87th St., Suite 15E, New York NY 10128. (212)860-2555. Fax: (212)360-6492. Art consultancy. Represents/exhibits mid-career and established artists. Exhibited artists include: Warhol, Johns and Haring. Open all year by appointment. Located uptown. 50% of sales are to private collectors, 50% corporate collectors.
Media: Considers oil and acrylic. Most frequently exhibits oils, acrylics and mixed media.
Style: Exhibits: Considers all styles. Genres include landscapes, florals, figurative and Latin. Prefers: realism, classical, neo classical, pre-Raphaelite, still lifes and florals.
Terms: Artwork is accepted on consignment and there is a commission. Retail price set by the gallery and the artist. Gallery provides insurance, promotion and contract.
Submissions: Finds artists through word of mouth, referrals by other artists, visiting art fairs and exhibitions.

N BILL HODGES GALLERY, 24 W. 57th St., 606, New York NY 10019. (212)333-2640. Fax: (212)333-2644. E-mail: behodges@erol.com. Owner/Director: Bill Hodges. Retail gallery. Estab. 1979. Represents/exhibits 10 emerging, mid-career and established artists/year. Exhibited artists include: Romare Bearden, Norman Lewis, Chester Higgins, Linda Touby and Jacob Lawrence. Sponsors 8 shows/year. Average display time 6 weeks. Open all year; Tuesday-Friday, 10-6; Saturday, 12-6. 1,000 sq. ft., 80% of space for gallery artists. Clients include upscale. 60% of sales are to private collectors, 20% corporate collectors. Overall price range: $2,000-90,000; most work sold at $5,000-40,000.
Media: Considers all media and all types of prints except posters. Most frequently exhibits works on canvas, sculpture and limited edition graphics.
Style: Exhibits: color field, hard-edge geometric abstraction and painterly abstraction. Genres include landscapes, Americana and figurative work. Prefers abstract paintings on canvas, figurative work and landscape.
Terms: Artwork is accepted on consignment (50% commission), or artwork is bought outright for 30% of the retail price; net 30 days. Retail price set by the artist. Gallery provides insurance, promotion and contract; shipping costs are shared.
Submissions: Send query letter with slides and photographs. Write for appointment to show portfolio of photographs

and slides. Replies in 3 weeks. Files material under consideration. Finds artists through word of mouth and referrals by other artists.

Tips: "Keep working."

MICHAEL INGBAR GALLERY OF ARCHITECTURAL ART, 568 Broadway, New York NY 10012. (212)334-1100. Curator: Millicent Hathaway. Retail gallery. Estab. 1977. Represents 145 emerging, mid-career and established artists. Exhibited artists include: Richard Haas and Judith Turner. Sponsors 6 shows/year. Average display time 6 weeks. Open all year; Tuesday-Saturday, 12-6. Located in Soho; 1,000 sq. ft. 60% of sales are to private collectors, 40% corporate clients. Overall price range: $500-10,000; most work sold at $5,000.
Media: Considers all media and all types of prints. Most frequently exhibits paintings, works on paper and sculpture.
Style: Exhibits: photorealism, realism and Impressionism. Prefers: New York City buildings, New York City structures (bridges, etc.) and New York City cityscapes.
Terms: Artwork accepted on consignment (50% commission). Artists pays shipping costs.
Submissions: Accepts artists preferably from New York City metro area. Send query letter with SASE to receive "how to submit" information sheet. Replies in 1 week.
Tips: "Study what the gallery sells before you go through lots of trouble and waste their time. Be professional in your presentation." The most common mistakes artists make in presenting their work are "coming in person, constantly calling, poor slide quality (or unmarked slides)."

LA MAMA LA GALLERIA, 6 E. First St., New York NY 10003. (212)505-2476. Director: Merry Geng. Assistant Director: Cesar Llamas. Nonprofit gallery. Estab. 1981. Exhibits the work of emerging, mid-career and established artists. Sponsors 14 shows/year. Average display time 3 weeks. Open September-June; Thursday-Sunday 1-6. Located in East Village; 2,500 sq. ft. "Large and versatile space." 20% of sales are to private collectors, 20% corporate clients. Overall price range: $1,000-5,000; most work sold at $1,000.
Media: Considers oil, acrylic, watercolor, pastel, pen & ink, drawings, mixed media, collage. Most frequently exhibits oil paintings. "No performance art."
Style: Exhibits: stylized expressionism, realism, neo-expressionism, postmodern works, Impressionism and photorealism. Considers still life, landscapes, nature scenes. Also considers thematic shows.
Terms: Accepts work on consignment (20% commission). Retail price set by artist, approved by gallery. Artist is responsible for delivery of sales. Artwork must be framed and ready to hang.
Submissions: "Call first to see if we are accepting slides at the time. Must include return mailer including postage."
Tips: "Interview does not guarantee an exhibit. Will not accept unsolicited work or give interviews without appointment. It makes an impression when I see artists presenting their work in a very amateur manner. Also, respect that a gallery director is very busy and does not have time to teach artists how to make a presentation, or advise where to apply for shows."

BRUCE R. LEWIN GALLERY, 136 Prince St., New York NY 10012. (212)431-4750. Fax: (212)431-5012. E-mail: gallery@brucerlewin.com. Website: http://www.brucerlewin.com. Director: Bruce R. Lewin. Retail gallery. Estab. 1992. Represents/exhibits 30 emerging, mid-career and established artists/year. Sponsors 20 shows/year. Average display time 3-4 weeks. Open all year; Tuesday-Saturday, 10-6. Located in Soho; 7,500 sq. ft.; high ceilings; 40 ft. walls; dramatic architecture. 100% of space for gallery artists. Clients include upscale. 80% of sales are to private collectors, 20% corporate collectors. Overall price range: $500-500,000; most work sold at $5,000-100,000.
Media: Considers all media. Most frequently exhibits paintings, watercolors and sculpture.
Style: Exhibits: photorealism, color field and realism. Genres include figurative work and also pop (Andy Warhol).
Terms: Artwork is accepted on consignment (50% commission). Retail price set by the gallery. Gallery provides insurance and promotion; shipping costs are shared. Prefers artwork framed.
Submissions: Send query letter with slides. Portfolio should include slides or transparencies. Replies only if interested within 1 week. Finds artists through word of mouth and submission of slides.

☑ **LIMNER GALLERY**, (formerly Slowinski Gallery), 870 Avenue of the Americas, New York NY 10001. Phone/fax: (212)725-0999. E-mail: slowart@aol.com. Website: http://www.slowart.com. Director: Tim Slowinski. Limner Gallery is an artist-owned alternative retail (consignment) gallery. Estab. 1987. Represents emerging and mid-career artists. Hosts biannual exhibitions of emerging artists selected by competition, cash awards up to $1,000. Entry available for SASE or from website. Sponsors 6-8 shows/year. Average display time 3 weeks. Open Wednesday-Saturday, 12-6, July 15-August 30, by appointment. Located in Chelsea, 1,200 sq. ft., 2 floors. 60-80% of space for special exhibitions; 20-40% of space for gallery artists. Clients include lawyers, real estate developers, doctors, architects. 95% of sales are to private collectors, 5% corporate collectors. Overall price range: $300-10,000.
Media: Considers all media, all types of prints except posters. Most frequently exhibits painting, sculpture and works on paper.
Style: Exhibits: primitivism, surrealism, all styles, postmodern works, all genres. "Gallery exhibits all styles but emphasis is on non-traditional figurative work."
Terms: Accepts work on consignment (50% commission). Retail price set by the gallery and the artist. Gallery provides promotion and contract; artist pays shipping costs to and from gallery. Prefers artwork framed.

Submissions: Send query letter with résumé, slides, bio and SASE. Call for appointment to show portfolio of originals, photographs, slides and transparencies. Replies in 2-3 weeks. Files slides, résumé. Finds artists through word of mouth, art publications and sourcebooks, submissions.

Tips: "Keep at least ten sets on slides out on review at all times."

THE JOE & EMILY LOWE ART GALLERY AT HUDSON GUILD, 441 W. 26th St., New York NY 10001. (212)760-9837. Director: Jim Furlong. Nonprofit gallery. Estab. 1948. Represents emerging, mid-career community-based and established artists. Sponsors 6 shows/year. Average display time 2 months. Open all year. Located in West Chelsea; 1,200 sq. ft.; a community center gallery in a New York City neighborhood. 100% of space for special exhibitions. 100% of sales are to private collectors.

Media: Considers oil, acrylic, watercolor, pastel, pen & ink, drawings, mixed media, collage, paper, sculpture, original handpulled prints, woodcuts, wood engravings, linocuts, engravings, mezzotints, etchings, lithographs, pochoir and serigraphs. Most frequently exhibits paintings, sculpture and graphics. Looking for artist to do an environmental "installation."

Style: Exhibits all styles and genres.

Terms: Accepts work on consignment (20% commission). Retail price set by artist. Sometimes offers payment by installments. Gallery provides insurance; artist pays for shipping. Prefers artwork framed.

Submissions: Send query letter, résumé, slides, bio and SASE. Portfolio should include photographs and slides. Replies in 1 month.

Tips: Finds artists through visiting exhibitions, word of mouth, various art publications and sourcebooks, artists' submissions/self-promotions, art collectors' referrals.

"My work is always a self-examination and sometimes ridicule of myself and the general state of the world," says artist Tom McKee, referring to his unique ink and pencil piece called *Could This Be Love*. "My art has always been a natural continuation of a child's use of art to entertain and amuse oneself." His work was shown at Limner Gallery in New York City, which he contacted through an address in a magazine in his search for "galleries dealing in a related range of imagery. I am constantly mailing out slides or color copies of my drawings to galleries and magazines, and I have made a number of contacts through publication of my work."

☑ **MALLET FINE ART LTD.**, 220 Park Ave. S., 789B, New York NY 10003. (212)477-8291. Fax: (212)673-1051. President: Jacques Mallet. Retail gallery, art consultancy. Estab. 1982. Represents 3 emerging and established artists/year. Exhibited artists include: Sonntag and Ouattara. Sponsors 1 show/year. Average display time 3 months. Open fall and spring; Tuesday-Saturday, 11-6. Clients include private and art dealers, museums. 80% of sales are to private collectors. Overall price range: $2,000-5,000,000; most work sold at $40,000-400,000.
Media: Considers oil, acrylic, watercolor, pastel, pen & ink, drawing, mixed media, collage, paper, sculpture, engraving, lithograph and etching. Most frequently exhibits oil, works on paper and sculpture.
Style: Exhibits: expressionism, surrealism, all styles and Impressionism.
Terms: Accepts work on consignment (20% commission) or buys outright for 50% of retail price (net 30 days). Retail price set by the gallery. Gallery provides insurance and contract; shipping costs are shared. Prefers artwork framed.
Submissions: Accepts only artists from America and Europe. Send query letter with résumé, slides, bio, photographs and SASE. Write for appointment to show portfolio of transparencies. Replies in 3 weeks. Finds artists through word of mouth.

THE MARBELLA GALLERY INC., 28 E. 72nd St., New York NY 10021. (212)288-7809. President: Mildred Thaler Cohen. Retail gallery. Estab. 1971. Represents/exhibits established artists. Exhibited artists include: Pre Ten and The Eight. Sponsors 1 show/year. Average display time 6 weeks. Open all year; Tuesday-Saturday, 11-5:30. Located uptown; 750 sq. ft. 100% of space for special exhibitions. Clients include tourists and upscale. 50% of sales are to private collectors, 10% corporate collectors, 40% dealers. Overall price range: $1,000-60,000; most work sold at $2,000-4,000.
Style: Exhibits: expressionism, realism and Impressionism. Genres include landscapes, florals, Americana and figurative work. Prefers Hudson River, "The Eight" and genre.
Terms: Artwork is bought outright for a percentage of the retail price. Retail price set by the gallery. Gallery provides insurance.

MARLBOROUGH GALLERY, 40 W. 57th St., New York NY 10019. (212)541-4900. Fax: (212)541-4948. Director: Pierre Levai. Retail gallery. Estab. 1962; renovated space opened Fall 1992. Represents 30 mid-career and established artists. Interested in seeing the work of emerging artists. Exhibited artists include Fernando Botero and Larry Rivers. Sponsors 8 shows/year. Average display time 1 month. Open all year. Located midtown; 19,000 sq. ft. Clients include domestic and international.
Media: Open.
Style: Open.
Terms: Accepts work on consignment or buys artwork outright. Retail price set by gallery and artist. Prefers artwork framed.
Submissions: Send query letter with résumé, slides and bio. Portfolio should include slides. Replies only if interested within 1 month. Files material of interest.

JAIN MARUNOUCHI GALLERY, 24 W. 57th St., New York NY 10019. (212)969-9660. Fax: (212)969-9715. E-mail: jainmar@aol.com. Website: http://www.jainmargallery.com. President: Ashok Jain. Retail gallery. Estab. 1991. Represents 30 emerging artists. Exhibited artists include: Fernando Pomalaza and Pauline Gagnon. Open all year; Tuesday-Saturday, 11-5:30. Located in New York Gallery Bldg., 800 sq. ft. 100% of space for special exhibitions. Clients include corporate and designer. 50% of sales are to private collectors, 50% corporate collectors. Overall price range: $1,000-20,000; most work sold at $5,000-10,000.
Media: Considers oil, acrylic and mixed media. Most frequently exhibits oil, acrylic and collage.
Style: Exhibits: painterly abstraction. Prefers: abstract and landscapes.
Terms: Accepts work on consignment (50% commission). Retail price set by artist. Offers customer discount. Gallery provides contract; artist pays for shipping costs. Prefers artwork framed.
Submissions: Send query letter with résumé, brochure, slides, reviews and SASE. Portfolio review requested if interested in artist's work. Portfolio should include originals, photographs, slides, transparencies and reviews. Replies in 1 week. Finds artists through referrals and promotions.

🅽 ☒ **NEXUS GALLERY**, 345 E. 12th St., New York NY 10003-7238. (212)982-4712. Fax: (212)982-5085. E-mail: nexusart@dt.net. Website: http://www.idt.net/nexusart. Director: Lee Muslin. Cooperative gallery. Estab. 1997. Approached by 100 artists/year. Represents emerging artists. Sponsors 24 exhibits/year, juried. Average display time 1 month. Open Tuesday-Saturday, 12-7; closed last week of August. Located in East Village neighborhood of Manhattan, between 1st and 2nd Avenues; 550 sq. ft. of floor space, 94 linear ft. of hanging wall space; storefront with 10 ft. of windows. Clients include local community and tourists. Overall price range $100-10,000; most work sold at $500.
Media: Considers acrylic, paper, pastel, collage, pen & ink, mixed media, sculpture, drawing, oil, watercolor, engravings, etchings, linocuts, lithographs, mezzotints, serigraphs and woodcuts. No crafts, video or installation. Most frequently exhibits paintings—oil, acrylic, watercolor.
Style: Considers all styles. Most frequently exhibits representational, expressionism and abstract. Considers all genres.
Terms: Co-op membership required; 10% commission. Retail price of art set by the artist. Gallery provides promotion and contract. Accepted work should be framed. Does not require exclusive representation locally. Accepts only artists from New York City tri-state area. Prefers wall-hung work, small to medium size (less than 40" wide).
Submissions: Call to arrange a personal interview to show portfolio of slides. Returns material with SASE. Replies

in 2 weeks. Files résumé; postcard of work, if available. Finds artists through word of mouth, submissions, referrals by other artists and juried show entries.
Tips: "Submit good slides."

THE PHOENIX GALLERY, 568 Broadway, Suite 607, New York NY 10012. (212)226-8711. Website: http://www.gallery-guide.com/gallery/phoenix. Director: Linda Handler. Nonprofit gallery. Estab. 1958. Exhibits the work of emerging, mid-career and established artists. 32 members. Exhibited artists include: Pamela Bennet Ader and Beth Cartland. Sponsors 10-12 shows/year. Average display time 1 month. Open fall, winter and spring. Located in Soho; 180 linear ft. "We are in a landmark building in Soho, the oldest co-op in New York. We have a movable wall which can divide the gallery into two large spaces." 100% of space for special exhibitions. 75% of sales are to private collectors, 25% corporate clients, also art consultants. Overall price range: $50-20,000; most work sold at $300-10,000.
 • In addition to providing a venue for artists to exhibit their work, the Phoenix Gallery also actively reaches out to the members of the local community, scheduling juried competitions, dance programs, poetry readings, book signings, plays, artists speaking on art panels and lectures. A special exhibition space, The Project Room, has been established for guest-artist exhibits.
Media: Considers oil, acrylic, watercolor, pastel, pen & ink, drawings, mixed media, collage, works on paper, sculpture, ceramic, photography, original handpulled prints, woodcuts, engravings, wood engravings, linocuts, etchings and photographs. Most frequently exhibits oil, acrylic and watercolor.
Style: Exhibits: painterly abstraction, minimalism, realism, photorealism, hard-edge geometric abstraction and all styles.
Terms: Co-op membership fee plus donation of time (25% commission). Retail price set by gallery. Offers customer discounts and payment by installment. Gallery provides promotion and contract; artist pays for shipping. Prefers artwork framed.
Submissions: Send query letter with résumé, slides and SASE. Call for appointment to show portfolio of slides. Replies in 1 month. Only files material of accepted artists. The most common mistakes artists make in presenting their work are "incomplete résumés, unlabeled slides and an application that is not filled out properly. We find new artists by advertising in art magazines and art newspapers, word of mouth, and inviting artists from our juried competition to be reviewed for membership."
Tips: "Come and see the gallery—meet the director."

N QUEENS COLLEGE ART CENTER, Benjamin S. Rosenthal Library, Queens College/CUNY, Flushing NY 11367. (718)997-3770. Fax: (718)997-3753. E-mail: sbsqc@cunyvm.cuny.edu. Website: http://www.qc.edu/Library/art/library/html. Director: Suzanna Simor. Curator: Alexandra de Luise. Nonprofit university gallery. Estab. 1955. Exhibits work of emerging, mid-career and established artists. Sponsors 10 shows/year. Average display time 1 month. Open all year; Monday-Thursday, 9-8; Friday, 9-5; Saturday, 12-6. Located in borough of Queens; 1,000 sq. ft. The gallery is wrapped "Guggenheim Museum" style under a circular skylight in the library's atrium. 100% of space for special exhibitions. Clients include "college and community, some commuters." 100% of sales are to private collectors. Overall price range: up to $10,000; most work sold at $300.
Media: Considers all media and all types of prints. Most frequently exhibits paintings, prints, drawings and photographs.
Style: Exhibits: Considers all styles.
Terms: Accepts work on consignment (40% commission). Retail price set by the artist. Gallery provides promotion. Artist pays for shipping costs and announcements. Prefers artwork framed.
Submissions: Cannot exhibit large 3-D objects. Send query letter with résumé, brochure, slides, photographs, reviews, bio and SASE. Replies in 3 weeks. Files all documentation.

N THE REECE GALLERIES, INC., 24 W. 57th St., New York NY 10019. (212)333-5830. Fax: (212)333-7366. E-mail: sireece@reecegalleries.com. Website: http://www.reecegalleries.com. President: Shirley Reece. Retail and wholesale gallery and art consultancy. Estab. 1974. Represents 40 emerging and mid-career artists. Exhibited artists include: Tsugio Hattori, Sica, Robert Natkin, Fred Otnes and Gustavo Lopez Armentia. Sponsors 5-6 shows/year. Average display time 1 month. Open all year. Located in midtown; 1,500 sq. ft.; gallery is broken up into 3 show areas. 90% of space for special exhibitions. Clients include corporate, private, architects and consultants. 50% of sales are to private collectors, 50% corporate collectors. Overall price range: $300-30,000; most work sold at $1,000-15,000.
Media: Considers oil, acrylic, watercolor, pastel, mixed media, collage, paper, original handpulled prints, engravings, mezzotints, etchings, lithographs, pochoir and serigraphs.
Style: Exhibits: expressionism, painterly abstraction, color field and Impressionism.
Terms: Accepts work on consignment (50% commission). Retail price set by gallery and artist. Gallery provides insurance; artist pays for shipping. Prefers artwork unframed.
Submissions: Prefers only work on canvas and prints. Send query letter with résumé, slides, bio, SASE and prices. Call or write for appointment to show portfolio of slides and photographs with sizes and prices. Replies in 2 weeks.
Tips: "A visit to the gallery (when possible) to view what we show would be helpful for you in presenting your work—to make sure the work is compatible with our aesthetics. Slides are the only way to present your work. And don't forget the SASE."

ST. LIFER FINE ART, 11 Hanover Square #703, New York NY 10005. (212)825-2059. Fax: (212)422-0711. E-mail: stliferart@aol.com. Director: Jane St. Lifer. Fine art appraisers, brokers and lectures. Estab. 1988. Represents established artists. May be interested in seeing the work of emerging artists in the future. Exhibited artists include: Miro and Picasso.

Open all year by appointment. Located in the Wall Street area. Clients include national and international contacts. 50% of sales are to private collectors, 50% corporate collectors. Overall price range: $300-8,000.

Media: Considers woodcuts, engravings, lithographs, wood engravings, mezzotints, serigraphs, linocuts, etchings, posters (original).

Style: Exhibits: postmodern works, Impressionism and realism. Considers all genres.

Terms: Accepts work on consignment or buys outright. Retail price set by the gallery. Gallery pays shipping costs from gallery; artist pays shipping costs to gallery. Prefers artwork framed.

Submissions: Send query letter with résumé, bio, photographs, SASE and business card. Portfolio should include photographs. Replies in 3-4 weeks. Files résumé, bio.

[N] SCULPTORS GUILD, INC., 110 Greene St., Suite 603, New York NY 10012. Phone/fax: (212)431-5669. Website: http://www.sculptorsguild.org. President: Stephen Keltner. Nonprofit gallery. Estab. 1937 (office exhibit space). Represents 110 emerging, mid-career and established artists/year. 110 members. Exhibited artists include: Clement Meadmore. Sponsors 5 shows/year. Average display time 1 month. Open all year; Tuesday-Thursday 10-5. Located in Soho; office space—700 sq. ft.; all kinds of sculpture. 100% of space for gallery artists. 50% of sales are to private collectors, 50% corporate collectors. Overall price range: $1,500-40,000; most work sold at $3,000-6,000.

Media: Considers mixed media, sculpture, ceramics, fiber and glass. Most frequently exhibits metal, stone and wood.

Style: Exhibits all styles and genres. Sculpture only by members.

Terms: Accepts work on consignment (20% commission). Membership fee plus donation of time (20% commission) "We are not a co-op gallery, but an organization with dues-paying members." Retail price set by the artist. Gallery provides promotion; shipping costs are shared.

Submissions: Sculptors only. Send query letter with résumé, slides and SASE. "Once a year we have a portfolio review." Call for application form. Portfolio should include photographs and slides. Replies in 2-3 weeks. Files "information regarding our members."

Tips: "Considers experience and exposure. Most importantly, the quality and professionalism of the work will be the determining factor. Members of the Guild are selected by a jury of their peers who view their work, and selections are made based on quality and excellence. A clean cohesive slide sheet with good shots (date, size, medium) are important! Most galleries will not return your work with SASE. Give permission to keep slides otherwise."

SCULPTURECENTER GALLERY, 167 E. 69th St., New York NY 10021. (212)879-3500. Fax: (212)879-7155. E-mail: sculptur@interport.net. Website: http://www.interport.net/~sculptur. Gallery Director: Marian Griffiths. Alternative space, nonprofit gallery. Estab. 1928. Exhibits emerging and mid-career artists. Sponsors 8-10 shows/year. Average display time 3-4 weeks. Open September-June; Tuesday-Saturday, 11-5. Located Upper East Side, Manhattan; main gallery, 1,100 sq. ft.; gallery 2, 104 sq. ft.; old carriage house with 14 ft. ceilings. 85% of space for gallery artists. 90% of sales are to private collectors, 10% corporate collectors. Overall price range: $100-100,000; most work sold at $200-3,000.

Media: Considers drawing, mixed media, sculpture and installation. Most frequently exhibits sculpture, installations and video installations.

Terms: Accepts work on consignment (25% commission). Retail price set by the gallery and the artist. Gallery provides promotion; artist pays shipping costs.

Submissions: Send query letter with résumé, 10-20 slides, bio and SASE. Call for appointment to show portfolio of photographs, slides and transparencies. Replies in 2 months. Files bios and slides. Finds artists through artists' and curators' submissions (mostly) and word of mouth.

NATHAN SILBERBERG FINE ARTS, 301 E. 63rd St., Suite 7-G, New York NY 10021. (212)752-6160. Owner: N. Silberberg. Retail and wholesale gallery. Estab. 1973. Represents 10 emerging and established artists. Exhibited artists include: Joan Miro, Henry Moore and Nadezda Vitorovic. Sponsors 4 shows/year. Average display time 1 month. Open March-July. 2,000 sq. ft. 75% of space for special exhibitions. Overall price range: up to $50,000; most work sold at $4,000.

Media: Considers oil, acrylic, watercolor, original handpulled prints, lithographs, pochoir, serigraphs and etchings.

Style: Exhibits: surrealism and conceptualism. Interested in seeing abstract work.

Terms: Accepts work on consignment (40-60% commission). Retail price set by gallery. Sometimes offers customer discounts. Gallery provides insurance and promotion; shipping costs are shared. Prefers framed artwork.

Submissions: Send query letter with résumé, slides and SASE. Write for appointment to show portfolio of originals, slides and transparencies. Replies in 1 month. Finds artists through visiting art schools and studios.

Tips: "First see my gallery and the artwork we show."

[N] STUDIO ZE GALLERY, 598 Broadway, 2nd Floor, New York NY 10012. (212)219-3304. Website: http://www.studioze.com. Contact: Sandra Sing. Alternative space. Estab. 1990. Represents 20 emerging, mid-career and established artists/year. Located on Broadway between Prince and Houston, Soho. Upscale clients. Most work sold at $3,000.

Media: Considers mixed media, sculpture and all types of prints.

Terms: Artwork is accepted on consignment (50% commission). Retail price is set by the artist. Gallery provides promotion and contract. Accepted work should be mounted. Does not require exclusive representation locally.

Submissions: Call to arrange a personal interview to show portfolio. Replies in 1 month if interested. Files material

only if interested. Finds artists through art exhibits and referrals by other artists. Prefers unframed artwork.

Ⓝ JOHN SZOKE GRAPHICS, INC., 164 Mercer St., New York NY 10012. (212)219-8300. Fax: (212)966-3064. E-mail: szoke@ix.netcom.com. Website: http://www.JohnSzokeEditions.com. President: John Szoke. Director: Susan Jaffe. Retail gallery and art publisher. Estab. 1974. Represents 30 mid-career artists. Exhibited artists include: Janet Fish and Peter Milton. Open all year. Located downtown in Soho; 1,500 sq. ft.; "gallery has a skylight." 50% of space for special exhibitions. Clients include other dealers and collectors. 20% of sales are to private collectors, 20% corporate collectors. Overall price range: $1,000-22,000.
 ● Gallery has recently increased exhibition space by 40%.
Media: Considers works on paper, multiples in relief and intaglio and sculpture. Most frequently exhibits prints and other multiples.
Style: Exhibits: surrealism, minimalism and realism. All genres.
Terms: Buys artwork outright. Retail price set by gallery. Gallery provides insurance and promotion; artist pays for shipping. Prefers unframed artwork.
Submissions: Send query letter with slides and SASE. Write for appointment to show portfolio of slides. The most common mistake artists make in presenting their work is "sending material without explanation, instructions or reference to our needs." Replies in 1 week. Files all correspondence and slides unless SASE is enclosed. Finds artists through word of mouth.

HOLLIS TAGGART GALLERIES, INC., 48 E. 73rd St., New York NY 10021. (212)628-4000. Gallery Contact: Hollis Taggart. Retail gallery. Estab. 1978. Interested in seeing the work of mid-career and established artists. Sponsors 2 shows/year in New York gallery. Average display time 4 weeks. "Interested only in artists working in contemporary realism." 80% of sales are to private collectors, 10% corporate clients. Overall price range: $1,000-1,000,000; most historical artwork sold at $20,000-500,000; most contemporary artwork sold at $7,000-30,000.
Media: Considers oil, watercolor, pastel, pen & ink and drawings.
Style: Prefers figurative work, landscapes and still lifes. "We specialize in 19th and early 20th century American paintings and contemporary realism. We are interested only in contemporary artists who paint in a realist style. As we handle a limited number of contemporary artists, the quality must be superb."
Terms: Retail price set by gallery and artist. Exclusive area representation required. Insurance, promotion, contract and shipping costs negotiable.
Submissions: "Please call first; unsolicited query letters are not preferred. Looks for technical excellence."
Tips: "Collectors are more and more interested in seeing traditional subjects handled in classical ways. Works should demonstrate excellent draftsmanship and quality."

Ⓝ TIBOR DE NAGY GALLERY, 724 Fifth Ave., New York NY 10019. (212)262-5050. Fax: (212)262-1841. Directors: Andrew H. Arnot, Philippe Alexander and Eric Brown. Retail gallery. Estab. 1950. Represents 18 emerging and mid-career artists. Exhibited artists include: Jane Frolicker, Brett Biglee, Estate of Mell Blanine, Will Barnet, Estate of Loren Mciver, Robert Berlind, Gretna Campbell, Rudy Burckhardt and Duncan Hannah. Sponsors 12 shows/year. Average display time 1 month. Closed August. Located midtown; 3,500 sq. ft. 100% of space for work of gallery artists. 60% private collectors, 40% corporate collectors. Overall price range: $1,000-100,000; most work sold at $5,000-20,000.
 ● The gallery focus is on painting within the New York school traditions and photography.
Media: Considers oil, pen & ink, paper, acrylic, drawings, sculpture, watercolor, mixed media, pastel, collage, etchings, and lithographs. Most frequently exhibits oil/acrylic, watercolor and sculpture.
Style: Exhibits representation work as well as abstrct painting and sculpture. Genres include landscapes and figurative work. Prefers abstract, painterly realism and realism.
Submissions: Gallery is not looking for submissions at this time.

Ⓝ ALTHEA VIAFORA, 203 E. 72nd St., New York NY 10021. (212)628-2402. Contact: Althea Viafora. Alternative space and art consultancy. Estab. 1981. Represents/exhibits 10 emerging, mid-career and established artists/year. Exhibited artists include: Matthew Barney and Emil Lukas. Sponsors 2 shows/year. Average display time 1 month. Open by appointment. 100% of space for special exhibitions. Clients include upscale. 100% of sales are to private collectors. Overall price range: $500-300,000; most work sold at $20,000-40,000.
Media: Considers oil, pen & ink, paper, acrylic, drawing, sculpture, watercolor, mixed media, installation, collage, photography, woodcut, wood engraving, linocut, engraving, mezzotint, etching, lithograph and serigraphs. Most frequently exhibits installation, mixed media and oil paintings.
Style: Exhibits: conceptualism and minimalism. Genres include action works. Prefers action works.
Terms: Artwork is accepted on consignment and there is a 50% commission. Retail price set by the gallery. Gallery provides insurance and promotion. Gallery pays for shipping costs. Prefers artwork framed.
Submissions: "Artists must have shown in alternative space." Send query letter with slides, reviews, bio and SASE. Contact through the mail. Replies in 1 month. Files bio. Finds artists through alternative spaces, art magazines, graduate schools, word of mouth.
Tips: "Go to galleries and museums to view your peers' work. Know the history of the dealer, curator, critic you are contacting."

VIRIDIAN ARTISTS INC., 24 W. 57 St., New York NY 10019. (212)245-2882. Director: Vernita Nemec. Cooperative gallery. Estab. 1970. Exhibits the work of 35 emerging, mid-career and established artists. Sponsors 13 solo and 2 group shows/year. Average display time 3 weeks. Clients include consultants, corporations, private collectors. 50% of sales are to private collectors, 50% corporate clients. Overall price range: $500-20,000; most work sold at $1,000-8,000.

Media: Considers oil, acrylic, watercolor, pastel, pen & ink, drawings, mixed media, collage, works on paper, sculpture, installation, photography and limited edition prints. Most frequently exhibits works on canvas, sculpture, mixed media, works on paper and photography.

Style: Exhibits: hard-edge geometric abstraction, color field, painterly abstraction, conceptualism, postmodern works, primitivism, photorealism, abstract, expressionism, and realism. "Eclecticism is Viridian's policy. The only unifying factor is quality. Work must be of the highest technical and aesthetic standards."

Terms: Accepts work on consignment (30% commission). Retail price set by gallery and artist. Sometimes offers customer discounts and payment by installment. Exclusive area representation not required. Gallery provides promotion, contract and representation.

Submissions: Send query letter, slides or call ahead for information on procedure. Portfolio review requested if interested in artist's work.

Tips: "Artists often don't realize that they are presenting their work to an artist-owned gallery where they must pay each month to maintain their representation. We feel a need to demand more of artists who submit work. Because of the number of artists who submit work our critieria for approval has increased as we receive stronger work than in past years as commercial galleries are closing."

SYLVIA WHITE CONTEMPORARY ARTISTS' SERVICES, 560 Broadway, #206, New York NY 10012. (212)966-3564. E-mail: artadvice@aol.com. Website: http://www.artadvice.com. Contact: Sylvia White. Retail gallery, art consultancy, artist's career development services.

● This gallery has two locations (New York and Santa Monica, California). See their California listing for information about the galleries' submission policies as well as media and style needs.

Tips: "Visit our website for monthly artists of interest and marketing tips for visual artists."

© Virginia E. Smit

Artist Virgina Smit created this monotype as part of an autobiographic series featuring an old family photo and an African fish motif. The work was shown at Viridian Artists Inc. and as a result Smit has received many inquiries and sales of her work. To promote her work, Smit sends one promotional mailing per year and Viridian sends several mailings throughout the year that include her work. Smit advises artists to enter as many group shows as they can. "Build an exhibition record and have good slides made of your best pieces."

N **YESHIVA UNIVERSITY MUSEUM**, 2520 Amsterdam Ave., New York NY 10033. (212)960-5390. Director: Sylvia A. Herskowitz. Nonprofit museum. Estab. 1973. Interested in emerging, mid-career and established artists. Sponsors 5-7 solo shows/year. Average display time 3 months. "4 modern galleries; track lighting; some brick walls." Clients include New Yorkers and tourists. Museum works can be sold through museum shop.

Media: Considers all media and original handpulled prints.

Style: Exhibits: postmodernism, surrealism, photorealism and realism with Jewish themes or subject matter. Genres include landscapes, florals, Americana, portraits and figurative work. "We mainly exhibit works of Jewish theme or subject matter or that reflect Jewish consciousness but are somewhat willing to consider other styles or mediums."

Terms: Accepts work for exhibition purposes only, no fee. Pieces should be framed. Retail price is set by gallery and artist. Gallery provides insurance, promotion and contract; artist pays for shipping and framing.

Submissions: Send query letter, résumé, brochure, good-quality slides, photographs and statement about your art. Prefers not to receive phone calls/visits. "Once we see the slides, we may request a personal visit." Resumes, slides or photographs are filed if work is of interest.

Tips: Mistakes artists make are sending "slides that are not identified, nor in a slide sheet." Notices "more interest in mixed media and more crafts on display."

North Carolina

✔ ASSOCIATED ARTISTS OF WINSTON-SALEM, 226 N. Marshall St., Winston-Salem NC 27101. (336)722-0340. Fax: (336)722-0446. E-mail: artists@triadntr.net. Website: http://www.triadntr.net/~artists. Executive Director: Ramelle Pulitzer. Nonprofit gallery. Gallery estab. 1982; organization estab. 1956. Represents 500 emerging, mid-career and established artists/year. 375 members. Sponsors 12 shows/year. Average display time 1 month. Open all year; office hours: Monday-Friday, 9-5; gallery hours: Monday-Friday, 9-9; Saturday, 9-6. Located in the historic Sawtooth Building downtown. "Our gallery is 1,000 sq. ft., but we often have the use of 2 other galleries with a total of 3,500 sq. ft. The gallery is housed in a renovated textile mill (circa 1911) with a unique 'sawtooth' roof. 30% of space for special exhibitions; 70% of space for gallery artists. Clientele: "generally walk-in traffic—this is a multi-purpose public space, used for meetings, receptions, classes, etc." 85% private collectors, 15% corporate collectors. Overall price range: $50-3,000; most work sold at $100-500.

Media: Considers oil, acrylic, watercolor, pastel, pen & ink, drawing, mixed media, collage, paper, sculpture, photography, woodcuts, engravings, lithographs, wood engravings, mezzotints, serigraphs, linocuts and etchings (no photoreproduction prints). Most frequently exhibits watercolor, oil and photography.

Style: Exhibits all styles, all genres.

Terms: "Artist pays entry fee for each show; if work is sold, we charge 30% commission. If work is unsold at close of show, it is returned to the artist." Retail price set by the artist; artist pays shipping costs to and from gallery. Artwork must be framed.

Submissions: Request membership information and/or prospectus for a particular show. Replies in 1 week to membership/prospectus requests. Files "slides and résumés of our exhibiting members only."

Tips: "We don't seek out artists per se—membership and competitions are generally open to all. We advertise call for entries for our major shows in national art magazines and newsletters. Artists can impress us by following instructions in our show prospecti and by submitting professional-looking slides where appropriate. Because of our non-elitist attitude, we strive to be open to all artists—from novice to professional, so first-time artists can exhibit with us."

✔ BARTON MUSEUM, Barton College, P.O. Box 5000, Wilson NC 27893-7000. (252)399-6477. E-mail: cwilson@e-mail.barton.edu. Director of Exhibitions: J. Chris Wilson. Nonprofit gallery. Estab. 1965. Represents mid-career and established artists, especially artists from North Carolina. Sponsors both solo and group shows during academic year. Artwork up to $3,500 has sold.

Media: Considers all media and original handpulled prints. Most frequently exhibits pottery, painting, historic decorative arts, prints and photographs. Interested in seeing "all types of visual arts—glass, sculpture, drawings, etc."

Style: Considers all styles.

Terms: Retail price set by artist. Gallery provides standard insurance coverage and promotion locally through the media and mailings; shipping expenses are negotiated.

Submissions: Contact the Director of Exhibitions for additional information.

Tips: "Make sure that the gallery you are approaching is a good match in terms of quality and profile."

N **BLUE SPIRAL 1**, 38 Biltmore Ave., Asheville NC 28801. (828)251-0202. Fax: (828)251-0884. E-mail: bluspiral1@aol.com. Director: John Cram. Retail gallery. Estab. 1991. Represents emerging, mid-career and established artists living in the Southeast. Exhibited artists include Paige Davis, Judy Jones, Stoney Lamar, Michael Sherrill and Art Werger. Sponsors 10 shows/year. Average display time 6-8 weeks. Open all year; Monday-Saturday, 10-5. Located downtown; 15,000 sq. ft.; historic building. 85% of space for special exhibitions; 15% of space for gallery artists. Clientele: "across the range." 90% private collectors, 10% corporate collectors. Overall price range: less than $100-50,000; most work sold at $100-2,500.

Media: Considers all media. Most frequently exhibits painting, clay, sculpture and glass.

Style: Exhibits all styles, all genres.

Terms: Accepts work on consignment (50% commission). Retail price set by the artist. Gallery provides insurance, promotion and contract; artist pays shipping costs to and from gallery. Prefers artwork framed.

Submissions: Accepts only artists from Southeast. Send query letter with résumé, slides, prices, statement and SASE. Replies in 3 months. Files slides, name and address. Finds artists through word of mouth, referrals and travel.

Tips: "Work must be technically well executed and properly presented."

BROADHURST GALLERY, 800 Midland Rd., Pinehurst NC 28374. (910)295-4817. Owner: Judy Broadhurst. Retail gallery. Estab. 1990. Represents/exhibits 50 emerging, mid-career and established artists/year. Sponsors about 4 large shows and many smaller shows/year. Average display time 1-3 months. Open all year; Tuesday-Friday, 11-5; Saturday, 1-4; and by appointment. Located on the main road between Pinehurst and Southern Pines; 3,000 sq. ft.; lots of space, lots of light, lots of parking spaces. 50% of space for special exhibitions; 50% of space for gallery artists. Clientele: people building homes and remodeling, also collectors. 80% private collectors, 20% corporate collectors. Overall price range: $500-20,000; most work sold at $1,000-5,000.

Media: Considers oil, acrylic, watercolor, pastel, mixed media, collage, sculpture, craft and glass. Most frequently exhibits oil, acrylic, sculpture (stone and bronze), watercolor, glass.

Style: Exhibits all styles, all genres.

Terms: Retail price set by the artist. Gallery provides insurance, promotion and contract; shipping costs are shared. Prefers artwork framed.

Submissions: Send query letter with résumé, slides and/or photographs, and bio. Write for appointment to show portfolio of originals and slides. Replies only if interested within 2-3 weeks. Files résumé, bio, slides and/or photographs. Finds artists through agents, by visiting exhibitions, word of mouth, various art publications and sourcebooks and artists' submissions.

Tips: "Talent is always the most important factor but professionalism is very helpful."

THE DAVIDSON COUNTY MUSEUM OF ART, 224 S. Main St., Lexington NC 27292. (336)249-2742. Curator: Mark Alley. Nonprofit gallery. Estab. 1968. Exhibits 30 emerging, mid-career and established artists. Interested in seeing the work of emerging artists. 400 members. Exhibited artists include Bob Timberlake and Zoltan Szabo. Disney Animation Archives (1993), Ansel Adams (1994), P. Bukeley Moss (1996). Sponsors 11 shows/year. Average display time 1 month. Open all year. 6,000 sq. ft; historic building, good location, marble foyer. 80% of space for special exhibitions; 10% of space for gallery artists. Clientele: 98% private collectors, 2% corporate collectors. Overall price range: $50-20,000; most work sold at $50-4,000.

Media: Considers all media and all types of prints. "Originals only for exhibition. Most frequently exhibits painting, photography and mixed media. "We try to provide diversity."

Style: Exhibits expressionism, painterly abstraction, postmodern works, expressionism, photorealism and realism. Genres include landscapes and Southern artists.

Terms: Accepts work on consignment (30% commission). Members can exhibit art for 2 months maximum per piece in our members gallery. 30% commission goes to Guild. Retail price set by gallery and artist. Gallery provides insurance, promotion and contract; artist pays for shipping. Prefers artwork framed for exhibition and unframed for sales of reproductions.

Submissions: Send query letter with résumé, slides, bio, brochure, photographs, business card, reviews and SASE. Write for appointment to show portfolio of originals, photographs and slides. Entries reviewed every May for following exhibition year.

N: DURHAM ART GUILD, INC., 120 Morris St., Durham NC 27701. (919)560-2713. E-mail: artguild@mindspring.com. Gallery Director: Lisa Morton. Nonprofit gallery. Estab. 1948. Represents/exhibits 500 emerging, mid-career and established artists/year. Sponsors 11 shows/year including an annual juried art exhibit. Average display time 3½ weeks. Open all year; Monday-Saturday, 9-9; Sunday, 1-6. Free and open to the public. Located in center of downtown Durham in the Arts Council Building; 3,600 sq. ft.; large, open, movable walls. 100% of space for special exhibitions. Clientele: general public. 80% private collectors, 20% corporate collectors. Overall price range: $100-14,000; most work sold at $200-1,200.

Media: Considers all media. Most frequently exhibits painting, sculpture and photography.

Style: Exhibits all styles, all genres.

Terms: Artwork is accepted on consignment (30-40% commission). Retail price set by the artist. Gallery provides insurance and promotion. Artist installs show. Prefers artwork framed.

Submissions: Artists 18 years or older. Send query letter with résumé, slides and SASE. We accept slides for review by January 31 for consideration of a solo exhibit or special projects group show. Does not reply. Artist should include SASE. Finds artists through word of mouth, referral by other artists, call for slides.

N: HODGES TAYLOR GALLERY, 401 N. Tryon St., Charolotte NC 28202-2125. (704)334-3799. Partner: Hodges. Retail gallery and art consultancy. Estab. 1980. Represents 25 mid-career and established artists of the Southeast. Exhibited artists include M. Gatewood and R. Marsh. Average display time 1 month. Located uptown, one block from square; 500 sq. ft.; "in a very nicely renovated older building." 25% of space for special exhibitions. 50% private collectors; 50% corporate collectors. Overall price range: $150-50,000.

Media: Considers oil, acrylic, watercolor, pastel, pen & ink, drawing, mixed media, collage, works on paper, sculpture, ceramic, glass, original handpulled prints, woodcuts, engravings, lithographs, wood engravings, mezzotints, serigraphs,

linocuts, etchings. Most frequently exhibits works on canvas, works on paper and sculpture.

Style: Exhibits expressionism, neo-expressionism, primitivism (on occasion), painterly abstraction, conceptualism, color field, Impressionism, realism and pattern painting. "It is the quality of the work, not the style, that attracts us."

Terms: Accepts artwork on consignment (50% commission). Retail price set by the gallery and artist. Gallery provides insurance, promotion and verbal contract. Gallery pays for shipping costs from gallery.

Submissions: Send query letter with résumé, slides, bio, SASE and retail price list, if available. Replies in 1 month. Files résumé, "slides if agreeable."

Tips: "We look for a consistent body of work. It is helpful if the artist has visited the gallery and has an idea of the work we exhibit, what our aesthestic choices cover."

RALEIGH CONTEMPORARY GALLERY, 323 Blake St., Raleigh NC 27601. (919)828-6500. Director: Rory Parnell. Retail gallery. Estab. 1984. Represents 20-25 emerging and mid-career artists/year. Sponsors 6 shows/year. Average display time 1 month. Open all year; Monday-Saturday, 11-4. Located downtown; 1,300 sq. ft.; architect-designed; located in historic property in a revitalized downtown area. 30% of space for special exhibitions; 70% of space for gallery artists. Clients include corporate and private. 35% of sales are to private collectors, 65% corporate collectors. Overall price range: $500-5,000; most work sold at $1,200-2,500.

Media: Considers oil, acrylic, watercolor, pastel, pen & ink, drawing, woodcut, engraving and lithograph. Most frequently exhibits oil/acrylic paintings, drawings and lithograph.

Style: Exhibits all styles. Genres include landscapes and florals. Prefers landscapes, realistic and impressionistic; abstracts.

Terms: Accepts work on consignment (50% commission). Retail price set by the gallery and the artist. Gallery provides insurance, promotion and contract; shipping costs are shared.

Submissions: Send query letter with résumé, slides, bio, SASE and reviews. Call or write for appointment to show portfolio of slides. Replies in 1 month. Finds artists through exhibitions, word of mouth, referrals.

N SOMERHILL GALLERY, 3 Eastgate E. Franklin St., Chapel Hill NC 27514. (919)968-8868. Fax: (919)967-1879. Director: Joseph Rowand. Retail gallery. Estab. 1972. Represents emerging, mid-career and established artists. Sponsors 10 major shows/year, plus a varied number of smaller shows. Open all year. 10,000 sq. ft.; gallery features "architecturally significant spaces, pine floor, 18′ ceiling, 6 separate gallery areas, stable, photo, glass." 50% of space for special exhibitions.

Media: Considers all media, woodcuts, wood engravings, linocuts, engravings, mezzotints, etchings, lithographs and serigraphs. Does not consider installation. Most frequently exhibits painting, sculpture and glass.

Style: Exhibits all styles and genres.

Submissions: Focus is on contemporary art of the United States; however artists from all over the world are exhibited. Send query letter with résumé, slides, bio, SASE and any relevant materials. Replies in 6-8 weeks. Files slides and biographical information of artists.

✓ TYLER-WHITE COMPTON ART GALLERY, (formerly Compton Art Gallery), 507 State St. Station, Greensboro NC 27405. (336)279-1124. Fax: (336)279-1102. Owners: Marti Tyler and Judy White. Retail gallery. Estab. 1985. Represents 60 emerging, mid-career and established artists. Exhibited artists include Marcos Blahove, Geoffrey Johnson and Connie Winters. Sponsors 8 shows/year. Open all year. Located in State Street Station, a unique shopping district 1 mile from downtown. Overall price range: $100-4,000; most work sold at $1,500.

Media: Considers oil, acrylic, watercolor and pastel.

Style: Considers contemporary expressionism, Impressionism and realism. Genres include landscapes, florals and figurative work.

Terms: Accepts artwork on consignment (45% commission). Retail price set by the artist. Gallery provides some insurance, promotion and contract; artist pays for shipping. Prefers artwork framed if oil, or a finished canvas. Prefers matted watercolors.

Submissions: Send query letter with slides, résumé, brochure, photographs and SASE. Write to schedule an appointment to show a portfolio, which should include originals, slides and transparencies. Replies in 1 month. Files brochures, résumé and some slides.

Tips: "We only handle original work."

North Dakota

THE ARTS CENTER, Dept. AGDM, 115 Second St. SW, Box 363, Jamestown ND 58402. (701)251-2496. Director: Taylor Barnes. Nonprofit gallery. Estab. 1981. Sponsors 8 solo and 4 group shows/year. Average display time 6 weeks. Interested in emerging artists. Overall price range: $50-600; most work sold at $50-350.

Style: Exhibits contemporary, abstraction, Impressionism, primitivism, photorealism and realism. Genres include Americana, figurative and 3-dimensional work.

Terms: 40% commission on sales from regularly scheduled exhibitions. Retail price set by artist. Gallery provides insurance, promotion and contract; shipping costs are shared.

Submissions: Send query letter, résumé, brochure, slides, photograph and SASE. Write for appointment to show

portfolio. Invitation to have an exhibition is extended by Arts Center curator.

Tips: "We are interested in work of at least 20-30 pieces, depending on the size."

[N] GANNON & ELSA FORDE GALLERIES, 1500 Edwards Ave., Bismarck ND 58501. (701)224-5601. Fax: (701)224-5550. Gallery Director: Jan Zidon. College gallery. Represents 12 emerging, mid-career and established artists per school year. Sponsors 6 shows/year. Average display time 6 weeks. Open all year; Monday-Thursday, 9-9; Friday, 9-4; Saturday, 1-5; Sunday, 6-9. Summer exhibit is college student work (May-August). Located Bismarck State College Campus; high traffic areas on campus. Clientele: all. 80% private collectors, 20% corporate collectors. Overall price range: $50-10,000; most work sold at $50-3,000.

Media: Considers oil, acrylic, watercolor, pastel, drawing, mixed media, collage, paper, sculpture, ceramics, fiber, photography, woodcut, engraving, lithograph, wood engraving, mezzotint, serigraphs, linocut and etching. Most frequently exhibits painting media (all), mixed media and sculpture.

Style: Exhibits expressionism, neo-expressionism, painterly abstraction, surrealism, Impressionism, photorealism, hard-edge geometric abstraction and realism, all genres. Prefers figurative, landscapes and abstract.

Terms: Accepts work on consignment (20% commission). Retail price set by the artist. Gallery provides insurance on premises, promotion, contract and shipping costs from gallery; artist pays shipping costs to gallery. Prefers artwork framed.

Submissions: Send query letter with résumé, slides, bio and SASE. Call or write for appointment to show portfolio of photographs and slides. Replies in 2 months. Files résumé, bio, photos if sent. Finds artists through word of mouth, art publications, artists' submissions, visiting exhibitions.

Tips: "Because our gallery is a university gallery, the main focus is not just selling work but exposing the public to art of all genres. However, we do sell work, occasionally."

HUGHES FINE ART CENTER ART GALLERY, Department of Visual Arts, University of North Dakota, Grand Forks ND 58202-7099. (701)777-2257. E-mail: mcelroye@badland.nodak.edu. Website: http://www.nodak.edu/dept/fac/visual_home.html. Director: Brian Paulsen. Nonprofit gallery. Estab. 1979. Exhibits emerging, mid-career and established artists. Sponsors 5 shows/year. Average display time 3 weeks. Open all year. Located on campus; 96 running ft. 100% of space for special exhibitions.

● Director states gallery is interested in "well-crafted, clever, sincere, fresh, inventive, meaningful, unique, well-designed compositions—surprising, a bit shocking, etc."

Media: Considers all media. Most frequently exhibits painting, photographs and jewelry/metal work.

Style: Exhibits all styles and genres.

Terms: Retail price set by artist. Gallery provides "space to exhibit work and some limited contact with the public and the local newspaper." Gallery pays for shipping costs. Prefers artwork framed.

Submissions: Send query letter with 10-20 slides and résumé. Portfolio review not required. Replies in 1 week. Files "duplicate slides, résumés." Finds artists from submissions through *Artist's & Graphic Designer's Market* listing, *Art in America* listing in their yearly museum compilation; as an art department listed in various sources as a school to inquire about; the gallery's own poster/ads.

Tips: "We are not a sales gallery. Send slides and approximate shipping costs."

NORTHWEST ART CENTER, Minot State University, 500 University Ave. W., Minot ND 58707. (701)858-3264 or 3836. Fax: (701)839-6933. E-mail: olsonl@warp6.cs.misu.nodak.edu. Director: Linda Olson. Nonprofit gallery. Estab. 1970. Represents emerging, mid-career and established artists. Sponsors 15-25 shows/year. Average display time 4-6 weeks. Open all year. Two galleries: Hartnett Hall Gallery; Monday-Friday, 8-5; The Library Gallery; Monday-Friday, 8-10. Located on University campus; 1,000 sq. ft. 100% of space for special exhibitions. 100% private collectors. Overall price range: $100-40,000; most work sold at $100-4,000.

Media: Considers all media and all types of prints except posters.

Style: Exhibits all styles, all genres.

Terms: Retail price set by the artist. Gallery provides insurance, promotion and contract; shipping costs are shared. Prefers artwork framed.

Submissions: Send query letter with résumé, slides, bio, SASE and artist's statement. Call for appointment to show portfolio of originals, photographs, slides and transparencies. Replies in 1-2 months. Files all material. Finds artists through submissions, visiting exhibitions, word of mouth.

Tips: "Develop a professional presentation. Use excellent visuals—slides, etc."

[N] NORTHWOODS GALLERY, 111 S. Fifth St., Bismarck ND 58501. (701)258-3939. E-mail: gallery@bti.com. Owner: Brenda Stone. Retail gallery. Estab. 1976. Represents over 100 mid-career and established artists/year. May be interested in seeing the work of emerging artists in the future. Exhibited artists include: Redlin and Doolittle. Average display time 2 months. Open all year; Monday-Saturday, 10-5; closed Sundays. Located downtown; 700 sq. ft. 10% of space for special exhibitions; 10% of space for gallery artists. Clients include local upscale. 10% of sales are to private collectors; 10% corporate collectors. Overall price range: $150-300; most work sold at $150-300.

Media: Considers all media except limited edition prints and all types of prints. Most frequently exhibits lithographs, serigraphs and giclée.

Style: Exhibits: expressionism, conceptualism, Impressionism, photorealism and realism. Genres include florals, western, wildlife, landscapes and Americana. Prefers wildlife, nostalgic and landscapes.

Terms: Accepts work on consignment (30% commission) or buys outright for 50% of retail price (net 30 days). Retail price set by the artist. Gallery provides promotion; gallery pays for shipping. Prefers artwork unframed.
Submissions: Accepts only artists from the Midwest. Send brochure. Call for appointment to show portfolio of photographs. Replies only if interested within 1 month. Files material relevant to Midwest nostalgia. Finds artists through mail.
Tips: "I like professional brochures."

LILLIAN AND COLEMAN TAUBE MUSEUM OF ART, Box 325, Minot ND 58702. (701)838-4445. Executive Director: Jeanne M. Rodgers. Nonprofit gallery. Estab. 1970. Represents emerging, mid-career and established artists. Sponsors 12-20 shows/year. Average display time 1-2 months. Open all year. Located at 2 North Main; 3,000 sq. ft.; "historic landmark building." 100% of space for special exhibitions. Clientele: 100% private collectors. Overall price range: $50-2,000; most work sold at $100-400.
Media: Considers oil, acrylic, watercolor, pastel, pen & ink, drawings, mixed media, collage, works on paper, sculpture, ceramic, fiber, glass, photograph, woodcuts, engravings, lithographs, serigraphs, linocuts and etchings. Most frequently exhibits watercolor, acrylic and mixed media.
Style: Exhibits all styles and genres. Prefers figurative, Americana and landscapes. No "commercial-style work (unless a graphic art display)." Interested in all media.
Terms: Accepts work on consignment (30% commission, members; 40% nonmembers). Retail price set by artist. Offers discounts to gallery members and sometimes payment by installments. Gallery provides insurance, promotion and contract; pays shipping costs from gallery or shipping costs are shared. Requires artwork framed.
Submissions: Send query letter with résumé and slides. Write for appointment to show portfolio of good quality photographs and slides. "Show variety in your work." Files material interested in. Finds artists through visiting exhibitions, word of mouth, submissions of slides and members' referrals.
Tips: "We will take in a small show to fill in an exhibit. Show your best. When shipping show, be uniform on sizes and frames. Have flat backs to pieces so work does not gouge walls. Be uniform on wire placement. Avoid sawtooth hangers."

Ohio

☑ **ACME ART COMPANY**, 1129 N. High St., Columbus OH 43201. (614)299-4003. Art Director: Margaret Evans. Nonprofit gallery. Estab. 1986. Represents 300 emerging and mid-career artists/year. 250 members. Sponsors 12 shows/year. Average display time 1 month. Open all year; Wednesday-Saturday, 1:00-7:00. Located in Short North District; 1,400 sq. ft.; 3 gallery areas. 70% of space for special exhibitions; 70% of space for gallery artists. Clientele: avant-garde collectors, private and professional. 85% private collectors, 15% corporate collectors. Overall price range: $30-5,000; most work sold at $50-1,000.
Media: Considers all media and all types of prints except posters. Most frequently exhibits painting, installations and sculpture.
Style: Exhibits all styles, prefers avante-garde and cutting edge. Genres include all types of experimental and emerging art forms. Prefers experimental, socio/political and avante-garde.
Terms: Accepts work on consignment (30% commission). Retail price set by the gallery and the artist. Gallery provides promotion and contract; shipping costs are shared. Prefers artwork framed.
Submissions: Prefers only "artists who push the envelope, who explore new vision and materials of presentation." Send query letter with résumé, slides, bio, SASE and reviews. Write for appointment to show portfolio of originals if possible, slides or transparencies. Call for following fiscal year line-up ("we work one year in advance"). Files bio, slides, résumé and other support materials sent by artists. Finds artists through art publications, slides from call-for-entries, minority organizations, universities and word of mouth.

ALAN GALLERY, 36 Park St., Berea OH 44017. (216)243-7794. Fax: (216)243-7772. President: Alan Boesger. Retail gallery and arts consultancy. Estab. 1983. Represents 25-30 emerging, mid-career and established artists. Sponsors 4 solo shows/year. Average display time 6-8 weeks. Clientele: 40% private collectors, 60% corporate clients. Overall price range: $700-6,000; most work sold at $1,500-2,000.
Media: Considers all media and limited edition prints. Most frequently exhibits watercolor, works on paper and mixed media.
Style: Exhibits color field, painterly abstraction and surrealism. Genres include landscapes, florals, western and figurative work.
Terms: Accepts work on consignment (40% commission). Retail price set by gallery and artist. Exclusive area representation not required. Gallery provides insurance, promotion and contract; shipping costs are shared.
Submissions: Send résumé, slides and SASE. Call or write for appointment to show portfolio of originals and slides. All material is filed.

THE ART EXCHANGE, 539 E. Town St., Columbus OH 43215. (614)464-4611. Fax: (614)464-4619. E-mail: artexg @ix.netcom.com. Art consultancy. Estab. 1978. Represents 40 emerging, mid-career and established artists/year. Exhibited artists include Mary Beam, Carl Krabill. Open all year; Monday-Friday, 9-5. Located near downtown; historic

neighborhood; 2,000 sq. ft.; showroom located in Victorian home. 100% of space for gallery artists. Clientele: corporate leaders. 20% private collectors; 80% corporate collectors. Overall price range: $150-6,000; most work sold at $1,000-1,500.

Media: Considers oil, acrylic, watercolor, pastel, mixed media, collage, sculpture, ceramics, fiber, glass, photography and all types of prints. Most frequently exhibits oil, acrylic, watercolor.

Style: Exhibits painterly abstraction, Impressionism, realism, folk art. Genres include florals and landscapes. Prefers Impressionism, painterly abstraction, realism.

Terms: Accepts work on consignment. Retail price set by the gallery and the artist.

Submissions: Send query letter with résumé and slides or photographs. Write for appointment to show portfolio. Replies in 2 weeks. Files slides or photos and artist information. Finds artists through word of mouth, referrals by other artists, visiting art fairs and exhibitions, submissions.

Tips: "Our focus is to provide high-quality artwork and consulting services to the corporate, design and architectural communities. Our works are represented in corporate offices, health care facilities, hotels, restaurants and private collections throughout the country."

☑ **CHELSEA GALLERIES**, 28120 Chagnn Blvd., Woodmere OH 44122. (216)591-1066. Fax: (216)591-1068. E-mail: chelsea@chelseagalleries.com. Director: Jill T. Wieder. Retail gallery. Estab. 1975. Represents/exhibits 400 emerging and mid-career artists/year. Exhibited artists include Leonard Urso and Tom Seghi. Sponsors 5 shows/year. Average display time 6 months. Open all year; Monday-Friday, 9-5; Saturday, 12-4. Adjustable showroom; easy access, free parking, halogen lighting. 40% of space for special exhibitions; 100% of space for gallery artists. Clientele: upscale. 85% private collectors, 15% corporate collectors. Overall price range: $50-10,000; most work sold at $500-2,000.

Media: Considers all media and all types of prints. Most frequently exhibits painting, glass and ceramics.

Style: Exhibits all styles and all genres. Prefers: Impressionism, realism and abstraction.

Terms: Artwork is accepted on consignment (50% commission). Retail price set by the gallery and the artist. Gallery provides insurance, promotion and contract; shipping costs are shared. Prefers artwork framed.

Submissions: Send query letter with résumé and slides. Call for appointment to show portfolio of photographs and slides. Replies in 6 weeks. Files résumé and slides.

Tips: "Be realistic in pricing—know your market."

☑ **CLEVELAND STATE UNIVERSITY ART GALLERY**, 2307 Chester Ave., Cleveland OH 44114. (216)687-2103. Fax: (216)687-9340. E-mail: rthurmer@csuohio.edu. Website: http://www.csuohio.edu/artgallery. Director: Robert Thurmer. Assistant Director: Tim Knapp. University gallery. Exhibits 50 emerging, mid-career and established artists. Exhibited artists include Ellen Phelan and Kay Walkingstick. Sponsors 6 shows/year. Average display time 1 month. Open Monday-Friday, 10-5; Saturday, 12-4. Closed Sunday and holidays. Located downtown: 4,500 sq. ft. (250 running ft. of wall space). 100% of space for special exhibitions. Clientele: students, faculty, general public. 85% private collectors, 15% corporate collectors. Overall price range: $250-50,000; most work sold at $300-1,000.

Media: Considers all media and all types of prints. Prefers painting, sculpture and new genres of work.

Style: Exhibits all styles and genres. Prefers: contemporary, modern and postmodern. Looks for challenging work.

Terms: 25% commission. Sales are a service to artists and buyers. Gallery provides insurance, promotion, shipping costs to and from gallery; artists handle crating. Prefers artwork framed.

Submissions: Send query letter with résumé and slides. Portfolio review requested if interested in artist's work. Files résumé and slides. Finds artists through visiting exhibitions, artists' submissions, publications and word of mouth. Submission guidelines available for SASE.

Tips: "No oversized or bulky materials please! 'Just the facts ma'am.' "

THE A.B. CLOSSON JR. CO., 401 Race St., Cincinnati OH 45202. (513)762-5510. Fax: (513)762-5515. Director: Phyllis Weston. Retail gallery. Estab. 1866. Represents emerging, mid-career and established artists. Average display time 3 weeks. Clientele: general. Overall price range: $300-75,000.

Media: Considers oil, watercolor, pastel, mixed media, sculpture, original handpulled prints, limited offset reproductions.

Style: Exhibits all styles and genres.

Terms: Accepts work on consignment or buys outright. Retail price set by gallery and artist. Customer discounts and payment by installment are available. Exclusive area representation required. Gallery provides insurance and promotion; shipping costs are shared.

Submissions: Send photos, slides and résumé. Call or write for appointment. Portfolio review requested if interested in artist's work. Portfolio should include originals. Finds artists through agents, visiting exhibitions, word of mouth, various art publications, sourcebooks, submissions/self-promotions and art collectors' referrals.

CHARLES FOLEY GALLERY, 973 E. Broad St., Columbus OH 43205. (614)253-7921. Director: Charles Foley. Retail gallery. Estab. 1982. Represents established artists. Interested in seeing the work of emerging artists. Exhibited artists include: Tom Wesselmann and Richard Anuszkiewicz. Sponsors 2 shows/year. Average display time 8 weeks. Open all year. Located east of the Columbus Museum of Art; 5,000 sq. ft.; "housed in a turn-of-the-century house, specializing in 20th-century masters." 50% of space for special exhibitions, 50% for gallery artists. 90% of sales are to private collectors, 10% corporate clients. Overall price range: $30-150,000; most artwork sold at $2,500-20,000.

Media: Considers oil, acrylic, watercolor, pen & ink, drawings, mixed media, collage, works on paper, sculpture,

ceramic, original handpulled prints, woodcuts, linocuts, engravings, etchings, lithographs, serigraphs and posters. Most frequently exhibits paintings, etchings and drawings.

Style: Exhibits: expressionism, color field and hard-edge geometric abstraction. Prefers pop art, op art and expressionism.

Terms: Accepts work on consignment (30% commission). Retail price set by the gallery and the artist. Gallery provides promotion. Gallery pays for shipping costs. Prefers framed artwork.

Submissions: Send query letter with SASE. Call to schedule an appointment to show portfolio, which should include originals and transparencies.

KUSSMAUL GALLERY, 140 E. Broadway, P.O. Box 338, Granville OH 43023. (740)587-4640. Owner: James Young. Retail gallery, custom framing. Estab. 1989. Represents 6-12 emerging and mid-career artists/year. Exhibited artists include: James Young and Greg Murr. Sponsors 3-4 shows/year. Average display time 30 days. Open all year; Tuesday-Saturday, 10-5; Sunday, 11-3. Located downtown; 3,200 sq. ft.; restored building erected 1830—emphasis on interior brick walls and restored tin ceilings. New gallery space upstairs set to open July 1999 with cathedral ceilings, exposed brick walls, skylights, approximately 1,600 sq. ft. devoted only to framed art and sculpture. 25% of space for art displays. Clients include upper-middle class. 75% of sales are to private collectors, 25% corporate collectors. Overall price range: $75-2,500; most work sold at $150-350.

Media: Considers oil, acrylic, watercolor, mixed media, sculpture, glass, all types of prints. Most frequently exhibits watercolor.

Style: Exhibits: expressionism, neo-expressionism, primitivism, abstraction, Impressionism, realism. Prefers: Impressionism and realism.

Terms: Accepts work on consignment (40% commission) or buys outright. Retail price set by the gallery. Gallery provides insurance on work purchased outright and promotion; artist pays shipping costs to and from gallery. Prefers artwork unframed.

Submissions: Send query letter with résumé, slides, bio and SASE. Replies only if interested within 1 month. Files slides, bio or returns them. Finds artists through networking, talking to emerging artists.

Tips: "Don't overprice your work, be original. Have large body of work representing your overall talent and style."

☑ **MALTON GALLERY**, 2709 Observatory, Cincinnati OH 45208. (513)321-8614. Director: Sylvia Rombis. Retail gallery. Estab. 1974. Represents about 100 emerging, mid-career and established artists. Exhibits 20 artists/year. Exhibited artists include Carol Henry, Mark Chatterley, Patrick Trauth and Philippe Lejeune. Sponsors 7 shows/year. Average display time 1 month. Open all year; Monday-Saturday, 10-5. Located in high-income neighborhood shopping district. 1,700 sq. ft. "Friendly, non-intimidating environment." 2-person shows alternate with display of gallery artists. Clientele: private and corporate. Overall price range: $250-10,000; most work sold at $400-2,500.

Media: Considers oil, acrylic, drawing, sculpture, watercolor, mixed media, pastel, collage and original handpulled prints.

Style: Exhibits all styles. Genres include contemporary landscapes, figurative and narrative and abstractions work.

Terms: Accepts work on consignment (50% commission). Retail price set by artist (sometimes in consultation with gallery). Gallery provides insurance, promotion, contract and shipping costs from gallery; artist pays shipping costs to gallery. Prefers framed works for canvas; unframed works for paper.

Submissions: Send query letter with résumé, slides or photographs, reviews, bio and SASE. Replies in 2-4 months. Files résumé, review or any printed material. Slides and photographs are returned.

Tips: "Never drop in without an appointment. Be prepared and professional in presentation. This is a business. Artists themselves should be aware of what is going on, not just in the 'art world,' but with everything."

☑ **THE MIDDLETOWN FINE ARTS CENTER**, 130 N. Verity Pkwy., P.O. Box 441, Middletown OH 45042. (513)424-2417. Contact: Peggy Davish. Nonprofit gallery. Estab. 1957. Represents emerging, mid-career and established artists. Sponsors 5 solo and/or group shows/year. Average display time 3 weeks. Clientele: tourists, students, community. 95% private collectors, 5% corporate clients. Overall price range: $100-1,000; most work sold at $150-500.

Media: Considers all media except prints. Most frequently exhibits watercolor, oil, acrylic and drawings.

Style: Exhibits all styles and genres. Prefers: realism, Impressionism and photorealism. "Our gallery does not specialize in any one style or genre. We offer an opportunity for artists to exhibit and hopefully sell their work. This also is an important educational experience for the community. Selections are chosen two years in advance by a committee."

Terms: Accepts work on consignment (30% commission). Retail price set by artist. Sometimes offers customer discounts and payment by installment. Exclusive area representation not required. Gallery provides promotion; artist pays for shipping. Artwork must be framed and wired.

Submissions: Send query letter with résumé, brochure, slides, photographs and bio. Write for an appointment to show portfolio, which should include originals, slides or photographs. Replies in 3 weeks-3 months (depends when exhibit committee meets.). Files résumé or other printed material. All material is returned if not accepted or under consideration. Finds artists through word of mouth, submissions and self-promotions.

Tips: "Decisions are made by a committee of volunteers, and time may not permit an on-the-spot interview with the director."

MILLER GALLERY, 2715 Erie Ave., Cincinnati OH 45208. (513)871-4420. Fax: (513)871-4429. E-mail: gallery123@ aol.com. Co-Directors: Barbara and Norman Miller. Retail gallery. Estab. 1960. Interested in emerging, mid-career and

established artists. Represents about 50 artists. Sponsors 5 solo and 4 group shows/year. Average display time 1 month. Located in affluent suburb. Clientele: private collectors. Overall price range: $100-35,000; most artwork sold at $300-12,000.

Media: Considers, oil, acrylic, mixed media, collage, works on paper, ceramic, fiber, bronze, stone, glass and original handpulled prints. Most frequently exhibits oil or acrylic, glass, sculpture and ceramics.

Style: Exhibits Impressionism, realism and painterly abstraction. Genres include landscapes, interior scenes and still lifes. "Everything from fine realism (painterly, Impressionist, pointilist, etc.) to beautiful and colorful abstractions (no hard-edge) and everything in between. Also handmade paper, collage, fiber and mixed mediums."

Terms: Accepts artwork on consignment (50% commission). Retail price set by artist and gallery. Sometimes offers payment by installment. Exclusive area representation is required. Gallery provides insurance, promotion and contract; shipping and show costs are shared.

Submissions: Send query letter with résumé, brochure, 10-12 slides or photographs with sizes, wholesale (artist) and selling price and SASE. All submissions receive phone or written reply. Finds artists through agents, visiting exhibitions, word of mouth, various art publications and sourcebooks, submissions/self-promotions, art collectors' referrals, and *Artist's and Graphic Designer's Market*.

Tips: "Artists often either completely omit pricing info or mention a price without identifying as artist's or selling price. Submissions without SASE will receive reply, but no return of materials submitted. Make appointment—don't walk in without one. Quality, beauty, originality are primary. Minimal, conceptual, political works not exhibited."

SPACES, 2220 Superior Viaduct, Cleveland OH 44113. (216)621-2314. Alternative space. Estab. 1978. Represents emerging artists. Has 300 members. Sponsors 10 shows/year. Average display time 6 weeks. Open all year; Tuesday-Sunday. Located downtown Cleveland; 6,000 sq. ft.; "loft space with row of columns." 100% private collectors.

Media: Considers all media. Most frequently exhibits installation, painting and sculpture.

Style: Exhibits all styles. Prefers challenging new ideas.

Terms: Accepts work on consignment. 20% commission. Retail price set by the artist. Sometimes offers payment by installment. Gallery provides insurance, promotion and contract.

Submissions: Send query letter with résumé, 15 slides and SASE. Annual deadline in spring for submissions.

Tips: "Present yourself professionally and don't give up."

THE ZANESVILLE ART CENTER, 620 Military Rd., Zanesville OH 43701. (614)452-0741. Fax: (614)452-0797. Director: Philip Alan LaDouceur. Nonprofit gallery, museum. Estab. 1936. Represents emerging, mid-career and established artists. Sponsors 25-30 shows/year. Average display time 6-8 weeks. Open all year; closed Mondays and major holidays. 1,152 sq. ft. 50% of space for special exhibitions; 50% of space for gallery artists. Clientele: artists, private collectors and corporate collectors. Most work sold at $500-3,000.

Media: Considers all media. Most frequently exhibits watermedia, oil, collage, ceramics, sculpture and children's art, as well as all photography media.

Style: Exhibits all styles and genres.

Terms: Accepts work on consignment (30% commission on sales). Retail price set by the artist. Gallery provides insurance and promotion; artist responsible for shipping costs to and from gallery. Artwork must be framed.

Submissions: Send query letter with résumé, slides, bio, photographs and reviews. Replies in 1 month. Artist should follow up after query letter or appointment. Files bio or résumé. Finds artists through exhibitions, word of mouth, art publications and submissions.

Oklahoma

[N] BONE ART GALLERY, 114 S. Broadway, Geary OK 73040. (405)884-2084. Owner/Operator: Jim Ford. Retail and wholesale gallery. Estab. 1988. Represents 6 emerging, mid-career and established artists/year. Exhibited artists include Jim Ford and Jerome Bushyhead. Average display time 6 months. Open all year; Monday-Friday, 10-6; Saturday, 10-6; Sunday by appointment. Located downtown. ⅔% of space for gallery artists. Clientele: tourists, upscale. 50% private collectors; 50% corporate collectors. Overall price range: $15-1,000; most work sold at $15-650.

Media: Considers oil, acrylic, watercolor, pastel, drawing, mixed media, sculpture, ceramics, lithographs and posters. Most frequently exhibits watercolor, sculpture and carvings, pipe making.

Style: Exhibits primitivism. Genres include Western, wildlife, Southwestern and landscapes. Prefers Southwestern, Western and landscapes.

Terms: Accepts work on consignment (20% commission). Retail price set by the artist. Gallery provides insurance and promotion; shipping costs are shared. Prefers artwork framed.

Submissions: Prefers only Southwestern, Western, landscapes and wildlife. Send query letter with résumé, brochure, photographs and business card. Write for appointment to show portfolio of photographs. Replies in 1 month. Files business cards, résumé, brochure and letter of introduction. Finds artists through referrals and visiting art exhibitions.

Tips: "New artists should be familiar with the types of artwork each gallery they contact represents. If after contacting a gallery you haven't had a response after 2-3 months, make contact again. Be precise, but not overbearing with your presentations."

⚡ COLOUR CONNECTION GALLERY, 3304 S. Peoria, Tulsa OK 74105-2029. (918)742-0515. Retail and cooperative gallery. Estab. 1991. Represents 11 mid-career artists. Sponsors 12 shows/year. Average display time 1 month. Open all year; Tuesday-Friday, 11-5:30; Saturday, 10-5. Located in midtown. Clientele: upscale, local community. 85% private collectors, 15% corporate collectors. Overall price range: $100-1,500; most work sold at $250-700.
Media: Considers oil, acrylic, watercolor, pastel, pen & ink, drawing, mixed media, collage, paper, sculpture, ceramics, glass, linocuts and etchings. Most frequently exhibits watercolor, oil, pastel and etchings.
Style: Exhibits expressionism, neo-expressionism, painterly abstraction, Impressionism and realism. Genres include florals, portraits, Southwestern, landscapes and Americana. Prefers Impressionism, painterly abstraction and realism.
Terms: Co-op membership fee plus donation of time. Retail price set by the artist. Gallery provides promotion and contract.
Submissions: Accepts only artists from Oklahoma. Send query letter with résumé, slides and bio. Call for appointment to show portfolio of photographs, slides and sample of 3-D work. Does not reply. Artist should contact in person. Finds artists through word of mouth, referrals by other artists, visiting art fairs and exhibitions and artist's submissions.

⚡ M.A. DORAN GALLERY, 3509 S. Peoria, Tulsa OK 74105. (918)748-8700. Fax: (918)744-0501. E-mail: madgallery@aol.com. Retail gallery. Estab. 1979. Represents 45 emerging, mid-career and established artists/year. Exhibited artists include: P.S. Gordon and Otto Duecker. Sponsors 10 shows/year. Average display time 1 month. Open all year; Tuesday-Saturday, 10:30-6. Located central retail Tulsa; 2,000 sq. ft.; up and downstairs, Soho like interior. 50% of space for special exhibitions; 50% of space for gallery artists. Clients include upscale. 65% of sales are to private collectors; 35% corporate collectors. Overall price range: $500-40,000; most work sold at $5,000.
Media: Considers all media except pen & ink, paper, fiber and installation; types of prints include woodcuts, engravings, lithographs, wood engravings, mezzotints, serigraphs, linocuts and etchings. Most frequently exhibits oil paintings, watercolor and crafts.
Style: Exhibits: painterly abstraction, Impressionism, photorealism, realism and imagism. Exhibits all genres. Prefers landscapes, still life and fine American crafts.
Terms: Accepts work on consignment (50% commission). Retail price set by the gallery and artist. Gallery provides insurance and promotion; shipping costs are shared. Prefers artwork framed.
Submissions: Send query letter with résumé, bio, SASE and artist's statement. Call for appointment. Replies in 1 month. Files any potential corporate artists.

FIREHOUSE ART CENTER, 444 S. Flood, Norman OK 73069. (405)329-4523. Contact: Gallery Committee. Non-profit gallery. Estab. 1971. Exhibits emerging, mid-career and established artists. 400 members. Sponsors 10-12 group and solo shows/year. Average display time 3-4 weeks. Open all year. Located in former fire station; 629.2 sq. ft. in gallery; consignment sales gallery has additional 620 sq. ft. display area; handicapped-accessible community art center offering fully equipped ceramics, painting, sculpture, jewelry and fiber studios plus b&w photography lab. Classes and workshops for children and adults are offered quarterly. Clientele: 99% private collectors, 1% corporate collectors.
Media: Most frequently exhibits functional and decorative ceramics and sculpture, jewelry, paintings and wood.
Style: All styles and fine crafts. All genres. Prefers: realism and Impressionism.
Terms: Accepts work on consignment (35% commission). Offers discounts to gallery members. Gallery provides insurance and promotion for gallery exhibits and consignment sales; artist pays for shipping. Prefers artwork framed.
Submissions: Accepts only artists from south central US. Send query letter with résumé, bio, artist's statement, 20 slides of current work and SASE. Portfolio review required. Replies in 4 months. Finds artists through word of mouth, art publications, and art collectors' referrals.
Tips: "Develop a well-written statement and résumé. Send professional slides! Be aware that we are small and our price ranges for sales rarely exceed $1,000."

HOUSE GALLERY, 5536 N. Western, Oklahoma City OK 73118. (405)848-3690. Fax: (405)848-0514. E-mail: wkhubbard@aol.com. Website: http://www.thehousegallery.com. President: Kay Hubbard. Retail and corporate art gallery and art consultancy. Estab. 1977. Represents 30 emerging and collectable artists and mid-career artists/year. Exhibited artists include Margaret Martin and Cletus Smith. Sponsors 12 shows/year. Average display time 1 month. Open all year; Monday-Friday, 9-5; Saturday by appointment. Located close to upper residential areas; 3,000 sq. ft.; contemporary building, space design, unique framing. 50% of space for special exhibitions; 50% of space for gallery artists. Clientele: upscale. 20% private collectors; 40% corporate collectors. Overall price range: $250-10,000; most work sold at $500-3,000.
Media: Considers all media and all types of prints. Most frequently exhibits abstract oils, Impressionist oils and traditional oils.
Style: Exhibits expressionism, painterly abstraction, conceptualism, Impressionism and realism. Exhibits all genres. Prefers landscapes, abstracts and Impressionism.
Terms: Accepts work on consignment (45% commission). Retail price set by the gallery. Gallery provides promotion and contract; shipping costs are shared. Prefers artwork framed.
Submissions: "Only artists working full time in the field who are dedicated to growth and have consistency in style." Send résumé, slides, bio, photographs and SASE. Write for appointment to show portfolio of photographs or slides. Replies in 2-4 weeks. Files only that of potentially good work. Finds artists through publications, major shows, submissions and word of mouth.
Tips: "Artist's four biggest mistakes are walking in, insisting on bringing work instead of following gallery rules of

submittal, sending slides or photos of work inconsistent in style and framing work inappropriately."

N INDIVIDUAL ARTISTS OF OKLAHOMA, P.O. Box 60824, Oklahoma City OK 73146. (405)232-6060. Fax: (405)236-0823. Director: Shirley Blaschke. Alternative space. Estab. 1979. Approached by 60 artists/year. Represents 30 emerging, mid-career and established artists/year. Sponsors 30 exhibits/year. Average display time 3-4 weeks. Open Tuesday-Friday, 11-4; weekends 1-4. Closed in August. Located in downtown arts district; 2,300 sq. ft.; 10 foot ceilings; track lighting. Clients include local community, students, tourists and upscale. 33% of sales are to corporate collectors. Overall price range: $100-1,000; most work sold at $300.
Media: Considers all media. Most frequently exhibits photography, painting, installation. Considers all types of prints.
Style: Considers all styles. Most frequently exhibits "bodies of work with cohesive style and expressed in a contemporary viewpoint." Considers all genres.
Making Contact & Terms: Artwork is accepted on consignment and there is a 20% commission. Retail price set by the artist. Gallery provides insurance, promotion and contract. Prefers artwork framed. Preference to Oklahoma artists.
Submissions: Mail portfolio for review. Send artist's statement, bio, photocopies or slides, résumé and SASE. Returns material with SASE. Replies in 3 months. Finds artists through word of mouth, art exhibits and referrals by other artists.
Tips: "Individual Artists of Oklahoma is committed to sustaining and encouraging emerging and established artists in all media who are intellectually and aesthetically provocative or experimental in subject matter or technique."

☑ ELEANOR KIRKPATRICK GALLERY AT CITY ARTS CENTER, (formerly City Arts Center), 3000 Pershing Blvd., Oklahoma City OK 73107. (405)951-0000. Fax: (405)951-0003. E-mail: cacoct@ix.netcom.com. Website: http://www.cityartscenter.com. Nonprofit gallery. Estab. 1988. Open all year; Monday-Thursday, 9-10; Friday and Saturday, 9-5. Located at State Fair Park. "Exhibitions in the Eleanor Kirkpatrick Gallery are always educational and accessible. The gallery supports the work of local, regional, and nationally recognized artists, as well as featuring the work of emerging Oklahoma artists." Overall price range: $12-3,000; most work sold at $500-3,000.
Media: Considers oil, pen & ink, paper, fiber, acrylic, oil, drawings, sculpture, glass, watercolor, mixed media, ceramic, installation, pastel, collage, photography, relief, intaglio, lithographs and serigraphs. Prefers mixed media, photography and ceramic.
Style: Exhibits expressionism, neo-expressionism, primitivism, painterly abstraction and realism. All genres. Prefers abstraction, conceptualism and postmodern works.
Terms: Accepts work on consignment (60% commission). Retail price set by artist. Gallery provides promotion and contract (when required); artist pays for shipping costs. Prefers artwork framed.
Submissions: Cannot exhibit works of a graphic sexual nature. Send query letter with résumé, brochure, business card, 15-20 slides, bio and SASE. Call or write for appointment to show portfolio of slides and transparencies. Replies in 2 months. Files résumé, bio, slides (unless artist wants returned).
Tips: "Professional quality slides are a must. Select work to be presented carefully—work should have related elements."

⯐ LACHENMEYER ARTS CENTER, 700 S. Little, P.O. Box 586, Cushing OK 74023. (918)225-7525. Director: Rob Smith. Nonprofit. Estab. 1984. Exhibited artists include Darrell Maynard, Steve Childers and Dale Martin. Sponsors 4 shows/year. Average display time 2 weeks. Open in August, September, December; Monday, Wednesday, Friday, 9-5; Tuesday, Thursday, 5-9. Located inside the Cushing Youth and Community Center; 550 sq. ft. 80% of space for special exhibitions; 80% of space for gallery artists. 100% private collectors.
Media: Considers oil, acrylic, watercolor, pastel, pen & ink, drawing, mixed media, collage, paper, sculpture, ceramics, fiber, photography, woodcuts, engravings, lithographs, wood engravings, mezzotints, serigraphs, linocuts and etchings. Most frequently exhibits oil, acrylic and works on paper.
Style: Exhibits all styles. Prefers: landscapes, portraits and Americana.
Terms: Retail price set by the artist. Gallery provides promotion; shipping costs are shared. Prefers artwork framed.
Submissions: Send query letter with résumé, professional quality slides, SASE and reviews. Call or write for appointment to show portfolio of originals. Replies in 1 month. Files résumés. Finds artists through visiting exhibits, word of mouth, other art organizations.
Tips: "I prefer local and regional artists."

NATIVE AMERICAN ART, 317 S. Main, Tulsa OK 74103. (918)584-5792. Owner: Wes Gan. Retail gallery. Estab. 1985. Represents 25 emerging, mid-career and established artists/year. Exhibited artists include: Ruthe Blalock Jones and Will Wilson. Sponsors 1 show/year. Open all year; Monday-Friday, 10-5. Located downtown; 1,000 sq. ft. 100% of space for gallery artists. Clients include: tourists, upscale, local community and students. 90% of sales are to private collectors; 10% corporate collectors. Overall price range: $100-5,000; most work sold at $250-500.
Media: Considers oil, acrylic, watercolor, pastel, pen & ink, drawing, mixed media, collage, paper, sculpture, ceramics and fiber; and all types of prints. Most frequently exhibits watercolor, monotype and acrylic.
Style: Exhibits: primitivism, surrealism, minimalism, Impressionism, photorealism, realism and imagism. Genres include Indian. Prefers: traditional, contemporary as in monotypes and Impressionism.
Terms: Accepts work on consignment (40% commission) or buys outright for 50% of retail price. Retail price set by the gallery and artist. Gallery provides insurance, promotion and framing; shipping costs are shared. Prefers artwork unframed.
Submissions: Membership in a Native American tribe. Send query letter with résumé, bio, brochure, photographs,

reviews and artist's statement. Call or write for appointment to show portfolio of photographs. Finds artists through referrals from other artists and submissions.

Tips: "Artists should let their work speak for itself and keep working—quality takes talent and much time and effort."

N **NO MAN'S LAND MUSEUM**, P.O. Box 278, Goodwell OK 73939-0278. (405)349-2670. Fax: (405)349-2670. Director: Kenneth R. Turner. Museum. Estab. 1934. Represents emerging, mid-career and established artists. Sponsors 12 shows/year. Average display time 1 month. Open all year; Tuesday-Saturday, 9-12 and 1-5. Located adjacent to university campus. 10% of space for special exhibitions. Clientele: general, tourist. 100% private collectors. Overall price range: $20-1,500; most work sold at $20-500.

Media: Considers all media and all types of prints. Most frequently exhibits oils, watercolors and pastels.

Style: Exhibits primitivism, Impressionism, photorealism and realism. Genres include landscapes, florals, Americana, Southwestern, Western and wildlife. Prefers realist, primitive and Impressionist.

Terms: "Sales are between artist and buyer; museum does not act as middleman." Retail price set by the artist. Gallery provides promotion and shipping costs to and from gallery. Prefers artwork framed.

Submissions: Send query letter with résumé, brochure, photographs and reviews. Call or write for appointment to show portfolio of photographs. Replies only if interested within 3 weeks. Files all material. Finds artists through art publications, exhibitions, news items, word of mouth.

SCISSORTAIL FINE ARTS, 103 N. Broadway, Poteau OK 74953. (918)647-4060. E-mail: handprints@clnk.com. Owner: Carol W. Smith. Retail and wholesale gallery. Estab. 1991. Represents 6 mid-career and established artists/year. Exhibited artists include Darran Cooper and Julie Mayser. Sponsors shows on an ongoing basis. Average display time 4 months. Open all year; Monday-Friday, 9:30-5:30; Saturday, 9:30-2:30. Located near Town Center; 1,000 sq. ft. Clientele: local and tourists. 85% private collectors, 15% corporate collectors. Overall price range: $100-1,200; most work sold at $150-500 (originals), $40-100 (prints).

• Included with Scissortail Fine Arts is Handprints, which does graphic arts and in-house silk screening.

Media: Considers oil, acrylic, watercolor, pastel, pen & ink, drawing, sculpture, ceramics, photography, lithographs, serigraphs and posters. Most frequently exhibits acrylics, graphite pencil and watercolor.

Style: Exhibits: Impressionism and realism. Genres include florals, western, wildlife, landscapes and Native American. Prefers: Native American realism, impressionist watercolors, realistic acrylics/oils.

Terms: Accepts work on consignment (30% commission). Retail price set by the artist. Gallery provides promotion; artist pays shipping costs. Prefers artwork framed.

Submissions: Accepts only artists from Oklahoma. Send query letter with brochure, photographs and SASE. Write for appointment to show portfolio of photographs, sample prints or brochure. Replies in 1 month. Finds artists through word of mouth, artists referral.

Tips: "We are not particularly looking for new artists because our space is committed to our area artists. However, we will always consider a new artist. Our primary purpose is to promote area artists and talent of other artists from Oklahoma."

THE WINDMILL GALLERY, 3750 W. Robinson, Suite 103, Norman OK 73072. (405)321-7900. Director: Andy Denton. Retail gallery. Estab. 1987. Focus is on Oklahoma American Indian art. Represents 20 emerging, mid-career and established artists. Exhibited artists include Rance Hood, Gina Gray, Donald Vann and Darwin Tsoodle. Sponsors 4 shows/year. Average display time 1 month. Open all year. Located in northwest Norman (Brookhaven area); 900 sq. ft.; interior decorated Santa Fe style: striped aspen, adobe brick, etc. 30% of space for special exhibitions. Clientele: "middle-class to upper middle-class professionals/housewives." 100% private collectors. Overall price range $50-15,000; most artwork sold at $100-2,000.

Media: Considers oil, acrylic, watercolor, pastel, pen & ink, drawings, mixed media, works on paper, sculpture, craft, original handpulled prints, offset reproductions, lithographs, posters, cast-paper and serigraphs. Most frequently exhibits watercolor, tempera and acrylic.

Style: Exhibits primitivism and realism. Genres include landscapes, southwestern, western, wildlife and portraits. Prefers Native American scenes (done by Native Americans), portraits and western-southwestern and desert subjects.

Terms: Artwork is accepted on consignment (40% commission). Retail price set by the artist. Customer discounts and payment by installments available. Gallery provides insurance and promotion. Shipping costs are shared. Prefers framed artwork.

Submissions: Send query letter with slides, bio, brochure, photographs, SASE, business card and reviews. Replies only if interested within 1 month. Portfolio review not required. Files brochures, slides, photos, etc. Finds artists through agents, visiting exhibitions, word of mouth, art publications and sourcebooks, artists' submissions/self-promotions and art collectors' referrals.

Tips: Accepts artists from Oklahoma area; Indian art done by Indians only. Director is impressed by artists who conduct business in a very professional manner, have written biographies, certificates of limited editions for prints, and who have honesty and integrity. "Call, tell me about yourself, try to set up appointment to view works or to hang your works as featured artist. Fairly casual—but must have bios and photos of works or works themselves! Please, no drop-ins!"

Oregon

N **BLACKFISH GALLERY**, 420 NW Ninth Ave., Portland OR 97209. (503)224-2634. Director: Stephanie Schlicting. Retail cooperative gallery. Estab. 1979. Represents 24 emerging and mid-career artists. Exhibited artists include: Carolyn Wilhelm and Stephan Soihl. Sponsors 12 shows/year. Open all year. Located downtown, in the "Northwest Pearl District; 2,500 sq. ft.; street-level, 'garage-type' overhead wide door, long, open space (100' deep)." 70% of space for feature exhibits, 15-20% for gallery artists. 80% of sales are to private collectors, 20% corporate clients. Overall price range: $250-12,000; most artwork sold at $900-1,400.
Media: Considers oil, acrylic, watercolor, pastel, pen & ink, drawings, mixed media, collage, sculpture, ceramic, photography, woodcuts, wood engravings, linocuts, engravings, mezzotints, etchings, lithographs, pochoir and serigraphs. Most frequently exhibits paintings, sculpture and prints.
Style: Exhibits: expressionism, neo-expressionism, painterly abstraction, surrealism, conceptualism, minimalism, color field, postmodern works, Impressionism and realism. Prefers neo-expressionism, conceptualism and painterly abstraction.
Terms: Accepts work on consignment from invited artists (50% commission); co-op membership includes monthly dues plus donation of time (40% commission on sales). Retail price set by artist with assistance from gallery on request. Customer discounts and payment by installment are available. Gallery provides insurance, promotion and contract, and shipping costs from gallery. Prefers artwork framed.
Submissions: Accepts only artists from northwest Oregon and southwest Washington ("unique exceptions possible"); "must be willing to be an active cooperative member—write for details." Send query letter with résumé, slides, SASE, reviews and statement of intent. Write for appointment to show portfolio of photographs and slides. "We review throughout the year." Replies in 1 month. Files material only if exhibit invitation extended. Finds artists through agents, visiting exhibitions, word of mouth, various art publications and sourcebooks, submissions/self-promotions and art collectors' referrals.
Tips: "Understand—via research—what a cooperative gallery is. Call or write for information packet. Do not bring work or slides to us without first having contacted us by phone or mail."

N **BUCKLEY CENTER GALLERY, UNIVERSITY OF PORTLAND**, 5000 N. Willamette Blvd., Portland OR 97203. (503)283-7258. E-mail: soissen@uofport.edu. Gallery Director: Michael Miller. University gallery. Exhibits emerging, mid-career and established artists. Exhibited artists include: Don Gray and Melinda Thorsnes. Sponsors 7 shows/year. Average display time 3-4 weeks. Open September-May; Monday-Friday; 8:30-8 and Saturday, 8:30-4. Located 5 miles from downtown Portland; 525 sq. ft.; 2 walls of floor to ceiling windows (natural light). Clients include university community and Portland community. Overall price range: $300-3,000; most work sold at $400-700.
Media: Considers all media and all types of prints. Prefers oil/acrylic, photography, watercolor and mixed media.
Style: Exhibits all styles and genres.
Terms: Accepts work on consignment (10% commission). Retail price set by artist. Gallery provides insurance and promotion. Prefers artwork framed.
Submissions: Accepts only artists from Portland metropolitan area. No shipping, artist must deliver and pick-up. Send query letter with résumé, professional slides, bio and SASE. Replies in 3 weeks. Files résumés.

FRAME DESIGN & SUNBIRD GALLERY, INC., 916 Wall St., Bend OR 97701. (541)389-9196. Fax: (541)389-8831. E-mail: sunbird@empnet.com Website: http://www.sunbirdartgallery.com. Gallery Director: Sandra Miller. Retail gallery. Estab. 1980. Represents/exhibits 25-50 emerging, mid-career and established artists/year. Sponsors at least 3 shows/year. Average display time 1 month. Open all year; Tuesday-Saturday, 11-5:30 or by appointment; open till 9 p.m. first Friday of every month. Located downtown; 2,000 sq. ft. 60% of space for special exhibitions; 40% of space for gallery artists. Clients include tourists, upscale, local community. 90% of sales are to private collectors, 2% corporate collectors. Overall price range: $100-15,000; most work sold at $200-2,500.
Media: Considers all media. Most frequently exhibits painting, sculpture, mixed media and ceramics.
Style: Exhibits all styles. All genres. Prefers: contemporary Native American and landscape (all media).
Terms: Artwork is accepted on consignment (50% commission). Retail price set by the gallery and the artist. Gallery provides promotion and contract; shipping costs are shared.
Submissions: Send query letter with résumé, brochure, business card, 10 slides, photographs, reviews, bio and SASE. Call or write for appointment to show portfolio of photographs, slides and transparencies. Replies in 4-6 weeks. Files material on possible future shows. Finds artists through word of mouth, referrals by other artists and exhibitions and artists' submissions.
Tips: "Know the kind of artwork we display before approaching us. Be sure you have something to offer the gallery. Make an appointment and ask for help. Invite the gallery person to your studio—find out the criteria for that gallery."

N **GALLERY AT SALISHAN**, P.O. Box 148, Gleneden Beach OR 97388-0148. (503)224-9442. E-mail: gallery@salishan.com. Website: http://www.salishan.com/gallery/. Director: Anita Eaton. Retail gallery. Estab. 1982. Represents 75 emerging, mid-career and established artists. Sponsors 6-8 solo and group shows/year. Average display time 1 month. "Always revolving work." Clientele: corporate, tourists and collectors. 50% private collectors, 50% corporate clients. Overall price range: $200-10,000; most work sold at $1,000-3,000.
Media: Considers oil, acrylic, watercolor, pastel, pen & ink, drawings, mixed media, collage, works on paper, sculpture,

ceramic, fiber, glass, photography and original handpulled prints. Most frequently exhibits oils, acrylics, ceramics and glass.

Style: Exhibits painterly abstraction, Impressionism and photorealism. Genres include landscapes and figurative work.

Terms: Accepts work on consignment (50% commission). Retail price set by gallery and artist. Exclusive area representation required. Gallery provides insurance, promotion and contract; artist pays for shipping.

Submissions: Send query letter, slides or 10-15 photographs with prices. Call for appointment to show portfolio of originals, slides and transparencies.

Tips: "Be aware of what gallery shows; see if you fit without overlapping what we already have. Do not expect to be seen without an appointment and having sent materials ahead for preview. Be professional."

✓ THE MAUDE KERNS ART CENTER, 1910 E. 15th Ave., Eugene OR 97403. (541)345-1571. Executive Director: Sandra Dominguez. Nonprofit gallery and educational facility. Estab. 1963. Exhibits hundreds of emerging, mid-career and established artists. Interested in seeing the work of emerging artists. 650 members. Sponsors 8-10 shows/year. Average display time 2 months. Open all year. Located in church bulding on Historic Register. 4 renovated galleries with over 2,500 sq. ft. of modern exhibit space. 100% of space for special exhibitions. 50% of sales are to private collectors, 50% corporate collectors. Overall price range: $200-20,000; most work sold at $200-500.

Media: Considers all media and original handpulled prints. Most frequently exhibits oil/acrylic, mixed media and sculpture.

Style: Contemporary artwork.

Terms: Accepts work on consignment (30% commission). Retail price set by artist. Offers customer discounts and payment by installments. Gallery provides insurance and contract; artist pays for shipping. Prefers artwork framed.

Submissions: Send query letter with résumé, slides, bio and SASE. Call for appointment to show portfolio of photographs, slides and transparencies. Files slide bank, résumé and statement. Finds artists through calls to artists, word of mouth, and local arts council publications.

Tips: "Call first! Come visit to see exhibits and think about whether the gallery suits you."

LANE COMMUNITY COLLEGE ART GALLERY, 4000 E. 30th Ave., Eugene OR 97405. (503)747-4501. Gallery Director: Harold Hoy. Nonprofit gallery. Estab. 1970. Exhibits the work of emerging, mid-career and established artists. Sponsors 7 solo and 2 group shows/year. Average display time 3 weeks. Most work sold at $100-2,000.

Media: Considers all media.

Style: Exhibits contemporary works. Interested in seeing "contemporary, explorative work of quality. Open in terms of subject matter."

Terms: Retail price set by artist. Sometimes offers customer discounts. Exclusive area representation not required. Gallery provides insurance, promotion and contract; shipping costs are shared. "We retain 25% of the retail price on works sold."

Submissions: Send query letter, résumé and slides with SASE. Portfolio review required. Résumés are filed.

LAWRENCE GALLERY, Box 187, Sheridan OR 97378. (503)843-3633. Owners: Gary and Carole Lawrence. Retail gallery and art consultancy. Estab. 1977. Represents 150 mid-career and established artists. Sponsors 15 shows/year. Open daily 10-5:30. "The gallery is surrounded by several acres of landscaping in which we feature sculpture, fountains and other outdoor art." Clientele: tourists, Portland and Salem residents. 80% private collectors, 20% corporate clients. Overall price range: $10-50,000; most work sold at $1,000-5,000.

Media: Considers oil, acrylic, watercolor, pastel, mixed media, collage, sculpture, clay, glass, jewelry and original handpulled prints. Always exhibits paintings, bronze sculpture, clay, glass and jewelry.

Style: Exhibits painterly abstraction, Impressionism, photorealism and realism. Genres include landscapes and florals. "Our gallery features beautiful artworks that celebrate life."

Terms: Accepts work on consignment (50% commission). Retail price set by artist. Offers payment by installments. Exclusive area representation required. Gallery provides insurance, promotion and contract; artist pays for shipping.

Submissions: Send query letter, résumé, brochure, slides and photographs. Portfolio review required if interested in artists' work. Files résumés, photos of work, newspaper articles, other informative pieces and artist's statement. Finds artists through agents, visiting exhibitions, word of mouth, art publications and sourcebooks, submissions/self-promotions, art collectors' referrals.

Tips: "Artists seen by appointment only."

[N] MINDPOWER GALLERY, 417 Fir Ave., Reedsport OR 97467. (800)644-2485 or (541)271-2485. Website: http://www.mindpowergallery.com. Manager: Tamara Szalewski. Retail gallery. Estab. 1989. Represents 50 mid-career and established artists/year. Exhibited artists include: Rose Szalewski, John Stewart and Jean McKendree. Sponsors 6 shows/year. Average display time 2 months to continuous. Open all year; Tuesday-Saturday, 10-5, November 1-May 29; open Tuesday-Sunday (same hours) Memorial Day to Halloween. Located in "Oldtown" area—front street is Hwy. 38; 5,000 sq. ft.; 8 rooms with 500' of wall space. 20% of space for "Infinity" gift store (hand-crafted items up to $100 retail, New Age music, books); 10% for special exhibitions; 70% of space for gallery artists. Clients include ⅔ from state, ⅓ travelers. 90% of sales are to private collectors, 10% small business collectors. Overall price range: $100-20,000; most work sold at $500.

Media: Considers oil, acrylic, watercolor, pastel, mixed media, paper, batik, computer, sculpture: wood, metal, clay, glass; all types of prints. Most frequently exhibits sculpture, acrylic/oil, watercolor, pastel.

Style: Exhibits all styles and genres. "We have a visual computer catalog accessible to customers, showing work not currently at gallery."

Terms: Accepts work on consignment (40% commission). Retail price set by the artist. Gallery provides promotion, contract and insurance; artist pays shipping costs to and from gallery. Prefers artwork framed.

Submissions: Send query letter with typewritten résumé, slides, photographs and SASE. Replies within 1 month. Files résumés. Finds artists through artists' submissions, visiting exhibitions, word of mouth.

Tips: Please call between 9-9:30 and 5-5:30 to verify your submission was received.

☑ **ROGUE GALLERY & ART CENTER**, 40 S. Bartlett, Medford OR 97501. (541)772-8118. Executive Director: Judy Barnes. Nonprofit sales rental gallery. Estab. 1961. Represents emerging, mid-career and established artists. Sponsors 8 shows/year. Average display time 6 weeks. Open all year; Tuesday-Friday, 10-5; Saturday, 10-4. Located downtown; main gallery 240 running ft. (2,000 sq. ft.); rental/sales and gallery shop, 1,800 sq. ft.; classroom facility, 1,700 sq. ft. "This is the only gallery/art center/exhibit space of its kind in the region, excellent facility, good lighting." 33% of space for special exhibitions; 33% of space for gallery artists. 95% of sales are to private collectors. Overall price range: $100-5,000; most work sold at $400-1,000.

Media: Considers all media and all types of prints. Most frequently exhibits mixed media, drawing, painting, sculpture, watercolor.

Style: Exhibits all styles and genres. Prefers: figurative work, collage, landscape, florals, handpulled prints.

Terms: Accepts work on consignment (35% commission to members; 40% non-members). Retail price set by the artist. Gallery provides insurance, promotion and contract; in the case of main gallery exhibit, gallery assumes cost for shipping 1 direction, artist 1 direction.

Submissions: Send query letter with résumé, 10 slides, bio and SASE. Call or write for appointment. Replies in 1 month.

Tips: "The most important thing an artist needs to demonstrate to a prospective gallery is a cohesive, concise view of himself as a visual artist and as a person working with direction and passion."

Pennsylvania

THE ART BANK, 3028 N. Whitehall Rd., Norristown PA 19403-4403. Phone/fax: (610)539-2265. Director: Phyllis Sunberg. Retail gallery, art consultancy, corporate art planning. Estab. 1985. Represents 40-50 emerging, mid-career and established artists/year. Exhibited artists include Lisa Fedon and Bette Ridgeway. Average display time 3-6 months. Open all year; by appointment only. Located in a Philadelphia suburb; 1,000 sq. ft.; Clientele: corporate executives and their corporations. 20% private collectors, 80% corporate collectors. Overall price range: $300-35,000; most work sold at $500-1,000.

Media: Considers oil, acrylic, watercolor, pastel, mixed media, collage, sculpture, glass, installation, holography, exotic material, lithography, serigraphs. Most frequently exhibits acrylics, serigraphs and sculpture.

Style: Exhibits expressionism, painterly abstraction, color field and hard-edge geometric abstraction. Genres include landscapes. Prefers color field, hard edge abstract and Impressionism.

Terms: Accepts work on consignment (40% commission). Shipping costs are shared. Prefers artwork unframed.

Submissions: Prefers artists from the region (PA, NJ, NY, DE). Send query letter with résumé, slides, brochure, SASE and prices. Write for appointment to show portfolio of originals (if appropriate), photographs and corporate installation photos. Replies only if interested within 2 weeks. Files "what I think I'll use—after talking to artist and seeing visuals." Finds artists through agents, by visiting exhibitions, word of mouth, art publications and sourcebooks, submissions.

☑ **BUCKNELL ART GALLERY OF BUCKNELL UNIVERSITY**, (formerly Center Gallery of Bucknell University), Elaine Langone Center, Lewisburg PA 17837. (570)577-3792. Fax: (570)577-3480. E-mail: peltier@bucknell.edu. Website: http://www.bucknell.edu/departments/center_gallery/. Director: Stuart Horodner. Assistant Director: Cynthia Peltier. Nonprofit gallery. Estab. 1983. Represents emerging, mid-career and established artists. Sponsors 6 shows/year. Average display time 6 weeks. Open all year; Monday-Friday, 11-5; Saturday-Sunday, 1-4. Located on campus; 3,500 sq. ft. plus 40 movable walls.

Media: Considers all media, all types of prints. Most frequently exhibits painting, prints and photographs.

Style: Exhibits all styles and genres.

Terms: Retail price set by the artist. Gallery provides insurance, promotion (local) and contract; artist pays shipping costs to and from gallery. Prefers artwork framed.

Submissions: Send query letter with résumé, slides and bio. Write for appointment to show portfolio of originals. Replies in 2 weeks. Files bio, résumé, slides. Finds artists through occasional artist invitationals/competitions.

Tips: "We usually work with themes and then look for work to fit that theme."

🅽 **THE CLAY PLACE**, 5416 Walnut St., Pittsburgh PA 15232. (412)682-3737. Fax: (412)681-1226. E-mail: clayplac el@aol.com. Website: http://www.clayplace.com. Director: Elvira Peake. Retail gallery. Estab. 1973. Represents 50 emerging, mid-career and established artists. Exhibited artists include Warren MacKenzie and Kirk Mangus. Sponsors 12 shows/year. Open all year. Located in small shopping area; "second level modern building with atrium." 2,000 sq. ft. 50% of space for special exhibition. Overall price range: $10-2,000; most work sold at $40-100.

Media: Considers ceramic, sculpture, glass and pottery. Most frequently exhibits clay, glass and enamel.
Terms: Accepts artwork on consignment (50% commission), or buys outright for 50% of retail price (net 30 days). Retail price set by artist. Sometimes offers customer discounts and payment by installments. Gallery provides insurance, promotion and shipping costs from gallery.
Submissions: Prefers only clay, some glass and enamel. Send query letter with résumé, slides, photographs, bio and SASE. Write for appointment to show portfolio. Portfolio should include actual work rather than slides. Replies in 1 month. Does not reply when busy. Files résumé. Does not return slides. Finds artists through visiting exhibitions and art collectors' referrals.
Tips: "Functional pottery sells well. Emphasis on form, surface decoration. Some clay artists have lowered quality in order to lower prices. Clientele look for quality, not price."

DOSHI GALLERY FOR CONTEMPORARY ART/THE SUSQUEHANNA ART MUSEUM, 511 Strawberry Square, Harrisburg PA 17101. (717)233-8668. Contact: Executive Director. Estab. 1972. Nonprofit gallery. Exhibits hundreds of emerging, mid-career and established artists. 150 members. Sponsors 10 shows/year. Average display time 1 month. Open all year; Monday-Saturday, 11-3. Located in Strawberry Square, Walnut and Fourth Streets. 100% of space for gallery artists. Clientele: 100% private collectors. Overall price range: $250-9,000.
Media: Considers all media and types of prints. Most frequently exhibits oil/acrylic, photography and mixed media.
Style: Exhibits all styles and genres. Prefers: figurative work, expressionism/painterly abstraction and geometric abstraction/realism.
Terms: Accepts work on consignment for annual art auction and holiday sale (40% commission); or is bought outright for 100% of retail price (gallery then receives 30% donation). Retail price is set by artist. Gallery provides insurance and promotion; artist pays for shipping. Prefers artwork framed.
Submissions: Send query letter with résumé, 15-20 slides and bio. "No portfolio reviews." Slides are accepted for possible show in June of each year. Files bios and résumés.
Tips: Jurors tend to select more cutting edge work.

N ⬥ EVERHART MUSEUM, 1901 Mulberry St., Scranton PA 18510-2390. (570)346-7186. Fax: (570)346-0652. Curator: Barbara Rothermel. Museum. Estab. 1908. Represents mid-career and established artists. Interested in seeing the work of emerging artists. 1,500 members. Sponsors 6 shows/year. Average display time 2-3 months. Open all year; Wednesday-Friday, 12-4; Saturday-Sunday, 12-5; closed Monday. Closed in January. Located in urban park; 300 linear feet. 20% of space for special exhibitions.
Media: Considers all media.
Style: Prefers regional, Pennsylvania artists.
Terms: Gallery provides insurance, promotion and shipping costs. 2-D artwork must be framed.
Submissions: Send query letter with résumé, slides, bio, brochure and reviews. Write for appointment. Replies in 1-2 months. Files letter of query, selected slides or brochures, other information as warranted. Finds artists through agents, by visiting exhibitions, word of mouth, art publications and sourcebooks, artists' submissions.
Tips: Sponsors regional juried exhibition in the fall. "Write for prospectus."

GALLERY ENTERPRISES, 310 Bethlehem Plaza Mall, Bethlehem PA 18018. (610)868-1139. Fax: (610)868-9482. E-mail: david@gallery/enterprises.com. Website: http://www.galleryenterprises.com. Owner: David Michael Donnangelo. Wholesale gallery. Estab. 1981. Represents/exhibits 10 established artists/year. May be interested in seeing the work of emerging artists in the future. Exhibited artists include K. Haring and Andy Warhol. Sponsors 1 show/year. Average display time 3 weeks. Open all year; 12:30-5:30. Located in mall, 700 sq. ft.; good light and space. 100% of space for special exhibitions. Clientele: upscale. 50% private collectors, 10% corporate collectors. Overall price range: $350-5,000; most work sold at $1,200-2,500.
Media: Considers all media, etchings, lithographs, serigraphs and posters. Most frequently exhibits serigraphs, lithography and posters.
Style: Exhibits neo-expressionism, realism, surrealism and environmental. Genres include landscapes and wildlife. Prefers: pop art, kenetic art, environmental and surrealism.
Terms: Artwork is accepted on consignment. Retail price set by the gallery. Prefers artwork unframed.
Submissions: Well-established artists only. Send query letter with 10 slides and photographs. Call for appointment to show portfolio of photographs and slides. "If slides or photos are sent they will be kept on file but not returned. We reply only if we are interested."
Tips: "Pay attention to what sells."

GALLERY 500, Church & Old York Rds., Elkins Park PA 19027. (215)572-1203. Fax: (215)572-7609. Owners: Harriet Friedberg and Rita Greenfield. Retail gallery. Estab. 1969. Represents emerging, mid-career and established artists/year. Sponsors 6-8 shows/year. Average display time 1 month. Open all year; Monday-Saturday, 10-5:30. Located in Yorktown Inn Courtyard of Shops; 3,000 sq. ft.; 40% of space for special exhibitions; 60% of space for gallery artists. 20% private collectors, 30% corporate collectors. Overall price range: $50-6,000; most work sold at $200-3,000.
Media: Considers oil, acrylic, watercolor, pastel, drawing, mixed media, collage, handmade paper, sculpture, ceramics, metal, wood, furniture, jewelry, fiber and glass. Most frequently exhibits jewelry, ceramics, glass, furniture and painting.
Style: Exhibits painterly abstraction, color field, pattern painting and geometric abstraction. Genres include landscape, still life and figurative work.

Terms: Accepts work on consignment (50% commission) or buys outright for 50% of retail price (net 30 days). Retail price set by the gallery and the artist. Gallery provides insurance, promotion, contract and shipping costs from gallery; artist pays shipping costs to gallery. Prefers artwork framed.
Submissions: Accepts only artists from US and Canada. Send query letter with résumé, at least 6 slides, bio, brochure, price list and SASE. Replies in 1 month. Files all materials pertaining to artists who are represented. Finds artists through craft shows, travel to galleries.
Tips: "Have at least three years of post-college experience in the field before approaching galleries."

GALLERY JOE, 304 Arch St., Philadelphia PA 19106. (215)592-7752. Fax: (215)238-6923. Director: Becky Kerlin. Retail and commercial exhibition gallery. Estab. 1993. Represents/exhibits 15-20 emerging, mid-career and established artists. Exhibited artists include Donna Dennis and Harry Roseman. Sponsors 6 shows/year. Average display time 6 weeks. Open all year; Wednesday-Saturday, 12-5:30. Located in Old City; 350 sq. ft. 100% of space for gallery artists. 80% private collectors, 20% corporate collectors. Overall price range: $500-20,000; most work sold at $1,000-5,000.
Media: Only exhibits sculpture, drawing and architectural drawings/models.
Style: Exhibits representational/realism.
Terms: Artwork is accepted on consignment (50% commission). Retail price set by the gallery and the artist. Gallery provides insurance and promotion. Artist pays for shipping costs. Prefers artwork framed.
Submissions: Send query letter with résumé, slides, reviews and SASE. Replies in 6 weeks. Finds artists mostly by visiting galleries and through artist referrals.

N HUB/ROBESON CONTEMPORARY ART GALLERIES, Penn State University, University Park PA 16802. (814)865-1878. Director: Ann Shields. Nonprofit gallery. Estab. 1955. Exhibits emerging and established artists. Open all year Tuesday-Thursday, 12-8, Friday-Saturday 12-4. Located on University Park Campus; 250 sq. ft. "Highly visible, nice new state-of-the-art contemporary spaces." Clients include students, faculty, staff, community. Overall price range: $100-10,000; most work sold at $100-1,500.
Media: Considers all media.
Style: Exhibits all styles and genres.
Terms: Artwork is bought outright. Retail price set by artist. Gallery provides insurance, promotion, contract, one-way shipping costs from gallery. Prefers artwork framed and ready to hang.
Submissions: Send query letter with résumé, slides or bio. Call for appointment to show portfolio of slides. Does not reply. Artist should call or send info to the above address.

INTERNATIONAL IMAGES, LTD., The Flatiron Building, 514 Beaver St., Sewickley PA 15143. (412)741-3036. Fax: (412)741-8606. E-mail: intimage@concentric.net. Director of Exhibitions: Charles M. Wiebe. Retail gallery. Estab. 1978. Represents 100 emerging, mid-career and established artists; primarily Russian, Estonian, Latvian, Lithuanian, Georgian, Bulgarian, African and Cuban. Sponsors 8 solo shows/year. Average display time: 4-6 weeks. 90% of sales are to private collectors, 10% corporate clients. Overall price range: $150-150,000; most work sold at $10,000-65,000.
Media: Considers oils, watercolors, pastels, pen & ink, drawings and original handpulled prints, small to medium sculptures, leather work from Africa and contemporary jewelry. Most frequently exhibits oils, watercolors and works on paper.
Style: Exhibits all styles. Genres include landscapes, florals and portraits. Prefers: abstraction, realism and figurative works.
Terms: Accepts work on consignment. Retail price set by gallery. Exclusive area representation required. Shipping costs are shared.
Submissions: Send query letter with résumé and slides. Portfolio should include slides. "Include titles, medium, size and price with slide submissions." Replies in 1 month. All material is returned if not accepted or under consideration.
Tips: "Founded by Elena Kornetchuk, it was the first gallery to import Soviet Art, with an exclusive contract with the USSR. In 1986, we began to import Bulgarian art as well and have expanded to handle several countries in Europe and South America as well as the basic emphasis on Eastern bloc countries. We sponsor numerous shows each year throughout the country in galleries, museums, universities and conferences, as well as featuring our own shows every four to six weeks. Looks for Eastern European, Bulgarian and International art styles." The most common mistakes artists make in presenting their work are "neglecting to include pertinent information with slides/photographs, such as size, medium, date, and cost and failing to send biographical information with presentations."

N LANCASTER MUSEUM OF ART, 135 N. Lime St., Lancaster PA 17602. (717)394-3497. Executive Director: Cindi Morrison. Assistant Director: Carol Foley. Nonprofit organization. Estab. 1965. Represents 12 emerging, mid-career and established artists/year. 500 members. Sponsors 12 shows/year. Average display time 1 month. Open all year; Monday-Saturday, 10-4; Sunday, 12-4. Located downtown Lancaster; 4,000 sq. ft.; neoclassical architecture. 100% of space for special exhibitions. 100% of space for gallery artists. Overall price range: $100-25,000; most work sold at $100-10,000.
Media: Considers all media.
Terms: Accepts work on consignment (30% commission). Retail price set by the artist. Gallery provides insurance; shipping costs are shared. Artwork must be ready for presentation.
Submissions: Send query letter with résumé, slides, photographs, SASE, and artist's statement for review by exhibitions committee.

Tips: Advises artists to submit quality slides and well-presented proposal. "No phone calls."

[N] MANGEL GALLERY, 1714 Rittenhouse Sq., Philadelphia PA 19103. (215)545-4343. Director: Tara F. Goings. Retail gallery. Estab. 1970. Represents 30 emerging, mid-career and established artists. Exhibited artists include: Alex Katz, Jane Piper, Harry Bertoia, Bill Scott, Stuart Shils and Francis McCarthy. Sponsors 9 shows/year. Average display time 3 weeks. Open all year; Tuesday-Friday, 11-6; Saturday, 11-5. Located in the center of the city; 2,000 sq. ft.; "building is 160 years old, former residence of the famous conductor Lepold Stokoski." 75% of space for special exhibitions. 95% of sales are to private collectors; 5% corporate collectors. Overall price range: $500-125,000; most work sold at $3,000-5,000.
Media: Considers all media except photography. Considers all types of prints. Most frequently exhibits paintings, sculpture and prints.
Style: Exhibits: neo-expressionism, color field, painterly abstraction, realism and all genres.
Terms: Accepts artwork on consignment. Retail price set by the artist. Gallery provides insurance and promotion; artist pays for shipping costs. Prefers artwork framed.
Submissions: Send query letter with résumé, slides, bio, photographs, reviews and SASE. Write for appointment to show portfolio of slides and transparencies. Replies only if interested within 2 months.

[N] MATTRESS FACTORY, 500 Sampsonia Way, Pittsburgh PA 15212. (412)231-3169. Fax: (412)322-2231. E-mail: info@mattress.org. Website: http://www.mattress.org. Curator: Michael Olijnyk. Nonprofit contemporary arts museum. Estab. 1977. Represents 8-12 emerging, mid-career and established artists/year. Exhibited artists include: James Turrell, Bill Woodrow, Ann Hamilton, Jessica Stockholder, John Cage, Allan Wexler, Winnifred Lutz and Christian Boltanski. Sponsors 8-12 shows/year. Average display time 6 months. Tuesday-Saturday, 10-5; Sunday 1-5; closed August. Located in Pittsburgh's historic Mexican War streets; 14,000 sq. ft.; a six-story warehouse and a turn-of-the century general store present exhibitions of temporary and permanent work.
Media: Considers site-specific installations—completed in residency at the museum.
Submissions: Send query letter with résumé, slides, bio. Replies in 1 year.

[N] THE MORE GALLERY, 1630 Walnut St., Philadelphia PA 19103. (215)735-1827. E-mail: morgallery@aol.com. Website: http://www.libertynet.org/~artst/more. President: Charles N. More. Retail gallery. Estab. 1980. Represents 20 artists; emerging, mid-career and established. Exhibited artists include Sidney Goodman and Paul George. Sponsors 8 shows/year. Average display time 1 month. Open all year. Located in center of the city; 1,800 sq. ft. 80% of space for special exhibitions. 60% of sales are to private collectors, 40% corporate collectors. Overall price range: $1,000-20,000; most work sold at $5-10,000.
Media: Considers oil, pen & ink, acrylic, drawing, sculpture, watercolor, mixed media, installation, pastel, collage and photography; woodcuts, wood engravings, linocuts, engravings, mezzotints, etchings, lithographs, pochoir and serigraphs. Most frequently exhibits oil and sculpture.
Style: Exhibits: expressionism, neo-expressionism and painterly abstraction. Interested in all genres. Prefers figurative work.
Terms: Accepts work on consignment (50% commission). Retail price set by the gallery and the artist. Gallery provides insurance and promotion; shipping costs are shared. Prefers artwork framed.
Submissions: Send query letter with résumé, slides, bio, photographs and SASE. Write to schedule an appointment to show a portfolio, which should include slides and transparencies. Replies only if interested within 1 month.
Tips: "Visit first."

NEWMAN GALLERIES, 1625 Walnut St., Philadelphia PA 19103. (215)563-1779. Fax: (215)563-1614. E-mail: newgall@ix.netcom.com. Website: http://www.newmangalleries1865.com. Manager: Terrence C. Newman. Retail gallery. Estab. 1865. Represents 10-20 emerging, mid-career and established artists/year. Exhibited artists include Tim Barr and Philip Jamison. Sponsors 2-4 shows/year. Average display time 1 month. Open September through June, Monday-Friday, 9-5:30; Saturday, 10-4:30; July through August, Monday-Friday, 9-5. Located in Center City Philadelphia. 4,000 sq. ft. "We are the largest and oldest gallery in Philadelphia." 50% of space for special exhibitions; 100% of space for gallery artists. Clientele: traditional. 50% private collectors, 50% corporate collectors. Overall price range: $1,000-100,000; most work sold at $2,000-20,000.
Media: Considers oil, acrylic, watercolor, pastel, sculpture, engraving, linocut, engraving, mezzotint, etching and lithograph. Most frequently exhibits watercolor, oil/acrylic, and pastel.
Style: Exhibits expressionism, Impressionism, photorealism and realism. Genres include landscapes, florals, Americana, wildlife and figurative work. Prefers: landscapes, Americana and still life.
Terms: Accepts work on consignment (45% commission). Retail price set by gallery and artist. Gallery provides insurance. Promotion and shipping costs are shared. Prefers oils framed; prints, pastels and watercolors unframed but matted.
Submissions: Send query letter with résumé, 12-24 slides, bio and SASE. Call for appointment to show portfolio of originals, photographs and transparencies. Replies in 2-4 weeks. Files "things we may be able to handle but not at the present time." Finds artists through agents, visiting exhibitions, word of mouth, art publications, sourcebooks and artists' submissions.

N PAINTED BRIDE ART CENTER, 230 Vine St., Philadelphia PA 19106. (215)925-9235. Fax: (215)925-7402. E-mail: thebride@onix.com. Website: http://www.paintedbride.org. Gallery Director: Christine A. Millan. Nonprofit gallery and alternative space. Estab. 1969. Represents emerging, mid-career and established artists. Sponsors 7-9 shows/year. Average display time 6 weeks. Open September-June. Located in Old City Philadelphia; 3,500 sq. ft.; "two levels and a large exhibit room contiguous to a performance space, wheel chair accessible." Clientele: students of all ages and professionals.

Media: Considers performance art and all media.

Style: Exhibits all styles. Promotes experimental works and non-traditional mediums.

Terms: "In the nonprofit/alternative space, artist pays 20% of retail price." Retail price set by the artist. Gallery provides insurance, promotion and contract; shipping costs are shared. "Artwork must be ready to present."

Submissions: Philadelphia artists encouraged. Send query letter with résumé, slides, brochure, reviews and artist statement. Call to schedule an appointment to show a portfolio, which should include originals and slides. Replies in 6 months.

Tips: "Include an artist statement and printed, not hand-written materials. Artist should be familiar with our institution, mission statement and artistic philosophy."

N ROSENFELD GALLERY, 113 Arch St., Philadelphia PA 19106. (215)922-1376. Owner: Richard Rosenfeld. Retail gallery. Estab. 1976. Represents 35 emerging and mid-career artists/year. Sponsors 18 shows/year. Average display time 3 weeks. Open all year; Wednesday-Saturday, 10-5; Sunday, noon-5. Located downtown, "Old City"; 2,200 sq. ft.; ground floor loft space. 85% of space for gallery artists. 80% private collectors, 20% corporate collectors. Overall price range: $200-6,000; most work sold at $1,500-2,000.

Media: Considers oil, acrylic, watercolor, pastel, drawing, mixed media, paper, sculpture, ceramics, craft, fiber, glass, woodcuts, engravings, lithographs, monoprints, wood engravings and etchings. Most frequently exhibits works on paper, sculpture and crafts.

Style: Exhibits all styles. Prefers painterly abstraction and realism.

Terms: Accepts work on consignment (50% commission). Retail price set by the gallery. Gallery provides insurance and promotion; shipping costs are shared. Prefers artwork framed.

Submissions: Send query letter with slides and SASE. Call or write for appointment to show portfolio of photographs and slides. Replies in 2 weeks. Finds artists through visiting exhibitions, word of mouth, various art publications and submissions.

THE STATE MUSEUM OF PENNSYLVANIA, Third and North St., Box 1026, Harrisburg PA 17108-1026. (717)787-4980. Contact: Senior Curator, Art Collections. The State Museum of Pennsylvania is the official museum of the Commonwealth, which collects, preserves and exhibits Pennsylvania history, culture and natural heritage. The Museum maintains a collection of fine arts, dating from 1645 to present. Current collecting and exhibitions focus on works of art by contemporary Pennsylvania artists. The Archives of Pennsylvania Art includes records on Pennsylvania artists and continues to document artistic activity in the state by maintaining records for each exhibit space/gallery in the state. Estab. 1905. Sponsors 3 shows/year. Accepts only artists who are Pennsylvania natives or past or current residents. Interested in emerging and mid-career artists.

Media: Considers all media including oil, works on paper, photography, sculpture, installation and crafts.

Style: Exhibits all styles and genres.

Submissions: Send query letter with résumé, slides, SASE and bio. Replies in 1-3 months. Retains résumé and bio for archives of Pennsylvania Art. Photos returned if requested. Finds artists through professional literature, word of mouth, Gallery Guide, exhibits, all media and unsolicited material.

Tips: "Have the best visuals possible. Make appointments. Remember most curators are also overworked, underpaid and on tight schedules."

N TANGERINE FINE ARTS, 320 Market St., Harrisburg PA 17101. (717)236-8180. Owner: Vanessa Carroll. Retail, rental gallery; alternative space, art consultancy. Estab. 1971. Represents/exhibits emerging and mid-career artists. Interested in seeing work from emerging artists. Exhibited artists include: Michael Kessler and Robert Patierno. Sponsors 4-5 shows/year. Average display time 4-6 weeks. Open all year; Monday-Saturday 10:30-6. Located downtown; 1,500 sq. ft. Clients include variety and upscale. 70% of sales are to private collectors, 30% corporate collectors. Overall price range: $25-10,000; most work sold at $100-450.

Media: Considers all media and all types of prints. Most frequently exhibits paintings, prints and sculpture.

Style: Exhibits all styles and genres. Prefers postmodern, Impressionism and abstraction.

Terms: Artwork is accepted on consignment (50% commission). Artwork is bought outright for 50% of the retail price; net 90 days. Retail price set by the gallery. Gallery provides promotion and contract; shipping costs are shared. Prefers artwork framed.

Submissions: Send query letter with résumé, slides and bio. Call or write for appointment to show portfolio of slides. Replies in 3 weeks. Finds artists through art fairs, word of mouth and artists' submissions.

✓ SANDE WEBSTER GALLERY, 2018 Locust St., Philadelphia PA 19102. (215)732-8850. Fax: (215)732-7850. E-mail: swgart@erols.com. Director: Jason Brooks. Retail gallery. Estab. 1969. Represents emerging, mid-career and established artists. "We exhibit from a pool of 40 and consign work from 200 artists." Exhibited artists include Charles Searles and Moe-Brooker. Sponsors 12-14 shows/year. Average display time 1 month. Open all year; Monday-Friday,

10-6; Saturday, 11-4. Located downtown; 2,000 sq. ft.; "We have been in business in the same location for 25 years." 50% of space for special exhibitions; 50% of space for gallery artists. Clients include art consultants, commercial and residential clients. 30% of sales are to private collectors, 70% corporate collectors. Overall price range: $25-25,000; most work sold at $1,000-2,000.

Media: Considers oil, acrylic, watercolor, drawing, mixed media, collage, sculpture, fiber, photography, woodcut, engraving, lithograph, wood engraving, mezzotint, serigraphs, linocut and etching.

Style: Exhibits all styles and genres. Prefers: non-objective painting and sculpture and abstract painting.

Terms: Accepts work on consignment (50% commission). Retail price set by agreement. Gallery provides insurance, promotion, contract and shipping costs from gallery; artist pays shipping costs to gallery. "We also own and operate a custom frame gallery."

Submissions: Send query letter with résumé, 10 slides with list of size, media and price, bio, SASE and retail PR. Call for appointment to show portfolio of slides. "All submissions reviewed from slides with no exceptions." Replies within 2 months. Files "slides, résumés of persons in whom we are interested." Finds artists through referrals from artists, seeing work in outside shows, and unsolicited submissions.

THE WORKS GALLERY, Dept. AGDM, 303 Cherry St., Philadelphia PA 19106. (215)922-7775. Owner: Ruth Snyderman. Retail gallery. Estab. 1965. Represents 200 emerging, mid-career and established artists. Exhibited artists include William Scholl and Catherine Butler. Sponsors 10 shows/year. Average display time 1 month. Open all year; Tuesday-Saturday, 10-6. First Friday of each month hours extend to 9 p.m. as all galleries in this district have their openings together. Exhibitions usually change on a monthly basis except through the summer. Located downtown; 2,000 sq. ft. 65% of space for special exhibitions. Clientele: designers, lawyers, businessmen and women, students. 90% private collectors, 10% corporate collectors. Overall price range: $25-10,000; most work sold at $200-600.

Media: Considers ceramic, fiber, glass, photography and metal jewelry. Most frequently exhibits jewelry, ceramic and fiber.

Style: Exhibits all styles.

Terms: Accepts artwork on consignment (50% commission); some work is bought outright. Gallery provides insurance, promotion and contract; shipping costs are shared.

Submissions: Send query letter with résumé, 5-10 slides and SASE. Files résumé and slides, if interested.

Tips: "Most work shown is one-of-a-kind. We change the gallery totally for our exhibitions. In our gallery, someone has to have a track record so that we can see the consistency of the work. We would not be pleased to see work of one quality once and have the quality differ in subsequent orders, unless it improved. Always submit slides with descriptions and prices instead of walking in cold. Enclose an self-addressed, stamped return envelope. Follow up with a phone call. Try to have a sense of what the gallery's focus is so your work is not out of place. It would save everyone some time."

Rhode Island

ARNOLD ART, 210 Thames, Newport RI 02840. (401)847-2273. President: Bill Rommel. Retail gallery. Estab. 1870. Represents 30-40 mid-career and established artists. Sponsors 8-10 solo or group shows/year. Average display time 2 weeks. Clientele: tourists and Newport collectors. 95% private collectors, 5% corporate clients. Overall price range: $150-12,000; most work sold at $150-750.

Media: Considers oil, acrylic, watercolor, pastel, pen & ink, drawings, mixed media, limited edition offset reproductions, color prints and posters. Most frequently exhibits oil, acrylic and watercolor.

Style: Exhibits painterly abstraction, primitivism, photorealism and realism. Genres include landscapes and florals. Specializes in marine art and local landscapes.

Terms: Accepts work on consignment. Retail price set by gallery or artist. Exclusive area representation not required. Gallery provides insurance, promotion and contract.

Submissions: Send query letter with résumé and slides. Call for appointment to show portfolio of originals. Files résumé and slides.

ARTIST'S COOPERATIVE GALLERY OF WESTERLY, 12 High St., Westerly RI 02891. (401)596-2020. Cooperative gallery and nonprofit corporation. Estab. 1992. Represents 40 emerging, mid-career and established artists/year. Sponsors 12 shows/year. Average display time 1 month. Offers spring and fall open juried shows. Open all year; Tuesday-Saturday, 11-4. Located downtown on a main street; 30' × 80'; ground level, store front, arcade entrance, easy parking. 80% of sales are to private collectors, 20% corporate collectors. Overall price range: $20-3,000; most work sold at $20-300.

Media: Considers all media and all types of prints. Most frequently exhibits oils, watercolors, ceramics, sculpture and jewelry.

Style: Exhibits: expressionism, primitivism, painterly abstraction, postmodern works, Impressionism and realism.

Terms: Co-op membership fee of $120/year, plus donation of time and hanging/jurying fee of $10. Gallery takes no percentage. Regional juried shows each year. Retail price set by the artist. Gallery provides promotion; artist pays for shipping. Prefers artwork framed.

Submissions: Send query letter with 3-6 slides or photos and artist's statement. Call or write for appointment. Replies in 2-3 weeks. Membership flyer and application available on request.

Tips: "Take some good quality pictures of your work in person, if possible, to galleries showing the kind of work you want to be associated with. If rejected, reassess your work, presentation and the galleries you have selected. Adjust what you are doing appropriately. Try again. Be upbeat and positive."

CADEAUX DU MONDE, 140 Bellevue Ave., Newport RI 02840. (401)848-0550. Fax: (401)624-8224. Website: http://www.cadeauxdumonde.com. Owners: Jane Perkins, Katie Dyer and Bill Perkins. Retail gallery. Estab. 1987. Represents emerging, mid-career and established artists. Exhibited artists include: John Lyimo and A.K. Paulin. Sponsors 3 changing shows and 1 ongoing show/year. Average display time 3-4 weeks. Open all year; daily, 10-6 and by appointment. Located in commercial district; 1,300 sq. ft. Located in historic district in an original building with original high tin ceilings, wainscoting and an exterior rear Mediterranean-style courtyard garden that has rotating exhibitions during the summer months. 15% of space for special exhibitions; 85% of space for gallery artists. Clients include tourists, upscale, local community and students. 95% of sales are to private collectors, 5% corporate collectors. Overall price range: $20-5,000; most work sold at $100-300.
Media: Considers all media suitable for display in a garden atmosphere for special exhibitions. No prints.
Style: Exhibits: folk art. Style is unimportant, quality of work is deciding factor—look for unusual, offbeat and eclectic.
Terms: Accepts work on consignment (30% commission). Retail price set by the artist. Gallery provides insurance. Artist pays shipping costs and promotional costs of opening. Prefers artwork framed.
Submissions: Send query letter with résumé, 10 slides, bio, photographs and business card. Call for appointment to show portfolio of photographs or slides. Replies only if interested within 2 weeks. Finds artists through word of mouth, referrals by other artists, visiting art fairs and exhibitions, artist's submissions.
Tips: Artists who want gallery representation should "present themselves professionally; treat their art and the showing of it like a small business; arrive on time and be prepared; and meet deadlines promptly."

COMPLEMENTS ART GALLERY, Fine Art Investments, Ltd., 50 Lambert Lind Hwy., Warwick RI 02886. (401)739-9300. Fax: (401)739-7905. E-mail: fineartinv@aol.com. Website: http://www.complementsartgallery.com. President: Domenic B. Rignanese. Retail gallery. Estab. 1986. Represents hundreds of international and New England emerging, mid-career and established artists. Exhibited artists include Fairchild and Hatfield. Sponsors 6 shows/year. Average display time 2-3 weeks. Open all year; Monday-Friday, 8:30-6; Saturday-Sunday, 9-5. 2,250 sq. ft.; "we have a piano and beautiful hardwood floors also a great fireplace." 20% of space for special exhibitions; 60% of space for gallery artists. Clientele: upscale. 40% private collectors, 15% corporate collectors. Overall price range: $25-5,000; most work sold at $600-1,200.
Media: Considers all media except offset prints. Types of prints include engravings, lithographs, wood engravings, mezzotints, serigraphs and etchings. Most frequently exhibits serigraphs, oils and etchings.
Style: Exhibits expressionism, painterly abstraction, Impressionism, photorealism, realism and imagism. Genres include florals, portraits and landscapes. Prefers realism, Impressionism and abstract.
Terms: Accepts work on consignment (30% commission) or bought outright for 50% of retail price (90 days). Retail price set by the gallery. Gallery provides insurance, promotion and contract. Shipping costs are shared. Prefers artwork unframed.
Submissions: Size limitation due to wall space. Drawing no larger than 40×60 sculpture not heavier than 150 pounds. Send query letter with résumé, bio, 6 slides or photographs. Call for appointment to show portfolio of photographs and slides. Replies in 3-4 weeks. Files all materials from artists. Finds artists through word of mouth, referrals by other artists, visiting art fairs and all exhibitions and artist's submissions.
Tips: "Artists need to have an idea of the price range of their work and provide interesting information about themselves."

N COTTAGE GALLERY LTD., 1336 Smith St., North Providence RI 02911. (401)353-1723. President: Robert Bert. Retail gallery and art consultancy. Estab. 1979. Represents 50+ established artists/year. May be interested in seeing the work of emerging artists in the future. Exhibited artists include: H.A. Dyer and G.W. Whittaker. Sponsors 4 shows/year. Average display time 1 month. Open all year; Monday-Friday, 8:30-3; Saturday, 8:30-noon. Located in town; 5,000 sq. ft.; Victorian building. 50% of space for special exhibitions; 25% of space for gallery artists. 70% of sales are to private collectors; 10% corporate collectors. Overall price range: $100-75,000; most work sold at $1,500.
Media: Considers oil, acrylic, watercolor, pastel, pen & ink, drawing, mixed media, sculpture woodcuts, lithographs, mezzotints, serigraphs and etchings. Most frequently exhibits oils, watercolors and sculpture.
Style: Exhibits all styles and genres. Prefers landscapes, genres and Americana.
Terms: Accepts work on consignment (25% commission) or buys outright for 40% of retail price (net 30 days). Retail price set by the gallery. Gallery provides promotion; shipping costs are shared. Prefers artwork framed.
Submissions: Send query letter with bio and photographs. Call for appointment to show portfolio of photographs. Replies only if interested within 2 weeks. Files photos. Finds artists through referrals.

THE DONOVAN GALLERY, 3879 Main Rd., Tiverton Four Corners RI 02878. (401)624-4000. Fax: (401)624-4100. E-mail: kdgallery@aol.com. Owner: Kris Donovan. Retail gallery. Estab. 1993. Represents 50 emerging, mid-career and established artists/year. Sponsors 8 shows/year. Average display time 1 month. Open all year; Tuesday-Saturday, 10-5; Sunday, 12-5; shorter winter hours. Located in a rural shopping area; 1,600 sq. ft.; located in 1820s historical home. 100% of space for gallery artists. Clientele: tourists, upscale, local community and students. 90% private collectors, 10% corporate collectors. Overall price range: $80-6,500; most work sold at $250-800.

Media: Considers oil, acrylic, watercolor, pastel, mixed media, collage, paper, sculpture, ceramics, some craft, fiber and glass; and all types of prints. Most frequently exhibits watercolors, oils and pastels.

Style: Exhibits conceptualism, Impressionism, photorealism and realism. Exhibits all genres. Prefers: realism, Impressionism and representational.

Terms: Accepts work on consignment (45% commission). Retail price set by the artist. Gallery provides limited insurance, promotion and contract; artist pays for shipping. Prefers artwork framed.

Submissions: Accepts only artists from New England. Send query letter with résumé, 6 slides, bio, brochure, photographs, SASE, business card, reviews and artist's statement. Call or write for appointment to show portfolio of photographs or slides or transparencies. Replies in 1 week. Files material for possible future exhibition. Finds artists through networking and submissions.

Tips: "Do not appear without an appointment, especially on a weekend. Be professional, make appointments by telephone, be preapred with résumé, slides and (in my case) some originals to show. Don't give up. Join local art associations and take advantage of show opportunities there."

[N] HELME HOUSE: SOUTH COUNTY ART ASSOCIATION, 2587 Kingstown Rd., Kingston RI 02881. (401)783-2195. President: Bob Hazard. Nonprofit gallery, studios and workshops. Estab. 1929. Represents emerging, mid-career and established artists/year; 230 members. Sponsors 11 shows/year. Average display time 3 weeks. Open all year; Wednesday-Sunday, 1-5. Located downtown; historic buildings (c. 1802). 100% of space for special exhibitions. Clients include tourists, upscale, local community, students. 100% of sales are to private collectors. Overall price range: $100-1,000; most work sold at $100-250.

Media: Considers all media and all kinds of fine art, including prints, photography and handmade pottery.

Style: Exhibits all styles and genres.

Terms: Co-op membership fee plus donation of time (25% commission). Retail price set by the artist. Gallery provides insurance and promotion. Artists pays shipping costs. Prefers artwork framed.

Submissions: Accepts only artists from New England. Send query letter with résumé. Phone or write to receive "call for entry" for open juried shows. Finds artists through word of mouth, referrals by other artists, visiting art fairs and exhibitions, artist's submissions.

HERA EDUCATIONAL FOUNDATION, HERA GALLERY, 327 Main St., P.O. Box 336, Wakefield RI 02880. (401)789-1488. Nonprofit professional artist cooperative gallery. Estab. 1974. Located in downtown Wakefield, a Northeast area resort community (near Newport beaches). Exhibits the work of emerging and established artists. 30 members. Sponsors 16 shows/year. Average display time 3 weeks. Open all year; Wednesday, Thursday and Friday, 1-5; Saturday, 10-4. Located downtown; 1,200 sq. ft. 40% of space for special exhibitions.

Media: Considers all media and original handpulled prints.

Style: Exhibits expressionism, neo-expressionism, painterly abstraction, surrealism, conceptualism, postmodern works, realism and photorealism. "We are interested in innovative, conceptually strong, contemporary works that employ a wide range of styles, materials and techniques." Prefers "a culturally diverse range of subject matter which explores contemporary social and artistic issues important to us all."

Terms: Co-op membership. Retail price set by artist. Sometimes offers customer discount and payment by installments. Gallery provides promotion; artist pays for shipping, and shares expenses like printing and postage for announcements.

Submissions: Send query letter with SASE. "After sending query letter and SASE artists interested in membership receive membership guidelines with an application. Twenty slides are required for application review along with résumé, artist statement and slide list." Portfolio required for membership; slides for invitational/juried exhibits. Finds artists through word of mouth, advertising in art publications, and referrals from members.

Tips: "Please write for membership guidelines, and send SASE. We are perfect for emerging artists and others needing venue."

[N] VIEWPOINT—ART, FRAMING & ARTISTIC GIFTS, 105 Swinburne Row, Newport RI 02840. (401)849-2328. Owners: Loren Deveau and Dana Swist. Retail gallery. Estab. 1977. Represents hundreds of emerging, mid-career and established artists/year. Open all year; winter 7 days, 9:30-5:30; summer 7 days, 9-9 . Located downtown; 900 sq. ft. Clientele: tourists, local community. Overall price range: $10-1,000; most work sold at $30-75.

Media: Considers all media except oil painting, sculpture and all types of prints. Most frequently exhibits etchings, posters and local prints.

Style: Exhibits: realism. Genres include local scenes.

Terms: Buys outright for 50% of retail price (net 0 days). Retail price set by the gallery and the artist. Gallery provides insurance, promotion and contract. Artist pays shipping costs. Prefers artwork unframed.

Submissions: Prefers only smaller etchings, intaglio of local scenes or New England scenes. Send query letter with slides or photographs. Call for appointment to show portfolio of photographs. Replies only if interested within 2 weeks. Finds artists through word of mouth, referrals by other artists, visiting art fairs and exhibitions and artist's submissions.

Tips: "We are looking for artists willing to do local scenes in a marketable format."

[N] WHEELER GALLERY, 228 Angell St., Providence RI 02906. (401)421-9230. Director: Sue L. Carroll. Nonprofit gallery. Presents emerging, mid-career and established artists. We have an open jury each year to select the 5 exhibitions for the next year." Sponsors 5 shows/year. Average display time 3 weeks. Open fall, winter, spring; Tuesday-Saturday, 12-5; Sunday, 3-5. Located in a university and residential area; 1,250 sq. ft.; award-winning architectural design. 100%

of space for special exhibitions. 50% private collectors, 50% corporate collectors. Overall price range: $100-25,000.
Media: Considers all media, all types of prints except posters. Most frequently exhibits oil and acrylic painting, sculpture and glass.
Style: Exhibits all styles, all genres.
Terms: Accepts work on consignment (33% commission). Retail price set by the artist. Gallery provides insurance, promotion and contract; artist pays shipping costs to and from gallery.
Submissions: Prefers artists from New England area. Send query letter with SASE. Write for appointment to show portfolio of slides. Replies in 1 month. Finds artists through word of mouth, various art publications and artists' submissions.
Tips: "We also mail out a 'call for slides' notice in late fall."

South Carolina

CECELIA COKER BELL GALLERY, Coker College, 300 E. College Ave., Hartsville, SC 29550. (803)383-8152. E-mail: lmerriman@pascal.coker.edu. Website: http://www.coker.edu/art.dept. Director: Larry Merriman. "A campus-located teaching gallery which exhibits a great diversity of media and style to expose students and the community to the breadth of possibility for expression in art. Exhibits include regional, national and international artists with an emphasis on quality. Features international shows of emerging artists and sponsors competitions." Estab. 1984. Interested in emerging and mid-career artitsts. Sponsors 5 solo shows/year. Average display time 1 month. "Gallery is 30×40, located in art department; grey carpeted walls, track lighting."
Media: Considers oil, acrylic, drawings, mixed media, collage, works on paper, sculpture, installation, photography, performance art, graphic design and printmaking. Most frequently exhibits painting, sculpture/installation and mixed media.
Style: Considers all styles. Not interested in conservative/commercial art.
Terms: Retail price set by artist (sales are not common). Exclusive area representation not required. Gallery provides insurance, promotion and contract; shipping costs are shared.
Submissions: Send résumé, 10-15 good-quality slides and SASE by October 15. Write for appointment to show portfolio of slides.

N CHARLESTON CRAFTS, 87 Hasell St., Charleston SC 29401. (843)723-2938. Gallery Manager: Regina Semko. Cooperative gallery. Estab. 1989. Represents 50 emerging, mid-career and established artists/year. 50-70 members. Exhibited artists include Alison McCauley and Sue Grier. Sponsors 8 shows/year. Average display time 3-4 weeks. Open all year; Monday-Saturday 10-5. Located downtown. 5% of space for special exhibitions; 95% of space for gallery artists. Clientele: tourists and local community. 98% private collectors, 2% corporate collectors. Overall price range: $2-700; most work sold at $30-125.
Media: Considers paper, fiber, sculpture, glass, ceramics, craft, fine photography, graphics, handpulled prints. Most frequently exhibits clay, glass, metal sculpture and jewelry.
Terms: Co-op membership fee plus donation of time (35% commissions). Retail price set by the artist. Gallery provides promotion; shipping costs are shared. Prefers artwork either framed or unframed.
Submissions: Accepts only artists from South Carolina. Send query letter with SASE. Replies in 2 weeks. Files only applications to jury as member. Finds artists through word of mouth; jury twice a year, referrals and craft shows call for new member-press releases.
Tips: "Artists must realize we are a cooperative of juried members—all local South Carolina artists. We look at expertise in technique and finishing. Also how work is presented—professional display, packaging or tagging."

N CONVERSE COLLEGE MILLIKEN GALLERY, 580 E. Main St., Spartanburg SC 29302. (864)596-9177. E-mail: art.design@converse.edu. Gallery Director: Jim Creal. College gallery. Estab. 1971. Represents emerging, mid-career and established artists. Exhibited artists include Teresa Prater. Sponsors 9 shows/year. Average display time 1 month. Open during fall, winter and spring. Located on campus; 1,800 sq. ft.; gallery has glass walls for sculpture exhibits. 100% of space for special exhibitions. Clientele: students and community. Overall price range: $50-5,000; most work sold at $50-500.
Media: Considers all media and all types of prints. Most frequently exhibits painting, sculpture and prints/photography.
Style: Exhibits all styles.
Terms: No commission. Retail price set by artist. Gallery provides insurance and promotion; shipping costs are shared. Prefers artwork framed.
Submissions: Send query letter with résumé, slides, brochure, photographs, SASE and reviews. Portfolio should include slides and photographs. Replies only if interested within several months. Files résumés.

N FROGMORE FROLICS, 849 Sea Island Pkwy., St. Helena Island SC 29920. (803)838-9102. E-mail: frogmore@h argray.com. Owner: Sherry Chesney. Retail gallery. Estab. 1992. Represents 6 established artists/year. May be interested in seeing the work of emerging artists in the future. Exhibited artists include Tina B. Fripp and J. Michael Kennedy. Sponsors 6 shows/year. Average display time 1 month. Open all year; Monday-Saturday, 10-5; Sunday, 1-5. Located

on an island named Frogmore; 1,000 sq. ft. Clientele: tourist, local community. 90% private collectors, 10% corporate collectors. Overall price range: $20-500; most work sold at $100-300.

Media: Considers oil, watercolor and pen & ink, oils and prints.

Style: Exhibits realism. Exhibits oils, watercolors, pen & ink, pastels, originals and prints. Genres include florals, wildlife and landscapes.

Terms: Accepts work on consignment (50% commission). Retail price set by the artist. Gallery provides promotion; artist pays shipping costs. Artwork can be unframed or framed.

Submissions: Prefers only artists from South Carolina. Send query letter with brochure, photographs and SASE. Call or write for appointment to show portfolio of photographs. Replies only if interested within 2 weeks. Files print catalogs. Finds artists through visiting art fairs and referrals.

IMPERIAL FRAMING & SPECIALTIES, 960 Bacons Bridge Rd., Summerville SC 29485. (803)891-9712. Owner: Clyde A. Hess. Retail gallery/framing shop. Estab. 1992. Represents 30 and up emerging, mid-career and established artists/year. Exhibited artists include Jim Booth, Redlin and Art Lemay. Sponsors 3 shows/year. Average display time 2 weeks. Open all year; Monday-Saturday, 10-6. Located in town, Palmetto Plaza; 1,000 sq. ft. 10% of space for special exhibitions; 90% of space for gallery artists. Clientele: local, upscale and students. Overall price range: $25-2,000; most work sold at $50-600.

Media: Considers oil, pen & ink, acrylic, drawing, watercolor, mixed media and photography; all types of prints. Most frequently exhibits signed limited edition prints, originals—oil, watercolor and posters.

Style: Exhibits all styles and genres. Prefers: wildlife, Charleston SC printers and eastern coastal scenes.

Terms: Buys outright for 50% of retail price (net 30 days). Will consider rental and co-op and acquire more space. Retail price set by the gallery. Gallery provides insurance, promotion and contract; gallery pays shipping costs to gallery. Prefers artwork unframed.

Submissions: Send query letter with résumé, brochure, business card, photographs and artist's statement. Call for appointment to show portfolio of photographs, slides or samples. Replies in 2 weeks. Finds artists through word of mouth, personal contact and artist submissions.

[N] STEVEN JORDAN GALLERY, 463 W. Coleman Blvd., Mt. Pleasant SC 29464. (843)881-1644. Website: http://www.stevenjordan.com. Owner: Penny Jordan. Retail gallery. Estab. 1987. Represents various 3 dimensional artists and 2 dimensional work by Steven Jordan. Open all year; Monday-Saturday, 11-6. Located 5 miles from downtown; 1,600 sq. ft. Clientele: tourists, upscale, local community, students. 80% private collectors, 20% corporate collectors.

Media: Considers only sculpture and ceramics.

Style: Prefers coastal realism, humor and abstracts.

Terms: Accepts work on consignment (40% commission) to gallery. Retail price set by the artist. Gallery provides promotion. Shipping costs are shared.

Submissions: Accepts only artists from America. Prefers 3 dimensional work. Send query letter with slides, bio, brochure and photographs. Call for appointment to show portfolio of photographs or slides. Replies in 2 weeks. Finds artists through word of mouth, referrals by other artists, visiting art fairs and exhibitions and artist's submissions.

Tips: "Be optimistic! Don't be discouraged by failures. Perseverance is more important than talent."

McCALLS, 111 W. Main, Union SC 29379. (864)427-8781. Owner: William H. McCall. Retail gallery. Estab. 1972. Represents 5-7 established artists/year. Exhibited artists include Mary Ellen Smith and William McCall. Sponsors 3 shows and 1 competition/year. Average display time 9-12 weeks. Open all year; Tuesday-Friday, 10-5 (10 months); Monday-Saturday, 10-6 (2 months). Located downtown; 900 sq. ft. 10% of space for special exhibitions; 90% of space for gallery artists. Clientele: upscale. 60% private collectors, 40% corporate collectors. Overall price range: $150-2,500; most work sold at $150-850.

Media: Considers oil, pen & ink, acrylic, drawing, watercolor, mixed media, pastel, collage; considers all types of prints. Most frequently exhibits acrylics, collage and watercolor.

Style: Exhibits painterly, realism and Impressionism. Genres include florals, western, southwestern, landscapes and Americana. Prefers: southwestern, florals and landscapes.

Terms: Accepts work on consignment (negotiable commission). Retail price set by the gallery and the artist. Gallery provides insurance, promotion and contract.

Submissions: "I prefer to see actual work by appointment only."

Tips: "Contact the gallery and request an appointment. Request that you would like to show some of your new work. Be persistent in your requests for an appointment."

PICKENS COUNTY MUSEUM, 307 Johnson St., Pickens SC 29671. (803)898-7818. E-mail: picmus@innova.net. Website: http://www.co.pickens.sc.us. Director: C. Allen Coleman. Nonprofit museum located in old county jail. Estab. 1976. Interested in emerging, mid-career and established artists. Sponsors 8 art exhibits/year. Average display time is 2 months. Open all year: Tuesdays, 8:30 a.m.-8:30 p.m.; Wednesday-Friday, 8:30 a.m.-5 p.m.; Saturday, 12-4 p.m.; closed Monday and Sunday. Clientele: artists and public. Overall price range: $200-2,000; most artwork sold at $400.

Media: Considers oil, acrylic, watercolor, pastel, pen & ink, drawings, sculpture, ceramics, fiber, photography, crafts, mixed media, collage and glass.

Style: Exhibits contemporary, abstract, landscape, floral, folk, primitive, non-representational, photo-realistic and real-

ism. "We exhibit historical perspective to contemporary art." Considers art of regional interest (South Carolina, Appalachia and South Eastern US).

Terms: Accepts work on consignment (30% commission). Retail price is set by artist. Sometimes offers customer discounts. Exclusive area representation not required. Gallery provides insurance, promotion and contract.

Submissions: Send query letter with résumé, 10-12 slides or photographs and SASE. Portfolio review required. Call or write, "no drop-ins." Find artists by visiting exhibitions, reviewing submissions, slide registries and word of mouth.

Tips: "We are interested in work produced by artists who have worked seriously enough to develop a signature style." Advises artists to "keep appointments, answer correspondence, honor deadlines."

PORTFOLIO ART GALLERY, 2007 Devine St., Columbia SC 29205. (803)256-2434. E-mail: portfolio@mindspring. com. Owner: Judith Roberts. Retail gallery and art consultancy. Estab. 1980. Represents 40-50 emerging, mid-career and established artists. Exhibited artists include Donald Holden, Sigmund Abeles and Joan Ward Elliott. Sponsors 4-6 shows/year. Average display time 3 months. Open all year. Located in a 1930s shopping village, 1 mile from downtown; 2,000 sq. ft.; features 12 foot ceilings. 100% of space for work of gallery artists. "A unique feature is glass shelves where matted and medium to small pieces can be displayed without hanging on the wall." Clientele: professionals, corporations and collectors. 40% private collectors, 40% corporate collectors. Overall price range: $150-12,500; most work sold at $300-3,000.

● Portfolio Art Gallery was selected by readers of the local entertainment weekly paper and by *Columbia Metropolitan* magazine as the best gallery in the area.

Media: Considers oil, acrylic, watercolor, pastel, mixed media, collage, works on paper, sculpture, ceramic, glass, original handpulled prints, woodcuts, wood engravings, linocuts, engravings, mezzotints, etchings, lithographs and serigraphs. Most frequently exhibits watercolor, oil and original prints.

Style: Exhibits neo-expressionism, painterly abstraction, imagism, minimalism, color field, Impressionism, realism, photorealism and pattern painting. Genres include landscapes and figurative work. Prefers: landscapes/seascapes, painterly abstraction and figurative work. "I especially like mixed media pieces, original prints and oil paintings. Pastel medium and watercolors are also favorites. Kinetic sculpture and whimsical clay pieces."

Terms: Accepts work on consignment (40% commission). Retail price set by gallery and artist. Offers payment by installments. Gallery provides insurance, promotion and contract; artist pays for shipping. Artwork may be framed or unframed.

Submissions: Send query letter with slides, bio, brochure, photographs, SASE and reviews. Write for appointment to show portfolio of originals, slides, photographs and transparencies. Replies only if interested within 1 month. Files tearsheets, brochures and slides. Finds artists through visiting exhibitions and referrals.

Tips: "The most common mistake beginning artists make is showing all the work they have ever done. I want to see only examples of recent best work—unframed, originals (no copies)—at portfolio reviews."

SMITH GALLERIES, The Village at Wexford, Suite J-11, Hilton Head Island SC 29928. Phone/fax: (803)842-2280. E-mail: info@smithgalleries.com. Website: http://smithgalleries.com. Owner: Wally Smith. Retail gallery. Estab. 1988. Represents 300 emerging, mid-career and established artists. Exhibited artists include Mike Smith and Hessam. Sponsors 10 shows/year. Average display time 6 weeks. Open all year; Monday-Friday, 10-6; Saturday, 10-5. Located in upscale shopping center near town center; 3,600 sq. ft.; designed by Taliesan Architect Bennett Strahan and accompanied by custom fixtures. 30% of space for special exhibitions; 70% of space for gallery artists. Clientele: 95% private collectors, 5% corporate collectors. Overall price range: $200-4,000; most work sold at $400-1,200.

Media: Considers oil, acrylic, watercolor, pastel, paper, sculpture, ceramics, craft, fiber, glass, photography, woodcuts, engravings, lithographs, mezzotints, serigraphs, linocuts, etchings and posters. Most frequently exhibits serigraphs, oil and acrylic.

Style: Exhibits all styles. Genres include florals, wildlife, landscapes, Americana and figurative work. Prefers: realism, expressionism and primitivism.

Terms: Buys outright for 50% of retail price (net 30 days). Retail price set by the gallery. Gallery provides insurance and promotion; shipping costs are shared. Prefers consigned artwork framed; purchase artwork unframed.

Submissions: No restrictions. "Please review artist submission page on website." Send query letter with résumé, 6-10 slides, bio, brochure, photographs, SASE, business card, reviews, artist's statement, "no phone or walk in queries." Write for appointment to show portfolio or photographs. "No slides or transparencies." Replies only if interested within 6 weeks. Files résumé, photos, reviews and bio. Finds artists through art expo, ABC shows and word of mouth.

Tips: "Know the retail value of your work. Don't skimp on framing. Learn to frame yourself if necessary. In short, make your work desirable and easy for the gallery to present. Don't wait until you are out of school to start developing a market. Give marketing a higher priority than your senior show or masters exhibition."

THE SPARTANBURG COUNTY MUSEUM OF ART, 385 S. Spring St., Spartanburg SC 29306. (803)583-2776. Fax: (803)948-5353. Executive Director: Theresa H. Mann. Nonprofit art museum. Estab. 1968. Represents emerging, mid-career and established artists. Sponsors 25 shows/year. Average display time 6-8 weeks. Open all year; Monday-Friday, 9-5; Saturday, 10-2; Sunday, 2-5. Located downtown, in historic neighborhood; 2,500 sq. ft.; Overall price range: $150-20,000; most work sold at $150-800.

Media: Considers oil, acrylic, watercolor, pastel, pen & ink, drawings, mixed media, collage, works on paper, sculpture, ceramic, craft, fiber, glass, installation and photography.

Style: Exhibits all styles and genres.

Terms: Accepts artwork on consignment (33⅓% commission). Retail price set by artist. The museum provides insurance and promotion; shipping costs are negotiable. Artwork must be framed.

Submissions: Send query letter with résumé, 10 slides, bio, brochure, SASE and reviews. Write for appointment to show portfolio of slides. Replies in 4-6 weeks. Files bio, résumé and brochure.

[N] SUMTER GALLERY OF ART, 421 N. Main Street, Sumter SC 29150. (803)775-0543. Publicity Director: Kit Soltan. Nonprofit gallery, gift shop and art school. Represents 50 emerging, mid-career and established artists, 500 members. Exhibited artists include: Rhea Gary and Amy Dixon. Sponsors 10 shows/year. Average display time one month. Open September-June; Tuesday-Friday, 12-5; Saturday-Sunday, 2-5. Located downtown; 1,800-2,400 sq. ft.; Greek Revival architecture on historic register. 75% of space for special exhibitions; 25% of space for gallery artists. Clients include tourists, upscale, local community and students. 75% of sales are to private collectors, 25% corporate collectors. Overall price range: $10-1,000; most work sold at $50-150.

Media: Considers all media and all types of prints. Most frequently exhibits oil, watercolor and ceramics.

Style: Exhibits: expressionism, painterly abstraction, surrealism, Impressionism and realism. Genres include florals, portraits, wildlife, landscapes and figurative work. Prefers figurative, landscapes and florals.

Terms: Accepts work on consignment (30% commission.) Retail price set by the artist. Gallery provides insurance, promotion and contract; gallery pays for shipping.

Submissions: Send query letter with bio and photographs. Write for appointment to show slides. Replies in 3 weeks. Files exhibit files. Finds artists through word of mouth, referrals by other artists, visiting art fairs and exhibitions and artist's submissions.

[N] [icon] WATERFRONT GALLERY, 167 E. Bay St., Charleston SC 29401. (803)722-1155. President: Karen Weihs. Cooperative gallery. Estab. 1995. Represents 21 established artists. May be interested in seeing the work of emerging artists in the future, 21 members. Exhibited artists include: Amelia Rose Smith and Bob Graham. Sponsors 12 shows/year. Average display time 5 months. Open all year; Monday-Thursday, 11-6; Friday-Saturday, 11-10; Sunday, 12-5. Located downtown; 5,200 sq. ft.; historic building in French Quarter one block from Charleston Harbors Waterfront Park. 5% of space for special exhibitions; 95% of space for gallery artists. Clients include upscale tourists. 90% of sales are to private collectors, 10% corporate collectors. Overall price range: $50-3,500; most work sold at $300-800.

Media: Considers all media and all types of prints except photography, crafts and installation. Most frequently exhibits watercolors, oils and pastels.

Style: Exhibits: expressionism, painterly abstraction, Impressionism and realism. Exhibits all genres. Prefers landscapes, wildlife and still life.

Terms: Co-op membership fee plus donation of time (10% commission). Rental fee for space; covers 1 month. Retail price set by the artist. Gallery provides promotion and pays shipping costs to gallery. Artist pays shipping costs from gallery.

Submissions: Accepts only artists from South Carolina. Only accepts new members when a current member departs. Send query letter with résumé, slides and bio. Write for appointment to show photographs or slides. Replies if interested within 3 months. Files slides, résumé, etc. Finds artists through referrals and artist's submissions.

Tips: "Don't submit work similar to what we already have. We look for something different when we need a new member. Send plenty of slides or photos."

South Dakota

[✓] DAKOTA ART GALLERY, 713 Seventh St., Rapid City SD 57701. (605)394-4108. Fax: (605)394-6121. Director: Duane Baumgartner. Retail gallery. Estab. 1971. Represents approximately 300 emerging, mid-career and established artists, approximately 150 members. Exhibited artists include James Van Nuys and Russell Norberg. Sponsors 12 shows/year. Average display time 1 month. Open all year; Monday, 12-5; Tuesday-Saturday, 10-5; Sunday, 1-5. Memorial Day through Labor Day: Monday, 12-7; Tuesday-Saturday 10-7; Sunday, 1-7. Located in downtown Rapid City; 1,800 sq. ft. 40% of space for special exhibitions; 60% of space for gallery artists. 80% private collectors, 20% corporate collectors. Overall price range: $25-7,500; most work sold at $25-400.

Media: Considers all media and all types of prints. Most frequently exhibits oil, acrylics, watercolors, pastels, stained glass and ceramics.

Style: Exhibits expressionism, painterly abstraction and Impressionism and all genres. Prefers: landscapes, western, regional, still lifes and traditional.

Terms: Accepts work on assignment (40% commission). Retail price set by the artist. Gallery provides insurance, promotion and contract. Artist pays shipping costs.

Submissions: "Our main focus is on artists from SD, ND, MN, WY, CO, MT and IA. We also show artwork from any state that has been juried in." Must be juried in by committee. Send query letter with résumé, 15-20 slides, bio and photographs. Call for appointment to show portfolio of photographs, slides, bio and résumé. Replies in 1 month. Files résumés and photographs. Finds artists through word of mouth, referrals by other artists, visiting art fairs and exhibitions, artist's submissions.

Tips: "Make a good presentation with professional résumé, biographical material, slides, etc. Know the gallery quality and direction in sales, including prices."

THE HERITAGE CENTER, INC., Red Cloud Indian School, Pine Ridge SD 57770. (605)867-5491. Fax: (605)867-1291. E-mail: rcheritage@6asec.net. Website: http://6asec.net/rcheritage/. Director: Brother Simon. Nonprofit gallery. Estab. 1984. Represents emerging, mid-career and established artists. Sponsors 6 group shows/year. Accepts only Native Americans. Average display time 10 weeks. Clientele: 80% private collectors. Overall price range: $50-1,500; most work sold at $100-400.

Media: Considers oil, acrylic, watercolor, pastel, pen & ink, drawings, sculpture and original handpulled prints.

Style: Exhibits contemporary, Impressionism, primitivism, western and realism. Genres include western. Specializes in contemporary Native American art (works by Native Americans). Interested in seeing pictographic art in contemporary style. Likes clean, uncluttered work.

Terms: Accepts work on consignment (20% commission). Retail price set by artist. Customer discounts and payment by installments are available. Exclusive area representation not required. Gallery provides insurance and promotion; artist pays for shipping.

Submissions: Send query letter, résumé, brochure and photographs Wants to see "fresh work and new concepts, quality work done in a professional manner." Portfolio review requested if interested in artist's work. Finds artists through word of mouth, publicity in Native American newspapers.

Tips: "Show art properly matted or framed. Good work priced right always sells. We still need new Native American artists if their prices are not above $300. Write for information about annual Red Cloud Indian Art Show."

N: VISUAL ARTS CENTER, (formerly Civic Fine Arts Center), 301 S. Main, Sioux Falls SD 57104. (605)367-6000 or (877)WASH-PAV. Fax: (605)367-7399. E-mail: washingtonpavilion.org. Nonprofit museum. Estab. 1961. Open Monday-Saturday, 9-5; Sundays 11-5.

Media: Considers all media.

Style: Exhibits local, regional and national artists.

Submissions: Send query letter with résumé and slides..

Tennessee

BENNETT GALLERIES, 5308 Kingston Pike, Knoxville TN 37919. (423)584-6791. Director: Mary Morris. Owner: Rick Bennett. Retail gallery. Represents emerging and established artists. Exhibited artists include Richard Jolley, Carl Sublett, Scott Duce, Andrew Saftel and James Tormey. Sponsors 10 shows/year. Average display time 1 month. Open all year; Monday-Thursday, 10-6; Friday-Saturday, 10-5:30. Located in West Knoxville. Clientele: 70% private collectors, 30% corporate collectors. Overall price range: $200-20,000; most work sold at $2,000-4,000.

Media: Considers oil, acrylic, watercolor, pastel, drawing, mixed media, works on paper, sculpture, ceramic, craft, photography, glass, original handpulled prints. Most frequently exhibits painting, ceramic/clay, wood, glass and sculpture.

Style: Exhibits abstraction, figurative, non-objective, Impressionism and realism. Genres include landscapes, still life and interiors.

Terms: Accepts artwork on consignment (50% commission). Retail price set by the gallery and the artist. Sometimes offers customer discounts and payment by installments. Gallery provides insurance on works at the gallery, promotion, contract from gallery. Prefers artwork framed. Shipping to gallery to be paid by the artist.

Submissions: Send query letter with résumé, no more than 20 slides, bio, photographs, SASE and reviews. Portfolio review requested if interested in artist's work. Portfolio should include originals, slides, photographs and transparencies. Replies in 6 weeks. Files samples and résumé. Finds artists through agents, visiting exhibitions, word of mouth, various art publications, sourcebooks, submissions/self-promotions and art collectors' referrals.

Tips: "When approaching a new gallery, do your research to determine if the establishment is the right venue for your work. Also make a professional presentation with clearly labeled slides and relevant reference material."

COOPER ST. GALLERY, 964 S. Cooper St., Memphis TN 38104. (901)272-7053. Owner: Jay S. Etkin. Retail gallery. Estab. 1989. Represents/exhibits 20 emerging, mid-career and established artists/year. Exhibited artists include: Rob vander Schoor and Pamela Cobb. Sponsors 10 shows/year. Average display time 1 month. Open all year; Tuesday-Saturday, 11-5. Located in midtown Memphis; 1,200 sq. ft.; gallery features public viewing of works in progress. 33⅓ of space for special exhibitions; 75% of space for gallery artists. Clientele: young upscale, corporate. 80% private collectors, 20% corporate collectors. Overall price range $200-12,000; most work sold at $500-2,000.

Media: Considers all media except craft, papermaking. Also considers kinetic sculpture and conceptual work. "We do very little with print work." Most frequently exhibits oil on paper canvas, mixed media and sculpture.

Style: Exhibits expressionism, conceptualism, neo-expressionism, painterly abstraction, postmodern works, realism, surrealism. Genres include landscapes and figurative work. Prefers: figurative expressionism, abstraction, landscape.

Terms: Artwork is accepted on consignment (60% commission). Retail price set by the gallery and the artist. Gallery provides promotion. Artist pays for shipping or costs are shared at times.

Submissions: Accepts artists generally from mid-south. Prefers only original works. Looking for long-term committed artists. Send query letter with 6-10 sildes or photographs, bio and SASE. Write for appointment to show portfolio of photographs, slides and cibachromes. Replies only if interested within 1 month. Files bio/slides if interesting work. Finds artists through referrals, visiting area art schools and studios, occasional drop-ins.

Tips: "Be patient. The market in Memphis for quality contemporary art is only starting to develop. We choose artists

whose work shows technical know-how and who have ideas about future development in their work. Make sure work shows good craftsmanship and good ideas before approaching gallery. Learn how to talk about your work."

N CUMBERLAND GALLERY, 4107 Hillsboro Circle, Nashville TN 37215. (615)297-0296. Director: Carol Stein. Retail gallery. Estab. 1980. Represents 55 emerging, mid-career and established artists. Sponsors 6 solo and 2 group shows/year. Average display time 5 weeks. 60% of sales are to private collectors, 40% corporate clients. Overall price range: $450-35,000; most work sold at $1,000-5,000.
Media: Considers oil, acrylic, watercolor, pastel, mixed media, collage, works on paper, sculpture, photography, woodcuts, wood engravings, linocuts, engravings, mezzotints and etchings. Most frequently exhibits painting, drawings and sculpture.
Style: Exhibits: realism, photorealism, minimalism, painterly abstraction, postmodernism and hard-edge geometric abstraction. Prefers landscapes, abstraction, realism and minimalism. "We have always focused on contemporary art forms including paintings, works on paper, sculpture and multiples. Approximately half of the artists have national reputations and half are strongly emerging artists. These individuals are geographically dispersed." Interested in seeing "work that is technically accomplished, with a somewhat different approach, not derivative."
Tips: "I would hope that an artist would visit the gallery and participate on the mailing list so that he/she has a sense of what we are doing. It would be helpful for the artist to request information with regard to how we prefer work to be considered for inclusion. I suggest slides, résumé, prices, recent articles and a SASE for return of slides. We are currently not actively looking for new work but always like to review work that may be appropriate for our needs."

PAUL EDELSTEIN GALLERY, (formerly Paul Edelstein Gallery/Edelstein Art Investments), 519 N. Highland St., Memphis TN 38122-4521. (901)454-7105. E-mail: pedelst414@aol.com. or pedelst@bellsouth.net. Owner/Director: Paul Edelstein. Assistant: Todd Perkins. Retail gallery and art consultancy. Estab. 1985. Represents 30 emerging, mid-career and established artists. Exhibited artists include Nancy Cheairs, Marjorie Liebman, Charles Tuthill and Carroll Cloar. Sponsors 1-2 shows/year. Average display time 12 weeks. Open all year; by appointment only. Located in East Memphis; 2,500 sq. ft.; 80% of space for special exhibitions. Clientele: upscale. 80% private collectors, 20% corporate collectors. Overall price range: $100-25,000; most work sold at $200-400.
● The gallery is in a 1920s farmhouse with many different rooms for exhibiting.
Media: Considers all media and all types of prints. Most frequently exhibits oil, watercolor and prints.
Style: Exhibits hard-edge geometric abstraction, color field, painterly abstraction, minimalism, postmodern works, feminist/political works, primitivism, photorealism, expressionism and neo-expressionism. Genres include florals, landscapes, Americana and figurative. Most frequently exhibits primitivism, painterly abstraction and expressionism. "Especially seeks new folk artists and N.Y. Soho undiscovered artists." Specializes in contemporary and black folk art, southern regionalism, modern contemporary abstract and WPA 1930s modernism. Interested in seeing modern, contemporary art and contemporary photography.
Terms: Accepts work on consignment (40% commission). Retail price set by gallery. Offers customer discounts and payment by installments. Gallery provides insurance and contract; artist pays for shipping. Prefers artwork framed.
Submissions: Send query letter with résumé, 20 slides, bio, brochure, photographs, SASE and business card. Portfolio review not required. Replies in 2 months. Files all material. Finds artists mostly through word of mouth, *Art in America*, and also through publications like *Artist's & Graphic Designer's Market*.
Tips: "Most artists do not present enough slides or their biographies are incomplete. Professional artists need to be more organized when presenting their work."

N HANSON FINE ART & CRAFT GALLERY, INC., 5607 Kingston Pike, Knoxville TN 37919. (423)584-6097. Fax: (423)588-3789. President: Diane Hanson. Retail gallery. Estab. 1988. Represents 150 mid-career artists/year. Exhibited artists include: Thomas Pradzynsky. Sponsors 3 shows/year. Average display time 1 month. Open all year; Monday-Friday, 10-5; Saturday, 10-4. Located in midtown; 3,500 sq. ft. showroom; features clean, contemporary organization of work. 33⅓% of space for special exhibitions; 33⅓% of space for gallery artists. Clients include upscale, professional. 70% of sales are to private collectors, 30% corporate collectors. Overall price range: $25-5,000; most work sold at $100-1,000.
Media: Considers oil, acrylic, watercolor, pastel, mixed media, collage, paper, sculpture, ceramics, craft, fiber, glass and all prints. Most frequently exhibits oil, acrylic, glass.
Style: Exhibits: expressionism, painterly abstraction, Impressionism, realism. Prefers landscape, figurative, abstract.
Terms: Accepts work on consignment (50% commission). Buys outright for 50% of retail price (net 30 days). Retail price set by the gallery. Gallery provides insurance, promotion, selective contract. Prefers artwork framed or unframed.
Submissions: Send query letter with résumé, slides, bio, photographs, SASE, reviews and artist's statement. Call for appointment to show portfolio of photographs or slides. Replies in 1 month. Files only material from artists of interest.

SPECIAL MARKET INDEXES, identifying Licensing, Medical Illustration, Religious Art, Science Fiction/Fantasy Art, Sport Art, T-Shirts, Textiles, Wildlife Art and other categories are located in the back of this book.

Tips: "Have high quality of personal presentation of work—we need assurance of a business-like relationship."

THE PARTHENON, Centennial Park, Nashville TN 37201. (615)862-8431. Fax: (615)880-2265. E-mail: info@parthe non.org. Website: http://www.parthenon.org. Museum Director: Ms. Wesley Paine. Nonprofit gallery in a full-size replica of the Greek Parthenon. Estab. 1931. Exhibits the work of emerging to mid-career artists. Clientele: general public, tourists. Sponsors 8 solo and 3 group shows/year. Average display time 6 weeks. Overall price range: $300-2,000; most work sold at $750. We also house a permanent collection of American paintings (1765-1923).
Media: Considers "nearly all" media.
Style: "Interested in both objective and non-objective work. Professional presentation is important."
Terms: "Sale requires a 20% commission." Retail price set by artist. Gallery provides a contract and limited promotion. The Parthenon does not represent artists on a continuing basis.
Submissions: Send 10-20 slides with résumé and supporting materials, addressed to Artist Submissions.
Tips: "We plan our gallery calendar at least one year in advance."

[N] RIVER GALLERY, 400 E. Second St., Chattanooga TN 37403. (423)267-7353. Fax: (423)265-5944. Owner Director: Mary R. Portera. Retail gallery. Estab. 1992. Represents 300 emerging and mid-career artists/year. Exhibited artists include: Sarah A. Hatch and Scott E. Hill. Sponsors 11 shows/year. Average display time 1 month. Open all year; Monday-Wednesday, 10-5; Thursday-Saturday, 10-7; Sunday, 1-5. Located in art district in downtown area; 2,500 sq. ft.; restored early New Orleans-style 1900s home; arched openings into rooms. 30% of space for special exhibitions; 70% of space for gallery artists. Clients include upscale tourists, local community. 95% of sales are to private collectors, 5% corporate collectors. Overall price range: $5-5,000; most work sold at $600-2,000.
Media: Considers all media. Considers woodcuts, engravings, lithographs, wood engravings, mezzotints, linocuts and etchnigs. Most frequently exhibits oil, photography, watercolor, mixed media, clay.
Style: Exhibits all styles and genres. Prefers painterly abstraction, Impressionism, photorealism.
Terms: Accepts work on consignment (50% commission). Retail price set by the gallery. Gallery provides insurance, promotion and contract; shipping costs are shared. Prefers artwork framed.
Submissions: Send query letter with résumé, slides, bio, photographs, SASE, reviews and artist's statement. Write for appointment to show portfolio of photographs and slides. Files all material "unless we are not interested then we return all information to artist." Finds artists through word of mouth, referrals by other artists, visiting art fairs and exhibitions, submissions, ads in art publications.

Texas

[T] ARCHWAY GALLERY, 2013C W. Gray St., #C, Houston TX 77019-3601. (713)522-2409. Director: Gary Kos mas. Cooperative gallery. Estab. 1976. Represents 15 emerging artists. Interested in emerging and established artists. Sponsors 9 solo and 3 group shows/year. Average display time 1 month. Accepts only artists from the Houston area. 70% of sales are to private collectors, 30% corporate clients. Overall price range: $150-4,000; most work sold at $150-1,000.
Media: Considers all 2- and 3- dimensional media.
Style: Considers all styles and genres.
Terms: Co-op membership "buy-in" fee, plus monthly rental fee, donation of time and 10% commission. Retail price set by artist. Exclusive area representation not required. Gallery provides promotion and contract.
Submissions: Send query letter with résumé, brochure and SASE. Write for appointment to show portfolio of originals, slides and photographs. Replies in 1 month. Files résumé, brochure and slides. All material returned if not accepted or under consideration.
Tips: "Please query before sending materials and know that we don't accept out-of-Houston-area artists. Make sure materials include telephone number. Since our gallery is artist owned and run, our decisions are strongly influenced by how well we feel the person will work within the group. When they are interacting with the artists, and when they are representing everyone when they work with the public in the gallery."

ART LEAGUE OF HOUSTON, 1953 Montrose Blvd., Houston TX 77006. (713)523-9530. Executive Director: Linda Haag Carter. Nonprofit gallery. Estab. 1948. Represents emerging and mid-career artists. Sponsors 12 individual/ group shows/year. Average display time 3-4 weeks. Located in a contemporary metal building; 1,300 sq. ft., specially lighted; smaller inner gallery/video room. Clientele: general, artists and collectors. Overall price range: $100-5,000; most artwork sold at $100-2,500.
Media: Considers all media.
Style: Exhibits contemporary avant-garde, socially aware work. Features "high-quality artwork reflecting serious aes thetic investigation and innovation. Additionally the work should have a sense of personal vision."
Terms: 30% commission. Retail price set by artist. Exclusive area representation not required. Gallery provides insur ance, promotion and contract; artist pays for shipping.
Submissions: Must be a Houston-area-resident. Send query letter, résumé and slides that accurately portray the work. Portfolio review not required. Submissions reviewed once a year in mid-June and exhibition agenda determined for upcoming year.

ARTHAUS GALERIE, 4319 Oak Lawn Ave., Suite F, Dallas TX 75219. (214)522-2721. Director: Michael Cross. Retail gallery, art consultancy. Estab. 1991. Exhibits 5 emerging, mid-career and established artists/year. Exhibited artists include Michael Cross. Sponsors 9 shows/year. Average display time 3 weeks. Open all year; Tuesday-Saturday, 11-5; Sunday, 1-5. Located in Highland Park/Oak Lawn area of Dallas; 500 sq. ft. of exhibition space. Clientele: international collectors of contemporary art. 80% private collectors, 20% corporate collectors. Overall price range: $500-8,000; most work sold at $500-3,000.

- Arthaus Galerie shows artists on an individual-exhibit basis.

Media: Considers oil, acrylic and mixed media. Most frequently exhibits mixed media, acrylic and oil.
Style: Exhibits painterly abstraction, minimalism and postmodern works. Genres include landscapes and abstract figurative work. Prefers: painterly abstraction and landscape.
Submissions: Send query letter with résumé, slides, bio and photographs of works from the past 2-3 years.

AUSTIN MUSEUM OF ART, 823 Congress Ave., Austin TX 78701; Box 5568, Austin TX 78763. (512)495-9224. Fax: (512)495-9024. E-mail: krobertson@amoa.org. Website: http://www.amoa.org. Director: Elizabeth Ferrer. Museum. Estab. 1961. Downtown and Laguna Gloria locations. Interested in emerging, mid-career and established artists. Sponsors 2-3 solo and 6 group shows/year. Average display time: 1½ months. Clientele: tourists and Austin and central Texas citizens.
Media: Currently exhibits 20th-21st Century art of the Americas and the Caribbean with an emphasis on two-dimensional and three-dimensional contemporary artwork to include experimental video, mixed media and outdoor site-specific installations.
Style: Exhibits all styles and genres. No commercial clichéd art.
Terms: Retail price set by artist. Gallery provides insurance and contract; shipping costs to be determined. Exhibitions booked 2 years in advance. "We are not a commercial gallery."
Submissions: Send query letter with résumé, slides and SASE. Replies only if interested within 2-3 months. Files slides, résumé and bio. Material returned only when accompanied by SASE. Common mistakes artists make are "not enough information—poor slide quality, too much work covering too many changes in their development."

BARNARDS MILL ART MUSEUM, 307 SW. Barnard St., Glen Rose TX 76043. (817)897-7494. Directors: Melody Flowers and Jessica Babin. Museum. Estab. 1989. Represents 30 mid-career and established artists/year. Interested in seeing the work of emerging artists. Sponsors 2 shows/year. Open all year; Saturday, 10-5; Sunday, 1-5. Located 2 blocks from the square. "Barnards Mill is the oldest structure (rock exterior) in Glen Rose. 20% of space for special exhibitions; 80% of space for gallery artists."
Media: Considers oil, acrylic, watercolor, pastel, pen & ink, drawing, mixed media, collage, paper, sculpture, ceramics, fiber, glass, installation, photography, woodcuts, engravings, lithographs, wood engravings, mezzotints, serigraphs, linocuts and etchings. Most frequently exhibits oil, pastel and watercolor.
Style: Exhibits expersssionism, postmodern works, Impressionism and realism, all genres. Prefers realism, Impressionism and Western.
Terms: Gallery provides promotion. Prefers artwork framed.
Submissions: Send query letter with résumé, slides or photographs, bio and SASE. Write for appointment to show portfolio of photographs or slides. Replies only if interested within 3 months. Files résumés, photos, slides.

JULIA C. BUTRIDGE GALLERY AT THE DOUGHERTY ARTS CENTER, (formerly Dougherty Arts Center Gallery) 1110 Barton Springs Rd., Austin TX 78704. (512)397-1455. E-mail: pardarts@bga.com. Website: http://www.ci.austin.tx.us/parks/. Gallery Coordinator: Megan Hill. Nonprofit gallery. Represents emerging, mid-career and established artists. Exhibited artists include John Christensen and T. Paul Hernandez. Sponsors 12 shows/year. Average display time 1 month. Open all year; Monday-Thursday, 9-9:30; Friday 9-5:30; Saturday 10-2. Located in downtown Austin; 1,800 sq. ft.; open to all artists. 100% of space for special exhibitions. Clientele: citizens of Austin and central Texas. Overall price range: $100-5,000.
Media: Considers all media, all types of prints.
Style: Exhibits all styles, all genres. Prefers: contemporary.
Terms: "Gallery does not handle sales or take commissions. Sales are encouraged but must be conducted by the artist or his/her affiliate." Rental fee for space; covers 1 month. Retail price set by the artist. Gallery provides insurance and promotion; artist pays shipping costs to and from gallery. Artwork must be framed.
Submissions: Accepts only regional artists, central Texas. Send query letter with résumé and 10-20 slides. Write for appointment to show portfolio of photographs and slides. Replies in 1 month. Files résumé, slides. Finds artists through visiting exhibitions, publications, submissions.
Tips: "Since most galleries will not initially see an artist via an interview, have fun and be creative in your paper presentations. Intrigue them!"

CONTEMPORARY GALLERY, 4152 Shady Bend Dr., Dallas TX 75244. (972)247-5246. Director: Patsy C. Kahn. Private dealer. Estab. 1964. Interested in emerging and established artists. Clients include collectors and retail.
Media: Considers oil, acrylic, drawings, sculpture, mixed media and original handpulled prints.
Style: Contemporary, 20th-century art—paintings, graphics and sculpture.
Terms: Accepts work on consignment or buys outright. Retail price set by gallery and artist; shipping costs are shared.
Submissions: Send query letter, résumé, slides and photographs. Write for appointment to show portfolio.

DALLAS VISUAL ART CENTER, 2801 Swiss Ave., Dallas TX 75204. (214)821-2522. Fax: (214)821-9103. Director: Katherine Wagner. Nonprofit gallery. Estab. 1981. Represents emerging, mid-career and established artists. Sponsors 20 shows/year. Average display time 3-6 weeks. Open all year. Located "downtown; 24,000 sq. ft.; renovated warehouse." Provides information about opportunities for local artists, including resource center.

Media: Considers all media.

Style: Exhibits all styles and genres.

Terms: Invitational and juried exhibitions are determined through review panels. Invitational exhibits, including shipping, insurance and promotion, are offered at no cost to the artist. The annual *Critics Choice* exhibition is juried by well-respected curators and museum directors from other arts institutions. They also offer an annual membership exhibition open to all members.

Submissions: Supports Texas-area artists. Send query letter with résumé, slides, bio and SASE.

Tips: "We offer a lot of information on grants, commissions and exhibitions available to Texas artists. We are gaining members as a result of our inhouse resource center and non-lending library. Our Business of Art seminar series provides information on marketing artwork, presentation, museum collection, tax/legal issues and other related business issues."

FLORENCE ART GALLERY, 2500 Cedar Springs at Fairmount, Dallas TX 75201. (214)754-7070. E-mail: floartgal@aol.com. Website: http://www.guidelive.com/dfw/florenceart. Director: Janice Meyers. Retail gallery. Estab. 1974. Represents 10-15 emerging and established artists. Exhibited artists include Veronica Ruiz de Velasco, Alexandra Nechita, Yuroz, Tamayo, Henrietta Milan and Kathy Hinson. Sponsors 5 shows/year. Average display time 2 months. Open all year; Tuesday-Friday, 10-5; Saturday, 11-5. Located in the heart of uptown, 5 minutes from downtown/arts and antique district. 20% of space for special exhibitions. Clientele: international, US, local. 90% private collectors, 10% corporate collectors.

Media: Considers oil, acrylic, watercolor, pastel, pen & ink, mixed media, collage, paper, sculpture, bronze, original handpulled prints, woodcuts, etchings, lithographs, serigraphs. Most frequently exhibits oils, bronzes and graphics.

Style: Exhibits all styles and genres. Prefers figurative, landscapes and abstract. Interested in seeing contemporary, impressionist, figurative oils.

Terms: Accepts work on consignment. Retail price set by gallery and artist. Sometimes offers payment by installment. Gallery provides insurance, promotion and contract; shipping costs are shared. Prefers artwork framed.

Submissions: Send query letter with photographs and bio. Does not want to see slides. Call for appointment to show portfolio of photographs. Replies in 2 weeks. Files artists accepted in gallery.

Tips: "Usually we are contacted by new and upcoming artists who have heard of the gallery through word of mouth or in various art publications. Local artists are recommended to come into the gallery with their original works. If they are not available, they may bring in photos. Slides are acceptable but not prefered. For out-of-town artists, send query letter with photos and biography. Please call for appointments. Have a complete body of representative work. We always need to see new artists."

CAROL HENDERSON GALLERY, 3409 W. Seventh, Ft. Worth TX 76107. (817)878-2711. Fax: (817)878-2722. Director: Donna Craft. Retail gallery. Estab. 1989. Represents/exhibits 21 emerging, mid-career and established artists/year. Exhibited artists include Wayne McKinzie, Michael Bane and Marton Varo. Sponsors 6 show/year. Average display time 3-4 weeks. Open all year; Monday-Saturday, 10-5:30. Located in West Fort Worth; 2,100 sq. ft. 90% of space for gallery artists. Clientele: upscale, local community. 90% private collectors, 10% corporate collectors. Overall price range: $100-10,000.

Media: Considers all media, woodcut, mezzotint and etching. Most frequently exhibits oil, acrylic and glass.

Style: Exhibits expressionism, photorealism, primitivism, painterly abstraction and realism. Genres include landscapes, florals and figurative work. Prefers figurative, abstract and landscape.

Terms: Artwork is accepted on consignment (50% commission). Retail price set by the gallery and the artist. Gallery provides insurance, promotion and contract; shipping costs are shared. Prefers artwork framed.

Submissions: Send query letter with résumé, brochure, business card, slides, photographs, reviews, bio and SASE. Call for appointment to show portfolio of photographs, slides and transparencies. Replies in 2 weeks. Finds artists through referrals, artists' submissions.

IRVING ARTS CENTER—MAIN AND NEW TALENT GALLERIES, 3333 N. MacArthur Blvd., Irving TX 75062. (972)252-7558. Fax: (972)570-4962. E-mail: minman@irving.lib.tx.us. Gallery Director: Marcie J. Inman. Nonprofit municipal arts center. Estab. 1990. Represents emerging, mid-career and established artists. Sponsors 25-30 shows/year. Average display time 3-6 weeks. Open all year; Monday-Friday, 9-5; Thursday, 9-8; Saturday, 10-5; Sunday, 1-5. Located in the middle of residential, commercial area; 4,600 sq. ft.; utilizes two theater lobbies for rotating exhibitions in addition to the galleries—Main Gallery has 30' ceiling, skylights and 45' high barrel vault. 100% of space for special exhibitions. Clientele: local community. Overall price range: $200-80,000; most work sold at $200-4,000.

Media: Considers all media except craft. Considers all types of prints except posters. Most frequently exhibits painting, sculpture, photography.

Style: Exhibits all styles.

Terms: Artists may sell their work and are responsible for the sales. Retail price set by the artist. Gallery provides insurance, promotion, contract and some shipping costs. Prefers artwork framed ready to install.

Submissions: Send query letter with résumé, brochure, business card, 10-20 slides, photographs, reviews, artist's statement, bio and SASE. Call for appointment to show portfolio of photographs, transparencies or slides. Replies in

6-18 months. Files slides, résumé, artist's statement. Finds artists through word of mouth, referrals by other artists, visiting galleries and exhibitions, submissions, visiting universities' galleries and graduate students' studios.

Tips: "Have high-quality slides or photographs made. It's worth the investment. Be prepared—i.e. know something about the Arts Center. Present yourself professionally—whatever your level of experience. We are not a commercial gallery—artists are chosen for exhibitions based on their work—not necessarily on name recognition and definitely not based on commercial viability (sales)."

IVÁNFFY & UHLER GALLERY, 4623 W. Lovers Lane, Dallas TX 75209. (214)350-3500. Fax: (214)353-8709. Director: Paul Uhler. Retail/wholesale gallery. Estab. 1990. Represents 20 mid-career and established artists/year. May be interested in seeing the work of emerging artists in the future. Sponsors 3-4 shows/year. Average display time 1 month. Open all year; Tuesday-Saturday, 10-7; Sunday, 1-6. Located near Love Field Airport. 4,000 sq. ft. 100% of space for gallery artists. Clientele: upscale, local community. 85% private collectors, 15% corporate collectors. Overall price range: $1,000-20,000; most work sold at $1,500-4,000.

Media: Considers oil, acrylic, watercolor, pastel, pen & ink, drawing, mixed media, collage, paper, sculpture, woodcuts, engravings, lithographs, wood engravings, mezzotints, serigraphs, linocuts and etchings. Most frequently exhibits oils, mixed media, sculpture.

Style: Exhibits neo-expressionism, painterly abstraction, surrealism, postmodern works, Impressionism, hard-edge geometric abstraction, postmodern European school. Genres include florals, landscapes, figurative work.

Terms: Gallery provides promotion; shipping costs are shared.

Submissions: Send query letter with résumé, photographs, bio and SASE. Write for appointment to show portfolio of photographs. Replies only if interested within 1 month.

Tips: "Put our gallery on your mailing list one year before sending application. Ask to be put on the gallery marketing list, so you know the gallery's general approach."

JOJUMA GALLERY, (formerly Jojuma CyberGallery), P.O. Box 221953, El Paso TX 79913. (505)589-3502. E-mail: director@jojumagallery.com. Website: http://www.jojumagallery.com. Retail gallery and alternative space. Estab. 1998. Represents emerging and mid-career artists. "We anticipate 30 for the year. Our space is electronic and mobile. Sales are made in cyberspace or by appointments in homes and offices in W. Texas and New Mexico." Overall price range: $100-5,000.

Media: Considers all media.

Style: Exhibits all styles and all genres. "We look for diversity in style and type."

Terms: No longer accepts work on consignment. Retail price set by the artist. Gallery provides promotions. Insurance provided by the artist. Prefers artwork unframed.

Submissions: Send slides, photos, brochure or URL address for first contact. Replies only if interested within 2 months. All SASEs returned.

LONGVIEW MUSEUM OF FINE ARTS, 215 E. Tyler St, P.O. Box 3484, Longview TX 75606. (903)753-8103. E-mail: foxhearne@kilgore.net. Director: Carolyn Fox Hearne. Museum. Estab. 1967. Represents 80 emerging, mid-career and established artists/year. 600 members. Sponsors 6-9 shows/year. Average display time 6 weeks. Open all year; Tuesday-Friday, 10-4; Saturday, 12-4. Located downtown. 75% of space for special exhibitions. Clientele: members, visitors (local and out-of-town) and private collectors. Overall price range: $200-2,000; most work sold at $200-800.

Media: Considers all media, all types of prints. Most frequently exhibits oil, acrylic and photography.

Style: Exhibits all styles and genres. Prefers contemporary American art and photography.

Terms: Accepts work on consignment (30% commission). Retail price set by the artist. Offers customer discounts to museum members. Gallery provides insurance and promotion. Prefers artwork framed.

Submissions: Send query letter with résumé and slides. Portfolio review not required. Replies in 1 month. Files slides and résumés. Finds artists through art publications and shows in other areas.

LYONS MATRIX GALLERY, 1712 Lavaca St., Austin, TX 78701. (512)479-0068. Fax: (512)479-6188. President: Camille Lyons. Retail gallery. Estab. 1981. Represents 25 mid-career and established artists. May consider emerging artists in the future. Exhibited artists include: David Everett and Robert Willson. Sponsors 6 shows/year. Average display time 2 months. Open all year. 2,500 sq. ft. 65% of space for special exhibitions; 100% of space for gallery artists. 75% of sales are to private collectors, 25% corporate collectors. Overall price range: $200-12,000; most work sold at $750-2,500.

Media: Considers oil, acrylic, mixed media, sculpture, glass, woodcuts, wood engravings, linocuts and etchings. Most frequently exhibits glass sculpture, original handpulled prints and oil on canvas.

Style: Exhibits: expressionism, painterly abstraction, postmodern works, realism and imagism. Genres include figurative work.

Terms: Accepts work on consignment (50% commission). Retail price set by artist. Gallery provides insurance, promotion and contract; shipping costs are shared. Prefers prints framed, paintings unframed.

Submissions: Prefers artists from Southwestern region. Send query letter with résumé, photographs and reviews. Do not send slides. Call for appointment to show portfolio of photographs. Replies in 3 months. Files résumés and brochures.

Tips: "Have a good-quality postcard made from an image and use it for all correspondence."

[N] MCMURTREY GALLERY, 3508 Lake St., Houston TX 77098. (713)523-8238. Fax: (713)523-0932. E-mail: mcgallery@aol.com. Owner: Eleanor McMurtrey. Retail gallery. Estab. 1981. Represents 20 emerging and mid-career artists. Exhibited artists include Ibsen Espada and Jenn Wetta. Sponsors 10 shows/year. Average display time 1 month. Open all year. Located near downtown; 2,600 sq. ft. Clients include corporations. 75% of sales are to private collectors, 25% corporate collectors. Overall price range: $400-17,000; most work sold at $1,800-6,000.
Media: Considers oil, acrylic, pastel, drawings, mixed media, collage, works on paper and sculpture. Most frequently exhibits mixed media, acrylic and oil.
Style: Exhibits figurative, narrative, painterly abstraction and realism.
Terms: Accepts work on consignment (50% commission). Retail price set by gallery and artist. Gallery pays shipping costs from gallery. Prefers artwork framed.
Submissions: Send query letter with résumé, slides and SASE. Call for appointment to show portfolio of originals and slides.
Tips: "Be aware of the work the gallery exhibits and act accordingly. Please make an appointment."

[N] ROBINSON GALLERIES, 2800 Kipling, Houston TX 77098. (713)521-2215. Fax: (713)526-0763. E-mail: robin@wt.net. Website: http://www.tvrobinson.com. Director: Thomas V. Robinson. Retail and wholesale gallery. Estab. 1969. Exhibits emerging, mid-career and established artists. Sponsors 2 solo and 4 group shows/year. Average display time 5 weeks. 90% of sales are to museum and private collectors, 10% corporate clients. Overall price range: $100-100,000; most work sold at $1,000-25,000.
Media: Considers all media, including egg tempera, woodcuts, wood engravings, linocuts, engravings, mezzotints, etchings, lithographs and serigraphs. Most frequently exhibits oil/acrylic paintings, works on paper, wood and bronze.
Style: Exhibits: expressionism, realism, photorealism, surrealism, primitivism and conceptualism. Genres include landscapes, art of the Americas and figurative work. Prefers figurative and representational work and social commentary. "I am interested in artists that are making a statement about the human condition. Accepts abstraction based on the figure or nature, but not pure abstraction."
Terms: Accepts work on consignment (50% commission) or buys outright for 50% retail price (net 10 days). Retail price set by gallery and artist. Exclusive area representation required. Gallery provides insurance and promotion. Prefers artwork framed.
Submissions: Send query letter with résumé, brochure, slides, photographs, bio and SASE. Write for appointment to show portfolio of originals, slides, transparencies and photographs. Replies in 1 week. Files résumé and slides. All material returned if not accepted or under consideration, "only by SASE."
Tips: The most common mistake artists make is that "they do not know, nor do they seem to be concerned with the direction of the prospective gallery. Artists should do their homework and predetermine if the gallery and the work it shows and promotes is compatible with the work and career objectives of the artist."

[N] THE ROSSI GALLERY, 2821 McKinney Ave., Dallas TX 75204. (214)871-0777. Fax: (214)871-1343. Owner: Rico Rossi. Retail gallery. Estab. 1990. Represents 10 emerging artists. Exhibited artists include: Constance Muller, Valeriya Veron and Helon Thomson. Sponsors 6 shows/year. Average display time 1 month. Open all year. Located downtown; 1,200 sq. ft.; historic two-story buildings built in 1910. 80% of space for special exhibitions. 80% of sales are to private collectors; 20% corporate collectors. Overall price range: $750-2,500; most work sold at $500-1,000.
Media: Considers oil, acrylic, watercolor, pen & ink, drawing, mixed media, collage, works on paper, sculpture, craft, photography and jewelry. Most frequently exhibits oil, watercolor and photography.
Style: Exhibits all styles. Prefers conceptualism, primitivism and realism.
Terms: Accepts artwork on consignment (50% commission). Retail price set by the gallery. Gallery provides insurance, promotion, contract and shipping costs from gallery. Prefers artwork framed.
Submissions: Send query letter with résumé, slides, SASE and reviews. Call for appointment to show portfolio of originals and slides. Replies only if interested in 2 weeks. Files slides and résumé.

SELECT ART, 10315 Gooding Dr., Dallas TX 75229. (214)353-0011. Fax: (214)350-0027. E-mail: selart@postoffice.s wbell.net. Owner: Paul Adelson. Private art gallery. Estab. 1986. Represents 25 emerging, mid-career and established artists. Exhibited artists include Barbara Elam and Larry Oliverson. Open all year; Monday-Saturday, 9-5 by appointment only. Located in North Dallas; 2,500 sq. ft. "Mostly I do corporate art placement." Clientele: 15% private collectors, 85% corporate collectors. Overall price range: $200-7,500; most work sold at $500-1,500.
Media: Considers oil, fiber, acrylic, sculpture, glass, watercolor, mixed media, ceramic, pastel, collage, photography, woodcuts, linocuts, engravings, etchings and lithographs. Prefers monoprints, paintings on paper and photography.
Style: Exhibits photorealism, minimalism, painterly abstraction, realism and Impressionism. Genres include landscapes. Prefers: abstraction, minimalism and Impressionism.
Terms: Accepts work on consignment (50% commission). Retail price set by consultant and artist. Sometimes offers customer discounts. Provides contract (if the artist requests one). Consultant pays shipping costs from gallery; artist pays shipping to gallery. Prefers artwork unframed.
Submissions: "No florals or wildlife." Send query letter with résumé, slides, bio and SASE. Call for appointment to show portfolio of slides. Replies only if interested within 1 month. Files slides, bio, price list. Finds artists through word of mouth and referrals from other artists.
Tips: "Be timely when you say you are going to send slides, artwork, etc., and neatly label slides."

EVELYN SIEGEL GALLERY, 3700 W. Seventh, Fort Worth TX 76107. (817)731-6412. Fax: (817)731-6413 or (888)374-3435. Owner: E. Siegel. Retail gallery and art consultancy. Estab. 1983. Represents about 50 artists; emerging, mid-career and established. Interested in seeing the work of emerging artists. Exhibited artists include Judy Pelt, Carol Anthony, Robert Daughters and Alexandra Nechita. Sponsors 9 shows/year. Average display time 3 weeks. Open all year; Monday-Friday, 11-5; Saturday, 11-4. Located in museum area; 2500 sq. ft.; diversity of the material and artist mix. "The gallery is warm and inviting; a reading area is provided with many art books and publications." 66% of space for special exhibitions. Clientele: upscale, community, tourists. 90% private collectors. Overall price range: $30-10,000; most work sold at $1,500.
Media: Considers oil, acrylic, watercolor, pastel, mixed media, collage, sculpture, ceramic; original handpulled prints; woodcuts, wood engravings, linocuts, engravings, mezzotints, etchings, lithographs and serigraphs. Most frequently exhibits painting and sculpture.
Style: Exhibits expressionism, neo-expressionism, painterly abstraction, color field, Impressionism and realism. Genres include landscapes, florals and figurative work. Prefers: landscape, florals, interiors and still life.
Terms: Accepts work on consignment (50% commission), or is sometimes bought outright. Retail price set by gallery and artist. Gallery provides insurance, promotion and contract. Artist pays for shipping. Prefers artwork framed.
Submissions: Send query letter with résumé, slides and bio. Call or write for appointment to show portfolio of two of the following: originals, photographs, slides and transparencies.
Tips: Artists must have an appointment. ✒

▥ THE UPSTAIRS GALLERY, 1038 W. Abram, Arlington TX 76013. (817)277-6961. Owner/Manager: Eleanor Martin. Retail gallery. Estab. 1967. Represents 15 mid-career and established artists. Exhibited artists include Al Brovillette and Judi Betts. Average display time 1-3 months. Open all year. Located near downtown; 1,500 sq. ft. "An antique house, vintage 1930." 100% of space for special exhibitions. Clientele: homeowners, businesses/hospitals. 90% private collectors, 10% corporate collectors. Overall price range: $50-5,000; most work sold at $200-600.
Media: Considers oil, acrylic, watercolor, mixed media, ceramic, collage, original handpulled prints, etchings, lithographs and offset reproductions (few). Most frequently exhibits watercolor, oil and acrylic.
Style: Exhibits expressionism, surrealism, conceptualism, Impressionism and realism. All genres.
Terms: Accepts work on consignment (40-60% commission). Retail price set by the gallery and the artist. Gallery provides insurance. Artist pays for shipping. Prefers artwork framed.
Submissions: Send query letter with slides, photographs and SASE. Call for appointment to show portfolio of slides or photographs. Replies in 3-4 weeks.

▥ WEST END GALLERY, 5425 Blossom, Houston TX 77007. (713)861-9544. E-mail: kpackl1346@aol.com. Owner: Kathleen Packlick. Retail gallery. Estab. 1991. Exhibits emerging and mid-career artists. Exhibited artists include Kathleen Packlick and Pam Johnson. Sponsors 6 shows/year. Average display time 6 weeks. Open all year; Saturday, 12-4. Located 5 mintues from downtown Houston; 800 sq. ft.; "The gallery shares the building (but not the space) with West End Bicycles. 75% of space for special exhibitions; 25% of space for gallery artists. Clientele: 100% private collectors. Overall price range: $30-2,200; most work sold at $300-600.
Media: Considers oil, pen & ink, acrylic, drawings, watercolor, mixed media, pastel, collage, woodcuts, wood engravings, linocuts, engravings, mezzotints, etchings, lithographs and serigraphs. Prefers collage, oil and mixed media.
Style: Exhibits conceptualism, minimalism, primitivism, postmodern works, realism and imagism. Genres include landscapes, florals, wildlife, Americana, portraits and figurative work. Prefers figurative and conceptual.
Terms: Accepts work on consignment (40% commission). Retail price set by artist. Payment by installment is available. Gallery provides promotion; artist pays shipping costs. Prefers artwork framed.
Submissions: Accepts only artists from Houston area. Send query letter with slides and SASE. Portfolio review requested if interested in artist's work.
Tips: "Don't be too impressed with yourself."

Utah

✓ THE GALLERY ETC., Ogden City Mall, 24th & Washington Blvd., Ogden UT 84401. (801)621-8282. Fax: (801)621-3461. Owner: Evaline Petersen. Retail gallery. Estab. 1994. Represents 25 established artists/year. May be interested in seeing the work of emerging artists in the future. Exhibited artists include Scott Wallis, David W. Jackson and Ron Chuh. Sponsors 4 shows/year. Average display time 2 months. Open all year. Located downtown; 4,000 sq. ft. 100% of space for gallery artists. Overall price range: $250-10,000; most work sold at $1,500-2,500.
Media: Considers all media and all types of prints. Most frequently exhibits oil, watercolor, sculpture.
Style: Exhibits expressionism, Impressionism and realism. Exhibits all genres. Prefers: landscapes, florals and Americana.
Term; Accepts work on consignment (40-50% commission). Retail price set by the gallery and the artist. Gallery provides insurance, promotion and contract. Shipping costs are shared.
Submissions: "We basically show northwest regional but not exclusively." Write for appointment to show portfolio of photographs, slides and transparencies. Replies only if interested within 1 month. Finds artists through word of mouth, referrals by other artists, visiting art fairs and exhibitions, artist's submissions.

N **KING'S COTTAGE GALLERY**, 2233 South, 7th East, Salt Lake City UT 84106. (801)486-5019. Director: Susan Gallacher. Retail gallery. Estab. 1985. Represents 15 mid-career and established artists/year. May be interested in seeing the work of emerging artists in the future. Exhibited artists include: Susan Gallacher and Rob Adamson. Sponsors 4 shows/year. Average display time 3 months. Open all year; Monday-Friday, 11-5; Saturday, 1-5. Located in business area away from downtown; 500 sq. ft.; an 1800s building with many rooms. Clients include local community and students. 10% of sales are to private collectors, 5% corporate collectors. Overall price range: $300-5,000; most work sold at $500.

Media: Considers oil, watercolor, woodcut, sculpture and acrylic.

Style: Exhibits: Impressionism and realism. Genres include florals, portraits, landscapes and figurative work. Prefers landscape, still life and figurative.

Terms: Accepts work on consignment (40% commission). Retail price set by the artist. Gallery provides insurance and promotion; shipping costs are shared. Prefers artwork framed.

Submissions: Accepts only artists from Utah—with some exceptions. Send query letter with slides, bio, photographs, reviews and artists's statement. Call or write for appointment to show portfolio of photographs and slides. Replies in 2 months.

Tips: "Try not to call too often."

N **MARBLE HOUSE GALLERY**, 44 Exchange Place, Salt Lake City UT 84111. (801)532-7332; 7338. Fax: (801)532-7338 (call first to turn on.) Owner: Dolores Kohler. Retail gallery and art consultancy. Estab. 1987. Represents 20 emerging, mid-career and established artists. Sponsors 6 solo or 2-person shows and 2 group shows/year. Average display time 1 month. Located in the historic financial district; modern interior, marble facade, well lit; 6,000 sq. ft. Clientele: 70% private collectors, 30% corporate clients. Overall price range $100-10,000; most work sold at $200-5,000.

• Now carries limited edition prints from Greenwich Workshop and Somerset House Publishing.

Media: Considers oil, acrylic, watercolor, pastel, pen & ink, mixed media, collage, sculpture, ceramic, photography, egg tempera, woodcuts, wood engravings, linocuts, engravings, mezzotints, etchings, lithographs, pochoir and serigraphs. Most frequently exhibits oil, watercolor, limited editions, large tile murals and molded tiles.

Style: Exhibits Impressionism, expressionism, realism, surrealism, painterly abstraction and postmodern works. Genres include landscapes, florals, Americana, Southwestern, Western, portraits, still lifes and figurative work. Prefers abstraction, landscapes and florals. Looking for "artwork with something extra: landscapes with a center of interest (people or animals, etc.); abstracts that are well designed; still life with a unifying theme; subjects of interest to viewers."

Terms: Accepts work on consignment (50% commission) or buys outright (net 30 days.) Retail price set by gallery and artist. Customer discounts and payment by installment are available. Exclusive area representation required. Gallery provides promotion and contract; shipping costs are shared.

Submissions: Send query letter with résumé, slides, photographs, bio and SASE. Portfolio review requested if interested in artist's work. Portfolio should include originals, slides, transparencies and photographs. Files slides, résumé and price list. All material returned if not accepted or under consideration. Finds artists through agents, associations, artists' submissions and referrals.

Tips: "Use striking colors. No crude, suggestive subjects. We look for professionalism and steady production in artists."

N **PHILLIPS GALLERY**, 444 E. 200 S., Salt Lake City UT 84111. (801)364-8284. Fax: (801)364-8293. Website: http://www.citysearch.com/slc/phillipsgallery. Director: Meri Ploetz. Retail gallery, art consultancy, rental gallery. Estab. 1965. Represents 80 emerging, mid-career and established artists/year. Exhibited artists include Tony Smith, Doug Snow, Lee Deffebach. Sponsors 8 shows/year. Average display time 1 month. Open all year; Tuesday-Friday, 10-6; Saturday, 10-4; closed August 1-20 and December 25-January 1. Located downtown; has 3 floors at 2,000 sq. ft. and a 2,400 sq. ft. sculpture deck on the roof. 40% private collectors, 60% corporate collectors. Overall price range: $100-10,000; most work sold at $200-4,000.

Media: Considers all media, woodcuts, engravings, lithographs, wood engravings, linocuts, etchings. Most frequently exhibits oil, acrylic, sculpture/steel.

Style: Exhibits expressionism, conceptualism, neo-expressionism, minimalism, pattern painting, primitivism, color field, hard-edge geometric abstraction, painterly abstraction, postmodern works, realism, surrealism, Impressionism. Genres include Western, Southwestern, landscapes, figurative work, contemporary. Prefers abstract, neo-expressionism, conceptualism.

Terms: Accepts work on consignment (50% commission). Gallery provides insurance and promotion; shipping costs are shared. Prefers artwork framed.

Submissions: Accepts only artists from western region/Utah. Send query letter with résumé, slides, reviews, artist's statement, bio and SASE. Finds artists through word of mouth, referrals.

SERENIDAD GALLERY, 360 W. Main, P.O. Box 326, Escalante UT 84726. Phone/fax: (435)826-4720. E-mail: hpriska@juno.com. Website: http://www.escalante-cc.com/serenida/html. Co-owners: Philip and Harriet Priska. Retail gallery. Estab. 1993. Represents 7 mid-career and established artists/year. May be interested in seeing the work of emerging artists in the future. Exhibited artists include Lynn Griffin and Rachel Bentley. All work is on continuous display. Open all year; Monday-Saturday, 8-8; Sunday, 1-8. Located on Highway 12 in Escalante; 1,700 sq. ft.; "rustic western decor with log walls." 50% of space for gallery artists. Clientele: tourists. 100% private collectors. Overall price range: $100-3,000; most work sold at $300-2,000.

Media: Considers oil, acrylic, watercolor, sculpture, fiber (Navajo and Zapotec rugs), photography and china painting. Most frequently exhibits acrylics, watercolors and oils.

Style: Exhibits realism. Genres include western, southwestern and landscapes. Prefers: Utah landscapes—prefer local area here, northern Arizona-Navajo reservation and California-Nevada landscapes.

Terms: Accepts work on consignment (commission set by artist) or buys outright (prices set by artist). Retail price set by the gallery. Gallery provides promotion.

Submissions: Accepts only artists from Southwest. Prefers only oil, acrylic and watercolor. Realism only. Contact in person. Call for appointment to show portfolio of photographs. Replies in 3 weeks. Finds artists "generally by artists coming into the gallery."

Tips: "Work must show professionalism and have quality. This is difficult to explain; you know it when you see it."

Vermont

"EAST MEETS WEST" LTD., Rt. Seven at Sangamon Rd., Pittsford VT 05763-0103. (802)773-9030. E-mail: emwltd@together.net. President: William T. Potts. Retail gallery and mail order house. Estab. 1988. Represents 30 emerging, mid-career and established artists/year. May be interested in seeing the work of emerging artists in the future if tribal or third world. Exhibited artists include Danny Dennis and Richard Shorty. Open all year; Monday-Saturday, 10-4:30 or by appointment. Located in rural area; 800 sq. ft.; cross-cultural ethnographic art gallery run by trained anthropologist. Clientele: tourists, upscale, local community and students and mail order through catalog. 100% private collectors. Overall price range: $5-6,000; most work sold at $100-500.

Media: Considers all media; types of prints include woodcuts, lithographs, serigraphs, etchings and posters. Most frequently exhibits Northwest Coast limited edition signed serigraphs, stone-cut and stencil, Northwest Coast, Indonesian and African masks and Indian (Native American) jewelry; and handmade textiles from around the world.

Style: Exhibits tribal and third world art.

Terms: Accepts work on consignment (40-50% commission) or buys outright for 50% of retail price (net 30 days). Retail price set by the artist. Gallery provides insurance, promotion and contract; shipping costs are shared.

Submissions: Accepts only tribal or third world background. Send query letter with résumé, business card, photographs, artist's statement and bio. Call for appointment to show portfolio of photographs. Replies in 2 weeks, otherwise artist can call a toll-free number. Finds artists through word of mouth, exhibits, contact by artists or third parties.

Tips: "Artists should understand the nature of what an ethnographic art gallery sells."

PARADE GALLERY, Box 245, Warren VT 05674. (802)496-5445. Fax: (802)496-4994. E-mail: jeff@paradegallery.com. Website: http://www.paradegallery.com. Owner: Jeffrey S. Burnett. Retail gallery. Estab. 1982. Represents 15-20 emerging, mid-career and established artists. Clients include tourist and upper middle class second-home owners. 98% of sales are to private collectors. Overall price range: $20-2,500; most work sold at $50-300.

Media: Considers oil, acrylic, watercolor, pastel, mixed media, collage, limited edition prints, fine arts posters, works on paper, sculpture and original handpulled prints. Most frequently exhibits etchings, silkscreen and watercolor. Currently looking for oil/acrylic and watercolor.

Style: Exhibits: primitivism, impressionistic and realism. "Parade Gallery deals primarily with representational works with country subject matter. The gallery is interested in unique contemporary pieces to a limited degree." Does not want to see "cutesy or very abstract art."

Terms: Accepts work on consignment (40% commission) or occasionally buys outright (net 30 days). Retail price set by gallery or artist. Sometimes offers customer discounts and payment by installment. Exclusive area representation required. Gallery provides insurance and promotion.

Submissions: Send query letter with résumé, slides and photographs. Portfolio review requested if interested in artist's work. A common mistake artists make in presenting their work is having "unprofessional presentation or poor framing." Biographies and background are filed. Finds artists through customer recommendations, shows, magazines or newspaper stories and photos.

Tips: "We need to broaden offerings in price ranges which seem to offer a good deal for the money."

TODD GALLERY, 614 Main, Weston VT 05161. (802)824-5606. E-mail: ktodd@sover.net. Website: http://www.toddgallery.com. Manager: Karin Todd. Retail gallery. Estab. 1986. Represents 10 established artists/year. May be interested in seeing the work of emerging artists in the future. Exhibited artists include Robert Todd and Judith Carbine. Sponsors 2 shows/year. Average display time 1 month. Open all year; daily, 10-5; closed Tuesday and Wednesday. Located at edge of small VT village; 2,000 sq. ft.; 1840 refurbished barn and carriage house—listed in National Register of Historic Places. Clientele: tourists, local community and second home owners. 80% private collectors, 20% corporate collectors. Overall price range: $200-5,000; most work sold at $400-1,000.

Media: Considers oil, acrylic, watercolor, pastel, ceramics, photography, woodcuts, engravings, lithographs, wood engravings, serigraphs, linocuts and etchings. Most frequently exhibits watercolor, oil and pastel.

Style: Exhibits expressionism, minimalism, Impressionism and realism. Genres include florals, landscapes and Americana. Prefers landscapes (New England), foreign (Ireland and Britain) and seascapes (New England).

Terms: Accepts work on consignment (40% commission). Retail price set by the artist. Gallery provides insurance and promotion. Gallery pays shipping costs from gallery.

Submissions: Prefers only artists from Vermont or New England. Prefers only oil, watercolor and pastel. Send query letter with résumé, slides, bio, SASE and artist's statement. Call for appointment to show portfolio of slides, transparencies and originals. Replies in 2 weeks. Files for potential inclusion in gallery. "We generally seek artists out whose work we have seen."

Tips: "Don't make the mistake of having no appointment, staying too long, or having work badly preserved."

[N] WOODSTOCK FOLK ART PRINTS & ANTIQUITIES, 6 Elm St., Woodstock VT 05091. (802)457-2012. Art Director: Marsha Bowden. Retail gallery. Estab. 1985. Represents 45 emerging, mid-career and established artists. Exhibited artists include Sabra Field and Anne Cady. Sponsors 5 shows/year. Open all year; Monday-Saturday, 10-5; Sunday, 10-4. Located downtown in village; 900 sq. ft.. Clients include tourists, local. 20% of sales are to private collectors. Overall price range: $17-4,000; most work sold at $100-200.

Media: Considers oil, acrylic, watercolor, pastel, drawing, mixed media, sculpture, ceramics, glass, photography and woodcuts. Most frequently exhibits woodcuts (prints), oil and watercolor.

Style: Exhibits primitivism, color field, Impressionism and photorealism. Genres include florals, landscapes and Americana. Prefers landscapes, Americana and florals.

Terms: Accepts work on consignment (50% commission). Retail price set by the artist. Gallery provides promotion. Shipping costs are shared. Prefers artwork framed.

Submissions: Send query letter with bio and photographs. Write for appointment to show portfolio of photographs. Replies only if interested within 1 month. Finds artists through word of mouth, referrals by other artists, visiting art fairs and exhibitions and artist's submissions.

Virginia

[N] THE ART LEAGUE, INC., 105 N. Union St., Alexandria VA 22314. (703)683-1780. Website: http://www.theartle ague.org. Executive Director: Linda Hafer. Gallery Director: Marsha Staiger. Cooperative gallery. Estab. 1954. Interested in emerging, mid-career and established artists. 1,000-1,200 members. Sponsors 7-8 solo and 14 group shows/year. Average display time 1 month. Located in The Torpedo Factory Art Center. Accepts artists from metropolitan Washington area, northern Virginia and Maryland. 75% of sales are to private collectors, 25% corporate clients. Overall price range: $50-4,000; most work sold at $150-500.

Media: Considers oil, acrylic, watercolor, pastel, pen & ink, drawings, mixed media, collage, works on paper, sculpture, ceramic, fiber, glass, photography and original handpulled prints. Most frequently exhibits watercolor, photography, all printmaking media and oil/acrylic.

Style: Exhibits all styles and genres. Prefers Impressionism, painted abstraction and realism. "The Art League is a membership organization open to anyone interested."

Terms: Accepts work by jury on consignment (33⅓% commission) and co-op membership fee plus donation of time. Retail price set by artist. Offers customer discounts (designers only) and payment by installments (if requested on long term). Exclusive area representation not required.

Submissions: Work juried monthly for each new show from actual work (not slides). Work received for jurying on first Monday evening/Tuesday morning of each month; pick-up non-selected work throughout rest of week.

Tips: "Artists find us and join/exhibit as they wish within framework of our selections jurying process. It is more important that work is of artistic merit rather than 'saleable.'"

[N] CUDAHY'S GALLERY, 1314 E. Cary St., Richmond VA 23219. (804)782-1776. Director: Helen Levinson. Retail gallery. Estab. 1981. Represents 50 emerging and established artists. Exhibited artists include Eldridge Bagley and Nancy Witt. Sponsors 12 shows/year. Average display time 4-5 weeks. Open all year; Monday-Thursday, 10-6; Friday-Saturday, 10-10; Sunday, 12-5. Located downtown in historic district; 3,600 sq. ft.; "1870s restored warehouse." 33% of space for special exhibits. Clientele: diverse. 70% private collectors, 30% corporate collectors. Overall price range: $100-10,000; most work sold at $400-2,500.

Media: Considers all media except fiber; and all types of prints except posters. Most frequently exhibits oil, watercolor and pastel.

Style: Exhibits Impressionism, realism and photorealism. Genres include landscapes, portraits and figurative work. Prefers realism, figurative work and abstraction.

Terms: Accepts work on consignment (45% commission). Retail price set by artist. Gallery provides insurance and promotion; shipping costs are shared. Prefers artwork framed.

Submissions: Prefers artists from Southeast or East Coast. Send query letter with résumé, slides, bio, brochure, business card, reviews, photographs and SASE. "Slide or photo submissions for review must include all pertinent information on slides or photos and ballpark price range." Replies in 1 month.

[N] FINE ARTS CENTER FOR NEW RIVER VALLEY, P.O. Box 309, Pulaski VA 24301. (540)980-7363. Fax: (540)994-5631. Director: Michael Dowell. Nonprofit gallery. Estab. 1978. Represents 75 emerging, mid-career and established artists and craftspeople. Sponsors 10 solo and 2 group shows/year. Average display time is 1 month (gallery); 3-6 months (Art Mart). Clients include general public, corporate, schools. 80% of sales are to private collectors, 20% corporate clients. Overall price range: $20-500; most artwork sold at $20-100.

• Downtown Pulaski has enjoyed a new growth in the arts, music and antiques areas thanks to an active and successful main street revitalization program.

Media: Considers all media. Most frequently exhibits oil, watercolor and ceramic.

Style: Exhibits: hard-edge/geometric abstraction, painterly abstraction, minimalism, post-modernism, pattern painting, feminist/political works, primitivism, Impressionism, photorealism, expressionism, neo-expressionism, realism and surrealism. Genres include landscapes, florals, Americana, Western, portraits and figurative work. Most frequently exhibits landscapes, abstracts, Americana.

Terms: Accepts work on consignment (30% commission). Retail price is set by gallery or artist. Sometimes offers payment by installments. Exclusive area representation not required. Gallery provides insurance (80% of value), promotion and contract.

Submissions: Send query letter with résumé, brochure, clearly labeled slides, photographs and SASE. Slides and résumés are filed. Portfolio review requested if interested in artist's work. "We do not want to see unmatted or unframed paintings and watercolors." Finds artists through visiting exhibitions and art collectors' referrals.

Tips: "In the selection process, preference is often (but not always) given to regional and Southeastern artists. This is in accordance with our size, mission and budget constraints."

N GALLERY WEST, LTD., 205 S. Union St., Alexandria VA 22314. (703)549-7359. Director: Sharon Mason. Cooperative gallery and alternative space. Estab. 1979. Exhibits the work of 30 emerging, mid-career and established artists. Sponsors 17 shows/year. Average display time 3 weeks. Open all year. Located in Old Town; 1,000 sq. ft. 60% of space for special exhibitions. Clients include individual, corporate and decorators. 90% of sales are to private collectors, 10% corporate collectors. Overall price range: $100-2,000; most work sold at $150-400.

Media: Considers all media.

Style: All styles and genres.

Terms: Co-op membership fee plus a donation of time. (25% commission.) Retail price set by artist. Sometimes offers customer discounts and payment by installments. Gallery assists promotion; artist pays for shipping. Prefers artwork framed.

Submissions: Send query letter with résumé, slides, bio and SASE. Call for appointment to show portfolio of slides. Replies in 3 weeks. Files résumés.

HAMPTON UNIVERSITY MUSEUM, Huntington Building on Ogden Circle, Hampton VA 23668. (757)727-5308. Fax: (757)727-5170. Website: http://www.hamptonu.edu. Director: Jeanne Zeidler. Curator of Exhibitions: Jeffrey Bruce. Museum. Estab. 1868. Represents/exhibits established artists. Exhibited artists include Elizabeth Catlett and Jacob Lawrence. Sponsors 4-5 shows/year. Average display time 6-8 weeks. Open all year; Monday-Friday, 8-5; Saturday-Sunday, 12-4; closed on major and campus holidays. Located on the campus of Hampton University.

Media: Considers all media and all types of prints. Most frequently exhibits oil or acrylic paintings, ceramics and mixed media.

Style: Exhibits African-American, African and/or Native American art.

Submissions: Send query letter with résumé and a dozen or more slides. Portfolio should include photographs and slides.

Tips: "Familiarize yourself with the type of exhibitions the Hampton University Museum typically mounts. Do not submit an exhibition request unless you have at least 35-45 pieces available for exhibition. Call and request to be placed on the Museum's mailing list so you will know what kind of exhibitions and special events we're planning for the upcoming year(s)."

MARSH ART GALLERY, University of Richmond, Richmond VA 23173. (804)289-8276. Fax: (804)287-6006. E-mail: rwaller@richmond.edu. Website: http://www.arts.richmond.edu/~marshart. Director: Richard Waller. Museum. Estab. 1968. Represents emerging, mid-career and established artists. Sponsors 10 shows/year. Average display time 6 weeks. Open all year; with limited summer hours May-August. Located on University campus; 5,000 sq. ft. 100% of space for special exhibitions.

Media: Considers all media and all types of prints. Most frequently exhibits painting, sculpture, photography and drawing.

Style: Exhibits all styles and genres.

Terms: Work accepted on loan for duration of special exhibition. Retail price set by the artist. Gallery provides insurance, promotion, contract and shipping costs. Prefers artwork framed.

Submissions: Send query letter with résumé, 8-12 slides, brochure, SASE, reviews and printed material if available. Write for appointment to show portfolio of photographs, slides, transparencies or "whatever is appropriate to understanding the artist's work." Replies in 1 month. Files résumé and other materials the artist does not want returned (printed material, slides, reviews, etc.).

N MIDDLE STREET GALLERY, 325 Middle St., Washington, VA 22747. (540)675-3440. Cooperative gallery. Estab. 1981. Exhibits 20 mid-career artists. Interested in seeing the work of emerging artists. 20 members. Sponsors 12 shows/year. Average display time 1 month. Open all year. Located downtown; 800 sq. ft. 100% of sales are to private collectors. Overall price range: $100-5,000; most work sold at $50-1,200.

Media: Considers all media and original handpulled prints. Most frequently exhibits oil, watercolor and fiber.

Style: Prefers realism, Impressionism and expressionism.

Terms: Co-op membership fee plus a donation of time. 30% commission. 50% commission for invited outside artists. Retail price set by artist. Gallery provides insurance and promotion; artist pays shipping costs. Prefers artwork framed. **Submissions:** Send query letter with slides, bio and SASE. Write for appointment to show portfolio of slides. Replies in 1 month.

THE PRINCE ROYAL GALLERY, 204 S. Royal St., Alexandria VA 22314. (703)548-5151. E-mail: princeroyal@look .net. Website: http://look.net/PrinceRoyal. Director: John Byers. Retail gallery. Estab. 1977. Interested in emerging, mid-career and established artists. Sponsors 6 shows/year. Average display time 3-4 weeks. Located in middle of Old Town Alexandria. "Gallery is the ballroom and adjacent rooms of historic hotel." Clientele: primarily Virginia, Maryland and Washington DC residents. 95% private collectors, 5% corporate clients. Overall price range: $75-8,000; most artwork sold at $700-1,200.
Media: Considers oil, acrylic, watercolor, pastel, mixed media, sculpture, egg tempera, engravings, etchings and lithographs. Most frequently exhibits oil, watercolor and bronze.
Style: Exhibits Impressionism, expressionism, realism, primitivism and painterly abstraction. Genres include landscapes, florals, portraits and figurative work. "The gallery deals primarily in original, representational art. Abstracts are occasionally accepted but are hard to sell in northern Virginia. Limited edition prints are accepted only if the gallery carries the artist's original work."
Terms: Accepts work on consignment (40% commission). Retail price set by artist. Customer discounts and payment by installment are available, but only after checking with the artist involved and getting permission. Exclusive area representation required. Gallery provides insurance, promotion and contract. Requires framed artwork.
Submissions: Send query letter with résumé, brochure, slides and SASE. Call or write to schedule an appointment to show a portfolio, which should include originals, slides and transparencies. Replies in 1 week. Files résumés and brochures. All other material is returned.
Tips: "Write or call for an appointment before coming. Have at least six pieces ready to consign if accepted. Can't speak for the world, but in northern Virginia collectors are slowing down. Lower-priced items continue okay, but sales over $3,000 are becoming rare. More people are buying representational rather than abstract art. Impressionist art is increasing. Get familiar with the type of art carried by the gallery and select a gallery that sells your style work. Study and practice until your work is as good as that in the gallery. Then call or write the gallery director to show photos or slides."

N: RESTON ART GALLERY, 11400 Washington Plaza W., Reston VA 20190. (703)481-8156. Website: http://www.sam.meda.com/rags. Publicity: Pat Macintyre. Estab. 1988. Represents 10 artists. Interested in emerging artists. Sponsors 8 solo and 2 group shows/year. Average display time 2 months. 75% private collectors, 25% corporate clients. Overall price range: $25-1,750; most work sold at $150-350.
● This gallery offers some working studios and exhibition space.
Media: Considers all media and prints. Most frequently exhibits oil, acrylic, watercolor, photos and graphics.
Style: Exhibits all styles and genres. Prefers realism and painterly abstraction. The gallery's purpose is to "promote local artists and to educate the public. Gallery sitting and attendance at meetings are required."
Terms: Retail price set by artist. Customer discounts and payment by installments are available. Exclusive area representation not required. Gallery provides promotion.
Submissions: Send query letter with résumé, slides, photographs, bio and SASE. Portfolio review requested if interested in artist's work. Portfolio should include originals, slides and photographs. Replies in 1 week. All material is returned if not accepted or under consideration. Finds artists through visiting exhibitions and word of mouth.

N: SECOND STREET GALLERY, 201 Second St. NW, Charlottesville VA 22902. (804)977-7284. Director: Sarah Sargent. Nonprofit gallery. Estab. 1973. Represents/exhibits emerging and established artists/year. Sponsors 9 shows/year. Average display time 1 month. Open all year except August; Tuesday-Saturday, 10-5; Sunday, 1-5. Located downtown; 825 sq. ft.; high ceilings lots of light (uv filtered). 100% of space for gallery artists. Clients include tourists and locals. 100% of sales are to private collectors. Overall price range: $300-20,000; most work sold at $500.
Media: Considers all media except computer art. Most frequently exhibits paintings, prints and photographs.
Style: Exhibits: conceptualism, primitivism, abstraction and realism. Prefers conceptualism and abstraction.
Terms: Artwork is accepted on consignment (25% commission). Retail price set by the artist. Gallery provides insurance, promotion and contract. Artist pays for shipping costs. Artwork must be exhibition-ready, framed where necessary.
Submissions: Send query letter with résumé, slides, reviews, bio and SASE. Replies in 5 weeks. Finds artists through word of mouth, studio visits and calls for art.

N: 1708 GALLERY, 103 E. Broad St., P.O. Box 12520, Richmond VA 23241. (804)643-7829. Contact: Exhibitions Chair. Alternative space, nonprofit gallery. Estab. 1978. Represents emerging and mid-career artists. 21 members. Sponsors 18 shows/year. Average display time 1 month. Open all year except July; Tuesday-Friday, 11-5; Saturday-Sunday, 1-5. Located downtown; one gallery space is 2,000 sq. ft., 16 ft. ceilings, art deco staircase; additional gallery space, 600 sq. ft. 100% of space for exhibitions. Clientele: broad cross-section of community. 70% private collectors, 30% corporate collectors. Overall price range: $50-7,000; most work sold at $250-800.
Media: Considers oil, acrylic, watercolor, pastel, pen & ink, drawing, mixed media, collage, sculpture, ceramics, installation, photography, "all contemporary media," woodcuts, engravings, lithographs, wood engravings, mezzotints,

serigraphs, linocuts, etchings, "all original print media." Most frequently exhibits painting and works on paper, sculpture and installations.

Style: Exhibits expressionism, neo-expressionism, painterly abstraction, surrealism, conceptualism, minimalism, postmodern works, realism, imagism, "no additional academic."

Terms: Work is for sale during exhibition only. Retail price set by the artist. Gallery provides insurance, promotion and contract; artist pays shipping costs.

Submissions: Open call for proposals. Send SASE for proposal form then send query letter with résumé, slides, bio and SASE. Reports in 2-3 months. Deadline is October, one review per year.

Tips: "Work should show focus and internal logic as well as originality and strength of presentation."

Washington

THE AMERICAN ART COMPANY, 1126 Broadway Plaza, Tacoma WA 98402. (206)272-4377. E-mail: amart-tac@msn.com. Director: Rick Gottas. Retail gallery. Estab. 1978. Represents/exhibits 50 emerging, mid-career and established artists/year. Exhibited artists include Toko Shinoda. Sponsors 10 shows/year. Open all year; Monday-Friday, 10-5:30; Saturday, 10-5. Located downtown; 3,500 sq. ft. 60% of space for special exhibitions; 40% of space for gallery artists. Clientele: local community. 95% private collectors, 5% corporate collectors. Overall price range: $500-15,000; most work sold at $1,800.

Media: Considers oil, fiber, acrylic, sculpture, glass, watercolor, mixed media, pastel, collage, woodcuts, wood engravings, linocuts, engravings, mezzotints, etchings, lithographs and serigraphs. Most frequently exhibits works on paper, sculpture and oils.

Style: Exhibits all styles. Genres include landscapes, Chinese and Japanese.

Terms: Artwork is accepted on consignment (50% commission) or bought outright for 50% of retail price; net 30 days. Retail price set by the gallery and the artist. Gallery provides insurance and promotion; shipping costs are shared. Prefers artwork unframed.

Submissions: Send query letter with résumé, slides, bio and SASE. Write for appointment to show portfolio of slides. Replies in 2-3 weeks. Finds artists through word of mouth, referrals by other artists, visiting art fairs and exhibitions, submissions.

✓ ART SHOWS, (formerly Walsdorf Gallery), P.O. Box 245, Spokane WA 99210-0245. (509)922-4545. President: Don Walsdorf. Major art show producer. Estab. 1988. Sponsors 8 1-or 2-artist shows and 3 large group shows/year. Clientele: collectors, hotel guests and tourists. 70% private collectors, 30% corporate collectors. Overall price range $200-250,000; most work sold at $500-3,000.

Media: Considers all media except craft.

Style: Interested in all genres.

Submissions: Send query letter with bio, brochure and photographs. Portfolio review requested if interested in artist's work. Files biography and brochures.

Tips: "Investigate and be selective in choosing art shows in which to participate. Submit early and read all of the promotor's prospectus information. Remember that you are being solicited to replace another artist who has elected not to return. Why? Choose only those events that can prove attendance. Check with other artists before selecting shows."

Ⓝ AMY BURNETT FINE ART GALLERY, 402 Pacific Ave., Bremerton WA 98337. (360)373-3187. Owner: Amy Burnett. Retail gallery and art consultancy. Estab. 1991. Represents 8 established artists. Exhibited artists include Amy Burnett. Sponsors 6 shows/year. Average display time 2 months. Open all year. Located "minutes from Seattle by ferry, downtown; almost 14,000 sq. ft.; the most spacious, gallery in the Northwest. The building was designed by the famous architect Harlem Thomas in 1922." 80% of space for special exhibitions. Clientele: "every kind from everywhere." Overall price range: $300-8,000; most work sold at $1,000-3,000.

Media: Considers oil, acrylic, watercolor, ceramic and glass. Does not consider prints. Most frequently exhibits mixed media, acrylic and watercolor. Seeks unusual pottery and blown glass.

Style: Exhibits expressionism, painterly abstraction, conceptualism, Impressionism and realism. Genres include Americana, Northwest Coast, Western, portraits and figurative work. Prefers figurative work.

Terms: Accepts work on consignment (50% commission). Retail price set by gallery and artist. Gallery provides insurance, promotion, negotiates a contract and pays for shipping costs from gallery. Prefers artwork framed.

Submissions: Restricted to "already recognized, well-educated professional artists. Send query letter with résumé, photographs and SASE. Gallery will contact artist if interested in a portfolio review. Replies immediately, if possible. Files everything, unless artist requests return.

Tips: "When you come in, leave a résumé and a few photographs. The extremely large gallery space can exhibit large 3-D works: representational, contemporary representational or Northwest Coast theme, monumental totems, ravens, horses or bears will attract gallery's immediate attention."

DAVIDSON GALLERIES, 313 Occidental Ave. S., Seattle WA 98104. (206)624-7684. E-mail: davidson@halcyon.com. Website: http://www.halcyon.com/davidson/. Director: Sam Davidson. Retail gallery. Estab. 1973. Represents 150 emerging, mid-career and established artists. Sponsors 36 shows/year. Average display time 3½ weeks. Open all year;

Tuesday-Saturday, 11-5:30. Located in old, restored part of downtown: 3,200 sq. ft.; "beautiful antique space with columns and high ceilings in 1890 style." 20% of space for special exhibitions; 80% of space for gallery artists. Clientele: 90% private collectors, 10% corporate collectors. Overall price range: $10-35,000; most work sold at $150-5,000.
Media: Considers oil, acrylic, drawing (all types), sculpture, watercolor, mixed media, pastel, woodcuts, wood engravings, linocuts, engravings, mezzotints, etchings, lithographs, limited interest in digital manipulation.
Style: Exhibits expressionism, neo-expressionism, primitivism, painterly abstraction, postmodern works, realism, surrealism, Impressionism.
Terms: Accepts work on consignment (50% commission). Retail price set by gallery and artist. Gallery provides insurance, promotion and contract; shipping costs are one way.
Submissions: Send query letter with résumé, 20 slides, bio and SASE. Replies in 4-6 weeks.
Tips: Impressed by "simple straight-forward presentation of properly labeled slides, résumé with SASE included. No videos."

N: FOSTER/WHITE GALLERY, 123 S. Jackson St., Seattle WA 98104. (206)622-2833. Fax: (206)622-7606. Owner/Director: Donald Foster. Retail gallery. Estab. 1973. Represents 90 emerging, mid-career and established artists/year. Interested in seeing the work of local emerging artists. Exhibited artists include Chihuly, Tobey, George Tsutakawa. Average display time 1 month. Open all year; Monday-Saturday, 10-5:30; Sunday, 12-5. Located historic Pioneer Square; 5,800 sq. ft. Clientele: private, corporate and public collectors. Overall price range: $300-35,000; most work sold at $2,000-8,000.

- Gallery has additional spaces at 126 Central Way, Kirkland WA 98033 (206)822-2305. Fax: (206)828-2270, and City Centre, 1420 Fifth Ave., Suite 214, Seattle WA 98101, (206)340-8025. fax (206)340-8757.

Media: Considers oil, acrylic, watercolor, pastel, pen & ink, drawing, mixed media, collage, paper, sculpture, ceramics, craft, fiber, glass and installation. Most frequently exhibits glass sculpture, works on paper and canvas and ceramic and metal sculptures.
Style: Contemporary Northwest art. Prefers contemporary Northwest abstract, contemporary glass sculpture.
Terms: Gallery provides insurance, promotion and contract.
Submissions: Accepts only artists from Pacific Northwest. Send query letter with résumé, slides, bio and reviews. Write for appointment to show portfolio of slides. Replies in 3 weeks.

N: GALLERY ONE, 408½ N. Pearl St., Ellensburg WA 98926. (509)925-2670. Director: Mary Francis. Nonprofit gallery. Estab. 1968. Represents emerging, mid-career and established artists. 400 members. Sponsors 10 shows/year. Average display time 3½ weeks. Open all year; Monday-Saturday, 11-5. Located in the heart of downtown business district; 5,000 sq. ft.; entire upper floor of 1889 building (Stewart Bldg.) listed in National Historical Directory. "In addition to five exhibit areas, we have three sales rooms. The atrium and four rooms have original skylights which result in special lighting for artwork." 75% of space for special exhibitions; 100% of space for gallery artists. Clients include general public, tourists, foreign visitors. Overall price range: $25-10,000; most work sold at $75-500.
Media: Considers all media including jewelry, woodcut, engraving, lithograph, wood engraving, mezzotint, serigraphs, linocut and etching. Most frequently exhibits oil, watercolor, ceramics and handblown glass.
Style: Exhibits: expressionism, primitivism, painterly abstraction, surrealism, conceptualism, minimalism, Impressionism, photorealism, hard-edge geometric abstraction and realism, all genres. Sells mainly landscapes, florals and wildlife, but tries "to introduce every style of art to the public."
Terms: Accepts work on consignment (35% commission). Retail price set by the artist. Gallery provides insurance and promotion; shipping costs are shared. Prefers artwork framed.
Submissions: Send query letter with résumé, slides or photographs and bio. Call or write for appointment to show portfolio of originals, photographs or slides. Replies only if interested within 2 weeks. Files "everything, if interested in artist and work." Finds artists through visiting exhibitions, art publications, sourcebooks, submissions, references from other artists, referrals and recommendations.
Tips: "Paintings, prints, etc. should be nicely presented with frames that do not 'overpower' the work."

KIRSTEN GALLERY, INC., 5320 Roosevelt Way NE, Seattle WA 98105. (206)522-2011. Director: R.J. Kirsten. Retail gallery. Estab. 1975. Represents 60 emerging, mid-career and established artists. Exhibited artists include Birdsall and Daiensai. Sponsors 4 shows/year. Average display time 1 month. Open all year. 3,500 sq. ft.; outdoor sculpture garden. 40% of space for special exhibitions; 60% of space for gallery artists. 90% private collectors, 10% corporate collectors. Overall price range: $75-15,000; most work sold at $75-2,000.
Media: Considers oil, acrylic, watercolor, mixed media, sculpture, glass and offset reproductions. Most frequently exhibits oil, watercolor and glass.
Style: Exhibits surrealism, photorealism and realism. Genres include landscapes, florals, Americana. Prefers: realism.
Terms: Accepts work on consignment (50% commission). Retail price set by artist. Offers payment by installments. Gallery provides promotion; artist pays shipping costs. "No insurance; artist responsible for own work."
Submissions: Send query letter with résumé, slides and bio. Write for appointment to show portfolio of photographs and/or slides. Replies in 2 weeks. Files bio and résumé. Finds artists through visiting exhibitions and word of mouth.
Tips: "Keep prices down. Be prepared to pay shipping costs both ways. Work is not insured (send at your own risk). Send the best work—not just what you did not sell in your hometown. Do not show up without an appointment."

N LIDTKE FINE ART, 318 2nd Ave. S, Seattle WA 98104. (206)623-5082. Director: Kurt Lidtke. Retail gallery. Estab. 1992. Represents 15 mid-career and established artists/year. Interested in seeing the work of emerging artists. Exhibited artists include: Morris Graves, Mark Tobey. Sponsors 10 shows/year. Average display time 1½ months. Open all year; Wednesday-Saturday 11-5 and by appointment. Located in historic Pioneer Square, 1,000 sq. ft. 95% of space for special exhibitions; 95% of space for gallery artists. Clients include collectors. 100% of sales are to private collectors. Overall price range: $1,000-80,000; most work sold at $5,000-15,000.
Media: Considers oil, acrylic, watercolor, pastel, pen & ink, drawing, tempera, gouache. Most frequently exhibits tempera, oil, acrylic.
Style: Exhibits: neo-expressionism, painterly abstraction and surrealism. Prefers figurative/modern, figurative abstraction and abstraction.
Terms: Accepts work on consignment (50% commission). Retail price set by the gallery and the artist. Gallery provides insurance, promotion, contract and shipping costs to gallery; artist pays shipping costs from gallery. Prefers artwork framed.
Submissions: Send query letter with bio, SASE and reproductions. Write for appointment to show portfolio of photographs, slides and transparencies. Replies in 1 month. Files bio and one reproduction. Finds artists through art publications, word of mouth.

✓ MING'S ASIAN GALLERY, 10217 Main St., Old Bellevue WA 98004-6121. (206)462-4008. Fax: (206)453-8067. Director: Vila Narrell. Retail gallery. Estab. 1964. Represents/exhibits 3-8 mid-career and established artists/year. Exhibited artists include Kim Man Hee, Kai Wang and Kaneko Jonkoh. Sponsors 8 shows/year. Average display time 1 month. Open all year; Monday-Saturday, 10-6. Located downtown; 6,000 sq. ft.; exterior is Shanghai architecture circa 1930. 20% of space for special exhibitions. 35% private collectors, 20% corporate collectors. Overall price range: $350-10,000; most work sold at $1,500-3,500.
Media: Considers oil, acrylic, watercolor, sumi paintings, Japanese woodblock. Most frequently exhibits sumi paintings with woodblock and oil.
Style: Exhibits expressionism, primitivism, realism and imagism. Genres include Asian. Prefers: antique, sumi, watercolors, temple paintings and folk paintings.
Terms: Artwork is accepted on consignment (50% commission). Retail price set by the gallery and the artist. Gallery provides insurance, promotion and contract; shipping costs are shared. Prefers artwork framed.
Submissions: Send query letter with résumé, brochure, slides, photographs, reviews, bio and SASE. Write for appointment to show portfolio of photographs, slides and transparencies. Replies in 2 weeks. Finds artists by traveling to Asia, visiting art fairs, and through submissions.

PAINTERS ART GALLERY, 30517 S.R. 706 E., P.O. Box 106, Ashford WA 98304-9739. (360)569-2644. E-mail: mtwoman@mashell.com. Owner: Joan Painter. Retail gallery. Estab. 1972. Represents 60 emerging, mid-career and established artists. Exhibited artists include Cameron Blagg, Kirk Stirnweis and David Bartholet. Open all year. Located 5 miles from the entrance to Mt. Rainier National Park; 1,200 sq. ft. 50% of space for work of gallery artists. Clientele: collectors and tourists. Overall price range $10-7,500; most work sold at $300-2,500.
 • The gallery has over 100 people on consignment. It is a very informal, outdoors atmosphere.
Media: Considers oil, acrylic, watercolor, pastel, pen & ink, drawings, mixed media, stained glass, reliefs, offset reproductions, lithographs and serigraphs. "I am seriously looking for totem poles and outdoor carvings." Most frequently exhibits oil, pastel and acrylic.
Style: Exhibits primitivism, surrealism, imagism, Impressionism, realism and photorealism. All genres. Prefers: Mt. Rainier themes and wildlife. "Indians and mountain men are a strong sell."
Terms: Accepts artwork on consignment (30% commission on prints and sculpture; 40% on paintings). Retail price set by gallery and artist. Gallery provides promotion; artist pays for shipping. Prefers artwork framed.
Submissions: Send query letter or call. "I can usually tell over the phone if artwork will fit in here." Portfolio review requested if interested in artist's work. Does not file materials.
Tips: "Sell paintings and retail price items for the same price at mall and outdoor shows that you price them in galleries. I have seen artists underprice the same paintings/items, etc. when they sell at shows."

PHINNEY CENTER GALLERY, 6532 Phinney Ave. N., Seattle WA 98103. (206)783-2244. Fax: (206)783-2246. E-mail: pnacenter@aol.com. Website: http://www.poppyware.com/PNA/. Arts Coordinator: Ed Medeiros. Nonprofit gallery. Estab. 1982. Represents 10-12 emerging artists/year. Sponsors 10-12 shows/year. Average display time 1 month. Open all year; Monday-Friday, 10-9; Saturday, 10-1. Located in a residential area; 92 sq. ft.; in 1904 building—hardwood floors, high ceilings. 20% of space for special exhibitions; 80% of space for gallery artists. Overall price range: $50-4,000; most work sold at $300-1,000.
 • Phinney Center Gallery is open to Puget Sound artists only.
Media: Considers oil, acrylic, watercolor, pastel, pen & ink, drawing, mixed media, collage, paper, sculpture, ceramics, installation, photography, all types of prints. Most frequently exhibits painting, sculpture and photography.
Style: Exhibits painterly abstraction, all genres. Holds theme (fiber, sculpture etc) calls twice a year (March and October)
Terms: Accepts work on consignment (30% commission). Retail price set by the artist. Gallery provides promotion and contract; artist pays shipping costs to and from gallery. Prefers artwork framed. Artist pays for invitations and mailings.
Submissions: Send query letter with résumé, bio, up to 20 slides and SASE. Finds artists through calls for work in

local publications.

Tips: "Do not send slides that show many styles of your work. Send a collection of slides that have a uniform feel—a theme—or a complete body of work."

West Virginia

THE ART STORE, 1013 Bridge Rd., Charleston WV 25314. (304)345-1038. Fax: (304)345-1858. Director: E. Schaul. Retail gallery. Estab. 1980. Represents 16 mid-career and established artists. Sponsors 6 shows/year. Average display time 3 weeks. Open all year. Located in a suburban shopping center; 2,000 sq. ft. 50% of space for special exhibitions. Clientele: professionals, executives, decorators. 60% private collectors, 40% corporate collectors. Overall price range: $200-8,000; most work sold at $1,800.

Media: Considers oil, acrylic, watercolor, pastel, mixed media, works on paper, ceramics and monoprints.

Style: Exhibits expressionism, painterly abstraction, color field and Impressionism.

Terms: Accepts artwork on consignment (50% commission). Retail price set by gallery and artist. Gallery provides insurance, promotion and shipping costs from gallery. Prefers artwork unframed.

Submissions: Send query letter with résumé, slides, SASE, announcements from other gallery shows and press coverage. Gallery makes the contact after review of these items; replies in 4-6 weeks.

Tips: "Do not send slides of old work."

Wisconsin

TORY FOLLIARD GALLERY, 233 N. Milwaukee St., Milwaukee WI 53202. (414)273-7311. Fax: (414)273-7313. Website: http://www.toryfolliard.com. Contact: Barbara Morris. Retail gallery. Estab. 1988. Represents mid-career and established artists. Exhibited artists include Tom Uttech and John Wilde. Sponsors 8-9 shows/year. Average display time 4-5 weeks. Open all year; Tuesday-Friday, 11-5; Saturday, 11-4. Located downtown in historic Third Ward; 3,000 sq. ft. 60% of space for special exhibitions; 40% of space for gallery artists. Clientele: tourists, upscale, local community and artists. 90% private collectors, 10% corporate collectors. Overall price range: $300-25,000; most work sold at $1,000-2,500.

Media: Considers all media except installation and craft. Most frequently exhibits painting, sculpture.

Style: Exhibits expressionism, abstraction, realism, surrealism and imagism. Prefers: realism.

Terms: Accepts work on consignment. Retail price set by the gallery and the artist. Gallery provides insurance and promotion; artist pays shipping costs. Prefers artwork framed.

Submissions: Prefers artists working in midwest regional art. Send query letter with résumé, slides, photographs, reviews, artist's statement and SASE. Portfolio should include photographs or slides. Replies in 2 weeks. Finds artists through referrals by other artists.

THE FANNY GARVER GALLERY, 230 State St., Madison WI 53703. (608)256-6755. Vice President: Jack Garver. Retail Gallery. Estab. 1972. Represents 100 emerging, mid-career and established artists/year. Exhibited artists include Claude Fauchere, Leon Applebaum, David Goldhagen, Tim Lazer, Dutch Schulze, Art Werger, Lee Weiss, Harold Altman and Josh Simpson. Sponsors 11 shows/year. Average display time 1 month. Open all year; Monday-Sunday, 10-8. Located downtown; 3,000 sq. ft.; older refurbished building in unique downtown setting. 33% of space for special exhibitions; 95% of space for gallery artists. Clientele: private collectors, gift-givers, tourists. 40% private collectors, 10% corporate collectors. Overall price range: $10-10,000; most work sold at $30-200.

Media: Considers oil, pen & ink, paper, fiber, acrylic, drawing, sculpture, glass, watercolor, mixed media, ceramics, pastel, collage, craft, woodcuts, wood engravings, linocuts, engravings, mezzotints, etchings, lithographs and serigraphs. Most frequently exhibits watercolor, oil and glass.

Style: Exhibits all styles. Prefers: landscapes, still lifes and abstraction.

Terms: Accepts work on consignment (50% commission) or buys outright for 50% of retail price (net 30 days). Retail price set by gallery. Gallery provides promotion and contract, artist pays shipping costs both ways. Prefers artwork framed.

Submissions: Send query letter with résumé, 8 slides, bio, brochure, photographs and SASE. Write for appointment to show portfolio, which should include originals, photographs and slides. Replies only if interested within 1 month. Files announcements and brochures.

Ⓝ A HOUBERBOCKEN, INC., 4045 E. Bottsford Ave., Cudahy WI 53110. (414)481-4000. President: Joan Houlehen. Art consultants. Estab. 1988. Represents 250 emerging and mid-career artists. Exhibited artists include Lisa Mandelkern, Carrie Parks, Gail Hefti and Kristine Gunther. Sponsors 3 shows/year. Average display time 6-8 weeks. Clientele: corporate, private, beginning collectors. Overall price range: $25-10,000; most work sold at $25-2,500.

● A Houberbocken, Inc. juries shows and places the work in four galleries in the Midwest—one in Chicago and three in the Milwaukee area.

Media: Considers oil, acrylic, watercolor, pastel, pen & ink, drawings, mixed media, collage, works on paper, sculpture,

ceramic, fiber, glass, original handpulled prints, woodcuts, engravings, lithographs, posters and serigraphs. Most frequently exhibits ceramics, oil/acrylic and jewelry.

Style: Exhibits primitivism, postmodern works, hard-edged geometric abstraction and all styles. Genres include landscapes, florals and wildlife.

Terms: Accepts artwork on consignment (50% commission); or buys outright for 50% of retail price (net 30 days). Retail price set by artist. Gallery provides insurance, promotion and contract; artist pays for shipping. Prefers artwork framed.

Submissions: Send query letter with SASE and requesting jury form. Write for appointment to show portfolio of slides and résumé. Replies in 3 weeks.

Tips: "Never come unannounced. We cannot do your work justice." Send SASE for jury form. All work is juried by slides.

N. DEAN JENSEN GALLERY, 759 N. Water St., Milwaukee WI 53202. Phone/fax: (414)278-7100. Director: Dean Jensen. Retail gallery. Estab. 1987. Represents/exhibits 20 mid-career and established artists/year. Exhibited artists include Alex Katz and Fred Stonehouse. Sponsors 8 shows/year. Average display time 5-6 weeks. Open all year. Tuesday-Friday, 10-6; Saturday, 10-4. Located downtown; 2,600 sq. ft.; in theater district in a high-ceiling, arts and crafts style building. 60% of space for special exhibitions; 30% of space for gallery exhibitions. Clients include local community, museums, visiting business people. 90% of sales are to private collectors, 10% corporate collectors. Overall price range: $350-35,000; most work sold at $1,500-6,000.

Media: Considers all media except crafts, fiber, glass; all types of prints except posters. Most frequently exhibits painting, prints and photography.

Style: Exhibits: conceptualism, neo-expressionism, minimalism, postmodern works, imagism and outsider art.

Terms: Artwork is accepted on consignment (50% commission). Retail price set by the gallery. Gallery provides insurance and promotion; shipping costs are shared. Prefers artwork framed.

Submissions: Send query letter with résumé, slides, bio and SASE. "We review portfolios only after reviewing slides, catalogs, etc." Replies in 4-6 weeks.

Tips: "Most of the artists we handle are nationally or internationally prominent. Occasionally we will select an artist on the basis of his/her submission, but this is rare. Do not waste your time—and ours—by submitting your slides to us unless your work has great clarity and originality of ideas, is 'smart,' and is very professionally executed."

N. NEW VISIONS GALLERY, INC., at Marshfield Clinic, 1000 N. Oak Ave., Marshfield WI 54449. Executive Director: Ann Waisbrot. Nonprofit educational gallery. Runs museum and art center program for community. Represents emerging, mid-career and established artists. Organizes a variety of group and thematic shows (10 per year), very few one-person shows, sponsors Marshfield Art Fair. "Culture and Agriculture": annual springtime invitational exhibit of art with agricultural themes. Does not represent artists on a continuing basis. Average display time 6 weeks. Open all year. 1,500 sq. ft. Price range varies with exhibit. Small gift shop with original jewelry, notecards and crafts at $10-50. "We do not show 'country crafts.' "

Media: Considers all media.

Style: Exhibits all styles and genres.

Terms: Accepts work on consignment (35% commission). Retail price set by artist. Gallery provides insurance and promotion. Prefers artwork framed.

Submissions: Send query letter with résumé, high-quality slides and SASE. Label slides with size, title, media. Replies in 1 month. Files résumé. Will retain some slides if interested, otherwise they are returned.

Tips: "Meet deadlines, read directions, make appointments—in other words respect yourself and your work by behaving as a professional."

N. WALKER'S POINT CENTER FOR THE ARTS, 911 W. National Ave., Milwaukee WI 53204. (414)672-2787. Staff Coordinator: Linda Corbin-Pardee. Alternative space and nonprofit gallery. Estab. 1987. Represents emerging artists; 150 members. Exhibited artists include Sheila Hicks and Carol Emmons. Sponsors 6-8 shows/year. Average display time 2 months. Open all year. Located in urban, multicultural area; gallery 23'6"×70.

Media: Considers all media. Prefers installation, sculpture and video.

Style: Considers all styles. Our gallery often presents work with Latino themes.

Terms: We are nonprofit and do not provide honoria. Gallery assumes a 20% commission. Retail prices set by the artist. Gallery provides insurance, contract and shipping costs. Prefers artwork framed.

Submissions: Send query letter with résumé, slides, bio, photographs, SASE and reviews. Call to schedule an appointment to show a portfolio, which should include slides, photographs and transparencies. Replies in 6-12 months. Files résumés and slides.

N. CHARLES A. WUSTUM MUSEUM OF FINE ARTS, 2519 Northwestern Ave., Racine WI 53404. (414)636-9177. Associate Curator: Caren Heft. Museum. Estab. 1941. Represents about 200 emerging, mid-career and established artists. Sponsors 8-10 shows/year. Average display time 6 weeks. Open all year. Located northwest of downtown Racine; 3,000 sq. ft.; "an 1856 Italianate farmhouse on 13 acres of parks and gardens." 100% of space for special exhibitions. "75% private collectors from a tri-state area between Chicago and Milwaukee, and 25% corporate collectors." Overall price range: $100-10,000; most work sold at $300-1,000.

Media: "We show all media, including video, but specialize in 20th-century works on paper, craft and artists' books."

Considers original handpulled prints, woodcuts, wood engravings, linocuts, engravings, mezzotints, etchings, lithographs and pochoir. Most frequently exhibits works on paper, ceramics, fibers.

Style: Exhibits all styles and genres. Most frequently exhibits abstraction, realism and surrealism. "We are interested in good craftsmanship and vision."

Terms: Accepts work on consignment (40% commission). Retail price set by artist. Gallery provides insurance, promotion, contract and shipping costs from gallery (for group); artist pays for shipping (for solo). Prefers artwork framed.

Submissions: Museum reviews artists' requests on an ongoing basis. Must submit 10-20 slides, current résumé and a statement about the work. Must also enclose SASE for return of slides. Files résumés and statements for future reference.

Tips: "I want to see evidence of a consistent body of work. Include a letter telling me why you are sending slides. The most common mistake artists make is sloppy presentation—no slide info sheet, no résumé, no SASE, etc."

Wyoming

N: ARTISAN'S GALLERY, 213 S. Second, Laramie WY 82070. (307)745-3983. Owners: Scott & Brenda Hunter. Retail gallery. Estab. 1993. Represented emerging and mid-career artists varies. Exhibited artists include Paul Tweedy and John Werbelow. Sponsors 12 shows/year. Average display time 1 month. Open all year; Tuesday-Friday, 10-6; Saturday, 12-5. Located in historic downtown Laramie; 1,000 sq. ft. Clientele: tourists, upscale, local community and students. 90% private collectors, 10% corporate collectors. Overall price range: $150-3,800; most work sold at $300-1,000.

Media: Considers oil, acrylic, watercolor, pastel, mixed media, collage, sculpture, ceramics, fiber, glass, miniatures, photography; all types of prints. Most frequently exhibits pottery, watercolors and oil.

Style: Exhibits all styles and all genres. Prefers functional pottery, wildlife and realistic.

Terms: Accepts work on consignment (30% commission). Retail price set by the artist. Gallery provides insurance and promotion. Artwork must be framed.

Submissions: Accepts only artists from Wyoming. Prefers 3-D artwork, sculpture, pottery, blown and stained glass. Send query letter with brochure, photographs and artist's statement. Please include phone number. Call for appointment to show portfolio of photographs. Replies in 2 weeks, if interested within 1 week. "We have searched half of Wyoming for artists, to bring them to Laramie."

Tips: "It has often been said that sales are 98% presentation and 2% art itself. With this in mind, presentation (framing, mating, glazing etc.) should be as clean and clear-cut as possible. This always improves sales as your customers, the art collectors, want to see a professional presentation for the art they are about to purchase, without framing hassels. If you value your artwork and think it's sellable, then frame it as such."

CROSS GALLERY, 180 N. Center, Box 4181, Jackson Hole WY 83001. (307)733-2200. Fax: (307)733-1414. Director: Mary Schmidt. Retail gallery. Estab. 1982. Exhibited artists include Penni Anne Cross, Kennard Real Bird, Joe Geshick, Val Lewis, Andreas Goff, Michael Chee and Kevin Smith. Sponsors 2 shows/year. Average display time 1 month. Open all year. Located at the corner of Center and Gill; 1,000 sq. ft. 50% of space for special exhibitions. Clientele: retail customers and corporate businesses. Overall price range: $20-35,000.

Media: Considers oil, acrylic, watercolor, pastel, pen & ink, drawings, mixed media, sculpture, original handpulled prints, engravings, lithographs, pochoir, serigraphs and etchings. Most frequently exhibits oil, original graphics, alabaster, bronze, metal and clay.

Style: Exhibits realism and contemporary styles. Genres include southwestern, western and portraits. Prefers contemporary western and realist work.

Terms: Accepts artwork on consignment (33⅓% commission) or buys outright for 50% of retail price. Retail price set by gallery and artist. Offers payment by installments. Gallery provides insurance, promotion and contract; shipping costs are shared. Prefers artwork unframed.

Submissions: Send query letter with résumé, slides and photographs. Portfolio review requested if interested in artist's work. Portfolio should include originals, slides and photographs. Samples not filed are returned by SASE. Reports back within "a reasonable amount of time."

Tips: "We are seeking artwork with creative artistic expression for the serious collector. We look for originality. Presentation is very important."

HALSETH GALLERY—COMMUNITY FINE ARTS CENTER, 400 C, Rock Springs WY 82901. (307)362-6212. Fax: (307)382-4101. E-mail: cfac@rock.swl.kl2.wy.us. Director: Gregory Gaylor. Nonprofit gallery. Estab. 1966. Represents 12 emerging, mid-career and established artists/year. Sponsors 8-10 shows/year. Average display time 1 month. Open all year; Monday-Friday, 9-12; Wednesday, 6-9; Saturday, 10-12 and 1-5; closed Sunday. Located downtown on the Rock Springs Historic Walking Tour route; 2,000 ground sq. ft. and 120 running sq. ft. of rotating exhibition space remodeled to accommodate painting and sculpture. 50% of space for special exhibitions; 50% of space for gallery artists. Clientele: community at large. 100% private collectors. Overall price range: $100-1,000; most work sold at $200-600.

Media: Considers all media, all types of prints. Most frequently exhibits oil/watercolor/acrylics, sculpture/ceramics, and installation.

Style: Exhibits all styles, all genres.

Terms: "We require a donation of a work." Retail price set by the artist. Gallery provides promotion; artist pays shipping costs to or from gallery. Prefers artwork framed.

Submissions: Send query letter with résumé, 15-30 slides, bio, brochure, photographs, SASE, business card, reviews, "whatever available." Call or write for appointment to show portfolio of slides. Replies only if interested within 1 month. Files all material sent. Finds artists through submissions.

Tips: "Prepare a professional portfolio."

N KATLYN'S GALLERY & FRAME, 97 Colonial St., Evanston WY 82930. (307)789-0068. Fax: (307)789-7404. Owner: Kathalyn McCormick. Retail, cooperative, wholesale gallery and art consultancy. Estab. 1988. Represents 10 emerging, mid-career and established artists. Exhibited artists include Ozz Francas and Cory Provostgaard. Sponsors 3 shows/year. Average display time 6 weeks. Open all year; Saturday and Sunday included, 10-6. Located downtown; 1,000 sq. ft.; Victorian antiques. 10% of space for special exhibitions. Clientele: tourists, upscale, local community and students. 50% private collectors, 50% corporate collectors. Overall price range: $50-40,000; most work sold at $300-500.

Media: Considers all media and all types of prints. Most frequently exhibits oil, watercolor, lithographs and serigraphs. Exhibits all styles and all genres. Prefers Western, wildlife and Native American.

Terms: Retail price set by the gallery. Gallery provides insurance, promotion and contract. Artist pays shipping costs. Prefers artwork unframed.

Submissions: Send query letter with résumé, slides, bio, brochure, photographs, SASE, business card, reviews and artist's statement. Call or write for appointment to show portfolio of photographs, slides and transparencies. Files all materials.

Tips: "The biggest mistake artists make is that they think they are great when they're not or think they are not great when they are."

N MANITOU GALLERY, 1715 Carey Ave., Cheyenne WY 82001. (307)635-0019. Fax: (307)778-3926. President: Robert L. Nelson. Retail, wholesale gallery and art consultancy. Estab. 1975. 50 emerging, mid-career and established artists/year. Exhibited artists include Jie Wei Zhou, Lyle Tayson and Santa Fe. Open all year; Monday-Friday, 8-5. Located downtown; 10,000 sq. ft. for gallery artists. Clients include tourists, upscale. 25% of sales are to collectors, 75% wholesale or other dealers. Overall price range: $100-75,000; most work sold at $300-5,000.

Media: Considers all media and types of prints. Most frequently exhibits oil, sculpture and watercolor.

Style: Exhibits all styles. Genres include florals, Western, wildlife, Southwestern and landscapes. Prefers Western, florals and landscapes.

Terms: Accepts work on consignment (50% commission) or buys outright for 40% of retail price. Retail price set by the gallery and the artist. Gallery provides insurance, promotion and contract; gallery pays shipping costs. Prefers artwork framed.

Submissions: Prefers only Western subject matter. Send query letter with slides, bio, brochure and photographs. Write for appointment to show portfolio of photographs and slides. Replies only if interested within 1 week.

Tips: "Many artists who contact our gallery are not ready to show in a gallery setting."

N NICOLAYSEN ART MUSEUM, 400 E. Collins Dr., Casper WY 82601. (307)235-5247. Director: Joe Ellis. Regional contemporary museum. Estab. 1967. Average display time 2 months. Interested in emerging, mid-career and established artists. Sponsors 10 solo and 10 group shows/year. Open all year. Clientele: 90% private collectors, 10% corporate clients.

Media: Considers all media with special attention to regional art.

Style: Exhibits all subjects.

Terms: Accepts work on consignment (40% commission). Retail price set by artist. Exclusive area representation not required. Gallery provides insurance, promotion and shipping costs from gallery.

Submissions: Send query letter with slides. Write to schedule an appointment to show a portfolio, which should include originals or slides. Replies in 2 months.

N WYOMING ARTS COUNCIL GALLERY, 2320 Capitol Ave., Cheyenne WY 82002. (307)777-7742. Fax: (307)777-5499. E-mail: lfranc@missc.state.wy.us. Website: http://www.commerce.state.wy.us/cr/arts. Visual Arts Program Manager: Liliane Francuz. Nonprofit gallery. Estab. 1990. Represents 15 emerging, mid-career and established artists/year. Sponsors up to 5 exhibitions/year. Average display time 6 ½ weeks. Open all year, Monday-Friday 8-5. Located downtown in capitol complex; 660 sq. ft.; in historical carriage house. 100% of space devoted to special exhibitions. Clientele: tourists, upscale, local community. 98% private collectors. Overall price range $50-$1,500; most work sold at $100-250.

Media: Considers all media. Most frequently exhibits photography, paintings/drawings, mixed media and fine crafts.

Style: Exhibits all styles and all genres. Most frequently exhibits contemporaty styles and craft.

Terms: Retail price set by the artist. Gallery provides insurance, promotion and contract. Shipping costs are shared. Prefers artwork framed.

Submissions: Accepts only artists from Wyoming. Send query letter with résumé, slides and bio. Call for portfolio review of photographs and slides. Replies in 2 weeks. Files résumé and slides. Finds artists through artist registry slide bank, word of mouth and studio visits.

Tips: "I appreciate artists letting me know what they are doing. Send me updated slides, show announcements, or e-

mail to keep me current on your activities."

Puerto Rico

GALERIA BOTELLO INC., 208 Cristo St., Old San Juan Puerto Rico 00901. (787)723-9987. Fax: (787)724-6776. E-mail: jbotcllo@galeriabotello.com. Website: http://www.galeriabotello.com. Owner: Juan Botello. Retail gallery. Estab. 1952. Represents 10 emerging and established artists. Sponsors 3 solo and 2 group shows/year. Average display time 3 months. Accepts only artists from Latin America. Clientele: 60% tourist and 40% local. 75% private collectors, 30% corporate clients. Overall price range: $500-30,000; most work sold at $1,000-5,000.
Media: Considers oil, acrylic, watercolor, pastel, drawings, mixed media, collage, sculpture, ceramic, woodcuts, wood engravings, linocuts, engravings, mezzotints, etchings, lithographs and serigraphs. Most frequently exhibits oil on canvas, mixed media and bronze sculpture. "The Botello Gallery exhibits major contemporary Puerto Rican and Latin American artists. We prefer working with original paintings and sculpture."
Style: Exhibits expressionism, neo-expressionism and primitivism. Genres include Americana and figurative work. Prefers: expressionism and figurative work.
Terms: Accepts work on consignment or buys outright. Retail price set by artist. Exclusive area representation required. Gallery provides insurance and contract; artist pays for shipping. Prefers artwork framed.
Submissions: Send query letter with résumé, brochure, slides and photographs. Call for appointment to show portfolio of originals. Replies in 2 weeks. Files résumés.
Tips: "Artists have to be Latin American or major European artists."

Canada

A & A GALLERY & CUSTOM FRAMING, 104-561 Johnson St., Victoria, British Columbia V8W 1M2 Canada. Phone/fax: (250)380-9461. andylou@bc.sympatico.ca. Website: http://www.bc-biz.com/aagallery. President: Andy Lou. Art consultancy, wholesale gallery. Estab. 1994. Approached by 20 artists/year. Represents 20 emerging, mid-career and established artists. Exhibited artists include: John Copper, Qiang Wu. Average display time 2 weeks. Open all year; Tuesday-Saturday, 10-5:30; weekends 12-4. Located in downtown Victoria, 2 stories of heritage building; professional lighting; 900 sq. ft. Clientele: local community, tourists and upscale. Overall price range: $200-2,000; most work sold at $400-1,000.
Media: Considers oriental brush painging, acrylic, collage, drawing, mixed media, oil, paper, pen & ink, watercolor. Most frequently exhibits watercolor, mixed media on paper, oil. Considers linocuts, lithographs, serigraphs, woodcuts.
Style: Exhibits: imagism, Impressionism, realism, oriental style. Genres include florals, landscapes, wildlife.
Terms: Artwork is accepted on consignment (40% commission). Artwork is bought outright for 30% of retail price; net 30 days. Retail price set by the artist. Gallery provides promotion and contract. Accepted work should be framed. Does not require exclusive representation locally.
Submissions: Write to arrange a personal interview to show portfolio of photographs, transparencies. Send artist's statement, bio, brochure, business card, résumé, reviews, SASE. Returns material with SASE. Replies in 1 month. Finds artists through submissions, portfolio reviews, referrals by other artists.
Tips: "Send me your best work. Photos and transparencies *must* be professionally done. Also include a detailed bio of the artist."

BAU-XI GALLERY, 340 W. Dundas St., Toronto, Ontario M5T 1G5 Canada. (416)977-0600. Fax: (416)977-0625. Managers: Fran Hill and Adam Penson. Commercial art gallery. Estab. 1965. Represents 31 emerging, mid-career and established artists/year. Exhibited artists include: Jack Shadbolt, Ken Lochhead, Roly Fenwick, Lynn Donoghue and David Sorensen. Open all year; Tuesday-Saturday, 10-5:30 or by appointment.
Media: Considers acrylic, collage, drawing, engraving, etching, lithographs, mixed media, oil, paper, pastel, pen & ink, serigraph and watercolor. Most frequently exhibits oil, acrylic and mixed media.
Style: Exhibits all styles and genres. Most frequently exhibits contemporary, abstract and figurative.
Terms: Accepts work on consignment. Retail price set by the artist. Gallery provides insurance and promotion. Prefers artwork framed or unframed paper. Requires exclusive representation locally.
Submissions: Mail portfolio for review with artist's statement, bio, slides and SASE. Returns material with SASE. Replies in 2 months. Finds artists by word of mouth, submissions, portfolio reviews and referrals by other artists.

DALES GALLERY, 537 Fisgard St., Victoria, British Columbia V8W 1R3 Canada. Fax: (250)383-1552. Manager: Sheila Kertesz. Museum retail shop. Estab. 1976. Approached by 6 artists/year; represents 40 emerging, mid-career and established artists/year. Exhibited artists include: Grant Fuller and Graham Clarke. Sponsors 2-3 exhibits/year. Average display time 2 weeks. Open all year; Monday-Saturday, 10-5:30; Sunday, 12-4 in spring and summer. Gallery situated in Chinatown (Old Town); approximately 650 sq. ft. of space—one side brick wall. Clients include: local community, students, tourists and upscale. Overall price range: $100-4,600; most work sold at $350.
Media: Considers most media except photography. Most frequently exhibits oils, etching and watercolor. Considers all

types of prints.

Style: Exhibits: expressionism, Impressionism, postmodernism, primitivism realism and surrealism. Most frequently exhibits Impressionism, realism and expressionism. Genres include figurative, florals, landscapes, humorous whimsical.

Terms: Accepts work on consignment (40% commission) or buys outright for 50% of retail price (net 30 days). Retail price set by both gallery and artist. Gallery provides promotion. Accepted work should be framed by professional picture framers. Does not require exclusive representation locally.

Submissions: Call to arrange a personal interview to show portfolio of photographs or slides or send query letter with photographs. Portfolio should include résumé, reviews, contact number and prices. Replies only if interested within 2-8 weeks. Finds artists through word of mouth, art exhibits, submissions, art fairs, portfolio reviews and referral by other artists.

 GALERIE ART & CULTURE, 227 St. Paul O, Old Montreal, Quebec H2Y 2A2 Canada. Phone/fax: (514)843-5980. President: Helen Doucet. Retail gallery. Estab. 1989. Approached by 55 artists/year; represents 30 mid-career and established artists/year. Exhibited artists include: Louise Martineau and Pierre A. Raymond. Sponsors 6 exhibits/year. Average display time 13 days. Open all year; Tuesday-Friday, 10-6; weekends 10-5. Located in the historic area of Old Montreal. St. Paul is the oldest established commercial street in North America. Original brick work and high ceilings fit well for the exhibition of works of art. Clients include: local community, tourists and upscale. 15% corporate collectors. Overall price range: $700-2,500; most work sold at $1,200-1,500.

Media: Considers acrylic, oil, sculpture, watercolor. Most frequently exhibits oil, acrylic, sculpture.

Style: Exhibits: Impressionism and postmodernism. Most frequently exhibits figurative works, landscapes, still lifes. Genres include figurative work, florals, landscapes, portraits.

Terms: Accepts work on consignment (50% commission). Retail price set by the gallery and the artist. Gallery provides promotion and contract. Accepted work should be unframed. Does not require exclusive representation locally. Accepts only artists from Canada, United States. Prefers only oils, acrylic.

Submissions: Mail portfolio for review. Send bio, photographs, résumé, reviews. Returns material with SASE. Replies in 1-2 months. Files dossiers of artists, exhibitions, portfolio reviews. Finds artists through submissions, portfolio reviews, referrals by other artists.

Tips: "Artists should present complete dossier of their works including photos of artworks, biographies, expositions, solo or group works, how they started, courses taken, number of years in the profession. As a gallery representative, it helps when selling a work of art that you have as much information on the artist, and when you present not just the work of art, but a complete dossier, it reassures the potential customer."

 HARRISON GALLERIES, 2932 Granville St., Vancouver, British Columbia V6H 3J7 Canada. (604)732-5217. Fax: (604)732-0911. Website: http://www.tourtheworld.com/bc03/bc03008.htm. Director: Chris Harrison. Estab. 1958. Approached by 20 artists/year; represents 25 emerging, mid-career and established artists/year. Exhibited artists include: George Bates, Jae Dougall and José Trinidad. Nicholas Bott, Kiff Holland, Francine Gravel and Ron Parker. Average display time 3 weeks. Open all year; Monday-Friday, 9:30-5:30; weekends 11-4. Clients include local community, students, tourists and upscale. 30% of sales are to corporate collectors. Overall price range $300-40,000; most work sold at $3,000-7,000.

 ● This gallery is one of Vancouver's oldest and most respected galleries. They have a second location at 109-1013 17th Ave. SW, Calgary, Alberta—same hours.

Media: Considers acrylic, glass, mixed media, oil, sculpture, watercolor. Most frequently exhibits oil, acrylic, watercolor. Considers engraving, etching, lithographs.

Style: Exhibits: conceptualism, imagism, Impressionism, landscapes, painterly abstraction, realism. Most frequently exhibits realism, impressionis and painterly abstraction. Genres include figurative work, florals, landscapes, western, wildlife, street scenes, cityscapes, still lifes.

Terms: Artwork is accepted on consignment (50% commission). Retail price set by the gallery. Gallery provides insurance, promotion and contract. Usually requires exclusive representation locally.

Submissions: Write to arrange a personal interview to show portfolio of photographs or mail portfolio for review. Portfolio should include query letter with artist's statement, bio, brochure, business card, photographs, résumé, reviews, SASE. Replies only if interested. Finds artists through word of mouth, portfolio reviews, referrals by other artists.

Tips: "To make your gallery submissions professional include digital photos or labelled and backed photos, curriculum vitae and bio. Deliver or mail and retrieve your portfolio on your own volition."

**FOR EXPLANATIONS OF THESE SYMBOLS,
SEE THE INSIDE FRONT AND BACK COVERS OF THIS BOOK.**

☑ ❧ **KAMENA GALLERY & FRAMES LTD.**, 5718-104 St., Edmonton, Alberta T6H 2K2 Canada. (403)944-9497. Fax: (403)430-0476. E-mail: kamena@junctionnet.com. Website: http://www.kamengallery.com. Assistant Manager: Willie Wong. Retail gallery. Estab. 1993. Approached by 10-20 artists/year; represents 20-25 emerging, mid-career and established artists/year. Exhibited artists include: Ted Harrison and Willie Wong. Sponsors 6-8 exhibits/year. Average display time 30-45 days. Open all year; Monday-Saturday, 10-6; weekends, 10-5. Clientele: local community and tourists. 10% corporate collectors. Overall price range: $150-1,200; most work sold at $300.
Media: Considers all media except installation and craft. Most frequently exhibits watercolor and mixed media. Considers etching, linocut, serigraph and woodcut.
Style: Exhibits: color field, conceptualism, expressionism, Impressionism and primitivism realism. Most frequently exhibits conceptualism, color field and expressionism. Genres include figurative work, florals and landscapes.
Terms: Artwork is accepted on consignment and there is a 40% commission. Retail price set by the artist. Gallery provides insurance and promotion. Accepted work should be framed. Requires exclusive representation locally. Prefers only watercolor, acrylic and oil.
Submissions: Call or write to arrange a personal interview to show portfolio of slides, bio, photographs, SASE. Returns material with SASE. Replies in 2 weeks. Files slides and bio. Finds artists through submissions.
Tips: "Have clean slides or photos, a large volume of reasonably priced work, short bio (one page)."

[N] ❧ **OPEN SPACE**, 510 Fort St., Victoria British Columbia V8W 1E6 Canada. (250)383-8833. Fax: (250)383-8841. Director: Todd Davis. Gallery Coordinator: Karen Scarth. Alternative space and nonprofit gallery. Estab. 1971. Represents emerging, mid-career and established artists. 311 members. Sponsors 8-10 shows/year. Average display time 3½ weeks. Open all year. Located downtown; 2,200 sq. ft.; "multi-disciplinary exhibition venue." 100% of space for gallery artists. Overall price range: $300-10,000.
Media: Considers oil, acrylic, watercolor, pastel, pen & ink, drawing, mixed media, collage, works on paper, sculpture, ceramic, installation, photography, video, performance art, original handpulled prints, woodcuts, wood engravings, linocuts, engravings, mezzotints and etchings.
Style: Exhibits all styles and all contemporary genres.
Terms: "No acquisition. Artists selected are paid exhibition fees for the right to exhibit their work." Retail price set by artist. Gallery provides insurance, promotion, contract and fees; shipping costs shared. Only artwork "ready for exhibition." Artists should be aware of the trend of "de-funding by governments at all levels."
Submissions: "Non-Canadian artists must submit by September 30 in order to be considered for visiting foreign artists' fees." Send query letter with résumé, 10-20 slides, bio, SASE (with IRC, if not Canadian), reviews and proposal outline. "No original work in submission." Replies in 1 month.

❧ **MARCIA RAFELMAN FINE ARTS**, 10 Clarendon Ave., Toronto, Ontario M4V 1H9 Canada. (416)920-4468. Fax: (416)968-6715. E-mail: mrfa@ican.net. President: Marcia Rafelman. Semi-private gallery. Estab. 1984. Approached by 100s of artists/year. Represents emerging and mid-career artists. Average display time 1 month. Open by appointment except the first 2 days of art openings which is open full days. Centrally located in Toronto's mid-town, 2,000 sq. ft. on 2 floors. Clients include local community, tourists and upscale. 40% of sales are to corporate collectors. Overall price range: $500-30,000; most work sold at $1,500-5,000.
Media: Considers all media. Most frequently exhibits photography, painting and graphics. Considers all types of prints.
Style: Exhibits: geometric abstraction, minimalism, neo-expressionism, primitivism and painterly abstraction. Most frequently exhibits high realism paintings. Considers all genres except southwestern, western and wildlife.
Terms: Artwork is accepted on consignment (50% commission); net 30 days. Retail price set by the gallery and the artist. Gallery provides insurance, promotion and contract. Requires exclusive representation locally.
Submissions: Mail portfolio of photographs, bio and reviews for review. Returns material with SASE if in Canada. Replies only if interested within 1-2 weeks. Files bios and visuals. Finds artists through word of mouth, submissions, art fairs and referrals by other artists.

International

🌐 **ABEL JOSEPH GALLERY**, Avenue Maréchal Foch, 89 Bruxelles Belgique 1030. Phone: 32-2-2456773. E-mail: ajgallery@neotown.com. Website: http://www.mbr-entertain.neotown.com/ajgallery/. Directors: Kevin and Christine Freitas. Commercial gallery and alternative space. Estab. 1989. Represents young and established national and international artists. Exhibited artists include Bill Boyce, Diane Cole, Régent Pellerin and Ron DeLegge. Sponsors 6-8 shows/year. Average display time 6 weeks. Open all year. Located in Brussels. 100% of space for work of gallery artists. Clientele: varies from first time buyers to established collectors. 80% private collectors; 20% corporate collectors. Overall price range: $500-15,000; most work sold at $1,000-8,000.
Media: Considers most media except craft. Most frequently exhibits sculpture, painting/drawing and installation (including active-interactive work with audience—poetry, music, etc.).
Style: Exhibits painterly abstraction, conceptualism, minimalism, post-modern works and imagism. "Interested in seeing all styles and genres." Prefers abstract, figurative and mixed-media.
Terms: Accepts artwork on consignment (50% commission). Retail price set by the gallery with input from the artist.

Customer discounts and payment by installments are available. Gallery provides insurance, promotion and contract; shipping costs are shared.

Submissions: Send query letter with résumé, 15-20 slides, bio, SASE and reviews. Portfolio review requested if interested in artist's work. Portfolio should include slides, photographs and transparencies. Replies in 1 month. Files résumé, bio and reviews.

Tips: "Submitting work to a gallery is exactly the same as applying for a job in another field. The first impression counts. If you're prepared, interested, and have any initiative at all, you've got the job. Know what you want before you approach a gallery and what you need to be happy, whether its fame, glory or money, be capable to express your desires right away in a direct and honest manner. This way, the gallery will be able to determine whether or not it can assist you in your work."

CHICHESTER GALLERY, 8 The Hornet, Chichester, West Sussex PO19 4JG United Kingdom. Phone: 01243-779821. Proprietor: Thomas J.P. McHale. Cooperative period picture gallery/retail. Estab. 1997. Represents established artists. Exhibited artists include: Copley Fielding, George Leonord Lewis, Jessie Mellor. Located in Georgian period building. Interior has undergone careful and sympathetic restoration of cornices, ceiling and arches, shirting and other mouldings. Clientele: local, regional and national community. "Contemporary work now stocked and displayed by gifted local and nationally respected artists."

Media: Considers mixed media, oil, pastel, watercolor. Considers etching, engraving, mezzotint, lithographs, prints and woodcut. Representational painting only.

Style: Genres include costal scenes, landscapes, marines, portraits and still life.

Terms: Retail price set by the gallery.

Submissions: Replies promptly by fax or mail. Finds artists through art exhibits, art fairs, auctions.

EGEE ART CONSULTANCY, 9 Chelsea Manor Studios, Flood St., London SW3 5SR United Kingdom. Phone: (44+)171 351 6818. Fax: (44+)171 376 3510. E-mail: egee.art@btinternet.com. Website: http://www.egeeart.com. Director: Dale Egee. Art Consultant: Kate Brown. Art consultancy. Estab. 1978. Approached by 50 artists/year. Represents 30-40 emerging, mid-career and established artists. Exhibited artists include: Mil Lubroth, Dia Azzawi. Average display time 1 month. Open all year; Monday-Friday, 8:30-5:30; weekends by appointment. Located in a Victorian artists studio just off the King's Rd. in Chelsea, Egee Art Consultancy is based in a light and airy gallery space. Clientele: government, corporate and hospitality. 50% corporate collectors. Overall price range: £100-80,000; most work sold at £1,500.

Media: Considers acrylic, drawing, glass, mixed media, oil, paper, pastel, pen & ink, photography, sculpture, watercolor, engraving, etching, linocut, lithographs, mezzotint, engraving, woodcut. Most frequently exhibits oil, watercolor, prints.

Style: Exhibits: Impressionism, orientalism/new orientalism, Middle Eastern and Islamic. Considers all genres as long as Middle Eastern theme.

Terms: Artwork is accepted on consignment; commission varies. Retail price set by the gallery. Gallery provides insurance, promotion and contract. Prefers exclusive representation locally. Accepts only artists whose work influenced by Middle East.

Submissions: Call or write to arrange a personal interview to show portfolio of photographs of work. Send query letter with bio, photographs, résumé. Don't send original work unless requested. Replies in 1 week. Files archive of artist's photos, slides, frames, bios, articles. Finds artists through word of mouth, submissions, portfolio reviews, art exhibits, art fairs, referrals by other artists, trade directories, Internet.

Tips: "It is worthwhile to type CV/résumé. Cover letter should make it clear you want us to represent you because we are Middle Eastern specialists. Also send good clear photos/transparencies and reviews/articles which we'll return if you send SASE."

GARDEN SUBURB GALLERY, 16 Arcade House Hampstead Way, London NW11 7TL United Kingdom. Phone/fax: +44 181 455 9132. Website: http://www.hgs.org.uk. Manager: R.J. Wakefield. Nonprofit gallery. Estab. 1995. Approached by 5 artists/year. Represents 32 emerging, mid-career and established artists. Exhibited artists include: Annie Walker, Judy Bermant and Jennie Dunn. Average display time 1 month. Open all year; Monday-Saturday, 10-5. Located in conservation area. Very small utyens summer house; 18×10'. Clientele: local community, tourists. Overall price range: $250. Most work sold at $250.

Media: Considers all media and all types of prints.

Style: Considers all styles. Genres include florals, landscapes, portraits.

Terms: Artwork is accepted on consignment (40% commission). Retail price set by the gallery. Gallery provides insurance and promotion. Accepted work should be framed or mounted.

Submissions: Write to arrange a personal interview to show portfolio. Returns material with SASE. Replies in 2 weeks. Finds artists through word of mouth, submissions, art exhibits and referrals by other artists.

GOLDSMITHS, 3 High St., Lenham, Maidstone, Kent ME17 2QD United Kingdom. Phone: (01622)850011. E-mail: simon4art@aol.com. Manager: Simon Bate. Retail gallery. Estab. 1987. Approached by 4 artists/year. Represents 15 emerging, mid-career and established artists. Exhibited artists include: John Trickett, Nigel Hemming, Mackenzie Thorpe, Mark Spain and Martin Goode. Sponsors 2 exhibits/year. Open all year; Tuesday-Friday, 10-5; Saturday, 9:30-4:30. Located in a medieval village in Kent just off main village square in a mid 19th century building with timber and

exposed fireplaces. 500 sq. ft. in 3 rooms. Clientele: local community, tourists aand upscale. 20% corporate collectors. Overall price range: £50-120. Most work sold at £70.

Media: Considers all media and all types of prints. Most frequently exhibits watercolor, mixed media and pen & ink.

Style: Exhibits contemporary original watercolors, etchings, mixed media and limited edition prints. Some abstracts but few oils. Considers landscape, animals and still life.

Terms: Artwork is accepted on consignment (40% commission) or is bought outright for 100% of retail price; net 30 days. Retail price set by the gallery or the artist. Gallery provides insurance and promotion. Accepted work should be framed and mounted after discussion with gallery regarding style.

Submissions: Call or write to arrange a personal interview to show portfolio of photographs. Send query letter with artist's statement, bio, brochure, business card, photographs, résumé, reviews and SASE. Returns material with SASE. Replies in 2 weeks. Files catalogs/brochures. Finds artists through word of mouth, submissions, art exhibits and referrals by other artists.

Tips: "Please discuss framing and mounting with us if submitting work. Inexperienced artists often submit without an eye to the commercial implications of retailing the work."

☑ ⊕ **HONOR OAK GALLERY**, 52 Honor Oak Park, London SE23 1DY United Kingdom. Phone: 0171-291-6094. Contact: John Broad or Victoria Bull. Estab. 1986. Approached by 15 artists/year. Represents 40 emerging, mid-career and established artists. Exhibited artists include: Jenny Devereux, Norman Ackroyd, Clare Leighton, Robin Tanner and Karolina Larmdoltir. Sponsors 2 total exhibits/year. Average display time 6 weeks. Open all year; Tuesday-Friday, 9:30-6; Saturday, 9:30-5. Closed 2 weeks at Christmas, New Years and August. Located on a main thoroughfare in South London. Exhibition space of 1 room 12×17′. Clientele: local community and upscale. 2% corporate collectors. Overall price range: £18-2,000; most work sold at £150.

Media: Considers collage, drawing, mixed media, pastel, pen & ink, watercolor, engravings, etchings, linocuts, lithographs, mezzotints, engravings, woodcuts, screenprints, wood engravings. Most frequently exhibits etchings, wood engravings, watercolor.

Style: Exhibits: postmodernism, primitivism, realism, 20th century works on paper. Considers all styles. Most frequently exhibits realism. Genres include figurative work, florals, landscapes, wildlife, botanical illustrations.

Terms: Artwork is accepted on consignment (40% commission). Retail price set by the gallery and the artist. Gallery provides promotion. Does not require exclusive representation locally. Prefers only works on paper.

Submissions: Write to arrange a personal interview to show portfolio of recent original artwork. Send query letter with bio, photographs. Replies in 1 month. Finds artists through word of mouth, submissions, art fairs.

Tips: "Show a varied, but not too large selection of recent work. Be prepared to discuss a pricing policy. Present work neatly and in good condition. As a gallery which also frames work, we always recommend conservation mounting and framing and expect our artists to use good quality materials and appropriate techniques."

⊕ **INSTITUTE OF FINE ART**, 5 Kirby St. Hatton Garden, London EC1N 8TS United Kingdom. Phone: (0171)831 4048. Fax: (0171)405 4448. Contact: Alon Zakaim. Wholesale gallery. Estab. 1990. Approached by 20 artists/year. Represents 50 emerging artists. Exhibited artists include: Derrick Sayer and Althea Wilson. Open all year; Monday-Friday, 10-6. 90% corporate collectors. Overall price range: £1,500-5,000; most work sold at £20,000.

Media: Considers acrylic, collage, drawing, oil, paper, pastel, pen & ink, watercolor and engravings. Most frequently exhibits oil, drawings and watercolor.

Style: Exhibits: conceptualism, expressionism, Impressionism, postmodernism and surrealism. Genres include florals landscapes, and contemporary European art.

Terms: Retail price set by the gallery. Gallery provides insurance, promotion and contract. Does not require exclusive representation locally.

Submissions: Call or write to arrange a personal interview to show portfolio of photographs and transparencies. Send query letter with brochure and business card. Replies in 1 week.

Tips: "Produce art that will inspire as well as sell."

⊕ **LE MUR VIVANT**, (incorporating CORPORART), 30 Churton St., London SW1V 2LP United Kingdom. Phone: (0171)821 5555. Website: http://www.corporart.co.uk. Contact: Caro Lyle Skyrme. Estab. 1996. Represents 15 established artists. Exhibited artists include: Charles MacQueen, Ron Bolt, Angus McEwan. Sponsors 10 exhibits/year. Average display time 3 weeks. Open Tuesday-Friday, 10-5; and one Saturday/month. Closed Mondays and Friday from noon. Gallery space is 2 connected rooms—each approximately 12×15′. Total 30′ long space. 2 offices in central London—Westminster. High ceilings, Victorian shop. Clientele: local community, tourists, upscale media and theater people. 20% corporate collectors. Overall price range: $500-10,000; most work sold at £1,000.

Media: Considers all media. Most frequently exhibits oil on canvas or board, watercolor, mixed media.

Style: Exhibits: color field, expressionism, imagism, Impressionism, neo-expressionism, painterly abstraction, postmodernism and surrealism. Most frequently exhibits abstract expressionism, Impressionism, magic realism and surrealism. Considers all genres including Northern Romantic and photo realism.

Terms: "We work on flexible percentages depending on standing of artist and potential following. We take smaller percentage from already established artists with excellent C.V. and good client list as we can rely on many sales. Retail price set with collaboration of the artist. Gallery provides contract. Accepted work should be framed or mounted. Requires exclusive representation locally. Prefers only fully professional artists with excellent curriculum vitae.

Submissions: Write to arrange a personal interview to show portfolio of photographs, slides, transparencies. Send

query letter with artist's statement, bio, photographs, résumé and SASE. Portfolio should include good photos or slides etc. Full curriculum vitae detailing college and professional experience. Returns material with SASE. Replies only if interested within 1 month. Finds artists through word of mouth, submissions, portfolio reviews, art exhibits, referrals by other artists, Royal Academy exhibitions, public shows and magazines.

Tips: "Send neatly presented details of past work/exhibitions/galleries, good quality transparencies, photos and/or slides. Do not expect to walk in and have your work looked at by a staff member in the middle of a business day!"

🌐 **NEVILL GALLERY**, 43 St. Peters St., Canterbury, Kent CT1 2BG United Kingdom. Phone/fax: (01227)765291. E-mail: chris@nevillgallery.com. Website: http://www.nevillgallery.com. Director: Christopher Nevill. Rental gallery. Estab. 1970. Approached by 6 artists/year. Represents 30 emerging, mid-career and established artists. Exhibited artists include: Matthew Alexander and David Napp. Average display time 3 weeks. Open all year; Monday-Saturday, 10-5. Located on High St. in the heart of Canterbury. Clientele: local community, tourists and upscale. Overall price range: £100-5,000.

Media: Considers acrylic, collage, mixed media, oil, paper, pastel, pen & ink, watercolor, engravings, etchings, linocuts, mezzotints and woodcuts. Most frequently exhibits oils, watercolor and pastels.

Style: Exhibits: expressionism, Impressionism and painterly abstraction. Genres include abstract, figurative work, florals and landscapes.

Terms: Artwork is accepted on consignment (40% commission). Retail price set by the artist. Gallery provides insurance while on the premises. Accepted work should be framed. Does not require exclusive representation locally.

Submissions: Call or write to arrange a personal interview to show portfolio of photographs, slides, transparencies. Send query letter with photographs and résumé. Return material with SASE. Replies in 2 weeks. Finds artists through word of mouth, submissions, portfolio reviews, art exhibits, art fairs and referrals by other artists.

🌐 **PARK WALK GALLERY**, (formerly Jonathan Cooper), 20 Park Walk, London SW10 AQ United Kingdom. Pohne/fax: (0171)351 0410. Gallery Owner: Jonathan Cooper. Gallery. Estab. 1988. Approached by 5 artists/year. Represents 8 mid-career and established artists. Exhibited artists include: Jay Kirkman and Kate Nessler. Sponsors 6 exhibits/year. Average display time 3 weeks. Open all year; Monday-Saturday, 10-6:30; Sunday, 11-4. Located in Park Walk which runs between Fulham Rd. to Kings Rd. Clientele: upscale. 10% corporate collectors. Overall price range: £500-50,000; most work sold at £2,000.

Media: Considers drawing, mixed media, oil, paper, pastel, pen & ink, photography, sculpture, watercolor. Most frequently exhibits watercolor, oil and sculpture.

Style: Exhibits: conceptualism, Impressionism. Genres include florals, landscapes, wildlife, equestrian.

Terms: Artwork is accepted on consignment (50% commission). Retail price set by the gallery. Gallery provides promotion. Requires exclusive representation locally.

Submissions: Call to arrange a personal interview to show portfolio. Returns material with SASE. Replies in 1 week. Finds artists through submissions, portfolio reviews, art exhibits, art fairs, referrals by other artists.

Tips: "Include full curriculum vitae and photographs of work."

🌐 **THE STUDIO**, 20 High St., Otford, Stevenoaks, Kent TN14 5PQ United Kingdom. Phone: 01959 524784. Website: http://www.yell.co.uk/sites/the-studio-oxford/. Contact: Wendy Peck. Estab. 1990. Exhibits established artists. Exhibited artists include: Deborah Scaldwell, Abigail Mill. Average display time 1 year. Open Tuesday-Saturday, 10-5:30. High street in picturesque village. The shop is fairly narrow but long—plenty of wall space—along shelving and alcoves for craftwork (16th century building with oak beams). Clientele: local community, tourists and upscale. Overall price range: £5-400; most work sold at £50.

Media: Considers all media except installations. Most frequently exhibits watercolor, bronze resin, ceramics. Considers etchings, linocuts, lithographs, mezzotints, serigraphs, engravings, woodcuts.

Style: Exhibits: color field, conceptualism, expressionism, Impressionism, minimalism, pattern painting, painterly abstraction. Most frequently exhibits Impressionism, pattern painting, expressionism. Genres include figurative work, florals, portraits, western and wildlife.

Terms: Artwork is accepted on consignment (40% commission) or bought outright for 50% of retail price; net 30 days. Retail price set by gallery. Gallery provides insurance, promotion. Accepted work should be framed or mounted. Does not require exclusive representation locally.

Submissions: Call or write to arrange a personal interview to show portfolio of photographs, slides, transparencies. Send query letter with artist's statement, brochure, business card. Replies in 1 months. Finds artists through word of mouth, art exhibits, art fairs, referrals by other artists.

Tips: "The work must beg a high standard. Framing must beg good quality—with an attractive mounting (not a cheap frame)."

Syndicates & Cartoon Features

Although newspaper syndication is still the most popular and profitable method of getting your comic strip to a wide audience, the past few years have seen a virtual revolution in the comic-strip field. Since the mid-'90s, the Web has become an exciting new venue for comic strips.

Strips like *User Friendly*, which debuted in 1977 by an author only known as "Illiad" and *Slow Wave*, launched in 1995 by Scott Gresham and Jessie Reklaw, have built large audiences on the Web. Dust Puppy, one of the main characters of *User Friendly*, even made it to the top ten of *TIME* magazine's online Man of the Year poll for 1999. According to *TIME*'s digital edition, *User Friendly* gets between 300 and 1,500 e-mails per week.

There are at least 100 other strips available on the Web. With the click of your mouse, you can laugh at *Eight Years in Braces* by Eric Petersen, *The Adventures of Joe the Circle* by Mike Shapiro, *Where the Buffalo Roams* by Hans Bodrick and other strips. (Yahoo! provides a great list of online comics at http://dir.yahoo.com/entertainment/comics and animation/comic strips.)

It's hard to know if such sites are making money for cartoonists, although it's clear they are a great promotional tool. It is rumored that scouts for the major syndicates have been known to surf the more popular comic strip sites in search of fresh voices.

Aside from the little problem of getting paid, the Web may be the ideal venue for cartoonists to showcase their work. Where else but on this fluid medium could readers click on a cartoon and find a sequential archive of hundreds of a cartoonist's past strips? Where else, but on the Web, could you click on a character and be instantly linked to dozens of cartoons featuring that one character?

Shooting for syndication

For the present, the national syndicates listed in this section are the holy grail that every comic strip artist strives for. Syndicates are agents who sell comic strips, panels and editorial cartoons to newspapers and magazines. They promote and distribute comic strips and other features in exchange for a cut of the profits.

The syndicate business is one of the hardest to break into. (Read how hard syndicated cartoonist Jan Eliot worked to land a contract on page 530.) If you know your competition (as you should) you'll realize spaces don't open up often. Newspapers are reluctant to drop long-established strips for new ones. Syndicates look for a "sure thing," a feature they'll feel comfortable investing more than $25,000 in for promotion and marketing.

Work worthy of syndication must be original, saleable and timely, and characters must have universal appeal in order to attract a diversity of readers. To crack this market, you have to be more than a fabulous cartoonist. The art won't sell if the idea isn't there in the first place.

HOW TO SUBMIT TO SYNDICATES

Each syndicate has a preferred method for submissions, and most have guidelines you can send for or access on the syndicate's website. Availability is indicated in the listings.

To submit a strip idea, send a brief cover letter (50 words or less is ideal) summarizing your idea, along with a character sheet (the names and descriptions of your major characters), and photocopies of 24 of your best strip samples on 8½×11 paper, six daily strips per page. Sending at least one month of samples, shows that you're capable of producing high-quality humor, consistent artwork and a long lasting idea. Never submit originals; always send photocopies of your work. Simultaneous submissions are acceptable. Response time can take several months.

Syndicates understand it would be impractical for you to wait for replies before submitting your ideas to other syndicates.

Editorial cartoons

If you're an editorial cartoonist, you'll need to start out selling your cartoons to a base newspaper (probably in your hometown) and build up some clips before approaching a syndicate. Submitting published clips proves to the syndicate that you have a following and are able to produce cartoons on a regular basis. Once you've built up a good collection of clips, submit at least 12 photocopied samples of your published work along with a brief cover letter.

Payment and contracts

If you're one of the lucky few to be picked up by a syndicate, your earnings will depend on the number of publications in which your work appears. It takes a minimum of about 60 interested newspapers to make it profitable for a syndicate to distribute a strip. A top strip such as Garfield may be in as many as 2,000 papers worldwide.

Newspapers pay in the area of $10-15 a week for a daily feature. If that doesn't sound like much, multiply that figure by 100 or even 1,000 newspapers. Your payment will be a percentage of gross or net receipts. Contracts usually involve a 50/50 split between the syndicate and cartoonist. Check the listings for more specific payment information.

Before signing a contract, be sure you understand the terms and are comfortable with them.

Self-syndication

Self-syndicated cartoonists retain all rights to their work and keep all profits, but they also have to act as their own salespeople, sending packets to newspapers and other likely outlets. This requires developing a mailing list, promoting the strip (or panel) periodically, and developing a pricing, billing and collections structure. If you have a knack for business and the required time and energy, this might be the route for you. Weekly newspapers are the best bet here (daily newspapers rarely buy from self-syndicated cartoonists).

For More Information

You'll get an excellent overview of the field by reading *Your Career in Comics*, by Lee Nordling (Andrews McMeel) available from the Newspaper Features Council (203)661-3386. This is a comprehensive review of syndication from the viewpoints of the cartoonist, the newspaper editor and the syndicate.

If you have access to a computer, go online at http://www.stus.com/research.html. Here you'll find a line-by-line review of a syndicate contract, courtesy of Stu Rees.

Determination: the determining factor in syndication success

For many cartoonists, the holy grail is the syndicate contract. Jan Eliot pursued this icon for years before signing with Universal Press Syndicate. But even more remarkable is that Eliot was offered a contract years before with another major syndicate. And she turned it down.

Jan Eliot

Not that it was easy. "I felt like I'd been beating my head against a wall," recalls Eliot. "Like maybe I'd blown it. I couldn't believe I'd get that close and get something I couldn't sign. But I didn't feel I had a choice. They wanted the copyright ownership. I was confused, stressed, and tired."

After declining the contract, she set aside her cartooning and focused on earning a regular income as a graphic artist to support her two daughters. Then in 1988 two things happened: she was no longer raising her family alone, thanks to the arrival of her new husband Ted; and with the responsibility of raising a family shared, the desire and opportunity to work on her strip returned.

In 1989 she submitted *Sister City*—the latest guise of essentially the same strip which caught a syndicate's attention in 1984—to Universal Press.

The response was positive. Says Eliot, "I got the 'We like it, send us some more,' followed by 'We like it, send us some more,' ending with 'We don't think this is really going to be marketable, don't send us any more for now.' " She continued to submit—every six months or so, still the same strip—and ventured into other forms of cartooning. "I used *Artist's & Graphic Designer's Market* (then *Artist's Market*) to seek magazines for cartoon publication, book companies that might want cartoon illustrations and greeting card companies. I also was inspired by the interviews, specifically one done with Lee Salem [Universal Press Syndicate vice president]. A book like *Artist's & Graphic Designer's Market* is an invaluable link to the 'paying world' when you are living in the often underpaid and underappreciated world of a freelancer."

JAN ELIOT

Comic Strip: Stone Soup
Syndicate: Universal Press
 Syndicate

While working her regular job, raising her family and freelancing her cartoons, Eliot decided to pick up the slack and try self-syndication. In the spring of 1989, she showed her strip to the Eugene, Ore-

gon daily newpaper, the *Register Guard*. After a year of monthly follow-ups, they took the strip. "Once I had the *Register Guard*," says Eliot, "which is pretty well known, I thought everyone in the state would take me. I drove up and down the I-5 corridor between Seattle and San Diego and visited newspapers. I made four sales trips, kept a mailing list and made phone calls. I got a lot of interest, but I didn't get any papers."

She did, however, receive an epiphany on the following New Year's, sparked by Val, friend, writer and cofounder of their once-a-week mutual support group "We'd been doing this for years," says Eliot, "getting together to prod each other along." This particular prod led to "a very determined letter I sent to Lee Salem, UPS vice president, that said, 'Look, this is my year. I think my stuff is great. I think you're missing a great opportunity. I really think you ought to look at this again." Several months later, Universal offered her a development contract.

When she relates this story, people are shocked by her temerity, but Eliot says, "Don't you believe you can set the universe into order by determination? That New Year's Eve I decided I was going to be a full-time cartoonist by the end of the year. If not syndication . . . greeting cards. If not that, *something*. I said to myself, 'I'm throwing my heart into this and I'm going to make it happen.' " Was it simply positive thinking? Did Eliot manage to spin a few of the universal gears for a Universal contract? "I think Universal decided to take my strip because I hung in there. They decided that the market might be right for it, and found enough improvement in it to warrant taking a chance." Following a seven-month development period, she also feels they confirmed her "stamina and tolerance for suggestions."

Another distinction to Eliot's success is that she didn't abandon her main characters. Why did she keep them employed? "The only way to answer this last question is to say that my strip's characters are so real to me that I could not imagine abandoning them. It's the only set of characters that I could imagine doing; these characters are so much a part of me and my life that there seemed no other choice. There were times when I wondered if I was making a mistake. Still, it seemed *this* was the group

Originally called *Sister City*, Eliot's strip evolved into *Stone Soup*.

I was meant to work with. Anyway, aren't we supposed to write about what we know? I mean, I really *know* these folks."

Stone Soup debuted in 1995, in 25 papers. Since many strips expire after the first year, she recalls some early trepidation. "Yeah, I was worried. They say between 25 and 40 papers is a likely average in the first year. But this time I felt there was more momentum. I had people reprinting my work in books and magazines and greeting cards. Regardless of the strip's success, I really intended to consider myself a cartoonist from that point forward."

Adding to the challenge was the next step she took—she quit her job. "It was risky, but I couldn't see risking this great opportunity. I was able to give it my full attention," which has led to 120 papers, with an income comparable to her graphic design days, as well as her first book, *Stone Soup, the First Collection of the Syndicated Comic Strip.* While Eliot occasionally entertains new projects—such as a second book and an animated feature for television—she's pleased to work at home. "My first love is doing a newspaper comic strip, and I am completely content doing only that. Unless, of course, I could do something about world hunger, the overuse of pesticides, the depletion of the ozone . . ."

A daunting list, but anyone who can walk away from a syndicate contract can likely do most anything.

—*Mark Heath*

N ☒ ARLINGTON CONNECTION, 1610 Kings St., Alexandria VA 22314. (703)549-7185. Managing Editor: Emily Schlesinger. Estab. 1986. Publishes weekly newspapers covering Arlington.
Needs: Buys from 2 freelancers/year. Prefers local or Virginia artists. Prefers pen & ink with washes.
First Contact & Terms: Send query letter with brochure or résumé and tearsheets. Samples are filed or are returned by SASE. Reports back only if interested. To show portfolio, mail tearsheets. Pays on publication; flat fee, $5-50. Considers clients' preferences when establishing payment. Negotiates rights purchased.
Tips: "We prefer local Northern Virginia freelancers who have local themes in their work."

BLACK CONSCIENCE SYNDICATION, INC., Dept. AGDM, 308A Deer Park Rd., Dix Hills NY 11746. (516)462-3933. Fax: (516)493-0820. President: Clyde R. Davis. Estab. 1987. Syndicate serving 10,000 daily and weekly newspapers, regional magazines, schools and television.
Needs: Considers comic strips, gag cartoons, caricatures, editorial or political cartoons, illustrations and spot drawings. Prefers single, double or multipanel cartoons. "All material must be of importance to the Black community in America and the world." Especially needs material on gospel music and its history. "Our new format is a TV video magazine project. This half hour TV program highlights our clients' material. We are accepting ½" tapes, two minutes maximum. Tape must describe the artist's work and provide brief bio of the artist. Mailed to 25 different Afrocentric publications every other month."
First Contact & Terms: Send query letter with résumé, tearsheets and photocopies. Samples are filed or are returned by SASE only if requested by artist. Reports back within 2 months. Portfolio review not required. Pays on publication; 50% of net proceeds. Considers client's preferences when establishing payment. Buys first rights.
Tips: "We need positive Afrocentric information. All material must be inspiring as well as informative. Our main search is for the truth."

CARTOON COMEDY CLUB, 560 Lake Forest Dr., Cleveland OH 44140. (440)871-5449. Cartoon Editor: John Shepherd. Estab. 1988. Publisher (syndicated). Guidelines and copy of publication available for 3 first-class stamps.
Needs: Approached by 12-20 cartoonists/year. Considers gag cartoons. Prefers single panel with gagline within body of cartoon. "No strips or series, please. Clean and clear black & white copies acceptable." Maximum size of artwork 8½×11 or less.
First Contact & Terms: Sample package should include finished cartoons. 6-12 samples should be included. Reports back to the artist only if interested. Pays $5-7 for previously published cartoons and rejects.
Tips: "We seek cartoons of a general nature, family oriented plus other humor cartoons."

CATHOLIC NEWS SERVICE, 3211 Fourth St. NE, Washington DC 20017. (202)541-3250. Fax: (202)541-3255. E-mail: cnsphotos@nccbusce.org. Photos/Graphics Editor: Nancy Wiechec. Estab. 1920. Syndicate serving 160 Catholic newspapers.

Needs: Buys from 3 cartoonists and 3-5 illustrators/year. Considers single panel, editorial political cartoons and illustrations. Prefers religious, church or family themes.

First Contact & Terms: Sample package should include cover letter and roughs. Pays on publication. Rights purchased vary according to project.

☑ **CELEBRATION: AN ECUMENICAL RESOURCE**, Box 419493, Kansas City MO 64141-6493. (800)444-8910. E-mail: patmarrin@aol.com. Website: http://www.ncrpub.com/celebration/. Editor: Patrick Marrin. Syndicate serving churches, clergy and worship committees.

Needs: Buys 75 religious theme cartoons/year. Does not run an ongoing strip. Buys cartoons on church themes (worship, clergy, scripture, etc.) with a bit of the offbeat.

First Contact & Terms: No originals returned to artist at job's completion. Payment upon use, others returned. Pays $40/illustration. Pays $30/cartoon.

Tips: "We only use religious themes (black & white). The best cartoons tell the 'truth'—about human nature, organizations, by using humor."

CHRONICLE FEATURES, was purchased by Universal Press Syndicate.

☑ **COMMUNITY PRESS SERVICE**, P.O. Box 717, Frankfort KY 40602. (502)223-1736. Fax: (502)223-2679. Editor: Phyllis Cornett. Estab. 1990. Syndicate serving 200 weekly and monthly periodicals.

Needs: Approached by 15-20 cartoonists and 30-40 illustrators/year. Buys from 8-10 cartoonists and 4-5 illustrators/year. Introduces 1-2 new strips/year. Considers comic strips. Prefers single panel b&w line drawings with or without gagline. Maximum size of artwork 8½×11; must be reducible to 50% of original size.

First Contact & Terms: Sample package should include cover letter, finished cartoons, photocopies. 5-10 samples should be included. Samples are filed. Reports back within 2 months. Call for appointment to show portfolio of b&w final art. **Pays on acceptance.** Buys all rights. Offers automatic renewal. Syndicate owns original art; artist owns characters.

CONTINENTAL FEATURES/CONTINENTAL NEWS SERVICE, 501 W. Broadway, Plaza A, Suite 265, San Diego CA 92101. (619)492-8696. E-mail: newstime@hotbot.com. Website: http://www.mediafinder.com.cnstore. Director: Gary P. Salamone. Parent firm established August, 1981. Syndicate serving 3 outlets: house publication, publishing business and the general public through the *Continental Newstime* magazine.

Needs: Approached by 200 cartoonists/year. Number of new strips introduced each year varies. Considers comic strips and gag cartoons. Does not consider highly abstract, computer-produced or stick-figure art. Prefers single panel with gagline. Recent features include *Mick's Nuts* by Mick Williams. Guidelines available for #10 SASE with first-class postage. Maximum size of artwork 8×10, must be reducible to 65% of original size.

First Contact & Terms: Sample package should include cover letter, photocopies (10-15 samples). Samples are filed or are returned by SASE if requested by artist. Reports back within 1 month only if interested and if SASE is received. To show portfolio, mail photocopies and cover letter. Pays 70% of gross income on publication. Rights purchased vary according to project. Minimum length of contract is 1 year. The artist owns the original art and the characters.

Tips: "We need single-panel cartoon and comic strips appropriate for adult readers of *Continental Newstime*. Do not send samples reflecting the highs and lows and different stages of your artistic development. CF/CNS wants to see consistency and quality, so you'll need to send your best samples."

CREATORS SYNDICATE, INC., 5777 W. Century Blvd., Suite 700, Los Angeles CA 90045. (310)337-7003. E-mail: cre8ors@aol.com. Website: http://www.creators.com. Address work to Editorial Review Board—Comics. President: Richard S. Newcombe. Executive Vice President: Mike Santiago. Vice President/Editorial Director: Katherine Searcy. Assistant Editor: Elizabeth Johns. Estab. 1987. Serves 2,400 daily newspapers, weekly and monthly magazines worldwide. Guidelines available.

Needs: Syndicates 100 writers and artists/year. Considers comic strips, caricatures, editorial or political cartoons and "all types of newspaper columns." Recent introductions: *Toby*, *Raw Material*, *Color Blind*.

First Contact & Terms: Send query letter with brochure showing art style or résumé and "anything but originals." Samples are not filed and are returned by SASE. Reports back in a minimum of 10 weeks. Considers saleability of artwork and client's preferences when establishing payment. Negotiates rights purchased.

Tips: "If you have a cartoon or comic strip you would like us to consider, we will need to see at least four weeks of samples, but not more than six weeks of dailies and two Sundays. If you are submitting a comic strip, you should include a note about the characters in it and how they relate to each other. As a general rule, drawings are most easily reproduced if clearly drawn in black ink on white paper, with shading executed in ink wash or Benday® or other dot-transfer. However, we welcome any creative approach to a new comic strip or cartoon idea. Your name(s) and the title of the comic or cartoon should appear on every piece of artwork. If you are already syndicated elsewhere, or if someone else owns the copyright to the work, please indicate this."

FOTO EXPRESSION INTERNATIONAL, Box 1268, Station "Q," Toronto, Ontario M4T 2P4 Canada. (416)299-4887. Fax: (416)299-6442. E-mail: operations@fotopressnews.com. Website: http://www.fotopressnews.com. Director: M.J. Kubik. Serving 35 outlets.

Needs: Buys from 80 freelancers/year. Considers b&w and color single, double and multiple panel cartoons, illustrations and spot drawings.

First Contact & Terms: Send query letter with brochure showing art style or résumé, tearsheets, slides and photographs. Samples not filed are returned by SASE with Canadian International Reply Coupon, $4 US money order or $4.50 Canadian money order. Reports within 1 month only if postage is included. To show portfolio, mail final reproduction/product and color and b&w photographs. Pays on publication; artist receives 50%. Considers skill and experience of artist and rights purchased when establishing payment. Negotiates rights purchased.

FUTURE FEATURES SYNDICATE, 1923 N. Wickham Rd., Suite 117, Melbourne FL 32935. (407)259-3822. Fax: (407)259-1471. E-mail: jforney@futurefeatures.com. Website: http://www.futurefeatures.com. Creative Director: Jerry Forney. Estab. 1989. Syndicate markets to 1,500 daily/weekly newspapers. Guidelines available for SASE with first-class postage.

● Future Features electronic studio is an online editorial art department providing professional cartoon, illustration, caricature and graphic design services.

Needs: Approached by 400-500 freelancers/year. Introduces 10-15 new strips/year. Considers comic strips, gag cartoons, editorial/political cartoons and humorous puzzles with contemporary drawing styles. Recent introductions include *Iggy & Spike* by Björn Ousland and *Nothing Is Not Something* by Greg Wallace. Prefers single, double and multiple panel strips with or without gagline; b&w line drawings. Prefers "unpublished, well designed art, themed for general newspaper audiences." Maximum size of artwork 8½×11 panel, 3½×14 strip: must be reducible to 25% of original size, suitable for scanning purposes.

First Contact & Terms: Sample package should include cover letter, photocopies and a short paragraph stating why you want to be a syndicated cartoonist. 12-36 samples should be included. "We are also interested in cartoons produced on a Macintosh or PC in Illustrator, FreeHand, Photoshop or Ray Dream Designer. We can review files saved as PICT, TIFF, GIF, JPEG or Adobe Acrobat (PDF) files." Samples are filed or are returned only if SASE is included. Reports back within 4-6 weeks. Portfolio review not required, but portfolio should not include original/final art. Pays on publication; 50% of gross income. Buys first rights. Minimum length of contract is 2 years. Artist owns original art; syndicate owns characters (if applicable) upon the death or retirement of the artist.

Tips: "Avoid elaborate résumés; short bio with important career highlights/achievements is preferable. Include clean, clear copies of your best work. Don't send binders or bound collections of features; loose samples on 8½×11 bond paper are preferable. Study the masters. Purchase a good cartoon history book and make it your Bible. Practice drawing, rendering and lettering. It's fine to be influenced by what you like, but avoid imitation. Strive to be polished and original. Work on good writing. Clean, simple and to the point. Say the most with the least. Avoid overwriting your gags. Always check spelling and grammar. Strive for a high degree of visual and verbal literacy in your work."

GRAHAM NEWS SERVICE, 2770 W. Fifth St., Suite G20, Brooklyn NY 11224. (718)372-1920. Contact: Paula Royce Graham. Syndicates to newspapers and magazines.

Needs: Considers b&w illustrations. Uses freelancers for advertising and graphics.

First Contact & Terms: Send business card and samples to be kept on file. Samples returned by SASE only if

Iggy & Spike by Bjorn Ousland

Future Features Syndicate ©1998 Björn Ousland

"*Iggy & Spike* demonstrates what a feature with exciting characters and the highest production standards can achieve," says Jerry Forney of Future Features Syndicate. Norwegian cartoonist Björn Ousland creates the strip featuring two teenage boys sharing an apartment. "I strongly advise to practice your writing skills as well as drawing skills," says Ousland. "The cartoonist has to tell a whole story in a very limited space—one to four panels—and the writing must be precise and the timing must be right. Make it simple."

requested. Reports within days. Write for appointment to show portfolio. Pays on publication; negotiable. Considers skill of artist, client's preferences and rights purchased when establishing payment. Buys all rights.
Tips: "Keep it simple—one or two samples."

INTERPRESS OF LONDON AND NEW YORK, 400 Madison Ave., New York NY 10017. (212)832-2839. Editor/Publisher: Jeffrey Blyth. Syndicates to several dozen European magazines and newspapers.
Needs: Buys from 4-5 freelancers/year. Prefers material universal in appeal; no "American only."
First Contact & Terms: Send query letter and photographs; write for artists' guidelines. Samples not kept on file are returned by SASE. Reports within 3 weeks. Purchases European rights. Pays 60% of net proceeds on publication.

JODI JILL FEATURES, 1705 14th St., Suite 321, Boulder CO 80302. (303)786-9401. E-mail: jjillone@aol.com or jjfeatures@hotmail.com. Art Editor/President: Jodi Jill. Estab. 1983. Syndicate serving 138 newspapers, magazines, publications.
Needs: Approached by 250 freelancers/year. "We try to average ten new strips per year." Considers comic strips, editorial/political cartoons and gag cartoons. "Looking for silly, funny material, not sick humor on lifestyles or ethnic groups." Introductions include *From My Eyes* by Arnold Peters and *Why Now?* by Ralph Stevens. Prefers single, double and multiple panel b&w line drawings. Needs art, photos and columns that are visual puzzles. Maximum size of artwork 8½×11.
First Contact & Terms: Sample package should include cover letter, résumé, tearsheets, finished cartoons and photocopies. 6 samples should be included. Samples are not filed and are returned by SASE if requested by artist. Portfolio review requested if interested in artist's work. Reports back within 1 month. Portfolio should include b&w roughs and tearsheets. **Pays on acceptance**; 50-60% of net proceeds. Negotiates rights purchased. Minimum length of contract is 1 year. The artist owns original art and characters. Finds artists "by keeping our eyes open and looking at every source possible."
Tips: "Would like to see more puzzles with puns in their wording and visual effects that say one thing and look like another. We like to deal in columns. If you have a visual puzzle column we would like to look it over. Some of the best work is unsolicited. Think happy, think positive, and think like a reader. If the work covers the three 'T's we will pick it. Please remember a SASE and remember we are human too. No need to hate us if we return the work, we are doing our job, just like you. Believe in your work, but listen to critiques and criticism. Be patient and think like the reader. Our 'new direction' is finding four new features for 1999."

A.D. KAHN, INC., 24567 Northwestern, Suite 333, Southfield Hills MI 48075-2412. (248)355-4100. Fax: (248)356-4344. E-mail: kahn@olmarket.com. Website: http://www.artistmarket.com. President/Editor: David Kahn. Estab. 1960. Syndicate serving daily and weekly newspapers, monthly magazines.
 • A.D. Kahn proactively invites newspaper and magazine editors, website designers and book publishers to use the Internet's largest resource of professional cartoonists and puzzle makers.
Needs: Approached by 24-30 freelancers/month. Considers comic strips, editorial/political cartoons, gag cartoons, puzzles/games.
First Contact & Terms: Sample package should include material that best represents artist's work. Files samples of interest; others returned by SASE if requested by artist. Pays 50% of net proceeds. Negotiates rights purchased according to project. The artist owns original art and characters.

KING FEATURES SYNDICATE, 235 E. 45th St., New York NY 10017. (212)455-4000. Website: http://KingFeatures .com. Editor-in-Chief: Jay Kennedy. Estab. 1915. Syndicate servicing 3,000 newspapers. Guidelines available for #10 SASE.
 • This is one of the oldest, most established syndicates in the business. It runs such classics as *Blondie, Hagar, Dennis the Menace* and *Beetle Bailey* and such contemporary strips as *Zippy the Pinhead, Zits* and *Mutts*. If you are interested in selling your cartoons on an occasional rather than fulltime basis, refer to the listing for The New Breed (also run by King Features).
Needs: Approached by 6,000 freelancers/year. Introduces 3 new strips/year. Considers comic strips and single panel cartoons. Prefers humorous single or multiple panel, and b&w line drawings. Maximum size of artwork 8½×11. Comic strips must be reducible to 6½″ wide; single panel cartoons must be reducible to 3½″ wide.
First Contact & Terms: Sample package should include cover letter, character sheet that names and describes major characters and photocopies of finished cartoons. "Résumé optional but appreciated." 24 samples should be included. Returned by SASE. Reports back within 8 weeks. Pays 50% of net proceeds. Rights purchased vary according to project. Artist owns original art and characters. Length of contract and other terms negotiated.
Tips: "We look for a uniqueness that reflects the cartoonist's own individual slant on the world and humor. If we see that slant, we look to see if the cartoonist is turning his attention to events other people can relate to. We also study a cartoonist's writing ability. Good writing helps weak art, better than good art helps weak writing."

✓ **LOS ANGELES TIMES SYNDICATE**, 218 S. Spring St., Los Angeles CA 90012. (213)237-7987. Contact: Comics Editor.
Needs: Considers comic strips, panel cartoons and editorial cartoons. "We prefer humor to dramatic continuity and general illustrations for political commentary. We consider only cartoons that run six or seven days/week. Cartoons may

be of any size, as long as they're to scale with cartoons running in newspapers." Strips usually run approximately $6\frac{7}{16} \times 2$; panel cartoons $3\frac{1}{8} \times 4$; editorial cartoons vary.

First Contact & Terms: Submit photocopies or photostats of 24 dailies. Submitting Sunday cartoons is optional; if you choose to submit them, send at least 4. Reports within 2 months. Include SASE. Finds artists through word of mouth, submissions, newspapers.

Tips: "Don't imitate cartoons that are already in the paper. Avoid linework or details that might bleed together, fade out or reproduce too small to be seen clearly. We hardly ever match artists with writers or vice versa. We prefer people or teams who can do the entire job of creating a feature."

NATIONAL NEWS BUREAU, Box 43039, Philadelphia PA 19129. (215)849-9016. Editor: Harry Jay Katz. Syndicates to 300 outlets and publishes entertainment newspapers on a contract basis.

Needs: Buys from 500 freelancers/year. Prefers entertainment themes. Uses single, double and multiple panel cartoons, illustrations; line and spot drawings.

First Contact & Terms: To show portfolio, send samples and résumé. Samples returned by SASE. Reports within 2 weeks. Returns original art after reproduction. Send résumé and samples to be kept on file for future assignments. Negotiates rights purchased. Pays on publication; flat fee of $5-100 for each piece.

THE NEW BREED, %King Features Syndicate, 235 E. 45th St., New York NY 10017. (212)455-4000. Website: http://KingFeatures.com. Contact: *The New Breed* Editors. Estab. 1989. Syndicated feature.

 ● *The New Breed* showcases single panel gag cartoons done by cartoonists with a contemporary or wild sense of humor. *The New Breed* is a place where people can break into newspaper syndication without making a commitment to producing a comic on a daily basis. The feature is intended as a means for King Features to encourage and stay in touch with promising cartoonists who might one day develop a successful strip for regular syndication.

Needs: Reviews 30,000 cartoons/year. Buys 500 cartoons/year. Maximum size of artwork $8\frac{1}{2} \times 11$; must be reducible to $3\frac{1}{2}$ wide.

First Contact & Terms: "Submissions should include 10-25 single panel cartoons per batch. The cartoons should be photocopied one per page and each page should have cartoonist's name and address on back. All submissions must include SASE large enough and with enough postage to return work. Do not send originals." Reports back within 2 months. **Pays on acceptance**; flat fee of $50. Buys first worldwide serial rights.

NEW ENGLAND MOTORSPORTS/INTERNATIONAL MOTORSPORTS SYNDICATES, 27-2 Bay Berry Dr., Shoron MA 02067. Phone/fax: (781)784-7857. E-mail: lmodestino@hotmail.com. Estab. 1988. Syndicate serving 15 daily newspapers, motorsports trade weeklies.

Needs: Considers sports pages material. Prefers single panel, motorsports motif. Maximum size 1 column.

First Contact & Terms: Sample package should include cover letter and 1 sample. Samples are filed. Reports back within 1 week. To show a portfolio, mail original/final art. **Pays on acceptance**; flat fee of $10. Syndicate owns original art and characters.

SINGER MEDIA CORP., Seaview Business Park, 1030 Calle Cordillera, Unit #106, San Clemente CA 92673. (949)498-7227. Fax: (949)498-2162. E-mail: singer@deltanet.com. Acquisitions Director: Helen Lee. Syndicates to 300 worldwide magazines, newspapers, book publishers. Geared toward the family, health and fitness, business management. Artists' guidelines $2.

Needs: Syndicates several hundred pieces/year. Considers single panel cartoons targeted at an international reader, mute humor or easily translatable text. No ballooned text, please. Recent features include *Sherlock Holmes' Crime Scene Chronicles* by Jack Harris and Howard Bender and *Oddly Enough* by Russ Miller. Current marketable cartoons are computer-related topics, as well as business, golf, travel, sex or family.

First Contact & Terms: Send query letter with synopsis and or samples, promotional material, photocopies, SASE and tearsheets. Do not send any original work. Show 10-12 samples. Reports within 1 month. Returns cartoons to artist at job's completion if requested at time of submission with SASE. Syndication rights with 50/50 split on all sales. Exceptions can be negotiated.

STATON GRAPHICS/SCRAMBLED EGGS STUDIO, P.O. Box 618, Winterville GA 30683-0618. E-mail: cowlick k@negia.net. Website: http://www.negia.net/~cowlick/statongraphics.html. Commander: Bill Staton. Estab. 1991. Syndicates almost exclusively to weekly newspapers. Art guidelines available for #10 SASE, or by e-mail.

Needs: Approached by 300 cartoonists/year. Buys from 10/year. Recently introduced features include *Sweaty Palms* by Dave Helwig. Considers comic strips and gag cartoons.

First Contact & Terms: Sample package should include minimum of 12 photocopied samples. Samples not filed are returned by SASE. Reports back within 2 weeks. Art director will contact artist for portfolio review if interested. Pays 50% of gross income at time of sale. Rights purchased vary according to project. Artist owns original art and characters. Finds artists through word of mouth, submissions.

Tips: "Don't take your cartooning too seriously (as an artform). It's more of a business these days. At best, you'll get rich and people will tape your work to their refrigerators; at worst, you'll work a day job and you will tape your work to your refrigerator."

TEENAGE CORNER INC., 70-540 Gardenia Court, Rancho Mirage CA 92270. President: Mrs. David J. Lavin. Syndicates rights.
Needs: Prefers spot drawings and illustrations.
First Contact & Terms: Send query letter and SASE. Reports within 1 week. Buys 1-time and reprint rights. Negotiates commission. Pays on publication.

UNITED FEATURE SYNDICATE/NEWSPAPER ENTERPRISE ASSOCIATION, 200 Madison Ave., New York NY 10016. (212)293-8500. Website: http://www.unitedmedia.com. Contact: Comics Editor. Syndicate serving 2500 daily/weekly newspapers. Guidelines available for #10 SASE.
Needs: Approached by 5,000 cartoonists/year. Buys from 2-3 cartoonists/year. Introduces 2-3 new strips/year. Strips introduced include *Dilbert, Over the Hedge*. Considers comic strips, editorial political cartoons and panel cartoons.
First Contact & Terms: Sample package should include cover letter, photocopies of finished cartoons. 18-36 dailies. Samples are returned by SASE if requested by artist. Reports back within 10 weeks.
Tips: "No oversize packages, please."

UNITED MEDIA, 200 Madison Ave., New York NY 10016. Website: http://www.unitedmedia.com. Editorial Director: Diana Loevy. Estab. 1978. Syndicate servicing US and international newspapers. Guidelines for SASE. "United Media consists of United Feature Syndicate and Newspaper Enterprise Association. Submissions are considered for both syndicates. Duplicate submissions are not needed." Guidelines available.
Needs: Introduces 2-4 new strips/year. Considers comic strips and single, double and multiple panels. Recent introductions include *Over the Hedge* by Mike Fry and T. Lewis. Prefers pen & ink.
First Contact & Terms: Send cover letter, résumé, finished cartoons and photocopies. Include 36 dailies; "Sundays not needed in first submissions." Do not send "oversize submissions or concepts without strips." Samples are not filed and are returned by SASE. Reports back within 3 months. "Does not view portfolios." UFS pays 50% of net proceeds. NEA pays flat fee, $500 and up a week. Buys all rights. Minimum length of contract 5 years and 5 year renewal. Automatic renewal.
Tips: "Send copies, but not originals. Do not send mocked-up licensing concepts." Looks for "originality, art and humor writing. Be aware of long odds; don't quit your day job. Work on developing your own style and humor writing. Worry less about 'marketability'—that's our job."

UNITED NEWS SERVICE, 48 Scribner Ave., Staten Island NY 10301. (718)981-2365. Fax: (718)981-6292. Assignment Desk: Jane Marie Johnson. Estab. 1936. Syndicate servicing 500 regional newspapers. Considers caricatures, editorial political cartoons, illustrations and spot drawings. Prefers b&w line drawings.
First Contact & Terms: Sample package should include cover letter and résumé. Samples are filed or returned by SASE if requested. Reports back within weeks. Mail appropriate materials. Pays on publication; $50-100. Buys reprint rights. Syndicate owns original art; artist owns characters.

UNIVERSAL PRESS SYNDICATE, 4520 Main St., Suite 700, Kansas City MO 64111. (816)932-6600. Editorial Director: Lee Salem. Syndicate serving 2,750 daily and weekly newspapers.
Needs: Considers single, double or multiple panel cartoons and strips; b&w and color. Requests photocopies of b&w, pen & ink, line drawings.
First Contact & Terms: Reports within 4-6 weeks. To show a portfolio, mail photostats. Send query letter with photocopies.
Tips: "Be original. Don't be afraid to try some new idea or technique. Don't be discouraged by rejection letters. Universal Press receives 100-150 comic submissions a week, and only takes on two or three a year, so keep plugging away. Talent has a way of rising to the top."

WHITEGATE FEATURES SYNDICATE, 71 Faunce Dr., Providence RI 02906. (401)274-2149. Website: http://www.whitegatefeatures.com. Talent Manager: Eve Green. Estab. 1988. Syndicate serving daily newspapers internationally, book publishers and magazines.
Needs: Introduced Dave Berg's *Roger Kaputnik*. Considers comic strips, gag cartoons, editorial/political cartoons, illustrations and spot drawings; single, double and multiple panel. Work must be reducible to strip size. Also needs artists for advertising and publicity. Looking for fine artists and illustrators for book publishing projects.
First Contact & Terms: Send cover letter, résumé, tearsheets, photostats and photocopies. Include about 12 strips. Does not return materials. To show portfolio, mail tearsheets, photostats, photographs and slides; include b&w. Pays 2500 daily/weekly newspapers. Guidelines available for #10 SASE.
Needs: Approached by 5,000 cartoonists/year. Buys from 2-3 cartoonists/year. Introduces 2-3 new strips/year. Strips introduced include *Dilbert, Over the Hedge*. Considers comic strips, editorial political cartoons and panel cartoons.
First Contact & Terms: Sample package should include cover letter, photocopies of finished cartoons. 18-36 dailies. Samples are returned by SASE if requested by artist. Reports back within 10 weeks.
Tips: "No oversize packages, please."

Stock Illustration & Clip Art Firms

A controversy is raging in the illustration field about stock illustration. There are those who maintain stock illustration hurts freelancers. They say it encourages art directors to choose ready-made artwork from catalogs at reduced rates instead of assigning illustrators for standard industry rates. Others maintain the practice gives freelancers a vehicle to resell their work. Defenders of stock point out that advertising agencies and major magazines continue to assign original illustrations. Stock just gives them another option. To find out more about the debate, log into http://www.theispot.com and head for one of the discussion groups posted there. Where do *you* stand? Educate yourself about both sides of this issue before considering stock as a potential market.

Marketing your work as stock allows you to sell an illustration again and again instead of filing it away in a drawer. That illustration can mean extra income every time someone chooses it from a stock catalog. But selling previously published illustrations isn't the only way to work with stock illustration agencies. You can also sell work directly to stock illustration agencies. But you'll have to create images agencies want.

Stock illustration is a concept that has its origins in the photography market. Photographers have known that reselling photos can be profitable for both the photographers and publishers who purchase rights to reprint photos at reduced rates. Realizing that what works for photographers could work for illustrators, businesses began to broker illustrations the same way. They promoted the illustrations to art directors through catalogs, brochures, CD-ROMs and websites. The idea took off. Art directors (already accustomed to using stock photography) quickly adapted to flipping through stock illustration catalogs or browsing the Web for artwork at reduced prices, while firms split fees with illustrators.

Stock vs. clip art

Stock illustration firms market relatively high-end images to book publishers, advertising agencies, magazines, corporations and other businesses through catalogs and websites. When most people think of clip art, they think of booklets of copyright-free graphics and cartoons, the kind used in church bulletins, high school newspapers, club newsletters and advertisments for small businesses. But these days, especially with some of the digital images available on disk and CD-ROMs, perceptions are changing. With the popularity of desktop publishing, newsletters that formerly looked homemade look more professional.

Copyright and payment

Aside from the subtle differences between the "look" of stock illustration as opposed to that of clip art, there is another crucial distinction between the two. That distinction is copyright. Stock illustration firms do not sell illustrations. They license the right to reprint illustrations, working out a "pay-per-use" agreement. Fees charged depend on how many times and for what length of time their clients want to reproduce the artwork. Stock illustration firms generally split their fees 50-50 with artists, and pay the artist every time his image is used. You should be aware that some agencies offer better terms than others. So weigh your options before signing any contracts.

Clip art, on the other hand, generally implies the buyer has been granted a license for any use. Buyers can use the image as many times as they want, and furthermore, they can alter it, crop it or retouch it to fit their purposes. Some clip art firms repackage artwork created many

years ago because it is in the public domain, and therefore, they don't have to pay an artist for the use of the work. But in the case of clip art created by living artists, firms either pay the artists an agreed-upon fee for all rights to the work, or will negotiate a royalty agreement. Keep in mind that if you sell all rights to your work, you will not be compensated each time it is used unless you also negotiate a royalty agreement. Once your work is sold as clip art, the buyer of that clip art can alter your work and resell it without giving you credit or compensation.

How to submit artwork

Companies are identified as either stock illustration or clip art firms in the first paragraph of each listing. Some firms, such as Metro Creative Graphics and Dynamic Graphics, seem to be hybrids of clip art firms and stock illustration agencies. Read the information under "Needs" to find out what type of artwork each firm needs. Then check "First Contact & Terms" to find out what type of samples you should send. Most firms accept samples in the form of slides, photocopies and tearsheets. Increasingly, disk submissions are encouraged in this market.

☑ **ART PLUS REPRO RESOURCE**, P.O. Box 3588, Sarasota FL 34230-4710. (941)955-2950. Fax: (941)955-5723. E-mail: editor@mmi-art.com. Website: http://www.mmi-art.com. Publisher: Wayne Hepburn. Estab. 1983. Clip art firm serving about 6,000 outlets, primarily churches, schools, associations and ministries. Guidelines, catalog and sample available for 9×12 SAE with 4 first-class stamps.
● This clip art firm works one year ahead of publication, pays within 90 days of acceptance, accepts any seasonal material at any time, and has been using more digitized and computer images. They will furnish a list of topics needed for illustration.
Needs: Buys 40-60 cartoons and 500-1,000 freelance illustrations/year. Prefers illustrations and single panel cartoons and b&w line art with gagline. Maximum size is 7×10 and must be reducible to 20% of size without losing detail. "We need very graphic material." Prefers religious, educational and seasonal themes. Accepts camera ready line art or digital files: CDR, CGM, EPS and WMF formats for Windows or Mac if digitized, prefers WMF.
First Contact & Terms: Send photocopies by mail. "Do not e-mail any image—will not view and will not reply." Samples not filed are returned by SASE. Reports back within 2-3 months. Portfolio review not required. Pays $15 for cartoons; $20-30 for spot or clip art. Buys all rights. Finds artists through *Artist's & Graphic Designer's Market* listing.
Tips: "All our images are published as clip art to be reproduced by readers in their bulletins and newsletters for churches, schools, associations, etc. We need art for holidays, seasons and activities; new material every three months. We want single panel cartoons, not continuity strips. We're always looking for people images, ethnic and mixed races. No cartoon strips."

🌐 **ARTBANK ILLUSTRATION LIBRARY**, 8 Woodcroft Ave., London NW7 2AG England. Phone: (+44)181 906 2288. Fax: (+44)181 906 2289. E-mail: info@artbank. ltd.uk. Website: http://www.artbank.ltd.uk. Estab. 1989. Picture library. Clients include advertising agencies, design groups, book publishers, calendar companies, greeting card companies and postcard publishers.
Needs: Prefers 4×5 transparencies.

N **CREATICOM**, 7100 N. Broadway, Suite 1P, Denver CO 80221. (303)650-2236. E-mail: info@creaticom.com. Website: http://www.creaticom.com. Creative Director: Claudia Bonser. Estab. 1995. Design firm specializing in providing stock illustration and clip art images. Clients include Adobe Studios, Denver Zoo and Texaco. Works with 50 freelancers/year.
● This company contacted *AGDM* at press time. Look for a full listing in the 2001 edition. Check their website for their illustration needs, requirements and pay rates.

CUSTOM MEDICAL STOCK PHOTO, INC., The Custom Medical Building, 3660 W. Irving Park Rd., Chicago IL 60618-4132. (800)373-2677. Fax: (773)267-6071. E-mail: info@cmsp.com. Website: http://www.cmsp.com. Contact: Mike Fisher or Henry Schleichkorn. Estab. 1985. Medical and scientific stock image agency. Specializes in medical photography and illustration for the healthcare industry. Distributes to magazines, advertising agencies and design firms. Clients include Satchi & Satchi, Foote Cone Belding, Merck, Glaxo, etc. Guidelines available for #10 SASE.
Needs: Approached by 20 illustrators/year. Works with 50+ illustrators/year. Prefers airbrush art, animation, 3-D and soundfiles, clip art, medical and technical illustration, multimedia projects and pen & ink. Themes include healthcare. Knowledge of Adobe Photoshop, Adobe Illustrator and Aldus Freehand helpful.
First Contact & Terms: "Call first to discuss before shipping." Accepts disk submission compatible with Mac or PC; send "low res files for viewing." Reports back within 1 month. Call or write for portfolio review. Pays royalties of 40%. Licenses non-exclusive rights to clients. Finds artists through word of mouth. "Our reputation precedes us among individuals who produce medical imagery. We also advertise in several medical and photographer's publications."
Tips: "Our industry is motivated by current events and issues that affect healthcare—new drug discoveries, advances and F.D.A. approval on drugs and medical devices."

© Dave Cutler

This is one of many images by mixed media artist Dave Cutler offered by England-based stock agency Artbank Illustration Library. "Cutler is one of the most sought after conceptual painters of today," says Rick Goodale of Artbank. "His colorful, whimsical images are packed full of original ideas and messages. His work can be seen featured in annual reports and corporate brochures for many of the world's most respected companies."

DREAM MAKER SOFTWARE, 925 W. Kenyon Ave., #16, Englewood CO 80110. (303)762-1001. Fax: (303)762-0762. E-mail: david@coolclipart.com. Art Director: David Sutphin. Estab. 1986. Clip art firm, computer software publisher serving homes, schools and businesses.

Needs: Approached by 20-30 freelancers/year. Considers a variety of work including cartoon type and realistic illustrations suitable for publication as clip art with a broad market appeal. Also interested in small watercolor illustrations in styles suitable for greeting cards.

First Contact & Terms: Sample package should include cover letter. 8-12 samples should be included. Samples are not filed and are returned by SASE. Reports back to the artist in 1-2 months only if interested. Considers both traditional and computer based (Adobe Illustrator) artwork. Does not accept initial samples on disk. Pays $10-50 flat fee on completion of contract. Typical contract includes artist doing 50-150 illustrations with full payment made upon completion and acceptance of work. Rights purchased include assignment of copyright from artist.

DYNAMIC GRAPHICS INC., 6000 N. Forest Park Dr., Peoria IL 61614-3592. (309)688-8800. Art Buyer: Frank Antal. Distributes to thousands of magazines, newspapers, agencies, industries and educational institutions.
- Dynamic Graphics is a clip art firm and publisher of *Step-by-Step Graphics* magazine. Uses illustrators from all over the world; 99% of all artwork sold as clip art is done by freelancers.

Needs: Works with 30-40 freelancers/year. Prefers illustration, graphic design and elements; primarily b&w, but will consider some 2- and full-color. Recently introduced colorized TIFF and EPS images. "We are currently seeking to contact established illustrators capable of handling b&w and highly realistic illustrations of contemporary people and situations."

First Contact & Terms: Submit portfolio with SASE. Reports within 1 month. **Pays on acceptance**. Negotiates payment. Buys all rights.

Tips: "We are interested in quality, variety and consistency. Illustrators contacting us should have top-notch samples that show consistency of style (repeatability) over a range of subject matter. We often work with artists who are getting started if their portfolios look promising. Because we publish a large volume of artwork monthly, deadlines are extremely important, but we do provide long lead time (4-6 weeks is typical). We are also interested in working with illustrators who would like an ongoing relationship. Not necessarily a guaranteed volume of work, but the potential exists for a considerable number of pieces each year for marketable styles."

THE IMAGE BANK INC., 2777 Stemmons Frwy., Suite 600, Dallas TX 75207. (214)863-4900. Fax: (214)863-4860. Website: http://www.theimagebank.com. Director, Artist Relations: Stephen V. Morelock. Also 111 Fifth Ave., 4th Floor, New York NY 10003. (212)539-8300. Fax: (212)539-8391. Also 4, Bd. Poissonniére, Paris 75009 France. Phone: (33)1-55-77-00-00. Fax: (33)1-55-77-00-44. Stock photography, illustration and film agency. Distributes to art directors, designers, editors, producer and publishers. Call or write for guidelines.
- The Image Bank Inc. is the largest stock photography, illustration and film agency in the world, with more than 70 offices in over 35 countries and more than 20 years experience.

Needs: Prefers all media. Themes include business, family life, financial, healthcare and restaurant.

First Contact & Terms: Send no more than 200 transparencies and/or 50 prints, along with image submission agreement from guidelines. "Please make sure all images are sleeved. Please do not place your sleeved images in any type of binder, as this slows down the review process." Include self-addressed, pre-paid ("bill recipient") FedEx or DHL airbill.

Tips: "We're looking for artists who have the same passion for great work that we do. Young talent, experienced talent, renowned talent—the adjective doesn't matter, the talent does. The Image Bank seeks artists who are capable of creating distinctive and relevant images on a consistent basis. We are interested in finding and working closely with photographers and illustrators who consistently deliver artistically and technically superb images."

METRO CREATIVE GRAPHICS, INC., 33 W. 34th St., New York NY 10001. (212)947-5100. Fax: (212)714-9139. Website: http://www.metrocreativegraphics.com. Contact: Ann Marie Weiss. Estab. 1910. Creative graphics/art firm. Distributes to 7,000 daily and weekly paid and free circulation newspapers, schools, graphics and ad agencies and retail chains. Guidelines available.

Needs: Buys from 100 freelancers/year. Considers all styles of illustrations and spot drawings; b&w and color. Editorial style art, oil paintings or cartoons for syndication not considered. Special emphasis on computer-generated art for Macintosh. Send floppy disk samples using Adobe Illustrator 5.0. or Adobe Photoshop. Prefers all categories of themes associated with newspaper advertising (retail promotional and classified). Also needs covers for special-interest newspaper, tabloid sections..

First Contact & Terms: Send query letter with brochure, photostats, photocopies, slides, photographs or tearsheets to be kept on file. Accepts submissions on disk compatible with Adobe Illustrator 5.0 and Adobe Photoshop. Send EPS or TIFF files. Samples returned by SASE if requested. Reports only if interested. Works on assignment only. **Pays on acceptance**; flat fee of $25-1,500 (buy out). Considers skill and experience of artist, saleability of artwork and clients' preferences when establishing payment.

Tips: This company is "very impressed with illustrators who can show a variety of styles." They prefer that electronic art is drawn so all parts of the illustration are drawn completely, and then put together. "It makes the art more versatile to our customers."

MILESTONE GRAPHICS, 1093 A1A Beach Blvd., #388, St. Augustine FL 32084. (904)823-9962. E-mail: miles@aug.com. Website: http://www.milestonegraphics.com. Owner: Jill O. Miles. Estab. 1993. Clip art firm providing targeted markets with electronic graphic images.

Needs: Buys from 20 illustrators/year. 50% of illustration demands knowledge of Adobe Illustrator.

First Contact & Terms: Sample package should include non-returnable photocopies or samples on computer disk. Accepts submissions on disk compatible with Adobe Illustrator on the Macintosh. Send EPS files. Interested in b&w and some color illustrations. All styles and media are considered. Macintosh computer drawings accepted (Adobe Illustrator preferred). "Ability to draw people a plus, but many other subject matters needed as well." Reports back to the artist only if interested. Pays flat fee of $25 minimum/illustration, based on skill and experience. A series of illustrations is often needed.

NOVA DEVELOPMENT CORPORATION, 23801 Calabasas Rd., Suite 2005, Calabasas CA 91302-1547. (818)591-9600. Fax: (818)591-8885. E-mail: submit@novadevelopment.com. Website: http://www.novadevelopment.com. Director of Business Development: Lisa Helfstein. Estab. 1983. Computer software publisher. Specializes in digital, royalty-free clip art for consumers and small businesses. Distributes to consumers via retail stores.

Needs: Approached by 100 illustrators/year. Works with 20 illustrators/year. Prefers clip art, photographs, watercolor paintings, greeting card art, humorous illustration and line drawing in electronic format. Themes include animals, business, current events, education, family life, food/cooking, healthcare, hobbies, holiday, pets, religion, restaurants and schools. Recent products: Art Explosion, Web Explosion, Web Animation Explosion and Art Explosion T-shirt Factory. 70% of illustration demands skills in Adobe Illustrator and Adobe Photoshop.

First Contact & Terms: Send cover letter and electronic samples. No phone calls, please. Accepts disk submissions. Prefers EPS/Macintosh format. Will also accept TIFF, WMF, CDR, BMP and others. Samples are filed. Reports back only if interested. Pays royalties of 7-20% of gross income depending on product type. Artist owns original art. Minimum length of contract is 5 years.

Tips: "We prefer collections of 500 or more illustrations. We look for the ability to produce a high volume of work while still meeting deadlines."

ONE MILE UP, INC., 7011 Evergreen Court, Annandale VA 22003. (703)642-1177. Fax: (703)642-9088. E-mail: gene@onemileup.com. Website: http://www.onemileup.com. President: Gene Velazquez. Estab. 1988.

Needs: Approached by 5 cartoonists and 10 illustrators/year. Buys from 5 illustrators/year. Prefers illustration and animation.

First Contact & Terms: Send photostats, résumé and/or diskettes. Include 3-5 samples. Call or mail appropriate materials for portfolio review of final art. Pays flat fee; $30-120. **Pays on acceptance.** Negotiates rights purchased.

STOCK ILLUSTRATION SOURCE, 16 W. 19th St., 9th Floor, New York NY 10011. (212)849-2900, (800)4-IMAGES. Fax: (212)691-6609. E-mail: sis@images.com. Website: http://www.images.com. Acquisitions Manager: Barbara Preminger. Estab. 1992. Stock illustration agency. Specializes in illustration for corporate, advertising, editorial, publishing industries. Guidelines available.

Needs: "We deal with 1,200 illustrators." Prefers painterly, conceptual images, including collage and digital works, occasionally humorous and medical illustrations. Themes include corporate, business, education, family life, healthcare, law and environment.

First Contact & Terms: Illustrators send sample work on reprints or digital media. Samples are filed. Reports back within 1 month. Will do portfolio review. Pays royalties of 50% for illustration sales. Negotiates rights purchased. Finds artists through agents, sourcebooks, on-line services, magazines, word-of-mouth, submissions.

STOCKWORKS-STOCK ILLUSTRATION, 11936 W. Jefferson Blvd., Suite C, Culver City CA 90230. (310)390-9744. Fax: (310)390-3161. E-mail: stockworks@earthlink.net. Website: http://www.stockwork.com and http://www.workbook.com. President: Martha Spelman. Estab. 1988. Stock illustration firm. Specializes in stock illustration for corporations, advertising agencies and design firms. Clients include IBM, First Fidelity, Macmillan Publishing, Lexis Nexis. Guidelines available for large SAE with 5 first-class stamps.

Needs: Approached by 100 illustrators/year. Works with 300 illustrators/year. Themes include animals, business, education, healthcare, holidays, conceptual, technology and computers, industry, education.

First Contact & Terms: Illustrators send slides, tearsheets, color copies of available stock work. Samples are filed or are returned with SASE. Reports back only if interested. Call for portfolio review of available stock images and leave behinds. Pays royalties of 50% for illustration. Negotiates rights purchased. Finds artists through *Workbook*, *Showcase*, *Creative Illustration*, magazines, submissions.

Tips: "Stockworks likes to work with artists to create images specifically for stock. We provide concepts and sometimes rough sketches to aid in the process. Creating or selling stock illustration allows the artist a lot of leeway to create images they like, the time to do them and the possibility of multiple sales. We like to work with illustrators who are motivated to explore an avenue other than just assignment to sell their work."

Animation & Computer Games

The growth in the animation industry in recent years has created an increased demand for artists with animation skills. Right now, there are more animation jobs in the industry than there are qualified animators to fill them. Animation graduates are recruited like college athletes. Disney, Nickelodeon, Fox Animation, Broderbund and Pixar take out full page advertisements in *Animation* magazine, urging artists to send résumés and reels. Studios are having such a tough time finding competent animators, that a few (Warner Bros., for one) have developed training programs to teach animation skills to artists. And animation studios aren't the only ones looking for great animation talent. Design firms need animators to bring movement to websites and enhance the impact of movie titles and TV graphics. (Read our interview with Jakob Trollbeck, creative director for R/Greenberg & Associates on page 545 for more insight into this hidden animation market.)

What does it take to break into animation? It takes talent, a background in fine art, experience in figure drawing and design. You'll need basic animation skills. If you don't have them, enroll in animation courses or get accepted to a training program at an animation studio. If you have access to a computer, animation software and tutorials, it's possible to train yourself to create computer animation. Read *So You Want to Be a Computer Animator* by Mike Morrison (Sams Publishing) to find out more about the computer animation field.

How to approach animation markets

Whether you specialize in hand drawn animation, clay animation or 3D, you'll need to prepare a VHS demo reel, so you can submit it for consideration to animation markets. Your demo tape should be short—three minutes is probably enough. (Sending three minutes worth of work on a 60-minute tape is considered amateurish, so have your tape dubbed professionally on a three-minute VHS tape.) It's helpful to show animated characters of your own creation on your reel. If possible, add a soundtrack that complements those characters and what they are doing. If your characters speak, make sure the voices are in sync with the animation or risk losing points. Be sure your reel has a label on the outside with your name, address and phone number. Attach a spine label so the tape can easily be recognized on a shelf full of tapes. To save money, have about a dozen tapes dubbed at a time. You'll need them eventually as you try to get jobs. Include a one-page résumé that looks professional and emphasizes animation skills and experience.

For More Information

To find out more about the exciting opportunities in this growing industry, check out a few issues of *Animation* magazine or visit their website at http://www.Animag.com. Another great resource is *Animation World Magazine*, and their extensive website at http://www.awn.com.

ASIFA (Association Internationale Du Film D'Animation) is a worldwide organization dedicated to animation, with over 1,100 members in 55 countries. ASIFA sponsors festivals, workshops and other activities. To find out more about ASIFA and its chapters, contact David Ehrlich, vice president, ASIFA RR1, Box 50, Randolph VT 05060, or visit an ASIFA website: http://www.asifa-hollywood.org.

If studios like your reel, they'll want to see more of your work. So prepare a professional portfolio of your drawings, animation stills and/or sculptures. Since your "book" should be ready to show at any time, it's wise to prepare two or more portfolios. Invest in a couple of simple portfolio binders or boxes of manageable size—something that fits comfortably on art directors' desks.

Networking at Animation Festivals

Aspiring artists can maximize their chances of getting work, according to Kat Fair, head of recruitment for Nickelodeon Animation Studio, by taking advantage of recruiting opportunities at animation festivals. Fair, who makes the rounds of art schools to recruit new talent, always tells students two things: to keep drawing, and to keep attending festivals. "There are several reasons to go to festivals," says Fair, "but make sure you go to the right festivals, that is, the ones set up for recruitment. The most important reason to go is to get your work seen by recruiters who are out there looking for you." She advises artists to make sure the festival they plan to attend has a recruitment center and is not just a trade show focusing on selling.

Animation festivals also give attendees a chance to meet their peers, who are in similiar situations and who can share with them tips on the job market, find out who's hiring, and learn what kind of work different animation studios are doing. Exhibitors can also give artists valuable information on how and when they recruit. "Recruitment centers usually offer a one-on-one meeting which gives artists a chance to make personal contact with a studio and talk about themselves and their work. It's like a job interview," says Fair.

There are a variety of festivals around the country, including the World Animation Festival in Pasadena, California, in early January, and the Ottawa Festival in Canada held in September. But dates are subject to change, and Fair recommends getting a complete updated festival list from ASIFA (Association Internationale du Film d'Animation), which has branches in major cities, or through the animation departments of local art schools. For more information on ASIFA, see page 543. "These festivals are an important resource for anyone interested in breaking into the animation industry."

—Brooke Comer

ADDITIONAL ANIMATION LISTINGS

The following advertising and design firms, record labels and other markets listed elsewhere in this book have also expressed the need for freelancers with animation skills. To read a complete listing, check for page numbers in the General Index beginning on page 696. You can also find more information by visiting a company's website. To submit your animation, send your reel, résumé and query letter to the markets listed below.

Adfiliation Advertising
Angel Films Company
Bramson & Associates
Butwin & Associates
Creative Consultants
John Crowe Advertising
Custom Medical Stock Photo
Norman Diegnan & Assoc.
Films for Christ
Fine Art Productions
The Ford Agency

Futuretalk Telecommunica-
 tions Company
Gold & Associates Inc.
Hedden-Nicely & Associates
Image Associates Inc.
Instructional Fair-TS Denison
Kaufman Ryan Stral Inc.
Linear Cycle Productions
McClanahan Graphics Inc.
Media Consultants
One Mile Up

On-Q Productions
Overtime Station
Steve Postal Productions
Rhythms Productions
Tasteful Ideaas, Inc.
UltiTech, Inc.
Verdical, LLC
Walker Design Group
Dana White Productions, Inc.

Design firms: the hidden animation market

For most of us, the word "animation" calls to mind feature-length cartoons by the likes of Disney and DreamWorks, or maybe a certain TV series set in Springfield. But some of the most exciting animation comes out of design firms, where freelancers are called upon to animate everything from characters to typography. Increasingly, their talents are needed to animate websites. If you have a passion for 3-D animation and the drive to learn the newest of the new technologies, you could find a welcome freelance market, or with any luck, a great career.

Jakob Trollbeck

R/GA (R/Greenberg Associates), the New York-based design house known for cutting-edge work in features, TV and interactive media, offers freelance illustrators and animators the opportunity to develop their talent and often to find fulltime work. R/GA creative director Jakob Trollbeck points out that he, like some 50 percent of the fulltime staff, started out as a freelancer.

Trollbeck's own experiences exemplify how a freelancer can hone a career at R/GA. The Swedish-born designer attended technical school in Stockholm. He combined his interest in graphic art with a passion for music and became a co-owner in a record store, then took over a movie theater which he and a partner turned into a gallery that doubled as a nightclub. Trollbeck used his artistry to design invitations and posters which caught the attention of local companies who began to hire him to design promotional materials. His immediate success enabled him to open his own design shop, Par Avion, where his jobs included print ads, posters and logos.

Trollbeck hadn't even heard of R/GA when he moved to New York seven years ago. His main interest then was movie titles. His first freelance job, landed through friends some four weeks after he arrived in the States, was at R/GA. Coincidentally enough, he found that the company had done some of the titles he most admired, including *The Untouchables, Altered States, Body Double, Alien* and *Superman*.

JAKOB TROLLBECK
Title: Senior Art Editor
Firm: R/Greenberg Associates

When he entered the company's gates, Trollbeck was impressed by R/GA's Bauhaus-inspired architecture. "While I was sitting in the lobby waiting to be interviewed, I told myself, 'This is where

I'm going to work. This is where I belong.' It just felt right." His first freelance assignment, doing animated titles for a Bayer commercial, convinced him and the creative directors who hired him that he did indeed belong at R/GA. After a few months Trollbeck went fulltime. Since he began his tenure, Trollbeck has won acclaim for the film opening of *Night Falls on Manhattan*, the opening credits for *Saturday Night Live* and a TV spot in which a Pontiac is X-rayed and turns into solid metal before the viewer's eyes.

The design department at R/GA is "something like a campus, in that it's a big open space and people are always talking and sharing ideas. It's very learning oriented. Basically the company is divided into linear and nonlinear units," Trollbeck explains. Freelancers are hired on a job-to-job basis On the linear side, or TV side, they are hired to do computer graphics and character animation; on the nonlinear or interactive side, they're brought in to do graphic design and illustration. Illustrators can cross the line to do character animation for the studio side of the company.

The studio side and the interactive side are very integrated, says Trollbeck. "It's important that the two groups are always communicating, because occasionally a project comes along that requires skill from both sides." Trollbeck points to a current job in which R/GA is redesigning a large portion of IBM's website. "They want us to do some animation and some commercials on the web. The demand for that combination of skills is one reason our interactive side is growing so quickly. Sooner or later, high bandwidth is going to provide fast enough connections to do full-motion video, and then we'll be in a very good position."

This animated sequence is typical of work done by R/GA. When considering freelancers, Trollbeck looks at portfolios and five-minute animation reels, which can be sent in or dropped off at the company ("We don't have portfolio review days—it's just a matter of the artist coming in or sending their work"). Better yet, if your work is showcased on the Web, send Trollbeck your Web address. "If we like what we see, and we don't have a staff job open for a particular artist, we add them to our freelance pool which fluctuates according to the jobs we have." The pool is a list of names R/GA can draw upon depending on the type of skills required. Sometimes a freelancer's name could sit in the file for up to six months before the right project for her talents comes up, says Trollbeck. He also points out that potential employees can go through R/GA's human resources department, headed by Kaitlyn Lynch.

When reviewing potential freelancers' work, Trollbeck looks for "something different, something very creative, something that surprises me, or that I haven't seen before." He adds that sometimes it's a matter of finding someone with extremely solid knowledge of typography, or someone whose style is extremely appropriate to a given job.

Interning is another way to break into R/GA. While interns are unpaid, they do receive reimbursement for transportation and meals and, depending on their enrollment status and school, class credit may be negotiated. "Obviously, we don't get our interns from RISD or Yale," says Trollbeck. "They tend to be people from [New

York's] School of Visual Arts, Parsons or Pratt who are between semesters, looking for experience. Depending on each intern's ability and willingness to learn, work may range from simple tasks to making storyboards. They may end up being an essential part of a project, and of course if they work out, their internship could lead to a permanent job. One of our senior art directors started out as an intern four years ago," says Trollbeck. "When he interviewed for the internship, he showed a portfolio of projects he had made uniquely for the interview. After he got the job, he worked so hard you felt bad for not paying him." That kind of dedication can ensure success in such a competitive industry.

—*Brooke Comer*

ACORN ENTERTAINMENT, 1800 N. Vine, #305, Hollywood CA 90028. (818)340-5272. E-mail: info@acornenterta inment.com. Website: http://www.acornentertainment.com. Development: Bill Hastings. Estab. 1991. Number of employees: varies to 80. Animation studio. Specializes in game design, CD-ROM development, advertising, animation for motion picture and music video industry. Recent clients include Disney, Fox, Interplay. Professional affiliations: ASIFA.
Needs: Approached by 300 animators/year. Works with 150 animators/year. Uses freelancers mainly for storyboard, layout, animation, BG, clean-up. 40% of freelance animation demands knowledge of Maya, Houdini, 3-D Studio Max.
First Contact & Terms: Send reel, computer disk, résumé. Samples are filed or returned by SASE. Reports back only if interested. Will contact for portfolio review of reel of previous paid work, demo reel, disk of computer animation if interested. Pays by the hour, by the project or by the day. Rights purchased vary according to project.
Tips: "Animators must have over five years experience. Please have materials viewable via Internet if possible."

ANGEL FILMS, 967 Hwy. 40, New Franklin MD 65274-4978 Phone/fax: (573)698-3900. E-mail: angelfilm@aol.com. Vice President: Matthew Eastman. Estab. 1980. Number of employees: 50. Animation studio, AV firm. Specializes in advertising, animation. Recent projects/clients include *The Fairy Bride*.
Needs: Approached by 24 animators/year. Uses freelancers for all areas of animation. 50% of freelance animation demands knowledge of 3-D Studio, Strata Studio Pro.
First Contact & Terms: Send query letter with reel, computer disk, résumé. Accepts IBM compatible 3½ disks. Samples are filed or are returned by SASE. Reports back within 6 weeks. Will contact for portfolio review of reel of previous paid work, disk of computer animation if interested. Pay depends on budget. Finds artists through word of mouth, submissions.
Tips: "Don't copy other work. Computers are the trend. We may hate them but we are stuck with them."

BIFROST DIGITAL EFFECTS, 6733 Sale Ave., West Hills CA 91307. (818)704-0423. Fax: (818)704-4629. E-mail: bifrost@earthlink.net. President: Howard Shore. Estab. 1982. Number of employees: 2. Animation studio. Specializes in advertising, animation, atmospheric laser effects and other visual effects for film and TV. Recent projects/clients include *Stargate*, *Batman Forever*, *Dark Planet*, *Time Lock*. Client list available upon request.
Needs: Prefers local freelancers with experience in 3-D animation. 100% of freelance animation demands skills in Alias/Wavefront, 3-D Studio Max.
First Contact & Terms: Send query letter with résumé. Accepts IBM-compatible disk submissions. Samples are filed. Will contact artist for portfolio review of demo reel if interested.
Tips: "IBM rules!"

N: HELLMAN ANIMATES, LTD., 1225 W. Fourth St., P.O. Box 627, Waterloo IA 50702. (319)234-7055. Fax: (319)234-2089. Animation studio. Specializes in animated TV commercials and programs.
Needs: Approached by 1 freelancer/month. Works with 3 animators/month. Prefers freelancers with experience in animation. Works on assignment only. Uses freelancers for storyboards and animatics.
First Contact & Terms: Send query letter with demo reel. Samples are filed or are returned. Reports back to the artist only if interested. Pays by foot of production, $35-135. Buys all rights.

GENE KRAFT PRODUCTIONS, 29 Calvados, Newport Beach CA 92657. (949)721-0609. Producer: Suzanne Stanford. Estab. 1980. Number of employees: 2. Animation studio and design firm specializing in animation production and title design for motion pictures and television. Recent clients include Nickelodeon, Paramount Pictures, Showtime, Warner Bros. and Universal Family Entertainment. Member of the Producer's Guild of America.
Needs: Approached by 12 freelance animators/year. Works with 6 freelance animators/year. Uses freelancers for design,

illustration and animation. 90% of freelance work demands skills in Softimage, Maya and Alias/Wavefront.
First Contact & Terms: Send query letter with reel and résumé. Samples are filed. Reports back within 2 weeks. Art director will contact artist for portfolio review of demo reel if interested. Pays by the project, $100-2,500. Buys all rights. Finds artists through agents, word of mouth and submissions.

☑ **LAWRENCE PRODUCTIONS**, (formerly Classic Animation), 1800 S. 35th St., Galesburg MI 49053-9688. (616)665-4800. Creative Director: David Baker. Estab. 1986. AV firm. Specializes in animation—computer (Topas, Lightwave, Wavefront SGI, Rio) and traditional. Current clients include Amway, Upjohn, Armstrong, NBC.
Needs: Approached by 60 freelancers/year. Works with 36 illustrators and 12 designers/year. Prefers artists with experience in animation. Uses freelancers for animation and technical, medical and legal illustration. Also for story-boards, slide illustration, animatics, TV/film graphics and logos. 10% of work is with print ads. 50% of freelance work demands computer skills.
First Contact & Terms: Send query letter with résumé, photocopies and ½″ VHS. Samples are filed or are returned by SASE. Reports back within 1 week only if interested. Write for appointment to show portfolio or mail appropriate materials. Portfolio should include slides and ½″ VHS. Pays for design and illustration by the hour, $25 minimum; or by the project, $250 minimum. Rights purchased vary according to project.

JAMES MURPHY CONSULTING, INC., 1431 Garland St., Green Bay WI 54301. (920)435-7345. Fax: (920)435-7395. E-mail: murph@virtualpartners.com. Websites: http://www.3d4all.com and http://www.virtualpartners.com. President: James M. Murphy. Estab. 1988. Number of employees: 2. Animation studio. Specializes in web page design/graphics, advertising, animation for motion picture industry. Recent clients include NBC Nightly News, Atlantic Records, McDonnell Douglas Corp., Epic MegaGames, Forensic Media, WFRV-TV, Blur Studios. "We support over 500 animation and graphics houses, many of whom have won numerous awards as a result of our training and support."
Needs: Approached by 75 freelance animators/year. Works with 200 freelance animators/year. Prefers freelancers with experience in architectural and character animation. 100% of freelance animation demands skills in 3-D Studio Max.
First Contact & Terms: Send query letter with reel. Samples are filed. Reports back within 2 weeks. Portfolio should include demo reel. Pays by the project, $500 minimum. Rights purchased vary according to project.
Tips: "Buy, learn and excel in 3-D Studio Max! This is not a 9-to-5 job! Also, sell the talent you have to communicate effectively through graphics. Use a variety of tools best suited to accomplish the job with disregard to platform preferences. Bad business will drive away the good."

NICKELODEON ANIMATION STUDIO, 231 W. Olive Ave., Burbank CA 91502. (818)736-3673 or (818)736-3000. Fax: (818)736-3539. Head of Recruitment: Kat Fair. Estab. 1992. Number of employees: 320. Cable TV network. Specializes in animation for television. Recent projects include *Catdog*, *Angry Beavers*, *Hey Arnold!*, *Oh Yeah!*. Professional affiliations: ASIFA, ATAS, Women in Animation.
Needs: Approached by 1,200 freelance animators/year. Prefers freelancers with animation experience. 1% of freelance illustration demands skills in Photoshop.
First Contact & Terms: Send portfolio. Samples are filed or returned. Reports back in 2 weeks. Portfolio review required. Portfolios may be dropped off every Monday-Thursday. "Reel is OK (no slides or CDs, please), but we're really looking for drawing ability." Artist should follow up. Pays by the project. Buys all rights. Finds artists through trade shows, word of mouth, submissions.
Tips: "Don't send huge, over-sized portfolios. Get to know Photoshop and animation software."

N OMNICAST CONSULTING, 2107 S. Oakland St., Arlington VA 22204. (703)685-0199. Owner: Teo Graca. Estab. 1995. Internet, intranet, extranet, ecommerce solutions, music production internet services and video production. Television programs include *Couch Potatoes*.
 • Full video, audio and music production services also available.
Needs: Currently seeking specialized internet artwork, some television animation.

☑ **N PERPLEXED PRODUCTIONS**, (formerly Deltasoft), 2137 Renfrew Ave., Elmont NY 11003. (516)775-4381. E-mail: mreiferson@aol.com. Website: http://www.perplexed.com. Contact: Matt Reiferson. Estab. 1996. Number of employees: 2. Entertainment (games) developers. Specializes in game design/development, web page design, graphics. Recent projects/clients include *Math Wars*, *Do or Die*.
 • Perplexed Productions is interested in working with animators who are just beginning their careers. This company might be a good place to start building a portfolio.
Needs: Approached by 4-5 freelance animators/year. Works with 2 freelance animators/year. Prefers local freelancers with experience in Truespace, POVRAY, Poser, Photoshop. Uses freelancers mainly for game graphics. 100% of freelance animation demands knowledge of Softimage, 3-D Studio, Truespace.
First Contact & Terms: Send query letter with computer disk. Submit IBM compatible disks. Samples are filed. Reports back within 3 days only if interested. Artist should follow-up with call for portfolio review of disk of computer animation, any graphics. Pays on a royalty of percentage profits, "strictly for the sake of making the game." Buys all rights. Finds artists through Internet.
Tips: Game/graphics history recommended. Open to beginning animators. "Learn and have experience in many graphic software programs."

✔️ 🏠 **RENEGADE ANIMATION, INC.**, 204 N. San Fernando Blvd., Burbank CA 91502. (818)556-3395. Fax: (818)556-3398. Executive Producer: Ashley Postlewaite. Estab. 1992. Number of employees: 8. Animation studio. Specializes in CD-ROM game animation, commercial animation, TV and film animation. Recent projects include Disney *101 Dalmations* CD-ROM game, Carl's Jr. "Tattoo" commercial, Cheeto's commercial, Trix Yogurt commercials, etc. Professional affiliations: ASIFA.

Needs: Approached by 15 freelance animators/year. Works with 30 freelance animators/year. Prefers local freelancers with experience in animation. Uses freelancers mainly for animation, asst. animation, fx animation, checking.

First Contact & Terms: Send query letter with reel, résumé. Samples are not filed and are returned. Reports back within 2 weeks. Portfolio review required. Request portfolio review of reel of previous paid work, demo reel, scenes to flip in original query. Pays by the project. Finds artists through word of mouth.

R/GREENBERG ASSOCIATES, 350 W. 39th St., New York NY 10018. (212)946-4000. Fax: (212)946-4160. Website: http://www.RGA.com. Executive Producer: Rick Wagonheim. Creative Director: Jakob Trollbeck. Head of Production: Michael Miller. Estab. 1977. Number of employees: 114. Animation/design firm. Specializes in visual effects and design for film titles, commercials and new media. Recent clients include Pontiac, Dodge, *Night Falls On Manhattan*.

• Jakob Trollbeck, creative director of R/GA is interviewed on page 545.

Needs: Approached by 30 freelance animators/year. Works with 25% freelance animators/year. Uses freelancers mainly for graphic design, CG-related work. "Don't bother to come to R/GA unless you have computer skills."

First Contact & Terms: Send query letter with reel and résumé. Samples are filed and are not returned. Reports back only if interested. Portfolio review required for design department, not CD work (reel only). Portfolios may be dropped of every Monday-Friday. Request portfolio review in original query. Artist should follow up with letter after initial query. Art director will contact artist for portfolio review if interested. Portfolio should include your best work. Pay depends on project. Finds artists through agents, trade shows, word of mouth.

Tips: "Don't give up. Be hungry, aggressive and talented."

SCULPTURED SOFTWARE STUDIOS, a Kodiak Interactive Company, 4001 S. 700 E., Suite 301, Salt Lake City UT 84107. (801)266-5400. Fax: (801)266-5570. E-mail: mmezo@kodiakgames.com. Website: http://www.kodiakgames.com. Director of Human Resources: Monique Mezo . Entertainment software developer.

Needs: Computer graphic artists with 3-D animation skills. Needs 3-D animation artists. Should have strong 2D art skills, especially figure drawing, and strong skills in animation programs such as 3-D Studio Max, Animator Pro, D Paint.

First Contact & Terms: Send a short reel of animation (especially 3-D animation) and graphics on a VHS tape plus slides or photos of 2-D artwork.

Tips: "Just include your best work on your VHS tape. Don't make the tape too long; three to five minutes is enough. Some artists include everything they've ever done and that's too much for us to have time to look at."

📺 🏠 **STARTOONS**, P.O. Box 1232, Homewood IL 60430. (708)335-3535. Fax: (708)335-3999. E-mail: star2ns@aol.com. General Manager: Terry Hamilton. Estab. 1989. Number of employees: 30. Animation studio. Specializes in advertising, animation for motion picture industry, etc. Recent clients include Warner Bros., Griffin Bacal. Client list available upon request. Professional affiliations: Women in Film.

• Startoons has won Emmy awards for work on *Animaniacs* and *Tiny Toons*, as well as many awards for the *Dudley the Dinosaur* series.

Needs: Approached by 2 freelance animators/week. Works with 5 freelance animators/year. Prefers local freelancers with experience in traditional animation. Uses freelancers mainly for storyboards.

First Contact & Terms: Send query letter with résumé, life drawing examples. Samples are not filed and are not returned. Reports back within 2 months. Will contact for portfolio review of demo reel if interested. Pays piece rates. Buys all rights. Finds artists through word of mouth, submissions.

WARNER BROS. FEATURE ANIMATION, 500 N. Brand Blvd., Suite 1800, Glendale CA 91203. Fax: (818)977-7111. Website: http://wbanimation.warnerbros.com/ Contact: Recruitment. Estab. 1994. Number of employees: varies by production. Animation studios. Specializes in animation for motion picture industry. Recent projects include *Tom and Jerry: The Movie* and *Tiny Toon Adventures*.

Needs: Approached by thousands of freelance animators/year. "We hire small studios. A good way to break in is to find small studios who get hired by big studios." Prefers to have previous relationships with freelancers. 100% of freelance animation demands skills in computer animation.

First Contact & Terms: Send query letter with reel, résumé and portfolio. "Identify your position! Don't just say, 'I want a job!' Don't give us too much." Samples are filed briefly or are returned. "Don't send portfolio; send cover letter asking if we are accepting portfolios." Reports back in 2-4 weeks. Portfolio review required "only if we have a job opening. Write first and ask when we are looking at portfolios. But we won't review if we're not looking for this category." Art director will contact artist for portfolio review if interested. Pays by the project. Rights purchased vary according to project. Finds artists through word of mouth

Tips: "Write first. Send query and list the job you want. Call to find out when we're hiring. Then send portfolio."

Advertising, Design & Related Markets

There are thousands of advertising agencies; public relations, design and marketing firms across the country and around the world. Though we alert you to a number of them, our page-count is limited. So be aware the listings on the following pages are the tip of the proverbial iceberg. Look for additional firms in industry directories, such as *Workbook* (Scott & Daughters Publishing), *Standard Directory of Advertisers* (National Register Publishing) and *The Design Firm Directory* (Wefler & Associates), available in the business section of most large public libraries. Find local firms in the yellow pages and your city's business-to-business directory. You can also pick up leads by reading *HOW*, *Print*, *Step-by-Step Graphics*, *Communication Arts* and other design publications.

The firms in this section vary in size, ranging from two-person operations to huge, international corporations. All, however, rely on freelancers. If you have the required talent and skills, these markets offer a steady stream of assignments.

Listings offer clues to clients

Read listings to identify firms whose clients and specialties are in line with the type of work you create. (You'll find clients and specialties in the first paragraph of each listing.) If you create charts and graphs, contact firms whose clients include financial institutions. Fashion illustrators should approach firms whose clients include department stores and catalog publishers. Sculptors and modelmakers might find opportunities with firms specializing in exhibition design.

WHAT THEY PAY

You will most likely be paid by the hour for work done on the firm's premises (inhouse), and by the project if you take the assignment back to your studio. Most checks are issued 40-60 days after completion of assignments. Fees depend on the client's budget, but most companies are willing to negotiate, taking into consideration the experience of the freelancer, the lead time given, and the complexity of the project. Be prepared to offer an estimate for your services and ask for a purchase order (P.O.) before you begin an assignment.

Some art directors will ask you to provide a preliminary sketch, which, if approved by the client, can land you a plum assignment. If you are asked to create something "on spec," you may not receive payment beyond an hourly fee for your time if the project falls through. So be sure to ask upfront about payment policy before you start an assignment.

If you're hoping to retain usage rights to your work, you'll want to discuss this upfront, too. You can generally charge more if the client is requesting a buyout. If research and travel are required, make sure you find out ahead of time who will cover these expenses.

Sourcebook ads open up market opportunities

Anyone who's advertised in a sourcebook knows it's an expensive proposition. However, making this investment paid off for artist Joe Lacey, whose sourcebook ad depicting a Halloween scene landed him an assignment for a national advertiser and a chance to expand into a more lucrative market.

Joe Lacey

Lacey's ad was spotted by art director Susan Binns-Roth of The Zipatoni Co., a St. Louis-based promotion agency specializing in the beer and beverage industries. Binns-Roth felt the illustration technique Lacey used in his ad would be well-suited to a holiday point-of-purchase display she was developing for Miller Lite. At that point, Lacey was one of six illustrators under consideration for the project, but after his portfolio had been reviewed and a fee agreed upon, Lacey got the job.

The Miller Lite point-of-purchase display represented a significant career departure for Lacey who, until then, had been working primarily as an illustrator for children's products and magazines. "Until we got his book, we didn't know [about him]," says Zipatoni art buyer Christine Molitor. It was Molitor's job to contact Lacey and act as liasion between the artist and art director. "What he sent wasn't really commercial and certainly not for beer," she states. Molitor, Binns-Roth and their client liked the way Lacey had treated the holiday illustrations which were included in his portfolio. The fact that most of them had been done for Crayola didn't seem to matter. "He said he had never done anything like this before," Molitor relates. "We said, 'if you can do the job, we don't care what your forte is.'"

Lacey agrees that the holiday-related samples and the Halloween illustration featured in his ad probably helped him land the assignment. "I've often heard that if you show a holiday image, they'll say, 'He does holidays,' and call you," he explains. Lacey points out that the portfolio samples he sent also supported the painterly style of the illustration that appeared in the ad. "I do a lot of computer work which tends to be simple, flat color," he says. "When I forwarded my portfolio to Zipatoni, I made sure all of the pieces I sent were similar in

JOE LACEY

Occupation: Freelance illustrator
Agency: The Zipatoni Co.
Art Buyer: Christine Molitor

style to the ad they saw." The 7 samples Lacey sent were a combination of acryllic and oil paintings submitted as 8 × 10 transparencies. "Because I was sending so few pieces, I wanted to be sure they were presented very nicely," says Lacey.

Because Lacey was dealing with a new situation, he did some research to get an idea of how to negotiate the job. "You don't want to bid too low, because it makes you look unprofessional," he says. "But, if you overbid, you look greedy." A call to a colleague with experience in advertising illustration helped him arrive at an appropriate bid. Lacey submitted his bid in writing, "and I also said I was open to negotiation if they were interested." Molitor contacted him shortly thereafter and they agreed upon a price. "They came very close to what I had suggested," says Lacey.

When Lacey started the assignment, he submitted preliminary sketches, based on Binns-Roth's specifications. "Because I had never worked with them before, I antici-pated a lot of changes," he says. However, Lacey was pleasantly surprised when his sketches came back with just a few minor revisions. The parameters for the point-of-purchase display didn't throw him off either. "The scale was huge," he says. "But I had done some point-of-purchase for Binney and Smith (manufacturer of Crayola) and other larger things before."

When Lacey's final sketches were approved, the job had to be turned around in just two weeks. Although the two-week time frame required him to work very quickly, he notes that it came as no surprise—all of his clients have shortened their deadlines in recent years. "I find when I get jobs from long-time clients, a job that I used to

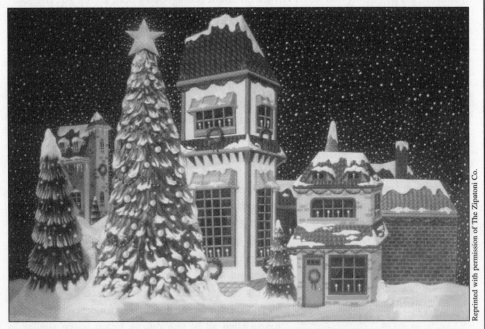

Joe Lacey created this 3-D point-of-purchase display for Miller Lite. He landed the lucrative assignment when The Zipatoni Co. spotted his painterly style in *American Showcase*.

get a month ahead of time, they now need in a week."

Because Lacey completed the project just a short time ago, he hasn't been able to determine whether or not it will generate additional business. However, he notes that the job more than paid for the $3,000 cost of his sourcebook ad. In addition to the call from Zipatoni, the ad generated five other calls from book publishers. Although none have, as yet, panned out into jobs, Lacey hopes they will eventually lead to additional business.

Lacey hopes to get more assignments like the Miller Lite project. He welcomes the change of pace advertising illustration brings as well as its lucrative payscale. "The Miller job was very different from what I had been doing," he says. "Having two or three jobs like this a year would be really nice."

—*Poppy Evans*

This painting of a silly but scary ghost, created for the children's market attracted The Zipatoni Co. to Lacey's work.

ART BUYERS RELIEVE ART DIRECTOR'S WORKLOAD

Joe Lacey's experience working with The Zipatoni Co.'s Christine Molitor is not unlike many large ad agencies where artists are selected, hired and paid by an art buyer, rather than an art director. "If our art directors took every call from every illustrator, they'd never get anything done," says Molitor, explaining that a 187-person agency such as Zipatoni needs someone in her position to handle all of the details associated with selecting and buying illustration and photography.

Molitor typically calls in portfolios of artists an art director is considering for a job, or pulls samples from her extensive library of tearsheets if they're seeking a particular look. "Sometimes we call in as many as eight portfolios for a project," she says. Molitor also gets involved in the bidding negotiations between the artist and Zipatoni, handles all correspondence and purchase orders, and returns portfolios when the reviewing process is completed.

"Once we've awarded the job, I'm the liasion between the art director and the artist," says Molitor, who is always available to field calls art directors may not be able to take. "I also make sure everyone gets paid. If it were up to the art director, it might take a while."

Christine Molitor, art buyer extraordinaire, brings her royal flair and hopeful attitude to her day-to-day projects at The Zipatoni Co.

Photo: Jon Bruton, Bruton–Stroube Studio

Get Your 2001 Edition Delivered Right to Your Door—<u>and Save!</u>

Finding the right markets for your art and design is crucial to your success. With constant changes in the industry, it's not always easy to stay informed. That's why every year the most savvy artists and designers turn to the current edition of *Artist's & Graphic Designer's Market* for the most up-to-date information on the people and places that will get work sold, commissioned or shown. It offers over 2,500 up-to-date listings of publishers, design firms, ad agencies, greeting card companies, galleries and more. You'll also find insider tips from today's art professionals that will further increase your opportunities.

Through this special offer, you can reserve your *2001 Artist's & Graphic Designer's Market* now at the 2000 price—just $24.99. Order today and save!

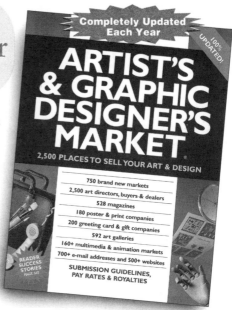

The 2001 edition of Artist's & Graphic Designer's Market will be published and ready for shipment in August, 2000.

More books to help you sell your work!

More Great Books to Help You Get Ahead!

Molitor is also the person to see if an artist wants to show a portfolio. "Because your art directors are so busy, artists have a much better chance hooking up with me and getting their work shown than if they hound an art director," she says. Molitor is willing to see anyone's portfolio and says artists need only to call her in advance. She generally schedules morning showings and rounds up Zipatoni's art directors to view the artist's portfolio after everything is set up. And, she laughs, "If they come in with donuts, they'll get a lot of attention." Artists unable to show portfolios in person shouldn't send slides or transparencies to Molitor, but should send tear sheets or 8½×11 photocopies or laser prints of their work.
—*Poppy Evans*

Alabama

COMPASS MARKETING, INC., (formerly Compass Communications), 175 Northshore Place, Gulf Shores AL 36542. (334)968-4600. Fax: (334)968-5938. E-mail: awboone@compasspoints.com. Website: http://www.compasspoints.com. Editor: April W. Boone. Estab. 1988. Number of employees: 20. Approximate annual billing: $4 million. Integrated marketing communications agency and publisher. Specializes in tourism products and programs. Product specialties are business and consumer tourism. Current clients include Alabama Bureau of Tourism, Gulf Shores Golf Assoc. and Alabama Gulf Coast CVB. Client list available upon request. Professional affiliations: STS, Mobile 7th Dist. Ad Fed, MCAN and AHA.
Needs: Approached by 2-10 illustrators/year and 5-20 designers/year. Works with 2 illustrators and 4-6 designers/year. Prefers freelancers with experience in magazine work. Uses freelancers mainly for sales collateral, advertising collateral and illustration. 5% of work is with print ads. 100% of design demands skills in Adobe Photoshop 5.0 and QuarkXPress. Some illustration demands computer skills.
First Contact & Terms: Designers send query letter with photocopies, résumé and tearsheets. Illustrators send postcard sample of work. Samples are filed and are not returned. Reports back within 1 month. Art director will contact artist for portfolio review of slides and tearsheets if interested. Pays by the project, $100 minimum. Rights purchased vary according to project. Finds artists through sourcebooks, networking and print.
Tips: "Be fast and flexible. Have magazine experience."

☑ **A. TOMLINSON ADVERTISING, INC.**, 306 W. Alabama St., Florence AL 35630. (256)766-4222. Fax: (256)766-4106. E-mail: allent2476@aol.com. President: Allen Tomlinson. Estab. 1990. Number of employees: 10. Approximate annual billing: $1.2 million. Ad agency. Specializes in magazine, collateral, catalog—business to business. Product specialties are home building products. Client list available upon request.
Needs: Approached by 20 illustrators and 20 designers/year. Works with 4 illustrators and 4 designers/year. Also for airbrushing, billboards, brochure and catalog design and illustration, logos and retouching. 35% of work is with print ads. 85% of design demands skills in Aldus PageMaker 5.0, Adobe Photoshop, Adobe Illustrator and QuarkXPress 3.2. 85% of illustration demands skills in Aldus PageMaker 5.0, Adobe Photoshop, Adobe Illustrator and QuarkXPress 3.2.
First Contact & Terms: Designers send query letter with brochure and photocopies. Illustrators send send query letter with brochure, photocopies, résumé and transparencies. Samples are filed and are not returned. Does not report back; artist should call. Artist should also call to arrange for portfolio review of color photographs, slides, thumbnails and transparencies. Pays by the project. Rights purchased vary according to project.

Arizona

N ANGEL FIRE PRODUCTIONS, INC., (formerly On-Location Video & Audio), Box 1866, Prescott AZ 86302. (520)445-5050. Fax: (520)445-5910. E-mail: boodie@goodnet.com. Website: http://www.angelfireproductions.com. President: Dawna May. Executive Assistant: Linda Landrum. Vice President: Steve LaVigne. Estab. 1997. Number of employees: 3. Approximate annual billing: $150,000. AV firm. Full-service, multimedia firm handling video and audio production for various clients, as well as some print. Specializes in documentaries, educational, cable and direct distribu-

tion. Product specialties are educational, nature, old West, entertainment. Current clients include Ralph Rose Productions, Prism Productions and Current Productions.

Needs: Approached by 7-8 freelancers/year. Works with 3 freelance illustrators and 4 designers/year. Prefers artists with experience in video, computer graphics, animation on Mac and PC. Uses freelance artists mainly for graphics and animation. Also for print ad and slide illustration, storyboards, posters, TV/film graphics, lettering and logos. 20% of work is with print ads. 90% of freelance work demands knowledge of Mac software: Toaster and Power Mac: Premiere, Photoshop, Strata, Studio, Illustrator, etc.

First Contact & Terms: Send query letter with brochure, photocopies, SASE, résumé, photographs, slides, computer disks or VHS videotape. Samples are filed or are returned by SASE if requested by artist. Reports back within 2 weeks. To show portfolio, mail photographs, computer disks (Mac), VHS or SVHS video tape. Payment for design and illustration varies by job and client.

CALDERA DESIGN, 1201 E. Jefferson, #A25, Phoenix AZ 85034. (602)495-1300. Fax: (602)495-1403. E-mail: studio@calderadesign.com. Principal-Designer: Doreen Caldera. Estab. 1985. Specializes in annual reports, product and capability brochures, strategic planning and branding, brand and corporate identity and package and publication design. Clients: corporations, retailers and manufacturers. Client list not available.

Needs: Approached by 50-75 artists/year. Works with 5-10 illustrators/year. Uses freelance computer designers for tight comps and layouts. Works on assignment only. Uses freelancers mainly for corporate systems, packaging and brochures. Also for retouching, airbrushing, computer needs and catalog and ad illustration.

First Contact & Terms: Send query letter with brochure, résumé, tearsheets, photographs and photocopies. Samples are filed. Reports back within 2 weeks, only if interested. To show a portfolio mail photostats. Pays for illustration by the project, $500-5,000. Rights purchased vary according to project.

CBI GRAPHICS & ADVERTISING, 8160 E. Batherus, Suite 6, Scottsdale AZ 85260. (602)948-0440. Fax: (602)443-1263. Owner: Catie Bossard. Estab. 1987. Number of employees: 4. Approximate annual billing: $600,000. Ad agency. Full-service, multimedia firm. Specializes in graphic design, computer graphics. Product specialty is high technology. Client list available upon request. Professional affiliations: AIN.

Needs: Approached by 100 freelance artists/year. Works with 10 freelance illustrators and 10 designers/year. Prefers local artists with experience in Macintosh computer graphics. Uses freelancers mainly for special projects and overflow. Also uses freelancers for brochure and catalog design and illustration, lettering, logos, model making, posters, retouching, signage and TV/film graphics. 50% of work is with print ads. 85% of freelance work demands skills in Aldus PageMaker, Adobe Photoshop, QuarkXPress, Adobe Illustrator and Painter.

First Contact & Terms: Send query letter with photocopies, résumé and tearsheets. Samples are filed or returned. Reports back to the artist only if interested. Portfolio should include b&w and color final art, roughs and thumbnails. Pays for design and illustration by the project. Rights purchased vary according to project.

CRICKET CONTRAST GRAPHIC DESIGN, 2301 N. 16th St., Phoenix AZ 85006. (602)258-6149. Fax: (602)258-0113. E-mail: cricket@neta.com. Owner: Kristie Bo. Estab. 1982. Number of employees: 4. Specializes in annual reports, corporate identity, web page design, advertising, package and publication design. Clients: corporations. Professional affiliations: AIGA and Phoenix Society of Communicating Arts.

Needs: Approached by 25-50 freelancers/year. Works with 5 freelance illustrators and 5 designers/year. Also uses freelancers for ad illustration, brochure design and illustration, lettering and logos. Needs computer-literate freelancers for design and production. 90% of freelance work demands knowledge of Adobe Illustrator, Adobe Photoshop and QuarkXPress.

First Contact & Terms: Send photocopies, photographs and résumé. Will contact artist for portfolio review if interested. Portfolio should include b&w photocopies. Pays for design and illustration by the project. Negotiates rights purchased. Finds artists through self-promotions and sourcebooks.

Tips: "Beginning freelancers should call and set up an appointment or meeting and show their portfolio and then make a follow-up call or calls."

DESIGNARTS, INC., 2343 W. Estrella Dr., Chandler AZ 85224. (602)786-9411. Fax: (602)786-4667. Contact: Kent Loott. Estab. 1990. Number of employees: 2. Specializes in brand and corporate identity, display, direct mail and package design. Clients: ad agencies and corporations.

Needs: Approached by 10-20 freelancers/year. Works with 3-5 freelance illustrators and 3-5 designers/year. Prefers local artists with experience in all media. Uses freelancers for ad, brochure and poster illustration, and charts/graphs. Needs computer-literate freelancers for design, illustration and production. 50% of freelance work demands skills in Adobe Illustrator and CorelDraw.

First Contact & Terms: Send query letter with photocopies. Samples are filed and are not returned. Will contact

MARKETS NEW TO THIS EDITION

artist for portfolio review if interested. Pays for design and illustration by the project, $100-1,500. Finds artists through sourcebooks (i.e. *Arizona Portfolio*) and submissions.

Tips: "Keep mailers short and sweet—three pages maximum."

GODAT/JONCZYK INC., 101 W. Simpson St., Tucson AZ 85701-2268. (520)620-6337. E-mail: ken@gojodesign.com. Website: http://www.gojodesign.com. Partners: Ken Godat and Jeff Jonczyk. Estab. 1983. Number of employees: 6. Specializes in corporate identity, annual reports, marketing communications, publication design and signage. Clients: corporate, retail, institutional, public service. Current clients include Tucson Electric Power, Tucson Airport Authority, Rain Bird and IBM. Professional affiliations: AIGA, ACD.

Needs: Approached by 75 freelancers/year. Works with 0-3 freelance illustrators and 2-3 designers/year. Freelancers should be familiar with PageMaker, FreeHand, Photoshop or Illustrator. Needs technical illustration.

First Contact & Terms: Send query letter with samples. Samples are filed. Request portfolio review in original query. Will contact artist for portfolio review if interested. Pays for design by the hour, $40-60 or by the project. Pays for illustration by the project. Finds artists through sourcebooks.

PAUL S. KARR PRODUCTIONS, 2925 W. Indian School Rd., Phoenix AZ 85017. (602)266-4198. Contact: Paul or Kelly Karr. Utah Division: 1024 N. 300 E., Orem UT 84057. Phone/fax: (801)226-3001. Contact: Michael Karr. Film and video producer. Clients: industry, business, education, TV, cable and feature films.

Needs: Occasionally works with freelance filmmakers in motion picture and video projects. Works on assignment only.

First Contact & Terms: Advise of experience, abilities and funding for project.

Tips: "If you know about motion pictures and video or are serious about breaking into the field, there are three avenues: 1) have relatives in the business; 2) be at the right place at the right time; or 3) take upon yourself the marketing of your idea, or develop a film or video idea for a sponsor who will finance the project. Go to a film or video production company, such as ours, and tell them you have a client and the money. They will be delighted to work with you on making the production work, and approve the various phases as it is being made. Have your name listed as the producer on the credits. With the knowledge and track record you have gained you will be able to present yourself and your abilities to others in the film and video business and to sponsors."

KC MARKETING GROUP, INC., 7920 E. Greenway Rd., Scottsdale AZ 85260. (602)948-2411. Fax: (602)948-6478. President: Evelyn Sarde. Estab. 1977. Number of employees: 30. Marketing promotions firm. Full-service multimedia firm. Specializes in promotional material. Product specialties are food, drugs. Client list available upon request. Professional affiliations: PMAA, PIAZ, AISB.

Needs: Approached by 10-15 freelancers/year. Works with 5 freelance illustrators and 2 designers/year. Prefers artists with experience in designing and rendering tight comps and Mac knowledge. Uses freelancers for illustrations and comps. Also for brochure and catalog design and illustration, logos. 35% of work is with print ads. Needs computer-literate freelancers for design and illustration. 98% of freelance work demands skills in Aldus PageMaker, Aldus FreeHand, Adobe Photoshop, QuarkXPress, Adobe Illustrator.

First Contact & Terms: Send query letter with tearsheets. Samples are filed. Does not report back. Artist should continue to send new pieces. Will contact artist for portfolio review if interested. Portfolio should include color photographs, slides, transparencies, final art. Pays for design by the project, $100-1,000. Pays for illustration by the project, $100-3,000. Buys all rights.

Tips: Finds artists through sourcebooks, reps, submissions and word of mouth.

THE M. GROUP GRAPHIC DESIGN, 2512 E. Thomas Rd., Suite #7, Phoenix AZ 85016. (602)957-7557. Fax: (602)957-7876. E-mail: mail@themgroupinc.com. Website: http://www.themgroupinc.com. President: Gary Miller. Estab. 1987. Number of employees: 12. Approximate annual billing: 2.75 million. Specializes in annual reports, corporate identity, direct mail and package design, and advertising. Clients: corporations and small business. Current clients include Arizona Public Service, Comtrade, Sager, Dole Foods, Giant Industries, Microchip, Coleman Spas, ProStar, Teksoft and CYMA.

Needs: Approached by 50 freelancers/year. Works with 5-10 freelance illustrators/year. Uses freelancers for ad, brochure, poster and P-O-P illustration. 95% of freelance work demands skills in Adobe Illustrator, Adobe Photoshop and QuarkXPress.

First Contact & Terms: Send postcard sample or query letter with samples. Samples are filed or returned by SASE if requested by artist. Reports back to the artist only if interested. Request portfolio review in original query. Artist should follow-up. Portfolio should include b&w and color final art, photographs and transparencies. Rights purchased vary according to project. Finds artists through publications (trade) and reps.

Tips: Impressed by "good work, persistence, professionalism."

MILES ADVERTISING, 3661 N. Campbell Ave., #276, Tucson AZ 85719. (520)795-2919. Contact: Bill Miles. Estab. 1973. Number of employees: 2. Approximate annual billing: $750,000. Ad agency. Full-service, multimedia firm. Specializes in local TV advertising, outdoor. Product specialty is automotive, home builders and ad associations. Client list available upon request.

Needs: Approached by 30 freelancers/year. Works with 1 freelance illustrator and 3 designers/year. Prefers local freelancers only. Uses freelancers mainly for newspaper and outdoor design and layout, plus television graphics. Also for signage. 20% of work is with print ads. Needs computer-literate freelancers for design and production.

First Contact & Terms: Send query letter with photocopies. Samples are filed and are not returned. Will contact artist for portfolio review if interested. Portfolio should include b&w and color final art and roughs. Pays for design by the project, $40-2,500. Pays for illustration by the project. Buys all rights.

PAPAGALOS AND ASSOCIATES, 5333 N. Seventh St., Suite 222, Phoenix AZ 85014. (602)279-2933. Fax: (602)277-7448. E-mail: nicholas@papagalos.com. Website: http://www.papagalos.com. Creative Director: Nicholas Papagalos. Specializes in advertising, brochures, annual reports, corporate identity, displays, packaging, publications and signage. Clients: major regional, consumer and business-to-business.
Needs: Works with 10-20 freelance artists/year. Works on assignment only. Uses artists for illustration, retouching, airbrushing, AV materials, lettering, design and production. Needs computer-literate freelancers, HTML programmers and web designers for design, illustration and production. 100% of freelance work demands skills in Adobe Illustrator, QuarkXPress or Photoshop. Needs editorial illustration.
First Contact & Terms: Send query letter with brochure or résumé and samples. Samples are filed or are returned only if requested. Call or write to schedule an appointment to show a portfolio, which should include thumbnails, roughs, final reproduction/product, photostats and photographs. Pays for design by the hour or by the project. Pays for illustration by the project. Considers complexity of project, client's budget, skill and experience of artist, how work will be used, turnaround time and rights purchased when establishing payment. Rights purchased vary according to project.
Tips: In presenting samples or portfolios, "two or three samples of the same type/style are enough."

[N] RAINWATER COMMUNICATIONS, INC., P.O. Box 14507, Scottsdale AZ 85267-4507. (602)314-1376. Fax: (602)314-1383. E-mail: nimbusgp@concentric.net. President/Creative Director: Bob Rainwater. Estab. 1980. Number of employees: 2. Approximate annual billing: $300,000. Specializes in magazine ads, corporate brochures and annual reports. Current clients include AT&T, Axxess Technologies, W.L. Gore. Client list available upon request. Professional affiliations: AIGA, GAG and IAGD.
Needs: Approached by 10 freelancers/year. Works with 6 freelance illustrators and 4 designers/year. Prefers artists with experience in consumer and corporate communications—must be Macintosh literate. Uses illustrators mainly for concept executions. Also for annual reports, billboards, brochure and catalog design and illustration, lettering, logos, mechanicals, posters, retouching, signage and TV/film graphics. Also for multimedia projects. 100% of design and 50% of illustration demand knowledge of Adobe Photoshop, QuarkXPress and Adobe Illustrator.
First Contact & Terms: Send query letter with photocopies, résumé, brochure, photographs, SASE, slides, tearsheets and transparencies. Accepts submissions on disk compatible with Adobe Illustrator 8.0, Adobe Photoshop 5.0 and QuarkXPress 4.04. Send EPS files. Samples are sometimes filed or returned by SASE if requested by artist. Will contact artist for portfolio review if interested. Portfolio should include samples of work used in printed pieces. Pays for design and illustration by the project. Rights purchased vary according to project. Finds artists through agents, sourcebooks, magazines, word of mouth and submissions.
Tips: This company is looking for a professional approach with presentation samples. "Prefers experienced people. No students please."

TIEKEN DESIGN & CREATIVE SERVICES, 3838 N. Central Ave., Suite 100, Phoenix AZ 85012. (602)230-0060. Fax: (602)230-7574. E-mail: team@tiekendesign.com. Website: http://www.tiekendesign.com. General Manager: Gail Tieken. Estab. 1980. Specializes in annual reports, corporate identity, package and publication design, signage, multimedia, websites. Clients: corporations and associations. Client list not available.
Needs: Approached by 30-40 freelance artists/year. Works with 3-4 freelance illustrators and 1-2 freelance designers/year. Prefers artists with experience in Macintosh. Works on assignment only.
First Contact & Terms: Send query letter with résumé. Samples are filed. Reports back to the artist only if interested. To show a portfolio, mail thumbnails, roughs and tearsheets. Pay varies by project and artist. Buys all rights.
Tips: It is important for freelancers to have "a referral from an associate and a strong portfolio."

Arkansas

[✓] KIRKPATRICK, WILLIAMS, GURLEY ASSOCIATES, 100 West Center, Suite 001, Fayetteville AR 72701. (501)251-1004. Fax: (501)251-1006. Manager: Ashley Lechtenberger. Art Director: Dan Kilpatrick. Estab. 1960. Ad agency. Full-service, multimedia firm. Specializes in packaging and print material. Clients include Southern Aluminum, Crane Vending Co., Jack Henry & Associates and town of Eureka Springs.
Needs: Approached by 2-3 freelancers/month. Works with 1-2 illustrators/month. Prefers artists with experience in automotive, healthcare, financial, tourism and space products. Works on assignment only. Uses freelancers mainly for illustration for packaging. Also for brochure, catalog and print ad illustration and retouching and posters. Needs computer-literate freelancers for design and production. 8-10% of work is with print ads. 75% of freelance work demands skills in QuarkXPress, Aldus FreeHand, Adobe Illustrator and Photoshop. Needs technical illustration.
First Contact & Terms: Send query letter with brochure, résumé, photographs and slides. Samples are filed or are returned by SASE only if requested by artist. Does not report back. Artist should "contact by letter." Call for appointment to show portfolio of "whatever best shows the artist's strengths." Pays for design by the hour, $50 maximum. Pays for illustration by the project, $250-3,000. Buys all rights.

N **TAYLOR MACK ADVERTISING**, 124 W. Meadow, Fayetteville AR 72071. (501)444-7770. Fax: (501)444-7977. Creative Director: Greg Mack. Estab. 1990. Number of employees: 12. Approximate annual billing: $3 million. Ad agency. Specializes in collateral. Current clients include Tyson, WalMart and Marathon. Client list available upon request.
Needs: Approached by 12 illustrators and 20 designers/year. Works with 4 illustrators and 6 designers/year. Uses freelancers mainly for brochure, catalog and technical illustration, TV/film graphics and web page design. 30% of work is with print ads. 50% of design and illustration demands skills in Adobe Photoshop, Adobe Illustrator and QuarkXPress.
First Contact & Terms: Designers send query letter with brochure and photocopies. Illustrators send postcard sample of work. Samples are filed or are returned. Reports back only if interested. Art director will contact artist for portfolio review of photographs if interested. Pays for design by the project or by the day; pays for illustration by the project, $10,000 maximum. Rights purchased vary according to project.

N **MANGAN/HOLCOMB & PARTNERS**, 320 W. Capitol Ave., Suite 911, Little Rock AR 72201. (501)376-0321. Contact: Steve Mangan (by mail only). Number of employees: 12. Approximate annual billing: $3 million. Ad agency. Clients: recreation, financial, tourism, retail, agriculture.
Needs: Approached by 50 freelancers/year. Works with 8 freelance illustrators and 20 designers/year. Uses freelancers for consumer magazines, stationery design, direct mail, brochures/flyers, trade magazines and newspapers. Also needs illustrations for print materials. Needs computer-literate freelancers for production and presentation. 30% of freelance work demands skills in Macintosh page layout and illustration software.
First Contact & Terms: Query with brochure, flier and business card to be kept on file. Include SASE. Reports in 2 weeks. Call or write for appointment to show portfolio of final reproduction/product. Pays by the project, $250 minimum.

☑ **McCLANAHAN GRAPHICS, INC.**, 405 W. Searcy, Heber Springs AR 72543. (501)362-4038. Fax: (501)362-5547. E-mail: mgi@arkansas.net. President: K.L. McClanahan. Estab. 1978. Number of employees: 7. Approximate annual billing: $5 million. Ad agency and design firm. Specializes in industrial print advertising, trade ads, design, corporate logos, corporate videos, industrial campaigns, catalogs, brochures. Client list available upon request.
Needs: Approached by 6 illustrators and 5 designers/year. Works with 2 illustrators and 1 designer/year. Prefers freelancers with experience in illustration. Also for animation, model making and storyboards. 90% of work is with print ads. 75% of design and illustration demands skills in Adobe Photoshop, Aldus FreeHand and QuarkXPress.
First Contact & Terms: Send postcard sample of work or query letter with brochure and résumé. Accepts disk submissions. Samples are filed. Reports back only if interested. Art director will contact artist for portfolio review of color, final art, photographs, roughs and slides if interested. Payment negotiable. Rights purchased vary according to project. Finds artists through sourcebooks and reps.
Tips: "Perseverance. Diversification. Specialize in what you love to do."

California

N **ADVANCE ADVERTISING AGENCY**, 606 E. Belmont Ave., Suite 202, Fresno CA 93701. (209)445-0383. Creative Director: M. Nissen. Estab. 1950. Ad agency. Full-service, multimedia firm. Current clients include Picd Computors, Sound Investment Recording Studio, Howard Leach Auctions, Mr. G's Carpets, Allied Floorcovering, Fresno Dixieland Society. Client list not available.
Needs: Approached by 2-5 freelancers/month. Prefers local freelancers with experience in all media graphics and techniques. Works on assignment only. Uses freelancers mainly for direct mail, cartoons, caricatures. Also for brochure design and illustration, catalog and print ad design, airbrushing, storyboards, mechanicals, retouching, billboards and logos. 75% of work is with print ads. 25% of freelance work demands computer skills.
First Contact & Terms: Send query letter with résumé, photocopies and SASE. Samples are filed or returned by SASE. Reports back within 2 weeks only if interested. Creative Director will contact artist for portfolio review if interested. Portfolio should include roughs, tearsheets and/or printed samples. Pays for design and illustration by the project, rate varies. Buys all rights. Finds artists through artists' submissions.

■ **THE ADVERTISING CONSORTIUM**, 10536 Culver Blvd., Suite D, Culver City CA 90232. (310)287-2222. Fax: (310)287-2227. E-mail: theadco97@earthlink.net. Contact: Kim Miyade. Estab. 1985. Ad agency. Full-service, multimedia firm. Specializes in print, collateral, direct mail, outdoor, broadcast. Current clients include Bernini, Royal-Pedic Mattress, Davante, Maison D'Optique, Westime, Modular Communication Systems.
Needs: Approached by 5 freelance artists/month. Works with 1 illustrator and 3 art directors/month. Prefers local artists only. Works on assignment only. Uses freelance artists and art directors for everything (none on staff), including brochure, catalog and print ad design and illustration and mechanicals and logos. 80% of work is with print ads. Also for multimedia projects. 100% of freelance work demands knowledge of Aldus PageMaker, QuarkXPress, Aldus FreeHand, Adobe Illustrator and Adobe Photoshop.
First Contact & Terms: Send postcard sample or query letter with brochure, tearsheets, photocopies, photographs and anything that does not have to be returned. Samples are filed. Write for appointment to show portfolio. "No phone calls, please." Portfolio should include original/final art, b&w and color photostats, tearsheets, photographs, slides and

transparencies. Pays for design by the hour, $60-75. Pays for illustration by the project, based on budget and scope.
Tips: Looks for "exceptional style."

[N] B&A DESIGN GROUP, 634-C W. Broadway, Glendale CA 91204-1008. (818)547-4080. Fax: (818)547-1629. Owner/Creative Director: Barry Anklam. Full-service advertising and design agency providing ads, brochures, P-O-P displays, packaging, corporate identity, posters and menus. Product specialties are food products, electronics, hi-tech, real estate and medical. Clients: high-tech, electronic, photographic accessory companies, financial institutions and restaurants. Current clients include Syncor International, California Egg Commission, Neptune Foods, Nissan Foods, Smart N' Final Foods, Viktor Benes Continental Pastries, NTC/National Teleconsultants.
Needs: Works with 5 freelancers/year. Assigns 15-20 jobs/year. Uses freelancers mainly for brochure, editorial newspaper and magazine ad illustration, mechanicals, retouching, direct mail packages, lettering, charts/graphs. Needs editorial, technical and medical illustration, photography, production on collateral materials, lettering and editorial cartoons. Needs computer-literate freelancers for design, illustration, and production. 95% of freelance work demands skills in QuarkXPress, Photoshop and Aldus FreeHand.
First Contact & Terms: Contact through artist's agent or send query letter with brochure showing art style. Samples are filed. Reports back only if interested. To show a portfolio, mail color and b&w tearsheets and photographs. Pays for production by the hour, $25-35. Pays for design by the hour, $75-150; or by the project, $500-2,000. Pays for illustration by the project, $250-3,000. Considers complexity of project, client's budget and turnaround time when establishing payment. Rights purchased vary according to project. Finds artists through agents, sourcebooks and sometimes by submissions.

BASIC/BEDELL ADVERTISING & PUBLISHING, 600 Ward Dr., Suite H, Box 30571, Santa Barbara CA 93130. (805)683-5857. President: C. Barrie Bedell. Specializes in advertisements, direct mail and how-to books and manuals. Clients: national and international newspapers, publishers, direct response marketers, retail stores, hard lines manufacturers, software developers and trade associations, plus extensive self-promotion of proprietary advertising how-to manuals.
● This company's president is seeing "a glut of 'graphic designers,' and an acute shortage of 'direct response' designers."
Needs: Uses artists for publication and direct mail design, book covers and dust jackets, and camera-ready computer desktop production. Also interested in hearing from professionals experienced in web commerce, and in converting printed training materials to electronic media.
First Contact & Terms: Especially wants to hear from publishing and "direct response" pros. Portfolio review not required. Pays for design by the project, $100-2,500 and up; pays for illustration by the project, $100 minimum. Considers client's budget, complexity of project, and skill and experience of artist when establishing payment.
Tips: "There has been a substantial increase in use of freelance talent and increasing need for true professionals with exceptional skills and responsible performance (delivery as promised and 'on target'). It is very difficult to locate freelance talent with expertise in design of advertising and direct mail with heavy use of type. If work is truly professional and freelancer is business-like, contact with personal letter and photocopy of one or more samples of work that needn't be returned."

THE BASS GROUP, Dept. AM, 102 Willow Ave., Fairfax CA 94930. (415)455-8090. Producer: Herbert Bass. Number of employees: 2. Approximate annual billing: $300,000. "A multimedia, full-service production company providing corporate communications to a wide range of clients. Specializes in multimedia presentations, video/film, and events productions for corporations."
Needs: Approached by 30 freelancers/year. Works with a variety of freelance illustrators and designers/year. Prefers solid experience in multimedia and film/video production. Works on assignment only. Uses freelancers for logos, charts/graphs and multimedia designs. Needs graphics, meeting theme logos, electronic speaker support and slide design. Needs computer-literate freelancers for design, illustration and production. 90% of freelance work demands skills in QuarkXPress, Aldus FreeHand, Adobe Illustrator and Photoshop.
First Contact & Terms: Send résumé and slides. Samples are filed and are not returned. Reports back within 1 month if interested. Will contact artist for portfolio review if interested. Sometimes requests work on spec before assigning a job. Pays by the project. Considers turnaround time, skill and experience of artist and how work will be used when establishing payment. Rights purchased vary according to project. Finds illustrators and designers mainly through word-of-mouth recommendations.
Tips: "Send résumé, samples, rates. Highlight examples in speaker support—both slide and electronic media—and include meeting logo design."

BERSON, DEAN, STEVENS, 210 High Meadow St., Wood Ranch CA 93065. (818)713-0134. Fax: (818)713-0417. Owner: Lori Berson. Estab. 1981. Specializes in annual reports, brand and corporate identity and display, direct mail, trade show booths, promotions, websites, package and publication design. Clients: manufacturers, ad agencies, corporations and movie studios. Professional affiliation: L.A. Ad Club.
Needs: Approached by 50 freelancers/year. Works with 10-20 illustrators and 5 designers/year. Works on assignment only. Uses illustrators mainly for brochures, packaging and comps. Also for catalog, P-O-P, ad and poster illustration, mechanicals retouching, airbrushing, lettering, logos and model making. 90% of freelance work demands skills in Aldus PageMaker, Adobe Illustrator, QuarkXPress, Adobe Photoshop and Aldus FreeHand, as well as web authoring/HTML, CGI, Java, etc.

First Contact & Terms: Send query letter with tearsheets and photocopies. Samples are filed. Will contact artist for portfolio review if interested. Pays for design and illustration by the project. Rights purchased vary according to project. Considers buying second rights (reprint rights) to previously published work. Finds artists through word of mouth, submissions/self-promotions, sourcebooks and agents.

BRAINWORKS DESIGN GROUP, INC., 2 Harris Court, #A7, Monterey CA 93940. (408)657-0650. Fax: (408)657-0750. E-mail: brainwks@mbay.net. Website: http://www.brainwks.com. Art Director: Al Kahn. Vice President Marketing: Michele Strub. Estab. 1970. Number of employees: 6. Specializes in ERC (Emotional Response Communications), graphic design, corporate identity, direct mail and publication. Clients: colleges, universities, nonprofit organizations; majority are colleges and universities. Current clients include Rutgers University, City University (New York), Hunter College, Baruch College, University of Scranton, Eastern Arizona University, Xavier University and Cal State University. Client list available upon request.
Needs: Approached by 100 freelancers/year. Works with 4 freelance illustrators and 10 designers/year. Prefers freelancers with experience in type, layout, grids, mechanicals, comps and creative visual thinking. Works on assignment only. Uses freelancers mainly for mechanicals and calligraphy. Also for brochure, direct mail and poster design; mechanicals; lettering; and logos. 100% of design work demands knowledge of Aldus PageMaker, QuarkXPress, Aldus FreeHand and Adobe Photoshop.
First Contact & Terms: Send brochure or résumé, photocopies, photographs, tearsheets and transparencies. Samples are filed. Artist should follow up with call and/or letter after initial query. Will contact artist for portfolio review if interested. Portfolio should include thumbnails, roughs, final reproduction/product and b&w and color tearsheets, photostats, photographs and transparencies. Pays for design by the project, $200-2,000. Considers complexity of project and client's budget when establishing payment. Rights purchased vary according to project. Finds artists through sourcebooks and self-promotions.
Tips: "Creative thinking and a positive attitude are a plus." The most common mistake freelancers make in presenting samples or portfolios is that the "work does not match up to the samples they show." Would like to see more roughs and thumbnails.

[N] JANN CHURCH PARTNERS ADVERTISING & GRAPHIC DESIGN, INC., P.O. Box 9527, Newport Beach CA 92660. (949)640-6224. Fax: (949)640-1706. President: Jann Church. Estab. 1970. Specializes in annual reports, brand and corporate identity, display, interior, direct mail, package and publication design, and signage. Clients: real estate developers, medical/high technology corporations, private and public companies. Current clients include The Nichols Institute, The Anden Group, Institute for Biological Research & Development, Universal Care, Inc., Alton Industries, The J. David Gladstone Institutes, Transportation Corridor Agencies and Datatape Incorporated, a Kodak company. Client list available upon request.
Needs: Approached by 100 freelance artists/year. Works with 3 illustrators and 5 designers/year. Works on assignment only. Uses designers and illustrators for all work. Needs technical illustration. 10% of freelance work demands computer literacy.
First Contact & Terms: Send query letter with résumé, photographs and photocopies. Samples are filed. Reports back only if interested. To show a portfolio, mail appropriate materials. Portfolio should be "as complete as possible." Pays for design and illustration by the project. Rights purchased vary according to project.

[✓] CLIFF & ASSOCIATES, 715 Fremont Ave., South Pasadena CA 91030. (626)799-5906. Fax: (626)799-9809. E-mail: cliffassoc@aol.com. Owner: Greg Cliff. Estab. 1984. Number of employees: 10. Approximate annual billing: $1 million. Specializes in annual reports, corporate identity, direct mail and publication design and signage. Clients: Fortune 500 corporations and performing arts companies. Current clients include ARCO, Nissan, Southern California Gas Co. and Kaiser Permanente.
Needs: Approached by 50 freelancers/year. Works with 10 freelance illustrators and 10 designers/year. Prefers local freelancers and Art Center graduates. Uses freelancers mainly for brochures. Also for technical, "fresh" editorial and medical illustration; mechanicals; lettering; logos; catalog, book and magazine design; P-O-P and poster design and illustration; and model making. Needs computer-literate freelancers for design and production. 90% of freelance work demands knowledge of QuarkXPress, Aldus FreeHand, Adobe Illustrator, Photoshop, etc.
First Contact & Terms: Send query letter with résumé and a non-returnable sample of work. Samples are filed. Art director will contact artist for portfolio review if interested. Portfolio should include thumbnails, b&w photostats and printed samples. Pays for design by the hour, $22-30. Pays for illustration by the project, $50-3,000. Buys one-time rights. Finds artists through sourcebooks.

[N] COAKLEY HEAGERTY ADVERTISING & PUBLIC RELATIONS, 1155 N. First St., Suite 201, San Jose CA 95112-4925. (408)275-9400. Fax: (408)995-0600. E-mail: chcre8ad@hooked.net. Vice President and Creative Director: Elissa Morrash. Art Director: J. D. Keser. Estab. 1961. Number of employees: 17. Approximate annual billing: $300 million. Full-service ad agency. Clients: consumer, senior care, banking/financial, insurance, automotive, real estate, public service. Client list available upon request. Professional affiliation: MAAN (Mutual Advertising Agency Network).
Needs: Approached by 100 freelancers/year. Works with 50 freelance illustrators and 3 designers/year. Works on assignment only. Uses freelancers for illustration, retouching, animation, lettering, logos and charts/graphs. Freelance work demands skills in Adobe Illustrator, Photoshop or QuarkXPress.

First Contact & Terms: Send query letter with brochure showing art style or résumé, slides and photographs. Samples are filed or are returned by SASE. Does not report back. Call for an appointment to show portfolio. Pays for design and illustration by the project, $600-5,000.

DENTON DESIGN ASSOCIATES, 491 Arbor St., Pasadena CA 91105. (818)792-7141. President: Margi Denton. Estab. 1975. Specializes in annual reports, corporate identity and publication design. Clients: nonprofit organizations and corporations. Current clients include California Institute of Technology, Huntington Memorial Hospital and University of Southern California.
Needs: Approached by 12 freelance graphic artists/year. Works with roughly 5 freelance illustrators and 4 freelance designers/year. Prefers local designers only. "We work with illustrators from anywhere." Works on assignment only. Uses designers and illustrators for brochure design and illustration, lettering, logos and charts/graphs. 100% of design work demands knowledge of QuarkXPress, Adobe Photoshop and Adobe Illustrator.
First Contact & Terms: Send résumé, tearsheets and samples (illustrators just send samples). Samples are filed and are not returned. Reports back to the artist only if interested. Art director will contact artist for portfolio review if interested. Portfolio should include color samples "doesn't matter what form." Pays for design by the hour, $20-25. Pays for illustration by the project, $250-6,500. Rights purchased vary according to project. Finds artists through sourcebooks, AIGA, *Print* and *CA*.

DESIGN AXIOM, 50 B, Peninsula Center Dr., 156, Rolling Hills Estates CA 90274. (310)377-0207. E-mail: tschorer@aol.com. President: Thomas Schorer. Estab. 1973. Specializes in graphic, environmental and architectural design, product development and signage.
Needs: Approached by 100 freelancers/year. Works with 5 freelance illustrators and 10 designers/year. Works on assignment only. Uses designers for all types of design. Uses illustrators for editorial and technical illustration. 50% of freelance work demands knowledge of Aldus PageMaker or QuarkXPress.
First Contact & Terms: Send query letter with appropriate samples. Will contact artist for portfolio review if interested. Portfolio should include appropriate samples. Pays for design and illustration by the project. Finds artists through word of mouth, self-promotions, sourcebooks and colleges.

N DIMON CREATIVE COMMUNICATION SERVICES, 3515 W. Pacific Ave., Burbank CA 91505. (818)845-3748. Fax: (818)954-8916. E-mail: dimon@earthlink.net. Creative Director: Georgia Graham. Number of employees: 12. Approximate annual billing: $2 million. Design/printing firm. Serves clients in industry, finance, real estate, healthcare and pharmaceutical.
Needs: Works with 3 freelance illustrators and 1 designer/year. 95% of freelance work demands skills in QuarkXPress, Adobe Illustrator and Adobe Photoshop. Needs freelancers experienced in multimedia, editorial, technical and medical illustration.
First Contact & Terms: Send query letter with tearsheets, finished art samples, photocopies and SASE. Provide brochure, flier, business card, résumé and tearsheets to be kept on file for future assignments. Accepts disk submissions. Send EPS, TIFF or PICT files. Portfolio should include comps. Pays for design by the hour, $20-35. Pays for illustration by the project, $150 minimum.
Tips: "We have cut staff so we rely more on freelancers to fill in the gaps when work load requires it."

N ERVIN ADVERTISING AND DESIGN, 16400 Pacific Coast Hwy., Suite 217, Huntington Beach CA 92649-1822. (310)598-3345. Fax: (310)430-3993. E-mail: mervin@ervinad.com. Website: http://www.ervinad.com. Estab. 1981. Specializes in annual reports, corporate identity and retail, direct mail, package and publication design. Clients: corporations, malls, financial firms, industrial firms and software publishers. Current clients include First American Financial, Certus Corporation, Toyota Certified, Ropak Corporation. Client list available upon request.
Needs: Approached by 100 freelancers/year. Works with 10 freelance illustrators and 6 designers/year. Works on assignment only. Uses illustrators mainly for package designs, annual reports. Uses designers, mainly for annual reports, special projects. Also uses freelancers for brochure design and illustration, P-O-P and ad illustration, mechanicals, audiovisual materials, lettering and charts/graphs. Needs computer-literate freelancers for production. 100% of freelance work demands knowledge of QuarkXPress or Adobe Photoshop.
First Contact & Terms: Send résumé and photocopies. Samples are filed and are not returned. Reports back to the artist only if interested. Request portfolio review in original query. Portfolio should include color roughs, tearsheets and transparencies. Pays for design by the hour, $15-30; by the project (rate varies); by the day, $120-240. Pays for illustration by the project (rate varies). Buys all rights.
Tips: Finds artists through sourcebooks, submitted résumés, mailings.

N ☥ ESSANEE UNLIMITED, INC., 710 Pier Ave., Santa Monica CA 90405. (310)396-0192. Fax: (310)392-4673. Art Director: Sharon Rubin. Estab. 1982. Integrated marketing communications agency/design firm. Specializes in packaging and promotion. Product specialties are film, TV, video, CD-ROM, consumer product. Current clients include NewLine Pictures, M&M Mars.
Needs: Works with 3-5 freelance illustrators and 3-5 designers/year. Prefers local freelancers with experience in graphic design. Also for brochure and web page design, mechanicals, multimedia projects. 20% of work is with print ads. 100% of design and some illustration demands skills in Adobe Photoshop, QuarkXPress.
First Contact & Terms: Send query letter with photocopies, photographs, résumé, SASE and slides. Accepts disk

submissions compatible with QuarkXPress 7.5/version 3.3. Samples are filed or returned by SASE. Reports back within 2 weeks. Portfolio review required only if interested in artist's work. Artist should follow-up with call. Finds artists through word of mouth, submissions.

☑ **EVENSON DESIGN GROUP**, 4445 Overland Ave., Culver City CA 90230. (310)204-1995. Fax: (310)204-4879. E-mail: edgmail@evensondesign.com. Website: http://evensondesign.com. Production Manager: Marnie Brown. Estab. 1976. Specializes in annual reports, brand and corporate identity, display design, direct mail, package design and signage. Clients: ad agencies, hospitals, corporations, law firms, entertainment companies, record companies, publications, PR firms. Current clients include Warner Bros., The Disney Channel, Mattel Toys, Twentieth Century Fox, MCA/Universal, Price Waterhouse and DayRunner.

Needs: Approached by 75-100 freelance artists/year. Works with 10 illustrators and 15 designers/year. Prefers artists with production experience as well as strong design capabilities. Works on assignment only. Uses illustrators mainly for covers for corporate brochures. Uses designers mainly for logo design, page layouts, all overflow work. Also for brochure, catalog, direct mail, ad, P-O-P and poster design and illustration, mechanicals, lettering, logos and charts/graphs. 100% of design work demands skills in QuarkXPress, Aldus FreeHand, Adobe Photoshop or Adobe Illustrator.

First Contact & Terms: Send query letter with résumé. Also has drop-off policy. Samples are filed. Returned by SASE if requested. Reports back to the artist only if interested. Portfolio should include b&w and color photostats and tearsheets and 4×5 or larger transparencies. All work must be printed or fabricated in form of tearsheets, transparencies or actual piece. Pays for design by the hour, $20-35. Rights purchased vary according to project.

Tips: "Be efficient in the execution of design work, producing quality designs over the quantity of designs. Professionalism, as well as a good sense of humor, will prove you to be a favorable addition to any design team."

☑ **FREEASSOCIATES**, 2800 28th St., Suite 305, Santa Monica CA 90405. (310)399-2340. Fax: (310)399-4030. E-mail: jfreeman@freeassoc.com. President: Josh Freeman. Estab. 1974. Number of employees: 4. Design firm. Specializes in marketing materials for corporate clients. Client list available upon request. Professional affiliations: AIGA.

Needs: Approached by 50 illustrators and 20 designers/year. Works with 15 illustrators and 5 designers/year. Prefers freelancers with experience in top level design and advertising. Uses freelancers mainly for design, production, illustration. Also for airbrushing, brochure design and illustration, catalog design and illustration, humorous illustration, lettering, logos, mechanicals, multimedia projects, posters, retouching, signage, storyboards, technical illustration and web page design. 10% of work is with print ads. 90% of design and 50% of illustration demand skills in Aldus PageMaker, Adobe Photoshop, QuarkXPress, Adobe Illustrator.

First Contact & Terms: Designers send query letter with photocopies, photographs, résumé, tearsheets and transparencies. Illustrators send postcard sample of work and/or photographs and tearsheets. Accepts Mac compatible disk submissions to view in current version of major software or self-running presentations. CD-ROM OK. Samples are filed or returned by SASE. Will contact for portfolio review if interested. Pays for design and illustration by the project; negotiable. Rights purchased vary according to project. Finds artists through *LA Workbook, CA, Print. Graphis*, submissions and samples.

Tips: Designers should have their own computer modem. Must have sensitivity to marketing requirements of projects they work on. Deadline commitments are critical.

DENNIS GILLASPY DESIGN/BRANDON TAYLOR DESIGN, 6305 Lusk Blvd., Suite 100, San Diego CA 92121-2752. (619)623-9084. Fax: (619)452-6970. Owner: Dennis Gillaspy. Estab. 1977. Specializes in corporate identity, displays, direct mail, package and publication design and signage. Clients: corporations and manufacturers. Client list available upon request.

Needs: Approached by 20 freelance artists/year. Works with 15 freelance illustrators and 10 freelance designers/year. Prefers local artists. Works on assignment only. Uses freelance illustrators mainly for technical and instructional spots. Uses freelance designers mainly for logo design, books and ad layouts. Also uses freelance artists for brochure, catalog, ad, P-O-P and poster design and illustration, retouching, airbrushing, logos, direct mail design and charts/graphs.

First Contact & Terms: Send query letter with brochure, résumé, photocopies and photostats. Samples are filed. Reports back within 2 weeks. Write to schedule an appointment to show a portfolio or mail thumbnails, roughs, photostats, tearsheets, comps and printed samples. Pays for design by the assignment. Pays for illustration by the project, $400-1,500. Rights purchased vary according to project.

GRAFF ADVERTISING INC., 200 Twin Dolphin Dr. #F, Redwood City CA 94065-1402. (415)637-8200. Fax: (415)637-8311. E-mail: graffad@graffad.com. Website: http://www.graffad.com. Creative Director: Steve Graff. Ad agency. Full-service, multimedia firm. Product specialties are science and medicine, industrial. Current clients include Fuji Medical, Skyway Inc., California Emergency Physicians, Med America, Panasonic Interactive Media and J.H. Baxter. Client list available upon request.

Needs: Approached by 6-10 freelance artists/month. Works with 1-2 freelance illustrators and 2-3 freelance designers/month. Prefers local artists proficient in electronic production. Works on assignment only. Uses freelance artists mainly for concept through final. Also uses freelance artists for brochure, catalog and print ad design and illustration and storyboards, mechanicals, retouching, model making, billboards, posters, TV/film graphics and logos. 50% of work is with print ads. Needs computer-literate freelancers for design, illustration and production. 90% of freelance work demands knowledge of Adobe Illustrator, QuarkXPress, Adobe Photoshop and/or Aldus FreeHand.

First Contact & Terms: Send query letter with résumé and examples of work. Samples are filed or returned by SASE

if requested. Does not report back. Artist should follow-up with call. Portfolio should include thumbnails, roughs and final art. Pays for design and illustration by the project. Rights purchased vary according to project.

GRAFICA DESIGN SERVICE, 7053 Owensmouth Ave., Canoga Park CA 91303. (818)712-0071. Fax: (818)348-7582. E-mail: graficaeps@aol.com. Website: http://www.grafica.com. Designer: Larry Girardi. Estab. 1974. Specializes in corporate identity, package and publication design, signage and technical illustration. Clients: ad agencies, corporations, government and medium- to large-size businesses; majority are high-tech.

Needs: Approached by 25-50 freelance artists/year. Works with 5-10 freelance illustrators and designers/year. Prefers local artists and artists with experience in airbrush and Macintosh computer graphics. Works on assignment only. Uses illustrators mainly for technical, medical and airbrush illustration. Uses designers mainly for design-layout/thumbnails and comps. Also uses artists for brochure design and illustration, catalog design and illustration, mechanicals, retouching, airbrushing, lettering, logos, ad design and illustration, P-O-P illustration, charts/graphs and production. Needs computer-literate freelancers for illustration and production. 90% of freelance work demands computer literacy in QuarkXPress, Adobe Illustrator, Photoshop.

First Contact & Terms: Send query letter with brochure, résumé, SASE, tearsheets, photographs, photocopies, photostats and slides. Samples are filed or are returned by SASE if requested. Reports back only if interested. To show a portfolio, mail thumbnails, roughs, b&w and color photostats, tearsheets, photographs, slides and transparencies. Pays for design by the hour, $10-50; or by the project, $75-5,000. Pays for illustration by the hour, $10-50; or by the project, $50-5,000. "Payment is based on complexity of project, budget and the experience of the artist." Rights purchased vary according to project.

Tips: " 'Doing is honest philosophy.' Get the projects and do as much work as you can. Experience is much more important than money. If your work is good, money will follow. Enjoy what you do and enjoy the people you work with. Too many creatives want to work in an ivory tower. Much like life, being able to adapt to change and transform challenges into success is what happy and fulfilling work is all about."

GRAPHIC DATA, 5111 Mission Blvd., P.O. Box 99991, San Diego CA 92169. Phone/fax: (619)274-4511 (call first before faxing). President: Carl Gerle. Estab. 1971. Number of employees: 3. Specializes in industrial design. Clients: industrial and publishing companies. Client list available upon request. Professional affiliations: IEEE, AGM, NCGA.

Needs: Works with 6 sculptors, 3 freelance illustrators and 3 designers/year. Needs sculptors and designers for miniature figurines. 60% of freelance work demands computer skills.

First Contact & Terms: Send query letter with brochure, résumé or photostats. Samples are returned if SASE included. Sometimes requests work on spec before assigning a job. Pays for design and sculpture by the project, $100-1,000 plus royalties. Rights purchased vary according to project.

Tips: "Know the fundamentals behind your craft. Be passionate about your work; care how it is used. Be professional and business-like."

N ✦ HARTUNG & ASSOCIATES, LTD., 10279 Field Lane, Forestville CA 95436. (707)887-2825. Fax: (707)887-1214. President: Tim Hartung. Estab. 1976. Specializes in display, direct mail, package and publication design and corporate identity and signage. Clients: corporations. Current clients include Zacson, Crown Transportation, Exigent, Intelegy Corp., McCusker Computer, Client list available upon request.

Needs: Approached by 20 freelance graphic artists/year. Works with 5 freelance illustrators and 1 freelance designer/year. Prefers local artists "if possible." Works on assignment only. Uses illustrators and designers mainly for brochures. Also uses freelance artists for brochure and package design and illustration, direct mail design, P-O-P illustration and design, mechanicals, retouching, airbrushing, audiovisual materials, lettering, logos and charts/graphs. 50% of freelance work demands skills in QuarkXPress or Adobe Illustrator.

First Contact & Terms: Send query letter with brochure, tearsheets and résumé. Samples are filed. Does not report back. Artist should follow up with call. Portfolio should include b&w and color thumbnails, roughs, final art, photostats and tearsheets. Pays for design by the hour or by the project. Pays for illustration by the project. "Rate depends on size, detail, etc. of project." Buys all rights. Finds artists through sourcebooks and artists' submissions.

KVCR-TV RADIO, 701 S. Mount Vernon Ave., San Bernardino CA 92410. (909)888-6511. General Manager: Lew Warren. Number of employees: 26. Specializes in public and educational radio/TV.

Needs: Approached by 1 freelancer/year. Assigns 1-10 jobs/year. Uses freelancers for graphic/set design and set design painting.

First Contact & Terms: Query and mail photos. Reports in 2 weeks. Samples returned by SASE.

✓ ✦ LEKASMILLER, 1460 Maria Lane, Suite 260, Walnut Creek CA 94596. (925)934-3971. Fax: (925)934-3978. E-mail: ali@lekasmiller.com. Production Manager: Ali Gencarelle. Estab. 1979. Specializes in annual reports, corporate identity, advertising, direct mail and brochure design. Clients: corporate and retail. Current clients include CivicBank of Commerce, Tosco Refining Co., Chevron USA, Interhealth and Cybercash.

Needs: Approached by 80 freelance artists/year. Works with 1-3 illustrators and 5-7 designers/year. Prefers local artists only with experience in design and production. Works on assignment only. Uses artists for brochure design and illustration, mechanicals, direct mail design, logos, ad design and illustration. 100% of freelance work demands knowledge of QuarkXPress, Adobe Photoshop and Adobe Illustrator.

First Contact & Terms: Designers send résumé. Illustrators send postcard samples. Samples are filed or are returned

"Our client wanted to speak about his project method-ology," says Ali M. Gencarelle of LekasMiller Design. "Our goal for this project was to break up the speech with light-hearted visuals that would illustrate his key points using a fun concept. We chose gardening as an example." Robin C. Awes was the designer of the project. She has a long-standing freelance and staff connection to the firm. "Robin is an incredible designer. Lekas-Miller takes incredible pride in the quality of the work that generates from our shop. We have the ability to take a project from concept to final product."

if accompanied by SASE. Reports back only if interested. To show a portfolio, mail thumbnails, roughs, final reproduction/product, tearsheets and transparencies. Considers skill and experience of artist when establishing payment. Negotiates rights purchased.

N THE LEPREVOST CORPORATION, 6781 Wildlife Rd., Malibu CA 90265. (310)457-3742. President: John LePrevost. Specializes in corporate identity, television and film design. Current clients include: NBC News, NBC Television, The Nashville Network.
Needs: Approached by 30 freelance artists/year. Works with 10 designers/year. Prefers "talented and professional" artists only. Works on assignment only. Uses freelancers for animation and film design and illustration, lettering and logo design. Animation and design becoming more sophisticated. Needs storyboards. Needs computer-literate freelancers for design, illustration and animation. 95% of freelance work demands skills in Adobe Illustrator, Photoshop or Electric Image.
First Contact & Terms: Call for appointment. Samples not returned. Provide information to be kept on file for possible future assignments; reports back. Payment for design by the project. Considers complexity of project, client's budget, skill and experience of artist, how work will be used, turnaround time and rights purchased when establishing payment.

LINEAR CYCLE PRODUCTIONS, P.O. Box 2608, San Fernando CA 91393-0608. Producer: Rich Brown. Production Manager: R. Borowy. Estab. 1980. Number of employees: 30. Approximate annual billing: $200,000. AV firm. Specializes in audiovisual sales and marketing programs and also in teleproduction for CATV. Current clients include Katz, Inc. and McDave and Associates.
Needs: Works with 7-10 freelance illustrators and 7-10 designers/year. Prefers freelancers with experience in teleproductions (broadcast/CATV/non-broadcast). Works on assignment only. Uses freelancers for storyboards, animation, TV/film graphics, editorial illustration, lettering and logos. 10% of work is with print ads. 25% of freelance work demands knowledge of Aldus FreeHand, Adobe Photoshop or Tobis IV.
First Contact & Terms: Send query letter with résumé, photocopies, photographs, slides, transparencies, video demo reel and SASE. Samples are filed or are returned by SASE if requested by artist. Reports back to the artist only if interested. To show portfolio, mail audio/videotapes, photographs and slides; include color and b&w samples. Pays for design and illustration by the project, $100 minimum. Considers skill and experience of artist, how work will be used and rights purchased when establishing payment. Negotiates rights purchased. Finds artists through reviewing portfolios and published material.
Tips: "We see a lot of sloppy work and samples, portfolios in fields not requested or wanted, poor photos, photocopies, graphics, etc. Make sure your materials are presentable."

JACK LUCEY/ART & DESIGN, 84 Crestwood Dr., San Rafael CA 94901. (415)453-3172. Contact: Jack Lucey. Estab. 1960. Art agency. Specializes in annual reports, brand and corporate identity, publications, signage, technical illustration and illustrations/cover designs. Clients: businesses, ad agencies and book publishers. Current clients include U.S. Air Force, TWA Airlines, California Museum of Art & Industry, CNN, NBC Television News, Lee Books, High Noon Books. Client list available upon request. Professional affiliations: Art Directors Club, Academy of Art Alumni.
 ● Recent assignments include courtroom artist work for CNN, ABC News, NBC News, criminal and civil trials such as that for "unabomber" Ted Kacynski. Also completed assignments with Associated Press for print media.
Needs: Approached by 20 freelancers/year. Works with 1-2 freelance illustrators/year. Uses mostly local freelancers. Uses freelancers mainly for type and airbrush. Also for lettering for newspaper work.
First Contact & Terms: Query. Prefers photostats and published work as samples. Provide brochures, business card and résumé to be kept on file. Portfolio review not required. Originals are not returned to artist at job's completion. Requests work on spec before assigning a job. Pays for design by the project.
Tips: "Show variety in your work. Many samples I see are too specialized in one subject, one technique, one style (such as air brush only, pen & ink only, etc.). Subjects are often all similar too."

MARKETING BY DESIGN, 2012 19th St., Suite 200, Sacramento CA 95818. (916)441-3050. Creative Director: Joel Stinghen. Estab. 1977. Specializes in corporate identity and brochure design, publications, direct mail, trade show, signage, display and packaging. Client: associations and corporations. Client list not available.
Needs: Approached by 50 freelance artists/year. Works with 6-7 freelance illustrators and 1-3 freelance designers/year. Works on assignment only. Uses illustrators mainly for editorial. Also uses freelance artists for brochure and catalog design and illustration, mechanicals, retouching, lettering, ad design and charts/graphs.
First Contact & Terms: Send query letter with brochure, résumé, tearsheets. Samples are filed or are not returned. Does not report back. Artist should follow up with call. Call for appointment to show portfolio of roughs, b&w photostats, color tearsheets, transparencies and photographs. Pays for design by the hour, $10-30; by the project, $50-5,000. Pays for illustration by the project, $50-4,500. Rights purchased vary according to project. Finds designers through word of mouth; illustrators through sourcebooks.

SUDI MCCOLLUM DESIGN, 3244 Cornwall Dr., Glendale CA 91206. (818)243-1345. Fax: (818)243-1345. Contact: Sudi McCollum. Specializes in product design and illustration. Majority of clients are medium-to large-size businesses. "No specialty in any one industry." Clients: home furnishing and giftware manufacturers, ad agencies, design studios.
Needs: Use freelance production people—either on computer or with painting and product design stills. Potential to

develop into full-time job.

First Contact & Terms: Send query letter "with whatever you have that's convenient." Samples are filed. Reports back only if interested.

[N] MOLLY DESIGNS, 18291 Gothard St., #103, Huntington Beach CA 92648. (714)841-1888. Fax: (714)841-5608. E-mail: mollydesigns@earthlink.net. Owner: Molly. Estab. 1972. Number of employees: 12. Approximate annual billing: $1 million. Specializes in corporate identity, signage and automotive graphics. Clients: corporations, ad agencies, PR firms, small companies. Current clients include Toyota Motor Sales, Buick, Chevy, TRD, Yamaha, Kawasaki.

Needs: Approached by 6-8 freelancers/year. Works with 3-4 freelance illustrators and 3-4 designers/year. Prefers freelancers with experience in the automotive field. Works on assignment only. Uses freelance illustrators mainly for presentations. Uses freelance designers mainly for graphic design. Also uses freelancers for brochure design, mechanicals, lettering, logos, P-O-P design and illustration and direct mail design. Needs computer-literate freelancers for illustration and presentation. 60% of freelance work demands knowledge of Adobe Illustrator and QuarkXPress.

First Contact & Terms: Send query letter with photographs. Samples are filed. Reports back within 2 weeks. Call for appointment to show portfolio of thumbnails, roughs, original/final art and photographs. Pays for design and illustration by the project, $100 minimum. Rights purchased vary according to project.

[N] [■] ON-Q PRODUCTIONS, INC., 618 E. Gutierrez St., Santa Barbara CA 93103. (805)963-1331. President: Vincent Quaranta. AV firm. "We are producers of multi-projector slide presentations and websites. We produce computer-generated slides for business presentations and interactive presentations on CD-ROM." Clients: banks, ad agencies, R&D firms and hospitals.

Needs: Works with 10 freelancers/year. Uses freelancers mainly for slide presentations. Also for editorial and medical illustration, retouching, animation, web design and programming, and lettering. 75% of freelance work demands skills in QuarkXPress, Aldus FreeHand Photoshop or Aldus Persuasion.

First Contact & Terms: Send query letter with brochure or résumé. Reports back only if interested. Write for appointment to show portfolio of original/final art and slides. Pays for design and illustration by the hour, $25 minimum; or by the project, $100 minimum.

Tips: "Artist must be *experienced* in computer graphics and on the board. The most common mistakes freelancers make are poor presentation of a portfolio (small pieces fall out, scratches on cover acetate) and they do not know how to price out a job. Know the rates you're going to charge and how quickly you can deliver a job. Client budgets are tight."

[N] [T] POWERS DESIGN INTERNATIONAL, A Division of Creative Powers, Inc., 828 Production Place, Newport Beach CA 92663. (949)645-2265. Fax: (949)645-9947. Vice President: John Lewis. Estab. 1978. Specializes in corporate identity; displays; and landscape, interior, package and transportation design. Clients: large corporations. Current clients include Paccar Inc., McDonnell Douglas, Ford Motor Co. and GM. Client list available upon request.

Needs: Works with varying number of freelance illustrators and 5-10 freelance designers/year. Prefers local artists only with experience in transportation design (such as those from Art Center College of Design), or with "SYD MEAD" type abilities. Works on assignment only. Uses freelance designers and illustrators for brochure, ad and catalog design, lettering, logos, model making and Alias Computer Cad-Cam 16 abilities.

First Contact & Terms: Send query letter with résumé and appropriate samples. Samples are returned. Reports back to the artist only if interested. Call to schedule an appointment to show a portfolio, which should include best work and references. Pays for design and illustration by the project.

[N] PRISCOMM, 3183 Airway, Suite G, Costa Mesa CA 92626. (714)433-7400. Fax: (714)433-7306. E-mail: info@priscomm.com. Website: http://www.priscomm.com. Contact: Creative Director. Estab. 1987. Ad agency/PR firm. Full-service, multimedia firm. Specializes in print ads, interactive presentations, collateral, corporate magazines and newsletters. Product specialties are high-tech music and pro audio.

● This agency looks for designers who can carry a project from initial concept through production.

Needs: Approached by 1-2 freelancers/month. Works with 2-3 illustrators and 2-3 designers/month. Prefers local freelancers with 3 years experience in Macintosh computers. Uses freelancers mainly for design and production. Also for brochures and logos. 70% of work is with print ads. Needs computer-literate freelancers with knowledge of Aldus PageMaker, Adobe Illustrator, QuarkXPress, Photoshop, Aldus FreeHand, Macromind Director, Multimedia.

First Contact & Terms: Send query letter with photocopies, SASE, slides and transparencies. Samples are filed and are returned by SASE. Reports back to artist only if interested. Pays for design by the hour. Pays for illustration by the project. Buys all rights.

[T] DEBORAH RODNEY CREATIVE SERVICES, 1635 16th St., Santa Monica CA 90404. (310)450-9650. Fax: (310)450-9793. E-mail: darbo4@aol.com. Owner: Deborah Rodney. Estab. 1975. Number of employees: 1. Specializes in advertising design and collateral. Clients: ad agencies and direct clients. Current clients include Rely Staff Temporary Services, Fresh Print (division of Epson), Modern Design, Jewelry Manufacturers, California Casualty Insurance, Long Beach Memorial Medical Center.

Needs: Approached by 30 freelancers/year. Works with 6-10 freelance illustrators and 4-5 designers/year. Prefers local freelancers. Uses illustrators mainly for finished art and lettering. Uses designers mainly for logo design. Also uses freelancers for mechanicals, charts/graphs, ad design and illustration, Photoshop and web page design. Especially needs

freelancers with Photoshop and digital imaging expertise. 100% of design demands knowledge of QuarkXPress, Adobe Illustrator 7.0 or Adobe Photoshop. Needs production help.

First Contact & Terms: Designers send postcard sample or query letter with brochure, tearsheets and photocopies. Illustrators send postcard samples and tearsheets. Request portfolio review in original query. Portfolio should include final reproduction/product and tearsheets or "whatever best shows work." Accepts disk submissions compatible with Adobe Illustrator 7.0. Send EPS files. Pays for design by the hour, $25-50; by the project; by the day, $100 minimum. Pays for illustration by the project, $200-500; varies. Negotiates rights purchased. Considers buying second rights (reprint rights) to previously published work. Finds artists through sourcebooks and referrals.

Tips: "I do more concept and design work inhouse and hire out production and comps because it is faster, cheaper that way. For illustrators, it helps to be in sourcebooks such as *Workbook*, *Black Book*, *Showcase*, etc." Advice to freelancers who want to get work in advertising/design: "Offer a free trial of your services or offer to intern at an ad agency or design firm. Decide who you want to work for and design a campaign to get yourself hired."

RUBIN POSTAER & ASSOCIATES, Dept. AM, 1333 Second St., Santa Monica CA 90401. (310)917-2425. Manager, Art Services: Annie Ross. Ad agency. Serves clients in automobile and heavy equipment industries, savings and loans and cable television.

Needs: Works with about 24 freelance illustrators/year. Uses freelancers for all media.

First Contact & Terms: Contact manager of art services for appointment to show portfolio. Selection based on portfolio review. Negotiates payment.

Tips: Wants to see a variety of techniques.

EDGAR S. SPIZEL ADVERTISING INC., 2610 Torrey Pines Rd. C-31, La Jolla CA 92037. (415)474-5735. President: Edgar S. Spizel. AV producer. Clients: "Consumer-oriented from department stores to symphony orchestras, supermarkets, financial institutions, radio, TV stations, political organizations, hotels, real estate firms, developers and mass transit, such as BART." Works a great deal with major sports stars and TV personalities. Specializes in marketing to "over-50" age group.

Needs: Uses artists for posters, ad illustrations, brochures and mechanicals.

First Contact & Terms: Send query letter with tearsheets. Provide material to be kept on file for future assignments. No originals returned at job's completion.

N SPLANE DESIGN ASSOCIATES, 10850 White Oak Ave., Granada Hills CA 91344. (818)366-2069. Fax: (818)831-0114. President: Robson Splane. Specializes in product design. Clients: small, medium and large companies. Current clients include Hanson Research, Accurida Corp., Hewlett Packard, Sunrise Corp. Client list available upon request.

Needs: Approached by 25-30 freelancers/year. Works with 1-2 freelance illustrators and 6-12 designers/year. Works on assignment only. Uses illustrators mainly for logos, mailings to clients, renderings. Uses designers mainly for sourcing, drawings, prototyping, modeling. Also uses freelancers for brochure design and illustration, ad design, mechanicals, retouching, airbrushing, model making, lettering and logos. 75% of freelance work demands skills in Aldus FreeHand, Ashlar Vellum, Solidworks and Excel.

First Contact & Terms: Send query letter with résumé and photocopies. Samples are filed or are returned. Reports back to the artist only if interested. Will contact artist for portfolio review if interested. Portfolio should include color roughs, final art, photostats, slides and photographs. Pays for design and illustration by the hour, $7-25. Rights purchased vary according to project. Finds artists through submissions and contacts.

JULIA TAM DESIGN, 2216 Via La Brea, Palos Verdes CA 90274. (310)378-7583. Fax: (310)378-4589. E-mail: taandm888@earthlink.net. Contact: Julia Tam. Estab. 1986. Specializes in annual reports, corporate identity, brochures, promotional material, packaging and design. Clients: corporations. Current clients include Southern California Gas Co., *Los Angeles Times*, UCLA. Client list available upon request. Professional affiliations: AIGA.

• Julia Tam Design won several awards including an American Graphic Design Award, an award of distinction from *Creativity 26*, and inclusion in *American Corporate Identity/12* and *Best of Business Card Design 2*.

Needs: Approached by 10 freelancers/year. Works with 6-12 freelance illustrators 2 designers/year. "We look for special styles." Works on assignment only. Uses illustrators mainly for brochures. Also uses freelancers for brochure design and illustration; catalog and ad illustration; retouching; and lettering. 50-100% of freelance work demands knowledge of QuarkXPress, Adobe Illustrator or Adobe Photoshop.

First Contact & Terms: Designers send query letter with brochure and résumé. Illustrators send query letter with résumé and tearsheets. Samples are filed. Reports back to the artist only if interested. Artist should follow up. Portfolio should include b&w and color final art, tearsheets and transparencies. Pays for design by the hour, $10-20. Pays for illustration by the project. Negotiates rights purchased. Finds artists through *LA Workbook*.

THARP DID IT, 50 University Ave., Suite 21, Los Gatos CA 95030. (Also an office in Portland OR—Tharp and Drummond Did It). Art Director/Designer: Rick Tharp. Estab. 1975. Specializes in brand identity; corporate, non-corporate, and retail visual identity; packaging; and environmental graphic design. Clients: direct and through agencies. Current clients include BRIO Scanditoy (Sweden), Iván Támas Winery, Harmony Foods, Hooked on Phonics, Mirassou Vineyards, LeBoulanger Bakeries and Time-Warner. Professional affiliations: American Institute of Graphic Arts (AIGA), Society for Environmental Graphic Design (SEGD), Western Art Directors Club (WADC).

• Tharp Did It won a gold medal in the International Packaging Competition at the 30th Vinitaly in Verona, Italy, for a wine label design. Their posters for BRIO are in the Smithsonian Institution's National Design Museum archives.

Needs: Approached by 250-350 freelancers/year. Works with 5-10 freelance illustrators and 2 designers each year. Needs advertising/product, food and people illustration. Prefers local designers with experience. Works on assignment only. 80% of freelance design work demands computer skills.

First Contact & Terms: Send query letter with printed promotional material. Samples are filed or are returned by SASE. Will contact artist for portfolio review if interested. "No phone calls please. We'll call you." Pays for design by the project. Pays for illustration by the project, $100-10,000. Considers client's budget and how work will be used when establishing payment. Rights purchased vary according to project. Finds artists through awards annuals, sourcebooks, and submissions/self-promotions.

☒ ☷ TOLLNER DESIGN GROUP, 111 N. Market St., Suite 1020, San Jose CA 95113. (408)293-5300. Fax: (408)293-5389. President: Lisa Tollner. Estab. 1980. Specializes in corporate identity, direct mail, package design and collateral. Clients: ad agencies, high tech industry and corporations. Current clients include Hewlett Packard, CIDCO. Client list available upon request.

Needs: Approached by 50 freelance artists/year. Works with 15 freelance illustrators/year. Prefers local artists. Works on assignment only. Uses freelance illustrators for brochure, catalog, P-O-P, poster and ad illustration. Needs computer-literate freelancers for design. Freelancers should be familiar with Quark XPress or Adobe Illustrator.

First Contact & Terms: Send query letter with tearsheets, photographs, photocopies, photostats, slides and transparencies. Samples are filed. Request portfolio review in original query. Will contact artist for portfolio review if interested. Portfolio should include tearsheets, photographs, slides and transparencies. Pays for design and illustration by the project, $75-3,000. Rights purchased vary according to project. Considers buying second rights (reprint rights) to previously published work. Finds artists through self-promotions.

☷ TRIBOTTI DESIGNS, 22907 Bluebird Dr., Calabasas CA 91302-1832. (818)591-7720. Fax: (818)591-7910. E-mail: bob4149@aol.com. Contact: Robert Tribotti. Estab. 1970. Number of employees: 2. Approximate annual billing: $200,000. Specializes in graphic design, annual reports, corporate identity, packaging, publications and signage. Clients: PR firms, ad agencies, educational institutions and corporations. Current clients include city of Calabasas, JLS Capital, Inc., Professional Psychology Seminars, Inc.

Needs: Approached by 8-10 freelancers/year. Works with 2-3 freelance illustrators and 1-2 designers/year. Prefers local freelancers only. Works on assignment only. Uses freelancers mainly for brochure illustration. Also for catalogs, charts/graphs, lettering and ads. Prefers marker, pen & ink and computer illustration. 75% of freelance design and 50% of illustration demand knowledge of Adobe PageMaker, Adobe Illustrator, QuarkXPress, Adobe Photoshop, FreeHand. Needs editorial and technical illustration and illustration for annual reports/brochures.

First Contact & Terms: Send postcard sample or query letter with brochure, photocopies and résumé. Accepts submissions on disk compatible with PageMaker 6.0, Adobe Illustrator or Adobe Photoshop. Send EPS files. Will contact artist for portfolio review if interested. Portfolio should include thumbnails, roughs, original/final art, final reproduction/product and b&w and color tearsheets, photostats and photographs. Pays for design by the hour, $35-85. Pays for illustration by the project, $100-1,000. Rights purchased vary according to project. Finds artists through word of mouth and self-promotion mailings.

Tips: "We will consider experienced artists only. Must be able to meet deadlines. Send printed samples. We look for talent and a willingness to do a very good job."

☒ THE VAN NOY GROUP, Dept. AM, 19750 S. Vermont Ave., Suite 200, Torrance CA 90502. (310)329-0800. Fax: (310)538-1435. Vice President: Ann Van Noy. Estab. 1972. Specializes in package design, brand and corporate identity, displays and package design. Clients: corporations. Current clients include Gaetano Specialties, Leiner Health Products, Pentel of America and Hiram Walker. Client list available upon request.

Needs: Approached by 1-10 freelance artists/year. Works with 2 illustrators and 3 designers/year. Prefers artists with experience in Macintosh design. Works on assignment only. Uses freelancers for packaging design and illustration, Quark and Photoshop production and lettering.

First Contact & Terms: Send query letter with résumé and photographs. Samples are filed. Will contact artist for portfolio review if interested. If does not report back, artist should follow up. Pays for design by the hour, $25-100. Pays for illustration by the hour or by the project at a TBD fee. Finds artists through sourcebooks, self-promotions and primarily agents.

Tips: "I think more and more clients will be setting up internal art departments and relying less and less on outside designers and talent. The computer has made design accessible to the user who is not design-trained."

☷ VERIDICAL, LLC, (formerly Access, Inc.), 3118 Capobella, Aliso Viejo CA 92656-1959. (949)716-9900. E-mail: stevep@veridical.com. Website: http://www.veridical.com. Chief Technology Officer: Steven Zellers. Art Director: Steve Pollack. Estab. 1995. Number of employees: 7. Approximate annual billing: $2 million. Visual agency. Specializes in architecture, real estate, computer gaming, urban planning. Need people with strong spatial design skills, modeling and ability to work with computer graphics. Current clients include Creative Balloons, Johnson Controls, Opus, Koll Development.

• Access Inc. was sold in 1998. Veridical opened a development facility at TIC Center in Iowa City, IA and shifted focus to visual projects for architecture.

Needs: Approached by 15 freelance illustrators and 5 designers/year. Works with 6 freelance illustrators and 20 designers/year. Prefers local designers with experience in architecture, technology. Uses freelancers mainly for concept, work in process computer modeling. Also for animation, brochure design, mechanicals, multimedia projects, retouching, technical illustration, TV/film graphics. 70% of work is with print ads. 100% of design and 30% of illustration demand skills in Photoshop, 3D Studio Max, Multigen, SGI, URML.

First Contact & Terms: Designers send query letter or e-mail with samples. Illustrators send postcard sample and/ or query letter with photocopies. Accepts disk submissions. Samples are filed or returned by SASE. Will contact for portfolio review if interested. Pays for design by the hour, $15-75. Pays for illustration by the project, $100-2,500. Rights purchased vary according to project. Finds artists through Internet, AIGA.

Tips: "Be innovative, push the creativity, understand the business rationale and accept technology."

N VIDEO RESOURCES, Box 18642, Irvine CA 92623. (949)261-7266. E-mail: brad@videoresouces.com. Producer: Brad Hagen. Number of employees: 7. Video and multimedia firm. Specializes in automotive, banks, restaurants, computer, health care, transportation and energy.

Needs: Approached by 10-20 freelancers/year. Works with 5-10 freelance illustrators and 5-10 designers/year. Works on assignment only. Uses freelancers for graphics, multimedia, animation, etc.

First Contact & Terms: Send query letter with brochure showing art style or résumé, business card, photostats and tearsheets to be kept on file. Samples not filed are returned by SASE. Considers complexity of the project and client's budget when establishing payment. Buys all rights.

VISUAL AID/VISAID MARKETING, Box 4502, Inglewood CA 90309. (310)399-0696. Manager: Lee Clapp. Estab. 1961. Number of employees: 3. Distributor of promotion aids, marketing consultant service, "involved in all phases." Specializes in manufacturers, distributors, publishers and graphics firms (printing and promotion) in 23 SIC code areas.

Needs: Approached by 25-50 freelancers/year. Works with 1-2 freelance illustrators and 6-12 designers/year. Uses freelancers for advertising, brochure and catalog design, illustration and layout; product design; illustration on product; P-O-P display; display fixture design; and posters. Buys some cartoons and humorous cartoon-style illustrations. Additional media: fiber optics, display/signage, design/fabrication.

First Contact & Terms: Works on assignment only. Send postcard sample or query letter with brochure, photostats, duplicate photographs, photocopies and tearsheets to be kept on file. Reports back if interested and has assignment. Write for appointment to show portfolio. Pays for design by the hour, $5-75. Pays for illustration by the project, $100-500. Considers skill and experience of artist and turnaround time when establishing payment.

Tips: "Do not say 'I can do anything.' We want to know the best media you work in (pen & ink, line drawing, illustration, layout, etc.)."

N W WESCO GRAPHICS, INC., 410 E. Grant Line Rd., #B, Tracy CA 95376. (209)832-1000. Fax: (209)832-7800. Art Director: Dawn Hill. Estab. 1977. Number of employees: 20. Service-related firm. Specializes in design, layout, typesetting, paste-up, ads and brochures. Clients: retailers. Current clients include Ben Franklin Crafts, Food 4 Less, Auto Deals.

Needs: Approached by 10 freelancers/year. Works with 2 freelance illustrators and 2 designers/year. Prefers local freelancers with experience in paste-up and color. Works on assignment only. Uses freelancers mainly for overload. Also for ad and brochure layout. Needs computer-literate freelancers for production. 90% of freelance work demands skills in Adobe Illustrator, QuarkXPress, Photoshop and Multi Ad Creator.

First Contact & Terms: Send query letter with résumé. Samples are filed. Will contact artist for portfolio review if interested. Artist should follow up with call. Portfolio should include b&w thumbnails, roughs, photostats and tearsheets. Sometimes requests work on spec before assigning a job. Pays for design and illustration by the hour, $10-15. Buys all rights. Finds artists through word of mouth.

Tips: "Combine computer knowledge with traditional graphic skills."

W DANA WHITE PRODUCTIONS, INC., 2623 29th St., Santa Monica CA 90405. (310)450-9101. E-mail: dwprods@aol.com. Owner/Producer: Dana C. White. AV firm. "We are a full-service audiovisual production company, providing multi-image and slide-tape, video and audio presentations for training, marketing, awards, historical and public relations uses. We have complete inhouse production resources, including computer multimedia, photo digitizing, image manipulation, program assembly, slidemaking, soundtrack production, photography and AV multi-image programming. We serve major industries such as GTE, Occidental Petroleum; medical, such as Whittier Hospital, Florida Hospital; schools, such as University of Southern California, Pepperdine University, Clairbourne School; publishers, such as McGraw-Hill, West Publishing; and public service efforts, including fundraising."

Needs: Works with 4-6 freelancers/year. Prefers freelancers local to greater Los Angeles, "with timely turnaround, ability to keep elements in accurate registration, neatness, design quality, imagination and price." Uses freelancers for design, illustration, retouching, characterization/animation, lettering and charts. 50% of freelance work demands knowledge of Adobe Illustrator or Aldus FreeHand.

First Contact & Terms: Send query letter with brochure or tearsheets, photostats, photocopies, slides and photographs. Samples are filed or are returned only if requested. Reports back within 2 weeks only if interested. Call or write for appointment to show portfolio. Pays by the project. Payment negotiable by job.

Tips: "These are tough times. Be flexible. Negotiate. Deliver quality work on time!"

N **YAMAGUMA & ASSOCIATES**, 255 N. Market St., #120, San Jose CA 95110-2409. (408)279-0500. Fax: (408)293-7819. E-mail: sayd2m@aol.com or info@yad2m.com. Website: http://www.yad2m.com. Estab. 1980. Specializes in corporate identity, displays, direct mail, publication design, signage and marketing. Clients: high technology, government and business-to-business. Current clients include Orbit Semiconductor, ASAT, Informix and MFS Worldcom. Client list available upon request.

Needs: Approached by 6 freelancers/year. Works with 3 freelance illustrators and 2 designers/year. Works on assignment only. Uses illustrators mainly for 4-color, airbrush and technical work. Uses designers mainly for logos, layout and production. Also uses freelancers for brochure, catalog, ad, P-O-P and poster design and illustration; mechanicals; retouching; lettering; book, magazine, model making; direct mail design; charts/graphs; and AV materials. Also for multimedia projects (Director SuperCard). Needs editorial and technical illustration. 100% of design and 75% of illustration demand knowledge of Aldus PageMaker, QuarkXPress, Aldus FreeHand, Adobe Illustrator, Model Shop, Strata, MMDir. or Adobe Photoshop.

First Contact & Terms: Send postcard sample or query letter with brochure and tearsheets. Accepts disk submissions compatible with Adobe Illustrator, QuarkXPress, Adobe Photoshop and Strata. Samples are filed. Will contact artist for portfolio review if interested. Portfolio should include thumbnails, roughs, b&w and color photostats, tearsheets, photographs, slides and transparencies. Sometimes requests work on spec before assigning a job. Pays for design by the hour, $15-50. Pays for illustration by the project, $300-3,000. Rights purchased vary according to project. Finds artists through self-promotions.

Tips: Would like to see more Macintosh-created illustrations.

Los Angeles

ASHCRAFT DESIGN, 11832 W. Pico Blvd., Los Angeles CA 90064. (310)479-8330. Fax: (310)473-7051. E-mail: info@ashcraftdesign.com. Website: http://www.ashcraftdesign.com. Estab. 1986. Specializes in corporate identity, display and package design and signage. Client list available upon request.

Needs: Approached by 2 freelance artists/year. Works with 1 freelance illustrator and 2 freelance designers/year. Works on assignment only. Uses freelance illustrators mainly for technical illustration. Uses freelance designers mainly for packaging and production. Also uses freelance artists for mechanicals and model making.

First Contact & Terms: Send query letter with tearsheets, résumé and photographs. Samples are filed and are not returned. Reports back to the artist only if interested. To show a portfolio, mail original/final art, tearsheets and 4×5 transparencies. Pays for design and illustration by the project. Rights purchased vary according to project.

✓ ☰ BRAMSON (+ ASSOC.), 7400 Beverly Blvd., Los Angeles CA 90036. (323)938-3595. Fax: (323)938-0852. E-mail: gbramson@aol.com. Art Director: Gene. Estab. 1970. Number of employees: 12. Approximate annual billing: more than $2 million. Advertising agency. Specializes in magazine ads, collateral, ID, signage, graphic design, imaging, campaigns. Product specialties are healthcare, consumer, business to business. Current clients include Johnson & Johnson, Chiron Vision, Lawry's and Surgin, Inc.

Needs: Approached by 150 freelancers/year. Works with 10 freelance illustrators, 2 animators and 5 designers/year. Prefers local freelancers. Works on assignment only. Uses freelancers for brochure and print ad design; brochure, technical, medical and print ad illustration, storyboards, mechanicals, retouching, lettering, logos. 30% of work is with print ads. 50% of freelance work "prefers" knowledge of Aldus Pagemaker, Adobe Illustrator, QuarkXPress, Adobe Photoshop, Aldus Freehand or 3-D Studio.

First Contact & Terms: Send query letter with brochure, photocopies, résumé, photographs, tearsheets, SASE. Samples are filed. Will contact artist for portfolio review if interested. Portfolio should include roughs, color tearsheets. Sometimes requests work on spec before assigning job. Pays for design by the hour, $15-25. Pays for illustration by the project, $250-2,000. Buys all rights or negotiates rights purchased. Finds artists through sourcebooks.

Tips: Looks for "very unique talent only." Price and availability are also important.

GORDON GELFOND ASSOCIATES, INC., 11500 Olympic Blvd., Los Angeles CA 90064. (310)478-3600. Fax: (310)477-4825. Creative Director: Barry Brenner. Estab. 1967. Ad agency. Full-service multimedia firm. Specializes in print campaigns. Product specialties are financial, general, consumer. Current clients include Fremont Investment and Loan, The Beverly Hills Hotel, Fujifilm and Deluxe Color Labs.

Needs: Works only with artists reps. Uses freelancers for print ad illustration, mechanicals, retouching and lettering. 95% of work is with print ads.

First Contact & Terms: Send query letter with photostats. Will contact artist for portfolio review if interested. Pays for illustration by the project, $200 minimum. Rights purchased vary according to project.

GRAPHIC DESIGN CONCEPTS, 4123 Wade St., Suite #2, Los Angeles CA 90066. (310)306-8143. President: C. Weinstein. Estab. 1980. Specializes in package, publication and industrial design, annual reports, corporate identity, displays and direct mail. "Our clients include public and private corporations, government agencies, international trading

companies, ad agencies and PR firms." Current projects include new product development for electronic, hardware, cosmetic, toy and novelty companies.

Needs: Works with 15 illustrators and 25 designers/year. "Looking for highly creative idea people, all levels of experience." All styles considered. Uses illustrators mainly for commercial illustration. Uses designers mainly for product and graphic design. Also uses freelancers for brochure, P-O-P, poster and catalog design and illustration; book, magazine, direct mail and newspaper design; mechanicals; retouching; airbrushing; model making; charts/graphs; lettering; logos. Also for multimedia design, program and content development. 50% of freelance work demands knowledge of Aldus PageMaker, Adobe Illustrator, QuarkXPress, Adobe Photoshop or Aldus FreeHand.

First Contact & Terms: Send query letter with brochure, résumé, tearsheets, photostats, photocopies, slides, photographs and/or transparencies. Accepts disk submissions compatible with Windows on the IBM. Samples are filed or are returned if accompanied by SASE. Reports back within 10 days with SASE. Portfolio should include thumbnails, roughs, original/final art, final reproduction/product, tearsheets, transparencies and references from employers. Pays for design by the hour, $15 minimum; pays for illustration by the hour, $50 minimum. Considers complexity of project, client's budget, skill and experience of artist, how work will be used, turnaround time and rights purchased when establishing payment.

Tips: "Send a résumé if available. Send samples of recent work or *high quality* copies. Everything sent to us should have a professional look. After all, it is the first impression we will have of you. Selling artwork is a business. Conduct yourself in a business-like manner."

RHYTHMS PRODUCTIONS, P.O. Box 34485, Los Angeles CA 90034. (310)836-4678. President: Ruth White. Estab. 1955. AV firm. Specializes in CD-ROM and music production/publication. Product specialty is educational materials for children.

Needs: Works with 2 freelance illustrators and 2 designers/year. Prefers artists with experience in cartoon animation and graphic design. Works on assignment only. Uses freelancers artists mainly for cassette covers, books, character design. Also for catalog design, multimedia, animation and album covers. 2% of work is with print ads. 75% of design and 50% of illustration demands graphic design computer skills.

First Contact & Terms: Send query letter with photocopies and SASE (if you want material returned). Samples are returned by SASE if requested. Reports back within 2 months only if interested. Will contact artist for portfolio review if interested. Pays for design and illustration by the project. Buys all rights. Finds artists through word of mouth and submissions.

San Francisco

THE AD AGENCY, P.O. Box 470572, San Francisco CA 94147. Creative Director: Michael Carden. Estab. 1972. Ad agency. Full-service multimedia firm. Specializes in print, collateral, magazine ads. Client list available upon request.

Needs: Approached by 120 freelancers/year. Works with 120 freelance illustrators and designers/year. Uses freelancers mainly for collateral, magazine ads, print ads. Also for brochure, catalog and print ad design and illustration, mechanicals, billboards, posters, TV/film graphics, multimedia, lettering and logos. 60% of freelance work is with print ads. 50% of freelance design and 45% of illustration demand computer skills.

First Contact & Terms: Send query letter with brochure, photocopies and SASE. Samples are filed or returned by SASE. Reports back in 1 month. Portfolio should include color final art, photostats and photographs. Buys first rights or negotiates rights purchased. Finds artists through word of mouth, referrals and submissions.

Tips: "We are an eclectic agency with a variety of artistic needs."

COMMUNICATIONS WEST, 1426 18th St., San Francisco CA 94107. (415)863-7220. Fax: (415)621-2907. E-mail: comwest@comwest.com. Website: http://www.comwest.com. Contact: Creative Director. Estab. 1983. Number of employees: 9. Approximate annual billing: $4 million. Ad agency/PR firm. Product specialties are transportation and consumer. Specializes in magazine ads and collateral. Current clients include P&O Nedlloyd, Sector Watches, Consolidated Freightways, Redwood Systems, Harbinger.

Needs: Approached by 48 freelancers/year. Works with 2-4 freelance illustrators and 6-8 designers/year. Prefers local freelancers with experience. Works on assignment only. Uses freelancers mainly for brochure and print ad design and illustration, slide illustration, mechanicals, retouching, posters, lettering and logos. 50% of work is with print ads. 50% of freelance work demands knowledge of Adobe Illustrator, QuarkXPress and Adobe Photoshop.

First Contact & Terms: Send query letter with brochure, résumé, photocopies and tearsheets. Samples are filed. Reports back to the artist only if interested. Call for appointment to show portfolio of color tearsheets and finished art samples. Pays for design by the project, $250-5,000. Pays for illustration by the project, $500-2,500. Buys all rights.

Tips: The president of this firm advises freelancers entering the advertising field to "start out small with easy-to-execute, inexpensive work."

ROY RITOLA, INC., 431 Jackson St., San Francisco CA 94111. (415)788-7010. President: Roy Ritola. Specializes in brand and corporate identity, displays, direct mail, packaging, signage. Clients: manufacturers.

Needs: Works with 6-10 freelancers/year. Uses freelancers for design, illustration, airbrushing, model making, lettering and logos.

First Contact & Terms: Send query letter with brochure showing art style or résumé, tearsheets, slides and photographs. Samples not filed are returned only if requested. Reports back only if interested. To show portfolio, mail final reproduction/product. Pays for design by the hour, $25-100. Considers complexity of project, client's budget, skill and experience of artist, turnaround time and rights purchased when establishing payment.

Colorado

BARNSTORM DESIGN/CREATIVE, 2902 W. Colorado Ave., Suite 200, Colorado Springs CO 80904. (719)630-7200. Fax: (719)630-3280. Owner: Douglas D. Blough. Estab. 1975. Specializes in corporate identity, brochure design and publications. Clients: high-tech corporations, nonprofit fundraising, business-to-business and restaurants. Current clients include The Colorado College, USOC, Concept Restaurants, US Swimming, Gray Brewing Co., Sky Sox Baseball Club, General Merchandise Distributors Council.
Needs: Works with 2-4 freelance artists/year. Prefers local, experienced (clean, fast and accurate) artists. Works on assignment only. Uses freelancers mainly for paste-up, editorial and technical illustration and layout. Also uses freelancers for design, mechanicals, retouching and calligraphy. Needs computer-literate freelancers for production. 90% of freelance work demands knowledge of Adobe Illustrator, QuarkXPress, Photoshop and Macromedia FreeHand.
First Contact & Terms: Send query letter with résumé and samples to be kept on file. Prefers "good originals or reproductions, professionally presented in any form" as samples. Samples not filed are returned by SASE. Reports only if interested. Call or write for appointment to show portfolio. Pays for design by the project, $300-500. Pays for illustration by the project, $100 minimum for b&w; $300 for color. Considers client's budget, skill and experience of artist, and turnaround time when establishing payment.
Tips: "Portfolios should reflect an awareness of current trends. We try to handle as much inhouse as we can, but we recognize our own limitations (particularly in illustration). Do not include too many samples in your portfolio."

CINE DESIGN FILMS, Box 6495, Denver CO 80206. (303)777-4222. E-mail: jghusband@aol.com. Producer/Director: Jon Husband. AV firm. Clients: automotive companies, banks, restaurants, etc.
Needs: Works with 3-7 freelancers/year. Works on assignment only. Uses freelancers for layout, titles, animation and still photography. Clear concept ideas that relate to the client in question are important.
First Contact & Terms: Send query letter to be kept on file. Reports only if interested. Write for appointment to show portfolio. Pays by the project. Considers complexity of project, client's budget and rights purchased when establishing payment. Rights purchased vary according to project.

JO CULBERTSON DESIGN, INC., 1034 Logan St., Denver CO 80203. (303)861-9046. E-mail: joculdes@aol.com. President: Jo Culbertson. Estab. 1976. Number of employees: 1. Approximate annual billing: $200,000. Specializes in direct mail, packaging, publication and marketing design, annual reports, corporate identity, and signage. Clients: corporations, not-for-profit organizations. Current clients include Love Publishing Company, American Cancer Society, Nurture Nature, Clarus Products Intl., Sun Gard Insurance Systems. Client list available upon request.
Needs: Approached by 15 freelancers/year. Works with 2 freelance illustrators/year. Prefers local freelancers only. Works on assignment only. Uses illustrators mainly for corporate collateral pieces, illustration and ad illustration. 50% of freelance work demands knowledge of QuarkXPress, Adobe Photoshop, CorelDraw.
First Contact & Terms: Send query letter with résumé, tearsheets and photocopies. Samples are filed. Reports back to the artist only if interested. Artist should follow up with call. Portfolio should include b&w and color thumbnails, roughs and final art. Pays for design by the project, $250 minimum. Pays for illustration by the project, $100 minimum. Finds artists through file of résumés, samples, interviews.

PAGEWORKS COMMUNICATION DESIGN, INC., 7535 E. Hampden Ave., Denver CO 80231. (303)337-7770. Fax: (303)337-7780. E-mail: pwcd@aol.com. Website: http://www.pwcd.com. CEO: Michael Guzofsky. Estab. 1981. Specializes in annual reports, corporate identity, direct mail, package and publication design. Clients: corporations, associations. Current clients include Richmond American Homes, Miller Global Properties, The VR Source, Fitzcom, Inc. Client list available upon request.
Needs: Approached by 50 freelance artists/year. Works with 5 illustrators and 5 designers/year. Prefers local artists with computer experience. Works on assignment only. Uses freelance designers and illustrators for brochure, catalog, magazine, direct mail and ad design; brochure, catalog and ad illustration; logos; and charts/graphs. Needs computer-literate freelancers for design, illustration and production. 90% of freelance work demands knowledge of QuarkXPress, Adobe Illustrator or Photoshop.
First Contact & Terms: Send query letter with brochure, résumé, tearsheets and photocopies. Samples are filed and are not returned. Reports back only if interested. Write for appointment to show portfolio or mail appropriate materials. Portfolio should include thumbnails, roughs, b&w and color tearsheets, printed samples. Pays for design and illustration by the hour, $20-50 or by the project. Negotiates rights purchased.

UNIT ONE, INC., 2201 S. Poplar St., Denver CO 80224. (303)757-5690. Fax: (303)757-6801. President: Chuck Danford. Estab. 1968. Specializes in annual reports, corporate identity, direct mail, publication design, corporate collateral and signage. Clients: industrial, financial, nonprofit and construction/architecture. Examples of recent projects

include FMI Corporation Marketing materials, Riviera Electric brochure, Royal Banner, Corp. I.D., product catalogs.
Needs: Approached by 15-30 freelancers/year. Works with 1 or 2 illustrators and 3-5 designers/year. Uses freelancers mainly for computer design and production, brochures, ad design, direct mail, posters, logos, charts/graphs, and signage. 100% of freelance work demands knowledge of Aldus PageMaker, Adobe Photoshop, MS Word/Works, QuarkXPress or Aldus FreeHand. Needs editorial and general print illustration.
First Contact & Terms: Send query letter with brochure, tearsheets, photographs, photocopies and résumé. Samples are filed or are returned by SASE if requested. Reports back only if interested. Will contact artist for portfolio review if interested. Portfolio should include thumbnails, photographs, slides and transparencies. Pays for design by the hour, $10-35; by the project, $50 minimum. Pays for illustration by the project, $100 minimum. Considers skill and experience of artist when establishing payment. Rights purchased vary according to project.
Tips: "Show printed pieces whenever possible; don't include fine art. Explain samples, outlining problem and solution. If you are new to the business develop printed pieces as quickly as possible to illustrate practical experience."

Connecticut

COPLEY MEDIAWORKS, 18 Reef Rd., Fairfield CT 06430. Mailing address: P.O. Box 751, Fairfield CT 06430. (203)259-0525. Fax: (203)259-3321. E-mail: copley@snet.net. Production Director: Melissa Capasse. Estab. 1987. Number of employees: 6. Approximate annual billing: $2,600,000. Integrated marketing communications agency. Specializes in television, business-to-business print. Product specialties are sports, publishing.
Needs: Approached by 12 freelance illustrators and 20 designers/year. Works with 2 freelance illustrators and 2 designers/year. Uses freelancers mainly for brochures and ads. Also for brochure illustration, catalog design, lettering, logos, mechanicals, storyboards, TV/film graphics. 25% of work is with print ads. 100% of freelance design demands skills in Aldus PageMaker, Adobe Photoshop, QuarkXPress, Adobe Illustrator. 50% of freelance illustration demands skills in Adobe Photoshop and Adobe Illustrator.
First Contact & Terms: Send query letter with brochure and résumé. Accepts disk submissions compatible with QuarkXPress. Samples are filed. Will contact for portfolio review if interested. Pays by project. Buys all rights. Finds artists through word of mouth, magazines, submissions.
Tips: "Bring overall business sense plus sense of humor. Must be punctual, trustworthy."

DONAHUE ADVERTISING, LLC, 227 Lawrence St., Hartford CT 06106. (860)728-0000. Fax: (860)247-9247. President: James Donahue. Vice President: Ellen Maurer. Estab. 1979. Number of employees: 11. Approximate annual billing: $6.5 million. Ad agency. Full-service, multimedia firm. Specializes in collateral, trade ads, packaging and PR. Product specialties are computer, tool and spirits.
Needs: Approached by 15 freelancers/year. Works with 3 freelance illustrators and 3 designers/year. Prefers freelancers with experience in reproduction, tight comps and mechanicals. Uses freelancers mainly for inhouse work: brochure and print ad design, catalog design and illustration, technical and editorial illustration, mechanicals, posters, lettering and logos. 80% of freelance work demands skills in QuarkXPress, Adobe Illustrator and Photoshop.
First Contact & Terms: Send query letter with résumé and tearsheets. Samples are filed. Will contact artist for portfolio review if interested. Portfolio should include thumbnails, roughs, original/final art and tearsheets. Sometimes requests work on spec before assigning a job. Pays for design by the hour, $20-65. Pays for illustration by the project, $200-5,000 maximum. Rights purchased vary according to project.

FORDESIGN GROUP, 87 Dayton Rd., Redding CT 06896. (203)938-0008. Fax: (203)938-0805. E-mail: steven@fordesign-group.com. Website: http://fordesign-group.com. Principal: Steve Ford. Estab. 1990. Specializes in brand and corporate identity, package and publication design and signage. Clients: corporations. Current clients include Black & Decker, Cadbury Beverage, Carrs, MasterCard. Professional affiliations: AIGA, PDC.
Needs: Approached by 100 freelancers/year. Works with 4-6 freelance illustrators and 4-6 designers/year. Uses illustrators mainly for brochures, ads. Uses designers mainly for corporate identity, packaging, collateral. Also uses freelancers for ad and brochure design and illustration, logos. Needs computer-literate freelancers for design, illustration and production. 90% of freelance work demands skills in Adobe Illustrator, Adobe Photoshop, FreeHand and QuarkXPress.
First Contact & Terms: Send postcard sample of work or send photostats, slides and transparencies. Samples are filed or returned by SASE if requested by artist. Will contact artist for portfolio review if interested. Portfolio should include b&w and color samples. Pays for design by the hour, $25-75; by the project, $100-5,000. Pays for illustration by the project, $2-3,000.
Tips: "We are sent all *Showcase*, *Workbook*, etc." Impressed by "great work, simply presented." Advises freelancers entering the field to save money on promotional materials by partnering with printers. Create a joint project or tie-in. "Send out samples—good luck!"

FREELANCE EXCHANGE, INC., P.O. Box 1165, Glastonbury CT 06033-6165. (860)633-8116. Fax: (860)633-8106. E-mail: stella1@ix.netcom.com. President: Stella Neves. Estab. 1983. Number of employees: 3. Approximate annual billing: $600,000. Specializes in annual reports, brand and corporate identity, animation, display, direct mail, package and publication design, web page design, illustration (cartoon, realistic, technical, editorial, product and computer). Clients: corporations, nonprofit organizations, state and federal government agencies and ad agencies. Current

clients include Lego Systems, PHS, Hartford Courant, Abrams Publishing Co., Otis Elevator, Phoenix Home Life Insurance Co., CIGNA, ABB, The Travelers, The Allied Group. Client list available upon request. Professional affiliations: GAIG, Connecticut Art Directors Club.

Needs: Approached by 350 freelancers/year. Works with 25-40 freelance illustrators and 30-50 designers/year. Prefers freelancers with experience in publications, website design, consumer products and desktop publishing. "Home page and website design are becoming more important and requested by clients." Works on assignment only. Uses illustrators mainly for editorial and computer illustration. Design projects vary. 95% of design and 50% of illustration demand knowledge of Aldus PageMaker, QuarkXPress, Aldus FreeHand, Adobe Illustrator, Adobe Photoshop, Persuasion, Powerpoint, Macromind Director, Page Mill and Hot Metal.

First Contact & Terms: Designers send postcard sample or query letter with résumé, SASE, brochure, tearsheets and photocopies. Illustrators send postcard sample or query letter with résumé, photocopies, photographs, SASE, slides and tearsheets. Samples are filed and are returned by SASE. Call or write for appointment to show portfolio of thumbnails, roughs, final art (if appropriate) and b&w and color photostats, slides, tearsheets, photographs. "We prefer slides and good quality color copies." Pays for design by the project, $500 minimum. Pays for illustration by the project, $300 minimum. Rights purchased vary according to project.

Tips: "Send us one sample of your best work that is unique and special. All styles and media are OK, but we're really interested in computer-generated illustration and websites. If you want to make money, learn to use the new technology. The 'New Media' is where our clients want to be, so adjust your portfolio accordingly. Your portfolio must be spectacular (I don't want to see student work). Having lots of variety and being well-organized will encourage one to take a chance on an unknown artist."

☑ **FREEMAN DESIGN GROUP**, 85 River Rd., #G4, Essex CT 06426-1341. (203)968-0026. President: Bill Freeman. Estab. 1972. Specializes in annual reports, corporate identity, package and publication design and signage. Clients: corporations. Current projects include company magazines. Current clients include Pitney Bowes, Continental Grain Co., IBM Credit, CB Commercial Real Estate. Client list available upon request.

Needs: Approached by 35 artists/year. Works with 5 illustrators and 5 designers/year. Prefers artists with experience in production. Works on assignment only. Uses illustrators for mechanicals, retouching and charts/graphs. Looking for technical illustration and editorial illustration with "montage, minimal statement."

First Contact & Terms: Send query letter with promotional piece showing art style, résumé and tearsheets. Samples are filed or are returned if accompanied by SASE. Does not report back. Call for appointment to show portfolio or mail appropriate materials and tearsheets. Pays for design by the hour, $25 minimum; by the project, $150-3,000.

📧 **IDC**, Box 312, Farmington CT 06034. (203)678-1111. Fax: (203)793-0293. E-mail: design@freewwweb.com. Website: http://www.industrial-design.com. President: Dick Russell. Estab. 1960. Number of employees: 6-8. Specializes in industrial design. Clients: corporations. Client list not available.

Needs: Approached by 50 freelance industrial designers/year. Works with 10-15 industrial designers/year. Prefers local freelancers. Uses designers mainly for product design. Also uses freelancers for model making and industrial design. Needs computer-literate freelancers for design. 50% of freelance work demands knowledge of CADKey or AutoCAD.

First Contact & Terms: Send résumé. Reports back only if interested. Designer should follow up with call after initial query. Will contact for portfolio review if interested. Portfolio should include thumbnails and roughs. Pays for design by the hour.

📝 **JMK CORP.**, 90 Grove St., Ridgefield CT 06877. Contact: Wynn Medinger. Specializes in annual reports, corporate identity and publications. Clients: corporations.

Needs: Works with 30 artists/year. Works on assignment only. Uses artists for editorial illustration. Needs computer-literate freelancers for illustration. 30% of freelance work demands knowledge of Adobe Illustrator.

First Contact & Terms: "No phone calls!" Send query letter with tearsheets, slides, photostats or photocopies. Samples not kept on file are returned by SASE only. Reports only if interested. Pays for illustration by the project $300-3,500 average. Considers client's budget, skill and experience of artist and how work will be used when establishing payment.

📝 📧 **MACEY NOYES ASSOCIATES, INC.**, 232 Danbury Rd., Wilton CT 06897. (203)762-9002. Fax: (203)762-2629. E-mail: j.arena@maceynoyes.com. Website: http://www.maceynoyes.com. Designer: Jason Arena. Structural Design Director: Tod Dawson. Estab. 1979. Specializes in package design. Clients: corporations (marketing managers, product managers). Current clients include Duracell, Hanes, BDF, Comstock, Motorola, Remington, Pitney Bowes. Majority of clients are retail suppliers of consumer goods.

Needs: Approached by 25 artists/year. Works with 2-3 illustrators and 5 designers/year. Prefers local and international artists with experience in package comps, Macintosh and type design. Works on assignment only. Uses technical and product illustrators mainly for ad slick, in-use technical and front panel product. Uses designers for conceptual layouts and product design. Also uses freelancers for mechanicals, retouching, airbrushing, lettering, logos and industrial/structural design. Needs computer-literate freelancers for design, illustration and production. 40% of freelance work demands knowledge of QuarkXPress, Aldus FreeHand, Adobe Illustrator or Photoshop.

First Contact & Terms: Send query letter with résumé. Samples are filed or are returned by SASE if requested by artist. Reports back to the artist only if interested. Will contact artist for portfolio review if interested. Portfolio should

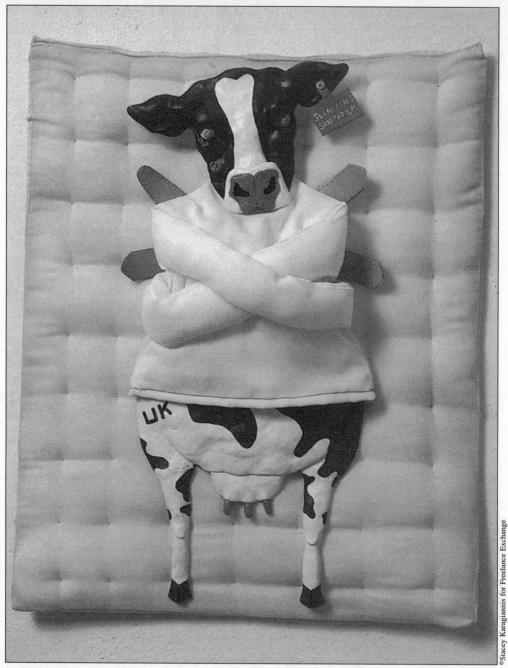

Stacey Karagiannis created this editorial illustration in Sculpey modeling compound, fabric and acrylic paints for Freelance Exchange. "The story was 'Mad Cow Disease,' and by coincidence, this piece was mailed at the same time that Oprah's Texas cattle trial began—totally unexpected," says Stella Neves of Freelance Exchange. "Stacey Karagiannis is one of the new, young talents entering our industry. She is a storyteller with a charming approach to contemporary issues."

include thumbnails, roughs and transparencies. Pays for design by the hour, $25-50. Pays for illustration by the project, $100-2,500. Rights purchased vary according to project.

Tips: Finds new artists through sourcebooks and agents.

Ⓝ MCKENZIE/HOLT CREATIVE SERVICES, 1 Morningside Dr. N., Westport CT 06880. (203)454-2443. Fax: (203)454-0416. E-mail: dmckenzie@www.mcholt.com. Website: http://www.mcholt.com. Principal: Penelope Holt. Specializes in annual reports, corporate identity, direct mail and publication design. Expanded services include: copywriting and editing, advertising and direct mail, marketing and public relations, website and development, and multimedia and CD-ROM.

Needs: Approached by 100 freelance artists/year. Works with 5 freelance designers/year. Uses freelance designers mainly for computer design. Also uses freelance artists for brochure and catalog design. 100% of design and 50% of illustration demand knowledge of QuarkXPress 4.0, Adobe Illustrator 7.0 and Adobe Photoshop 4.0.

First Contact & Terms: Send query letter with brochure, résumé, photographs and photocopies. Samples are filed or are returned by SASE if requested by artist. Write to schedule an appointment to show a portfolio. Portfolio should include slides. Pays for design by the hour, $15-30. Pays for illustration by the project, $150-3,000. Rights purchased vary according to project.

ULTITECH, INC., Foot of Broad St., Stratford CT 06497. (203)375-7300. Fax: (203)375-6699. E-mail: comcowic@meds.com. Website: http://www.meds.com. President: W.J. Comcowich. Estab. 1993. Number of employees: 3. Approximate annual billing: $1 million. Integrated marketing communications agency. Specializes in interactive multimedia, software, online services. Product specialties are medicine, science, technology. Current clients include Glaxo, Smithkline, Pharmacia. Professional affiliation: IMA.

Needs: Approached by 10-20 freelance illustrators and 10-20 designers/year. Works with 2-3 freelance illustrators and 6-10 designers/year. Prefers freelancers with experience in interactive media design and online design. Uses freelancers mainly for interactive media—online design (WWW). Also for animation, brochure and web page design, medical illustration, multimedia projects, TV/film graphics. 10% of work is with print ads. 100% of freelance design demands skills in Adobe Photoshop, QuarkXPress, Adobe Illustrator, 3D packages.

First Contact & Terms: Designers send query letter with résumé. Illustrators send postcard sample and/or query letter with photocopies, résumé, tearsheets. Accepts disk submissions in PC formats. Samples are filed. Reports back only if interested. Request portfolio review in original query. Pays for design by the project or by the day. Pays for illustration by the project. Buys all rights. Finds artists through sourcebooks, word of mouth.

Tips: "Learn design principles for interactive media."

Delaware

☑ ALOYSIUS BUTLER & CLARK (AB&C), 819 Washington St., Wilmington DE 19801. (302)655-1552. Contact: Tom McGivney. Ad agency. Clients: healthcare, banks, industry, restaurants, hotels, businesses, government offices.

Needs: Works with 12 or more illustrators and 3-4 designers/year. Uses artists for trade magazines, billboards, direct mail packages, brochures, newspapers, stationery, signage and posters. 95% of design and 15% of illustration demand skills in QuarkXPress, Adobe Illustrator or Adobe Photoshop.

First Contact & Terms: Designers send query letter with résumé and photocopies. Illustrators send postcard samples. Samples are filed; except work that is returned only if requested. Reports only if interested. Works on assignment only. Pays for design by the hour, $20-50. Pays for illustration by the hour; or by the project, $250-1,000.

CUSTOM CRAFT STUDIO, 310 Edgewood St., Bridgeville DE 19933. (302)337-3347. Fax: (302)337-3444. AV producer. Vice President: Eleanor H. Bennett.

Needs: Works with 12 freelance illustrators and 12 designers/year. Works on assignment only. Uses freelancers mainly for work on filmstrips, slide sets, trade magazines and newspapers. Also for print finishing, color negative retouching and airbrush work. Prefers pen & ink, airbrush, watercolor and calligraphy. 10% of freelance work demands knowledge of Adobe Illustrator. Needs editorial and technical illustration.

First Contact & Terms: Send query letter with résumé, slides or photographs, brochure/flyer and tearsheets to be kept on file. Samples returned by SASE. Reports back in 2 weeks. Originals not returned. Pays by the project, $25 minimum.

Washington DC

Ⓨ ARNOLD & ASSOCIATES PRODUCTIONS, 1834 Jefferson Place NW, Washington DC 20036. (202)223-0900. Fax: (202)223-3603. President: John Arnold. AV/video firm.

Needs: Works with 30 artists/year. Prefers local artists, award-winning and experienced. "We're an established, national firm." Works on assignment only. Uses freelancers for multimedia, slide show and staging production.

First Contact & Terms: Send query letter with brochure, tearsheets, slides and photographs to be kept on file. Call

for appointment to show portfolio, which should include final reproduction/product and color photographs. Pays for design by the hour, $50-100 or by the project, $500-3,500. Pays for illustration by the project, $500-4,000. Considers complexity of the project, client's budget and skill and experience of artist when establishing payment.

LOMANGINO STUDIO INC., 3209 M St. NW, Washington DC 20007. (202)338-4110. Fax: (202)625-0848. Website: http://www.lomangino.com. President: Donna Lomangino. Estab. 1987. Number of employees: 6. Specializes in annual reports, corporate identity and publication design. Clients: corporations, nonprofit organizations. Client list available upon request. Professional affiliations: AIGA Washington DC.
Needs: Approached by 25-50 freelancers/year. Works with 1 freelance illustrator/year. Uses illustrators and production designers occasionally for publication. Also for multimedia projects. Accepts disk submissions, but not preferable. 99% of design work demands skills in Adobe Illustrator, Adobe Photoshop and QuarkXPress.
First Contact & Terms: Send postcard sample of work. Samples are filed. Will contact artist for portfolio review if interested. Pays for design and illustration by the project. Finds artists through sourcebooks, word of mouth and studio files.
Tips: "Please don't call. Send samples for consideration."

N ⬛ **VISUAL CONCEPTS**, 5410 Connecticut Ave., Washington DC 20015. (202)362-1521. Owner: John Jacobin. Estab. 1984. Service-related firm. Specializes in visual presentation, mostly for retail stores. Clients: retail stores, residential and commercial spaces. Current clients include Cafe Paradiso, Urban Outfitters, Steve Madden Shoes, Guess Jean/neckwear.
Needs: Approached by 15 freelancers/year. Works with 2 freelance illustrators and 6 designers/year. Assigns 10-20 projects/year. Prefers local artists with experience in visual merchandising and 3-D exhibit building. Works on assignment only. Uses freelancers mainly for design and installation. Prefers contemporary, vintage or any classic styles. Also uses freelancers for editorial, brochure and catalog illustration, advertising design and layout, illustration, signage, and P-O-P displays.
First Contact & Terms: Contact through artist rep or send query letter with brochure showing art style or résumé and samples. Samples are filed. Reports back in 2 weeks. Call for appointment to show portfolio of thumbnails, roughs and color photographs or slides. Pays for design and illustration by the hour, $6.50-30. Rights purchased vary according to project.

Florida

AD CONSULTANT GROUP INC., 3111 University Dr., #408, Coral Springs FL 33065. (954)340-0883. Fax: (954)340-0996. President: B. Weisblum. Creative Director: Michael Cadieux. Estab. 1994. Number of employees: 3. Ad agency. Full-service multimedia firm.
Needs: Prefers local artists only. Also uses freelancers for animation, brochure and catalog design and illustration, posters and TV/film graphics. 25% of work is with print ads. Needs computer-literate freelancers for design, illustration, production and presentation. 100% of freelance work demands computer skills.
First Contact & Terms: Send query letter. Samples are filed. Reports back within 1 week. Artist should follow-up with call. Portfolio should include final art. Buys first rights or all rights.

AURELIO & FRIENDS, INC., 14971 SW 43 Terrace, Miami FL 33185. (305)225-2434. Fax: (305)225-2121. E-mail: aurelio97@aol.com. President: Aurelio Sica. Vice President: Nancy Sica. Estab. 1973. Number of employees: 3. Specializes in corporate advertising and graphic design. Clients: corporations, retailers, large companies, hotels and resorts.
Needs: Approached by 4-5 freelancers/year. Works with 1-2 freelance illustrators and 3-5 designers/year. Also uses freelancers for ad design and illustration, brochure, catalog and direct mail design, and mechanicals. 50% of freelance work demands knowledge of Adobe Ilustrator, Adobe Photoshop and QuarkXPress.
First Contact & Terms: Send brochure and tearsheets. Samples are filed. Will contact artist for portfolio review if interested. Portfolio should include b&w and color final art, photographs, roughs and transparencies. Pays for design and illustration by the project. Buys all rights.

N ⬛ **BUGDAL GROUP INC.**, 7314 SW 48th St., Miami FL 33155. (305)665-6686. Fax: (305)663-1387. Vice President: Margarita Spencer. Estab. 1971. Specializes in annual reports, brand and corporate identity, displays/signage design. Clients: corporations, public agencies. Current clients include Spillis Candella & Partners, Ampco Products, Tri-County Commuter Rail, Metro Dade Public Works, Metro Dade Transit, Megavending Inc., Walker Parking Systems, Archdiocese of Miami and Pacific Visions Communications. Client list available upon request.
Needs: Approached by 50 freelancers/year. Works with 1 freelance illustrator/year. Prefers local freelancers with experience in signage and corporate. Works on assignment only. Uses illustrators mainly for print, brochure, catalog and ad illustration. Needs computer-literate freelancers for illustration and production. 100% of freelance work demands knowledge of Aldus PageMaker, Aldus FreeHand, Adobe Illustrator or Adobe Photoshop.
First Contact & Terms: Send query letter with brochure, résumé, photographs and transparencies. Samples are filed.

Reports back to the artist only if interested. Request portfolio review in original query. Portfolio should include roughs, tearsheets and slides. "Pay depends on the job."

GOLD & ASSOCIATES INC., 6000-C Sawgrass Village Circle, Ponte Vedra Beach FL 32082. (904)285-5669. Fax: (904)285-1579. Creative Director/President: Keith Gold. Estab. 1988. Full-service multimedia communications firm. Specializes in graphic design and advertising. Product specialties are entertainment, fashion, publishing, tourism and sports. Three locations. Total staff of 50+.
- The president of Gold & Associates believes agencies will offer more services than ever before, as commissions are reduced by clients.

Needs: Approached by 80-100 freelancers/year. Works with 20-30 freelance illustrators and 6-8 freelance designers/year. Works primarily with artist reps. Works on assignment only. Uses freelancers for brochure, catalog, medical, editorial, technical, slide and print ad illustration; storyboards, animatics, animation, mechanicals. 50% of work is with print ads. 50% of freelance work demands knowledge of Adobe Illustrator, QuarkXPress and Adobe Photoshop.
First Contact & Terms: Contact through artist rep or send query letter with photocopies, tearsheets and capabilities brochure. Samples are filed. Reports back to the artist only if interested. Request portfolio review in original query. Will contact artists for portfolio review if interested. Follow-up with letter after initial query. Portfolio should include tearsheets. Pays for design by the hour, $35-125. "Maximum number of hours is negotiated up front." Pays for illustration by the project, $200-7,500. Buys all rights. Finds artists primarily through sourcebooks and reps.

☑ 🎨 **PETER JAMES DESIGN STUDIO**, 700 E. Atlantic Blvd., Studio 307, Pompano Beach FL 33060. (954)784-8440. Fax: (954)784-8429. Creative Director: Jim Spangler. Estab. 1980. Specializes in business-to-business advertising, package design, direct mail advertising and corporate identity. Clients: manufacturers, corporations and hospitality companies. Client list available upon request.
- Jim Spangler thinks "electronic artwork and design will continue to evolve . . . hopefully to be less mechanical and more inspired."

Needs: Approached by dozens of freelance artists/year. Works with 6 freelance art directors and designers/year. Prefers local artists with 7 years experience minimum in corporate design. Also uses artists for technical, editorial and graphic illustration and mechanicals, retouching, lettering and logo design. Needs computer-literate freelancers for design, illustration and production. Freelance work demands skills in QuarkXPress, Adobe Photoshop or Adobe Illustrator.
First Contact & Terms: Send query letter with samples, tearsheets, photocopies and résumé. Samples are filed or are returned by SASE if requested by artist. Will contact artist for portfolio review if interested. Pays for inhouse design by the hour, $15-50. Pays for illustration by the project, $50-1,500. Rights purchased vary according to project. Considers buying second rights (reprint rights) to previously published work. Finds artists through magazines, artists' submissions/self-promotions, sourcebooks and agents.

☑ 🎨 **KELLY & CO., GRAPHIC DESIGN, INC.**, 54 Dolphin Dr., Treasure Island FL 33706. (727)360-0750. Art Director: Ken Kelly. Estab. 1971. Specializes in print media design, logo design, corporate identity, ad campaigns, direct mail, brochures, publications, signage, architectural and technical illustrations. Clients: industrial, banking, auto, boating, real estate, accounting, furniture, travel and ad agencies. Majority of clients are industrial.
Needs: Works with 2 illustrators and 1 designer/year. Prefers artists with a minimum of 5 years of experience. "Local artists preferred. Must have a good working attitude." Uses artists for design, technical illustration, brochures, catalogs, magazines, newspapers, P-O-P displays, retouching, airbrushing, posters, model making, direct mail packages, charts/graphs, lettering and logos. 90% of design and 75% of illustration demands skills in Aldus PageMaker, QuarkXPress, Aldus FreeHand, Adobe Illustrator, Adobe Photoshop or "other programs."
First Contact & Terms: Send query letter with résumé, brochure and photocopies, or "copies of work showing versatility." Accepts submissions on Mac floppy or CD. Samples are filed. Reports back only if interested. Pays for design by the hour, $35-55. Pays for illustration by the hour, $65-95; by the day, $90-110. Buys all rights.
Tips: "Be highly talented in all areas with reasonable rates. Don't oversell yourself. Must be honest with a high degree of integrity and appreciation. Send clean, quality samples and résumé. I prefer to make the contact. Our need for freelancers has been reduced."

STEVE POSTAL PRODUCTIONS, P.O. Box 428, Carraway St., Bostwick FL 32007-0428. (904)325-9356. Website: http://www.caisa.com/worstfilms. Director: Steve Postal. Estab. 1958. Number of employees: 8. Approximate annual billing: $1 million. AV firm. Full-service multimedia firm. Specializes in documentaries, feature films. Product specialty is films and videos. Professional affiliations: Directors Guild of Canada, FMPTA.
Needs: Approached by 150 freelancers/year. Works with 10 freelance illustrators and 5 designers/year. Prefers artists with experience in advertising, animation, design for posters. Works on assignment only. Uses freelancers mainly for films and film ads/VHS boxes. Also for brochure, catalog and print ad design and illustration, animation, TV/film graphics and lettering. 10% of work is with print ads. 10% of design and 15% of illustration demand knowledge of Aldus FreeHand.
First Contact & Terms: Send query letter with résumé, brochure, photocopies and SASE. Samples are filed. Reports back to the artist only if interested. "Artist should follow-up their mailing with at least two telephone calls within two weeks of mailing." Portfolio should include b&w and color final art, tearsheets and photographs. Pays for design and illustration by the project. Buys all rights. Finds artists through submissions.
Tips: "The one who contacts me the most wins the job!"

PRODUCTION INK, 2826 NE 19th Dr., Gainesville FL 32609. (352)377-8973. Fax: (352)373-1175. E-mail: tvn@pro ink.com. Website: http://www.proink.com. President: Terry Van Nortwick. Estab. 1979. Number of employees: 5. Specializes in publications, marketing, healthcare, engineering, development and ads. Professional affiliations: Public Relations Society of America, Society of Professional Journalists, International Association of Business Communicators, Gainesville Advertising Federation, Florida Public Relations Association.
Needs: Works with 6-10 freelancers/year. Works on assignment only. Uses freelancers for brochure illustration, airbrushing and lettering. 80% of freelance work demands knowledge of Aldus PageMaker, Adobe Illustrator, QuarkXPress, Adobe Photoshop or Aldus FreeHand. Needs editorial, medical and technical illustration.
First Contact & Terms: Send résumé, samples, tearsheets, photostats, photocopies, slides and photography. Samples are filed or are returned if accompanied by SASE. Reports back only if interested. Call or write for appointment to show portfolio of original/final art. Pays for design and illustration by the project, $50-500. Rights purchased vary according to project.

ROBERTS COMMUNICATIONS & MARKETING, INC., 5405 Cypress Center Dr., Suite 250, Tampa FL 33609-1025. (813)281-0088. Fax: (813)281-0271. Website: http://www.robertscommunications.com. Creative Director: Amy Phillips. Art Director: Susan Farrow. Estab. 1986. Number of employees: 9. Ad agency, PR firm. Full-service multimedia firm. Specializes in integrated communications campaigns using multiple media and promotion. Professional affiliations: AIGA, PRSA, AAF.
Needs: Approached by 50 freelancers/year. Works with 10 freelance illustrators and designers/year. Prefers local artists with experience in conceptualization and production knowledge. Uses freelancers for billboards, brochure design and illustration, lettering, logos, mechanicals, posters, retouching and signage. 60% of work is with print ads. 95% of freelance work demands knowledge of Adobe Photoshop 2.5, QuarkXPress 3.3 and Adobe Illustrator 5.0.
First Contact & Terms: Send postcard sample or query letter with photocopies, résumé and SASE. Samples are filed or are returned by SASE if requested by artist. Portfolios may be dropped off every Monday. Will contact artist for portfolio review if interested. Portfolio should include b&w and color final art, roughs and thumbnails. Pays for design by the hour, $20-50; by the project, $100 minimum; by the day, $150-500. Pays for illustration by the project, negotiable. Refers to Graphic Arts Guild Handbook for fee structure. Rights purchased vary according to project. Finds artists through agents, sourcebooks, seeing actual work done for others, annuals (*Communication Arts*, *Print*, *One Show*, etc.).
Tips: Impressed by "work that demonstrates knowledge of product, willingness to work within budget, contributing to creative process, delivering on-time. Continuing development of digital technology hand-in-hand with new breed of traditional illustrators sensitive to needs of computer production is good news."

VAN VECHTEN BURKE & ASSOCIATES PUBLIC RELATIONS, P.O. Box 99, Boca Raton FL 33429. (561)243-2900. President: Jay Van Vechten. Number of employees: 8. Approximate annual billing: $1.1 million. PR firm. Clients: medical, consumer products, industry. Client list available for SASE.
Needs: Approached by 20 freelancers/year. Works with 8 freelance illustrators and 8 designers/year. Works on assignment only. Uses artists for editorial and medical illustration, consumer and trade magazines, brochures, newspapers, stationery, signage, AV presentations and press releases. 20% of freelance work demands computer skills.
First Contact & Terms: Send query letter with brochure, résumé, business card, photographs or photostats. Samples not returned. Reports back only if interested. Pays for design and illustration by the project. Considers client's budget when establishing payment. Buys all rights.
Tips: Advises freelancers starting out in the field to research agencies. "Find out what clients the agency has. Create a thumbnail sketch or original idea to get yourself in the door."

MICHAEL WOLK DESIGN ASSOCIATES, 3841 NE Second Ave., Suite #303, Miami FL 33137. (305)576-2898. President: Michael Wolk. Estab. 1985. Specializes in corporate identity, displays, interior design and signage. Clients: corporate and private. Client list available upon request.
Needs: Approached by 10 freelancers/year. Works with 5 illustrators and 5 freelance designers/year. Prefers local artists only. Works on assignment only. Needs editorial and technical illustration mainly for brochures. Uses designers mainly for interiors and graphics. Also for brochure design, mechanicals, logos and catalog illustration. Needs "progressive" illustration. Needs computer-literate freelancers for design, production and presentation. 75% of freelance work demands knowledge of Aldus PageMaker, QuarkXPress, Aldus FreeHand, Adobe Illustrator or other software.
First Contact & Terms: Send query letter with slides. Samples are not filed and are returned by SASE. Reports back to the artist only if interested. To show a portfolio, mail slides. Pays for design by the hour, $10-20. Rights purchased vary according to project.

Georgia

COMPRO PRODUCTIONS, 2080 Peachtree Industrial Court, Suite 114, Atlanta GA 30341-2281. (770)455-1943. Fax: (770)455-3356. Creative Director: Nels Anderson. Estab. 1977. AV firm. Specializes in film and video. Product specialties are travel industry and airlines.
Needs: Approached by 12-24 freelancers/year. Uses freelancers mainly for animation.
First Contact & Terms: Send query letter with videotape demo reel, VHS, ¾", betacam sp. Samples are filed. Reports

back only if interested. Call or write for appointment to show portfolio. Buys all rights.

☑ 🖼 **EJW ASSOCIATES & TRADE PR SERVICE**, 1602 Abbey Court, Alpharetta GA 30004. (770)664-9322. Fax: (770)664-9324. E-mail: advertise@ejwassoc.com. Website: http://www.ejwassoc.com. President: Emil Walcek. Estab. 1980. Ad agency. Specializes in magazine ads, public relations, collateral and website design. Product specialty is business-to-business.
Needs: Works with 24 freelance illustrators and 12 designers/year. Prefers local freelancers with experience in Mac computer design and illustration and Photoshop expertise. Works on assignment only. Uses freelancers for brochure, catalog and print ad design and illustration, editorial, technical and slide illustration, retouching and logos. 50% of work is with print ads. Needs computer-literate freelancers for design, illustration, production and presentation. 75% of freelance work demands skills in PageMaker, FreeHand or Photoshop.
First Contact & Terms: Send query letter with résumé, photostats and slides. Samples are filed or are returned by SASE if requested by artist. Reports back to the artist only if interested. Write for appointment to show portfolio of thumbnails, roughs, final art, tearsheets. Pays for design by the hour, $15-25; by the day, $85-200; or by the project. Pays for illustration by the project. Buys all rights.
Tips: Looks for "experience in non-consumer, industrial or technology account work. Visit our website first—then e-mail or call."

GRANT/GARRETT COMMUNICATIONS, INC., Box 53, Atlanta GA 30301. (404)755-2513. President: Ruby Grant Garrett. Estab. 1979. Production and placement firm for print media. Specializes in recruitment advertising and graphics. Clients: banks, organizations, products-service consumer. Client list available for SASE.
● Grant/Garrett Communications predicts there will be more small jobs in the future.
Needs: Assigns 24 jobs/year. Works with 2-3 illustrators and 2 designers/year. "Experienced, talented artists only." Works on assignment only. Uses freelancers for billboards, brochures, signage and posters. 100% of work is with print ads. Needs editorial, technical and medical illustration. Especially needs "help-wanted illustrations that don't look like clip art." 30% of freelance work demands knowledge of Aldus PageMaker.
First Contact & Terms: Designers send query letter with résumé to be kept on file. Illustrators send postcard samples and résumé. Reports within 10 days. Will contact artist for portfolio review if interested. Portfolio should include roughs and tearsheets. "Do not send samples or copies of fine art or paintings." Requests work on spec before assigning a job. Pays for design by the hour, $25-35; by the project, $75-3,500. Pays for illustration by the project, $35-2,500. Considers client's budget, skill and experience of artist and turnaround time when establishing payment. Negotiates rights purchased. Finds artists through submissions and sourcebooks.

🅽 **GROOVER DESIGN INC.**, 1123 Zonolite Rd., Suite 20B, Atlanta GA 30306. (404)875-5295. Fax: (404)875-8990. E-mail: grooverdesign@mindspring.com. Estab. 1982. Number of employees: 3. Approximate annual billing: $350,000. Specializes in annual reports, corporate identity, website development and direct mail design. Clients: corporations. Professional affiliations: AIGA.
Needs: Approached by 50 freelancers/year. Works with 5 freelance illustrators and 1 designer/year. Uses freelancers for ad and catalog illustration, airbrushing, lettering, mechanicals and retouching. Needs computer-literate freelancers and web programmers for design, illustration, production and presentation. 85% of freelance work demands skills in Adobe Illustrator, Adobe Photoshop, Aldus FreeHand and QuarkXPress.
First Contact & Terms: Send postcard sample of work. Samples are filed. Will contact artist for portfolio review if interested. Pays for design by the hour or by the project. Pays for illustration by the project. Rights purchased vary according to project. Finds artists through sourcebooks.

🅽 **J. WALTER THOMPSON COMPANY**, One Atlanta Plaza, 950 E. Paces Ferry Rd., 30th Floor, Atlanta GA 30326. (404)365-7300. Fax: (404)365-7399. Executive Art Director: Bill Tomassi. Executive Creative Director: Mike Lollis. Ad agency. Clients: mainly financial, industrial and consumer. "This office does creative work for Atlanta and the southeastern U.S."
Needs: Works on assignment only. Uses freelancers for billboards, consumer and trade magazines and newspapers. Needs computer-literate freelancers for design, production and presentation. 60% of freelance work demands skills in Adobe Illustrator, Photoshop or QuarkXPress.
First Contact & Terms: *Deals with artist reps only.* Send slides, original work, stats. Samples returned by SASE. Reports only if interested. Originals not returned. Call for appointment to show portfolio. Pays by the hour, $20-80; by the project, $100-6,000; by the day, $140-500.
Tips: Wants to see samples of work done for different clients. Likes to see work done in different mediums, variety and versatility. Freelancers interested in working here should "be *professional* and do top-grade work."

🅽 🖼 **T-P DESIGN INC.**, 7007 Eagle Watch Court, Stone Mountain GA 30087. (770)413-8276. Fax: (770)413-9856. Creative Director: Charlie Palmer. Estab. 1991. Number of employees: 5. Approximate annual billing: $450,000. Specializes in brand identity, display, package and publication design. Clients: corporations. Current clients include Coca-Cola, Hanes, Disney, Nation's Bank, Denny's, MLB.
Needs: Approached by 4 freelancers/year. Works with 2 freelance illustrators and 2 designers/year. Prefers local artists with Mac systems traditional background. Uses illustrators and designers mainly for comps and illustration on Mac. Also uses freelancers for ad, brochure, poster and P-O-P design and illustration; book design, charts/graphs, lettering,

logos, mechanicals (important) and page layout. Also for multimedia projects. 75% of freelance work demands skills in Adobe Illustrator, Adobe Photoshop, Aldus FreeHand and QuarkXPress. "Knowledge of multimedia programs such as Director and Premier would also be desirable."

First Contact & Terms: Send query letter or photocopies, résumé and tearsheets. Accepts disk submissions compatible with Adobe Illustrator 5.5 or Aldus FreeHand. Samples are filed. Will contact artist for portfolio review if interested. Portfolio should include b&w and color final art, roughs (important) and thumbnails (important). Pays for design and illustration by the project. Rights purchased vary according to project. Finds artists through submissions and word of mouth.

Tips: "Be original, be creative and have a positive attitude. Need to show strength in illustration with a good design sense. A flair for typography would be desirable."

Hawaii

MILICI VALENTI NG PAC, 999 Bishop St., 4th Floor, Honolulu HI 96813. (808)536-0881. Creative Director: Walter Wanger. Ad agency. Serves clients in food, finance, utilities, entertainment, chemicals and personal care products. Clients include First Hawaiian Bank, Aloha Airlines, Sheraton Hotels.

Needs: Works with 2-3 freelance illustrators/month. Artists must be familiar with advertising demands; used to working long distance through the mail; and be familiar with Hawaii. Uses freelance artists mainly for illustration, retouching and lettering for newspapers, multimedia kits, magazines, radio, TV and direct mail.

First Contact & Terms: Send brochure, flier and tearsheets to be kept on file for future assignments. Pays $200-2,000.

ERIC WOO DESIGN, INC., 733 Bishop St., Suite 1280, Honolulu HI 96813. (808)545-7442. Fax: (808)545-7445. E-mail: woostuff@pixi.com. Principal: Eric. Estab. 1985. Number of employees: 1.5. Approximate annual billing: 500,000. Design firm. Specializes in image development, packaging, web and CD-ROM design, print. Specializes in state/corporate. Current clients include State of Hawaii and University of Hawaii. Client list available upon request.

Needs: Approached by 5-10 illustrators and 10 designers/year. Works with 1-2 illustrators/year. Prefers freelancers with experience in multimedia. Uses freelancers mainly for multimedia projects and lettering. 5% of work is with print ads. 90% of design demands skills in Aldus PageMaker 6.0, Adobe Photoshop, Adobe Illustrator.

First Contact & Terms: Designers send query letter with brochure, photocopies, photographs, résumé, slides and tearsheets. Illustrators send postcard sample of work or query letter with brochure, photocopies, photographs, photostats, résumé, slides, tearsheets, transparencies. Send follow-up postcard samples every 1-2 months. Accepts submissions on disk in above software. Samples are filed. Does not report back. Artist should call. Will contact for portfolio review of final art, photographs, photostats, roughs, slides, tearsheets, thumbnails and transparencies. Pays for design by the hour, $12-25. Pays for illustration by the project. Rights purchased vary according to project.

Tips: "Design and draw constantly. Have a good sense of humor."

Idaho

N CIPRA, Dept. AGDM, 314 E. Curling Dr., Boise ID 83702. (208)344-7770. Fax: (208)344-7794. E-mail: cipra@rmci.net. President: Ed Gellert. Chairman of the Board: Audrey Gellert. Estab. 1979. Number of employees: 2. Ad agency. Full-service, multimedia firm. Specializes in trade magazines, TV, marketing consulting and logos.

Needs: Works with illustrators once/year. Prefers freelancers with experience in airbrushing. Works on assignment only. Uses freelancers mainly for retouching and logos.

First Contact & Terms: Send query letter. Samples are filed for reference. Does not report back unless needed. To show portfolio, mail appropriate materials, including color photocopies. Pays for design and illustration by the project. Payment negotiated for each job. Buys all rights.

N ⬛ EL CRANMER DESIGN ASSOC., 11875 Thames Court, Hayden Lake ID 83835. (208)772-0692. Owner: El Cranmer. Estab. 1970. Specializes in items related to corporate image and product sales. Clients: small companies and corporations; mostly industrial. Current clients include Reliance Metals, Tube Service, Metal Center and Gemini Productions. Client list available upon request.

Needs: Approached by 3-6 freelancers/year. Works with 1 freelance illustrator and 1 designer/year. Prefers local artists with experience in industrial work. Works on assignment only. Uses illustrators mainly for airbrush illustration. Uses designers mainly for creative design/layout. Also uses freelancers for brochure, catalog and P-O-P design and illustration; direct mail and ad design; computer production; retouching; lettering; logos; and charts/graphs. Needs computer-literate freelancers for design, illustration and production. 50% of freelance work demands skills in Aldus PageMaker, Adobe Illustrator, QuarkXPress and Photoshop.

First Contact & Terms: Send query letter with brochure and résumé. Samples are filed. Reports back within 1 week. Call for appointment to show portfolio of thumbnails, roughs, tearsheets, photographs and transparencies. Pays for design and illustration by the hour, $30-50; by the project, $300 minimum; by the day, $300-700. Buys all rights.

N ☒ **HEDDEN-NICELY & ASSOC.**, 512 N. 13th St., Suite A, Boise ID 83702. (208)344-4631. Fax: (208)344-2458. E-mail: kim@hedden-nicely.com. Estab. 1986. Number of employees: 4. Approximate annual billing: $300,000. Ad agency. Specializes in print materials—collateral, display, direct mail. Product specialties are industrial, manufacturing.

Needs: Approached by 5 illustrators and 10 designers/year. Works with 1 illustrator and 6 designers/year. Prefers local freelancers. Prefers that designers work electronically with own equipment. Uses freelancers mainly for logos, brochures. Also for airbrushing, animation, billboards, brochure and web page design, brochure illustration, lettering, model making, posters, retouching, storyboards. 10% of work is with print ads. 90% of design demands knowledge of Aldus PageMaker 6.0, Adobe Photoshop 3, Adobe Illustrator 6.0. 40% of illustration demands knowledge of Adobe Photoshop 3, Adobe Illustrator 6.0.

First Contact & Terms: Designers send query letter with brochure and résumé. Illustrators send postcard sample of work. Accepts any Mac-compatible Photoshop or Adobe file on SyQuest or Bernoulli. Samples are filed. Reports back only if interested when an appropriate project arises. Art director will contact artists for portfolio review of color, final art, tearsheets if interested. Pays by the project. Rights purchased vary according to project, all rights preferred. "All of our freelancers have approached us through query letters or cold calls."

Illinois

ARTONWEB, P.O. Box 1160, Wayne IL 60184-1160. (630)289-6262. E-mail: sbastian@artonweb.com. Website: http://www.artonweb.com. Owner: Thomas Sebastian. Estab. 1996. Number of employees: 10. Integrated marketing communications agency and internet service. Specializes in website design and marketing. Current clients include Design Strategies, Creative FX. Client list available upon request.

Needs: Approached by 12 illustrators and 12 designers/year. Works with 2-3 illustrators and 1-2 designers/year. Uses freelancers mainly for design and computer illustration. Also for humorous illustration, lettering, logos and web page design. 5% of work is with print ads. 90% of design and 70% of illustration demands knowledge of Adobe Photoshop, Adobe Illustrator, QuarkXPress.

First Contact & Terms: Send e-mail and follow-up postcard samples every 6 months. Accepts Mac-compatible disk submissions—floppy, Zip disk or CD-ROM. Samples are filed and are not returned. Does not report back. Artist should contact via e-mail. Will contact artist for portfolio review if interested. Pays by the project. Negotiates rights purchased. Finds freelancers through *Black Book*, creative sourcebooks, Web.

BEDA DESIGN, 26179 Tarvin Lane, Ingleside IL 60041. Phone/fax: (847)973-1719. President: Lynn Beda. Estab. 1971. Number of employees: 2-3. Approximate annual billing: $250,000. Design firm. Specializes in packaging, publishing, film and video documentaries. Current clients include business-to-business accounts, producers to writers, directors and artists.

Needs: Approached by 6-12 illustrators and 6-12 designers/year. Works with 6 illustrators and 6 designers/year. Prefers local freelancers. Also for retouching, technical illustration and production. 50% of work is with print ads. 75% of design demands skills in Adobe Photoshop, QuarkXPress, Adobe Illustrator.

First Contact & Terms: Designers send query letter with brochure, photocopies and résumé. Illustrators send postcard samples and/or photocopies. Samples are filed and are not returned. Will contact for portfolio review if interested. Payments are negotiable. Buys all rights. Finds artists through word of mouth.

☒ **BENTKOVER'S DESIGN & MORE**, 1222 Cavell, Suite 3C, Highland Park IL 60035. (847)831-4437. Fax: (847)831-4462. Creative Director: Burt Bentkover. Estab. 1989. Number of employees: 2. Approximate annual billing: $100,000. Specializes in annual reports, ads, package and brochure design. Clients: business-to-business, FOODSERVICE.

Needs: Works with 3 freelance illustrators/year. Works with artist reps. Prefers local artists only. Uses freelancers for ad and brochure illustration, airbrushing, lettering, mechanicals, retouching and desktop mechanicals. 80% of freelance work demands computer skills.

First Contact & Terms: Send brochure, photocopies and tearsheets. No original art—only disposable copies. Samples are filed. Reports back in 1 week if interested. Request portfolio review in original query. Will contact artist for portfolio review if interested. Portfolio should include b&w and color photocopies. "No final art or photographs." Pays for design and illustration by the project. Rights purchased vary according to project. Finds artists through sourcebooks and agents.

☒ **BRAGAW PUBLIC RELATIONS SERVICES**, 800 E. Northwest Hwy., Palatine IL 60067. (847)934-5580. Fax: (847)934-5596. Principal: Richard S. Bragaw. Number of employees: 3. PR firm. Specializes in newsletters and brochures. Clients: professional service firms, associations and industry. Current clients include Arthur Andersen, Kaiser Precision Tooling, Inc. and Nykiel-Carlin and Co. Ltd.

Needs: Approached by 12 freelancers/year. Works with 2 freelance illustrators and 2 designers/year. Prefers local freelancers only. Works on assignment only. Uses freelancers for direct mail packages, brochures, signage, AV presentations and press releases. 90% of freelance work demands knowledge of Aldus PageMaker. Needs editorial and medical illustration.

First Contact & Terms: Send query letter with brochure to be kept on file. Reports back only if interested. Pays by the hour, $25-75 average. Considers complexity of project, skill and experience of artist and turnaround time when establishing payment. Buys all rights.

Tips: "We do not spend much time with portfolios."

JOHN CROWE ADVERTISING AGENCY, INC., 2319½ N. 15th St., Springfield IL 62702-1226. Phone/fax: (217)528-1076. President: Bryan J. Crowe. Ad/art agency. Number of employees: 3. Approximate annual billing: $250. Specializes in industries, manufacturers, retailers, banks, publishers, insurance firms, packaging firms, state agencies, aviation and law enforcement agencies. Product specialty is creative advertising. Current clients include US West Direct, Fitness America.

Needs: Approached by 250-300 freelancers/year. Works with 10-15 freelance illustrators and 2-5 designers/year. Works on assignment only. Uses freelancers for color separation, animation, lettering, paste-up and type specing for work with consumer magazines, stationery design, direct mail, slide sets, brochures/flyers, trade magazines and newspapers. Especially needs layout, camera-ready art and photo retouching. Needs technical illustration. Prefers pen & ink, airbrush, watercolor and marker. 75% of freelance design and 25% of illustration demand computer skills.

First Contact & Terms: "Send a letter to us with photocopies of your work regarding available work at agency. Tell us about yourself. We will reply if work is needed and request additional samples of work." Reports back in 2 weeks. Pays for design and illustration by the hour, $15-25. Originals not returned. No payment for unused assigned illustrations.

Tips: "Current works are best. Show your strengths and do away with poor pieces that aren't your stonghold. A portfolio should not be messy and cluttered. There has been a notable slowdown across the board in our use of freelance artists."

N ■ **LEE DeFOREST COMMUNICATIONS**, 300 W. Lake St., Elmhurst IL 60126. (630)834-7855. Fax: (630)834-0908. E-mail: ldc@deforestgroup.com. Estab. 1983. Number of employees: 4. AV firm. Full-service, multimedia firm. Specializes in electronic speaker support, Internet web art and meeting modules. Professional affiliations: President's Resource Group.

Needs: Approached by 50 freelance artists/year. Works with 3 freelance designers/year. Prefers artists with experience in TVL, HTML, PowerPoint (PC). Uses freelancers mainly for TVL and PowerPoint. Needs computer-literate freelancers production and presentation. 75% of work demands skills in PowerPoint 4.0, HTML, TVL.

First Contact & Terms: Send query letter with résumé, slides and video. Samples are filed or returned by SASE if requested by artist. To arrange for portfolio review artist should follow-up with call after initial query. Pays for production by the hour, $25-50. Finds designers through word of mouth and artists' submissions.

Tips: "Be hardworking, honest, and good at your craft."

DESIGN RESOURCE CENTER, 1979 N. Mill, Suite 208, Naperville IL 60565. (708)357-6008. Fax: (708)357-6040. E-mail: drc1@ix.netcom.com. Website: http://designresource.com. President: John Norman. Estab. 1990. Number of employees: 5. Approximate annual billing: $400,000. Specializes in package design and display, brand and corporate identity. Clients: corporations, manufacturers, private label.

Needs: Approached by 5-10 freelancers/year. Works with 3-5 freelance illustrators and 3-5 designers/year. Uses illustrators mainly for illustrating artwork for scanning. Uses designers mainly for Macintosh or concepts. Also uses freelancers for airbrushing, brochure, poster and P-O-P design and illustration, lettering, logos and package design. Needs computer-literate freelancers for design, illustration and production. 100% of freelance work demands knowledge of Adobe Illustrator 7.0, Aldus FreeHand 4.0, QuarkXPress, Photoshop.

First Contact & Terms: Send query letter with brochure, photocopies, photographs and résumé. Samples are filed. Does not report back. Artist should follow up. Portfolio review sometimes required. Portfolio should include b&w and color final art, photocopies, photographs, photostats, roughs and thumbnails. Pays for design by the hour, $10-30. Pays for illustration by the project. Buys all rights. Finds artists through word of mouth, referrals.

N ✠ **ESROCK PARTNERS**, 14550 S. 94th Ave., Orland Park IL 60462. (708)349-8400. Fax: (708)349-8471. E-mail: esrock@flash.net. President & Executive Creative Director: Jack Coughlin. Advertising Group Vice President: Ciela Quitsch. Estab. 1978. Number of employees: 35. Approximate annual billing: $20 million. Ad Agency. Full-service, multimedia firm. Specializes in magazine ads, direct mail, catalogs, sales support materials. Product specialties are food, food service, food processing. Current clients include Sargento Foods Co., Dean Foods, American Egg Board and Schwan's Food Service.

Needs: Approached by 10 freelance artists/month. Works with 3-5 illustrators and 3-5 designers/month. Prefers local artists only. Works on assignment only. Uses freelancers mainly for illustration. Also for posters, lettering and logos. 40% of work is with print ads.

First Contact & Terms: Send query letter with brochure, photocopies and résumé. Samples are filed and are not returned. Reports back only if interested. Write for appointment to show portfolio. Portfolio should include thumbnails,

roughs, b&w. Pays for design by the project. Pays for illustration by the project. Buys all rights.

GUERTIN ASSOCIATES, 1200 N. Arlington Heights Rd., #490, Itasca IL 60143. (630)775-1111. Fax: (630)775-1143. Vice President Creative: Mark Cramer. Estab. 1987. Number of employees: 8. Approximate annual billing: $3 million. Marketing service agency. Specializes in P.O.S. materials, magazine ads, direct mail and business-to-business communications. Product specialties are boating, gasolines, financial and pharmaceuticals. Current clients include Heinz Pet Foods, Firstar Bank, Unocal, Outboard Marine Corp. Effidac. Client list available upon request.

Needs: Approached by 50 freelancers/year. Works with 10 freelance illustrators/year. Prefers freelancers with experience in Mac Quark, Illustrator, Freehand, Photoshop who can work off-site. Uses freelancers mainly for keyline and layout. Also for billboards, brochure design, catalog design and illustration, logos, mechanicals, posters and signage. 10% of work is with print ads. Needs computer-literate freelancers for illustration and production. 90% of freelance work demands skills in Aldus FreeHand, Adobe Photoshop, QuarkXPress and Adobe Illustrator.

First Contact & Terms: Send query letter with photocopies and résumé. Samples are not returned. Will contact artist for portfolio review if interested. Pays for design by the project, $100-1,000. Pays for illustration by the project. Buys all rights.

IDENTITY CENTER, 1350 Remington Rd., Suite A, Schaumburg IL 60173-4822. E-mail: identctr@starnetinc.com. President: Wayne Kosterman. Number of employees: 3. Approximate annual billing: $250,000. Specializes in brand and corporate identity, print communications and signage. Clients: corporations, hospitals, manufacturers and banks. Professional affiliations: AIGA, American Center for Design, SEGD.

● Seventeen corporate identity programs (before and after) appeared in *Design/Redesign*, a book by David Carter. More than 70 of their programs have appeared in his books over the past 15 years.

Needs: Approached by 40-50 freelancers/year. Works with 4 freelance illustrators and 4 designers/year. Prefers 3-5 years of experience minimum. Uses freelancers for editorial and technical illustration, mechanicals, retouching and lettering. 50% of freelance work demands knowledge of QuarkXPress, Photoshop and Adobe Illustrator.

First Contact & Terms: Designers send résumé and photocopies. Illustrators send postcard samples, color photocopies or other non-returnable samples. To show a portfolio, send photocopies or e-mail. Do not send samples you need back without checking with us first. Pays for design by the hour, $12-35. Pays for illustration by the project, $200-5,000. Considers client's budget, skill and experience of artist and how work will be used when establishing payment. Rights purchased vary according to project.

Tips: "Not interested in amateurs or 'part-timers.' "

INNOVATIVE DESIGN & GRAPHICS, 1234 Sherman Ave., Suite 214, Evanston IL 60202-1375. (847)475-7772. E-mail: idgemail@sprintmail.com. Contact: Tim Sonder. Clients: corporate communication and marketing departments.

Needs: Works with 1-5 freelance artists/year. Prefers local artists only. Uses artists for editorial and technical illustration and desktop (CorelDraw, FreeHand, Adobe Illustrator).

First Contact & Terms: Send query letter with résumé or brochure showing art style, tearsheets, photostats, slides and photographs. Will contact artist for portfolio review if interested. Pays for design by the hour, $20-45. Pays for illustration by the project, $200-1,000 average. Considers complexity of project, client's budget and turnaround time when establishing payment. Interested in buying second rights (reprint rights) to previously published work.

Tips: "Interested in meeting new illustrators, but have a tight schedule. Looking for people who can grasp complex ideas and turn them into high-quality illustrations. Ability to draw people well is a must. Do not call for an appointment to show your portfolio. Send non-returnable tearsheets or self-promos, and we will call you when we have an appropriate project for you."

LUCY LESIAK DESIGN, 1030 Busse Way, Park Ridge IL 60068. (847)692-6688. Fax: (847)692-6693. Current clients include Harper Collins Publishers, Scott Foresman, National Text Book, McGraw-Hill, World Book. Client list available upon request.

Needs: Approached by 20 freelance artists/year. Works with 5-10 illustrators and 2-3 designers/year. Works on assignment only. Uses illustrators mainly for story or cover illustration, also editorial, technical and medical illustration. Uses designers mainly for text design. Also for book design, mechanicals and logos. 100% of design work demands knowledge of QuarkXPress, Adobe Illustrator or Adobe Photoshop.

First Contact & Terms: Send postcard sample or query letter with photocopies, brochure and résumé. Accepts disk submissions compatible with Mac Adobe Illustrator 5.0 and QuarkXPress 3.3. Samples are filed. Will contact artist for portfolio review if interested. Portfolio should include final art, color tearsheets and transparencies. Pays for design by the hour, $30-50. Pays for illustration by the project, $30-3,000. Rights purchased vary according to project. Finds artists through agents, sourcebooks and self-promotions.

QUALLY & COMPANY INC., 2238 Central St., Suite 3, Evanston IL 60201-1457. (847)864-6316. Creative Director: Robert Qually. Specializes in integrated marketing/communication and new product development. Clients: major corporations.

Needs: Works with 20-25 freelancers/year. "Freelancers must have talent and the right attitude." Works on assignment only. Uses freelancers for design, illustration, mechanicals, retouching, lettering and computer graphics.

First Contact & Terms: Send query letter with brochure, résumé, business card and samples. Samples not filed are

returned by SASE. Reports back within several days. Call or write for appointment to show portfolio.
Tips: Looking for "talent, point of view, style, craftsmanship, depth and innovation" in portfolio or samples. Sees "too many look-alikes, very little innovation."

[N] JOHN STRIBIAK & ASSOCIATES, INC., 11160 SW Hwy., Palos Hills, IL 60465. (708)430-3380. Fax: (708)974-4975. President: John Stribiak. Estab. 1981. Number of employees: 2. Approximate annual billing: $300,000. Specializes in corporate identity and package design. Clients: corporations. Professional affiliations: IOPP, PDC.
Needs: Approached by 75-100 freelancers/year. Works with 20 freelance illustrators and 2 designers/year. Prefers artists with experience in illustration, design, retouching and packaging. Uses illustrators mainly for packaging and brochures. Uses designers mainly for new products. Also uses freelancers for ad and catalog illustration, airbrushing, brochure design and illustration, lettering, model making and retouching. Needs computer-literate freelancers for production. 70% of freelance work demands skills in Adobe Illustrator, Adobe Photoshop and QuarkXPress.
First Contact & Terms: Send postcard sample of work. Samples are filed. Will contact artist for portfolio review if interested. Portfolio should include b&w and color roughs and transparencies. Pays for design and illustration by the project. Rights purchased vary according to project. Finds artists through sourcebooks.

[N] CHUCK THOMAS CREATIVE, INC., One W. Illinois St., Suite 210, St. Charles IL 60174. (630)587-6000. Estab. 1989. Integrated marketing communications agency. Specializes in consulting, creative branding, collateral. Product specialties healthcare, family. Current clients include Kidspeace, Cook Communications, Opportunity International.
Needs: Works with 1-2 freelance illustrators and 2-3 designers/year. Needs freelancers for brochure design and illustration, logos, multimedia projects, posters, signage, storyboards, TV/film graphics. 20% of work is with print ads. 100% of freelance design demands skills in Aldus PageMaker, Aldus FreeHand.
First Contact & Terms: Designers send query letter with brochure and photocopies. Illustrators send postcard sample of work. Samples are filed. Reports back only if interested. Portfolio review not required. Pays by the project. Buys all rights.

[N] WATERS & WOLFE, 1603 Orrington, Suite 990, Evanston IL 60201. (847)475-4500. Fax: (847)475-3947. E-mail: jbeuving@wnwolfe.com. Senior Art Director: Jeff Beuving. President: Paul Frankel. Estab. 1984. Number of employees: 15. Approximate annual billing: $2 million. Ad agency, AV firm, PR firm. Full-service, multimedia firm. Specializes in collateral, annual reports, magazine ads, trade show booth design, videos, PR. "We are full service from logo design to implementation of design." Product specialty is business-to-business. Current clients include Nazdar, 3D Image Technology. Client list not available. Professional affiliation: BMA
Needs: Approached by 50 freelancers/year. Works with 5 freelance illustrators and 5 designers/year. Uses freelancers mainly for layout and illustrations. Also for animation, lettering, logos, mechanicals, retouching, signage and TV/film graphics. 25% of work is with print ads. Needs computer-literate freelancers for design, web programming, illustration, production and presentation. 90% of freelance work demands knowledge of Photoshop 4.0, QuarkXPress 4.0, Adobe Illustrator 7.0.
First Contact & Terms: Send query letter with brochure, photocopies, photographs, résumé and tearsheets. Will also accept printouts of artist's samples. Samples are filed. Will contact artist for portfolio review if interested. Portfolio should include color final art, roughs, tearsheets and thumbnails. Pays for design by the hour or by the project. Pays for illustration by the project. Rights purchased vary according to project. Finds artists through sourcebooks, word of mouth, artists' submissions and agents.
Tips: "I am impressed by professionalism. Complete projects on timely basis, have thorough knowledge of task at hand."

Chicago

THE CHESTNUT HOUSE GROUP INC., 1980 Berkeley Rd., Highland Park IL 60035. (847)831-0757. Fax: (847)831-2527. E-mail: chestnuthouse@compuserve.com or mileszim@interaccess.com. Contact: Miles Zimmerman. Clients: major educational publishers.
Needs: Illustration, layout and electronic page production. Needs computer-literate freelancers for production. Uses experienced freelancers only. Freelancers should be familiar with QuarkXPress and various drawing and painting programs for illustrators. Pays for production by the hour. Pays for illustration by the project.
First Contact & Terms: "Illustrators submit samples."

[N] CLEARVUE, INC., 6465 N. Avondale, Chicago IL 60631. (773)775-9433. President: Mark Ventling. Educational publishing and distribution.
Needs: Works with 10-12 freelance artists/year. Works on assignment only. Uses freelance artists mainly for video programs and computer animation. Needs editorial and catalog layout.
First Contact & Terms: Send query letter with SASE to be kept on file. Prefers to review proposal and demo tape. Reports back within 10 days. Write for appointment to show portfolio. Average program is 10-20 minutes long. Considers

the complexity of the project and budget when establishing payment. Particularly interested in combining existing archival art and video materials with computer animations. Pays by the project, $50-2,500, depending on the scope of the work. Rights negotiable.

Tips: "Have some knowledge of the educational video marketplace. Review our catalogs. Write a proposal that tells how you fill a need in one or more curricular subject areas."

COMUNIGRAFIX INC., 320 W. Ohio St., Chicago IL 60610. (312)944-3000. Fax: (312)944-8587. Production Manager: John Sakounis. Estab. 1953. Number of employees: 100. Approximate annual billing: $20 million. Specializes in brand and corporate identity, direct response catalogs, direct mail and package design. Clients: agencies and corporations. Current clients include Empire, Davidson Marketing. Client list available upon request.

Needs: Approached by 50 freelancers/year. Works with 2 freelance illustrators and 5 designers/year. Uses illustrators mainly for illustrations for designs. Uses designers mainly for Macintosh. Also uses freelancers for ad illustration, brochure design and illustration, airbrushing and magazine design. Needs computer-literate freelancers for production. 50% of freelance work demands skills in Adobe Illustrator, Adobe Photoshop and QuarkXPress.

First Contact & Terms: Send postcard sample of work and résumé. Samples are filed. Will contact artist for portfolio review if interested. Portfolio should include color final art and photographs. Pays for design by the hour, $10-25. Pays for illustration by the hour, $10-50. Rights purchased vary according to project.

DeFRANCESCO/GOODFRIEND, 444 N. Michigan Ave., Suite 1000, Chicago IL 60611. (312)644-4409. Fax: (312)644-7651. E-mail: johnde@dgpr.com. Partner: John DeFrancesco. Estab. 1985. Number of employees: 8. Approximate annual billing: $1 million. PR firm. Full-service multimedia firm. Specializes in marketing, communication, publicity, direct mail, brochures, newsletters, trade magazine ads, AV presentations. Product specialty is consumer home products. Current clients include S-B Power Tool Co., Northern Trust Co., Wells Lamont, Ace Hardware Corp., Promotional Products Association International. Professional affiliations: Chicago Direct Marketing Association, Sales & Marketing Executives of Chicago, Public Relations Society of America, Publicity Club of Chicago.

Needs: Approached by 15-20 freelancers/year. Works with 2-5 freelance illustrators and 2-5 designers/year. Works on assignment only. Uses freelancers mainly for brochures, ads, newsletters. Also for print ad design and illustration, editorial and technical illustration, mechanicals, retouching and logos. 90% of freelance work demands computer skills.

First Contact & Terms: Send query letter with brochure and résumé. Samples are filed. Does not report back. Request portfolio review in original query. Artist should call within 1 week. Portfolio should include printed pieces. Pays for design and illustration by the project, $50 minimum. Rights purchased vary according to project. Finds artists through word of mouth and queries.

Tips: "Many new people are opening shop and you need to keep your name in front of your prospects."

DESIGN ASSOCIATES, 6117 N. Winthrop Ave., Chicago IL 60660. (773)338-4196. Fax: (773)338-4197. Contact: Paul Uhl. Estab. 1986. Number of employees: 3. Specializes in annual reports, corporate identity, website development, text and trade book design. Clients: corporations, publishers and museums. Client list available upon request.

Needs: Approached by 10-20 freelancers/year. Works with 100 freelance illustrators and 5 designers/year. Uses freelancers for design and production, illustration and photography, lettering. 100% of freelance work demands knowledge of Adobe Illustrator, Adobe Photoshop and QuarkXPress.

First Contact & Terms: Send query letter with samples that best represent work. Accepts disk submissions. Samples are filed. Will contact artist for portfolio review if interested. Portfolio should include b&w and color samples. Pays for design by the hour and by the project. Pays for illustration by the project. Buys all rights. Finds artists through sourcebooks, reps and word of mouth.

DAVE DILGER, 1467 N. Elston, Suite 200, Chicago IL 60622. (773)772-3200. Fax: (773)772-3244. E-mail: paulsen@paulsenpartners.com. Website: http://www.paulsenpartners.com. Contact: Dave Dilger. Estab. 1951. Number of employees: 8. Ad agency. Full-service, multimedia firm. Specializes in print ads, collateral and other print material. Product specialty is industrial.

Needs: Approached by 5-10 freelancers/year. Works with 3-4 freelance illustrators and 10 designers/year. Prefers local artists only. Uses freelancers mainly for design and illustration. Also for brochure and catalog design; and retouching. 100% of work is with print ads. Needs computer-literate freelancers for design and production. 85% of freelance work demands knowledge of Adobe Photoshop 3.1, QuarkXPress 3.3 and Adobe Illustrator.

First Contact & Terms: Send query letter with résumé. Samples are filed or returned. Request portfolio review in original query. Portfolio should include b&w and color final art and roughs. Pays for design and illustration by the hour or by the project. "We work with the artist." Buys all rights or negotiates rights purchased.

GETER ADVERTISING INC., 75 E. Wacker Dr., #410, Chicago IL 60601. (312)782-7300. Account Executive: Jill Rubin. Estab. 1978. Ad agency. Full-service, multimedia firm. Product specialty is professional services. Client list not available.

Needs: Approached by 20-50 freelancers/year. Permanent part-time positions in design available. Prefers artists with experience in computer layout—work done at our office. Uses freelancers mainly for print ads, brochures and outdoor design. Also uses freelancers for billboards, brochure design, logos, posters, signage and TV/film graphics. 50% of work is with print ads. Needs computer-literate freelancers for design, illustration, production and presentation. 100%

of freelance work demands skills in Aldus PageMaker, Aldus FreeHand, Adobe Photoshop, QuarkXPress, Adobe Illustrator and Corel Draw (latest versions).

First Contact & Terms: Send query letter with photocopies and résumé. Samples are reviewed immediately and filed or returned. Agency will contact artist for portfolio review if interested. Portfolio should include b&w and color final art and tearsheets. Pays for design by the hour, $15-25; by the project, $50-2,000; by the day, $100-200. Buys all rights.

Tips: Impressed with freelancers who possess "skill on computer, good artistic judgment, speed, and who can work with our team."

HIRSCH O'CONNOR DESIGN INC., 205 W. Wacker Dr., Suite 622, Chicago IL 60606. (312)329-1500. President: David Hirsch. Executive Vice President: Joseph O'Connor. Number of employees: 11. Specializes in annual reports, corporate identity, publications and promotional literature. Clients: manufacturing, PR, real estate, financial and industrial firms. Professional affiliations: American Center for Design, AIGA and IABC.

Needs: Approached by more than 100 freelancers/year. Works with 6-10 freelance illustrators and 3-5 designers/year. Uses freelancers for design, illustration, brochures, retouching, airbrushing, AV materials, lettering, logos and photography. Freelancers should be familiar with Adobe Photoshop and Adobe Illustrator.

First Contact & Terms: Send query letter with promotional materials showing art style or samples. Samples not filed are returned by SASE. Reports back only if interested. Call for appointment to show portfolio of roughs, final reproduction/product, tearsheets and photographs. Pays for design and illustration by the project. Considers complexity of project, client's budget and how work will be used when establishing payment. Interested in buying second rights (reprint rights) to previously published work. Finds artists primarily through sourcebooks and self-promotions.

Tips: "We're always looking for talent at fair prices."

N HUGHES & CO., 920 N. Franklin, Suite 401, Chicago IL 60610. (312)664-4700. Fax: (312)944-3595. Art Director: Sally Hughes. Estab. 1978. Number of employees: 10. Approximate annual billing: $400,000. Specializes in annual reports, corporate identity and publication design. Current clients include Surrey Books, Sew/Fit Co., Illinois Int. Port and Garborside G.C.

Needs: Approached by 15 freelancers/year. Works with 5 freelance illustrators/year. Uses illustrators mainly for bookcovers and interiors. Also uses freelancers for ad, brochure and catalog illustration, airbrushing and book design. 20% of freelance work demands computer skills.

First Contact & Terms: Send postcard sample of work or send brochure, photocopies and photographs. Samples are filed. Will contact artist for portfolio review if interested. Pays for illustration by the project. Rights purchased vary according to project.

■ HUTCHINSON ASSOCIATES, INC., 1147 W. Ohio, Suite 305, Chicago IL 60622. (312)455-9191. Fax: (312)455-9190. E-mail: hutch@hutchinson.com. Website: http://www.hutchinson.com. Contact: Jerry Hutchinson. Estab. 1988. Number of employees: 3. Specializes in annual reports, corporate identity, multimedia, direct mail, publication design and website design and development. Clients: corporations, associations and PR firms. Professional affiliations: AIGA, ACD.

● Work from Hutchinson Associates has been published in the design books *Work With Computer Type* Vols. 1-3 by Rob Carter (Rotovision).

Needs: Approached by 5-10 freelancers/year. Works with 3-10 freelance illustrators and 5-15 designers/year. Uses freelancers mainly for brochure design, illustration, annual reports, multimedia and web designs. Also uses freelancers for ad and direct mail design, catalog illustration, charts/graphs, logos, multimedia projects and mechanicals.

First Contact & Terms: Send postcard sample of work or send query letter with résumé, brochure, photocopies and photographs. Accepts disk submissions compatible with Adobe Illustrator and Director. Samples are filed. Request portfolio review in original query. Artist should follow-up with call. Will contact artist for portfolio review if interested. Portfolio should include transparencies and printed pieces. Pays by the project, $100-10,000. Rights purchased vary according to project. Finds artists through *Creative Illustration, Workbook*, sourcebooks, Illinois reps, submissions.

Tips: "Persistence pays off."

■ KAUFMAN RYAN STRAL INC., 650 N. Dearborn St., Suite 700, Chicago IL 60610. (312)467-9494. Fax: (312)467-0298. E-mail: big@bworld.com. Website: http://www.bworld.com. President/Creative Director: Robert Ryan. Estab. 1993. Number of employees: 7. Ad agency. Specializes in all materials in print and website development. Product specialty is business-to-business. Client list available upon request. Professional affiliations: BMA, American Israel Chamber of Commerce.

Needs: Approached by 30 freelancers/year. Works with 6 freelance illustrators and 5 designers/year. Prefers local freelancers. Uses freelancers for design, production, illustration and computer work. Also for brochure, catalog and print ad design and illustration, animation, mechanicals, retouching, model making, posters, lettering and logos. 30% of work is with print ads. 50% of freelance work demands knowledge of QuarkXPress, html programs FrontPage or Page Mill, Adobe Photoshop or Adobe Illustrator.

First Contact & Terms: Send query letter with résumé and photostats. Samples are filed or returned by SASE. Reports back only if interested. Artist should follow-up with call and/or letter after initial query. Will contact artist for portfolio review if interested. Portfolio should include b&w and color roughs and final art. Pays for design by the hour, $40-120; or by the project. Pays for illustration by the project, $75-8,000. Buys all rights. Finds artists through sourcebooks, word of mouth, submissions.

▣ 目 **MSR ADVERTISING, INC.**, P.O. Box 10214, Chicago IL 60610-0214. (312)573-0001. Fax: (312)573-1907. E-mail: marc@msradv.com. Website: http://msradv.com. President: Marc S. Rosenbaum. Art Director: Margaret Wilkins. Office Manager: Danielle Davidson. Estab. 1983. Number of employees: 6. Approximate annual billing: $2.5 million. Ad agency. Full-service multimedia firm. Specializes in collateral. Product specialties are medical, food, industrial and aerospace. Current clients include Baxter Healthcare, Mama Tish's, Pizza Hut, hospitals, healthcare, Helene Curtis, Colgate-Palmolive.
 • MSR opened a Tampa, Florida office at the end of 1996 and has new clients including insurance agencies, law firms and an engineering firm interested in growing their identities in the marketplace.
Needs: Approached by 6-10 freelancers/year. Works with 5-10 freelance illustrators and 5-10 designers/year. Prefers local artists who are "innovative, resourceful and hungry." Works on assignment only. Uses freelancers mainly for creative through boards. Also for brochure, catalog and print ad design and illustration, multimedia, storyboards, mechanicals, billboards, posters, lettering and logos. 30% of work is with print ads. 75% of design and 25% of illustration demand computer skills.
First Contact & Terms: Send query letter with brochure, photographs, photocopies, slides, SASE and résumé. Accepts submissions on disk. Samples are filed or returned. Reports back within 1-2 weeks. Write for appointment to show portfolio or mail appropriate materials: thumbnails, roughs, finished samples. Artist should follow up with call. Pays for design by the hour, $45-95. Buys all rights. Finds artists through submissions and agents.
Tips: "We maintain a relaxed environment designed to encourage creativity; however, work must be produced timely and accurately. Normally the best way for a freelancer to meet with us is through an introductory letter and a follow-up phone call a week later. Repeat contact every 2-4 months. Be persistent and provide outstanding representation of your work."

THE QUARASAN GROUP, INC., 214 W. Huron St., Chicago IL 60610-3613. (312)787-0750. President: Randi S. Brill. Specializes in educational products. Clients: educational publishers. Client list not available.
Needs: Approached by 400 freelancers/year. Works with 700-900 illustrators/year. Freelancers with publishing experience preferred. Uses freelancers for illustration, books, mechanicals, charts/graphs, lettering and production. Needs computer-literate freelancers for illustration. 50% of freelance illustration work demands skills in Adobe Illustrator, QuarkXPress, Photoshop or Aldus FreeHand. Needs editorial, technical, medical and scientific illustration.
First Contact & Terms: Send query letter with brochure or résumé and samples to be circulated and kept on file. Prefers "anything that we can retain for our files: photostats, photocopies, tearsheets, disks or dupe slides that do not have to be returned" as samples. Reports only if interested. Pays for illustration by the piece/project, $40-2,000 average. Considers complexity of project, client's budget, how work will be used and turnaround time when establishing payment. "For illustration, size and complexity are the key factors."
Tips: "Our publishers continue to require us to use only those artists willing to work on a work-for-hire basis. This is slowly changing, but at present, this is still often a requirement."

N ▣ **SELZ/SEABOLT COMMUNICATIONS**, 221 N. LaSalle St., Suite 3500, Chicago IL 60601-1520. (312)372-7090. Fax: (312)372-6160. E-mail: info@selz.com. Website: http://www.selz.com. Graphics Coordinator: Charles Hutchinson. Estab. 1928. Number of employees: 46. Approximate annual billing: $5.5 million. PR firm. Full-service, multimedia firm. Specializes in newspaper, magazine, collaterals, video. Product specialties are consumer and business to business. Current clients include Bombardier, Sargento, Square D, McCain Foods.
Needs: Approached by 2 freelance artists/month. Works with 2 illustrators and 3 designers/month. Prefers artists with experience in desktop publishing (Macintosh). Works on assignment only. Uses freelancers mainly for newsletters. Also for brochure and catalog design, lettering and logos. 70% of work is with print ads. Needs computer-literate freelancers for design, illustration, production and presentation. 80% of freelance work demands skills in Aldus Pagemaker, Adobe Illustrator, QuarkXPress, Photoshop or Aldus FreeHand.
First Contact & Terms: Send query letter with brochure, photocopies and résumé. Samples are not returned. To show portfolio, mail appropriate materials: thumbnails, rough, printed piece. Pays for design by the hour, $20-65. Pays for illustration by the project, $150-500. Rights purchased vary according to project.

TESSING DESIGN, INC., 3822 N. Seeley Ave., Chicago IL 60618. (312)525-7704. Fax: (312)525-7756. E-mail: tess46@aol.com. Principals: Arvid V. Tessing and Louise S. Tessing. Estab. 1975. Number of employees: 2. Specializes in corporate identity, marketing promotions and publications. Clients: publishers, educational institutions and nonprofit groups. Majority of clients are publishers. Professional affiliation: Women in Design, Chicago Book Clinic.
Needs: Approached by 30-80 freelancers/year. Works with 5 freelance illustrators and 2 designers/year. Works on assignment only. Uses freelancers mainly for publications. Also for book and magazine design and illustration, mechanicals, retouching, airbrushing, charts/graphs and lettering. 90% of design and 75% of illustration demand knowledge of QuarkXPress, Adobe Photoshop or Adobe Illustrator. Needs textbook, editorial and technical illustration.
First Contact & Terms: Designers send query letter with photocopies. Illustrators send postcard samples. Samples are filed and are not returned. Request portfolio review in original query. Artist should follow up with letter after initial query. Will contact artist for portfolio review if interested. Portfolio should include original/final art, final reproduction/product and photographs. Pays for design by the hour, $40-60. Pays for illustration by the project, $100 minimum. Rights purchased vary according to project. Finds artists through word of mouth, submissions/self-promotions and sourcebooks.
Tips: "We prefer to see original work or slides as samples. Work sent should always relate to the need expressed. Our

advice for artists to break into the field is as always—call prospective clients, show work and follow up."

Indiana

N **ADVANCED DESIGNS CORPORATION**, 1169 W. Second St., Bloomington IN 47403. (812)333-1922. Fax: (812)333-2030. President: Martin Riess. Estab. 1982. AV firm. Weather radar systems and associated graphics. Specializes in TV news broadcasts. Product specialties are the Doppler Radar and Display Systems.
Needs: Prefers freelancers with experience. Works on assignment only. Uses freelancers mainly for TV/film (weather) and cartographic graphics. Needs computer-literate freelancers for production. 100% of freelance work demands skills in ADC Graphics.
First Contact & Terms: Send query letter with résumé and SASE. Samples are not filed and are returned by SASE. Pays for design and illustration by the hour, $7 minimum. Will contact artist for portfolio review if interested. Rights purchased vary according to project. Finds artists through classifieds.

C.R.E. INC., 400 Victoria Centre, 22 E. Washington St., Indianapolis IN 46204. (317)631-0260. E-mail: mark_gaus e@cremarcom.com. Website: http://www.cremarcom.com. VP/Creative Director: Mark Gause. Associate Creative Directors: Mary Hayes, Rich Lunseth and Sean Cunat. Art Director: Monty Jorgensen. Designers: Jim Collins, Kevin Nelson and Julie Taylor. Number of employees: 40. Approximate annual billing: $26 million. Ad agency. Specializes in business-to-business, transportation products and services, computer equipment, biochemicals and electronics.
Needs: Approached by 50 freelancers/year. Works with 15 freelance illustrators and 2 designers/year. Works on assignment only. Uses freelancers for technical line art, color illustrations and airbrushing. Also for multimedia, primarily CD-ROM and Internet applications. 100% of freelance design and 25% of illustration demand computer skills.
First Contact & Terms: Send query letter with résumé and photocopies. Accepts disk submissions. Samples not filed are returned. Reports back only if interested. Call or write for appointment to show portfolio, or mail final reproduction/product and tearsheets. Pays by the project, $100 minimum. Buys all rights.
Tips: "Show samples of good creative talent."

JMH CORPORATION, 921 E. 66th St., Indianapolis IN 46220. (317)255-3400. Website: http://jmhdesign.com. President: J. Michael Hayes. Number of employees: 3. Specializes in annual reports, corporate identity, advertising, collateral, packaging, publications and website development. Clients: publishers, consumer product manufacturers, corporations and institutions. Professional affiliations: AIGA.
Needs: Approached by 30-40 freelancers/year. Works with 5 freelance illustrators and 2 designers/year. Prefers experienced, talented and responsible freelancers only. Works on assignment only. Uses freelancers for advertising, brochure and catalog design and illustration, P-O-P displays, retouching, charts/graphs and lettering. Needs editorial and medical illustration. 100% of design and 30% of illustration demand skills in QuarkXPress, Adobe Illustrator or Adobe Photoshop (latest versions).
First Contact & Terms: Send query letter with brochure/flyer, résumé, photocopies, photographs, tearsheets and slides. Accepts disk submissions compatible with QuarkXPress 4.0 and Adobe Illustrator 8.0. Send EPS files. Samples returned by SASE, "but we prefer to keep them." Reporting time "depends entirely on our needs." Write for appointment to show portfolio. Pays for design by the hour, $20-50, or by the project, $100-1,000. Pays for illustration by the project, $300-2,000.
Tips: "Prepare an outstanding mailing piece and 'leave-behind' that allows work to remain on file. Keep doing great work and stay in touch." Advises freelancers entering the field to "send samples regularly. Call to set a portfolio presentation. Do great work. Be persistent. Love what you do. Have a balanced life."

Iowa

N **F.A.C. MARKETING**, P.O. Box 782, Burlington IA 52601. (319)752-9422. Fax: (319)752-7091. President: Roger Sheagren. Estab. 1952. Number of employees: 5. Approximate annual billing: $500,000. Ad agency. Full-service, multimedia firm. Specializes in newspaper, television, direct mail. Product specialty is funeral home to consumer.
Needs: Approached by 30 freelancers/year. Works with 1-2 freelance illustrators and 4-6 designers/year. Prefers freelancers with experience in newspaper and direct mail. Uses freelancers mainly for newspaper design. Also for brochure design and illustration, logos, signage and TV/film graphics. Freelance work demands knowledge of Aldus PageMaker, Adobe Photoshop, CorelDraw and QuarkXPress.

First Contact & Terms: Send query letter with brochure, photostats, SASE, tearsheets and photocopies. Samples are filed or returned by SASE if requested by artist. Request portfolio review in original query. Portfolio should include b&w photostats, tearsheets and thumbnails. Pays by the project, $100-500. Rights purchased vary according to project.

Kansas

[N] [icon] BRYANT, LAHEY & BARNES, INC., 5300 Foxridge Dr., Shawnee Mission KS 66202. (913)262-7075. Art Director: Terry Pritchett. Ad agency. Clients: agriculture and veterinary firms.
Needs: Prefers local freelancers only. Uses freelancers for illustration and production, including keyline and paste-up; consumer and trade magazines and brochures/flyers.
First Contact & Terms: Query by phone. Send business card and résumé to be kept on file for future assignments. Originals not returned. Negotiates pay.

[N] [icon] GOLDSMITH YAMASAKI SPECHT INC, 9903 Pflumm Rd., Kansas City KS 66215. (913)492-4044. Industrial design consultancy. Contact: Peter Falt. Specializes in corporate identity, new media, industrial design, graphic design. Clients: industrial firms, institutions, service organizations, ad agencies, government agencies, etc.
Needs: Works with 6-10 freelance artists/year. "We generally use local artists, simply for convenience." Works on assignment only. Uses artists for design (especially graphics), illustration, retouching, model making, lettering and production art. Prefers collage and marker.
First Contact & Terms: Send query letter with résumé and samples to be kept on file. Samples not kept on file are returned only if requested. Reports only if interested. Call or write to schedule an appointment to show a portfolio, which should include roughs and final reproduction/product. Pays for design by the hour, $20 minimum. Pays for illustration by the project; payment depends on project. Considers complexity of project, client's budget, skill and experience of artist, how work will be used, turnaround time and rights purchased when establishing payment.
Tips: "If we receive many inquiries, obviously our time commitment may necessarily be short. Please understand. We use very little outside help, but it is increasing (mostly graphic design and production art)."

[icon] GRETEMAN GROUP, 142 N. Mosley, Third Floor, Wichita KS 67202-4617. (316)263-1004. Fax: (316)263-1060. E-mail: greteman@gretemangroup.com. Website: http://www.gretemangroup.com. Owner: Sonia Greteman. Estab. 1989. Number of employees: 11. Approximate annual billing: $2.5 million. Design firm. Specializes in corporate identity, annual reports, signage, website design, interactive media, brochures, collateral. Professional affiliations: AIGA.
Needs: Approached by 2 illustrators and 10-20 designers/year. Works with 2 illustrators and 2 designers/year. Also for brochure illustration. 10% of work is with print ads. 100% of design demands skills in Aldus PageMaker, Aldus FreeHand, Adobe Photoshop, QuarkXPress, Adobe Illustrator. 30% of illustration demands computer skills.
First Contact & Terms: Send query letter with brochure and résumé. Accepts disk submissions. Send EPS files. Samples are filed. Will contact for portfolio review of b&w and color final art and photostats if interested. Pays for design by the hour. Pays for illustration by the project. Rights purchased vary according to project.

[N] MARKETAIDE SERVICES, INC., Box 500, Salina KS 67402-0500. (913)825-7161. Fax: (913)825-4697. E-mail: tkuntz@marketaide.com. Website: http://www.marketaide.com. Production Manager: Tina Kuntz. Graphic Designer: Pam Harris. Full-service ad/marketing/direct mail firm. Clients: financial, industrial and educational.
Needs: Prefers artists within one-state distance who possess professional expertise. Works on assignment only. Uses freelancers for technical illustrations, retouching, signage. Needs computer-literate freelancers for design, illustration, production and presentation. 90% of freelance work demands knowledge of QuarkXPress, Adobe Illustrator and Photoshop.
First Contact & Terms: Send query letter with résumé, business card and samples to be kept on file. Samples not filed are returned by SASE only if requested. Reports only if interested. Write for appointment to show portfolio. Pays for design by the hour, $15-75 average; "since projects vary in size we are forced to estimate according to each job's parameters." Pays for illustration by the project.
Tips: "Artists interested in working here should be highly polished in technical ability, have a good eye for design and be able to meet all deadline commitments."

[N] TASTEFUL IDEAS, INC., 5822 Nall Ave., Mission KS 66205. (913)722-3769. Fax: (913)722-3967. E-mail: tasteful@tfs.net. Website: http://www.tastefulideas.com. President: John Thomsen. Estab. 1986. Number of employees: 4. Approximate annual billing: $500,000. Design firm. Specializes in consumer packaging. Product specialties are largely, but not limited to, food and foodservice.
Needs: Approached by 15 illustrators and 15 designers/year. Works with 3 illustrators and 3 designers/year. Prefers local freelancers. Uses freelancers mainly for specialized graphics. Also for airbrushing, animation, humorous and technical illustration. 10% of work is with print ads. 75% of design and illustration demand skills in Adobe Photoshop and Adobe Illustrator.
First Conact & Terms: Designers send query letter with photocopies. Illustrators send query letter with photostats. Accepts disk submissions from designers and illustrators compatible with Adobe Illustrator, Photoshop—Mac based.

Samples are filed. Reports back only if interested. Art director will contact artist for portfolio review of final art of photostats if interested. Pays by the project. Finds artists through submissions.

Kentucky

HAMMOND DESIGN ASSOCIATES, INC., 206 W. Main, Lexington KY 40507. (606)259-3639. Fax: (606)259-3697. Vice-President: Mrs. Kelly Johns. Estab. 1986. Specializes in direct mail, package and publication design and annual reports, brand and corporate identity, display and signage. Clients: corporations, universities and medical facilities.
Needs: Approached by 35-50 freelance/year. Works with 5-7 illustrators and 5-7 designers/year. Works on assignment only. Uses freelancers mainly for brochures and ads. Also for editorial, technical and medical illustration, airbrushing, lettering, P-O-P and poster illustration; and charts/graphs. 100% of design and 50% of illustration require computer skills.
First Contact & Terms: Send postcard sample or query letter with brochure or résumé. "Sample in query letter a must." Samples are filed or returned by SASE if requested by artist. Reports back only if interested. Will contact artist for portfolio review if interested. Sometimes requests work on spec before assigning job. Pays by the project, $100-10,000. Rights negotiable.

THE WILLIAMS McBRIDE GROUP, (formerly Williams McBride Design, Inc.), 344 E. Main St., Lexington KY 40507. (606)253-9319. Fax: (606)233-0180. E-mail: mail@williamsmcbride.com. Website: http://www.williamsmcbride .com. Partners: Robin Williams Brohm and Kimberly McBride. Estab. 1988. Number of employees: 13. Design firm specializing in corporate communications, brand management and corporate identity. Clients: health care, manufacturing, software. Client list available upon request.
Needs: Approached by 7-10 freelance artists/year. Works with 4 illustrators and 2 designers/year. Prefers freelancers with experience in corporate design, branding. Works on assignment only. Uses illustrators for annual reports, brochure design and illustration, logos, mechnicals and technical illustrations. Needs computer-literate freelancers for design and illustration. 80% of freelance design work demands knowledge of QuarkXPress, Adobe Photoshop and Adobe Illustrator.
First Contact & Terms: Designers send query letter with résumé, tearsheets or photocopies. Illustrators send postcard sample of work. Accepts disk submissions compatible with Macintosh QuarkXPress, EPS or TIFF. PC also acceptable. Samples are filed. Reports back only if interested. Pays for design by the hour, $25-60. Pays for illustration by the project, $100-3,500. Rights purchased vary according to project. Finds artists through submissions, word of mouth, *Creative Black Book*, *Workbook* and *American Showcase*.
Tips: "Keep our company on your mailing list; remind us that you are out there, and understand the various rights that can be purchased."

Louisiana

🔲 **ANTHONY DI MARCO**, 301 Aris Ave., New Orleans LA 70005. (504)833-3122. Creative Director: Anthony Di Marco. Estab. 1972. Number of employees: 1. Specializes in illustration, sculpture, costume design and art photo restoration and retouching. Current clients include Audubon Institute, Louisiana Nature and Science Center, Fair Grounds Race Course, City of New Orleans, churches, agencies. Client list available upon request. Professional affiliations: Art Directors Designers Association, Energy Arts Council, Louisiana Crafts Council, Louisiana Alliance for Conservation of Arts.
● Anthony DiMarco recently completed the re-creation of a 19th century painting, *Life on the Metairie*, for the Fair Grounds racetrack. The original painting was destroyed by fire in 1993.
Needs: Approached by 50 or more freelancers/year. Works with 5-10 freelance illustrators and 5-10 designers/year. Seeks "local freelancers with ambition. Freelancers should have substantial portfolios and an understanding of business requirements." Uses freelancers mainly for fill-in and finish: design, illustration, mechanicals, retouching, airbrushing, posters, model making, charts/graphs. Prefers highly polished, finished art in pen & ink, airbrush, charcoal/pencil, colored pencil, watercolor, acrylic, oil, pastel, collage and marker. 25% of freelance work demands computer skills.
First Contact & Terms: Send query letter with résumé, business card, slides, brochure, photocopies, photographs, transparencies and tearsheets to be kept on file. Samples not filed are returned by SASE. Reports back within 1 week if interested. Call or write for appointment to show portfolio. Pays for illustration by the hour or by the project, $100 minimum.
Tips: "Keep professionalism in mind at all times. Put forth your best effort. Apologizing for imperfect work is a common mistake freelancers make when presenting a portfolio. Include prices for completed works (avoid overpricing). Three-dimensional works comprise more of our total commissions than before."

🔲 **FOCUS COMMUNICATIONS, INC.**, 712 Milam, #102, Shreveport LA 71101. (318)221-3808. Fax: (318)221-3871. President: Jim Huckabay. Estab. 1976. Number of employees: 3. Approximate annual billing: $1 million. Specializes in corporate identity, direct mail design and full service advertising. Clients: medical, financial and retail. Professional affiliations: AAF.

Needs: Approached by 5 freelancers/year. Works with 2 freelance illustrators and designers/year. Prefers local artists with experience in illustration, computer (Mac) design and composition. Uses illustrators mainly for custom projects; print ads. Uses designers mainly for custom projects; direct mail, logos. Also uses freelancers for ad and brochure design and illustration, audiovisual materials, charts/graphs, logos, mechanicals and retouching. Needs computer-literate freelancers for design, illustration and production. 85% of freelance work demands skills in Adobe Photoshop, Aldus FreeHand and QuarkXPress.

First Contact & Terms: Send postcard sample of work or send query letter with brochure, photocopies, photostats, slides, tearsheets and transparencies. Samples are filed. Will contact artist for portfolio review if interested. Portfolio should include b&w and color final art and slides. Pays for design by the hour, $40-75; by the project. Pays for illustration by the project, $100-1,000. Negotiates rights purchased.

Tips: Impressed by "turnkey capabilities in Macintosh design and finished film/proof composition."

PETER O'CARROLL ADVERTISING, 710 W. Prien Lake Rd., Suite 209, Lake Charles LA 70601. (318)478-7396. Fax: (318)478-0503. E-mail: ocarroll@laol.net. Website: http://www.ocarroll.com. Operations Manager: Jeanne Rogers. Estab. 1978. Ad agency. Specializes in newspaper, magazine, outdoor, radio and TV ads. Product specialty is consumer. Current clients include Players Island Casino, Greengate Garden Center and Cellular One. Client list available upon request.

Needs: Approached by 1 freelancer/month. Works with 1 illustrator every 3 months. Prefers freelancers with experience in computer graphics. Works on assignment only. Uses freelancers mainly for time-consuming computer graphics. Also for brochure and print ad illustration and storyboards. Needs website programmers. 65% of work is with print ads. 50% of freelance work demands skills in Adobe Illustrator and Adobe Photoshop.

First Contact & Terms: Send query letter with résumé, transparencies, photographs, slides and tearsheets. Samples are filed or returned by SASE if requested. Reports back to the artist only if interested. Will contact artist for portfolio review if interested. Portfolio should include color roughs, final art, tearsheets, slides, photostats and transparencies. Pays for design by the project, $30-300. Pays for illustration by the project, $50-275. Rights purchased vary according to project. Find artists through viewing portfolios, submissions, word of mouth, American Advertising district conferences and conventions.

Maine

THE DW COMMUNICATIONS GROUP, 85 Exchange St., Suite 200, Portland ME 04101. (207)775-5100. Fax: (207)775-5147. E-mail: dw@dwgroup.com. Website: http://www.dwgroup.com. Creative Director: Kyle C. Murphy. Production Manager: Angela Canan. Estab. 1985. Number of employees: 15. Approximate annual billing: $2 million. Integrated marketing communications agency. Current clients include Outward Bound, Maine Cellular, Eastern Maine Healthcare, Hancock Lumber, Bangor Gas Co. and Harvard. Professional affiliations: G.A.G., Portland Art Director Club, Boston Ad Club, Portland Ad Club and One Club.

Needs: Approached by 10 illustrators and 10 designers/year. Works with 5 illustrators and 2 designers/year. Uses freelancers mainly for illustration. Also for airbrushing, catalog, humorous, medical and technical illustration, model making, multimedia projects, signage, storyboards, signage and TV/film graphics. 25% of work is with print ads. 100% of design demands skills in Adobe Photoshop, Adobe Illustrator and QuarkXPress.

First Contact & Terms: Designers send query letter with brochure, photographs, résumé, slides, tearsheets and transparencies. Illustrators send postcard sample and query letter with brochure, photographs, résumé, slides, tearsheets and transparencies. Send follow-up postcard every 6 months. Accepts disk submissions compatible with Mac formats. Samples are filed. Reports back only if interested. Art director will contact artist for portfolio review of b&w and color photographs, roughs, slides, tearsheets and transparencies if interested. Pays for design by the hour, $35-55; pays for illustration by the project, $50-2,500. Rights purchased vary according to project. Finds artists through word of mouth.

MICHAEL MAHAN GRAPHICS, 48 Front, P.O. Box 642, Bath ME 04530-0642. (207)443-6110. Fax: (207)443-6085. E-mail: m2design@ime.net. Contact: Linda Delorme. Estab. 1986. Number of employees: 5. Approximate annual billing: $400,000. Design firm. Specializes in publication design—catalogs and direct mail. Product specialties are furniture, fine art and high tech. Current clients include Bowdoin College, Bath Iron Works and Newport Data. Client list available upon request. Professional affiliations: G.A.G., AIGA and Art Director's Club-Portland, ME.

Needs: Approached by 5-10 illustrators and 10-20 designers/year. Works with 2 illustrators and 2 designers/year. Uses freelancers mainly for production. Also for brochure, catalog and humorous illustration and lettering. 5% of work is with print ads. 100% of design demands skills in Adobe Photoshop and QuarkXPress.

First Contact & Terms: Designers send query letter with photocopies and résumé. Illustrators send query letter with photocopies. Accepts disk submissions. Samples are filed and are not returned. Reports back only if interested. Art director will contact artist for portfolio review of final art roughs and thumbnails if interested. Pays for design by the hour, $15-40. Pays for illustration by the hour, $18-60. Rights purchased vary according to project. Finds artists through word of mouth and submissions.

Maryland

SAM BLATE ASSOCIATES, 10331 Watkins Mill Dr., Montgomery Village MD 20886-3950. (301)840-2248. Fax: (301)990-0707. E-mail: samblate@bellatlantic.net. Website: http://members/bellatlantic,net/~samblate/index.html. President: Sam Blate. Number of employees: 2. Approximate annual billing: $90,000. AV and editorial services firm. Clients: business/professional, US government, some private.
Needs: Approached by 6-10 freelancers/year. Works with 1-5 freelance illustrators and 1-2 designers/year. Only works with freelancers in the Washington DC metropolitan area. Works on assignment only. Uses freelancers for cartoons (especially for certain types of audiovisual presentations), editorial and technical illustrations (graphs, etc.) for 35mm slides, pamphlet and book design. Especially important are "technical and aesthetic excellence and ability to meet deadlines." 80% of freelance work demands knowledge of CorelDraw, PageMaker, Photoshop or Powerpoint for Windows.
First Contact & Terms: Send query letter with résumé and tearsheets, brochure, photocopies, slides, transparencies or photographs to be kept on file. Accepts disk submissions compatible with CorelDraw, Photoshop and PageMaker. IBM format only. "No original art." Samples are returned only by SASE. Reports back only if interested. Pays by the hour, $20-40. Rights purchased vary according to project, "but we prefer to purchase first rights only. This is sometimes not possible due to client demand, in which case we attempt to negotiate a financial adjustment for the artist."
Tips: "The demand for technically oriented artwork has increased."

DEVER DESIGNS, 1056 West St., Laurel MD 20707. (301)776-2812. Fax: (301)953-1196. President: Jeffrey Dever. Estab. 1985. Number of employees: 8. Approximate annual billing: $450,000. Specializes in annual reports, corporate identity and publication design. Clients: corporations, museums, government agencies, associations, nonprofit organizations. Current clients include Population Reference Bureau, University of Maryland, McGraw-Hill, National Gallery of Art, Washington Post. Client list available upon request.
 ● Dever Designs won 31 awards for graphic design in 1998, including the 1998 American Graphic Design Award Competition and several awards in the *Creativity 28* competition.
Needs: Approached by 100 freelancers/year. Works with 30-50 freelance illustrators and 1-2 designers/year. Prefers artists with experience in editorial illustration. Uses illustrators mainly for publications. Uses designers mainly for on-site help when there is a heavy workload. Also uses freelancers for brochure illustration, charts/graphs and in-house production. 100% of design demands knowledge of QuarkXPress.
First Contact & Terms: Send postcard, samples or query letter with photocopies, résumé and tearsheets. Accepts disk submissions compatible with Adobe Illustrator or QuarkXPress, but prefers hard copy samples which are filed. Will contact artist for portfolio review if interested. Portfolio should include b&w and/or color photocopies for files. Pays for design and illustration by the project. Rights purchased vary according to project. Finds artists through referrals.
Tips: Impressed by "uniqueness and consistant quality."

DIRECT SOURCE ADVERTISING, 4403 Wickford Rd., Baltimore MD 21210. (410)366-5424. Fax: (410)366-6123. Owner: Cynthia Gerew-Serfas. Estab. 1988. Number of employees: 3. Specializes in direct mail design. Clients: financial and insurance corporations.
Needs: Approached by 10-15 freelancers/year. Works with 4 freelance illustrators and 4 designers/year. Prefers artists with experience in drawing realistic people/family situations. Also need b&w spot art (icon art) provided in electronic illustrator files. Uses illustrators mainly for brochure illustration and logo work. Uses designers mainly for direct mail. Also uses freelancers for ad illustration, brochure and logo design, illustration, direct mail design and digital file preparation. Freelancers should have experience in Adobe Illustrator, Adobe Photoshop and QuarkXPress. "Very interested in finding graphic artists with direct mail experience—familiar with full-package design."
First Contact & Terms: Send postcard sample of work or send query letter. Will contact artist for portfolio review if interested. Portfolio should include color final art, photocopies, photographs, photostats and transparencies. Pays for design by the hour, $25-30. Pays for illustration by the project. Negotiates rights purchased. Finds artists through sourcebooks and local referrals.
Tips: Impressed by freelancers "who are not only talented, but also dependable."

FSP COMMUNICATIONS, 609 Allegheny Ave. Towson MD 21204. (410)296-8680. E-mail: fspcom@hom e.com. Website: http://www.members.home.net:80/fil/. President: Fil Sibley. Co-Producer: Barbara Thompson. Estab. 1981. Number of employees: 2. Approximate annual billing: $80,000. AV firm. Specializes in multimedia graphics, animation, video and still photography. Product specialties are music, education, PR, sales training. Client list available upon request.
Needs: Approached by 10 freelance illustrators and 10 designers/year. Works with 2 freelance illustrators and 2 designers/year. Prefers freelancers with experience in video and multimedia. Also for animation, brochure design and illustration, humorous illustration, lettering, logos, mechanicals, multimedia projects, posters, signage, storyboards, TV/film graphics, web page design. 10% of work is with print ads. 50% of freelance work demands skills in Aldus PageMaker, Aldus FreeHand, Adobe Photoshop, Adobe Illustrator.
First Contact & Terms: Send query letter with brochure, photographs, résumé, slides. Accepts websites and disk submissions compatible with Windows or Mac. Samples are filed or returned by SASE. Portfolio review not required. Pays by the project; negotiable. Finds artists through sourcebooks and recommendations.

Tips: Looks for freelancers who are "willing to have passion for the project and do their best and act with integrity."

☑ **NORTH LIGHT COMMUNICATIONS**, 7100 Baltimore Ave., #300, College Park MD 20740. (301)864-2626. Fax: (301)864-2629. E-mail: brands@nlightcom.com. President: Bill Briggs. Estab. 1989. Number of employees: 15. Approximate annual billing: $15 million. Ad agency. Product specialties are business-to-business and consumer durables. Current clients include General Dynamics, US Air, US Navy, Pacific Industries, American Institute of Physics, Chemical Manufacturing Assoc., Bruning Paint Co.
Needs: Approached by 6 freelancers/year. Works with 4 freelance illustrators and 6 designers/year. Prefers artists with agency background and experience in collateral. Uses freelancers for annual reports, brochure design and illustration, mechanicals, posters and signage. 20% of work is with print ads. 100% of design and 50% of illustration demands skills in Adobe Photoshop, QuarkXPress and Adobe Illustrator.
First Contact & Terms: Designers send query letter with brochure, photocopies, résumé and SASE. Illustrators send query letter with photocopies and SASE. Samples are filed are returned by SASE if requested by artist. Will contact artist for portfolio review if interested. Portfolio should include: b&w and color final art, tearsheets and thumbnails. Pays for design by the hour, $20-60 or by the day, $150-800. Pays for illustration by the project. Buys all rights. Finds artists through *Black Book*, *Sourcebook*, classified ads.

PICCIRILLI GROUP, 502 Rock Spring Rd., Bel Air MD 21014. (410)879-6780. Fax: (410)879-6602. E-mail: info@pi cgroup.com. Website: http://www.picgroup.com. President: Charles Piccirilli. Executive Vice President: Micah Piccirilli. Estab. 1974. Specializes in design and advertising; also annual reports, advertising campaigns, direct mail, brand and corporate identity, displays, packaging, publications and signage. Clients: recreational sport industries, fleet leasing companies, technical product manufacturers, commercial packaging corporations, direct mail advertising firms, realty companies, banks, publishers and software companies.
Needs: Works with 4 freelance designers/year. Works on assignment only. Mainly uses freelancers for layout or production. Prefers local freelancers. 75% of design demands skills in Adobe Illustrator 5.5 and QuarkXPress 3.3.
First Contact & Terms: Send query letter with brochure, résumé and tearsheets; prefers originals as samples. Samples returned by SASE. Reports on whether to expect possible future assignments. To show a portfolio, mail roughs and finished art samples or call for an appointment. Pays for design and illustration by the hour, $20-45. Considers complexity of project, client's budget, and skill and experience of artist when establishing payment. Buys one-time or reprint rights; rights purchased vary according to project.
Tips: "Portfolios should include work from previous assignments. The most common mistake freelancers make is not being professional with their presentations. Send a cover letter with photocopies of work."

SPIRIT CREATIVE SERVICES INC., 3157 Rolling Rd., Edgewater MD 21037. (410)956-1117. Fax: (410)956-1118. E-mail: spiritcs@annap.infi.net. Website: http://www.annapinfi.net/~spiritcs/. President: Alice Yeager. Estab. 1992. Number of employees: 2. Approximate annual billing: $90,000. Specializes in annual reports, brand and corporate identity, display, direct mail, package and publication design, web page design, technical and general illustration, copywriting, photography and marketing, catalogs, signage and books. Clients: associations, corporations, government. Client list available upon request.
Needs: Approached by 5-10 freelancers/year. Works with 3-4 freelance illustrators and 4-5 designers/year. Prefers local designers. Uses freelancers for ad, brochure, catalog, poster and P-O-P design and illustration, books, direct mail and magazine design, audiovisual materials, crafts/graphs, lettering, logos and mechanicals. Also for multimedia and Internet projects. 100% of design and 10% of illustration demands knowledge of Adobe Illustrator, Adobe Photoshop and Adobe PageMaker. Also HTML coding and knowledge of web design.
First Contact & Terms: Send 2-3 samples of work with résumé. Accepts disk submissions compatible with Adobe Illustrator 5.0 to 6.0. Send EPS files. Samples are filed. Reports back within 1-2 weeks if interested. Request portfolio review in original query. Artist should follow-up with call and/or letter after initial query. Portfolio should include b&w and color final art, tearsheets, sample of comping ability. Pays for design by the project, $50-6,000. Pays for illustration by the project, $50 minimum. Rights purchased vary according to project.
Tips: "Paying attention to synchronicity and intuition is vital."

Massachusetts

▓ **A.T. ASSOCIATES**, 63 Old Rutherford Ave., Charlestown MA 02129. (617)242-6004. Partner: Annette Tecce. Estab. 1976. Specializes in annual reports, industrial, interior, product and graphic design, model making, corporate identity, signage, display and packaging. Clients: nonprofit companies, high tech, medical, corporate clients, small businesses and ad agencies. Client list available upon request.
Needs: Approached by 20-25 freelance artists/year. Works with 3-4 freelance illustrators and 2-3 freelance designers/year. Prefers local artists; some experience necessary. Uses artists for posters, model making, mechanicals, logos, brochures, P-O-P display, charts/graphs and design.
First Contact & Terms: Send résumé and nonreturnable samples. Samples are filed or are returned by SASE if requested by artist. Reports back only if interested. Call to schedule an appointment to show a portfolio, which should

include a "cross section of your work." Pays for design and illustration by the hour or by the project. Rights purchased vary according to project.

RICHARD BERTUCCI/GRAPHIC COMMUNICATIONS, 3 Juniper Lane, Dover MA 02030-2146. (508)785-1301. Fax: (500)785-2072. Owner: Richard Bertucci. Estab. 1970. Number of employees: 2. Approximate annual billing: $1 million. Specializes in annual reports, corporate identity, display, direct mail, package design, print advertising, collateral material. Clients: companies and corporations. Professional affiliations: AIGA.

Needs: Approached by 12-24 freelancers/year. Works with 6 freelance illustrators and 3 designers/year. Prefers local artists with experience in business-to-business advertising. Uses illustrators mainly for feature products. Uses designers mainly for fill-in projects, new promotions. Also uses freelancers for ad, brochure and catalog design and illustration, direct mail, magazine and newspaper design and logos. 50% of design and 25% of illustration demand knowledge of Aldus FreeHand, Adobe Illustrator, CorelDraw and QuarkXPress.

First Contact & Terms: Send postcard sample of work or send query letter with brochure and résumé. Samples are filed. Will contact artist for portfolio review if interested. Portfolio should include b&w and color roughs. Pays for design by the project, $500-5,000. Pays for illustration by the project, $250-2,500. Rights purchased vary according to project.

Tips: "Send more information, not just a postcard with no written information." Chooses freelancers based on "quality of samples, turn-around time, flexibility, price, location."

JEF FILMS INC., 143 Hickory Hill Circle, Osterville MA 02655-1322. (508)428-7198. Fax: (508)428-7198. President: Jeffrey H. Aikman. Vice President: Elsie Aikman. Estab. 1973. AV firm. Full-service, multimedia firm. Specializes in covers for home videotapes, magazine ads (trade and consumer) and movie posters. Current clients include VIP Video, TAM Productions, XTC Video. Client list not available.

Needs: Approached by 400-500 freelancers/month. Works with 10-12 illustrators and designers/month. Prefers freelancers with movie and video background. Uses freelancers for all promotional design and editorial and technical illustration. Also for brochure, catalog and print ad design and illustration and slide illustration, storyboards, animatics, animation, mechanicals, retouching, TV/film graphics, lettering and logos. 20% of work is with print ads. Needs computer literate freelancers for design, illustration, production and presentation. 40% of freelance work demands skills in Aldus PageMaker, Quark XPress, Aldus FreeHand, Adobe Illustrator and Adobe Photoshop.

First Contact & Terms: Send query letter with SASE and any of the following: brochure, photocopies, résumé, photographs, photostats, slides, tearsheets and transparencies. Samples are filed or returned by SASE if requested by artist. Reports back only if interested. Art director will contact for portfolio review if interested. Portfolio should include thumbnails, b&w or color photostats, tearsheets, photographs and slides. Sometimes requests work on spec before assigning job. Pays for design and illustration by the project, $50-300. Buys all rights. Finds artists through word of mouth, agents, sourcebooks, magazines.

MATZELL RICHARD & WATTS, 142 Berkeley St., Boston MA 02116-5100. (617)236-4700. Fax: (617)236-8604. E-mail: kcmrw@wing.net. Website: http://www.mrwinc.com. Executive Vice President and Art Director: Jim Richard. Estab. 1983. Number of employees: 11. Approximate annual billing: $10 million. Ad agency. Specializes in ads, collateral, DM. Product specialties are high tech, healthcare. Client list available upon request.

Needs: Approached by 40-50 freelance illustrators and 40-50 designers/year. Works with 5-10 freelance illustrators and 2-5 designers/year. Prefers freelancers with experience in a variety of techniques: brochure, medical and technical illustration, multimedia projects, retouching, storyboards, TV/film graphics and web page design. 75% of work is with print ads. 90% of design and 90% of illustration demands skills in Aldus FreeHand, Adobe Photoshop, QuarkXPress, Adobe Illustrator.

First Contact & Terms: Designers send query letter with photocopies, photographs, résumé. Illustrators send postcard sample and résumé, follow-up postcard every 6 months. Accepts disk submissions compatible with QuarkXPress 7.5/version 3.3. Send EPS files. Samples are filed. Will contact for portfolio review of b&w, color final art if interested. Pays by the hour, by the project or by the day depending on experience and ability. Rights purchased vary according to project. Finds artist through sourcebooks and word of mouth.

DONYA MELANSON ASSOCIATES, 437 Main St., Boston MA 02129. (617)241-7300. Fax: (617)241-5199. E-mail: dma7300@aol.com. Contact: Donya Melanson. Advertising agency. Number of employees: 6. Clients: industries, institutions, education, associations, publishers, financial services and government. Current clients include: US Geological Survey, Mannesmann, Cambridge College, American Psychological Association and US Dept. of Agriculture. Client list available upon request.

Needs: Approached by 30 artists/year. Works with 3-4 illustrators/year. Most work is handled by staff, but may occasionally use illustrators and designers. Uses artists for stationery design, direct mail, brochures/flyers, annual reports, charts/graphs and book illustration. Needs editorial and promotional illustration. 50% of freelance work demands skills in Adobe Illustrator, QuarkXPress or Adobe Photoshop.

First Contact & Terms: Query with brochure, résumé, photostats and photocopies. Provide materials (no originals) to be kept on file for future assignments. Originals returned to artist after use only when specified in advance. Call or write for appointment to show portfolio or mail thumbnails, roughs, final art, final reproduction/product and color and b&w tearsheets, photostats and photographs. Pays for design and illustration by the project, $100 minimum. Considers

complexity of project, client's budget, skill and experience of artist and how work will be used when establishing payment.

Tips: "Be sure your work reflects concept development. We would like to see more electronic design and illustration capabilities."

STEWART MONDERER DESIGN, INC., 10 Thacher St., Suite 112, Boston MA 02113. (617)720-5555. Senior Designer: Joe LaRoche. Estab. 1982. Specializes in annual reports, corporate identity, package and publication design, employee benefit programs, corporate cabability brochures. Clients: corporations (hi-tech, industry, institutions, healthcare, utility, consulting, service). Current clients include Aspen Technology, Vivo Software, Voicetek Corporation, Pegasystems and Millipore. Client list not available.

Needs: Approached by 200 freelancers/year. Works with 5-10 freelance illustrators and 1-5 designers/year. Works on assignment only. Uses illustrators mainly for corporate communications. Uses designers for design and production assistance. Also uses freelancers for mechanicals and illustration. Needs computer-literate freelancers for design, illustration and production. 50% of freelance work demands knowledge of Aldus PageMaker, Adobe Illustrator, QuarkXPress, Photoshop or Aldus FreeHand. Needs editorial and corporate illustration.

First Contact & Terms: Send query letter with brochure, tearsheets, photographs and photocopies. Samples are filed. Will contact artist for portfolio review if interested. Portfolio should include b&w and color-finished art samples. Sometimes requests work on spec before assigning a job. Pays for design by the hour, $10-25; by the project. Pays for illustration by the project, $250 minimum. Negotiates rights purchased. Finds artists through submissions/self-promotions and sourcebooks.

RUTH MORRISON ASSOCIATES, INC., 246 Brattle St., Cambridge MA 02138. (617)354-4536. Fax: (617)354-6943. Account Executive: Rebecca Field. Estab. 1972. PR firm. Specializes in food, travel, design, education, non-profit. Assignments include logo/letterhead design, invitations and brochures.

Needs: Prefers local freelancers with experience in advertising and/or publishing. Uses freelancers mainly for brochure design and direct mail. Also for catalog and print ad design, mechanicals, editorial illustration, posters, lettering and logos. 5% of work is with print ads. 10% of freelance work demands computer skills.

First Contact & Terms: Send query letter with photocopies. Samples are filed or returned by SASE only if requested by artist. Does not report back. Pays for design and illustration by the project. Rights purchased vary according to project. Finds artists through word of mouth, magazines and advertising.

THE PHILIPSON AGENCY, 241 Perkins St., Suite B201, Boston MA 02130. (617)566-3334. Fax: (617)566-3363. President and Creative Director: Joe Philipson. Marketing design firm. Specializes in packaging, collateral, P-O-P, corporate image, sales presentations, direct mail, business-to-business and high-tech.

Needs: Approached by 3-4 freelancers/month. Works with 4 illustrators and 3 designers/month. Prefers freelancers with experience in design, illustration, comps and production. Works on assignment only. Uses freelancers mainly for overflow and special jobs. Also for brochure, catalog and print ad design and illustration; packaging, multimedia, mechanicals, retouching, posters, lettering and logos. Needs editorial illustration. 65% of work is with print ads. 100% of design and 50% of illustration demands knowledge of PageMaker, Illustrator, QuarkXPress, Aldus FreeHand or Adobe Photoshop.

First Contact & Terms: Send postcard sample, query letter with brochure, tearsheets, photocopies, SASE, résumé. Samples are filed or are returned by SASE. Reports back to the artist only if interested. To show a portfolio, mail roughs, photostats, tearsheets, photographs and slides. Pays by the project. Buys all rights.

PRECISION ARTS ADVERTISING INC., One Princeton Rd., Fitchburg MA 01420. (978)348-1007. Fax: (978)348-1047. E-mail: designs@precisionarts.com. Website: http://www.precisionarts.com. President: Terri Adams. Estab. 1985. Number of employees: 2. Ad agency. Specializes in trade ads, public relations, media marketing, web page design. Product specialty is industrial. Client list available upon request.

Needs: Approached by 5 freelance illustrators and 5 designers/year. Works with 1 freelance illustrator and 1 designer/year. Prefers local freelancers. 40% of work is with print ads. 50% of freelance work demands skills in Adobe Photoshop, QuarkXPress, Adobe Illustrator, Adobe Cyberstudio.

First Contract & Terms: Send query letter with photocopies and résumé. Accepts disk submissions. Samples are not filed and are returned by SASE. Reports back only if interested.

RICHLAND DESIGN ASSOCIATES, 47 Studio Rd., Newton MA 02466. (617)965-8900. Fax: (617)796-9223. E-mail: richland@media1.net. President: Judy Richland. Estab. 1981. Number of employees: 3. Approximate annual billing: $500,000. Specializes in annual reports, corporate identity, direct mail and package design. Clients: corporations, museums, schools, state agencies. Current clients include Nynex Properties, Apple Computer, Thomson Financial, Integrate Computer Solutions. Client list available upon request. Professional affiliations: AIGA.

Needs: Approached by 10 freelancers/year. Works with 5 freelance illustrators and 10 designers/year. Prefers local artists only. Uses illustrators mainly for annual reports. Also uses freelancers for ad, catalog and direct mail design. Freelancers should be familiar with QuarkXPress, Adobe Photoshop, Illustrator and Aldus Freehand.

First Contact & Terms: Send query letter with brochure, photographs, résumé and tearsheets. Samples are filed. Will contact artist for portfolio review if interested. Portfolio should include b&w and color photographs, slides and thumbnails. Pays for design and illustration by the project. Rights purchased vary according to project.

N RSVP MARKETING, INC., 450 Plain St., Suite 5, Marshfield MA 02050. (781)837-2804. Fax: (781)837-5389. E-mail: rsvpmktg@aol.com. President: Edward C. Hicks. Direct marketing consultant services—catalogs, direct mail, brochures and telemarketing. Clients: insurance, wholesale, manufacturers and equipment distributors.
Needs: Works with 1-2 illustrators and 7-8 designers/year. Prefers local freelancers with direct marketing skills. Uses freelancers for advertising, copy and catalog design, illustration and layout, and technical illustration. Needs line art for direct mail. 80% of design and 50% of illustration demands skills in Aldus PageMaker, QuarkXPress and Adobe Illustrator.
First Contact & Terms: Designers send query letter with résumé and finished, printed work. Illustrators send postcard sample. Samples are kept on file. Accepts disk submissions. Will contact artist for portfolio review if interested. Sometimes requests work on spec before assigning a job. Pays for design and illustration by the hour, $25-70 or by the project $300-5,000. Considers skill and experience of artist when establishing payment.
Tips: "We are an agency and therefore mark up pricing. Artists should allow for agency mark up."

TR PRODUCTIONS, 1031 Commonwealth Ave., Boston MA 02215. (617)783-0200. Fax: (617)783-4844. Creative Director: Cary M. Benjamin. Estab. 1947. Number of employees: 12. AV firm. Full-service multimedia firm. Specializes in slides, collateral, AV shows and video.
Needs: Approached by 15 freelancers/year. Works with 5 freelance illustrators and 5 designers/year. Prefers local freelancers with experience in slides and collateral. Works on assignment only. Uses freelancers mainly for slides, collateral. Also for brochure and print ad design and illustration, slide illustration, animation and mechanicals. 25% of work is with print ads. Needs computer-literate freelancers for design, production and presentation. 95% of work demands skills in Aldus FreeHand, Adobe Photoshop, Adobe Premier, Adobe After Effects, Microsoft Powerpoint, Aldus Persuasion, QuarkXPress or Adobe Illustrator.
First Contact & Terms: Send query letter. Samples are filed. Does not report back. Artist should follow-up with call. Will contact artist for portfolio review if interested. Rights purchased vary according to project.

N TRIAD DESIGNS, INC., 18 Water St., Holliston MA 01746. (508)429-2498. Fax: (508)429-3042. Design Director: Alan King. Estab. 1981. Number of employees: 3. Approximate annual billing: $350,000. Specializes in brand and corporate identity, display and package design, technical illustration and signage. Clients: ad agencies, corporations. Current clients include Sony, Pennzoil, Lotus and GTE.
Needs: Approached by 2-3 freelancers/year. Works with 2-3 freelance designers/year. Prefers local artists with experience in silkscreen printing prep. Uses designers mainly for exhibit and T-shirt graphics. Also uses freelancers for lettering, mechanicals and retouching. Also for multimedia projects. 100% of design and 50% of illustration demands knowledge of Adobe Illustrator, Adobe Photoshop and Aldus FreeHand.
First Contact & Terms: Designers send postcard sample of work or résumé, brochure and tearsheets. Illustrators send postcard sample and tearsheets. Samples are filed. Reports back to the artist only if interested. Will contact artist for portfolio review if interested. Portfolio should include color final art, roughs and thumbnails. Pays for design by the project. "I ask designers to price out their end of the job first. I need a quotation before I can present a bid to my client." Rights purchased vary according to project. Finds artists through sourcebooks and word of mouth recommendations.
Tips: "Be exceptionally good."

N VIP VIDEO, 143 Hickory Hill Circle, Osterville MA 02655-1322. Phone/fax: (508)428-7198. President: Jeffrey H. Aikman. Estab. 1980. AV firm. Full-service, multimedia firm. Specializes in magazine ads, video jackets, brochures. Product specialty is videotapes. Current clients include TAM Products and USAmericana Films. Client list not available.
Needs: Approached by 10-12 freelancers/month. Works with 5-6 illustrators and designers/month. Prefers freelancers with experience in video and film business. Works on assignment only. Uses freelancers mainly for video covers, brochures. Also for brochure, catalog and print ad design and illustration and storyboards, slide illustration, animation, retouching, billboards, posters, TV/film graphics, lettering and logos. 50% of work is with print ads. Needs computer-literate freelancers for design, illustration, production and presentation. 25% of work demands skills in Aldus PageMaker, QuarkXPress, Aldus FreeHand, Adobe Illustrator or Adobe Photoshop.
First Contact & Terms: Send query letter with brochure and photographs. Samples are filed or are returned by SASE. Reports back to the artist only if interested. Will contact artist for portfolio review if interested. Portfolio should include b&w and color final art, slides, photographs and transparencies. Pays for design and illustration by the project, $50-300. Buys all rights. Finds artists through agents, word of mouth, submissions and sourcebooks.

WEYMOUTH DESIGN, INC., 332 Congress St., Boston MA 02210-1217. (617)542-2647. Fax: (617)451-6233. E-mail: benfari@weymouthdesign.com. Office Manager: Judith Benfari. Estab. 1973. Number of employees: 16. Specializes in annual reports, corporate collateral, designing websites and laptop presentations, CD-ROMs and miscellaneous multimedia. Clients: corporations and small businesses. Client list not available. Professional affiliation: AIGA.
Needs: Works with 3-5 freelance illustrators and/or photographers. Needs editorial, medical and technical illustration mainly for annual reports. Also uses freelancers for multimedia projects.
First Contact & Terms: Send query letter with résumé or illustration samples and/or tearsheets. Samples are filed or are returned by SASE if requested by artist. Will contact artist for portfolio review if interested.

Michigan

▣ LEO J. BRENNAN, INC. Marketing Communications, 2359 Livernois, Suite 300, Troy MI 48083-1692. Phone/fax: (810)362-3131. E-mail: vjanusis@ljbrennan.com or lbrennan@ljbrennan.com. Website: http://www.ljbrennan.com. Vice President: Virginia Janusis. Estab. 1969. Ad agency, PR and marketing firm. Clients: industrial, electronics, robotics, automotive, banks and CPAs.
Needs: Works with 2 illustrators and 2 designers/year. Prefers experienced artists. Uses freelancers for design, technical illustration, brochures, catalogs, retouching, lettering, keylining and typesetting. Also for multimedia projects. 50% of work is with print ads. 100% of freelance work demands knowledge of IBM software graphics programs.
First Contact & Terms: Send query letter with résumé and samples. Samples not filed are returned only if requested. Reports back to artist only if interested. Call for appointment to show portfolio of thumbnails, roughs, original/final art, final reproduction/product, color and b&w tearsheets, photostats and photographs. Payment for design and illustration varies. Buys all rights.

COMMUNICATIONS ELECTRONICS, INC., Dept AM, Box 2797, Ann Arbor MI 48106-2797. (734)996-8888. E-mail: cei@usascan.com. Editor: Ken Ascher. Estab. 1969. Number of employees: 38. Approximate annual billing: $5 million. Manufacturer, distributor and ad agency (13 company divisions). Specializes in marketing. Clients: electronics, computers.
Needs: Approached by 500 freelancers/year. Works with 40 freelance illustrators and 40 designers/year. Uses freelancers for brochure and catalog design, illustration and layout, advertising, product design, illustration on product, P-O-P displays, posters and renderings. Needs editorial and technical illustration. Prefers pen & ink, airbrush, charcoal/pencil, watercolor, acrylic, marker and computer illustration. 30% of freelance work demands skills in Aldus PageMaker or QuarkXPress.
First Contact & Terms: Send query letter with brochure, résumé, business card, samples and tearsheets to be kept on file. Samples not filed are returned by SASE. Reports within 1 month. Will contact artist for portfolio review if interested. Pays for design and illustration by the hour, $10-120; by the project, $10-15,000; by the day, $40-800.

▣ CREATIVE HOUSE ADVERTISING INC., 30777 Northwestern Hwy., Suite 301, Farmington Hills MI 48334. (248)737-7077. E-mail: washburn@creativechai.com. Executive Vice President/Creative Director: Robert G. Washburn. Art Director/Electronic System Officer: Kristen Brooks. Estab. 1964. Advertising/marketing/promotion graphics/display/art firm. Clients: home building products, sporting goods, automotive OEM, industrial manufacturing OEM, residential and commercial construction, land development, consumer, retail, finance, manufacturing.
Needs: Assigns 20-30 jobs; buys 10-20 illustrations/year. Works with 6 illustrators and 4 designers/year. Prefers local artists. Uses freelancers for work on filmstrips, consumer and trade magazines, multimedia kits, direct mail, television, slide sets, brochures/flyers and newspapers. Most of work involves illustration, design and comp layouts of ads, brochures, catalogs, annual reports and displays. 50-60% of work is with print ads.
First Contact & Terms: Query with résumé, business card and brochure/flier to be kept on file. Artist should follow up with call. Samples returned by SASE. Reports in 2 weeks. Originals not returned. Call or write for appointment to show portfolio of originals, reproductions and published pieces. Pays for design by the hour, $25-45; by the day, $240-400; or by the project. Pays for illustration by the project, $200-50,000. Considers complexity of project, client's budget and rights purchased when establishing payment. Reproduction rights are purchased as a buy-out.
Tips: "Flexibility is a necessity; do not send too much of the same style or technique. Have an outgoing friendly attitude. Provide quality, service and price."

Ⓝ HEART GRAPHIC DESIGN, 501 George St., Midland MI 48640. (517)832-9710. Fax: (517)832-9420. Owner: Clark Most. Estab. 1982. Number of employees: 3. Approximate annual billing: $200,000. Specializes in corporate identity, magazine advertising and publication design. Clients: corporations. Current clients include Tannoy North America (Canadian Company), Snow Makers.
Needs: Approached by 6 freelancers/year. Works with 1-2 freelance illustrators and 2-3 designers/year. Uses illustrators mainly for computer illustration. Uses designers mainly for brochure design. Also uses freelancers for ad design, brochure illustration, charts/graphs, logos and mechanicals. 100% of design and 50% of illustration demands skills in Adobe Illustrator, Adobe Photoshop, Aldus FreeHand, Painter, Aldus PageMaker and QuarkXPress.
First Contact & Terms: Send postcard sample or query letter with brochure and résumé. Accepts disk submissions. Send EPS or TIFF files. Samples are filed (if interested) or returned if requested. Reports back only if interested. Artist should follow-up with call and/or letter after initial query. Portfolio should include b&w and color final art, photographs, roughs and transparencies. Pays for design and illustration by the project. Negotiates rights purchased. Finds artists through word of mouth, sourcebooks and design books.
Tips: "Present yourself as diligent, punctual and pliable. Let your portfolio speak for itself (it should)."

Ⓝ ▣ THE MARKETING CONNECTION, 93 Piquette, Detroit MI 48202. (313)873-7744. Fax: (313)873-0799. Contact: Leon Lebeau. Estab. 1958. Number of employees: 10. AV firm. Full-service, multimedia firm. Specializes in electronic presentations/business meetings. Product specialties are automotive, boating and restaurant. Client list available upon request.
Needs: Approached by 20-50 freelancers/year. Works with 20-30 freelance illustrators and 10-20 designers/year. Prefers

Creative House Advertising creative director Robert Washburn wanted an image that depicted the durability of a new product from Nailite International, so he researched stock illustration houses and found this piece by the late Robert Rigs. "Art should be purchased with the thought and intent to create interest for the reader, and to communicate information," Washburn says.

artists with experience in Windows/Mac. Uses freelancers for computer graphics. Also for animation, annual reports, brochure design and illustration, retouching, TV/film graphics and AV/presentations. 5% of work is with prints ads. Needs computer-literate freelancers for design, illustration, production and presentation. 90% of freelance work demands skills in Adobe Photoshop, Adobe Illustrator and all window applications.
First Contact & Terms: Send query letter with résumé. Samples are filed. Reports back to the artist only if interested. Artist should follow-up with call after initial query. Payment negotiable. Buys all rights.

N ▣ **PHOTO COMMUNICATION SERVICES, INC.**, 6055 Robert Dr., Traverse City MI 49864. (616)943-5050. Contact: Ms. M'Lynn Hartwell. Estab. 1970. Full-service, multimedia firm. Specializes in corporate and industrial products, as well as radio spots.
Needs: Works on assignment. Uses freelancers mainly for brochure, catalog and print ad design and illustration storyboards, slide illustration, animation, retouching, lettering, logos and more. 70% of work is with print ads.
First Contact & Term: Send query with brochure, SASE and tearsheets. Samples are filed or returned by SASE if requested by artist. Reports back only if interested. To show portfolio, mail tearsheets and transparencies. Pays for design and illustration by the project, negotiated rate. Rights purchased vary according to project.

N 🖈 **WILLIAM M. SCHMIDT ASSOCIATES**, 20296 Harper Ave., Harper Woods MI 48225. (313)881-8075. Fax: (313)881-1930. E-mail: wmsa@ix.netcom.com. Website: http://www.wmsa.com. President: John M. Schmidt. Vice President: Richard K. Gresens. Estab. 1942. Primarily specializes in product and transportation design, as well as corporate identity, displays, interior and package design, signage and technical illustration. Clients: companies and agencies. Majority of clients are in Fortune 500. Client list available upon request.
Needs: Approached by 30-40 freelance artists/year. Works with 2-3 freelance illustrators and 3-5 freelance designers/year. Prefers local artists with experience in automotive and product design. Works on assignment only. Also uses freelance artists for brochure design and illustration, mechanicals, airbrushing, logos and model making. Needs technical illustrations. Needs computer-literate freelancers for design and production. 40% of freelance work demands computer literacy in Aldus PageMaker, Aldus FreeHand, Photoshop, Illustrator, Alias/Wavefront.
First Contact & Terms: Send query letter with résumé, SASE and slides. Samples are not filed and are returned by SASE. Reports back within 1-2 weeks. To show a portfolio, mail slides, roughs and preliminary sketches. Pays for design and illustration by the hour, $15-30 or by the project. Buys all rights.

N **ROGER SHERMAN PARTNERS, INC.**, 2532 Monroe St., Dearborn MI 48124. (313)277-8770. Contact: Joy Walker. Interior design and contract purchasing firm providing architectural and interior design for commercial restaurants, stores, hotels, shopping centers; complete furnishing purchasing. Clients: commercial and hospitality firms.
Needs: Artists with past work experience only, able to provide photos of work and references. Works on assignment only. Uses artists for architectural renderings, furnishings, landscape and graphic design, model making and signage; also for special decor items as focal points for commercial installations, such as paintings, wood carvings, etc.
First Contact & Terms: Send query letter with brochure/flyer or résumé and samples to be kept on file. Prefers slides and examples of original work as samples. Samples not returned. Reporting time depends on scope of project. Call or write for appointment. Pays for design by the project, $300-5,000. Negotiates payment; varies according to client's budget.
Tips: "Art is used as accessories and focal points in architectural projects so the project concept will affect our design and the art we use. The economy has minimized the amount and price paid for the art we select. We still use artists to create these pieces but less often and price is a major concern to clients."

✔ 🖈 **VARON & ASSOCIATES, INC.**, 31255 Southfield, Beverly Hills MI 48025. (248)645-9730. Fax: (248)642-4166. President: Shaaron Varon. Estab. 1963. Specializes in annual reports; brand and corporate identity; display, direct mail and package design and technical illustration. Clients: corporations (industrial and consumer). Current clients include Dallas Industries Corp., Enprotech Corp., FEC Corp., Johnstone Pump Corp., Microphoto Corp., PW & Associates. Client list available upon request.
Needs: Approached by 20 freelancers/year. Works with 7 illustrators and 7 designers/year. Prefers local freelancers only. Works on assignment only. Uses freelancers mainly for brochure, catalog, P-O-P and ad design and illustration, direct mail design, mechanicals, retouching, airbrushing, audiovisual materials and charts/graphs. Needs computer-literate freelancers for design, illustration and presentation. 70% of freelance work demands knowledge of Aldus PageMaker, QuarkXPress, Aldus FreeHand or Adobe Illustrator.
First Contact & Terms: Send brochure, samples, slides and transparencies. Samples are filed. Reports back to the artist only if interested. Portfolios may be dropped off every Monday-Friday. Call for appointment. Portfolio should include color thumbnails, roughs, final art and tearsheets. Buys all rights. Finds artists through submissions.

Minnesota

N 🖈 **BUTWIN & ASSOCIATES ADVERTISING, INC.**, 8700 Westmoreland Lane, Minneapolis MN 55426. Phone/fax: (612)545-3886. President: Ron Butwin. Estab. 1977. Ad agency. "We are a full-line ad agency working with both consumer and industrial accounts on advertising, marketing, public relations and meeting planning." Clients: banks,

restaurants, clothing stores, food brokerage firms, corporations and a "full range of retail and service organizations."

● This agency offers some unique services to clients, including uniform design, interior design and display design.

Needs: Works with 30-40 illustrators and 20-30 designers/year. Prefers local artists when possible. Uses freelancers for design and illustration of brochures, catalogs, newspapers, consumer and trade magazines, P-O-P displays, retouching, animation, direct mail packages, motion pictures and lettering. 20% of work is with print ads. Prefers realistic pen & ink, airbrush, watercolor, marker, calligraphy, computer, editorial and medical illustration. Needs computer-literate freelancers for design and illustration. 40% of freelance work demands computer skills.

First Contact & Terms: Send brochure or résumé, tearsheets, photostats, photocopies, slides and photographs. Samples are filed or are returned only if SASE is enclosed. Reports back only if interested. Call for appointment to show portfolio. Pays for design and illustration by the project; $25-3,000. Considers client's budget, skill and experience of artist and how work will be used when establishing payment. Buys all rights.

Tips: "Portfolios should include layouts and finished project." A problem with portfolios is that "samples are often too weak to arouse enough interest."

LUIS FITCH DESIGN, 3131 Excelsior Blvd., Suite 206, Minneapolis MN 55416. (612)929-1439. E-mail: luis@fitchdesign.com. Website: http://www.fitchdesign.com. Creative Director: Luis Fitch. Marketing Director: Carolina Ornelas. Estab. 1990. Number of employees: 6. Approximate annual billing: $890,000. Specializes in brand and corporate identity, display, package and retail design and signage. Clients: Latin American corporations, retail. Current clients include MTV Latino, Target, Mervyn's, 3M, Dayton's. Client list available upon request. Professional affiliations: AIGA, GAG.

Needs: Approached by 33 freelancers/year. Works with 40 freelance illustrators and 20 designers/year. Works only with artists reps. Prefers local artists with experience in retail design, graphics. Uses illustrators mainly for packaging. Uses designers mainly for retail graphics. Also uses freelancers for ad and book design, brochure, catalog and P-O-P design and illustration, audiovisual materials, logos and model making. Also for multimedia projects (Interactive Kiosk, CD-Educational for Hispanic Market). 60% of design demands computer skills in Adobe Illustrator, Adobe Photoshop, Aldus FreeHand and QuarkXPress.

First Contact & Terms: Designers send postcard sample, brochure, résumé, photographs, slides, tearsheets and transparencies. Illustrators send postcard sample, brochure, photographs, slides and tearsheets. Accepts disk submissions compatible with Adobe Illustrator, Adobe Photoshop, Aldus FreeHand. Send EPS files. Samples are filed. Will contact artist for portfolio review if interested. Portfolio should include color final art, photographs and slides. Pays for design by the project, $500-6,000. Pays for illustration by the project, $200-20,000. Rights purchased vary according to project. Finds artists through artist reps, *Creative Black Book* and *Workbook*.

Tips: "It helps to be bilingual and to have an understanding of Hispanic cultures."

PATRICK REDMOND DESIGN, P.O. Box 75430-AGDM, St. Paul MN 55175-0430. (651)646-4254. E-mail (for design education only): redmo002@maroon.tc.umn.edu. Website (for design education only): http://www.dha.c he.umn.edu/Redmond/. Designer/Owner/President: Patrick M. Redmond, M.A. Estab. 1966. Number of employees: 1. Specializes in book cover design, logo and trademark design, brand and corporate identity, package, publication and direct mail design, website design, design consulting and education and posters. Has provided design services for more than 130 clients in the following categories: publishing, advertising, marketing, retail, financial, food, arts, education, computer, manufacturing, small business, healthcare, government and professions. Recent clients include: Norwest, American Swedish Institute Museum Shop, Mid-List Press, Hauser Artists, Dog Show Annual, Bend & Ellingson and others.

Needs: Receive promotional mailings from 600 freelancers/year. Works with 2-4 freelance illustrators and 2-4 designers/year (some years more of both, depending on client needs). Uses freelancers mainly for editorial and technical illustration, publications, books, brochures and newsletters. Also for website and multimedia projects. 80% of freelance work demands knowledge of Macintosh, QuarkXPress, Adobe Photoshop, Adobe Illustrator (latest versions).

First Contact & Terms: Send postcard sample, brochure, and/or photocopies. Also "send us quarterly mailings/ updates; a list of three to four references; a rate sheet/fee schedule." Samples not filed are thrown away. No samples returned. Reports back only if interested. "Artist will be contacted for portfolio review if work seems appropriate for client needs. Patrick Redmond Design will not be responsible for acceptance of delivery or return of portfolios not specifically requested from artist or rep. Samples must be presented in person unless other arrangements are made. Unless specifically agreed to in writing in advance, portfolios should not be sent unsolicited." Pays for design and illustration by the project. Rights purchased vary according to project. Considers buying second rights (reprint rights) to previously published work. Finds artists through word of mouth, magazines, submissions/self-promotions, exhibitions, competitions, CD-ROM, sourcebooks, agents and WWW. Provide e-mail address and URL.

Tips: "I see trends toward extensive use of WWW and a broader spectrum of approaches to images, subject matter and techniques. Clients also seem to have increasing interest in digitized, copyright-free stock images of all kinds." Advises freelancers starting out in the field to "create as much positive exposure for your images or design examples as possible. Make certain your name and location appear with image or design credits. Photos, illustrations and design are often noticed with serendipity. For example, your work may be just what a client needs—so make sure you have name credit. If possible, include your e-mail address and www URL with or on your work."

Missouri

🔲 **ANGEL FILMS COMPANY**, 967 Hwy. 40, New Franklin MO 65274-9778. Phone/fax: (573)698-3900. E-mail: angelfilm@aol.com. Vice President of Marketing/Advertising: Linda G. Grotzinger. Vice President Production: Matthew P. Eastman. Estab. 1980. Number of employees: 9. Approximate annual billing: more than $10 million. Ad agency, AV firm, PR firm. Full-service multimedia firm. Specializes in "all forms of television and film work plus animation (both computer and art work)." Product specialties are feature films, TV productions, cosmetics. Current clients include Azian, Mesn, Angel One Records.
- Angel Films recently purchased a CD production house.

Needs: Approached by 100 freelancers/year. Works with 10 freelance illustrators and 10 designers/year. Prefers freelancers with experience in graphic arts and computers. Works on assignment only. Uses freelancers mainly for primary work ("then we computerize the work"). Also for brochure and print ad design and illustration, storyboards, animation, model making, posters and TV/film graphics. 45% of work is with print ads. 50% of freelance work demands knowledge of Adobe Illustrator, Adobe Photoshop or CorelDraw.

First Contact & Terms: Send query letter with résumé and SASE. Samples are filed. Reports back within 6 weeks. Will contact artist for portfolio review if interested. Portfolio should include b&w and color slides and computer disks (IBM). Pays for design and illustration by the hour, $9 minimum. Buys all rights.

Tips: "You can best impress us with what you can do now not what you did ten years ago. Times change; the way people want work done changes also with the times. Disney of today is not the same as Disney of ten or five years ago."

AWESOME ADVERTISING & MARKETING, 207 Westport Rd., Suite 202, Kansas City MO 64111. (816)753-7560. Fax: (816)753-7566. E-mail: eallen@awesomeads.com. Website: http://www.awesomeads.com. Executive Director: Elizabeth Allen. Account Service Managers: Rick Neece and Niccoli Rocket. Estab. 1994. Approximate annual billing: $500,000. Ad agency, marketing firm. Specializes in business-to-business.

Needs: Approached by 75 illustrators and 200 designers/year. Works with 50 illustrators and 50 designers/year. Uses freelancers for all work including billboards, brochure design and illustration, catalog design and illustration, humorous illustration, lettering, logos, mechanicals, model making, multimedia projects, posters, signage, storyboards, technical illustration, TV/film graphics, web page design. 85% of work is with print ads. 100% of freelance work demands knowledge of Aldus PageMaker, Aldus FreeHand, Adobe Photoshop, Adobe Illustrator, QuarkXPress.

First Contact & Terms: Designers send query letter with brochure, photocopies and résumé. Illustrators send postcard sample of work. Samples are filed and are not returned. Reports back only if interested. Art director will contact designer for portfolio review of b&w, color, final art, thumbnails if interested. Payment depends on the project and the type of designer. Rights purchased vary according to project.

Tips: "Artists should have flexible attitudes, pay prompt attention to deadlines."

🆖🔲 **BRYAN/DONALD, INC. ADVERTISING**, 2345 Grand, Suite 1625, Kansas City MO 64108. (816)471-4866. Fax: (816)421-7218. E-mail: 76443.3156@compserve.com. President: Rick Rhyner. Associate Creative Director: Larry Stocker. Number of employees: 12. Approximate annual billing: $5.5 million. Multimedia, full-service ad agency. Clients: food, pharmaceutical chemicals, insurance, hotels, franchises.

Needs: Works with 6 freelance illuatrators and 2 designers/year. Works on assignment only. Uses freelancers for design, illustration, brochures, catalogs, books, newspapers, consumer and trade magazines, P-O-P display, mechanicals, retouching, animation, billboards, posters, direct mail packages, lettering, logos, charts/graphs and ads.

First Contact & Terms: Send samples showing your style. Samples are not filed and are not returned. Reports back only if interested. Call for appointment to show portfolio. Considers complexity of project and skill and experience of artist when establishing payment. Buys all rights.

🔲 **MEDIA CONSULTANTS**, P.O. Box 130, Sikeston MO 63801. (314)472-1116. Fax: (314)472-3299. E-mail: media@ldd.net. President: Rich Wrather. Estab. 1981. Number of employees: 10. Ad agency, AV and PR firm. Full-service multimedia firm. Specializes in print, magazines, AV. Product specialty is business-to-business. Client list not available.

Needs: Appoached by 25 freelancers/year. Works with 10-15 freelance illustrators and 5-10 designers/year. Works on assignment only. Uses freelancers mainly for layout and final art. Also for brochure, catalog and print ad design and illustration, storyboards, animation, billboards, TV/film graphics and logos. 40% of work is with print ads. Needs computer-literate freelancers for design, illustration, production and presentation. 100% of freelance work demands knowledge of Aldus PageMaker, Aldus FreeHand or Adobe Photoshop.

First Contact & Terms: Send query letter with brochure, résumé, photocopies, photographs, SASE and tearsheets. Samples are filed. Will contact artist for portfolio review if interested. Portfolio should include b&w and color roughs, final art, tearsheets, photostats and photographs. Pays for design by the project, $150-1,000. Pays for illustration by the project, $25-250. Buys all rights. Finds artists through word of mouth.

Tips: Advises freelancers starting out to "accept low fees first few times to build a rapport. Put yourself on the buyer's side."

■ ▓ **PHOENIX FILMS**, 2349 Chaffee Dr., St. Louis MO 63146. (314)569-0211. E-mail: phoenixfilms@worldnet. att.net. President: Heinz Gelles. Vice President: Barbara Bryant. Number of employees: 50. Clients: libraries, museums, religious institutions, US government, schools, universities, film societies and businesses. Produces and distributes educational films.

Needs: Works with 1-2 freelance illustrators and 2-3 designers/year. Prefers local freelancers only. Uses artists for motion picture catalog sheets, direct mail brochures, posters and study guides. Also for multimedia projects. 85% of freelance work demands knowledge of Aldus PageMaker and QuarkXPress.

First Contact & Terms: Send postcard sample and query letter with brochure (if applicable). Send recent samples of artwork and rates to director of promotions. "No telephone calls please." Reports if need arises. Buys all rights. Keeps all original art "but will loan to artist for use as a sample." Pays for design and illustration by the hour or by the project. Rates negotiable. Free catalog upon written request.

▓ **SIGNATURE DESIGN**, 2101 Locust, St. Louis MO 63103. (314)621-6333. Fax: (314)621-0179. E-mail: therese mckee@compuserve.com. Owner: Therese McKee. Estab. 1988. Specializes in graphic and exhibit design. Clients: museums, nonprofit institutions, corporations, government agencies, botanical gardens. Current clients include Missouri Botanical Garden, US Army Corps of Engineers, Monsanto Corporation, United States Post Office. Client list available upon request.

Needs: Approached by 15 freelancers/year. Works with 1-2 illustrators and 1-2 designers/year. Prefers local freelancers only. Works on assignment only. 50% of freelance work demands knowledge of Aldus PageMaker, QuarkXPress, Adobe Illustrator or Adobe Photoshop.

First Contact & Terms: Send query letter with résumé, tearsheets and photocopies. Samples are filed. Reports back to the artist only if interested. Artist should follow up with letter after initial query. Portfolio should include "whatever best represents your work." Pays for design by the hour. Pays for illustration by the project.

▓ **STOBIE BRACE MARKETING COMMUNICATIONS**, 240 Sovereign Court, St. Louis MO 63011. (314)256-9400. Fax: (314)256-0943. E-mail: adguys@ilon-stl.net. Creative Director: Mary Tuttle. Estab. 1935. Number of employees: 10. Approximate annual billing: $3.5 million. Ad agency. Full-service, multimedia firm. Product specialties are business-to-business, industrial and consumer services. Current clients include Dine-Mor Foods, Star Manufacturing. Professional affiliation: AAAA.

Needs: Approached by 100-150 freelancers/year. Works with 12 freelance illustrators and 6 designers/year. Uses freelancers for illustration, production and retouching. Also for brochure, catalog, print ad and slide illustration, storyboards, mechanicals and lettering. 40% of work is with print ads. 75% of freelance work demands knowledge of QuarkXPress or Adobe Illustrator. Needs technical, medical and creative illustration.

First Contact & Terms: Send query letter with résumé, photostats, photocopies, and slides. Samples are filed or are returned by SASE if requested by artist. Will contact artist for portfolio review if interested. Portfolios may be dropped off Monday-Friday. Portfolio should include thumbnails, roughs, original/final art and tearsheets. Sometimes requests work on spec before assigning a job. Pays for design by the project, $150-5,000. Pays for illustration by the project. Negotiates rights purchased. Finds artists through word of mouth, reps and work samples.

Tips: Freelancers "must be well organized, meet deadlines, listen well and have a concise portfolio of abilities."

▓ **THE ZIPATONI CO.**, 1017 Olive St., St. Louis MO 63101-2019. (314)231-2400. Fax: (314)231-6622. E-mail: administrator@zipatoni.com. Website: http://www.zipatoni.com. Art Buyer: Christine Molitor. Estab. 1985. Number of employees: 70. Approximate annual billing: $9,412,000. Sales promotion agency, creative/design service, event marketing agency. Specializes in brand development. Product specialties are food and beverage. Current clients include Miller Brewing Co., Energizer Battery, Chicken of the Sea. Client list available on website.

• See the interview with Christine Molitor on page 554.

Needs: Approached by 200 illustrators and 50 designers/year. Works with 35 illustrators/year. Uses freelancers mainly for point-of-purchase displays, brochures. Also for brochure design and illustration, model making, posters and web graphics.

First Contact & Terms: Send query letter with brochure or photocopies and résumé. Send postcard sample of work with follow-up postcard samples every 3 months. Accepts disk submissions. Samples are filed. Pays by the project, $300-8,000. Negotiates rights purchased. Finds illustrators through *American Showcase, Black Book, Directory of Illustration* and submissions.

Montana

WALKER DESIGN GROUP, 47 Dune Dr., Great Falls MT 59404. (406)727-8115. Fax: (406)791-9655. President: Duane Walker. Number of employees: 6. Design firm. Specializes in annual reports and corporate identity. Professional affiliations: AIGA and Ad Federation.

Needs: Uses freelancers for animation, annual reports, brochure, medical and technical illustration, catalog design, lettering, logos and TV/film graphics. 80% of design and 90% of illustration demand skills in Aldus PageMaker, Adobe Photoshop and Adobe Illustration.

First Contact & Terms: Send query letter with brochure, photocopies, photographs, résumé, slides and/or tearsheets.

Accepts disk submissions. Samples are filed and are not returned. Reports back only if interested. To arrange portfolio review, artist should follow-up with call or letter after initial query. Portfolio should include color photographs, photostats and tearsheets. Pays by the project; negotiable. Finds artists through *Workbook*.
Tips: "Stress customer service and be very aware of time lines."

Nevada

☑ **ASAP ADVERTISING**, P.O. Box 51570, Sparks NV 89435-1570. Phone/fax: (775)356-7680. Owner: Brian Dillon. Estab. 1982. Specializes in copywriting and production of print advertising for business-to-business and retail accounts.
Needs: All design and production is currently handled inhouse. Not seeking new outside sources, or full- or part-time or freelance help. Works on assignment only.

New Hampshire

🄽 **YASVIN DESIGNERS**, 45 Peterborough Rd., Box 116, Hancock NH 03449. (603)525-3000. Fax: (603)525-3300. Contact: Creative Director. Estab. 1990. Number of employees: 4. Specializes in annual reports, brand and corporate identity, package design and advertising. Clients: corporations, colleges and institutions. Current clients include Antioch University, Bagel Works Restaurants, Dynafit Ski, University Medical Group, CIM Industries, The Credit Index, Water-Wear, Inc.
Needs: Approached by 10-15 freelancers/year. Works with 6 freelance illustrators and 2 designers/year. Uses illustrators mainly for annual report and advertising illustration. Uses designers mainly for production, logo design. Also uses freelancers for brochure illustration and charts/graphs. Needs computer-literate freelancers for design and production. 50% of freelance work demands knowledge of Adobe Illustrator, Adobe Photoshop, Aldus FreeHand and/or QuarkX-Press.
First Contact & Terms: Send postcard sample of work or send query letter with photocopies, SASE and tearsheets. Samples are filed. Reports back only if interested. Request portfolio review in original query. Portfolio should include b&w and color photocopies, roughs and tearsheets. Pays for design by the project and by the day. Pays for illustration by the project. Rights purchased vary according to project. Finds artists through sourcebooks and artists' submissions.
Tips: "Show us rough sketches that describe the creative process."

New Jersey

🖳 **AM/PM ADVERTISING INC.**, 196 Clinton Ave., Newark NJ 07108. (201)824-8600. Fax: (201)824-6631. President: Bob Saks. Estab. 1962. Number of employees: 130. Approximate annual billing: $24 million. Ad agency. Full-service multimedia firm. Specializes in national TV commercials and print ads. Product specialties are health and beauty aids. Current clients include J&J, Bristol Myers, Colgate Palmolive. Client list available upon request. Professional affiliations: AIGA, Art Directors Club, Illustration Club.
Needs: Approached by 35 freelancers/year. Works with 3 freelance illustrators and designers/month. Works only with artist reps. Works on assignment only. Uses freelancers mainly for illustration and design. Also for brochure and print ad design and illustration, storyboards, slide illustration, animation, mechanicals, retouching, model making, billboards, posters, TV/film graphics, lettering and logos and multimedia projects. 30% of work is with print ads. 50% of work demands knowledge of Aldus PageMaker, QuarkXPress, Aldus FreeHand, Adobe Illustrator or Adobe Photoshop.
First Contact & Terms: Send postcard sample and/or query letter with brochure, résumé and photocopies. Samples are filed or returned. Reports back within 10 days. Portfolios may be dropped off every Friday. Artist should follow up after initial query. Portfolio should include b&w and color thumbnails, roughs, final art, tearsheets, photographs and transparencies. Pays for design by the hour, $35-100; by the project, $300-5,000; or by the day, $150-700. Pays for illustration by the project, $500-10,000. Rights purchased vary according to project.
Tips: "When showing work, give time it took to do job and costs."

🔲 **CUTRO ASSOCIATES, INC.**, 47 Jewett Ave., Tenafly NJ 07670. (201)569-5548. Fax: (201)569-8987. E-mail: cutroassoc@aol.com. Manager: Ronald Cutro. Estab. 1961. Number of employees: 2. Specializes in annual reports, corporate identity, direct mail, fashion, package and publication design, technical illustration and signage. Clients: corporations, business-to-business, consumer.
Needs: Approached by 5-10 freelancers/year. Works with 2-3 freelance illustrators and 2-3 designers/year. Prefers local artists only. Uses illustrators mainly for wash drawings, fashion, specialty art. Uses designers for comp layout. Also uses freelancers for ad and brochure design and illustration, airbrushing, catalog and P-O-P illustration, direct mail design, lettering, mechanicals, and retouching. Needs computer-literate freelancers for design, illustration and production. 98% of freelance work demands knowledge of Adobe Illustrator, QuarkXPress and Adobe Photoshop.
First Contact & Terms: Send postcard sample of work. Samples are filed. Will contact artist for portfolio review if

interested. Portfolio should include final art and photocopies. Pays for design and illustration by the project. Buys all rights.

■ NORMAN DIEGNAN & ASSOCIATES, 3 Martens Rd., Lebanon NJ 08833. (908)832-7951. President: N. Diegnan. Estab. 1977. Number of employees: 5. Approximate annual billing: $1 million. PR firm. Specializes in magazine ads. Product specialty is industrial.
Needs: Approached by 10 freelancers/year. Works with 20 freelancers illustrators/year. Works on assignment only. Uses freelancers for brochure, catalog and print ad design and illustration, storyboards, slide illustration, animatics, animation, mechanicals, retouching and posters. 50% of work is with print ads. Needs editorial and technical illustration.
First Contact & Terms: Send query letter with brochure and tearsheets. Samples are filed and not returned. Reports back within 1 week. To show portfolio, mail roughs. Pays for design and illustration by the project. Rights purchased vary according to project.

N ✝ IRVING FREEMAN DESIGN CO., 10 Jay St., #2, Tenafly NJ 07670. (201)569-4949. Fax: (201)569-4979. E-mail: freemandes@aol.com. President: Irving Freeman. Estab. 1972. Approximate annual billing: $100,000. Specializes in book cover and interior design. Clients: corporations and publishers. Current clients include HarperCollins, Simon & Schuster and Warner Books. Client list available upon request. Professional affiliations: GAG.
Needs: Approached by 10 freelancers/year. Works with 2 freelance illustrators and 2 designers/year. Prefers local artists only. Uses illustrators mainly for book covers. Uses designers mainly for book interiors. Also uses freelancers for airbrushing, book design and lettering. Needs computer-literate freelancers for design, illustration, production and presentation. 100% of freelance work demands knowlege of Adobe Illustrator, Adobe Photoshop and QuarkXPress.
First Contact & Terms: Send postcard sample of work or send brochure, photocopies, photographs and tearsheets. Samples are filed. Reports back within 1 month. Will contact artist for portfolio review if interested. Portfolio should include final art. Pays for design by the hour, by the project and by the day. Pays for illustration by the project. Rights purchased vary according to project. Finds artists through sourcebooks.

N ■ IMPACT COMMUNICATIONS, INC., 1300 Mt. Kemble Ave., Morristown NJ 07960. (201)425-0700. Fax: (201)425-0505. E-mail: impact@planet.net. Creative Director: Scott R. Albini. Estab. 1983. Number of employees: 15. Marketing communications firm. Full-service, multimedia firm. Specializes in electronic media, business-to-business and print design. Current clients include AT&T, BASF, Schering-Plough, Warner-Lambert and Ricoh. Professional affiliations: IICS, NCCC and ITVA.
Needs: Approached by 12 freelancers/year. Works with 12 freelance illustrators and 12 designers/year. Uses freelancers mainly for illustration, design and computer production. Also for brochure and catalog design and illustration, multimedia and logos. 10% of work is with print ads. 90% of design and 50% of illustration demands knowledge of Adobe Photoshop, QuarkXPress, Adobe Illustrator and Macro Mind Director.
First Contact & Terms: Designers send query letter with photocopies, photographs, résumé and tearsheets. Illustrators send postcard sample. Samples are filed and are not returned. Will contact artist for portfolio review if interested. Portfolio should include b&w and color final art, photographs, photostats, roughs, slides, tearsheets and thumbnails. Pays for design and illustration by the project, depending on budget. Rights purchased vary according to project. Finds artists through sourcebooks and self-promotion pieces received in mail.
Tips: "Be flexible."

JANUARY PRODUCTIONS, INC., 210 Sixth Ave., Hawthorne NJ 07507. (201)423-4666. Fax: (201)423-5569. E-mail: awpeller@worldnet.att.net. Website: http://www.awpeller.com. Art Director: Karen Sigler. Estab. 1973. Number of employees: 12. AV producer. Serves clients in education. Produces children's educational materials—videos, sound filmstrips, read-along books, cassettes and CD-ROM.
Needs: Works with 1-2 freelance illustrators/year. "While not a requirement, a freelancer living in the same geographic area is a plus." Works on assignment only, "although if someone had a project already put together, we would consider it." Uses freelancers mainly for illustrating children's books. Also for artwork for filmstrips, sketches for books and layout work. 50% of freelance work demands knowledge of QuarkXPress, Aldus FreeHand and Adobe Photoshop.
First Contact & Terms: Send query letter with résumé, tearsheets, SASE, photocopies and photographs. Will contact artist for portfolio review if interested. "Include child-oriented drawings in your portfolio." Requests work on spec before assigning a job. Pays for design and illustration by the project, $20 minimum. Originals not returned. Buys all rights. Finds artists through submissions.

RPD GROUP/RICHARD PUDER DESIGN GROUP, 2 W. Blackwell St., P.O. Box 1520, Dover NJ 07802-1520. (973)361-1310. Fax: (973)361-1663. E-mail: strongtype@aol.com. or talentbank@strongtype.com. Website: http://www.strongtype.com. Estab. 1985. Number of employees: 3. Approximate annual billing: $300,000. Specializes in annual reports, direct mail and publication design, technical illustration. Current clients include Hewlett-Packard, Micron Electronics, R.R. Bowker, Scholastic, Simon & Schuster and Sony. Professional affiliation: Type Directors Club.
Needs: Approached by 100 freelancers/year. Works with 20 freelance illustrators and 5 designers/year and some interns. Prefers artists with experience in anatomy, color, perspective—many illustrative styles; prefers artists without reps. Uses illustrators mainly for publishing clients. Uses designers mainly for corporate, publishing clients. Also uses freelancers or ad and brochure design and illustration, book, direct mail, magazine and poster design, charts/graphs, lettering, logos

and retouching. 90% of freelance work demands skills in Illustrator, Photoshop, FreeHand, Acrobat, XPress, Director, CyberStudio, Dreamweaver.

First Contact & Terms: Send postcard sample of work or send résumé and tearsheets. Samples are filed. Will contact artist for portfolio review if interested. Portfolio should include b&w and color photocopies, photographs, roughs and thumbnails. Pays for design by the hour, $10-65. Pays for illustration by the job. Buys first rights or rights purchased vary according to project. Finds artists through sourcebooks (e.g., *American Showcase* and *Workbook*) and by client referral.

Tips: Impressed by "listening, problem-solving, speed, technical competency and creativity."

SMITH DESIGN ASSSOCIATES, 205 Thomas St., Box 190, Glen Ridge NJ 07028. (973)429-2177. Fax: (973)429-7119. E-mail: assoc@smithdesign.com. Website: http://www.smithdesign.com. Vice President: Larraine Blauvelt. Clients: cosmetics firms, toy manufacturers, life insurance companies, office consultants. Current clients: Popsicle, Good Humor, Breyer's and Schering Plough. Client list available upon request.

Needs: Approached by more than 100 freelancers/year. Works with 10-20 freelance illustrators and 2-3 designers/year. Requires quality and dependability. Uses freelancers for advertising and brochure design, illustration and layout, interior design, P-O-P and design consulting. 90% of freelance work demands knowledge of Adobe Illustrator, QuarkXPress, Adobe Photoshop and Painter. Needs children's, packaging and product illustration.

First Contact & Terms: Send query letter with brochure showing art style or résumé, tearsheets and photostats. Samples are filed or are returned only if requested by artist. Reports back within 1 week. Call for appointment to show portfolio of color roughs, original/final art and final reproduction. Pays for design by the hour, $25-100; by the project, $175-5,000. Pays for illustration by the project, $175-5,000. Considers complexity of project and client's budget when establishing payment. Buys all rights. Also buys rights for use of existing non-commissioned art. Finds artists through word of mouth, self-promotions/sourcebooks and agents.

Tips: "Know who you're presenting to, the type of work we do and the quality we expect. We use more freelance artists not so much because of the economy but more for diverse styles."

New York

ALBEE SIGN CO., 561 E. Third St., Mt. Vernon NY 10553. (914)668-0201. President: William Lieberman. Produces interior and exterior signs and graphics. Clients are banks and real estate companies.

Needs: Works with 6 freelance artists/year for sign design, 6 for display fixture design, 6 for P-O-P design and 6 for custom sign illustration. Prefers local artists only. Works on assignment only.

First Contact & Terms: Send query letter with samples, SASE, résumé and business card to be kept on file. Pays by job. Previous experience with other firms preferred. Reports within 2-3 weeks. Samples are not returned. Reports back as assignment occurs.

AUTOMATIC MAIL SERVICES, INC., 30-02 48th Ave., Long Island City NY 11101. (212)361-3091. Fax: (718)937-8568. E-mail: info@aols.com. Website: http://www.automatic-mail.com or www.aols.com. Contact: Michael Waskover. Manufacturer and service firm. Provides printing Internet sites and direct mail advertising. Clients: publishers, banks, stores, clubs, businesses.

Needs: Works with 5-10 artists/year. Uses freelancers for advertising, brochure and catalog design, illustration and layout.

First Contact & Terms: Send business card and photostats to be kept on file. Call for appointment to show portfolio. Samples not kept on file are returned if requested. Works on assignment only. Pays by the project, $10-1,000 average. Considers skill and experience of artist and turnaround time when establishing payment.

DALOIA DESIGN, 149-30 88 St., Howard Beach NY 11414. (718)835-7641. E-mail: daloiades@aol.com. Owner/Designer: Peter Daloia. Estab. 1983. Number of employees: 2. Design firm. Specializes in stationery, novelty and gift products design. Product specialties are magnets, photo frames, coasters, bookmarks, framed mirrors, etc.

Needs: Works with 1 illustrator and 1 designer/year. Prefers local freelancers with experience in consumer products. Uses freelancers mainly for art and/or design for retail products. Also for airbrushing, brochure and catalog design, humorous illustration, mechanicals, model making, posters, signage, design for stationery, novelties and gift products. Freelancers must know software appropriate for design or production of project including PageMaker, FreeHand, Photoshop, QuarkXPress, Illustrator or "whatever is necessary."

First Contact & Terms: Designers send query letter with b&w or color photocopies, photographs, résumé. Illustrators send query letter with photocopies, photographs, résumé or laser color copies. Samples are filed and are not returned. Reports back only if interested. Will contact artist for portfolio review of b&w, color, final art, roughs, thumbnails and design showing use of type. Payment "depends on project and use." Negotiates rights purchased. Finds artists through *Creative Black Book*, *RSVP*, etc.

Tips: "Keep an open mind, strive for excellence, push limitations."

DESIGN CONCEPTS, 104 Main St., Box 5A1, RR 1, Unadilla NY 13849. (607)369-4709. Owner: Carla Schroeder Burchett. Estab. 1972. Specializes in annual reports, brand identity, design and package design. Clients:

corporations, individuals. Current clients include American White Cross and Private & Natural.

Needs: Approached by 6 freelance graphic artists/year. Works with 2 freelance illustrators and designers/year. Prefers artists with experience in packaging, photography, interiors. Uses freelance artists for mechanicals, poster illustration, P-O-P design, lettering and logos.

First Contact & Terms: Send query letter with tearsheets, brochure, photographs, résumé and slides. Samples are filed or are returned by SASE if requested by artist. Reports back. Artists should follow up with letter after initial query. Portfolio should include thumbnails and b&w and color slides. Pays for design by the hour, $15 minimum. Negotiates rights purchased.

Tips: "Artists and designers are used according to talent; team cooperation is very important. If a person is interested and has the professional qualification, he or she should never be afraid to approach us—small or large jobs."

■ FINE ART PRODUCTIONS, RICHIE SURACI PICTURES, MULTIMEDIA, INTERACTIVE, 67 Maple St., Newburgh NY 12550-4034. Phone/fax: (914)561-5866. E-mail: rs7.fap@mhv.net. Websites: http://www.broadcast. com/books, http://www.mhv.net/~rs7.fapnetworkEROTICA.html, http://www.audiohwy.com, http://www.woodstock69. com, http://indyjones.simplenet.com/kunda.htm. Contact: Richie Suraci. Estab. 1990. Ad agency, AV and PR firm. Full-service multimedia firm. Specializes in film, video, print, magazine, documentaries and collateral. "Product specialties cover a broad range of categories."

• Fine Art Productions is looking for artists who specialize in science fiction and erotic art for upcoming projects.

Needs: Approached by 288 freelancers/year. Works with 12-48 freelance illustrators and 12-48 designers/year. "Everyone is welcome to submit work for consideration in all media." Works on assignment only. Uses freelancers for brochure, catalog and print ad design and illustration, storyboards, slide illustration, animatics, animation, mechanicals, retouching, billboards, posters, TV/film graphics, lettering and logos. Also for multimedia projects. Needs editorial, technical, science fiction, jungle, adventure, children's, fantasy and erotic illustration. 20% of work is with print ads. 50% of freelance work demands knowledge of "all state-of-the-art software."

First Contact & Terms: Send query letter with brochure, photocopies, résumé, photographs, tearsheets, photostats, slides, transparencies and SASE. Accepts submissions on disk compatible with Macintosh format. Samples are filed or returned by SASE if requested by artist. Reports back in 4-6 months if interested. Will contact artist for portfolio review if interested. Portfolio should include thumbnails, roughs, b&w and color photostats, tearsheets, photographs, slides and transparencies. Requests work on spec before assigning a job. Pays for design and illustration by the project; negotiable. Rights purchased vary according to project.

Tips: "We need more freelance artists. Submit your work for consideration in field of interest specified."

N ■ IMAC, Inter-Media Art Center, 370 New York Ave., Huntington NY 11743. (516)549-9666. Fax: (516)549-9423. Executive Director: Michael Rothbard. Estab. 1974. AV firm. Full-service, multimedia firm. Specializes in TV and multimedia productions.

Needs: Approached by 12 freelancers/month. Works with 3 illustrators and 2 designers/month. Prefers freelancers with experience in computer graphics. Uses freelancers mainly for animation, TV/film graphics and computer graphics. 50% of work is with print ads.

First Contact & Terms: Send query letter with photographs. Samples are not filed and are not returned. Reports back within 10 days. Rights purchased vary according to project.

✓ McANDREW ADVERTISING, 210 Shields Rd., Red Hook NY 12571. Phone/fax: (914)756-2276. Art/Creative Director: Robert McAndrew. Estab. 1961. Number of employees: 3. Approximate annual billing: $225,000. Ad agency. Clients: industrial and technical firms. Current clients include Yula Corp. and Electronic Devices, Inc.

Needs: Approached by 20 freelancers/year. Works with 3 freelance illustrators and 5 designers/year. Uses mostly local freelancers. Uses freelancers mainly for design, direct mail, brochures/flyers and trade magazine ads. Needs technical illustration. Prefers realistic, precise style. Prefers pen & ink, airbrush and occasionally markers. 50% of work is with print ads. 5% of freelance work demands computer skills.

First Contact & Terms: Query with photocopies, business card and brochure/flier to be kept on file. Samples not returned. Reports in 1 month. Originals not returned. Will contact artist for portfolio review if interested. Portfolio should include roughs and final reproduction. Pays for illustration by the project, $35-300. Pays for design by the project. Considers complexity of project, client's budget and skill and experience of artist when establishing payment. Finds artists through sourcebooks, word of mouth and business cards in local commercial art supply stores.

Tips: Artist needs "an understanding of the product and the importance of selling it."

N ■ MESMERIZED HOLOGRAPHIC MARKETING, P.O. Box 295, Mt. Kisco NY 10549. (914)948-6138. Fax: (914)948-9509. Creative Director: Jeff Levine. Estab. 1986. Number of employees: 5. Holographic promotional marketing firm. Specializes in holographic promotional marketing from print promotions to P-O-P displays. Product specialties are custom 3-D holograms and molded premiums.

• Jeff Levine says he is very interested in finding freelancers to create 3-D environments, either computer-generated or by traditional model-making techniques.

Needs: Approached by 3 freelance illustrators and 3 designers/year. Works with 12 freelance illustrators and 8 designers/year. Prefers freelancers with experience in 3-D animation and virtual environments. Uses freelancers mainly for 3-D graphic animation, medical modeling, general model making. Also for medical illustration, multimedia projects, story-

boards. 20% of design and 80% of illustration demands skills in Aldus FreeHand, Adobe Photoshop, SGI. Also interested in working with model makers and sculptors for figurines.

First Contact & Terms: Designers send brochure, photocopies, photographs, résumé, tearsheets. Illustrators send postcard sample and/or query letter with brochure, photocopies, photographs, CD-ROM. Accepts disk submissions compatible with Mac and QuarkXPress. Samples are filed and are not returned. Does not report back. Artist should follow-up. Will contact for portfolio review if intereted. Pays by the project. Buys all rights. Finds artists through word of mouth.

Tips: "Always make suggestions, then take direction."

MITCHELL STUDIOS DESIGN CONSULTANTS, 1111 Fordham Lane, Woodmere NY 11598. (516)374-5620. Fax: (516)374-6915. E-mail: msdcdesign@aol.com. Principals: Steven E. Mitchell and E.M. Mitchell. Estab. 1922. Specializes in brand and corporate identity, displays, direct mail and packaging. Clients: major corporations.

Needs: Works with 5-10 freelance designers and 20 illustrators/year. "Most work is started in our studio." Uses freelancers for design, illustration, mechanicals, retouching, airbrushing, model making, lettering and logos. 100% of design and 50% of illustration demands skills in Adobe Illustrator 7.0, Adobe Photoshop 4.0 and QuarkXPress 3.3. Needs technical illustration and illustration of food, people.

First Contact & Terms: Send query letter with brochure, résumé, business card, photographs and photocopies to be kept on file. Accepts non-returnable disk submissions compatible with Adobe Illustrator, QuarkXPress, Aldus FreeHand and Adobe Photoshop. Reports only if interested. Call or write for appointment to show portfolio of roughs, original/final art, final reproduction/product and color photostats and photographs. Pays for design by the hour, $25 minimum; by the project, $250 minimum. Pays for illustration by the project, $250 minimum.

Tips: "Call first. Show actual samples, not only printed samples. Don't show student work. Our need has increased—we are very busy."

JACK SCHECTERSON ASSOCIATES, 5316 251 Place, Little Neck NY 11362. (718)225-3536. Fax: (718)423-3478. Principal: Jack Schecterson. Estab. 1967. Ad agency. Specializes in packaging, product marketing, corporate and graphic design and new product introduction.

Needs: Works direct and with artist reps. Prefers local freelancers only. Works on assignment only. Uses freelancers for package and product design and illustration, brochures, catalogs, retouching, lettering, logos. 100% of design and 40% of illustration demands skills in Adobe Illustrator, Adobe Photoshop and QuarkXPress.

First Contact & Terms: Send query letter with brochure, photocopies, tearsheets, résumé, photographs, slides, transparencies and SASE; "whatever best illustrates work." Samples not filed are returned by SASE only if requested by artist. Request portfolio review in original query. Will contact artist for portfolio review if interested. Portfolio should include roughs, b&w and color—"whatever best illustrates creative abilities/work." Pays for design and illustration by the project; depends on budget. Buys all rights.

SMITH & DRESS, 432 W. Main St., Huntington NY 11743. (516)427-9333. Contact: A. Dress. Specializes in annual reports, corporate identity, display, direct mail, packaging, publications and signage. Clients: corporations.

Needs: Works with 3-4 freelance artists/year. Prefers local artists only. Works on assignment only. Uses artists for illustration, retouching, airbrushing and lettering.

First Contact & Terms: Send query letter with brochure showing art style or tearsheets to be kept on file (except for works larger than 8½×11). Pays for illustration by the project. Considers client's budget and turnaround time when establishing payment.

VISUAL HORIZONS, 180 Metro Park, Rochester NY 14623. (716)424-5300. Fax: (716)424-5313. E-mail: slides1@aol.com. or info@visualhorizons.com. Website: http://www.visualhorizons.com. Estab. 1971. AV firm. Full-service multimedia firm. Specializes in presentation products. Current clients include US government agencies, corporations and universities.

Needs: Works on assignment only. Uses freelancers mainly for catalog design. 10% of work is with print ads. 100% of freelance work demands skills in Aldus PageMaker and Photoshop.

First Contact & Terms: Send query letter with tearsheets. Samples are not filed and are not returned. Reports back to the artist only if interested. Portfolio review not required. Pays for design and illustration by the hour or project, negotiated. Buys all rights.

New York City

AVANCÉ DESIGNS, INC., 648 Broadway, Suite 201, New York NY 10012-2314. (212)420-1255. Fax: (212)473-3309. Estab. 1986. "Avancé Designs are specialists in visual communications. We maintain our role by managing multiple design disciplines from print and information design to packaging and interactive media. For more information, visit our website at http://www.avance-designs.com."

Needs: Illustrators, designers, 2/3-dimensional computer artists, web designers, programmers strong in Photoshop, Illustrator and Quark as well as HTML, CGI scriptings, Flash animation and Director.

First Contact & Terms: Send query letter. Samples of interest are filed and are not returned. Reports back to the

artist only if interested. Samples of best work may be dropped off every Monday-Friday. Pays for design by the hour. Pays for illustration by the project. Rights purchased vary according to project.

☑ BARRY DAVID BERGER & ASSOCIATES, INC., 54 King St., New York NY 10014. (212)255-4100. Senior Industrial Designer: Robert Ko. Senior Graphic Designer: Mark Battle. Number of employees: 5. Approximate annual billing: $500,000. Specializes in brand and corporate identity, P-O-P displays, product and interior design, exhibits and shows, corporate capability brochures, advertising graphics, packaging, publications and signage. Clients: manufacturers and distributors of consumer products, office/stationery products, art materials, chemicals, healthcare, pharmaceuticals and cosmetics. Current clients include Dennison, Timex, Sheaffer, Bausch & Lomb and Kodak. Professional affiliations IDSA, AIGA, APDF.

Needs: Approached by 12 freelancers/year. Works with 5 freelance illustrators and 7 designers/year. Uses artists for advertising, editorial, medical, technical and fashion illustration, mechanicals, retouching, direct mail and package design, model making, charts/graphs, photography, AV presentations and lettering. Needs computer-literate freelancers for illustration and production. 50% of freelance work demands computer skills.

First Contact & Terms: Send query letter, then call for appointment. Works on assignment only. Send "whatever samples are necessary to demonstrate competence" including multiple roughs for a few projects. Samples are filed or returned. Reports immediately. Provide brochure/flyer, résumé, business card, tearsheets and samples to be kept on file for possible future assignments. Pays for design by the project, $1,000-10,000. Pays for illustration by the project.

Tips: Looks for creativity and confidence.

ANITA HELEN BROOKS ASSOCIATES, PUBLIC RELATIONS, 155 E. 55th St., New York NY 10022. (212)755-4498. President: Anita Helen Brooks. PR firm. Specializes in fashion, "society," travel, restaurant, political and diplomatic, and publishing. Product specialties are events, health and health campaigns.

Needs: Works on assignment only. Uses freelancers for consumer magazines, newspapers and press releases. "We're currently using more abstract designs."

First Contact & Terms: Send query letter with résumé. Call for appointment to show portfolio. Reports back only if interested. Considers client's budget and skill and experience of artist when establishing payment.

Tips: "Artists interested in working with us must provide rate schedule, partial list of clients and media outlets. We look for graphic appeal when reviewing samples."

CANON & SHEA ASSOCIATES, INC., 224 W. 35th St., Suite 1500, New York NY 10001. (212)564-8822. E-mail: canonshea@aol.com. Website: http://members.aol.com/canonshea. Art Buyer: Sal Graci. Estab. 1978. Print, Internet, multimedia, advertising/PR/marketing firm. Specializes in business-to-business and financial services.

Needs: Works with 20-30 freelance illustrators and 2-3 designers/year. Mostly local freelancers. Uses freelancers mainly for design and illustrations. 100% of freelance work demands knowledge of QuarkXPress, Adobe Illustrator, Adobe Photoshop, Director, Pagemill or FrontPage.

First Contact & Terms: Send postcard sample and/or query letter with résumé, photocopies and tearsheets. Accepts submissions on disk. Will contact artist for portfolio review if interested. Pays by the hour: $15-35 for design, annual reports, catalogs, trade and consumer magazines; $25-50 for packaging; $50-250 for corporate identification/graphics; $10-45 for layout, lettering and paste-up. Pays for illustration by the hour, $10-20. Finds artists through art schools, design schools and colleges.

Tips: "Artists should have business-to-business materials as samples and should understand the marketplace. Do not include fashion or liquor ads. Common mistakes in showing a portfolio include showing the wrong materials, not following up and lacking understanding of the audience."

🄽 CARNASE, INC., 30 E. 21st St., New York NY 10010. (212)777-1500. Fax: (212)979-1927. President: Tom Carnase. Estab. 1978. Specializes in annual reports, brand and corporate identity, display, landscape, interior, direct mail, package and publication design, signage and technical illustration. Clients: agencies, corporations, consultants. Current clients include: Clairol, Shiseido Cosmetics, Times Mirror, Lintas: New York. Client list not available.

• President Tom Carnase predicts "very active" years ahead for the design field.

Needs: Approached by 60 freelance artists/year. Works with 2 illustrators and 1 designer/year. Prefers artists with 5 years experience. Works on assignment only. Uses artists for brochure, catalog, book, magazine and direct mail design and brochure and collateral illustration. Needs computer-literate freelancers. 50% of freelance work demands skills in QuarkXPress or Adobe Illustrator.

First Contact & Terms: Send query letter with brochure, résumé and tearsheets. Samples are filed. Reports back within 10 days. Will contact artist for portfolio review if interested. Portfolio should include photostats, slides and color tearsheets. Negotiates payment. Rights purchased vary according to project.

Tips: Finds artists through word of mouth, magazines, artists' submissions/self-promotions, sourcebooks and agents.

☒ COUSINS DESIGN, 599 Broadway, New York NY 10012. (212)431-8222. E-mail: cousinsma@aol.com. President: Michael Cousins. Number of employees: 4. Specializes in packaging and product design. Clients: marketing and manufacturing companies. Professional affiliation: IDSA.

Needs: Works with freelance designers. Prefers local designers. Works on assignment only. Uses artists for design, illustration, mechanicals, retouching, airbrushing, model making, lettering and logos.

First Contact & Terms: Send query letter with brochure or résumé, tearsheets and photocopies. Samples are filed or

are returned, only if requested. Reports back within 2 weeks only if interested. Write for appointment to show portfolio of roughs, final reproduction/product and photostats. Pays for design by the hour or flat fee. Considers skill and experience of artist when establishing payment. Buys all rights.

Tips: "Send great work that fits our direction."

[N] [icon] CSOKA/BENATO/FLEURANT, INC., 134 W. 26th St., New York NY 10001. (212)242-6777. (212)675-2078. President: Robert Fleurant. Estab. 1969. Specializes in brand and corporate identity, display, direct mail, package and publication design. Clients: corporations and foundations. Current clients include Metropolitan Life Insurance and RCA/BMG Special Products.

Needs: Approached by approximately 120 freelancers/year by mail. Works with 3-4 freelance illustrators/year. Prefers local freelancers with experience in print, full color, mixed media. Seeks freelancers "with professionalism and portfolio who can meet deadlines, work from layouts and follow instructions." Works on assignment only. Uses illustrators mainly for album covers, publications and promotions. Also for brochure, catalog and P-O-P illustration, mechanicals, retouching, airbrushing and lettering. 90% of freelance work demands skills in Aldus PageMaker, QuarkXPress, Aldus FreeHand, Adobe Illustrator, Adobe Photoshop, Adobe Streamline, OmniPage and Microsoft Word 5.1.

First Contact & Terms: Send query letter with tearsheets and résumé. Samples are filed. Reports back only if interested. Write for appointment to show portfolio of thumbnails, roughs, final art and b&w and color tearsheets. Pays for design by the hour, $20-35. Pays for illustration by the project (estimated as per requirements). Buys all rights.

[icon] DE FIGLIO DESIGN, 11 W. 30th St., Suite 6, New York NY 10001-4405. (212)695-6109. Fax: (212)695-4809. Creative Director: R. De Figlio. Estab. 1981. Number of employees: 2. Design firm. Specializes in magazine ads, annual reports, collateral, postage stamps and CD albums. Specializes in postage stamps.

Needs: Approached by 10 illustrators and 10 designers/year. Works with 4 illustrators and 10 designers/year. Prefers local designers with experience in Mac-based programs. Uses freelancers mainly for mechanicals on the Mac. Also for airbrushing, annual reports, brochure design and illustration, logos, posters, retouching and web page design. 80% of design and 25% of illustration demands skills in latest versions of Adobe Photoshop, QuarkXPress and Adobe Illustrator. Illustrators can use any version that works for project.

First Contact & Terms: Designers send photocopies and résumé. Illustrators send postcard sample or photocopies and résumé. Samples are filed. Does not report back. Payment negotiable. Finds artists through submissions and networking.

[icon] DLS DESIGN, 156 Fifth Ave., New York NY 10010. (212)255-3464. E-mail: dsdesign@interport.net. Website: http://www.dlsdesign.com. President: David Schiffer. Estab. 1986. Number of employees: 4. Approximate annual billing: $150,000. Graphic design firm. Specializes in high-end corporate websites, logo and corporate identity materials, some annual reports, collateral and book jackets. Product specialties are corporate, publishing, nonprofit, entertainment. Current clients include The Foundation Center, Disney Magazine Publishing, American Management Association, Timex Watchbands, Newcastle/Acoustone Fabrics, CHIC Jeans and many others. Professional affiliation: WWWAC (World Wide Web Artists' Consortium).

• Awards won in 1998: two logo designs selected for *Logo 2000*, three web sites in *Creativity 28*.

Needs: "Over 50% of our work is high-end corporate websites. Work is clean, but can also be high in the 'delight factor.' " Requires designers and illustrators fluent in Photoshop and Illustrator for original website art, including splash screens, banners, GIF animations and interactive banners. Other essential programs include BBEdit, GIF Builder, DeBabelizer. Also uses freelancers fluent in clean, intermediate to advanced HTML, as well as an understanding of Javascript and CGI.

First Contact & Terms: E-mail is acceptable, but unsolicited attached files will be rejected. "Please wait until we say we are interested, or direct to your URL to show us samples." Uses some hourly freelance help in website authoring; rarely needs editorial illustrations in traditional media.

[N] ERICKSEN ADVERTISING & DESIGN, INC., 12 W. 37th St., New York NY 10018. Fax: (212)239-3321. Director: Robert Ericksen. Full-service ad agency providing all promotional materials and commercial services for clients. Product specialties are promotional, commercial and advertising material for the entertainment industry. Current clients include Warner Bros., Hearst Entertainment, WCBS, WNBC.

Needs: Works with several freelancers/year. Assigns several jobs/year. Works on assignment only. Uses freelancers mainly for advertising, packaging, brochures, catalogs, trade, P-O-P displays, posters, lettering and logos. Prefers composited and computer-generated artwork.

First Contact & Terms: Contact through artist's agent or send query letter with brochure or tearsheets and slides. Samples are filed and are not returned unless requested with SASE; unsolicited samples are not returned. Reports back within 1 week if interested or when artist is needed for a project. Does not report back to all unsolicited samples. "Only on request should a portfolio be sent." Pays for illustration by the project, $500-5,000. Buys all rights and retains ownership of original. Finds artists through word of mouth, magazines, submissions and sourcebooks.

Tips: "Advertising artwork is becoming increasingly 'commercial' in response to very tightly targeted marketing (i.e., the artist has to respond to increased creative team input versus the fine art approach."

[N] LEO ART STUDIO, INC., 276 Fifth Ave., Suite 610, New York NY 10001. (212)685-3174. Fax: (212)685-3170. Studio Manager and Art Director: Robert Schein. Number of employees: 8. Approximate annual billing: $1 million. Specializes in textile design for home furnishings. Clients: wallpaper manufacturers/stylists, glassware compa-

nies, furniture and upholstery manufacturers. Current clients include Burlington House, Blumenthal Printworks, Columbus Coated, Eisenhart Wallcoverings, Victoria's Secret, Town and Country, Fieldcrest-Cannon and Western Textile. Client list available upon request.

Needs: Approached by 25-30 freelancers/year. Works with 3-4 freelance illustrators and 20-25 textile designers/year. Prefers freelancers trained in textile field, not fine arts. Must have a portfolio of original art designs. Should be able to be in NYC on a fairly regular basis. Works both on assignment and speculation. Prefers realistic and traditional styles. Uses freelancers for design, airbrushing, coloring and repeats. "We are always looking to add fulltime artists to our inhouse staff (currently at 8). We will also look at any freelance portfolio to add to our variety of hands. Our recent conversion to CAD system may require future freelance assistance. Knowledge of Coreldraw is a plus."

First Contact & Terms: Send query letter with résumé. Do not send slides. Request portfolio review in original query. "We prefer to see portfolio in person. Contact via phone is OK—we can set up appointments with a day or two's notice." Samples are not filed and are returned. Reports back within 5 days. Portfolio should include original/final art. Sometimes requests work on spec before assigning job. Pays for design by the project, $500-1,500. "Payment is generally a 60/40 split of what design sells for—slightly less if reference material, art material, or studio space is requested." Considers complexity of project, skill and experience of artist and how work will be used when establishing payment. Buys all rights.

Tips: "Stick to the field we are in (home furnishing textiles, upholstery, fabrics, wallcoverings). Understand manufacture and print methods. Walk the market; show that you are aware of current trends. Go to design shows before showing portfolio. We advise all potential textile designers and students to see the annual design show—Surtex—at the Jacob Javitz Center in New York, usually in spring. Also attend High Point Design Show in North Carolina and Heimtex America in Florida."

N **LIEBER BREWSTER DESIGN, INC.**, 19 W. 34th St., Suite 618, New York NY 10001. (212)279-9029. E-mail: lieber@interport.net. Principal: Anna Lieber. Estab. 1988. Specializes in annual reports, corporate identity, direct mail and package design, publications, exhibits, advertising and signage. Clients: publishing, nonprofits, corporate, financial, foodservice, retail and website development. Client list available upon request. Professional affiliations: NAWBO, PRSA.

Needs: Approached by more than 100 freelancers/year. Works with 10 freelance illustrators and 10 designers/year. Works on assignment only. Uses freelancers for HTML programming, lettering, logos, direct mail design, charts/graphs, audiovisual materials. Needs computer-literate freelancers for design, illustration, production and presentation. 90% of freelance work demands skills in Adobe Illustrator, QuarkXPress or Photoshop. Needs editorial, technical, medical and creative color illustration.

First Contact & Terms: Send query letter with résumé, tearsheets and photocopies. Samples are filed. Will contact artist for portfolio review if interested. Portfolio should include b&w and color work. Pays for design by the hour. Pays for illustration by the project. Rights purchased vary according to project. Finds artists through promotional mailings.

LUBELL BRODSKY INC., 21 E. 40th St., Suite 1806, New York NY 10016. (212)684-2600. Art Directors: Ed Brodsky and Ruth Lubell. Number of employees: 5. Specializes in corporate identity, direct mail, promotion and packaging. Clients: ad agencies and corporations. Professional affiliations: ADC, TDC.

Needs: Approached by 100 freelancers/year. Works with 10 freelance illustrators and 1-2 designers/year. Works on assignment only. Uses freelancers for illustration, retouching, airbrushing, charts/graphs, AV materials and lettering. 100% of design and 30% of illustration demands skills in Adobe Photoshop.

First Contact & Terms: Send postcard sample, brochure or tearsheets to be kept on file. Reports back only if interested.

Tips: Looks for unique talent.

JODI LUBY & COMPANY, INC., 808 Broadway, New York NY 10003. (212)473-1922. Fax: (212)473-2858. E-mail: jodi.luby@worldnet.att.net. President: Jodi Luby. Estab. 1983. Specializes in corporate identity, promotion and direct mail design. Clients: magazines, corporations.

Needs: Approached by 10-20 freelance artists/year. Works with 5-10 illustrators/year. Prefers local artists only. Uses freelancers for brochure and catalog illustration, mechanicals, retouching and lettering. 80% of freelance work demands computer skills.

First Contact & Terms: Send postcard sample or query letter with résumé and photocopies. Samples are not filed and are not returned. Will contact artist for portfolio review if interested. Portfolio should include thumbnails, roughs, b&w and color printed pieces. Pays for design by the hour, $25 minimum; by the project, $100 minimum. Pays for illustration by the project, $100 minimum. Rights purchased vary according to project. Finds artists through word of mouth.

N **MCCAFFERY RATNER GOTTLIEB & LANE, INC.**, 370 Lexington Ave., New York NY 10017. (212)661-8940. E-mail: mri@inch.com. Senior Art Director: Howard Jones. Estab. 1983. Ad agency specializing in advertising and collateral material. Current clients include Olympus Corporation (cameras, digital imaging, microscopes), General Cigar (Macadudo, Partagas), Jean Patou Fragrances, Northwest Airlines, Tetra Foods, Italian Trade Commission, WQXR-FM and WQEW-AM radio stations.

Needs: Works with 6 freelance illustrators/year. Works on assignment only. Also uses artists for brochure and print ad illustration, mechanicals, retouching, billboards, posters, lettering and logos. 80% of work is with print ads.

First Contact & Terms: Send query letter with brochure, tearsheets, photostats, photocopies and photographs. Reports back to the artist only if interested. To show a portfolio, mail appropriate materials or drop off samples. Portfolio should include original/final art, tearsheets and photographs; include color and b&w samples. Pays for illustration by the project, $75-5,000. Rights purchased vary according to project.

Tips: "Send mailers and drop off portfolio."

N MIZEREK DESIGN INC., 318 Lexington Ave., New York NY 10016. (212)689-4885. E-mail: mizerek@aol.com. President: Leonard Mizerek. Estab. 1975. Specializes in catalogs, direct mail, jewelry, fashion and technical illustration. Clients: corporations—various product and service-oriented clientele. Current clients include: Rolex, Leslie's Jewelry, World Wildlife, The Baby Catalog, Time Life and Random House.

Needs: Approached by 20-30 freelancers/year. Works with 10 freelance designers/year. Works on assignment only. Uses freelancers for design, technical illustration, brochures, retouching and logos. 85% of freelance work demands skills in Adobe Illustrator, Adobe Photoshop and QuarkXPress.

First Contact & Terms: Send postcard sample or query letter with résumé, tearsheets and transparencies. Accepts disk submissions compatible with Adobe Illustrator and Adobe Photoshop 3.0. Will contact artist for portfolio review if interested. Portfolio should include original/final art and tearsheets. Pays for design by the project, $500-5,000. Pays for illustration by the project, $500-3,500. Considers client's budget and turnaround time when establishing payment. Finds artists through sourcebooks and self-promotions.

Tips: "Let the work speak for itself. Be creative. Show commercial product work, not only magazine editorial. Keep me on your mailing list!"

N ✦ ▣ NAPOLEON ART STUDIO, 420 Lexington Ave., Suite 3020, New York NY 10170. (212)967-6655. Fax: (212)692-9200. Director of Art Studio Services: Jane Carter. Studio Manager: Doug Miller. Estab. 1985. Number of employees: 10. AV firm. Full-service, multimedia firm. Specializes in storyboards, magazine ads, mechanicals. Product specialty is consumer. Current clients include "all major New York City ad agencies." Client list not available.

Needs: Approached by 60 freelancers/year. Works with 15 freelance illustrators and 2 designers/year. Prefers local freelancers with experience in advertising art. Works on assignment only. Uses freelancers for brochure, catalog and print ad design and illustration, storyboards, mechanicals, billboards, posters, TV/film graphics, lettering and logos. 50% of work is with print ads. Needs computer-literate freelancers for design, illustration, production and presentation. 50% of freelance work demands skills in Adobe Illustrator or Adobe Photoshop.

First Contact & Terms: Send query letter with photocopies, tearsheets and ¾" or VHS tape. Samples are filed. Reports back to the artist only if interested. Will contact artist for portfolio review if interested. Portfolio should include b&w and color thumbnails. Pays for design and illustration by the project; or by the day. Rights purchased vary acording to project. Finds artists through word of mouth and submissions.

LOUIS NELSON ASSOCIATES INC., 80 University Place, New York NY 10003. (212)620-9191. Fax: (212)620-9194. E-mail: lnanyc@aol.com. President: Louis Nelson. Estab. 1980. Number of employees: 6. Approximate annual billing: $750,000. Specializes in environmental, interior and product design and brand and corporate identity, displays, packaging, publications, signage, exhibitions and marketing. Clients: nonprofit organizations, corporations, associations and governments. Current clients include Korean War Veterans Memorial, Port Authority of New York & New Jersey, Richter+Ratner Contracting Corporation, Central Park Conservancy, Steuben, MTA and NYC Transit. Professional affiliations: IDSA, AIGA, SEGD, APDF.

Needs: Approached by 30-40 freelancers/year. Works with 30-40 designers/year. Works on assignment only. Uses freelancers mainly for specialty graphics and 3-dimensional design. Also for design, mechanicals, model making and charts/graphs. 100% of design demands knowledge of Aldus PageMaker, QuarkXPress, Adobe Photoshop, Velum or Adobe Illustrator. Needs editorial illustration.

First Contact & Terms: Send postcard sample or query letter with résumé. Accepts disk submissions compatible with Adobe Illustrator 5.0 or Adobe Photoshop 4.0. Send EPS files. Samples are returned only if requested. Reports within 2 weeks. Write for appointment to show portfolio of roughs, color final reproduction/product and photographs. Pays for design by the hour, $15-25 or by the project, negotiable. Less need for illustration or photography.

Tips: "I want to see how the artist responded to the specific design problem and to see documentation of the process—the stages of development. The artist must be versatile and able to communicate a wide range of ideas. Mostly, I want to see the artist's integrity reflected in his/her work."

N ✦ NICHOLSON NY L.L.C., 295 Lafayette St., Suite 805, New York NY 10012. (212)274-0470. Fax: (212)274-0380. Website: http://www.nny.com. President: Tom Nicholson. Manager of Design Department and Senior Art Director: Maya Kopytman. Contact: Wells Packard. Estab. 1987. Specializes in design of interactive computer programs. Clients: corporations, museums, government agencies and multimedia publishers. Client list available upon request.

Needs: Works with 3 freelance illustrators and 12 designers/year. Prefers local freelancers. Uses illustrators mainly for computer illustration and animation. Uses designers mainly for computer screen design and concept development. Also for mechanicals, charts/graphs and AV materials. Needs editorial and technical illustration. Especially needs designers with interest (not necessarily experience) in computer screen design plus a strong interest in information design. 80% of freelance work demands computer skills.

First Contact & Terms: Send query letter with résumé; include tearsheets and slides if possible. Samples are filed

or are returned if requested. Will contact artist for portfolio review if interested. Portfolio should include thumbnails, original/final art and tearsheets. Considers complexity of project, client's budget and skill and experience of artist when establishing payment. Rights purchased vary according to project. Interested in buying second rights (reprint rights) to previously published work. Finds artists through submissions/self-promotions and sourcebooks.

Tips: "I see tremendous demand for original content in electronic publishing."

☑ ♛ **NICOSIA CREATIVE EXPRESSO LTD.**, 355 W. 52nd St., New York NY 10019. (212)515-6600. Fax: (212)265-5422. E-mail: info@niceltd.com. Website: http://www.niceltd.com. President/Creative Director: Davide Nicosia. Estab. 1993. Number of employees: 23. Specializes in graphic design, corporate/brand identity, brochures, promotional material, packaging, signage, marketing, website design and video production. Current clients include Calvin Klein, Victoria's Secret, Elizabeth Arden, Tiffany & Co., Bath & Body Works and *The New York Times*.

● NICE is an innovative graphic firm with offices in Madrid, Spain and New York. Their team of multicultural designers deliver design solutions for the global marketplace. Recent awards include an American Graphic Design Award for their corporate website.

Needs: Approached by 70 freelancers/year. Works with 6 freelance illustrators and 8 designers/year. Works by assignment only. Uses illustrators, designers, 3-D computer artists and computer artists familiar with Adobe Illustrator, Adobe Photoshop, QuarkXPress and Macromedia Director.

First Contact & Terms: Send query letter and résumé. Reports back to artist for portfolio review only if interested. Pays for design by the hour. Pays for illustration by the project. Rights purchased vary according to project.

Tips: Looks for "promising talent and an adaptable attitude."

♛ ♞ **NOVUS VISUAL COMMUNICATIONS, INC.**, 18 W. 27th St., New York NY 10001. (212)689-2424. Fax: (212)696-9676. E-mail: novuscom@aol.com. President: Robert Antonik. Vice President/Creative Director: Denis Payne. Estab. 1984. Creative marketing and communications firm. Specializes in advertising, annual reports, brand and corporate identity, display, direct mail, fashion, package and publication design, technical illustration and signage. Clients: healthcare, telecommunications, consumer products companies. Client list available upon request.

● Novus was recently featured in *Creativity 28* and won a National Calendar award.

Needs: Approached by 12 freelancers/year. Works with 2-4 freelance illustrators and 2-6 designers/year. Works with artist reps. Prefers local artists only. Uses freelancers for ad, brochure, catalog, poster and P-O-P design and illustration, airbrushing, audiovisual materials, book, direct mail, magazine and newpaper design, charts/graphs, lettering, logos, mechanicals and retouching. 75% of freelance work demands skills in Adobe Illustrator, Adobe Photoshop, Aldus FreeHand, Aldus PageMaker and QuarkXPress.

First Contact & Terms: Contact only through artist rep. Send postcard sample of work. Samples are filed. Reports back ASAP. Follow-up with call. Pays for design by the hour, $15-75; by the day, $200-300; by the project, $200-1,500. Pays for illustration by the project, $150-1,750. Rights purchased vary according to project. Finds artists through *Creative Illustration, Workbook*, agents and submissions.

Tips: "First impressions are important, a portfolio should represent the best, whether it's 4 samples or 12." Advises freelancers entering the field to "always show your best creation. You don't need to overwhelm your interviewer and it's always a good idea to send a thank you or follow-up phone call."

PRO/CREATIVES COMPANY, 25 W. Burda Place, New York NY 10956-7116. President: D. Rapp. Estab. 1986. Ad agency and marketing/promotion PR firm. Specializes in direct mail, ads, collateral. Product specialties are consumer/trade, goods/services.

Needs: Works on assignment only. Uses freelancers for brochure and print ad design and illustration. 30% of work is with print ads.

First Contact & Terms: Samples are filed and are returned by SASE. Portfolio review not required. Pays for design and illustration by the project.

♞ **MIKE QUON/DESIGNATION INC.**, 53 Spring St., New York NY 10012. (212)226-6024. Fax: (212)219-0331. E-mail: mikequon@aol.com. Website: http://www.mikequondesign.com. President: Mike Quon. Estab. 1982. Number of employees: 3. Specializes in corporate identity, displays, direct mail, packaging, publications and technical illustrations. Clients: corporations (financial, healthcare, high technology) and ad agencies. Current clients include Pfizer, Bristol-Myers Squibb, American Express, Chase Manhattan Bank, Bell Atlantic, AT&T. Client list available upon request. Professional affiliations: AIGA, Society of Illustrators, Graphic Artists Guild.

Needs: Approached by 50 illustrators and 50 designers/year. Works with 6 freelance illustrators and 10 designers/year. Prefers local freelancers. Works on assignment only. Prefers graphic style. Uses artists for brochures, design and catalog illustration, P-O-P displays, logos, mechanicals, charts/graphs and lettering. Especially needs computer artists with skills in QuarkXPress, Adobe Illustrator, Adobe Photoshop.

First Contact & Terms: Send query letter with résumé and photocopies. Samples are filed or are returned if accompanied by SASE. Reports back only if interested. Portfolio may be dropped off Monday-Friday. Pays for design by the hour, $20-45. Pays for illustration by the project, $100-500. Buys first rights.

Tips: "Do good work and continually update art directors with mailed samples."

PETER ROTHHOLZ ASSOCIATES INC., 355 Lexington Ave., 17th Floor, New York NY 10017. (212)687-6565. E-mail: pr4pr@aol.com. President: Peter Rothholz. PR firm. Specializes in government (tourism and industrial

development), publishing, pharmaceuticals (health and beauty products) and business services.
Needs: Works with 2-4 freelance illustrators and 2-4 designers/year. Works on assignment only. Needs editorial illustration.
First Contact & Terms: Call for appointment to show portfolio of résumé or brochure/flyer to be kept on file. Samples are returned by SASE. Reports back in 2 weeks. Assignments made based on freelancer's experience, cost, style and whether he/she is local. Originals are not returned. Sometimes requests work on spec before assigning a job. Negotiates payment based on client's budget. Finds artists through word of mouth and submissions.

ARNOLD SAKS ASSOCIATES, 350 E. 81st St., New York NY 10028. (212)861-4300. Fax: (212)535-2590. E-mail: afiorillo@compuserve.com. Vice President: Anita Fiorillo. Estab. 1967. Specializes in annual reports and corporate communications. Clients: Fortune 500 corporations. Current clients include Alcoa, 3M, American Home Products, Olin, Hospital for Special Surgery and UBS. Client list available upon request.
Needs: Works with 1 or 2 mechanical artists and 1 designer/year. "Mechanical artists: accuracy and speed are important, as is a willingness to work late nights and some weekends." Uses illustrators for technical illustration and occasionally for annual reports. Uses designers mainly for in-season annual reports. Also uses artists for brochure design and illustration, mechanicals and charts/graphics. Needs computer-literate freelancers for production and presentation. 80% of freelance work demands knowledge of QuarkXPress, Adobe Illustrator or Photoshop.
First Contact & Terms: Send query letter with brochure and résumé. Samples are filed. Reports back to the artist only if interested. Write for appointment to show portfolio. Portfolio should include finished pieces. Pays for design by the hour, $25-60. Pays for illustration by the project, $200 minimum. Payment depends on experience and terms and varies depending upon scope and complication of project. Rights purchased vary according to project.

TONI SCHOWALTER DESIGN, 1133 Broadway, Suite 1610, New York NY 10010. (212)727-0072. Fax: (212)727-0071. E-mail: toni@schowalter.com. Website: http://www.schowalter.com. Estab. 1986. Number of employees: 4. Approximate annual billing: $500,000. Specializes in corporate identity, publication design and sales promotion brochures. Clients: architects, furniture industry, technology, healthcare, management consultants, law firms, financial investments firms. Client list available upon request. Professional affiliations: AIGA, SMPS.
Needs: Approached by 25 freelancers/year. Works with 25 freelance illustrators and 10 designers/year. Prefers artists with experience in illustration and photography. Uses illustrators and designers mainly for publications. Also uses freelancers for brochure design and illustration, charts/graphs, lettering, logos and poster illustration. Needs computer-literate freelancers for design and production. 100% of freelance design work demands skills in Adobe Illustrator, Adobe Photoshop and QuarkXPress.
First Contact & Terms: Send postcard sample of work or send query letter with brochure, résumé and tearsheets. Samples are filed. Does not report back. Request portfolio review in original query. Artist should follow-up with call. Portfolio should include b&w and color final art. Pays for design by the hour, $20-45 or by the project, $200-2,000. Pays for illustration by the project, $200-1,000. Negotiates rights purchased. Finds artists through sourcebooks and awards books.
Tips: Looks for a unique portfolio. Send a résumé and 3 color prints of samples, with a cover letter.

TALCO PRODUCTIONS, 279 E. 44th St., New York NY 10017. (212)697-4015. Fax: (212)697-4827. E-mail: alaw@cnct.com. President: Alan Lawrence. Number of employees: 5. TV/film producer. Specializes in nonprofit organizations, industry, associations and PR firms. Produces videotapes, motion pictures and some filmstrips and sound-slide sets. Professional affiliation: DGA.
Needs: Works with 1-2 freelance illustrators and 1-2 designers/year. Prefers local freelancers with professional experience. 15% of freelance work demands skills in Aldus FreeHand or Adobe Illustrator.
First Contact & Terms: Send query letter with résumé, brochure and SASE. Reports back only if interested. Portfolio should include roughs, final reproduction/product, and color photostats and photographs. Payment varies according to assignment. Pays on production. Originals sometimes returned at job's completion. Buys all rights. Considers complexity of project, client's budget and rights purchased when establishing payment.

North Carolina

BOB BOEBERITZ DESIGN, 247 Charlotte St., Asheville NC 28801. (828)258-0316. E-mail: bobb@main.nc.us. Website: http://www.main.nc.us/bbd. Owner: Bob Boeberitz. Estab. 1984. Number of employees: 1. Approximate annual billing: $80,000. Specializes in graphic design, corporate identity and package design. Clients: retail outlets, hotels and restaurants, textile manufacturers, record companies, publishers, professional services. Majority of clients are business-to-business. Current clients include Para Research Software, Blue Duck Music, Laurens County Chamber of Commerce, Owen Manufacturing Co., Cross Canvas Co. and High Windy Audio. Professional affiliations: AAF, Asheville Chamber, NARAS, Asheville Freelance Network.
• Owner Bob Boeberitz predicts "everything in art design will be done on computer; more electronic; more stock images; photo image editing and conversions will be used; there will be less commissioned artwork."
Needs: Approached by 50 freelancers/year. Works with 5 freelance illustrators/year. Works on assignment only. Uses freelancers primarily for technical illustration and comps. Prefers pen & ink, airbrush and acrylic. 50% of freelance

work demands knowledge of Adobe PageMaker, Adobe Illustrator, Adobe Photoshop or CorelDraw.

First Contact & Terms: Send query letter with résumé, brochure, SASE, photographs, slides and tearsheets. "Anything too large to fit in file" is discarded. Accepts disk submissions compatible with IBM PCs. Send AI-EPS and TIFF files. Samples are returned by SASE if requested. Reports only if interested. Will contact artist for portfolio review if interested. Portfolio should include thumbnails, roughs, final art, b&w and color slides and photographs. Sometimes requests work on spec before assigning a job. Pays for design and illustration, by the project, $50 minimum. Rights purchased vary according to project. Will consider buying second rights to previously published artwork. Finds artists through word of mouth, submissions/self-promotions, sourcebooks, agents.

Tips: "Show sketches—sketches help indicate how an artist thinks. The most common mistake freelancers make in presenting samples or portfolios is not showing how the concept was developed, what their role was in it. I always see the final solution, but never what went into it. In illustration, show both the art and how it was used. Portfolios should be neat, clean and flattering to your work. Show only the most memorable work, what you do best. Always have other stuff, but don't show everything. Be brief. Don't just toss a portfolio on my desk; guide me through it. A 'leave-behind' is helpful, along with a distinctive-looking résumé. Be persistent but polite. Call frequently. I don't recommend cold calls (you rarely ever get to see anyone) but it is an opportunity for a 'leave behind.' I recommend using the mail. I like postcards. They get noticed, maybe even kept. They're economical. And they show off your work. And you can do them more frequently. Plus you'll have a better chance to get an appointment. After you've had an appointment send a thank you note. Say you'll keep in touch and do it!"

■ **IMAGE ASSOCIATES INC.**, 4909 Windy Hill Dr., Raleigh NC 27609. (919)876-6400. Fax: (919)876-7064. E-mail: dc@imageassociates.com. Website: http://www.imageassociates.com. President: David Churchill. Estab. 1984. Number of employees: 35. AV firm. Visual communications firm specializing in computer graphics and AV, multi-image, interactive multimedia, Internet development, print and photographic applications.

Needs: Approached by 10 freelancers/year. Works with 4 freelance illustrators and 4 designers/year. Prefers freelancers with experience in high-tech orientations and computer graphics. Works on assignment only. Uses freelancers mainly for brochure design and illustration. Also for print ad design and illustration, slide illustration, animation and retouching. 25% of work is with print ads. 90% of freelance work demands skills in Aldus FreeHand, Adobe Photoshop and Macromind Director.

First Contact & Terms: Send query letter with brochure, résumé and tearsheets. Samples are filed or are returned by SASE if requested by artist. Reports back to the artist only if interested. To show portfolio, mail roughs, finished art samples, tearsheets, final reproduction/product and slides. Pays for design and illustration by the project, $100 minimum. Considers complexity of project, client's budget and how work will be used when establishing payment. Rights purchased vary according to project.

N ■ **POTTER & ASSOCIATES**, 4507 Forest Glen Rd., Greensboro NC 27410-3743. (336)854-0800. Fax: (336)854-2216. Contact: Alex or Gary Potter. Estab. 1982. Number of employees: 2. Approximate annual billing: $1.5 million. Ad agency. Full-service, multimedia firm. Specializes in collateral, direct mail, client campaigns including print and broadcast. Product specialties are consumer and business-to-business. Client list available upon request.

Needs: Approached by 15-20 freelancers/year. Works with 4-5 freelance illustrators and 3-4 designers/year. Prefers freelancers with experience in computer graphics. Uses freelancers mainly for computer illustrations, mechanicals, design. Also for brochure design and illustration, logos, mechanicals, posters, retouching and TV/film graphics. 20% of work is with print ads. Needs computer-literate freelancers for production and presentation. 95% of freelance work demands skills in Adobe Photoshop, QuarkXPress and Adobe Illustrator.

First Contact & Terms: Send query letter with nonreturnable sample such as brochure, photocopies, résumé, disks or tearsheets. Samples are filed. Will contact artist for portfolio review if interested. Finds artists through *Creative Black Book*, word of mouth and artists' submissions.

North Dakota

■ **FLINT COMMUNICATIONS**, 101 Tenth St. N., Fargo ND 58102. (701)237-4850. Fax: (701)234-9680. Art Directors: Gerri Lien and Dawn Koranda. Estab. 1947. Number of employees: 25. Approximate annual billing: $9 million. Ad agency. Full-service, multimedia firm. Product specialties are agriculture, manufacturing, healthcare, insurance and banking. Client list available upon request. Professional affiliations: AIGA.

Needs: Approached by 50 freelancers/year. Works with 6-10 freelance illustrators and 3-4 designers/year. Uses freelancers for annual reports, brochure design and illustration, lettering, logos and TV/film graphics. 40% of work is with print ads. 20% of freelance work demands knowledge of Aldus PageMaker, Adobe Photoshop, QuarkXPress and Adobe Illustrator.

First Contact & Terms: Send postcard-size sample of work and query letter. Samples are filed. Will contact artist for portfolio review if interested. Pays for illustration by the project, $100-2,000. Rights purchased vary according to project.

Ohio

BARON ADVERTISING, INC., Hanna Bldg., Suite 645, 1422 Euclid Ave., Cleveland OH 44115-1901. (216)621-6800. Fax: (216)621-6806. President: Selma Baron. Estab. 1956. Ad agency. Specializes in magazine ads and collateral. Product specialties are business-to-business, food, building products, technical products, industrial food service.
Needs: Approached by 30-40 freelance artists/month. Prefers artists with experience in food and technical equipment. Works on assignment only. Uses freelance artists mainly for specialized projects. Also uses freelance artists for brochure, catalog and print ad illustration and retouching. 90% of work is with print ads. Freelancers should be familiar with Aldus PageMaker, QuarkXPress, Aldus FreeHand, Adobe Illustrator or Adobe Photoshop.
First Contact & Terms: Send query letter with résumé and photocopies. Samples are filed and are not returned. Does not report back. "Artist should send only samples or copies that do not need to be returned." Will contact artist for portfolio review if interested. Portfolio should include final art and tearsheets. Pay for design depends on style. Pay for ilustration depends on technique. Buys all rights. Finds artists through agents, sourcebooks, word of mouth and submissions.

☑ ⚟ ▣ **LIGGETT-STASHOWER**, 1228 Euclid Ave., Cleveland OH 44115. (216)348-8500. Fax: (216)736-8113. E-mail: adeal@liggett.com. Website: http://www.liggett.com. Art Buyer: Alyssa Deal. Estab. 1932. Ad agency. Full-service multimedia firm. Works in all formats. Handles all product categories. Current clients include Sears Optical, Babcock & Wilcox, Evenflo, Forest City Management, Cleveland Cavaliers, BF Goodrich and Cedar Point.
Needs: Approached by 120 freelancers/year. Works with freelance illustrators and designers. Prefers local freelancers. Works on assignment only. Uses freelancers mainly for brochure, catalog and print ad design and illustration, storyboards, slide illustration, animatics, animation, retouching, billboards, posters, TV/film graphics, lettering and logos. Needs

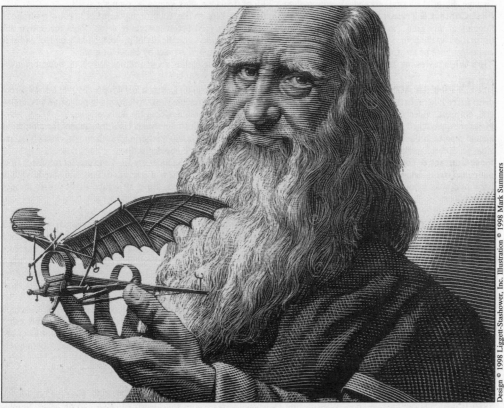

Design © 1998 Liggett-Stashower, Inc. Illustration © 1998 Mark Summers

This illustration of Leonardo da Vinci is one in a series by Mark Summers for a campaign designed to raise awareness of the BF Goodrich Company in the aerospace industry. "Each drawing was intended to be a serious portrayal of the subject, but with a very slight push towards caricature," says Summers. He had worked with Liggett-Stashower, a Cleveland-based firm with 70 consumer and business-to-business clients, on a past project and they had seen his work in sourcebooks. Summers advises illustrators to "find a look you love to do, a style that represents not only your personality, but the subject matter which speaks to your interest."

computer-literate freelancers for illustration and production. 90% of freelance work demands skills in QuarkXPress, Aldus FreeHand, Photoshop or Adobe Illustrator.

First Contact & Terms: Send query letter. Samples are filed. Reports back to the artist only if interested. To show portfolio, mail tearsheets and transparencies. Pays for design and illustration by the project. Negotiates rights purchased.

LOHRE & ASSOCIATES, 2330 Victory Parkway, Suite 701, Cincinnati OH 45206. (513)961-1174. E-mail: sales@loh re.com. Website: http://www.lohre.com. President: Chuck Lohre. Number of employees: 8. Approximate annual billing: $1 million. Ad agency. Specializes in industrial firms. Professional affiliation: BMA.

Needs: Approached by 24 freelancers/year. Works with 10 freelance illustrators and 10 designers/year. Works on assignment only. Uses freelance artists for trade magazines, direct mail, P-O-P displays, multimedia, brochures and catalogs. 100% of freelance work demands knowledge of Aldus PageMaker, Aldus FreeHand, Adobe Photoshop and Illustrator.

First Contact & Terms: Send postcard sample. Accepts submissions on disk, any Mac application. Pays for design and illustration by the hour, $10 minimum.

Tips: Looks for artists who "have experience in chemical and mining industry, can read blueprints and have worked with metal fabrication. Needs Macintosh-literate artists who are willing to work at office, during day or evenings."

▓ ART MERIMS COMMUNICATIONS, Bank One Center, Suite 1300, 600 Superior Ave., Cleveland OH 44114-2650. (216)522-1909. Fax: (216)479-6801. E-mail: amerims@hqcom.com. President: Arthur M. Merims. Number of employees: 4. Approximate annual billing: $600,000. Ad agency/PR firm. Current clients include Ohio Pest Control Association, Patrick Douglas, Inc., Woodruff Foundation, Associated Builders and Contractors, Inc., Cleveland Marshall Law Alumni Assn., Cleveland World Trade Assn.

Needs: Approached by 10 freelancers/year. Works with 1-2 freelance illustrators and 3 designers/year. Prefers local freelancers. Works on assignment only. Uses freelancers mainly for work on trade magazines, brochures, catalogs, signage, editorial illustrations and AV presentations. 20% of freelance work demands computer skills.

First Contact & Terms: Send query letter with samples to be kept on file. Call for appointment to show portfolio of "copies of any kind" as samples. Sometimes requests work on spec before assigning a job. Pays for design and illustration by the hour, $40-60, or by the project, $300-1,200. Considers complexity of project, client's budget and skill and experience of artist when establishing payment. Finds artists through contact by phone or mail.

Tips: When reviewing samples, makes decisions based on "subjective feeling about abilities and cost if budget is low."

▓ ▢ PIHERA ADVERTISING ASSOCIATES, INC, P.O. Box 676, Lebanon OH 45036. (513)932-5649. President: Larry Pihera. Estab. 1970. Ad agency, PR firm. Full-service multimedia firm. Specializes in magazine ads, collateral, corporate video production. Product specialties are industrial and retail. Client list not available.

Needs: Approached by 10 freelancers/year. Works with 5 freelance illustrators/year. Uses freelancers for animation, annual reports, billboards, brochure design and illustration, catalog illustration, lettering, mechanicals, retouching and signage. 50% of work is with print ads. 10% of freelance work demands computer skills.

First Contact & Terms: Send query letter with brochure and photostats. Samples are filed and are not returned. Does not report back. Artist should follow up. Will contact artist for portfolio review if interested. Portfolio should include b&w and color photographs. Pays for design and illustration by the project. Buys all rights. Finds artists through submissions.

✓ ▢ TERRY ROBIE COMMUNICATIONS, (formerly Triad), 7654 W. Bancroft St., Toledo OH 43617-1656. (419)841-2272. E-mail: jrobie@terryrobie.com. Website: http://www.terryrobie.com. President/Creative Director: Janice Robie. Ad agency specializing in graphics, promotions and electronic media. Product specialties are industrial, consumer.

Needs: Assigns 30 freelance jobs/year. Works with 5 illustrators/year and 20 designers/year. Works on assignment only. Uses freelancers for consumer and trade magazines, brochures, catalogs, P-O-P displays, AV presentations, posters and illustrations (technical and/or creative). 100% of design and 50% of illustration require computer skills. Also needs freelancers experienced in electronic authoring, animation, web design, programming and design.

First Contact & Terms: Send query letter with résumé and slides, photographs, photostats or printed samples. Accepts disk submissions compatible with Mac or Windows. Samples returned by SASE if not filed. Reports only if interested. Write for appointment to show portfolio, which should include roughs, finished art, final reproduction/product and tearsheets. Pays by the hour, $10-60 or by the project, $25-2,500. Considers client's budget and skill and experience of artist when establishing payment. Negotiates rights purchased.

Tips: "We are interested in knowing your specialty."

WILDER-FEARN & ASSOC., INC., 2035 Dunlap St., Cincinnati OH 45214. (513)621-5237. Fax: (513)621-4880. E-mail: wfa@wilderfearn.com. Website: http://www.wilderfearn.com. President: Gary Fearn. Estab. 1946. Number of employees: 7. Specializes in annual reports; brand and corporate identity; and display, package and publication design. Clients: ad agencies, corporations, packaging. Current clients include Jergens Co., Kenner Toys, Kroger and Kraft. Client list available upon request. Professional affiliation: Art Directors Club of Cincinnati.

Needs: Approached by 20-25 freelancers/year. Works with 5-10 freelance illustrators and 2-5 designers/year. Prefers freelancers with experience in packaging and illustration comps. Uses freelance illustrators mainly for comps and finished art on various projects. Needs editorial illustration. Uses freelance designers mainly for packaging and brochures.

Freelancers should be familiar with QuarkXPress, Adobe Illustrator, Aldus FreeHand, Adobe Photoshop, Adobe Streaml ine and O-Photo-Scan.
First Contact & Terms: Send query letter with photocopies, résumé and slides. Accepts disk submissions compatible with Adobe Illustrator. Send EPS files. Samples are filed or are returned by SASE if requested by artist. Reports back to the artist only if interested. Call for appointment to show portfolio of roughs, original/final art and color tearsheets and slides. Payment for design and illustration is based upon talent, client and project. Rights purchased vary according to project.

Oklahoma

N ☐ **THE FORD AGENCY**, 42 E. 16th St., Tulsa OK 74152-1180. (918)743-3673. Creative Director: C.A. Ford. Estab. 1985. Design firm. Product specialties are corporate financial, food, retail, packaging.
Needs: Uses freelancers mainly for logo work, custom lettering, type design and technical illustration. Also for animation, medical and technical illustration, mechanicals, multimedia projects, retouching, storyboards, TV/film graphics and web page design.
First Contact & Terms: Designers send query letter with résumé. Illustrators send sample. Accepts disk submissions compatible with Macintosh format only. Samples are filed. Reports back only if interested. Will contact artist for portfolio review of final art, roughs, tearsheets, thumbnails if interested. Pays $50-1,000. Finds artists through sourcebooks, magazines and networking at speakers events and affiliated peer organizations.
Tips: "Dependability is essential. But I also appreciate and want to work with freelancers who understand the business side of design. A technical illustration should be beautiful, but you must meet the function it requires."

Oregon

ADFILIATION ADVERTISING, 323 W. 13th Ave., Eugene OR 97401. (541)687-8262. Fax: (541)687-8576. E-mail: vip@adfiliation.com. Website: http://www.adfiliation.com. President/Creative Director: Gary Schubert. Media Director/ VP: Gwen Schubert. Estab. 1976. Ad agency. "We provide full-service advertising to a wide variety of regional and national accounts. Our specialty is print media, serving predominantly industrial and business-to-business advertisers." Product specialties are forest products, heavy equipment, software, sporting equipment, food and medical.
Needs: Works with approximately 4 freelance illustrators and 2 designers/year. Works on assignment only. Uses freelancers mainly for specialty styles. Also for brochure and magazine ad illustration (editorial, technical and medical), retouching, animation, films and lettering. 80% of work is with print ads. 80% of freelance work demands knowledge of Adobe Illustrator, QuarkXPress, FreeHand, Director or Adobe Photoshop.
First Contact & Terms: Send query letter, brochure, résumé, slides and photographs. Samples are filed or are returned by SASE only if requested. Reports back only if interested. Write for appointment to show portfolio. Pays for design and illustration and by the hour, $25-100. Rights purchased vary according to project.
Tips: "We're busy. So follow up with reminders of your specialty, current samples of your work and the convenience of dealing with you. We are looking at more electronic illustration. Find out what the agency does most often and produce a relative example for indication that you are up for doing the real thing! Followup after initial interview of samples. Do not send fine art, abstract subjects."

⚓ ☐ OAKLEY DESIGN STUDIOS. 519 SW Park Ave., Suite 521, Portland OR 97205. (503)241-3705. Fax: (503)241-3812. E-mail: oakleyds@teleport.com or oakleyds@aol.com. Creative Director: Tim Oakley. Estab. 1992. Number of employees: 3. Specializes in brand and corporate identity, display, package and publication design and advertising. Clients: ad agencies, record companies, surf apparel manufacturers, mid-size businesses. Current clients include American Marketing Solution, Bratwear, Judan Records, Amigo Records, Contemplato Records, Jantzen, Inc., Triad Pools, Barran Liebman, Paragon Cable, Mira Mobile Television, Kink FM 102. Professional affiliations OMPA, AIGA, PDXAD and PAF.
Needs: Approached by 5-10 freelancers/year. Works with 3 freelance illustrators and 2 designers/year. Prefers local artists with experience in technical illustration, airbrush. Also for multimedia projects. Uses illustrators mainly for advertising. Uses designers mainly for logos. Also uses freelancers for ad and P-O-P illustration, airbrushing, catalog illustration, lettering and retouching. 60% of design and 30% of illustration demands skills in Adobe Illustrator, Adobe Photoshop and QuarkXPress.
First Contact & Terms: Contact through artist rep or send query letter with brochure, photocopies, photographs, résumé and tearsheets. Accepts disk submissions compatible with Adobe Illustrator 5.0. Send EPS files. Samples are filed or returned by SASE if requested by artist. Reports back within 4-6 weeks. Request portfolio review in original query. Will contact artist for portfolio review if interested. Portfolio should include b&w and color final art, photocopies, photostats, roughs and slides. Pays for design by the project, $200 minimum. Pays for illustration by the project. Rights purchased vary according to project. Finds artists through design workbooks.
Tips: "Be yourself. No phonies. Be patient and have a good book ready."

Pennsylvania

■ **THE BALL GROUP**, 1689 Crown Ave., Lancaster PA 17601. (717)299-1598. Fax: (717)299-9690. Creative Director: Marlin Miller. Estab. 1985. Number of employees: 7. Approximate annual billing: $5 million. Integrated marketing communications agency. Specializes in new market development. Professional affiliation: Central Pennsylvania Ad Club, American Marketing Assoc., Baltimore Chapter.
Needs: Approached by 5 freelance illustrators and 5 designers/year. Works with 5 freelance illustrators and 5 designers/year. Uses freelancers mainly for illustration. Also for animation, brochure, catalog, technical illustration, logos, multimedia projects, retouching, signage, storyboards, TV/film graphics and web page design. 20% of work is with print ads. 80% of design demands skills in Aldus PageMaker, Aldus FreeHand, Adobe Photoshop.
First Contact & Terms: Designers send query letter with photocopies, résumé. Illustrators send query letter with photocopies, photographs. Accepts disk submissions compatible with Aldus PageMaker 6.5, Quark, Aldus FreeHand 7.0 or Adobe Photoshop 4.0. Samples are filed. Will contact for portfolio review of final art, photographs if interested. Pays for design by the hour, $15-35. Pays for illustration by the project. Rights purchased vary according to project. Finds artists through agents, direct mail, sourcebooks.

N ■ **BJORNSON DESIGN ASSOCIATES, INC.**, 217 Church St., Philadelphia PA 19106. (215)928-9000. Fax: (215)928-9019. E-mail: artr@bjornsondesign.com. Principal: Jon A. Bjornson. Estab. 1989. Number of employees: 5. Specializes in corporate identity and publication design. Professional Affiliations: AIGA.
Needs: Prefers local artists only. Needs computer-literate freelancers for design, illustration and production. 100% of freelance work demands skills in Photoshop, FreeHand and QuarkXPress.
First Contact & Terms: Send query letter. Will contact artist for portfolio review if interested. Pays for design and illustration by the project. Rights purchased vary according to project.

■ **DESIGN & MARKET RESEARCH LABORATORY**, 1035 Longford Rd., Oaks PA 19456. (215)935-4114. Fax: (215)935-4051. Director: M. Ryan. Estab. 1945. Number of employees: 19. Approximate annual billing: $3 million. Specializes in package design. Clients: corporations. Client list available upon request. Professional affiliations: AIGA, IOPP, Art Directors Club.
Needs: Approached by 40 freelancers/year. Works with 10 freelance illustrators and 20 designers/year. Prefers local freelancers only. Uses freelancers mainly for packaging. Also for brochure and P-O-P illustration and design, mechanicals, retouching, airbrushing, lettering and logos. Needs computer-literate freelancers for design and production. 60% of freelance work demands skills in QuarkXPress (mostly), Adobe Illustrator or Adobe Photoshop.
First Contact & Terms: Send query letter with brochure and résumé. Samples are filed. Reports back to artist only if interested. Request portfolio review in original query. Portfolio should include b&w and color thumbnails, final art and slides. Pays for design by the hour, rate negotiable. Pays for illustration by the project. Buys all rights.

■ **DLD ADVERTISING**, 620 E. Oregon Rd., Lititz PA 17543. (717)569-6568. Fax: (717)569-7410. E-mail: dldesign @success.net. Website: http://www.dldadv.com. Director of Operations: Lynn Ritts and Heather Parke. Estab. 1986. Number of employees 14. Design firm. Specializes in capabilities brochures, corporate ID. Client list available upon request.
Needs: Approached by 2 illustrators and 4 designers/year. Works with 2 illustrators/year. Uses freelancers mainly for illustration. Also for animation, catalog, humorous and technical illustration and TV/film graphics. 10% of work is with print ads. 50% of design demands skills in Adobe Photoshop, QuarkXPress, Adobe Illustrator.
First Contact & Terms: Designers send query letter with photocopies, résumé and tearsheets. Illustrators send postcard sample of work. Accepts disk submissions compatible with QuarkXPress 7.5/version 3.3. Send EPS files. Samples are filed. Reports back only if interested. Artist should follow-up with call. Portfolio should include color final art, roughs and tearsheets. Pays for design and illustration by the project. Buys all rights. Finds artists through *American Showcase*, postcard mailings, word of mouth.
Tips: "Be conscientious of deadlines, willing to work with hectic schedules."

■ **FULLMOON CREATIONS INC.**, 330 Farm Ln., Doylestown PA 18901. (215)345-1233. Fax: (215)348-5378. E-mail: info@fullmooncreations.com. Website: http://www.fullmooncreations.com. Contact: Art Director. Estab. 1986. Number of employees: 5. Specializes in brand and corporate identity; packaging design; corporate literature systems; new brand and new product development. Clients: Fortune 500 corporations. Current clients include M&M Mars, Educom, Paris Technology and The Atlantic Group.
Needs: Approached by 100-120 freelancers/year. Works with 5-15 freelance illustrators and 10-20 designers/year. Uses freelancers for ad, brochure and catalog design and illustration; airbrushing; audiovisual materials; book, direct mail and magazine design; logos; mechanicals; poster and P-O-P illustration. Needs computer-literate freelancers for design, illustration and production. 50% of freelance work demands knowledge of Adobe Illustrator, Adobe Photoshop, Aldus FreeHand and QuarkXPress.
First Contact & Terms: Send postcard sample of work, photocopies, résumé and url. Samples are filed. Reports back within 1 month with SASE. Will contact artist for portfolio review if interested. Portfolio should include b&w and color roughs, thumbnails and transparencies.
Tips: "Send samples every three months."

☑ **LECHNER & BENSON ADVERTISING DESIGN**, 135 E. 30th St., Erie PA 16501. (814)459-6291. Fax: (814)454-6297. E-mail: lxbdesign@aol.com. Partners: Chuck Benson and Bill Lechner. Estab. 1992. Number of employees: 3. Approximate annual billing: $200,000. Ad agency/design firm. Specializes in collateral, magazine ads, sales promotion and logo design. Product specialties are consumer and industrial. Current clients include Reed Manufacturing, United Refining, YMCA and Erie Chamber of Commerce. Client list not available. Professional affiliation: Erie Ad Club.

Needs: Approached by 3-5 freelancers/year. Works with 3 freelance illustrators and 2 designers/year. Uses freelancers for brochure design and illustration, catalog design, mechanicals, retouching and signage. 20% of work is with print ads. Needs computer-literate freelancers for design, illustration and production. 80% of freelance work demands skills in Adobe PageMaker, Aldus FreeHand, Adobe Photoshop, QuarkXPress and Adobe Illustrator.

First Contact & Terms: Send postcard-size sample of work or send query letter with brochure, photocopies and tearsheets. Samples are filed or returned by SASE if requested by artist. Reports back to the artist only if interested. Artist should follow-up. Portfolio should include b&w and color roughs, tearsheets and thumbnails. Pays for design by the hour, $50 minimum or by the project, $1,000-3,000. Pays for illustration by the hour, $50-80 or by the project, $100-2,000. Buys all rights or negotiates rights purchased. Finds artists through submissions, word of mouth.

Tips: "Always give the client more than they expect."

🅽 🅸 ☐ **NAISH, COHEN & ASSOC. (NC&A INC.)**, 1420 Locust St., Suite 310, Philadelphia PA 19102. (215)985-1144. Fax: (215)985-1077. E-mail: ads@p3.net. Vice President: Frank Naish. Estab. 1969. Number of employees: 7. Approximate annual billing: $3.5 million. Ad agency. Full-service, multimedia firm. Specializes in business-to-business ads, radio and TV, brochures. Product specialty is healthcare. Client list not available.

Needs: Approached by 20-30 freelancers/year. Works with 5-10 freelance illustrators/year. Prefers local freelancers only. Uses freelancers mainly for brochures. Also for lettering, logos and TV/film graphics. 30% of work is with print ads. Needs computer-literate freelancers for design. 50% of freelance work demands skills in Aldus PageMaker, Aldus FreeHand, Adobe Photoshop, QuarkXPress and Adobe Illustrator.

First Contact & Terms: Send postcard-size sample of work or query letter with brochure and photocopies. Samples are filed and are not returned. Artist should follow-up with call after initial query to arrange portfolio review. Portfolio should include b&w and color photographs. Pays for design by the hour $15; by the project, $200. Pays for illustration by the project. Negotiates rights purchased.

☐ **PERCEPTIVE MARKETERS AGENCY LTD.**, 1100 E. Hector St., Suite 301, Conshohocken PA 19428-2394. (610)825-8710. Fax: (610)825-9186. E-mail: perceptmkt@aol.com. Creative Director: Jason Solovitz. Estab. 1972. Number of employees: 8. Approximate annual billing: $4 million. Ad agency. Product specialties are communications, sports, hospitals, healthcare consulting, computers (software and hardware), environmental products, automotive, insurance, financial, food products and publishing. Professional Affiliation: Philadelphia Ad Club, Philadelphia Direct Marketing Association, AANI, Second Wind Network, Philadelphia Art Directors Club.

Needs: Approached by 50 freelancers/year. Works with 6 freelance illustrators and 8 designers/year. Uses 80% local talent. In order of priority, uses freelancers for computer production, photography, illustration, comps/layout and design/art direction. Also for multimedia. "Concepts, dynamic design, ability to follow instructions/layouts and precision/accuracy are important." 50% of work is with print ads. 100% of design and 50% of illustration demands skills in QuarkXPress, Adobe Illustrator or Adobe Photoshop.

First Contact & Terms: Send résumé and photostats, photographs and tearsheets to be kept on file. Accepts as samples "whatever best represents artist's work—but preferably not slides." Accepts submissions on disk. Samples not filed are returned by SASE only. Reports back only if interested. Graphic designers call for appointment to show portfolio. Pays for design by the hour or by the project. Pays for illustration by the project, up to $3,500. Considers complexity of the project, client's budget and turnaround time when establishing payment. Buys all rights.

Tips: "Freelance artists should approach us with unique, creative and professional work. And it's especially helpful to followup interviews with new samples of work (i.e., to send a month later a 'reminder' card or sample of current work to keep on file)."

🅽 ☐ **SAI COMMUNICATIONS**, 15 S. Bank St., Philadelphia PA 19106. (215)923-6466. Fax: (215)851-9410. AV firm. Full-service, multimedia firm.

Needs: Approached by 5 freelance artists/month. Works with 3 freelance designers/month. Uses freelance artists mainly for computer-generated slides. Also uses freelance artists for brochure and print ad design, storyboards, slide illustration and logos. 1% of work is with print ads.

First Contact & Terms: Send query letter with résumé. Samples are filed. Call to schedule an appointment to show a portfolio. Portfolio should include slides. Pays for design by the hour, $15-20. Pays for illustration by the project. Buys first rights.

WILLIAM SKLAROFF DESIGN ASSOCIATES, 124 Sibley Ave., Ardmore PA 19003. (610)649-6035. Fax: (610)649-6063. E-mail: wsklaroff@aol.com. Design Director: William Sklaroff. Estab. 1956. Specializes in display, interior, package and publication design and corporate identity and signage. Clients: contract furniture, manufacturers, healthcare corporations. Current clients include: Kaufman, Halcon Corporation, L.U.I. Corporation, McDonald Products, Smith Metal Arts, Baker Furniture, Novikoff and Metrologic Instruments. Client list available upon request.

Needs: Approached by 2-3 freelancers/year. Works with 2-3 freelance illustrators and 2-3 designers/year. Works on

assignment only. Uses freelancers mainly for assistance on graphic projects. Also for brochure design and illustration, catalog and ad design, mechanicals and logos.

First Contact & Terms: Send query letter with brochure, résumé and slides to Lori L. Minassian, PR Coordinator. Samples are returned. Reports back within 3 weeks. To show portfolio, mail thumbnails, roughs, finished art samples and color slides and transparencies. Pays for design by the hour. Rights purchased vary according to project. Finds artists through word of mouth and submissions.

N WARKULWIZ DESIGN ASSOCIATES INC., 2218 Race St., Philadelphia PA 19103. (215)988-1777. Fax: (215)988-1780. President: Bob Warkulwiz. Estab. 1985. Number of employees: 3. Approximate annual billing: $1 million. Specializes in annual reports, publication design and corporate communications. Clients: corporations and universities. Current clients include Citibank, Bell Atlantic and Wharton School. Client list available upon request. Professional affiliations: AIGA, 1ABC.

Needs: Approached by 100 freelancers/year. Works with 10 freelance illustrators and 5-10 photographers/year. Works on assignment only. Uses freelance illustrators mainly for editorial and corporate work. Also uses freelance artists for brochure and poster illustration and mechanicals. Freelancers should be familiar with most recent versions of QuarkXPress, Illustrator, Photoshop, FreeHand and Director.

First Contact & Terms: Send query letter with tearsheets and photostats. Samples are filed. Reports back to the artist only if interested. Call for appointment to show portfolio of "best edited work—published or unpublished." Pays for illustration by the project, "depends upon usage and complexity." Rights purchased vary according to project.

Tips: "Be creative and professional."

Rhode Island

N ▣ MANCINI ASSOCIATES, 18 Imperial Place, Suite 1D, Providence RI 02903. (401)421-8490. Fax: (401)273-2808. E-mail: manciniol@aol.com. President/Creative Director: Stephen M. Mancini. Estab. 1980. Number of employees: 5. Ad agency. Full-service, multimedia firm. Product specialties are jewelry and consumer.

Needs: Approached by many freelancers/year. Works with several freelance illustrators and designers/year. Needs computer-literate freelancers for design, illustration and production. Most work demands computer skills.

First Contact & Terms: Send postcard-size sample of work. Samples are filed. Will contact artist for portfolio review if interested.

MARTIN THOMAS, INC., 334 County Rd., Barrington RI 02806-4108. (401)245-8500. Fax: (401)245-1242. Production Manager: Brenda L. Pottle. Estab. 1987. Number of employees: 12. Approximate annual billing: $7 million. Ad agency, PR firm. Specializes in industrial, business-to-business. Product specialties are plastics, medical and automotive. Professional affiliations: American Association of Advertising Agencies, Boston Ad Club.

Needs: Approached by 10-15 freelancers/year. Works with 6 freelance illustrators and 10-15 designers/year. Prefers freelancers with experience in business-to-business/industrial. Uses freelancers mainly for design of ads, literature and direct mail. Also for brochure and catalog design and illustration. 85% of work is print ads. 70% of design and 40% of illustration demands skills in QuarkXPress.

First Contact & Terms: Send query letter with brochure and résumé. Samples are filed and are returned. Reports back within 3 weeks. Will contact artist for portfolio review if interested. Portfolio should include b&w and color final art. Pays for design and illustration by the hour and by the project. Buys all rights. Finds artists through *Creative Black Book.*

Tips: Impress agency by "knowing industries we serve."

Tennessee

AB STUDIOS INC., 807 Third Ave. S., Nashville TN 37210. (615)256-3393. Fax: (615)256-3464. E-mail: abinfo@abs tudios.com. Website: http://www.abstudios.com. President: Rick Arnemann. Estab. 1988. Number of employees: 20. Approximate annual billing: $2.5 million. Specializes in brand identity, display and direct mail design and signage. Clients: ad agencies, corporations, mid-size businesses. Current clients include Best Products, Service Merchandise, WalMart, Hartmann Luggage. Client list available upon request. Professional affiliations: Creative Forum.

Needs: Approached by 20 freelancers/year. Works with 4-5 freelance illustrators and 5-6 designers/year. Uses illustrators mainly for P-O-P. Uses designers mainly for fliers and catalogs. Also uses freelancers for ad, brochure, catalog, poster and P-O-P design and illustration, logos, magazine design, mechanicals and retouching. 85% of freelance work demands skills in Adobe Illustrator 5.5, Adobe Photoshop 3.0 and QuarkXPress 3.31.

First Contact & Terms: Send photographs, résumé, slides and transparencies. Samples are filed. Will contact artist for portfolio review if interested. Portfolio should include color final art, roughs, slides and thumbnails. Pays for design and illustration by the project. Rights purchased vary according to project. Finds artists through sourcebooks and portfolio reviews.

ANDERSON STUDIO, INC., 2609 Grissom Dr., Nashville TN 37204. (615)255-4807. Fax: (615)255-4812. Contact: Andy Anderson. Estab. 1976. Number of employees: 13. Approximate annual billing: $1.6 million. Specializes in T-shirts (designing and printing of art on T-shirts for retail/wholesale market). Clients: business, retail, catalog and gift stores.

Needs: Approached by 20 freelancers/year. Works with 1-2 freelance illustrators and 1-2 designers/year. "We use freelancers with realistic (photorealistic) style or approach to various subjects, animals and humor. Also contemporary design and loose film styles accepted." Works on assignment only. Needs freelancers for retail niche markets, resorts, theme ideas, animals, zoos, educational, science, American motorcycle v-twin art, hip kid art (skateboarder/BMX bike type art for T's), humor-related themes and hot rod art. Also creative graphic work for above. Catchy marketable ideas welcome. Educational and science art needed.

First Contact & Terms: Send postcard sample or query letter with color copies, brochure, photocopies, photographs, SASE, slides, tearsheets and transparencies. Samples are filed and are returned by SASE if requested by artist. Portfolio should include slides, color tearsheets, transparencies and color copies. Sometimes requests work on spec before assigning a job. Pays for design and illustration by the project, $300-1,000 or in royalties per piece of printed art. Negotiates rights purchased. Considers buying second rights (reprint rights) to previously published work.

Tips: "We're looking for fresh ideas and solutions for art featuring animals, zoos, science, humor and education. We need work that is marketable for specific tourist areas—state parks, beaches, islands; also for women's markets. Be flexible in financial/working arrangements. Most work is on a commission or flat buy out. We work on a tight budget until product is sold. Art-wise, the more professional the better." Advises freelancers entering the field to "show as much work as you can. Even comps or ideas for problem solving. Let art directors see how you think. Don't send disks. Takes too long to review. Most art directors like hard copy art."

MEDIA GRAPHICS, 717 Spring St., P.O. Box 820525, Memphis TN 38182-0525. (901)324-1658. Fax: (901)323-7214. E-mail: devkinney@worldnet.att.net. Website: http://www.mediagraphics.qpg.com. CEO: J.D. Kinney. Estab. 1973. Integrated marketing communications agency. Specializes in all visual communications. Product specialties are financial, fundraising, retail, business-to-business. Client list available upon request. Professional affiliations: Memphis Area chamber, B.B.B.
- This firm reports they are looking for top illustrators only. When they find illustrators they like, they generally consider them associates and work with them on a continual basis.

First Contact & Terms: Send query letter with résumé and tearsheets. Accepts disk submissions compatible with Mac or PC. Only 1 sample JPEG, 65K maximum; prefer HTML reference. Send PDF file. Also CD-ROM. Samples are filed and are not returned. Will contact for portfolio review on web or via e-mail if interested. Rights purchased vary according to project.

Tips: Chooses illustrators based on "portfolio, availability, price, terms and compatibility with project."

■ **THE TOMBRAS GROUP**, 630 Concord St., Knoxville TN 37919. (423)524-5376. Fax: (423)524-5667. E-mail: mmccampbell@tombras.com. Website: http://www.tombras.com. Creative Director: Mitch McCampbell. Estab. 1946. Number of employees: 50. Approximate annual billing: $21 million. Ad agency. Full-service multimedia firm. Specializes in full media advertising, collateral, PR. Current clients include PHP Cariten Healthcare and Eastman Chemical. Client list available upon request. Professional affiliations: AAAA, 3AI, PRSA.

Needs: Approached by 20-25 freelancers/year. Works with 5-10 freelance illustrators and 2-5 designers/year. Uses freelancers mainly for illustration. Also for brochure design and illustration, model making and retouching. 60% of work is with print ads. Needs computer-literate freelancers for design and presentation. 25% of freelance work demands skills in Aldus FreeHand, Adobe Photoshop and QuarkXPress.

First Contact & Terms: Send query letter with photocopies and résumé. Samples are filed. Will contact artist for portfolio review if interested. Portfolio should include b&w and color samples. Pays for design by the hour, $25-40; by the project, $250-2,500. Pays for illustration by the project, $100-10,000. Rights purchased vary according to project.

Tips: "Stay in touch with quality promotion. 'Service me to death' when you get a job."

Texas

◨ **DYKEMAN ASSOCIATES INC.**, 4115 Rawlins, Dallas TX 75219. (214)528-2991. Fax: (214)528-0241. E-mail: adykeman@airmail.net. Website: http://dykemanassoc.net. Contact: Alice Dykeman. PR/marketing firm. Specializes in business, industry, hospitality, sports, environmental, energy, health.

Needs: Works with 12 illustrators and designers/year. Local freelancers only. Uses freelancers for editorial and technical illustration, brochure design, exhibits, corporate identification, POS, signs, posters, ads and all design and finished artwork for graphics and printed materials.

First Contact & Terms: Request portfolio review in original query. Pays by the project, $250-3,000. "Artist makes an estimate; we approve or negotiate."

Tips: "Be enthusiastic. Present an organized portfolio with a variety of work. Portfolio should reflect all that an artist can do. Don't include examples of projects for which you only did a small part of the creative work. Have a price structure but be willing to negotiate per project. We prefer to use artists/designers/illustrators who will work with barter (trade) dollars and join one of our associations. We see steady growth ahead."

■ **FUTURETALK TELECOMMUNICATIONS COMPANY, INC.**, P.O. Box 270942, Dallas TX 75227-0942. Website: http://www.ld.net/?futuretalk. Contact: Marketing Department Manager. Estab. 1993. Ad agency and PR firm. Full-service multimedia firm and telecommunications company. Current clients include small to medium businesses and individuals, and 7.5¢ interstate long distance.

Needs: Approached by 20-30 freelancers/year. Works with 10-15 illustrators and 2-3 designers/year. Prefers freelancers with experience in computer graphics. Works on assignment only. Uses freelancers mainly for promotional projects. Also for brochure and catalog illustration, storyboards, animation, model making, billboards and TV/film graphics. 20% of work is with print ads. 60% of freelance work demands computer skills.

First Contact & Terms: Send query letter with résumé, photocopies, photographs and SASE. Samples are filed or are returned by SASE if requested by artist. Reports back within 3 weeks. Art Director will contact artist for portfolio review if interested. Portfolio should include b&w and color final art, tearsheets and photostats. Pays for design by the hour, $10-25; by the project, $250-2,500; by the day, $250-2,500. Pays for illustration by the hour, $20-40; by the project, $250-2,500; by the day, $250-2,500. Rights purchased vary according to project. Finds artists through sourcebooks, word of mouth and artists' submissions.

Tips: "This year Futuretalk will be also seeking an artist to develop a cartoon book to sell our 7.5¢/minute Futuretalk long distance service. Artist's abilities must be very professional, but not overly expensive, pay cash and artist credits will be compensation. Send $5 for 'guidelines information packet' that explains project before submitting prospective ideas and samples. Address envelope to: Artists/Production Guidelines, Futuretalk Telecom, P.O. Box 270942, Dallas, Texas 75227-0942. Include note with your interest for guidelines."

HEPWORTH ADVERTISING COMPANY, 3403 McKinney Ave., Dallas TX 75204. (214)526-7785. Manager: S.W. Hepworth. Full-service ad agency. Clients: finance, consumer and industrial firms.

Needs: Works with 3-4 freelancers/year. Uses freelancers for brochure and newspaper ad design, direct mail packages, magazine ad illustration, mechanicals, billboards and logos.

First Contact & Terms: Send a query letter with tearsheets. Samples are not filed and are returned by SASE only if requested by artist. Does not report back. Portfolio should include roughs. Pays for design and illustration by the project. Considers client's budget when establishing payment. Buys all rights.

Tips: Looks for variety in samples or portfolio.

Ⓝ **McCANN-ERICKSON WORLDWIDE**, 1360 Post Oak Blvd., Suite 1900, Houston TX 77056. (713)965-0303. Creative Director: Mark Daspit. Ad agency. Clients: all types including consumer, industrial, gasoline, transportation/air, entertainment, computers and high-tech.

Needs: Works with about 20 illustrators/month. Uses freelancers in all media.

First Contact & Terms: Will contact artist for portfolio review if interested. Selection based on portfolio review. Pays for design by the hour, $40 minimum. Pays for illustration by the project, $100 minimum. Negotiates payment based on client's budget and where work will appear. Finds artists through word of mouth.

Tips: Wants to see full range of work including past work used by other ad agencies and tearsheets of published art in portfolio.

✓ **ORIGIN DESIGN, INC.**, (formerly Zierhut Design Studios, Inc.), 2014 Platinum St., Garland TX 75042. (972)276-1722. Fax: (972)272-5570. E-mail: origin@ont.com. Website: http://www.origin2000.net. Owners: Kathleen Zierhut, Clarence Zierhut and Jerry Nichols. President: Jerry Nichols. Estab. 1955. Specializes in display, product and package design and corporate identity. Clients: corporations, museums, individuals. Client list not available.

Needs: Works with 1-2 freelance graphic artists and 3-4 freelance designers/year. Works on assignment only. Uses designers mainly for renderings and graphics. Also uses freelance artists for illustration, mechanicals, retouching, airbrushing and model making. Needs computer-literate freelancers for design. 100% of freelance work demands knowledge of CAD and/or Pro-Engineering.

First Contact & Terms: Send query letter with résumé. Samples are filed. Reports back to the artist only if interested. Will contact artist for portfolio review if interested. Porfolio should include b&w and color final art and photographs. Pays for design by the hour, $15-50, by the project or by direct quote. Buys all rights. Finds artists through sourcebooks and word of mouth.

Tips: "Be computer-literate and persistent."

Ⓝ ✠ **PENN-JUDE PARTNERS**, 1911 W. Alabama Suite C, Houston TX 77098-2705. (713)520-6682. Fax: (713)520-6692. E-mail: pennjude@earthlink.net. Creative Director: Judith Dollar. Estab. 1994. Number of employees: 2. Approximate annual billing: $230,000. Design firm. Specializes in printed material, brochure, trade show, collateral. Product specialties are industrial, food, high-tech business to business. Current clients include Precise, Pro-nexus, Merie Catering. Professional affiliations: Art Directors of Houston, AAF.

Needs: Approached by 20 illustrators and 6 designers/year. Works with 10 illustrators and 2 designers/year. Prefers local designers only. Uses freelancers mainly for newsletter, logo and brochures. Also for airbrushing; brochure design and illustration; humorous, medical, technical illustration; lettering, logos, mechanicals and retouching. 90% of design demands skills in Aldus FreeHand 7, Adobe Photoshop 5, QuarkXPress 4. 30% of illustration demands skills in Aldus FreeHand 7, Adobe Photoshop 5, QuarkXPress 4.

First Contact & Terms: Designers send brochure, photocopies, photographs, photostats, résumé, tearsheets. Illustrators send postcard sample of work. Send query letter with brochure, photocopies, photographs or tearsheets. Accepts

disk submissions. Send TIFF, EPS or JPEG files. Samples are filed and are not returned. Art director will contact artist for portfolio review if interested. Pays by the project; varies. Negotiates rights purchased. Finds artists through *American Showcase*, *Workbook*, *RSVP* and artist's reps.

Tips: Wants freelancers with good type usage who contribute to concept ideas. We are open to designers and illustrators who are just starting out their careers.

Vermont

HARRY SPRUYT DESIGN, 451 Jacksonville Stage Rd., Brattleboro VT 05301-6909. Specializes in design/invention of product, package and device, design counseling service shows "in-depth concern for environments and human factors with the use of materials, energy and time; product design evaluation and layout." Clients: product manufacturers, design firms, consultants, ad agencies, other professionals and individuals. Client list available.

Needs: Works on assignment only.

Virginia

DEADY ADVERTISING, Dept. AM, 17 E. Cary St., Richmond VA 23219. (804)643-4011. President: Jim Deady. Specializes in industrial, manufacturing equipment, foodservice manufacturing, real estate and displays and graphics. Clients: industrial manufacturing, food service, healthcare.

Needs: Works with 10-12 freelance illustrators and 8-10 designers/year. Seeks only local or regional artists with minimum of 2 years experience with an agency. Works on assignment only. Uses freelancers for design and illustration, brochures, magazine ads, websites and interactive presentation.

First Contact & Terms: Designers send query letter with résumé to be kept on file; also send photocopies with SASE to be returned. Reports back only if interested. Call or write for appointment to show portfolio, which should include photostats. Pays for design by the project, $250-2,500. Pays for illustration by the project, $275-1,500 average.

Tips: "Agency is active; freelancers who are accessible are our most frequently used resource."

Washington

AUGUSTUS BARNETT ADVERTISING/DESIGN, 632 St. Helens Ave., Tacoma WA 98402. (253)627-8508. Fax: (253)593-2116. E-mail: abarnett1@aol.com. President: Charlie Barnett. Estab. 1981. Number of employees: 4. Approximate annual billing: $1.2 million. Specializes in food, beverages, mass merchandise, retail products, corporate identity, package design, business-to-business advertising and marketing. Clients: corporations, manufacturers. Current clients include Tree Top, Inc., Vitamilk Dairy, Frank Russell Co., University of Washington, Gilbert Global, Pace International, Martinac Shipbuilding. Client list available upon request. Professional affiliations: AAF and AIGA.

Needs: Approached by more than 50 freelancers/year. Works with 2-4 freelance illustrators and 2-3 designers/year. Prefers freelancers with experience in food/retail and Mac usage. Works on assignment only. Uses illustrators for product, theme and food illustration. Uses designers mainly for concept refinement. Also uses freelancers for illustration, multimedia projects and lettering. 90% of freelance work demands skills in Aldus FreeHand 8.01 and Adobe Photoshop 4.01. Send query letter with samples, résumé and photocopies. Samples are filed. Reports back within 2 weeks. Portfolios may be dropped off if pre-arranged and should include b&w and color printer samples. Pays for design by the hour, $20-55. Pays for illustration by project/use. Rights purchased vary according to project.

Tips: "Freelancers must understand design is a business, deadlines and budgets. Freelancers need to go above and beyond the norm to get noticed."

BELYEA, 1809 Seventh Ave., Suite 1007, Seattle WA 98101. (206)682-4895. Fax: (206)623-8912. Website: http://www.belyea.com. Estab. 1980. Marketing/communication/design firm. Specializes in annual reports, brand and corporate identity, marketing materials, in-store P-O-P, direct mail, package and publication design. Clients: corporate, manufacturers, retail. Current clients include Weyerhaeuser and Princess Tours. Client list available upon request.

Needs: Approached by 20-30 freelancers/year. Works with 10 freelance illustrators and 3-5 designers/year. Prefers local design freelancers only. Works on assignment only. Uses illustrators for "any type of project." Uses designers mainly for overflow. Also uses freelancers for brochure, catalog, poster and ad illustration; and lettering. 100% of design and 70% of illustration demands skills in QuarkXPress, Aldus FreeHand or Adobe Photoshop.

First Contact & Terms: Send postcard sample and résumé. Accepts disk submissions. Samples are filed. Reports back to the artist only if interested. Pays for illustration by the project, $125-1,000. Rights purchased vary according to project. Finds artists through submissions by mail and referral by other professionals.

Tips: "Designers must be computer-skilled. Illustrators must develop some styles that make them unique in the marketplace. When pursuing potential clients, send something (one or more) distinctive. Follow up. Be persistent (it can take one or two years to get noticed) but not pesky. Get involved in local AIGA. Always do the best work you can—exceed everyone's expectations."

N ▣ CREATIVE CONSULTANTS, 2608 W. Dell Dr., Spokane WA 99208-4428. (509)326-3604. Fax: (509)327-3974. E-mail: ebruneau@netroplex.net. Website: http://www.creativeconsultants.com. President: Edmond A. Bruneau. Estab. 1980. Approximate annual billing: $300,000. Ad agency and design firm. Specializes in collateral, logos, ads, annual reports, radio and TV sports. Product specialties are business and consumer. Client list available upon request.
Needs: Approached by 20 illustrators and 25 designers/year. Works with 10 illustrators and 15 designers/year. Uses freelancers mainly for animation, brochure, catalog and technical illustration, model making and TV/film graphics. 36% of work is with print ads. Designs and illustration demands skills in Aldus PageMaker 6.5, FreeHand 8.0, Adobe Photoshop and QuarkXPress 4.0.
First Contact & Terms: Designers send query letter. Illustrators send postcard sample of work and e-mail. Accepts disk submissions if compatible with Adobe Photoshop, QuarkXPress, Aldus PageMaker and Aldus FreeHand. Samples are filed. Reports back only if interested. Pays by the project. Buys all rights. Finds artists through Internet, word of mouth, reference books and agents.

▣ ▣ DAIGLE DESIGN INC., 180 Olympic Dr. SE, Bainbridge Island WA 98110. (206)842-5356. Fax: (206)780-2526. Website: http://www.daigle.com. Creative Director: Candace Daigle. Estab. 1987. Number of employees: 4. Approximate annual billing: $600,000. Design firm. Specializes in brochures, catalogs, logos, magazine ads, trade show display and web pages. Product specialties are communication, restaurant and automotive. Current clients include AT&T Wireless Services, Tollycraft and Wells Manufacturing. Professional affiliations: AIGA.
Needs: Approached by 20 illustrators and 40 designers/year. Works with 5 illustrators and 10 designers/year. Prefers local designers with experience in Adobe Photoshop, Adobe Illustrator and Aldus PageMaker. Uses freelancers mainly for concept and production. Also for airbrushing, brochure design and illustration, lettering, logos, multimedia projects, signage, technical illustration and web page design. 15% of work is with print ads. 90% of design demands skills in Aldus PageMaker 6.0, Adobe Photoshop 3.0, Adobe Illustrator 6.0 and Aldus FreeHand 5.0. 50% of illustration demands skills in Adobe Illustrator 6.0 and Aldus FreeHand 5.0.
First Contact & Terms: Designers send query letter with résumé. Illustrators send query letter with photocopies. Accepts disk submissions compatible with Photoshop 3.0 and Pagemaker 6.0. Send EPS files. Samples are filed and are not returned. Reports back only if interested. Will contact for portfolio review of b&w, color, final art, slides and tearsheets if interested. Pays for design by the hour, $25-50; pays for illustration by the project, $100-1,000. Buys all rights. Finds artists through submissions, reps, temp agencies and word of mouth.

DITTMANN DESIGN, P.O. Box 31387, Seattle WA 98103-1387. (206)523-4778. E-mail: danditt@aol.com. Owner/Designer: Martha Dittmann. Estab. 1981. Number of employess: 2. Specializes in brand and corporate identity, display and package design and signage. Clients: corporations. Client list available upon request. Professional affiliations: AIGA.
Needs: Approached by 50 freelancers/year. Works with 5 freelance illustrators and 2 designers/year. Uses illustrators mainly for corporate collateral and packaging. Uses designers mainly for color brochure layout and production. Also uses freelancers for brochure and P-O-P illustration, charts/graphs and lettering. Needs computer-literate freelancers for design, illustration, production and presentation. 75% of freelance work demands knowledge of Adobe Illustrator, Photoshop, PageMaker, Persuasion, FreeHand and Painter.
First Contact & Terms: Send postcard sample of work or brochure and photocopies. Samples are filed. Will contact artist for portfolio review if interested. Portfolio should include final art, roughs and thumbnails. Pays for design by the hour, $35-100. Pays for illustration by the project, $250-5,000. Rights purchased vary according to project. Finds artists through sourcebooks, agents and submissions.
Tips: Looks for "enthusiasm and talent."

▣ EMMAL BUTLER CREATIVES, 1735 Westlake N. #207, Seattle WA 98109. (206)283-7223. Fax: (206)284-9362. E-mail: cemmal@aol.com. Contact Cheryl Butler. Estab. 1989. Number of employees: 1. Approximate annual billing: 150,000. Integrated marketing communications agency/broker of art talent. Specializes in print and web design/illustration.
 ● Emmal Butler is involved in several pro bono projects per year for child advocacy causes. To be included, please contact.
Needs: Approached by 50 illustrators and 50 designers/year. Works with 10 illustrators and 10 designers/year. Uses freelancers mainly for print/web design. Also for airbrushing, annual reports, billboards, brochure and catalog design and illustration, humorous illustration, lettering, logos, multimedia projects, posters, retouching, signage, storyboards, signage, technical illustration and web page design. 25% of work is with print ads. 95% of design demands skills in Adobe Photoshop, Adobe Illustrator, Aldus FreeHand, QuarkXPress and Web software. 50% of illustration demands skills in Adobe Photoshop, Adobe Illustrator and Aldus FreeHand.
First Contact & Terms: Designers and illustrators send examples of work (any form). Postcards preferred. Send follow-up every 6 months. Accepts digital portfolios and e-mail queries with links to websites. Samples are filed and are not returned. Does not report back. Artist should check in. To arrange portfolio review, follow-up with call. Payment determined by value of work. Rights purchased vary according to project. Finds artists through word of mouth and submissions.
Tips: "Specialize—become known for one area of expertise and one distinctive style. I send cooperative postcard mailings to art buyer lists two times per year. To be included or inquire, e-mail me. Be persistent or get a good rep."

[N] TIM GIRVIN DESIGN, 1601 Second Ave., 5th Floor, Seattle WA 98101-1575. (206)623-7808. Fax: (206)340-1837. Design Services Manager: Laurel Check. Design Firm. Estab. 1977. Number of employees: 65. Specializes in corporate identity and brand, marketing graphics, publication design, signage, film titles, packaging and mulitmedia design. Current clients include Kraft, Microsoft, Warner Bros., Encyclopedia Britannica, IBM, Nabisco Brands Inc., Nintendo, Paramount, Pepsi Cola and The Walt Disney Company.

• Tim Girvin Design is known for its work in brand identity. In 1999 they designed identity for retail stores, restaurants and in-room amenities for the Bellagio Hotel in Las Vegas, the most expensive hotel/casino ever built.

Needs: Works with several freelance illustrators and designers/year. Prefers freelancers with experience in brand identity.

First Contact & Terms: Designers send query letter with appropriate samples. Illustrators send postcard sample or other non-returnable samples. Will contact for portfolio review if interested. Payment negotiable.

[N] [■] [♥] HORNALL ANDERSON DESIGN WORKS, INC., 1008 Western Ave., Suite 600, Seattle WA 98104. (206)467-5800. Fax: (206)467-6411. E-mail: info@hadw.com. Website: http://www.hadw.com. Estab. 1982. Number of employees: 45. Design firm. Specializes in full range—brand and marketing strategy, corporate, brand and product identity systems, packaging, collateral, signage, trade show exhibits, environmental graphics, annual reports, new media and interactive media websites. Product specialties are large corporations to smaller businesses. Current clients include Wells Fargo, Airborne Express, K2 Corporation, Frank Russell Company, Novell, Inc. Professional affiliations: AIGA, Society for Typographic Arts, Seattle Design Association.

• This firm has received numerous awards and honors, including the International Mobius Awards, National Calendar Awards, London International Advertising Awards, Northwest and National ADDY Awards, Industrial Designers Society of America IDEA Awards, Communication Arts, Los Angeles Advertising Women LULU Awards, Brand Design Association Gold Awards, AIGA.

Needs: "Interested in all levels, from senior design personnel to interns with design experience. Additional illustrators and freelancers are used on an as needed basis in design and online media projects."

First Contact & Terms: Designers send query letter with photocopies and résumé. Illustrators send query letter with brochure and follow-up postcard. Accepts disk submissions compatible with QuarkXPress, Aldus FreeHand or Adobe Photoshop, "but the best is something that is platform/software independent (i.e., Director)." Samples are filed. Reports back only if interested. Portfolios may be dropped off. Pays for design by the hour. Pays for illustration by the project. Rights purchased vary according to project. Finds designers through word of mouth and submissions; illustrators through sourcebooks, reps and submissions.

[■] TED MADER ASSOCIATES, INC. (TMA), 2562 Dexter Ave. N., Seattle WA 98109. (206)270-9360. Also 280 Euclid Ave., Oakland, CA. E-mail: info@tmadesign.com. Website: http://www.tmadesign.com. Principal: Ted Mader. General Manager: Scot French. Number of employees: 12. Specializes in corporate and brand identity, displays, direct mail, fashion, packaging, publications, signage, book covers, interactive media and CD-ROM. Client list available upon request.

Needs: Approached by 150 freelancers/year. Works with 25 freelance illustrators and 10-20 designers/year. Uses freelancers for illustration, retouching, electronic media, production and lettering. Freelance work demands knowledge of QuarkXPress, Macromedia FreeHand, Adobe Illustrator, Photoshop, Macromedia Director or HTML programming.

First Contact & Terms: Send postcard sample or query letter with résumé and samples. Accepts disk submissions compatible with Mac. Samples are filed. Write or call for an appointment to show portfolio. Pays by the project. Considers skill and experience of freelancer and project budget when establishing payment. Rights purchased vary according to project.

Wisconsin

[■] AGA COMMUNICATIONS, 2557C N. Terrace Ave., Milwaukee WI 53211-3822. (414)962-9810. E-mail: greink@juno.com. CEO: Art Greinke. Estab. 1984. Number of employees: 8. Marketing communications agency (includes advertising and public relations). Full-service multimedia firm. Specializes in special events (large display and photo work), print ads, TV ads, radio, all types of printed material (T-shirts, newsletters, etc.). Current clients include Great Circus Parade, Circus World Museum, GGS, Inc., IBM, Universal Savings Bank and Landmark Theatre Chain. Also sports, music and entertainment personalities. Professional affiliations: PRSA, IABC, NARAS.

• AGA also has audio recording and video facilities.

Needs: Approached by 125 freelancers/year. Works with 25 freelance illustrators and 25 designers/year. Uses freelancers for "everything and anything"—brochure and print ad design and illustration, storyboards, slide illustration, retouching, model making, billboards, posters, TV/film graphics, lettering and logos. Also for multimedia projects. 40% of work is with print ads. 75% of freelance work demands skills in PageMaker, Illustrator, Quark, Photoshop, FreeHand or Powerpoint.

First Contact & Terms: Send postcard sample and/or query letter with brochure, résumé, photocopies, photographs, SASE, slides, tearsheets, transparencies. Accepts disk submissions compatible with BMP files, PageMaker, Quark and Illustrator. Samples are filed and are not returned. Reports back only if interested. Will contact artists for portfolio

Celia Johnson sought to create a feeling of warmth, comfort and intimacy for the packaging for Nordstrom coffee designed through Hornall Anderson Design Works. "The package was designed so each side would be a different color and represent a different aspect of coffee. The front (red) suggested the roasting process. The yellow side represented the morning sun/mug of coffee with croissant and news-paper. The design allowed not only the coffee story to be told, but greater interest for shelf impact, as the front panel and sides could be displayed for a variety of color," says Hornall Anderson's Christina Arbini.

review if interested. Portfolio should include b&w and color thumbnails, roughs, final art, tearsheets, photographs, transparencies, etc. Pays by personal contract. Rights purchased vary according to project. Finds artists through submissions and word of mouth.

Tips: "We look for stunning, eye-catching work—surprise us! Fun and exotic illustrations are key!"

HARE STRIGENZ DESIGN, INC., 306 N. Milwaukee St., Milwaukee WI 53202. (414)272-0072. Fax: (414)291-7990. E-mail: info@harestrigenz.com. Website: http://www.hare-strigenz.com. Owner/Creative Director: Paula Hare. Estab. 1986. Number of employees: 9. Specializes in packaging, annual reports, collateral, corporate communications. Clients: manufacturers, retail, healthcare, electronics industries. Client list available upon request.

Needs: Approached by 12-18 freelancers/year. Works with 8-10 freelance illustrators and 5-10 designers/year. Prefers local illustrators but uses national designers. 100% of freelance work demands skills in Adobe Photoshop, QuarkXPress and Adobe Illustrator.

First Contact & Terms: Send query letter with brochure and tearsheets. Samples are filed. Reports back to the artist only if interested. Portfolios may be dropped off every Monday. Artist should follow-up with letter after initial query. Buys all rights.

IMAGINASIUM DESIGN STUDIO, INC., 1240 Main St., Suite 2, Green Bay WI 54302-1307. (920)431-7872. Fax: (920)431-7875. E-mail: inquire@imaginasium.com. Website: http://www.imaginasium.com. Creative Director: Joe Bergner. Estab. 1991. Number of employees: 5. Approximate annual billing: $600,000. Design firm. Specializes in corporate identity, collateral. Product specialties are industrial, business to business. Current clients include Georgia Pacific, Shopko. Client list available upon request. Professional affiliation: Green Bay Advertising Federation.

Needs: Approached by 15 illustrators and 5 designers/year. Works with 10 illustrators and 2 designers/year. Prefers local designers. Uses freelancers mainly for overflow. Also for brochure illustration and lettering. 15-20% of work is with print ads. 100% of design and 10-20% of illustration demands skills in Adobe Photoshop, QuarkXPress and Adobe Illustrator.

First Contact & Terms: Designers send query letter with brochure, photographs and tearsheets. Illustrators send postcard sample of work with follow-up postcard every 6 months. Accepts Macintosh disk submissions of above programs. Samples are filed and are not returned. Will contact for portfolio review of color tearsheets, thumbnails and transparencies if interested. Pays for design by the hour, $20-40. Pays for illustration by the project. Rights purchased vary according to project. Finds artists through submissions, word of mouth.

UNICOM, 9470 N. Broadmoor Rd., Bayside WI 53217. (414)352-5070. Fax: (414)352-4755. Senior Partner: Ken Eichenbaum. Estab. 1974. Specializes in annual reports, brand and corporate identity, display, direct, package and publication design and signage. Clients: corporations, business-to-business communications, and consumer goods. Client list available upon request.

Needs: Approached by 15-20 freelancers/year. Works with 1-2 freelance illustrators/year. Works on assignment only. Uses freelancers for brochure, book and poster illustration.

First Contact & Terms: Send query letter with brochure. Samples not filed or returned. Does not report back; send nonreturnable samples. Write for appointment to show portfolio of thumbnails, photostats, slides and tearsheets. Pays by the project, $200-6,000. Rights purchased vary according to project.

Canada

NORTHWEST IMAGING & F.X., 2339 Columbia St., Suite 100, Vancouver, British Columbia V5Y 3Y3 Canada. (604)873-9339. Fax: (604)873-9339. E-mail: alex@nwfx.com. Website: http://www.nwfx.com. Vice President: Alex Tkach. Estab. 1956. AV firm. Specializes in graphics and visual special effects for TV and motion pictures, including storyboards and animation. Product specialties are TV commercials and shows. Current clients include: NBC, CBC, CBS, CTV, FOX, MGM, Paramount, Cannell and MTV.

Needs: Approached by 5 freelancers/month. Works with 2 illustrators and 2 designers/month. Prefers freelancers with experience in Soft Image. Works on assignment only. Uses freelancers mainly for backup computer design and animation. Also for brochure design and illustration, print ad design, storyboards, animatics, animation, TV/film graphics, lettering and logos. 10% of work is with print ads.

First Contact & Terms: Send query letter with résumé, samples or reel. Samples are filed. Reports back within 3 days. Will contact artist for portfolio review if interested. Pays for design by the hour, $10-45; by the project, $100-2,500; also short term contract work by the week and by the day, $100-750. Pays for illustration by the project, $250 minimum. Buys all rights.

Tips: "I look for young, affordable artists we can train on our systems. Attitude plays an important role in their development."

2 DIMENSIONS TORONTO INC., 88 Advance Rd., Toronto, Ontario M8Z 2T7 Canada. (416)234-0088. Fax: (416)234-8599. E-mail: kam@2dimensions.com. Website: http://www.2dimensions.com. Estab. 1989. Also: 100 Park Avenue, New York NY 10017. (212)551-3218. Fax: (212)880-6499. Number of employees: 23. Specializes in image marketing, advertising, annual reports, brand and corporate identity; direct mail, package and

©Two Dimensions, Inc.

Three artists worked on various stages of this illustration for a project for Canadian ad agency Two Dimensions: Mark Janeck produced the pencil linear; Michael Custode produced black and white line art; and Raffi Anderian colorized the piece after it was scanned. "This represents one style of literally dozens we use," says creative director Kam Wai Yu. "We work with many illustrators and are one of the largest 'buyers' of illustration. As creative director, I work with illustrators as a team. Most of our work wins awards, so we need illustrators who work to a very high standard, but only illustrators who can take direction."

publication design. Clients: Fortune 500 corporations (IBM, etc.), major distributors and manufacturers (Letraset), most government ministries (Canadian), television (Fox TV, CBC). Partial client list available (does not include confidential clients). Professional affiliations: GAG, GDAC

- 2 Dimensions has won over 64 international awards in 1997, with a running total of 356. In 1998, 2 Dimensions also captured several grands and best in shows. The company was profiled in *Step by Step Graphics* in March 1998 and *Applied Arts Magazine* in February 1998.

Needs: Approached by 200 freelancers/year. Works with 35 freelance illustrators and 3 designers/year. Looks for unique and diverse signature styles. Designers must be local to either the Toronto or New York office, but not illustrators. Works on assignment only (illustrators mostly). Uses illustrators mainly for advertising, collateral. Uses designers mainly for special projects and overflow work. Designers must work under creative director. Also uses freelancers for brochure design and illustration, magazine design, catalog, P-O-P, poster and ad illustration, and charts/graphs. 100% of freelance design demands skills in QuarkXPress, Aldus FreeHand, Adobe Photoshop, Microsoft Word or Suitcase.

First Contact & Terms: Send query letter with brochure or tearsheets, résumé, SASE. Samples are filed or are returned by SASE if requested by artist. Reports back within 2 weeks. Write for appointment to show portfolio. "Don't send portfolio unless we phone. Send tearsheets that we can file." Pays for design by the project, $300-10,000. Pays for illustration by the project, $300-8,000. Negotiates rights purchased.

Tips: "We look for diverse styles of illustration for specific projects. Send tearsheets for our files. Our creative director refers to these files and calls with assignment offers. We don't normally have time to view portfolios except relative to a specific job. Strong defined styles are what we notice. The economy has reduced some client budgets and increased demand for speculative work. Since we are emphatically opposed to spec work, we do not work this way. Generalist artists who adapt to different styles are not in demand. Unique illustrative styles are easier to sell."

Record Labels

Record labels use freelance artists for more than just CD covers. In addition to retail budgets for packaging, each CD release has budgets for promotion and merchandising, too. You could be hired to design store displays, promotional materials, T-shirts or posters.

Your greatest challenge will be working within the size constraints of CD and cassette covers. The dimensions of a CD cover are 4¾ × 4¾ inches, packaged in a 5 × 5 inch jewel box. Inside each CD package is a 4-5 panel fold-out booklet, inlay card and CD. Photographs of the recording artist, illustrations, liner notes, titles, credit lines and lyrics all must be placed into that relatively small format. Art and typography choices are perhaps more crucial than they were in the days of 12 × 12 inch album covers.

The recording industry is dominated by a handful of major labels, but there are thousands of independent labels. Some are thriving, others struggling, but they are a big part of the industry. And you'll find indies are great places to start when looking for freelance assignments. One such "indie" label is Silver Wave Records. Read how art director Valerie Sanford relies on freelancers on page 632.

LANDING THE ASSIGNMENT

Submit your work to record labels the same way you would approach any market. Check the listings in the following section to see how the art director prefers to be approached and what type of samples to send. Check also to see what type of music they produce. Assemble a portfolio of your best work in case an art director wants to see more of your work.

Be sure your portfolio includes quality samples. It doesn't matter if the work is of a different genre—quality is key. If you don't have any experience in the industry create your own CD package, featuring one of your favorite recording artists or groups.

Get the name of the art director or creative director from the listings in this section and send a cover letter that asks for a portfolio review. If you are not contacted within a couple of weeks, make a polite follow-up call to the office manager.

Once you nail down an assignment, get an advance and a contract. Independent labels usually provide an advance and payment in full when a project is done. When negotiating a contract, ask for a credit line on the finished piece and samples for your portfolio.

You don't have to live in one of the recording capitals to land an assignment, but it does help to familiarize yourself with the business. Visit record stores and study the releases of various labels. For further information about CD design read *Rock Art*, by Spencer Drate (PBC International).

I ## For More Information

Learn more about major labels and "indies" by reading industry trade magazines, like *Spin*, *Rolling Stone*, *Vibe*, *Ray Gun* and *Billboard*. Each year around March, the Recording Industry Association of America releases sales figures for the industry. The RIAA's report also gives the latest trends on packaging and format, and music sales by genre. To request the most recent report, call the RIAA at (202)775-0101.

insider report

Indie labels offer exposure and creative freedom

Valerie Sanford, art director for Boulder, Colorado-based Silver Wave Records, considers herself lucky to have a job in which aesthetics are not defined by dollar signs. Unlike major labels, which often try to hit the masses from a marketing point of view, independents such as Silver Wave appeal to a select audience. "We realize we're an esoteric niche, trying to appeal to people's intelligence and integrity. That makes us a little different."

Valerie Sanford

The independent label, which originated in 1986 with a focus on jazz/New Age recordings, now primarily releases Native American product. Silver Wave segued into Native American sounds when the label's main artist, keyboardist Peter Kater, made recordings with Navajo flute player R. Carlos Nakai. The collaborations that combined traditional and contemporary music sold well, as did Joanne Shenandoah's Iroquois women's chant, *Lifeblood*. Shenandoah's subsequent recording, *Matriarch*, won Best Native American recording in North America in 1997. "As a result of this kind of success," says Sanford, "Silver Wave began to go almost exclusively in a Native direction."

Sanford hires artists from all over the country to design and/or provide existing art that catches the spirit of Silver Wave's artists. "I can art direct by phone," she explains. "Sometimes I'll send them profiles, or draw them a picture of what I have in mind." She likes illustrations or fine art on the front cover, with a full photo of the musician on back, "something that shows drama and expresses their culture."

Sanford relies extensively on freelance artists and designers, "since the art department is only one person—me." But she urges artists to become familiar with the company before sending out their samples. "If you've got a contemporary, '90s, punk style, don't send your work to me, because that's not what I'm looking for." What she is looking for are earthy, fine art styles that may integrate ancient and modern design elements.

VALERIE SANFORD

Title: Art Director
Record Label: Silver Wave Records

Silver Wave product consists primarily of contemporary Native music, "and the cover art should reflect that," says Sanford. "Most art is not literal, it's more moody and abstract." In a recent cover for recording artist Alice Gomez's CD *Obsidian But-*

terfly, artist Robert Gilormo "did some graphic and very playful petroglyph-style work on handmade paper. The shapes are very simple, which is ideal for a small format. That's important to remember," she points out, "because it's a challenge for artists to work in such a small space and seduce the viewer."

When completing assignments, whether for major labels or indies, it is important to give art directors the style of work you've shown them in your samples or portfolio—that's the type of work they're expecting. Sanford had originally asked Gilormo to send her sketches for *Obsidian Butterfly*, but he opted to send her a finished artwork instead. Gilormo's first attempt wasn't exactly what Sanford had in mind. "He put a figure in the middle with butterfly wings, and on the sides his figures wore Peruvian hats which made them look masculine. I had to call him and say, 'Bob, lose the hats, and make it more in the style of the androgynous figures you're known for.' "

Sanford searches for artwork that expresses specific elements of Native culture. She and Silver Wave president James Marienthal both appreciate fine art. Sanford and Marienthal often end up loving the work so much, they buy it, as opposed to simply buying the one-time rights to it. Silver Wave usually pays freelance artists $500 for cover art.

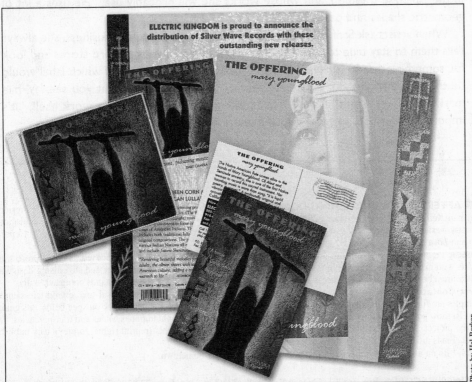

Record labels depend on freelancers not just for CD covers alone. The same image is often used on promotional material. Silver Wave Records used Helen Ragheb's dramatic image for *The Offering* in direct mail pieces and posters.

Photo by Hal Barkan

Artists who see a niche for their particular style unfailingly send samples to Silver Wave. Sanford receives three to five postcards or one-sheets a week. "That's all I need to see in terms of work samples," she notes. "Artists can still sell their original art to someone else. The art also gets maximized exposure when it's used for marketing pieces. Record stores don't usually want big posters unless it's Eric Clapton, but one-sheets, which are full-color pages with bio information, go out, as do postcard mailings with marketing information."

Considering the number of Native artists signed to Silver Wave, few of Sanford's freelance artists have been Native Americans. "I haven't had any Native artists yet, but I have had artists who were very connected to Natives in their philosophy, like Bill Worrel (who did the watercolor on Joanne Shenandoah's *Orenda*). While canoeing Worrel came across 11,000-year-old petroglyphs in nearby caves. He was so inspired by them that for years he just painted and sculpted these people."

Sanford would like to work with Native artists, and scouts the bi-annual Native American Trade Show in Denver as part of her search. "We also check southwestern art magazines and galleries. Gallery owners who know what we're looking for will pull work for us." She recently discovered an artist who is Native but who has studied in the Japanese tradition, and whose works she will probably use. "He uses a lot of geometric shapes and paints in a very Japanese style."

When artists ask Sanford for advice on how to break into the business, she always tells them to stay true to their style. "I urge people to go to record stores and look for something that feels like their art— that gives them an idea of which label would be the best markets. But it's important not to be swayed by what you see." While marketing is important, it should not be a major influence on the work itself. "It's important for artists to grow out of a process of self discovery."

—*Brooke Comer*

AFTERSCHOOL PUBLISHING COMPANY, P.O. Box 14157, Detroit MI 48214. (313)894-8855. President: Herman Kelly. Estab. 1978. Produces CDs and tapes: rock, jazz, rap, R&B, soul, pop, classical, folk, educational, country/western, dance and new wave. Recent releases: *Emotional Love Maintenance*, *Tell You What You're Going To Do* and *Love Letter*.

Needs: Produces 1 solo artist/year. Works with 10 freelance designers and 10 illustrators/year. Prefers professional artists with experience in all forms of the arts. Uses artists for CD cover design, tape cover and advertising design and illustration, brochure design, multimedia projects and posters. 10% of freelance work demands computer skills.

First Contact & Terms: Send query letter with brochure, résumé, SASE, bio, proposal and appropriate samples. Samples are filed or are returned by SASE. Reports back within 2-4 weeks. Requests work on spec before assigning a job. To show portfolio, mail roughs, printed samples, b&w/color tearsheets, photographs, slides and transparencies. Pays by the project. Negotiates rights purchased. Interested in buying second rights (reprint rights) to previously published work. Finds artists through Michigan Artist Directory and Detroit Area.

Tips: "Be on a local or national artist roster to work outside your hometown."

AIRWAX RECORDS, Box 288291, Chicago IL 60628. (773)779-2384. Fax: (773)779-7898. President: Casey Jones. Estab. 1983. Produces CDs, tapes and albums: rhythm and blues, soul and blues. Recent releases: *On My Way to Chicago*, by Casey Jones and *100% Chicago Style Blues*, by various artists.

Needs: Produces 2 soloists and 2 groups/year. Works with 5 visual artists/year. Prefers artists with experience in the performing circuit. Works on assignment only. Uses artists for posters.

First Contact & Terms: Send query letter with brochure. Samples are not filed and are returned. Reports back only if interested. To show a portfolio, mail b&w material. Pays by the project. Rights purchased vary according to project.

☑ **ALBATROSS RECORDS/R&D PRODUCTIONS**, P.O. Box 540102, Houston TX 77254-0102. (713)521-2616. Fax: (713)529-4914. E-mail: rpds2405@aol.com. Website: http://users.aol.com/rpds2405/Albatross.html. Art Director: Darin Gates. Estab. 1987. Produces CDs, cassettes: country, jazz, R&B, rap, rock by solor artists and groups. Recent releases: *Judgment Day*, by H.E.A.T.; *Screw Theory: The Next Millenium*, rap compilation.
Needs: Produces 22 releases/year. Works with 3 freelancers/year. Prefers freelancers with experience in QuarkXPress, Aldus Freelance. Uses freelancers for cassette cover design and illustration; CD booklet design; CD cover design and illuatraion; poster design; Web page design. Also for advertising design/illustration. 70% of freelance work demands knowledge of QuarkXPress, Aldus FreeHand, Adobe Photoshop.
First Contact & Terms: Send postcard sample of work. Samples are filed and not returned. Will contact for portfolio review of b&w and color final art if interested. Pays for design by the project, $600 maximum. Pays for illustration by the project, $250 maximum. Buys all rights. Finds freelancers through word of mouth.

☒ **ALEAR RECORDS**, Rt. 2, Box 2910, Berkeley Springs WV 25411. (304)258-2175. Owner: Jim McCoy. Estab. 1973. Produces tapes and albums: country/western. Releases: "The Taking Kind," by J.B. Miller; "If I Throw away My Pride," by R.L. Gray; and "Portrait of a Fool," by Kevin Wray.
Needs: Produces 12 solo artists and 6 groups/year. Works with 3 freelancers/year. Works on assignment only. Uses artists for CD cover design and album/tape cover illustration.
First Contact & Terms: Send query letter with résumé and SASE. Samples are filed. Reports back within 1 month. To show portfolio, mail roughs and b&w samples. Pays by the project, $50-250.

ALJONI MUSIC CO., P.O. Box 52417, Jacksonville FL 32201. (904)564-4297. E-mail: hall_a2@popmail.firn.edu. Production Manager: Al Hall, Jr. Estab. 1971. Produces albums, CDs, cassettes, videos: classical, country, gospel, jazz, R&B, rap, rock, soul, world by solo artists and groups. Recent releases: *Buffalo Soldier Suite*, by Cosmos Dwellers; *Explorations*, by various artists.
Needs: Produces 4-6 releases/year. Works with minimum of 2 freelancers/year. Uses freelancers for album cover design and illustration; animation; cassette cover design and illustration; CD booklet design and illustration; CD cover design and illustration; poster design, web page design. 50% of freelance work demands computer skills.
First Contact & Terms: Send postcard sample or query letter with brochure, résumé, photographs, SASE. Samples are filed or returned by SASE if requested by artist. Reports back to the artist only if interested. Portfolio review not required. Pays for design by the project; negotiable. Negotiates rights purchased. Rights purchased vary according to project.
Tips: "Be bold, different. Make your work 'jump out!!' at the viewer—I keep my eyes open for Great Stuff! Gospel will be the focus in 1999 for us."

ANGEL RECORDS, (formerly Angel/EMI Records), 304 Park Ave S., New York NY 10010.
• Angel Records merged with Blue Note. See listing for Blue Note in this section.

◩ **AQUARIUS RECORDS/TACCA MUSIQUE**, 1445 Lambert-Closse, Suite 200, Montreal, Quebec H3H 1Z5 Canada. (514)939-3775. Fax: (514)939-1691. E-mail: info@aquariusrecords.com. Production Manager: Rene LeBlanc. Estab. 1970. Produces CDs, cassettes and CD-ROMs: folk, pop, progressive and rock by solo artists and groups. Recent releases: *Present*, by Sass Jordan; *I Bificus*, by Bif; and *The Sound and the Jerry*, by Jerry Jerry.
Needs: Produces 2-8 releases/year. Works with 4 freelancers/year. Prefers designers who own IBM PCs. Uses freelancers for album, cassette and CD cover design and illustration; CD booklet design and illustration; CD-ROM design and packaging; poster design; advertising and brochure. 90% of freelance work demands knowledge of Adobe Photoshop, Adobe Illustrator and QuarkXPress.
First Contact & Terms: Send postcard sample of work or query letter with brochure, résumé and photographs. Samples are filed and are not returned. Will contact for portfolio review of b&w and color photocopies and photographs if interested. Pays for design and illustration by the project. Rights purchased vary according to project. Finds artists through word of mouth, showcases and buzz.
Tips: "Be creative. Understand that each project is different and unique. Stay away from generics!"

ARIANA RECORDS, 1336 S. Avenida Polar, Tucson AZ 85710. (520)790-7324. E-mail: arianarecords@geo.cities.com. Website: http://www.geocities.com. President: Jim Gasper. Estab. 1980. Produces albums, CDs, CD-ROMs, cassettes: folk, pop, progressive and rock by solo artists and groups. Recent releases: "I'm A Tree," by Jtiom; "Love's a Mess," The Rakeheads.
Needs: Produces 5 releases/year. Works with 2 freelancers/year. Prefers freelancers with experience in cover design. Uses freelancers for album cover design and illustration; cassette cover design and illustration; CD cover design and

MARKET CONDITIONS are constantly changing! If you're still using this book and it is 2001 or later, buy the newest edition of *Artist's & Graphic Designer's Market* at your favorite bookstore or order directly from Writer's Digest Books (1-800-289-0963).

illustration and multimedia projects. 70% of design and 50% of illustration demands computer skills.
First Contact & Terms: Send postcard sample of work. Samples are filed or returned by SASE if requested by artist. Reports back within 1 month. Portfolio review not required. Pays by the project.

☑ **ARISTA RECORDS**, 6 W. 57th St., 11th Floor, New York, NY 10019. (212)489-7400. Director: Margery Greenspan. Senior Art Director: Sheri G. Lee. Produces CDs and LPs: all types. Recent releases include: *Surfacing* by Sarah McLachlan; *19 Naughty 9* by Naughty By Nature; and *My Love Is Your Love* by Whitney Houston.
Needs: Uses designers and illustrators for music packaging, advertising, broadcast, promotion and P.O.P.
First Contact & Terms: Call or write for appointment to show portfolio or drop off portfolio Monday-Friday, 10:30-5:30. Call back after 2 days to arrange pick up of portfolio. Payment varies. Rights purchased vary according to project.

⊠ ARK 21, 14724 Ventura Blvd., Penthouse Suite, Sherman Oaks CA 91403. (818)461-1700. Production Manager: John Bevilacqua. President: Miles Copeland. Estab. 1996. Produces albums, CDs and cassettes for a variety of niche markets: swing, hillbilly by solo artists and groups. Recent releases include *Clandestino*, by Manu Chao and *People*, by Howard Jones.
Needs: Produces 20-30 releases/year. Works with 5-10 freelancers/year. Prefers local designers and illustrators who own Macs. Uses freelancers for album and CD cover and CD booklet design and illustration; poster design; point of purchase and production work. 100% of design demands knowledge of Adobe Illustrator, QuarkXPress, Adobe Photoshop.
First Contact & Terms: Send postcard sample of work. Accepts disk submissions compatible with Mac. Samples are filed or returned by SASE if requested. Does not report back. Artist should send a different promo in a few months. Portfolios may be dropped off Monday through Friday. Will contact for portfolio review if interested. Portfolio should include b&w and color final art, photocopies, photographs, photostats, roughs, slides, tearsheets, thumbnails or transparencies. Pays by the project. Buys all rights. Finds artists through interesting promos, *"The Alternative Pick."*

ATLAN-DEC/GROOVELINE RECORDS, 2529 Green Forest Ct., Snellville GA 30278. (770)985-1686. E-mail: atlandec@prodigy.net. Website: http://www.atlan-dec.com. Art Director: Wileta J. Hatcher. Estab. 1994. Produces CDs and cassettes: gospel, jazz, pop, R&B, rap artists and groups. Recent releases: *Stepping Into the Light*, by Mark Cocker.
Needs: Produces 2-4 releases/year. Works with 1-2 freelancers/year. Prefers freelancers with experience in CD and cassette cover design. Uses freelancers for alblum cover, cassette cover, CD booklet and poster design. 80% of of freelance work demands knowledge of Adobe Photoshop.
First Contact & Terms: Send postcard sample of work or query letter with brochure, photocopies, photograhs and tearsheets. Samples are filed. Will contact for portfolio review of b&w, color, final art if interested. Pays for design by the project, negotiable. Negotiates rights purchased. Finds artists through submissions.

BAL RECORDS, Box 369, LaCanada CA 91012. (818)548-1116. President: Adrian P. Bal. Estab. 1965. Produces 4-6 rpm (singles): rock & roll, jazz, R&B, pop, country/western and church/religious. Recent releases include: *Special Day, what's the matter with me* and *Lord You've Been So Good To Me*, by Rhonda Johnson.
Needs: Produces 2-4 soloists and 1 or 2 groups/year. Uses 1-3 artists/year for direct mail packages.
First Contact & Terms: Samples are not filed and are returned by SASE. Reports back ASAP. Portfolio review requested if interested in artist's work. Sometimes requests work on spec before assigning a job.
Tips: Finds new artists through submissions. "I don't like the abstract designs."

☑ **BLUE NOTE AND ANGEL RECORDS**, 304 Park Ave. S., New York NY 10010. (212)253-3000. Fax: (212)253-3170. Website: http://www.bluenote.com. Creative Director: Gordon H. Jee. Estab. 1939. Produces albums, CDs, cassettes, advertising and point-of-purchase materials. Produces classical, jazz, pop, and world music by solo artists and groups. Recent releases by Cassandra Wilson, Vanessa May, Itzhak Perlman, Holly Cole, Mose Allison, Richard Elliot.
Needs: Produces qpproximately 200 releases in US/year. Works with about 10 freelancers/year. Prefers designers with experience in QuarkXPress, Adobe Illustrator, Adobe Photoshop who own Macs. Uses freelancers for album cover design and illustration; cassette cover design and illustration; CD booklet and cover design and illustration; poster design. Also for advertising. 100% of design demands knowledge of Adobe Illustrator, QuarkXPress, Adobe Photoshop (most recent versions on all).
First Contact & Terms: Send postcard sample of work. Samples are filed. Reports back to the artist only if interested. Portfolios may be dropped off every Thursday and should include b&w and color final art, photographs and tearsheets. Pays for design by the hour, $12-20; by the project, $1,000-5,000. Pays for illustration by the project, $750-2,500. Rights purchased vary according to project. Finds artists and designers through submissions, portfolio reviews, networking with peers.

BOUQUET-ORCHID ENTERPRISES, P.O. Box 1335, Norcross GA 30091. (770)814-2420. President: Bill Bohannon. Estab. 1972. Produces CDs and tapes: rock, country, pop and contemporary Christian by solo artists and groups. Releases: *Blue As Your Eyes*, by Adam Day; and *Take Care Of My World*, by Bandoleers.
Needs: Produces 6 solo artists and 4 groups/year. Works with 8-10 freelancers/year. Works on assignment only. Uses freelancers for CD/tape cover and brochure design; direct mail packages; advertising illustration. 25% of freelance work demands knowledge of Aldus PageMaker, Adobe Illustrator and QuarkXPress.

First Contact & Terms: Send query letter with brochure, SASE, résumé and samples. "I prefer a brief but concise overview of an artist's background and works showing the range of his talents." Include SASE. Samples are not filed and returned by SASE if requested by artist. Reports within 1 month. To show a portfolio, mail b&w and color tearsheets and photographs. Pays for design by the project, $100-500. Rights purchased vary according to project.
Tips: "Study current packaging design on cassette and CD releases. Be creative and willing to be different with your approach to design."

BROADLAND INTERNATIONAL, 50 Music Sq. W., Suite 407, Nashville TN 37203. (615)327-3410. Fax: (615)327-3571. A&R Director: Gary Buck. Estab. 1975. Produces CDs, cassettes: country and gospel. Recent releases: "Again," by Johnny Duncan; "Can't Get Enough," by Gunslinger.
Needs: Produces 15-20 releases/year. Works with 3-4 freelancers/year. Prefers designers who own computers. Uses freelancers for album cover design and illustration; cassette cover design and illustration; CD booklet design and illustration; CD cover design and illustration; poster design. Also for in-store promotional posters. 80% of freelance work demands computer skills.
First Contact & Terms: Send query letter with brochure, résumé, photocopies, photographs, tearsheets. Accepts disk submissions (Windows). Samples are filed or returned by SASE if requested by artist. Will contact artist for portfolio review of b&w, color photocopies, photographs, tearsheets if interested. Pays by the project; negotiable. Rights purchased vary according to project.

C.P.R. RECORD COMPANY, 4 West St., Massapequa Park NY 11762. (516)797-1995. Fax: (516)797-1994. E-mail: sandrina@earthink.net. President: Denise Thompson. Estab. 1996. Produces CDs, CD-ROMs, cassettes: R&B, rap, rock, soul by solo artists and groups.
• As *AGDM* went to press, this label was in the process of launching a website.
Needs: Produces 3-4 releases/year. Works with 5 freelancers/year. Prefers local freelancers who own IBM-compatible PCs. Uses freelancers for album cover design and illustration; animation; cassette cover design; CD booklet design and illustration; CD cover design and illustration; CD-ROM design and packaging and multimedia projects. Design demands knowledge of Aldus PageMaker, Aldus FreeHand, Adobe Photoshop.
First Contact & Terms: Send postcard sample or query letter with photocopies, tearsheets, résumé, photographs and photostats. Samples are filed or returned by SASE if requested by artist. Reports back within 6 weeks. Will contact artist for portfolio review of b&w, color photocopies, photographs if interested. Pays for design by the project; negotiable. Pays for illustration by the project, $500-5,000. Rights purchased vary according to project; negotiable. Finds artists through *Black Book* and *Workbook*.
Tips: "Be original. We always look for new and fresh material with a new twist. Don't be scared of rejection. It's the only way you learn, and always be positive! Be professional, be flexible, work hard and never stop learning."

CAPITOL RECORDS, 1750 N. Vine St., Hollywood, CA 90028-5274. (323)462-6252. Website: http://www.hollywoo dandvine.com. Art Director: Tommy Steele. Produces CDs, tapes and albums. Recent releases include *Suicaine Gratification* by Paul Westerberg.
• Art Director Tommy Steele was featured in an Insider Report in *AGDM*'s 1998 edition. Capitol also has offices in New York at 1290 Avenue of the Americas, 35th Floor, New York, NY 10104. (212)492-5300.
Needs: Uses freelance designers and illustrators for CD projects. Works on assignment only.
First Contact & Terms: Send non-returnable samples. Reports back only if interested. If you are planning a visit to Los Angeles or New York, call to make arrangements to drop off your portfolio.

CASH PRODUCTIONS, INC. (Recording Artist Development Corporation), 744 Joppa Farm Rd., Joppatowne MD 21085. Phone/fax: (410)679-2262. President/CEO: Ernest W. Cash. Estab. 1987. Produces CDs and tapes: country/western by solo artists and groups. Releases: *Beer Drinkin' Belly Rubbin' Liein' Cheatin' Songs*, by Randy Allen St. Clair.
Needs: Produces 20-30 releases/year. Works with 10-12 freelancers/year. Works only with artist reps. Works on assignment only. Uses artists for cassette, album and CD cover design and illustration; animation and World Wide Web page design. 50% of freelance work demands computer skills.
First Contact & Terms: Send query letter with brochure, photographs, résumé and SASE. Samples are filed. Reports back to the artist only if interested. Will contact for portfolio review of b&w and color final art if interested. Pays for design by the project. "Price will be worked out with rep or artist." Buys all rights.

[N] [⊕] CELESTIAL SOUND PRODUCTIONS, 23 Selby Rd. E. 113LT, London England. 081503-1687. Managing Director: Ron Warren Ganderton. Produces rock, classical, soul, country/western, jazz, pop, R&B by group and solo artists. Recent releases: "Dancing with My Shadow," by Sound Ceremony; and "Shame on You," by Carole Boyce.
Needs: Works with "many" freelancers/year. Uses freelancers for album cover, advertising and brochure design and illustration; and posters.
First Contact & Terms: Send query letter with brochure showing art style or send résumé, business card and photographs to be kept on file "for a reasonable time." Samples not filed are returned by SASE only if requested. Reports within 5 days. Call for appointment to show portfolio of roughs, color and b&w photographs. Original artwork returned after job's completion. Pays by the project. Considers available budget, how work will be used and rights purchased when establishing payment. Buys all rights, reprint rights or negotiates rights purchased.

Tips: "We are searching for revolutionary developments and those who have ideas and inspirations to express in creative progress."

CHERRY STREET RECORDS, INC., P.O. Box 52681, Tulsa OK 74152. (918)742-8087. E-mail: cherryst@msn.com. Website: http://www.cherrystreetrecords.com. President: Rodney Young. Estab. 1991. Produces CDs and tapes: rock, R&B, country/western, soul, folk by solo and group artists. Recent releases: *Land of the Living*, by Richard Elkerton; *Find You Tonight*, by Brad Absher; and *Rhythm Gypsy*, by Steve Hardin.
Needs: Produces 2 solo artists/year. Approached by 10 designers and 25 illustrators/year. Works with 2 designers and 2 illustrators/year. Prefers freelancers with experience in CD and cassette design. Works on assignment only. Uses freelancers for CD/album/tape cover design and illustration; catalog design; multimedia projects; and advertising illustration. 100% of design and 50% of illustration demand knowledge of Adobe Illustrator and CorelDraw for Windows.
First Contact & Terms: Send postcard sample or query letter with photocopies and SASE. Accepts disk submissions compatible with Windows '95 in above programs. Samples are filed or are returned by SASE. Reports back only if interested. Write for appointment to show portfolio of printed samples, b&w and color photographs. Pays by the project, up to $1,250. Buys all rights.
Tips: "Compact disc covers and cassettes are small—your art must get consumer attention. Be familiar with CD and cassette music layout on computer in either Adobe or Corel. Be familiar with UPC bar code portion of each program. Be under $500 for layout to include buyout of original artwork and photographs. Copyright to remain with Cherry Street—no reprint rights or negatives retained by illustrator, photographer or artist."

CRANK! A RECORD COMPANY, 1223 Wilshire Blvd., Suite 823, Santa Monica CA 90403. (310)264-0439. Fax: (310)264-0539. E-mail: fan@crankthis.com. Website: http://www.crankthis.com. Main Guy: Jeff Matlow. Estab. 1994. Produces albums, CDs 7″, 10″: rock and indie/alternative by solo artists and groups. Recent releases: *End Serenading*, by Mineral; *Posthumous*, by Vitreous Humor.
Needs: Produces 10 releases/year. Works with 3 freelancers/year. Prefers local designers. Uses freelancers for album cover design and illustration; CD booklet design and illustration; CD cover design and illustration; poster design; Web page design. Also for advertising and catalogs. 100% of freelance design and 30% of illustration demands knowledge of Aldus PageMaker, Adobe Illustrator, QuarkXPress, Adobe Photoshop, Aldus FreeHand.
First Contact & Terms: Send query letter with photocopies. Samples are filed. Reports back to the artist only if interested. Artist may follow-up with e-mail after initial query. Portfolio should include b&w, color, final art, photocopies, photographs and tearsheets. Rights purchased vary according to project.

☑ **CRESCENT RECORDING CORPORATION**, P.O. Box 520195, Bronx NY 10452. (212)591-2148. Fax: (718)716-2963. Operations Officer: Leon G. Pinkston. Produces albums, CDs and cassettes: pop, R&B, rap, rock, soul. Recent releases: *Crazytown*, by Dodging Reality; and *Something On My Mind*, by Camille Watson.
Needs: Produces 1-3 releases/year. Works with 2-5 freelance artists/year. Prefers designers who own Mac/IBM computers with experience in QuarkXPress, FreeHand, Illustrator, etc. Uses freelancers for album cover design and illustration, cassette cover design and illustration, CD booklet design and illustration, CD cover design and illustration, poster and World Wide Web page design. Also for advertising, mail packages, brochure design/illustration. 75% of design and illustration demands knowledge of Adobe Illustrator, Adobe Photoshop, Aldus FreeHand, Aldus PageMaker, QuarkXPress.
First Contact & Terms: Send postcard sample of work or query letter with résumé. Samples are filed and are not returned. Reports back with 2-3 months only if interested. Will contact for portfolio review of b&w, color, final art if interested. Pays for design by the project, $750-1,000; pays for illustration by the project, $400-700. Negotiates rights purchased. Finds artists "mainly through artists' submissions. Sometimes we use artists' reps and the WWW."
Tips: "Continue to grow and to reinvent your skills within the scope of the art industry. Keep up with the changing packaging and technological trends."

CRS ARTISTS, 724 Winchester Rd., Broomall PA 19008. (215)544-5920. Fax: (215)544-5921. E-mail: crsnews@erols.com. Website: http://www.erols.com/crsnews. Administrative Assistant: Caroline Hunt. Estab. 1981. Produces CDs, tapes and albums: jazz and classical by solo artists and compilations. Recent releases: *Excursions* and *Albumleaf*.
 • Sponsors Competition for Performing Artists and National Competition for Composers Recording.
Needs: Produces 20 CDs/year. Works with 4 designers and 5 illustrators/year on assignment only. Also uses freelancers for multimedia projects. 50% of freelance work demands knowledge of Word Perfect and Wordstar.
First Contact & Terms: Send query letter with brochure, résumé, SASE and photocopies. Samples are filed or are returned by SASE if requested by artist. Reports back within 1 month only if interested. Call for appointment to show portfolio or mail roughs, b&w tearsheets and photographs. Requests work on spec before assigning a job. Pays by the project. Buys all rights; negotiable. Finds new artists through *Artist's and Graphic Designer's Market*.

◫ **MARKETS NEW TO THIS EDITION**

A STARTRACKS RECORDING

uomini d'onore
by FIRESIDE

©1998 Crank! A Record Company

A man with a gun—and a sharp Italian suit—is the centerpiece of this illustration by Henrik Walse for Fireside's album entitled *uomini d'onore*, which means "men of honor" in Italian. Jeff Matlow at Crank! A Record Company, the label that distributes the album, was attracted to Walse's sparse illustration because it's "a simple yet powerful piece that displays both a sense of fun as well as a hard edge."

DAPMOR PUBLISHING COMPANY, 3031 Acorn St., Kenner LA 70065. (504)468-9820. Fax: (504)466-2896. Owner: Kelly Jones. Estab. 1977. Produces CDs, cassettes: country, jazz, pop, R&B, rap, rock and soul by solo artists and groups.
First Contact & Terms: Send postcard sample of work. Samples are not filed and not returned. Reports back within 1 month.

☑ **DRIVE ENTERTAINMENT**, 10451 Jefferson Blvd., Culver City CA 90232. (310)815-4900. E-mail: drive@earth link.net. Production Coordinator: Priscilla Sanchez. Estab. 1991. Produces albums, CDs, cassettes, videos: country, folk, jazz, big band by solo artists and groups. Recent releases: albums by Sara Vaughn, Don Redman All Stars and children's Golden Records.
Needs: Produces 48 releases/year. Works with 3-6 freelancers/year. Prefers local designers who own Mac computers and are able to give first drafts. Uses freelancers for album cover design, cassette cover illustration and design, CD booklet design, CD cover design and poster design. 100% of design demands knowledge of Quark XPress and Adobe Photoshop.
First Contact & Terms: Send postcard sample of work and send query letter with brochure, photocopies, tearsheets and résumé. Accepts Mac-compatible disk submissions. Samples are filed or are returned by SASE if requested by artist. Reports back only if interested. Art director will contact artist for portfolio review of b&w and color final art,

photocopies, photographs, photostats, roughs, slides, tearsheets, thumbnails and transparencies if interested. Pays for design by the project; $700-820/CD (design and film). Buys all rights. Finds artists through word of mouth, submissions and Internet.

Tips: "Send postcards, samples to all companies. Basically, advertise! Any samples are acceptable—classy designs, professional, beautiful colors, eye-catching designs."

EMF RECORDS & AFFILIATES, 633 Post St., #145, San Francisco CA 94109. (415)263-5727. Fax: (415)752-2442. Sales & Marketing Director: Mark Jarvis. Estab. 1994. Produces CDs, CD-ROMs, cassettes: classical, country, jazz, pop, progressive, R&B, rock, soul, urban, dance, Latin, new age. Recent releases: *Like The Mist That Lingers*, by Joe Tsongo (vol. 1, 2 and 3); and *Hot On The Groove*, by Slam Jam.

Needs: Produces 7 releases/year. Works with 1 freelance artist/year. Prefers designers who own Mac/IBM computers with experience in cover designing. Uses freelancers for cassette cover design and illustration, CD booklet design and illustration, CD cover design and illustration, poster design. Also for advertising design, catalog design, direct mail packages, multimedia projects. 70-80% of design and illustration demands knowledge of Adobe Illustrator, Adobe Photoshop.

First Contact & Terms: Send query letter with brochure, photocopies, photographs, résumé. Accepts disk submissions. Samples are filed or are returned by SASE if requested by artist. Reports back with 2 months. Will contact for portfolio review of b&w, color, final art, photocopies, photographs, photostats. Pays for design and illustration by the project. Rights purchased vary according to project. Finds artists through submissions and sourcebooks.

N: EMI LATIN, 21700 Oxnard St., Suite 250, Woodland Hills CA 91367. (818)615-2411. Fax: (818)615-2442. Art and Production Manager: Nelson González. Estab. 1989. Produces albums, CDs and cassettes: pop, rock, salsa, Merengue, Regional Mexican by solo artists and groups. Recent releases: *Selena Anthology*, by Selena; *Amor a la Mexicana*, by Thalia; *Carlos Ponce*, by Carlos Ponce; and *Amor Platónico*, by Los Tucanes De Tijuana.

Needs: Produces 250 releases/year. Works with 10 designers/year. Prefers local designers. Uses freelancers for the design of packages: CD and cassette covers, CD booklets, inlays and posters. 100% of design work demands knowledge of Aldus PageMaker, Adobe Illustration, QuarkXPress; Adobe Photoshop; Aldus FreeHand.

First Contact & Terms: Send postcard sample of work. Samples are filed. Reports back only if interested. Pays for design: by the project, $2,000-$3,500. Negotiates rights purchased. Finds artists through artists' submissions.

N: THE ETERNAL SONG AGENCY, 6326 E. Livingston Ave., #153, Reynoldsburg OH 43068. (614)834-1272. E-mail: leopold@netexp.net. Website: http://www.eternalsong.com. Art Director: Anastacia Crawford. Estab. 1986. Produces CDs, tapes and videos: rock, jazz, pop, R&B, soul, progressive, classical, gospel, country/western. Recent releases: *Escape*, by Robin Curenton; and *You Make Me New*, by Greg Whigtscel.

Needs: Produces 6 releases/year. Works with 5-7 freelancers/year. Prefers freelancers with experience in illustration and layout. "Designers need to be computer-literate and aware of latest illustration technology." Uses freelancers for CD/tape cover, and advertising design and illustration, direct mail packages, posters, catalog design and layout. 65% of freelance work demands knowledge of Aldus PageMaker, Adobe Illustrator, Adobe Photoshop, Aldus FreeHand. "Other programs may be acceptable."

First Contact & Terms: Send postcard sample of work or send query letter with brochure, photocopies, résumé, photographs. Samples are filed. Reports back within 4-5 weeks. Art Director will contact artist for portfolio review if interested. Portfolio should include b&w and color final art and photocopies. Pays for design by the project, $300-5,000. Pays for illustration by the hour, $15-35; by the project, $300-5,000. Finds artists through word of mouth, seeing previously released albums and illustration, art colleges and universities. "Be persistent. Know your trade. Become familiar with technical advances as related to your chosen profession."

FIRST POWER ENTERTAINMENT GROUP, 5801 Riverdale Rd., Suite 105, Riverdale MD 20737. (301)277-1671. Fax: (301)277-0173. E-mail: powerpla@mail.erols.com. Vice President: Adrianne Harris. Estab. 1992. Produces albums, CDs, cassettes and *Street Jam* magazine: classical, gospel, R&B, rap, rock, soul, dance, alternative. Recent releases: "Set it Out" and *Do the Lasso* by Da Foundation.

Needs: Produces 2-4 releases/year. Works with 3-6 freelancers/year. Prefers local freelancers with experience in Adobe PageMaker, Photoshop, Extreme 3D. Uses freelancers for album cover design and illustration, animation, cassette cover design, CD booklet design and illustration, CD cover design and illustration, CD-ROM design, poster design, multimedia projects, *Street Jam* magazine. 100% of design and illustration work demands knowledge of Adobe Illustrator, Adobe Photoshop and Adobe PageMaker

First Contact & Terms: Send brochure, résumé, photostats, photocopies, photographs, tearsheets, SASE. Samples are filed or are returned by SASE if requested. Reports back only if interested. Request portfolio review of b&w and color photographs ("whatever you have available; work samples") in original query. Artist should follow-up with call. Pays by the project. Buys all rights. Finds artists through advertising and word of mouth.

Tips: "Trends are always changing. The current ones (listed above) and the DVD formats are what's currently in demand. Know your business and get all the experience you can. However, don't just follow trends. Be creative, break barriers and present yourself and your work as something unique."

FOREFRONT RECORDS/EMI CHRISTIAN MUSIC GROUP, 201 Seaboard Lane, Franklin TN 37067. (615)771-2900. Fax: (615)771-2901. E-mail: f2creative@aol.com. Website: http://www.forefrontrecords.com. Creative Services

Manager: Cindy Simmons. Estab. 1988. Produces CDs, CD-ROMs, cassettes: Christian alternative rock by solo artists and groups. Recent releases: *Supernatural*, by dc Talk; *Some Kind of Zombie*, by Audio Adrenaline; *Pray*, by Rebecca St. James.

Needs: Produces 15-20 releases/year. Works with 5-10 freelancers/year. Prefers designers who own Macs with experience in cutting edge graphics and font styles/layout, ability to send art over e-mail, and attention to detail and company spec requirements. Uses freelancers for cassette cover design and illustration; CD booklet design and illustration; CD cover design and illustration; CD-ROM design and packaging; poster design. 100% freelance design and 50% of illustration demands knowledge of Adobe Illustrator, QuarkXPress, Adobe Photoshop.

First Contact & Terms: Send postcard sample or query letter with résumé, photostats, transparencies, photocopies, photographs, slides, SASE, tearsheets. Accepts disk submissions compatible with Mac/Quark, Adobe Photoshop or Illustrator, EPS files. Samples are filed or returned by SASE if requested by artist. Reports back to the artist only if interested. Portfolios may be dropped every Tuesday and Wednesday. Will contact artist for portfolio review if interested. Payment depends on each project's budgeting allowance. Negotiates rights purchased. Finds artists through artist's submissions, sourcebooks, web pages, reps, word-of-mouth.

Tips: "I look for cutting edge design and typography along with interesting use of color and photography. Illustrations must show individual style and ability to be conceptual."

GLASS HOUSE PRODUCTIONS, P.O. Box 602, Columbus IN 47202. (812)372-6983. Fax: (812)372-3985. E-mail: info@glasshousecd.com. Website: http://www.GlassHouseCD.com. Executive Producer: S. Glass. Estab. 1989. Produces CDs, cassettes: classical, country, folk, pop, progressive, rock by solo artists and groups. Recent releases: *Turn It Around*, by Sacred Project; *Suzanne Glass*, by Suzanne Glass.

Needs: Produces 2-10 releases/year. Works with 5 freelancers/year. Prefers local designers with experience in Quark, PageMaker. Uses freelancers for cassette cover design and illustration; CD booklet design and illustration; CD cover design and illustration; poster design. Also for multimedia. 95% of design and 50% of illustration demands knowledge of Aldus PageMaker, Adobe Illustrator, QuarkXPress, Adobe Photoshop.

First Contact & Terms: Send postcard sample. Samples are filed. Will contact artist for portfolio review if interested. Pays for design by the project, $300-2,000. Negotiates rights purchsed. Finds artists through word of mouth, submissions.

Tips: "Be willing to do 'generic' design for independent artists. There is a great demand and should lead to more creative work."

GODDESS RECORDS/McCARLEY ENTERTAINMENT MEDIA, P.O. Box #502, Pacific Palisades CA 90272. (310)281-1934. E-mail: mem@monitor.net. Website: http://www.goddessrecords.com. President: Kevin McCarley. Estab. 1990. Produces enhanced CDs, albums, CDs, CD-ROMs, cassettes, merchandise: psychedelic hard pop and dance metal. Recent releases: *Wild Seeds of The Winter Wild*, by Thee Imagine Nation; *Venus Envy*, by Star 69.

Needs: Produces 2 releases/year. Works only with artist reps. Prefers designers who own the best computers with experience in illustration and animation. Uses freelancers for album cover design and illustration, animation, cassette cover design and illustration, CD booklet design and illustration, CD cover design and illsutration, CD-ROM design, CD-ROM packaging, poster design, World Wide Web page design. 100% of design and illustration demands knowledge of Adobe Illustrator, Adobe Photoshop, Aldus FreeHand, Aldus PageMaker, QuarkXPress.

First Contact & Terms: Samples are filed. Reports back within 1 month. Artist should follow-up with letter after initial query. Will contact for portfolio review of b&w, color, final art, photographs, tearsheets, transparencies if interested. Pays for design by the project. Rights purchased vary according to project, negotiable.

Tips: "Try anything once. Use your imagination. Find a vision."

GRAY DOT, INC., 1979 S. Cobb Dr., Marietta GA 30060. (770)384-0001. Fax: (770)384-0002. E-mail: david@graydot.com. Website: http://www.graydot.com. Art Director: David Vanderpoel. Estab. 1990. Produces CDs, cassettes: gospel, pop, rock by solo artists and groups. Recent releases: *The Absent Sounds of Me*, by Dear Ephesas; *Sci Fi Canon Blues*, by Annie.

Needs: Produces 18 releases/year. Works with 4 freelancers/year. Prefers local designers and illustrators. Uses freelancers for album cover design and illustration; animation; cassette cover design and illustration; CD booklet design and illustration; CD cover design and illustration; poster design; World Wide Web page design. 90% of design and illustration demands knowledge of Adobe Illustrator, QuarkXPress, Adobe Photoshop.

First Contact & Terms: Send query letter with résumé, slides, tearsheets. Accepts disk submissions compatible with Macintosh only. Samles are filed. Reports back within 2 weeks. Request portfolio review of final art in original query. Pays for design and illustration by the project; negotiable. Buys all rights. Finds artists through direct submissions, referrals, competitor's products, magazines.

Tips: Sees a trend in "packages shrinking—layouts need to be more direct and clean." Recommends doing "gratis work for indie bands—treat them as major projects." Looking for "new approach, sense of taste, ability to modify to please client."

GREEN LINNET RECORDS, INC., 43 Beaver Brook Rd., Danbury CT 06810. (203)730-0333. Fax: (203)730-0345. Production Manager: Kevin Yatarola. Estab. 1975. Produces CDs and tapes: folk, world music (Irish, African, Cuban).

Needs: Produces 40 releases/year. Works with 5 freelancers/year. Prefers local freelancers with experience in CD

packaging. Uses freelancers for CD cover design and illustration; catalog design; direct mail packages, posters. Needs computer-literate freelancers for production.

First Contact & Terms: Samples are not filed. Does not report back. Artist should send only disposable reproductions (no originals). Art Director will contact artist for portfolio review if interested. Rights purchased vary according to project.

N HAMMERHEAD RECORDS, 41 E. University Ave., Champaign IL 61820. (217)355-9052. Fax: (217)355-9057. E-mail: hammerhd@shout.net. Website: http://www.hammerheadrecords.com. President: Todd Thorstenson. Estab. 1993. Produces CDs and tapes: rock, by groups. Recent releases: *Swoon*, by Swoon; *The Finest of Silks*, by Bantha.

Needs: Produces 6 releases/year. Works with 3-4 freelancers/year. Uses freelancers for CD/tape cover design and illustration; posters. 80% of freelance work demands knowledge of Aldus PageMaker 5.0, Adobe Illustrator (version 4 for Windows).

First Contact & Terms: Send query letter with résumé, photographs, tearsheets. Samples are filed or returned by SASE if requested by artist. Reports back to the artist only if interested. Artist should follow-up with call and/or letter after initial query. Portfolio should include b&w and color roughs, photostats. Pays for design and illustration by the project. Rights purchased vary according to project.

Tips: "We work with artists but it is ultimately the band's decision."

HIGHWAY ONE MEDIA ENTERTAINMENT, 2950 31st St., Suite 376, Santa Monica CA 90405. (310)664-6686. Fax: (310)664-6685. E-mail: hwyone@aol.com or general@highway1media.com. Website: http://www.highway1media. com. President: Ken Caillat. Estab. 1994. Produces CD-ROMs, DVD-ROMs and enhanced music CDs for the entertainment industry. Recent releases: *DVD Audio Sampler*, Warner Music Group; *Full Moon and the Shrine*, by Keiko Matsui; *BrightHouse: The Ideation Corporation*, Corporate Presentation; *Hit Connection Music Compilation Series*, by Highway One.

Needs: Produces 6-10 releases/year. Works with 10-20 freelancers/year. Prefers local designers who own computers. Uses freelancers for CD booklet and cover design and illustration; CD-ROM design and packaging. 100% of freelance work demands knowledge of Adobe illustrator, QuarkXPress, Adobe Photoshop.

First Contact & Terms: Fulltime positions may be available. Send query letter with brochure, photocopies, tearsheets, résumé. Accepts disk submissions. Samples are filed. Will contact for portfolio review of color photocopies if interested. Pays by the project, $200-6,000. Send to attention of Anna Rambo.

HOTTRAX RECORDS, 1957 Kilburn Dr., Atlanta GA 30324. (770)662-6661. E-mail: hotwax@hottrax.com. Website: http://www.hottrax.com. Publicity and Promotion: Teri Blackman. Estab. 1975. Produces CDs and tapes: rock, R&B, country/western, jazz, pop and blues/novelties by solo and group artists. Recent releases: *Real Time*, by Sheffield-Webb; *Live From The Eye Of The Storm*, by Roger Hurricane Wilson; and *Blue in Dixieland*, by Bob Page.

Needs: Produces 2 soloists and 4 groups/year. Approached by 90-100 designers and 60 illustrators/year. Works with 6 designers and 6 illustrators/year. Prefers freelancers with experience in multimedia—mixing art with photographs—and caricatures. Uses freelancers for CD/tape cover, catalog and advertising design and illustration; and posters. 25% of freelance work demands knowledge of Aldus PageMaker, Adobe Illustrator and Photoshop.

First Contact & Terms: Send postcard samples. Accepts disk submissions compatible with Adobe Illustrator and CorelDraw. Some samples are filed. If not filed, samples are not returned. Reports back only if interested. Pays by the project, $150-1,250 for design and $1,000 maximum for illustration. Buys all rights.

Tips: "We file all samples that interest us even though we may not respond until the right project arises. We like simple designs for blues and jazz, including cartoon/caricatures, abstract for New Age and fantasy for heavy metal and hard rock."

N HULA RECORDS, 2290 Alahao Place, Honolulu HI 96819-2283. (808)847-4608. E-mail: hularec@aloha.net. Website: http://www.hawaiian-music.com. President: Donald P. McDiarmid III. Produces pop, educational and Hawaiian records; group and solo artists.

Needs: Produces 1-2 soloists and 3-4 groups/year. Works on assignment only. Uses artists for album cover design and illustration, brochure and catalog design, catalog layout, advertising design and posters.

First Contact & Terms: Send query letter with tearsheets and photocopies. Samples are filed or are returned only if requested. Reports back within 2 weeks. Write for appointment to show portfolio. Pays by the project, $50-350. Considers available budget and rights purchased when establishing payment. Negotiates rights purchased.

N IMAGINARY ENTERTAINMENT CORP., P.O. Box 66, Whites Creek TN 37189. (615)299-9237. Proprietor: Lloyd Townsend. Estab. 1982. Produces CDs, tapes and albums: rock, jazz, classical, folk and spoken word. Releases include: *Kaki*, by S.P. Somtow; and *Panorama*, by Stevens, Siegel and Ferguson.

Needs: Produces 1-2 solo artists and 1-2 groups/year. Works with 1-2 freelancers/year. Works on assignment only. Uses artists for CD/album/tape cover design and illustration and catalog design.

First Contact & Terms: Send query letter with brochure, tearsheets, photographs and SASE. Samples are filed or returned by SASE if requested by artist. Reports back within 2-3 months. To show portfolio, mail thumbnails, roughs and photographs. Pays by the project, $25-500. Negotiates rights purchased.

Tips: "I always need one or two dependable artists who can deliver appropriate artwork within a reasonable time frame."

KIMBO EDUCATIONAL, 10 N. Third Ave., Long Branch NJ 07740. E-mail: kimboed@aol.com. Website: http://www.kimboed.com. Production Manager: Amy Laufer. Educational record/cassette company. Produces 8 cassettes and compact discs/year for schools, teacher supply stores and parents. Primarily early childhood/physical fitness, although other materials are produced for all ages.

Needs: Works with 3 freelancers/year. Prefers local artists on assignment only. Uses artists for CD/cassette/covers; catalog and flier design; and ads. Helpful if artist has experience in the preparation of CD covers jackets or cassette inserts.

First Contact & Terms: "It is very hard to do this type of material via mail." Send letter with photographs or actual samples of past work. Reports only if interested. Pays for design and illustration by the project, $200-500. Considers complexity of project and budget when establishing payment. Buys all rights.

Tips: "The jobs at Kimbo vary tremendously. We produce material for various levels—infant to senior citizen. Sometimes we need cute 'kid-like' illustrations and sometimes graphic design will suffice. We are an educational firm so we cannot pay commercial record/cassette/CD art prices."

N K-TEL INTERNATIONAL (USA) INC., 2605 Fernbrook Lane N., Plymouth MN 55447. (612)559-6800. Website: http://www.ktel.com. Creative Director: Marcia Button. Art Directors: Mark McKay, Nikki Bach and Megan McGinlon. Estab. 1969. Produces CDs and tapes: rock, jazz, rap, R&B, soul, pop, classical, country/western and electronica. Also produces books on cassette and CD-ROM. Releases: *Club Mix '99*, *Atomic Babies-Breuklen Heights*, *'90s Hot Country*, all compilations by various artists.

Needs: "Frequently uses freelancers for illustration and design. Works on assignment only. Uses freelancers for CD/cassette/tape package design and illustration for books and CD-ROM. Needs illustration in all media. Freelance designers should be familiar with Adobe Illustrator and Adobe Photoshop.

First Contact & Terms: Designers send query letter with résumé and tearsheets. Illustrators send postcard sample or other non-returnable samples. Samples are filed. Reports back only if interested. Pays by project, $500-1,500.

♣ L.A. RECORDS, P.O. Box 1096, Hudson, Quebec J0P 1H0 Canada. (514)869-3236. Fax: (514)458-2819. E-mail: larecord@total.net. Website: http://www.radiofreedom.com. Manager: Tina Sexton. Estab. 1991. Produces CD and tapes: rock, pop, R&B, alternative; solo artists and groups. Recent releases: *Natural Descent*, by Pigeon Hole and *Astral Guide*, by Ecclestone.

Needs: Produces 8-12 releases/year. Works with 2-5 freelancers/year. Prefers local freelancers. Uses freelancers for CD/tape cover, brochure and advertising design and illustration. Needs computer-literate freelancers for design and illustration. 80% of freelance work demands computer skills.

First Contact & Terms: Send postcard sample of work or query letter with brochure, résumé, photostats, photocopies, photographs and SASE. Samples are filed. Art Director will contact artist for portfolio review if interested. Portfolio should include color photocopies and photographs. Pays for design and illustration by the project. Rights purchased vary according to project. Finds artists through word of mouth.

Tips: "Make an emotional impact."

N LAMBSBREAD INTERNATIONAL RECORD COMPANY/LBI, Box 328, Jericho VT 05465. (802)899-3787. Creative Director: Robert Dean. Estab. 1983. Produces CDs, tapes and albums: R&B, reggae. Recent releases: *Then To Now* and *Carnival on Main Street*, by Lambsbread; and *The Runnings*, by The Hackneys.

Needs: Produces 2 soloists and 2 groups/year. Approached by 30 designers and 20 ilustrators/year. Works with 2 designers and 2 illustrators/year. Works on assignment only. Uses freelancers for CD cover, catalog and advertising design; album/tape cover design and illustration; direct mail packages; and posters. 70% of freelance work demands computer skills.

First Contact & Terms: Send query letter with brochure, tearsheets, résumé, photographs, SASE and photocopies. Samples are filed. Reports back only if interested. To show a portfolio, mail thumbnails, roughs, photostats and tearsheets. Sometimes requests work on spec before assigning a job. Payment negotiated by the project. Buys all rights or negotiates rights purchased according to project.

Tips: "Become more familiar with the way music companies deal with artists. Also check for the small labels which may be active in your area. The technology is unreal regarding computer images and graphics. So don't over price yourself right out of work."

N LAMON RECORDS INC., P.O. Box 25371, Charlotte NC 28229. (704)882-8843. Fax: (704)882-2063. E-mail: dmoodyjrnc@aol.com. Website: http://www.lamonrecords.com. Chairman of Board: Dwight L. Moody Jr. Produces CDs and tapes: rock, country/western, folk, R&B and religious music; groups. Releases: *Going Home* and *Picking with Friends*, by Moody Brothers; and *The Woman Can Love*, by Billy Marshall.

Needs: Works on assignment only. Works with 3 designers and 4 illustrators/year. Uses freelancers for album cover design and illustration, brochure and advertising design, and direct mail packages. 50% of freelance work demands knowledge of Adobe Photoshop.

First Contact & Terms: Send brochure and tearsheets. Samples are filed and are not returned. Reports back only if interested. Call for appointment to show portfolio or mail appropriate materials. Considers skill and experience of artist and how work will be used when establishing payment. Buys all rights.

Tips: "Include work that has been used on album, CD or cassette covers."

N LANDMARK COMMUNICATIONS GROUP, Box 1444, Hendersonville TN 37077. E-mail: lmarkcom@aol.com. President: Bill Anderson Jr. Estab. 1980. Produces CDs, albums and tapes: country/western and gospel. Releases include: *You Were Made for Me*, by Skeeter Davis and *Talkin' Bout Love*, by Gail Score.

Needs: Produces 6 soloists and 2 groups/year. Works with 2-3 freelance designers and illustrators/year. Works on assignment only. Uses artists for CD cover design and album/tape cover illustration.

First Contact & Terms: Send query letter with brochure. Samples are filed. Reports back within 1 month. Portfolio should include tearsheets and photographs. Rights purchased vary according to project.

LCDM ENTERTAINMENT, Box 79564, 1995 Weston Rd., Weston, Ontario M9N 3W9 Canada. E-mail: guitarbabe@hotmail.com. Website: http://www.canmusic.com. Publisher: L.C. DiMarco. Estab. 1991. Produces CDs, tapes, publications (quarterly): pop, folk, country/western and original. Recent releases: "Glitters & Tumbles," by Liana; and *Indie Tips & the Arts* (publication).

Needs: Prefers local artists but open to others. Uses freelancers for CD cover design, brochure illustration, posters and publication artwork. Needs computer-literate freelancers for production, presentation and multimedia projects.

First Contact & Terms: Send query letter with brochure, résumé, photocopies, photographs, SASE, tearsheets, terms of renumeration (i.e., pay/non-pay/alternative). Samples are filed. Art Director will contact artist for portfolio review if interested. Pays for design and illustration by the project. Rights purchased vary according to project.

Tips: "The best experience is attainable through indie labels. Ensure that the basics (phone/fax/address) are on all of your correspondence. Seldom do indie labels return long distance calls. Include SASE in your mailings always. Get involved and offer to do work on a volunteer or honorarium basis. The best chance to be hired is the second time around when approaching."

✔ PATTY LEE RECORDS, 6034½ Graciosa Dr., Hollywood CA 90068. (323)469-5431. Contact: Susan Neidhart. Estab. 1986. Produces CDs and tapes: New Orleans rock, jazz, folk, country/western, cowboy poetry and eclectic by solo artists. Recent releases: *Return to BeBop*, by Jim Sharpe; *Alligator Ball*, by Armand St. Martin; *Horse Basin Ranch*, by Timm Daughtry; and *Afternoon Candy*, by Angelyne.

Needs: Produces 2-3 soloists/year. Works with several designers and illustrators/year. Works on assignment only. Uses freelancers for CD/tape cover, sign and brochure design; and posters.

First Contact & Terms: Send postcard sample. Samples are filed or are returned by SASE. Reports back only if interested. "Please do not send anything other than an introductory letter or card." Payment varies. Rights purchased vary according to project. Finds new artists through word of mouth, magazines, submissions/self-promotional material, sourcebooks, agents and reps and design studios.

Tips: "Our label is small. The economy does not affect our need for artists. Sending a postcard representing your 'style' is very smart and inexpensive. We can keep your card on file. We are 'mom and pop' and have limited funds so if you don't hear back from us, it is no reflection on your talent. Keep up the good work!"

N ⊕ LEMATT MUSIC LTD., Pogo Records Ltd., Swoop Records, Grenouille Records, Zarg Records, Lee Sound Productions, R.T.F.M., Lee Music Ltd., Check Records, Value For Money Productions, White House Farm, Shropshire TF9 4HA England. (01630) 647374. Fax: (01630)647612. Manager, Director: Ron Lee. Produces CDs, tapes and albums: rock, dance, country/western, pop, and R&B by group and solo artists. Recent releases: *New York Jets*, by Michael J. Lawson; *Great Balls of Fire 2*, by Ron Dickson.

Needs: Produces 25 CDs, tapes/year. Works with 3-4 freelance designers and 3-4 illustrators/year. Works on assignment only. Uses a few cartoons and humorous and cartoon-style illustrations where applicable. Uses freelancers for album cover design and illustration; advertising design, illustration and layout; and posters. Needs computer-literate freelancers for design, illustration and presentation. 30% of freelance work demands computer skills.

First Contact & Terms: Send query letter with brochure, résumé, business card, slides, photographs and videos to be kept on file. Samples not filed are returned by SASE (nonresidents send IRCs). Reports within 3 weeks. To show portfolio mail final reproduction/product and photographs. Original artwork sometimes returned to artist. Payment negotiated. Finds new artists through submissions and design studios.

LIVING MUSIC, P.O. Box 72, Litchfield CT 06759. (860)567-8796. Fax: (860)567-4276. E-mail: pwclmr@aol.com. Website: http://www.livingmusic.com. Director of Communications: Kathi Fragione. Estab. 1980. Produces CDs and tapes: classical, jazz, folk, progressive, world, New Age. Recent releases: *Celtic Solstice*, by Paul Winter & Friends; *Paul Winter's Greatest Hits*; and *Brazilian Days*, by Oscar Castro-Neves and Paul Winter.

• Living Music is now distributed by Windham Hill.

Needs: Produces 1-3 releases/year. Works with 1-5 freelancers/year. Uses freelancers for CD/tape cover and brochure design and illustration; direct mail packages; advertising design; catalog design, illustration and layout; and posters. 70% of freelance work demands knowledge of Aldus PageMaker, Adobe Illustrator, QuarkXPress, Adobe Photoshop, Aldus FreeHand.

First Contact & Terms: Send postcard sample of work or query letter with brochure, transparencies, photographs, slides, SASE, tearsheets. Samples are filed or returned by SASE if requested by artist. Reports back to the artist only if interested. Art Director will contact artist for portfolio review of b&w and color roughs, photographs, slides, transparencies and tearsheets. Pays for design by the project. Rights purchased vary according to project.

Tips: "We look for distinct 'earthy' style." Prefers nature themes.

LUCIFER RECORDS, INC., Box 263, Brigantine NJ 08203. (609)266-2623. President: Ron Luciano. Produces pop, dance and rock.
Needs: Produces 2-12 records/year. Prefers experienced freelancers. Works on assignment only. Uses freelancers for album cover and catalog design; brochure and advertising design, illustration and layout; direct mail packages; and posters.
First Contact & Terms: Send query letter with résumé, business card, tearsheets, photostats or photocopies. Reports only if interested. Original art sometimes returned to artist. Write for appointment to show portfolio, or mail tearsheets and photostats. Pays by the project. Negotiates pay and rights purchased.

N **JIM McCOY MUSIC**, Rt. 2 Box 2910, Berkeley Springs WV 25411. (304)258-9381. Owner: Bertha McCoy. Estab. 1972. Produces CDs and tapes: country/western. Recent releases: *Mysteries of Life*, by Carroll County Ramblers.
Needs: Produces 12 solo artists and 10 groups/year. Works on assignment only. Uses artists for CD cover design and illustration; tape cover illustration.

METAL BLADE RECORDS, INC., 2828 Cochran St., Suite 302, Simi Valley CA 93065. (805)522-9111. Fax: (805)522-9380. E-mail: mtlbldrcds@aol.com. Website: http://www.iuma.com/metal_blade. Vice President/General Manager: Tracy Vera. Estab. 1982. Produces CDs and tapes: rock by solo artists and groups. Recent releases: *Carnival of Chaos*, by Gwar; and *A Pleasant Shade of Gray*, by Fates Warning.
Needs: Produces 10-20 releases/year. Approached by 10 designers and 10 illustrators/year. Works with 1 designer and 1 illustrator/year. Prefers freelancers with experience in album cover art. Uses freelancers for CD cover design and illustration. Needs computer-literate freelancers for design and illustration. 80% of freelance work demands knowledge of Aldus PageMaker, Adobe Illustrator, QuarkXPress, Adobe Photoshop.
First Contact & Terms: Send postcard sample of work or query letter with brochure, résumé, photostats, photocopies, photographs, SASE, tearsheets. Samples are filed or returned by SASE if requested by artist. Reports back to the artist only if interested. Art Director will contact artist for portfolio review if interested. Portfolio should include b&w and color, final art, photocopies, photographs, photostats, roughs, slides, tearsheets. Pays for design and illustration by the project. Buys all rights. Finds artists through *Black Book*, magazines and artists' submissions.
Tips: "Please send samples of work previously done. We are interested in any design."

MIGHTY RECORDS, BMI Music Publishing Co.—Corporate Music Publishing Co.—ASCAP, Stateside Music Publishing Co.—BMI, 150 West End Ave., Suite 6-D, New York NY 10023. (212)873-5968. Manager: Danny Darrow. Estab. 1958. Produces CDs and tapes: jazz, pop, country/western; by solo artists. Releases: *Falling In Love*, by Brian Dowen; and *A Part of You*, by Brian Dowen/Randy Lakeman.
Needs: Produces 1-2 solo artists/year. Works on assignment only. Uses freelancers for CD/tape cover, brochure and advertising design and illustration; catalog design and layout; and posters.
First Contact & Terms: Samples are not filed and are not returned. Rights purchased vary according to project.

MUSIC MIND ENTERTAINMENT LTD., P.O. Box 803213, Chicago IL 60680. E-mail: etaylor950@aol. Vice Presidents: Eric C. Taylor, Susie M. Taylor and Anthony Portee. Estab. 1996. Produces CDs, cassettes, video: gospel, pop, R&B, rap, soul by solo artists and groups. Recent releases: "Climbing Up," by Sister Susie; "Shake," by The Fortress.
Needs: Produces 3 releases/year. Works with 2 freelancers/year. Prefers designers who own Macs. Uses freelancers for album cover design and illustration; Cassette cover design and illustration; CD booklet design and illustration; CD cover design and illustration; poster design Web page design. 70% of design and 70% of illustration demands knowledge of Adobe Illustrator, Adobe Photoshop, Aldus FreeHand.
First Contact & Terms: Send query letter with brochure, résumé, photocopies, slides. Accepts disk submissions compatible with Mac. Samples are filed or returned by SASE if requested by artist. Reports back within 1 month. Art Director will contact artist for portfolio review or b&w, color, final art, photocopies, thumbnails if interested. Pays for design and illustration by the project; negotiable. Rights purchased vary according to project. Finds artists through *Black Book* and magazines.
Tips: "Record companies are always looking for a new hook so be creative. Keep your price negotiable. I look for creative and professional-looking portfolio."

N **MUSIC QUEST**, P.O. Box 822, Newark NJ 07102. (973)374-4421. Fax: (973)374-5888. E-mail: music@mqtv.c om. Website: http://www.mqtv.com. President: Tania D. Eggleston. Estab. 1993. Produces albums, cassettes, books and merchandise: country, folk, gospel, jazz, pop, progressive, R&B, rap, rock, soul and hip hop by solo artists, producers and songwriters. Recent releases: *I Whipped Him Good*, by Willie Asbury (comedian); *Love Poems & Affirmation*, featuring Synthia Saint James.
Needs: Produces 100 releases/year. Works with 25 freelancers/year. Uses freelancers for album cover design and illustration; animation; cassette cover illustration and design; CD booklet design and illustration; CD cover design and illustration; poster design; World Wide Web page design. 100% of design and 100% of illustration demands knowledge of Adobe Illustrator; QuarkXPress; and Adobe Photoshop.
First Contact & Terms: Send postcard sample of work with brochure, résumé, photostats, photocopies, photographs and tearsheets. Samples are filed. "Do not send originals." Reports back to the artist only if interested. Art Director will contact artist for portfolio review if interested. Payment netogiatble. Rights purchased vary according to project.

Finds artists through artists' submissions, sourcebooks, magazines, WorldWide Web, artists' reps and word of mouth. **Tips:** "The industry is becoming very competitive because there are thousands of new artists and companies who are very creative and knowledgable. You must be creative and willing to work fast. Don't give up. If you're good, come up with good ideas and concepts."

NEURODISC RECORDS, INC., 4592 N. Hiatus, Ft. Lauderdale FL 33351. (954)572-0289. Fax: (954)572-2874. E-mail: neurodisc@aol.com. Website: http://www.neurodisc.com. Contact: John Wai and Tom O'Keefe. Estab. 1990. Produces albums, CDs, cassettes: pop, progressive, rap and electronic. Recent releases: *Booty Party Ta' Go, Pure Flamenco, Holiday Mood, Ultimate Bass Challenge.*
Needs: Produces 10 releases/year. Works with 5 freelancers/year. Prefers designers with experience in designing covers. Uses freelancers for album cover design and illustration; animation; cassette cover design and illustration; CD booklet design and illustration; cover design and illustration; poster design; Web page design. Also for print ads. 100% of freelance work demands computer skills.
First Contact & Terms: Send postcard sample or query letter with brochure, photocopies and tearsheets. Samples are not filed and are returned by SASE if requested by artist. Will contact artist for portfolio review if interested. Pays by the project. Buys all rights.

N OPUS ONE, Box 604, Greenville ME 04441. (207)997-3581. President: Max Schubel. Estab. 1966. Produces CDs, LPs, 78s, contemporary American concert and electronic music.
Needs: Produces 6 releases/year. Works with 1-2 freelancers/year. Prefers freelancers with experience in commercial graphics. Uses freelancers for CD cover design.
First Contact & Terms: Send postcard sample or query letter with rates and example of previous artwork. Samples are filed. Pays for design by the project. Buys all rights. Finds artists through meeting them in arts colonies, galleries or by chance.
Tips: "Contact record producer directly. Send samples of work that relate in size and subject matter to what Opus One produces."

OREGON CATHOLIC PRESS, 5536 NE Hassalo, Portland OR 97213-3638. (503)281-1191. Fax: (503)282-3486. E-mail: jeang@ocp.org. Website: http://www.ocp.org/. Art Director: Jean Germano. Estab. 1934. Produces liturgical music CDs, cassettes, songbooks, missalettes, books. Recent releases: *More Stories and Songs of Jesus*, Christopher Walker.
Needs: Produces 10 collections/year. Works with 5 freelancers/year. Uses freelancers for cassette cover design and illustration; CD booklet illustration; CD cover design and illustration. Also for spot illustration.
First Contact & Terms: Send query letter with brochure, transparencies, photocopies, photographs, slides, tearsheets and SASE. Samples are filed or returned by SASE. Reports back within 2 weeks. Will contact artist for portfolio review if interested. Pays for illustration by the project, $35-500. Finds artists through submissions and the Web.
Tips: Looks for attention to detail.

ORINDA RECORDS, P.O. Box 838, Orinda CA 94563. (510)441-1300. A&R Director: H. Balk. Produces CDs and tapes: jazz, pop, classical by solo artists and groups.
Needs: Works with 6 visual artists/year. Works on assignment only. Uses artists for CD cover design and illustration; tape cover design and illustration.
First Contact & Terms: Send postcard sample or query letter with photocopies. Samples are filed and are not returned. Reports back to the artist only if interested. Write for appointment to show portfolio of b&w and color photographs. Pays for design by the project. Rights purchased vary according to project.

N OVERTIME STATION, P.O. Box 402, Massapequa Park NY 11762. Phone/fax: (516)795-2721. President: Jackie Chazey. Estab. 1996. Produces cassettes and CDs: rock, music for stories; by solo artists. Recent releases: *Newt Soup*, by Dragon Aerogator and Agent 3.
Needs: Produces 1-2 releases/year. Works with 1-2 freelancers/year. Uses freelancers for animation, cassette cover design and illustration, poster design. Also for advertising, general illustrations. 75% of design and illustration demands knowledge of QuarkXPress.
First Contact & Terms: Send postcard sample of work or query letter with brochure, photocopies, resume, SASE. Samples are not filed and are returned by SASE if requested by artist. Reports back within 2 months if interested. Payment for illustration arranged per project. Negotiates rights purchased. Finds artists through word of mouth.

✓ ▣ PALM PICTURES, (formerly Islandlife), 4 Columbus Circle, New York NY 10019. (212)506-5841. Fax: (212)506-5849. E-mail: sandi@islandlife.com. Website: http://www.islandlife.com or www.palmpictures.com. Studio Director: Sandi Tansky. Estab. 1959. Produces films, albums, CDs, CD-ROMs, cassettes, LPs: folk, gospel, pop, progressive, R&B, rap and rock by solo artists and groups.
Needs: Works with 15 freelancers/year. Prefers designers who own Mac computers. Uses freelancers for album, cassette, CD, DVD and VHS cover design and illustration; CD booklet design and illustration; and poster design; advertising; merchandising. 99% of design and 20% of illustration demand knowledge of Adobe Illustrator, QuarkXPress, Adobe Photoshop and Aldus FreeHand.
First Contact & Terms: Send postcard sample and or query letter with tearsheets. Accepts disk submissions. Samples

are filed. Portfolios of b&w and color final art and tearsheets may be dropped off Monday through Friday. Pays for design by the project, $50-5,000; pays for illustration by the project, $500-5,000. Rights purchased vary according to project. Finds artists through submissions, word of mouth and sourcebooks.

Tips: "Have a diverse portfolio."

N PANDISC MUSIC/STREET BEAT RECORDS, 6157 NW 167T ST., SUITE F-9, Miami Beach FL 33139. (305)557-1914. Fax: (305)557-9262. E-mail: crissy@pandisc.com. Website: http://www.pandisc.com and www.streetbea trecords.com. Art Director: Christina Di Lucia. Estab. 1982. Produces CDs, cassettes and vinyl: dance, underground/club, electronica, bass and rap. Recent releases: *Happy & You Kno It*, by Crazy L'eggs; and *Uhh, Ohh*, by Splack Pack.

Needs: Produces 35-50 releases/year as well as many print ads and miscellaneous jobs. Works with many freelancers and design firms. Prefers freelancers with experience in record industry. Uses freelancers for CD/CS/records jacket design, posters, direct mail packages as well as print ads, promotional materials, etc. Needs computer-literate freelancers for design and production. 75% of freelance work demands computer knowledge.

First Contact & Terms: Send query letter with samples of work or via e-mail. Samples are filed. Art Director will contact artist if interested. "Call for per-job rates." Buys all rights.

Tips: "Must be deadline conscious and versatile."

N PINEWOOD PRODUCTIONS/BAYPORT RECORDS, P.O. Box 5241, Chesapeake VA 23324. (757)627-0957. Producer: Bill Johnson. Estab. 1954. Produces tapes and vinyl records: soul, gospel, blues by solo artists and groups.

Needs: Uses freelancers for tape cover and advertising design; brochure design and illustration; catalog illustration; and direct mail packages.

First Contact & Terms: Send query letter with photographs, information. Samples are not filed and are returned by SASE if requested by artist. Reports back within 1 month. Write for appointment to show portfolio of color photographs. Buys one-time rights; or rights purchased vary according to project.

PPI ENTERTAINMENT GROUP, 88 St. Francis St., Newark NJ 07105. (973)344-4214. Creative Director: Dave Hummer. Estab. 1923. Produces CDs and tapes: rock and roll, dance, soul, pop, educational, rhythm and blues; aerobics and self-help videos; group and solo artists. Specializes in children's health and fitness. Also produces children's books, cassettes and DVDs. Recent releases: *The Method*, fitness tapes and *Felix and the Buzzcatz*, swing recording.

Needs: Produces 200 records and videos/year. Works with 10-15 freelance designers/year and 10-15 freelance illustrators/year. Uses artists for album cover design and illustration; brochure, catalog and advertising design, illustration and layout; direct mail packages; posters; and packaging.

First Contact & Terms: Works on assignment only. Send query letter with samples to be kept on file; call or write for appointment to show portfolio. Prefers photocopies or tearsheets as samples. Samples not filed are returned only if requested. Reports only if interested. Original artwork returned to artist. Pays by the project. Considers complexity of project and turnaround time when establishing payment. Purchases all rights.

PPL ENTERTAINMENT GROUP, P.O. Box 8442, Universal City CA 91618. (818)506-8533. Fax: (818)506-8534. E-mail: pplzmi@aol.com. Website: http://www.pplzmi.com. Art Director: Kaitland Diamond. Estab. 1979. Produces albums, CDs, cassettes: country, pop, R&B, rap, rock and soul by solo artists and groups. Recent releases: "Shake Down," The Band AKA; "Change of Heart," by Jay Sattiewhite.

Needs: Produces 12 releases/year. Works with 2 freelancers/year. Prefers designers who own Mac or IBM computers. Uses freelancers for album cover design and illustration; cassette cover design and illustration; CD booklet design and illustration; CD cover design and illustration; CD-ROM design and packaging; poster design; Web page design. Freelance work demands knowledge of Aldus PageMaker, Adobe Illustrator, Adobe Photoshop.

First Contact & Terms: Send query letter with brochure, photocopies, tearsheets, résumé, photographs, photostats, slides, transparencies and SASE. Accepts disk submissions. Samples are filed or returned by SASE if requested by artist. Reports back within 2 months. Request portfolio review in original query. Pays by the project, monthly.

☑ PRAIRIE MUSIC LTD., P.O. Box 492, Anita IA 50020. (712)762-4363. President: Bob Everhart. Estab. 1967. Produces tapes and albums: folk, traditional, country and bluegrass. Releases: *Time After Time* and *Fishpole John*, by Bob Everhart; and *Smoky Mountain Heartbreak*, by Bonnie Sanford.

Needs: Produces 2 solo artists and 2 groups/year. Prefers freelancers with experience in traditional rural values. Works on assignment only. Uses artists for album/tape cover design and illustration and posters.

First Contact & Terms: Send query letter with résumé, photocopies and photostats. Samples are filed. Reports back within 4 months only if interested. To show portfolio, mail b&w photostats. Pays by the project, $100-250. Buys one-time rights.

N PRAVDA RECORDS, 6311 N. Neenah, Chicago IL 60631. (773)763-7509. Fax: (773)763-3252. E-mail: pravdaus a@aol.com. Website: http://www.pravdamusic.com. Contact: Kenn Goodman. Estab. 1986. Produces CDs, tapes and posters: rock, progressive by solo artists and groups. Recent releases: *Greatest Bits*, by New Duncan Imperials; *Soul Bucket*, by The Civiltones.

Needs: Produce 1 solo artist and 3-6 groups/year. Works with 1-2 freelancers/year. Works on assignment only. Uses freelancers for CD/tape covers and advertising design and illustration; catalog design and layout; posters. Needs com-

puter-literate freelancers for design and production. 100% of freelance work demands knowledge of Adobe Illustrator, QuarkXPress and Adobe Photoshop.

First Contact & Terms: Send query letter with résumé, photocopes, SASE. Samples are not filed and are returned by SASE if requested by artist. Reports back within 2 months. Portfolio should include roughs, tearsheets, slides, photostats, photographs. Pays for design by the project, $250-1,000. Rights purchased vary according to project.

N PUTUMAYO WORLD MUSIC, 324 Lafayette St., 7th Floor, New York NY 10012. (212)625-1400, ext. 214. Fax: (212)460-0095. E-mail: info@putumayo.com. Website: www.putumayo.com. Production Manager: Sarah Re. Estab. 1974. Produces CDs, cassettes: folk, world. Recent releases: *Women of the World: Celtic*; *Women of the World: International*.

Needs: Produces 16 releases/year. Works with 1-4 freelancers/year. Prefers local designers who own computers with experience in digi pak CDs. Uses freelancers for album and cassette design and World Wide Web page design. 90% of design demands knowledge of QuarkXPress, Adobe Photoshop.

First Contact & Terms: Send postcard sample. Samples are not filed and are returned by SASE if requested. Will contact for portfolio review of final art if interested. Pays by the project.

Tips: "We use a CD-digi pak rather than the standard jewel box."

N ☒ RAMMIT RECORDS, 414 Ontario St., Toronto, Ontario M5A 2W1 Canada. (416)923-7611. Fax: (416)923-3352. President: Trevor G. Shelton. Estab. 1988. Produces CDs, tapes and 12-inch vinyl promos for CDs: rock, pop, R&B and soul by solo artists and groups. Recent releases: *2 Versatile*, by 2 Versatile, hip hop/R&B, A&M distribution; *Hopping Penguins*, by Trombone Chromosome, ska/reggae, MCA distribution; *Line Up In Paris*, by Line Up in Paris, rock, A&M distribution.

Needs: Produces 4 releases/year. Works with 3-5 freelancers/year. Uses freelancers for CD cover design and illustration, tape cover illustration, advertising design and posters. 75% of freelance work demands computer skills.

First Contact & Terms: Send query letter with "whatever represents you the best." Reports back to the artist only if interested. Artist should follow-up with call and/or letter after initial query. Portfolio should include b&w and color photostats. Pays for design by the project, $1,000-3,000. Negotiates rights purchased. Finds artists through word of mouth, referrals and directories.

ROCK DOG RECORDS, P.O. Box 3687, Hollywood CA 90028-9998. (213)661-0259. E-mail: rockdogrec@aol.com. Website: http://members.aol.com/empathcd/web/index.htm. President, A&R and Promotion: Gerry North. Estab. 1987. Produces CDs and tapes: rock, R&B, dance, New Age, contemporary instrumental, ambient and music for film, TV and video productions. Recent releases: *Circadian Breath*, by Elijah; *Abduction*, by Empath; and *The Technology of Art*, by Brainstorm.

● This company has a second location at P.O. Box 884, Syosset, NY 11791-0899. (516)544-9596. Fax: (516)364-1998. E-mail: rockdogrec@aol.com. A&R, Promotion and distribution: Maria Cuccia.

Needs: Produces 2-3 solo artists and 2-3 groups/year. Approached by 50 designers and 200 illustrators/year. Works with 5-6 designers and 25 illustrators/year. Prefers freelancers with experience in album art. Uses artists for CD album/tape cover design and illustration, direct mail packages, multimedia projects, ad design and posters. 95% of design and 75% of illustration demand knowledge of Print Shop or Adobe Photoshop.

First Contact & Terms: Send postcard sample or query letter with photographs, SASE and photocopies. Accepts disk submissions compatible with Windows '95. Send Bitmap, TIFF, GIF or JPG files. Samples are filed or are returned by SASE. Reports back within 2 weeks. To show portfolio, mail photocopies. Sometimes requests work on spec before assigning a job. Pays for design by the project, $50-500. Pays for illustration by the project, $50-500. Interested in buying second rights (reprint rights) to previously published work. Finds new artists through submissions from artists who use *Artist's & Graphic Designer's Market*.

Tips: "Be open to suggestions; follow directions. Don't send us pictures, drawings (etc.) of people playing an instrument. Usually we are looking for something abstract or conceptual. We look for prints that we can license for limited use."

N ROTTEN RECORDS, P.O. Box 2157, Montclair CA 91763. (909)624-2332. Fax: (909)624-2392. E-mail: rotten @rottenrecords.com. Website: http://www.rottenrecords.com. President: Ron Peterson. Estab. 1988. Produces CDs and tapes: rock by groups. Recent releases: *Pomona Queen*, by Street Cleaners; *Full Speed Ahead*, by D.R.I.; *One More Mega-byte*, by Toy Dolls; *Token Remedies Research*, by Damaged.

Needs: Produces 4-5 releases/year. Works with 3-4 freelancers/year. Uses freelancers for CD/tape cover design; and posters. Needs computer-literate freelancers for desigin, illustration, production.

First Contact & Terms: Send postcard sample of work or query letter with photocopies, tearsheets (any color copies samples). Samples are filed and not returned. Reports back to the artist only if interested. Artist should follow-up with call. Portfolio should include color photocopies. Pays for design and illustration by the project.

RRRECORDS, 23 Central St., Lowell MA 01852. (508)454-8002. Contact: Ron. Estab. 1984. Produces CDs, tapes and albums: experimental, electronic and avant-garde.

Needs: Produces 30-40 releases/year. Uses 5-6 artists/year for CD and album/tape cover design and illustration; and CD booklet design and illustration.

First Contact & Terms: Send query letter with résumé, SASE and appropriate samples. Samples are filed. Reports

back only if interested. To show a portfolio, mail thumbnails, roughs, final art and b&w and color photostats. Pays by the project, negotiable. Buys first rights.

N SAN FRANCISCO SOUND, 29903 Harvester Rd., Malibu CA 90265. (310)457-4844. Fax: (310)457-1855. Owner: Matthew Katz. Produces CDs and tapes: rock and jazz. Recent releases: *Then and Now*, Volumes 1 and 2, featuring Jefferson Airplane, Moby Grape and many others; *Fraternity of Man*, by Tripsichord; and *It's a Beautiful Day*, by Indian Puddin and Pipe.
Needs: Produces 2 soloists and 2 groups/year. Works with 2 artists/year with experience in airbrush and computer graphics. Works on assignment only. Uses artists for CD cover, brochure and advertising design; catalog and advertising illustration; posters; and catalog layout.
First Contact & Terms: Send query letter with brochure, tearsheets, photographs, photocopies, photostats, slides and transparencies. Samples are filed. Reports back to the artist only if interested. Call or mail appropriate materials. Portfolio should include photostats, slides, color tearsheets, printed samples and photographs. Pays by the project, $250-1,200. Buys all rights.
Tips: "Know the style of 1960s San Francisco artists—Mause, Kelley-Moscoso, Griffin— and bring it up to date. Know our products."

✓ SELECT RECORDS, 19 W. 21st St., 10th Floor, New York NY 10010. (212)691-1200. Fax: (212)691-3375. Contact: Art Director. Produces CDs, tapes, 12-inch singles and marketing products: rock, R&B, rap and comedy solo artists and groups. Recent releases: *Jerky Boys II*, by Jerky Boys; and *To the Death*, by M.O.P.
Needs: Produces 6-10 releases/year. Works with 6-8 freelancers/year. Prefers local freelancers with experience in computer (Mac). Uses freelancers for CD/tape cover design and illustration, brochure design, posters. 70-80% of freelance work demands knowledge of Adobe Illustrator, QuarkXPress, Adobe Photoshop and Aldus FreeHand.
First Contact & Terms: Send postcard sample of work or query letter with photostats, transparencies, slides and tearsheets. Samples are not filed or returned. Portfolios may be dropped off Monday-Friday. Art Director will contact artist for portfolio review if interested. Portfolio should include slides, transparencies, final art and photostats. Payment depends on project and need. Rights purchased vary according to project. Finds artists through submissions, *Black Book*, agents.
Tips: Impressed by "good creative work that shows you take chances; clean presentation."

🎵 SILVER WAVE RECORDS, 2475 Broadway, Suite 300, Boulder CO 80304. (303)443-5617. Fax: (303)443-0877. E-mail: valerie@silverwave.com. Website: http://www.silverwave.com. Art Director: Valerie Sanford. Estab. 1986. Produces CDs, cassettes: Native American and World by solo artists and groups. Recent releases: *Orenda*, by Joanne Shenandoah and Lawrence Laughing; *The Offering*, by Mary Youngblood.
Needs: Produces 4 releases/year. Works with 4 illustrators or artists a year. Prefers local designers. Illustrators need not be local. Uses illustrators for CD booklet and cover illustration. Freelance designers need Quark, Photoshop and Illustrator skills.
First Contact & Terms: Send postcard sample or query letter with 2 or 3 samples. Samples are filed. Will contact for portfolio review if interested. Pays by the hour or by the project. Rights purchased vary according to project.
Tips: "Try to work with someone at first and get some good samples and experience. Many artists I've hired are local. Word of mouth is effective. I also look for artists at Native American 'trade shows'. I look at *Workbook* and other sourcebooks but haven't hired from there yet. We will call if we like work or need someone." When hiring freelance designers, looks for "level of professionalism, good design, do they understand technical, i.e. printers, separations etc." When hiring freelance illustrators, looks for style for a particular project. "Currently we are producing contemporary Native American music and will look for art that expresses that."

JERRY SIMS RECORDS, Box 648, Woodacre CA 94973. (415)789-8322. Owner: Jerry Sims. Estab. 1984. Produces vinyl albums, CDs and cassettes: rock, R&B, classical, Celtic. Recent releases: *Viaggio* and *December Days*, by Coral; and *King of California*, by Chuck Vincent.
Needs: Produces 5-6 releases/year. Works with 2-3 freelancers/year. Prefers local artists who own Mac computers and have experience in album cover art. Uses freelancers for album, cassette and CD cover design. 30% of design and 40% of illustration demand knowledge of QuarkXPress and Adobe Photoshop.
First Contact & Terms: Send postcard sample of work or query letter with brochure and résumé. Samples are filed. Art Director will contact artist for portfolio review if interested. Portfolio should include photocopies and roughs. Pays for design and illustration by the project. Rights purchased vary according to project. Finds artists through submissions, word of mouth.
Tips: "Try to develop local clientele as well as clients out of your area."

N SOLID ENTERTAINMENT INC., 11328 Magnolia Blvd., Suite 3, North Hollywood CA 91601. (818)763-3535. Fax: (818)508-1101. President: James Warsinske. Estab. 1989. Produces CDs and tapes: rock & roll, R&B, soul, dance, rap and pop by solo artists and groups. Recent releases: *Let It Be Right*, by Duncan Faure; *Knowledge to Noise*, Madrok; *Push Harder*, 7th Stranger; *Psycho Love Child*, by Psycho Love Child.
Needs: Produces 2-6 soloists and 2-6 groups/year. Uses 4-10 visual artists for CD and album/tape cover design and illustration; brochure design and illustration; catalog design, layout and illustration; direct mail packages; advertising

design and illustration. 50% of freelancers work demands knowledge of Aldus PageMaker, Adobe Illustrator, QuarkX-Press, Adobe Photoshop.

First Contact & Terms: Send query letter with SASE, tearsheets, photographs, photocopies, photostats, slides and transparencies. Samples are filed. Reports back within 1 month. To show portfolio, mail roughs, printed samples, b&w and color photostats, tearsheets, photographs, slides and transparencies. Pays by the project, $100-1,000. Buys all rights.

Tips: "Get your art used commercially, regardless of compensation. It shows what applications your work has."

N **SONY MUSIC CANADA**, 1121 Leslie St., North York, Ontario M3C 2J9 Canada. (416)391-3311. Fax: (416)447-1823. Art Director: Catherine McRae. Estab. 1962. Produces albums, CDs, cassettes: classical, country, folk, jazz, pop, progressive, R&B, rap, rock, soul. Recent releases include LPs by Corey Hart and Celine Dion, *Our Lady Peace* by Amanda Marshal Starkicker.

Needs: Produces 40 domestic releases/year. Works with 10-15 freelancers/year. Prefers local designers who own Mac computers. Uses freelancers for album, cassette and CD cover design and illustration, CD booklet design and illustration, poster design. 80% of design and photography and 20% of illustration demand knowledge of Adobe Illustrator, Adobe Photoshop, QuarkXPress.

First Contact & Terms: Send query letter with photocopies, photographs, photostats, tearsheets. Accepts disk submissions compatible with Mac TIFF or EPS files. Reports back only if interested. Will contact for portfolio review of b&w, color, photocopies, photographs, tearsheets if interested. Pays by the project. Buys all rights. Finds artists through other CD releases, magazines, art galleries, word of mouth.

Tips: "Know what is current musically and visually. Read *Raygun*, *The Face*, *QMagazine*, *Details*, etc."

N **STARDUST RECORDS/WIZARD RECORDS/THUNDERHAWK RECORDS**, 341 Billy Goat Hill Rd., Winchester TN 37398. (931)649-2577. Fax: (931)649-2732. E-mail: cbd@edge.net. Website: http://www.a-page.com/colonelscorner. Contact: Col. Buster Doss, Produces CDs, tapes and albums: rock, folk, country/western. Recent releases: *Ghost of Another Man*, by John Hamilton; *The New American Dream*, by Brant Miller.

Needs: Produces 12-20 CDs and tapes/year. Works with 2-3 freelance designers and 1-2 illustrators/year on assignment only. Uses freelancers for CD/album/tape cover design and illustration; brochure design; and posters.

First Contact & Terms: Send query letter with brochure, tearsheets, résumé and SASE. Samples are filed. Reports back within 1 week. Call for appointment to show portfolio of thumbnails, b&w photostats. Pays by the project, $300. Buys all rights. Finds new artists through *Artist's & Graphic Designer's Market*.

N **STRICTLY RHYTHM RECORDS**, 920 Broadway, #1403, New York NY 10010. (212)254-2400. Fax: (212)254-2629. E-mail: info@strictly.com. Website: http://www.strictly.com. Vice President Promotion: Bari G. Estab. 1989. Produces albums, CDs, cassettes: pop, dance, underground, house. Recent releases: *Club Cuts* series; *Do It Again*, by Razor & Guide; *Find Another Woman*, by Reina; and *We Like To Party*, by Venga Boys.

Needs: Produces 20 releases/year. Works with "as many freelance artists as possible." Prefers designers who own Mac computers with experience in CD cover art. Uses freelancers for album cover design and illustration, cassette cover design and illustration, CD booklet design and illustration, CD cover design and illustration, poster design, World Wide Web page design. Also for catalog design/illustration, slip mats, postcards, clothing etc. 100% of design and 50% of illustration demand knowledge of Adobe Illustrator, Adobe Photoshop, QuarkXPress.

First Contact & Terms: Send postcard sample of work and call. Samples are filed. Reports back only if interested. Will contact for portfolio review of b&w, color, final art, photographs, photostats, slides if interested. Pays for design by the project, $250-2,000; pays for illustration by the project. Rights purchased vary according to project. Finds artists through word of mouth, NY design schools.

Tips: "Be willing to work cheap for exposure. If your work is good, you'll get higher paying projects and great references for other companies."

⊕ **SWOOP RECORDS**, White House Farm, Shropshire, TF9 4HA United Kingdom. Phone: 01630-647374. Fax: 01630-647612. A&R International Manager: Xavier Lee. Estab. 1971. Produces albums, CDs, cassettes and video: classical, country, folk, gospel, jazz, pop, progressive, R&B, rap, rock, soul by solo artists and groups. Recent releases: "Latin," by Emmitt Till; "The Old Days," by Groucho.

Needs: Produces 40 releases/year. Works with 6 freelancers/year. Prefers album cover design and illustration; cassete cover design and illustration; CD booklet design and illustration; CD cover design and illustration; poster design.

First Contact & Terms: Send postcard sample of work with SASE. Samples are not filed and are returned by SASE. Reports back within 6 weeks. Payment negotiated. Buys all rights. Finds artists through submissions.

THUNDERDOG MUSIC, 315 E. 86th St., Suite 6FE, New York NY 10028. (212)534-8641. Fax: (212)534-0271. E-mail: thunderdog1@juno.com. Website: http://www.crownjewelsnyc.com. President: Steven Conte. Estab. 1995. Produces CDs: rock by groups. Recent release: *Linoleum* and *Spitshine*, by Crown Jewels.

Needs: Produces 1 release/year. Works with 1-2 freelancers/year. Prefers local designers with experience in website design. Uses freelancers for album cover design; CD booklet design; poster design; web page design. 60% of freelance design demands knowledge of QuarkXPress or Adobe Photoshop.

First Contact & Terms: Send postcard sample or query letter with photocopies. Samples are filed. Reports back to the artist only if interested. Request portfolio review in original query. Portfolio should include b&w, color, photocopies. Pays by the project; negotiable. Negotiates rights purchased. Finds artists/designers through word of mouth.

Tips: "Work a lot and cheaply until you're known." Looks for "originality, excellence (technically), eye for beauty. . . ."

N **TOP RECORDS**, 4, Galleria del Corso, Milano Italy. (02)76021141. Fax: 0039/2/76021141. Estab. 1975. Produces CDs, tapes, albums: rock, rap, R&B, soul, pop, folk, country/western, disco; solo and group artists. Recent releases: *Raga-ragazzina*, by Alex Nardi; *Cocktail d'amore*, by Alessandra; *Inside Myself*, by Claudia Delon; *Al mercato dell'usato*, by Paolo Luciani; *Non ci credo più*, by Monica Dore; *Tu mi hai fatto innamorare, tu*, by Federico Gelfi; *Anzi Benissimo*, by Lucia Vale; *Spirito Guida*, by Elele.

Needs: Produces 5 solo artists and 5 groups/year. Works with 2 freelancer/year on assignment only.

First Contact & Terms: Send query letter with brochure. Samples are filed but not returned, unless requested and paid for by the artist. Reports back within 1 month. Call for appointment to show portfolio or mail appropriate materials. Portfolio should include original/final art and photographs. Buys all rights.

Tips: "Have a new and original idea."

TOPNOTCH® ENERTAINMENT CORP., Box 1515, Sanibel Island FL 33957-1515. (941)982-1515. Fax: (941)472-5033. E-mail: wolanin@earthlink.net. President/CEO: Vincent M. Wolanin. Estab. 1973. Produces albums, CDs, CD-ROMs, tour merchandise, cassettes: pop, progressive, R&B, rock, soul by solo artists and groups. Recent releases: "Angry Room," by Lyndal's Burning and "Lingerie," by Natalia.

Needs: Produces 6-8 releases/year. Works with 3-6 freelancers/year. Prefers designers who own IBM computers. Uses freelancers for album cover design and illustration; animation; cassette cover deisgn and illustration; CD booklet design and illustration; CD cover design and illustration; CD-ROM design and packaging; poster design; web page design. Also for outside entertainment projects like Superbowl related events. 90% of design and illustration demands knowledge of Aldus PageMaker, Adobe Illustrator, QuarkXPress, Adobe Photoshop, Aldus FreeHand, Corel.

First Contact & Terms: Send query letter with brochure, résumé, photostats, transparencies, photocopies, photographs, slides, SASE, tearsheets. Accepts disk submissions compatible with IBM. Samples are filed. Does not report back. Artist should contact again in 4-6 months. Request portfolio review in original query. Artist should follow-up with letter after initial query. Portfolio should include color, final art, photographs, slides, tearsheets. Pays for design and illustration by the project. Buys all rights.

Tips: "We look for new ways, new ideas, eye catchers—let me taste the great wine right away. Create great work and be bold. Don't get discouraged."

N **TOUCHE RECORDS CO.**, P.O. Box 96, El Cerrito CA 94530. (510)524-4937. Fax: (510)524-9577. Executive Vice President: James Bronson, Jr. Estab. 1955. Produces CDs, tapes and LPs: jazz, soul, R&B and rap. Recent releases: *Happiness Is Takin Care Of Natural Business*, by 'Al' Tanner.

Needs: Produces 1-10 solo artists/year. Approached by 10 designers and 6 illustrators/year. Works with 3 designers and 1 illustrator/year. Works on assignment only. Uses artists for CD cover design and illustration; tape cover illustration; brochure design and illustration; catalog design, illustration and layout; direct mail packages; advertising design and illustration; and posters.

First Contact & Terms: Send query letter with brochure, résumé, photocopies and tearsheets. Samples are filed. Reports back within 10 days. To show portfolio, mail portfolio of roughs. Pays for design by the project. Buys all rights.

Tips: "All artwork gets my attention."

TROPIKAL PRODUCTIONS/WORLD BEATNIK RECORDS, 516 Storrs St., Rockwall TX 75087. Phone/fax: (972)771-3797. E-mail: tropikalproductions@juno.com. Website: http://www.mammothartists.com/watusi. Contact: Ana Towry. Estab. 1981. Produces albums, CDs, cassettes: gospel, jazz, pop, R&B, rap, rock, soul, and reggae/worldbeat. Recent releases: *Cool Runner*; *Alive Montage*; *The Island*, all by Watusi.

Needs: Produces 5-10 releases/year. Works with 5-10 freelancers/year. Prefers freelancers with experience in CD/album covers, animation and photography. Uses freelancers for CD cover design and illustration; animation; cassette cover design and illustration; CD booklet design and illustration; CD cover design and illustration; poster design. 50% of freelance work demands knowledge of Adobe Illustrator, Adobe Photoshop.

First Contact & Terms: Send postcard or query letter with brochure, résumé, photostats, photocopies, photographs, tearsheets. Accepts Mac or IBM-compatible disk submissions. Send EPS files. "No X-rated material please." Samples are filed or returned by SASE if requested by artist. Reports back within 15 days. Will contact for portfolio review of b&w, color, final art, photocopies, photographs, roughs if interested. Pays by the project; negotiable. Rights purchased vary according to project; negotiable. Finds artists through referrals, submissions.

Tips: "Show versatility; create theme connection to music."

N **TRUE NORTH RECORDS/FINKELSTEIN MANAGEMENT CO. LTD.**, Suite 501, 151 John St., Toronto, Ontario M5V 2T2 Canada. (416)596-8696. Fax: (416)596-6861. E-mail: truenorthrecords@inforamp.net. Contact: Alana Ruoso. Estab. 1969. Produces CDs, tapes and albums: rock and roll, folk and pop; solo and group artists. Recent releases: *The Charity of Night*, by Bruce Cockburn; *Industrial Lullaby*, by Stephen Fearing; *High or Hurtin*, by Blackie and the Rodeo Kings; and *Raggle Taggle*, by John Bottomley.

Needs: Produces 2 soloist and 2 groups/year. Works with 4 designers and 1 illustrator/year. Prefers artists with experience in album cover design. Uses artists for CD cover design and illustration, album/tape cover design and illustration, posters and photography. 50% of freelance work demands computer skills.

First Contact & Terms: Send postcard sample, brochure, résumé, photocopies, photographs, slides, transparencies

with SASE. Samples are filed or are returned by SASE if requested by artist. Reports only if interested. Pays by the project. Buys all rights.

28 RECORDS, 19700 NW 86 Court, Miami FL 33015. (305)829-8142. Fax: (305)829-8142. E-mail: rec28@aol.com. President/CEO: Eric Diaz. Estab. 1994. Produces CDs: pop, rock, alternative, metal, punk by solo artists and groups. Recent releases: "Near Life Experience," by Eric Knight and *Julian Day*, by Hell Town's Infamous Vandal.
Needs: Produces 4 releases/year. Works with 2 freelancers/year. Prefers designers who own Macs. Uses freelancers for CD booklet design and illustration; CD cover design and illustration; poster design, web page design. 80% of freelance work demands knowledge of QuarkXPress, Adobe Photoshop.
First Contact & Terms: Send query letter with résumé, photocopies. Samples are filed and not returned. Reports back to the artist only if interested. Artist should follow-up with call and/or letter after initial query. Pays by the project, $300-700. Buys all rights. Finds artists through word of mouth.
Tips: "Get out there and sell yourself. Get multiple portfolios out there to everyone you can." Looks for cutting edge and original design.

VAN RICHTER RECORDS, 100 S. Sunrise Way, Suite 219, Palm Springs CA 92262. (760)320-5577. Fax: (760)320-4474. E-mail: vrichter@netcom.com. Website: http://vr.dv8.net. Label Manager: Paul Abramson. Estab. 1993. Produces CDs: rock, industrial. Recent releases: *MMMYAOOOO*, by Testify; *Nachtstrom*, by Sielwolf; *Crack The Mind*, by Testify.
Needs: Produces 3-4 releases/year. Works with 2-3 freelancers/year. Prefers freelancers with experience in production design. Uses freelancers for CD booklet design and illustration; CD cover design and illustration; posters/pop. 100% of freelance work demands knowledge of Adobe Illustrator, QuarkXPress, Adobe Photoshop.
First Contact & Terms: Send postcard sample or query letter with brochure, tearsheets, photographs, print samples. Accepts Mac-compatible disk submissions. Samples are not filed and are returned by SASE if requested by artist. Will contact artist for portfolio review of final art if interested. Payment negotiable. Buys all rights. Finds artists through World Wide Web and submissions.
Tips: "You may have to work for free until you prove yourself/make a name."

V2 RECORDS, 14 E. Fourth, Suite 3, New York NY 10012. (212)320-8588. Fax: (212)320-8600. E-mail: davidcalderley@v2music. Head of Design: David Calerley. Estab. 1996. Produces albums, CDs, cassettes: pop, progressive, R&B, rap, rock, soul, hip hop and dance by solo artists and groups. Recent releases: *N'Dea Davenport*; *RZA as Bobby Digital*, *Shovel*, by Gravedigger; *Word Gets Around*, by Stereophonics.
Needs: Produces 15 releases/year. Works with 3 freelancers/year. Prefers local designers with experience in music packaging and typography who own Macs. Uses freelancers for album cover design and illustration; CD booklet design and illustration; CD cover design and illustration and poster design. 100% of freelance design and 50% of illustration demands knowledge of Adobe Illustrator, QuarkXPress, Adobe Photoshop, Strata, 3D.
First Contact & Terms: Send postcard sample or query letter with brochure and tearsheets. Samples are returned by SASE if requested by artist. Reports back within 4 days if interested. Request portfolio review of photographs, roughs and tearsheets in original query. Pays for design by the project, $75-7,000; pays for illustration by the project, $200-2,000. Buys all rights. Finds artists through submissions, sourcebooks, magazines, Web, artists' reps.
Tips: "Some CD-ROMs are starting to appear as samples. It can be irritating to stop work to load in a portfolio. Show as near to what is final (i.e. real print) as possible—create own briefs if necessary. We look for originality, playfullness and confidence."

WARNER BROS. RECORDS, 3300 Warner Blvd., Burbank CA 91505. (818)953-3361. Fax: (818)953-3232. Art Dept. Assistant: Michelle Barish. Produces the artwork for CDs, tapes and sometimes albums: rock, jazz, hip hop, alternative, rap, R&B, soul, pop, folk, country/western by solo and group artists. Releases include: *This Fire*, by Paula Cole; and *Jagged Little Pill*, by Alanis Morrissette. Releases approximately 300 total packages/year.
Needs: Works with freelance art directors, designers, photographers and illustrators on assignment only. Uses freelancers for CD and album tape cover design and illustration; brochure design and illustration; catalog design, illustration and layout; advertising design and illustration; and posters. 100% of freelance work demands knowledge of QuarkXPress, Aldus FreeHand, Adobe Illustrator or Adobe Photoshop.
First Contact & Terms: Send query letter with brochure, tearsheets, résumé, slides and photographs. Samples are filed or are returned by SASE if requested by artist. Reports back to the artist only if interested. Submissions should include roughs, printed samples and b&w and color tearsheets, photographs, slides and transparencies. "Any of these are acceptable." Do not submit original artwork. Pays by the project.
Tips: "Send a portfolio—we tend to use artists or illustrators with distinct/stylized work—rarely do we call on the illustrators to render likenesses; more often we are looking for someone with a conceptual or humorous approach."

WATCHESGRO MUSIC, BMI—INTERSTATE 40 RECORDS, 9208 Spruce Mountain Way, Las Vegas NV 89134. (702)363-8506. President: Eddie Lee Carr. Estab. 1975. Produces CDs, tapes and albums: rock, country/western and country rock. Releases include: *Princess Fatima*; *Oz, All At Once We Were Old*; and *Heaven's in a Hell of a Mood*.
 ● Watchesgro Music has placed songs in five feature films: *Mafia*, *Out of Sight*, *Slums of Beverly Hills*, *Rush House* and *There's Something About Mary*.
Needs: Produces 8 solo artists/year. Works with 3 freelancers/year for CD/album/tape cover design and illustration; and videos.

Spelunkers
demand your annual rent

Artwork ©Tim Bradstreet

Artist Tim Bradstreet was going for a suave, James-Bond type feel with this album cover for Waterdog Records recording artists Spelunkers. While he usually charges $1,000-1,500 for an illustration, Bradstreet did this one for free since he's been friends with the band for years. He doesn't work with an agent, but has kept his work in demand for the past ten years through tireless self-promotion. "If you know you have a talent, a hunger," Bradstreet says, "what's important is that you keep working because you're only going to get better."

First Contact & Terms: Send query letter with photographs. Samples are filed or are returned by SASE. Reports back within 1 week only if interested. To show portfolio, mail b&w samples. Pays by the project. Negotiates rights purchased.

☑ **WATERDOG/WHITEHOUSE/ABSOLUTE RECORDS**, 329 W. 18th St., #313, Chicago IL 60616-1120. (312)421-7499. E-mail: wthouse@housedog.com. Website: http://www.housedog.com. Label Manager: Rob Gillis. Estab. 1991. Produces CDs: folk, pop, progressive, rock, spoken word by solo artists and groups. Recent releases: *Demand Your Annual Rent*, by Spelunkers; *Ever Since Ever*, by Middle 8.
Needs: Produces 3-4 releases/year. Works with 2-3 freelancers/year. Prefers local freelancers with experience in CD design who own Macs. Uses freelancers for album cover design and illustration; CD booklet design and illustration; CD cover design and illustration; poster design. 100% of design and 50% of illustration demands knowledge of QuarkXPress.
First Contact & Terms: Send postcard sample or query letter with brochure, résumé. Samples are not filed. Portfolio review not required. Pays by the project. Buys all rights. Finds artists through referrals.

WIND-UP ENTERTAINMENT, 72 Madison Ave., 8th Floor, New York NY 10016. (212)251-9665. Fax: (212)251-0779. E-mail: mdroescher@wind-up.com. Website: http://www.wind-up.com. Creative Director: Mark Droescher. Estab. 1997. Produces CDs, cassettes, music videos and TV commercials: pop, R&B, rock by solo artists and groups. Recent releases: *My Own Prison*, by Creed; *You and I*, by Teddy Pendergrass; *Tip*, by Finger Eleven; *I'd Rather Have Love*, by Teddy Pendergrass.

Needs: Produces 8 releases/year. Works with 8-10 freelancers/year. Prefers local freelancers who own Macs. Uses freelancers for album cover design and illustration; cassette cover design and illustration; CD booklet design and illustration; CD cover design and illustration; poster design and web page design. 100% of design and 50% of illustration demands knowledge of QuarkXPress 3.3 or 4, Adobe Photoshop 4.

First Contact & Terms: Send query letter with brochure, résumé, photostats, transparencies, photocopies, photographs, slides, SASE, tearsheets. Accepts disk submissions compatible with Mac. Samples are filed or returned by SASE if requested by artist. Will contact artist for portfolio review if interested. Pays for design by the hour, $25-50. Finds artists through word of mouth, magazines, reps, directories.

Tips: "Work should be as personal as possible."

☑ **WORD ENTERTAINMENT INC.,** 25 Music Square West, Nashville TN 37203. (615)457-2077. Fax: (615)457-2099. E-mail: mlee@wordentertainment.com. Art Director: Beth Lee. Produces albums, CDs, CD-ROMs, cassettes, videotapes: classical, gospel, pop, progressive, R&B, rock by solo artists and groups. Recent releases: *Anybody Out There*, by Burlap To Cashmere; and *The Jesus Record*, by Rich Mullins and a Ragamuffin Band.

Needs: Produces 80 releases/year. Works with lots of freelancers/year. Prefers designers who own Macs with experience in the music industry. Uses freelancers for album cover design and illustration; cassette cover design and illustration; CD booklet design and illustration; CD cover design and illustration. 100% of freelance design demands knowledge of QuarkXPress (current), Adobe Photoshop (current).

First Contact & Terms: Send postcard sample of work. Send query letter with appropriate samples. Samples are filed. Reports back to the artist only if interested. Will contact artist for portfolio review if interested. Pays by the project. Buys all rights. Finds artists through wide net of local artists and people who call us.

Tips: "Know the market, stay appropriate but new."

XICAT INTERACTIVE GAMES & SOFTWARE PUBLISHERS/X:TREME RECORDS INC. UK & USA, (formerly Advance Cybertech Enterprises & X:treme Records, Inc.), 800 E. Broward, Suite 700, Ft. Lauderdale FL 33301. (954)522-3900. Fax: (954)522-0280. E-mail: mlabate@xicat.com. Website: http://www.xicat.com. Art Director: Michael Labate. Estab. 1990. Produces CDs, CD-ROMs, cassettes, software games. Produces compilations, techno, New Age by solo artists and groups. Recent releases: *Fresh Summer Mix, Absolute Dance Mix, Genre, Chillout Forever*.

Needs: Produces 50 releases/year. Works with 7 freelancers/year. Prefers local freelancers who own Mac/IBM computers with experience in 3-D animation, modeling, TV, radio, design. "Interns are welcome as well." Uses freelancers for album cover design and illustration; animation; cassette cover design and illustration; CD booklet design and illustration; CD cover design and illustration; CD-ROM design and packaging; poster design; web page design and packaging design for software i.e. game boxes. 90% of freelance design and 10% of illustration demands knowledge of Adobe Illustrator, QuarkXPress, Adobe Photoshop, Aldus FreeHand, 3D Studio Max, Light Wave or Adobe Premier.

First Contact & Terms: Send or e-mail postcard sample and/or query letter with résumé. Accepts disk submissions in IBM format (Zip, 3.5″, CD). Samples are filed. Reports back within 30 days. Will contact for portfolio review if interested. Portfolio should include b&w, color, final art, slides, thumbnails, transparencies or CD-ROM. Pays by the hour, $100-150 depending on complexity. Buys all rights. Finds artists through local art college like International Fine Arts College in Miami.

Tips: "Don't stop; continue networking yourself, your ideas. Don't take no for an answer! I look for flawless work, with a not so conservative style. Prefer wild, flashy, distorted, fun designs."

Resources

Artists' Reps

Many artists find leaving promotion to a rep allows them more time for the creative process. In exchange for actively promoting an artist's career, the representative receives a percentage of sales (usually 25-30%). Reps concentrate on either the commercial or fine art markets, rarely both. Very few reps handle designers.

Two types of reps

☑ **Fine art reps** promote the work of fine artists, sculptors, craftspeople and fine art photographers to galleries, museums, corporate art collectors, interior designers and art publishers.

☑ **Commercial reps** help illustrators obtain assignments from advertising agencies, publishers, magazines and other art buyers.

What they do

☑ Work with you to bring your portfolio up-to-speed.

☑ Recommend advertising in one of the many creative directories such as *American Showcase* or *Creative Illustration* so that your work will be seen by hundreds of art directors. (Expect to make an initial investment in costs for duplicate portfolios and mailings).

☑ Negotiate contracts, handle billing and collect payments.

Getting representation isn't as easy as you might think. Reps are choosy about who they represent, not just in terms of talent, but in terms of marketability and professionalism. A rep will only take on talent she knows will sell.

WHAT TO SEND

Once you've narrowed down a few choices, contact them with a brief query letter and direct mail piece. If you do not have a flier or brochure, send photocopies or (duplicate) slides along with a self-addressed, stamped envelope. Check the listings for specific information.

I **For More Information**
The Society of Photographers and Artists Representatives (SPAR) is an organization for professional representatives. SPAR members are required to maintain certain standards and follow a code of ethics. For more information, write to SPAR, 60 E. 42nd St., Suite 1166, New York NY 10165, phone (212)779-7464.

insider report

Win national assignments with consistent style and savvy agent

If you have a proven track record as an illustrator and dream of working in the lucrative national arena, you may benefit from working with an agent.

Ceci Bartels Associates, headquartered in St. Louis with offices in New York and Chicago, is an artist's representative firm that works nationally with such high-profile accounts as Hasbro, Celestial Seasonings, Anheuser Busch, The Children's Workshop and Pepsi.

The 40 artists the firm handles live all over the country. The agency solicits work from advertising and sales promotion agencies, publishing companies and corporations across the country. Through target marketing and advertising, CBA seeks assignments for its artists while simultaneously working to satisfy the needs of their clients in the marketplace.

Ceci Bartels

With over 20 years in the industry, Bartels is in a good position to observe, and respond to, industry trends. She's noticed that buyers of art have become increasingly strapped for time and are turning to artist's representatives as a means of viewing prequalifed quality work. A relationship with a respectable agent offers art buyers a wide variety of styles and techniques with one call.

"Agents have to spend their time profitably to stay in business so they become very sensitive to what is 'representable work' for the marketplace," Bartels says. "They can't afford to represent people that don't deliver consistently in a professional manner with a professional attitude. The art buyer benefits by receiving greater assurance that what they commissioned will be even better than they expected." Bartels remembers being in an art director's office when he turned to her and said, "I like working with agents because when I work with an agent there are two careers on the line with me, not just one!"

Illustrators who want to work in the national arena need to be willing to market a consistent style or technique because it may take a long time for the marketplace to acknowledge it. "Decades ago, an illustrator expressed whatever needed to be expressed in whatever medium or technique was required, and to some extent that still applies in their local market. However, in re-

CECI BARTELS

Firm: Ceci Bartels Associates
Offices: St. Louis, New York, Chicago

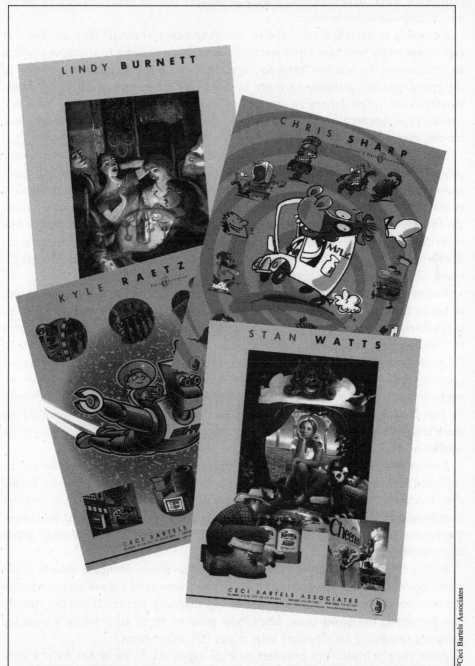

One of the big advantages of working with an agency like Ceci Bartels Associates is that your samples can be published as part of a dynamic group promotion. The work of Lindy Burnett, Chris Sharp, Kyle Raetz and Stan Watts, just four of the artists Bartels represents, are pictured here.

cent years, artists have sought to specialize because the market requires they deliver a specific, purchasable product."

According to Bartels, if you hope to join an agency, you should seek out one that represents artists who have styles and techniques that are similar to yours, or projects an attitude you like and can relate to. "If you can relate to the 'visual personality' of the group, you will probably be more likely to succeed in that group." You should also try to determine if there's a specific market category or strength being presented overall, (i.e., editorial or advertising work) and decide if your work is appropriate for that category."

Bartels acknowledges that joining an agency that represents artists with similar genres or techniques may run contrary to most artist's grain but in reality if an agent and a group become successful in a certain arena, they attract more and more business in that arena. "No two artists are the same, which you find out very quickly when the finished assignments are presented to you. An agent quickly recognizes that one artist does a better job of handling a particular subject matter and that another artist does a better job of handling the energy level or desired color palette for the assignment, or whatever the hot buttons are in the mind of the art director."

Bartels adds, "An artist's unique abilities ultimately make him or her the right choice to handle the assignment for all the right reasons." Because her clients rely on her to come through with excellent work on a consistent basis, Bartels says it's only prudent to have several artists to work with for popular illustration styles and techniques. "If I'm getting opportunities for work because art buyers know my group can solve their problems," she says, "I don't want to say, 'I'm sorry we can't do your assignment, because that artist is already busy.' If I spot a market niche which has the potential for high volume over time, I'm going to make sure I have somebody who can do the work and someone who can back them up. And if I get enough work, I'm going to be sure I have back-up for the back-ups."

One of the big advantages of working with an agent is that your samples can be published as part of a group promotion. Group promotions tend to have more impact than any one individual, says Bartels. "It's very expensive for independent illustrators to achieve that same level of awareness on their own." Bartels points out because of the volume of their buys from printers, agents receive discounts individual artists don't qualify for.

Bartels tries to do whatever she can to help her group dominate visually in the marketplace. This year the group presented itself with vivid yellow backgrounds in the sourcebooks and tied the color theme together with postcards and the website also presenting the background. She's even gone so far as to produce a postcard campaign requesting art directors turn to the *CBA Yellow Pages*.

Advertising provides the broadest base of exposure. Some artists have a well-articulated technique or a style so unique they need a broad-based exposure just to support it. In those cases, Bartels recommends the artist should definitely be doing sourcebooks with an agent.

Agents can also be helpful with producing targeted direct mail campaigns. "Most agents have a strong sense of what market niches an artist is best qualified for," she says. "More often our problems are related to convincing artists that repetition in a direct mail campaign is important and that the postage is the most expensive part of any campaign. You simply can't afford to send out to even a fraction of the art directors the sourcebooks reach, but you should plan for a quantity large enough to anticipate at least a one or two percent return."

Agents are also extremely helpful at working with you to develop the most appropriate image for your target audience. They can assist you in advancing the design of your promotional pieces. Bartels says many agents have added websites to their arsenal of marketing devices.

Bartels is always willing to look at portfolios (provided they come with a SASE if they want a reply or anything returned) and has even represented one person straight out of art school. However, if she doesn't believe that an artist will have a good chance of being successful in her group, she will suggest they look for a better fit . "Don't get me wrong," she says, "we don't try to limit ourselves to an extremely narrow market niche and we thrive on new, but after so many years of showing work you develop a sixth sense about what you think you can market. A rejection from my agency shouldn't be viewed as a statement about an artist's talent or ability, it's really about how I think my agency may or may not be able to succeed with that particular illustrator's skills or vision.

"I really love coming to an understanding of the fine points of an artist's work," Bartels says. "Illustrators are such a unique and wonderful group. They are blessed with so much talent, skill and imagination. I truly believe that the finest art being done in the world today is being done by illustrators. I love work with energy and work that embraces contemporary sensibilities."

—*Poppy Evans*

ADMINISTRATIVE ARTS, INC., P.O. Box 547935, Orlando FL 32854-1266. (407)849-9744. E-mail: mangoarts@worldnet.att.net. President: Brenda B. Harris. Fine art advisor. Estab. 1983. Registry includes 1,000+ fine artists (includes fine art crafts). Markets include: architects; corporate collections; developers; private collections; public art.
 • The software division of this company develops and distributes software, Mango Arts Management System™, for artists, art organizations, consultants and advisors that focus on project and inventory management, marketing (for artists), presentation development and registry management. The advisory division assists corporations with art acquisitions. They analyze artistic growth, experience record and conduct an interview with the artist to determine the artist's professional management skills in order to advise artists on career growth.
Handles: Fine art. "We prefer artists with established regional and national credentials. We also review and encourage emerging talent."
Terms: "Trade discount requested varies from 15-50% depending on project and medium. "
How to Contact: "For first contact, submissions must include: 1) complete résumé; 2) artist's statement or brief profile; 3) labeled slides (artist's name, title of work, date, medium, image size and *retail price*); 4) availability of works submitted. E-mail contact also acceptable." SASE. Reports in 1-4 weeks.
Tips: "Artists are generally referred by their business or art agent, another artist or art professional, educators, or art editors who know our firm. A good impression starts with a cover letter and a well organized, typed résumé. *Always place your name and slide identification on each slide*. Make sure that slides are good representations of your work. Know your retail and net pricing and the standard industry discounts. Invite the art professional to visit your studio. To get placements, be cooperative in getting art to the art professional when and where it's needed."

ANNE ALBRECHT AND ASSOCIATES, 405 N. Wabash, Suite 4410, Chicago IL 60611. E-mail: aaartagent@aol.c om. Agent: Anne Albrecht. Commercial illustration, photography representative. Estab. 1991. Member of Chicago Artist Representatives. Represents 7 illustrators, 3 photographers. Markets include advertising agencies, corporations/client direct, design firms, editorial/magazines.
Handles: Illustration, photography.
Terms: Rep receives 25% commission. Exclusive area representation is required. For promotional purposes, talent must provide a presentation portfolio and advertise in a national sourcebook. Advertises in *American Showcase*, *The Workbook*.
How to Contact: For first contact, send direct mail flier/brochure, tearsheets. Reports back within 2 days if interested. After initial contact, drop off or mail in appropriate materials. Portfolio should include tearsheets, slides, photographs.
Tips: Looks for artists who are "motivated, easy to work with, and have great and unique portfolios."

ALBRECHT & JENNINGS ART ENTERPRISES, 3546 Woodland Trail, Williamsburg MI 49690. (616)938-2163. E-mail: tctomkaren@aol.com. Contact: Tom Albrecht. Fine art representative. Estab. 1991. Represents 60 fine artists (includes 15 sculptors). Staff includes Tom Albrecht, Karen Jennings. Specializes in Michigan and Midwest art, especially by emerging artists. Markets include: corporate collections; private collections.
Handles: Fine art.
Terms: Agent receives 40% commission. Advertising costs are paid by representative. For promotional purposes, talent must provide slides and photographs of artwork, and up-to-date résumés.
How to Contact: For first contact, send query letter, résumé, bio, slides, photographs and SASE. Reports in 2 weeks. After initial contact, call for appointment to show portfolio of slides and photographs. Obtains talent "by referral from other artists, looking at galleries, and solicitation."

☑ **FRANCE ALINE ASSOCIATES**, 7507 Sunset Blvd., Suite 10, Hollywood CA 90046. (323)933-2500. E-mail: francealine@aol.com. Owner: France Aline. Commercial illustration, photography and graphic design representative. Represents illustrators, photographers, designers. Specializes in advertising. Markets include: advertising, corporations, design firms, movie studios, record companies. Artists include: Jim Krantz, Lendon Flanagan, Grove Pashley, Jill Sabella, Bruce Wolfe, Craig Mullins and Ezra Tucker.
Handles: Illustration, photography.
Terms: Rep receives 25% commission. Exclusive area representation is required. Advertises in *American Showcase*, *The Workbook*.
How to Contact: For first contact, send tearsheets. Reports back within a few days. Mail in appropriate materials. Portfolio should include tearsheets, photographs.
Tips: "Send promotions. No fashion."

AMERICAN ARTISTS, REP. INC., 353 W. 53rd St., #1W, New York NY 10019. (212)582-0023. Fax: (212)582-0090. E-mail: amerart@aol.com. Commercial illustration representative. Estab. 1930. Member of SPAR. Represents 40 illustrators. Markets include: advertising agencies; corporations/client direct; design firms; editorial/magazines; paper products/greeting cards; publishing/books; sales/promotion firms.
Handles: Illustration, design.
Terms: Rep receives 30% commission. "All portfolio expenses billed to artist." Advertising costs are split: 70% paid by talent; 30% paid by representative. "Promotion is encouraged; portfolio must be presented in a professional manner—8×10, 4×5, tearsheets, etc." Advertises in *American Showcase*, *Black Book*, *RSVP*, *The Workbook*, medical and Graphic Artist Guild publications.
How to Contact: For first contact, send query letter, direct mail flier/brochure, tearsheets. Reports in 1 week if interested. After initial contact, drop off or mail appropriate materials for review. Portfolio should include tearsheets, slides.
Tips: Obtains new talent through recommendations from others, solicitation, conferences.

JACK ARNOLD FINE ART, 5 E. 67th St., New York NY 10021. (212)249-7218. Fax: (212)249-7232. E-mail: jackald@idt.net. Contact: Jack Arnold. Fine art representative. Estab. 1979. Represents 15 fine artists. Specializes in contemporary graphics and paintings. Markets include: galleries; museums; private collections; corporate collections.
Handles: Looking for contemporary impressionists and realists.
Terms: Agent receives 50% commission. Exclusive area representation preferred. No geographic restrictions. To be considered, talent must provide color prints or slides.
How to Contact: For first contact, send bio, photographs, retail prices and SASE. Reports in days. After initial contact, drop off or mail in portfolios of slides, photographs.
Tips: Obtains new talent through referrals.

N ART EMOTION CORP., P.O. Box 8121, Rolling Meadows IL 60008. (847)397-9300. Fax: (847)397-9306. E-mail: gperez@artcom.com. Website: http://www.artcom/artemo/. Contact: Gerard V. Perez. Estab. 1977. Represents 45 fine artists. Specializes in "selling to art galleries." Markets include: corporate collections; galleries; interior decorators.
Handles: Fine art.
Terms: "We buy for resale." Exclusive area representation is required. For promotional purposes talent must provide slides, color prints, "any visuals." Advertises in *Art News*, *Decor*, *Art Business News*.

How to Contact: For first contact, send tearsheets, slides, photographs and SASE. Reports in 1 month, only if interested. "Don't call us—if interested, we will call you." Portfolio should include slides, photographs.

ART SOURCE L.A., INC., 11901 Santa Monica Blvd., Suite 555, Los Angeles CA 90025. (310)479-6649. Fax: (310)479-3400. E-mail: ellmanart@aol.com. Website: http://www.artsourcela.com. Contact: Francine Ellman. Fine art representative. Estab. 1980. Represents artists in all media in fine art and accessories. Specializes in fine art consulting and curating worldwide. Markets include: architects; corporate collections; developers; hospitality public space; interior designers; private collections and government projects.
- Art Source has an additional office in Washington, D.C. Contact L.A. office for more information.

Handles: Fine art in all media, including a broad array of accessories handmade by American artists.

Terms: Agent receives commission, amount varies. Exclusive area representation required in some cases. No geographic restrictions. "We request artists submit a minimum of 12 slides/visuals, résumé and SASE." Advertises in *Art News*, *Artscene*, *Art in America*, *Blue Book*, *Gallery Guide*, *Art Diary*, *Art & Auction*, *Guild*, and *Internet*.

How to Contact: For first contact, send résumé, bio, slides or photographs and SASE. Reports in 1-2 months. After initial contact, "we will call to schedule an appointment" to show portfolio of original art, slides, photographs. Obtains new talent through recommendations, artists' submissions and exhibitions.

Tips: "Be professional when submitting visuals. Remember—first impressions can be critical! Have a body of work that is consistent and of the highest quality. Work should be in excellent condition and already photographed for your records. Framing does not enhance the presentation to a dealer."

N: ARTCO INCORPORATED, 3148 RFD Cuba Rd., Long Grove IL 60047-9606. (847)438-8420. Fax: (847)438-6464. Contact: Sybil Tillman. Fine art representative. Estab. 1970. Member of International Society of Appraisers and Appraisers Association of America Inc. Represents 60 fine artists. Specializes in contemporary artists' originals and limited edition graphics. Markets include: architects; art publishers; corporate collections; galleries; private collections.

Handles: Fine art.

Terms: "Each commission is determined mutually. For promotional purposes, I would like to see original work or transparencies." No geographic restrictions. Advertises in newspapers, magazine, etc.

How to Contact: For first contact, send query letter, résumé, bio, slides, SASE, photographs or transparencies. After initial contact, call for appointment to show portfolio of original art, slides, photographs. Obtains new talent through recommendations from others, solicitation, conferences, advertising.

ARTISAN CREATIVE, INC., 1950 S. Sawtelle Blvd., Suite 320, Los Angeles CA 90025. (310)312-2062. Fax: (310)312-0670. E-mail: info@cre8art.com. Website: http://www.cre8art.com. Creative Recruiter: Christine Roth. Estab. 1996. Represents creative directors, art directors, graphic designers, illustrators, animators (3D and 2D), storyboarders, packaging designers, photographers, web designers, broadcast designers and multimedia designers. Markets include: advertising agencies, corporations/client direct, design firms, entertainment industry.
- Artisan Creative has a second location at 850 Montgomery, Suite C-50, San Francisco CA 94133. (415)362-2699. Fax: (415)362-2698. Contact: Renee Gellatly.

Handles: Design web, multimedia, illustration, photography and production. Looking for web, packaging, traditional and multimedia-based graphic designers.

Terms: 100% of advertising costs paid by the representative. For promotional purposes, talent must provide 8½ × 11 color photocopies in a mini-portfolio and six samples scanned on disk. Advertises in magazines for the trade, direct mail and the internet.

How to Contact: For first contact, send/fax résumé to Creataive Staffing Department. "You will then be contacted regarding if a portfolio review is needed." Portfolio should include roughs, tearsheets, photographs, or color photos of your best work.

Tips: "Have at least two years working experience and a great portfolio."

N: ARTIST DEVELOPMENT GROUP, 21 Emmett St., Suite 2, Providence RI 02903-4503. (401)521-5774. Fax: (401)521-5176. Contact: Rita Campbell. Represents photography, fine art, graphic design, as well as performing talent to advertising agencies, corporate clients/direct. Staff includes Rita Campbell. Estab. 1982. Member of Rhode Island Women's Advertising Club, NE Collaborative of Artist's Representatives. Co-Op America; Mass Land Trust. Markets include: advertising agencies; corporations/client direct. Clients include Hasbro, Etonic, Puma, Tretorn, Federal Computer Week. Client list available upon request.

Handles: Illustration, photography.

Terms: Rep receives 20-25% commission. Advertising costs are split: 50% paid by talent; 50% paid by representative. For promotional purposes, talent must provide direct mail promotional piece; samples in book for sales meetings.

How to Contact: For first contact, send résumé, bio, direct mail flier/brochure. Will respond if interested. Portfolios should include tearsheets, photographs. Obtains new talent through "referrals as well as inquiries from talent exposed to agency promo."

ARTISTS' EXHIBITION, sponsored by Traditional Fine Arts Online, Inc., (formerly Traditional Fine Arts Online, Inc.), 8502 E. Chapman, Suite 392, Orange CA 92869. (714)997-8500. Fax: (714)997-0937. E-mail: ae@tfaoi.com. Website: http://www.tfaoi.com/catalog.htm. President: John Hazeltine. Fine art representative. "Artist Exhibition's focus is on art works by established and nationally recognized American artists. Artist exhibition provides wide selection and

convenience to purchasers of American representational art and service to those who wish to sell their art." Estab. 1996. Represents 40 representational, objective artists (includes 2 sculptors). Artist guidelines available on website. Specializes in American representational paintings and sculpture. Markets include architects, interior designers, museums, corporate and private collectors. Artists include: G. Baker, G. Benes, B. Buer, P. Collins, J. Ellison, T. Enman, D. Jenks, H. Khorasani, J. Kilb, F. LaLumia, B. Mahieu, C. Nissen, M. Patnode, J. Pike, M. Raffaele-Vergori, T. Ragir, R. Scherbarth, L. Snith, R. Sussex and G. Tognoni.
Handles: Fine art valued over $3,000.
Terms: Agent receives 0-10% commission for US sales (sliding scale). Exclusive representation not required. Advertises nationally.
How to Contact: Print agreement from website and send with slides, photos and SASE.

ARTISTS INTERNATIONAL, 320 Bee Brook Rd., Washington CT 06777-1911. (860)868-1011. Fax: (860)868-1272. E-mail: artsintl@javanet.com. Contact: Michael Brodie. Commercial illustration representative. Estab. 1970. Represents 20 illustrators. Specializes in children's books. Markets include: design firms; editorial/magazines; licensing. Artists include: Jane Maday, John Lund, Barbara Lanla, Peter Barrett, Richard Walz and Kathy Mitchell.
Handles: Illustration.
Terms: Rep receives 30% commission. No geographic restrictions. Advertising costs are split: 70% paid by talent; 30% paid by representative. "We have our own full-color brochure, 24 pages, and featured in *Picture Book '97*."
How to Contact: For first contact, send slides, photocopies and SASE. Reports in 1 week.
Tips: Obtains new talent through recommendations from others, solicitation, conferences, *Literary Market Place*, etc. "SAE with example of your work; no résumés please."

ARTREPS, 20929 Ventura Blvd., Suite 47, Woodland Hills CA 91364. (818)992-4278. Fax: (818)992-6040. Art Director: Phoebe Batoni. Fine art representative. Estab. 1993. Represents fine artists. Specializes in getting artists published. Markets include: art publishers; corporate collections; galleries; interior decorators. Artists include: Barbara Cleary, Lili Maglione, Peter Colvine, Ann Christensen and Bill Vonderdaison.
 ● This agency attends Art Expo New York and Art Expo Los Angeles to promote its clients.
Handles: Fine art.
Terms: Handled on a individual basis. For promotional purposes, talent must provide adequte materials.
How to Contact: For first contact, send query letter with résumé, bio, either direct mail flier/brochure, tearsheets, slides, photographs, photocopies or photostats and SASE. Reports in 10 days.
Tips: "Looks for high quality, universally appealing fine art presented in a professional manner."

ARTVISIONS, 12117 SE 26th St., Suite 202A, Bellevue WA 98005-4118. E-mail: neilm@artvisions.com. Website: http://www.artvisions.com. Owner: Neil Miller. Estab. 1993. Markets include publishers, manufacturers and others who may require fine art.
Handles: Fine art licensing.
Terms: Rep receives 40% for licenses. "We produce highly targeted direct marketing programs focused on opportunities to license art. Fees for promotional materials vary for each artist, but are strictly cost reimbursement for time and materials with no profit added." Requires exclusive world-wide representation for licensing (the artist is free to market his work via other means).
How to Contact: Send slides/photos/tearsheets/brochures via mail, with SASE for return. ALWAYS label your materials. "We cannot respond to inquiries that do not include examples of your art. We do not see drop-ins. Unsolicited phone calls will not be returned."
Tips: "We do not buy art, we are a licensing agent for artists.. We derive our income from commissions, so, if you don't make money, neither do we. We are very careful about selecting artists for our service. Our way of doing business is very labor intensive and each artist's market plan is unique. Be prepared to invest in yourself."

Ⓝ ASCIUTTO ART REPS., INC., 1712 E. Butler Circle, Chandler AZ 85225. (602)899-0600. Fax: (602)899-3636. Contact: Mary Anne Asciutto. Children's illustration representative. Estab. 1980. Member of SPAR, Society of Illustrators. Represents 20 illustrators. Specializes in children's illustration for books, magazines, posters, packaging, etc. Markets include: publishing/packaging/advertising.
Handles: Illustration only.
Terms: Rep receives 25% commission. No geographic restrictions. Advertising costs are split: 75% paid by talent; 25% paid by representative. For promotional purposes, talent should provide "prints (color) or originals within an 8½×11 size format."
How to Contact: Send a direct mail flier/brochure, tearsheets, photocopies and SASE. Reports in 2 weeks. After initial contact, send appropriate materials if requested. Portfolio should include original art on paper, tearsheets, photocopies or color prints of most recent work. If accepted, materials will remain for assembly.
Tips: In obtaining representation "be sure to connect with an agent who handles the kind of accounts you (the artist) *want*."

Ⓝ ATELIER KIMBERLEY BOEGE, P.O. Box 7544, Phoenix AZ 85011-7544. Phone/fax: (602)265-4389. Owner: Kimberley Boege. Commercial illustration, photography representative. Estab. 1992. Represents 17 illustrators, 3 photographers. Markets include: advertising agencies, corporations/client direct, design firms, editorial/magazines. Artists

include: Robert Case, Jacques Barbey, Rick Gayle, Roberta Hancock, John Nelson, Kevin Cruff, Jim McDonald, John Lambert, Paul Janovsky, Matt Foster, Dale Verzaal, Kevin Short, Howard Post, Tracy Hill, Adair Payne and JoAnn Daley.

Handles: Illustration.

Terms: Rep receives 25% commission. Advertising costs are split: 75% paid by talent; 25% paid by representative. For promotional purposes, talent should provide 1-3 portfolios. Advertises in *The Workbook*, *Everest Guide* and *Showcase*.

How to Contact: For first contact, send query letter, tearsheets, photocopies. Reports back in 2 weeks. After initial contact, call to schedule an appointment for portfolio review. Portfolio should include 4×5 transparencies or laminated samples/printed pieces.

Tips: Wants artists with experience working in the freelance illustration/commercial illustration market.

CAROL BANCROFT & FRIENDS, 121 Dodgingtown Rd., P.O. Box 266, Bethel CT 06801. (203)748-4823. Fax: (203)748-4581. Owner: Carol Bancroft. Illustration representative for children's publishing. Estab. 1972. Member of SPAR, Society of Illustrators, Graphic Artists Guild. Represents 40 illustrators. Specializes in illustration for children's publishing—text and trade; any children's-related material. Clients include Scholastic, Houghton Mifflin, HarperCollins, Penguin, Viking. Client list available upon request.

Handles: Illustration for children of all ages. Seeking multicultural and fine artists.

Terms: Rep receives 25-30% commission. Advertising costs are split: 75% paid by talent; 25% paid by representative. For promotional purposes, talent must provide "laser copies (not slides), tearsheets, promo pieces, good color photocopies, etc.; 6 pieces or more is best; narrative scenes and children interacting." Advertises in *RSVP*, *Picture Book*.

How to Contact: For contact, "call for information or send samples and SASE." Reports in 1 month.

Tips: "We're looking for artists who can draw animals and people well. They need to show characters in an engaging way with action in situational settings. Must be able to take a character through a story."

[N] SAL BARRACCA ASSOC. INC., 381 Park Ave. S., New York NY 10016. (212)889-2400. Fax: (212)889-2698. Contact: Sal Barracca. Commercial illustration representative. Estab. 1988. Represents 23 illustrators. "90% of our assignments are book jackets." Markets include: advertising agencies; publishing/books. Artists include Alan Ayers, Donato, Rich Grote, Tim Jacobus, Roger Loveless, Hugo Di Pietro, Brad Clark and Cynthia Clark.

Handles: Illustration.

Terms: Rep receives 25% commission. Exclusive area representation is required. Advertising costs are split: 75% paid by talent; 25% paid by representative. For promotional purposes "portfolios must be 8×10 chromes that are matted. We can shoot original art to that format at a cost to the artist. We produce our own promotion and mail out once a year to over 16,000 art directors."

How to Contact: For first contact, send direct mail flier/brochure, tearsheets and SASE. Reports in 1 week; 1 day if interested. After initial contact, drop off or mail in appropriate materials for review. Portfolio should include tearsheets, slides.

Tips: "Make sure you have at least three years of working on your own so that you don't have any false expectations from an agent."

CECI BARTELS ASSOCIATES, 3284 Ivanhoe, St. Louis MO 63139. (314)781-7377. Fax: (314)781-8017. E-mail: ceci@cecibartelsassociates.com. Contact: Ceci Bartels. Commercial illustration and photography representative. Estab. 1980. Member of SPAR, Graphic Artists Guild, ASMP. Represents 40 illustrators, 3 photographers, 1 graphic designer and 3 digital imaging artists. Markets include: advertising agencies, corporations, design firms, publishing houses and firms, and sales/promotion firms.

Handles: Illustration, photography. "Illustrators capable of action with a positive (often realistic) orientation interest us as well as conceptual styles."

Terms: Rep receives 30% commission. Advertising costs are paid by talent. "We welcome 6 portfolios/artist. Artist is advised not to produce multiple portfolios or promotional materials until brought on." Advertises in *The Workbook*.

How to Contact: For first contact, send query letter, direct mail flier/brochure, tearsheets, slides, SASE or portfolio. Obtains new talent through recommendations from others; "I watch the annuals and publications."

Tips: "We are interested in artists who are committed intellectually and financially to the advancement of their careers nationally."

BERENDSEN & ASSOCIATES, INC., 2233 Kemper Lane, Cincinnati OH 45206. (513)861-1400. Fax: (513)861-6420. E-mail: bob@illustratorsrep.com. Website: http://www.illustratorsrep.com. President: Bob Berendsen. Commercial illustration, photography, artists' representative. Incorporated 1986. Represents 25 illustrators, 4 photographers. Specializes in "high-visibility consumer accounts." Markets include: advertising agencies; corporations/client direct; design firms; editorial/magazines; paper products/greeting cards; publishing/books; sales/promotion firms. Clients include Disney, CNN, Pentagram, F&W Publications. Client list available upon request. Artists include: Bruce Armstrong, David Chestnut, Jake Ellison, Bill Fox, Rocky Fuller, George Hardebeck, Marcia Hartsock, Daniel Krovatin, Mahammad Mansoor, Tom Marcotte, Thomas O. Miller, Garry Nichols, Frank Ordaz, Duff Orlemann, Jack Pennington, Dave Reed, Garry Richardson, Brent Riley, Ursula Roma, Robert Schuster, Fariba Shiadaz, Kevin Torline, Christina Wald, Dave Warren, Wendy Wassink Ackison, Misty Wheatley-Maxwell, Lee Wollery, Mike Bonilla, Darron Thompson, Mike Kreffel.

● This rep launched four websites: illustratorsrep.com, photographersrep.com, designersrep.com and stockartrep.

com. The fast-loading pages are easy for art directors to access—a great promotional tool for their talent.

Handles: Illustration, photography. "We are always looking for illustrators who can draw people, product and action well. Also, we look for styles that are metaphoric in content and it's a plus if the stock rights are available."

Terms: Rep receives 25% commission. Charges "mostly for postage but figures not available." No geographic restrictions. Advertising costs are split: 75% paid by talent; 25% paid by representative. For promotional purposes, "artist must co-op in our direct mail promotions, and sourcebooks are recommended. Portfolios are updated regularly." Advertises in *RSVP, Creative Illustration Book, Directory of Illustration* and *American Showcase*.

How to Contact: For first contact, send query letter, résumé, and any nonreturnable tearsheets, slides, photographs or photocopies. Follow up with a phone call.

Tips: Artists should have a "proven style with at least ten samples of that style."

BERNSTEIN & ANDRIULLI INC., 60 E. 42nd St., New York NY 10165. (212)682-1490. Fax: (212)286-1890. Website: artinfo@ba-reps.com or photoinfo@ba-reps.com. Contact: Sam Bernstein. Commercial illustration and photography representative. Estab. 1975. Member of SPAR. Represents 54 illustrators, 16 photographers. Staff includes Anthony Andriulli; Howard Bernstein; Sam Bernstein; Gregg Lhotsky; Melanie Spiegel; Molly Birenbaum; Ivy Glick; Fran Rosenfeld. Markets include: advertising agencies; corporations/client direct; design firms; editorial/magazines; paper products/greeting cards; publishing/books; sales/promotion firms.

Handles: Illustration and photography.

Terms: Rep receives a commission. Exclusive career representation is required. No geographic restrictions. Advertises in *American Showcase, Black Book, The Workbook, New York Gold, Bernstein & Andriulli International Illustration, CA Magazine, Archive*.

How to Contact: For first contact, send query letter, direct mail flier/brochure, tearsheets, slides, photographs, photocopies. Reports in 1 week. After initial contact, drop off or mail appropriate materials for review. Portfolio should include tearsheets, slides, photographs.

N SAM BRODY, ARTISTS & PHOTOGRAPHERS REPRESENTATIVE & CONSULTANT, 77 Winfield St., Apt. 4, E. Norwalk CT 06855-2138. Phone/fax: (203)854-0805 (for fax, add 999). Contact: Sam Brody. Commercial illustration and photography representative and broker. Estab. 1948. Member of SPAR. Represents 4 illustrators, 3 photographers, 2 designers. Markets include: advertising agencies; corporations/client direct; design firms; editorial/magazines; publishing/books; sales/promotion firms.

Handles: Illustration, photography, design, "great film directors."

Terms: Agent receives 30% commission. Exclusive area representation is required. For promotional purposes, talent must provide back-up advertising material, i.e., cards (reprints—*Workbook*, etc.) and self-promos.

How to Contact: For first contact, send bio, direct mail flier/brochure, tearsheets. Reports in 3 days or within 1 day if interested. After initial contact, call for appointment or drop off or mail in appropriate materials for review. Portfolio should include tearsheets, slides, photographs. Obtains new talent through recommendations from others, solicitation.

Tips: Considers "past performance for clients that I check with and whether I like the work performed."

N BROOKE & COMPANY, 4911 W. Hanover, Dallas TX 75209. (214)352-9192. Fax: (214)350-2101. Contact: Brooke Davis. Commercial illustration and photography representative. Estab. 1988. Represents 3 illustrators, 4 photographers. "Owner has 18 years experience in sales and marketing in the advertising and design fields."

How to Contact: For first contact, send bio, direct mail flier/brochure, "samples we can keep on file if possible" and SASE. Reports in 2 weeks. After initial contact, write for appointment to show portfolio or drop off or mail portfolio of tearsheets, slides or photographs.

Tips: Obtains new talent through referral or by an interest in a specific style. "Only show your best work. Develop an individual style. Show the type of work that you enjoy doing and want to do more often. Must have a sample to leave with potential clients."

PEMA BROWNE LTD., HCR Box 104B, Pine Rd., Neversink NY 12765. (914)985-2936 or (914)985-2062. Fax: (914)985-7635. Contact: Pema Browne or Perry Browne. Commercial illustration representative. Estab. 1966. Represents 10 illustrators. Specializes in general commercial. Markets include: all publishing areas; children's picture books; collector plates and dolls; advertising agencies. Clients include HarperCollins, Thomas Nelson, Bantam Doubleday Dell, Nelson/Word, Hyperion, Putnam. Client list available upon request. Artists include: John Standford, Richard Hull, Todd Doney, Charles Jordan, Maren Scott and Robert Barrett.

Handles: Illustration. Looking for "professional and unique" talent.

Terms: Rep receives 30% commission. Exclusive area representation is required. For promotional purposes, talent must provide color mailers to distribute. Representative pays mailing costs on promotion mailings.

How to Contact: For first contact, send query letter, direct mail flier/brochure and SASE. If interested will ask to mail appropriate materials for review. Portfolios should include tearsheets and transparencies or good color photocopies, plus SASE. Obtains new talent through recommendations and interviews (portfolio review).

Tips: "We are doing more publishing—all types—less advertising." Looks for "continuity of illustration and dedication to work."

N BRUCK AND MOSS ASSOCIATES, 100 Bleeker St., New York NY 10012. (212)980-8061 or (212)982-6533. Fax: (212)832-8778 or (212)674-0194. Contact: Eileen Moss or Nancy Bruck. Commercial illustration representative.

Estab. 1978. Represents 12 illustrators. Markets include: advertising agencies; corporations/client direct; design firms; editorial/magazines; publishing/books; sales/promotion firms; direct marketing.
Handles: Illustration.
Terms: Rep receives 30% commission. Exclusive representation is required. No geographic restrictions. Advertising costs are split: 70% paid by talent; 30% paid by representative. For promotional purposes, talent must provide "4×5 transparencies mounted on 7×9 black board. Talent pays for promotional card for the first year and for trade ad." Advertises in *American Showcase* and *The Workbook*.
How to Contact: For first contact, send tearsheets, "if sending slides, include SASE." After initial contact, drop off or mail in appropriate materials for review. Portfolios should include tearsheets. If mailing portfolio include SASE or Federal Express form.
Tips: Obtains new talent through referrals by art directors and art buyers, mailings of promo card, source books, art shows, *American Illustration* and *Print Annual*. "Make sure you have had experience repping yourself. Don't approach a rep on the phone, they are too busy for this. Put them on a mailing list and mail samples. Don't approach a rep who is already repping someone with the same style."

SID BUCK SYDRA TECHNIQUES CORP., 481 Eighth Ave., New York NY 10001. (212)631-0009. Fax: (212)631-0715. E-mail: andi9@aol.com. President: Sid Buck. Commercial illustration representative. Estab. 1964. Markets include: advertising agencies; corporations/client direct; design firms; editorial/magazines; paper products/greeting cards; publishing/books; fashion.
Handles: Illustration, fashion and editorial.
Terms: Rep receives 25% commission. Exclusive area represention is required. Advertising costs are split: 75% paid by talent; 25% paid by representative. Advertises in *American Showcase*, *Black Book*, *The Workbook*.
How to Contact: For first contact, send photocopies, photostats. Reports in 1 week. After initial contact, call to schedule an appointment for portfolio review. Portfolio should include photostats, photocopies.

WOODY COLEMAN PRESENTS INC., 490 Rockside Rd., Cleveland OH 44131. (216)661-4222. Fax: (216)661-2879. E-mail: woody@portsort.com. Website: http://www.portsort.com. Contact: Woody. Creative services representative. Estab. 1978. Member of Graphic Artists Guild. Specializes in illustration. Markets include: advertising agencies; corporations/client direct; design firms; editorial/magazines; paper products/greeting cards; publishing/books; sales/promotion firms; public relations firms.
Handles: Illustration.
Terms: Rep receives 25% commission. If chosen—will place free 12-image portfolio on Internet Database (see www.portsort.com). For promotional purposes, talent must provide "all 12 or more image portfolios in 4×5 transparencies as well as 12 scans." Advertises in *American Showcase*, *Black Book*, *The Workbook*, other publications.
How to Contact: For first contact, send query letter, tearsheets, slides, SASE. Reports in 30 days, only if interested. Portfolio should include tearsheets, 4×5 transparencies.
Tips: "Solicitations are made directly to our agency. Concentrate on developing 12 specific examples of a single style exhibiting work aimed at a particular specialty, such as fantasy, realism, Americana or a particular industry such as food, medical, architecture, transportation, film, etc."

JAN COLLIER REPRESENTS, INC., P.O. Box 470818, San Francisco CA 94147. (415)383-9026. E-mail: jan@collierreps.com. Website: http://www.collierreps.com. Contact: Leah. Commercial illustration representative. Estab. 1978. Represents 12 illustrators. Markets include: advertising agencies; design firms and editorial.
Handles: Illustration.
Terms: Rep receives 25% commission. Exclusive national representation is required. Advertising costs are split: 75% paid by talent; 25% paid by representative. Advertises in *American Showcase*, *The Workbook*.
How to Contact: For first contact, send tearsheets, slides and SASE. Reports in 1 week, only if interested. "After initial contact, we will call for portfolio if interested."

N: CONRAD REPRESENTS . . ., 2149 Lyon St., #5, San Francisco CA 94115. (415)921-7140. E-mail: jeva@conradreps.com. Website: http://www.conradreps.com. Contact: James Conrad. Commercial art rep for assignment and stock illustration. Estab. 1984. Represents 20-30 illustrators. Markets include: advertising agencies; corporate art departments; graphic designers and publishers of books; magazines; posters; calendars and greeting cards.
Handles: Illustration.
Terms: Rep receives 25-30% commission. Exclusive national representation is required. No geographic restrictions. For promotional purposes, talent must provide a portfolio "and participate in promotional programs."
How to Contact: For first contact, send samples. Follow up with phone call.

CORNELL & MCCARTHY, LLC, 2-D Cross Hwy., Westport CT 06880. (203)454-4210. Fax: (203)454-4258. E-mail: cmartreps@aol.com. Contact: Merial Cornell. Children's book illustration representative. Estab. 1989. Member of SCBWI and Graphic Artists Guild. Represents 30 illustrators. Specializes in children's books: trade, mass market, educational. Artists include: Renée Graef, Laura Rader, Benton Mahan, Steve Henry, Rusty Fletcher and Dennis Hockerman.
Handles: Illustration.
Terms: Agent receives 25% commission. Advertising costs are split: 75% paid by talent; 25% paid by representative.

For promotional purposes, talent must provide 10-12 strong portfolio pieces relating to children's publishing.
How to Contact: For first contact, send query letter, direct mail flier/brochure, tearsheets, photocopies and SASE. Reports in 1 month. Obtains new talent through recommendations, solicitation, conferences.
Tips: "Work hard on your portfolio."

CORPORATE ART PLANNING, 27 Union Square W., Suite 407, New York NY 10003. (212)242-8995. Fax: (212)242-9198. E-mail: virtual2ads@infohouse.com. Principal: Maureen McGovern. Fine art exhibitors, virtual entities. Estab. 1986. Represents 2 illustrators, 2 photographers, 5 fine artists (includes 1 sculptor). Guidelines available for #10 SASE. Markets include: advertising agencies; corporations/client direct; design firms; editorial/magazines; publishing/books; architects; art publishers; corporate collections; private collections. Artists include: Richard Rockwell and Alberto Allegri.
Handles: Fine art only.
Terms: Consultant receives 15%. Advertising costs are split: 50% paid by talent; 50% paid by representative. For promotional purposes, prefers all artists have museum connections and professional portfolios. Advertises in *Creative Black Book*, *The Workbook*, *Art in America*.
How to Contact: Reports back in 15 days. After initial contact, write to schedule an appointment for portfolio review. Portfolio should include color photocopies only (non-returnable).

CREATIVE ARTS OF VENTURA, P.O. Box 684, Ventura CA 93002. E-mail: ulrichxcal@aol.com. Owners: Don and Lamia Ulrich. Representative not currently seeking new talent. Clients include Tempe Arts Center, Arizona; Beverly Hills Recreation Parks Dept.; U.S. Embassy in Panama/U.S. State Dept. Artists include: Don Ulrich, Cameron Kempsell and Elianne Kempsell.
Tips: "High quality photographic imagery of artist's art form or product is most important. Lengthy résumés are of secondary value to us."

CREATIVE FREELANCERS MANAGEMENT, INC., 99 Park Ave., #210A, New York NY 10016. (800)398-9544. Fax: (203)532-2927. Website: http://www.freelancers.com. Contact: Marilyn Howard. Commercial illustration representative. Estab. 1988. Represents 30 illustrators. "Our staff members have art direction, art buying or illustration backgrounds." Specializes in children's books, advertising, architectural, conceptual. Markets include: advertising agencies; corporations/client direct; design firms; editorial/magazines; paper products/greeting cards; publishing/books; sales/promotion firms.
Handles: Illustration. Artists must have published work.
Terms: Rep receives 30% commission. Exclusive area representation is preferred. Advertising costs are split: 75% paid by talent; 25% paid by representative. For promotional purposes, talent must provide "printed pages to leave with clients. Co-op advertising with our firm could also provide this. Transparency portfolio preferred if we take you on but we are flexible." Advertises in *American Showcase*, *Workbook*.
How to Contact: For first contact, send tearsheets or "whatever best shows work." Reports back only if interested.
Tips: Looks for experience, professionalism and consistency of style. Obtains new talent through "word of mouth and website."

DWYER & O'GRADY, INC., P.O. Box 239, Lempster NH 03605. (603)863-9347. Fax: (603)863-9346. E-mail: donorth@srnet.com. Contact: Elizabeth O'Grady. Agents for children's picture book artists and writers. Estab. 1990. Member of Society of Illustrators, SCBWI, ABA. Represents 12 illustrators and 12 writers. Staff includes Elizabeth O'Grady, Jeffrey Dwyer. Specializes in children's picture books (middle grade and young adult). Markets include: publishing/books, audio/film. Artists include: Earl B. Lewis, Mary Azariah, Pat Collins, Lousia Baker and Irving Toddy.
Handles: Illustrators and writers of children's books. "Favor realistic and representational work for the older age picture book. Artist must have full command of the figure and facial expressions."
Terms: Receives 15% commission domestic, 20% foreign. Additional fees are negotiable. Exclusive representation is required (world rights). Advertising costs are paid by representative. For promotional purposes, talent must provide both color slides and prints of at least 20 sample illustrations depicting the figure with facial expression.
How to Contact: When making first contact, send query letter, slides, photographs and SASE. Reports in 1½ months. After initial contact, call for appointment and drop off or mail in appropriate materials for review. Portfolio should include slides, photographs.

N FORTUNI, 2508 E. Belleview Place, Milwaukee WI 53211. (414)964-8088. Fax: (414)332-9629. Contact: Marian F. Deegan. Commercial illustration, photography representative. Estab. 1989. Member of Graphic Artists Guild. Represents 6 illustrators, 2 photographers. Markets include: advertising agencies; corporations/client direct; design firms; editorial/magazines; publishing/books. Artists include Peter Carter, Samantha Burton, Janet Drew, Dick Baker, Zelda Bean, Bijalynne Saari, Jody Winger and Kendra Shaw.
Handles: Illustration, photography. "I am interested in artists who have developed a consistent, distinctive style of illustration, and target the national advertising market."
Terms: Rep receives 30% commission. Advertising costs are split: 70% paid by talent; 30% paid by representative. For promotional purposes, talent must provide direct mail support, advertising, and a minimum of 4 duplicate transparency portfolios. "All promotional materials are developed and produced within my advertising specifications." Advertises in *Directory of Illustration*, *The Workbook*.

How to Contact: For first contact, send direct mail flier/brochure, slides, photographs, photocopies, SASE. Reports in 2 weeks if SASE is enclosed.

FREELANCE ADVANCERS, INC., 420 Lexington Ave., Suite 2007, New York NY 10170. (212)661-0900. Fax: (212)661-1883. E-mail: info@freelanceadvancers.com. Website: http://www.freelanceadvancers.com. President: Gary Glauber. Commercial illustration, graphic design, freelance artist representative. Estab. 1987. Member of Society of Illustrators. Represents 150 illustrators, 250 designers. Specializes in freelance project work. Markets include: advertising agencies; corporations/client direct; design firms; editorial/magazines; publishing/books.
Handles: Illustration, design. Looks for artists with Macintosh software and multimedia expertise.
Terms: Rep receives 20% commission. 100% of advertising costs are paid by the representative. Advertises in *Art Direction, Adweek*.
How to Contact: For first contact, send query letter, résumé, tearsheets. Reports back within 1 week. After initial contact, call to schedule an appointment.
Tips: Looking for "talent, flexibility and reliability" in an artist. "Always learn, but realize you are good enough now."

ROBERT GALITZ FINE ART/ACCENT ART, 166 Hilltop Court, Sleepy Hollow IL 60118. (847)426-8842. Fax: (847)426-8846. Contact: Robert Galitz. Fine art representative. Estab. 1985. Represents 100 fine artists (includes 2 sculptors). Specializes in contemporary/abstract corporate art. Markets include: architects; corporate collections; galleries; interior decorators; private collections. Artists include: Roland Poska, Jan Pozzi, Diane Bartz and Louis De Mayo.
Handles: Fine art.
Terms: Agent receives 25-40% commission. No geographic restrictions; sells mainly in Chicago, Illinois, Wisconsin, Indiana and Kentucky. For promotional purposes talent must provide "good photos and slides." Advertises in monthly art publications and guides.
How to Contact: For first contact, send query letter, slides, photographs. Reports in 2 weeks. After initial contact, call for appointment to show portfolio of original art. Obtains new talent through recommendations from others, solicitation, conferences.
Tips: "Be confident, persistent. Never give up or quit."

☑ **RITA GATLIN REPRESENTS INC.**, P.O. Box 7080, Corte Madera CA 94925. (415)924-7881. Fax: (415)924-7891. E-mail: gatlin@ritareps.com. Website: http://www.ritareps.com. Agent: Rita Gatlin. Commercial illustration. Estab. 1991. Member of Society of Illustrators. Represents 12 illustrators. Markets include: advertising agencies; corporations/client direct; design firms; editorial/magazines; paper products/greeting cards; publishing/books.
Handles: Commercial illustrators only.
Terms: Rep receives 25% commission. Charges fees for portfolio materials (mounting and matting); postage for yearly direct mail divided among artists. Advertising costs are split: 75% paid by talent; 25% paid by representative. For promotional purposes, talent must provide at least one 8½×11 printed page. Prefers portfolios in transparency form. Advertises in *American Showcase, The Workbook, Creative Illustration, Blackbook*.
How to Contact: For first contact, send query letter and tearsheets. Reports back within 5 days. After initial contact, call to schedule an appointment for portfolio review. Portfolio should include tearsheets, slides.
Tips: "Artists must have a minimum of five years experience as commercial illustrators." When asked what their illustration style is, artists should never say they can do all styles—it's "a sign of a beginner."

DENNIS GODFREY REPRESENTING ARTISTS, 201 W. 21st St., Suite 10G, New York NY 10011. Phone/fax: (212)807-0840. E-mail: dengodfrey@aol.com. Contact: Dennis Godfrey. Commercial illustration representative. Estab. 1985. Represents 7 illustrators. Specializes in publishing and packaging. Markets include: advertising agencies; corporations/client direct; design firms; publishing/books. Clients include Putnam Berkley, Dell, Avon, Ogilvy & Mather, Oceanspray, Tropicana, Celestial Seasonings.
Handles: Illustration.
Terms: Rep receives 25% commission. Prefers exclusive area representation in NYC/Eastern US. Advertising costs are split: 75% paid by talent; 25% paid by representative. For promotional purposes, talent must provide mounted portfolio (at least 20 pieces), as well as promotional pieces. Advertises in *The Workbook, American Showcase*.
How to Contact: For first contact, send tearsheets. Reports in 2 weeks, only if interested. After initial contact, write for appointment to show portfolio of tearsheets, slides, photographs, photostats.

BARBARA GORDON ASSOCIATES LTD., 165 E. 32nd St., New York NY 10016. (212)686-3514. Fax: (212)532-4302. Contact: Barbara Gordon. Commercial illustration and photography representative. Estab. 1969. Member of SPAR, Society of Illustrators, Graphic Artists Guild. Represents 9 illustrators, 1 photographer. "I represent only a small, select group of people and therefore give a great deal of personal time and attention to the people I represent."
Terms: No information provided. No geographic restrictions in continental US.
How to Contact: For first contact, send direct mail flier/brochure. Reports in 2 weeks. After initial contact, drop off or mail appropriate materials for review. Portfolio should include tearsheets, slides, photographs; "if the talent wants materials or promotion piece returned, include SASE." Obtains new talent through recommendations from others, solicitation, conferences, etc.
Tips: "I do not care if an artist or photographer has been published or is experienced. I am essentially interested in people with a good, commercial style. Don't send résumés and don't call to give me a verbal description of your work.

Send promotion pieces. *Never* send original art. If you want something back, include a SASE. Always label your slides in case they get separated from your cover letter. And always include a phone number where you can be reached."

ℕ COREY GRAHAM REPRESENTS, Pier 33 N., San Francisco CA 94111. (415)956-4750. Fax: (415)391-6104. Contact: Corey Graham. Commercial illustration, photography representative. Estab. 1983. Represents 15 illustrators, 2 photographers. Markets include: advertising agencies; corporations/client direct; design firms.
Handles: Illustration, photography.
Terms: Rep receives 25% commission. Exclusive area representation is sometimes required. Advertising costs are split: 75% paid by talent; 25% paid by representative. Advertises in *American Showcase, The Workbook.*
How to Contact: For first contact, send query letter and tearsheets. Reports back within a few days. After initial contact, drop off or mail in appropriate materials. Portfolio should include tearsheets.

ANITA GRIEN—REPRESENTING ARTISTS, 155 E. 38th St., New York NY 10016. E-mail: agrien@aol.com. Representative not currently seeking new talent.

CAROL GUENZI AGENTS, INC., 865 Delaware St., Denver CO 80210. (303)820-2599. E-mail: artagent@artagent. com. Website: http://www.artagent.com. Contact: Carol Guenzi. Commercial illustration, film and animation representative. Estab. 1984. Member of Denver Advertising Federation and Art Directors Club of Denver. Represents 26 illustrators, 5 photographers, 4 computer illustrators, 3 multimedia developers and 1 animator. Specializes in a "wide selection of talent in all areas of visual communications." Markets include: advertising agencies; corporations/client direct; design firms; editorial/magazine, paper products/greeting cards, sales/promotions firms. Clients include The Integer Group, Karsh & Hagan, BB00, DDB Needham. Partial client list available upon request.
Handles: Illustration, photography. Looking for "unique style application."
Terms: Rep receives 25% commission. Exclusive area representative is required. Advertising costs are split: 75% paid by talent; 25% paid by the representation. For promotional purposes, talent must provide "promotional material after six months, some restrictions on portfolios." Advertises in *American Showcase, Black Book, Rocky Mountain Sourcebook, The Workbook,* "periodically."
How to Contact: For first contact, send direct mail flier/brochure. Reports in 2-3 weeks, only if interested. Call or write for appointment to drop off or mail in appropriate materials for review, depending on artist's location. Portfolio should include tearsheets, slides, photographs. Obtains new talent through solicitation, art directors' referrals, an active pursuit by individual artist.
Tips: "Show your strongest style and have at least 12 samples of that style, before introducing all your capabilities. Be prepared to add additional work to your portfolio to help round out your style. Have a digital background."

GUIDED IMAGERY DESIGN & PRODUCTIONS, (formerly Guided Imagery Productions), 2995 Woodside Rd., #400, Woodside CA 94062. (650)324-0323. Fax: (650)324-9962. Owner/Director: Linda Hoffman. Fine art representative. Estab. 1978. Member of Hospitality Industry Association. Represents 2 illustrators, 12 fine artists. Specializes in large art production—perspective murals (trompe l'oiel); unusual painted furniture/screens. Markets include: design firms; interior decorators; hospitality industry.
Handles: Looking for "mural artists (realistic or trompe l'oiel) with good understanding of perspectives."
Terms: Rep receives 33% commission. 100% of advertising costs paid by representative. For promotional purposes, talent must provide a direct mail piece to preview work, along with color copies of work (SASE too). Advertises in *The Workbook.*
How to Contact: For first contact, send query letter, résumé, photographs, photocopies and SASE. Reports in 2-4 weeks. After initial contact, drop off or mail appropriate materials. Portfolio should include photographs.
Tips: Wants artists with talent, references and follow-through. "Send color copies of original work that show your artistic style. Never send one-of-a-kind artwork or snapshots. My focus is 3-D murals. References from previous clients very helpful."

PAT HACKETT/ARTIST REPRESENTATIVE, 1809 Seventh Ave., Suite 1710, Seattle WA 98101. (206)447-1600. Fax: (206)447-0739. E-mail: pathackett@aol.com. Contact: Pat Hackett. Commercial illustration and photography representative. Estab. 1979. Represents 29 illustrators, 3 photographers. Markets include: advertising agencies; corporations/client direct; design firms; editorial/magazines.
Handles: Illustration.
Terms: Rep receives 25-33% commission. Exclusive area representation is required. No geographic restrictions, but sells mostly in Washington, Oregon, Idaho, Montana, Alaska and Hawaii. Advertising costs are split: 75% paid by talent; 25% paid by representative. For promotional purposes, talent must provide "standardized portfolio, i.e., all pieces within the book are the same format. Reprints are nice, but not absolutely required." Advertises in *American Showcase, The Workbook.*
How to Contact: For first contact, send direct mail flier/brochure. Reports in 1 week, only if interested. After initial contact, drop off or mail in appropriate materials: tearsheets, slides, photographs, photostats, photocopies. Obtains new talent through "recommendations and calls/letters from artists moving to the area."
Tips: Looks for "experience in the *commercial* art world, professional presentation in both portfolio and person, cooperative attitude and enthusiasm."

BARB HAUSER, ANOTHER GIRL REP, P.O. Box 421443, San Francisco CA 94142-1443. (415)647-5660. Fax: (415)546-4180. Estab. 1980. Represents 11 illustrators. Markets include: primarily advertising agencies and design firms; corporations/client direct.
Handles: Illustration.
Terms: Rep receives 25-30% commission. Exclusive representation in the San Francisco area is required. No geographic restrictions.
How to Contact: For first contact, send direct mail flier/brochure, tearsheets, slides, photographs, photocopies and SASE. Reports in 3-4 weeks. Call for appointment to show portfolio of tearsheets, slides, photographs, photostats, photocopies.

JOANNE HEDGE/ARTIST REPRESENTATIVE, 1415 Garden St., Glendale CA 91201. (818)244-0110. Fax: (818)244-0136. Contact: J. Hedge. Commercial illustration representative. Estab. 1975. Member of Graphic Artists Guild. Represents 14 illustrators. Specializes in "high-quality, painterly and realistic illustration and lettering." Markets include advertising agencies, design firms, movie studios, package design firms.
Handles: Illustration. Seeks established realists in airbrush, painting. Also quality computer-generated art suppliers.
Terms: Rep receives 30% commission. Artist pays quarterly portfolio maintenance expenses. Advertising costs are split: 75% paid by talent; 25% paid by representative. For promotional purposes, talent should provide "ad reprint flyer, 4×5 or 8×10 copy transparencies, matted on 11×14 laminate mattes." Advertises in *The Workbook*.
How to Contact: For first contact, send query letter with direct mail flier/brochure, 35mm slides OK with SASE. Reports in 1 week, if interested. After initial contact, call or write for appointment to show portfolio of tearsheets (laminated), photocopies, 4×5 or 8×10 transparencies.
Tips: Obtains new talent after talent sees *Workbook* directory ad, or through referrals from art directors or other talent. "Have as much experience as possible and zero or one other rep. That, and a good looking $8\frac{1}{2} \times 11$ flier!"

HK PORTFOLIO, 666 Greenwich St., New York NY 10014. (212)675-5719. E-mail: harriet@hkportfolio.com. Website: http://www.hkportfolio.com. Contact: Harriet Kasak or Mela Bolinao. Commercial illustration representative. Estab. 1986. Member of SPAR, Society of Illustrators and Graphic Artists Guild. Represents 50 illustrators. Specializes in illustration for juvenile markets. "Sub-agent for Peters, Fraser & Dunlop (London)." Markets include: advertising agencies; editorial/magazines; publishing/books.
Handles: Illustration.
Terms: Rep receives 25% commission. No geographic restrictions. Advertising costs are split: 75% paid by talent; 25% paid by representative. Advertises in *American Showcase*, *Picture Book*.
How to Contact: No geographic restrictions. For first contact, send query letter, direct mail flier/brochure, tearsheets, slides, photographs, photostats and SASE. Reports in 1 week. After initial contact, drop off or mail in appropriate materials for review. Portfolio should include tearsheets, slides, photographs, photostats, photocopies.
Tips: Leans toward highly individual personal styles.

MELISSA HOPSON REPRESENTING, 1605C Stemmons Freeway, Dallas TX 75207. (214)747-3122. Fax: (214)720-0080. Owner: Melissa Hopson. Commercial illustration, digital/computer representative. Estab. 1982. Member of Society of Illustrators. Represents 6 illustrators. Specializes in comps/presentations and high-end computer illustration.
Handles: Traditional illustrators, digital illustrators, specializing in photo manipulating, 3-D illustration and animation.
Terms: Rep receives 25-30% commission. Exclusive area representation is required. Advertising costs are split: 75% paid by talent; 25% paid by representative. For promotional purposes, requires ads in national books, leave behinds and 2 full portfolios.
How to Contact: For first contact, send query letter, tearsheets and slides. Reports in 1-2 weeks, only if interested. After initial contact, call to schedule an appointment. Portfolio should include transparencies of work (mounted).
Tips: Impressed by "upbeat personality, willingness to work hard, friendliness—does not mind client changes—professional appearance, professionally put together portfolio."

SCOTT HULL ASSOCIATES, 68 E. Franklin S., Dayton OH 45459. (937)433-8383. Fax: (937)433-0434. E-mail: scott@scotthull.com. Website: http://www.scotthull.com. Contact: Scott Hull or Lynn Roberts. Commercial illustration representative. Estab. 1981. Represents 20 plus illustrators.
● This rep showcases his illustrators periodically in imaginative promotional projects. Hull was featured in the 1997 *AGDM*.
Terms: No information provided.
How to Contact: Contact by sending slides, tearsheets or appropriate materials for review. Follow up with phone call. Reports within 2 weeks.
Tips: Looks for "an interesting style and a desire to grow, as well as a marketable portfolio."

INDUSTRY ARTS, P.O. Box 1737, Beverly Hills CA 90213. (310)302-0088. Fax: (310)305-7364. E-mail: iacreative@industryarts.com. Website: http://www.industryarts.com. Agent/Broker: Marc Tocker. Commercial illustration, photography, graphic design representative and copywriters. Estab. 1997. Member of California Lawyers for the Arts. Represents 1 copywriter, 1 illustrator, 1 photographer, 1 designer. Specializes in clever cutting edge design. Markets include: advertising agencies, corporations/client direct, design firms.
Handles: Illustration, photography, design, Web design/programming. "We are looking for design mindful people who

create cutting edge work that challenges dominant cultural paradigms."
Terms: Rep receives 20-25% commission. Exclusive area representation is required. Advertising costs are paid by talent. For promotional purposes, portfolio should be adapted to digital format for website presentation. Advertises in *The Workbook.*
How to Contact: For first contact, send query letter, bio, direct mail flier/brochure, tearsheets, photocopies and SASE. Reports in 2 weeks. Call to schedule an appointment. Portfolio should include original art, tearsheets, slides, photographs.
Tips: Looks for artists with an awareness of the cutting edge in contemporary design.

✓ **THE IVY LEAGUE OF ARTISTS**, 1133 Broadway, Suite 825, New York NY 10010. (212)243-1333. E-mail: ilartists@aol.com. Graphic design representative, illustration or photography broker. Commercial illustration, photography, fine art, graphic design representative. Estab. 1985. Represents 5 illustrators, 2 designers. Staff includes sales and graphic designers. Specializes in graphic design, illustration representatives. Markets include: advertising agencies, corporations/clients direct, publishing/books.
Will Handle: Interested in reviewing illustration, design.
Terms: Rep receives 30% commission.
How to Contact: For first contact, send tearsheets. Reports in 2 weeks. Portfolio should include prints, tearsheets.
Tips: "At this point, we are not looking for new talent."

JEDELL PRODUCTIONS, INC., 370 E. 76th St., New York NY 10021. (212)861-7861. Contact: Joan Jedell. Commercial photography representative. Estab. 1969. Member of SPAR. Specializes in photography. Markets include: advertising agencies.
Handles: Photography, fine art.
How to Contact: After initial contact, drop off or mail in portfolio of photographs. For returns, include SASE or Federal Express number.

N **KASTARIS & ASSOCIATES**, 3301a S. Jefferson, St. Louis MO 63118. (314)773-2600. Fax: (314)773-6406. E-mail: harriet@kastaris.com. Commercial illustration representative. Estab. 1987. Represents 21 illustrators. Markets include: advertising agencies; design firms; editorial/magazines; publishing/books; sales promotion firms.
Handles: Illustration.
Terms: Rep receives 30% commission. Exclusive area representation is negotiable. Advertising costs are split: 75% paid by talent; 25% paid by representative. Talent must advertise with my firm; must provide 4×5 transparencies for portfolio." Produces own promotional book every year with a distribution of 12,000.
How to Contact: For first contact, send direct mail flier/brochure, tearsheets and SASE if you want sampler back. Reports in 1 month if interested. After initial contact, call for appointment.
Tips: "Show me your style. I enjoy reviewing samples. Have a strong portfolio that includes images of people, products, animals, food and typography."

N **PEGGY KEATING**, 30 Horatio St., New York NY 10014. (212)691-4654. Contact: Peggy Keating. Commercial illustration representataive. Estab. 1969. Represents 4 illustrators. Specializes in fashion illustration (men, women, children, also fashion-related products). Markets include: advertising agencies; corporations/client direct; editorial/magazines; sales/promotion firms; "mostly pattern catalog companies and retail."
Handles: "Fashion illustration, but only if top-drawer."
Terms: Rep receives 25% commission. Exclusive area representation is required. For promotional purposes, talent must provide "strong sample material that will provide an excellent portfolio presentation." Advertises by direct mail.
How to Contact: For first contact, send tearsheets, photocopies. Reports in days, only if interested. After initial contact, drop off or mail appropriate materials for review. Portfolio should include thumbnails, roughs, original art, tearsheets, slides, photographs, photostats, photocopies. "It might include all or one or more of these materials. The selection and design of the material are the important factor." Obtains new talent through "recommendations from others, or they contact me directly.
Tips: "Most artists can produce good, sometimes outstanding work. What you must look for is consistency."

KIRCHOFF/WOHLBERG, ARTISTS REPRESENTATION DIVISION, 866 United Nations Plaza, #525, New York NY 10017. (212)644-2020. Fax: (212)223-4387. Director of Operations: John R. Whitman. Estab. 1930s. Member of SPAR, Society of Illustrators, AIGA, Associaton of American Publishers, Bookbuilders of Boston, New York Bookbinders' Guild. Represents over 50 illustrators. Artist's Represenative: Elizabeth Ford. Specializes in juvenile and young adult trade books and textbooks. Markets include: publishing/books.
Handles: Illustration and photography (juvenile and young adult).
Terms: Rep receives 25% commission. Exclusive representation to book publishers is usually required. Advertising costs paid by representative ("for all Kirchoff/Wohlberg advertisements only"). "We will make transparencies from portfolio samples; keep some original work on file." Advertises in *American Showcase, Art Directors' Index, Society of Illustrators Annual*, children's book issues of *Publishers Weekly.*
How to Contact: Please send all correspondence to the attention of Elizabeth Ford. For first contact, send query letter, "any materials artists feel are appropriate." Reports in 4-6 weeks. "We will contact you for additional materials." Portfolios should include "whatever artists feel best represents their work. We like to see children's illustration in any style."

KLIMT REPRESENTS, 15 W. 72nd St., 7-U, New York NY 10023. (212)799-2231. Contact: Bill or Maurine. Commercial illustration representative. Estab. 1978. Member of Society of Illustrators, Graphic Artists Guild. Represents 14 illustrators. Specializes in paperback covers, young adult, romance, science fiction, mystery, etc. Markets include: advertising agencies; corporations/client direct; design firms; editorial/magazines; paper products/greeting cards; publishing/books; sales/promotion firms.
Handles: Illustration.
Terms: Rep receives 25% commission, 30% commission for "out of town if we do shoots. The artist is responsible for only his own portfolio. Exclusive area representation is required. Advertising costs are split: 75% paid by talent; 25% paid by representative. For promotional purposes, talent must provide 4×5 or 8×10 mounted transparencies. Advertises through direct mail.
How to Contact: For first contact, send direct mail flier/brochure, and "any image that doesn't have to be returned unless supplied with SASE." Reports in 5 days. After initial contact, call for appointment to show portfolio of professional, mounted transparencies.

ELLEN KNABLE & ASSOCIATES, INC., 1233 S. LaCienega Blvd., Los Angeles CA 90035. (310)855-8855. (310)657-0265. E-mail: pearl2eka@aol.com. Contact: Ellen Knable. Commercial production representative. Estab. 1978. Member of SPAR, Graphic Artists Guild. Markets include: advertising agencies; corporations/client direct; design firms. Clients include Chiat/Day, BBDO, J.W. Thompson/SF, Ketchum/SF. Client list available upon request.
Terms: Rep receives 25-30% commission. Exclusive West Coast/Southern California representation is required. Advertising costs split varies. Advertises in *The Workbook*.
How to Contact: For first contact, send query letter, direct mail flier/brochure and tearsheets. Reports within 2 weeks. Call for appointment to show portfolio. Obtains new talent from creatives/artists.
Tips: "Have patience and persistence!"

CLIFF KNECHT–ARTIST REPRESENTATIVE, 309 Walnut Rd., Pittsburgh PA 15202. (412)761-5666. Fax: (412)761-4072. E-mail: cliff@artrep1.com. Website: http://www.artrep1.com. Contact: Cliff Knecht. Commercial illustration representative. Estab. 1972. Represents 20 illustrators. Markets include: advertising agencies; corporations/client direct; design firms; editorial/magazines; paper products/greeting cards; publishing/books; sales/promotion firms.
Handles: Illustration.
Terms: Rep receives 25% commission. No geographic restrictions. Advertising costs are split: 75% paid by the talent; 25% paid by representative. For promotional purposes, talent must provide a direct mail piece. Advertises in *Graphic Artists Guild Directory of Illustration*.
How to Contact: For first contact, send résumé, direct mail flier/brochure, tearsheets, slides. Reports in 1 week. After initial contact, call for appointment to show portfolio of original art, tearsheets, slides, photographs. Obtains new talent directly or through recommendations from others.

N **SHARON KURLANSKY ASSOCIATES**, 192 Southville Rd., Southborough MA 01772. (508)872-4549. Fax: (508)460-6058. E-mail: laughstoc@aol.com. Website: http://www.laughing-stock.com. Contact: Sharon Kurlansky. Commercial illustration representative. Estab. 1978. Represents 9 illustrators. Markets include: advertising agencies; corporations/client direct; design firms; editorial/magazines; paper products/greeting cards; publishing/books; sales/promotion firms. Client list available upon request. Artists include: Tim Lewis and Bruce Hutchison.
Handles: Illustration.
Terms: Rep receives 25% commission. Exclusive area representation is required. Advertising costs are split: 75% paid by talent; 25% paid by representative. "Will develop promotional materials with talent. Portfolio presentation formated and developed with talent also." Advertises in *American Showcase*, *The Creative Illustration Book*, under artist's name.
How to Contact: For first contact, send direct mail flier/brochure, tearsheets, slides and SASE. Reports in 1 month if interested. After initial contact, call for appointment to show portfolio of tearsheets, photocopies. Obtains new talent through various means.

MARY LAMONT, 56 Washington Ave., Brentwood NY 11717. E-mail: lamman@aol.com. Representative not currently seeking new talent.

✓ **LANGLEY & ASSOCIATES REPRESENTING ILLUSTRATORS**, (formerly Langley Artist Representative), 333 N. Michigan Ave., Chicago IL 60601. (312)782-0244. Fax: (312)782-1535. E-mail: artrepsjl@aol.com. Contact: Sharon Langley. Commercial illustration representative. Estab. 1988. Member of CAR (Chicago Artists Representatives). Represents 21 illustrators. Markets include: advertising agencies; corporations/client direct; design firms; editorial/magazines; publishing/books; sales/promotion firms. Clients include Leo Burnett Advertising, Davidson Marketing,

MARKET CONDITIONS are constantly changing! If you're still using this book and it is 2001 or later, buy the newest edition of *Artist's & Graphic Designer's Market* at your favorite bookstore or order directly from Writer's Digest Books (1-800-289-0963).

Kemper Insurance Co. Artists include: Tim Jonke, Matt Zumbo and Clem Bedwell.

Handles: Illustration. Although representative prefers to work with established talent, "I am always receptive to reviewing illustrators' work."

Terms: Rep receives 25% commission. Exclusive area representation is preferred. Advertising costs are split: 75% paid by talent; 25% paid by representative. For promotional purposes, talent must provide printed promotional piece, well organized portfolio. Advertises in *The Workbook, Blackbook Illustration.*

How to Contact: For first contact, send printed promotional piece. Reports in 3 weeks if interested. After initial contact, call for appointment to show portfolio of tearsheets, transparencies. Obtains new talent through art directors, clients, referrals.

Tips: "When an artist starts freelancing it's a good idea to represent yourself for a while. Only then are you able to appreciate a professional agent. Don't be discouraged when one rep turns you down. Contact the next one on your list!"

N 🌐 **LAVAPEPPER LTD.**, 40 Weir Rd., London UK SW12 0NA. (+44)(0)7050 192 354. Fax: (+44)(0)7050 286 044. E-mail: its@lavapepper.com. Website: http://www.lavapepper.com. Directors: Izabella Knights and James Muchmore. Commercial illustration representative. Estab. 1998. Represents 16 illustrators. Markets include: advertising agencies, editorial/magazines, paper products/greeting cards, publishing/books and record labels.

• Lavapepper has plans for a stock illustration library in September 1999.

Will Handle: Illustration.

Terms: Rep receives 25-30% commission. Advertises in *Contact.* Send query letter, photocopies and SASE. Reports back within 2 weeks. Call or write to schedule an appointment. Portfolio should include original art and photocopies.

Tips: "Looking for a strong style, a bit unconventional and lively."

N **JEFF LAVATY & ASSOCIATES**, 217 E. 86th St., Suite 212, New York NY 10028-3617. (212)427-5632. Commercial illustration and fine art representative. Represents 30 artists.

Handles: Illustration.

How to Contact: For first contact, send query letter, direct mail flier/brochure, tearsheets, slides and SASE. Reports in 1 week. After initial contact, call for appointment to show portfolio of tearsheets, 8×10 or 4×5 transparencies. Obtains new talent through solicitation.

Tips: "Specialize! Your portfolio must be focused."

N **LEHMEN DABNEY INC.**, 1431 35th Ave. S., Seattle WA 98144. (206)325-8595. Fax: (206)325-8594. Principals: Nathan Dabney, Connie Lehmen. Commercial illustration, photography representative. Estab. 1989. Represents 20 illustrators, 1 photographer. Specializes in commercial art. Markets include: advertising agencies; corporations/client direct; design firms; editorial/magazines; paper products/greeting cards; publishing/books.

Handles: Illustration, photography.

Terms: Rep receives 25% commission. "Artists are responsible for providing portfolio pieces and cases." Exclusive area representation is required. Advertising costs are split: 75% paid by talent; 25% paid by representative. For promotional purposes, talent must provide transparencies or printed art on 11×14 art boards with museum box case; backlog of printed samples 1,000-1,500 minimum. Advertises in *American Showcase, The Workbook, Alternative Pic.*

How to Contact: For first contact, send direct mail flier/brochure and tearsheets. Reports in 10 days. After initial contact, call to schedule an appointment. Portfolio should include tearsheets, photographs, photocopies, transparencies (4×5), proofs.

Tips: Artists "must have published work, experience working with art directors and designers; computer skills a plus."

LEIGHTON & COMPANY, INC., 7 Washington St., Beverly MA 01915. (978)921-0887. Fax: (978)921-0223. E-mail: leighton@leightonreps.com. Website: http://www.leightonreps.com. Contact: Leighton O'Connor. Commercial illustration representative. Estab. 1986. Member of Graphic Artists Guild, ASMP. Represents 25 illustrators. Markets include: advertising agencies; corporations/clients direct; design firms; editorial/magazines; publishing/books.

Handles: Illustration. "Looking for conceptual illustrators who can create their work on computer."

Terms: Rep receives 25% commission. Advertising costs are split: 75% paid by talent; 25% paid by representative. For promotional purposes, "talent is required to supply me with 6×9 color mailer(s) and laminated portfolios as well as two 4×5 color transparency portfolios." Advertises in *Creative Illustration, Graphic Artist Guild Directory of Illustration, American Showcase, Workbook.*

How to Contact: For first contact, send query letter, direct mail flier/brochure, tearsheets and SASE. Reports in 1 week if interested. After initial contact, drop off or mail in appropriate materials with SASE for review. Portfolio should include tearsheets, slides, photographs.

Tips: "My new talent is almost always obtained through referrals. Occasionally, I will solicit new talent from direct mail pieces they have sent to me. It is best to send work first, i.e., tearsheet or direct mail pieces. Only send a portfolio when asked to. If you need your samples returned, always include a SASE. Follow up with one phone call. It is very important to get the correct spelling and address of the representative. Also, make sure you are financially ready for a representative, having the resources available to create a portfolio and direct mail campaign."

LESLI ART, INC., Box 6693, Woodland Hills CA 91364. (818)999-9228. Fax: (818)999-0833. E-mail: artlesli@aol.com. Contact: Stan Shevrin. Fine art agent, publisher and advisor. Estab. 1965. Represents emerging, mid-career and established artists. Specializes in artists painting in oil or acrylic, in traditional subject matter in realistic or impressionist

style. Also represents illustrators who want to establish themselves in the fine art market. Sells to leading art galleries throughout the US. Artists include: Tom Darro, Greg Harris, Christa Kieffer, Roger LaManna, Dick Plonk, Rick Peterson and John Stephens.

Terms: Receives 50% commission. Pays all expenses including advertising and promotion. Artist pays one-way shipping. All artwork accepted unframed. Exclusives preferred. Contract provided.

How to Contact: For first contact, send either color prints or slides with short bio and SASE. Material will be filed if SASE is not included. Reports in 30 days. Obtains new talent through "reviewing portfolios."

Tips: "Artists should show their most current works and state a preference for subject matter and medium."

LINDGREN & SMITH, 250 W. 57th St., #521, New York NY 10107. (212)397-7330. E-mail: inquiry@lindgrens mith.com. Website: http://www.lindgrensmith.com. Assistant: Wini Barron. Commercial illustration representative. Estab. 1984. Member of SPAR. Markets include advertising agencies; corporations/client direct; design firms; editorial/ magazines; paper products/greeting cards; publishing/books, children books. Artists include: Doug Fraser, Michael Paraskeras, Steven Salerno and Bill Mayer.

Handles: Illustration.

Terms: Exclusive representation is required. Advertises in *American Showcase*, *The Workbook*, *The Black* and *Picture Book*.

How to Contact: For first contact, send direct mail flier/brochure, tearsheets, photocopies. "We will respond by mail or phone."

Tips: "Check to see if your work seems appropriate for the group. We only represent experienced artists who have been professionals for some time."

LONDON CONTEMPORARY ART, 6950 Phillips Hwy., Suite 51, Jacksonville FL 32216. (904)296-4982. Contact: Marketing Manager. Fine art representative and publisher. Estab. 1977. Represents 45 fine artists. Specializes in "selling to art galleries." Markets include: galleries; corporate collections; interior designers.

Handles: Fine art.

Terms: Publisher of original art. Exclusive representation is required. For promotional purposes talent must provide slides, color prints, "any visuals." Advertises in *Art Business News*, *Art & Antiques*, *Preview*, *Sunstorm*.

How to Contact: For first contact, send tearsheets, slides, photographs and SASE. LCA will report in 1 month, only if interested. "If interested, we will call you." Portfolio should include slides, photographs. Obtains new talent through recommendations from others and word of mouth.

MARLENA AGENCY, 278 Hamilton Ave., Princeton NJ 08540. (609)252-9405. Fax: (609)252-1949. E-mail: marzena @bellatlantic.net. Website: marlenaagency.com. Artist Rep: Marlena Torzecka. Commercial illustration representative. Estab. 1990. Member of Art Directors Club of New York. Represents 14 illustrators. Specializes in conceptual illustration. Markets include: advertising agencies; corporations/client direct; design firms; editorial/magazines; publishing/books; theaters. Artists include: Cyril Cabry, Gerard Dubois, Ferruccio Sardella, Linda Helton and Waldemar Shierzy.

● This agency collaborated with a design firm to create promotional wrapping paper for their illustrators.

Handles: Illustration, fine art.

Terms: Rep receives 30% commission. Costs are shared by all artists. Exclusive area representation is required. Advertising costs are split: 70% paid by talent; 30% paid by representative. For promotional purposes, talent must provide slides (preferably 8×10 framed); direct mail type helpful. Advertises in *American Showcase*, *Black Book*, *Illustrators 35* (New York City), *Workbook*, *Alternative Pick*.

How to Contact: For first contact send tearsheets. Reports back within 1 week only if interested. After initial contact, drop off or mail appropriate materials. Portfolio should include tearsheets.

Tips: Wants artists with "talent, good concepts—intelligent illustration, promptness in keeping up with projects, deadlines, etc."

MARTHA PRODUCTIONS, INC., 11936 W. Jefferson, Suite C, Culver City CA 90230. (310)390-8663. Fax: (310)390-3161. E-mail: marthaprod@earthlink.net. Contact: Martha Spelman. Commercial illustration and graphic design representative. Estab. 1978. Member of Graphic Artists Guild. Represents 25 illustrators. Staff includes Martha Spelman (artist representative) and Shannon Tinker (artist representative). Specializes in b&w and 4-color illustration. Markets include: advertising agencies; corporations/client direct; design firms; editorial/magazines; paper products/ greeting cards. Artists include: Steve Vance, Peter Sui, Catherine Leary, Dennis Mukai and Eric C. Westbrook.

Handles: Illustration.

Terms: Rep receives 30% commission. Exclusive area representation is required. No geographic restrictions. Advertising costs are split: 70% paid by talent; 30% paid by representative. For promotional purposes, talent must provide "a minimum of 12 images, 4×5 transparencies of each. (We put the transparencies into our own format.) In addition to the transparencies, we require 4-color promo/tearsheets and participation in the biannual Martha Productions brochure." Advertises in *The Workbook*, *Single Image*.

How to Contact: For first contact, send query letter, direct mail flier/brochure, tearsheets, slides and SASE (if materials are to be returned). Reports only if interested. After initial contact, drop off or mail in appropriate materials for review. Portfolio should include tearsheets, slides, photographs, photostats. Obtains new talent through recommendations and solicitation.

Tips: "Artists should have a style we feel would sell and does not compete with those artists we are currently represent-

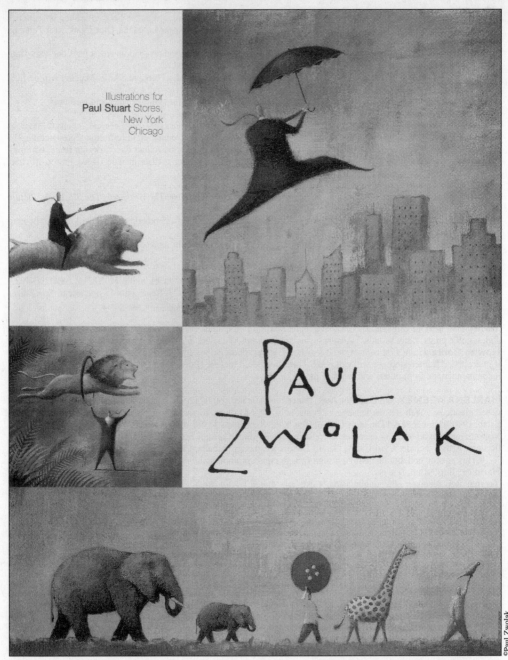

Illustrations for
Paul Stuart Stores,
New York
Chicago

©Paul Zwolak

This montage of whimsical pieces showcases the work of Canadian artist Paul Zwolak, represented by the Marlena Agency, based in Princeton, New Jersey. Zwolak's work has appeared in national and corporate magazines such as *Playboy* and *U.S. News & World Report*, and he's worked for clients like IBM and *The Wall Street Journal*. The Marlena Agency represents talent (both fine and commercial artists) from 18 countries, handling work that is conceptual and artistic at the same time. To see more samples of artists represented by Marlena, see their website at http://www.marlena agency.com.

ing, as well as a solid body of consistent (in style and execution) work that includes a variety of topics (i.e., people, landscape, product concept, etc.). We'll often work with the artist on a job-to-job basis prior to representation to see how competent the artist is and how smooth the working relationship will be."

☑ **MASON ILLUSTRATION**, 3810 Edmund Blvd., Minneapolis MN 55406. (612)729-1774. Fax: (612)729-0133. Creative Rep/Owners: Marietta and Jerry Mason. Commercial illustration representative. Estab. 1984. Represents 12 illustrators. Markets include advertising agencies; corporations/client direct; design firms; editorial/magazines; publishing/books; sales; promotion; incentives. Artists include: Neal Aspinall, Kenn Backhaus, Patrick Faricy, Paul Fricke, Glenn Gustafson, Joe Heffron, Kurt Lang, Dan Lotts, Mark Mille, Jeff Meyer, Chris Monroe, Randy Rogers, Tom Rosboroush, Harlan Scheffler and Dan Wiemer.
Handles: Illustration, digital image and photo retouching.
Terms: Rep receives 25% commission. Exclusive area representation is required. Advertising costs are split: 75% paid by talent; 25% paid by representative. For promotional purposes, talent must provide 2 complete portfolios of transparencies or reflective samples, "unmounted as we mount to coordinate as group."
How to Contact: For first contact, send query letter, bio, direct mail flier/brochure, tearsheets, slides, photocopies and SASE. Reports in 1 month. After initial contact, drop off or mail in appropriate materials. Portfolio should include tearsheets, slides, photocopies, 4×5 transparencies.
Tips: Artist must have "good communication/visual/verbal skills."

🅽 **MATTELSON ASSOCIATES LTD.**, 37 Cary Rd., Great Neck NY 11021. (212)684-2974. Fax: (516)466-5835. Contact: Judy Mattelson. Commercial illustration representative. Estab. 1980. Member of SPAR, Graphic Artists Guild. Represents 3 illustrators. Markets include: advertising agencies; corporations/client direct; design firms; editorial/magazines; paper products/greeting cards; publishing/books; sales/promotion firms.
Handles: Illustration.
Terms: Rep receives 25-30% commission. Exclusive area representation is required. No geographic restrictions. Advertising costs are split: 75% paid by talent; 25% paid by representative. For promotional purposes, talent must provide c-prints and tearsheets, custom-made portfolio. Advertises in *American Showcase*, *RSVP*.
How to Contact: For first contact, send direct mail flier/brochure, tearsheets and SASE. Reports in 2 weeks, if interested. After initial contact, call for appointment to show portfolio of tearsheets, c-prints. Obtains new talent through "recommendations from others, solicitation.
Tips: "Illustrator should have ability to do consistent, professional-quality work that shows a singular direction and a variety of subject matter. You should have a portfolio that shows the full range of your current abilities, at least ten good pieces. Work should show strong draftsmanship and technical facility. Person should love her work and be willing to put forth great effort in each assignment."

☑ **MENDOLA ARTISTS**, 420 Lexington Ave., New York NY 10170. (212)986-5680. Fax: (212)818-1246. Contact: Tim Mendola. Commercial illustration representative. Estab. 1961. Member of Society of Illustrators, Graphic Artists Guild. Represents 60 or more illustrators, 3 photographers. Markets include: advertising agencies; corporations/client direct; design firms; editorial/magazines; sales/promotion firms.
Handles: Illustration. "We work with the top agencies and publishers. The calibre of talent must be in the top 5%."
Terms: Rep receives 25% commission. Artist pays for all shipping not covered by client and 75% of promotion costs. Exclusive area representation is sometimes required. Advertising costs are split: 75% paid by talent; 25% paid by representative. For promotional purposes, talent must provide 8×10 transparencies and usually promotion in at least one sourcebook. Advertises in *American Showcase*, *Black Book*, *RSVP*, *The Workbook*.
How to Contact: For first contact, send direct mail flier/brochure, tearsheets, slides. Reports in 1 week. After initial contact, drop off or mail in appropriate materials for review. Portfolio should include original art, tearsheets, slides, photographs.

MONTAGANO & ASSOCIATES, 11 E. Hubbard, 11th Floor, Chicago IL 60611. (312)527-3283. Fax: (312)527-2108. E-mail: dmontag@aol.com. Contact: David Montagano. Commercial illustration, photography and television production representative and broker. Estab. 1983. Represents 7 illustrators, 1 photographer. Markets include: advertising agencies; corporations/client direct; design firms; editorial/magazines; paper products/greeting cards.
Handles: Illustration, photography, design.
Terms: Rep receives 30% commission. No geographic restrictions. Advertises in *American Showcase*, *The Workbook*, *CIB*.
How to Contact: For first contact, send direct mail flier/brochure, tearsheets, photographs. Portfolio should include original art, tearsheets, photographs.

VICKI MORGAN ASSOCIATES, 194 Third Ave., New York NY 10003. (212)475-0440. E-mail: vmartrep@akula.c om. Website: http://www.vickimorganassociates.com. Partners: Vicki Morgan and Gail Gaynin. Commercial illustration representative. Estab. 1974. Member of SPAR, Graphic Artists Guild, Society of Illustrators. Represents 16 illustrators. Markets include: advertising agencies; corporations/client direct; design firms; editorial/magazines; paper products; publishing/books; sales/promotion firms.
Handles: Illustration. "Fulltime illustrators only."
Terms: Rep receives 30% commission. Exclusive area representation is required. No geographic restrictions. Advertis-

ing costs are split: 70% paid by talent; 30% paid by representative. "We require samples for three duplicate portfolios; the presentation form is flexible." Advertises in *American Showcase*, other directories and individual promotions.

How to Contact: For first contact, send any of the following: direct mail flier/brochure, tearsheets, slides with SASE. "If interested, we keep on file and consult these samples first when considering additional artists. No drop-off policy." Obtains new talent through "recommendations from artists we represent and mail solicitation."

MUNRO GOODMAN, 4 E. Ohio St. #B, Chicago IL 60611. (312)321-1336. Fax: (312)321-1350. E-mail: munroreps@aol.com. President: Steve Munro. Commercial illustration, photography representative. Estab. 1987. Member of SPAR, CAR (Chicago Artists Representatives). Represents 22 illustrators, 2 photographers. Markets include advertising agencies; corporations/client direct; design firms; publishing/books. Artists include: Pat Dypold and Douglas Klauba.

Handles: Illustration.

Terms: Rep receives 25-30% commission. Exclusive area representation is required. Advertising costs are split: 75% paid by talent; 25% paid by representative. For promotional purposes, talent must provide 2 portfolios. Advertises in *American Showcase, Black Book, The Workbook*.

How to Contact: For first contact, send query letter, bio, tearsheets and SASE. Reports back within 2 weeks. After initial contact, write to schedule an appointment. Portfolio should include 4×5 or 8×10 transparencies.

☑ THE NEWBORN GROUP, 115 W. 23rd St., Suite 43A, New York NY 10011. (212)989-4600. Fax: (212)989-8998. Website: http://www.illustrators.net/newborn. Owner: Joan Sigman. Commercial illustration representative. Estab. 1964. Member of SPAR, Society of Illustrators, Graphic Artists Guild. Represents 12 illustrators. Markets include: advertising agencies; design firms; editorial/magazines; publishing/books. Clients include Leo Burnett, Berkley Publishing, Weschler Inc.

Handles: Illustration.

Terms: Rep receives 25% commission. Exclusive area representation is required. Advertising costs are split: 75% paid by talent; 25% paid by representative. Advertises in *American Showcase, The Workbook, Directory of Illustration*.

How to Contact: "Not reviewing new talent."

Tips: Obtains new talent through recommendations from other talent or art directors.

LORI NOWICKI AND ASSOCIATES, 37 W. 20th St., Suite 902, New York NY 10011. E-mail: lori@lorinowicki.com. Website: http://www.lorinowicki.com. Estab. 1993. Represents 13 illustrators. Markets include: advertising agencies; design firms; editorial/magazines; publishing/books, children's publishing.

Handles: Illustration.

Terms: Rep receives 25-30% commission. Cost for direct mail promotional pieces is paid by illustrator. Exclusive area representation is required. Advertising costs are split: 75% paid by talent; 25% paid by representative. Advertises in *The Workbook, Black Book*.

How to Contact: For first contact, send query letter, résumé, tearsheets. Samples are not returned. "Do not phone, will contact if interested." Wants artists with consistent style.

100 ARTISTS, 4170 S. Arbor Circle, Marietta GA 30066. (770)924-4793. Fax: (770)924-7174. Owner: Brenda Bender. Commercial illustration, photography, graphic design representative. Estab. 1990. Member of Society of Illustration, Graphic Artists Guild. Represents 40 illustrators, 8 photographers, 8 designers. Markets include: advertising agencies; corporations/client direct; design firms; editorial/magazines; publishing/books.

Handles: Illustration, photography.

Terms: Rep receives 30% commission. $30-50 is added to all out-of-town projects for miscellaneous expenses, i.e. long distance calls, fax, etc. Exclusive area representation is required. Advertising costs are split: 70% paid by talent; 30% paid by representative. For promotional purposes, talent must provide direct mail/self-mailer (no overlarge or bulky promos), new material every 3 months Advertises in *American Showcase, The Workbook*.

How to Contact: For first contact, send query letter, direct mail flier/brochure or tearsheets. Reports back within 1 month if interested. SASE or postcard required for replies or return of material. After initial contact, call to schedule an appointment or drop off or mail in appropriate materials. Portfolio should include roughs, tearsheets, slides or photographs.

Tips: Needs artists with "originality who do not conflict with talent we already represent."

THE PENNY & STERMER GROUP, 2031 E. Holly Dr. N., Prescott AZ 86301. Contact: Carol Lee Stermer. Commercial illustration representative. Member of Graphic Artists Guild. Represents 9 illustrators, animation artists. Specializes in illustration for packaging and humor markets. Markets include: advertising agencies; corporations/client direct; design firms; editorial/magazines; paper products/greeting cards; publishing/books; sales/promotion firms; and creative print.

Handles: Illustration. Looking for highly conceptual artists and established food packaging artists, as well as humorists.

Terms: Rep receives 30% commission. Artists billed for portfolio supplies and bulk mailings. Advertising costs are split: 75% paid by talent; 30% paid by representative. For promotional purposes, talent must provide fisrt direct mail pieces. Advertises in *American Showcase, Black Book, The Workbook, Directory of Illustration* and *Picture Book*.

How to Contact: For first contact, send nonreturnable promos, direct mailers, etc. Reports only if interested. After initial contact, "I'll call."

N CAROLYN POTTS & ASSOC. INC., 1872 N. Clybourn, Suite #404, Chicago IL 60614. (773)935-8840. E-mail: carolyn@cpotts.com. President: Carolyn Potts. Commercial illustration, photography representative. Estab. 1976. Member of SPAR, CAR (Chicago Artists Reps). Represents illustrators and photographers. Specializes in contemporary advertising and design. Markets include: advertising agencies; corporations/client direct; design firms; publishing/books. Artists include Julia La Pine, John Craig, Rhonda Voo and Karen Bell.
Handles: Illustration, photography. Looking for "artists able to work with new technologies (interactive, computer, etc.)."
Terms: Rep receives 30-35% commission. Artists share cost of their direct mail postage and preparation. Exclusive area representation is required. Advertising costs are split: 70% paid by the talent; 30% paid by the representative after initial trial period wherein artist pays 100%. For promotional purposes, talent must provide direct mail piece and multiple portfolios. Advertises in *American Showcase, Black Book, The Workbook, Single Image.*
How to Contact: For first contact, send direct mail flier/brochure and SASE. Reports back within 3 days. After initial contact, write to schedule an appointment. Portfolio should include tearsheets, slides, photographs.
Tips: Looking for artists with high level of professionalism, awareness of current advertising market, professional presentation materials and positive attitude.

PUBLISHERS' GRAPHICS, 251 Greenwood Ave., Bethel CT 06801. (203)797-8188. Fax: (203)798-8848. Commercial illustration representative for juvenile markets. Estab. 1970. Member of Society of Children's Book Writers and Illustrators, Author's Guild Inc. Staff includes Paige C. Gillies (President, selects illustrators, develops talent). Specializes in children's book illustration. Markets include: design firms; editorial/magazines; paper products/greeting cards; publishing/books; sales/promotion firms.
Handles: Illustration.
Terms: Rep receives 25% commission. Exclusive area representation is required. For promotional purposes, talent must provide original art, proofs, photocopies "to start. The assignments generate most sample/promotional material thereafter unless there is a stylistic change in the work."
How to Contact: For first contact, send résumé, photocopies and SASE. Reports in 6 weeks. After initial contact, "We will contact them. We don't respond to phone inquiries." Portfolios should include original art, tearsheets, photocopies. Obtains new talent through "clients recommending our agency to artists. We ask for referrals from our illustrators. We receive submissions by mail."

GERALD & CULLEN RAPP, INC., 108 E. 35th St., New York NY 10016. (212)889-3337. Fax: (212)889-3341. E-mail: gerald@rappart.com. Website: http://www.theispot.com/rep/rapp. Contact: John Knepper. Commercial illustration representative. Estab. 1944. Member of SPAR, Society of Illustrators, Graphic Artists Guild. Represents 45 illustrators. Markets include: advertising agencies; corporations/client direct; design firms; editorial/magazines; paper products/greeting cards; publishing/books; sales/promotion firms. Artists include: Christian Northeast, Drew Struzan, Natalie Ascencios, Henrik Drescher, Jack Davis, Beth Adams and Mark Fredrickson.
Handles: Illustration.
Terms: Rep receives 25-30% commission. Exclusive area representation is required. No geographic restrictions. Split of advertising costs is negotiated. Advertises in *American Showcase, The Workbook, Graphic Artists Guild Directory* and *CA, Print* magazines. "Conducts active direct mail program and advertises on the internet."
How to Contact: For first contact, send query letter, direct mail flier/brochure. Reports in 1 week. After initial contact, call for appointment to show portfolio of tearsheets, slides. Obtains new talent through recommendations from others, solicitations.

REDMOND REPRESENTS, 4 Cormer Court, #304, Timonium MD 21093. (410)560-0833. E-mail: sony@erols.com. Contact: Sharon Redmond. Commercial illustration and photography representative. Estab. 1987. Markets include: advertising agencies; corporations/client direct; design firms.
Handles: Illustration, photography.
Terms: Rep receives 30% commission. Exclusive area representation is required. No geographic restrictions. Advertising costs and expenses are split: 50% paid by talent; 50% paid by representative. For promotional purposes, talent must provide a small portfolio (easy to Federal Express) and at least 6 direct mail pieces (with fax number included). Advertises in *American Showcase, Black Book.*
How to Contact: For first contact, send photocopies. Reports in 2 weeks if interested. After initial contact, representative will call talent to set an appointment.
Tips: "Even if I'm not taking in new talent, I do want *photocopies* sent of new work. You never know when an ad agency will require a different style of illustration/photography and it's always nice to refer to my files."

REPERTOIRE, 2029 Custer Pkwy., Richardson TX 75080. (972)761-0500. Fax: (972)761-0501. E-mail: info@repertoir eart.com. Website: http://www.repertoireart.com. Contact: Larry Lynch (photography) or Andrea Lynch (illustration). Commercial illustration and photography representative and broker. Estab. 1974. Member of SPAR. Represents 12 illustrators and 6 photographers. Specializes in "importing specialized talent into the Southwest." Markets include advertising agencies, corporations/client direct, design firms, editorial/magazines. Artists include Aaron Jones and Eric Dinyer.
Handles: Illustration, photography, design.
Terms: Rep receives 25-30% commission. Exclusive area representation is required. Advertising costs are split; printing

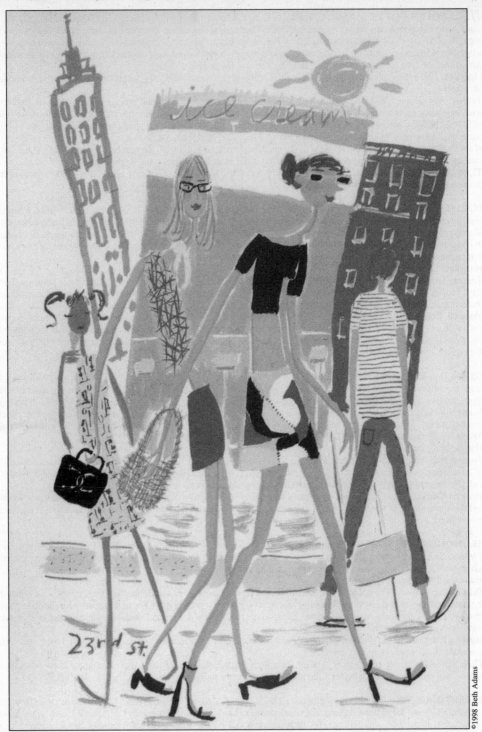

Beth Adams created this upbeat lifestyle illustration in gouache especially for a promotional postcard sent by reps Gerald & Cullen Rapp, Inc., based in New York City. Adams's work is promoted through postcard mailings and directory advertisements. She suggests artists "keep a sketchbook of images—things you like to draw. Use one medium or tool for a while. Do mailings monthly or at least every season."

costs are paid by talent; distribution costs are paid by representative. Talent must provide promotion, both direct mail and a national directory. Advertises in *The Workbook*.

How to Contact: For first contact, send direct mail flier/brochure, tearsheets. Reports in 1 month. After initial contact, write for appointment or drop off or mail portfolio of tearsheets, slides, photographs. Obtains new talent through referrals, solicitations.

Tips: Looks for "sense of humor, honesty, maturity of style, ability to communicate clearly and relevance of work to our clients."

THE ROLAND GROUP, 4948 St. Elmo Ave., Suite #201, Bethesda MD 20814. (301)718-7955. Fax: (301)718-7958. E-mail: info@therolandgroup.com. Website: http://www.therolandgroup.com. Commercial illustration and photography representative. Estab. 1988. Member of SPAR, Society of Illustrators, Ad Club, Production Club. Represents 20 illustrators, and over 200 photographers. Markets include: advertising agencies; corporations/client direct; design firms; editorial/magazines; paper products/greeting cards; publishing books.

Handles: Illustration and photography.

Terms: Rep receives 35% commission. Exclusive and non-exclusive representation available. Also work with artists on a project-by-project basis. For promotional purposes, talent must provide 8½×11 promo sheet. Advertises in *American Showcase*, *The Workbook*, *International Creative Handbook*, *Black Book* and *KLIK*.

How to Contact: For first contact, send query letter, tearsheets and photocopies. Reports back, if interested. Portfolio should include nonreturnable tearsheets, photocopies.

S.I. INTERNATIONAL, 43 E. 19th St., New York NY 10003. (212)254-4996. Fax: (212)995-0911. E-mail: hspiers@-tiac.net. Website: http://www.si-i.com. Commercial illustration representative. Estab. 1983. Member of SPAR, Graphic Artists Guild. Represents 50 illustrators. Specializes in license characters, educational publishing and children's illustration, digital art and design, mass market paperbacks. Markets include design firms; publishing/books; sales/promotion firms; licensing firms; digital art and design firms.

Handles: Illustration. Looking for artists "who have the ability to do children's illustration and to do license characters either digitally or reflexively."

Terms: Rep receives 25-30% commission. Advertising costs are split: 70% paid by talent; 30% paid by representative. "Contact agency for details. Must have mailer." Advertises in *Picture Book*.

How to Contact: For first contact, send query letter, tearsheets. Reports in 3 weeks. After initial contact, write for appointment to show portfolio of tearsheets, slides.

JOAN SAPIRO ART CONSULTANTS, 4750 E. Belleview Ave., Littleton CO 80121. (303)793-0792. Contact: Joan Sapiro. Art consultant. Estab. 1980. Specializes in "corporate art with other emphasis on hospitality, health care and art consulting/advising to private collectors."

Handles: All mediums of artwork and all prices if applicable for clientele.

Terms: "50/50. Artist must be flexible and willing to ship work on consignment. Also must be able to provide sketches, etc. if commission piece involved." No geographic restrictions.

How to Contact: For first contact, send résumé, bio, direct mail flier/brochure, tearsheets, slides, photographs, price list—net (wholesale) and SASE. Reports in 2 weeks. After initial contact, drop off or mail in appropriate materials for review. Portfolios should include tearsheets, slides, price list and SASE.

Tips: Obtains new talent through recommendations, publications, travel, research, university faculty.

FREDA SCOTT, INC., 1015 Battery St., Suite #B, San Francisco CA 94111. (415)398-9121. Fax: (415)398-6136. Contact: Melinda Meinke or Freda Scott. Commercial illustration and photography representative. Estab. 1980. Member of SPAR. Represents 10 illustrators, 15 photographers. Markets include: advertising agencies; corporations/client direct; design firms; editorial/magazines; paper products/greeting cards; publishing/books; sales/promotion firms. Clients include Saatchi & Saatchi, Young & Rubicam, J. Walter Thompson, Anderson & Lembke, *Smart Money*, *Travel & Leisure*, Oracle Corp., Sun Microsystems. Client list available upon request.

Handles: Illustration, photography.

Terms: Rep receives 25% commission. No geographic restrictions. Advertising costs are split: 75% paid by talent; 25% paid by representative. For promotional purposes, talent must provide "promotion piece and ad in a directory. I also need at least three portfolios." Advertises in *American Showcase*, *Black Book*, *The Workbook*.

How to Contact: For first contact, send direct mail flier/brochure, tearsheets and SASE. If you send transparencies, reports in 1 week, if interested. "You need to make follow up calls." After initial contact, call for appointment to show portfolio of tearsheets, photographs, 4×5 or 8×10.

Tips: Obtains new talent sometimes through recommendations, sometimes solicitation. "If you are seriously interested in getting repped, keep sending promos—once every six months or so. Do it yourself a year or two until you know what you need a rep to do."

☑ **FRAN SEIGEL, ARTIST REPRESENTATIVE**, 160 W. End Ave., #23-S, New York NY 10023. (212)712-0830. Fax: (212)712-0857. Commercial illustration. Estab. 1982. Member of SPAR, Graphic Artists Guild. Represents 10 illustrators. Specializes in "stylized realism leaning toward the conceptual." Markets include advertising agencies; client direct; design firms; magazines; paper products/greeting cards; book jackets.

Handles: Illustration, fine art. "Artists in my group must have work applicable to wide commercial market; a unique

marketable style for book jackets and/or licensing is a plus."

Terms: Rep receives 30% commission. Exclusive national representation is required. Advertising costs are split: 70% paid paid by talent; 30% paid by representative. "First promotion is designed by both of us, paid for by talent; subsequent promotion costs are split." Advertises in *Graphic Artists Guild Directory of Illustration*.

How to Contact: For first contact, send 12-20 images, direct mail flier/brochure, tearsheets, slides and SASE. Reports in 2 weeks only if SASE is included.

Tips: Looking for artists with " 'uniquely wonderful' artwork, vision and energy, market-oriented portfolio, and absolute reliability and professionalism."

[N] SHARPE + ASSOCIATES INC., 25 W. 68th St., Suite 9A, New York NY 10023. (212)595-1125. Contact: Colleen Hedleston. Commercial illustration and photography representative. Estab. 1987. Member of APA, ADLA. Represents 6 illustrators, 4 photographers. Not currently seeking new talent but "always willing to look at work." Staff includes: John Sharpe (in Los Angeles) and Colleen Hedleston (general commercial—advertising and design), "both have ad agency marketing backgrounds. We tend to show more non-mainstream work." Markets include: advertising agencies; corporations/client direct; design firms; editorial/magazines; sales/promotion firms.

● Sharpe + Associates has a Los Angeles office. Contact John Sharpe, 7536 Ogelsby Ave., Los Angeles CA 90045.

Handles: Illustration, photography.

Terms: Agent recieves 25% commission. Exclusive area representation is required. For promotional purposes, "promotion and advertising materials are a shared responsibility, though the talent must be able to afford 75% of the material/media. The portfolios are 100% the talent's responsiblity and we like to have at least 6 complete books." Advertises in *The Workbook*, *Klik*, *Archive*.

How to Contact: For first contact, call, then followup with printed samples. Reports in 2 weeks. Call for appointment to show portfolio of c- or r-prints of original work for illustration and transparencies or prints for photography.

Tips: Obtains new talent mostly through referrals, occasionally through solicitations. "Once you have a professional portfolio together and at least one representative promotional piece, target reps along with potential buyers of your work as if the two groups are one and the same. Market yourself to reps as if the reps are potential clients."

SIMPATICO ART & STONE, 1221 Demaret Lane, Houston TX 77055-6115. (713)467-7123. Contact: Billie Blake Fant. Fine art broker/consultant/exhibitor. Estab. 1973. Specializes in unique fine art, sculpture and Texas domestic stone furniture, carvings, architectural elements. Market includes: corporate; institutional and residential clients.

Handles: Unique fine art and sculpture not presently represented in Houston, Texas.

Terms: Standard commission. Exclusive area representation required.

How to Contact: For first contact, send query letter, résumé, slides. Obtains new talent through travel, publications, exhibits and referrals.

SUSAN AND CO., 5002 92nd Ave. SE, Mercer Island WA 98040. (206)232-7873. Fax: (206)232-7908. E-mail: susanandco@accessone.com. Owner: Susan Trimpe. Commercial illustration, photography representative. Estab. 1979. Member of SPGA. Represents 19 illustrators, 2 photographers. Specializes in commercial illustrators and photographers. Markets include advertising agencies; corporations/client direct; design firms; publishing/books. Artists include: Greg Stadler, Fred Ingram, Nina Laden and Eric Larsen.

Handles: Illustration, photography. Looks for "computer illustration, corporate, conceptual."

Terms: Rep receives 30% commission. Charges postage if portfolios are shipped out of town. Exclusive area representation is required. Advertising costs are split: 70% paid by talent; 30% paid by representative. "Artists must take out a page in a publication, i.e., *American Showcase*, *CIB*, *The Workbook* with rep."

How to Contact: For first contact, send query letter and direct mail flier/brochure. Reports back within 2 weeks only if interested. After initial contact, call to schedule an appointment. Portfolio should include tearsheets, slides, photographs, photostats, photocopies.

Tips: Wants artists with "unique well-defined style and experience."

[N] THOSE 3 REPS, 2909 Cole, Suite #118, Dallas TX 75204. (214)871-1316. Fax: (214)880-0337. Contact: Debbie Bozeman, Carol Considine, Jill Belcher, Elizabeth Shuey. Artist representative. Estab. 1989. Member of Dallas Society of Visual Community, ASMP, SPAR and Dallas Society of Illustrators. Represents 15 illustrators, 3 photographers. Specializes in commercial art. Markets include: advertising agencies; corporations/client direct; design firms; editorial/magazines.

Handles: Illustration, photography (including digital).

Terms: Rep receives 30% commission; 30% for out-of-town jobs. Exclusive area representation is required. Advertising costs are split: 70% paid by talent; 30% paid by representative. For promotional purposes, talent must provide 2 new pieces every 2 months, national advertising in sourcebooks and at least 1 mailer. Advertises in *Workbook*, own book.

How to Contact: For first contact, send query letter and tearsheets. Reports within days or weeks only if interested. After initial contact, call to schedule an appointment, drop off or mail in appropriate materials. Portfolio should include tearsheets, photostats, transparencies.

Tips: Wants artists with "strong unique consistent style."

✓ **T-SQUARE, ETC.**, 1426 Main St., Venice CA 90291. (310)581-2200. Fax: (310)581-2204. E-mail: diane@t-squareetc.com. Website: http://www.t-squareetc.com. Managing Director: Diane Pirritino. Graphic design representative. Estab. 1990. Member of Advertising Production Association of California, Ad Club of LA. Represents 50 illustrators, 100 designers. Specializes in computer graphics. Markets include advertising agencies; corporations/client direct; design firms; editorial/magazines.
Handles: Design.
Terms: Rep receives 25% commission. Advertising costs are split: 25% paid by talent; 75% paid by representative. For promotional purposes, talent must provide samples from their portfolio (their choice).
How to Contact: For first contact, send résumé. Reports back within 5 days. After initial contact, call to schedule an appointment. Portfolio should include thumbnails, roughs, original art, tearsheets, slides.
Tips: Artists must possess "good design, computer skills, flexibility, professionalism."

CHRISTINA A. TUGEAU: ARTIST AGENT, 110 Rising Ridge Rd., Ridgefield CT 06877. (203)438-7307. Fax: (203)438-7060. Owner: Chris Tugeau. Children's market illustration representative. Estab. 1994. Member of Graphic Artists Guild, SPAR, SCBWI. Represents 30 illustrators. Specializes in children's book publishing and educational market and related areas. Artists include: Stacey Schrett, James Bernardin, Larry Day, Bill Farnsworth, Melissa Iwai, Paul Kratter, Keiko Motoyama, Daniel Powers, Teri Sloat, Jason Wolff, Jeremy Tugeau, Priscilla Burris, John Kanaler, Naomi Hawland and Ann Barrow.
Handles: Illustration. Must be proficient at illustrating children and animals in a variety of interactive situations, in real space, full color/b&w, and with a strong narrative sense.
Terms: Rep receives 25% commission. Exclusive USA representation is required (self-promotion is OK). Advertising costs are split: 80% paid by the talent; 20% paid by the representative. For promotional purposes, talent must provide a direct mail promo piece, 8-10 good "back up" samples (multiples), 3 strong portfolio (8×10 or printed pieces). Advertises in *RSVP* and *GAG Directory of Illustration, Showcase, Picturebook, American Showcase.*
How to Contact: For first contact call, then send direct mail flier/brochure, tearsheets, photographs, photocopies, SASE, "prefer no slides!" Reports in 1-2 weeks. Call to schedule an appointment. Portfolio should include tearsheets, books, photocopies, "no originals."
Tips: "You should have a style uniquely and comfortably your own and be great with deadlines. I've taken on young, new artists with great potential and desire, as well as published, more experienced illustrators."

N GWEN WALTERS, 50 Fuller Brook Rd., Wellesley MA 02181. (617)235-8658. E-mail: artincgw@aol.com. Commercial illustration representative. Estab. 1976. Member of Graphic Artists Guild. Represents 17 illustrators. "I lean more toward book publishing." Markets include: advertising agencies; corporations/client direct; editorial/magazines; paper products/greeting cards; publishing/books; sales/promotion firms.
Handles: Illustration.
Terms: Rep receives 30% commission. Charges for color photocopies. Advertising costs are split; 70% paid by talent; 25% paid by representative. For promotional purposes, talent must provide direct mail pieces. Advertises in *RSVP, Directory of Illustration* and *Black Book.*
How to Contact: For first contact, send résumé bio, direct mail flier/brochure. After initial contact, representative will call. Portfolio should include "as much as possible."

WARNER & ASSOCIATES, 1425 Belleview Ave., Plainfield NJ 07060. (908)755-7236. E-mail: bwarnet@sci-imagemakers.com. Website: http://www.sci-imagemakers.com. Contact: Bob Warner. Commercial illustration and photography representative. Estab. 1986. Represents 4 illustrators, 4 photographers. "My specialized markets are advertising agencies that service pharmaceutical, medical, health care clients." Artists include: Tomo Narashima, Victor Valla, Birck Cox, Michael Aniel, Dimitry Schidlousky and Alex Pietersen.
Handles: Illustration, photography. Looking for medical illustrators: microscope photographers (photomicrography), science illustrators, special effects photographers.
Terms: Rep receives 25% commission. "Promo pieces and portfolios obviously are needed; who makes up what and at what costs and to whom, varies widely in this business."
How to Contact: For first contact send query letter "or phone me." Reports back in days. Portfolio should include "anything that talent considers good sample material." Obtains new talent "by hearsay and recommendations. Also, specialists in my line of work often hear about my work from art directors and they call me."

N W/C STUDIO INC., 208 Providence Rd., Annapolis MD 21401. (410)349-8669. Fax: (410)349-8632. E-mail: acomport@aol.com. Artist's Representative: Allan Comport. Commercial illustration, photography representative. Estab. 1983. Member of SPAR, Society of Illustrators. Represents 5 illustrators, 1 photographer. Markets include: advertising agencies, design firms, editorial/magazines, publishing.
Handles: Illustration, photography.
Terms: Rep receives 25% commission. Advertising costs are split: 75% paid by talent; 25% paid by representative. For promotional purposes, talent must provide 4×5 transparencies; "We put them into our own 11×12 format." Advertises in *American Showcase, The Workbook.*
How to Contact: Send query letter, direct mail flier/brochure, tearsheets, photocopies and SASE. Reports in 1 month. Portfolio should include tearsheets.
Tips: Artists must have "strong conceptual talent, highest professional/work ethic, good attitude."

☑ **THE WILEY GROUP**, (formerly David Wiley Represents), 94 Natoma St., Suite 200, San Francisco CA 94105. (415)442-1822. Fax: (415)442-1823. E-mail: dww@wco.com. Website: http://www.thewileygroup.com. Contact: David Wiley. Commercial illustration and photography representative. Estab. 1984. Member of AIP (Artists in Print). Society of Illustrators, Graphic Artists Guild, Bay Area Lawyers for the Arts. Represents 12 illustrators and 3 photographers. Specializes in "being different and effective!" Clients include Coke, Pepsi, '96 Summer Olympics, Disney Co., Bank of America, NHL, US Open. Client list available upon request.

Terms: Rep receives 25% commission. Artist is responsible for 100% of portfolio costs. Creative directory costs are paid 100% by artist. Annual tearsheet mailing is paid 100% by rep, as well as each artist's website. Quarterly postcard mailings are paid 100% by artist. Advertises in *American Showcase*, *Directory Of Illustration*, *Black Book*, *Workbook*.

How to Contact: For first contact, send 1-2 direct mail samples, tearsheets, slides, photographs, and SASE ("very important"). Will call back, if interested, within 48 hours. After initial contact, call for appointment or drop off appropriate materials. Portfolio should include self promotion and commissioned jobs.

Tips: "I suggest working in a style that will allow quick turnaround, one to two weeks. Present portfolios with examples of self promotion and commissioned work in 4×5 transparency format. Send color and black & white imagery. Ask questions and then sit back and listen and take notes. Three key words I work with 'ask, listen and act.' Learn to work with these and new discoveries will unfold! Remember to give yourself permission to make mistakes."

DEBORAH WOLFE LTD., 731 N. 24th St., Philadelphia PA 19130. (215)232-6666. Fax: (215)232-6585. Contact: Deborah Wolfe. Commercial illustration representative. Estab. 1978. Represents 25 illustrators. Markets include: advertising agencies; corporations/client direct; design firms; editorial/magazines; publishing/books.

Handles: Illustration.

Terms: Rep receives 25% commission. Advertises in *American Showcase*, *Black Book* and *The Workbook*.

How to Contact: For first contact, send direct mail flier/brochure, tearsheets, slides. Reports in 3 weeks. "Artists usually contact us through mail or drop off at our office. If interested, we ask to see more work."

Websites for Artists

BY MEGAN LANE

The Internet has emerged as an important resource for artists. Web pages offer valuable, instant information about art buyers. Galleries, large and small, have launched websites to market their artists' work, and artists are posting their work on personal sites and group sites of electronic portfolios. If you don't have access to the Web, try your local library. Surfing time is often limited on these public computers, but a carefully planned search can yield excellent results.

Researching on the Web

The first step to making the most of your time online is to know where you want to go. Using Internet search engines such as Yahoo! or AltaVista, plugging in key words like *magazines* or *posters* or *graphic design* will generate a long list of potential sites which can lead you to potential clients. We've included websites within listings whenever possible. Check out the following sites in your target markets.

Greeting Cards, Gifts & Products
- Greeting Card Association—http://www.greetingcard.org
- *Greetings Today*—http://www.greetingstoday.com
- *Party & Paper* magazine—http://www.partypaper.com

Magazines
- Electronic Journal—http://www.edoc.com
- Electronic Newsstand—http://www.enews.com
- *Folio Magazine*—http://www.mediacentral.com

Posters & Prints
- The Art & Framing Headquarters—http://www.artframing.com
- ArtCatalogue.com—http://www.artcatalog.com
- Art, Posters and Prints—http://www.art-posters-prints.com

Book Publishers
- Literary Market Place—http://lmp.bookwire.com
- Publisher's Catalogues Home Page—http://www.lights.com/publisher/index.html
- Publishers on the Internet—http://www.faxon.com/html/it_pl_am.html

Galleries
- Art Dealers Association of America—http://www.artdealers.org
- Art Links—http://www.fine-art.com/link.html
- GenArt—http://www.genart.org
- Doubletake Gallery—http://www.DoubletakeArt.com.
- *Art Calendar*—http://www.artcalendar.com
- Art Network—http://www.artmarketing.com

Syndicates & Cartoon Features
- Cartoon links—http://cartooning.miningco.com/msub01.htm
- Cartoonists at Large—http://www.cyberenet.net/~jasper/cal_home.html
- Internet Cartoon Forum—http://www.cartoonsforum.com
- Dan Cagle's Professional Cartoonists Index—http://www.cagle.com/
- Stu's Comic Strip Connection—http://www.stus.com/

Stock Illustration & Clip Art Firms
- Custom Medical Stock—http://www.cmsp.com

- Image Club Graphics—http://www.imageclub.com
- Nova Development Corporation—http://www.novadevcorp.com

Animation & Computer Games
- Animation World Network—http://www.awn.com
- Computer Animation Pages—http://www.bergen.org/AAST/ComputerAnimation/
- International Animation Association—http://www.swcp.com/~asifa/
- Quickdraw Animation Society—http://www.awn.com

Advertising, Design & Related Markets
- Advertising links—http://www.adtalk.com
- Graphic Arts Guild—http://www.gag.org
- *HOW* magazine—http://www.howdesign.com/

Record Labels
- Arista Records—http://www.artistarec.com
- Capitol Records—http://www.hollywoodandvine.com
- Geffen Records—http://www.geffen.com
- Record Label links—http://www.ddc.com/extra/labels.htm

Competitions
- The Art Deadlines List—http://.3xensei.com/adl/

Online portfolios and sourcebooks

If you're considering posting your art on-line in an electronic portfolio, check out these sites. They may give you ideas about creating your own web page or offer you the opportunity to post your work through an established site.

- American Showcase—www.showcase.com
- Art Net Web—http://artnetweb.com
- Art on the Net Index—http://www.art.net/
- Art Scope—http://www.artscope.com
- Artisan's Corner—http://www.esinet.net/ac.html
- Arts Online—http://www.arts-online.com
- Designlink—http://www.designlink.com
- Illo.com—http://www.illo.com
- Kaleidospace—http://www.kspace.com
- The Nose, online caricature artist index—http://ww4.choice.net/~ktbarney/thenose/
- On Line Gallery—http://www.OnLineGallery.com
- Portfolio Central—http://portfoliocentral.com
- Pure Art Mkt.—http://www.PureArtMkt.com
- The*i*spot—http://www.theispot.com
- U.S. Creative Directory—http://www.uscreative.com

Let your fingers do the typing

Quite possibly the most valuable resources the Web has to offer are electronic yellow pages. Using these sites, you can generate long lists of potential markets in your region. Searching for all the galleries in the U.S. will yield more information than can possibly be used by one person. However, searching for all the galleries in a chosen area can lead to an effective submission strategy. There are many online address directories. Here are just a few.

- Big Book—http://www.bigbook.com
- The Electronic Yellow Pages—http://eisc-eyp.com
- The Internet Yellow Pages—http://www.the-yellowpages.com

A carefully planned, well-researched self-promotion campaign will always be more successful than a blind mass mailing. Use the vast resources of the web to become a more effective marketer of yourself and of your artwork.

insider report

Online directories: the newest way to showcase your work

Illustrators have traditionally marketed their work by sending samples to art directors or placing ads in talent directories. The rapid growth of the Internet is changing all that. Many art directors are turning to online directories to quickly locate, view and purchase the art they need.

"Print is a slow medium—the web is like lightning," says Jami Giovanopoulos, client service manager for the*i*spot (http://www.theispot.com). The*i*spot is one of several websites featuring illustrators' portfolios online, and was one of the first to offer this service. The site was conceived in 1996, when illustrators' representative Gerald Rapp discussed the possibility with Applied Graphics Technologies, a communications conglomerate experienced in the build-

Jami Giovanopoulos

ing of major websites. "Jerry felt art directors and designers would want one central directory where they could view a wide variety of illustration talent," says Giovanopoulos. AGT launched the*i*spot later that year with 35 artists' portfolios.

Since then, the*i*spot has grown rapidly and now showcases about 350 portfolios from artists throughout the world, averaging 750,000 hits a month. When art buyers enter the site, they can locate artists' samples by selecting an artist's name from an alphabetized list, browsing images by subject, or doing a more refined search by specifying medium and style as well as subject. If they're interested in seeing more of a particular artist's work, they're guided to a portfolio of 12 images on the artist's personal web page. From there, they can contact the artist to negotiate an assignment. Giovanopoulos believes the benefits of posting a portfolio online outweigh placing an ad in a talent directory. "Looking at a printed directory page only offers art directors a few samples of an illustrator's work," she explains. However, from a website such as the*i*spot, they can view a portfolio "and get their project underway in minutes." Also advertising in a print directory costs more than posting a portfolio on the*i*spot.

JAMI GIOVANOPOULOS

Title: Client Service Manager
Website: the*i*spot

After paying a $100 set-up fee, artists pay $650 a year for their to paying about $3,000 per page for an ad in a print directory. According to Giavanopoulos, "artists are finding the site is paying for itself with just one job." Illustrators web page as compared new to the industry may especially benefit

from promoting themselves on a website such as theispot. "It's going to put them in the same league as some of the biggest names in the industry," says Giovanopoulos. "Newcomers' images pop up as readily as those of established names like Brad Holland."

In addition to featuring assignment portfolios, theispot also has a sub-site where artists resell rights to their existing images. "We wanted to give artists a situation where they can perform as their own stock houses," says Giovanopoulos. Artists with assignment portfolios on theispot can also post stock illustrations for an annual fee Theispot's home page, where art buyers can access the work of over 350 artists. of $25 for each piece. Artists negotiate their own fee with a client, while theispot does the billing and delivery of the art for a small percentage of the agreed upon fee. Theispot also offers chatboards for artists to discuss topics of interest such as, computer illustration, pricing and even difficult clients.

Giovanopoulos notes that Internet-savvy illustrators who market their work from their own websites have much more to gain from becoming part of an online directory. "The more artists there are on a website, the more art directors come to look," she relates. "You can have the most beautiful site on Earth, but if nobody knows it's there, it won't work for you."

Giovanopoulos says artists who don't work on a computer shouldn't shy away from using the Internet as a marketing tool. To post a portfolio on theispot, artists need only to submit transparencies or tearsheets of their work. Theispot digitizes their samples and composes their web page. "Even artists who are completely without digital access understand the impact of this medium," she states. "The Internet is no longer the marketing tool of tomorrow—it's here today."

—*Poppy Evans*

Theispot's home page, where art buyers can access the work of over 350 artists.

Glossary

Acceptance (payment on). An artist is paid for his work as soon as a buyer decides to use it.

Adobe Illustrator®. Drawing and painting computer software.

Adobe PageMaker. Illustration software (formerly Aldus PageMaker).

Adobe Photoshop®. Photo manipulation computer program.

Advance. Amount paid to an artist before beginning work on an assigned project. Often paid to cover preliminary expenses.

Airbrush. Small pencil-shaped pressure gun used to spray ink, paint or dye to obtain gradated tonal effects.

Aldus FreeHand. Illustration software (see Macromedia FreeHand).

Aldus PageMaker. Page layout software (see Adobe PageMaker).

Art director. In commercial markets, the person responsible for choosing and purchasing artwork and supervising the design process.

Biannually. Occurring twice a year.

Biennially. Occurring once every two years.

Bimonthly. Occurring once every two months.

Biweekly. Occurring once every two weeks.

Book. Another term for a portfolio.

Buy-out. The sale of all reproduction rights (and sometimes the original work) by the artist; also subcontracted portions of a job resold at a cost or profit to the end client by the artist.

Calligraphy. The art of fine handwriting.

Camera-ready. Art that is completely prepared for copy camera platemaking.

Capabilities brochure. A brochure, similar to an annual report, outlining for prospective clients the nature of a company's business and the range of products or services it provides.

Caption. See gagline.

CD-ROM. Compact disc read-only memory; non-erasable electronic medium used for digitized image and document storage and retrieval on computers.

Collateral. Accompanying or auxiliary pieces, such as brochures, especially used in advertising.

Color separation. Photographic process of separating any multi-color image into its primary component parts (cyan, magenta, yellow and black) for printing.

Commission. 1) Percentage of retail price taken by a sponsor/salesman on artwork sold. 2) Assignment given to an artist.

Comprehensive. Complete sketch of layout showing how a finished illustration will look when printed; also called a comp.

Copyright. The exclusive legal right to reproduce, publish and sell the matter and form of a literary or artistic work.

Consignment. Arrangement by which items are sent by an artist to a sales agent (gallery, shop, sales rep, etc.) for sale with the understanding the artist will not receive payment until work is sold. A commission is almost always charged for this service.

Direct-mail package. Sales or promotional material that is distributed by mail. Usually consists of an outer envelope, a cover letter, brochure or flier, SASE, and postpaid reply card, or order form with business reply envelope.

Dummy. A rough model of a book or multi-page piece, created as a preliminary step in determining page layout and length. Also, a rough model of a card with an unusual fold or die cut.

Edition. The total number of prints published of one piece of art.

Elhi. Abbreviation for elementary/high school used by publishers to describe young audiences.

Environmental graphic design (EGD). The planning, designing and specifying of graphic elements in the built and natural environment; signage.

EPS files. Encapsulated PostScript—a computer format used for saving or creating graphics.

Estimate. A ballpark figure given to a client by a designer anticipating the final cost of a project.

Etching. A print made by the intaglio process, creating a design in the surface of a metal or other plate with a needle and using a mordant to bite out the design.

Exclusive area representation. Requirement that an artist's work appear in only one outlet within a defined geographical area.

Finished art. A completed illustration, mechanical, photo, or combination of the three that is ready to go to the printer. Also called camera-ready art.

Gagline. The words printed with a cartoon (usually directly beneath); also called a caption.

Giclée Method of creating limited and unlimited edition prints using computer technology in place of traditional methods of reproducing artwork. Original artwork or transparency is digitally scanned, and the stored information is manipulated on screen using computer software (usually Photoshop). Once the image is refined on screen, it is printed on an Iris printer, a specialized ink-jet printer designed for making giclée prints.

Gouache. Opaque watercolor with definite, appreciable film thickness and an actual paint layer.

Halftone. Reproduction of a continuous tone illustration with the image formed by dots produced by a camera lens screen.

IRC. International Reply Coupon; purchased at the post office to enclose with artwork sent to a foreign buyer to cover his postage cost when replying.

Iris print. Limited and unlimited edition print or giclée output on an Iris or ink-jet printer (named after Iris Graphics of Bedford, Massachusetts, a leading supplier of ink-jet printers).

JPEG files. Joint Photographic Experts Group—a computer format used for saving or creating graphics.

Keyline. Identification of the positions of illustrations and copy for the printer.

Kill fee. Portion of an agreed-upon payment an artist receives for a job that was assigned, started, but then canceled.

Layout. Arrangement of photographs, illustrations, text and headlines for printed material.

Licensing. The process whereby an artist who owns the rights to his or her artwork permits (through a written contract) another party to use the artwork for a specific purpose for a specified time in return for a fee and/or royalty.

Lithography. Printing process based on a design made with a greasy substance on a limestone slab or metal plate and chemically treated so image areas take ink and non-image areas repel ink.

Logo. Name or design of a company or product used as a trademark on letterhead, direct mail packages, in advertising, etc., to establish visual identity.

Macromedia PageMaker. Page layout software (formerly Aldus PageMaker).

Mechanicals. Preparation of work for printing.

Multimedia. A generic term used by advertising, public relations and audiovisual firms to describe productions involving animation, video, web graphics or other visual effects. Also, a term used to reflect the varied inhouse capabilities of an agency.

Naif. Native art of such cultures as African, Eskimo, Native American, etc., usually associated with daily life.

Offset. Printing process in which a flat printing plate is treated to be ink-receptive in image areas and ink-repellent in non-image areas. Ink is transferred from the printing plate to a rubber plate, and then to the paper.

Overlay. Transparent cover over copy, on which instruction, corrections or color location directions are given.

Panel. In cartooning, the boxed-in illustration; can be single panel, double panel or multiple panel.

Photostat. Black & white copies produced by an inexpensive photographic process using paper negatives; only line values are held with accuracy. Also called stat.

PMT. Photomechanical transfer; photostat produced without a negative.

P-O-P. Point-of-purchase; in-store marketing display that promotes a product.

Print. An impression pulled from an original plate, stone, block screen or negative; also a positive made from a photographic negative.

Production artist. In the final phases of the design process, the artist responsible for mechanicals and sometimes the overseeing of printing.

QuarkXPress. Page layout computer program.

Query. Letter to an art director or buyer eliciting interest in a work an artist wants to illustrate or sell.

Quotation. Set fee proposed to a client prior to commencing work on a project.

Rendering. A drawn representation of a building, interior, etc., in perspective.

Retail. The sale of goods in small quantities directly to the consumer.

Roughs. Preliminary sketches or drawings.

Royalty. An agreed percentage paid by a publisher to an artist for each copy of a work sold.

SASE. Self-addressed, stamped envelope.

Self-publishing. In this arrangement, an artist coordinates and pays for printing, distribution and marketing of his/her own artwork and in turn keeps all ensuing profits.

Semiannual. Occuring twice a year.

Semimonthly. Occurring twice a month.

Semiweekly. Occuring twice a week.

Serigraph. Silkscreen; method of printing in which a stencil is adhered to a fine mesh cloth stretched over a wooden frame. Paint is forced through the area not blocked by the stencil.

Speculation. Creating artwork with no assurance that a potential buyer will purchase it or reimburse expenses in any way; referred to as work on spec.

Spot illustration. Small illustration used to decorate a page of type, or to serve as a column ending.

Storyboard. Series of panels that illustrate a progressive sequence or graphics and story copy of a TV commercial, film or filmstrip. Serves as a guide for the eventual finished product.

Tabloid. Publication whose format is an ordinary newspaper page turned sideways.

Tearsheet. Published page containing an artist's illustration, cartoon, design or photograph.

Thumbnail. A rough layout in miniature.

TIFF files. Tagged Image File Format—a computer format used for saving or creating graphics.

Transparency. A photographic positive film such as a color slide.

Type spec. Type specification; determination of the size and style of type to be used in a layout.

Velox. Photoprint of a continuous tone subject that has been transformed into line art by means of a halftone screen.

VHS. Video Home System; a standard videotape format for recording consumer-quality videotape, most commonly used in home videocassette recording and portable camcorders.

Video. General category comprised of videocassettes and videotapes.

Wash. Thin application of transparent color or watercolor black for a pastel or gray tonal effect.

Wholesale. The sale of commodities in large quantities usually for resale (as by a retail merchant).

Special Markets Index

The following indexes can help you find the most appropriate listings for the kind of artwork you create. Check the individual listings for specific information about submission requirements.

Informational Graphics

Religious Art

General Index

Companies or galleries that appeared in the 1999 edition but do not appear in this edition are identified by a two-letter code explaining why the market was omitted: (**ED**)—Editorial Decision, (**NS**)—Not Accepting Submissions, (**NR**)—No (or late) Response to Listing Request, (**OB**)—Out of Business, (**RR**)—Removed by Market's Request, (**UC**)—Unable to Contact.

Companies that appeared in the 1999 edition of *Artist's & Graphic Designer's Market*, but do not appear this year, are listed in this General Index with the following codes explaining why these markets were omitted: **(ED)**—Editorial Decision, **(NS)**—Not Accepting Submissions, **(NR)**—No (or late) Response to Listing Request, **(OB)**—Out of Business, **(RR)**—Removed by Market's Request, **(UC)**—Unable to Contact.